PHOTOGRAPHY BOOKS
Index III

A Subject Guide to Photo Anthologies

MARTHA KREISEL

The Scarecrow Press, Inc.
Lanham, Maryland • Toronto • Oxford
2006

SCARECROW PRESS, INC.

Published in the United States of America
by Scarecrow Press, Inc.
A wholly owned subsidary of The Rowman & Littlefield Publishing Group, Inc.
4501 Forbes Boulevard, Suite 200, Lanham, Maryland 20706
www.scarecrowpress.com

PO Box 317
Oxford
OX2 9RU, UK

British Library Cataloguing in Publication Information Available

Library of Congress Cataloging-in-Publication Data
Kreisel, Martha, 1948–
 Photography books index III : a subject guide to photo anthologies / Martha Kreisel.
 p. cm.
 Includes bibliographical references and index.
 ISBN 0-8108-5693-X (pbk. : alk. paper)
 1. Photographs–Catalogs. 2. Photographs–Indexes. I. Title: Photography books index 3.
 II. Title: Photography book index three. III. Title.
 TR199.M67 2006
 779'.01.6–dc22
 2005051306

CONTENTS

This one is for my daughter Sara, with all my love.

PREFACE

The premise for and use of the *Photography Books Index III* are as purposely straightforward as they were for the original *Index* and the first supplement: to continue to provide access to the increasingly abundant photographs published in photo anthologies. It is intended that this *Index* will provide librarians, artists, students, historians, and the general public access by subject and photographer to thousands of these photographs.

As with the first two editions, the list of books indexed was gathered from the *WorldCat*, the OCLC catalog of books and other materials in libraries worldwide, and includes some of the most important and widely held photo anthologies. The books chosen have been published since 1985 and are held by at least 500 libraries across the United States. The exceptions to this limit were the inclusion of volumes from two important photographic series, *Graphis Photo: The International Annual of Photography* and *The Best of Photojournalism: Newspaper and Magazine Photographs of the Year*. The list was further refined by the elimination of purely technical manuals and those works not classified by the Library of Congress as photography books, for example, travelogues and books on social history. Books by or about the photographs of individual photographers were also not included.

Thanks are due for the extraordinary work done by Maureen Brown, Danielle Czarnomski, Sonny McCarron, and Carol Saletto, the staff of the Interlibrary Loan Department for the Hofstra University Libraries, for locating and retrieving dozens of titles for me.

Photographs on the cover are of my Father (far left), my Mother, and me.

USERS' GUIDE

The *Index* has three sections:

I PHOTOGRAPHERS—with an alphabetized listing of their photographs included in the books indexed

II SUBJECTS—with an alphabetized listing of the subject matter of the photographs

III PORTRAITS—with subdivisions for Children, Groups, Men, and Women, alphabetized by the sitters' names.

With slight modifications Library of Congress Subject Headings served as the thesaurus for Section II. Where *see also* is indicated, the additional subjects should also be consulted, as they are unique citations and not merely repetitions of the original entries. Where *see* is indicated, please consult that subject heading.

Not all photographs will be included in the subjects section, and some photographs may appear in more than one section, when appropriate. When it seemed relevant to index by nationality or race, I have done so; otherwise, relevant indication of race or nationality is found in the description of the photograph in the subjects section.

Capitalization and punctuation of titles of photographs may be inconsistent; however, this reflects the style of the sources analyzed. There may also be slight variations in the titles of the photographs between the sections due to space limitations.

Key to Notations

MOMA 2	photo is on page 2
MOMA #23	photo is listed as figure number 23
MOMA \4	photo is listed as plate number 4
*	color reproduction
a	photo position is upper left on page
b	photo position is bottom left on page
c	photo position is upper right on page
d	photo position is bottom right on page
[]	no title given, title provided is subject of photograph
n.d.	no date given

BOOKS INDEXED

Art

The Art of Photography, 1839-1989. Edited by Mike Weaver. London: The Royal Academy of Arts, 1989.

Best11

The Best of Photojournalism/11: Newspaper and Magazine Pictures of the Year. National Press Photographers Association and the University of Missouri School of Journalism. Philadelphia: Running Press Books, 1986.

Best12

The Best of Photojournalism/12: Newspaper and Magazine Pictures of the Year. National Press Photographers Association and the University of Missouri School of Journalism. Philadelphia: Running Press Books, 1987.

Best13

The Best of Photojournalism/13: Newspaper and Magazine Pictures of the Year. National Press Photographers Association and the University of Missouri School of Journalism. Philadelphia: Running Press Books, 1988.

Best14

The Best of Photojournalism/14: Newspaper and Magazine Pictures of the Year. National Press Photographers Association and the University of Missouri School of Journalism. Philadelphia: Running Press Books, 1989.

Best16

The Best of Photojournalism/16: Newspaper and Magazine Pictures of the Year. National Press Photographers Association and the University of Missouri School of Journalism. Philadelphia: Running Press Books, 1991.

Best17

The Best of Photojournalism/17: Newspaper and Magazine Pictures of the Year. National Press Photographers Association and the University of Missouri School of Journalism. Philadelphia: Running Press Books, 1992.

Best18

The Best of Photojournalism/18: Newspaper and Magazine Pictures of the Year. National Press Photographers Association and the University of Missouri School of Journalism. Philadelphia: Running Press Books, 1993.

Best19

The Best of Photojournalism/19: Newspaper and Magazine Pictures of the Year. National Press Photographers Association and the University of Missouri School of Journalism. Philadelphia: Running Press Books, 1994.

Best21

The Best of Photojournalism/21: Newspaper and Magazine Pictures of the Year. National Press Photographers Association and the University of Missouri School of Journalism. Philadelphia: Running Press Books, 1996.

Best22

The Best of Photojournalism/22: Newspaper and Magazine Pictures of the Year. National Press Photographers Association and the University of Missouri School of Journalism. Philadelphia: Running Press Books, 1997.

Best23

The Best of Photojournalism/23: Newspaper and Magazine Pictures of the Year. National Press Photographers Association and the University of Missouri School of Journalism. Philadelphia: Running Press Books, 1998.

Best24

The Best of Photojournalism/24: Newspaper and Magazine Pictures of the Year. National Press Photographers Association and the University of Missouri School of Journalism. Philadelphia: Running Press Books, 1999.

Capture

Capture the Moment: The Pulitzer Prize Photographs. Edited by Cyma Rubin and Eric Newton. New York: W. W. Norton, 2000.

Committed

Committed to the Image: Contemporary Black Photographers. Edited by Barbara Head Millstein. Brooklyn: Brooklyn Museum of Art, 2001.

Decade

Decade by Decade: Twentieth-Century American Photography from the Collection of the Center for Creative Photography. Edited by James Enyeart. Boston: Little, Brown, 1988.

Documenting

Documenting America 1935-1943. Edited by Carl Fleischhauer and Beverly W. Brannan. Berkeley, CA: University of California Press, 1988.

Eyes

Eyes of Time: Photojournalism in America. Edited by Marianne Fulton. New York: New York Graphic Society, 1988.

Fisher

Fisher, Andrea. *Let Us Now Praise Famous Women: Women Photographers for the U.S. Government, 1935 to 1944.* London: Pandora Press, 1987.

Goldberg

Goldberg, Vicki, and Robert Silberman. *American Photography: A Century of Images.* San Francisco: Chronicle Books, 1999.

Graphis89

Graphis Photo: The International Annual of Photography. Zurich, Switzerland: Graphis Press, 1989.

Graphis90

Graphis Photo: The International Annual of Photography. Zurich, Switzerland: Graphis Press, 1990.

Graphis91

Graphis Photo: The International Annual of Photography. Zurich, Switzerland: Graphis Press, 1991.

Graphis92

Graphis Photo: The International Annual of Photography. Zurich, Switzerland: Graphis Press, 1992.

Graphis93

Graphis Photo: The International Annual of Photography. Zurich, Switzerland: Graphis Press, 1993.

Graphis96

Graphis Photo: The International Annual of Photography. Zurich, Switzerland: Graphis Press, 1996.

Graphis97

Graphis Photo: The International Annual of Photography. Zurich, Switzerland: Graphis Press, 1997.

Hambourg

Hambourg, Maria Morris. *The New Vision: Photography between the World Wars: Ford Motor Company Collection at the Metropolitan Museum of Art.* New York: Metropolitan Museum of Art, 1989.

Icons

Icons of Photography: The 20th Century. Edited by Peter Stepan. Munich: Prestel, 1999.

Lacayo

Lacayo, Richard, and George Russell. *Eyewitness: 150 Years of Photojournalism.* New York: Time Books, 1995.

Life

Life Sixty Years: A 60th Anniversary Celebration, 1936-1996. New York: Time Life Books, 1996.

Marien

Marien, Mary Warner. *Photography: A Cultural History.* New York: Harry N. Abrams, 2002.

MOMA

Museum of Modern Art (New York, N.Y.) *American Photography, 1890-1965, from the Museum of Modern Art, New York.* Edited by Peter Galassi. New York: The Museum of Modern Art, 1995.

Monk

Monk, Lorraine. *Photographs That Changed the World: The Camera as Witness, the Photograph as Evidence.* New York: Doubleday, 1989.

National

National Museum of American Art. *American Photographs: The First Century: From the Isaacs Collection in the National Gallery of American Art*. Merry A. Foresta. Washington, DC: Smithsonian Institution Press, 1996.

Peterson

Peterson, Christian A. *After the Photo-Secession: American Pictorial Photography, 1910-1955*. Minneapolis: Minneapolis Institute of Arts, 1997.

Photo00

Photo Annual 2000: The International Annual of Photography. Zurich, Switzerland: Graphis Press, 2000.

Photography

Photography Past Forward; Aperture at 50. With a history by R. H. Cravens. New York: Aperture, 2002.

Photography1

Photography in Nineteenth-Century America. Edited by Martha A. Sandweiss. Fort Worth, TX: Amon Carter Museum of Western Art, 1991.

Photography2

Photography and Art: Interactions since 1946. Andy Grundberg and Kathleen McCarthy Gauss. Fort Lauderdale, FL: Museum of Art, 1987.

Photos

Photos That Changed the World: The 20th Century. Edited by Peter Stephan. Munich: Prestel, 2000.

Rolling

Rolling Stone: The Photographs. New York: Simon & Schuster, 1989.

Rosenblum

Rosenblum, Naomi. *A History of Women Photographers*. New York: Abbeville, 1994.

Rosenblum2

Rosenblum, Naomi. *A World History of Photography*. New York: Abbeville, 1997.

San

San Francisco Museum of Modern Art. *Photography: A Facet of Modernism*. New York: Hudson Hills Press, 1986.

Sandler

Sandler, Martin W. *Against the Odds: Women Pioneers in the First Hundred Years of Photography*. New York: Rizzoli International, 2002.

Szarkowski

Szarkowski, John. *Photography Until Now*. New York: Museum of Modern Art, 1989.

Through

Through the Lens: National Geographic Greatest Photographs. Washington, DC: National Geographic Society, 2003.

Vanity

Vanity Fair: Photographs of an Age: 1914-1936. Edited by Diana Edkins Richardson. New York: Clarkson N. Potter, 1982.

Waking

The Waking Dream: Photography's First Century: Selections from the Gilman Paper Company Collection. Maria Morris Hambourg. New York: Metropolitan Museum of Art, 1993.

Willis

Willis, Deborah. *Reflections in Black: A History of Black Photographers 1840 to the Present*. New York: W.W. Norton, 2000.

Women

Women Photographers. Edited by Constance Sullivan. New York: Abrams, 1990.

I
PHOTOGRAPHERS

descend from plants that took root there 75 million years ago" 1991* (Through 398)

"Carnival participants in whimsical costumes stroll along a street in Venice" 1995* (Through 114)

"Cowboys in Montana" 1984* (Through 10)

"A father, son, and dog roll past miles of hedgegrows in Wales" 1993* (Through 96)

"Fishermen use nets to harvest the waters off Newfoundland" 1974 (Through 368)

"In Seattle, Washington, an artist's baby sleeps while a party gets under way elsewhere in the house" 2000* (Through 342)

"In Tokyo, Japan, guests of the emperor attend a garden party honoring statesmen, scientists, and other exceptional citizens" 2001* (Through 138)

"Pears ripen on a windowsill near the Kremlin in Moscow" 1986* (Through 38)

"Unique to North America, the pronghorn is an unforgettable sight" 1984* (Through 334)

ABRY, Stephan
"Kaiserkrone" c. 1999* (Photo00 196)
[Taro root, Lotus root, Cameroonian gourd, Turia gourd] c. 1995* (Graphis96 93)

ACKERMAN, Peter
"Chris Purpura, 8, gives moral support to Matt Johnson, 8, between rounds at a weekly boxing clinic" 1988 (Best14 128c)
"Gregory Cranmer, 4, cries as referee corrects his starting position during the Just for Fun wrestling tournament" 1993* (Best19 152)
"Sam Hung, master sneakbox builder, bayman, hunter and folk musician, plays on the harmonica he's had for decades" 1996* (Best22 209d)

ACME NEWSPICTURES
"Amelia Earhart" 1932 (Vanity 128)
"Bill Tilden" 1934 (Vanity 177)
"Charles A. Lindbergh" 1935 (Vanity 129)
"Josef Stalin" n.d. (Vanity 76)
"Large fancy hats adorn ladies from the Spreewald swamps near Berlin" 1937 (Through 84)
"Passengers on a German Junkers trimotor enjoy first-class service on a flight between Berlin and Amsterdam" 1933 (Through 100)

ADAM-SALOMON
"Portrait of a Girl" c. 1862 (Rosenblum2 #55)

ADAMS, Ansel, 1902-1984
"Aspens, Northern New Mexico" 1958 (MOMA 186)
"Black Giant near Muir Pass, King's Canyon" 1930 (Goldberg 75)
"Church at Ranchos de Taos" c. 1930 (Decade 41c)
"Frozen Lake and Cliffs, The Sierra Nevada, Sequoia National Park, California" 1932 (Hambourg 54c; Rosenblum2 #536)
"The Great Plains from Cimarron, New Mexico" 1961 (Decade \79)
"Half Dome from Glacier Point, Yosemite National Park" c. 1956 (Decade \60)
"Lake McDonald, Glacier National Park" 1942 (MOMA 117)
"Monolith, The Face of Half Dome, Yosemite Valley" c. 1927 (Rosenblum2 #537)
"Moonrise Over Hernandez, New Mexico" c. 1941 (Icons 96)
"North Dome, Basket Dome, Mount Hoffman, Yosemite" c. 1935 (National \63)

"Old Faithful Geyser, Yellowstone National Park" 1942 (MOMA 120, 121)
"Plant of the U.S. Potash Company, Carlsbad, New Mexico" 1941 (Photography 21)
"Rocks and Grass, Moraine Lake, Sequoia National Park, California" c. 1932 (Szarkowski 223)
"Roots, Foster Gardens, Honolulu, Hawaii" 1948 (Photography2 30)
"Sculptor's Tools, San Francisco, California" c. 1930 (Decade 37d)
"Valley View, Yosemite National Park, California" c. 1933 (Marien \5.49)
"White House Ruin, Canyon de Chelly, Arizona" 1942 (Icons 97)
"Windmill, Owens Valley" 1938 (Decade \35)

ADAMS, Edward T., 1934-
"Viet Cong Execution" or "Execution of a Viet Cong Suspect, Vietnam" or "South Vietnamese National Police Chief Nguyen Ngoc Loan Executing Vietcong Suspect" 1968 (Capture 64; Eyes #300-302; Goldberg 174; Lacayo 156; Marien \6.72; Monk #42; Photos 115)

ADAMS, Mac, 1943-
"Smoke and Condensation" 1978 (Photography2 156)

ADAMS, Robert, 1937-
"Adams County, Colorado" 1973 (Icons 168)
"Berthoud, Colorado" 1979 (Art \372)
"Clearcut, Columbia County, Oregon" 2001 (Photography 189)
"Clearcut, Oregon" 1999 (Photography 188)
"Colorado Springs, Colorado" 1968 (Art \369)
"East from Flagstaff Mountain, Boulder County, Colorado" 1976 (Szarkowski 290)
"Fort Collins, Colorado" 1979 (Art \371)
"Garden of the Gods, El Paso County, Colorado" 1977 (Art \367; Decade \98)
"La Loma Hills, Colton, California" 1983 (Art \368)
"Los Angeles, Spring" 1984 (Art \366)
"Newly occupied tract houses, Colorado Springs, Colorado" 1968 (Goldberg 201; Marien \6.56)
"Untitled" 1973 (Art \370)

ADASKAVEG, Mike
"Mailman works his way down a rack of mailboxes at a trailer park" 1985 (Best11 143b)

ADDICKS, Rich
"Child and mother huddle inside a feeding center run by relief agencies where omnipresent flies gather" 1998 (Best24 185c)
"Considered one of the greatest hurdlers of all time, Edwin Moses enters his new career as a financial consultant" 1995* (Best21 117d)
"Long jump world record holder Mike Powell lies in the sand after his final attempt at the 1996 Olympics" 1996* (Best22 118a)
"Mexican diver Fernando Platos displays perfect form" 1995* (Best21 107)
"Paralympian shows his determination in the long jump as he tries out new leg" 1995* (Best21 104a)
"Two youngsters pass time in a San Salvadoran cemetery on a Sunday" 1986 (Best12 66b)

ADENIS, Pierre
[Russian soldier] c. 1995* (Graphis96 62)

AFANDOR, Ruven
"Ethan Stiefel" c. 1995 (Graphis96 137)
[feather headdress on man smoking] c. 1997
(Graphis97 107)
[untitled] c. 1995* (Graphis96 14, 16, 17)
"Val Kilmer as Batman in *Batman Forever*" c. 1995*
(Graphis96 102)
"Wayne Wang" c. 1995* (Graphis96 139)

AFONG LAI
"Wreck of the Steamers 'Leonor' and 'Albay' Praya
and Douglas Wharf Destroyed by Typhoon" 1874
(Marien \3.38)

AGEE, Bill
"November Light" c. 1990 (Graphis90 \151)

AGUADO, Onésipe, 1831-1893
"Woman Seen from the Back" c. 1862 (Waking #45)

AGUILERA-HELLWIG, Max
"Martin Scorsese" c. 1992* (Graphis93 122a)
"Traveling the Texas-Mexico border" c. 1991
(Graphis91 \185-\188)

AHRENS, Judy
"On Orient, Long Island, an unhappy owner tried to
get to his auto" 1985 (Best11 71b)

AIGNER, Lucien, 1901-
"Austrian Chancellor, Dr. Kurt Schuschnigg" 1935
(Eyes #158)
"Benito Mussolini at Stresa" 1935 (Eyes #157)
"A diplomatic conference at the Quai d'Orsay" 1935
(Eyes #155)
"Edouard Herriot, French Prime Minister" 1932
(Eyes #156)

AIKEN, Paul
"An unidentified man wields a knife in a photo" 1987
(Best13 62)

AIREY, Chris
[desk lamp] c. 1992* (Graphis93 152c)

AKELEY, C. E.
"A picture of a black rhino helped illustrate 'Where
Roosevelt Will Hunt'" 1909 (Through 280)

AKIN, Gwen and Ludwig, Allan
"Goose" 1985* (Decade \IX)

ALBERGAMO, Giuseppe, 1888-1964
"Light Weavings" 1939 (Hambourg \78)

ALBERS, Clem
"A young evacuee of Japanese ancestry waits with
baggage before leaving for assembly center" 1942
(Goldberg 112)

ALBERS, Josef, 1888-1976
"El Lissitzky at the Bauhaus" 1928 (Hambourg \76)
"Paul Klee, Dessau" 1929 (Szarkowski 245)

ALBIN GUILLOT, Laure, 1879-1962
"Diatom" 1931 (Marien 5.74)
"Untitled" before 1930 (Rosenblum \113)

ALBRECHT, Eric
"Boy gets lots of mileage from an old rocking horse

his grandfather tied to a tree" 1986 (Best12 170)
"Yavonna Prophet sweeps her apartment as the only
heat comes from a gas stove" 1991* (Best17 112b)

ALCOCK, Amanda
"The Ackermans spend a sad, tense moment in their
daughter's room before pleading for her return"
1985 (Best11 111a)
"When a Japanese visitor toasted Chicago's Mayor
Harold Washington with a cup of sake, the mayor's
reaction was hardly diplomatic" 1986 (Best12 95a)

ALENIUS, Edward, 1892-1950
"Stainless Steel" c. 1940 (Peterson #22)

ALESSANDRI, Claudio
[athlete of the Austrian Olympic team] c. 1992*
(Graphis93 108)
[tail of a chameleon] c. 1995* (Graphis96 184)

ALEXANDER, Cherry
"Chinstrap penguins hitch a ride on an intricately
sculpted blue iceberg in the sub-Antarctic" 1995*
(Best21 159a)

ALEXANDER, Dean
[Pricewaterhouse Coopers employee] c. 1999*
(Photo00 34)

ALEXANDER, Jeff
"Apple's eye view of a childhood tradition makes
Halloween art" 1985* (Best11 145b)
"Courtney Jackson slams into the fence during a city
softball championship" 1987 (Best13 225)
"2-year-old leads world's smallest horse" 1985
(Best11 172a)

ALEXANDROVNA, Xenia, Grand Duchess of Russia,
1875-1960
"Outings at Gatchina" 1905 (Waking #139)

ALI, Salimah, 1954-
"Day of Atonement at the UN Plaza, Muslim
Women" 1996 (Committed 45; Willis \299)
"Million Women March in Philadelphia" 1997
(Willis \300)
"Million Youth March" 1998* (Committed 44)

ALINARI, Leopoldo, 1832-1865; Giuseppe, 1836-
1891; Romualdo, 1830-1891
"Palazzo delle Cascine, Florence" c. 1855
(Szarkowski 122)

ALINSANGAN, Susan
[transformation of the human body in water] c. 1992*
(Graphis93 199)

ALKOFER, Bill
"Flock of sheep" 1985 (Best11 155a)
"An old woman struggles through 20-foot high snow
drifts left by a blizzard" 1997* (Best23 117)
"Remote camera records the action as a minor league
player dives back safely" 1995* (Best21 115)

ALLARD, William Albert
"At a summer festival in Boston, Italian Americans
honor St. Anthony, whose statue bears offerings for
miracles" 2000* (Through 292)
"An eight-year-old boy proudly sports his best suit for
a wedding in Sciacca, Sicily" 1995* (Through 76)

"Gazing through a black veil, a Sicilian actress strikes a dramatic pose" 1995* (Through 89)

"In Catania, Sicily, soccer fans react to World Cup action on their TV screen" 1995* (Through 90)

"In Lima, Peru, the Plaza de Acho–oldest bullring in the Americas–attracts matadors from Spain and Latin America" 1982* (Through 374)

"Laundry in Sicily" 1995* (Through 4)

"Models wearing Yves Saint Laurent designer gowns prepare to parade down a runway in France" 1989* (Through 86)

"A mounted guard keeps close watch over inmates from the Mississippi State Penitentiary" 1989* (Through 376)

"Players compete for major-league positions at a Milwaukee Brewers training facility near Phoenix, Arizona" 1991* (Through 354)

"Playing the blues–often called America's music–is a family affair in Clarksdale, Mississippi" 1999* (Through 358)

"Provence, France, poppies are like dashes of red paint in an idyllic landscape" 1995* (Through 56)

"A villager spends the afternoon at a café in Alcara li Fusi, Sicily" 1995* (Through 118)

"Vineyards near the hilltop town of La Morra, Italy" 2002* (Through 40)

"A white-clad *razeteur* dodges the horns of a charging bull and thrills spectators at a bullfight in St. Remy-de-Provence" 1995* (Best21 127)

ALLBRITTON, Raymond
[untitled] c. 1995* (Graphis96 105)

ALLEMAN, Thomas
"Arkansas delegates wear 'Let Pat Speak' stickers over their mouths" 1996* (Best22 110b)
"Flood waters" 1995* (Best21 214b)
"Kidnapped daughter" 1995* (Best21 214a)
"Mexican wrestling, 'Grand entrance'" 1995* (Best21 215a)
"Santa School" 1995* (Best21 215d)
"Stetson-hatted Arizona delegate looms above Ohioans of a different sartorial persuasion while all listen to Bob Dole" 1996* (Best22 110d)
"Ten-year-old finishes his solo at the Democratic National Convention" 1996* (Best22 110a)
"TV cameramen seem weary and bored at the 1996 convention" 1996* (Best22 110a)

ALLEN, Frances, 1854-1941, and Mary, 1858-1941
"The Doorway" c. 1890 (Sandler 16c)
"A Holbein Woman" c. 1890 (Sandler 32)
"Pocumtuck basket makers" c. 1900 (Rosenblum \53)

ALLEN, James Latimer, 1907-1977
"Jacob Lawrence, artist" c. 1937-1939 (Willis \72)
"Langston Hughes, writer" c. 1927 (Willis \73)
"Norman Lewis with etching press" c. 1937-1939 (Willis \74)
"Richard B. Harrison, actor" 1933 (Willis \75)

ALLEN, Jules, 1947-
"Gleason's Gym" 1983 (Committed 46)
"Untitled" 1987 (Committed 47)

ALLERT, Peter
"180 Objectiv" c. 1999* (Photo00 177)

ALLISON, Robert
"Binti-Jua rescues a 3-year-old who fell into the primate habitat at the Brookfield Zoo" 1996* (Best22 143)

ALPERN, Merry
"A.J. and Jim Bob" 1988 (Best14 168-172)

ALPERT, Max
"Construction Site of the Fergana Grand Canal" 1939 (Rosenblum2 #600)

ALPS, Bernardo
"Rescuers load an abandoned newborn gray whale on a stretcher" 1997* (Best23 119c)
"A striking janitor is clubbed by Los Angeles police officers after breaking through police lines during a protest march" 1990* (Best16 111)

ALTMAN, Jennifer Sue
"[Boys] keep score for the Kingsbridge All-Stars vs Westside game in Bronx, NY" 1996 (Best22 199b)

ALTOBELLI, Gioacchino
"Night View of the Roman Forum" 1865-1875 (Rosenblum2 #128)

ALVAREZ, Angelica M.
[swimming pool and ocean] c. 1991 (Graphis92 \210)

ALVAREZ BRAVO, Manuel, 1902-
"Daydream" 1931 (Szarkowski 230)
"The Dreamer" 1931 (Icons 49)
"Good Reputation Sleeping" 1938-39 (Marien \6.12)
"Optic Parable" 1931 (Rosenblum2 #501)
"Sunday Cyclists" 1966 (Icons 48)

AMAKI, Amalia, 1949-
"Three Cheers for the Red, White & Blue, nos. 8, 15, 16" 1995* (Willis \454-\456)

AMDURSKY, Ralph
"Colorama (Blue 'Woody' Stationwagon in Front of Summer Cottage)" n.d. (Marien \6.64)

AMMONS, Linda L., active 1980s-date
"Scenes from the Southwest" 1990* (Willis \478)

AMRUTH, Ramesh
[pear halves] c. 1992* (Graphis93 87)

AMUNDSON, Garth
[from *Dr. Kempf's Nightmare*] 1995 (Marien \7.92)

ANDERS, William, 1933-
"Earthrise" or "Apollo 8 Earthrise view" 1968* (Goldberg 178; Lacayo 163; Monk #51)

ANDERSON, Christopher
"A cyclist is treated to a rainbow as he rides to work" 1993* (Best19 70)
"High school drill in lycra sacks" 1998* (Best24 88a)

ANDERSON, Daniel
"Dune Magic" 1990* (Best16 141d)
"A great blue heron finds refuge from the California desert at a watering hole" 1987* (Best13 175c)
"Grossman, 67, brings down the house when he swishes in elephantine drag" 1986 (Best12 136b)
"Socks Appeal" 1990* (Best16 142b)
"Sundress Sweet" 1990* (Best16 143)

ANDERSON, Daniel A.
"Alarmingly high lead blood levels have been found in Mexican children whose parents work in certain manufacturing area" 1998* (Best24 190)
"During opening ceremonies for the Summer Olympics in Barcelona, the torch bearer circles the track" 1992* (Best18 156a)
"Loss of Hope, motel children" 1998* (Best24 146-155)
"Mark Henry sets his personal best of 468 pounds in the clean-and-jerk lift in the super heavyweights in the Summer Olympics" 1992* (Best18 155)
"Members of the Nigerian 4x100 relay team celebrate as the scoreboard indicates a bronze-medal performance" 1992* (Best18 156d)
"Pablo Morales rests after capping a comeback from a layoff by winning the gold medal in the 100-meter butterfly" 1992* (Best18 144)
"This silverback gorilla, found in the mountains bordering Rwanda, is an endangered species" 1995* (Best21 158b)

ANDERSON, David P., and Southern Methodist University
"Venus–a brilliant light in Earth's morning and evening skies–presents a craggy face to the orbiting Magellan spacecraft" 1993* (Through 468)

ANDERSON, Gustav, 1897-1974
"Winter Eve" 1938 (Peterson #51)

ANDERSON, James
"Michelangelo's *Moses* from the Tomb of Julius II" early 1850s (Rosenblum2 #284)

ANDERSON, Kathy
"Cycle of Abuse" 1993* (Best19 172)
"Four days after the mud slide, the arm of a corpse sends a grim signal" 1985 (Best11 21a)
"New Orleans police officers restrain the Rev. Avery Alexander, longtime civil-rights leader during scuffle" 1993* (Best19 190b)

ANDERSON, Keith
"Sherri Sutherland is the only girl on the Junior League football team" 1986 (Best12 198a)

ANDERSON, Paul L., 1880-1956
"Sunday Morning" 1939 (Peterson #5; Szarkowski 172)
"Under the Brooklyn Bridge" 1917 (Decade \8)

ANDERSON, Todd
"Pole vaulter misses an attempt to clear the bar during a Big 10 triangular track meet" 1992 (Best18 136a)
"Youngsters watch the movie *Dances with Wolves* at a drive-in theater near Jackson Hole, Wyo." 1991 (Best17 72)

ANDONIAN, Michelle
"Belle Island in Detroit was the location for this fashion shoot" 1988 (Best14 156d)

ANDREWS, Nancy
"After a long day, neighbors let out a little steam as they talk of the day's events" 1998 (Best24 186)
"Army sergeants trade backrubs after a long day's work" 1997 (Best23 19c)
"Bosnia: A Hopeful Peace" 1997 (Best23 129a, 202)
"City religious leaders lay their hands on Washington D.C. delegate before she returns to Capitol Hill" 1997 (Best23 21d)
"Competitors in the boys group wait as the winners are called" 1997 (Best23 17d)
"Co-workers share some fun and excitement during an office Christmas party" 1997 (Best23 20b)
"Divorced Family" 1995 (Best21 204)
"Every day is Father's Day" 1997 (Best23 28-29)
"Feline Haven" 1997 (Best23 22-23)
"Historic Entrance" 1997 (Best23 24-25)
"Last all-male class at Virginia Military Institute lines up 'nuts to butts' during ritualized hazing" 1997 (Best23 18)
"A look inside VMI" 1995 (Best21 211)
"Mei Ling stands in the light of a snowflake" 1997 (Best23 15c)
"More and more older women are becoming Bat Mitzvah" 1997 (Best23 15d)
"Patient in AIDS hospice in Thailand" 1998 (Best24 89a)
"People live in these cribs all their lives at Bosnia home for children" 1997 (Best23 17a)
"Portrait of author Norman Mailer" 1997 (Best23 14)
"Prostitutes look for customers on a rainy night" 1995 (Best21 186a)
"Religious Row" 1997 (Best23 26-27)
"Renee Johnson, after being baptized, rushes into the arms of Mother Arlgo Jordan" 1997 (Best23 20a)
"Shawantee cries because she doesn't want to go home from daycare program" 1997 (Best23 16a)
"Sisters model their wedding gowns for their grandmother" 1992 (Best18 118)
"Teenagers grieve for classmates who vanished from their home and were later found dead near a river" 1997 (Best23 21a)
"Ukranians who live downwind from Chernobyl stayed with American families this summer" 1997 (Best23 16b)
"White-gloved cadets at Virginia Military Institute take down the flag at sunset" 1997 (Best23 19d)

ANDREWS, Nancy N.
"To tame wild blackberries, all you need is a spoon and some cream" 1987* (Best13 183d)

ANDRIESSE, Emmy, 1914-1953
"Germaine Richier" 1948 (Rosenblum \184)

ANDRUS, Ellen Amanda, 1871-1950 attribution
"Man Jumping Fence" 1889 (Photography1 \81a)
"Pier Ditto" 1889 (Photography1 \81d)

ANDUJAR, Claudia, 1931-
"Yanomami" 1976 (Rosenblum \190)
"Yanomami Youth During a Traditional Reahu Festival" 1978 (Marien \6.6)

ANGELICAS, Emmanuel
"Nightlife of Bangkok" c. 1990 (Graphis90 \261-\264)

ANGERER, Bernhard
"Ad for the gastronomic profession" c. 1989* (Graphis89 \328)
[custom-made shoes] c. 1992* (Graphis93 40)
[from a catalog for sanitary installations] c. 1991* (Graphis91 \257)

ANGLO-AUSTRALIAN OBSERVATORY
"Scattered stars amid the Orion nebula illuminate an evolving cloud of gas and dust" 1995* (Through 464)
"Whirling millions of light-years from Earth, Galaxy NGC 2997 resembles our spiral galaxy–the Milky Way" 1983* (Through 454)

ANIKEEF, Sybil
"Lighthouse Lens" c. 1937 (Sandler 178)

ANNAN, James Craig, 1864-1946
"A Back Canal (probably Venice)" 1894 (Rosenblum2 #369)
"Miss Janet Burnet" 1893 (Marien \4.15)

ANNAN, Thomas, 1829-1887
"Close #37, High Street" 1868 (Marien \3.87)
"Close #75, High Street" 1868 (Rosenblum2 #437)

ANNAS, Harry
"Hispanic Father and Son" 1943 (Goldberg 114)

ANSCHÜTZ, Ottomar, 1846-1907
"Storks" 1884 (Rosenblum2 #300; Szarkowski 133)

ANSHUTZ, Thomas, 1851-1912
"Boys with a Boat, Ohio River" 1880 (National \44)

ANTHONY, Edward and Henry T.
"El Capitán" n.d. (Decade 5)
"New York Street Scene" 1859 (Rosenblum2 #189)

ANZAI, Shigeo, 1939-
[from a book on the Isamu Noguchi Garden Museum] c. 1991 (Graphis91 \316-\320)

APOLLO II
[The far side of the moon] 1969* (Marien \6.65)

APPELT, Dieter
"Hands" 1978 (Rosenblum2 #731)

APPLETON, Jeannette M.
"Eagle Head Rock" 1890 (Rosenblum \88)

APPS, Steve
"An early-morning summer storm builds over the Gulf of Mexico near Sarasota" 1991* (Best17 74)

ARAKAWA, Patience
"Winter Dreams–Seasons pass but we remain" c. 1989* (Graphis89 \309)

ARAKI, Nobuyoski, 1932-
[toy dinosaur on shoe] c. 1997* (Graphis97 43)
"Untitled" 1996-1997* (Marien \7.70)

ARBUS, Amy
"Neck," "Sneeze," "Ear," "Angry Girl" c. 1995 (Graphis96 124)

ARBUS, Diane, 1923-1971
"Albino Sword Swallower at a Carnival" 1970 (Women \130)
"Boy with Straw Hat Waiting to March in a Pro-War Parade" 1967 (Icons 159; MOMA 237)
"A Child crying, New Jersey" 1967 (Art \330)
"Child with Toy Hand Grenade in Central Park, New York City" 1962 (MOMA 243; Photos 101)

"A Family on their Lawn one Sunday in Westchester, New York" 1969 (Art \329)
"Girl in her circus costume" 1970 (Photography 91)
"Girl with a Watch Cap, New York City" 1965 (Women \132)
"Girl with patterned stockings" c.1967 (Women \131)
"Identical twins, Roselle" 1967 (Photography 90)
"Mother Holding Her Child" 1967 (Rosenblum2 #674)
"Puerto Rican Woman with a Beauty Mark, New York City" 1965 (Art \331)
"Seated man in bra and stockings" 1967 (Rosenblum \256)
"Teenage Couple on Hudson Street, New York City" 1963 (MOMA 246)
"Untitled" 1970-71 (Szarkowski 260)
"Untitled (6)" 1970-71 (Art \328)
"Untitled (7)" 1970-71 (Women \133)

ARBUTHNOT, Malcolm, 1874-1968
"Elsie Janis" n.d. (Vanity 25)
"George Bernard Shaw" 1920 (Vanity 35)
"Irene Castle" 1919 (Vanity 26)
"Joseph Conrad" 1924 (Vanity 68)

ARCHER, Charles K., 1869-1955
"Bridge Beam Shadows" c. 1927 (Peterson #80)

ARCHER, Fred R., 1889-1963
"An Illustration for the Arabian Nights" c. 1924 (Peterson #43)

ARIAS, Juana
"Dancing at the Happy Hour, at Adult Daycare" 1998 (Best24 101d)
"Mitch Destruction" 1998 (Best24 26-27)
"Welfare caseworker talks to child while brother sleeps" 1997 (Best23 136a)
"Woman losing her bikini top during the WHFS concert" 1998 (Best24 100a)

ARMER, Laura Adams
"Americans" 1930s (Sandler 109)
"Chinatown" c. 1908 (Rosenblum2 #394)

ARMSTRONG, Neil, 1930-
"Edwin 'Buzz' Aldrin on the Moon" 1969* (Eyes #367; Monk #47; Photos 125)

ARNDT, Gertrud, 1903-
"Untitled" 1930 (San #32, San \13)

ARNDT, Thomas Frederick
"Men Riding Bus" 1981 (Rosenblum2 #696)

ARNOLD, C. D. (Charles Dudley) 1844-1927
"Basin and the Court of Honor" 1893 (Marien \4.51)
"Ferris Wheel: World Columbian Exposition" 1893 (Szarkowski 154)
"World's Columbian Exposition, Chicago" 1893 (Photography1 \13)

ARNOLD, Eve, 1913-
"Owner of the 711 Bar" 1952 (Rosenblum \178)

ARNOLD, Rudy
"Hindenburg, May 6" 1937 (Eyes #170)

ARTHUS-BERTRAND, Yann
[Hulis men, a tribe from Papua, wearing swimming

trunks] c. 1991* (Graphis92 \37)
"Lido di Jesolo, Venice" c. 1990* (Graphis90 \102)

ASAYAMA, Nobuo
[from a brochure for the Kokuyo Co.] c. 1991*
(Graphis 91 \275-\277)

ASHE, Terry
"Law Professor Anita Hill confers during Senate
confirmation hearings for Supreme Court nominee
Clarence Thomas" 1991* (Best17 116a)
"Oliver North taking the stand during the Iran Contra
hearings" c. 1987* (Graphis89 \252)

ASHTON, Horace D.
"Underwood & Underwood photographer making
views from Metropolitan Tower, New York City"
1911 (Goldberg 10)

ASHTON, Ken D., 1963-
"Downtown Baltimore" 1998* (Willis \424)
"The Howard Theatre, Washington, D.C." 1998
(Willis \325)

ASKEW, Thomas E., c. 1850s-1914
"Summit Avenue Ensemble" c. 1880s (Willis \34)

ASNIN, Marc
"Skinheads salute a Nazi flag" 1988 (Best14 14b)

ASSAF, Christopher T.
"Late at night, workers change the movie marquee"
1993 (Best19 72a)

ASSET, Bernard
"At the Grand Prix de Monaco 1980 Dekek Daly on
Tyrrell is carried from the curve of Sainte Dévote"
c. 1980 (Graphis89 \238)

ASTOR, Josef
[for fashion feature on what famous people would
wear] c. 1991* (Graphis91 \57)

ATANIAN, Matthew
[climbing a mast] c. 1995* (Graphis96 201)

ATGET, Eugène, 1857-1927
"Avenue des Gobelins" 1925 (Art \270; Rosenblum2
#319)
"Brothel at Versailles" c. 1921 (Art \268)
"Café, Avenue de la Grande-Armée" 1924-25
(Marien \5.65; Waking #169)
"Magasin, Avenue des Gobelins" 1925 (Art \271;
Decade 11a; Hambourg \31)
"La Marne à la Varenne" 1925-1927 (Rosenblum2
#328)
"The Organ-Grinder and the Singing Girl" 1898-99
(Icons 13; Waking #162)
"Parc de Sceaux" 1921 (Art \267)
"Parc de Sceaux, May–7 a.m." c. 1925 (Art \266)
"The Pond, Ville-d'Avray" 1923-25 (Art \264)
"Rue Asselin" 1924-25 (Waking #166)
"Saint-Cloud" 1915-19 (Szarkowski 235); 1926
(Szarkowski 234)
"Verrières–Picturesque Corner, Old Building" 1922
(Art \265)
"Versailles, Brothel, Petite Place" 1921 (Icons 12)
"Versailles, Orangerie Staircase" 1901 (Waking
#165)
"La Villette, rue Asselin, prostitute taking a break"

1921 (Art \269; Rosenblum2 #327)

ATKINS, Anna, 1799-1871
"Iris pseudacorus" c. 1861* (Women \3)
"Lycopodium Flagellatum (Algae)" 1840s-1850s*
(Rosenblum2 #329)
"Papaver Rhoeas" 1845* (Rosenblum \2)
"Polypodium aureum (Jamaica)" c. 1854* (Women
\2)
"Poppy" c. 1852* (Marien \2.14)

ATKINS, Chloe
[fruit and a key] c. 1997* (Graphis97 88)

ATKINS, Doug
"More than 500,000 people flocked to the 50th
anniversary of San Francisco's Golden Gate
Bridge" 1987 (Best13 109a)
"Police arrest an anti-apartheid protester on the
University of California campus in Berkeley" 1986
(Best12 54c)

ATKINS, Ollie
"President Nixon at dinner hosted by Chinese Premier
Chou En-Lai, Hangchow" 1972* (Life 31d)

ATLAN, Jean-Louis
"President and First Lady make a Thanksgiving visit
to U.S. troops in Saudi Arabia" 1990* (Life 36d)

ATS SATELLITE
"Earth as viewed from ATS Satellite" 1967* (Marien
\6.67)

ATWOOD, Jane Evelyn
"U.S.S.R. Women's Prisons" 1990 (Best16 215-228)
"Women Behind Bars" 1997 (Best23 212)

AUBES
"Paul Valéry" 1929 (Vanity 108b)

AUBIN, Theresa
"Protesting a call by the referee" 1986 (Best12 206b)

AUBRY, Charles Hippolyte, 1811-1877
"Leaf arrangement" 1860s (Szarkowski 100)
"Study of Leaves" 1864 (Art \84; Rosenblum2 #262)

AUERBACH, Ellen, 1906-
"Eckstein with Lipstick" 1930 (Icons 37)
"Kurfursterstr" 1931 (Women \93)
"Slums, London" 1935 (Icons 36)
"Threads" 1930 (Rosenblum \132)

AUSTEN, Alice, 1866-1952
"Hester Street Egg Stand Group" 1895 (Rosenblum
\104; Rosenblum2 #317; Sandler 27)
"Organ-Grinder Couple, N.Y." 1896 (Marien \4.45)
"South Beach" 1886 (Photography1 \84)
"Trude & I Masked, Short Skirts" 1891 (Sandler 26)

AUSTIN, Alice, 1862-1933
"Reading" c. 1900 (Rosenblum \77; Sandler 64a)

AVAKIAN, Alexandra
"Fall of Berlin Wall" 1989* (Lacayo 172; Life 78)
"Gaza: Where Peace Walks a Tightrope" 1996*
(Best22 242a, c)
"In the battle-weary Gaza Strip, a woman holds a
symbol of freedom and peace" 1996* (Best22

242a; Through 248)
"Palestinian security forces rousted this woman when they raided the house of a suspected member of Hamas" 1996* (Through 268)

AVEDON, Richard, 1923-2004
"Boy George" 1984* (Rolling #53)
"Brigitte Bardot" 1959 (MOMA 230; Szarkowski 273)
"Clint Eastwood" 1976* (Rolling #38)
[cover of *Harper's Bazaar*]1965* (Marien \6.58)
"Cyndi Lauper" 1984* (Rolling #52)
"Donyale Luna in Dress by Paco Rabanne" 1966 (Rosenblum2 #651)
"Dovima with Elephants" 1955 (MOMA 229)
"Eddie Murphy" 1983* (Rolling #51)
"The Generals of the Daughters of the American Revolution, Washington, D.C." 1963 (Icons 148)
"George Wallace" 1976 (Rolling #36)
"Henry Kissinger" 1976 (Rolling #34)
"Isak Dinesen, Copenhagen" 1958 (Goldberg 145)
"John Belushi" 1976* (Rolling #39)
"Julian and John Lennon" 1985* (Rolling #54)
"Lew Alcindor, 61st Street and Amsterdam Avenue, New York City" 1963 (Photography 140)
"Marian Anderson" 1955 (Decade \67)
"Nastassja Kinski" 1982 (Rolling #49)
"Penelope Tree" 1967 (Photography 141)
"Prince" 1983* (Rolling #50)
"Renée, The New Look of Dior, Place de la Concorde" 1947 (Goldberg 128)
"Roger Baldwin" 1976 (Rolling #37)
"Ronald Reagan" 1976 (Rolling #33)
"Rose Kennedy" 1976 (Rolling #35)
"Steven Spielberg" 1976* (Rolling #40)
"Two Tall Women" c. 1995* (Graphis96 45)
"Veiled Red" 1978* (Rosenblum2 #634)

AXENE, Eric
"Tail Section, Arizona Desert" c. 1999* (Photo00 209)

AZEL, José
"A carriage ride in New York City's Central Park takes on a surreal quality after a snowstorm" 1993* (Best19 80a)
"Romanian gymnast Nicolae Bejenaru competes in the Summer Olympics, Barcelona" 1992* (Best18 142a)
"Trout fishing in Patagonia" 1988* (Best14 103)
"A trusting sleeper finds peace and privacy among the 843 acres of Central Park in New York City" 1993* (Through 356)
"Worshippers bidding good-bye to Pope John Paul II as his helicopter takes off after open-air mass in Quetzaltenango, Guatemala" 1983* (Eyes \31)

AZIM, Sayyid
"Nairobi Embassy Bombings" 1998* (Capture 190)

—B—

BABBITT, Platt D.
"Stranded in the Niagara River" 1853 (Lacayo 21a)

BAČA, Vlado
"The Shapes of the Bodies" c. 1999* (Photo00 181)
"The Young Fashion" c. 1999* (Photo00 49)

BACEWICZ, Tony
"As umbrellas collapse, a crowd races for the Connecticut state capitol during an April storm that dumped 5 inches of rain" 1987 (Best13 124d)

BACH, Laurence
"Choice" c. 1989* (Graphis89 \280)

BACHRACH STUDIO
"John F. Kennedy" 1953 (Goldberg 136)

BADGER, Rob
[Antarctica] c. 1995* (Graphis96 161)

BADMAN, John
"Smoke and flames envelop Shell Oil Co.'s Wood River complex in Illinois" 1985 (Best11 98c)

BADULESCU, Enrique
[doll on window sill] c. 1997* (Graphis97 39)
[two-piece bathing suit] c. 1997 (Graphis97 38)
[various objects] c. 1997* (Graphis97 68-69)

BADZ, Stan
"Chocolate shells delight" 1988* (Best14 108)

BAER, Brian
"A tornado moves out onto the open waters of Tampa Bay after ripping apart a condominium complex" 1995* (Best21 174a)

BAER, Gordon
"Patriotic fashion" c. 1991* (Graphis91 \198)
"Waxing the geometric pattern of a floor" c. 1991* (Graphis91 \312)

BAGBY, Donna
"Texas Christian University's Booker tackles Southern Methodist University's Romo during a game" 1990* (Best16 118a)

BAHNSEN, Axel, 1907-1978
"Conscience" 1941* (Peterson #38)

BAILEY, David, 1938-
"Aidan Quinn" c. 1995 (Graphis96 116d)
"Kray Brothers" 1965 (Art \447)
"Michael Caine" 1965 (Art \446)
"Mick Jagger" 1964 (Marien \6.93)
"Sharon Tate and Roman Polanski" 1969 (Art \448)
"Sting" 1982 (Rolling #55)

BAILEY, Hillary G., 1894-1988
"He is Risen" c. 1934 (Peterson #10)
"The Last Chord" c. 1935 (Peterson #28)

BAILEY, Liberty Hyde, 1858-1954
"Cucumber Pollination Experiments" 1891* (Szarkowski 135)

BAIN, George Grantham
"Helen Keller" 1919 (Vanity 17)

BAIN NEWS SERVICE
"Henry Ford" 1926 (Vanity 80c)

BAIRD, James D.
"Greco-Roman wrestling match" 1996* (Best22 122d)
"High school hurdlers clear the first jump en masse"

1996* (Best22 207c)
"In a late afternoon playoff game at Busch Stadium"
1996* (Best22 199a)
"Jockey celebrates atop 40-1 longshot Dare-and-Go
as he defeats Cigar" 1996* (Best22 197c)

BAJANDE, Francine
"The conditions of hospital nurseries in Romania" c.
1991* (Graphis91 \80-\83)

BAKER, Bob
"Members of the girls basketball team watch the
clock in closing seconds of the game" 1986
(Best12 200d)

BAKER, Richard
"For the third time, the Argyl and Sutherland
Highlanders practice their official regimental
portrait" 1996* (Best22 170b)

BAKER, Tracy
"Michael Dukakis takes a tank ride during a
presidential campaign visit to General Dynamic
factory in Detroit" 1988 (Best14 8a)

BAKHSHANDAGI, Hoda
"Chan Gai, 13, is hospitalized for malnutrition in
Sudan" 1991* (Best17 82d)

BAKOR, Omar Said, 1932-1993
"Untitled" 1975 (Marien \6.14)

BALDESSARI, John, 1931-
"Chimpanzees and Man with Arms in Arc" 1984
(Rosenblum2 #804)
"Untitled" 1967* (Marien \6.92)
"Wrong" 1967 (Photography2 145)

BALDUS, Édouard-Denis, 1813-1889
"Cloister of Saint-Trophîme, Arles" c. 1851-1861
(Marien \2.43; Waking #47)
"The Enghien Watermill" c. 1855 (Art \70)
"Entrance to the Donzère Pass" c. 1861 (Waking
293a)
"Flooding of the Rhône at Avignon" 1856
(Rosenblum2 #104)
"Lyons During the Floods" 1856 (Waking #55)
"Pavillon Richelieu" c. 1860 (Art \77; Szarkowski
314a)
Pont de Gard c. 1855 (Szarkowski 75)
Pont de la Mulatière c. 1855 (Rosenblum2 #172)

BALL, J. P. (James Presley), 1825-1905 & Son
"Execution of W. Biggerstaff, hanged for the murder
of 'Dick' Johnson, flanked by the Rev. Victor Day
and H. Jurgens, sheriff" 1896 (Willis \11)
"Portrait of an unidentified black man wearing a
Masonic apron and vest" c. 1890s (Willis \13)
"Portrait of an unidentified black woman in a high-
necked dress with a decorated beaded bodice" c.
1890s (Willis \7)
"Portrait of an Unidentified Man with High Collar
and Plain Cravat" n.d. (Marien \2.58; Willis \14)
"Portrait of an unidentified young black man in a
high-collar shirt" c. 1890s (Willis \8)
"Portrait of an unidentified young man in a plaid suit
and glove" c. 1890s (Willis \9)
"Portrait of William Biggerstaff seated in a chair with
his hand on his face, wearing a flower in his lapel"
1896 (Willis \10)
"William Biggerstaff in a coffin" 1896 (Willis \12)

BALLARD, Karen
"Boy Scout checks out the cheerleaders during
opening day festivities at the Redskins' stadium"
1997* (Best23 176d)

BALLHAUSE, Walter
"Untitled" 1930-1933 (Rosenblum2 #455)

BALOG, James
"Chuka, the Drill" c. 1991* (Graphis91 \356)
"Florida Panther" c. 1991* (Graphis91 \355)
"Jordy, The Great Indian Rhinoceros" c. 1991*
(Graphis91 \358)
"Male Dama Gazelle" c. 1991* (Graphis91 \357)
"New Delhi Dolly, Greater Indian Hornbill" c. 1991
(Graphis91 \354)
"Returning every 76th year, Hailey's Comet made its
appearance right on time" 1986* (Best12 106c)

BALOGH, Rudolf, 1879-1944
"Nijinksy in *Spectre de la rose*" 1912 (Waking #149)

BALTERMANTS, Dmitri, 1912-
"Attack" 1941 (Art \419)
"Grief or The Eastern front: Searching for loved ones
at Kerch" 1942 (Art \422; Lacayo 114; Photos 57;
Rosenblum2 #613)
"Outskirts of Moscow" 1941 (Art \421)

BALTZ, Lewis, 1945-
"Industrial Structure during Painting" 1974 (San \19)
"Nevada 33, Looking West" 1977 (Decade 91a)
"South Wall, Mazda Motors" 1974 (Rosenblum2
#679)
"South Wall, Resources Recovery Systems, 1822
McGaw" 1974 (Marien \6.55; Photography2 155)

BAMBRIDGE, Ron
[Iceland] c. 1992* (Graphis93 171)
[man on bumper of old car] c. 1999* (Photo00 139)

BANCROFT, Dick
"Leonard Peltier" 1994 (Photos 136)

BAND, Marice Cohn
"Kids dancing on street at night" 1998 (Best24 101a)
"A mother with 6 children and no home of her own
feeds her famished kids with leftovers brought back
by her mother-in-law" 1997 (Best23 140b)
"Roselyne, 12, tried twice to reach the United States
and been sent back" 1995* (Best21 144a)

BANGASH, B. K.
"Taliban fighters greet each other in Kabul as the
bodies of former Afghanistan President Najibullah
and his brother hang from a traffic post" 1996*
(Best22 158a)

BAR-AM, Micha
"Freed hostages return from Entebbe" 1976 (Eyes
#356)
"Holocaust survivors search for familiar names" 1981
(Eyes #354)

BARABAN, Joe
"Man in 'Popeye' costume" c. 1989* (Graphis89
\174)

BARAN, Zefer and Barbara
[bottle of ink] c. 1992* (Graphis93 153)

[self-promotional] c. 1991* (Graphis92 \249-\253)

BARANOWSKI, André
[advertising photograph] c. 1990 (Graphis90 \313)
[pears] c. 1992* (Graphis93 88)
"Sculpture garden of the Metropolitan Museum of
Art" c. 1991 (Graphis91 \304)
[still life with paper bags] c. 1992* (Graphis93 90)
[still life on table] c. 1995* (Graphis96 84-85)

BARBEY, Bruno
"Camels search for food as Kuwait's oil wells burn"
1991* (Best17 12b)
"A donkey carries prized cargo through the narrow
streets of Fex, Morocco" 1986* (Through 270)

BARBOT, Candace B.
"Five-year-old twins were abandoned by their father,
a crack addict" 1993 (Best19 62)
"Village schoolchildren in Ecuador play a coin-toss
game during recess" 1991 (Best17 197)

BARBOZA, Anthony, 1944-
[from Black Dreams/White Sheet series] 1996
(Committed 48, 49)

BARBOZA, Ronald, 1946-
"Framed for the Future" 1979* (Committed 50)
"Nanna (Emily Barrows)" 1987* (Committed 51)

BARGER, Rebecca
"A man eats from a garbage bin in a Philadelphia
alley" 1987 (Best13 33b)
"MOVE sympathizers gather near the sheet-covered
remains of John Africa and Frank Africa during
graveside rites" 1985 (Best11 27a)
"This woman is one of the 250 West Philadelphians
left homeless by the MOVE confrontations" 1985
(Best11 27b)

BARKER, George, 1844-1894
"Bird's Eye View of Fort Marion and City Gates, St.
Augustine, Florida" 1886 (Photography1 #V-15)
"Charlotte Street–St. Augustine, Florida" 1886
(Photography1 #V-14)
"The Falls in Winter" c. 1888 (National \38)
"Ice Bridge, Ice Mound and American Fall, Niagara,
Instantaneous" 1883 (Photography1 \69)
"Landscape, Florida" 1886 (Photography1 \68)
"Luna Island in Winter" 1888 (Photography1 #V-10)
"Moonlight on the St. Johns River" 1886
(Rosenblum2 #161)
"Niagara from Below" or "Niagara in Summer, from
below" c.1888 (National 121a; Photography1 #V-
8)
"Oklawaha River" 1886 (Photography1 #V-12)
"Silver Springs, Florida From the Morgan House,
Steamboat Approaching Dock" 1886
(Photography1 #V-16)
"A slightly damaged house, Johnston, Pennsylvania"
1889 (Eyes #38; Lacayo 21b)
"Spanish Moss on the Banks of St. Johns River,
Florida" 1886 (Photography1 #V-11)
"Wayside Scene, Stoney Creek, Va." 1887
(Photography1 \74)
"The Wonder Oaks of Ft. George Island, Florida"
1888 (Photography1 #V-13)

BARKER, Kent
"Dan and Pat Moore, 18" c. 1989 (Graphis89 \178)

[from series on Texas Intercoastal Waterway] c.
1997* (Graphis97 160)

BARLETTI, Don
"Highway Camp" 1989 (Goldberg 211)

BARMANN, Timothy
"Dan Webber, an AIDS victim, is comforted by Rick
Holderman during an October gay rights march in
Washington, D.C." 1987 (Best13 60a)
"Matthew and cousin Alyssa plead with passing
motorists to adopt a kitten" 1988 (Best14 121c)
"Providence homicide" 1990 (Best16 203-210)

BARNABA
"William Powell" 1930 (Vanity 193d)

BARNACK, Oskar
"Self-Portrait with the Leica" 1936 (Eyes #153)

BARNARD, George N., 1819-1902
"Bonaventure, Savannah" c. 1866 (National 121b)
"City of Atlanta" 1864 (Photography1 \46)
"Gymnastic Field Sports of the Gallant 7th. The
Human Pyramid" 1861 (Photography1 #IV-9)
"The 'Hell Hole' New Hope Church, Ga." 1866
(National 121b; Photography1 #IV-28)
"Mill fire in Oswego, New York" or "Fire in the
Ames Mills, Oswego, New York" 1853* (Eyes #5-
6; Lacayo 20; Marien \2.26; Photography1 \2;
Rosenblum2 #188)
"Quartermaster's Buildings, Nashville, Tennessee"
1864 (Photography1 #IV-23)
"Rebel Works in Front of Atlanta, Georgia" 1864
(Rosenblum2 #211)
"Ruins in Charleston, S.C." c. 1865 (Eyes #36)
"Ruins of the Railroad Depot, Charleston, South
Carolina" 1864-1865 (Szarkowski 314b)
"Sherman's Hairpins" 1864 (Marien \3.17)

BARNEY, Tina, 1945-
"The Graham Cracker Box" 1983* (Women \159)
"The Landscape" 1988* (Women \158)
"Marina's Room" 1987* (Marien \7.74)

BARON, Stevan A.
"Nepal" 1987 (Photography 131)

BARRERA, Aurelio José
"18th Street gang" 1996* (Best22 235b)
"Payasito is a member of the 18th Street gang: 1996*
(Best22 216a)

BARRERA, Joe M., Jr.
"Movers took five days to move San Antonio's Hotel
Fairmount six blocks away" 1985 (Best11 158b)
"A Santa Gertrudis cow that wandered away from the
San Antonio Union Stockyards tried to take over a
moving van" 1986 (Best12 133b)

BARRIOS, Henry A.
"Christopher Lightsey is gagged in court after
repeatedly disrupting the proceedings" 1995*
(Best21 169c)

BARROW, Scott
"Seaside Park" c. 1989* (Graphis89 \97)

BARROW, Thomas F., 1938-
"Self-Reflexive" 1978* (San \62)

[from the *Trivia* series] 1973 (Photography2 130)
"Untitled" 1973 (Decade 96)

BARRY, Philip
"Leo Vyvjala, 61, sits helplessly in his car as rising
waters surround him" 1986 (Best12 41a)

BARTH, Uta
"Ground #42" 1994* (Marien \8.4)

BARTHOLOMEW, Brad
[octopus] c. 1997* (Graphis97 97)

BARTHOLOMEW, Ralph, 1907-1985
"Kodak Advertisement" c. 1950 (MOMA 233)
"Playtex" c. 1950 (Goldberg 70)

BARTLETT, Linda
"Children in their neighborhood" c. 1960 (Sandler
96)

BARTLETT, Mary
"Three Young Women in Woods" c. 1900
(Rosenblum \97)
[Young Woman at Window] c. 1900 (Sandler 59)

BARTON, Emma, 1872-1938
"Saint Margaret" c. 1903 (Rosenblum \101)

BARUCH
"Harald Kreutzberg" 1928 (Vanity 58)

BASSMAN, Lillian
[Evening gown and brooch] c. 1997 (Graphis97 17)
"Untitled" c. 1996 (Graphis97 4)
[untitled] c. 1995* (Graphis96 20)
[Woman with floral hat] c. 1997 (Graphis97 16)

BATCHELOR, Berk
"San Francisco Stables, Utica, N.Y." 1874
(Photography1 #V-4)

BATES, Jim
"6-week-old Matthew catches everyone by surprise
during a routine exam at the Community Health
Center" 1991 (Best17 198b)

BATSON, William H.
"Goalpost goes over at the University of Oklahoma in
Norman" 1985 (Best11 226)

BATTEY, C. M. (Cornelius Marion), 1873-1927
"Booker Taliaferro Washington" c. 1908 (Willis \36)
"Commencement" 1917 (Willis \37)
"Commencement Sunday" 1917 (Willis \39)
"Domestic Services Class, Tuskegee Institute" c.
1917 (Willis \38)
"Frederick Douglass" c. 1895 (Willis \42)
"Mrs. Booker T. Washington (Margaret Murray)" c.
1914 (Willis \35)
"New Rising Star School, Macon County, Alabama"
n.d. (Willis \40)
"W. E. B. DuBois" 1918 (Willis \41)

BATTISTONI, Peter
"Mango magic" 1991* (Best17 172a)

BAUER, Manuel
"To gain freedom from China's rule, a Tibetan man
takes his 6-year-old daughter on a journey through
the world's highest mountains" 1995 (Best21 200)

BAUER, Stuart
"A man is arrested after shooting two police officers
who responded to a fight" 1995 (Best21 173b)

BAUER, Wilfried
"In Zagreb, refugees from Eastern Croatia find shelter
in this camp" c. 1992* (Graphis93 59)
"In Zagreb, wreckage of Yugoslavian fighter brought
from the East now serves as a memorial" c. 1992*
(Graphis93 59a)
"In Zagreb, the new Croatian emblem is already
embossed on the holster of toy pistols" c. 1992*
(Graphis93 59d)

BAUGHMAN, J. Ross, 1953-
"Anti-Guerrilla Operations in Rhodesia" or
"Questioning–Rhodesian-style" 1977 (Capture 104;
Eyes #364)

BAULUZ, Javier
"Despair of Rwanda" 1994* (Capture 176)

BAUMAN, David
"Confrontation after a playoff game" 1986 (Best12
199b)

BAUMAN, Doug
"Jack Nicholson, an avid Los Angeles Lakers fan,
keeps his eye on the action during the NBA finals"
1988 (Best14 12c)

BAUMANN, Jennifer
[book jacket] c. 1990* (Graphis90 \300)
[faucet on in bathroom sink] c. 1992* (Graphis93 73)
[self-promotional] c. 1990* (Graphis90 \299)
"Yellow room" c. 1990* (Graphis90 \199)

BAVAGNOLI, Carlo
"Jane Fonda" 1968* (Life 89c)

BAVENDAM, Fred
"Feathery-looking sea pens spread out in the waters
off Tasmania" 1996* (Best22 190d)

BAYARD, Hippolyte, 1801-1887
"Arrangement of Specimens" c. 1842* (Szarkowski
20)
"Excavation for rue Tholozé" 1842 (Rosenblum2
#24)
"Remains of the Barricades of the Revolution of
1848, rue Royale, Paris" 1849 (Rosenblum2 #198)
"Self-portrait" c. 1842-1850 (Szarkowski 33)
"Self-portrait as a Drowned Man" 1840 (Marien
\1.14; Rosenblum2 #25)
"Self-portrait with Plaster Casts" 1850 (Marien \2.10)
"Windmills, Montmartre" 1839 (Waking #38)

BAYER, Alexander
[self-promotional] c. 1992* (Graphis93 76-77, 138)

BAYER, Herbert, 1900-1985
cover of *Bauhaus 1* 1928 (Marien \5.15)
"Lonely City Dweller–Self-portrait" 1932 (Icons 54)
"Lonely Metropolitan" 1932 (Szarkowski 203)
"Metamorphosis" 1936 (Hambourg \83)
"Pont Transbordeur, Marseilles" 1928 (Hambourg
89a; Rosenblum2 #505)
"Self-Portrait" 1932 (Icons 55)

"Small Harbor, Marseilles" 1928 (Hambourg \96)

BAYTOFF, Michael A.
"Young men from a rehabilitation center for juveniles convicted of serious crimes are helping to restore some old buildings" 1985 (Best11 138b)

BAZ, Patrick
"An Orthodox Jew carries the hats of his comrades who are covered with *taleth* during prayer at Jerusalem's Wailing Wall" 1993* (Best19 121d)
"Young girl runs for safety during a clash between Palestinian demonstrators and Israeli border police in the Gaza Strip" 1993* (Best19 183)

BAZSO, Les
"Exhibition Park Racetrack exercise boy shares his feelings of disrespect with a Canada Goose guarding its nest next to track" 1988 (Best14 128d)

BAZYK, Dede, 1951-
"The Grand Facade Soon Shall Burn" 1986* (Photography2 204)

BEAHAN, Virginia, and McPHEE, Laura
"Spokane" 2001* (Photography 166)

BEALE, Anthony, 1970-
"The Irony of Acquiring Color" 1995 (Willis \477)

BEALE, John
"Deputy coroner stands outside a holding area as suspect talks with his lawyer" 1996* (Best22 155c)
"Hayes reads using a magnifier" 1996 (Best22 218c)
"Leader of a color guard during groundbreaking ceremonies for a Vietnam veterans' memorial in Pittsburgh" 1986 (Best12 59b)
"Lone fan is wrapped in plastic as he passes the Roberto Clemente statue after a rainout" 1995 (Best21 195c)
"Longtime friends tell a secret at the homestead of Anna Jarvis, the founder of Mother's Day" 1995 (Best21 194c)
"Photographers strain to get a view of a coroner's hearing" 1996 (Best22 218b)
"Physics teacher uses librarian to demonstrate how much weight bathroom-size dixie cups will support" 1996 (Best22 219a)
"Pittsburgh police officer keeps his mouth covered as he directs traffic away from a burning building" 1996 (Best22 218a)
"Preschool deaf students react as non-toxic smoke fills room for fire safety program" 1996 (Best22 219d)
"Rev. Susan Luttner watches her adopted daughters swing in the yard" 1995 (Best21 194b)
"Russian World War II veterans lead a group of other Russian war veterans observing V-E Day at the Jewish Center" 1995 (Best21 195d)

BEALL, William C.
"Faith and Confidence" 1957 (Capture 41)

BEALS, Jesse Tarbox, 1879-1942
"Children with Burlap Sacks" n.d. (Sandler 143; Women \25)
"Family in Tenement" n.d. (Sandler 142)
"Men and Children in Tenement Back Yard, New York" n.d. (Women \24)

BEAMAN, E. O.
"The Heart of Lodore, Green River" 1871 (Rosenblum2 #154)

BEATO, Antonio, d. 1903?
"Interior of Temple of Horus, Edfu" after 1862 (Rosenblum2 #135)

BEATO, Félice, c. 1825-c. 1907
"After the Capture of Taku Forts" or "Embrasure, Taku Fort" 1860 (Rosenblum2 #204; Waking #84)
"Beato's Artist" c. 1868 (Marien \3.41)
"A British entrenchment during the Indian Mutiny" 1858 (Lacayo 15)
"The Execution of Mutineers in the Indian Mutiny" 1857 (Marien \3.39)
"Giving Prayer to Buddha" c. 1865 (Art \124)
"Interior of Pehtang Fort Showing the Magazine and Wood Gun" 1860 (Szarkowski 314c)
"Interior of the Angle of North Fort" 1860 (Marien \3.32)
"Mount Fuji" 1868 (Marien \3.40)
"Panorama of Hong Kong, Showing the Fleet for the North China Expedition" 1860 (Marien \3.34)
"Samurai with raised sword" c. 1860 (Art \125)
"Tycoons' Halting Place on the Tocaido Hasa" 1868 (Art \123)
"Woman Using Cosmetics" c. 1867* (Rosenblum2 #333)

BEATON, Cecil, 1904-1980
"Alfred Lunt and Lynn Fontanne" n.d. (Vanity 88)
"Carole Lombard" n.d. (Vanity 191)
"Clare Boothe Brokaw" 1934 (Vanity 173b)
"Edith Sitwell" 1962 (Icons 147)
"Gary Cooper" n.d. (Vanity 190)
"Katharine Hepburn" 1934 (Vanity 194)
"Laurence Kerr Olivier" n.d. (Vanity 156)
"London bomb damage" 1940 (Lacayo 106d)
"Marlene Dietrich" 1932 (Rosenblum2 #639)
"Ruth Gordon" 1929 (Vanity 104)
"Self-Portrait" n.d. (Vanity 200c)
"Self-Portrait in the Studio" 1951 (Icons 146)
"The Sitwells (Edith, Osbert, Sacheverell)" 1929 (Vanity 117)
"Tallulah Bankhead" 1931 (Vanity 138)
"Tilly Losch" 1934 (Vanity 158)
"W. Somerset Maugham" 1933 (Vanity 139)

BÉCHARD, Henri
"Ascending the Great Pyramid" c. 1878 (Rosenblum2 #178)

BECHER, Bernd, 1931-, and BECHER, Hilla, 1934-
"Anonymous Sculpture" 1970 (Szarkowski 314d)
"Cooling Tower, Mt. Cenis Colliery, Herne, Ruhr" 1965 (Icons 157)
"Gas Tower (Telescoping Type), off Pulaski Bridge, Jersey City" 1981 (Marien \6.87)
"Plant for Styrofoam Production" 1997 (Photography 19a)
"Typology of Half-Timbered Houses" 1959-1974 (Icons 156)
"Water Towers" 1980 (Photography2 146; Rosenblum \216)
"Winding Towers" 1983 (Rosenblum2 #736)

BECK, Heinrich
"Childhood Dreams" 1903 (Rosenblum2 #381)

BECK, Maurice, and MACGREGOR, Helen
 "Léonide Massine" 1923 (Vanity 60)

BECK, Myron
 "Fruits and leather" c. 1989* (Graphis89 \225, \226)

BECKER, Murray
 "Explosion of the Hindenburg" 1937 (Goldberg 94)

BECKETT, Samuel Joshua
 "Loie Fuller Dancing" c. 1900 (Waking #135)

BECKLEY, Bill
 "Sad Story" 1976* (Photography2 157)

BECKLEY, Chuck, 1946-
 "It's a long stretch for a peanut" 1985 (Best11 176b)

BECKWITH, Carol, and FISHER, Angela
 "In Kumasi, Asante sword bearers escort their king
 on the 25th anniversary of his coronation" 1996*
 (Through 256)

BEDELL, Robbie
 "A painter takes a lunch break" 1985 (Best11 170a)

BEDFORD, Francis
 "Glas Pwil Cascade" 1865 (Rosenblum2 #122)

BEDOU, A. P., 1882-1966
 "Booker Taliaferro Washington on his horse" 1915
 (Willis \44)
 "Booker Taliaferro Washington on his last southern
 tour in Shreveport, Louisiana" 1915 (Willis \43)
 "The Louisiana Shakers" c. 1920 (Willis \46)
 "Warren Logan" n.d. (Willis \45)

BEEBY, John
 "New York" c. 1893 (Photography1 #VI-6)

BEESE, Lotte, 1903-1988
 "Beese's Studio in the Bauhaus" c. 1927 (Women
 \92)
 "Portrait of Katt Both" c. 1928 (Women \89)
 "Spheres in Glass" c. 1929 (Rosenblum \123)

BEIERMANN, Jeff
 "Pam Christian lies asleep from exhaustion after
 helping to build a sandbag dike during flooding in
 Des Moines" 1993* (Best19 187a)

BEISCH, Leigh
 [cattle] c. 1997* (Graphis97 174)
 [landscape] c. 1997* (Graphis97 145)

BEKKER, Philip
 [bones, flowers, and fruit] c. 1991* (Graphis92 \69,
 \80)
 [peppers] c. 1989* (Graphis89 \265, \266, \267)
 [self-promotional] c. 1990* (Graphis90 \333)

BELL, Bert
 "Photographic reproduction of Pieter Brueghel's *The
 Wedding Feast*" c. 1989* (Graphis89 \186)

BELL, Charles Milton, 1848-1893
 "Red Cloud" 1880 (Waking 329)

BELL, Hugh, 1927-
 "Billie Holiday. Carnegie Hall Dressing Room" 1956
 (Committed 52)
 "Charles Parker at Open Door Café" 1953
 (Committed 53)

BELL, Ron
 [fashion illustration] 1986 (Best12 113a)
 "Two days after Christmas, 23-year-old changes her
 daughter's diapers on the floor of a rest room in the
 Travelers Aid offices" 1987 (Best13 43)

BELL, William, 1830-1910
 "Cañon of Kanab Wash, Looking South" 1872
 (National 18b, \32; Waking #123)
 "General H. A. Barnum, Recovery After a Penetrating
 Gunshot Wound" 1865 (National 18a, \14)
 "Grand Cañon, Colorado River, Looking West" 1872
 (National 122c)
 "Gunshot Wound of Left Femur" 1865-1867
 (Photography1 #IV-21)
 "Heads and Fragments of Heads of Humeri. . ." 1865
 (National \18)
 "Looking South into the Grand Cañon, Colorado
 River" 1872 (National \33)
 "Perched Rock, Rocker Creek, Arizona" 1872
 (National \29)
 "Private George Ruoss" 1867 (Waking #107)
 "Pvt. Charles Myer, Amputation of the Right Thigh"
 1865 (National 121d)
 "Utah Series No. 10, Hieroglyphic Pass, Opposite
 Parowan, Utah" 1872 (Rosenblum2 #152)

BELLMER, Hans, 1902-1975
 "The Doll" 1934-1935 (Hambourg \69); 1935*
 (Marien \5.24)
 [from *Minotaure*] 1935 (San #15)
 Les Jeux de la Poupée plate VIII" 1936
 (Rosenblum2 #550)
 Maschinengewehr im Zustand de Gnade" 1937 (San
 #41, \26)

BELLO, Al
 "Swimming through a wall of water during the
 championship" 1997* (Best23 168a)

BELLOCQ, Ernest J., 1873-1949
 "Nude with a Mask" c. 1912 (Waking #153)
 "Untitled" c. 1912 (MOMA 71; Rosenblum2 #315)

BELLON, Denise, 1902-
 "High Jump, Terrace of the Trocadero" 1938
 (Rosenblum \138)

BELT, Annie Griffiths
 "Australia welcomes the New Year with a spectacular
 fireworks display, lighting up Sydney Harbor and
 the renowned Opera House" 1982* (Through 400)
 "An off-duty sergeant in the Israeli Army lets down
 his guard for a kiss in West Jerusalem's Zion
 Square" 1996* (Through 276)
 "On Good Friday, a pilgrim worships in a Jerusalem
 grotto" 1996* (Through 240)
 "Sunbathers on Bondi Beach in Sydney bask in the
 warmth of Southern Hemisphere Christmas" 2000*
 (Through 440)

BEMIS, Samuel
 "New Hampshire Landscape" 1840 (Rosenblum2
 #97)

BEN-YUSUF, Zaida, active c. 1896-1915
"The Odor of Pomegranates" c. 1899 (Rosenblum \67; Sandler 33)

BENALI, Remi
"Dr. Ian Wilmut, a genetic pioneer, in a field across from his Roslin Institute" 1997 (Best23 155d)

BENCZE, Louis
"Hoar frost on a pheasant in the undergrowth" c. 1990* (Graphis90 \192)

BENDER, Fred
[ad for the Nevamar Corporation] c. 1991* (Graphis91 \273)

BENEDICTO, Nair, 1940-
"Sisal Women, Bahia" 1985 (Rosenblum \192)

BENEZRA, Douglas
[roses in vase] c. 1991* (Graphis92 \61)
"Still life with roses and white table cloth" c. 1991* (Graphis91 \119)

BENGIVENO, Nicole
"A girl looks out of a bus window on a rainy May day in Moscow" 1987 (Best13 107a)
"In Albania, a fat goose holds the promise of simple pleasures–a good meal for a man and his family" 1992* (Through 118)
"New York City Hotel Holland for the homeless" 1987 (Best13 45)
"Resting her chin on the fire escape rail, 5-year-old La Tasha Davis watches other children playing four stories below" 1987 (Best13 107d)

BENGSCH, Alexander
"Max Reinhardt" 1928 (Vanity 110)

BENN, Nathan
"Demonstrators overwhelm police in downtown Seoul" 1987* (Best13 27a)
[Korean student protestors with slingshot and firebomb] 1987* (Best13 24b, 25d)
"With patriotic pride, a resident of a blue-collar neighborhood in Pittsburgh displays a large U.S. flag and a big American-made automobile" 1991* (Through 364)

BENNETT, Henry Hamilton, 1843-1908
"Layton Art Gallery, Milwaukee, Wisconsin" c. 1890 (MOMA 65)
"Panorama from Overhanging Cliff, Wis. Dells" 1897-1898 (MOMA 58-59; Photography1 \78)
"Sugar Bowl with Rowboat, Wisconsin Dells" c. 1889 (Rosenblum2 #162)

BENNETT, Sue
[abandoned sheep ranch] c. 1991 (Graphis92 \13, \14)
[cowboys] c. 1991 (Graphis93 \108-\111)
[from the series The Nature of Excellence] c. 1995 (Graphis96 130)
"Men's sportswear" c. 1991 (Graphis91 \51, \52)
"Mule wranglers of the Grand Canyon" c. 1990 (Graphis90 \175-\176)
[a Native American] c. 1992* (Graphis93 128)
"Native American calendar" 1990* (Graphis92 \136)
"Racing cyclist" c. 1990 (Graphis90 \239)
"Rhythm and Blues singer Francine Reed" c. 1991

(Graphis91 \193)
[sportswear catalog] c. 1990* (Graphis90 \47-\50)

BENSCHNEIDER, Ben
"The North Head Lighthouse at the south end of Long Beach Peninsula" 1998* (Best24 42c)

BENSIMON, Gilles
"Array of trendy sneakers" c. 1991* (Graphis91 \234)
[from an article on fashion] c. 1989* (Graphis89 \40)
"Isabella Rosselini" c. 1995* (Graphis96 52, 53)
"Swimwear" c. 1991* (Graphis91 \13-\16)

BENSON, Harry
"Cyndi Lauper hits her mark" 1985* (Best11 42d)
"Dennis Rodman and Mom" 1996* (Life 149)
"Jim and Tammy Bakker" 1987* (Best13 30)
"Jodie Foster" 1991* (Life 93c)
"John Wayne Bobbit jumps for joy near Las Vegas" 1995* (Best21 141a)
"Lisa Marie Presley and Michael Jackson on their first wedding anniversary" 1995* (Life 177c)
"Nixon and daughter Tricia rehearse on the eve of her wedding, White House Rose Garden" 1971 (Life 31c)
"On May 22, having delivered his 4,531st Tonight Show monologue, Johnny Carson said good night–and goodbye" 1992* (Life 176)
"Quincy Jones and all-stars run through solos with Stevie Wonder" 1985* (Best11 42c)
"United Support of Artists for Africa" 1985* (Best11 2)
"Willie Nelson and Michael Jackson exchange confidences" 1985* (Best11 42b)

BENSON, Richard, 1943-
"Cannon, Vicksburg" 1986 (Szarkowski 315a)
"Paul Strand, Orgeval" c. 1975 (Photography 136)

BENTLEY, P. F.
"The afternoon before giving his nomination-acceptance speech presidential candidate Bill Clinton rests in a steam room" 1992 (Best18 73)
"Bill and Hillary Clinton relax after a late-night pizza party in their hotel suite" 1992 (Best18 76a)
"Bill Clinton meets with the Rev. Jesse Jackson in the candidate's suite" 1992* (Best18 80a)
"Bob Dole during Presidential campaign" 1996 (Best22 108-109)
"Dan Quayle seems to be saying, 'I want you,' as he boards a plane" 1988* (Best14 110)
"Gingrich addresses members of the AHA" 1995 (Best21 202a)
"Gingrich shares the spotlight with then-Senate majority leader Bob Dole" 1995 (Best21 202c)
"Near the end of the first 100 days, Gingrich shows his frustration as fellow Republicans argue all around him" 1995 (Best21 202b)
"War-weary Newt Gingrich" 1995 (Best21 138b)

BERENHOLTZ, Richard
"Atlas (with clock) at Tiffany's No. 727 Fifth Avenue (crafted by Metzler)" c. 1989* (Graphis89 \102)
"The current inner court of the Alwyn Court apartment house with a trompe l'œil mural by Richard Haas" c. 1989* (Graphis89 \101)
"A picture of the contrasts in New York's financial district–a building at No. 90 West Street, and the World Trade Center" c. 1989* (Graphis89 \100)
"A section of the Chrysler Building" c. 1989*

(Graphis89 \103)

BERG, Ron
[from an article on hats and hat-makers] c. 1990*
 (Graphis90 \3, \4)

BERGER, Paul, 1948-
"Camera Text or Picture #2" 1979 (Decade \96)
"Mathematics #57" 1977 (Photography2 185)

BERGER, Wout
"Café Martinho da Arcada in Lisbon" c. 1990*
 (Graphis90 \305)

BERGLUND, Per-Erik
[nude] c. 1995* (Graphis96 138)

BERGMAN, Beth
"Guardian angel" 1992* (Best18 171)

BERGMAN, David
"Members of the Columbus High School 400
 freestyle relay team celebrate after finishing first"
 1993 (Best19 148b)

BERGSTRESSER BROTHERS
"Bergstresser's Photographic Studio. 3d. Div., 5th
 Corps, Army of the Potomac" c. 1862-1864
 (Marien \3.11; Photography1 #IV-10)

BERKA, Ladislav
"Leaves" 1929 (Rosenblum2 #514)

BERMAN, Chuck
"Winter in Chicago can be a study in patterns,
 textures—and snow shovels" 1985 (Best11 142a)

BERMAN, Gene
"A reverend from Florida shouts as three gay men
 embrace during the 1993 Gay Rights March"
 1993* (Best19 190a)

BERMAN, Mieczyslaw, 1903-1975
"Lindbergh II" 1927 (Waking #190)
"On the Construction Site" 1929 (Hambourg \8)

BERMAN, Morris
"New York Giants Quarterback Y. A. Tittle, after
 being sacked by a Steeler" 1964 (Life 143d)

BERMAN, Nina
"Anorexic shows off how skinny she is" 1997*
 (Best23 140a)
"18-year-old Muslim woman hides her head in shame
 after having an abortion when she became pregnant
 after being raped by Serbs" 1993* (Best19 66b)
"Pink Cadillacs, White Rocks" 1993* (Best19 217-
 220)
"A woman, forbidden by Taliban law to work, study
 or show her face, sits proudly with one of her
 diplomas at home in Kabul" 1998* (Best24 82)

BERMAN, Wallace, 1926-1976
"Untitled" 1957 (Photography2 92)

BERMAN, Zeke, 1951-
"Untitled" 1979 (Szarkowski 283)

BERNAGER, Elie
[birds and objects] c. 1992* (Graphis93 213)

BERNARD, Donald L., 1942-
"Earth Mother" 1997* (Willis \468)
"Giftgiver" 1997* (Willis \467)
"Million Man March: Blurrrrred vision" 1996*
 (Committed 54)
"Million Man March: 'Cuz I'm Black'" 1996*
 (Committed 55)

BERNER, Alan
"Cowboy takes a cigarette break at the Loma Theatre
 in Socorro, New Mexico" 1995 (Best21 155)
"D.C. Moons" 1995 (Best21 218a)
"Graduates" 1995 (Best21 219)
"Hood Canal shrimp" 1985* (Best11 148b)
"Interior designer Michael McQuiston's dalmatian-
 spotted shoes are enough for you to beg for more"
 1987 (Best13 180d)
"Lenin" 1995 (Best21 218b)
"Organic farmer works in his bare feet" 1996*
 (Best22 160a)
[sheep bounding in the air to catch the other sheep]
 1995 (Best21 234)
"SuperMall" 1995 (Best21 219a)
"Grebe can't get off the ground" 1985 (Best11 179)
"Wheelchair-bound Mike Haven has his 'wake-up' in
 the Second Avenue Seattle storefront that he often
 calls home" 1987 (Best13 42a)

BERNHARD, Ruth, 1905-
"Cactus" 1937 (Sandler 135)
"Creation" 1936 (Rosenblum \233)
"Eighth Street Movie (Kiesler), New York" 1946
 (Decade 53)
"Rockport Nude" c. 1946 (Decade \48)
"Two Forms" 1963 (Rosenblum \254)
"Violet Snailshow" 1943 (Sandler 136)

BERNSTEIN, Lois
"After their car smashed into a tree, the children wait
 for word on a fourth passenger" 1985 (Best11
 102d)
"As tourists swamped the summer shores, dead
 dolphins began washing up on the beaches from
 New Jersey to North Carolina" 1987 (Best13 97a)
"Bruce Springsteen plays the crowd during the
 second stop of his 'Tunnel of Love' tour in Chapel
 Hill, N.C." 1988 (Best14 46a)
"Collision during a 500-meter speedskating heat"
 1987 (Best13 199b)
"The Dark Side of Light" 1988 (Best14 184-185)
"Louis Nelson practices at a rehearsal of the Cardinal
 State Harmonica Club" 1988 (Best14 50b)
"Michele Dill, with binoculars, and Donnie Holder
 scan the deck of the USS Iowa for their husbands
 as the battleship pulls in to the Norfolk Naval
 Station" 1988 (Best14 47a)
"Mr. Fatwrench, also known as Wilson Toula, is a
 fix-it man, stand-up comedian and part-time
 professor" 1988 (Best14 46d)
"New life in the hills of Virginia" 1988 (Best14 48-
 49)
"Oakland Athletics star Jose Canseco checks his bat
 after whittling it a bit" 1988 (Best14 50a)
"Pearl onions make a fashion statement at any dinner
 party" 1987 (Best13 187a)
"A photo of Marine Lance Cpl. Thomas A. Jenkins
 hangs outside his family home" 1991* (Best17 12a)
"Tony Rementer and his wife, Deborah, embrace
 under the Iowa's big guns" 1988 (Best14 47b)

BERTEAUX, Bryan S.
"Audubon Zoo officials discuss the death of a female
rhinoceros" 1990* (Best16 114)
"The cab of a tractor-trailer dangles over the railings
of Interstate10 in New Orleans after a rush-hour
accident" 1985 (Best11 103b)
"Thanks to Hurricane Juan, C. Boudreaux bails water
from his home near Houma" 1985 (Best11 72d)

BERTRAM, Charles
"Volunteer firefighter takes a break during a forest
fire in Kentucky" 1987 (Best13 75a)

BERTSCH, Auguste-Adolphe, d. 1871
"Epidermis and Stigmata of a Larva" c. 1853
(Szarkowski 315b)
"Head of a Coudin Larva" c. 1853 (Szarkowski 315a)
"Mouth of a Wasp" c. 1853 (Szarkowski 315b)

BESNYÖ, Eva, 1910-
"Paulien" 1954 (Rosenblum \117)

BETANCOURT, John
"After taking off in near blizzard conditions,
Continental Flight 1713 slammed back to the
runway and flipped over at Denver's Stapleton
Airport" 1987 (Best13 73b)

BETZLER, Rafael
[from ad for Amadeus Fashions] 1989 (Graphis89
\12, \12a)

BEUYS, Joseph, 1921-1986
"No. 1. *Greta Garbo Cycle*" 1964-1969 (Art \452)
"No. 8. *Greta Garbo Cycle*" 1964-69 (Art \453)

BEY, Dawoud, 1953-
"A Girl in a Deli Doorway" 1988 (Willis \400)
"The James Twins" 1992* (Willis \439)
"Man at Fulton Street and Cambridge Place" 1988
(Willis \401)
"Peg, Brooklyn, New York" 1988 (Willis \399)

BIANCHI, Stefano
"Omega Watch" c. 1991* (Graphis91 \228)

BICKING-BYERS, Debra
"Lake Sebu, in the Southern Philippines, is a breeding
spot for fish" 1996* (Best22 182d)

BIDAUT, Jayne Hinds
[goblet] c. 1991* (Graphis92 \64)
[hat on wooden hand] c. 1997* (Graphis97 78)
[horse in a pasture] c. 1997* (Graphis97 176)
[one of the big cats] c. 1997 (Graphis97 178b, c)
[owl] c. 1997 (Graphis97 178a)
[peacock] c. 1997 (Graphis97 178d)
"Portrait of a Butterfly Lady" c. 1997 (Graphis97 28)
"Trees in Water–Texas" c. 1997* (Graphis97 146)
[umbrella] c. 1991* (Graphis92 \63)

BIDDLE, Geoffrey
"Loisaida: unchanging" 1986 (Best12 42-49)

BIDDLE, Susan
"During the signing ceremony for the Adoption Safe
Families Act, 7-year-old sits next to President
Clinton" 1997 (Best23 131d)
"First grader gets teary as she tries a math problem in
front of class" 1998 (Best24 86)

"Haitian political prisoner being held in a Virginia
jail" 1997 (Best23 138a)

BIEBER, Tim
"The Black Lone Ranger" c. 1991* (Graphis92 \136)
[cigarette ad in southern Morocco] c. 1991*
(Graphis92 \99)
"Cozumel, Mexico" c. 1990* (Graphis90 \248)
[for a printing firm] c. 1990* (Graphis90 \245)
[swimming pool] c. 1991* (Graphis92 \192)

BIEDER, E.
"George Grosz" n.d. (Vanity 57)

BIELIK, Ladislav
"The End of the Prague Spring" 1968 (Photos 121)

BIERMANN, Aenne, 1898-1933
"Aus dem Fahrenden Zug" c. 1930 (Women \96)
"Child's Hands (Helga)" 1928 (Rosenblum \1928;
Rosenblum2 #519)
"Portrait mit Champs-Elysées, Paris" c. 1929
(Women \94)
"Rubber Tree" c. 1927 (Waking 359)
"Sonnenbad" c. 1929 (Women \95)

BIERSTADT, Charles, 1819-1903
"The Rapids, Below the Suspension Bridge" c. 1870
(National 2)

BIGBEE, Walter
"Lead me around the circle" 1994 (Photography 169)

BIGGER, Chuck
"Flying less than 50 feet above the Nevada desert,
pilot herds a group of wild mustangs toward a
corral trap set by the Bureau of Land Management"
1987 (Best13 97b)

BILLINGHAM, Richard
"Untitled" 1994* (Marien \7.75)

BINDER, David
"Jon Parker, founder of the National AIDS Brigade,
distributes needles and alcohol to addicts" 1990
(Best16 9c)

BINDER, Ellen
"Cossack Thunder" 1993 (Best19 207-212)

BING, Ilse, 1899-1998
"Can-Can Dancers, Moulin Rouge" 1931 (Women
\60)
"It Was a Windy Day on the Eiffel Tower" 1931
(Rosenblum \135)
"Paris" 1932 (Women \59)
"Paris, Eiffel Tower Scaffolding with Star" 1931
(Rosenblum2 #541)
"Self-Portrait with Leica" 1931 (Icons 39)
"Street Organ, Amsterdam" 1933 (Women \61)
"Three Men on Steps at the Seine" 1931 (Icons 38)

BINGHAM, Hiram
"Hiram Bingham discovered the ancient Inca site of
Machu Picchu, high in the Peruvian Andes" 1912
(Through 300)
"Machu Picchu after ten days of clearing" 1911
(Goldberg 30)

BIONDO, Michael
"Chinese hat" c. 1991* (Graphis92 \151)
"Kris Kross" c. 1992* (Graphis93 130)
[man in jacket] c. 1992* (Graphis93 34)

BIOW, Hermann
"Alexander von Humboldt, Berlin" 1847
(Rosenblum2 #35)
"Ruins of Hamburg Fire" 1842 (Marien \2.25)

BIRNBAUM, Lillian
"Model resembling Virginia Woolf" c. 1991*
(Graphis91 \147)

BISBEE, Albert, active 1850s
"Child on a Rocking Horse" c. 1855 (National 122d)

BISCHOF, Werner, 1916-1954
"India: Jamshedpur Steel Factory" 1951
(Rosenblum2 #618)
"On the Way to Cuzco, Peru" 1954 (Icons 119)
"Rural Tavern, Puszta, Hungary" 1947 (Icons 118)

BISPING, Bruce
"San Diego's Craig Nettles plays catch with sons Tim
and Jeff during All-Star game warm-up" 1985
(Best11 201a)

BISSON, Bernard
"A baby with AIDS is treated in Romania" 1990*
(Best16 180a)

BISSON, Louis-Auguste, 1814-1876
"Dog" 1841-1849 (Waking #42)

BISSON FRÈRES (Louis-Auguste, 1814-1876, and
Auguste-Rosalie, 1826-1900)
"Passage des Echelles, the ascent of Mont Blanc"
1862 (Rosenblum2 #117)
"Passage des Echelles, the second ascent of Mont
Blanc" 1862 (Lacayo 27c; Waking 293)
"Portal of Saint-Ursin, Bourges" c. 1855 (Art \78;
Waking #37)
"Two Bridges" n.d. (Rosenblum2 #175)

BJORNSON, Howard
[self-promotional] c. 1990* (Graphis90 \315)

BLACK, James Wallace, 1825-1896
"Boston, as the Eagle and the Wild Goose See It,
October 13" 1860 (Waking 315)
"Boston From Hot-Air Balloon" 1860 (Photography1
\66; Rosenblum2 #288)
"Head of Artist's Falls, North Conway, New
Hampshire" 1854 (Photography1 \36)
"In the White Mountain Notch" 1854 (Rosenblum2
#143)
"Ruins of the Boston fire" 1872 (Eyes #37;
Photography1 \67)

BLACKBIRD, Ken
"Eaglestaff, Boise, Idaho" 1990* (Photography 168)

BLACKMER, John
"Ficarra crashes while traveling at more than 60 mph
during a gravity bike race" 1987 (Best13 214a)
"Rookie outfielder Jose Gonzalez playing on the
expanded Dodgers team signs autographs before an
exhibition game" 1987 (Best13 202a)

BLAIR, James P.
"Children share secrets in an overgrown garden in
Grebeni, one of the many villages on the banks of
Russia's Volga Matushka" 1994* (Through 82)
"A young herder performs a back flip off a water
buffalo in the Turag River west of Dhaka,
Bangladesh" 1993* (Through 162)

BLAIR, John H.
"Money-borrowers Revenge" 1977 (Capture 102)

BLAISE, Oliver
"Around the Andaman Island in the Bay of Bengal,
elephants swim" 1995* (Best21 158a)

BLAKELY, Alan
[breakfast] c. 1995* (Graphis96 95)

BLANCH, Andrea
[ad for Michelle Marc] c. 1989* (Graphis89 \59)

BLANDING, John
"Biker Brian Griffith tumbles over a fallen Ed
Bernasky" 1985 (Best11 225a)

BLASSI, Jaume
[for personal studies] c. 1989* (Graphis89 \324, \325)

BLICKENSDERFER, Clark, 1882-1962
"Lines and Angles" 1925 (Peterson #85)

BLOCH, Ernest
"Fair in Fribourg, Switzerland" c. 1902 (Decade \11)

BLOCK, Ira
"Ceramic urns hold the 'liquid gold' known as Italian
olive oil, produced at this Tuscan estate for more
than a thousand years" 1999* (Through 70)

BLONDEAU, Barbara, 1938-1974
"Untitled" 1967* (Photography2 126; Rosenblum
\255)

BLOSSFELDT, Karl, 1865-1932
"Adiantum pedatum, Maidenhair Fern" c. 1925
(Icons 25)
"Cucurbita" n.d. (Decade 31)
"Delphinium" 1928 (Hambourg 91c)
"Eryngium Bourgatti" 1928 (Hambourg 91a)
"Impatiens Glandulifera" 1927 (Rosenblum2 #511)
"Papaver orientale, Oriental Poppy" c. 1920 (Icons
24)

BLUE, Carroll Parrott, 1943-
"Angela Davis, political activist" 1972 (Willis \208)
"Fannie Lou Hamer" c. 1967* (Willis \414)
"Free Huey!" 1969* (Willis \415)
"Kathleen Cleaver" c. 1968* (Willis \413)

BLUM, Dieter
[East African rhinos in a zoo] c. 1991* (Graphis92
\227)
"Ismael Ivo" c. 1995* (Graphis96 110)
[A scene from Naumeier's ballet version of
Magnificat] c. 1992* (Graphis93 120a)
"Vladimir Molokhov im Studio" c. 1999* (Photo00
97)

BLUME, Bernhard Johannes, 1937-
"Magischer Determinismus" 1976 (San \64)

BLUMENFELD, Erwin, 1897-1969
"Cecil Beaton" c. 1937 (San \30)
"Untitled" c. 1940 (San #44)
"Wet Veil, Paris" 1937 (Rosenblum2 #552)
"What Looks New" 1947* (Rosenblum2 #645)

BLUMER, Ronald
"Order your Photo Watch!" 1997* (Goldberg 220)

BOCXE, Wesley
"A Kuwaiti soldier embraces his father on the
morning of the liberation of his country" 1991*
(Best17 14)
"U.S. Army Special Forces troops detain Iraqi
soldiers in the liberation of Kuwait City" 1991*
(Best17 13)

BODDIE, Terry E., 1965-
"Expatriate" 1997 (Willis \532)
"The Return" 1997 (Willis \534)
"Separation" 1997 (Willis \533)

BODINE, A. Aubrey, 1906-1970
"Baltimore Harbor" 1940s (Peterson #25)
"Dock Workers, Pratt Street" 1925 (Peterson #50)
"Fels Point, Baltimore" 1950 (Peterson #47)

BOGDAN, Lisa
"Amalia Lacroze de Fortabat" c. 1991* (Graphis91
\184)
"Lorraine, pregnant nude study no. 2" c. 1991*
(Graphis91 \183)

BOHM, Linda
[child in overalls] c. 1992* (Graphis93 35)

BOHNE, Petra
"Take off on painter Otto Dix" c. 1990* (Graphis90
\36)

BOKALDERS, Sig
"This bullet-spangled banner takes aim at America's
love affair with weapons" 1987 (Best13 143a)

BOLESCH, Sebastian
"Demonstrations of Palestinians in Hebron against the
Israeli settlements" 1996* (Best22 167d)

BOLTANSKI, Christian, 1944-
"Jewish School of Gosse, Hamburgerstrasse in 1938"
1994* (Photography 154)
"Monuments (Les Enfants de Dijon)" 1985* (Art
\454a, 454b; Marien \7.27)

BONFILS, Felix
"Dead Sea, A View of the Expanse" 1860-1890
(Rosenblum2 #134)
"Vendeurs d'eau fraîche dans les rues du Caire" n.d.
(Decade 3a)

BONFILS, Marie Lydie Cabannis
"Group of Syrian Bedouin Women" c. 1870
(Rosenblum2 #414)

BONINE, Elias A., 1843-1916
"Maricopa Indian, Arizona" c. 1875 (National 123a)

BONNEY, Thérèse, 1894-1978
"Refugee" 1940 (Rosenblum \174)

BONSEY, Dan
"Composition of natural and man-made shapes" c.
1991 (Graphis92 \54)

BOOTH, Alvin
[nude] c. 1995* (Graphis96 135)

BOOTH, Greg
[Canyon de Chelley] c. 1992* (Graphis93 129)

BORAN, Michael
"Tony Potts" 1989* (Marien \7.55)

BORCHERS, Karen T.
[feather illustrates lightness of puff pastries] 1986*
(Best12 110c)
"Filipinos stop a car to retrieve ballots that Marcos
supporters were trying to steal" 1986 (Best12 21c)
"'Smoky Mountain,' a garbage dump in Manila where
poor people live in a squatter village and pick
through trash looking for scraps of plastic" 1985
(Best11 75d)

BORCHERS, Kathy
"Boy is delighted as Norton, the zoo's polar bear,
pushes off the window of his swimming tank"
1996* (Best22 173a)

BORDNICK, Barbara
[advertising photograph] c. 1990* (Graphis90 \39)
[nude] c. 1989 (Graphis89 \147)
"Pleats" c. 1991* (Graphis91 \10)

BORDO, Mike
"Steven Burch jams a cocked pistol into clerk Pamela
Hinkle's neck after taking her hostage at a local
grocery store" 1996* (Best22 149c)

BOROWSKI, Nadia
"Baby Vegetables" 1996* (Best22 180c)

BORUM, Mike
[wine auction catalog] c. 1989* (Graphis90 \327)

BOSSE, Henry, 1844-1903
"Mouth of the St. Croix River" 1885 (National 123d)

BOSTON, Bernie
"After unveiling a bust of Dr. Martin Luther King in
the U.S. Capitol rotunda, his widow, Coretta Scott
King, smiles up at his image" 1986 (Best12 58a)
"Antiwar protest at the Pentagon" or "Flower Power"
1967 (Goldberg 172; Life 158)
"President Ronald Reagan gets a going-away gavel
during Republican convention" 1988 (Best14 9d)
"U.S. Marshalls and Washington, D.C. police level
guns at fugitives caught in a sting operation" 1985
(Best11 104a)

BOTELLA, Pepe
"Mannequin Carmen Gongora" c. 1990* (Graphis90
\18)

BOUBAT, Edouard, 1923-
"First Snow, Jardin du Luxembourg, Paris" 1955
(Icons 133)
"Portugal" 1958 (Rosenblum2 #627)

BOUCHER, Pierre, 1908-
"Ondine" 1938 (San \31)

BOUGHTON, Alice, 1866-1943
"Children–Nude" 1902 (Rosenblum2 #361)
"Maxim Gorky" 1914 (Vanity 6)
"Nature's Protection" c. 1905 (Rosenblum \262)
"Nude" 1909 (Marien \4.26)
"The Seasons" c. 1905 (Sandler 57c)

BOUJU, Jean-Marc
"A fighter of the National Patriotic Front of Liberia
steps on the beheaded body of a rival Krahn fighter
in downtown Monrovia" 1996* (Best22 148c)
"Man tumbles after being executed by victorious
Zairean rebels" 1997* (Best23 125b)
"Nairobi Embassy Bombings" 1998* (Capture 191)

BOURG, Jim
"Vice President Dan Quayle snaps a picture of a
young fan in New Hampshire" 1992* (Best18 80b)

BOURGOIGNIE, Lelen
"One of the estimated 2,000 street children in
Bucharest, sniffs Arviac while in his underground
home" 1995 (Best21 188)

BOURKE-WHITE, Margaret, 1904-1971
"Ammonia Storage Tanks" 1930 (Sandler 153)
"At the Time of the Louisville Flood" 1937 (Eyes
#123; MOMA 149; Szarkowski 224)
"Chrysler Building, NYC" c. 1932 (Hambourg \11)
"Decoy Tanks of Tin and Wooden Guns" 1939 or
earlier (Szarkowski 315c)
"Fazenda Rio des Preda" 1930s (Women \121)
"Female 'Burners' bevel armor plating for tanks"
1943 (Life 41)
"Fort Peck Dam" 1936 (Lacayo 97)
"Fort Peck Dam, Montana" 1936 (Eyes #167;
Goldberg 88; Hambourg \26; Marien \5.61;
Rosenblum2 #602)
"Gandhi Beside His Spinning Wheel" 1946 (Icons
103; Monk #34; Photos 71)
"George Washington Bridge" 1930s (Sandler 154;
Women \56); 1953 (Decade \59)
"High Level Bridge, Cleveland" 1929 (Rosenblum2
#543)
"Hydro Generators, Niagara Falls Power Co." 1928
(Women \58)
"A Judge at the Horse Races" 1941 (Sandler 161)
"The liberation of Buchenwald" or "The Living Dead
at Buchenwald" 1945 (Eyes #213; Lacayo 116d;
Monk #30)
"Liberation of Buchenwald concentration camp"
1945 (Photos 67)
"Logs" c. 1940 (Sandler 149)
"Montana Saturday Nights: Finis" 1936 (Eyes #168;
Goldberg 90)
"Nazi suicides" 1945 (Eyes #199)
"Staff Sergeant Robert Wilson and Private First Class
Wilbur Derrickson at an Artillery Outpost, Italy"
1944-1945 (Marien \5.60)
"Taxi dancers, Fort Peck, Montana" 1936 (Goldberg
91; Lacayo 96; Sandler 146)
"Two Women, Lansdale, Arkansas" 1936
(Rosenblum2 #452)
"Untitled" late 1920s (Women \57)
"Wind Tunnel Construction, Ft. Peck Dam" 1936
(Rosenblum frontispiece; Rosenblum2 #582)
"Winding Condensor Coils" c. 1933 (Sandler 150)
"Woman with Plough, Hamilton, Alabama" 1936
(Rosenblum \164)
"Wounded G.I. Cassino Valley, Italy" 1943-1944

(Rosenblum \176)

BOURNE, St. Clair, 1943-
"Harlem Snowstorm" c. 1969 (Willis \224, \225)
"Stokely Carmichael" 1969 (Willis \226)

BOURNE, Samuel, 1834-1912
"Boulders on the Road to Muddan Mahal" c. 1867
(Rosenblum2 #136)
"Group of Todas" c. 1868 (Art \133)
"Lepcha Man" 1868 (Art \134)
"The Manirung Pass" 1866 (Waking 304)
"Valley and Snowy Peaks Seen from the Hamta Pass,
Spiti Side" 1863-1866 (Marien \3.28)

BOURSAULT, A. K.
"Under the skylight" c. 1903 (Rosenblum \69)

BOURSEILLER, Philippe
"Ash rains down after eruption of Mount Pinatubo,
Luzon Islands, the Philippines" 1991* (Life 17)

BOUTAN, Louis, 1859-1934
"Underwater Self-Portrait" 1898 (Monk #13)

BOWERS, Harry, 1938-
"Jane, Far and Few" 1978* (Photography2 196)
"Untitled (HB-28-80)" 1979* (San \55)

BOWERS, W. R.
"Roald Amundsen" c. 1912 (Photos 22)
"Scott's Expedition Sights Amundsen's Tent" c. 1912
(Photos 23)

BOWLUS, Susan
[self-promotional] c. 1991 (Graphis92 \34)

BOYD, Chris
"Exhausted after finishing a three-mile cross-country
race in a downpour" 1986 (Best12 227b)

BOYD, G. Andrew
"Spring Fashion Dreams #1" 1995* (Best21 151a)

BOYER, Dwight
"Firefighters flee a rooftop as a church wall begins to
collapse toward them" 1944 (Best18 13)

BRACK, Dennis
"President Ronald Reagan and Soviet leader Mikhail
Gorbachev" 1986* (Best12 7a)

BRACKENBURY, Deborah
"Dignity" c. 1995* (Graphis96 77)
[Monkey] c. 1995* (Graphis96 8)
"Regal" c. 1995 (Graphis96 97)
"Sectional" c. 1995* (Graphis96 169a)
"Twain" c. 1995* (Graphis96 169b)
"Whirligigs" c. 1995* (Graphis96 168)

BRACKLOW, Robert L.
"Statue of Virtue, New York" 1909 (Rosenblum2
#313)

BRADNER, Heidi
"Refugee Boy" 1996 (Best22 212b)
"A young Chechen man affiliated with the anti-
Dyadavev forces in courtyard" 1996 (Best22 217a)

BRADSHAW, Ian
"Rugby match streaker" 1974 (Life 116)

BRADY, Mathew B., 1823-1896
"Abraham Lincoln" 1860 (Marien \3.16; Monk #6)
"Albert Edward, Prince of Wales" 1860
(Photography1 #II-8)
"Charles Dickens" 1867 (Photography1 #II-15)
"Clara Barton" c. 1866 (Marien \3.69)
"Commodore Matthew Calbraith Perry" 1856-1858
(Waking 312d)
"Cornelia Van Ness Roosevelt" c. 1860 (Waking
#90)
"Edward McPherson" c. 1860 (Photography1 #II-10)
"Edwin Booth and His Daughter, Edwina" 1866
(Photography1 #II-11)
"George Armstrong Custer" c. 1864 (Eyes #13)
"James Brooks" c. 1857-1859 (Photography1 \28)
"John C. Breckenridge" c. 1857 (Photography1 #II-7)
"Joint Committee on the Army Appropriations Bill"
1856 (Eyes #12)
"Martin Van Buren" c. 1856 (Photography1 #II-6)
"Nathaniel Willis" c. 1860 (Photography1 #I-2)
"Oliver Wendell Holmes" c. 1860 (Photography1
61c)
"Portrait of a Man" c. 1857 (Waking #94)
"Soldiers on the Battlefield" or "Confederate Dead
Gathered for Burial" 1862 (Marien \3.20;
Photography1 #IV-14)
"Washington Irving" c. 1860 (Photography1 #II-4)

BRADY STUDIO
"Aftermath of war in Charleston" 1865 (Lacayo 25c)
"Andersonville Still Life" 1866 (Waking #109)
"The Futurist Painter Giacomo Balla" 1912 (Marien
\4.56)
"Landing Supplies on the James River" c. 1861
(Rosenblum2 #207)
"Matériel assembled for the Peninsular Campaign"
1862 (Lacayo 23c)
"Senator and Mrs. James Henry Lane" 1861-1866
(Waking #95)
"The Sick Soldier" c. 1863 (National \19)

BRAINERD, Brian
"A SWAT team approaches apartment of a man after
a shootout with police" 1987 (Best13 66a)

BRAGAGLIA, Anton Giulio, 1890-1960
"Change of Position" 1911 (Waking #186)

BRAKHA, Moshe
"Arnold Schwarzenegger" 1985* (Rolling #71)

BRANCUSI, Constantin, 1876-1957
"Golden Bird" c. 1920 (Hambourg \122)

BRANDENBURG, Jim
"An Arctic wolf leaps from ice raft to ice raft in the
wilds of northern Canada" 1987* (Best13 90;
Graphis90 \190; Through 336)
"Arctic wolf surveying his domain from an iceberg
throne" c. 1990* (Best13 93; Graphis90 \191)
"Arctic wolves" 1987* (Best13 86-93)
"The grey wolf is considered the spirit of the forest
by some Native Americans" 1991* (Best17 174)
"In Namibia, a protective labyrinth of stick walls can
be moved to confound foes who try to reach the
Ovambo headman's hut" 1982* (Through 220)
"A lone bison pauses at sundown near the Oglala

Sioux Pine Ridge Reservation in South Dakota"
1991* (Best17 69b)
"North Woods Journal" 1997* (Best23 246-247)

BRANDT, Bill, 1904-1983
"'Charlie Brown's,' London" c. 1936 (Szarkowski
218)
"Coach Party, Royal Hunt Club Day, Ascot" 1933
(Art \293)
"Drawing Room, Mayfair" 1930s (Art \292; Icons 89)
[from Perspective of Nudes] 1953 (Szarkowski 255)
"Halifax" c. 1940s (Icons 88)
"Halifax" 1936 (Rosenblum2 #459)
"Madam Has a Bath" 1934 (Waking #170)
"Northumberland Miner at his Evening Meal" 1937
(Art \288)
"Nude, East Sussex Coast" 1953 (Rosenblum2 #710)
"Nude, London" 1956 (Photography2 67)
"Parlourmaid and Under-Parlourmaid Ready to Serve
Dinner" 1934 (Art \289; Hambourg \45; Marien
\5.70)
"Quarrel" 1936 (Art \291)
"Soho Bedroom" 1936 (Hambourg \36)
"Tic-tac men at Ascot Races" 1935 (Art \290)

BRANDT, David Allan
[chimpanzee] c. 1999* (Photo00 222)

BRAQUEHAIS, Bruno
"Vendôme Column after its Destruction" 1871
(Marien \3.25)

BRASSAÏ, 1899-1984
"At Suzy's" 1932 (Art \287)
Bijou of Montmartre c. 1933 (Marien \5.28;
Rosenblum2 #623)
[from Minotaure] 1935 (San #16)
"Graffiti, 'The Sun King'" 1945-1950 (Icons 52)
"Introduction at Suzy's" 1932-1933 (Hambourg \34)
"Lesbian Couple at The Monocle" 1932 (Waking
#168)
"Lovers in a Café on the Place d'Italie, Paris" 1932
(Icons 53) or "Rue de Lappe" 1932 (Art \284)
"A man falls in the street" 1932 (Eyes #117)
"Matisse and His Model at the Villa D'Alesia" 1939
(Hambourg \67)
"Members of Big Albert's Gang, Place d'Italie" 1932
(Art \285)
"A Monastic Brothel, rue Monsieur Le Prince,
Quartier Latin" 1932 (Art \283)
"On Suit for Two" 1932-1933 (Art \286)
"Paris in the Fog at Night" 1934 (Rosenblum2 #622)
"Picasso and Stove" n.d. (Photography 79)
"Pont Marie, Île Saint-Louis" c. 1932 (Waking #164)
"Prostitute playing Russian Billiards, boulevard
Rochechouart, Montmartre" 1932 (Art \282)
"Prostitutes in a Bar, Boulevard Rochechouart,
Montmartre" 1932 (Hambourg 101)
"Sculpture involontaire" 1933 (Marien \5.22)
"Three Masked Women" 1935 (Szarkowski 221)
"Two Toughs in Big Albert's Gang" 1932-1933
(Hambourg \40)

BRATHWAITE, Kwame, 1938-
"Castro Returns to Harlem" 1995* (Committed 56)
"James Brown–Apollo Theatre" 1988 (Committed
57)

BRAUCHLI, David
"Two Axeri men wash the body of a Khojali refugee

who was killed while fleeing fighting in Nagorno Karabakh" 1992* (Best18 124a)

BRAULT, Bernard
"Country singer Dolly Parton, backlighted during an appearance at Montreal Forum" 1986 (Best12 50d)
"Cubs infielder gets out of the way as he doubles the runner" 1986 (Best12 209a)
"Pilot John Voss is ejected from his 2.5 liter boat during the 50th annual Valleyfield Regatta in Quebec" 1988 (Best14 124a)

BRAUN, Adolphe, 1812-1877
"Flower Study" c. 1855 (Rosenblum2 #261)
"Holbein's Dead Christ" 1865 (Rosenblum2 #285)
"Lake Steamers at Winter Mooring, Switzerland" c. 1865 (Rosenblum2 #119)
"Port of Marseilles" c. 1855 (Photography 19d)
"Still Life with Deer and Wildfowl" c. 1865* (Rosenblum2 #263, #335)
"Still life with Game" 1865 (Art \82)

BRAZAN, Joseph
"Watch Dog" c. 1995* (Graphis96 183)

BREAKER, Helen
"Ernest Hemingway" 1928 (Vanity 51)

BREIDENBACH, Bob
"Dennis Connor, and his crew sail the Stars and Stripes during a practice run the week before they raced–and beat–Kookaburra II for the America's Cup" 1987 (Best13 221b)

BREITENBACH, Josef
"Hong Kong" 1964 (Photography 44)

BRESLAUER, Marianne, 1909-
"Paris" 1929 (Rosenblum \137)

BRETZ, George
"Breaker Boys, Eagle Hill, Colliery" c. 1884 (Rosenblum2 #432)

BREWSTER, David
"A lot of wind combined with a lot of rain provides an adventure in driving for motorists on Interstate 94" 1986 (Best12 180b)

BRIDGES, Bill
"Polio vaccination drive" 1960 (Life 44, 45)

BRIDGES, George Wilson, 1788-1864
"Temple of Wingless Victory, Lately Restored" 1848 (Waking #70)

BRIDGES, Marilyn, 1948-
"Arrows over Rise, Nazca, Peru" 1979 (Rosenblum \243)
"Burning Man, Black Rock Desert" 1997 (Photography 106a)
"Desertscape, Death Valley, California" c. 1997 (Graphis97 138)
"Jockey Club, Argentina" 1996 (Photography 106b)
"Journey, Monument Valley, Utah" c. 1997 (Graphis97 140a)
"Playing Baseball, Allen's Creek, New York" c. 1997 (Graphis97 140b)

BRIGMAN, Anne W., 1869-1950
"The Bubble" 1905 (Rosenblum2 #389)
"The Dying Cedar" 1906 (National 24d, \66)
"The Heart of the Storm" c. 1910 (Marien \4.28)
"Incantation" 1905 (Rosenblum \102)
"Invictus" c. 1907-1911 (Goldberg 23)
"Saga–The Golden Fleece" 1924 (Women \16)
"Soul of the Blasted Pine" c. 1905 (Sandler 55)
"The Spirit of Photography" c. 1903 (Sandler 2)
"A Study in Radiation" 1924 (Women \15)
"Untitled" 1922 (Women \17)
"The Wondrous Globe" c. 1905 (Sandler 56)

BRIHAT, Denis
"William Pear" 1972 (Rosenblum2 #765)

BRIMBERG, Sisse
"As brilliant as Christmas trees, dancers in Acapulco, Mexico, twirl in sequined dresses inspired by the Orient" 1990* (Through 316)
"A couple in Montreal, Canada, enjoys a quiet moment on Mount Royal Park's iced-over Beaver Lake" 1991* (Through 344)
"Despite the chilly air, bathers in Iceland keep warm in a thermal spring dubbed the Blue Lagoon" 2000* (Through 442)
"St. Basil's Cathedral in Moscow's Red Square" 1998* (Through 42)

BRINK, Benjamin
"Preparing to put a feeding tube into a severely dehydrated child in Kenya" 1992* (Best18 132d)

BRINK, Gaby
[self-promotional] c. 1991* (Graphis92 \90)

BRISKI, Zana
"Female infanticide in India" 1995 (Best21 211b, 221d)

BRISTOL, Horace
"Men scramble to find camphor-scented batons tossed to them by a priest at a New Year's celebration in Japan" Post-WWII (Through 188)

BRODBECK, Robert
"Racing collision of Stan Fox after his car hit Eddie Cheever's car on the first lap of the 1995 Indianapolis 500" 1995* (Best21 123, 122b)

BROENING, Thomas
"Joe Hakim, Author" c. 1999* (Photo00 117)

BRONSTEIN, Paula
"The Boston Red Sox celebrate their American League pennant victory at Fenway Park" 1986 (Best12 214d)
"People cling to a street sign in Old Saybrook, Conn., as they experience Hurricane Gloria's force" 1985 (Best11 70d)
"Woman cries after she tells of her medical problems after the Bhopal Union Carbide gas tragedy" 1985 (Best11 118)

BROODTHAERS, Marcel, 1924-1976
Le Soupe de Daguerre 1976* (Marien \6.90; Photography2 149)

BROOKS, Charlotte, 1918-
"Farm Cellar, New York" 1945 (Rosenblum \207)

BROOKS, Dudley M.
"After a mudslide Nicaraguan young people play with a dog" 1998 (Best24 93b)
"Before the bench press competition a coach gets his powerlifter focused" 1997 (Best23 232b)
"Game of Life" 1997 (Best23 214b, 215b, d)
"The mother of a police officer weeps quietly at his burial" 1997 (Best23 232a)
"Paige's Palace" 1998 (Best24 39a, 64, 96)
"Players from the Anacostia High School football team" 1997 (Best23 232b)
"Relatives of Navy diver Robert Stetham meet plane that brought his body home" 1985 (Best11 49d)
"A retired Araber takes a drag" 1997 (Best23 233)
"12-year-old boxer met his match" 1997 (Best23 232d)
"A woman gestures as she listens to remarks by Pope John Paul II during one of the masses he presided over in Cuba" 1998 (Best24 28)
"Young contestant in the National Spelling Bee" 1998 (Best24 87b)

BROOKS, Ellen, 1946-
"Doctor and Nurse" 1979* (Photography2 219)

BROOKS, Milton
"Desperate for work, a Detroiter advertises" 1932 (Eyes #162)
"The Picket Line; Ford Plant, River Rouge, Michigan" 1941 (Capture 8; Lacayo 91)

BROOM, Christina, 1863-1939
"Christabel Pankhurst speaking on women's suffrage in Hyde Park" c. 1909 (Rosenblum \63)

BROWN, Beatrice A.
"Students at work, Clarence H. White School of Photography" 1924-1925 (Rosenblum \103)

BROWN, Charlaine
"During hot weather, two young deer seek shade under a weeping willow" 1987 (Best13 177d)

BROWN, Dean
[from series *Martin Luther King*] 1969 (Decade \83)
"Navajo Reservation, North of Cameron, Arizona" 1969* (Decade \II)

BROWN, George O.
"Portrait of Maggie L. Walker" n.d. (Willis \32)

BROWN, John, 1957-
"*Nature* series flowers" 1995 (Willis \546-\549)

BROWN, Michael R.
"Christa and fellow astronauts" 1986* (Best12 11)

BROWN, Paul
"A traditional merry-go-round spins at the foot of the Cathedral of Sacre Coeur which stands on a hill overlooking Paris" 1987 (Best13 176a)

BROWNE, John C., 1838-1918
"Mill Creek" 1878 (Photography1 \82)

BROWNE, Malcolm
"Buddhist monk burns himself to death to protest the Diem government in South Vietnam" or "Quang Duo immolating Himself" 1963 (Goldberg 162; Lacayo 129)

BROWNELL, Elizabeth
[from *Dream Children*] c. 1890 (Sandler 65a)

BROWNS STUDIO, active 1875-1977
"Cooking class, Armstrong High School" c. 1925 (Willis \33)
"Typewriting club, Armstrong High School" c. 1930 (Willis \31)

BRUEHL, Anton, 1900-1982
"Hands Threading a Needle" c. 1929 (Rosenblum2 #630)
"Louis Armstrong" 1935 (Vanity 163)
"Mexican Potter" 1932 (Decade \24)
"The Queen Mary" 1932 (Hambourg \20)
"Untitled" 1927 (Decade 21a)

BRUEMMER, Fred, 1929-
"Harp Seal Pup" 1977* (Monk #48)

BRUGUIÈRE, Francis Joseph, 1879-1945
"Cut paper" c. 1928 (Szarkowski 179)
"Cynthia Fuller" c. 1935 (Decade \31)
"Design in Abstract Forms of Light" 1925 (Hambourg \101; Rosenblum2 #553)
"Untitled" c. 1932 (San \8)

BRUMMETT, Thomas
"Rethinking the Natural" c. 1997* (Graphis97 89)

BRUSH, Gloria Defilipps, 1947-
"Untitled" 1982* (Rosenblum \17)

BRUTY, Simon
"American tennis player Venus Williams at the U.S. Open" 1998* (Best24 81)

BRYANT, Michael
"On a bitterly cold day, man finds he has his choice of park benches for the next race at Philadelphia Park" 1988 (Best14 42d)
"The real Adrian Cronauer belts out the words that made him famous as a disc jockey in Saigon during the Vietnam War" 1988 (Best14 43a)
"Rehova Bennett, a client of the Catholic Social Services Adult Daycare in Indianapolis, awaits the start of the day at the center" 1988 (Best14 42a)
"Rev. Jesse Jackson stands above a sea of supporters at the University of Pennsylvania after giving a speech the day before election" 1988 (Best14 42b)
"Sudan's Refugees" 1988 (Best14 41, 44-45)

BUBLEY, Esther, 1921-
"At the Memphis Greyhound terminal" 1943 (Documenting 329c)
"Between Knoxville and Bristol, Tennessee" 1943 (Documenting 328a)
"Boarders often speculate on the identity of the owner of the house across the street. Washington, D.C." 1943 (Fisher 60)
"Brother Edwin Foote preaching a sermon at the First Wesleyan Methodist Church" 1943 (Fisher 42)
"Bus Terminal in Pittsburgh" 1943 (Sandler 151)
"Children playing in a fountain in DuPont Circle. Washington, D.C." 1943 (Fisher 56)
"The Cochran children doing dishes after Sunday dinner" 1943 (Documenting 323c)
[A conversation in the hallway] 1943 (Fisher 92)
"Crude Oil Pipe Still No. 7" n.d. (Sandler 160)

"A driver removing the baggage from a bus that broke down en route to Pittsburgh" 1943 (Documenting 316a)
"The drivers' room at the Pittsburgh Greyhound garage" 1943 (Documenting 318b)
[Drying laundry in a boarding house room] 1943 (Fisher 154)
"Duluth, Mesabi, and Iron Ore Range" 1947 (Rosenblum \206)
[Girl lying on bed, near radio] 1943 (Fisher 104)
"Girl sitting alone in the Sea Grill, a bar and restaurant, waiting for a pickup" 1943 (Fisher 95)
"Girls in cafeteria flock around a sailor who graduated in June" 1943 (Fisher 94)
"Greyhound driver Bernard Cochran at the end of his run in Cincinnati" 1943 (Documenting 322b)
"Greyhound driver Clem Carlson in a hotel room" 1943 (Documenting 320a)
"Highway between Gettysburg and Pittsburgh photographed through the windshield of a bus" 1943 (Documenting 315)
"In the Hall of a boarding house" 1943 (Fisher 71)
"In the ladies room at the Chicago Greyhound bus terminal" 1943 (Documenting 326b)
"In the lounge at the United Nations service center" 1943 (Fisher 69)
"Indianapolis terminal" 1943 (Documenting 326a)
"Inside restaurant across from the Columbus Greyhound terminal" 1943 (Documenting 324a)
"Listening to a murder mystery on the radio in a boarding house" 1943 (Fisher 117; Marien \5.59)
"Little boy riding on a streetcar. Washington, D.C." 1943 (Fisher 89)
[Men and women playing cards near sleeping woman] 1943 (Fisher 90)
"Miss Genie Lee Neal reading a perforated tape at the Western Union telegraph office" 1943 (Fisher 87)
"Mopping the floor of a bus in the Pittsburgh Greyhound garage" 1943 (Documenting 318a)
"Mr. and Mrs. Bernard Cochran at home in Cincinnati" 1943 (Documenting 322a)
"Passenger in a small Pennsylvania town waiting to board a Greyhound bus" 1943 (Documenting 317b)
"Passengers exchanging moron jokes between Pittsburgh and St. Louis" 1943 (Documenting 325b)
"The Pittsburgh Greyhound bus station waiting room" 1943 (Documenting 321b)
"The Pittsburgh Greyhound Garage" 1943 (Documenting 319c)
"Railroad Yard, Wisconsin" c. 1945 (Sandler 162)
"Sally Dessez, a student at Woodrow Wilson High School, in her room" 1943 (Fisher 63)
"Soldier in front of Capitol Theatre" 1943 (Fisher 59)
[Soldier in photo booth] n.d. (Fisher 58)
"Soldiers looking at the statue at the Federal Trade Commission, Washington, D. C." 1943 (Fisher 57)
"Students at Woodrow Wilson High School" 1943 (Fisher 91)
"The telephone in a boarding house is always busy" (Fisher 64)
[Things on a dresser] n.d. (Fisher 118)
"Tombal, Texas, Gasoline Plant" 1945 (Sandler 155)
[Two women near a headboard] 1943 (Fisher 61)
"Unloading baggage in Chattanooga" 1943 (Documenting 328b)
"Waiting for a bus at the Memphis terminal" 1943 (Documenting 327c)
"The waiting room at the Greyhound Bus Terminal. Pittsburgh, Pennsylvania" 1943 (Fisher 55)

[Washing diapers in the kitchen] 1943 (Fisher 138)
"Women gossiping in a drugstore over Cokes" 1943 (Fisher 65)

BUCHANAN, Todd
"Boaters on the Ohio River examine the shoreline after a record drought dropped the water to its lowest level since 1930" 1988 (Best14 80)

BUCKLER, Susanne
[self-promotional] c. 1991* (Graphis91 \244)

BUEHMAN, Henry, and HARTWELL, F. A.
"Apaches in Ambush" 1885 (Photography1 #III-17)

BUERHMANN, Elizabeth, 1886-after 1954
"Helena Modjeská" c. 1909 (Sandler 62a)
"Portrait of Julie Hudak" n.d. (Rosenblum \79)

BUI, Khue
"Family watches a skateboarder perform tricks at a new skateboarding park" 1996 (Best22 222a)
"Field of Dreams" 1997 (Best23 167b, 216a, c)
"Goalkeeper and player struggle for control of the ball" 1996 (Best22 222c)
"Mourners hold a candlelight vigil and prayer in memory of loved ones who have passed away from AIDS" 1996 (Best22 222b)
"Police officers question a man apprehended after allegedly purchasing crack" 1996 (Best22 223d)
"Suspect carries his belongings, as he and others are arrested" 1996 (Best22 223b)
"University students mourn the loss of a friend who was murdered" 1996 (Best22 223a)

BULL, Clarence Sinclair, 1895-1979
"Greta Garbo" 1930 (Monk #17); 1931 (Goldberg 76)

BULLARD, Timothy
"Gertrude Baccus, 18 and 84" 1984 (Goldberg overleaf)

BULLOCK, John G., 1854-1939
"Marjorie in the Garden" c. 1903 (National 67)
"Untitled" c. 1910 (MOMA 86)
"Young Anglers" 1896 (Photography1 \99)

BULLOCK, Wynn, 1902-1975
"Child in the Forest" 1951 (Decade 68a)
"Light Abstraction" 1939 (Decade \34)
"Palo Colorado Road" 1952 (Decade \62)
"Point Lobos Wave" 1958 (Rosenblum2 #667)
"Sea Palms" 1968 (Decade 81a)
"Tide Pool" 1957 (Photography2 32)

BUNKER, Earle L., 1913-1975
"A Hero's Return" 1943 (Capture 14; Eyes #208)

BUNTROCK, Gerrit
[bread] c. 1992* (Graphis93 89)
[milk ladles and pails] c. 1992* (Graphis93 70)

BURBANK, Joe
"Bobby Burton, a transient from Georgia, tries to strike a man during a fight that broke out in a homeless shelter" 1988 (Best14 75a)

BURBRIDGE, Richard
"Buddy Guy" c. 1999* (Photo00 163)

"Nick Cave" c. 1997 (Graphis97 118)

BURCHARTZ, Max
"Eye of Lotte" c. 1928 (Rosenblum2 #517)

BURCKHARDT, Rudy, 1914-1999
[An Afternoon in Astoria] 1940 (MOMA 154-155)

BURDEN, W. Douglas
"Beauty is abundant in Bali, an Indonesian paradise where villagers enjoy an open-air bath" 1927 (Through 152)

BURGIN, Victor, 1941-
"The Bridge–Dora in S.F." 1984 (Photography2 224)
"Four Word Looking from U.S. 77" 1977 (Rosenblum2 #745)
"Office at Night, no. 1" 1986* (Art \456)
"Park Edge" refabricated 1988* (Art \455)

BURKARD, Hans Jürgen
"Moloch Moscow" 1992* (Best18 195-198)
"Street children of Sao Paolo" c. 1990* (Graphis90 \269)

BURKE, Adrian
[frogs] c. 1992* (Graphis93 195)

BURKINS, Nathaniel, 1953-
"Monroe Street, Chicago" 1977 (Committed 58)
"Times Square" 1987 (Committed 59)

BURNETT, David, 1946-
"Bill and Hillary Clinton, Inauguration Gala" 1993* (Life 37d)
"Korem Camp, Wollo, Ethiopia" 1984* (Eyes \15)
"Mary Decker falls at the 1984 Olympics" 1984* (Lacayo 184)
"Presidential candidate Paul Tsongas takes a media dip" 1992* (Best18 78d)
"Pro-Shah meeting, Teheran, Iran" 1979* (Eyes \17)
"Reagan and Soviet leader Mikhail Gorbachev, Geneva Summit" 1985* (Life 34a)
"Shi'ite after dipping his hands in blood of a 'martyr' killed by the Shah's troops" 1979* (Eyes \14)

BURNS, Marsha, 1945-
"Kassa, New York" c. 1986 (Graphis89 \124)
"No. 45006" 1979 (Rosenblum \258)
"Yaz, New York" c. 1986 (Graphis89 \123)

BURRI, René, 1933-
"São Paulo" 1960 (Icons 139)
"Tien An Men Square, Beijing" 1965 (Rosenblum2 #615)

BURRISS, Andrew
"The Rev. Jerry Falwell goes down the 68-foot 'Typhoon' waterslide at PTL's Heritage USA theme park near Fort Mill, S.C." 1987 (Best13 31)

BURROWS, Larry, 1926-1971
"An American Marine in the 'Demilitarized' Zone" 1966* (Eyes \9)
"Ammunition airlift into besieged Khesanh" 1968* (Eyes \7)
"Farley gives way" 1965 (Eyes #290)
"First-aid station near the demilitarized zone, South Vietnam" 1966* (Life 60; Marien \6.70)
"One ride with Yankee Papa 13" 1965 (Eyes #289)

"Reaching out (during the aftermath of taking the hill 484, South Vietnam)" 1966* (Eyes \8)
"South of DMZ, South Vietnam" 1966* (Lacayo 130)
"Vietnamese woman and the body of her son" 1966* (Eyes \10)

BURSON, Nancy, 1948-
"Mankind (an Asian, a Caucasian, and Black blended, weighted according to current population statistics" 1983-1984 (Marien \8.23)
"Untitled" 1988 (Rosenblum \237; Rosenblum2 #801)

BURTON, Dean
[Tucson] c. 1992* (Graphis93 212)

BURTON, Tim
"Channel Surfing" 1993* (Best19 173d)

BUTCHER, Solomon D., 1856-1927
"Canyon on Peter Forney Land Near Merna, Nebraska" c. 1890 (Photography1 \89)
"John Curry House Near West Union, Custer County, Nebraska" 1886 (Photography1 \90)

BUTLER, Jack, 1947-
[Excitable Pages series] 1978* (Photography2 195)

BUTLER, Linda, 1947-
"Magic Garden, Japan" 1987 (Rosenblum \240)

BUTOW, David
"Dreaming of Stars" 1996 (Best22 260-261)
"Inner City Sports" 1997 (Best23 166c, 218)

BYBEE, Gerald
"For a brochure" c. 1989* (Graphis89 \219)
"Marisa" c. 1991* (Graphis92 \143)

BYER, Renee C.
"City workers in Peoria remove parking meters so they won't rust as the Illinois River went over flood stage" 1985 (Best11 65)

BYOUS, Jim
"A DC-6 dives into a canyon at Yosemite National Park to fight a huge forest fire that threatened the park" 1987 (Best13 75b)

BYRD, Richard E.
"Pictures from the South Pole" 1930 (Eyes #100-101)

BYRON, Joseph, 1836-1923
"Sitting Room Interior (Relaxing in the Parlor)" 1897 (Photography1 \83)

BYRD ANTARCTIC EXPEDITION
"Adm. Richard E. Byrd poses with his pet terrier Igloo" 1930 (Through 24)

—C—

CABALLERO, Ed
promotion of fitness centers c. 1990 (Graphis90 \244)

CABLE, Wayne
"Chicago Board of Trade building" c. 1991 (Graphis92 \221)

"Douglass ('Jocko') Henderson" 1997 (Willis \442)
"Man Who Hears Music, Andre Raphel Smith" n.d.*
 (Committed 63)
"Man Who Writes, John Edgar Wideman" 1997*
 (Committed 62; Willis \441)

CAMP, E. J.
 "Billy Idol" 1985 (Rolling #79)
 "Chris Isaak" 1988* (Rolling #82); c. 1990*
 (Graphis90 \148)
 "Daryl Hannah" 1984* (Rolling #95)
 "Denzel Washington" 1989* (Life 92)
 "Sammy Hagar" 1988* (Rolling #83)
 "Tattoos" 1986* (Rolling #72)
 "Tom Hanks" 1988* (Life 93d)

CAMP, Roger
 [dying flowers] c. 1991* (Graphis92 \73)
 "Junior lifeguards on the Californian coast during
 training" c. 1990* (Graphis90 \170)

CAMPBELL, Ron, 1955-
 "A Day of Atonement" 1985 (Committed 65)
 "Smokin'" 1997 (Committed 64)

CAMPBELL, Steve
 "A sudden downpour fails to dampen the patriotic
 spirit of flag-waving at a May welcome home rally
 in Houston for Vietnam War veterans" 1987
 (Best13 112c)

CAMPBELL, William
 "An Ethiopian mother holds her malnourished son at
 a Belgian medical station in northern Ethiopia"
 1987 (Best13 120)

CAMPBELL STUDIO
 "Henri Bergson" 1917 (Vanity 18)

CAMPUS, Peter, 1937-
 "Man's Head" 1978 (Photography2 164)

CANEVA, Giacomo, 1812/13-1865
 "Carlotta Cortinino" c. 1852 (Waking #72)

CANNERELLI, Stephen D.
 "Dating Software" 1995* (Best21 148a)
 "11-year-old watches a minor league game from a
 hilltop behind right field" 1997* (Best23 172a)

CAPA, Cornell
 "JFK and Jackie" 1960 (Photography 149)

CAPA, Robert, 1913-1954
 "Air-raid alarm" 1936 (Eyes #174; Lacayo 80b)
 "Carnival, Zürs, Austria" 1950 (Photography 217)
 "Death of a Loyalist Soldier" or "Soldier at the
 Moment of Death, Spanish Civil War" 1936 (Art
 \410; Eyes #187; Icons 68; Lacayo 88; Marien
 \5.84; Monk #22; Photos 50; Rosenblum2 #606)
 "Ernest Hemingway" 1941 (Life 167)
 "Naples" or "Mothers of Naples" 1943 (Eyes #195;
 Lacayo 115)
 "Normandy invasion on D-Day" or "D-Day, Omaha
 Beach" 1944 (Art \409; Eyes #189; Goldberg 116;
 Lacayo 105d; Marien \5.85; Rosenblum2 #607)
 "South of Bastogne, Belgium" 1944 (Art \411)
 "Spain" 1936 (Art \412)

CAPEL-CURE, Alfred, 1826-1896
 "Bat and insects" 1850s (Szarkowski 51)

CAPONIGRO, Paul, 1932-
 "Bloomfield, New York" 1957 (San \49)
 "Frosted Window" 1957 (Photography2 33)
 "Ice, Nahant, Massachusetts" 1958 (Decade 69)
 "Inner Night Sky" 1999 (Photography 105)
 "Schoodic Point, Maine" 1960 (Rosenblum2 #666)
 "Stone and Tree, Avebury" 1967 (Decade 81d)
 "Stonehenge, England" 1967 (Decade \100)
 "Untitled" 1957 (MOMA 212); 1964 (Szarkowski
 274)

CAPS, John, III
 "Gilbertville, Iowa, farmer surveys the damage to his
 drought-stricken crop" 1988 (Best14 10d)

CAPUCILLI, Karen
 "Personal studies" c. 1989* (Graphis89 \354-\357)
 [tarnished knives] c. 1997* (Graphis97 79)

CAPUTO, Robert
 "Tens of thousands of flamingos flock into Kenya's
 Rift Valley to feed on algae in an alkaline lake"
 1986* (Best12 106b)
 "A worker on a Kenya estate on the coast of the
 Indian Ocean begins harvesting sisal, one of the
 country's major exports" 1986* (Best12 105b)

CARAEFF, Ed
 "Jimi Hendrix" 1987 (Rolling #9)
 "Jimi Hendrix at the Monterey Pop Festival" 1967
 (Life 173d)

CARDONA, Julián
 "A canal of contaminated water near their cardboard-
 and-wood house" 1997* (Photography 116a)
 "Hosiery discarded by El Paso shopkeepers is bought,
 mended, dyed, and dried in the sun" 1995*
 (Photography 116b)

CAREY, Charles Philippe Auguste
 "Still life with waterfowl" c. 1873 (Rosenblum2
 #265)

CARJAT et CIE, Etienne, active 1861-1876
 "Alexandre Dumas" 1878 (Rosenblum2 #87)
 "Charles Baudelaire" c. 1862 (Marien \3.92); 1878
 (Rosenblum2 #93)
 "Émile Louis Gustave de Marcère" 1878
 (Rosenblum2 #95)
 "Emile Zola" 1877 (Rosenblum2 #91)
 "Gioacchino Antonio Rossini" 1877 (Rosenblum2
 #89)
 "Gustave Courbet" c. 1867-1875 (Szarkowski 83)
 "Victor Hugo" 1876 (Rosenblum2 #94)

CARMACK, Russ
 "Police and sheriff's deputies bear down on armed
 robbery suspects" 1995* (Best21 176a)

CARON, George R.
 "Atomic Bomb from the bomber" 1945 (Photos 69)
 "Hiroshima destroyed" 1945 (Photos 68)

CARON, Gilles, 1939-1970
 "Biafra" 1968 (Eyes #259)
 "Interrogation of peasant, Vietnam" 1967 (Eyes
 #260)

"Paris, 1968" (Eyes #257-258)

CARREON, Ed
"Rioting in Los Angeles" 1992* (Best18 127; Lacayo 182; Life 163)
"Two competitors collide during the Dan D'Lion Pro-Am Criterium Bicycle race in Anaheim, Calif" 1988 (Best14 13d)

CARRICK, William, 1827-1878
"A Fishmonger, St. Petersburg" 1859-1878 (Marien \3.86)
"Russian Types (Balalaika Player)" c. 1859 (Rosenblum2 #412)
"Russian Types (Milkgirl)" c. 1859 (Rosenblum2 #411)

CARRIER, Hoyt, II
"Wishy washy asparagus" 1988* (Best14 108d)

CARRIERI, Fernando Luiz
[self-promotional] c. 1991* (Graphis92 \71, \72)

CARRIERI, Mario
"Chairs designed by the architect Richard Meier" c. 1991 (Graphis91 \271, \272)

CARROLL, Lewis, 1832-1898
"Alice Liddell as 'The Beggar Maid'" c. 1859 (Marien 3.106; Waking #28)
"Beatrice Hatch" 1873* (Rosenblum2 #334)
"Edith, Lorina, and Alice Liddell" c. 1859 (Rosenblum2 #73)
"Irene MacDonald" 1863 (Szarkowski 92)
"Irene MacDonald, Flo Rankin, and Mary MacDonald at Elm Lodge" 1863 (Waking #31)
"The Reverend C. Barker and his Daughter May" 1864 (Szarkowski 96)
"St. George and the Dragon" c. 1874 (Waking #29)

CARROLL, Patty, 1946-
"Motel in Hell, Michigan" 1975* (Women \180)
"Xmas Tree in Window" 1976* (Women \179)

CARROLL, Peter J., 1911-1966
"Yanks parade through Paris" 1944 (Eyes #193)

CARSON, Richard J.
"As President-elect Bush gives his acceptance speech, granddaughter Barbara yawns with campaign weariness" 1988 (Best14 90a)

CARTER, Charles William, 1832-1918
"Mormon Emigrant Train, Echo Canyon" c. 1870 (Waking #118)

CARTER, Keith
"At a small church" c. 1991 (Graphis91 \223)

CARTER, Kevin
"Waiting Game for Sudanese Child" 1993* (Best19 195; Capture 172; Lacayo 180)

CARTER, Paul
"Death Be Not Proud" 1997 (Best23 219b,d)

CARTIER-BRESSON, Henri, 1908-2004
"L'Abbé Pierre" 1994 (Photography 148)
"Alberto Giacometti at work in his Paris studio" 1960 (Lacayo 138b)

"Alicante, Spain" 1933 (Icons 59)
"Barrio Chino, Barcelona" 1933 (Hambourg \33)
"Brussels" 1932 (Art \279; Rosenblum2 #659)
"Calle Cuauhtemoctzin, Mexico City" 1934 (Art \278; Hambourg \41)
"Cardinal Pacelli (later Pope Pius XII) at Montmartre, Paris" 1938 (Eyes #253)
"Chinese Nationalist recruits massing in Beijing" 1948 (Lacayo 160)
"Chinese Parade" c. 1958 (Eyes #255)
"Coney Island" 1946 (Lacayo 110)
"Cordoba, Spain" 1933 (Art \272)
"Dessau: Exposing a Gestapo informer" 1945 (Eyes #254; Marien \5.83)
"Eunuch of the Imperial Court of the Last Dynasty, Peking" 1949 (Art \273)
"Gypsies, Seville" 1933 (Hambourg 100)
"Henri Matisse, Vence" 1944 (Rosenblum2 #620)
"Kashmir" 1948 (Lacayo 93)
"Lock at Bougival" 1955 (Art \275)
"Madrid, Spain" 1933 (Art \276)
"On the Banks of the Marne" 1938 (Art \277; Rosenblum2 #621)
"Paris, Gare, St. Lazare" or "Behind the Gare St. Lazare" 1932 (Art \274; Marien \5.31; Rosenblum2 #619)
"Peter and Paul Fortress, Leningrad" 1973 (Art \281)
"Roman Amphitheater, Valencia, Spain" 1933 (San \24; Waking #194)
"Santa Clara, Mexico" 1934 (Szarkowski 220)
"Seville, Spain" 1933 (Waking 364)
"Spain speaks: 'On the threshold of the future'" 1933 (Eyes #111)
"Trying to buy gold before the Red Army enters Shanghai" (Lacayo 90a)
"Turkey" 1964 (Photography 112)
"Untitled" c. 1931 (Hambourg \52)
"Valencia, Spain" 1933 (Art \280; Rosenblum2 #660)

CARUCI, Jose
"A Venezuelan police officer closes his eyes from teargas as police surround the National Congress in Caracas" 1996* (Best22 144a)

CARVALHO, Duda
[handtool] c. 1997* (Graphis97 75)
[saws] c. 1997* (Graphis97 74)

CASALS, José Gimeno
"Puruchuco" 1979-1980 (Rosenblum2 #704)

CASASOLA, Agustín Victor
"Mexican Revolution" c. 1912 (Rosenblum2 #588)

CASEBERE, James, 1953-
"Chuck Wagon with Yucca" 1988 (Marien \7.52)
"Stonehouse" 1983 (Photography2 228)

CASH, Howard T., 1953-
"Abiodun, King of Hunters" 1984 (Committed 66)
"Faces: An African American in Ghana" 1978 (Committed 67)

CASOLINO, Peter
"Targeting Your Inner Emotions" 1993* (Best19 173a)

CASTLEBERRY, Howard
"Hussein Fiiffiddo digs a grave for his daughter in what once was a Mogadishu botanical garden"

1992* (Best18 131)

CATAFFO, Linda
"New York Mets catcher Gary Carter jumps on relief pitcher Jesse Orosco after the Mets downed the Boston Red Sox in the seventh game of the World Series" 1986 (Best12 215)

CAVANAUGH, Christine
"Robert Monaghan, reading a book on the streets of downtown San Diego, refuses money offered by a passer-by" 1987 (Best13 33a)

CAVARETTA, Joe
"Gallup: A Town Under the Influence" 1988 (Best14 191-193)

CEFARATTI, Carol
"Dale Schrauth takes a jab from his instructor while practicing epee fencing" 1988 (Best14 124d)

CENICOLA, Tony
[self-promotional] c. 1989* (Graphis89 \323)

CEPPAS, Cristiana
"Synchronized Swimmers" c. 1999* (Graphis97 206; Photo00 187)

CHADWICK, Helen
"The Oval Court (detail)" 1988* (Photography 230)

CHALASANI, Radhika
"In Zaire, a young Rwandan refugee waits outside medical tent for treatment" 1997* (Best23 187d)
"Waiting in the Jungle" 1997 (Best23 128a, 206)

CHALMERS, Catherine
"Bug from Food Chain" 1994-1996 (Marien \8.11)

CHAMBEFORT, Maria, active c. 1850
Stéphanie Poyet, agée de 7" c. 1850 (Women \1)

CHAMBERS, Bruce
"Cheryle McCabe sits among her belongings after an early morning fire destroyed her apartment" 1986 (Best12 190c)
"Jamie Leverentz is a Liberty lookalike who kept her torch aloft even as she quenched her thirst" 1986 (Best12 96d)
"Making an all-out dive for the softball" 1986 (Best12 230a)
"Tugs help a freighter turn" 1986 (Best12 157a)
"Vice officers arrest a man on charges of soliciting prostitution" 1988 (Best14 76)

CHAMBI, Martín, 1891-1973
"Festival in Ayaviri, Puno" 1940 (Rosenblum2 #448)
"Flute-Playing Indio with Llama" 1933 (Icons 61)
"Urubamba Valley near Cuzco" 1925 (Photos 21)

CHAN, Amos
[self-promotional] c. 1995* (Graphis96 194)

CHAN, John
[ad for "Tea Rose" perfume] c. 1989* (Graphis89 \29)
"Editorial on men's fashion" c. 1991* (Graphis91 \56)
"To be included in 'Beauty' column of magazine" c. 1989* (Graphis89 \180)

CHANDLER, Curt
"Three Amish youths urge oncoming truckers to blast their horns while passing at an overpass south of Mansfield, Ohio" 1987 (Best13 108)

CHANG, Al, 1925-
"Korea" 1950 (Eyes #229)

CHANG, Chien-Chi
"Bachelor Society – Illegal Chinese Immigrants in New York" 1998 (Best24 116, 122-123)
"The Chain" 1998 (Best24 118-119)
"Driven from their home in the mountains of Laos, refugees from the ancient Hmong tribe have been living in camps" 1997 (Best23 234b)
"Female patients receive comfort and care from nuns in Taiwan" 1997 (Best23 235b)
"Gloria Wyadd, who is blind and on welfare, is frequently visited by neighbors" 1991 (Best17 76)
"In a ceremony in Taiwan head monk symbolically closes the Buddhist Temple to the public" 1997 (Best23 235a)
"In spring Taiwanese followers of Saint Matsu make a pilgrimage to honor her" 1997 (Best23 234a)
"New York's Chinatown" 1998* (Best24 124-125)
"An old female elephant is set loose to wander as far as her chain will allow after daily treatment at an animal hospital" 1997 (Best23 158b)
"A patient who has died of AIDS is ritually cleansed prior to cremation" 1997 (Best23 234d)
"Say Cheese" 1998 (Best24 117, 120-121)
"Yes, I Do" 1997 (Best23 147a, 227d)

CHANGFEN, Chen
"Environmental Metamorphic Fission" c. 1983* (Rosenblum2 #726)

CHAO, Chan
"Member of KNLA" 1999* (Marien \7.0)

CHAPMAN, Arthur D., 1882-1956
"Diagonals" 1914 (Peterson #27)

CHAPMAN, Gary
"Black and White and Red" 1986* (Best12 111d)
"For stripes and high contrast" 1986 (Best12 140)
"Hand-painted backgrounds, hand-colored prints and period props highlight a fashion series on the look that's new–deja vu" 1987* (Best13 179b)
"Illustrate a story on off-the-wall-DJs" 1985* (Best11 156)
[illustrates an article on breast cancer] 1986* (Best12 112d)
"Several yards of cheap muslin and seven well-paid models show the season's new dress shapes" 1987* (Best13 178a)

CHAPMAN, Tim
"'John' of the mental ward: Naked he stares into the mirror all day long in the jail" 1986 (Best12 191a)

CHAPOULLIÉ, Denis
"Portrait of a young woman" c. 1989* (Graphis89 \184)

CHAPPELL, Walter, 1925-
"Burned Mirror, Denver, Colorado" 1956 (Photography2 71)
"Feather Torso Ceremonial" 1967 (Photography 76)
"Number 10" 1958 (MOMA 211)

CHARGESHEIMER, 1924-1971
"Before the Procession, Cologne" 1950s (Icons 124)
"Konrad Adenauer" 1954 (Icons 125)

CHARLES, Roland, 1941-
"Doing Hair" c. 1970-1995 (Willis \241)
"Geneva Clark Celestin holding portrait of her father, Robert" c. 1970-1995 (Willis \244)
"Man on Central Avenue, Los Angeles" c. 1970-1995 (Willis \242)
"Sholumbo playing cards with his grandpa" c. 1970-1995 (Willis \243)

CHARNAY, Désiré, 1828-1915
"Chichén-Itzá, Yucatan" c. 1858 (Rosenblum2 #141)
"Façade, Governor's Palace, Uxmal" 1860 (Art \138)
"Family Group" 1863 (Waking #77)
"Landscape with Tree Planted by Hernán Cortés, Mexico" 1856 (Marien \3.49)
"A Mission in Madagasgar: Marou, Malgache" 1863 (Marien \3.50)
"Raharla, Minister to the Queen" 1863 (Waking 308)
"Tree of Santa-Maria del Tule, Mexico" c. 1858 (Art \140)

CHATER, Melville
"Basuto women pick apples in the Prairie Province of South Africa" 1931* (Through 238)

CHEMETOV, Marianne
[from article on new makeup colors] c. 1989* (Graphis89 \58)

CHEN, Chieh-Jen
"Self-Destruction" 1996 (Marien \8.16)

CHENEY, Robert Henry
"Guy's Cliffe, Warwickshire" 1850s (Rosenblum2 #107)

CHENG, Sam
[still life with ears of corn] c. 1999* (Photo00 212)

CHENOWETH, Doral, III
"Police detectives inspect the body of a man who was deliberately run over after a dispute" 1997* (Best23 118c)

CHERNEY, Charles
"Johnny DuPlessis of New Orleans hangs through the ropes after being pushed by Louie Lomelli during their fight" 1988 (Best14 126d)

CHEUNG, Stephen
[flower] c. 1999* (Photo00 199)

CHEVALLIER, Pascal
"Flower Lady" c. 1990* (Graphis90 \141)

CHIANG, Jack
"Afghan government soldiers captured by freedom fighters ponder their fate" 1986 (Best12 76d)

CHIARENZA, Carl, 1935-
"Untitled" 1964 (Photography2 72)

CHIASSON, John
"At the International Center for Diarrheal Research in Bangladesh, this child is near death from pneumonia" 1990* (Best16 175)

CHILD, Thomas
"Damaged Portal of Yuen-Ming-Yuan, Summer Palace, Peking, after the Fire of 1860" 1872 (Rosenblum2 #140)

CHIN, Barry
"A multiple exposure captures this gymnast's vault in the men's individual finals" 1996* (Best22 126b)
"Olympic boxer David Reid" 1996* (Best22 113)
"Portland Trailblazer Coach Ramsey takes personal charge of Celtic Johnson" 1985 (Best11 229)
"U.S. Olympians Inger Miller, Chryste Gaines and Gail Devers are pumped up after their 4x100-meter relay gold medal victory" 1996* (Best22 116c)

CHIND, Mary
"Despite losing his goggles, Brad Shinn finishes first in a swim meet" 1996* (Best22 200b)

CHINN, Paul
"California Angels second baseman Mark McLemore twists and strains as he throws a player out" 1987 (Best13 198a)
"San Francisco Giants infielder Jeff Leonard loses his cap as he avoids a sliding LA Dodger base runner" 1985 (Best11 201c)

CHIOCCHIO, Esha
"Workers make repairs on the walls of the Great Mosque in Djénné, Mali" 2001* (Through 234)

CHISLETT, John, 1856-1938
"Pond in the Fog" c. 1900 (National \59)
"Woodland Stream, Winter" c. 1900 (National 25a)

CHOISELAT, Marie Charles Isidore, 1815-1858
"The Pavillon de Flore and the Tuileries Gardens" 1849 (Waking #2)

CHONG, Albert, 1958-
"Aunt Winnie" 1996* (Committed 68; Marien \7.79)
"Justice Variant with Eyes of Cowrie" 1998 (Committed 69)
"Natural Mystic, Heralding" 1982 (Willis \515)
"The Sisters" 1986 (Willis \516)
"Story Bout My Father" 1994* (Goldberg 215)
"Throne for the Ancestors" 1990 (Willis \514)
"Trespass" 1994* (Willis \459)
"Untitled" 1998* (Willis \458)

CHOW, Michael
"Arizona State University forward is introduced before the school's first basketball practice" 1991 (Best17 153)

CHRISTENBERRY, William
[series The Klan Room] 1982* (Photography 163)

CHRISTIE, Casey
"California teenager is clutched by three men who rescued him from River" c. 1988* (Best14 6b)

CHRISTO, Steve
"Boxer cools off during boxing competition" 1998* (Best24 73b)

CHRYSANTHA
"Portrait of Charlotte" c. 1991 (Graphis92 \133, 134)

CHU, Eric
"Paradise" 1994* (Goldberg 210)

CHUCKOVITCH, Milan
"Just one more line of commuters on their way to
work: elephants from the Ringling Brothers,
Barnum & Bailey Circus" 1985 (Best11 176c)
"Snow stopped traffic on the I-5 bridge" 1985
(Best11 110a)

CHURCH, Frederick Fargo, 1864-1925
"George Eastman with Kodak Camera" 1890 (Monk
#12)

CHURCHILL AND DENISON STUDIO (attributed to)
"Group at the Sanitary Commission Fair, Albany"
1864 (National \20)

CIRCELLI, Mary
"For a saucy change of pace, mustard comes in a
variety of flavors" 1987* (Best13 183a)
"Orchard Apple" 1996* (Best22 180)

CIVIALE, Aimé, 1821-1893
"Circular Panorama Taken from Bella Tolla" 1866
(Marien \3.76)

CLAIBORNE, Barron, 1967-
"The Ethiopian: Timaj" 1999* (Committed 70)
"Orleans" 1999* (Committed 71)

CLANG
"Chis" c. 1999* (Photo00 105)
"Fighting Cocks" c. 1999* (Photo00 229)

CLARIDGE, John
[ad for Cunard Line voyages to New York] c. 1990*
(Graphis90 \84)
"Clouds and Sea" 1987* (Graphis89 \65)
"Dead Gannet" 1984 (Graphis89 \198)
"Putting People First" c. 1991 (Graphis91 \166-\174)

CLARK, Carl, 1933-
[from the Man and Woman series] 1997 (Willis \317)
[from Woman series] 1991-1998 (Willis \318, \319)
"Government Official" 1989 (Committed 72)
"Sunday Morning During a Decisive Moment, Image
No. 43" 1991 (Committed 73)

CLARK, Edward, 1911-
"As FDR's body is carried to the train at Warm
Springs on the day after his death, CPO Graham
Jackson's tear-stained face symbolizes the nation's
sorrow" 1945 (Eyes #206)
"Shoe swapping" 1947 (Life 112)

CLARK, Larry, 1943-
[from the series Tulsa] 1963-1971 (Decade 78d, \81;
Marien \6.52)
"Untitled" 1963-1971 (San #65)
"Untitled" 1971 (Rosenblum2 #699; San \51)

CLARK, Linda Day, 1963-
"Junior, North Avenue" 1994* (Committed 75)
"North Avenue, Image No. 24" 1993 (Willis \422)
"North Avenue, Image No. 28" 1993 (Willis \321)
"North Avenue, Image No. 30" 1993 (Willis \320)
"North Avenue, Image No. 85" 1994* (Committed
74; Willis \421)

CLARK, Rob, Jr.
"Racer Repairs" 1990* (Best16 65)

CLARKE, Wayne, 1945-
"Hands and Strings" 1995* (Committed 77)
"Talking Bass" 1997 (Committed 76)

CLARKSON, Rich
"Florence Griffith-Joyner wins the gold for the 100
meters at the Summer Olympics in Seoul" 1988
(Best14 131d)

CLAUDET, Antoine
"Portrait of William Henry Fox Talbot" c. 1844
(Rosenblum2 #2)

CLAUDET, J. F. A.
"The Geography Lesson" c. 1851 (Marien \2.51;
Rosenblum2 #31)

CLAUSEL, Alexandre-Jean-Pierre, 1802-1884
"Landscape near Troyes, France" c. 1855 (Marien
\2.3; Rosenblum2 #98)
"Untitled" c. 1855* (Art \21)

CLAY, Maude Schuyler, 1953-
"Langdon and Anna Clay, near Rome" 1988*
(Women \162)
"William Eggleston, Memphis" 1988* (Women \163)

CLAYTON, Tim
"Adam Meinershagen pitching for Sydney during an
electrical storm" 1995* (Best21 113)
"The Avoca Beach female surfboard crew is sent
airbourne in Sydney" 1996* (Best22 200a)
"Butterfly swimmer Emma Johnson reflected off the
underside of the water" 1995* (Best21 106c)
"Olympic backstroker Stephen Dewick training"
1996* (Best22 201b)
"Paraplegic rock climber Nick Morozoff dangles
precariously" 1995 (Best21 124)
"A shadowed Greg Norman at the Australian Open
Golf Tournament" 1996 (Best22 207b)

CLEERE, Carol
"Gay teen" 1995 (Best21 141b)
"Voodoo" 1996* (Best22 213d)

CLEMENS, Clint
[ad for clothing by Barry Bricken] c. 1990*
(Graphis90 \16, \27)
[ad for Infiniti by Nissan] c. 1990* (Graphis90 \231)
[ad for Northeastern University] c. 1990* (Graphis90
\76)
[documenting heavy weather sailing] c. 1991*
(Graphis91 \367-\371)
[dog running] c. 1992* (Graphis93 194)
[Harley Davidson motorcycles] c. 1992* (Graphis93
147)
"Mobile home" 1990* (Graphis90 \75)
"Woman sitting in a museum in the Soviet Union" c.
1990* (Graphis90 \174)

CLEMENT, Michele
"Daniel Day-Lewis" c. 1992* (Graphis93 122d)
"Morro Bay" c. 1999* (Photo00 93)
"Reality Check" c. 1992* (Graphis93 209)

CLERGUE, Lucien
"At the time of the Alternativa ceremony where the

novice Torero is elevated to Matador status" 1996*
(Best22 197d)
"Nude" 1962 (Rosenblum2 #767)

CLERY, Marc
"The *Renegade Reef*, a 26-year-old Dutch coaster
abandoned in Florida's Miami River, went up in an
80-foot cloud of smoke" 1985 (Best11 108)

CLIFFORD, Charles, c. 1819-1862/3
"The Court of the Alhambra in Granada" c. 1856
(Rosenblum2 #130)
"Courtyard of the House Known as Los Infantes,
Zaragoza" 1860 (Waking #75)
"Martorell, Spain: Devil's Bridge" 1850s[?]
(Szarkowski 76a)
"Shield" c. 1863-1866 (Szarkowski 104)
"The Walnut Tree of Emperor Charles V, Yuste"
1858 (Waking #76)

CLIFFORD, Clark
"Statue of St. Bruno in Carthusian Monastery of Our
Lady of Miraflores, Burgos" 1853 (Waking #3)

CLIFFORD, Geoffrey
"Aerial view of Turtle Island" c. 1991* (Graphis91
\292)
"Black Hawk Helicopter" c. 1991* (Graphis91 \293)
[from the series *At Home in Vietnam*] c. 1989*
(Graphis89 \254)

CLIFT, Bradley
"Bebe: The Ultimate Child Laborer's Life over the
Edge" 1996* (Best22 160b; 236a, b)
"Caught in a sudden shower a student took shelter on
the porch of house" 1986 (Best12 176d)
"Drug addicts–a series of photographs" 1991 (Best17
63-66); 1998 (Best24 126-135)
"The 400-plus statues are dusted off four times a
year" 1986 (Best12 160a)
"The hottest day of summer hit Connecticut, Michael
Kirkland got plenty of help from his children in a
pool-moving project" 1986 (Best12 161a)
"In August, a dog stands on what used to be a 12-
foot-deep lake" 1986 (Best12 37d)
"Jason Levine waits while Tim Corkran tries to take a
table off his shoulders" 1986 (Best12 161b)
"On a crystal clear night in Washington, D.C. one of
the largest candlelight vigils ever ends the last
display of the AIDS quilt" 1996* (Best22 186b)
"Our House" 1991 (Best17 219-222)
"Rachel whispers something to James at a playground
near their school" 1986 (Best12 135a)
"Rupert Brooks slams down the winning domino as
he plays with friends" 1991 (Best17 61)
"Sometimes Shawn refuses to come up for air" 1997*
(Best23 168c)
"Stephen Rothstein pauses to take in his new
surroundings at a group home for retarded
children" 1991 (Best17 62)
"Stevie's world" 1986 (Best12 72-75)
"13- and 14-year-old boys in New Haven smoke
marijuana, using a technique called a 'shotgun' to
give them a quicker, more intense high" 1986
(Best12 176a)
"Trying to make his punches more precise, boxer
Santos Santiago uses a string on a clothesline"
1986 (Best12 218d)
"12-year-old tries on Jack Lambert's old helmet"
1997* (Best23 165)

"Two girls get involved with aluminum playground
equipment in a housing project" 1986 (Best12 94b)

CLIFT, William
"Law Books, Hinsdale County Courthouse, Lake
City, Colorado" c. 1975 (Decade \94)

CLIFTON, Carr
"Acadia National Park, Maine" 1990* (Life 190)

CLOSE, Chuck, 1940-
"Bob" 2000 (Photography 32a)
"Cindy" 2000 (Photography 32c)
"Self Portrait" 1979* (Photography2 163;
Rosenblum2 #806)

COALE, Phil
"Pit crew members at the Stock Car Race try to
extinguish a fire that engulfed a crew member while
he was filling a car with gas" 1988 (Best14 126a)

COATES, David C.
"Peggy Briller, 78, owner of a grill in Detroit's Cass
Corridor, explains how she stopped a would-be
robber the day before" 1988 (Best14 94a)

COBB, Jodi
"After winning Taiwan's baseball championship, the
Brother Elephants run from the dugout as fans hurl
plastic streamers" 1993* (Best19 153)
"Big Ben competes with cell phones on Westminster
Bridge in London, England" 2000* (Through 60)
"A child is chained to his bunk to keep him from
wandering off at a camp for Vietnamese boat
people in Hong Kong" 1990* (Best16 197c)
"A couple wait to be photographed during a mass
wedding in Taiwan" 1993* (Best19 126a)
"Geisha" 1995* (Best21 220-221)
"Geisha in Japan" 1995* (Through cover)
"High and dry, a French tourist gets carried ashore
after an outrigger cruise in Tahiti" 1997* (Best23
148a; Through 450)
"In Japan, the life of a geisha still requires hours of
preparation...before a date" 1985* (Best11 46c)
"In the Armenian village of Voskevaz, a doll keeps an
eye on the day's wash" 1987* (Best13 171d)
"Only women may enter an old fortress on Tarut
Island in Saudi Arabia" 1987* (Through 222)
"The palm-fringed sands of Bora Bora lie about 150
miles northwest of Tahiti in the Society Islands"
1996* (Through 382)
"A pubgoer downs a pint at London's Lamb Tavern,
founded in 1780" 2000* (Through 98)
"Steamy Streets" 1990* (Best16 70)
"Times Square, in New York City, has long been a
gaudy center of neon lights and lively diversions"
1990* (Through 312)

COBURN, Alvin Langdon, 1882-1966
"August[e] Rodin" 1918 (Vanity 5)
"Brooklyn Bridge" 1910-1912 (Rosenblum2 #397)
"The Coal Cart" 1911-1912 (Art \171)
"Flatiron Building" 1912 (Szarkowski 165)
"Grand Canyon" 1911 (MOMA 91)
"The Octopus, New York" 1912 (Decade 15c;
Hambourg \1; Rosenblum2 #398)
"The Park Row Building" 1910 (Decade \9)
"St. Paul's from Ludgate Circus" 1905 (Art \170)
"Singer Building, New York" 1909-1910 (Art \172)
"The Singer Building, Noon" c. 1910 (Decade 15d)

"Trinity Church" 1912 (Art \173)
"Vortograph" 1917 (Decade 16a; Marien \4.41)
"Vortograph No. 1" 1917 (Rosenblum2 #503)
"Vortograph #8" 1917 (San #6)
"Wapping" 1909 (Marien \4.40)
"Williamsburg Bridge" 1910 (Photography1 #V-32)

CODFOD, Arthur, Jr.
"Amateur sequence of photographs of the burning of
the *Hindenburg*" 1937 (Eyes #171)

COHEN, Lynne, 1944-
"Corporate Office" n.d. (Rosenblum \214)
"Corridor" n.d. (Rosenblum2 #700)
"Lecture Hall" n.d. (Women \175)
"Observation Room" n.d. (Marien \7.26; Women
\176)

COHEN, Matt
"Michael O'Brien" c. 1991* (Graphis92 8)

COHEN, Nancy R.
[untitled] c. 1992 (Graphis93 206)

COHEN, Robert
"The Fourth of July" 1990* (Best16 140)
"John Read holds his ex-wife, at the funeral of their
slain 8-year-old daughter" 1990* (Best16 107)
"With his mother at his side, 3-year-old talks to fire
department battalion chief after using a lighter to
ignite a mattress" 1997* (Best23 119d)

COHEN, Serge
"Above the Clouds" c. 1990* (Graphis90 \146)
"Hemingway's Double with a Fish" c. 1991*
(Graphis91 \156)
"Miles Davis" c. 1990* (Graphis90 \140)
"*Padrao des Descobrimentos* monument in Lisbon"
c. 1990* (Graphis90 \93)

COHN, Alfred
"Group discussion at the Clarence White School" c.
1918 (Decade 20)

COLE, Allen L.
"Company E. (all male) basketball team" c. 1920s
(Willis \106)
"Councilman L. O. Payne's (all female) basketball
team" 1935 (Willis \105)
"Group portrait of *Call* and *Post* newsboys" c. 1930s
(Willis \104)
"Home of Mrs. H. S. Sink" c. 1930s (Willis \107)
"Watkin's Products delivery man" c. 1930s (Willis
108)

COLE, Barbara
"Sahara" c. 1991* (Graphis92 \43)
"Ship at Sea" c. 1991 (Graphis92 \194)

COLE, Bernard
"Shoemaker's Lunch" 1944 (Rosenblum2 #464)

COLE, Carolyn
"California's Fragile Future" 1996 (Best22 238b)
"Child asks a stranger 'Did you kill my mommy?'"
1997* (Best23 137a)
"A woman waits to be taken into custody for cocaine
possession" 1993* (Best19 117)

COLE, Charlie
"South Korean police with riot shields during a
demonstration in Masan" 1987* (Graphis89 \256)
"Student protestors at Seoul University" 1987*
(Best13 27d)

COLE, Ernest
"Untitled" c. 1967 (Marien \6.17)

COLE, Kevin
"Blizzard Rams New England" 1978 (Capture 108)

COLEMAN, Emma, 1853-
"Alice Baker" c. 1890 (Sandler 23)

COLLARD, Albert, c. 1838-c. 1887
"Bridge" 1860s[?] (Szarkowski 99)
"Roundhouse on the Bourbonnais Railway, Nevers"
1860-1863 (Rosenblum2 #173)

COLLEN, Henry
"Queen Victoria with Her Daughter, Victoria,
Princess Royal" 1844-1845 (Rosenblum2 #49)

COLLIE, William
"Dr. Wolfe" 1852 (Szarkowski 50)
"Still life" c. 1850 (Szarkowski 65)

COLLIER, Jim, 1942-
"Living Room (One-Room Shack)–Southern U.S.A."
1971 (Committed 79)
"Mom Sweeps Yard–Southern U.S.A." 1971
(Committed 78)

COLLIER, John, Jr.
"Almanac, magazine photograph, and calendar" 1943
(Documenting 300b)
"Bedroom" 1943 (Documenting 304a)
"Considering the purchase of a sixty-dollar harness in
a mail-order catalog" 1943 (Documenting 306b)
"Father Walter Cassidy celebrates mass at the
Trampas church" 1943 (Documenting 310a)
"In grandfather Juan Romero's room" 1943
(Documenting 307c)
"Juan Lopez" 1943 (Documenting 311b)
"Juan Lopez going to the mountains for wood" 1943
(Documenting 298b)
"Loading firewood in the Santa Fe National Forest"
1943 (Documenting 298a)
"Lopez house and corrals" 1943 (Documenting 299c)
"Maclovia Lopez" 1943 (Documenting 303c)
"Maclovia Lopez helping her children with their
homework" 1943 (Documenting 306a)
"Maclovia Lopez spinning wool" 1943 (Documenting
309b)
"Photographs of family and friends" 1943
(Documenting 305b)
"Religious images and family snapshots" 1943
(Documenting 300a)
"Serving dinner" 1943 (Documenting 302a)
"View through three rooms in the Lopez home; in the
foreground drying meat hangs from the rafter"
1943 (Documenting 301c)
"Wall Street speculator Boesky" 1986 (Best12 51b)
"Washing up" 1943 (Documenting 302b)
"Youngest child asleep" 1943 (Documenting 308a)

COLLINS, Chris
"Alessi kettle on a flame" c. 1990* (Graphis90 \203)
[parrot] c. 1997* (Graphis97 179)

COLLINS, Edwin
 "Boy with Hat and Cane" 1904 (Goldberg 16)

COLLINS, Florestine Perrault, 1895-1987
 "Emily Jules Perrault" c. 1920s (Willis \52)
 "Herbert W. Collins" c. 1932 (Willis \53)
 "Jeannette Warburg Altimus and Arthur Joseph
 Perrault" 1925 (Willis \54)
 "Lastinia Martinez Warren, a bridesmaid in the
 DeCuir wedding, New Orleans" 1939 (Willis \57)
 "Mae Fuller Keller" c. 1925 (Willis \55)
 "Unidentified World War II Merchant marine" n.d.
 (Willis \56)

COLLINS, Herbert, active 1890-1920
 "Mrs. Tell's daughters" c. 1910-1916 (Willis \65)
 "Portrait of Herbert C. Collins (?) holding a baby" c.
 1910-1916 (Willis \63)
 "Three top-hatted men" c. 1910-1916 (Willis \64)

COLLINS, Jim
 "Early in the Boston Marathon, Partev Popalian looks
 back as he takes the lead" 1993 (Best19 147)
 "Group of women in a World War II-era life raft go
 over the 10-foot-high dam" 1993 (Best19 149)

COLLINS, John F.
 "Duplex Razors" 1934 (Goldberg 68)

COLLINS, Marjory, 1912-
 "Armistice Day parade. Lancaster, Pennsylvania"
 1942 (Fisher 67)
 "Benjamin Lutz presiding at his butcher shop at 4:30
 p.m., when the shifts changed in Lititz's factories"
 1942 (Documenting 260a)
 "Between Lititz and Manheim" 1942 (Documenting
 275c)
 "Bidders at an Auction" 1942 (Documenting 255a;
 Sandler 152)
 "Bill's Peanut Stand and Lutz's Central Market"
 1942 (Documenting 258c)
 "Defense industry worker Irwin R. Steffy, who
 commutes to Lancaster every day, having his car
 serviced at the Pierson Motor Company" 1942
 (Documenting 263c)
 "Draft board Number 5 in Ephrata, which selects
 Lititz's men for service" 1942 (Documenting 274a)
 "Elizabeth Almoney, who has three sons and three
 brothers in the service" 1942 (Documenting 269b)
 "Emma Dougherty cleaning out her end-grinding
 machine" 1942 (Documenting 266a)
 "Father and son Lewis and Bob Haines packing
 pretzels at their Lititz Springs Pretzel Company"
 1942 (Documenting 258b)
 "Hardware store owner Morris Kreider, who operates
 a machine shop that makes small parts for nearby
 defense plants" 1942 (Documenting 267c)
 "Junior choir performance in the Moravian Sunday
 school" 1942 (Documenting 268a)
 "The Lititz borough council meeting in a room
 decorated with pictures of local people who had
 served in earlier wars" 1942 (Documenting 257b)
 "Mennonite apple seller at the farmers' market" 1942
 (Documenting 262a)
 "The Moravian church sewing circle" 1942
 (Documenting 256a)
 "Mr. Pennepacker, one of Lititz's seven barbers"
 1942 (Documenting 261b)
 "Mrs. Frank Romano putting her baby to bed" n.d.
 (Fisher 62)

"Mrs. Julian Bachman checking the size of a bullet
 before the cartridge is assembled" 1942
 (Documenting 265c)
"Mrs. Julian Bachman, living at home, writes to her
 husband in an Army Air Corps officer candidate
 school in Kentucky. The couple has been married
 for one year" 1942 (Documenting 273b)
"Mrs. Morris Kreider, the wife of the hardware store
 owner, and Dr. Posey" 1942 (Documenting 264a)
"Paul Ritz, worker in a chocolate candy factory,
 serves as a volunteer airplane spotter at a hilltop
 post for two hours every week" 1942
 (Documenting 275b)
"Photographer's display on Bleeker [sic] Street. New
 York" 1942 (Fisher 70; Rosenblum \167)
"Postmaster Robert Pautz, who has three sons and
 one son-in-law in the service and a daughter in the
 U.S. War Department, chatting with two friends in
 the Post Office" 1942 (Documenting 271b)
"Punching out at the Animal Trap Company,
 converted to the production of ammunition during
 the war" 1942 (Documenting 258a)
"R. H. Macy & Co., department store during the week
 before Christmas. New York" n.d. (Fisher 122)
"Recalled tires at the train station ready for shipment
 to Harrisburg" 1942 (Documenting 262b)
"Recently employed women being sworn into the
 Rubber Workers Union at a Sunday meeting" 1945
 (Fisher 78)
"St. Mark's Place and the Bowery at midnight. New
 York City" 1942 (Fisher 75)
"Self-Portrait at auction" 1942 (Documenting 255b)
"Shopping district just before closing time at 9pm on
 Thursday night. Baltimore" 1943 (Fisher 54)
"Signs, labels, and newsletters printed by Lititz
 Record-Express" 1942 (Documenting 267b)
"The sixth grade current events class" 1942
 (Documenting 272a)
"Sleeping in a car on Sunday in Rock Creek park"
 1942 (Fisher 93)
"Sunday school picnic on the edge of the Patuxent
 river" 1942 (Fisher 77)
"Third Avenue and 42nd Street from the steps leading
 to the elevated train" 1942 (Fisher 74)
"Turkish night club on Allen Street. New York" 1942
 (Fisher 76)
"Twenty-three-year-old Mrs. Julian Bachman and two
 other gauge inspectors at the Animal Trap
 Company" 1942 (Documenting 265b)
"Waterworks superintendent Walter Miller dictates
 water bills to borough secretary and real estate
 broker Elam Habecker" 1942 (Documenting 270a)
"Window of a Jewish religious shop on Broom Street.
 New York City" 1942 (Fisher 68)
"Youngsters bringing scrap metal from their barn to
 the curb for collection" 1942 (Documenting 271c)

COLOMB, Denise, 1902-
 "Natalya Goncharova" 1953 (Rosenblum \181)

COLOTTA
 "Lionel Barrymore" 1918 (Vanity 23)

COMEGYS, Fred
 "Army-Navy game photos" 1985 (Best11 210-213)
 "Florence Griffith-Joyner takes a victory lap after
 winning the 100-meter dash at the Summer
 Olympics in Seoul, South Korea" 1988* (Best14 2)
 "John McEnroe, trying for a comeback, drops to his
 knees and bows to Tim Mayotte who won the

match" 1987 (Best13 217a)
"1,000 students donned lion masks and posed for this
 Halloween portrait" 1985 (Best11 184)
"Penn Relays runner stays on track to finish first in
 the 400 relay" 1986 (Best12 142)
"Raring to go, a police horse throws his rider at an
 equestrian competition" 1987 (Best13 198d)

COMPÈRE, Charles, ZIMMERMAN, Thomas
 [automobile company calendar] c. 1991* (Graphis92
 \238, \233)

COMPOINT, Stephane
 "Capping a burning oil well, Kuwait" 1991* (Lacayo
 174)
 "Exhausted firemen in mud and oil of burning oil
 wells" c. 1991* (Graphis92 \49)

COMTE, Michel
 "Longing for the sun" c. 1990* (Graphis90 \5)

CONANT, Howell
 "Grace Kelly before her wedding" 1956 (Life 70)

CONES, Nancy Ford, 1869-1962
 "Threading the Needle" c. 1907 (Rosenblum \57;
 Sandler 18)

CONGER, Dean
 "Alan Shepard after trip in *Mercury* capsule" 1961
 (Eyes #368)

CONISON, Joel
 [self-promotional] c. 1991* (Graphis92 86)

CONNELL, Will, 1898-1961
 "Southern California Edison Plant at Long Beach"
 1932 (Peterson #83)

CONNER, Bruce, 1933-
 "Starfinger Angel" 1975 (Photography2 78)

CONNER, Lois, 1951-
 "Beijing, China" 1988 (Women \184)
 "Buddha, Szechuan, China" 1986 (Women \185)
 "Halong Bay" 1993 (Rosenblum2 #680)
 "Military Museum, Beijing, China" 2000
 (Photography 28a, 29a)
 "Sydney Opera House" 2000* (Photography 28b)

CONNOR, Linda, 1944-
 "Ceremony, Sri Lanka" 1979 (Decade \87)
 "Chörten, Ladakh, India" 1985 (Women \186)
 "Dots and Hand, Fourteen Window Ruin, Bluff,
 Utah" 1987 (Rosenblum \242)
 "Monks, Phiyang Monastery, Ladakh, India"1985
 (Women \188)
 "The Oracle of Sabu in Trance, Ladakh, India" 1988
 (Women \189)
 "Prayer Flag with Chörtens, Ladakh, India" 1988
 (Women \187)
 "Untitled" 1976 (Decade 86a)

CONRAD, Fred R.
 "Alice spreads her sheltering arms over wet weather
 drop-ins at her New York Wonderland" 1985
 (Best11 175a)

CONSTANTIN, Dmitri, active 1858-1870
 "Philoappos Monument, Athens" c. 1865

(Szarkowski 317b)

CONTENT, Marjorie, 1895-1984
 "From 29 Washington Square" c. 1928 (Women \62)
 [Skies at Mill House] 1941 (Rosenblum \147)
 "Untitled" c. 1928 (Women \63)

CONWAY, Richard T.
 "A runner in the Revco-Cleveland 10-K marathon
 gets her message across" 1986 (Best12 225)

COOK, Chuck
 "Residents of a subdivision in Braithwaite sandbag a
 levee to help protect their property from rising
 waters caused by the storm" 1985 (Best11 72a)

COOK, Dennis
 "President Ronald Reagan gives the OK sign from the
 window of his hospital room" 1985 (Best11 88a)
 "San Franciscan Victor Amburgy is welcomed home
 by niece Danelle Kruse after his release from Flight
 847" 1985 (Best11 49c)

COOK, George S.
 "Charleston Cadets Guarding Yankee Prisoners"
 1861 (Rosenblum2 #208)
 "Portrait of Major Robert Anderson" 1860-1865
 (Marien \3.10)

COOLEY, Samuel A.
 "Self-portrait with staff" c. 1864 (Photography1 #IV-
 24)

COONLEY, Jacob F.
 "View of Battle of December 15 from front of State
 House, Nashville" 1864 (Photography1 #IV-3)

COPELAND, Tom
 "God's Light" 1996* (Best22 185a)
 "Phillip Ross dives from a fiery race car during a
 qualifying race" 1991* (Best17 146a)

COPLANS, John
 "Self-Portrait (Standing Hand)" 1987 (Photography
 75)

COPPIN, Kerry Stuart, 1953-
 "Penumbro" 1985* (Committed 80)
 "Untitled" 1988* (Committed 81)

COPPOLA, Horacio
 "Grandmother's Doll" 1932 (Rosenblum2 #549)

CORBETT, Allison
 "Police officer searches a man's shoe after seizing
 marijuana plants from house" 1996* (Best22 152)

CORNELIUS, Robert
 "Seated Couple" c. 1840 (Marien \2.47)

CORNETT, Mary Jo
 "Mamaw and my sister with the picture of my cousin
 that died" 1976 (Goldberg 188)

CORPRON, Carlotta, 1901-1988
 "Fluid Light Design" c. 1947 (Photography2 38)
 "Light Pours Through Space" 1946 (Rosenblum \229;
 Sandler 172)
 "Mardi Gras" c. 1946 (Rosenblum2 #555)

CORTES, Ronald
"Admitting mistakes, Joseph R. Biden Jr. announces he is dropping out of the race for the Democratic nomination for president" 1987 (Best13 55b)
"Bobby Czyz makes a quick statement to Bash Ali during a 12-round World Boxing Association cruiserweight championship" 1991 (Best17 147)
"Diamonds in the Rough" 1992 (Best18 148-150)
"During a football game a group of fans ran through the other team's sidelines" 1991 (Best17 158b)
[events before the Holyfield-Foreman match] 1991 (Best17 162)
"[Father] is comforted by son" 1996 (Best22 210b)
"Philadelphia Phillies' ground crew holds down a tarp during a game delayed by heavy wind and rain" 1991 (Best17 158a)
"The Philadelphia Sixers' Dr. J isn't the young player he once was, but he shows the Chicago Bulls that he can still fly" 1985 (Best11 206a)
"Pole-vaulter Scott Riggs celebrates after clearing the bar on his third try" 1992 (Best18 147)
"A Senior Senior" 1990 (Best16 89-95)
"Somalian refugees in the Kebre Beyah camp in Ethiopia are beaten by a guard after trying to storm the food lines" 1991 (Best17 105)
"Teammates mob Lou Russell after his two-run, 10th inning home run brought the players a trip to the Little League World Series" 1986 (Best12 228a)
"Tenor Luciano Pavarotti looks grim as he rehearses with the Delaware Symphony" 1986 (Best12 53d)
"Turner of the 76ers is mugged from behind by Connors of the Bucks" 1991 (Best17 157)
"A wave of lacrosse players celebrate after scoring the winning goal in overtime" 1986 (Best12 228)

CORY, Kate, 1861-1958
"Indian women shucking corn" c. 1905 (Sandler 105)
"A Young Hopi Girl" 1905-1912 (Rosenblum \80)

COSINDAS, Marie
"Conger Metcalf Still Life" 1976 (Rosenblum2 #787)
"Richard Merkin" 1967* (Rosenblum \25)

COSTA, Joe, 1904-
"March on Washington, July 28" 1932 (Eyes #165)

COSTANZA, Rusty
"Eddie Robinson, the winningest coach in college football history" 1997* (Best23 174a)

COSTER, Howard
"James Abbé" 1934 (Vanity 199c)

COTTINGHAM, Keith
"Untitled (Triple)" 1993* (Marien \8.0)

COUGHANOUR, Harry
"Cassius Clay after knocking out Charley Powell" 1963 (Life 142)

COUGHLIN, Hale
[bridge at night] c. 1995* (Graphis96 179)

COULSON, Cotton
"Thunderstorm threatens wheatfields west of Dodge City" 1985* (Best11 41a)

COUPON, William
"Duncan Hannah" c. 1990* (Graphis90 \134)
"Dustin Hoffman" c. 1990 (Graphis90 \118)

"Former Beatle George Harrison" c. 1989* (Graphis89 \129; Rolling Stone 110)
"Homeless people of New York City" c. 1991 (Graphis91 \70-\73)
"Howard Chapnick" c. 1991* (Graphis91 26c)
"John Jay" c. 1991* (Graphis91 26d)
"Peter Howe" c. 1991* (Graphis91 26b)
"Portrait of rock/pop singer Paul Simon" c. 1989 (Graphis89 \164)
"William Bernard" c. 1991* (Graphis91 26a)

COURIER-JOURNAL & LOUISVILLE TIMES
Photographic Staff
"Busing in Louisville" 1975 (Capture 93)

COURSON, J. Gillis
"Farmer watches a brush fire roll across his land in Brevard County, Fla." 1985 (Best11 56a)

COURTNEY, Mark
"Arthur Rothstein" n.d. (Best11 1)
"Two students rig up a buddy system to mow lawns on the steep campus" 1985 (Best11 172d)

COUTAUSSE, Jean-Claude
"Civilians huddle in a ditch to escape bombing during air raid near Osijek in Croatia" 1991* (Best17 114)

COVATTA, Chris
"More than 1,300 men and women from around the world compete in the Ironman Triathlon near Kailua-Kona, Hawaii" 1987* (Best13 190b)

COWAN, Frank
"America's first 'test-tube' baby, Elizabeth Carr, nine months" 1982* (Life 104)

COWANS, Adger W., 1936-
"Daydream" 1980 (Committed 83)
"Djuka Men Making a Boat" 1969 (Willis \218)
"Djuka Women" 1969 (Willis \220)
"Djuka Women and Child" 1969 (Willis \219)
"Djuka Women by the Water" 1969 (Willis \221)
"P.B. (Nude)" 1975 (Committed 82)

COWHERD, Barney
"What are all these people so worried about?" 1949 (Lacayo 87)

COWIN, Eileen, 1947-
"Untitled" 1980* (Photography2 217); 1987* (Rosenblum \27)

COX, George, 1851-1903
"Walt Whitman" 1887 (Photography1 \70)

COX, Renée, 1960-
"Chillin with Liberty" 1998* (Committed 84a)
"Eve" 1994 (Willis \531)
"Hott-en-tot" 1996 (Willis \529)
"Yo Mama's Last Supper" 1996* (Committed 84d)
"*Yo Mama* series: The Sequel" 1995 (Willis \530)

COYNE, Michael
"A blind Kurdish shepherd who stepped on a mine is hugged by his father" 1985* (Best11 40a)
"Mullahs of the Faizeh Theological School in the holy city of Qom" 1985* (Best11 40d)

CRACE, John G., 1809-1889
"Irish Peasants" 1855 (Szarkowski 317a)

CRAFTERS
"John Maynard Keynes" 1928 (Vanity 80b)

CRAIG, Andrew
[self-promotional] c. 1990* (Graphis90 \339)

CRAIG, Matthew
"A surgeon applies fluorescent drops to a patient's eye" 1993* (Best19 74c)

CRAMER, Konrad, 1888-1963
"Untitled" c. 1938 (San #51); c. 1946 (San \34)

CRANE, Barbara, 1928-
"Bicentennial Polka" 1975 (Decade 86d)
"Neon Cowboy, Las Vegas" 1969 (Decade \73)
"Wrightsville Beach, North Carolina" 1971 (Rosenblum \238)

CRANE, David
"Are VDTs hazardous to pregnant women in the workplace?" 1988 (Best14 115)

CRANE, Ralph
"Encounter group" 1968 (Life 116b)
"Warren Beatty" 1968* (Life 89a)

CREIGHTON, Linda L.
"Children being reared by their grandparents" 1991* (Best17 81)
"Hard life in a poor southern Mississippi town has aged this 49-year-old woman" 1990* (Best16 79a)
"When Russell Anderson's mother left to fight in the Persian Gulf war, his grandfather quit his job and moved to care for the boy" 1991* (Best17 79)

CREMER, James
"Three Views of Philadelphia" 1871 (Photography1 #V-5)
"Three Views on the Pennsylvania Central Rail Road" 1871 (Photography1 #V-6)

CRESSEY, R. M.
"Rail Road Bridge Across Chattanooga Creek, Tennessee" c. 1863-1864 (Photography1 #IV-17)

CREWDSON, Gregory
"Untitled (penitent girl)" 2001-2002* (Photography 215)

CREWELL, Chris
"Despite the proximity of her opponent's leg, goalie stops a shot" 1998* (Best24 67)

CRISOSTOMO, Manny
"Class Act at Southwestern High" 1987-1988 (Capture 152)
"Kids, guns and blood" 1987 (Best13 46-49)
"Participants in the Great Peace March trudge under a hot Iowa sun" 1986 (Best12 139b)

CROCETTA, Joe
"A stagefront security guard helps a concertgoer out of the 'moshing pit'" 1993* (Best19 193a)

CROCIANI, Paola
"Emotional departure" 1982 (Eyes #358)

CROFOOT, Ron
[self-promotional] c. 1989* (Graphis89 \358)

CROFT, Richard
"Science Fiction author J. G. Ballard" c. 1989* (Graphis89 \127)

CROISILLE, Hubert
"Big American car in front of a cattle barn" c. 1991* (Graphis91 \285)

CRONER, Ted, 1922-
"Untitled" 1947-1949 (MOMA 218)

CRONIS, Vicki
"Autistic and mentally retarded 7-year-old watches her favorite channel" 1997* (Best23 141a)
"Betsy & Bill" 1995 (Best21 140a)
"On Beyer's Trail" 1997 (Best23 222a,b)
"While taking a make-up quiz after school, teen mother tries to concentrate as her crying baby lays in her lap" 1996* (Best22 162c)

CROSS, Pete
"The Gesture" 1988 (Best14 121d)

CROSSETT, Edward C., c. 1882-1955
"Cloud Shadows" c. 1941 (Peterson #76)

CROUCH, Bill
"Air Show High Drama" 1949 (Capture 24)

CROWE, Pat
"Geese fly past a house near Bombay Hook Wildlife Refuge in Delaware" 1987 (Best13 164a)
"Shot put teammates push each other to greater heights at Wilmington High" 1987 (Best13 116)

CROZET, Marcel
"Leap from the window" c. 1990* (Graphis90 \266)

CRUCES AND CO.
"Fruit Vendors" 1870s (Rosenblum2 #409)

CRUFF, Kevin
"Barron Hilton Soaring Cup" c. 1988* (Graphis89 \237)
"Olympian Jay L. Barrs" c. 1991 (Graphis91 \362)
"Olympian Lisa Jacquin" c. 1991 (Graphis91 \363)

CRUM, Lee
[from calendar for Lackawanna Leather Company] c. 1991* (Graphis91 \278)
[nude on elephant] c. 1989 (Graphis89 \149)

CRUZE, Tom
"Chicago firefighters cluster around the body of one of three comrades killed in a fire in northwest Chicago" 1985 (Best11 100c)
"Everyone's an Irishman on St. Patrick's Day including Ramon Cervantes" 1985 (Best11 167c)

CRYOR, Cary Beth, 1947-1997
"Grandmother's Hands: #1 with hymnal" 1993 (Willis \201)
"Grandmother's Hands: #2 with sewing needle" 1993 (Willis \202)

CULVER PICTURES
"Neville Chamberlain" 1933 (Vanity 168)

"Sigmund Freud" 1932 (Vanity 170)

CUMMING, Robert, 1943-
"Academic Shading Exercise" 1974 (Marien \6.97, \6.98)
"Barrier Explosion" 1973 (Photography2 186)
"Spray-Snow Christmas" 1969 (San \59)
"Two Views of One Mishap of Minor Consequence" 1973 (Szarkowski 282)

CUMMING, Steven, 1965-
"By Any Means Necessary" 1996 (Willis \363)
"Washington D.C. series" 1997-1998 (Willis \361-\362)
"We All Got the Blues" 1998 (Willis \364)

CUNNINGHAM, Imogen, 1883-1976
"Agave Design I" c. 1929 (Decade 33; Goldberg 63; San \5)
"Aloe" 1925 (Hambourg \118; San #25)
"Aloe Bud" c. 1926 (Women \40)
"Breast" c. 1927 (Women \39)
"Calla" c. 1929 (Women \42)
"Ernest Lubitsch" 1932 (Vanity 181)
"Exploding Bud" 1920 (Sandler 137)
"Fagoel Ventilators" 1934 (Decade 37c)
"False Hellebore" 1926 (Rosenblum \141)
"Frida Kahlo Rivera" 1937 (Decade \30)
"In My Studio in Seattle, 1117 Terry Avenue" 1910 (Decade \4)
"Irene 'Bobby' Libarry" n.d. (Marien \5.48)
"James Cagney" 1932 (Vanity 133)
"Joan Blondell" 1933 (Vanity 132)
"Minor White, Photographer" 1963 (Decade \69)
"Morris Graves, Painter" 1950 (Photography 95)
"Nude" 1932 (Icons 130; MOMA 111; Women \38)
"Pregnant Nude" 1959 (Icons 131)
"Self-Portrait" 1915 (National \69)
"Shredded Wheat Water Tower" 1928 (Rosenblum2 #583)
"Snake in Bucket" 1929 (Marien \5.47; Women \37)
"Spencer Tracy" 1934 (Vanity 195)
"Triangles" 1928 (Peterson #61; Rosenblum2 #546; Women \36)
"Two Callas" 1929 (Rosenblum2 #535)
"Two Sisters" 1928 (Rosenblum \155)
"Untitled (Portia Hume)" c. 1930 (Women \41)
"Warner Oland" 1932 (Vanity 187)

CURLEY, Jim
"Gary Hart's five-minute television speech plays to an empty house in the lobby of the Kirkwood Hotel in Des Moines, Iowa" 1988 (Best14 112b)

CURRAN, Darryl, 1935-
"L.A. Series" 1970 (Photography2 121)
"Savoy Cabbage, Baby's Breath Blade" 1995* (Goldberg 226)

CURREY, Francis Edmund, 1814-1896
"Heron" 1863 (Szarkowski 79)

CURRIER, Charles H., 1851-1938
"Kitchen in the Vicinity of Boston, Massachusetts" c. 1900 (MOMA 70)

CURTIS, Asahel, 1874-1941
"The Leveling of Hills to Make Seattle" 1910 (Goldberg 198)

CURTIS, Edward S., 1868-1952
"Cutting Rushes, Mandan" 1908 (Szarkowski 317c)
"Upshaw–Apsaroke–in Headdress" 1906 (Goldberg 28)
"Vanishing Indian Types" or "The Vanishing Race" 1906 (Marien \4.36; Rosenblum2 #196)
"Watching the Dancers–Hopi" 1906 (MOMA 60)
"Woman's Costume & Baby Swing–Assiniboin" c. 1900-1906 (Decade 11c)

CURTIS, John
[for an article] c. 1990* (Graphis90 \31)
[for a Christmas article for Dellaria Hair Products] c. 1990 (Graphis90 \53)
[self-promotional] c. 1990* (Graphis90 \57)

CURTSINGER, Bill
"A hatchling hurries away from his birth beach in Michoacán, Mexico, a major nesting site for black turtles" 1994* (Through 410)
"A Steller sea lion patrols rich Pacific feeding grounds near Canada's Bowie Seamount" 1996* (Through 420)

CUSHING, Frank
"Teen-age Shooter" 1947 (Capture 20)

CUSHNER, Susie
[cup, saucer, and leaves] c. 1997* (Graphis97 72)
"Overhead shot of office furniture" c. 1990* (Graphis90 \200)

CUSTIS, Eleanor Parke, 1897-1983
"Penguins Three" c. 1939 (Peterson #19)
"Port of Dreams" c. 1936 (Peterson #20)

CUTLER, A. W.
"In Kingswinford, England, walls lean and floors tilt at the Crooked Inn" 1931 (Through 30)
"Tide pools in Lynmouth, England delight a budding yachtsman and his friends" 1929 (Through 78)

CUTLER, Craig
"Les Beaux, Provence" c. 1997* (Graphis97 87)
[cigarettes in ashtray] c. 1999* (Photo00 204)
"Crushed Objects" c. 1999* (Photo00 178)
"Diner" c. 1999* (Photo00 17)
"Diptych with Fish and Crabs" c. 1999 (Photo00 57)
[eggs on thermoses] c. 1999* (Photo00 205)
"Floral Brushes" c. 1999* (Photo00 200)
[flowers] c. 1995* (Graphis96 86)
"Gare du Lyon, Paris" c. 1997* (Graphis97 150)
[glass objects] c. 1992* (Graphis93 158c)
"Grand Army Plaza, Brooklyn" 1997 (Graphis97 168b)
[man and horse] c. 1999 (Photo00 193)
[metal file] c. 1999* (Photo00 206)
[napkin holders] c. 1999* (Photo00 206)
"Paris Café" c. 1997* (Graphis97 167)
[personal study of common objects] c. 1995* (Graphis96 73)
"Porch Lines" c. 1997 (Graphis97 168a)
[Roller blades] c. 1999* (Photo00 174)
"Snake" c. 1996* (Graphis97 6)
[soldiers in Chile] c. 1999* (Photo00 69)
[untitled] c. 1999* (Photo00 179)
"Water Fire Smoke" c. 1999* (Photo00 201)

CUTRARO, Andrew
"Keshia Thomas uses her body to shield a man–who

was spotted wearing a Confederate flag shirt–from being beaten by a violent mob of anti-Klan demonstrators" 1996* (Best22 142)

CYRUS, Gerald, 1957-
[cemetery, New Orleans] 1993 (Willis \332)
"Fergie at the juke box, Harlem" 1994 (Willis \331)
from the Kinship series 1992 (Committed 86, 87)
"Keith hoisting Seth" 1992 (Willis \333)
[St. Nick's Pub, Harlem] 1994 (Willis \330)

CZERNIAWSKI, Tadeusz
"Events surrounding the dismantling of the Berlin Wall" 1989 (Graphis91 \74-\77)

—D—

DAGUERRE, Louis Jacques Mandé, 1787-1851
"Boulevard du Temple, Paris" 1839 (Lacayo 8; Marien \1.13; Monk #3; Rosenblum2 #7)
"Collection of shells and miscellany" 1839 (Szarkowski 27)
"Notre-Dame from the Pont des Trounelles" 1838-1839* (Art \17)
"Still Life (Interior of a cabinet of curiosities)" 1837 (Marien \1.12; Rosenblum2 #27)

D'ANNA, Melanie Rook
"Dog day at the movie 101 Dalmatians" 1991* (Best17 168)

DAHL-WOLFE, Louise, 1895-1989
"The Covert Look" 1949* (Rosenblum \6; Rosenblum2 #646; Sandler 167)
"In Sarasota" 1947 (Decade \53)
"Nashville" 1932 (MOMA 150)

DALE, Bruce
"Bullet bursts through glass globe" 1988* (Best14 154)
"Women in Shanghai, China trust their tresses to a hairdresser–and perm machines more than 50 years old" 1980* (Through 148)

DALE, David E.
"Richard Zaboroski flees from Sharon police Officer Jeff Jennings after crashing his car during a police chase" 1990 (Best16 106a)

DALLAL, Thomas
"A Polish artisan ambles home through Krakow Square at end of his workday" 1992 (Best18 82)

DALY, Kelso
"Pearl Harbor resident watches bombing by Japanese planes" 1941 (Goldberg 108; Lacayo 102)

DANIELS, John T.
"The first powered flight ever" 1903 (Photos 18)

DANKLOOF, Ruurd
[from a cookbook] c. 1990* (Graphis90 \329)

DASSONVILLE, William E., 1897-1957
"Beach Grass" c. 1920 (Peterson #54)

DATER, Judy, 1941-
"Consuelo Cloos" 1980 (Rosenblum \247)
"Joyce Goldstein in Her Kitchen" 1969 (Decade \85)
"Laura Mae" 1973 (Decade 88; Rosenblum2 #733)

"Maureen with Fan" 1972 (Marien \7.45)

DAUGHERTY, Bob
"President Carter takes to the road" 1979 (Life 33)

DAUGHTY, Charles
"Three Italian air force jets collide during air show over U.S. Air Base at Ramstein, West Germany" 1988 (Best14 71)

DAVENPORT, Fulton
[untitled] c. 1992* (Graphis93 205)

DAVID-TU, Alan
"Blue Head" c. 1991* (Graphis91 \385)
"Sun-bathing" c. 1991* (Graphis91 \40)

DAVIDSON, Barbara
"Caregivers of all ages and toddlers crowd the waiting area of mobile clinic" 1997 (Best23 222c)
"Dressed as his favorite comic book hero, 3-year-old pauses before attempting a third try to fly" 1998 (Best24 39b)
"Mother agonizes over the pain of her son as he receives a shot" 1997 (Best23 222d)
"Nine-year-old smiles up at his music teacher as the two were rehearsing together" 1996 (Best22 108)

DAVIDSON, Bruce, 1933-
"Alabama" 1963 (Eyes #275)
"A decoy police officer arrests a mugger on a New York subway" 1985* (Best11 160a)
"Edward Steichen" 1963 (MOMA 37)
"The Queen Elizabeth II during sand blast operation while in dry dock, Southampton, England" 1996 (Photography 31)
"Securing mooring lines for the Queen Elizabeth II, Capetown, South Africa" 1998 (Photography 30)
"South Carolina" 1962 (Lacayo 148)
"A tenement in New York City" 1970 (Lacayo 146)
"Untitled" 1966-1968 (Marien \6.50)
"Untitled, East 100th St." 1966 (Rosenblum2 #687)
[from the series Teenagers] or "Two Youths, Coney Island" 1959 (Goldberg 149; MOMA 226)
[from the series Welsh Miners] 1965 (Decade 78c)

DAVIDSON, Cameron
[golf course by the shore] c. 1997* (Graphis97 147)
"A sailboat rests in a stand of mangrove trees after being pushed ashore by Hurricane Andrew at Key Biscayne, Fla." 1993* (Best19 115)
[self-promotional] c. 1990* (Graphis90 \99)

DAVIDSON, Rob
"Jesse & Julian" c. 1999* (Photo00 136)
"Os Chair" c. 1999 (Photo00 180)

DAVIES, Brian
"At a Head Start preschool not every five-year-old can be persuaded to wear a cap for graduation" 1993 (Best19 226a)
"Four days after the O.J. Simpson verdict Dake-Smith's estranged husband slashed her with a butcher's knife" 1995* (Best21 145d)
"Hattie Bains practices the violin with her mother in their backyard" 1993* (Best19 225)
"High school centerfielder makes a catch during a playoff game" 1993 (Best19 226c)
"Paula Villarreal embraces her boyfriend before commencement exercises" 1993 (Best19 226c)

140)
"Test mannequins at an atom bomb site" 1955
(Lacayo 133d)

DeCARAVA, Roy, 1919-
"Graduation" 1949-1952 (Decade \71; Marien \6.42)
"Ketchup Bottles, Table and Coat" 1953 (Willis
\142)
"Man Coming up Subway Stairs" 1952 (San \46)
"Pepsi, New York" 1964 (Rosenblum2 #684)
"Self-Portrait" 1956 (MOMA 206)
"Three Men with Hand Trucks, New York" 1963
(Decade 78b)
"Untitled" 1955 (MOMA 205); 1959 (Szarkowski
250)
"Woman Resting, Subway Entrance, New York"
1952 (San #61)

De CLERCQ, Louis-Constantin-Henri-François, 1836-
1901
"Eighth Station of the Cross" 1859-1860 (Marien
\3.47)
"Entrance Portal, Dendera" 1860 (Waking #66)
"Southern Side, Krak of the Knights, Syria" 1859
(Szarkowski 107)
"The Tower of Gold, Seville" 1860 (Waking #78)
"Tripoli" 1859 (Waking 299)

De COCK, Liliane, 1939-
"At the Base of Acoma, New Mexico" 1970
(Rosenblum \241)

De FRISCO, Tim
"Edward Morse is caught in a midair spin during his
dive off the one-meter springboard at the U.S.
Outdoor Nationals" 1988 (Best14 130)
"Maciel Malone and Arlise Emerson run the 400
meter race at the Athletics Congress 1989 national
championships in Houston" 1990* (Best16 137a)

De Los SANTOS, Penny
"Innocence Lost" 1998 (Best24 174-175)
"Two children at an orphanage in Mexico" 1997
(Best23 255)

De MEYER, Adolf, 1868-1949
"Advertisement for Elizabeth Arden" 1926 (Art \437
"Charles Chaplin" 1921 (Vanity 41)
"Claude Monet" 1921 (Vanity 42)
"George Arliss" 1918 (Vanity 24)
"Geraldine Farrar" 1915 (Vanity 12)
"Grace George" 1920 (Vanity 30)
"Green and Silver Leaves" 1925 (MOMA 126)
"Helen Lee Worthing" 1920 (Szarkowski 191)
"John Barrymore" 1920 (Vanity 38)
"Josephine Baker" c. 1923 (Art \436; Hambourg \46)
"Lady Ottoline Morrell" c. 1912 (Waking #138)
"Lillian Gish" c. 1920 (Vanity 33)
"Man with a Cane" c. 1919 (Art \435)
"Tamara Karsavina" 1911-1914* (Waking #133)
"Vaslav Nijinsky" 1916 (Vanity 11)
"Water Lilies" 1906 (Rosenblum2 #399)
"Wedding Dress Modeled by Helen Lee Worthing"
1920 (Rosenblum2 #636)

De MOLINA, Raul
"Spanish bullfighters are protected by police while
trying to leave the bull ring as fans throw cushion
seats in protest " 1988 (Best14 131a)
"Tampa residents move to safety along a flooded

causeway as Hurricane Elena moves in" 1985 (Best11
68a)

De OLAZABAL, Eugenia
"Cactus" c. 1990* (Graphis90 \298)

De VASSON, Jenny, 1872-1920
"Untitled" 1906 (Rosenblum \106)

De ZITTER, Harry
"An abandoned house on the bank of the Canal du
Midi" c. 1990* (Graphis90 \71)
[Chrysler Building] c. 1995* (Graphis96 172)
[the look and spirit of New England] c. 1991*
(Graphis92 \195)
"Members of the Samburu tribe wearing Nike
walking shoes" c. 1991* (Graphis91 \33)
"Nantucket Island" c. 1991* (Graphis91 \297)
[neglected wooden shack] c. 1997* (Graphis97 149)
[self-promotional] c. 1991* (Graphis91 \104)
[self-promotional] c. 1989* (Graphis89 \79 - \85)
"Vanishing Texas" c. 1991* (Graphis92 \196-\198)
[Vlieland Island, the North Sea, a region of Friesland]
c. 1992* (Graphis93 176)

DEE, Stuart N.
[self-promotional] c. 1991* (Graphis91 \195)
"Vacation on the beach" c. 1992* (Graphis93 169)

DEGAS, Edgar, 1834-1917
"Pierre Auguste Renoir and Stéphane Mallarmé"
1890-1895 (Marien \4.38; Szarkowski 318a)

DeJONG, Lisa
"Three-on-three basketball" 1996 (Best22 187a)

DEJONG, Peter
"Chechnya: the war for Grozny" 1995* (Best21 208)

DELAHAYE, Luc
"Afghanistan That Still Bleeds" 1996* (Best22 242d,
243d)

DELAMOTTE, Philip Henry, 1820-1889
"The Open Colonnade, Garden Front" c. 1853
(Rosenblum2 \170)
"Setting up the Colossi of Ramses the Great" 1853
(Rosenblum2 #179)
"View through Circular Truss, Crystal Palace" 1853-
1854 (Szarkowski 74)

DELANEY, Michael
"FAA officials inspect the tail section of Delta Flight
191" 1985 (Best11 52)

DELANO, Jack
"At the concourse information desk" 1943
(Documenting 289b)
"Convict Camp, Georgia" 1941 (Rosenblum2 #470)
"Engineer and trainman on the platform" 1943
(Documenting 281c)
"Gateman serves as an interpreter for speakers of
Yiddish, Polish, German, Russian, Slovak, and
Spanish" 1943 (Documenting 282a)
"Greeting relatives" 1943 (Documenting 284a)
"In the concourse" 1943 (Documenting 293c)
"Interlocking tower, where inbound and outbound
traffic is controlled" 1943 (Documenting 285c)
"Lining up for train reservations in the concourse "
1943 (Documenting 279)

"Main waiting room, 1 a.m." 1943 (Documenting 292a)
"Model military aircraft hanging from the ceiling of the train concourse" 1943 (Documenting 290b)
"Office Directory" 1943 (Documenting 284b)
"Painting on a Barn near Thompsonville, Connecticut, along Route 5" 1940 (Decade 43d)
"Parmelee transfer cabs carry passengers to other Chicago stations" 1943 (Documenting 292b)
"Pullman porter" 1943 (Documenting 283b)
"Ticket sales cashier's office" 1943 (Documenting 287b)
"Timetable information room" 1943 (Documenting 288a)
"Tracks leading into the station" 1943 (Documenting 280a)
"Train concourse" 1943 (Documenting 290a)
"Passengers arriving on a Chicago, Burlington, and Quincy Railroad Zephyr" 1943 (Documenting 281b)
"Unloading a mail car" 1943 (Documenting 285d)
"The watch inspector's office, where trainmen's watches receive periodic inspection" 1943 (Documenting 286a)

DELAY, Jerome
"Beirut residents living in a war-torn building wave as Pope John Paul II makes his way from the airport" 1997* (Best23 126)
"Israeli soldiers drag a Palestinian child suspected of stone-throwing during clashes in the occupied West Bank town of Hebron" 1995* (Best21 176b)

DELPHI
"Jean Cocteau" 1922 (Vanity xi)

DeLUCA, Louis
"After missing the catch on a foul ball, Texas Ranger Chad Kreiter watches Chicago's King and Woodson make the play in the dugout" 1990* (Best16 131)
"Members of the Richardson Pearce High School basketball team watch tensely as their teammates win a playoff game" 1990* (Best16 130)
"A passer-by strolls over the outlines of 610 Dallas AIDS victims who have died" 1987 (Best13 60d)
"Texas Ranger Nolan Ryan hurls a pitch against the New York Yankees in his quest for his 300th career win" 1990* (Best16 128-129)

DEMACHY, Robert
"A Ballerina" 1900 (Rosenblum2 #372)
"Struggle" 1904 (Marien \4.8)

DEMAND, Thomas, 1964-
"Copyshop" 1999* (Marien \7.53)

DEMARCHELIER, Patrick
[black- and white-striped dress] c. 1997* (Graphis97 29)
"French actress Isabelle Adjani" 1991 (Graphis91 \148)
"Madonna" c. 1991 (Graphis92 \116)
[red- and white-striped dress] c. 1997* (Graphis97 36)
[untitled] c. 1999* (Photo00 32, 33)

DEMATTEIS, Louis
"A downed American flyer is led out of the Nicaraguan jungle to a helicopter after Sandinista

soldiers captured him" 1986 (Best12 76a)

DeNADOR, Dudley
"Golden Gate Bridge" c. 1995* (Graphis96 175)

DEPARDON, Raymond, 1942-
"Angola" 1994 (Rosenblum2 #714)
"Bogota, July" 1968 (Eyes #262)
"Christian Phalangist militiaman fires to cover himself as he races for a new position in the shattered streets of Beirut" 1978 (Eyes #261)
"Fainting Bride, Bois de Boulogne, Paris, France" 1956 (Photography 203)
[glassblower] c. 1991 (Graphis92 \215)
"In an insane asylum, Turin" 1979 (Lacayo 155d)
"Sioux City" 1968 (Eyes #263)
"Thursday, 11th January 1990, Barthelemy Foundry Crest" c. 1991 (Graphis92 \128)

DERBY, Doris A., active 1960s to date
"Meditation (woman with hat)" 1968 (Willis \237)

DERLETH, Günter
[from a public relations campaign for Knoll International] c. 1990* (Graphis90 \201)

DESFOR, Max, 1913-
"Korean War" or "Koreans flee Communists" 1950 (Capture 27; Eyes #226)
"This pair of tied hands was found protruding from the snow at Yangii on the central front, Korea" 1951 (Eyes #225)

DETRICH, Allan
"Fred and Andy, roommates at the Group Home, wave to passerbys" 1993* (Best19 228d)
"Ilja Miller and his grandmother spend a quiet evening on the porch" 1993* (Best19 227)
"Ilja Miller and his uncle play chess to help pass the time as Ilja's father lies near death, a victim of AIDS" 1993* (Best19 118)
"Ilja Miller dribbles a ball in front of a rainbow painted on the garage by his father who died of AIDS" 1993* (Best19 5)
"Larry Seitz carries a miniature horse at his farm" 1993* (Best19 228)
"Rescue workers pull a truck driver from wreckage after a rollover" 1993* (Best19 228a)

DEUTSCH, Robert
"U.S. Olympian Carl Lewis cries and looks upward after receiving his last Olympic gold medal" 1996* (Best22 118b)

DEVENS, Mary
"The Ferry, Concarneau" 1904 (Sandler 58c)

DeVERA, Joseph
"High school basketball games" 1993 (Best19 162-165)
"Soccer player hugged by her teammates after scoring winning goal in the playoffs" 1993* (Best19 166)
"With just a few seconds left in the NCAA final game, Chris Webber of Michigan calls a timeout his team doesn't have" 1993* (Best19 161)

DeVOE, Doug
"A North Carolina guard finds no dribbling room through a Georgian defender during an NCAA semifinal game" 1995* (Best21 110b)

DI BAIA, Eduardo
"Mothers and Grandmothers of the Plaza de Mayo"
1979 (Photos 147)

di BATTISTA, Michelangelo
[untitled] c. 1999* (Photo00 28, 29)

DIAMOND, Hugh Welch, 1808-1886
"Patients, Surrey County Lunatic Asylum" 1850-1858
(Rosenblum2 #77; Waking #33)
"Seated Woman with Bird" c. 1855 (Marien \2.17)

DIAMOND, Paul
"Man Smoking, New York" 1974 (Decade 89)

DIANA, Peter
"All 462 competitors hit the water for a half-mile
swim to begin the Allegheny County Triathlon"
1986 (Best12 229d)
"Detective applies force to a drug suspect who
allegedly had sold crack to the undercover officer"
1996 (Best22 146c)
"Suzie McConnell" 1998 (Best24 94c)
"Suzie McConnell jumps for joy after winning in the
opener of the WNBA" 1998* (Best24 57)

DIAZ, Alan
"Artists and twins Haydee and Sahara Scull ham it up
in their Miami Beach home" 1991* (Best17 77)
"Elain" 2000* (Capture 198)

DIBBETS, Jan, 1941-
"Sea, Land" 1975* (Photography2 162)

DICKINSON, E. E., active 1915
"Group Portrait at a Patriotic Celebration" c. 1915
(National \51)

DICKMAN, James B.
"El Salvador: Killing Ground" 1982 (Capture 125)

DICKMAN, Jay
"Hunting dogs in Papua New Guinea make a meal of
a northern cassowary, a flightless bird they
cornered and killed" 1994* (Through 424)
"In tiny Guayabal, the town square was used as a
collection spot for the bodies of the dead" 1985
(Best11 20)

DICKSON, Albert
"Security guards tackle Yankees fan who ran onto the
field during World Series" 1996* (Best22 199c)

DICKSON, Edward R., 1880-1922
"Untitled" 1910s (Peterson #12)

DICKSON, Nigel
"Tip O'Neill" 1986* (Rolling #44)
"William Burroughs" 1986 (Rolling #43)

DIDLICK, Nick
"An injured soccer fan is carried to safety after a
stand wall collapsed" 1985 (Best11 227)

DIEBOLD, George
[for a chair catalog] c. 1990* (Graphis90 \198)

DIEDRICH, J. B.
"Texas Oil Spill–Galveston Bay" 1990* (Best16
149d)

DIEUZAIDE, Jean
"My Adventure with Pitch" 1958 (Rosenblum2 #766)

DIEZ-DÜHRKOOP, Minya, 1873-1929
"Untitled" c. 1915 (Rosenblum \83)

DIJKSTRA, Rineke
"Tiergarten, Berlin" 2000* (Marien \8.3)

DILLWYN, Mary, 1816-1906
"The Picnic Party" 1854 (Rosenblum \38)

DILTZ, Henry
"Michael Jackson" 1971 (Rolling #8)

DILYARD, Matt
"Fans duck for cover as a fly ball comes into the
stands" 1986 (Best12 214a)

DINGUS, Rick, 1951-
"Untitled" 1977-1979 (San \61)

DiROCCO, Henry
"2-year-old uses a wooden playground structure in a
game of hide and seek" 1985 (Best11 143a)

DISDÉRI, André Adolphe Eugène
"Portrait of an Unidentified Woman" c. 1860-1865
(Rosenblum2 #59)

DISDÉRI, Geneviève Elisabeth Francart, c. 1818-1878
"Abbaye de Saint Mathieu" c. 1857 (Rosenblum \42)

DiVITALE, Jim
[chambered nautilus] c. 1992* (Graphis93 74)
[perfume bottles] c. 1992* (Graphis93 148)

DIVOLA, John, 1949-
"Zuma Number 29" 1978* (Photography2 187)

DIXON, Martin, 1965-
"Skin Deep, Ann Arbor" 1990* (Committed 89)
"Times Square Dance Queen" 1991 (Committed 88)

DIXON, Phillip
[men's sweaters] c. 1997* (Graphis97 34)

DLOTT, Debbie
"Naomi Lane is on the receiving end during a
snowball fight in Burlington" 1986 (Best12 120b)

DODGE, Katherine T.
"Issue Day at San Carlos, Arizona" c. 1899 (Sandler
101)

DODGE, Thomas
"These men were among some 600 farmers who
shouted 'No Sale!' at a foreclosure auction of land"
1985 (Best11 59c)

DÖHLER, Axel
[sneaker] c. 1992* (Graphis93 152)

DOISNEAU, Robert, 1912-1995
"Kiss in front of Hôtel, Paris" 1950 (Icons 107)
"3 Children in the Park" 1971 (Rosenblum2 #625)

DOJC, Yuri
"Black and white studies" c. 1991 (Graphis91 \196)
"Nude" c. 1991 (Graphis92 \135)

DOLAN, Mark
"Two brothers let it all hang out as they deliberate
over a matter of basic rights" 1986 (Best12 95b)

DOLE, Jody
[ad for Escada perfume] c. 1991* (Graphis92 \173)
[beetle] c. 1997* (Graphis97 170)
[blue crab] c. 1997* (Graphis97 173)
[electricity] c. 1992* (Graphis93 152d)
[fish] c. 1999* (Photo00 202)
[fish, bird, rat] c. 1995* (Graphis96 187)
[for folder] c. 1990* (Graphis90 \296)
[for Lears magazine] c. 1991* (Graphis91 \245)
[light bulb] c. 1997* (Graphis97 130); c. 1992*
(Graphis93 152b)
"Odalisque" c. 1989* (Graphis89 \150)
"Smirnoff Vodka" c. 1991* (Graphis91 \143)
[still life with flowers] c. 1989* (Graphis89 \306-
\308)
[wasp nest] c. 1997* (Graphis97 172)

DOLL, Don
"Gordon Swift Hawk decorated his motorcycle with
'Red Power' stickers" 1996 (Best22 70)
"Myrtis Walking Eagle attends Christmas Mass in the
Jesuit Mission church at Soldier Creek, S.D."
1988* (Best14 151; Best22 60b)
"Nick and Laura Therchik wear the mountain-squirrel
parkas of Laura's handiwork" 1996 (Best22 69a)
"Noah and Emily Kills in Sight" 1996 (Best22 69b)
"Rosebud Sioux Reservation" 1996 (Best22 73-77)
"Sewel Makes Room for Them died of a cardiac
arrest due to drinking when he was 25" 1996
(Best22 68)
"Tooksook Bay, Alaska" 1996 (Best22 71-79)
"Vision Quest: Men, Women and Sacred Sites of the
Sioux Nation" 1993-1996* (Best22 60-65)
"Wounded Knee, South Dakota, December 29, 1990,
on the 100th anniversary of the massacre" 1990
(Best22 66)

DOMELA, Cesar, 1900-1992
"Photomontage" 1928 (Hambourg \18)

DOMINIS, John
"Cathy Rigby" 1972* (Life 145d)
"Leopard, Botswana, Africa" 1966* (Life 186)
"Robert Redford" 1970 (Life 88)

DOMON, Ken, 1909-1990
"Detail" c. 1960s (Rosenblum2 #719)
"Hiroshima: The Marriage of A-Bomb Victims" 1957
(Marien \6.25)

DOOLITTLE, James, active 1920s-1930s
"Marlene Dietrich" c. 1931 (Hambourg \42)

D'ORA, Madame, 1881-1963
"Fashion photograph for the Wiener Werkstätte" 1921
(Rosenblum \114)
"Maria Likarz" c. 1916 (Rosenblum \84)
"The Writer Colette" c. 1953 (Rosenblum2 #730)

DORR, Nell, 1893/95-1988
"Happiness" 1940 (Rosenblum \166)

DORRANCE, Scott
[self-promotional] c. 1990* (Graphis90 \202)

DOSTATNI, Yvette Marie
"Man with his prize birds" 1998 (Best24 88b)

DOTTER, Earl
"Scotia Mine Disaster" 1976 (Rosenblum2 #694)

DOUBILET, David
"Australia's Great Barrier Reef supports a diversity of
species" 2001* (Through 388)
"Cold, deep and remote waters are filled with fanciful
creatures such as the weedyseadragon" 1997*
(Best23 162b)
"A dolphin swims near people at Monkey Mia, a
fishing community in Shark Bay, Western
Australia" 1991* (Best17 176)
"Evening light coats the stark thousand-foot cliffs of
Tasmar Island" 1997* (Best23 162a)
"Fish swim in a lagoon at Lord Howe Island" 1991*
(Best17 175b)
"Jellyfish in Pacific lagoon" 2000* (Through 12)
"'Nightmare flat tire'—home to a moray eel" 1990*
(Best16 145)
"A 150-pound black cod lives in a sunken fishing
ship at Middleton Reef" 1991* (Best17 175a)
"Sharks and yellowtail snappers feed on scraps
tossed from a dive boat" 2002* (Through 422)
"Small fish seek safety amid the kinks, frills, and
tentacles of jellyfish in the Tasman Sea" 2000*
(Through 412)
"Sponges and coralline algae encrust a Japanese Zero
downed in World War II in the southwestern
Pacific" 1988* (Best14 153a)
"A stingray flaps its fins like wings in the sky-clear
waters of North Sound, off Grand Cayman Island"
2000* (Through 392)
"Underside view of Southern Saw Shark" 1997*
(Best23 162c)

DOUGHERTY, Sean
"First Lady Barbara Bush visits a Florida nursery that
cares for children with AIDS" 1990* (Best16 110)
"A jellyfish floats through silt-filled water off of Key
Biscayne" 1998* (Best24 52b)
"Swimmer Kim Ecott" 1996* (Best22 214b)
"Tyana, 3, born with spina bifida" 1990 (Best16 74b)

DOUGLASS, Steve
"Natural gas vs. electricity; which is best for heating
and cooling a home?" 1988 (Best14 115b)

DOWNING, Larry
"As part of the Iran-Contra arms sale, the president
confronts two National Security advisers and his
chief of staff" 1986* (Best12 7b)

DRAPER, Eric
"St. Louis Cardinal's slugger Mark McGwire cools
off in the dugout" 1998* (Best24 65a)
"Senior Clinton adviser George Stephanopoulos rubs
his face during an interview" 1996* (Best22 106d)

DRAPER, John, 1811-1882
"Photomicrographic Daguerreotype" 1856
(Photography1 \29)

DRAPER, John William
"Dorothy Catherine Draper" 1840 (Rosenblum2 #38)

DRAPKIN, David
"A Chinese gymnast competes in Seoul" 1988*
(Best14 149a)
"Herman Reid slams one for two during basketball at
the Summer Olympics in Seoul" 1988* (Best14
148)
"Men's tae kwon do competition: France vs. Korea"
1988* (Best14 149b)
"U.S. men's basketball team, Chamshil Gymnasium,
in Seoul" 1988* (Best14 150)

DRENNER, Dennis
"On the bottom rung of Pakistan's social ladder, the
eunuch-transvestites or *Hijras*" 1998* (Best24 80)

DREZDZON, Gregory
"Satanata's Sue Sprenkle strains to hand off the baton
to the anchor" 1987 (Best13 212)

DRIDI, Kamel
"Mosque, Fes" 1987 (Marien \7.37)

DRISKELL, David C., 1931-
"Boa Morte, Brazil" 1987* (Willis \479)
"Pelecypoda" 1997* (Willis \481)
"Window, Old City, Salvador" 1983* (Willis \480)

DRTIKOL, František, 1883-1961
"Studie" 1929 (San #28)
"Untitled" c. 1927 (Rosenblum2 #545; San \9)

DRUET, Eugène, 1868-1917
"The Clenched Hand" before 1898 (Waking #1898)

DRYDEN, Frazer
"Young Professionals" 1996 (Best22 239d)

DUBOIS, Michel
"Kyoto 1885" c. 1991* (Graphis91 \115)
[from *Mnemosyne*] c. 1992* (Graphis93 132, 133)
"Hollywood 1932" c. 1991 (Graphis91 \309)

DUBOIS DE NEHAUT, Louis-Pierre-Théophile, 1799-
1872
"Another Impossible Task" 1854 (Waking #56)
"Promenade in Malines" 1854-1856 (Waking #57)
"View of the Square in Melting Snow" 1854-1856
(Waking 290)

DUBOSCQ-SOLEIL, Louis Jules, 1817-1886
"Still life with skull" c. 1850 (Szarkowski 318a)

DUBREUIL, Pierre, 1872-1944
"Les Boulevards" 1909 (Hambourg 69)
"Dusk on the Marsh in the Snow" 1898 (Rosenblum2
#374)

Du CAMP, Maxime, 1822-1894
"Colossus of Memnon" 1850 (Marien \2.40)
"Colossus of Ramses II at Abu Simbel, Egypt" 1850
(Monk #4; Lacayo 16; Rosenblum2 #111)
"House and Garden in the Frankish Quarter, Cairo"
1850 (Waking 296)
"Temple of Kertassi, Kerdasah, Egypt" 1849-1851
(Szarkowski 318b)
"Westernmost Colossus of the Temple of Re, Abu
Simbel" 1850 (Waking #65)

DUCHAINE, Randy
[inserting piano strings] c. 1999* (Photo00 183)

DUCHAMP, Marcel, 1887-1968
"Cigarette" 1936 (Hambourg \120)

DUCHENNE de BOULOGNE, Guilaume-Benjamin-
Amand, 1806-1875
"Fright" or "Electrical contraction of the eyelids, the
forehead with voluntary lowering of the jaw" c.
1870 (Marien \3.77; Szarkowski 97d)
[from *The Expressions of the Emotions*] before 1872
(Marien \3.78; Rosenblum2 #79)

duCILLE, Michel
"Colombian police chopper lifts a volcano victim
from Armero's mud" 1985 (Best11 16c)
"The Graveyard" 1987 (Capture 149)
"Volcanic mudslide, Colombia" 1985 (Capture 140*,
141)

DUCOS du HAURON, Louis, 1837-1920
"Diaphanie (Leaves)" 1869* (Rosenblum2 #338)
"Rooster and Parrot" 1879* (Rosenblum2 #340)
"Self-portrait" c. 1888 (Rosenblum2 #497)
"View of Angoulême" 1877* (Rosenblum2 #339)

DUFKA, Corinne
"Liberia: a dead man's wallet" 1996* (Best22 227)

DUGDALE, John
[from ad for Dayton's department store] c. 1991*
(Graphis91 \20-\23)

DUGDALE, T. G.
"Pit Brow Girl, Shevington" 1867 (Rosenblum2
#410)

DUGMORE, Arthur Radclyffe
"The Author and his Camera" 1910 (Marien \4.63)

DUKA, Lonnie
[chemical plant] c. 1999* (Photo00 24)
"Freeway Construction" c. 1997* (Graphis97 158,
159, 166)
"MCI telephone company's earth stations" c. 1989*
(Graphis89 \217)
[Power plants] c. 1992* (Graphis93 187)
"Senior citizens' housing development" c. 1989
(Graphis89 \99)

DUMAS, Nora, 1890-1979
"The Farm Horse" c. 1935 (Rosenblum \136)

DUNCAN, David Douglas, 1916-
"*Black Avni* Turkish Calvary on Maneuvers" 1948
(Rosenblum2 #609)
"Christmas in Korea" 1950 (Lacayo 136)
"Korea" 1950 (MOMA 201)
"Picasso in his studio" 1960* (Lacayo 138c)
"U.S. Marine, South Korea" 1950 (Life 57; Marien
\6.33)
"U.S. Marines in Korea" 1950 (Lacayo 119a)
"Wounded soldier near Naktong River" 1950 (Life
56)

DUNCAN, Mark
"Debris in residential section of Albion, Pa., shows
the path of a tornado" 1985 (Best11 67a)
"Defused mines on the deck of captured Iranian ship
provide the proof the United States was looking
for" 1987 (Best13 11c)
"Uwe Dassler of the German Democratic Republic

cheers his world record time as he wins the 400 meter freestyle gold medal at the Summer Olympics" 1988 (Best14 13b)

DUNMORE, John L., active 1865-1875
"The Glacier as Seen Flowing" 1869 (National 127a)
"Hunting by Steam in Melville Bay" 1869 (National 19d, \43)
"Sailing Ships in Ice Field" 1869 (Rosenblum2 #158)

DUNN, John
"A firefighter crawls into the attic of a burning home in an effort to avoid fumes from the blaze" 1985 (Best11 171a)

DUPONT, Stephen
"Abdul Rahman, Sere Tribe champion wrestler" 1997 (Best23 237b)
"Australia's Black Olympics" 1998 (Best24 180-181)
"Backstage at Maurizo Galante Fashion Show" 1997 (Best23 252c)
"Commander Ahmed Shah Massoud" 1998* (Best24 178-179)
"India's last steam trains" 1996 (Best22 250-251)
"Jeremy Scott fashion show, Paris" 1997 (Best23 236)
"Little girl with a Chinese flag at the time of the Hong Kong takeover by China" 1997 (Best23 237c)
"A lone tree protestor stands in the burning tree debris after a heavy forced eviction and battle with police" 1996 (Best22 164b)
"A Scots-guard mourns with the crowd at Princess Diana's funeral" 1997 (Best23 237d)
"Sere wrestler during a training session on Banju Beach" 1997 (Best23 254)
"A wrestler inspects himself in a mirror in Mongolia" 1997 (Best23 237a)
"Wrestling in Gambia" 1997 (Best23 217)
"A young Mexican fan gets as close to the action as possible during the historic Padres vs. Mets series in Monterey, Mexico" 1996* (Best22 198c)

DURANDELLE, Louis-Emile, 1839-1917
"Ornamental Sculpture, New Paris Opera" 1865-1872 (Szarkowski 101)

DURELL, Robert E.
"Ken Exner says goodbye to friend Casey Coor after a night at the movies while his mother waits" 1988 (Best14 120)
"Swift, high water of Kings River swirls over a car that crashed in Sequoia National Park in California" 1985 (Best11 103a)

DURHEIM, Carl
"Katharina Wächter" 1852-1853 (Marien \2.65)

DURIEU, Eugène, 1800-1874
"Académie de l'Album Delacroix réunissant" 1853-1854 (Marien \2.55)
"Figure Study No. 6" c. 1853 (Rosenblum2 #242)
"Nude" c. 1854 (Waking #62)

DURR, George, active 1980s to date
"Rock in Merced" n.d. (Willis \551)
"Some Hi-Way, Arizona" n.d. (Willis \550)

DURRETT, Nekeisha, 1976-
"Two Children with Book" 1998 (Willis \385)

DYER, John
[self-promotional] 1990* (Graphis90 \18)

DYKES, Steve
"Jockey Jack Kaenel leaves his mount, Years of Fun, in the second race of opening day at Hollywood Park" 1986 (Best12 223)

DYKINGA, Jack
"State Schools for the Retarded" 1970 (Capture 74)

DZIEKAN, John
"Four persons died in this mid-winter blaze in Chicago" 1985 (Best11 99b)

—E—

EAKINS, Thomas, 1844-1916
"Amelia Van Buren with a Cat" c. 1891 (Rosenblum2 #297)
"History of a Jump" 1884-1885 (Rosenblum2 #298)
"Marey Wheel Photographs of Unidentified Model" 1884 (Photography1 \85)
"Pole Vaulter" 1884-1885 (Marien \4.57)

EAKINS' circle
"Eakins' Students at the Site of *The Swimming Hole*" 1883 (Photography1 \71; Rosenblum2 #254)

EARHART, Walter J.
"David Schmitz runs in circles on a track" 1986 (Best12 142)

EASTCOTT, John
"A sailboarder looking for whales on Bonavista Bay is rewarded by a close encounter with two humpbacks" 1986* (Best12 107a)

EASTERLY, Thomas M., 1809-1882
"Big Mound at 5th & Mound Streets" 1852 (Photography1 #III-8); 1869 (Photography1 #III-9)
"Chouteau's Mill Creek, East from 13th and Gratiot, Construction of Sewer" c. 1855 (Photography1 \31)
"Chouteau's Pond" 1850 (Photography1 #III-10)
"Chouteau's Pond, drained" 1851 (Photography1 #III-11)
"Keokuk, or the Watchful Fox" 1847 (Marien \2.66; Rosenblum2 #47)
"Na-che-ninga, Chief of the Iowas" 1845 (Photography1 \26)

EASTMAN, George, 1854-1932
"Portrait of (Felix) Nadar taken with a No. 2 Kodak Camera" after 1888 (Szarkowski 144a)

EASTWOOD, Richard
[colorful staircase] c. 1992* (Graphis93 185)

EATON, Charles F., Jr.
"Infield play in North Carolina" 1985 (Best11 190)
"A prisoner in solitary confinement peers through a slit in his cell door" 1986 (Best12 138)

EATON, Edric L., c. 1836-1890s, attribution
"Sky Chief" c. 1867 (Waking #120)

EBERLE, Todd
[mannequin and spiral forms] c. 1999* (Photo00 26)

ECCLES, Andrew
"Designer/Illustrator/Artist Milton Glaser" c. 1991*
(Graphis92 112)
[Olympic athlete, shirtless man with ski poles] c.
1992* (Graphis93 198)

ECHAGÜE, José Ortíz
"Young Singers" c. 1934 (Rosenblum2 #383)

ECK, Imre Gabor
[still life with trash] c. 1995* (Graphis96 87)

ECKERT, Peter
[church] c. 1997 (Graphis97 161)
[industrial sections of Portland, Oregon] c. 1992
(Graphis93 170b)

ECONOMOPOULOS, Aristide
"5-year-old hangs on to his mother during the
family's visit to the Moving Vietnam Veterans
Wall" 1997 (Best23 130)
"Girl rests on an inflatable raft" 1998 (Best24 91c)

EDDY, Sarah J., 1851-1945
"The Bride" c. 1900 (Rosenblum \66)
"Contentment" c. 1895 (Sandler 17a)
"Welcome Interruption" c. 1899 (Photography1 \98)

EDELSTEIN, Jillian
"Among the youngest to testify before the
commission about being shot by police officers"
1997 (Best23 183d)

EDENS, Joe
"A freight train eases past a Piedmont Airlines
Boeing 737 which ran off the runway" 1986
(Best12 57d)

EDER, Josef Maria, 1855-1944, and Eduard Valenta
"Newborn Rabbit" c. 1896 (Szarkowski 137)

EDGERTON, Harold, 1903-1990
"Bouncing Golf Ball" c. 1940 (Szarkowski 318d)
"Bullet Through the Apple" 1964 (Goldberg 123a)
"Dangerous Weapon" 1936 (MOMA 165)
"Drop of Milk" 1931 (Monk #18) or "Milk Drop
Coronet" 1936 (Goldberg 105; Marien \5.77)
"Fesler Kicking a Football" c. 1935 (Hambourg \71)
"Moving Skip Rope" 1952 (Goldberg 133)
"Study of impact of a golf ball" 1939 (Lacayo 84d)
".30 Caliber Bullet as It Crashes through a Bar of
Soap" n.d. (Decade \33)

EDINGER, Claudio
"Young girls compete to see who can look like their
idol, the singer Selena" 1995* (Best21 163b)

EDMONDS, Ron
"Assassination Attempt" 1981 (Capture 118-119)

EDWARDS, Jay Dearborn, 1831-1900
"Artillery Battery, Pensacola, Florida" 1861
(Photography1 #IV-12)
"Confederate Sand Batteries, Pensacola, Florida" c.
1861 (Photography1 \39)
"Princess Steamboat" 1857-1860 (Photography1 \33)

EDWARDS AND SON, active 1860-1885
"Landscape with Portrait of Alfred R. Waud" c. 1883
(Szarkowski 127)

EGGITT, John
"A zookeeper takes the problem of parking Bella the
elephant into her own hands" 1985 (Best11 177)

EGGLESTON, William, 1939-
"Black Bayou Plantation, near Glendora, Mississippi"
1971* (Art \360)
"Greenwood, Mississippi" 1970* (Marien \6.94)
"Huntsville, Alabama" 1971* (Art \363)
"Memphis" 1971* (Art \362; Rosenblum2 #779)
"Near Greenwood, Mississippi" 1971* (Art \361)
"Plains, Georgia" 1976* (Szarkowski 292)
"Sumner, Mississippi, Cassidy Bayou in
Background" 1971* (Art \365)
"Tallahatchie County, Mississippi" 1971* (Art \359)
"Untitled" 1980* (Icons 171)
"Untitled (Morton, Mississippi)" 1969-1970*
(Photography 211)
"Whitehaven, Mississippi" 1971* (Art \364)

EHRHARDT, Alfred, 1901-1984
"Düne, Kurische Nehrung, Ostdeutschland" 1936
(San \48)
"Polygratia polygrata (Brasilien)" c. 1937 (San #63)

EHRLICH, Pauline
"Detail of a baling machine showing hay being
picked up at Spring Run Farm" 1944 (Fisher 85)
"Detail of a hay baler showing rotating knives which
cut hay into proper lengths" 1944 (Fisher 83)

EICKEMEYER, Rudolf, 1862-1932
"The Lily Gatherer" 1892 (Photography1 \100)
"Under the Greenwood Tree" 1901 (National 127a)

EISELE, Dino
"Dietmar Henneka" c. 1990* (Graphis90 12)

EISENSTAEDT, Alfred, 1898-1995
"Children watching a puppet show" 1963 (Lacayo
153a)
"Dirigible Graf Zeppelin Being Repaired Over the
South Atlantic on Flight to Rio de Janeiro" 1934
(Icons 62)
"Ethiopian soldiers" 1935 (Eyes #96)
"Feet of Ethiopian Soldier" 1935 (Rosenblum2 #596)
"Fighting fat with the splendid massager" 1940 (Life
111c)
"Joseph Goebbels" 1933 (Eyes #179; Lacayo 75;
Marien \5.78)
"Katharine Hepburn" 1939 (Life 83a)
"Marilyn Monroe" 1953 (Life 84d)
"Mia Farrow" 1967* (Life 89d)
"Mother and child at Hiroshima" 1945 (Lacayo 79)
"Mrs. Bun Wylie, Honorary Regent of Georgia's
D.A.R." n.d. (Photography 80)
"National Bedtime Characters at Work" 1936 (Eyes
#169)
"Sophia Loren" 1961 (Life 87)
"V-J Day, Times Square" 1945 (Eyes #210; Lacayo
121)
"Waiters, St. Moritz" 1932 (Lacayo 86)

EISNER, Sandra
[for album sleeve] c. 1990* (Graphis90 \108)
[from a portfolio] c. 1990* (Graphis90 \181)
"Jamie Baum" c. 1992* (Graphis93 123)
"Yellow Tulips" c. 1990* (Graphis90 \286)

ELCHA, Edward (Eduard), active 1915-1930s
"Man holding a cigar and cane" c. 1922 (Willis \77)
"Two dancers, Al Moore and female partner" c. 1925 (Willis \80)
"Woman draped in velvet and holding a whip" c. 1922 (Willis \78)
"Woman wearing bracelets" c. 1925 (Willis \79)

ELETA, Sandra, 1942-
"Josefa, Healer of the Evil Eye" 1980 (Rosenblum \189)
"Lovers from Portobelo" 1977 (Rosenblum2 #702)

ELISOFON, Eliot
"Tennessee Williams on the set of *Streetcar*, Barrymore Theatre" 1947 (Life 168a)

ELLERT, Luzia
"Razor Sharp" c. 1992* (Graphis93 82)

ELLIOTT, James
"Quite a Hopeless Case" c. 1856 (Marien \3.99)

ELLIOTT, Philip, 1903-1985
"Bar-B-Q" 1952 or earlier (MOMA 222)

ELLIOTT & FRY, Limited
"D. H. Lawrence" 1921 (Vanity 37)

ELLIS, Harry C., 1857-1928
"Untitled" c. 1912 (Szarkowski 150)

ELLIS AND WALERY
"Olive Terry" 1916 (Vanity 21)

ELLIS, Darryl
"Untitled (Grandfather)" 1990 (Marien \7.78)

ELLISON, Robert
"Khesanh, Vietnam" 1968* (Eyes \11-13)

ELLISON, Sulaiman, 1951-
"Early Morning Mass at the Church of Saint Emanuel" 1982 (Committed 90)
"Ethiopian Landscape I" 1982 (Committed 91)

ELLMERER, Andreas Paul
[at the harbor entrance to Cuxhaven] c. 1991 (Graphis92 \213)

ELSÄSSER, Dieter
"For Mayon Company" c. 1990* (Graphis90 \14)

ELUARD, Nusch, 1906-1946
Bois des Iles" c. 1936 (Rosenblum \129)

EMERSON, Peter Henry, 1856-1936
"The Clay Mill" before 1888 (Szarkowski 140)
"Coming Home from the Marshes" 1886 (Art \151)
"The Fetters of Winter" 1895 (Art \156)
"Gathering Water-Lilies" 1886 (Decade 7; Monk #11)
"In Marsh Land" c. 1885 (Art \149)
"In the Barley Harvest" 1888 (Rosenblum2 #281)
"Poling the Marsh Hay" 1886 (Art \152; Marien \4.5; Waking 331)
"Rowing Home the Schoof-stuff" 1886 (Art \150)
"A Rushy Shore" 1886 (Art \154)
"Snipe Shooting" 1886 (Art \153)
"The Snow Garden" 1895 (Art \155)

EMERSON, Wally
"Cars carve an oval path through a snowy downtown parking lot" 1987 (Best13 172d)

EMMET, Herman LeRoy
"Family of migrant workers" 1979-1987 (Best13 130-141)

EMMITE, David
[dashboard religious icons] c. 1999* (Photo00 85)

EMMONS, Chansonetta, 1858-1937
"Children at Well" 1900 (Rosenblum \96; Rosenblum2 #316)
"Feeding the Hens, West New Portland, Maine" c. 1900 (Sandler 22)
"Grist Mill, West New Portland, Maine" c. 1901 (Sandler 21)
"Old Table Chair No. 2 West New Portland, Maine" c. 1901 (Sandler 36)
"Scene in Charleston" 1926 (Sandler 76)
"Shelling Corn, Kingfield, Maine" 1901 (Sandler 20)
"Spinning Wool, West Portland, Maine" 1910 (Rosenblum \54)

EMRIC, Amel
"A soccer ball slips through an opening of a makeshift goal during a game played by Bosnian children" 1998* (Best24 66d)

ENDLICHER, Dieter
"Polish athlete lets the effort show during her long jump at the European track and field championships" 1986 (Best12 121a)
"Some 35 coffins are placed in a common grave in Tereso, Italy" 1985 (Best11 92a)

ENGEL, Morris
"Rebecca, Harlem" 1947 (Rosenblum2 #478)

ENGLAND, William
"Niagara Suspension Bridge" 1859 (Rosenblum2 #174)

ENGLE, Douglas
"A woman threads a flower onto a stripped palm leaf spine in El Salvador" 1996* (Best22 214b)

ENGLISH, Greg
"Nelson Mandela's Release from Prison" 1990* (Photos 167)

ENGLISH, Rick
[ad for *Macintosh* software] c. 1989* (Graphis89 \288)
[baby in pajamas] c. 1989* (Graphis89 \191)
[bathroom faucet] c. 1989* (Graphis89 \287)
"Chia Bean, Inc." c. 1989* (Graphis89 \234)
"Landscape architect Dan Kilen" c. 1989 (Graphis89 \128)

ENGSTEAD, John
"Marlon Brando" 1947 (Life 85)

ENNADRE, Touhami, 1953-
"Trance" 1993-1995 (Icons 184)
"Hands" 1978 (Icons 185)

EPPRIDGE, Bill, 1938-
"Robert F. Kennedy after he was shot" 1968 (Eyes

#288; Lacayo 144)

EPSTEIN, Mitch
"Monsoon, Jaimahal, Jaipur" 1985* (Photography 113a)
"Pushkar Camel Fair, India" 1978* (Rosenblum2 #782)

ERFURT, Stephan
[from article about ocean liner *Queen Mary* anchored at Long Beach] c. 1989* (Graphis89 \74, \75)

ERFURTH, Hugo, 1874-1948
"Austrian Writer Franz Blei" 1914 (Icons 40)
"Käthe Kollwitz" c. 1925 (Marien \4.35)
"Mies van der Rohe" c. 1930 (Szarkowski 174)
"Otto Dix with Brush" 1929 (Icons 41)
"Paul Klee" 1930 (Vanity 154c)
"Portrait" c. 1929 (Szarkowski 319a)
"Professor Dorsch" 1903 (Rosenblum2 #378)
"Renée Sintenis" c. 1925 (Szarkowski 175)

ERGENBRIGHT, Ric
"A young Indian boy from the highlands of Ecuador visits the weekly Ambato market with his father" 1988 (Best14 118)

ERICKSON, Jim
[ad for Zippo] c. 1999* (Photo00 2)
[car on bow of ship] c. 1997* (Graphis97 135)
[dog with stick] c. 1997* (Graphis97 181)
[elderly people] c. 1999* (Photo00 124)
[interior of hair salon] c. 1997* (Graphis97 164a)
[jumping in skates] c. 1995* (Graphis96 199)
[motorcycle near café sign] c. 1997* (Graphis97 134)
[motorcycle near motel sign] c. 1997* (Graphis97 133)
[nude on bed] c. 1999* (Photo00 119)
[self-promotional] c. 1990* (Graphis90 \227)
[toddler and teenager in party dresses] c. 1999 (Photo00 125)

ERLER, Glen
"Bob Mould" c. 1990* (Graphis90 \164)

ERNOULT, Alain
"Four-man bob at Olympic games in Calgary" c. 1991* (Graphis91 \359)
"Planes of the *Patrouille de France* carry out loopings" c. 1990* (Graphis90 \246)
"Two Fencers" c. 1991* (Graphis91 \364)

ERNST, Max, 1891-1976
"Loplop Introduces Members of the Surrealist Group" 1931 (Szarkowski 207)

ERWITT, Elliott, 1928-
"Alabama, U.S.A." 1974 (Rosenblum2 #677)
"Fontainebleau Hotel, Miami Beach" 1962 (MOMA 239; Szarkowski 248)
"New York" 1964 (MOMA 231)
"A Nudist Wedding" 1984 (Photography 202)

ESS, Barbara, 1948-
[from the *Food for the Moon* series] 1986* (Marien \7.40; Women \192)
"No Title" 1997-1998* (Photography 231)
"Untitled" 1988* (Women \193)

ESSICK, Peter
"City noises in West Harlem, accentuated by the rumble of a train, make the task of placing a phone call nearly impossible" 1991 (Best17 50a)
"During a Labor Day carnival in Brooklyn, two police officers are encouraged to participate in the festivities" 1991 (Best17 49)
"The Fulton Mall in Brooklyn serves a largely black clientele, but there are no black-owned businesses on the mall" 1991 (Best17 52)
"Japanese bowman keeps alive the samurai art of *yabusame*, or mounted archery" 1996* (Best22 197c)
"Jordana Guzman and Luis Camacho wait at the 125th Street station in Harlem for the subway to take them to school" 1991 (Best17 50b)
"Officers of the New York Recycling Police check for compliance with the recycling program in Harlem" 1991 (Best17 51b)
"This Siberian tiger, oblivious to the tram ride, lives at the St. Louis zoo" 1986 (Best12 180c)
"A Town is Born, Metcalfe, Mississippi " 1991 (Best17 45-48)
"Used hypodermic needles litter an abandoned lot in East Harlem frequented by heroin addicts" 1991 (Best17 51a)

ESSIEN, Mfon (Mmekutmfon)
"Amazon's New Clothes, No. 1" 1999 (Committed 92); "No. 2" 1999 (Committed 93)

ETKIN, Rick
[self-promotional] c. 1990* (Graphis90 \332)

ETTINGSHAUSEN, Andreas Ritter von, 1796-1878
"Section of Climatis" 1840* (Marien \2.11)

EUBANKS, Jonathan, 1927-
"Bobby Seale" 1969 (Willis \205)
"Eldridge Cleaver" 1969 (Willis \204)
[from *Black Panther* series] 1969 (Willis \206, \207)
"Kathleen Neal Cleaver with Black Panther party member and police officer" 1969 (Willis \203)
"Two children in the Panther Breakfast Program, Oakland" 1970 (Willis \202)

EUGENE, Frank, 1865-1936
"Adam and Eve" 1910 (Marien \4.10)
"Alfred Stieglitz" 1909 (Peterson #1)
"Arthur and Guinevere" 1899 (Photography1 \102)
"La Cigale" 1904 (Decade \1)
"Emmy and Kitty, Tutzing, Bavaria" 1907* (Rosenblum2 #350)
"Frank Eugene, Alfred Stieglitz, Heinrich Kühn, and Edward Steichen" 1907 (Rosenblum2 #408)
"Study" c. 1899 (Rosenblum2 #360)

EULITT, David
"Bicyclists streak around a turn in the Mayor's Cup International Bike Race in Indianapolis" 1987 (Best13 206a)
"Kansas State University fullback comes down hard on the head of Missouri safety who made the tackle on a short gain" 1987 (Best13 207)
"Peeking through the banners to see a track and field event" 1987 (Best13 224d)
"Spectators lean over a retaining wall to congratulate the gold medal ride of the U.S. team pursuit cycling team at Pan-American games" 1987 (Best13 202d)
"Teammates celebrate second place finish in National

EVERGON
"Centaur Teaching the Young Hercules to use the Bow and Arrow" c. 1990* (Graphis90 \130)

EVERITT, David
[from series *Thomas' Dollhouse*] c. 1995* (Graphis96 173)

EWEN, Mike
"80-year-old had a dream that finally came true, that her dilapidated home was to be demolished and a new home built for her" 1987 (Best13 110c)
"[Mother and daughter] comfort each other after seeing the damage Hurricane Elena caused the home" 1985 (Best11 69a)

EXLEY, Jonathan
[neon signs in Paris] c. 1995* (Graphis96 160)

EXNER, Frank
"A contemporary tile oven designed by Manfred Lang" c. 1989* (Graphis89 \215)

EYERMAN, J. R.
"Premiere of *Bwana Devil*, Paramount Theater, Hollywood" 1952 (Life 113)

EYESTONE, Allen
"The president-elect relaxes in the surf in Gulfstream, Fla., after the election" 1988 (Best14 90d)
"220-yard dash for ages 65-69" 1985 (Best11 221c)

EYNARD-LULLIN, Jean-Gabriel, 1775-1863
"Panorama of Geneva" c. 1850* (Art \18)

—F—

FAAS, Horst, 1933-
"The dirty, nasty war in Vietnam" 1964 (Eyes #304)
"A Stillness–Then Shock, Pain, and Hysterical Wonder" 1965 (Eyes #303)
"Torture in Dacca" 1971 (Capture 77; Eyes #363)
"Vietnam–Crime and Punishment" 1964 (Capture 54)

FACIO, Sara, 1932-
"Untitled" c. 1976 (Marien \6.7)
"Women of Bolivia" n.d. (Rosenblum \193)

FADELY, Chuck
"Blessing" 1995 (Best21 228a)
"Blue Man" 1995* (Best21 228d)
"Cooling off in summer heat, kids illegally dive from a Miami-area pier" 1995* (Best21 front cover)
"Ellistine Gaines grieves for her grandfather, killed by Miami police in a fusillade of bullets during a drug raid" 1996* (Best22 154b)
"Groundbreaking" 1995* (Best21 229a)
"Michael Laughlin Jr. is trapped in his car after crashing" 1996* (Best22 204a)
"Mother's Grief" 1995* (Best21 229d)

FALK, Harvey A., 1903-1983
"World of Today" c. 1940 (Peterson #29)

FALKENTHAL, Achim
[bananas] c. 1995* (Graphis96 99)

FALLAI, Aldo
[taken in Africa for an article on men's fashions] c. 1989 (Graphis89 \22)

FALTNER, Meinrad
[Haas building, Vienna] c. 1992* (Graphis93 186)

FANDEL, Gary
"Back pain problems get graphic" 1985* (Best11 145d)

FARBMAN, Nat R.
"Bushmen children" 1947 (Lacayo 92)
"Independence Day" 1954* (Life 70)

FARDON, George, 1806-1886
"Kearny St., San Francisco" 1856 (Photography1 \37)

FARKAS, Antal
[medical capsules] c. 1990* (Graphis90 \295)

FARLOW, Melissa
"American alligator in the Okefenokee National Wildlife Refuge in Georgia" 1992* (Best18 218a)
"Expressing herself, a sousaphone player makes music at the Burning Man Festival in Nevada's Black Rock Desert" 2001* (Through 350)
"Home health care on Stinking Creek" 1987 (Best13 152-153)
"The metamorphosis of Wendy Fraser" 1987 (Best13 144-148)
"A potential suicide changes her mind after jumping into the icy waters of the Allegheny River in Pittsburgh" 1986 (Best12 38)
"Sleep disorder clinic" 1987 (Best13 158-159)

FARNSWORTH, Emma J., 1860-1952
"Diana" 1898 (Sandler 58a)
"A Muse" n.d. (Rosenblum \98)

FARRELL, Patrick
"A young Haitian refugee jumps the wire fence surrounding a tent city in Guantanamo Bay, Cuba" 1991* (Best17 110a)

FASSBENDER, Adolf, 1884-1980
"City, Thy Name is Blessed" 1934 (Peterson #90)
"Daisy Trail" 1938 (Peterson #6)
"Dynamic Symbol, New York World's Fair" 1939 (Peterson #24)

FAUCON, Bernard
"Flying Papers" c. 1990* (Graphis90 \154; Marien \7.66)

FAUL, Jan
"Henry Hill, Manassas" c. 1999* (Photo00 88d)
"Marching order for Antietam" c. 1999* (Photo00 88b)
"Table Rock, Gettysburg" c. 1999* (Photo00 88a)

FAULKNER, Colin
[promotional project for a paper company] c. 1995* (Graphis96 74, 75)
[untitled] c. 1995* (Graphis96 106, 107)

FAURER, Louis, 1916-
"Bingo skirt for four players" 1953 (Life 112)
"George Barrows in Robert Frank's Loft" 1947 (MOMA 207)
"Untitled" 1950 (MOMA 221)
[Robert and Mary Frank] c. 1948 (MOMA 22)

FAWUNDU, Delphine A., 1971-
"Assata Shakur in political exile in Cuba" 1998 (Willis \378)
[from South Africa series] 1995 (Willis \379)
"I Am Seven Months Pregnant" 1997 (Committed 94)
"Patiently Waiting" 1995 (Committed 95)

FAYEMI, Alfred Olusegun
"Niger (boys swimming in river)" 1995 (Willis \335)
"Senegal (women dancing)" 1993 (Willis \334)

FEARING, Jeffrey John, 1949-
"Million Man March, Washington, D.C." 1995 (Willis \554)
"Snow, Rock Creek Park, Washington, D.C." 1989 (Willis \552)
"Untitled, Big Sur, California" 1984 (Willis \553)

FEARY, Dwan
"Brenda Young and her son are one of 424 families that received lease terminations for their Lafayette Shores apartment" 1987 (Best13 44)
"Kootenai Indian tribe member raises his Bald Eagle staff while singing traditional songs during a celebration of Hellgate treaty" 1987 (Best13 111b)

FEFERBERG, Eric
"Jews in Jerusalem's Old City are confronted by a new reality following an accord between Israel and the PLO" 1993* (Best19 121a)

FEHLING, Ron
"Honey" c. 1992* (Graphis93 136)

FEIG, Bill
"Liberty" 1987 (Best13 72d)

FEIN, Nathaniel
"Babe Ruth Retires No. 3" or "Babe Ruth Bows Out" 1948 (Capture 22; Goldberg 81)

FEININGER, Andreas, 1906-1999
"Burlesque in New York" c. 1941 (Decade \55)
"Chicago Grain Elevator on Cermak Road" 1941 (Decade 49d)
"Hudson River Waterfront" 1942 (Icons 87)
"The Photojournalist" 1955 (Rosenblum2 #616)

FEININGER, T. Lux, 1910-
"Charleston on Bauhaus Roof" 1927 (Hambourg \72)
"Clemens Röseler" c. 1928 (Hambourg \55; Rosenblum2 #510)
"Eurythmy, or Jump Over the Bauhaus" 1927 (Waking #189)

FEIST, Werner, 1909-
"Electrola" 1930 (Hambourg 66c)

FELLMAN, Sandi, 1952-
"Horiyoshi III and His Son" 1984* (Rosenblum \33)
[untitled] c. 1999* (Photo00 35)

FELTUS, H. Ross
[children play dress-up] c. 1991* (Graphis92 \25, \26)
[Japanese children in paper hats] c. 1991* (Graphis92 \24)

FENDER, Mike
"Greg Foster and Mark McCoy tangled in the 60-meter hurdles final" 1987 (Best13 209)

FENNAR, Albert R., 1938-
"Chet Cole's Farm" 1969 (Committed 97)
"Jersey Shore" 1975 (Committed 96)

FENTON, Roger, 1819-1869
"British officer at ease in Crimea" 1855 (Lacayo 11)
"Cloud Study" 1859 (Art \100)
"Col. Doherty, officers and men, 13th Light Dragoon" c. 1856 (Eyes #14)
"Dinornis Elephantopus" c. 1858 (Szarkowski 78)
"Dome of the Cathedral of the Assumption in the Kremlin, Moscow" 1852 (Waking #79)
"External Walls of the Kremlin" 1852 (Art \97)
"The Genoese fort at the entrance to Balaclava Harbour" 1855 (Eyes #16)
"Harbour of Balaklava, Cattle Pier" 1855 (Art \18)
"Harewood House from the Lake" 1860 (Art \104)
"Interior, Salisbury Cathedral" c. 1858 (Waking #36)
"Into the valley of the shadow of death" 1855 (Eyes #15)
"The Keeper's Rest, Ribbleside" 1858 (Art \105)
"Lambeth Palace" 1857 (Waking 272)
"Landing Place, Railway Stores, Balaclava" 1855 (Waking 302b)
"Lichfield Cathedral: Portal of the South Transept" 1858 (Art \107)
"The Long Walk, Windsor" 1860 (Art \101)
"Lt. Col. Hallewell–28th Regiment–His Day's Work Over" 1855 (Rosenblum2 #201)
"Odalisque" 1858 (Art \109)
"Pont y Garth near Capel Curig" 1858 (Art \102)
"Rievaulx Abbey" 1854 (Waking #13)
"Rosslyn Chapel, South Porch" 1856 (Waking #270d)
"The Royal Family in Buckingham Palace Garden" 1854 (Marien \3.7)
"Salisbury Cathedral Spire" c. 1860 (Szarkowski 114)
"Sebastopol from Cathcart's Hill" 1855 (Szarkowski 106; Waking 302c)
"Still Life with Fruit" 1860 (Art \111; Rosenblum2 #260; Waking #27)
"Still Life with Statue" (Art \110)
"Terrace and Park, Harewood House" 1861 (Rosenblum2 #120)
"Untitled" 1858 (Art \108)
"The Valley of the Shadow of Death" 1855 (Art \99; Rosenblum2 #203)
"View in the Slopes, Windsor" 1860 (Art \103)
"Vista, Furness Abbey" 1860 (Art \106)
"The Wharfe and Pool Below the Stride" 1854-1858 (Waking #8)

FERNANDEZ, Benedict J.
"Union Square, New York" 1967 (Eyes #310)

FERNIQUE, Albert
"Construction of the Statue of Liberty, Workshop View, Paris" c. 1880 (Rosenblum2 #180)

FERORELLI, Enrico
"Aerobics class at the Snowbird Ski Resort, Little Cottonwood Canyon, Utah" 1981* (Life 119)
"Caspar Weinberger" c. 1987* (Graphis89 \250)
"Dolly Parton" 1986* (Life 177b)
"George Schultz" c. 1987* (Graphis89 \249)
"Oliver North" c. 1987* (Graphis89 \251)

FERRARO, Peter
[self-promotional] c. 1990* (Graphis90 \204)

FERRATO, Donna, 1949-
"Battered women and their abusers" 1982-1990
(Best16 22-26; Best14 162-167)
"Battered women and their children seek refuge at the
Women's Advocates Shelter in St. Paul, Minn."
1988 (Best16 21)
"Darkness at home" 1981-1982* (Best16 13-20)
"Eve finds her g-spot" 2000 (Photography 218b)
[from *Living with the Enemy*] 1991 (Marien \7.15)
"I hit you with the pot to make you stop hitting her. I
hate you!" 1988 (Best14 82)
"Imprisoned battered women" 1990 (Best16 26)
"Jackie—in the hospital" 1984 (Rosenblum \202;
Rosenblum2 #695)
"Katherine Cronin, Lakewood, Ohio" 2001
(Photography 218a)
"Policeman answering domestic abuse call" 1987
(Eyes #340)
"Rita, 25, two days after her nose was broken" 1987
(Eyes #339)
"Stabbed with a butcher knife by her boyfriend during
a family quarrel" 1987 (Eyes #342)
"Young mother and baby son, first night in the
shelter, Philadelphia" 1986 (Eyes #341)

FERREZ, Marc
"Rocks at Itapuco" 1870 (Rosenblum2 #142)

FERRI, Fabrizio
"Global beauty calendar" c. 1989 (Graphis91 \4-\6)
"Sarong" c. 1991* (Graphis91 \26)

FERRI, Mark
"The Boxer" c. 1991 (Graphis91 \360)

FERRO, Ricardo J.
"Hurricane Gilbert pushed a Cuban fishing ship
against a hotel in Cancun, Mexico, despite its two
anchors" 1988 (Best14 11d)
"This baby opossum cools off in a St. Petersburg
animal shelter" 1985 (Best11 178d)

FERRON, Karl Merton
"Emotions of the moment show on Cal Ripken's face
during the 22-minute ovation after he had surpassed
Lou Gehrig's consecutive games streak of 2,130"
1995* (Best21 114b)
"Yankee fan competes with Orioles outfielder for
catch in the ALCS championship" 1996* (Best22
198b)

FÉVRIER, Christian
"Eric Tabarly's yacht, Côte d'Or, close to an
enormous iceberg" c. 1991* (Graphis91 \291)

FICHTER, Robert, 1939-
"Negative Figure and Moonscape" 1969*
(Photography2 122)
"Untitled" 1976 (Decade 93)

FIDKOWSKI, Judy
"Admirers of Chicago's first black mayor, Harold
Washington, wept over his death" 1987 (Best13
53b)

FIGHT, Greg
"A man grieves over the body of Dreama Combs who
died in a car crash" 1995* (Best21 177b)

FILA, Bob

"Edible Flowers" 1990* (Best16 139)
"Fresh Fish" 1998* (Best24 49)
"President Clinton, Hilary Rodham Clinton and other
VIPs celebrate at the Democratic National
Convention's festivities" 1996* (Best22 107a)

FILAN, Frank, 1905-1952
"Tarawa" 1943 (Capture 12; Eyes #222)

FILMER, Lady, c. 1840-1903
"Untitled" c. 1864* (Marien \3.104; Rosenblum \3;
Women \4)

FILO, John Paul, 1948-
"Kent State Massacre" or "After the massacre of
students at Kent State University" or "A God-
Awful Scream, Kent State University" 1970
(Capture 72; Eyes #311; Goldberg 180; Lacayo
145; Marien \6.73; Monk #43; Photos 129)

FINCH, Rob
"Grandmother of shooting victim mourns at prayer
vigil" 1998 (Best24 33c)

FINLAY, Colin H.
"Child Labor–Cairo" 1996 (Best22 230)

FINSLER, Hans, 1891-1972
"Bridge at Halle" c. 1929 (Rosenblum2 #539)
"Ceramic Tubing" c. 1930 (Rosenblum2 #513)
[Toothpaste and brush] c. 1930 (Marien \5.28; San
\15)

FIORIO, Giorgia
"Underwater commando training of the
Kampfschwimmerkompanie" 1999 (Photography
53)

FISCHER, Curt
"For cycling magazines" c. 1989* (Graphis89 \202)

FISCHER, Dirk
[elephant in its zoo house] c. 1991 (Graphis92 \228)

FISCHER, Richard
[on England's piers] c. 1990* (Graphis90 \106)
[near the French city of Poitiers] c. 1992* (Graphis93
189)

FISCHER, Roland
[woman's face] c. 1992* (Graphis93 131)

FISCHLI, Peter, and WEISS, David
"Untitled" 1985* (Marien \7.51)

FISHER, Don
"The Behm family enjoys ice cream at a roadside
stand" 1985 (Best11 138)
"Chrysler chief Lee A. Iacocca" 1985 (Best11 162a)

FISHER, Gail
"Shelter on Stage" 1996* (Best22 80-97)

FISKE, George
"Upper Yosemite Falls & Ice Cone" c. 1878 (Decade
4)

FISLER, L. F.
"Selling Pears (Shanghai)" 1870s (Marien \3.35)

FITCH, Bob
"Black power" 1966 (Eyes #278)

FITZ, Grancel, 1894-1963
[advertisement for Isotta-Fraschini automobile] 1931
(Szarkowksi 188)
"Cellophane" 1928-1929 (MOMA 123)
"Oldsmobile" 1929 (Hambourg 35)

FITZGERALD, Christopher
"Boy ponders next move" 1985 (Best11 173d)
"A cat, named Beauty, looks through a screen
window" 1995 (Best21 154a)
"A house in Massachusetts was split in two so it
could be more easily moved to a new location"
1985 (Best11 158a)
"World War II navy veteran salutes during a
Memorial Day observance" 1993* (Best19 66a)

FITZGERALD, Ralph
"Convicted spy Arthur J. Walker leaves Norfolk, Va.,
Federal Courthouse" 1985 (Best11 123b)

FITZGIBBON, John H., 1816?-1882
"Kno-Shr, Kansas Chief" 1853* (Art \26; Waking
#87)

FITZMAURICE, Deanne
"Lala Lopez was one of hundreds who went to St.
Charles Catholic Church in San Francisco to pray
for relatives in Mexico City" 1985 (Best11 12d)
"Young woman gives up Western lifestyle to become
a nun and study Buddhism" 1998* (Best24 90a)

FLAHERTY, Frances Hubbard, c. 1886-1972
"Untitled" 1936 (Rosenblum \215)

FLAHERTY, Robert
"Portrait of Mother and Child, Ungava Peninsula"
1910-1912 (Rosenblum2 #197)

FLEISCHMANN, Trude, 1895-1990
"Portrait of Alban Berg" 1934 (Rosenblum \115)

FLEMING, Lucy, active 1860s
"Interior, Castle Hedington" c. 1864 (Women \5)

FLETCHER, Christine B., c. 1872-1961
"Muscats" c. 1934 (Peterson #65; Rosenblum \150)

FLICK, Robbert, 1939-
"Manhattan Beach, Looking West from Vista" 1980
(San \65)
"Solstice Canyon #8" 1982 (Decade \102)

FLOREA, Johnny
"Cologne, Germany" 1945 (Life 54b)
"Nordhausen, Germany" 1945 (Life 55)

FLORESCU, Viorel
"A uniformed police officer on the scene of an
election day massacre where 15 people were slain
while trying to vote" 1987* (Best13 18d)

FLOWERS, Adrian
[personal study] c. 1990* (Graphis90 \301)

FLOWERS, Joe, 1937-1996
"Negro owned (sign in window), Watts riot" 1965
(Willis \199)

"Police officer and burned store mannequin, Watts
riot, Los Angeles" 1965 (Willis \195)
"Police waving at National Guard, Watts riot" 1965
(Willis \196)
"Two Negroes Were Employed (sign in window),
Watts riot" 1965 (Willis \198)
"U.S. Army soldier talking with National Guard,
Watts riot" 1965 (Willis \197)

FLOYD, William Pryor
"Photographers' Studios, Hong Kong" c. 1870
(Marien \3.33)

FOBES, Natalie
"Exxon Valdez Clean Up" 1989* (Goldberg 207)
"A shoot on salmon eggs–part of a Pacific salmon
photo project–took an unexpected turn when the
eggs hatched into alevins" 1987* (Best13 95c)

FOGEL, Walter
[woman underwater] c. 1992* (Graphis93 121)

FOLBERG, Neil
"Scorpius Milky Way Rising" 1997 (Photography
180)

FOLEY, Bill, 1954-
"Angry Scene at Sabra" 1982 (Capture 122)
"Egyptian President Anwar Sadat speaks to Egyptian
Minister of Defense" 1981 (Eyes #352)

FONG, Gary
"Ironworker is center of attention" 1985 (Best11
142d)

FONTANA, Franco
"Landscape" 1975* (Rosenblum2 #775)

FONTANA, Roberto
"Scene in an Asylum" 1980 (Rosenblum2 #703)

FONTCUBERTA, Joan, 1955-
"Guillumeta Polymorpha" 1982 (Szarkowski 294)
Ich Danken Ihnen für die Rosen 1990* (Marien
\7.42)
Lavandula Angustifolia c. 1984 (Rosenblum2
#769)

FORBES, J. B.
"New clothing hangs from protruding reinforcing
rods in a building in Mexico City's garment
district" 1985* (Best11 10)
"Rescue workers carry an 8-day-old baby from the
rubble of Benito Juarez Hospital, five days after the
building was destroyed" 1985* (Best11 7)

FORD, James, 1827-c. 1877
"San Francisco, Corner of California and
Montgomery Streets" c. 1857 (National \9)

FORELLI, Chip
"Pebbles and Pool" c. 1995* (Graphis96 154)
"Three Rocks and an Island" c. 1995* (Graphis96
156b)
"Turbulence and Rocks" c. 1995* (Graphis96 156a)

FORENCICH, Sam
"Double play throw despite a rough slide" 1986
(Best12 209b)
"Firefighters battle a spreading grass fire in Palo

Alto, Calif." 1985 (Best11 98a)

FORMAN, Stanley J., 1945-
"Boston Fire" 1975 (Capture 95)
"Dorchester fire" 1986 (Best12 24-25)
"The Soiling of Old Glory" or "Anti-busing demonstration in Boston" 1976 (Capture 98; Eyes #309; Lacayo 128)

FORRESTER, James Joseph
"Peasants of the Alto Douro" 1856 (Rosenblum2 #422)

FORSTER, Daniel
"The *Merit* during training for the 'Whitebread Round the World Race'" c. 1990* (Graphis90 \241)
"Sailing, *Matador2*" c. 1999* (Photo00 195)
[schooner sailing past chalk cliffs, Isle of Wight, England] c. 1999* (Photo00 84)

FORSTERLING, Hermann
[nude] c. 1989* (Graphis89 \148)

FOSTER, Greg
"An afternoon storm clears in northern New Mexico" 1991* (Best17 70b)
"Travelers in Cameron, Ariz., consult a map" 1991* (Best17 67)

FOUCAULT, Léon
"Blood cells of a frog" 1843 (Goldberg 39)
"Microscopic Studies" 1845 (Marien \2.12)

FOURNIER, Collette, 1952-
"James Van Der Zee, NYC" 1979 (Committed 99)
"Man on a Harley Motorcycle, Buffalo" 1985 (Committed 98)
"Muslim Woman and Child, New Jersey" 1991 (Willis \367)
"Women of Rastafari, Jamaica" 1983 (Willis \366)
"Women of the Sunset Riders" 1985 (Willis \365)

FOURNIER, Frank
"The bodies of AIDS victims lie unclaimed at a hospital in Romania" 1990* (Best16 197b)
"A doctor from relief organization Doctors Without Borders works to save the arm of a child in Mogadishu, Somalia" 1991* (Best17 178)
"13-year-old died after 60 hours were spent in attempts to free her from the water-filled hole in which she was trapped" 1985* (Best11 14b)

FOWX, Egbert Guy, 1821-after 1883
"New York 7th Regiment Officers" c. 1863 (National \16)

FOX, Bill
"Running back loses more than yardage as he is hit by a tackle" 1986 (Best12 198d)

FOX, E.
"Spanish Chestnut in Summer" early 1860s (Szarkowski 80)
"Spanish Chestnut in Winter" early 1860s (Szarkowski 81)

FOX, Fred
"A volleyball net in the gym serves as a clothes line for Floridians whose homes were flooded or cut off by high water from Tampa Bay during Hurricane

Elena" 1985 (Best11 69d)

FOX, Lloyd
"Cal Ripken: 2,131" 1995* (Best21 133)
"Fighting back tears after losing the championship game in the Little League World Series" 1993* (Best19 151a)
"Navy boxers gather to celebrate a midshipmen friend's victory" 1995 (Best21 134a)

FRADELIZIO, Leonard
[advertising for hair care] c. 1990* (Graphis90 \25)

FRAHM, Klaus
"Still lifes with flowers" c. 1991* (Graphis91 \109-\111)

FRAJNDLICH, Abe
"French film director Louis Malle" c. 1989* (Graphis89 \143)
"Interior architect Putman, with a lamp created by the Italian Mariano Fortuny, that she rediscovered and reproduced" c. 1989* (Graphis89 \177)

FRAKES, Bill
"At the Monticello raceway in upstate New York a harness driver barely stays ahead of the second place horse" 1997* (Best23 170b)
"Australian rugby rover is slammed to the ground as he tries to score in Final" 1992* (Best18 162a)
"Basketball superstar Magic Johnson is surrounded by other athletes during the opening ceremonies of the Summer Olympics" 1992* (Best18 164b)
"Boston Red Sox slugger Ted Williams reflects on his life and career" 1996* (Best22 199c)
"Bye-bye, Ty!, Pete Rose photo essay" 1985 (Best11 194-199)
"Captain of the U.S. swim team wears a new 'fast mask' during a workout" 1998* (Best24 72a)
"Carl Lewis celebrates as he crosses the 100-meter finish line with the fastest time ever recorded" 1992* (Best18 139)
"Chinese diving champion Xi relaxes in a break in the XXV Summer Olympics" 1992* (Best18 161)
"Corey charms Kendra at a baseball game in Scottsbluff, Nebraska" 1990* (Best16 138)
"Dennis Rodman snags a rebound while Michael Jordan watches" 1996* (Best22 194d)
"Eric Wynalda, volatile top scorer for the U.S. soccer team, has raised his game" 1996* (Best22 205a)
"Former golfing world champion Betty Jamenison, now 80 and out of resources" 1996* (Best22 213b)
[from an essay on NFL players who weigh more than 325 pounds] 1995* (Best21 109a)
"Jose Marie Perec wins the 200 meters, completing an historic double sprint victory while the rest of the field struggles to place" 1996* (Best22 120d)
"Marion Jones, the world champion in the 100-meter dash, runs in the woods" 1998* (Best24 63)
"Nigerian runners exult in their third-place finish in the 100-meter relay at the Summer Olympics in Barcelona" 1992* (Best18 142d)
"Olympians practice in front of giant American flag" 1996* (Best22 203a)
"Olympic boxer Eric Griffin juggles while balancing on a railroad track as he returns home from a workout" 1992* (Best18 164a)
"Riders on the subway kept their enthusiasm under control when 'George Washington' rode with them on the Fourth of July" 1986 (Best12 136a)

"Thunder Gulch wins the 1995 Kentucky Derby"
1995* (Best21 126a)
"Trotter is taken back to a barn at a raceway after a
workout" 1996* (Best22 197a)
"2 men compete in the Yukon-Jack arm-wrestling
championship" 1992* (Best18 162d)
"U.S. divers at an international meet in the tandem
competition" 1995* (Best21 106a)
"University of Miami's Dawkins is cheered after a
Sugar Bowl win against the University of
Alabama" 1990* (Best16 136d)
"Warren Sapp celebrates his selection in the first
round of the NFL draft" 1995* (Best21 140d)
"With his country's flag as a backdrop, Olympic
diver Kent Ferguson practices at a pool" 1992*
(Best18 163)

FRAMPTON, Hollis, 1936-1984, and FALLER, Marion
"Apple Advancing" 1975 (Photography2 151)

FRANCIS, Jamie
"Richland County councilwoman drives through the
neighborhood" 1995 (Best21 145a)
"This South Carolina Life" 1998 (Best24 172-173)
"A world apart" 1993 (Best19 127-132)

FRANCIS, Omar, 1972-
"Untitled (Orange)" 1999* (Committed 100)
"Untitled (Red)" 1999* (Committed 101)

FRANCK, Martine
"Exhibition, Pompidou Center" 1977 (Photography
214)
"Provence" 1976 (Rosenblum2 #715)
"Sarah Moon in Paris Bistro" 1983 (Rosenblum \182)

FRANCO, Angel
"Juvenile handcuffed" 1986 (Eyes #336)

FRANK, Anne, 1929-1945
"Self-Portrait" 1939 (Monk #31)

FRANK, Robert, 1924-
"Beaufort, South Carolina" 1955 (Art \320)
"Butte, Montana" 1955 (Eyes #240)
"Canal Street, New Orleans" 1955 (Art \322)
"Charleston, South Carolina" 1955 (Art \321; Eyes
#239)
"City Fathers, Hoboken" 1955 (Decade 71; San \47)
"Drive-in Movie, Detroit" 1955 (Art \324)
"Drug Store, Detroit" 1955 (Marien \6.39)
"Fourth of July–Jay, New York" 1955 (Art \327;
Eyes #242)
"Los Angeles" 1955-1956 (MOMA 217)
"Metropolitan Life Insurance Building" 1955-1956
(Art \323)
"New York City" 1948 (Decade \54)
"Newburgh, New York" 1955-1956 (Decade 70)
"Parade, Hoboken, New Jersey" 1955 (Eyes #237;
MOMA 215; Szarkowski 258)
"Parade, Valencia" 1952 (MOMA 204)
"Political Rally, Chicago" c. 1955 (Rosenblum2
#672)
"Ranch Market, Hollywood" 1958 (Eyes #238; Monk
#37)
"Reno, Nevada" 1956 (MOMA 216)
"Street Line, New York" 1951 (MOMA 208)
"Trolley, New Orleans" c. 1955 (Rosenblum2 #671)
"U.S. 91, Leaving Blackfoot, Idaho" 1956 (Art \325)
"U.S. Number 61, Texas" 1955 (MOMA

frontispiece)
"View from Hotel Window, Butte, Montana" 1956
(Art \326)
"Yom Kippur–East River, NYC" 1955 (Eyes #241)

FRANK, Stephen, 1947-
"Untitled (Diane Arbus with her photo of a boy
holding a toy grenade in Central Park, New York)"
1970 (Marien \6.48)

FRANKLIN, Jack T., 1922-
"Civil rights leaders and celebrities join Rosa Parks
as she addresses demonstrators in Montgomery,
Alabama" 1965 (Willis \171)
"Coretta Scott King and C. Delores Tucker, left of
Dr. Martin Luther King, Jr. with other marchers at
Selma to Montgomery March" 1963 (Willis \172)
"James Baldwin and Julie and Harry Belafonte at the
March on Washington" 1963 (Willis \170)
"Judge Herbert Mullen, Roy Wilkins, and Cecil
Moore" 1965 (Willis \173)

FRANKLIN, Michael P.
"Champagne jumps out of the glass" 1985* (Best11
148a)

FRANKLIN, Stuart
"Afternoon traffic in Buenos Aires streaks along the
world's widest street" 1994* (Through 302)
"Celebrants at the Festival of the Virgin of Guadalupe
in Mexico City mix traditional costumes and
Roman Catholic images" 1996* (Through 346)
"Lined up like loaves at a market, infants nearly fill a
countertop at a hospital washing station in
Shanghai, China" 1994* (Through 170)
"One man blocking a line of Chinese government
tanks" 1989* (Lacayo 165)
"Tiananmen Square, Beijing" 1989* (Life 162)
"With a kiss and a yellow balloon, a couple lightens
the mood at Oxford, while bowler-topped
'bulldogs' monitor security" 1995* (Through 120)
"With professional aplomb, a couple in Buenos Aires
performs the tango, the national dance of
Argentina" 1994* (Through 348)

FRANZ-MOORE, Paul
[for culinary festival] c. 1990* (Graphis90 \326)
"Homage to Uncle Floyd" c. 1989* (Graphis89 \303)
"Offerings" c. 1989* (Graphis89 \302)

FRAPRIE, Frank R., 1874-1951
"Warmth of the Winter Sun" 1937 (Peterson #7)

FRARE, Therese
"Peta Church, who feels both the spirit of man and
woman inside relaxes in a cabin while visiting
Rosebud Indian Reservation in South Dakota"
1991 (Best17 82a)

FRASER, Mark
"On a slow day, barber stretches out in his favorite
chair for a snooze" 1987 (Best13 105)

FRAZIER, Danny Wilcox
"High school cross country racers cry tears of joy"
1997* (Best23 175c)

FRAZIER, Elnoa, 1924-
"Elaine Williams, Houston" c. 1965 (Willis \209)

"Traveller's Boat at Ibrim" c. 1859 (Rosenblum2 #132)

FRITZ, Craig
"Washington, D.C., 'cityscape'" 1991* (Best17 71)

FROELICH, John
"Crew members lay reinforcing rods on a section of I-94 near Tomah, Wisconsin" 1986 (Best12 143d)

FROHMAN, Susanna
"A young tourist battles a gust of wind as he descends from the top of a lighthouse" 1997* (Best23 159c)

FROST, Robert
"Glenn Chapman helps his wife away after a fire in which their son died" 1943 (Best18 12)

FRUTH, Rowena, 1896-1983
"Unafraid" n.d. (Peterson #66)

FUCHS, Al
"Guest at Disneyland Hotel checks out the territory" 1985 (Best11 141a)

FUCHS, Christian
"Cowboy is stunned after being thrown by his bull at Rodeo Championships" 1997* (Best23 171d)

FUJII, Craig
"Two firefighters study the south flank of Yellowstone National Park's Storm Creek inferno after it jumped fire lines" 1988* (Best14 10c)

FUKASE, Masahisa
"Nayoro" 1977 (Photography 103)

FUKUDA, Frank
[Western Diamondback rattlesnake on man's feet] c. 1991* (Graphis92 \230)

FUKUDA, Nob
[fish, lemon and tableware] c. 1991* (Graphis92 17)
"Portfolio" c. 1991* (Graphis92 16a, \88, \89)
"Record jacket for Mar-Pa" 1991* (Graphis92 16b)
[traditional Japanese Temple in Kyoto] c. 1992* (Graphis93 154)

FUKUHARA, Roso, 1892-1946
"Sangaatsudo" c. 1915 (Marien \6.23)

FUKUHARA, Shinzo, 1883-1948
"Light With Its Harmony 8: Pond" c. 1910 (Marien \6.22)

FULTON, Jack, 1939-
"Seams of the Passed" 1976* (Photography2 127)

FUNKE, Jaromír, 1896-1945
"Untitled" c. 1927 (San #27, \7)

FURMAN, Michael
[bicycle gears and spokes] c. 1992* (Graphis93 146)
[classic cars] c. 1995* (Graphis96 148)
"Details of old cars" c. 1991* (Graphis91 \264-\270)
[Porsche 917K and Porsche 718 RSK] c. 1992* (Graphis93 162a, 163)

FURST, Peter H.
"Karin with Blossom" c. 1990 (Graphis90 \17)

FUSCO, Paul
"Mud-moshing" 1994* (Life 120)

FUSS, Adam
"Love" 1992* (Rosenblum2 #750)
"My Ghost" 1999* (Photography 236)
"Wish" 1992 (Marien \7.41)

FUTASHIMA, Junji
[swimmer] c. 1992* (Graphis93 106b, 106d)

—G—

GADBERY, Brian
"Agular and three Forcaderos find protection from the bull behind a barrier during Portuguese-style bloodless bullfighting in California" 1988 (Best14 127)

GAHR, David
"Bob Dylan" 1963 (Life 170b)
"Janis Joplin at Newport Folk Festival" 1968 (Life 172)

GAILLARD, Didier
[hand-colored series] c. 1990* (Graphis90 \307)
[personal work] c. 1991* (Graphis91 \120-\123)

GALANTE, Jim
[personal study] c. 1991* (Graphis91 \202)

GALELLA, Ron
"Jackie O Contact Sheet" 1972 (Goldberg 182)

GALL, Sandy
"Swimsuits influenced by the styles of the Thirties" c. 1991 (Graphis91 \18)

GALLACHER, Michael
"Exxon employee climbs a 630,000-gallon storage tank to retrieve a sample of the gasoline within" 1985 (Best11 141d)

GALLAGHER, Barrett, 1913-
"Firefighters of the U.S.S. Intrepid battling blazes caused by kamikaze hit during the battle for Leyte Gulf" 1944 (Eyes #220)

GALLAGHER, William M.
"Adlai Bares His Sole" 1952 (Capture 30)

GALLANT, Marc
"Farmer Norman Brown searches for day-old piglets during flooding" 1993* (Best19 187b)

GALLARDO, Alexander
"Los Angeles Rams Coach John Robinson looks to the heavens for help in a game against the Green Bay Packers" 1985 (Best11 230d)

GALLO
"Michael Arlen" 1925 (Vanity 116)

GALUP, Amélie, 1856-1943
"Bal Champétre" 1898 (Rosenblum \105)

GAMBLE, David
"American Jazz singer Elizabeth Welch" c. 1991 (Graphis92 \149)

GAMERTSFELDER, Chip
"Edward A. Cottingham in a contemplative posture in his office" 1986 (Best12 122a)

GANAWAY, King Daniel, 1883-?
"The Gardner's Cart" c. 1924 (Willis \71)
"The Spirit of Transportation" c. 1924 (Willis \70)

GANTER, J. Carl
"Playing on a monument [of Daniel Boone] at Fort Harrod State Park" 1985 (Best11 174d)

GAPS, John, III
"Nicaragua" 1985 (Best11 119)

GARBER, Ira
"Antique fishing equipment" c. 1991* (Graphis91 \101)

GARCIA, Esteban
"First Battalion April 24 in the Trenches of Tuyuty" 1866 (Marien \3.23)

GARCIA, Eugene
"A frenzied circle forms around the basketball" 1996* (Best22 194b)
"A sky-typed heart floats over the Angelus Temple for gang shooting victim" 1995* (Best21 156c)

GARCÍA, Héctor, 1923-
"Campesino Covered with a Leaf" 1965 (Marien \6.9)

GARCIA RODERO, Cristina, 1949-
"Pilgrimage from Lumbier, Spain" 1980 (Rosenblum \213; Rosenblum2 #713)

GARDIN, Gianni Berengo
"Milano, servizio fotografico, pausa di lavoro" 1987 (Photography 42)

GARDNER, Alexander, 1821-1882
"Abraham Lincoln" 1865 (Art \65; Rosenblum2 #68)
"Abraham Lincoln and his Son Thomas (Tad)" 1865 (Art \64)
"Antietam Battlefield" 1862 (Waking #106)
"Burnside Bridge, Across Antietam Creek" 1862 (National 128c)
"Commissioner, General Sherman among them, seated with Indians" 1868 (Marien \3.66)
"Confederate Dead Gathered for Burial" 1862 (Photography1 #IV-14)
"A Contrast: Federal buried, Confederate unburied where they fell, on the battlefield of Antietam" 1862 (Eyes #20)
"Edward Spangler, a Conspirator" 1865 (Rosenblum2 #228)
"General John F. Hartranft and Staff, Responsible for Securing Conspirators" 1865 (Rosenblum2 #232)
"George A. Atzerodt, a Conspirator" 1865 (Rosenblum2 #230)
"Grand Army Review, Washington, D.C." 1865 (Waking 321)
"Hanging the Lincoln conspirators" 1865 (Eyes #33-35; Marien \3.22; Rosenblum2 #233-#239; Waking #113)
"Home of a rebel sharpshooter" 1863 (Eyes #31; Lacayo 14; Marien \3.21)
"Incidents of the War. Unfit for service at the battle of Gettysburg" 1863 (Eyes #25)
"Lewis Paine" 1865 (Rosenblum2 #231; Waking #112)
"Lincoln reading his Second Inaugural Address" 1865 (Art \66)
"Mr. Wilkeson" c. 1859 (National \12)
"The President (Abraham Lincoln) and General McClellan on the Battlefield of Antietam" 1862 (Photography1 \43)
"President Lincoln on battlefield of Antietam, October" 1862 (Eyes #18; Photography1 #IV-6)
"Railroad Commissioners at the State Line, Kansas" 1867 (Art \67)
"Red Cloud, Ogalalla Sioux" 1872 (Photography1 \58)
"Ruins of Richmond" 1865 (Lacayo 25b)
"Samuel Arnold, a Conspirator" 1865 (Rosenblum2 #229)
"Seal Rock" 1868 (Photography1 #III-19)
"Sharpshooter's last home" 1863 (Eyes #24; Lacayo 24a)
"Sho-E-Tat" 1872 (Photography1 #III-18)
"Westward, the Course of Empire Takes its Way" n.d. (Marien \3.52)
"Wilderness Battlefield" 1863 (Photography1 \5)

GARDNER, Susan
"The cryonics controversy: We have seen the future, and it is cold" 1988 (Best14 113)

GARDUÑO, Flor
"Owner of the Big Table" 1989 (Photography 204)

GARFINKEL, Mark
"After a high-school football game dedicated to 4 teammates who had died in a traffic accident, teammates share a moment" 1991 (Best17 151)

GARGASZ, Norma Jean
"A lone motorcyclist rides through the twilight on Mount Tamalpais" 1993* (Best19 76)

GARNER, Gretchen, 1939-
"Echo Pond Woods" 1990* (Rosenblum \24)

GARNETT, William A., 1916-
"Dry Wash with Alluvium, Death Valley, California" 1957 (MOMA 190)
"Two Trees on a Hill with Shadows, Paso Robles" 1947 (Rosenblum2 #668)

GARRISON, Brad
"Stunt pilot gets too close to the runway for crew members" 1995* (Best21 177a)

GARRISON, Ron
"Moira Laframboise and her steed part company during the Rolex Three-Day Event at Kentucky Horse Park" 1990* (Best16 120a)

GARVEY, Robert
"Untitled" c. 1990* (Graphis90 \127)

GASKELL, Anna
"Untitled #5 (wonder series)" 1996* (Photography 198)

GASKIN, Gerard H., 1966-
[from Walk in the Park] 1997 (Committed 104, 105)

GASKINS, Bill, 1953-
"Kenny, Proud Lady Beauty Show, Chicago, Illinois" 1994 (Committed 107; Willis \490)

"Nicole" 1993 (Willis \491)
"Stanley, Brommer Brothers Beauty Show" 1991 (Willis \492)
"Stylist's model, hairstyling competition" 1994 (Willis \408)
"Tamara and Tireka, Easter Sunday, Baltimore, Maryland" 1994 (Committed 106; Willis \493)

GAUNT, John L., Jr.
"Tragedy by the Sea" 1954 (Capture 34)

GAUTHIER, Robert
"Somalians eager for work peel through a large gate outside the Mogadishu port" 1992* (Best18 84)

GAUTREAU, Jean-Loup
"Spanish tennis player Sergei Bruguera rejoices in his French Open victory" 1993* (Best19 146)
"U.S. sprinter Gwen Torrence is jubilant after winning an Olympic gold medal in the 200-meter dash in Barcelona" 1992* (Best18 137)

GAY, C. H., active 1850s
"Panorama of New London, Connecticut" 1851 (Photography1 \34)

GAY, E. Jane
"Mother and Child" c. 1890 (Sandler 103)

GAY, Gerald H.
"Lull in the Battle" 1974 (Capture 90)

GAY, Stephanie
"Firefighters await the report of a fellow firefighter, who pokes his head through the roof after inspecting an attic fire" 1986 (Best12 79)

GAYLE, Rick
"Software brochures" c. 1989* (Graphis89 \218)

GAZ, Stan
"Fish and Chilies" 1993* (Best19 182a)

GEBHARD, Erwin
"Illustrate the texture of autumn shoe fashions" 1985* (Best11 149d)

GEHMAN, Raymond
"Ambassador Han Xu of China expresses his personal satisfaction with the election of George Bush while speaking at a university" 1988 (Best14 197a)
"An Australian shepherd awaits the next command from a cowboy during the farm's last roundup" 1988 (Best14 199d)
"Chrysler Museum Director David Steadman delights in an exhibit of Chinese robes" 1988 (Best14 197b)
"Flapping furiously, wild turkeys in Asheville, North Carolina, try to escape a net hurled over their heads" 1992* (Through 328)
"Jim DiNardo, 96, can still fit into the uniform he wore in World War I, where he fought in the Battle of Argonne Forest" 1988 (Best14 196)
"Karate enthusiasts brave the 45-degree waters of the Atlantic Ocean during a workout to improve strength and discipline" 1985 (Best11 144a)
"Operating-room nurses take a break in their lounge" 1988 (Best14 200d)
"P. D. Lambert rests against a barn on the farm in southwest Virginia where he was born and raised" 1988 (Best14 199a)

"A pass play is broken up during the annual Oyster Bowl between the Virginia Military Institute and The Citadel" 1988 (Best14 198)
"The president of Newport News Savings Bank leaves a hearing at which he was forced to resign" 1988 (Best14 201)
"Scrub nurse Mattie Davis remains at the doctor's side throughout the operation" 1988 (Best14 200a)
"Vanishing prairie dog" 1998* (Best24 35; 75b)

GEHR, Herbert
"Frank Sinatra singing" 1943 (Life 166b)

GEHRING, Karl
"Subdued spectators of the *Challenger* explosion leave the launch viewing area" 1986 (Best12 13a)

GEHRZ, Jim
"4-year-old finds the family pet has a mind of its own" 1985 (Best11 172a)
"A group of Mennonite women exchange uneasy glances with [African American men] on a street corner" 1996* (Best22 171a)

GEIGER, Ken
"Olympics in Barcelona" 1992* (Capture 167)

GEIGER, Michael
[still life with flowers] c. 1989* (Graphis89 \268-\274)

GEIL, Kevin G.
"Evelyn Higgins performs her own brand of levitation while cleaning window blinds" 1985 (Best11 147b)

GEISSLER, Claus Dieter
[self-promotional] c. 1990* (Graphis90 \213)

GELFAN, Lars
"A Vietnamese couple row a fishing boat in Halong Bay on the Gulf of Tonkin" 1993* (Best19 80d)

GEMELLI, Piero
"Elegance in technicolor" c. 1995* (Graphis96 42)
"Sheer swag" c. 1990* (Graphis90 \46)

GENSHEIMER, Jim
"Pillars and Clouds" 1990* (Best16 63)
"With victory almost in her grasp Aquino greets a crowd" 1986 (Best12 23a)

GENTHE, Arnold, 1869-1942
"Chinatown, San Francisco" 1896-1906 (MOMA 72)
"Eleanora Duse" 1924 (Vanity xviii)
"Elsie Ferguson" 1917 (Vanity 22)
"Greta Garbo" 1926 (Vanity xi)
"A Group of Russian Masters" 1923 (Vanity 54-55)
"Holiday Visit, Chinatown, San Francisco" c. 1897 (Photography1 \95)
"Ignace Jan Paderewski" 1918 (Vanity 19)
"John D. Rockefeller" 1919 (Vanity 2)
"Man and Girl in Chinatown" c. 1896 (Rosenblum2 #314)
"Maxine Elliott" 1917 (Vanity 13)
"Ruth St. Denis" 1928 (Vanity 94)
"The San Francisco Fire" 1906 (Rosenblum2 #586)
"Smoke and flames after San Francisco earthquake" 1906 (Eyes #65; Lacayo 38; Photos 15)
"William Butler Yeats" 1915 (Vanity 7)
"Woodrow Wilson" 1921 (Vanity xii)

1989 (Graphis89 \41, \42)

GIRAULT de PRANGEY, J. P.
"The Dome of the Rock and the Wailing Wall" c. 1850 (Marien \2.39)

GIROUX, Robert
"President Clinton finds the pigskin beyond his reach during a touch football game" 1993* (Best19 192a)

GIULIO, Anton
"The Smoker" 1913 (Rosenblum2 #490)

GLEATON, Tony, 1948-
"Black Girl, White Flowers, Belize, Central America" 1992 (Committed 108)
"Una Hija de Jesus (Daughter of Jesus), Guatemala, Latin America" 1992 (Committed 109)

GLEDHILL, Caroline Even, 1871-1935
"Portrait of Keith" 1917* (Rosenblum \4)

GLEIZES, Pierre
"Kidnapper Georges Courtois shoots at a crowd of journalists while running in Nantes, France" 1985 (Best11 79a)

GLENDELL, Paul
"A Guillemot seabird, covered with oil from the tanker Sea Empress oil spill" 1996* (Best22 191d)

GLENN, John
"CLICK–Photos of the XXVI Olympiad" 1996* (Best22 124a)

GLENTZER, Don
[advertising photograph] c. 1990* (Graphis90 \34)

GLINN, Burt
"Sammy Davis Jr. in New York City" 1959 (Lacayo 139c)

GLOEDEN, Wilhelm von, 1856-1931
"Nude Sicilian Youths" c. 1885 (Marien \4.27)
"Study, Taormina, Sicily" 1913 (Rosenblum2 #362)

GLOVER, L. S.
"In the Heart of the Copper Country, Calumet, Michigan" 1905 (MOMA 68-69; Szarkowski 320d)

GLUSGOLD, Andrej
[ad for underwear] c. 1995* (Graphis96 56)

GOEBEL, Robert
"Helping his grandchildren jump rope while he gets a jump on the news" 1987 (Best13 99)
"His wife was a deputy police officer" 1996* (Best22 151b)
"Two junior members of the Carson & Barnes Circus get all wound up in their act" 1985 (Best11 176c)

GOHLKE, Frank, 1942-
"Aerial View, Downed Forest Near Elk Rock, Approximately Ten Miles Northwest of Mount St. Helens, Washington" 1981 (Szarkowski 296)
[annual report] c. 1997* (Photo00 79)

GOLD, Arnold
"It took this crew eight weeks to dismantle a 1,250 ton hydraulic bending press" 1985 (Best11 139b)

GOLDBERG, Maurice
"Bette Davis" 1935 (Vanity 188)
"Maurice Valentino" 1923 (Vanity 92)
"Percy Grainger" 1917 (Vanity x)

GOLDBLATT, David
"The Colonial Mine with blue asbestos tailings, Wittenoom, Western Australia" 1999* (Photography 187a)
"The Settlement, Colonial Mine, Wittenoom, Western Australia" 1999* (Photography 187b)
"Untitled" 1989 (Marien \6.18)

GOLDEN, Judith, 1934-
[from the Self-Portrait Fantasy series #4, People Magazine] 1976-1978* (Photography2 190)
"Live It as a Blonde" 1975* (San \53)
"Plays it Hot" 1977* (Rosenblum \12)

GOLDIN, Nan, 1953-
"Brian on our bed with bars" 1983* (Photography2 229)
"Brian on the Phone, New York City" 1981* (Women \155)
"Cookie at Tin Pan Alley, New York City" 1983* (Women \156)
"Jimmy Paulette and Tabboo! In the bathroom, NYC" 1991* (Icons 195)
"Nan and Brian in bed, New York City" 1983* (Marien \7.69; Rosenblum \29)
"Patrick Fox and Teri Toye on their Wedding Night, New York City" 1987* (Women \154)
"Simon and Jessica, faces lit from behind, Paris" 2001* (Photography 92b)
"Simon and Jessica looking at each other with faces lit, Paris" 2001* (Photography 93b)
"Valerie in light, Bruno in dark, kitchen, Paris" 2001* (Photography 93a)
"Valerie on the stair in yellow light, Paris" 2001* (Photography 92a)

GOLDING, Craig
"The Grand Sumo" 1997* (Best23 216b)

GOLDSMITH, Lynn
"Bruce Springsteen" 1978 (Rolling #11)

GOLDSMITH, Scott
"Muhammad Ali gets a facial" 1985 (Best11 166d)
"A Vietnam veteran observes Memorial Day by visiting the graves of friends" 1986* (Best12 103b)

GOLDSTEIN, G. P.
"Lenin's Call to Arms" 1920 (Photos 36)

GOMEL, Bob
"Arthur Ashe" 1965 (Life 143c)

GONZALEZ, Eduardo
"Dazed survivor sits atop his house in Armero, waiting for the next Red Cross helicopter" 1985 (Best11 16d)

GONZALEZ, Miquel
[Barcelona, one year before the Olympic games] c. 1992* (Graphis93 182)

GONZALEZ, Rudolpho
"Columbine" 1999* (Capture 194)

GONZALEZ-TORRES, Felix
"Untitled (*Aparición*)" 1991 (Marien 2)

GOOD, Frank M.
"Philæ, near view [sic] Hypæthral Temple" c. 1870-1875 (Art #8)

GOODIN, Faith, 1970-
"Pretty Lady in a Black Dress" 1991 (Committed 110)
"Two Girls with Dolls" 1990 (Committed 111)

GOODMAN, Charles
"Edwin Natural Bridge, in San Juan County, Utah, rises nearly 100 feet and measures 194 feet long" 1910 (Through 298)

GOODMAN, John
"Men's fashion photographed on an old private airport" c. 1991* (Graphis91 \62, \63)

GOODRIDGE, Glenalvin J., 1829-1867
"Unidentified mortuary portrait" c. 1845 (Willis \17)
"Unidentified portrait of a woman with books" c. 1845 (Willis \19)
"Unidentified portrait of a woman with books and purse" c. 1845 (Willis \18)

GOODRIDGE BROTHERS (William, 1846-1890, Wallace, 1840-1922)
"Portrait of William and Wallace Goodridge" 1879 (Willis \15)
"Unidentified group portrait" c. 1880 (Willis \16)

GOODWIN, Elizabeth
[dark building] c. 1997* (Graphis97 165)

GORDANEER, Chris
"Curtis" c. 1999* (Photo00 194)
"Welder" c. 1999* (Photo00 110)

GORDON, Larry Dale
"Storm clouds over the state of Wyoming" c. 1987* (Graphis89 \64)

GORE, Bob, 1947-
"Abyssinian Baptist Church, Harlem, New York" 1990 (Willis \292)
[baptism] 1992 (Willis \293)
"Dr. Samuel D. Proctor signing books at the Abyssinian Baptist Church, Harlem" n.d. (Willis \295)
"Rev. Calvin O. Butts III with ministers" n.d. (Willis \294)

GORO, Fritz
"Atomic bomb test, Bikini" 1947 (Lacayo 122)

GOSHGARIAN, Robert
"Lock" c. 1999* (Photo00 219)

GOTTLIEB, Mark
"Nude" c. 1990* (Graphis90 \173)

GOUDE, Jean-Paul
"Farida" c. 1989* (Graphis89 \192)
"Grace Jones on the sleeve of her album 'Slave to the Rhythm'" c. 1989* (Graphis89 \165)

GOULD, Dan
"New England police officers, 5,000 strong, pay final tributes to slain patrolman who was killed in the line of duty" 1985 (Best11 83)

GOULDING, Michael
"They called him 'Night Stalker': Richard Ramirez, was charged with 14 slayings" 1985 (Best11 107)
"An underdog U.S. Olympic boxer David Reid leaps into the arms of his coach after a surprise knockout" 1996* (Best22 268)
"Volunteers help this 'winner' from the track" 1996* (Best 22 118c)

GOWIN, Emmet
"Edith, Danville, Virginia" 1967, 1971 (Decade 79a; Photography 45)
"Edith, Ruth, and Mae, Danville, Virginia" 1967 (Decade \82; Rosenblum2 #732)

GRAFF, Monika
"'Circle of Love' prom for mentally retarded students at Jersey City School" 1995* (Best21 184a)

GRAHAM, David
"Xina" 1994* (Photography 199)

GRAHAM, Lonnie, 1954-
"Gangaja Village, Papua New Guinea" 1997 (Willis \370)
"High school student" 1994 (Willis \368)
"Living in a Spirit House: Aunt Dora's Room" 1992* (Committed 112)
"Living in a Spirit House: The Artist's Studio" 1998* (Committed 113)
"Three Girls on a Road, Kenya" 1995 (Willis \369)

GRAHAM, Paul, 1956-
"Army Helicopter and Observation Post, Border Area, County Armagh" 1986* (Art \432)
"Army Stop and Search, Warrenpoint" 1986* (Art \434)
"Graffiti, Ballysillan Estate, Belfast" 1986* (Art \433)

GRALISH, Tom
"Philadelphia's Homeless" 1985 (Capture 139)

GRALL, George
"Anchored to twigs and grasses by their tails, tiny sea horses drift with the currents in waters off Australia" 1994* (Through 409)

GRAMES, Eberhard
"Coal carriers in Schwerin" c. 1991* (Graphis92 \125)
"Elderly residents of the Irish countryside" c. 1991 (Graphis91 16)
[from a series with dead birds, pelts, and blossoms] c. 1990* (Graphis90 \287-\290)
"Still life" c. 1991* (Graphis91 17)
"Still life from calendar" c. 1991* (Graphis91 \88-\91)
"Truck driver from Meissen" c. 1991* (Graphis92 \147)

GRANT, Allan
"Gregory Peck" 1957 (Life 84c)

GRANT, G. A.
"Thrill-seekers descend steep dunes at White Sands National Monument in N.M." 1935 (Through 352)

GRAUBARD, Robin
"Yechiel Bitton, 12, cowers near his father, Isaac, during violence directed at Hasidic Jews in Crown Heights section of New York" 1991 (Best17 112a)

GRAULICH, Richard
"Ray Mickens appears about to be beaned by a penalty flag as he goes down with Miami receiver" 1996* (Best22 202b)

GRAVERSON, Brad Alan
"Having problems dealing with his son's impending death, father took part in son's care, including shaving and showering him" 1987 (Best13 60c)
"Tabloid Trouble" 1993* (Best19 174a)

GRAY, Barry
"Foul weather doesn't stop avid reader as he waits for bus during a spring snowstorm" 1987 (Best13 125)

GRAY, Colin
[older couples] c. 1997* (Graphis97 122, 123)

GRAY, Todd, 1954-
"Free Passage" 1983 (Committed 115)
"History Repeating Itself" 1987 (Willis \495)
"Memory Sleeps" 1987 (Willis \496)
"Odysseus" 1983 (Willis \497)
"The Problem" 1987 (Willis \498)
"Untitled" 1982* (Committed 114)
"When Is Now?" 1987 (Willis \494)

GREEN, Christopher
[study of Summer and Winter at Craigville Beach on Cape Cod] c. 1991* (Graphis92 \203-\204)

GREEN, Richard D.
"Salinas police officer explains that it wasn't his fault his car hit a stolen truck head-on during a chase" 1990* (Best16 169)

GREEN-ARMYTAGE, Stephen
"Condition training on the mat" c. 1990* (Graphis90 \242)

GREENBERG, Steve
[yellow shoe] c. 1999* (Photo00 46)

GREENE, Bill
"After drinking all day, B. Chase passes out on his friend at her kitchen table" 1996* (Best22 163d)
"Arriving in a tuxedo for his middle school graduation" 1998 (Best24 111)
"Assembly members join hands in prayer after a meeting" 1998 (Best24 110b)
"Assembly member Jamison makes his Monday morning rounds to see if he can help anyone locked up over the weekend" 1998 (Best24 110a)
"At the Benedictine Monastery nuns use recreation time to go snowshoeing" 1996 (Best22 247d)
"Black Monday, October 19, the day the Dow Jones Industrials plunged 508.32 points" 1987 (Best13 15a)
"Bored with the proceedings inside the town hall, man doodles in the window" 1998 (Best24 107a)
"A Cambodian girl stares beyond a barbed-wire fence surrounding the refugee camp where she lives in Thailand" 1987 (Best13 2)
"Cambodian refugees living along the Thailand-Cambodian border" 1987 (Best13 126, 127)
"A cooking pot doubles as a pen for this five-month-old child in Dhravi, the worst slum in Bombay, India" 1986 (Best12 68a)
"Couple suffer from emphysema" 1996 (Best22 165a)
"Dale Goyet wrestles with his son during a break in the action at the annual horseshoe competition" 1996 (Best22 247a)
"During July's testimony on the Iran-Contra affair, the face of Lt. Col. Oliver North shone from television sets across America" 1987 (Best13 7a)
"Fidel Castro greets the pope upon his arrival in Havana" 1998 (Best24 29d)
"The Great Flood of '93" 1993* (Best19 199-202)
"Haitian change–Tension mounts" 1986 (Best12 28-29)
"Hanging campaign poster in a cotton field" 1998 (Best24 109c)
"Hardly reminiscent of an old-timey Yule log, but a youngster on a tree farm brings out a Christmas tree to last-minute patrons" 1986 (Best12 146)
"A Hindu militant in the Punjab, under threat of death at the hands of Sikhs, poses with his rifle and his grandson" 1986 (Best12 66c)
"His umbrella a victim of the wind, a pedestrian braves the elements in downtown Boston" 1987 (Best13 129d)
"Kids were re-enacting an average 1924 school day as part of a history unit" 1998 (Best24 107b)
"Maria and Alberto Gomes arrive on the scene of a fatal fire which claimed the lives of their two grandsons" 1996* (Best22 246d)
"Myron Skinner stands outside his home" 1996 (Best22 247b)
"New England Patriot jams a football through a basketball net before the start of a mini-camp" 1998 (Best 24 106)
"New York Mets rookie Mookie Wilson runs for third base during a World Series game against the Red Sox in Fenway Park" 1986 (Best12 212)
"One of a handful of attendance officers lectures a young girl at her home about why she was not in school" 1995 (Best21 189d)
"Petsitter untangles herself during her daily walk with her clients' dogs" 1998 (Best24 41b)
"Playing during recess at the Star School" 1996 (Best22 247c)
"Pope John Paul II is greeted by thousands who line the streets as he arrives in the 'Popemobile' in Cuba" 1998 (Best24 29c)
"Protestors smash store windows in riots that led to Duvalier's flight from country" 1986 (Best14 27b)
"Receiving the spirit of the Lord at a church altar, a worshipper falls to his knees" 1987 (Best13 128a)
"Rico Harvey bathes in an old washtub, with stove-heated water inside the three-room house" 1998 (Best24 109a)
"Security guard watches as garden club member works on her floral interpretation" 1996* (Best22 246b)
"Selling the Farm" 1998 (Best24 112-115)
"7-year-old on probation for stealing cigarettes" 1996* (Best22 162a)
"Slave ancestors are buried in a plot outside of his front door" 1998 (Best24 108a)
"SWAT team in the five-man tag team event during

the SWAT challenge" 1996* (Best22 246c)
"Three die-hard fans stay dry during an NFL
replacement game at Sullivan Stadium in Foxboro,
Mass." 1987 (Best13 128d)
"Tina Mayer stares out her apartment window at Fort
Devens" 1996* (Best22 246a)
"12-year-old watches the Lynn Mad Dog's game
from cheap seats behind right field" 1996* (Best22
198a)
"Two Hmong children, a brother and a sister, pose
inside Phanat Nikom refugee camp near Bangkok,
Thailand" 1987 (Best13 129c)
"Woman watches over her husband who had his foot
amputated after getting gangrene" 1998 (Best24
108d)
"A woman walks through new-fallen snow at
Boston's City Hall Plaza" 1986 (Best12 146d)
"The woman who feeds the dogs at an animal shelter
has no doubt she's appreciated" 1986 (Best12 134)
"A young boy receives some help reading the
Bible from his mother inside Grace Community
Church" 1987 (Best13 128b)

GREENE, Bob, 1935-
"Papua New Guinea" 1994* (Committed 116, 117)

GREENE, Herb
"The Grateful Dead" 1969 (Rolling #4)

GREENE, Jeff
"A bright sunny day, a good book, and a good
window to take advantage of" 1985 (Best11 170c)
"The Palm Beach County Sheriff's Organized Crime
Bureau raid the A-About-Town escort service"
1990 (Best16 112b)
"Worker cleans snow from fire escape" 1985 (Best11
140a)

GREENE, John Beasley, active 1832-1856
"Ancient Ruin, North Africa" 1855-1856
(Szarkowski 45)
"The Banks of the Nile at Thebes"1854 (Marien
\2.41)
"Dakkeh" 1853-1854 (Waking #68)
"The Nile" 1853-1854 (Waking #67)

GREENE, Milton
"Faye Dunaway" 1968* (Life 89b)

GREENE, Stanley
"What Happened to Fred Cuny?" 1996 (Best22 237b)

GREENFIELD, Lauren
"Amy, 17, a model, before a photo shoot for her
portfolio" 1995* (Best21 83a)
"Ashleigh, 13, talks to her friends on the phone from
her Santa Monica bedroom" 1995* (Best21 78)
"Ashleigh, 13, weighs herself in the bathroom on the
day of her Bat Mitzvah" 1985* (Best21 88a)
"Aspiring models in exercise class" 1999* (Best21
91c)
"Beverly Hills High School Senior Beach Day"
1995* (Best21 92a)
"Emily, 10, at the Peninsula Hotel, where her family
and staff have been living in the presidential suite
for the past three months" 1995* (Best21 82)
"An extra in camouflage on the set of the low-budget
feature film Summer Camp" 1995* (Best21 95)
"Friends and family at a funeral for a teenage tagger
from Los Angeles suburbs" 1995* (Best21 87)

"G-MO counts money in a Calabasas mansion for the
music video of his rap single" 1995* (Best21 86b)
"Inhaling nitrous oxide from air freshener in restroom
during nutrition break at the Hollywood High
School for the Performing Arts" 1995* (Best21 84)
"Learning dance moves to rap music at a barbeque"
1995* (Best21 88b)
"Lindsay at a Fourth of July barbeque shortly after
her plastic surgery" 1995* (Best21 80b)
"Lindsay, 18, after her nose job, with a nurse showing
the doctor's photograph of Lindsay's preoperative
nose" 1995* (Best21 80a)
"Mara Wilson, the young star of Miracle on 34th
Street, waves to the photographers at the 1995
Academy Awards" 1995* (Best21 85)
"Matthew's real iguana and designer stuffed animals
in the bedroom he designed himself" 1995*
(Best21 90)
"Members of the tagging crew LCK (Loving Crime
Kings) spray paint their 'tags' on a bus in East Los
Angeles" 1995* (Best21 79)
"Mijanou, 17, and her brother Nick, 12, give away
their mother in the ceremony of their mother's
second wedding" 1995* (Best21 93a)
"Model search at Universal Studios" 1995* (Best21
91d)
"Models for a photo shoot" 1995* (Best21 92d)
"Ozzie, a 17-year-old rapper, with his 4-day-old baby
and her mother Chantal" 1995* (Best21 81)
"Paris pretends he's a rapper in his musician father's
home recording studio" 1995 (Best21 77)
"'Reckon' from the 'tag-banger' crew 'Kings with
style' displays his tattoos" 1995* (Best21 83d)
"Skyler, 7, in his parents' dressing room" 1994*
(Best21 89)
"Skyler, 7, plays ball in front of his Malibu home"
1995* (Best21 86a)
"Tag group Triple Threat sign their first television
contract" 1995* (Best21 93b)
"Todd gets his photo taken at Ari's Bar Mitzvah party
in Beverly Hills" 1995* (Best 21 76)

GREENFIELD, Lois, 1949-
"Untitled (Daniel Ezralow and David Parsons)" 1982
(Rosenblum 231)

GREENFIELD-SANDERS, Timothy
"Artists who use photography in their work and who
are not photographers" c. 1991* (Graphis92 \132)
"Honey, Karen Finley" 2001* (Photography 143)
"Portrait of William Wegman with Fay" c. 1991*
(Graphis92 \130)

GREENHOUSE, Pat
"5-year-old patiently waits for an autograph from a
Bangor Blue Ox player" 1996* (Best22 198d)

GREGORY, Herbert E.
"Visitors marvel at a chasm seen from atop 4,070-
foot Bald Mountain in south Queensland,
Australia" 1916 (Through 390)

GREUEL, Paulo
"Art and Fashion" c. 1992* (Graphis93 150)

GREWAL, Ranjit
[wings strapped on woman] c. 1992* (Graphis93 29)

GRIESDIECK, Judy
"Last of the Issei" 1986 (Best12 124-129)

"No place to die" 1986 (Best12 150-155)
"San Francisco attorney Melvin Belli relaxes with his
 menagerie" 1986 (Best12 130b)
"Spending the earlier part of their lives as strangers in
 a foreign land, living in the shadows of their
 husbands, this group of elderly Japanese immigrant
 women share a home" 1985 (Best11 139a)

GRIFFIN, C. W., 1953-
"Admiration" 1994* (Committed 119)
"Mealtime" 1994* (Committed 118)

GRIFFITH, Tim
[Tokyo Budokan] c. 1992* (Graphis93 188)

GRIFFITHS, Philip Jones, 1936-
"Captured Vietcong" 1970 (Eyes #295)
"Company of U.S. 9th Division pinned down in some
 houses in District 8, Saigon" 1968 (Eyes #294)
"Napalm victim" 1967 (Eyes #296; Marien \6.71)
"Twelve-year-old deformed child of victim of Agent
 Orange" 1995 (Photography 123a)
"Village children before one of many mounds of
 skulls in Cambodia" 1996 (Photography 123d)

GRIGORIAN, Eric
"Youth mis-diagnosed by doctors, his complications
 led to retardation" 1997 (Best23 182b)

GRINKER, Lori
"Child care specialists talk to six-year-old about his
 anger" 1995 (Best21 187d)

GROBET, Lourdes, 1940-
"Double Wrestling" c. 1980 (Rosenblum \188)
"Proposiciones" 1978 (Marien \6.10)

GROOVER, Jan, 1943-
"Untitled" 1975* (Szarkowski 268); 1977*
 (Photography2 153; Rosenblum \14); 1978*
 (Decade \IV; Photography 100); 1979*
 (Rosenblum2 #778); 1983 (Women \171, \172)
 1984 (Women \173); 1988* (Women \174)

GROPIUS, Walter, 1883-1969
"Flatiron Building, New York" 1928 (Hambourg \9)

GROS, Jean-Baptiste-Louis, 1793-1870
"Athens, the Acropolis" 1850* (Art \23)
"Bridge and Boats on the Thames" 1851
 (Rosenblum2 #9)
"Monument of Lysicrates, Athens" 1850* (Art \24)

GROSKINSKY, Henry
"Happy 100th, Brooklyn Bridge" 1983* (Life 76)

GROSS, Gad
"A statue of Lenin is taken down in Bucharest,
 Romania" 1990* (Best16 200)

GROSSFELD, Stan, 1951-
"Ahmad, a man in his 80s who cannot move, lies in a
 tomb" 1993 (Best19 57)
"At 2 years old, child's weight is equivalent to a
 healthy 9-month old" 1993 (Best19 53)
"Brian Brunner lost his job and lives with his family
 in a 1971 station wagon" 1993 (Best19 54a)
"Ella Mae Sale, on the Torreon Reservation in New
 Mexico, drinks water fetched from over two miles
 away" 1993 (Best19 54d)

"Ethiopian Famine" or "An Ethiopian mother
 comforts her son in a refugee camp" 1984 (Capture
 135; Eyes #347)
"Francesca Casillas, 74, almost blind and barely able
 to lift her arms, sits at the bedside of her adult
 daughter" 1993 (Best19 60)
"Francisco Bautista, 2, stands next to a nearly empty
 refrigerator" 1993 (Best19 55)
"Mexicans Cross Rio Grande" 1984 (Capture 136)
"Mother wipes snow off a memorial to her son and
 other victims of the Chernobyl nuclear accident"
 1993 (Best19 59)
"Palestinian children frightened by shelling are
 evacuated into trucks. Tripoli, Lebanon" 1983
 (Eyes #360)
"Phillip Lee, 72, suffers from a uranium-related lung
 disease" 1993 (Best19 56)
"Syzdykov lives downwind of the Semipalatinski test
 site in Kazakhstan" 1993 (Best19 58)
"War in Lebanon" 1983 (Capture 126)

GROSSMAN, G. Loie
"Taking advantage of an available lap in
 Philadelphia's Logan Circle" 1985 (Best11 174a)

GROSSMAN, Sid
"Coney Island" c. 1947 (Decade 51; Rosenblum2
 #463)
"Folksingers I–Sonny Terry" c. 1947 (Decade \50)
"Harlem, New York" 1939 (Decade 44a)

GROSVENOR, Gilbert H.
"Octave Chanute, a 19th century American aviation
 pioneer, designed the multi-winged Katydid glider"
 1907* (Through 476)

GROSZ, George, 1893-1959
"Life and Activity in the Universal City at Five Past
 Twelve" 1919 (Marien \5.11)

GROVE, Irene L.
[from "Doorways of Santo Domingo"] c. 1990*
 (Graphis90 \306)

GROW, Jason M.
"Brown Sugar" 1995* (Best21 147d)

GRUBER, Jack
"An Air Force C-5A Galaxy transport drops out of
 low clouds at the air show" 1990 (Best16 192d)
"Army Reserve Sgt. Vernon Beasley gets hit by
 'hostile' water-gun fire from a Flint Boy Scout"
 1990 (Best16 194)
"A driver turns his back on the sight of his fire-gutted
 recreational vehicle as firefighters extinguish the
 blaze" 1990 (Best16 192a)
"A Gannett Outdoors Co. employee does some
 legwork on a billboard" 1990 (Best16 192c)
"Joe Carpenter, 10, takes off his socks to ease the
 blisters on his feet after marching in Young Marine
 drills" 1990 (Best16 193a)
"Teenager after missing a putt that would have made
 her the winner of the division" 1990 (Best16 193d)
"Traylor shatters the glass after a monster dunk"
 1996* (Best22 194a)

GRUBMAN, Steve
[dog and pig] c. 1995* (Graphis96 188)
[elephant] c. 1995* (Graphis96 193)
[growling dog] c. 1995* (Graphis96 189)

GRUNDMANN, Bernd
"Untitled" c. 1989 (Graphis89 \240)

GRUNDY, William
"A Day's Shooting" c. 1857 (Rosenblum2 #270)

GRÜNEWALD, Axel
"The breaking up of a ship for usable parts" c. 1990*
(Graphis90 \101)
"Mujahideen in Afghanistan" 1988 (Graphis90 \253-
\256)

GSELL, M., active 1860s-1870s
"Angkor Wat, Cambodia" 1866 (Waking #85)

GUILLEMOT, Dominick
[Guess? Fall collection] c. 1991 (Graphis92 \27)

GUMINER, Yakov, 1896-1942
"1917" 1927 (Szarkowski 206)

GUNTERMAN, Mattie, 1872-1945
"Two Prospectors" early 1900s (Rosenblum \108)

GUPTA, Sunil
"Lodhi Gardens" 1988* (Marien \7.89)

GURFINKEL, Elli
"Boy reacts to a skimpy outfit worn by one of the
models in a fashion show" 1998 (Best24 36d)

GURNEY, Jeremiah, 1812-1895
"Henry Ward Beecher and Harriet Beecher Stowe" c.
1870 (Photography1 61d)

GURSKY, Andreas
"Bundestag, Bonn" 1998* (Marien \7.1)

GUSTUS, Camille
"Towards the Mirror" 1998* (Willis \460)
"Trimeditate" 1995* (Willis \461)

GUTMANN, John, 1905-
"Diver" 1936 (Hambourg \77)
"Elevator Garage, Chicago" 1936 (Decade \29;
Hambourg \17)
"Jitterbug, New Orleans" 1937 (MOMA 160)
"The Jump" 1939 (Rosenblum2 #669)
"Turning to Look" 1935 (Hambourg \57)

GUTTENFELDER, David
"'Cobra' rebels sit on a sofa set up near a roadblock
in Republic of Congo" 1997* (Best23 133)
"Fighters of the National Patriotic Front of Liberia
drag a wounded man off a front line street in
Monrovia during factional fighting for the capital"
1996* (Best22 150b)
"Hundreds of thousands of Rwandan refugees stream
toward their homeland after leaving a camp in
Zaire" 1996* (Best22 158c)
"Liberia in Turmoil" 1996* (Best22 234a,b)
"Young Rwandan refugee peers into a makeshift ring
assembled by former members of the Rwandan
boxing team at refugee camp" 1996* (Best22 203b)

GUTTMAN, Peter, 1954-
[from series *Nights to Remember*] c. 1997*
(Graphis97 164b)

GUZY, Carol
"Andrew's Legacy" 1992 (Best18 23-26)
"At an all-girls school in Nairobi, Kenyan students
are laughing between classes" 1996 (Best22 10)
"Blankenship, a 19-year-old prostitute with AIDS, is
sentenced to the Miami Women's Detention
Center" 1987 (Best13 58)
"Carnival time in Haiti affords the people the
opportunity to dress up" 1996 (Best22 10)
"Couple embraces the romance and sensuality of
Florence, Italy" 1997 (Best23 228b)
"Crisis in Haiti" 1994 (Capture 174)
"A Day of Brotherhood" 1995 (Best21 213a)
"During a funeral for victims of the Tonton Macoutes
in Haiti, suspected member of Macoutes is led from
mob intent on killing him" 1990 (Best16 11d)
"During the violent days before the election, a woman
prays in the main Port-au-Prince cathedral" 1987*
(Best13 21b)
"A dying woman lies amidst volcanic mud and
Armero's rubble" 1985 (Best11 17)
"Exodus–Rwandan Hutu refugees" 1996 (Best22 12-
17)
"First Communion, Little Haiti, Florida" 1987
(Best13 154)
"Fleeing Kosovo" 1999* (Capture 197a)
"Following radiation therapy, Bradley who has AIDS,
cries in a hospital chapel after reading the 23rd
Psalm, the passage he chose to have read at his
funeral" 1987 (Best13 121b)
"Haiti's new police" 1996 (Best22 22-23)
"Henchmen of deposed dictator Duvalier started
burning electoral offices, scattering ballots and
gunning down voters" 1987 (Best13 114)
"In the barn where he trained for fights, Muhammad
Ali reminisces" 1997 (Best23 229d)
"Legacy of Love" 1997 (Best23 201c)
"Married to Christ" 1995 (Best21 212a)
"Mission of Mercy" 1992 (Best18 16)
"Nguyen cries as she looks at the present her sister
bought for the family before she was kidnaped"
1996 (Best22 11a)
"Nomads" 1996 (Best22 24-27)
"Pallbearers carry Holala's special Mercedes-inspired
coffin through the streets" 1997 (Best23 228a)
"Pampered pooch" 1995 (Best21 212b)
"Peasant women weep when they arrive at the Marche
Soloman and discover the marketplace has burned
during the night" 1987 (Best13 22a)
"Policing Haiti: 'Demons'" 1995 (Best21 213)
"Political conventions" 1996 (Best22 20-21)
"Pro-communist demonstrator peers out from behind
flags during a demonstration against President
Yeltsin's reforms" 1992 (Best18 15)
"Residents at an insane asylum in Port-au-Prince,
Haiti, peer through openings in their padlocked
door" 1996 (Best22 11b)
"Russian Babushkas" 1992 (Best22 17-22)
"Rwandan Hutu refugees scramble to board a bus that
was transporting them to their home villages after
their long exodus home" 1996 (Best22 147b)
"A Somali man walks past Marine to get his ration of
wheat" 1992 (Best18 5)
"Street Justice" 1996 (Best22 18-19)
"Tbilisi, Soviet Georgia" 1992 (Best18 175-180)
"Ten-year-old lathers up for bath in courtyard of her
apartment in the Ivory Coast" 1997 (Best23 229c)
"Traditional birth attendant in Ethiopia sings praises
after a successful birth" 1997 (Best23 223c)
"Volcanic mudslide in Colombia" 1985 (Capture

140*, 141)
"A woman pleads for help from her roof after being stranded by floods, Bangladesh" 1988 (Best14 11c)
"World of His Own" 1997 (Best23 221)
"Young Kenyan girl, responsible for erasing the blackboard, plays with the chalk residue instead" 1996 (Best22 271c)

GWALTNEY, Bob
"81-year-old woman takes careful aim with a squirt gun" 1985 (Best11 136d)

GYORI, Antoine
"A Cemetery in Sarajevo" 1993* (Lacayo 179d)

—H—

HAACKE, Hans, 1936-
"The Safety Net (Proposal for Grand Central Station)" 1982* (Photography2 147)

HAAS, Ernst, 1921-1986
"New York" 1966 (Icons 100)
"Returning prisoner of war" 1945 or "Homecoming Prisoners, Vienna" 1947 (Eyes #196; Icons 101; Lacayo 117)

HAAS, Philip, active 1837-1863
"John Quincy Adams" c. 1843 (Photography1 #II-2)

HABERKERN, Richard
"Baby clear-nose skate has already gained its ability to camouflage itself" 1996* (Best22 190b)

HABIB, Dan
"Bill Clinton stands at the door of a plane and waves" 1992 (Best18 77)
"A brutal New Hampshire primary campaign catches up with Bill Clinton in a Manchester rest room" 1992 (Best18 75)
"Clinton Survives a Primary" 1992 (Best18 181-184)
"A gay teen sits on the bus to school alone" 1995* (Best21 189a)
"Tina lunges for Michael as their wedding reception begins" 1995* (Best21 162a)

HACKLEY, Colin
"A Florida State University football fan jumps from the goalpost" 1996* (Best22 202a)

HADEBE, Themba
"Police reservist points a gun at a young man who attempted to rob him" 1998* (Best24 31b)

HAEBERLE, Ronald, 1941-
"My Lai massacre scene" 1968 (Eyes #298; Goldberg 177; Marien \6.75)

HAFFER, Virna
"Butterfly wings" 1960s (Sandler 134)
"Into Limbo" 1960s (Sandler 171)
"New Sprouted Ferns" 1960s (Sandler 170)

HAFFEY, Sean M.
"Credit Card Privacy" 1995* (Best21 148d)
"With El Niño pounding the coastline of California, surfers got out their fastest boards to try to tame the 15-foot surf" 1998* (Best24 60a)

HAGEMEYER, Johan, 1884-1962
"Castles of Today" 1922 (Decade 21c)
"Modern American Lyric (Gasoline Station)" 1924 (Rosenblum2 #532)
"Pedestrians" 1921 (Decade \13)
"Utility Lines" 1928 (Hambourg \22)

HAGGINS, Robert L., 1922-
"Malcolm X" 1965 (Willis \186)
"Malcolm X greets Lewis Micheaux" c. 1960 (Willis \184)
"Malcolm X holding his daughter Qubilah, with daughter Attallah standing nearby at Rally" 1963 (Willis \185)
"Malcolm X speaking in front of Micheaux's National Memorial African Bookstore in Harlem" c. 1960 (Willis \183)
"Malcolm X with daughters Qubilah and Attallah at home in East Elmhurst, Queens" 1963 (Willis \187)
"Malcolm X with minister James Shabazz at Harlem rally" 1964 (Willis \182)
"Malcolm X with Muhammad Ali in Harlem after Ali's championship win" 1964 (Willis \180)
"Watching My Back!, ministers, and Nation of Islam members at Harlem rally" 1964 (Willis \181)

HAGIWARA, Brian
"Assignment was to show the how and why of exotic fruit and vegetables" 1985* (Best11 157b)
"Untitled" c. 1997 (Graphis97 93)

HAGLER, Erwin "Skeeter"
"The American Cowboy" 1979 (Capture 113)

HAHN, Betty, 1940-
"Botanical Layout (Peony)" 1979* (Decade \VII)
"Ultra Red and Infra Violet" 1967* (Photography2 123; Rosenblum \36)

HAHN, Walter
"Dresden Destroyed" 1945 (Photos 63)

HAIDAR
"Gunmen from Amal, Lebanon's Shiite Muslim militia killed him with assault rifles" 1986* (Best12 102)

HAILONG, Xie
"The Entire School, Nanyantou Village" 1992 (Rosenblum2 #724)

HAIMAN, Todd Merritt
"All-terrain tire" c. 1991* (Graphis92 \169)

HAJEK-HALKE, Heinz, 1898-1983
"Black and White Nude" 1936 (Icons 57)
"Eva-Chançon" c. 1932 (Icons 56)

HALASY, Don
"A mounted police officer orders a murder suspect to freeze after witnesses saw a security guard stabbed to death in lower Manhattan" 1987 (Best13 65a)

HALEBIAN, Carol
"Four days before the elections, a commando group formed to protect Haitians against pre-election violence, hacked a man to death in the streets of Port-au-Prince" 1987* (Best13 19d)

HALEVI, Marc
"Storm on Plum Island" 1990 (Best16 211-214)

HALEY, Bruce
"A rebel with the Karen National Liberation Army
executes a man he suspects of collaborating with
the government in Burma" 1990* (Best16 199)

HALFFTER, Wilhelm
"Statue of Frederick the Great, Berlin" 1851
(Rosenblum2 #10)

HALL, Durell, Jr.
"Replica of Auguste Rodin's statue, *The Thinker*"
1985 (Best11 175d)
"17-month-old who suffers from an 'aging' disease
called progeria" 1986 (Best12 68a)

HALL, Michael
"Wellington Kendo Club, Waitarere" c. 1999*
(Photo00 127)

HALLER, Grant M.
"Herschel, a sea lion, eating fish" 1985 (Best11 117a)
"Silhouette and shadow of a window washer play on
window and blinds" 1985 (Best11 146)

HALLINEM, Bob
"Eagle with a salmon in Alaska" c. 1988 (Best14 7c)

HALSMAN, Philippe
"Albert Einstein" c. 1955 (Lacayo 134)
"Aquacade Championships, Silver Springs, Florida"
1953 (Life 7)
"Audrey Hepburn" 1959 (Life 86c)
"Dali Atomicus" 1948 (Rosenblum2 #727; San #52)
"Dean Martin and Jerry Lewis" 1951 (Life 168c)
"Elizabeth Taylor" 1948* (Life 84a)
"Lucille Ball" 1950 (Life 168b)
"Mock black-seamed stockings" 1943 (Life 111c)
"Popcorn Nude" 1949 (San \35)

HALSTEAD, Dirck
"James Baker, campaign manager for President Bush,
takes a break after reading polls listing his
candidate as trailing" 1992* (Best18 79a)

HALVERSON, Karen, 1941-
"Hite Crossing, Lake Powell" 1988* (Women \183)
"Lake Powell, near Wahweap Marina, Utah" 1987*
(Women \182)

HAMILTON, Dennis, Jr.
"Bananas: handle with care" 1988* (Best14 108a)
"15-year-old lost his right leg in a motorcycle
accident when he was 10, but he still surfs with his
buddies" 1986 (Best12 226a)

HAMILTON, Jeffrey Muir
[promotional photographs with theme of toys] c. 1991
(Graphis91 \206)

HAMILTON, John R.
"John Wayne" 1965 (Life 86b)

HAMM, Hubertus
"Chair" c. 1999* (Photo00 217)
"Classic Car" c. 1999* (Photo00 176)

HAMMOND, Arthur, 1880-1962
"Semi-Lunar" 1939 (Peterson #23)

HAMPTON, Liz
"Erin, 1995" c. 1995* (Graphis96 111)

HANASHIRO, Robert
"Brazilian players celebrate their upset victory over
the United States for the gold medal at the Pan-
American Games" 1987 (Best13 217b)
"Cuban handball players trying to make a shot past
the U.S. players during the gold medal match at the
Pan American Games" 1987 (Best13 218d)
"Heavyweight champion Evander Holyfield receives
a crushing blow from Larry Holmes" 1992*
(Best18 136b)

HANAUER, Mark
"Actor Robert Downey, Jr." c. 1991 (Graphis91 \191)
"Batman" c. 1992* (Graphis93 122b)
"Brian Wilson" 1987* (Rolling #81)
"Carol Kane and George" c. 1990* (Graphis90 \139)
"Stevie Wonder" 1987* (Rolling #74)

HANDBERG, Lucille
"Tornado" 1943 (Life 124)

HANDS, Bruce
"American flag being flown at the annual kite
festival" c. 1990* (Graphis90 \74)

HANDSCHUH, David
"A man in top hat and tails jumped off the Brooklyn
Bridge" 1985 (Best11 78)
"300 feet above Grand Central Station, New York
police Officer Andy Nugent talks to a girl who was
threatening suicide" 1990 (Best16 109b)

HANFSTAENGL, Franz
"Man with Hat" 1857 (Rosenblum2 #54)

HANKEL-PUENTENER, Magrit
[from cover of a catalog] c. 1990* (Graphis90 \215)

HANNA, Forman G., 1881-1950
"Cloud Study" c. 1925 (National \64)
"Grand Canyon" 1920s (Peterson #53)

HANNA, Paul
"Would-be matadors take refuge during the running
of the bulls in Segovia, Spain" 1990* (Best16 166)

HANRAHAN, Jack
"A youth seeks relief from the heat wave that gripped
the Northeast by cooling off at the Perry Square
Fountain" 1995* (Best21 153c)

HANSCOMB, Adelaide, 1876-1932
"Charles Keeler posing for an illustration from the
Rubaiyat of Omar Khayyam" c. 1903-1905
(Decade \2); 1912 (Rosenblum \58)

HANSEN, Hans
[ad campaign for WMF] c. 1990* (Graphis90 \234)
[ad for a designer] c. 1990* (Graphis90 \285)
[bicycle gears] c. 1991* (Graphis92 \154, \155)
"Flounder" c. 1990* (Graphis90 \338)
[from a catalog for Mustang apparel] c. 1991*
(Graphis92 8, 9)
[from a cookbook] c. 1990* (Graphis90 \340)

"Herring and Vodka are Like Brother and Sister" c.
 1991* (Graphis91 \139)
"Ocean perch" c. 1991* (Graphis91 \140)
"Pumpkin" c. 1991* (Graphis91 \141)
"Squid" c. 1991* (Graphis91 \142)
[subtleness of fabric] c. 1991* (Graphis92 \32)

HANSEN, Marie
 "Addressing the nation from the White House in a
 'Fireside Chat' the night before D-Day, June 5"
 1944 (Life 23)
 "J. Robert Oppenheimer" 1945 (Life 96)

HANSEN, Russell C.
 "A black-capped chickadee's landing maneuvers are
 so complex that a split-second image can only hint
 at how it flies" 1996* (Best22 188b)

HANSON, David
 "Waste Ponds and Evaporation Ponds" 1984*
 (Goldberg 196)

HANSON, Pamela
 [for *Vogue Paris*] c. 1990 (Graphis90 \24)

HARA
 [white pelicans living amongst the flamingos] c.
 1992* (Graphis93 190)

HARBISON, Robert
 "Charlie and Bill, who have been close friends more
 than 60 years, enjoy a moment together in a
 playground where they watch the young people
 play basketball" 1986 (Best12 177d)

HARBRON, Patrick
 [man with goggles in pool] c. 1997* (Graphis97 119)

HARBUS, Richard
 "Buster Drayton connects with a right to the head of
 Carlos Santos" 1986 (Best12 219a)
 "Eighth-seed John McEnroe 'chokes' and loses a
 game" 1987 (Best13 117d)
 "Marilyn Klinghoffer kisses the coffin of her husband
 on its arrival in New York" 1985 (Best11 91a)
 "Mitch Green's hair goes flying as undefeated Mike
 Tyson rocks him" 1986 (Best12 218a)

HARBUTT, Charles, 1935-
 "Blind Boy" 1961 (MOMA 197)

HARDISON, Inge, 1914-
 "Awake" 1951 (Committed 120)
 "Harlem Newspaper Boy" 1949 (Committed 121)

HARDISON, Wes
 "Artist Point / Monument Valley View #1" c. 1999*
 (Photo00 86)
 "Monument Valley / Navajo Nation" c. 1999*
 (Photo00 87)

HARDY, Arnold E.
 "Death Leap From Blazing Hotel" 1946 (Capture 19)

HARDY, Chris
 "Clint Eastwood received more attention in 1986 as
 mayor of Carmel than as a movie star" 1986
 (Best12 52a)
 "Founders of an AIDS quilt project grieve at the loss
 of friends whose names are added to the

commemorative quilt" 1987 (Best13 57)
 "Grace Jones at a press conference for the opening of
 the James Bond Film, *A View to a Kill*" 1985
 (Best11 166a)

HARE, James, 1856-1946
 "Carrying out the Wounded During the Fighting at
 San Juan" c. 1914 (Marien \4.72; Rosenblum2
 #587)
 "List of *Lusitania* survivors outside British Crown
 Office" 1915 (Eyes #58)
 "*Lusitania* coffins at Queenstown Harbor" 1915
 (Eyes #60)
 "Mass grave for the dead *Lusitania* victims" 1915
 (Eyes #59)
 "Mexican revolutionaries Francisco I. Madero and
 Pancho Villa" 1911 (Lacayo 40a)
 "News photographers covering dynamite explosion at
 Communipaw, New Jersey" 1911 (Eyes #66)
 "Orville Wright Takes Off" 1908 (Goldberg 34)
 "Street fighting in Juárez" 1911 (Lacayo 40d)
 "*Viva Cuba Libre-Viva Americanos!*" 1898 (Eyes
 #56)
 "Wreckage of the *Maine*, Havana" 1898 (Eyes #54)

HARLESTON, Elise Forrest, 1891-1970
 "Portrait" n.d. (Rosenblum \142)
 "Portrait study (woman with cane)" 1922 (Willis \76)

HARNIK, Nati
 "Residents of a West Bank town react to the injuries
 of a fellow Palestinian who was shot in the head
 during a protest over land" 1996* (Best22 144b)

HAROLD-STEINHAUSER, Judith, 1941-
 "Dancing Tulips" c. 1983* (Rosenblum \35)

HARPER, Acey
 "Don Johnson and Philip Michael Thomas of *Miami
 Vice*" 1985 (Best11 165b)

HARPER, Steve
 "A return to the look of the early 1900s" 1987
 (Best13 180c)

HARRINGTON, Marshall
 "Columbina" c. 1999* (Photo00 162)
 "*Commedia del Arte* Performers" c. 1999* (Photo00
 146-147)
 "Rubberman" c. 1999* (Photo00 149)

HARRIS, Charles
 "Blue Canoe" c. 1999* (Photo00 92)
 [from *Italy* series] c. 1999* (Photo00 138)
 "Steve" c. 1999* (Photo00 116)

HARRIS, Charles (Teenie), 1908-1998
 "Beauty Queen" n.d. (Willlis \140)
 "Fair Employment Practice Demonstration" n.d.
 (Willis \135)
 "Homestead Grays Baseball Game" n.d. (Willis \136)
 "Negro League Baseball Player" n.d. (Willis \141)
 "President John F. Kennedy" n.d. (Willis \139)
 "Restaurant Scene" c. 1940s (Willis \138)
 "Workers Outside United Steelworkers of America
 Office" n.d. (Willis \137)

HARRIS, Joe, 1940-
 "Baptism" 1995* (Committed 123)
 "Biker" 1990* (Committed 122)

"Crucifixion #2" 1994 (Willis \255)
"Speedo and Smiley in Harlem" 1969 (Willis \254)

HARRIS, Peter
"Elizabeth Eckford pursued by mob, Little Rock,
Arkansas" 1957 (Goldberg 144)

HARRIS AND EWING
"Franklin Delano Roosevelt" 1932 (Vanity 167)

HARRIS BROTHERS (Thomas Allen, 1962-, and Lyle
Ashton, 1965-)
[from *Alchemy* series] 1998* (Willis \469-\472)

HARRISON, Art (Heru), 1937-
"Jubilation" 1993 (Committed 124)
"Winged Victory" 1998 (Committed 125)

HARRISON, Gabriel, 1818-1902
"California News" c. 1850 (Photography1 \27)
"Past, Present, Future" c. 1854 (Rosenblum2 #276)

HARRITY, Chick
"Cuban President Fidel Castro makes a point during
conversations in Havana" 1995* (Best21 137)

HART, Alfred A., 1816-1908 attribution
"Piute Squaws and Children, at Reno" 1867-1870
(Photography1 \60)

HART, Steve
"A Bronx Family Album: The Legacy of AIDS" 1997
(Best23 244-245, 252b)
"The killing of dolphins" c. 1991* (Graphis91 \69)

HARTOG, Richard
"Artist Cruz Lopez finishes a wood carving of
Nuestra Señora de Guadalupe" 1997* (Best23
195a)
"Brothers meet the press on their big wheels" 1997*
(Best23 194b)
"Celebrating win in men's beach volleyball" 1997*
(Best23 164c)
"Dejected player sits with her father" 1997* (Best23
194c)
"Deputy public defender can hardly bear to watch
convicted jail escapee" 1996* (Best22 220b)
"Girls trying out for the U.S. national water polo
team" 1997* (Best23 168d)
"Goalie does unsuccessful dive to save a shot" 1998*
(Best24 66a)
"The Harbor College bench erupts in celebration at
strike out" 1997* (Best23 172b)
"High school soccer coach goes airborne as he and
his team celebrate win" 1997* (Best23 193b)
"High school wrestler looks up at the referee while
pinning opponent" 1996* (Best22 206c)
"Lifeguard looks and keeps cool watching the swim
team practice" 1996* (Best22 221c)
"Peace activist Jerry Rubin spends a quiet moment
alone at the graveside of a longtime friend and
political activist" 1996* (Best22 220a)
"Pinning a high school wrestling opponent" 1997*
(Best23 176a)
"Police officers surround and arrest an unruly soccer
fan after a fight" 1996* (Best22 221a)
"Pro beach volleyball player Mike Dodd gets
horizontal as he dives to dig the ball" 1996*
(Best22 220d)
"Susan Stanfield watches a firestorm sweep near her

home at midnight" 1993* (Best19 186a)
"Taking advantage of warm weather" 1997* (Best23
195b)
"UCLA's Jelani McCoy blocks a shot by putting his
hand through the basket" 1996* (Best22 195d)
"UCLA's Jelani McCoy finishes off a slam dunk"
1997* (Best23 192)

HARTZ, Daniel M.
"Prototype automobile" c. 1990* (Graphis90 \226)
[sink] c. 1992* (Graphis93 140)

HARVEY, David Alan
"A celebration of Easter in Atacama Desert, Chile,
reflects an extension of European brotherhood"
1988* (Best14 153d)
"Children play in bubbles in Barcelona, Spain" 1998*
(Through 108)
"A flood of suds at Amnesia, a popular disco on the
island of Ibiza" 1992* (Best18 119a)
"Glowing pillars and a telephone tower mark the
Olympic Esplanade in Barcelona, Spain, host of the
1992 Olympic Games" 1998* (Through 54)
"Havanna residents play a pickup game of
baseball–one of Cuba's most popular American
imports" 1999* (Through 444)
"Mud-streaked revelers dance the night away during
Carnival in Trinidad" 1994* (Through 430)
"On a branch of the Saigon River, traders sell rice
from the Mekong Delta" 1989* (Through 176)
"Vision and strength are evident in the construction
of the Sagrada Familia Church in Barcelona,
Spain" 1998* (Through 62)

HARVEY, Gail, 1952-
"Terry Fox" 1980 (Monk #46)

HARVEY, Harold Leroy, 1899-1971
"Self-Portrait with Camera and Model" c. 1930
(Waking #183)

HASCH, Elsa
"The Fargo Red Hawks do the limbo to pass the time
during a train delay" 1998 (Best24 58)

HATHAWAY, Steve
[Lamborghini Diablo] c. 1995* (Graphis96 149a)
"Photographer Guido Rosenmann peering through an
old stereo camera" c. 1991* (Graphis91 \246)
[self-promotional] c. 1989* (Graphis89 \20)

HAUSER, Marc
"Ben Feldman" c. 1991* (Graphis91 \212)
"Chicago art critic, Dennis Adrian" c. 1991*
(Graphis91 \211)
[faces] c. 1992* (Graphis93 100-101)
"Pat" c. 1991 (Graphis91 \178)
"Patti Smith" c. 1991* (Graphis91 \210)
"Photo of young woman" c. 1991* (Graphis91 \209)
"Untitled" c. 1990* (Graphis90 \189)

HAUSMANN, Raoul, 1886-1971
"ABCD" 1924 or later (Hambourg \86)
"Mechanical Toys" 1957 (Rosenblum2 #487)

HÄUSSER, Robert, 1924-
"Bicyclist" 1953 (Icons #162)
"J.R. 5-9-70" 1970 (Icons 163)

HAVILAND, Paul B., 1880-1950
"Passing Steamer" c. 1912 (San #4)
"Portrait of a Man" c. 1908 (National \72)
"Two Sisters" c. 1908 (National 130c)

HAVIV, Ron
"Politics in Panama" 1989* (Lacayo 176a)
[scene of a massacre by Serbs in Bosnia] c. 1995*
 (Best21 183a; Graphis96 65)

HAWARDEN, Clementina, 1822-1865
"Clementina Maude" c. 1863-1864 (Szarkowski 90)
"Girl in Fancy Dress" or "Young Girl with Mirror
 Reflection" c. 1860 (Marien \3.105; Rosenblum
 \37; Rosenblum2 #272)
"Photographic study" c. 1862-1863 (Waking #14;
 Women \7, \8, \9)

HAWES, Josiah Johnson
"McKay's Shipyard, East Boston" c. 1855 (Marien
 \2.60)

HAWKES, William
"Actor Peter Weller as Robo Cop" c. 1991*
 (Graphis91 \200)
[self-promotional] c. 1990* (Graphis90 \33)

HAWLEY, Thomas J.
"[Elderly couple] take an aquatic route from their
 home after Lake Erie's windblown water threatened
 100 family dwellings" 1985 (Best11 65a)

HAY, Alexei
"Twins in their room" 1998* (Best24 85)

HAYES, Durwood
"Dwight D. Eisenhower" c. 1952 (Eyes #146)

HAYNES, F. Jay, 1853-1921
"Bicyclists Group on Minerva Terrace, Yellowstone
 National Park" 1896 (Photography1 #V-19)
"Cascades of Columbia" c. 1885 (Photography1 \11)
"East Entrance, Jefferson Canyon" 1890 (National
 130b)
"Geyser, Yellowstone, Wyoming" c. 1885
 (Rosenblum2 #167)
"Gibbons Falls, 84 ft." 1884-1888 (Photography1
 \72)
"Gloster Mill, 60 Stamps, 24 Pans, 12 Settlers" c.
 1885 (National \41)
"Grand Canyon of the Yellowstone (Looking East).
 Yellowstone National Park" c. 1880 (Photography1
 #V-18)
"Harvesting, Dalrymple Farm, Red River Valley,
 Dakota Territory" 1877 (Photography1 #V-17)
"Lone Star Geyser Cone, Yellowstone National Park"
 1884 (National 130a)

HEALEY, Steve
"Doubles partners celebrate the win that propelled
 their team to championship" 1997* (Best23 175d)
"A halo of light surrounds a swimmer as he relaxes in
 the cool-down pool" 1997* (Best23 168b)
"Nursing Home Dilemma" 1997 (Best23 207b, d)

HEARTFIELD, John, 1891-1968
"Adolf the Superman: He Eats Gold and Spews
 Idiocies" 1932 (Rosenblum2 #488)
"Before the War Defeats You" 1936 (Szarkowski
 204)

"Hitler's dove of peace" 1935 (Eyes #106;
 Rosenblum2 #597)
"Through Light to Night" 1933 (Marien \5.80)
"Untitled" 1930 (Hambourg \91)

HEATH, Bonnie
"Gun Shy No Longer" 1996 (Best22 179a)

HEDRICH, Jim
[for leasing brochure] c. 1992* (Graphis93 180, 181)
[office building foyer] c. 1991* (Graphis92 \219)

HEESOON YIM
"South Korean student armed with a bottle to be used
 as a Molotoff cocktail" c. 1990* (Graphis90 \252)

HEFFERNAN, Terry
[ad for Ridomil] c. 1992* (Graphis93 65)
"Andrew Carnegie's Fly-fishing Equipment" c. 1991*
 (Graphis91 \125)
"Baseball memorabilia of James 'Cool Papa' Bell,
 one of the first Black Leaguers to be accepted in
 Baseball Hall of Fame" c. 1991* (Graphis92 \56)
"Beauty of Gold" c. 1992* (Graphis93 136)
"Bulb" c. 1995* (Graphis96 92)
[company brochure] c. 1990* (Graphis90 \316, \318)
[company report] c. 1990* (Graphis90 \334)
[eyeglasses] c. 1997* (Graphis97 132)
[for cruises] c. 1990* (Graphis90 \317, \319)
[for 50th anniversary of the National Baseball Hall of
 Fame] c. 1991* (Graphis91 \108)
[for the American President Lines] c. 1989*
 (Graphis89 \289, \290)
[locks and keys] c. 1995* (Graphis96 4)
[mining company report] c. 1991* (Graphis92 \68)
[report for Weyerhaeuser, paper and cartonage
 manufacturers] c. 1989* (Graphis89 \291-\293)
"U. S. President (Stephen) Grover Cleveland's Flies
 on an Atlantic Salmon" c. 1991* (Graphis91 \135)
"Used for the diary of the shipping company
 American President Lines" c. 1989* (Graphis89
 \140, \141)

HEGEDUS, Eric
"Keith Darling, 10, heads for third base, powered by
 his brother, Greg, 12, during a Challenger Division
 Little League baseball game" 1990 (Best16 119)

HEIKES, Darryl
"Just before daylight, a lobsterman rows a dinghy out
 to his lobster boat moored off Spruce Island,
 Maine" 1988* (Best14 106)

HEIN, Rich
"After the Chicago Bears beat the New England
 Patriots in Super Bowl XX, fans turned out for the
 biggest ticker-tape parade since Neil Armstrong
 visited after walking on moon" 1986 (Best12 194)
"Kindergarten graduate reacts to the commencement
 address" 1985 (Best11 137b)

HEINECKEN, Robert, 1931-
"Costumes of a Woman" 1966* (Szarkowski 286)
[from "Are You Rea"] 1964-1968 (Photography2 120)
"Periodical #5" 1971 (Goldberg 217)
"Refractive Hexagon" 1965* (Marien \6.99)
"U.C.B. Pin Up" 1968 (Decade 82)
"Le Voyeur/Robbe-Grillet #1" 1972 (Rosenblum2
 #758)
"Waking Up in News America" 1984* (Decade \XV)

HERZOG, Harald
 "Amazon rainforest ablaze" 1997* (Photos 152)
 "Destruction of the Yanomami Territory" 1983*
 (Photos 153)

HESLER, Alexander, 1823-1895
 "Falls of Minnehaha, Minnesota" c. 1855 (National \7)
 "Three Pets" c. 1851 (Rosenblum2 #275)

HESS, Bill
 "Malik, an Inupiat Eskimo who helped engineer a
 path to open water for California gray whales
 trapped near Alaska, stays before a Soviet ice
 breaker approaches" 1988 (Best14 88)

HESTER, Jeff
 "Eagle Nebula" 1995* (Life 106)

HEVEY, David
 "Untitled" 1992* (Marien \7.93)

HEYMAN, Abigail, 1942-
 "Passover Seder" 1979 (Rosenblum \263)

HIBEN, Frederique
 "A mother from Kiev, 80 miles from the Chernobyl
 nuclear explosion, has her boy checked out for
 radiation" 1986* (Best12 6c)

HICKMAN, R. C., 1922-
 "Coca-Cola (NAACP meeting)" 1954 (Eyes #148)
 "Colored City Hall, Texas. White city hall officers at
 installation of council-men" 1953 (Eyes #150)
 "Nat King Cole, Long Horn Ranch House" 1954
 (Eyes #149)

HICKS, Calvin, active 1970s-date
 "Nude Form" 1985 (Willis \545)
 "Synthesis" 1976 (Willis \544)

HIDALGO, Francisco
 [Paris] c. 1995* (Graphis96 167)

HIETT, Steve
 "Bastille Day in fashion" c. 1991* (Graphis91 \2)

HIGDON, Paul
 "Yalta Conference?" 1990 (Lacayo 171)

HIGGINS, Chester, Jr.
 "African Burial Ground, uncovered in New York
 City" 1992 (Willis \342)
 "Brazilian immigrant dressed as Oshun, the African
 deity of the River and Love" 1989 (Willis \345)
 "The first haircut" 1969 (Willis \347)
 [Mali and travel on Niger River] 1993 (Willis \343)
 "Memorial to African ancestors who perished in
 Atlantic Ocean during transfer from Africa to
 American enslavement" 1990 (Goldberg 208)
 "New York City (a young Moslem woman in
 Brooklyn)" 1990 (Willis \344)
 "Young Ethiopian Orthodox deacon is holding a
 processional cross" 1993 (Willis \346)

HILDEBRAND, Ron
 [untitled] c. 1995* (Graphis96 128)

HILL, David Octavius, 1802-1870, and ADAMSON,
 Robert, 1821-1848
 "Cottage Door" 1843 (Waking 269a)

"Disruption Group: Rev. Dr. John Bruce, Rev. John
 Sym, Rev. Dr. David Walsh" c. 1843 (Art \35)
"Dr. Alexander Keith" c. 1843 (Marien \2.63)
"East Gable of the Cathedral and St. Rule's Tower,
 St. Andrews, Scotland" c. 1844 (Szarkowski 41)
"Elizabeth Johnstone, Newhaven" c. 1846 (Art \40)
"George Meikle Kemp" c. 1843 (Art \42)
"Glynn, An Actress and Reader" c. 1845 (Art \39)
"Gordon Highlanders at Edinburgh Castle" 1845-
 1846 (Art \38)
"Hugh Miller" 1843-1847 (Art \43)
"Masons working on a carved Griffin for the Scott
 Monument" c. 1844 (Art \36)
"Mrs. Elizabeth Hall and Unknown Woman
 (Newhaven Fishwives)" c. 1845 (Marien \2.64)
"The Misses Binny and Miss Monro" c. 1845
 (Rosenblum2 #52)
"Portrait of Elizabeth Rigby, Later Lady Eastlake" c.
 1845 (Rosenblum2 #243)
"Redding the Line" c. 1846 (Rosenblum2 #51)
"Reverend Thomas Henshaw Jones" 1843 (Art \41)
"Robert Adamson" c. 1843 (Rosenblum2 #81)
"Sergeant of the 42nd Gordon Highlanders reading
 the Orders of the Day" 1846 (Art \37)
"Sir David Brewster" c. 1843 (Szarkowski 31)
"William Gillespie" c. 1844 (Szarkowski 42)

HILL, Erik
 "A customer in a pool hall in Tulsa, Okla." 1986
 (Best12 123b)

HILL, Paul
 "Arrow and Puddle" 1974 (Rosenblum2 #711)

HILLE, Ed
 "So many deaths, so quickly; so little time, so little
 space" 1985 (Best11 21b)

HILLER, Lejaren A., 1880-1969
 "Étienne Gourmelen" c. 1933 (Marien \5.45)
 "Hugh of Lucca from the Surgery Through the Ages
 Series" 1937 (Rosenblum2 #632)

HILLERS, John K., 1843-1925
 "Hedipa, a Navajo Woman" c. 1880 (National 131)
 "Marble Canyon, Shinumo Altar" 1872 (Rosenblum2
 #153)
 "A Navajo Shaman" 1870s (Photography1 \59)
 "Santo Domingo, New Mexico" c. 1875 (Szarkowski
 123)
 "Tewa, Cicomavi, Wolpi, Mokitowns, Arizona" or
 "Hopi Mesa" c. 1879 (National \41; Photography1 \9)

HILST, Robert van der
 "In Cuba, waiting for wheels" c. 1990* (Graphis90
 \268)

HIMMEL, Lizzie
 [mother and children in kitchen] c. 1995* (Graphis96
 141)
 [untitled] c. 1995* (Graphis96 6-7)
 [walking upstairs] c. 1995* (Graphis96 37)

HINATSU, Kam
 [self-promotional] c. 1989 (Graphis89 \182)

HINDS, Geff
 "Fatigue flattens millions of people every year" 1987
 (Best13 143b)
 "Petals of the palette" 1986* (Best12 110a)

HINE, Lewis Wickes, 1874-1940
 "Albanian Woman, Ellis Island" 1905 (Decade \10)
 "Biloxi, Mississippi" 1911 (National 132c)
 "A carrying boy in a Virginia glass factory" 1911
 (Lacayo 62b)
 "Child Spinner, North Carolina" or "Carolina Cotton
 Mill" 1909-1911 (Goldberg 42; Marien \4.49;
 Monk #14; Lacayo 62a; Photos 17)
 "Climbing into America" 1908 (Eyes #61; Lacayo 57)
 "Coalbreakers, Pennsylvania" or "Breaker boys in a
 coal chute" 1910-1911 (Eyes #62; Goldberg 40;
 MOMA 74; Lacayo 63; Rosenblum2 #474)
 "A family works at home making flower wreaths"
 1912 (Lacayo 65b)
 "A girl at work in a cotton mill" 1911 (Lacayo 64c)
 "Handyman in Washington, D.C." 1909 (National
 \78)
 "Homework, Artificial Flowers, New York City"
 1908 (Decade 12)
 "Icarus, Empire State Building" 1930 (Hambourg \6)
 "Immigrants at Ellis Island" c. 1905 (Lacayo 65c)
 "Little Orphan Annie in a Pittsburgh Institution" 1909
 (National \75)
 "Looking for lost baggage, Ellis Island" 1905
 (Photography 206)
 "A Madonna of the Tenements" c. 1911 (Marien
 \4.48)
 "Making Human Junk" c. 1915 (Rosenblum2 #466)
 "Newsies at Skeeter's Branch, St. Louis, Missouri"
 1910 (Hambourg 56a)
 "Refugee group, Lescowatz, Serbia" 1918 (Eyes #64)
 "Refugees on railroad tracks en route to Gradletza,
 Serbia" 1918 (Eyes #63)
 "A Russian family on Ellis Island" 1905 (Lacayo 58)
 "A Sleeping Newsboy" 1912 (Waking #161)
 "Steamfitter" or "Powerhouse Mechanic" 1920-1921
 (Hambourg \19; MOMA 129; Rosenblum2 #446)
 "Sunday Noon, Some of the Newsboys Returning
 Sunday Papers" 1909 (Icons 19)
 "Ten-Year-Old Spinner" 1908-1909 (Rosenblum2
 #476)

HING/NORTON
 [self-promotional] c. 1990 (Graphis90 \308)

HINTON, Alfred Horsley
 "Recessional" c. 1895 (Rosenblum2 #365)

HINTON, Milton J., 1910-
 "Billie Holiday, vocalist, and William James (Count)
 Basie, jazz pianist and bandleader, at television
 studio" c. 1957 (Willis \154)
 "Joe Williams, jazz and blues singer, and Jimmy
 Jones at recording studio" c. 1959 (Willis \151)
 "John Coltrane and George Russell at recording
 studio" c. 1956 (Willis \150)
 "Lester Young, jazz tenor saxophonist, and Roy
 Eldridge, jazz trumpeter, in Harlem" c. 1958
 (Willis \153)

HIRO
 "Apollo Training Suits" 1978* (Rolling #41)
 "Chanteclair, the unofficial national bird of France" c.
 1991* (Graphis91 \337)
 "Fabric" 1967* (Rosenblum2 #647)
 "Sean Penn" 1983 (Rolling #48)
 "Tilly Tizzani with a Blue Scarf" 1963* (Marien \6.0)

HIROSHI, Hamaya
 "Untitled" 1940-1944 (Rosenblum2 #462)

HIRSCH, Karen J.
 "View of the Marina City Building in Chicago" c.
 1989* (Graphis89 \105)

HISCOCK, David
 [from Zoom magazine] c. 1989* (Graphis89 \183)

HISPARD, Marc
 [ad for fashions of the Complice brand] c. 1989*
 (Graphis89 \18)

HÖCH, Hannah, 1889-1978
 "Die Braut" c. 1928 (Women \88)
 "Cut with the Kitchen Knife Dada through the Last
 Weimar Beer Belly Cultural Epoch of Germany"
 1919 (Marien \5.10; Rosenblum2 #486)
 "Monument 1" 1924 (Marien \5.12)
 "The Strong Man" 1931 (Rosenblum \126)

HOCKNEY, David, 1937-
 "Christopher Isherwood Talking to Bob Holman,
 Santa Monica" 1983* (Photography2 167)
 "Henry Geldzahler #1" 1990* (Photography 89)
 "The Skater, New York" 1983* (Icons 177)
 "Stephen Spender, Mas Saint-Jerome" 1985
 (Szarkowski 278)

HODGSON, Valerie
 "Meet Nuka the walrus, who turned the tables by
 staring back at visitors to the New York Aquarium
 in Coney Island" 1985 (Best11 151b)

HOEDT, Axel
 "Anya Chopra" c. 1999* (Photo00 48)
 "Eggs" c. 1999* (Photo00 59)

HOFER, Evelyn
 "Haughwout Building, NY" 1975 (Rosenblum \226)

HOFF, Charles, 1905-1975
 "Explosion of the Hindenburg, Lakehurst, N.J." 1937
 (Hambourg \73)
 "Rocky Marciano and Ezzard Charles" 1954
 (MOMA 228)

HOFFMAN, R. Todd
 "A grandmother and child in Tia Aicha, Mali, East
 Africa" 1986 (Best12 67a)

HOFFMAN, Samuel
 "Sabra Fair and daughter waltz away the minutes
 before Fair's wedding" 1996* (Best22 174c)

HOFFMAN, Scott
 "World-class hurdler Greg Foster leads a pack of
 competitors" 1987 (Best13 208b)

HOFFMANN, Fritz
 "Unaware of a hound's activity, the Rev. prepares to
 bless the dogs on the opening of fox-hunting
 season" 1990* (Best16 165)

HOFMEISTER, Oskar and Theodor
 "The Haymaker" c. 1904 (Rosenblum2 #379)

HOGAN, John R., 1888-1965
 "Crossing the Stream" c. 1938 (Peterson #78)
 "The Life Ring" c. 1940 (Peterson #79)

HOGREFE, Michael
[nuts and bolts] c. 1992* (Graphis93 134)

HÖHLIG, Martin
"Albert Einstein" 1923 (Vanity 79)

HOLBROOKE, Andrew
"A British soldier seen through his protective plastic
 shield in Northern Ireland" 1997 (Best23 154c)
"Children on the streets of West Belfast" 1997*
 (Best23 150c)
"A homeless man keeps warm over a steam vent on
 the streets of New York City" 1987* (Best13 32)
"A homeless man sits in the afternoon sun in the
 streets of Greenwich Village" 1988 (Best14 119)
"Hutterite children" 1997 (Best23 184-185)
"A starving girl tugs at her brother's robe at a feeding
 station in Baidoa, Somalia" 1992* (Best18 130)

HOLDER, Leland
"Elementary school children take notes on a field trip
 at a local nature preserve" 1987 (Best13 122d)

HOLLANDER, Jim
"Coffin of Yamya Ayyash is carried into a mosque"
 1996* (Best22 150c)
"Runners in full stride expertly lead a pack of fighting
 bulls around a sharp corner during the weeklong
 Fiesta" 1993* (Best19 143b)
"The running of the bulls in Pamplona, Spain" 1993*
 (Best19 141)

HOLLAR, Thomas
[Barber's chair] c. 1991* (Graphis92 \60)

HOLLYMAN, Stephenie
[from a book entitled Children of the Frontline] c.
 1991* (Graphis91 \208)
[from a book entitled We the Homeless] c. 1989
 (Graphis89 \258-\261)
"Kalahari Desert of Botswana" c. 1991* (Graphis91
 \302)

HOLMAN, Raymond W., Jr., 1948-
"African American March on Grays Ferry,
 Philadelphia" 1997 (Willis \311)
"Big Ray" 1998 (Committed 129)
"Day of Atonement, New York" 1996 (Willis \312)
"Havana, Cuba" 1997 (Willis \310)
"Ignorance" 1997 (Committed 128)

HOLMES, Burton, 1870-1958
"An almost incredible train accident at Montparnasse
 Railroad Station" 1891-1895 (Eyes #67)

HOLMES, Martha
"Actors Danny Kaye, June Havoc, Humphrey Bogart,
 and Lauren Bacall, House Committee on Un-
 American Activities hearings" 1947 (Life 154)

HOLMES, Oliver Wendell, 1809-1894
"At the Doorway" c. 1864 (Photography1 #I-11)

HOLT, David
[ad for handbags] c. 1991* (Graphis91 \229)
[Christ's crucifixion] c. 1992* (Graphis93 126c)
"Cover of a special issue of Bicycle Magazine" c.
 1989 (Graphis89 \199)
[Italian Trade Commission] c. 1991* (Graphis91
 \230)

"Girl with golden hair" c. 1990* (Graphis90 \55)

HOLTZMER, Buck
"Ad for Galleria fashions" c. 1989* (Graphis89 \349-
 \352)

HOLZER, Felix
[Eiffel Tower] c. 1999* (Photo00 19)

HOM, Calvin
"Drury's Rod Gorman runs into a roadblock in the
 form of Charleston's Antonio Martin as he goes
 after a loose ball" 1986 (Best12 203)
"Kansas City right fielder Mike Kingery grimaces as
 he dives and misses a looping double hit by
 Boston's Tony Armas" 1986 (Best12 211)
"Kansas City's second baseman, Frank White takes
 the ball from right fielder Mike Brewer in a near
 collision in short right field" 1986 (Best12 213)
"St. Thomas' Curtis Washington unsuccessfully
 pleads his case with referee" 1986 (Best12 202)

HOOD, Robin
"Moment of Reflection" 1976 (Capture 101)

HOOKE, Tom
"Depiction of a negative role model" c. 1991
 (Graphis91 \192)

HOOPER, Willoughby Wallace, 1837-1912
"The Last of the Herd, Madras Famine" 1876-1878
 (Rosenblum2 #316)
"Victims of Madras Famine" 1876-1878 (Marien
 \3.107)

HOPE, Christina
[part of a series to transport viewer to another world]
 c. 1991 (Graphis92 \101-\103)

HOPPÉ, Emil O.
"Flower Seller" 1921 (Rosenblum2 #444)
[from Die Koralle] 1929 (San #11)
"H. G. Wells" 1919 (Vanity 15b)
"Sir Arthur Conan Doyle" 1920 (Vanity 15a)
"Willa Cather" 1922 (Vanity 75)

HOPPER, Dennis
[Evening gowns] c. 1997* (Graphis97 18-19)

HORAN, Kevin
"With energy plentiful and cheap, few corporations or
 consumers put conservation on their priority lists"
 1997* (Best23 153c)

HOREAU, Hector
"Abu Simbel" 1840 (Rosenblum2 #99)
"Medinet Habu" 1841 (Marien \2.34)

HORENSTEIN, Henry
[a ray swimming] c. 1997* (Graphis97 175b)
[whale's fluke] c. 1997* (Graphis97 175a)

HORNE, Bernard S., 1867-1933
"Design" c. 1917 (Peterson #59)

HORNE, Fallon
"Youth and Age" 1855 (Szarkowski 94)

HORNER, Jeff
"'Shades' of Summer" 1993* (Best19 177)

[man diving] c. 1997* (Graphis97 190, 191)
"Smoking enjoyment" c. 1995* (Graphis96 118-121)
[street basketball player] c. 1992* (Graphis93 200)
[swimmer] c. 1995* (Graphis96 202)
[wheelchair athlete] c. 1997* (Graphis97 192)
[woman athlete] c. 1997 (Graphis97 188)

HUFFMAN, Laton Alton, 1854-1931
"The Night Hawk in His Nest" c. 1885-1890
(Photography1 \10)

HUGNET, Georges, 1906-1974
Initiation préliminaire aux arcanes de la fort
1936* (San \29)

HUGUIER, Françoise
"Series of couturier Christian Lacroix" c. 1990*
(Graphis90 \147)

HUI, Zhuang
"Commemorative Picture of Teachers and Students of
Loyang Police School, Hunan Province" 1997
(Marien \7.21)

HUJAR, Peter
"C. Darling, her Deathbed" 1973 (Photography 99)
"David Wojnarowicz" 1981 (Photography 88)

HUMBERT DE MOLARD, A., 1800-1874
"The Hunters" 1851 (Rosenblum2 #257)

HUMPHREY, Curtis, 1907-1996
"Postmortem portrait, Texas" c. 1959 (Willis \210)

HUNT, George
"Kwakiutl woman in the process of cedar-bark
weaving" n.d. (Marien \4.77)

HUNT, Sherrie
[trophy sports figures] c. 1997* (Graphis97 80-81)

HUNTING, Dan
"Boyd, who for 20 years has resisted efforts of resort
developers to buy his farm" 1986 (Best12 130)

HURLEY, Frank, 1885-1962
"In Urama, Papua New Guinea, tribal elders wear
goblin masks to perform certain ceremonial
functions" 1927 (Through 439)
"Shackleton Expedition, Antarctica" 1916
(Szarkowski 148)

HURN, David
"Seaside in Wales" 1997 (Marien \7.9)

HURRELL, George
"Bill (Bojangles) Robinson" 1935 (Vanity 162)
"Jean Harlow" 1935 (Vanity 135)
"John Barrymore" 1933 (Goldberg 79c)
"Marlene Dietrich" c. 1938 (Goldberg 80)

HURTEAU, Teresa
"Senior league baseball coach gives his son a
comforting pat after loss" 1992 (Best18 146a)

HUSEBYE, Terry
"Kern County Fair" c. 1992* (Graphis93 170a)

HUTCHINSON, Eugene
"Anna Pavlova" 1915 (Vanity 10)

HUTCHINSON, Peter, 1930-
[from *Alphabet* Series] 1974* (Photography2 158)

HUTCHISON, Kevin
"Small bay and swaying cattails" c. 1991 (Graphis91
\298)

HUTCHISON, Mark Wendell
"Art as Food" c. 1991* (Graphis91 \134)

HUTTON, Kurt, 1893-1960
"October: Month of Fairs" 1938 (Eyes #118)
"Planning the march" 1939 (Eyes #121)

—I—

IBRAHIM, Achmad
[a man allegedly shot by police is carried following
clashes in Jakarta] c. 1999* (Photo00 67)

IGARASHI, Takenobu
"G–in aluminum alphabet" c. 1991* (Graphis92 26)

IGNATOVICH, Boris
"At work" 1929 (Lacayo 72)
"On the Construction Site" 1929 (Rosenblum2 #542)

IKKO
"Two Garbage Cans, Indian Village, New Mexico"
1972 (Rosenblum2 #721)

ILLINGSWORTH, W. H.
"Indian's Eye view of Custer Expedition Entering the
Black Hills" 1874 (Marien \3.67)

IM, Sunkyu
"Roh Tae Woo, the president's hand-picked
successor, parades through Pusan protected by
shields and bodyguards" 1987* (Best13 26b)

IMARI (DuSauzay), 1927-
"Badu" 1998* (Committed 130)
"Marlene" 1999* (Committed 131)

IMHOFF, Robert
"Heather Marygold" c. 1991 (Graphis91 22a)
"Mercedes Benz Press Campaign" c. 1991*
(Graphis91 23)
"Portrait of a Child for a Pharmaceutical Company"
c. 1991* (Graphis91 22c)

INOUYE, Itsuo, 1950-
"Rescue crews search wreckage of a Japan Air Lines
747 in rugged terrain in Japan" 1985 (Best11 54c)
"South Korean student squares off in a duel with riot
police during an anti-government demonstration at
Yonsei University in Seoul" 1987* (Eyes #366)

INTERNATIONAL FILM SERVICE
"The Defenders of Verdun, They shall not pass" 1917
(Eyes #83)
"Kerensky as Minister of War, reviewing the Russian
troops at the front" 1917 (Eyes #73)

INTERNATIONAL NEWS
"World War II fliers enjoy local companies while
they wait for their damaged aircraft to be repaired"
1943 (Through 448)

IOOSS, Walter
[going downstairs on bike] c. 1997* (Graphis97 194)
[skateboarding] c. 1997* (Graphis97 193)

IPOCK, Don
"For a walk on the wild side, leopard trim
complements an elegant suit" 1987* (Best13 182d)

IRVINE, Edith, 1884-1949
"The Burned Tree" 1906 (Rosenblum \59)

IRVING, Henry
"Cornflowers, Poppies, Oat, Wheat, Corncockle" c.
1907* (Rosenblum2 #348)

ISAAC, John
"Traditional 'Fantasia' Fete of Morocco" c. 1991*
(Graphis91 \295)

ISAACS, Chuck
"Police work with crane to search for evidence in the
burned-out neighborhood, Philadelphia" 1985
(Best11 25a)

ISABEY
"Jean Cocteau" 1922 (Vanity 49)
"Les Six" 1921 (Vanity 46-47)

ISELI, Alfons
"Figure with Flower Head" c. 1992* (Graphis93 80)
[tulip] c. 1992* (Graphis93 240)
[untitled] c. 1990* (Graphis90 \320)

ISHIMOTO, Yashuhiro
"Chicago" 1962 (Marien \6.31)

ISMAIL
"TWA Pilot John Testrake answers journalists'
questions under hijacker's gun" 1985 (Best11 51a)

ITKOFF, Andrew
"After a spar and a workout, a fighter takes a breather
on the ropes at the gym" 1987 (Best13 98)
"Homeless teen, Fort Lauderdale" 1990* (Best16 8c)

ITURBIDE, Graciela, 1942-
"The Chickens" 1980 (Rosenblum \187)
"Gaigo (Greyhound), Hernan de Soto's, Tampa,
Florida" 1996 (Photography 60)
"Laganto, Juchitán" 1988 (Women \137)
"Nuestra Señora de las Iguanas, Juchitán" 1980
(Women \136)
"Señor de Pájoros" 1984 (Rosenblum2 #706)
"Woman Angel, Sonora Desert, Mexico" 1979
(Marien \6.11)

IVANSCO, Joey
"Father and son" 1988 (Best14 16)
"Five-year-old Shoin 'Pinkie' Bass nestles next to her
grandmother, Vester Bass, outside their Atlanta
apartment" 1990* (Best16 12a)
"Girdles" 1995 (Best21 146)
"Michael Johnson left nothing to question after
winning the 200-meter race in world record time"
1996* (Best22 115a)

IWAGO, Mitsuaki
"Zebras and wildebeests, Africa" 1986* (Through 8)

IWAI, Keiji
[from the Red Planet series] c. 1999* (Photo00 89)
"Untitled" c. 1997 (Graphis97 143)

IZIS
"Place St. André des Arts, Paris" 1949 (Rosenblum2
#626)

IZU, Kenro
"Asprey sunflowers" c. 1995* (Graphis96 79)
[flowers] c. 1989 (Graphis89 \286); c. 1992*
(Graphis93 81)

—J—

JACHNA, Joseph, 1935-
"Door County, Wisconsin" 1970 (Decade \93;
Photography2 42)

JACKSON, Lawrence
"Homicide detectives meet the day after a set of
murders to discuss scenarios" 1995 (Best21 172c)

JACKSON, Reginald L., 1945-
[from Black Panther Party series] 1970* (Willis
\409-\412)
"Ghana: Things Go Better?" 1970 (Committed 133)
"Last Frontier, West Africa" 1972 (Committed 132)

JACKSON, Robert H., 1934-
"Jack Ruby Shoots Lee Harvey Oswald" or "The
murder of Lee Harvey Oswald" 1963 (Capture 52;
Eyes #286; Lacayo 142; Marien \6.103)

JACKSON, Ted
"George Bush signals he 'can't hear' when asked
about running mates upon arrival to New Orleans
for the Republican Convention" 1988 (Best14 9a)
"Masked against the smell of decomposition, a
woman waits outside a makeshift morgue in
Mexico City" 1985 (Best11 12c)
"The Tracy Look" 1990* (Best16 144b)
"Waiting for the umpire's call on slide into second
base" 1985 (Best11 192b)

JACKSON, William Henry, 1843-1942
"Cañon of the Rio Las Animas, Colorado" after 1880
(Art \144)
"Currecanti Needle, Black Cañon of the Gunnison" c.
1880 (National 132d)
"Entrance to the Highlands, Hudson River" c. 1898
(National \42)
"Excursion Train and Niagara Rapids, Lewiston
Branch, N.Y." 1890 (Photography1 \12)
"Grand Canyon of the Colorado" c. 1883 (Art \145;
National 21b, \24; Rosenblum2 #169)
"Hot Springs on the Gardiner River, Upper Basin"
1871 (Rosenblum2 #156)
"Members of the Hayden Survey" 1870 (Rosenblum2
#155)
"Mud Geyser in Action" 1871 (Marien \3.63)
"Old Faithful, Yellowstone National Park, Wyoming"
1871 (Art \146; Monk #8)
"(Omaha) Indians Building Houses for the Tribe"
1877 (Marien \3.62)
"South Pass City" 1871 (Photography1 #V-7)

JACOBI, Lotte, 1896-1990
"Albert Einstein, Princeton, N.J." 1938 (Sandler 40)
"Dimensions 3" c. 1946 (Sandler 169)

"Franz Lederer (Actor)" c. 1929 (Women \75)
"Girl, Berlin" c. 1930 (Icons 42)
"Head of a Dancer, Berlin" 1930s (Rosenblum \121; Sandler 30; Women \76)
"Käthe Kollwitz" 1929 (Icons 43)
"Untitled from Portfolio #3" 1946-1955 (Rosenblum \232)
"Untitled Photogenic" 1946-1955 (Marien \6.35; Photography2 39; Rosenblum2 #554)

JACOBS, Charles Fenno, 1904-1975
"A crowd gathered in front of the White House awaits further news after the announcement of FDR's death" 1945 (Eyes #207)
"New York City" 1937 (Life 40)

JACOBSOHN, Jed
"Evander Holyfield celebrates after defeating Mike Tyson for the heavyweight championship title" 1996* (Best22 206b)
"Katherin Fritz is the winner of the Butterbean look-a-like contest in Las Vegas" 1996* (Best22 271d)

JACOBSON, Jeff, 1946-
"Congressional Medal of Honor, posthumous, Chesterfield, Mass." 1983* (Eyes \42)
"Farm auction, Chariton, Iowa" 1984* (Eyes \39)
"Farm foreclosure, Flandreau, South Dakota" 1985* (Eyes \40)
"Foreclosed farmer, Iowa" 1983* (Eyes \38)
"Republican Convention, Dallas" 1984* (Eyes \41)

JACOT, Max
"The Header" c. 1991 (Graphis92 \254)

JAFFE, Stephen
"First daughter Chelsea Clinton meets her classmates on the first day of school at Sidwell Friends private school in Washington, D.C." 1993* (Best19 120)

JAGOE, Tom
"More than 2,000 women answered the casting call when ex-lead Van Halen singer David Lee Roth held auditions" 1985 (Best11 164d)

JAKOBSEN, Robert
"Private John Winbury says goodbye to his son" 1940 (Lacayo 104)

JAKSE, Barbara, and JERSIC, Stane
[nudes in chiffon] c. 1992* (Graphis93 32)

JANAH, Sunil, 1918-
"Untitled (People pouring into the streets of Calcutta after the news of Gandhi's assassination" 1948 (Marien \6.19)

JANSSEN, Pierre-César Jules
"Transit of Venus" 1874* (Marien \3.75)

JANSSENS, Alain
"Interior views of the Royal Conservatory in Liege" c. 1991 (Graphis91 \307, \308)

JAPANESE GOVERNMENT RAILWAYS
"A housewife in Beppu, Japan, boils eggs over bubbling hot springs, which also heat stoves around the town" 1942 (Through 158)

JAPARIDZE, Misha
"A relative weeps as she sits on the bed in a Chechen hospital ward with an injured relative" 1995* (Best21 183b)

JAQUES, Bertha Evelyn, 1863-1941
"American Senna, *Cassia Marylandica*, South Haven River Bank" 1909 (Rosenblum \39)
"Dandelion Seeds, *Taraxacium Officinale*" c. 1910 (National \56)
"Lavender, *Lavendula Labiatae*" c. 1910 (National 133c)
"Milkweed Pods, *Asclepias Cornuti*" c. 1910 (National 133d)

JARECKE, Kenneth
"The charred body of an Iraqi soldier still clings to the side of armored personnel carrier" 1991* (Best17 9)
"Coffee mug in hand, George Bush makes small talk with diners at Couzzin Richie's truck stop" 1988* (Best14 55d)
"During the burial of three members of the outlawed Irish Republican Army, in Belfast, Northern Ireland, snipers launch a grenade and gun attack on mourners" 1988* (Best14 51)
"Elvis Lives" 1998 (Best24 192)
"Michael Dukakis searches for answers for reporters aboard his campaign bus" 1988* (Best14 55b)
"Protection takes precedence over privacy for presidential candidate Jesse Jackson on the campaign trail in Iowa" 1988* (Best14 55a)
"Pumped up?" 1988* (Best14 54b)
"Sleeping Michael Dukakis" 1988* (Best14 112a)
"The XXIV Olympiad Summer Games in Seoul boasted a record 13,000 athletes from 161 nations" 1988* (Best14 52-53)
"Under boardwalk, Coney Island" 1990 (Best16 181)
"A veteran stops by the airport in Billings to see candidate George Bush" 1988* (Best14 54a)

JARVINEN, Barry
"Baby Richard reaches back for his adoptive parents as his biological father Otakar Kirchner takes custody of the child" 1995* (Best21 179c)

JASCHINSKI, Britta
[camel] c. 1992* (Graphis93 192a)
[elephant] c. 1992* (Graphis93 192b)

JASKOL, Ellen
"Pig on Point" 1993 (Best19 180)

JEAN-BART, Leslie, 1954-
"Untitled" 1992* (Committed 135); 1996* (Committed 134)

JENKINS, Ron
"When a spring flash flood hit Fort Worth two passers-by pushed a stranded auto out of the high water" 1986 (Best12 40a)

JENNINGS, Jim
"Honolulu beachgoers stake out a place in the sand in preparation for a day in sun" 1988* (Best14 105)

JENNINGS, Stephen
"Robert Imhoff" c. 1991* (Graphis91 20)

JENSEN, Phyllis Graber
"John Bys tackles the gentle inclines of the Boston Commons, which was transformed for one day into a ski slope" 1986 (Best12 227a)

JENSHEL, Len, COOK, Diane
"517 Katonah Avenue, Charlotte, North Carolina" c. 1997* (Graphis97 152)

JERKOVICH, Roger
"To Make a Man Whole" 1996 (Best22 241b,d)

JINSONG, Wang
"Parents" 1998* (Marien \7.63)

JOACHIM, Bruno
"Black car" c. 1989* (Graphis89 \203)

JODICE, Mimmo
"Solfatara Volcano, Pozzuoli, Naples, Italy" 1990-1995 (Photography 176)

JOEL, Yale
"Jackie wannabes" 1961 (Life 114a)
"Little Leaguers" 1954 (Life 42a)

JOHNS, Carolyn
[self-promotional photograph in Queenscliff, Victoria, Australia] c. 1990* (Graphis90 \92)

JOHNS, Chris
"Admired for their genetic hardiness but reviled as pesky predators, cheetahs in Namibia prowl under the cover of night" 1999* (Through 288)
"Adrift in thought, woman nurses her baby before church" 1997* (Best23 150a)
"A barbed wire clothesline delineates a Bushman settlement in the Kalahari Desert of southern Africa" 2001* (Through 272)
"Built of moon glow and water spray, a bridge of colored light arches over the chasm at Victoria Falls" 1997* (Best23 152c)
"A Bushman of southern Africa enters a trance state and tries to rid a girl of the evil that caused her to hoard meat" 2001* (Through 264)
"Canoes based on Seminole Indian designs ply the waters of Everglades" 1994* (Through 370)
"Cowboy works 14-hour days in south-central Nevada" 1992* (Best18 71)
"The fire of dawn lights a path across Africa's Zambezi River where villagers travel in a dugout canoe" 1997* (Best23 153d)
"Giraffe feeds among fever trees in the Ndumo Game Reserve of South Africa" 2001* (Through 284)
"A hunter and his dogs search the brush for delectable cane rats in KwaZulu-Natal Province, South Africa" 2001* (Through 228)
"Inside the Big 4, a legal bordello and bar in Ely, Nevada" 1992* (Best18 72a)
"Makishi dancers in Zambia perform for a group of recently circumcised boys" 1997* (Through 258)
"A 700-foot-long footbridge bobs and sways over the Zambezi River at Chinyingi, Zambia" 1997* (Through 214)
"Village women enjoy pampering in a beauty salon near the Zambezi River" 1996* (Through 246)
"Zulu in South Africa" 1996* (Through 16)

JOHNSON, Belle, 1864-1965
"Three women" 1898 (Rosenblum \78)

JOHNSON, Brian K.
"Allison Hightshoe, the only girl on the high school soccer team, waits with three teammates for a direct free kick on their goal" 1988 (Best14 129)

JOHNSON, Bruce
"A West Philadelphia residential block goes up in flames" 1985 (Best11 24)

JOHNSON, Chris, 1948-
[Untitled Triptych] 1991 (Willis \511-\513)

JOHNSON, Clifton, 1865-1940
"Barred Door, Rocky Hill Meeting House" c. 1910 (MOMA 63)

JOHNSON, Cynthia
"George Bush at a New Jersey campaign rally in October" 1988* (Best14 111)

JOHNSON, Jason Miccolo, 1956-
"Laying of Hands: Rev. Lassiter Offers Prayers During Deacon's Ordination Service at Metropolitan Baptist Church in Washington, D.C." 1996 (Committed 136)
"You Can Burn the Building, But Not the Spirit: Rev. Larry Hill, Pastor of the Church in Charlotte, North Carolina" 1996 (Committed 137)

JOHNSON, Lynn
"Breast reconstruction" 1987 (Best13 160-161)
"A head by two feet: soaking in a health-giving pool near the Japan Sea" 1985* (Best11 160b)
"Romania's Gymnasts" 1996 (Best22 231)
"Supported by her mother, a starving child receives soy milk at the Kersey Home for Children in Ogbomosho, Nigeria" 1991* (Through 274)
"Swans prepare for flight near banks of daffodils south of Amsterdam" 1997 (Through 51)
"Triumph of the Human Spirit" 1997 (Best23 219a,c)
"A workman makes his way across the former estate of Alexander Pushkin" 1992* (Through 64)

JOHNSON, Todd
"Self-portrait" c. 1999* (Photo00 91)

JOHNSON, William
"Group of Cotton Carders" 1856 (Rosenblum2 #191)

JOHNSTON, Alfred Cheney
"Billie Burke" 1920 (Vanity 31)

JOHNSTON, Derek
"Landscape Specimen 004 (Havisu Falls)" 1996 (Marien \8.7)

JOHNSTON, Frances Benjamin, 1864-1952
"Aboard Commodore Dewey's Flagship" 1899 (Sandler 145)
"Agriculture mixing fertilizer" 1899-1900 (Women \23)
"Alice Lee Roosevelt" 1902 (Rosenblum \75)
"Class in American History" 1899-1900 (Photography1 \93)
"Cobblers Class" 1902 (Sandler 4)
"Couple at Home" 1899 (Sandler 75)
"Geography: Studying the Cathedral Towns" 1899-1900 (Szarkowski 169)
"Kohinore Mine, Shenandoah City, Pa." 1891 (Photography1 \92)

"Lower Falls of the Yellowstone" 1903 (Sandler 117c)
"Lynn Shoeworker" 1895 (Sandler 144c)
"Mark Twain" 1906 (Sandler 35)
"Measuring and Pacing" 1899-1900 (Rosenblum \61)
"Self-Portrait" 1895 (Lacayo 37; Marien \4.0; Rosenblum \49; Sandler 34c)
"Selling Tintypes at County Fair" 1903 (Sandler frontispiece and 15)
"Stairway of Treasurer's Residence, Students at Work, The Hampton Institute, Hampton, Virginia" or "Student Carpenters" 1899-1900 (MOMA 67; Rosenblum2 #443; Sandler 74; Women \22)
"Students on Field Trip" 1899 (Sandler 73)

JOHNSTON, Frank B.
"Longbow hunter draws back his trusty arrow" 1997 (Best23 167a)

JOHNSTON, John Dudley
"Liverpool–An Impression" 1906 (Rosenblum2 #368)

JOLY, John
"Arum Lily and Anthuriums" 1898* (Rosenblum2 #341)

JONES, Aaron
[ad for *Nike* products] c. 1989* (Graphis89 \230)
"Still life with colored light" c. 1989* (Graphis89 298)

JONES, Calvert Richard
"*Porta della Ripetta*, Rome" 1846 (Rosenblum2 #101)
"Young Man" late 1840s (Waking #21)

JONES, Clifton B.
"De Marco Witness" 1959 (Goldberg 9b)

JONES, Ken, 1956-
"Bull's Eye" 1995 (Willis \350)
"Family Day, Members of the Nation of Islam" 1994 (Willis \351)
"Mr. Journet's Repose, Houston" 1996 (Willis \348)
"Rough Rider, Rodeo Patron at an African American Rodeo" 1995 (Willis \349)

JONES, Leslie
"Sacco and Vanzetti put on view after being executed" 1927 (Goldberg 54)

JONES, Lou, 1945-
[from *Portraits of Death Row* series] 1992-1994 (Willis \402-405)
[illustration for *Moby Dick*] c. 1992* (Graphis93 175)

JONES, Mary Carroll
"Taylor and her baby were among hundreds of flood victims airlifted out of Guerneville, California" 1986 (Best12 70d)

JONES, Sam
"Kevin DiGiorgio national high school shot-put champion" c. 1999* (Photo00 165)

JONES, Steve
"Diane Peterson, umbrella well in hand, heads for work" 1985 (Best11 140b)

JORDAHL, Geir
[promoting tourism to Waikiki Beach] c. 1991* (Graphis91 \301)

JORDAN, Robert
"Students used everything from inner tubes to garbage can lids to take advantage of wintry weather" 1985 (Best11 187a)

JORDANO, Dave
"Winter" c. 1991* (Graphis92 \55)

JORGENSEN, Victor, 1913-
"WW II: Lunch for a kamikaze victim, burn ward, U.S.S. *Solace*" 1945 (Eyes #219)

JOSEF, Hermann
"Art paper coating machine" c. 1991* (Graphis91 \247-\249)

JOSEPH, Benny A., 1924-
"KCOH Mobile Studio, Houston, Texas" c. 1957 (Willis \223)

JOSEPHS, Alexandar
[self-promotional] c. 1989* (Graphis89 \45-\48)

JOSEPHSON, Kenneth, 1932-
"Chicago" 1970 (Decade 86c)
"Drottningholm, Sweden" 1967 (Rosenblum2 #742)
"Postcard Visit, Buffalo" 1970 (Photography2 100)
"Stockholm" 1967 (Decade \77)

JOUANNEAU, Daniel
[ad for *Parker* pens] c. 1989* (Graphis89 \231)

JOUVIN, Hippolyte
"Porte St. Denis, Paris" c. 1860 (Rosenblum2 #190)

JUMONJI, Bishin
[from a series of posters to promote artificial sweeteners] c. 1990* (Graphis90 \155)

JUSTE, Carl
"A suspect turns around surprisingly to find Officer Willy Bell in hot pursuit" 1995* (Best21 173c)

—K—

KADEN, Hans, c. 1890-1961
"Path of Light" c. 1943 (Peterson #30)

KAHANA, Menehem
"An Israeli policeman charges an ultra-orthodox protester in East Jerusalem" 1998* (Best24 16c)

KAHN, Nicholas K., SELESNICK, Richard S.
"The Black Sun" 2001* (Photography 172b)
"Luggage" 2001* (Photography 172a)
"Rider" 2001* (Photography 172a)

KALES, Arthur F., 1882-1936
"Cameo" c. 1922 (Peterson #17)
"The Forbidden Door" c. 1927 (Peterson #18)

KALISHER, Simpson, 1926-
"Untitled" 1961 (MOMA 238)

KALLMUS, Dora *see* D'ORA, Madame

KAMELHAAR, Aaron
"White king pigeons roost at a breeding farm" 1993 (Best19 77b)

KAMMERDIENER, Michael
[bird] c. 1995* (Graphis96 190)

KAMPER, George
[motorcycle and license plates] c. 1991* (Graphis92 \184)

KAMPERT, Klaus
[car, cactus and fashion] c. 1992 (Graphis93 25)
[designer's collection] c. 1991 (Graphis92 \28)

KANAGA, Consuelo, 1894-1978
"Creatures on a Rooftop" 1937 (Sandler 181)
"Fire" 1922 (Sandler 144a)
"Frances with a Flower" 1928-1930 (Sandler 44a; Women \52)
"Ghost Town, New Mexico" c. 1950s (Sandler 127)
"Girl in Straw Hat" c. 1940 (Women \51)
"Mother with Children" 1922-1924 (Rosenblum \170)
"Seddie Anderson's Farm" c. 1920s (Sandler 126)
"Snow on Clapboard" n.d. (Sandler 179)
"Tennessee Girl with Ribbon" 1948 (Sandler 44c)

KANDER, Nadav
[ad for Librex notebook computers] c. 1991* (Graphis92 \175)
"Citroën" c. 1989* (Graphis89 \88)
"Cornfield after the Harvest" c. 1991 (Graphis92 \189)
[durability and heavy duty properties of Dunham boots] c. 1991 (Graphis92 \176, \177, 208)
"Just add water" c. 1991* (Graphis91 \50)
[landscapes in Iceland] c. 1992* (Graphis93 177)
"Legs" c. 1991* (Graphis92 \248)
"Morocco" c. 1991* (Graphis91 \299)
[self-promotional] c. 1991 (Graphis92 \74)

KANE, Art
[ad for the Sunday edition of the English newspaper *Daily Mail*] c. 1990* (Graphis90 \104)

KAPLAN, Barry
"Knit Minidresses" 1967* (Life 117)

KAPLAN, Carol
[bowls and pears] c. 1992* (Graphis93 86)
[bowls, pitchers and vase] c. 1997* (Graphis97 62)
[flowers] c. 1997* (Graphis97 63)
[ice cream cones] c. 1991* (Graphis92 \77, \78)
"Nan's Shoes" c. 1999* (Photo00 47)
"Pomegranates" c. 1999* (Photo00 54)
[self-promotional] c. 1991* (Graphis91 \130)
[twin girls as dolls] c. 1991* (Graphis92 \92)

KAPLAN, John
"Age '21' in America" 1991 (Capture 164-165)
"Bodies of suspected communist sympathizers are stacked in a makeshift mortuary in the city of Davao, Philippines" 1985 (Best11 76b)
"A disabled rock 'n' roll fan gets a better view at the Monsters of Rock heavy metal concert in Pittsburgh" 1988 (Best14 23)
"An ecstatic Margaret Groos qualifies for the U.S. Olympic team by placing first in the Pittsburgh Marathon" 1988 (Best14 24)
"Ferdinand Marcos gets a cooling hand from his wife after a campaign speech" 1985 (Best11 77a)
"Fifteen seconds after fatally wounding a gunman in a downtown office building, Pittsburgh policeman is comforted by a fellow officer" 1985 (Best11 80)
"Filipino peasants re-vitalize their land by burning the husks of rice that they harvest" 1985 (Best11 74)
"High school wrestler Jim Herriot meditates before a crucial match" 1988 (Best14 22b)
"Hilda East, who won't reveal her age but admits to probably being older than the tree she's peering from" 1988 (Best14 22a)
"'I ain't no deacon,' says Mark Face, janitor and parishioner at Mount Zion Baptist Church in Pittsburgh" 1988 (Best14 17)
"Ken and Lisa Martin made sports history, winning both male and female divisions in a major race" 1985 (Best11 221c)
"A Life in the Balance" 1988 (Best14 26-27)
"Opposition continues to mount as Corazon Aquino campaigns against Marcos in her home town of Tarlac" 1985 (Best11 77b)
"Philippine Army Rangers comb the jungle of Davao del Norte in search of New People's Army communist guerillas" 1985 (Best11 76a)
"Pittsburgh police officers lead Armstrong away from the Allegheny River where his brother drowned" 1988 (Best14 24)
"Rodney's Crime" 1988 (Best14 18-21)
"Scales of Justice" 1988 (Best14 28)
"Sergei: A Child Alone" 1992 (Best18 209-212)
"Sierra Smith is the only baby ever born to a woman who had a heart transplant" 1985* (Best11 47b)
"Student protestors rush a wounded comrade along a Manila street to a hospital" 1985 (Best11 75d)
"Washable silks" 1988 (Best14 25c)

KAR, Ida, 1908-1970
"Iris Murdoch" late 1950s (Rosenblum \180)

KARAKAS, Osman
"Vidals cradles his brother, Edwardo, who was shot on a subway in Brooklyn" 1990 (Best16 102)

KARALES, James H.
"A march for integration in Selma, Alabama" 1968 (Lacayo 149)
"Marchers, Selma to Montgomery, Alabama" 1965 (Goldberg 167)

KARAS, Marlene
"Kerri nails the landing on that final vault effort" 1996* (Best22 127a)
"No words are needed as Ron Newman, coach of the San Diego Sockers, suggests officials may need glasses" 1985 (Best11 228a)

KARSH, Yousuf, 1908-2002
"Albert Einstein" 1948 (Photos 75)
"Pablo Casals" 1954 (Icons 127)
"Winston Spencer Churchill" 1941 (Icons 126; Monk #26; Rosenblum2 #728)

KARSTEN, Dirk
[self-promotional] c. 1989* (Graphis89 \53); c. 1991 (Graphis92 \30)
"Japanese Kendo fighter in a traditional outfit" c. 1991* (Graphis92 \150)

KASAHARA, Katsumi
"A 12-year-old girl was one of two persons who survived the JAL crash" 1985 (Best11 54d)

KÄSEBIER, Gertrude, 1852-1934
"Auguste Rodin" 1905 (Sandler 39)
"Baron Adolf de Meyer" 1903 (Szarkowski 173)
"Blessed Art Thou Among Women" 1899 (Marien \4.32; Sandler 50)
"Flora"(or "Portrait study," "The Velvet Mantle," "Florentine Boy") c. 1897 (Rosenblum \70)
"French Landscape" 1898 (Photography1 #V-29)
"The Garden Party" c. 1905 (National 135a)
"Gertrude and Charles O'Malley, Newport, Rhode Island: A Triptych" 1902 (Women \20)
"Gertrude Käsebier O'Malley at Billiards" c. 1909 (Women \21)
"The Heritage of Motherhood" c. 1904 (Photography1 #V-30)
"Josephine (Portrait of Miss B)" 1903 (Sandler 37)
"The Manger" 1899 (Decade \3; MOMA 84; National \68; Rosenblum \76)
"Maurice Prendergast" 1915 (Vanity 14c)
"Miss Dix" n.d. (Women \18)
"Mrs. Ward and Baby" 1903 (Goldberg 24)
"The Picture Book" 1903 (Rosenblum2 #356; Sandler 48)
"Portrait (Miss N.)" 1902 (Marien \4.33)
"Portrait of a Boy" 1897 (Sandler 38)
"Portrait of Robert Henri" c. 1900 (Rosenblum \64); c. 1907 (Rosenblum2 #387)
"The Red Man" 1903 or "Indian Portrait" c. 1905 (Peterson #3; Sandler 102a; Women \19)
"The Road to Rome" 1903 (MOMA 88)
"Robert Henri" 1916 (Vanity 14d)
"Samuel American Horse" c. 1900 (Sandler 100a)
"Silhouette of a Woman" c. 1899 (Photography1 \103)
"The Sketch" 1902 (Photography1 #V-31)
"Where there is so much smoke, there is always a little fire" c. 1906 (Sandler 52)
"Yoked and Muzzled–Marriage" c. 1915 (Sandler 53)
"Zitkala-Sa" 1898 (Rosenblum \82; Sandler 102c)

KASHI, Ed
"After fleeing war-torn Kirkuk, Iraq, Kurdish family clings to life in the ruins of a town destroyed by Iraqi forces" 1992* (Best18 122)
"America's Aging Inmates" 1997 (Best23 213)
"At the Mayo Hospital, a victim of 'wife burning' receives treatment after her estranged husband threw acid on her face" 1997 (Best23 135)
"Bedouin in Syria drill for water in the northern steppe" 1993* (Through 226)
"In a terrorist court in Turkey, Yildiz Alpodogan denies charges of belonging to the violently separatist Kurdistan Worker's Party" 1992* (Best18 115)
"Saudi visitors view a dust storm over the suburbs of Damascus, Syria" 1996* (Through 266)

KASLIN, Beat
"Lens-shaped foehn clouds over Central Switzerland" c. 1987* (Graphis89 \63)

KASMAUSKI, Karen
"Defying gravity, 85-year-old Carol Johnson pole vaults" 1997* (Best23 178c)
"For days after the Soviet Union's Chernobyl accident in 1987, reindeer herds in Sweden and Norway were showered with radiation" 1988* (Best14 159)
"'I stay right here,' proclaims 85-year-old resident of Hilton Head" 1987* (Best13 163c)
"In Niger, a family of cattle herders relies on mosquito netting to protect themselves against malaria" 2002* (Through 252)

KASTEN, Barbara, 1936-
"Architectural Site 7, 1986" 1986* (Rosenblum \16)
"Construct II-C" 1980* (Decade \XI)
"Construct PC/III-A" 1981* (Photography2 198)
"El Medol, Roman Quarry, Spain" 1992* (Rosenblum2 #791)
"Puye Cliff Dwelling" 1990* (Women \181)

KASTERINE, Dmitri
"Mary Elizabeth Johnson" c. 1991* (Graphis91 \190)

KATVAN, Rivka
"Christian Noll backstage at *Jekyll and Hyde*" 1998* (Photo00 148)

KATZMAYR, Mario
[self-promotional] c. 1990 (Graphis90 \77)

KAWACHI, Yutaka
[self-promotional] c. 1991* (Graphis91 \116-\118)

KAZIMIERAS, Linkevicius
"Richly decorated Soviet military veterans: Gordiyevsky Mitrofanovich, Krapivko Borisovich, and A. Aleksnrovich" c. 1991 (Graphis92 \96-\98)

KAZUNAGA, Seiichi
[self-promotional] c. 1990* (Graphis90 \131)

KEARL, Stan
"Vibrance of Stilled Motion" c. 1989* (Graphis89 \188-\190)

KEATS, Doug
"Ranchos de Taos Church, New Mexico" c. 1989* (Graphis89 \106-\109)

KEAY, Bill
"Rugby players reach for ball" 1987 (Best13 211a)

KEEGAN, Marcia
"Former Nun in Hotel Room" c. 1960 (Sandler 95)

KEENE, Minna, 1861-1943
"Motherhood" 1906 (Rosenblum \148)

KEENER, J. Kyle
"Bearing the Yellow Death" 1993* (Best19 176a)
"Black Magic" 1988 (Best14 97a)
"Gloomsday" 1996 (Best22 179c)
"Static Zing" 1996* (Best22 178c)

KEIGHLEY, Alexander
"Fantasy" 1913 (Rosenblum2 #367)

KEILEY, Joseph, 1869-1914
"Mercedes de Cordoba" 1902 (National 135d)
"Scene in a Garden" c. 1899 (National 135b)
"A Sioux Chief" c. 1898* (Photography1 \14)

KEISER, Beth A.
"A girl on father's shoulders waves flag at President

Clinton's helicopter" 1996* (Best22 106a)

KEITA, Seydou, 1923-2001
"Two Women" 1959 (Marien \6.13)

KEITH, Christine
"Youngstown police officer shows Jean Westveld how to aim a handgun" 1990 (Best16 109a)

KEITH, John Frank
"Baby on a Stoop, Philadelphia" c. 1925 (National 136d)
"Boys on Steps, Philadelphia" c. 1925 (National 136c)
"Two Girls on a Stoop, Philadelphia" c. 1925 (National \76)

KEITH, Perry A., active 1900-1910
"Frank and George Powell" c. 1906-1909 (Willis \50)

KEITH, Thomas, 1827-1895
"Doorway, St. Oran's Chapel" 1856 (Rosenblum2 #109)
"Trees" c. 1854 (Waking #17)

KELLER, Joseph
[sunflowers] c. 1995* (Graphis96 76)

KELLEY, Bill, III
"An elderly Haitian attends mass" 1986 (Best12 26c)
"Medical mission to Haiti" 1986 (Best12 32-33)

KELLEY, Mary M.
"Cooks with good taste turn to fresh herbs for unmatched, just-picked flavor and fragrance" 1987* (Best13 186c)
"Forties Style Suits" 1990* (Best16 141a)

KELLEY, Robert W., 1920-
"March on Washington" 1963 (Monk #40)
"Waiting wives whose astronaut husbands are at launching" 1961 (Eyes #369)

KELLOGG BROTHERS
"Engine of USS Kearsarge" c. 1861 (National \21)

KELLY, Andrew T., c. 1890-1965
"The Junior Matrons" c. 1928 (Willis \92)
"Tea Time with Holmes Family" c. 1935 (Willis \91)

KELLY, Angela, 1950-
"Monica in Her Bedroom" 1986 (Rosenblum \209)

KELLY, Thomas J., III
"Calvin Spence, whose 350-acre farm straddles the North Carolina-Virginia border, looks over his drought-damaged peanut crop" 1986 (Best12 37a)
"Tragedy on Sanatoga Road" 1978 (Capture 106)

KELSEN, Don
"It may be only T-ball, but for these Little Leaguers it's as tough as the 'Bigs'" 1986 (Best12 192)
"Teachers obviously want more volume from the school choir" 1986 (Best12 118a)

KELSEY, Thomas
"Photographers scurry to greet the President at Los Angeles during Christmas" 1985 (Best11 4)

KELSH, Nick
"An arsonist's fire destroyed virtually the entire industrial area of Passaic" 1985 (Best11 98d)
"Eugene White finds shelter and prayer at the New Life Institute" 1988* (Best14 102a)

KEMMLER, Florence B., 1900-1972
"The Trapeze Act" 1928 (Rosenblum \159)

KEMP, Kenny
"It was a highly charged murder trial in Charleston, " 1987 (Best13 68d)

KEMPADOO, Roshini, 1959-
"Colonised #2" 1993 (Willis \565)
"Colonised #3" 1993 (Willis \564)
"ECU. European Currency Unfolds" 1992* (Willis \489)
"Untitled" n.d. (Willis \563)

KEN, David
[from an article describing fashion styles from the 1920s to 1950s] c. 1989* (Graphis89 \57)

KENDALL, Marie Hartig, 1854-1943
"Haycocks with Haystack Mountains" c. 1890 (Rosenblum \56)

KENDRICK, Robb
"Dr. Michael De Bakey, pioneer heart surgeon" 1990* (Best16 79b)
"A pipeline carrying water to a wealthier suburb of Bombay goes through part of town where poor residents must share public spigots" 1998* (Through 166)
"Polio victims at Binzhou Medical College in China" 1990* (Best16 195)
"Sumo wrestlers in Nigata, Japan, parade in pre-tournament ceremony" 1997* (Through 184)

KENNEALLY, Brenda A.
"Andy Vasquez dreams of a basketball scholarship so he can go to college" 1997 (Best23 166a)
"Destiny, 4, waits for her parents to come in from smoking a 'blunt' in the hall" 1997 (Best23 250)
"Junior" 1997 (Best23 256)
"Off Broadway" 1997 (Best23 136c, 242-244)
"One of the last holdouts at one of the few remaining squatter camps under Miami's Highway 395" 1996 (Best22 217c)

KENNEDY, David Michael
"Deborah Harry" c. 1990* (Graphis90 \144)

KENNEDY, Winston, 1944-
"Uncle Johnny in Bridgeton, New Jersey" 1980 (Willis \230)

KENNER, J. Kyle
"The clown prince of baseball, Max Patkin, throws dirt in his face to get a laugh during a minor-league game" 1987* (Best13 190a)

KENNERLY, David Hume, 1947-
"Ford and Secretary of State Kissinger conferencing in Oval Office" 1976 (Eyes #267)
"President Bill Clinton reacts to the tragic crash of TWA flight 800" 1996 (Best22 106c)
"President Ford being photographed by Richard Avedeon" 1976 (Eyes #264)

"President Ford meeting with Emperor Hirohito of
 Japan" 1976 (Eyes #265)
"Vietnam–Lone U.S. Soldier" 1971 (Capture 78)
"While the First Lady recovered from a mastectomy,
 daughter Susan accompanied the President to a
 reception at the White House" 1974 (Life 32)

KENNEY, James
 "Dumped by his mount during National Rodeo
 Finals"1986 (Best12 220)
 "Topsy Swain, a Paiute Indian, is one of the few
 remaining elders on Arizona's Hualapah
 Reservation" 1986 (Best12 164a)

KEPES, Gyorgy, 1906-
 "Shadow of a Policeman" 1930 (Waking #195)
 "Untitled" 1939 (San \16); 1948 (Photography2 34)

KEPLER, Victor
 "A Little Glass Tube" 1938 (Goldberg 69)

KER-SEYMER, Barbara, 1905-after 1986
 "Nancy Cunard" c. 1930 (Rosenblum \130)

KERESZTES, Lajos
 [from book *Pro Art–Magic Moments*] c. 1990*
 (Graphis90 \109)

KERLEE, Charles
 "A Douglas SBD Dauntless dive bomber over Wake
 Island" 1943 (Lacayo 106c)

KERN, Geof
 "The Art of Fashion–advertising for Neiman Marcus"
 c. 1995* (Graphis96 38-39)
 "The Machos" c. 1990* (Graphis90 \143)
 [Maid ironing at the side of the highway] c. 1995*
 (Graphis96 151a)
 [Partial view of model with jewelry and handbags] c.
 1997* (Graphis97 20-25)
 [Rose and Mirrors] c. 1997* (Graphis97 14)
 "The Victim" c. 1990* (Graphis90 \142)

KERS, Martin
 "The Celts offered sacrifices to one of their gods
 under this cross" c. 1989* (Graphis89 \73)
 "19th century castle" c. 1989* (Graphis89 \70)
 "On All Saints' Day in Plougastel Daoulas, a mass is
 held for the dead" c. 1989* (Graphis89 \71)
 "On All Saints' Day in Plougastel Daoulas, graves are
 decorated" c. 1989* (Graphis89 \72)

KERTÉSZ, André, 1894-1985
 "Afternoon Constitutional of M. Prudhomme,
 Retired" 1926 (Waking #167)
 "Anne-Marie Merkel" 1926 (Art \250)
 "At Zadkine's Studio" 1926 (Art \253)
 Carrefour Blois 1930 (Rosenblum2 #508)
 Chez les marchands d'avenir 1929 (San \23)
 Chez Mondrian 1926 (Art \249)
 "Distortion No. 4" 1933 (Rosenblum2 #498)
 "Distortion No. 6" 1932 (Hambourg \64)
 "Distortion No. 102" n.d. (Marien 5.29)
 "Distortion No. 141" 1933 (Art \258)
 "Dubo, Dubon, Dubonnet" 1934 (Hambourg \30)
 "Eiffel Tower, Paris" 1929 (Hambourg \10)
 "Etienne Béothy, A Satiric Dancer" 1928 (Art \254)
 "Fork" 1928 (Art \251; Hambourg \113; Icons 31)
 "The house of silence" 1929 (Lacayo 77)
 "John Szarkowski" 1963 (MOMA 39)

"Melancholic Tulip" 1939 (Art \257)
"Meudon" 1928 (Marien \5.30)
"Mondrian's Glasses and Pipe, Paris" 1926 (Art \252)
"Mondrian's Studio" 1926 (Art \248)
"Montmartre" 1926 (Szarkowski 222)
"Railroad Station, Poughkeepsie, New York" 1937
 (Hambourg \23; MOMA 158)
"Satiric Dancer" 1926 (Art \255; Rosenblum2 #507)
"Swimmer Under Water" 1917 (Icons 30)

KESSEL, Dmitri, 1902-
 "The coffin bearing the body of Winston Churchill is
 borne slowly down the aisle of Saint Paul's
 Cathedral in his funeral ceremony" 1965* (Eyes \6)
 "Henri Matisse, at his studio in Nice, France" 1950
 (Life 169)
 "Soviet soldier, off duty" 1948 (Lacayo 111)
 "Wushan Gorge, China" 1946 (Life 182)

KESTING, Edmund, 1892-1970
 "Frau G. Kesting" 1930 (Rosenblum2 #496)
 "Kennwort: Kulturerbe" 1933 (San #30)
 "Sun of the Midi" 1928 (Hambourg \62)

KETCHUM, Robert Glenn
 "December 20 /3:30 p.m" 1983* (Photography 182)

KEYSTONE VIEW COMPANY
 "Franklin Delano Roosevelt and family" 1932
 (Vanity 166)
 "Ghostly glimpse of wounded Belgians in hospital,
 Antwerp, Belgium" c. 1914-1918 (Eyes #43)
 "Repairing field telephone lines during a gas attack at
 the front" c. 1914-1918 (Eyes #44)

KHALDEI, Evgenii, 1917-
 "The Reichstag" or "Raising of the Hammer and
 Sickle over the Reichstag" 1945 (Icons 99; Marien
 \5.87; Rosenblum2 #601)
 "The Sea of War. Arctic Ocean" 1941 (Icons 98)

KHANH, Vo Anh
 "U Minh Forest, CA Mau" 1970 (Marien \6.76)

KHAREM, Omar, 1927-
 "On the Beat" 1966 (Committed 138)
 "Shadows" 1968 (Committed 139)

KICHERER, Christoph
 [for an article on Borek Sipek and his furniture] c.
 1990* (Graphis90 \216)

KIEFER, Anselm, 1945-
 [cover from *Brünhilde Schläft*]1980 (Photography2
 168)
 "Siegfried's Difficult Way to Brünhilde" 1988*
 (Marien \7.4)

KIESS, Stefan
 "The Henninger Tower in Frankfurt am Main" c.
 1991 (Graphis92 \217)
 "Image Folder Isoge" c. 1999 (Photo00 14, 16)

KILBURN, William Edward, active 1846-1862
 "The Great Chartist Meeting at Kennington
 Common" 1848* (Art \19; Marien \2.29;
 Rosenblum2 #331)

KILCULLEN, Justin
 "Children in kindergarten and victims of famine in

North Korea" 1997* (Best23 139d)

KILLIP, Chris, 1946-
"Helen and Her Hula Hoop" 1983 (Photography 55)
"Mr. John Moore, Ballalonna, Isle of Man" 1969-1973 (Art \392)
"Portrait" n.d. (Art \391)
"Swans, Cass-ny-Hawin, Santon, Isle of Man" 1969 (Art \396)
"Untitled" 1987 (Szarkowski 289)
"Youth on Wall, Jarrow" 1976 (Art \395)

KILMER, Malinda
"The Swimmer" c. 1999 (Photo00 82, 83)
"Tattoos: Human Canvas" c. 1999* (Photo00 108)

KIM, Intae
"Death Valley at Dawn" c. 1992* (Graphis93 174a)
"Dream in the Desert" c. 1992* (Graphis93 174a)
"Light of Symphony" c. 1992* (Graphis93 174b)

KIM, Yunghi
"Deadly Road Home" 1996 (Best22 36-41)
"Forgotten Women: Comfort Women" 1996 (Best22 30-35)
"A girl proudly displays her family's dinner in the Dominican Republic" 1992 (Best18 72b)
"Janet Smith waits to pay respects to Sec. of Commerce Ron Brown as he lies in state at the commerce building" 1996 (Best22 28c)
"Kang Hae Jung of South Korea still doesn't know what blinded her forever" 1996 (Best22 28a)
"Overthrowing a Dynasty" 1998 (Best24 20-21)
[portraying the real struggle to oust the corrupt Suharto government in Indonesia] c. 1998* (Photo00 73)
"Rev. Pastorius of St. Peter and Paul Church walks past 19th century monastery" 1996 (Best22 22d)
"A Somali woman drinks from a kettle provided at refugee camp in Kenya" 1992* (Best18 68)
"A young boy clings to his parents as he waits to cross the border in Rwanda" 1996 (Best22 29)

KIMBALL, Myron H., active 1860s
"Emancipated Slaves" 1863 (Waking #103)

KIMBEI, Kusakabe
"Geisha Resting" c. 1885 (Marien \3.84)
"New Year Drill of Japanese Fire Brigade" c. 1890 (Rosenblum2 #194)

KIMMICH, John
"A Basque rural sport 'Lelanta Piedras' lifting heavy granite stones" 1998 (Best24 60b)
"Running of the bulls, Pamplona" 1997 (Best23 171a); 1998 (Best24 74a)
"With the sword stuck in its back, the bull has just moments to live" 1997 (Best23 171c)

KINEO, Kuwabara
"Scene at a Fair" 1936 (Rosenblum2 #461)

KING, Kit
"Horses and riders careen down Suicide Hill into the Okanogan River" 1986 (Best12 221)
"Wee Davina" 1986 (Best12 184-187)

KINMONTH, Rob
"Lou Duva" c. 1990* (Graphis90 \124)

KINNEY, Barbara
"Israel's Yitzak Rabin, Egypt's Hosni Mubarak, Jordan's King Hussein and President Bill Clinton adjust their ties before signing the Middle East peace accord while P.L.O. Yassir Arafat waits" 1995 (Best21 178a)

KINNEY, Dallas
"Migration to Misery" 1969 (Capture 68, 69)

KINSEY, Darius, 1869-1945
"Felling a Fir Tree, 51 Feet in Circumference" 1906 (MOMA 75)
"Self-Portrait" 1914 (MOMA 10)

KIRA, Hiromu, 1898-1991
"Curves" c. 1930 (Peterson #35)
"Study, Paperwork" 1927 (Peterson #34)

KIRBY, David
"Untitled (AIDS patient)" 1992* (Marien \7.97)

KIRCHNER, Stefan
"Kettle" c. 1991* (Graphis92 \153)
[small windows] c. 1992* (Graphis93 137)

KIRK, Malcolm
"Inhabitants of Papua, New Guinea" c. 1991* (Graphis91 \179-\182)

KIRK, Ted
"Doing the 'twist' during a wrestling match" 1987 (Best13 222)
"Freshly-painted feed wagons are arranged outside Nebraska State Fair dairy barn in Lincoln, awaiting start of activities" 1985* (Best11 47a)

KIRKLAND, Charles D.
"Cutting Out" c. 1895 (Photography1 #III-15)

KIRKLAND, Douglas
"Kathleen Turner" 1985* (Life 90b)

KIRKLAND, Wallace
"An old woman in an Indiana poorhouse" 1952 (Lacayo 154)

KIRKSEY, Gary Jackson, 1955-
"Kirksey Sisters, Claudia May, 86, and Caressa, 80" 1997 (Committed 140)
"The Terrells, Andrew and Veetta" 1996 (Committed 141)

KIRN, Jonathan
"Infielder Mark Gunther is late with his tag as he tries to catch Darren Tyson" 1985 (Best11 200)

KIRSCHBAUM, F. J.
"Cannibals undergo bloody and dangerous trial initiation rites near the Septik River in Papua, New Guinea" 1929 (Through 434)

KIRSCHBAUM, Jed
"Three months after the tragedy, the remains of the astronauts are brought to Dover Air Force Base in Delaware" 1986 (Best12 13c)

KIRSTEL, M. Richard
[from *Water Babies*] 1976 (Rosenblum2 #761)

KIRTLEY, Michael and Aubine
"Stilt dancers rest after a performance in Côte
d'lvoire" 1982* (Through 260)

KISCHNICK, Sergej
[from fashion collection of Augostino Nori] c. 1990
(Graphis92 \10)
"Polish author and film director Zbigniew Tczinski"
c. 1991 (Graphis92 \139)

KITAGAKI, Paul, Jr.
"Body of one of the estimated 10,000 persons who
died in the second earthquake" 1985 (Best11 8d)
"Chinese shoe factory and workers" 1997* (Best23
210a,c)
"Relatives weep at the funeral of a quake victim"
1985 (Best11 13c)
"A woman waiting for news of relatives reacts to the
smell of death" 1985 (Best11 12a)

KJELLSTRAND, Torsten
"Built on Love: the story of one family" 1995 (Best21
54-55)
"Cheerleaders in Jasper" 1995 (Best21 52-53)
"The Kahle Brothers" 1995 (Best21 46-51)
"The people of Jasper, Indiana" 1995 (Best21 36-45)
"The sign at the pool entrance says to shower before
entering the pool" 1995 (Best21 232)

KLEIN, Dieter
"Wooden kitchen utensils" c. 1991* (Graphis92 \65,
\66)

KLEIN, Irwin, 1933-1974
"Minneapolis Fire" 1962 (MOMA 244)

KLEIN, Reinhard
"Automobile rally in Kenya with two Masai
tribesmen" c. 1987 (Graphis89 \239)

KLEIN, Steven
"The Big Game" 1989* (Graphis89 \7)
[from feature in *Vogue*] c. 1991* (Graphis92 \21)

KLEIN, William, 1928-
"Broadway and 103rd" 1954 (Goldberg 137)
"Garment Center" 1954 (Rosenblum2 #673)
"Gun, Gun, Gun, New York" 1955 (MOMA 219)
"Heads, New York" 1954 (Icons 121)
"Moscow Beach" or "Moscow" 1959 (MOMA 224;
Szarkowski 256)
"Stickball Dance" 1954 (Decade \65)
"Swing and Boy and Girl" 1954 (Marien \6.43)

KLEINMAN, Kathryn
[apricots] c. 1989* (Graphis89 \318)
[canapes] c. 1989* (Graphis89 \314-\317)
[corn] c. 1989* (Graphis89 \321)
[eggs] c. 1989* (Graphis89 \313)
[fish] c. 1989* (Graphis89 \319)
[from a book entitled *On Flowers*] c. 1989*
(Graphis89 \26; Graphis90 \302)
[from a book entitled *Les Immortelles: Everlasting
Blooms*] c. 1995* (Graphis96 2, 82-83)
[from a cookbook entitled *Fruit*] c. 1990* (Graphis90
\321-\324)
[lemon] c. 1989* (Graphis89 \318)
[limes] c. 1989* (Graphis89 \312)
[mussels] c. 1989* (Graphis89 \320)
"Wall flower" c. 1991* (Graphis91 \114)

[Waterford Crystal] c. 1991* (Graphis92 \87)

KLEPITSCH, Jim
"Gary Dotson faces the press after his release" 1985
(Best11 93a)

KLETT, Mark
"Making coq au vin near the site of Smithson's Spiral
Jetty, Salt Lake" 2000* (Photography 173b)
"Tracks on Arid Land, Coral Sand Dunes, Utah"
1984* (Decade \XII)
"Viewing Thomas Moran at the source, Artist's Point,
Yellowstone" 2000* (Photography 173a)

KLOPPENBURG, Guy
"Bowden's Cabin, Hyde County, North Carolina" c.
1991* (Graphis92 \191)
[bowling alley] c. 1997* (Graphis97 157)
[restaurant] c. 1997* (Graphis97 156a)
[small general store] c. 1997* (Graphis97 156d)
[swimming pool] c. 1997* (Graphis97 157b)
['39 Ford, Beaufort County, North Carolina] c. 1991*
(Graphis92 \190)

KLUCSIS, Gustav, 1895-1944
"Electrification of the Entire Country" 1920 (Marien
\5.6)

KLUM, Mattias
"From toenails to tail, the Asiatic elephant feeds 18
hours a day" 1997* (Through 201)
"In northeastern Thailand, a man-snake encounter
amuses villagers and tempts them to buy snakebite
remedies" 2001* (Through 182)
"Staying alert, a meerkat keeps watch while its group
mates forage in the Kalahari Desert" 2002*
(Through 278)

KLUTE, Jeanette
"American Copper Butterfly" c. 1954 (Sandler 133)

KNIGHT, Nick
"Cut to pieces" c. 1995* (Graphis96 44)
[for a fashion catalog] c. 1990* (Graphis90 \30, \138)
[from *The Body Is Back*] c. 1995* (Graphis96 46-47)
"Sweet Dreams" c. 1995* (Graphis96 58-59)
[woman with necklace] c. 1997 (Graphis97 27)

KNOPP, Peter
"Strike at the Lenin Shipyards" 1980 (Photos 148)

KNOTE, Keba, 1966-
"Angel Boy" 1997* (Willis \473)
"Semion" 1998* (Willis \474)

KNOTT, Franklin Price
"The Poetry of Motion and the Charm of Color" c.
1916 (Eyes #71)

KNOTT, Janet, 1952-
[Death in the streets of Port-au-Prince in pre-election
violence] 1987 (Best 22-23)
"Lornardi, with the AIDS Action Committee, helps
his friend who went to the Deaconess Hospital in
Boston for treatment" 1985 (Best11 29b)
"Palestinian refugees in Baqaa camp in Jordan line up
outside the food distribution center for weekly
provisions" 1987 (Eyes #357)

KNOX, David
"Mortar Dictator, in Front of Petersburg" 1864
(Photography1 #IV-4)

KNUDSEN, Knud
"Torghatten, Nordland" c. 1885 (Rosenblum2 #126)

KNYSZEK, Steven E.
Spondylus Princeps–Pacific Thorny Oyster" c.
1999* (Photo00 234b)
Strombus Listeri–Lister's Conch" c. 1999* (Photo00
234a)

KOÇASLAN, Sinan
[self-promotional] c. 1989* (Graphis89 \284)

KOCHANIEC, George, Jr.
"Columbine" 1999* (Capture 194, 195b)

KODEY, Wayne C.
"Heavyweight Larry Holmes getting psyched by
trainer in fight with Michael Spinks" 1985 (Best11
215b)

KOELZER, Jay
"Buffalo Spring" 1992* (Best18 170b)
"Catholic Food" 1993* (Best19 178b)
"Neverending deadlines" 1992* (Best18 169)
[sexual harassment in school] 1993* (Best19 171)
"Swimmin' with the fish" 1992* (Best18 166d)
"Wish I Were Beautiful" 1993* (Best19 174b)

KOENIG, Glenn
"In Santa Ana, Calif., a police officer responds to a
silent alarm, and waits to see if anyone's inside a
closed gun shop" 1985 (Best11 82b)
"A single-engine airplane is silhouetted against the
setting sun" 1986 (Best12 56d)

KOHANIM, Parish
[ad for a flooring product] c. 1992* (Graphis93 67)
[flowers] c. 1991* (Graphis92 \62, \67)
[self-promotional] c. 1990* (Graphis90 \326)

KOJIMA, Tak
[bathing suit in neon colors] c. 1992* (Graphis93 43)

KOLESA, John
[very close and personal portraits] c. 1991
(Graphis92 \127)

KOLFF, Sicco
[self-promotional] c. 1989* (Graphis89 \305)

KOMENICH, Kim
"Aquino takes the oath of office as president of the
Republic of the Philippines" 1986 (Best12 23c)
"Ferdinand Marcos Takes a Fall" 1986 (Capture 145)
"A Marcos loyalist is kicked down a street by Aquino
supporters after Marcos fled" 1986 (Best12 20a)

KON, Michiko
"Dress of Peas" 1994 (Rosenblum2 #768)

KOOISTRA, Blair
"Football coach emotes in response to a delay-of-
game call against his team" 1985 (Best11 230a)
"Cross-country runners struggle over the top of 'Goat
Hill'" 1993 (Best19 142b)

KORDA, Alberto, 1928-
"Che Guevara" 1960 (Icons 143; Photos 91)
"Quixote Atop Lamppost, Havana" 1959 (Icons 142)

KOREN, Zio
"A year after the assassination of Israeli Prime
Minister Yitzhak Rabin, people gather to light
candles at the site of the incident" c. 1996*
(Graphis97 54)

KORNISS, Peter
"The Vials' home in County Donegal, Ireland" 1991*
(Best17 68)

KORTH, Fred G. 1902-1982
"Galvanized Sheets" c. 1948 (Peterson #46)

KOSMICKI, Ed
"U.S. Congresswoman Pat Schroeder gets tear wiped
away by husband, Jim, just after she announced she
would not be running for the Democratic
nomination of president" 1987 (Best13 55a)

KOSTIN, Igor
"Chernobyl Fetus" 1990* (Best16 146)

KOTHARI, Sanjay
"Annaliese" c. 1999* (Photo00 36)
"Maline Looking Down" c. 1999* (Photo00 38)
"Melissa–Beauty" c. 1999* (Photo00 39)
"Melissa on Chair" c. 1999* (Photo00 37)

KOUDELKA, Josef, 1938-
"Czechoslovakia" 1968 (Icons 167)
"Rumania" 1968 (Rosenblum2 #717)
"Transylvania" 1999 (Photography 175)
"Velka Lomnica, Czech." 1966 (Szarkowski 295)

El KOUSSY, Mohammad Rachad
"Sadat: The parade of death" 1981 (Eyes #353)

KOZAK, Richard
"Midshipmen at Annapolis Naval Academy" 1990*
(Best16 182)
"Robert Penn Warren, America's first poet laureate,
outside his studio/home in Connecticut" 1986*
(Best12 104b)

KRAFFT, Maurice
"Eruption of the Krafla, Iceland" c. 1990* (Graphis90
\100)

KRAFT, Annalisa
"U.S. jumper Jennifer Innis takes a broad jump at the
Pan-American Games" 1987 (Best13 219)

KRAL, Jon
"Florida cracker house is poised on the crest of a
bridge while being towed" 1985 (Best11 159)
"Florida state high school champion does a one and a
half with a twist from the high dive springboard
during practice" 1987 (Best13 221a)
"An Israeli settler and his son walk away from a
roadblock set up to keep Palestinians away from
the area where a young Israeli girl was shot in the
Israeli-occupied territories" 1988 (Best14 78d)
"Miami Gangs" 1988 (Best14 188-189)

KRAMER, David
[from a calendar] c. 1989* (Graphis89 \68)

KRANTZ, Jim
"Advertising photograph" c. 1989* (Graphis89 \175)
[from ad for a book on the good life in Nebraska] c.
1991* (Graphis91 \100)
"Rope" c. 1991* (Graphis91 \99)
"Union Pacific Railroad prototype model" c. 1991*
(Graphis91 \102)

KRASEMANN, Stephen J.
"Coming down from a tree with the remains of a kill,
leopard heading for the bush" 1985* (Best11 153b)
"In Ngorongroro Crater, Tanzania, a flock of
crowned cranes take flight" 1985* (Best11 153b)

KRATOCVIL, Antonin
"Old lumberjack in Sakhalin is rallying the Cossacks
to keep the Kuriles Russian" 1992 (Best18 65)

KRATZER, Brian W.
"A farmstead lies nestled in snow-rimmed hills"
1996* (Best22 189d)

KRAUS, René
"Political portraits in *Münchner Illustrierte Presse*"
1929 (Lacayo 70)

KREITER, Suzanne
"Caring for Special Adults" 1991 (Best17 91-96)
"Mentally retarded adults, residents of a home play
basketball in neighborhood park" 1991 (Best17
198a)

KREMENTZ, Jill, 1940-
"E. B. White" 1976 (Rosenblum \198)

KRETSCHMER, Anneliese, 1903-
"Head of a Young Woman" c. 1930 (Rosenblum
\118)

KRETSCHMER, Hugh
"Gastronopolis #2" c. 1999* (Photo00 4)
"Gastronopolis #3" c. 1999* (Photo00 203)
"Gastronopolis #5" c. 1999* (Photo00 112)
"Gastronopolis #8" c. 1999* (Photo00 113)
"Morning Glory" c. 1999* (Photo00 30)
"Stepping Out" c. 1999* (Photo00 31)
"Tulip" c. 1999* (Photo00 210)
[untitled] c. 1992* (Graphis93 202)
[*Utah Business* magazine] c. 1999* (Photo00 135)

KRIEWALD, Jürgen
"The Anglophile character of the Fall/Winter
Collection by McGregor" c. 1991* (Graphis91 \54)

KRIMS, Les, 1942-
"Homage to the Crosstar Filter Photograph" 1971*
(Rosenblum2 #764)
"A Marxist View; Bark Art; Bark (for ART PARK)
Irving's Pens; A Chinese Entertainment; and
Brooklyn: Another View" 1983* (San \58)

KRIST, Bob
"In a land of volcanoes, earthquakes and glaciers,
Icelanders survive and prosper" 1987* (Best13
95b)

KRISTOF, Emory
"Bearded in rust, the prow of R.M.S. *Titanic* rests
two and a half miles below the surface of the North
Atlantic" 1991* (Through 404)

KRONE, Hermann
"Nude Study" c. 1850 (Rosenblum2 #249)
"Still Life of the Washerwoman" 1853 (Rosenblum2
#259)
"Waterfall in Saxon Switzerland" 1857 (Rosenblum2
#123)

KRONLUND, Andrea Davis, 1965-
"Eye No See, Jamaica" 1989 (Committed 142)
"Hairpiece #5 (Jamika-Dreads)" 1994 (Committed
143)

KRUEGER, Catharine
"After being arrested [at an anti-apartheid rally] one
of the protesters peers through the smashed window
of a sheriff's bus" 1986 (Best12 54b)
"Hale and King put on makeup before performing
with New Frontier Gunfighters" 1987 (Best13 4)
"Mark Bradshaw is upward bound in his one-meter
springboard dive at the McDonald's International
Diving Championship" 1988 (Best14 137b)
"Miami Heat head coach Ron Rothstein is in the
center of attention at the team's first day of rookie
camp" 1988 (Best14 137a)
"Ready to Ride" 1988 (Best14 138-139)

KRUGER, Barbara, 1945-
"Everything will be okay/Everything will work
out/Everything is fine" 2001* (Photography 171)
"Use only as directed" 1988* (Rosenblum \26)
"You Get Away with Murder" 1987* (Rosenblum2
#746)
"You substantiate our horror" 1983 (Photography2
223)

KRULL, Germaine, 1897-1985
"La Cinéma Paramount" c. 1935 (Women \97)
[cover of *Metal*] 1928 (Marien \5.16)
"Eiffel Tower" 1928 (Hambourg 95)
"Fairs" 1928 (Eyes #110)
"Iron-Work, Pont à Mousson" 1926 (Women \101)
"No. 37 from the book *Metal*" 1927 (Rosenblum
\112)
"Nude" c. 1926 (Women \99)
"Traffic in Paris" 1926 (Women \98)
"Untitled" c. 1929 (Women \100)

KRULWICH, Sara
"800 homeless men sleep on the drill floor in
Brooklyn's Franklin Street Armory on winter
nights" 1986 (Best12 70a)
"Mary Beth Whitehead and husband Richard await
start of press conference the day following negative
court ruling" 1987 (Best13 14)

KRUPA, Charles
"President Clinton sits in his car after arriving at
Martha's Vineyard" 1998 (Best24 17)

KRYGER, Matt
"Living with death" 1995* (Best21 196)

KRZYZANOWSKI, Michel Szulc, 1949-
"The Great Sand Dunes" 1979 (San \63)

KUBLY, Jon
"*Honda* motorcycle" c. 1989* (Graphis89 \200)

KUBUS, James W.
"A deaf child hears for the first time" 1993* (Life 18)

KÜHN, Heinrich, 1866-1944
"The Artist's Umbrella" c. 1908 (Rosenblum2 #400; Szarkowski 153; Waking #152)
"Flowers in a Bowl" 1908-1910* (Art \175; Waking #132)
"Lotte and Edeltrude" c. 1908* (Art \176; 177)
"Miss Mary and Edeltrude Lying on the Grass" c. 1910* (Waking #131)
"Miss Mary and Lotte (?) at the Hill Crest" c. 1910* (Waking #130)
"Mother and Children on the Hillside" 1905* (Rosenblum2 #349)
"On the Hillside (A Study in Values)" before 1910 (Marien \4.9; Waking #129)
"Untitled" c. 1909-1912 (Art \174)

KULISH, Kim
"Dodger teammates hoist Orel Hershiser after he pitched a four-hitter to help Los Angeles win the World Series" 1988 (Best14 12a)
"In Livingston, Alabama, one of the poorest areas in the South, Arthur Watson stares through his screen door" 1986 (Best12 158)

KUNHARDT, Amelia
"In Rome, a woman brings flowers and cat food to a grave in Protestant cemetery" 1998 (Best24 40a)

KUNZ, Wolfgang
"Lebanon, Armenians in Anjar" c. 1989* (Graphis89 \257)

KUPREJANOV, Vladimir
"The lights of day extinguished" 1985 (Marien \7.22)

KURODA, Paul
"Cheryl Migriel chats with Derek Ramon while he studies in this dormitory room at Sherman Indian High School in Riverside" 1990* (Best16 31)
"Consumer Advocate David Horowitz demonstrates his grocery-shopping tips" 1990* (Best16 32a)
"Death of people trying to cross into California" 1990* (Best16 36)
"Five trumpet players provide the only live music for commencement" 1986 (Best12 171)
"A golfer loses his hat, but the game goes on" 1986 (Best12 224)
"Hispanic immigrants trying to cross into California" 1990* (Best16 33-35)
"Karen Miner of Orange, Calif. expresses the joy of quadruplets" 1990* (Best16 27)
"The president and four former presidents gather for the opening of the Nixon Library in Yorba Linda, Calif." 1990* (Best16 28)
[series on Vietnamese gangs] 1990 (Best16 81-88)
"Sharon Smaldino waits in her car for emergency units in Anaheim, Calif." 1990* (Best16 39d)
"Vietnamese gang leader Michele Nguyen receives a light in a café in Westminster, Calif." 1990* (Best16 29c)
"A young man cruises Hollywood Boulevard in California" 1990 (Best16 30)

KURTZ, Nicola
"Texas Dustbowl" 1996 (Best22 238c,d)

KUWABARA, Shisei, 1936-
"Untitled (People affected by 'Minamata Disease')" 1972 (Marien \6.26)

KYLE, Lisa
"M. Shropshire has fond memories of her brother who was Passaic's first African-American soldier to die in World War II" 1996* (Best22 211b)

—L—

La BROSSE, Celeste
"Giraffes at the London Zoo" 1986 (Best12 133a)

LÁBADY, István
[beach cabins] c. 1995 (Graphis96 162b)
[beach grasses] c. 1995 (Graphis96 162a)

LABROT, Syl, 1929-1977
"Untitled" c. 1960* (Photography2 41)

LaCHAPELLE, David
"Prince Naseem Hamed, world featherweight boxing champion" c. 1999* (Photo00 161)

LACHINIAN, Garo
"Snow dusts the Anderson Memorial Church in Webster, N.H., on a frosty January morning" 1987 (Best13 165d)

LACOMBE, Brigitte
"Anna Sui" c. 1997 (Graphis97 128)
"Michelle Pfeiffer" c. 1995 (Graphis96 116c)

LACHOWICZ, Andrzej
"Myself as . . ." 1976* (Rosenblum2 #740)

LADGEGOFED, Joachim
"Boys play in a ditch along road to the airport outside of Tirana, capital of Albania" 1998 (Best24 2)

LAHDESMAKI, Markku
[advertising for Nintendo] c. 1995* (Graphis96 78)

LAI, Afong
"Hong Kong Island" late 1860s (Rosenblum2 #139)

LAITA, Mark
[Apple iMac] c. 1999* (Photo00 170)
"Beetle on Calla Lily" c. 1999* (Photo00 233)
"Blackspotted Moray Eel" c. 1999* (Photo00 224)
[bugs on leaves] c. 1995* (Graphis96 191a, c)
[frog on leaf] c. 1995* (Graphis96 191b)
"Golden Butterfly Fish" c. 1999* (Photo00 225)
[insect on a leaf] c. 1997* (Graphis97 187)
"Octopus" c. 1999* (Photo00 226)
[Shimano bicycle shoes] c. 1999* (Photo00 168, 171)
[snail on mushroom] c. 1995* (Graphis96 191d)
"Southern Stingray" c. 1999* (Photo00 227)

LAJCZYK, Miko
[partial nude] c. 1992* (Graphis93 27)
[shimmering blouse and hood] c. 1992* (Graphis93 37)

LAM DUC, Hien
"Iraqi Innocents" c. 1999* (Photo00 68)

LAMAA
"Family takes shelter under a bridge in west Beirut during an artillery barrage" 1985 (Best11 121a)

LAMAN, Tim
"Distinctive markings identify this denizen of the rain

picking season, applying to FSA for relief" 1938
(Fisher 24)
"Mexican migrant woman harvesting tomatoes" 1938
(Fisher 20)
"Mexican truck driver's family"1935 (Fisher 17)
"Mexican woman at the U.S. immigration station"
1938 (Fisher 25)
"A migrant agricultural worker in Holtville" 1936
(Documenting 122a)
"Migrant farm worker, Klamath County, Oregon"
1939 (Lacayo 100)
"Migrant Mother, Nipomo, California" or "Destitute
pea pickers in California, a 32-year-old mother of
seven children 'Migrant Mother'" 1936
(Documenting 16-17, 69; Fisher 26; Goldberg 92;
Icons 71; MOMA 148; Marien \5.55; Monk #20;
Lacayo 101; Photos 49; Rosenblum2 #451; Sandler
158)
"Migrants on Road" 1936 (Sandler 78)
"Migratory Cotton Picker, Eloy, Arizona" 1940
(Rosenblum \165; Szarkowski 217)
"Migratory family traveling across the desert, U.S.
Highway 70, in search of work in the cotton fields"
1937 (Fisher 13)
"Migratory Mexican field worker's home on the edge
of a frozen pea field" 1936 (Documenting 124a)
"Migratory workers from Oklahoma washing in a hot
spring in the desert" 1937 (Documenting 120a)
"A mother in California who, with her husband and
two children, will be returned to Oklahoma by the
relief administration" n.d. (Fisher 14)
"Native of Indiana in a migratory labor contractor's
camp" 1937 (Fisher 21)
"Oklahoma" 1938 (Eyes #166)
"Opening the service with a collection" 1939
(Documenting 163b)
"Passerby at the open-air meeting" 1939
(Documenting 171c)
"Plantation owner, Clarksdale, Mississippi" 1936
(Documenting 24, 25)
"Pledge of Allegiance, San Francisco" 1942
(Rosenblum \204)
"Refugee camp near Holtville" 1937 (Documenting
119b)
"Return from the open-air meeting, as seen through a
hotel lobby" 1939 (Documenting 170a)
"Revival Meeting in a Garage" 1938 (Sandler 159)
"The Road West, New Mexico" or "Desert Highway
70; the route on which many refugees cross" 1938
(Fisher 15; MOMA 147)
"Salvation Army 'lassies' at the service" 1939
(Documenting 164a)
"San Francisco" c. 1942 (Eyes #124; MOMA 170)
"San Francisco from the First Street ramp of the San
Francisco-Oakland Bay Bridge" n.d. (Fisher 53)
"San Francisco Waterfront" 1933 (Women \118)
"Selling the Easter edition of the War Cry" 1939
(Documenting 166b)
"A soldier with twelve years' Salvation Army service
preaches at the open-air meeting" 1939
(Documenting 169b)
"Spring in Berkeley" 1951 (MOMA 203;
Photography 43)
"Street Demonstration, San Francisco" 1933 (MOMA
136)
"Street Meeting, San Francisco" 1937 (Decade 38)
"Tenant farmers displaced by power farming" 1937
(Fisher 22)
"Tenant farmers who have been displaced from their
land by tractor farming" n.d. (Fisher 23)

"Torso, San Francisco" 1923 (Women \43)
"Waiting for relief checks in Calipatria" 1936
(Documenting 127b)
"Waiting for the service to begin" 1939
(Documenting 163a)
"The water supply in a squatter camp near Calipatria
is an open settling basin fed by an irrigation ditch"
1936 (Documenting 120b)
"We ain't no paupers" n.d. (Fisher 142)
"We got troubles enough without going communist"
n.d. (Fisher 143)
"White Angel bread line, San Francisco" 1932 (Eyes
#164; Goldberg 82)
"White Angel Kitchen, San Francisco" 1933 (Women
\117)
"Wife and children of tobacco sharecropper on front
porch, North Carolina" 1939 (Documenting 18c)

LANGENHEIM, William, 1807-1874, and Frederick,
1809-1879
"African Youth" 1848 (Marien \2.20)
"Eclipse of the Sun" 1854* (Marien \2.13)
"Frederick Langenheim" c. 1848 (Waking 310)
"North-East Corner of Third Dock streets, Girard
Bank, at the time the latter was occupied by the
Military during the riots" 1844 (Eyes #4;
Rosenblum2 #16)

LANGLOIS, Charles
"Taking of Sebastopol (detail)" 1885 (Marien \3.9)

LANKER, Brian
"Eva Jessye, choral director for the first Broadway
production of Porgy and Bess" c. 1991 (Graphis91
\216)
"Kevin Costner" c. 1991* (Graphis91 \199)
"Moment of Life" 1972 (Capture 82)
"Ms Coretta Scott King" c. 1991 (Graphis91 \215)
"Septima Clark, one of the heroes of the Civil Rights
Movement" c. 1991* (Graphis91 \214)

LANSNER, Erica
"A woman and her belongings are carried through
Beijing by a bicycle taxi" 1993* (Best19 126d)

LANTING, Frans Marten
"Adult Emperor Penguin searching for a chick"
1996* (Best22 188a)
"The African night gives way to another dawn"
1993* (Best19 75)
"Black egret fishing in the Okavango" c. 1991*
(Graphis92 \226)
"Bull kelp clings to the Snares Islands coastline,
hiding sea lions that prey on Snares crested
penguins" 2002* (Through 406)
"A curious skua hovers in front of the camera in the
Falkland Islands" 1987* (Best13 94d)
"An Emperor Penguin colony during a spring
blizzard" 1996* (Best22 187b)
"Flamingos in Botswana" c. 1991* (Graphis92 \225)
"The ghostly fingers of a shrinking lake reach across
the Makgadikgadi Pans of Botswana" 1990*
(Through 218)
"Lesser flamingos gather at dawn at Lake Nakuru,
Kenya" 1987* (Best13 174)
"Like an amiable group of theatergoers, crested
penguins queue up in the Snares Islands of New
Zealand" 2002* (Through 414)
"Many of the Island of Madagascar's larger animals,
such as the Aepyornis–the world's largest known

bird–disappeared in a wave of extinctions ending 500 years ago" 1987* (Best13 94a)

"A pair of black-browed albatross court in the Falkland Islands" 1987* (Best13 175b)

"Parents bowing over their chick in an Emperor Penguin greeting ritual" 1996* (Best22 184a)

"Survivors from the age of dinosaurs, chameleons abound in Madagascar, where half the world's species are found" 1987* (Best13 96d)

"The tuatara, whose name means 'dorsal spine' in Maori, grows up to two and a half feet long and lives only in New Zealand" 2002* (Through 418)

LARAGY, Jim
"Selling garden art" 1985 (Best11 186a)

LARKIN, Kevin
"New York Islander Chris Luongo and New York Ranger Adam Graves fight after tossing off their gloves" 1995* (Best21 112a)

LARRABEE, Constance Stuart, 1914-
"Fallen German soldier near Belfort, France, in World War II" 1944 (Rosenblum \173)

LARRAIN, Gilles
"A gallery of portraits of celebrities" c. 1991* (Graphis92 \122)
"Romeo and Juliet" c. 1992* (Graphis93 114)
"Sunset and Dawn" c. 1991* (Graphis92 \106)
"Uses of Enchantment" c. 1991* (Graphis92 \107)

LARSEN, Kristine
"Untitled" 1988 (Rosenblum \197)

LARSON, Bob
"Bounty hunter puts a chokehold on prisoner who pulled free from handcuffs while trying to escape" 1997* (Best23 124a)

LARSON, Frederic
"A couple from a small California town lost their son to AIDS" 1985 (Best11 31b)

LARSON, William, 1942-
[from the series *Transmissions*] 1974-1975 (Decade 86d; Photography2 131)

LARTIGUE, Jacques-Henri, 1894-1986
"*Avenue du Bois de Boulogne*" 1911 (Rosenblum2 #309)
"Bibi in Nice" 1920* (Rosenblum2 #351)
"Cousin 'Bichonade' in Flight" 1905 (Decade 16b; Marien \4.39)
"Gerda" 1937 (Photography 52)
"Grand Prix at the Automobile Club of France" 1912 (Icons 23; Waking #156)
"Paris, *Avenue des Acacias*" 1912 (Szarkowski 130)

LaRUE, Lester
"Fire captain Chris Fields cradles one-year-old Baylee Almon, killed in the bombing of the Federal Building in Oklahoma City" 1995* (Best21 170c)

LATEGAN, Barry
"Colors: A Divertimento on the Theme of Black" 1989* (Graphis89 \4, \5, \6)

LATHAN, Bill, 1937-
"Loretta Green, Veronica Redd, and Debbi Morgan,

as they appeared in *The Sirens*" 1974 (Willis \234)
"Melvina Lathan" 1974 (Willis \235)
"Phylicia Ayers-Allen, actress" 1974 (Willis \236)
"Robert and Helen Macbeth" 1979 (Willis \233)

LA TONA, Kevin
[self-promotional] c. 1989* (Graphis89 \294-\295)

LAUGHLIN, Clarence John, 1905-1985
"Birds Inside and Out" 1935 (Hambourg \109)
"The Eye That Never Sleeps" 1946 (MOMA 175)
"Fierce-Eyed Building" 1938 (Rosenblum2 #500)
"The House of the Past" 1948 (Photography 232)
"The Insect-Headed Tombstone" 1953 (MOMA 179)
"Light and Time" 1949 (Decade \44)
"The Masks Grow to Us" 1947 (Photography2 66)
"We Reached for Our Lost Hearts" 1941 (Decade 52)

LAUNOIS, John
"With elaborate good manners, hotel maids in Matsuyama, Japan, bow in farewell to a departing guest" 1960* (Through 190)

LAURENT, Michel, 1945-1975
"Torture in Dacca" 1971 (Capture 76; Eyes #363)

LAURIE, Jim
"Marvelous Marvin Hagler is hoisted high by his trainers after scoring a decisive third-round knockout against Hearns" 1985 (Best11 214d)

LAUSCHMANN, Jan
"Castle Staircase" 1927 (Rosenblum2 #506)

LAUTMAN, Robert
"Night view of the swimming pool of a Caribbean-style house designed by architect Hugh Newell Jacobsen" c. 1989* (Graphis89 \115)

LAVENSON, Alma, 1897-1989
"Calaveras Dam II" 1932 (Rosenblum \158; Rosenblum2 #538; Women \55)
"Child with Doll" 1932 (Women \53)
"Egg Box" 1931 (Women \54)

LAVIES, Bianca
"Black timber rattlesnake strikes a white-footed mouse" 1987* (Best13 96a)

LAW, Denis W.
"First snowfall of the year brought these three youngsters to one of Seattle's steepest hills" 1985 (Best11 187)

LAWLER, Louise, 1947-
[from "Slides by Night (Now That We Have Your Attention What Are We Going to Say)] 1985* (Photography2 222)

LAWRENCE, Richard Hoe (co-worker with Jacob Riis)
"Bandit's Roost" c. 1888 (Eyes #47)

LAWSON, Gary
"A motorist exits his snow-covered car during a fierce storm that dumped 10 inches of snow in one day" 1987 (Best13 173a)

LAXTON, William
[for *Vogue Paris*] c. 1991 (Graphis91 \39)

LAZI, Claudio
"Eau de Toilette" c. 1992* (Graphis93 148)

LE BLONDEL, A., active 1842-1892
"Postmortem" c. 1850 (Waking #43)

LE GRAY, Gustave, 1820-1882
"Arrival of the Body of Admiral Bruat and Flagship
'Montebello' at Toulon" 1855 (Art \90)
"Beech Tree in the Forest of Fontainebleau" before
1858 (Art \92)
"Breakwater at Sète" c. 1855 (Art \85)
"Brig Upon the Water" 1856 (Rosenblum2 #116)
"Cavalry Maneuvers, Camp de Châlons" 1857 (Art
\93, \94; Szarkowski 322b; Waking #58)
"Effect of the Sun, Normandy" 1856-1859 (Art \87)
"Forest of Fontainebleau" c. 1856 (Marien \2.69;
Szarkowski 59; Waking #63)
"The Great Wave, Sète" 1856-1859 (Art \86)
"Group near the Mill at Petit-Mourmelon" 1857
(Waking 289)
"Imperial Yacht, 'La Reine Hortense,' Le Havre"
1856 (Art \88)
"Karnak: Pillars of the Great Hall" c. 1859 (Art \96)
"Mediterranean Sea at Sète" 1856-1859 (Marien
\2.70; Waking #64)
"Pavillon Molien, Louvre, Paris" c. 1858 (Art \95)
"The Ramparts of Carcassonne" 1851 (Waking #39)
"Souvenirs du Camp de Châlons au Général Decaën"
1857 (Rosenblum2 #199)
"The Sun at its Zenith, Normandy" c. 1860 (Art \89)
"Tree study in forest of Fontainebleau" 1856 (Art \91)
"View on the Sea: The Cloudy Sky" c. 1856
(Szarkowski 110)

LE MENE, Marc
[ad for Azzaro eau de parfum] c. 1991* (Graphis91
\232)
[ad for Boucheron jewelers] c. 1991* (Graphis91
\231)

LE SECQ, Henri, 1818-1882
"Farmyard Scene, near St. Leu-d'Esserent" c. 1852*
(Marien \2.45)
"Forest Stream" c. 1850-1855 (Art \73)
"Strasbourg Cathedral" 1851 (Rosenblum2 #102)
"Tower of Kings, Rheims Cathedral" 1851 (Marien
\2.44)
"The Violin Player, Maison des Musiciens, Rheims"
c. 1851 (Szarkowski 56)
"Water Jug, engraved Glass and Pears on a Plate" c.
1862 (Art \81)
"Wooden Staircase at Chartres" 1852 (Waking #40)

LEACHMAN, Jim
"Asia's Urban Monkeys" 1998* (Best24 176-177)

leBÈGUE, René
"Académie" 1902 (Rosenblum2 #359)

LEDER, Harry, 1916-1982
"John Fitzgerald Kennedy, Jr." 1963 (Monk #43)

LEDFORD, Charles
"A Beninese boy displays a Christmas ornament he
made in school" 1991* (Best17 83)
"A Cambodian boy and his brothers play" 1991
(Best17 82b)
"A mother keeps a vigil over her sick son in a Kikwit,
Zaire, hospital" 1991* (Best17 80)

LEDRU, P.
"Demonstrators burn an effigy of Uncle Sam,
Tehran" 1979 (Life 161)
"An embassy hostage on display in Tehran" 1979
(Eyes #350; Life 160)

LEE, Craig
"During the rainy season, a levee break in Yuba City
put part of the town under water" 1986 (Best12 39)
"In San Francisco, people concerned with the lack of
medical progress in AIDS cases hold a candlelight
vigil near City Hall" 1985 (Best11 30a)
"When Carol Lynn Pearson discovered her gay
husband had AIDS, her home became his haven,
and her solace his support" 1986 (Best12 190d)

LEE, Dennis
"After answering a domestic complaint police take a
photograph of injuries this man sustained in an
argument with his wife" 1986 (Best12 80b)

LEE, J. K.
"Nude" c. 1989* (Graphis89 \146)

LEE, John
"A loose dog corrals a trio of Chicago Bears during
morning practice" 1996* (Best22 202c)

LEE, Richard
"Actor Yul Brynner takes a curtain call after his
4,625th and final appearance as the lead in The
King and I" 1985 (Best11 125)

LEE, Russell, 1903-1986
"After lunch" 1941 (Documenting 217c)
"At the baseball game" 1941 (Documenting 220a)
"Barker Concession at State Fair, Donaldsonville,
Louisiana" 1938 (Decade 43c)
"Child of migrant worker in car, Oklahoma" 1939
(Lacayo 99)
"Child tagged for evacuation" 1942 (Documenting
249c)
"Cleaning the cemetery before evacuation, San
Benito County" 1942 (Documenting 247c)
"Cold drinks inside the Red Robin café" 1941
(Documenting 210a)
"Decorations on the main street" 1941 (Documenting
225b)
"Examining the baggage of evacuees at the Santa
Anita reception center" 1942 (Documenting 250a)
"Family picnic" 1941 (Documenting 216b)
"Farm family, Los Angeles County" 1942
(Documenting 244a)
"A farmer about to be relocated shows his equipment
to a prospective buyer, Los Angeles County" 1942
(Documenting 245c)
"A farmer awaiting final evacuation orders, San
Benito County, California" 1943 (Documenting
246a)
"Farmer packing his tools before he is relocated, Los
Angeles County" 1942 (Documenting 244b)
"Father and daughters on the midway merry-go-
round" 1941 (Documenting 222a)
"Fighting a grass fire" 1941 (Documenting 216a)
"Hidalgo County, Texas" 1939 (Goldberg 98)
"Housing at the Santa Anita reception center" 1942
(Documenting 251c)
"Lighting a firecracker" 1941 (Documenting 215c)
"Little Tokyo, Los Angeles" 1942 (Documenting
243a)

"Looking east on Vale's main street" 1941
(Documenting 209)
"Lumberjacks–Saturday Night, Minnesota" 1937
(MOMA 151)
"Motorcycle with stunt bar" 1941 (Documenting
215b)
"Motorcyclist and friends" 1941 (Documenting 218a)
"On the midway" 1941 (Documenting 223b, 224a)
"Outside the Red Robin café" 1941 (Documenting
211b)
"Parade float" 1941 (Documenting 212b)
"Picnic lunch for members of the Japanese-American
citizens' league just before their evacuation, San
Benito County" 1942 (Documenting 248a)
"The pledge of allegiance at the ball field" 1941
(Documenting 221b)
"Preparing for the show" 1941 (Documenting 212a)
"Reading evacuation orders on a bulletin board at
Maryknoll Mission" 1942 (Documenting 243b)
"Second Hand Tires" 1940 (Rosenblum2 #468)
"Shop in Little Tokyo, Los Angeles" 1942
(Documenting 246b)
"Tug-of-war" 1941 (Documenting 219b)
"Waiting for the parade to begin" 1941
(Documenting 212c)
"Waiting for the train to Owen Valley, Los Angeles"
1942 (Documenting 248b)
"Waiting to register at the Santa Anita reception
center" 1942 (Documenting 250b)
"Watching the parade" 1941 (Documenting 214a)

LEE, Wellington, b. 1918
"Girl from Mars" 1959 (Peterson #26)

LEEN, Nina
"Lemcke's Record Store" 1944 (Life 41a)
"Ozark farmers, four generations" 1955 (Goldberg
138)
"Rag curls and men's pajamas" 1944 (Life 111d)
"Santa Lucia Mountain Range between Carmel and
San Simeon, California" 1945 (Lacayo 89)
"A week's housework" 1947 (Lacayo 94)

LEEN, Sarah
"Carmen Sotelo, a laundress at the Masso fish
cannery in Cangas, Galicia hangs towels to dry in
the early morning" 1987* (Best13 167d)
"Losing Max" 1985 (Best11 126-129)
"To play outside with his friends, a 14-year-old boy
wears a protective outfit designed by NASA"
2002* (Through 366)

LEES, David
"Flood in Florence museum" 1966* (Life 130)

LEHMAN, Danny
"Listening to the universe in quiet isolation the Very
Large Array radio telescope includes this giant dish
on the Plains of San Augustin, New Mexico" 1987*
(Through 496)

LEHMAN, Steve
"A member of the People's Armed Police Honor
Guard stands at attention as the flag
commemorating the death of Deng Xiao Peng
hangs at half staff" 1997 (Best23 120)

LEHN, Bernhard
"Helicopter belonging to the MBB aircraft company"
c. 1989* (Graphis89 \213)

"*Tornado* belonging to the MBB aircraft company" c.
1989* (Graphis89 \211, \212)

LEHNERT AND LANDROCK
"Travelers in the Sahara bow in praise to Allah" 1911
(Through 224)
"Wearing her dowry, woman belongs to the Ouled
Nails tribe of North Africa" 1922 (Through 244)

LEIBING, Peter
"East Berlin" 1961 (Life 58; Photos 99)

LEIBOVITCH, Jean-Louis
[automobile workers] c. 1992* (Graphis93 208)

LEIBOVITZ, Annie, 1949-
"Al Hirschfeld" c. 1990* (Graphis90 \145)
"Alan King" c. 1989 (Graphis89 \162)
"Alice Cooper" 1972 (Rolling #18)
"Beth Henley" c. 1989* (Graphis89 \159)
"Billy Kidd" c. 1989* (Graphis89 \154)
"Bob Dylan" 1978 (Rolling #29)
"Brian Wilson" 1976* (Rolling #22)
"Candice Bergen" c. 1989* (Graphis89 \153)
"Dan Rather" 1974 (Rolling #30)
"David Byrne, Los Angeles" 1989* (Women \161)
"David Letterman" 1982* (Rolling #46)
[diver leaving a diving board] c. 1997 (Graphis97
201)
"Ella Fitzgerald" c. 1989* (Graphis89 \155)
"Eric Heiden" c. 1989* (Graphis89 \156)
"Evelyn Ashford" c. 1989* (Graphis89 \160)
"Film Producer Sherry Lansing" c. 1991* (Graphis91
\197)
"Fleetwood Mac" 1977* (Rolling #28)
"Helen Hayes" c. 1989 (Graphis89 \163)
"Isabella Rosellini and David Lynch" 1986
(Rosenblum \225)
"James Earl Jones" c. 1989* (Graphis89 \156)
"James Taylor and Carly Simon" 1979* (Rolling #27)
"Jennifer Jason Leigh" c. 1995* (Graphis96 25-27)
"John Belushi" 1982* (Rolling #47)
"John Elway" c. 1989* (Graphis89 \161)
"Keith Richards" 1972 (Rolling #13)
"Liberace and Chauffeur" 1981* (Rolling #25)
"Lily Tomlin" 1974 (Rolling #17)
"Linda Ronstadt" 1976* (Rolling #20)
"Mick Jagger and Keith Richards" 1975 (Rolling
#15)
"Nixon leaving" 1974 (Rolling #31)
"Norman Mailer" 1975* (Rolling #23)
"Pete Townshend" 1980* (Rolling #19)
"Randy Travis, Nashville" 1987* (Women \160)
"Rodney Dangerfield and Baby" 1980* (Rolling #26)
"Ron Vawter" 1993 (Photography 36)
"Salvador Dali and Alice Cooper" 1973* (Rolling
#14)
[shirtless man on horse] c. 1997 (Graphis97 198)
"Sissy Spacek" 1979* (Rolling #21)
[swimmers form a pyramid] c. 1997 (Graphis97 200)
[throwing a ball] c. 1997 (Graphis97 203)
[torso of shirtless weightlifter] c. 1997 (Graphis97
199)
"Willie Shoemaker, jockey, and Wilt Chamberlain,
former basketball player" c. 1989* (Graphis89
\158)
"Yoko Ono and John Lennon" 1981* (Rolling #32)

LEIFER, Neil
"Fu Mingxia, Chinese diving gold medalist" c. 1992*
(Graphis93 201a)

LEISTNER, Dieter
[interior spaces] c. 1995* (Graphis96 173)

LEMOYNE, Roger
"Displaced Albanian woman uses a mobile telephone
of an aid worker" 1998 (Best24 91d)
"Funeral of an Albanian shot on the Kosovo border"
1998 (Best24 92)
"Lost in Zaire: Hutu Refugees" 1997 (Best23 128c,
205)

LENDVAI-DIRCKSEN, Erna, 1883-1962
"Young Hessian Farmer" c. 1930 (Rosenblum \116)

LENNIHAN, Mark
"A woman mourns next to a rose she placed in the
sand at Smith Point Beach in Fire Island, New
York" 1996* (Best22 150a)

LENNOX, Anne
"Pricey catch" 1988 (Best14 109b)

LEONG, Mark
"The China Left Behind" 1996 (Best22 237d)

LEONG, Ray
"Mothers of Invention, Freak Out" 1966* (Goldberg
171)

LEPKOFF, Rebecca, 1916-
"Broadway near Times Square" 1948 (Rosenblum
\217)

LERNER, Paula
"Hyperactivity" 1993* (Best19 176b)
"A Widow on Welfare" 1997 (Best23 211)

LEROY, Catherine, 1944-
"Beirut, August 8, 1982. Israeli shelling from the air,
the ground, the sea" 1982* (Eyes \35)
"Searchlight beams and anti-aircraft fire rise from
Tripoli during the American bombing raid" 1986*
(Best12 14)

LERSKI, Helmar
"German Metal Worker" 1930 (Rosenblum2 #445)

LESSIG, Alan
"Baby Jessica" 1993* (Best19 222)
"Lacking a bat didn't stop Traylor from playing
baseball near his home" 1993* (Best19 221)
"Mark Riashi is tagged out despite running over
second baseman during a company softball game"
1993* (Best19 223)
"The Young Artists for Christ Workshop Choir
performs at a gospel concert in Detroit" 1993*
(Best19 224)

LETBETTER, Dennis
[stones] c. 1997* (Graphis97 64-65)

LEVENTON, Alexander, 1895-1950
"Paul White" 1927 (Peterson #45)
"Russian Boy" 1929 (Peterson #44)

LEVINE, Les, 1935-
[from the series *The Troubles: An Artist's Document
of Ulster*] 1979 (Photography2 165)

LEVINE, Sherrie, 1947-
"After Ludwig Kirchner" 1982* (Photography2 221)

LEVINSTEIN, Leon, 1913-1988
"Coney Island" 1953 or earlier (MOMA 223)

LEVINTHAL, David, 1949-
"Spring offensive begins, June 1942" 1974*
(Photography2 227)

LEVISON, Marlin
"Minnesota North Stars Mark Pavelich checks St.
Louis Blues Cliff Ronning into the Blues' net"
1987 (Best13 224a)

LEVITT, Helen, 1913-
"Children and Fire Hydrant" c. 1945 (Women \122)
"Masked Kids, Brownstone" c. 1945 (Sandler 93) or
"New York" 1939 (MOMA 157, 159) or "Three
Kids on a Stoop" 1940 (Hambourg \28)
"Mexico City" 1941 (Women \125)
"New York" c. 1940 (Icons 85; Marien \6.53); c.
1942 (Rosenblum \218; Szarkowski 229; Women
\124); c. 1945 (Rosenblum2 #683)
"New York City" 1945 (Women \123)
"Untitled" c. 1942 (San \45)
"Walker Evans, New York" c. 1940 (MOMA 19)

LEVY, Caryn
"With his amazing 50" vertical leap, Joey Johnson
should light up the court at Arizona State
University" 1987* (Best13 191)

LEVY, Karen
[from brochure for an exclusive children's clothing
designer] c. 1991* (Graphis91 \43-\46)

LEVY, Tom
"Portrait of photographer, Robert Frank, taken in a
Greyhound Bus Station" c. 1989 (Graphis89 \151)
"Tram 106 arrives in San Francisco, but not by foot,
as it appears here" 1986 (Best12 183)

LEWIS, Carl, 1951-
"Headroom" n.d.* (Willis \487)
"Torso Walking" n.d.* (Willis \488)

LEWIS, Matthew
"1970s Washington Lifestyle" 1974 (Capture 88)

LEWIS, Scott
"Aurora, Illinois 60504" 1997 (Best23 74-89)

LEWIS, Vickie
"In Phoenix, the pope was blessed by E. White, a
Pima Indian, in a special ceremony" 1987* (Best13
17b)
"Wearing a hat is one way to be the center of
attention" 1987* (Best13 179a)

LEX-NERLINGER, Alice, 1893-1975
"*Näherlin*" c. 1930 (Women \90)
"Seamstress" 1930 (Rosenblum \127; Rosenblum2
#495)

LEYDA, Jay
"Alfred H. Barr, Jr." 1931-1933 (MOMA 29)

LHERMITTE, Charles
"On the Coast of *Plomarc'h, Douarnenez*" 1912
(Rosenblum2 #420)

LIBBY, Miss
"Young Woman in Garden" 1897 (Sandler 67)

LICATA, Jeff
[from a series on the beauty and form of the black
male] c. 1995 (Graphis96 136)

LICHFIELD, Patrick
"Queen Elizabeth and her new daughter-in-law,
Diana, prepare to greet the public, Buckingham
Palace, July 29" 1981* (Life 8)

LICHTENSTEIN, Andrew
"Behind Bars" c. 1997-1999* (Best23 210d; Photo00
70, 71)
"Member of the Aryan Brotherhood in a recreation
yard" 1997* (Best23 210b)

LIEBERT, Alphonse
"Nevada City, California" 1857 (Photography1 #III-
12)

LIEBLING, Jerome, 1924-
"Blind Home" 1963 (Rosenblum2 #685)
"Boy and Car, New York City" 1948 (MOMA 202)
"Slaughterhouse, South Saint Paul, Minnesota" 1962
(Decade \74; Photography 162)

LIEPKE, Peter
"Philip Boscoe" c. 1992* (Graphis93 108b)

LIMBACH, Fred
"Survivor" c. 1999* (Photo00 109)

LIMBORG, Thomas, 1894-1992
"The Water Nymph" c. 1949 (Peterson #70)

LINCOLN, Edwin Hale, 1848-1938
"Thistle" 1893-1907 (MOMA 66)

LINCOLN, Fay Sturtevant, 1894-1975
"45 Rockefeller Plaza" 1938 (Hambourg \15)

LINDBERGET, Eivind
[chili peppers] c. 1995* (Graphis96 94)

LINDBERGH, Peter
[for fashion catalog] c. 1991 (Graphis92 \42)
[from an article with fashion in the style of the 1930s]
c. 1989 (Graphis89 \36, \37)

LINDO, Nashormeh, 1953-
[from *Venetian Door* series] 1998* (Willis \465-\466)

LINDSAY, Charles
[from *Science Fiction Project*] 2001 (Photography
227)

LINDSAY, John
"Soviet sound off" 1953 (Eyes #236)

LINDSTROM, Mel
"Fencer" c. 1999* (Photo00 102)

LINK, O. Winston, 1911-
"Hot Shot East Bound at Iager, West Virginia" 1956
(MOMA 232)
"Main Line on Main Street" 1958 (Photography 18)
"O. Winston Link and George Thom with part of
equipment used in making night scenes with
synchronized flash" 1956 (Goldberg 231; MOMA
23)

LINSLEY, Brennan
[starving Sudanese boy roams around a compound
run by Doctors Without Borders] c. 1999*
(Photo00 60)

LINTON, Malcolm
"A Georgian loyalist exults after shooting a rebel
sniper in the Abkhazia region" 1993* (Best19 65)

LION, Jules, 1810-1866
"St. Louis Cathedral" 1842 (Willis \1)

LIPCHITZ, Michael
"The Gulf War" 1991* (Photos 169)

LIPCIUS, Kathi
"Suffering from the effects of pollution and
malnutrition, four sisters stand their ground in
Copsa Mica, Romania" 1990 (Best16 75)

LIPPMAN, Marcia
[bracelets over long gloves] c. 1997* (Graphis97 46)
[hat with veil] c. 1997 * (Graphis97 47)

LIPPMANN, Pete
"Sunflower" c. 1999* (Photo00 216)

LIPSKI, Richard
"Cal Ripken and cheering for his game streak record"
1995* (Best21 132)
"First Lady Nancy Reagan tries her hand (and feet) at
flamenco dancing with a young Spanish dancer"
1985 (Best11 124)
"Mike Tyson" 1997 (Best23 167c)

LISS, Steve
"America gets the news: War in the Gulf" 1991*
(Lacayo 175c)
"Community Policing" 1996* (Best22 228)
"Policemen play basketball with local children as part
of efforts to reduce crime" 1996* (Best22 170c)
"Remembering the victims of the bomb" 1995*
(Lacayo 188d)
"Robert ('Yummy') Sandifer, executed at 11" 1994
(Lacayo 183c)
"Working Mom" 1996* (Best22 240a,c)

LISSITZKY, El, 1890-1941
"The Constructor (Self-portrait)" 1924 (Art \263;
Marien \5.5; Szarkowski 176; Waking #191)
"In the Studio" 1923 (Hambourg \88)
"Photomontage: Study for Poster" c. 1928 (Art \262)
"Photomontage: Study for Richard Neutra's *Amerika*"
1929-1930 (Art 259)
"Runner in the City" c. 1926 (Hambourg \79)
"Socialist Construction, Dresden" 1929 (Art \260)
"Untitled" c. 1928 (Art \261)

LIST, Herbert, 1903-1975
"Santorin" 1937 (Hambourg \123; San \27)

LITT, Richard
[from a series] c. 1990 (Graphis90 \19-20)

LITTLE, Harlee, 1947-
"Author Shireen Dodson and daughters" 1998 (Willis \276)
"Betty Carter in performance" 1979 (Willis \278)
"The photographer's son" 1979 (Willis \275)
"Untitled, Washington D.C." n.d. (Willis \277)

LITZEL, Otto
"Mighty Manhattan" 1951 (Peterson #89)

LIU, Xin
"Cloudy reflections are seen in the window of a church soon to be turned into a cultural center" 1996* (Best22 188d)
"Following child abuse by their parents, four children have shuffled between relatives for a year" 1996 (Best22 210a)

LIVESEY, Andy
[lily in blue vase] c. 1992* (Graphis93 66)

LIVOLSI, Michael
[tents and hills] c. 1997* (Graphis97 144b)

LLEWELLYN, Michael
"Tim Burton" c. 1992* (Graphis93 122c)

LLEWELLYN, Robert
"Snow-sugared prairie like a vast gingerbread, raisined with feeding cattle" c. 1989* (Graphis89 \69)

LLEWELYN, John Dillwyn, 1810-1877
"Thereza" c. 1853 (Marien \2.15; Waking #16)

LOBOVIKOV, Sergei, 1870-1942
"Peasant Scene" late 1890s (Rosenblum2 #384)
"The Widow's Pillow" c. 1900 (Marien \4.11)

LODRIGUSS, Jerry (Gerard Michael)
"Atlanta Hawks guard Spud Webb gets a noseful of Philadelphia 76er Ben Coleman while going for a loose ball" 1988 (Best14 133)
"A celestial dazzler, Comet Hale-Bopp delights earthbound observers in Arizona's Sonoran Desert" 1997* (Through 500)
"Charles Barkley of the Philadelphia 76ers gets hit with an elbow by Michael Jordan of the Chicago Bulls" 1991 (Best17 163)
"Chris Organtini is a club fighter who works in a tire warehouse during the day" 1988 (Best14 132)
"Club boxer Bernard 'The Executioner' Hopkins shadowboxed during a training session" 1991 (Best17 164)
"Czechoslovakia's Pribilinec crosses the finish line to win the 20-kilometer walk and the gold medal during the Summer Olympics" 1988 (Best14 134)
"Dickie Thon of the Philadelphia Phillies is jubilant after hitting a two-run home run to beat the Pittsburgh Pirates" 1991 (Best17 166a)
"Diver Kent Ferguson practices before the indoor diving championship" 1987 (Best13 195a)
"Florence Griffith-Joyner is lifted by husband, Al Joyner, for a victory ride after winning the 200-meter dash finals and setting world record" 1988 (Best14 136b)
"Heavyweight boxer Ray Mercer pounds opponent Wesley Watson" 1990 (Best16 124)
"Jonathan Drummond of Texas Christian University finishes first in the 400-meter relay at the Penn relays" 1990 (Best16 123)
"Little League World Series" 1990 (Best16 126-127)
"Opponents Reginald Little and William Jones embrace after a fight" 1991 (Best17 164d)
"Philadelphia Phillies third baseman Mike Schmidt has to contend with a broken bat as well as fielding the ball" 1988 (Best14 136a)
"Temple University's Donald Hodge sits dejectedly on the court as North Carolina celebrates" 1991 (Best17 166b)
"Tony 'Dynamite' Green rests after a workout" 1991 (Best17 165b)
"University of Pittsburgh defensive back Marcus Washington knocks the ball out of the hands of the intended receiver" 1990 (Best16 125d)
"Villanova University coach disagrees with a referee's call during a game" 1990 (Best16 125a)
"William 'The Hammer' Jones takes a punch on the jaw during a bout with Little" 1991 (Best17 165a)

LÖCHERER, Aloïs
"Chess Game" c. 1850 (Rosenblum2 #258)
"Transport of the *Bavaria* (torso)" 1850 (Rosenblum2 #181)

LOENGARD, John
"The Beatles in the swimming pool of a Miami Beach Hotel" 1964 (Lacayo 150a)

LOGAN, Fern, 1945-
"Earth Goddess" 1997* (Committed 144)
"Eunice" 1998* (Committed 145)
"Jacob Lawrence" 1995 (Willis \390)
"Joseph Delaney, painter" 1985 (Willis \388)
"Romare Bearden" 1983 (Willis \389)
"Self-portrait" 1985 (Willis \387)

LONG, John
"At Mystic the sign was superfluous, and Hurricane Gloria blew everything on shore" 1985 (Best11 71b)

LONG, Richard
"A Circle in Alaska. Bering Strait Driftwood on the Arctic Circle" 1977 (San #18)

LONGIN, Stefan
"View" c. 1995* (Graphis96 177)

LONGSTREATH, David
"In Oklahoma City an unidentified man falls to the ground, shot by members of an Oklahoma City SWAT team" 1985 (Best11 79b)
"President-elect Clinton joins the band at a Democratic Rally" 1992* (Life 37a)
"A street urchin waits outside a church in Calcutta with a bouquet of flowers to pay his respects to Mother Theresa" 1997* (Best23 187c)

LOOMIS, Rick
"Staring into the barrel of an officer's gun" 1997* (Best23 124d)

LOPEZ, Andrew
"Castro Firing Squad Execution" 1959 (Capture 45)

LOPEZ, Martina
"Revolutions in Time 1" 1994* (Goldberg 224;
Rosenblum2 #800)

LOPEZ, Nacho, 1923-1986
"Campesino" 1949 (Marien \6.8)

LOPINOT, John J.
"Days before the election, a man lies slumped in a
stairwell after being shot in the back by soldiers in
a Port-au-Prince alley" 1987* (Best13 20)

LOS ALAMOS NATIONAL LABORATORY
"First Atomic Bomb Explosion" 1945 (Monk #32)

LoSCALZO, Jim
"Crack addict from Virginia says he feels safer in the
county jail than the streets" 1996* (Best22 211d)
"Draped in a black chador, an Iranian woman walks
through courtyard of mosque" 1998* (Best24 50c)
"Sent to identify a murder victim inside Port-au-
Prince's only morgue, U.S. MP's discover children
the city can't afford to bury" 1995* (Best21 182a)
"Vernon Baker, 76, learned he will be the first
African-American veteran of World War II to
receive the Congressional Medal of Honor" 1996*
(Best22 216c)

LOTT, Jimi
"Cowboy looks over the land where he carries on the
tradition of his great-grandfather–being a cowboy"
1987 (Best13 177a)
"Members of the VAQ 137 Airborne are greeted by
their families" 1986 (Best12 16a)
"Seattle's homeless' 1987 (Best13 34-41)

LOUISE, Ruth Harriet, 1906-1944
"Self-portrait (?) with Joan Crawford" 1928
(Rosenblum \160)

LOVEKIN, Jonathan
[personal work] c. 1991* (Graphis92 \51)

LOVETT, Greg
"A Haitian man balances a mattress on his head as he
walks in Port-de-Paix" 1992* (Best18 85)

LOWE, Jacques
"Camelot and the Kennedy mystique" 1958-1961
(Best23 58-73)
"Little Caroline Kennedy kisses her father" 1960
(Eyes #284)

LOWE, Paul
"Blood stains frozen snow as the living try to deal
with the carnage caused by Russian airstrikes in
Chechnya" 1995* (Best21 169d)
"Chechnya War" 1995* (Best21 225-226)
"A requiem in Sarajevo, Bosnia-Herzegovina" 1992*
(Best18 50)
"Results of nuclear testing in Kazakhstan" 1992*
(Best18 46-49)
"Starvation in Somalia" 1992 (Best18 43-45)
"Watching a child die in Baidoa, Somalia" 1992
(Best18 128)

LOWIT, Roxanne
"Disco fever at Xenon, NYC" 1978* (Life 118)

LU, Steve
[jellyfish] c. 1999 (Photo00 231)

LUBENS, Pauline
"A Family Lets Go" 1991 (Best17 97-102)
"It's probably the last time this Detroit fourth-grader
will ever volunteer to hold a visiting tarantula"
1986 (Best12 119b)

LUCKETT, Cara H.
"Bolla and Murano–The Italian Classic" c. 1990*
(Graphis90 \294)

LUDWIG, Gerd
"In this pastoral scene, the camera captures familiar
features of Russia–snow and ice and a stand of
conifers" 1998* (Through 48)
"On a shopping expedition, a couple in Moscow seem
oblivious to the eye-catching ad behind them"
2001* (Through 102)
"Return of the Cossacks" 1998* (Best24 38d)
"Taking liberties–a political painting on the Berlin
Wall shows former Soviet Premier Leonid
Brezhnev and East German leader Erich Honeker
locked in a mock embrace" 1996* (Through 58)
"Trans-Siberian Railroad" 1998* (Best24 45d)

LUKAS, Neil
"Café Diderot" c. 1989* (Graphis89 \66)

LUKE, John
"Body Pierce" 1993* (Best19 179)
"Glasses of wine" 1991* (Best17 172)

LUKE, Wellington O., and WHEELER, Dansford
Nobel
"Little Giant" c. 1879-1881 (Photography1 \56)

LUKOSKI, James
"Palestinian prisoners, tied and blindfolded, await
their fates in the Gaza Strip" 1990 (Best16 8a)

LUMIÈRE BROTHERS
"Lumière Family in the Garden at La Ciotat" c. 1907-
1915* (Rosenblum2 #342)
"Untitled" c. 1907-1915* (Rosenblum2 #343)

LUPER, Joe
[cherries took on elegance] 1986* (Best12 110d)

LURIE, Jonathan
"During a KKK rally, anti-Klan demonstrators beat a
man suspected of being a Klan supporter" 1996*
(Best22 159c)

LUSE, Eric
"An Air Force honor guard escorts the remains of
nine Americans brought home–after a decade–from
Vietnam" 1985 (Best1 91b)
"Badly burned but purring loudly, this cat waited for
her owners to return after a devastating forest fire"
1985 (Best11 101c)
"Fans of the 49rs went crazy on Market Street after
their team won the Super Bowl before a home town
crowd" 1985 (Best11 188)
"Hunting for a goose" 1985 (Best11 154b)
"Life continues for a 5-day-old girl found buried in
the rubble with her mother" 1985 (Best11 13a)
"Piloted by Dick Rutan and Jeana Yeager, the
'Voyager' touches down at Edwards Air Force

base, completing a historic, nonstop, non-refueling, globe-circling flight" 1986 (Best12 56a)
"Salvation Army Lt. Col. Robinson braves wet weather to bring the Christmas spirit" 1985 (Best11 167b)
"Survivors at the Benito Juarez Hospital in Mexico City, waiting for word of their loved ones, face the agony of covered stretchers" 1985 (Best11 12b)
"Volunteers form a human chain to remove the bodies of earthquake victims from one collapsed structure" 1985 (Best11 9a)

LUSK, Nita
"Fruit" 1997* (Best23 144a)

LUSTER, Bill
"J.S. Morgan, editor emeritus of the Springfield Sun" 1985 (Best11 132-135)
"President and Mrs. Reagan meet with each bereaved family to offer consolation after the service" 1985 (Best11 51d)

LUTZ, Judy
"Trevor Berbick takes a break as he trains for a heavyweight title fight against Mike Tyson" 1986 (Best12 219b)

LUYS, Jules
"Four-Diameter Cross-Section of Segments of Cerebellum" c. 1873 (Marien \3.71)

LYNES, George Platt, 1907-1955
"Arthur Lee's Model" 1940 (Rosenblum2 #548)
"Lincoln Kirstein" c. 1940 (MOMA 30)
"Marc Blitzstein, Orson Welles, and Lehman Engle" 1937 (MOMA 164)
"Self-Analysis" c. 1940 (MOMA 174)
"The Sleepwalker" 1935 (Hambourg \70)

LYON, Danny
"Cal, Eikhorn, Wisconsin" 1966 (Marien \6.51)
"Cambridge, Maryland, fellow SNCC photographer is arrested by National Guard" 1964 (Goldberg 166)
"The Line, Ferguson Unit, Texas" 1967-1969 (Decade 78a; Rosenblum2 #688)
"Nancy" 1981 (Photography 208)
"Shakedown, Ramsey Unit, Tex." c. 1967-1969 (Decade \84)

LYON, Santiago
"Albanian Unrest" 1997* (Best23 122, 204a,b)

LYONS, Bill
"A hurdler tries to avoid landing on another racer who had an epileptic seizure and collapsed" 1987 (Best13 214d)
"Volunteer firefighters retreat from flames that exploded through a window at home of an Amish farmer in Pennsylvania" 1990 (Best16 106d)

LYONS, Kenneth D.
"Blue Salad Dressings" 1995* (Best21 147a)
"Teflon Suits" 1996* (Best22 176a)

LYONS, Lauri, 1971-
"Testament" 1995* (Committed 146, 147)

LYONS, Nathan, 1930-
"Untitled" c. 1959 (Photography2 70)

LYONS, William E.
"Firemen rest after sifting through rubble seeking survivors of five tornadoes that ripped through area" 1985 (Best11 67d)

—M—

MAAR, Dora, 1907-1997
"Père Ubu" 1936 (Hambourg \58; Marien \5.26)
"Untitled" c. 1940 (San \28; Women \91)

McADAMS, Dona Ann
"St. Valentine's Day Massacre" 1989 (Photography 98)

McADORY, Jeff
"Tunica, Mississippi" 1986 (Best12 114-117)

McAVOY, Thomas
"The First Lady at a party she threw for Army troops" 1942 (Life 22a)
"Franklin Delano Roosevelt" 1935 (Goldberg 85)

McBEAN, Angus
"Bea Lillie" c. 1937 (San #14)
"Elsa Lancaster" 1938 (Rosenblum2 #642)

McBRIDE, Will, 1931-
"Overpopulation" 1968 (Icons 160)

McCAIN, Edward
[untitled] c. 1999* (Photo00 121)

McCARTHY, Mathew
"Cyclists negotiate a turn during a race on the world's steepest and shortest outdoor Velodrome" 1993* (Best19 143a)

McCLEES, James
"Jefferson's House, Philadelphia" 1855 (National 16d)
"The Waterworks, Fairmount, Philadelphia" 1855 (National \10)

McCLELLAND, Bruce
"Business as usual for beautician Yolanda Ponce after a pickup truck intruded" 1986 (Best12 122b)

McCOLLUM, Allan, 1944-
[Perpetual Photo series] 1985 (Photography2 226)

McCOMBE, Leonard, 1923-
"A child imitates the expression of his baby-sitter" 1957 (Lacayo 155a)
"Frat brothers sing the Sigma Chi 'Sweetheart Song' Westminster College" 1949 (Life 42b)
"Mexican woman and her daughter making tortillas" 1950 (Lacayo 1950)
"Wind and waves near the Thacher's Island Lighthouse, Cape Anne" 1962* (Life 184)

McCONNICO, John
"Rescue workers struggle to keep 1-year-old from falling into rushing waters" 1996* (Best22 145)

McCORMACK, Larry
"Students stretch for a better glimpse of then-Vice President George Bush during a campaign visit" 1988 (Best14 89)

McCORMICK, Chandra, 1957-
[boy with television] c. 1987 (Willis \268)
[cane workers] 1987 (Willis \269-\271)
"Coolin' Out, New Orleans" 1984 (Committed 155)
"Lady Zulu's" 1993 (Willis \265)
"Mark Gale" 1986 (Committed 154)
"New Orleans Jazz Drummers' Jazz Funeral of James
Black" 1987 (Willis 267)
"The Prayer, Louisiana" 1986 (Willis \266)

McCOSH, John
"Artillery in front of Stone Dragons, Prome, Burma"
1852 (Marien \2.33)

McCOY, James P.
"I've got it" 1985 (Best11 193a)
"When a boat got too close to water skiers in the Boat
Festival, competitor hit it" 1986 (Best12 94a)

McCOY, John
"Despondent lover talked down from a 40-story Los
Angeles building after 4 hours" 1986 (Best12 87a)

McCREA, Gerald P.
"Newark N.J. firefighter rescues a *Sesame Street*
character during taping of a fire-safety video" 1990
(Best16 167b)

McCREA, Jerry
"Cuban boys play stickball on an inner city lot in
Havana" 1996* (Best22 193)

McCULLERS, Charlie
[untitled] c. 1999* (Photo00 220)

McCULLIN, Don, 1935-
"Bangladesh" 1971 (Lacayo 162)
"Christian fighters in the lobby of the Holiday Inn"
1976 (Eyes #318)
"A Christian kicking a Palestinian who has been
selected for death behind this factory wall" 1976
(Eyes #319)
"Congolese Soldiers Ill-Treating Prisoners Awaiting
Death in Stanleyville" 1964 (Rosenblum2 #611)
"Corpse of North Vietnamese Soldier" 1968 (Marien
\6.102)
"Cyprus" 1964 (Eyes #355)
"Fallen North Vietnamese Soldier with his personal
Effects scattered by body-plundering Soldiers"
1968 (Art \426)
[from series *AIDS in Zambia*] 2001 (Photography
126-127)
"Man throwing Grenade, Hué" 1968 (Art \428)
"One of the Lebanese nurses who stayed on was able
to pacify some patients by her presence" 1982
(Eyes #315)
"Palestinian woman whose husband has been
murdered discovering the destruction of her home"
1982 (Eyes #317)
"Palestinians surrendering to Phalange troops" 1976
(Eyes #316)
"Shell-shocked Soldier awaiting Transportation away
from the Front Line, Hué" 1968 (Art \425)
"Tet Offensive, Hué" 1968 (Eyes #291-292)
"Vietnamese Marines running across a dangerous
Road in Cambodia" 1970 (Art \427)

McCURRY, Steve
"An Afghan woman poses with a picture of herself,
taken 17 years earlier" 2002* (Through 157)
"Amid the rubble of 14 years of civil war, Afghan
refugees return to rebuild Herat" 1993* (Best19
78)
"Camels search for untainted shrubs and water in the
burning oil fields of southern Kuwait after the
Persian Gulf war" 1991* (Best17 173)
"Celebrants powder their faces for the Ganesh
Chaturthi festival in Mumba, formerly known as
Bombay" 1997* (Best23 180)
"Environmentalist examines a field where the ground
has become encrusted with oil" 1991* (Best17 20)
"Farmer waits for rain in the heat of the afternoon
outside his home" 1987* (Best13 163b)
"Firefighters from Kuwait Oil Co. spray foam to
smother a 2-week-old blaze at a sabotaged farm"
1991* (Best17 17b)
"The highway out of Kuwait City became the last
battleground for many retreating Iraqi troops"
1991* (Best17 16)
"In a modern link with the past, two Padaung women
wear heavy stacks of brass neck rings, a legendary
protection from tiger attacks" 1995* (Best21 201d)
"It is believed that Burma's 'Golden Rock' is
balanced by a single strand of the Buddha's hair"
1995* (Best21 201a)
"Like outlandish herons, a flock of men fish the Sri
Lankan south coast on their traditional wooden
perches" 1996* (Best22 171a)
"Much less costly than using tractors, elephants move
teak logs with ease" 1995* (Best21 20a,b)
"An oil-covered corpse and a Soviet-built tank waste
away in a Kuwait oil field" 1991* (Best17 19)
"Oil-covered hand of a dead Iraqi is grim testimony
to the Persian Gulf War" 1991* (Best17 15)
"Pilgrims who travel to the temple of Angkor Wat, in
Cambodia, offer locally grown lotus flowers to
Buddhas at the site" 2000* (Through 134)
"Sri Lanka: A Continuing Ethnic War Tarnishes the
Pearl of the Indian Ocean" 1996* (Best22 240b)
"A stripped car is claimed by a shepherd boy" 1991*
(Best17 18)
"Thousands in Bombay, India–like this woman and
child–survive only by begging in the streets" 1995*
(Best21 162b)
"Thousands of birds, caught in oil slicks, became
casualties of war" 1991* (Best17 17a)
"Victims of the war in the desert surrounding Kuwait
City" 1991* (Goldberg 212)
"Visitors walk among the ruins of 12th-century
Khmer temples at Angkor's Preah Khan in
Cambodia" 2000* (Through 142)
"Women in Sanaa, Yemen line up to vote in a
parliamentary election" 2000 (Through 254)

McCUSKER, John
"Fighting to lower a giant flag, Deputy Lloyd Dupuy
is lifted into the air by the winds of Hurricane
Opal" 1995* (Best21 170)

McDERMOTT, David, and McGOUGH, Peter
"Varying greatly in style, shape, and materials, Anh
Duong" 1917 (Photography 82)

McDERMOTT, John
"Balance" c. 1989* (Graphis89 \236)

McDONALD, Dennis
"Photographers cover Rick Springfield at Live Aid
concert" 1985 (Best11 4d)
"The referee isn't trying to be part of a study on

contrasts; he's just working a soccer game" 1986
(Best12 141)

MacDONALD, Ian, 1946-
"Equinox Flood Tide, Greatham Creek, Teesmouth"
1974 (Art \386)
"Ken Robinson, Greatham Creek, Teesmouth" 1973
(Art \390)
"Mandy Jemmerson and Paula Woods drawing
Hedgerows, Secondary School" 1983 (Art \385)
"Mathematics Detention, Secondary School,
Cleveland" 1983 (Art \387)
"South Gare, Teesmouth, June" 1980 (Art \389)
"Tipped Slag, Redcar, No. 1 Blastfurnace,
Teesmouth, Cleveland (night)" c. 1985 (Art \388)

McDONALD, James
"Distant View of Jerbel Serbal, from the Palm Grove,
Wady Feiran" 1868-1869 (Marien \3.48)

MacDONALD, Kristy
"11-year-old competes against–and beats–adult men
on the rodeo circuit" 1992 (Best18 143)

McDONALD, Michele
"After a 22-month drug trial, John DeLorean" 1985
(Best11 162d)
"An Albanian child smokes a cigarette in Kosovo"
1993 (Best19 64d)
"*Challenger*'s final agony" 1986* (Best12 10)
"Croagh Patrick, holy mountain in Ireland" 1997
(Best23 226a)
"A man struggles with a woman after she robbed
another woman who had just cashed her paycheck"
1990 (Best16 112a)

McDONOGH, Pat
"After his tractor-trailer jackknifed, flipped a
guardrail and caught fire, trucker Tom McClanahan
receives help from motorists" 1986 (Best12 77a)
"Douglas Hill walks across the 2nd Street Bridge
from his job in Louisville to his home in
Jeffersonville" 1986 (Best12 148)
"An employee at Churchill Downs tries to get
firefighters to save horses still trapped in the
burning building behind her" 1986 (Best12 78)
"Firefighters fighting a four-hour blaze at a tire
storage sending black toxic smoke billowing over
Louisville's skyline" 1985 (Best 100b)
"Heaven" 1995* (Best21 151d)
"Multiculturalism in the news business" 1991*
(Best17 169)
"Religious Broadcasting" 1996* (Best22 178b)
"Reno Young screams in pain as he is pulled from
quicksand on the banks of the Ohio River" 1986
(Best12 81a)
"Russian Brides" 1996* (Best22 177a)

McFARLAND, Lawrence
"San Simeon, California" 1978 (Decade \99)

McGHEE, Fi
"Glenda Jackson" c. 1992* (Graphis93 109)

MacGREGOR, Greg, 1941-
"Backyard Sales Demonstration, Hayward,
California" 1983 (San \66)

McGUIRK, Paul
"Boat on the shores of Cape Cod" c. 1991 (Graphis91

\294)

McHUGH, Jim
"Portrait of David Hockney" c. 1999* (Photo00 167)
"Portrait of Russell Crowe" c. 1999* (Photo00 128)

MACIJAUSKAS, Aleksandras, 1938-
"In the Veterinary Clinic" 1977 (Rosenblum2 #718)
"Untitled" 1977 (San \54)

McINTYRE, David G.
"At a young age a Thai kickboxer is already an
efficient fighter in the ring" 1998* (Best24 87d)
"Basketball player rejoices after his team won an
upset" 1991 (Best17 152)

MACK, Preston
"Anna Johnson is a 29-year-old mother of five"
1996* (Best22 210a)
"Russia's Yulia Pakhalina hits the springboard during
her last dive" 1997* (Best23 169c)

McKAY, Ricky
"Anguished sendoffs are a regular occurrence at Tan
Son Nhut airport outside Ho Chi Minh City in
Vietnam as part of the UN-sanctioned Orderly
Departure program" 1985 (Best11 90a)

McKINNELL, Ian
"Compressed air equipment" c. 1991 (Graphis92
\159)

McKOY, Kirk D.
"A Ghanian police officer threatens a man with a rifle
after he was caught stealing goods from hotel room
in Accra" 1996* (Best22 143a)

MACKU, Michal
[human body] c. 1992* (Graphis93 204)

MacLAREN, Mark
[self-promotional] c. 1990* (Graphis90 \54)

McLAUGHLIN-GILL, Frances, 1919-
"At the Galerie des Glaces, Versailles" 1952
(Rosenblum \221)

McLEISH, Donald
"Wearing wooden shoes and other traditional garb,
three children greet each other with smiles in the
village of Staphorst, Holland" 1929* (Through 80)

McLEISTER, Joey
"Maria Rivera, mayor of Crystal City, Texas, takes a
break from her 1500-mile drive to join her family
for summer work" 1993 (Best19 63d)

McLENDON, Lennox
"Bull-rider gets stomped during the final round of
competition" 1996* (Best22 196d)
"A priest makes the sign of the cross over ice-packed
bodies of quake victims" 1985* (Best11 11)

McLEOD, William Mercer
[from *Travels with Ava Ray* series] c. 1995*
(Graphis96 134b)

MacMILLAN, Donald B., 1874-1970
"8 exposures on the same photographic plate, made at
20-minute intervals, capture the midnight sun over

Littleton Island near Greenland" 1925 (Through 492)

MacMILLAN, Jim
"A hostage tries to talk murder suspect out of shooting himself" 1996* (Best22 149d)

MacMULLAN, Michael
"Bride2" 1997* (Best23 145)

McMURTY, Edward P., 1883-1969
"On the Elbe" c. 1933 (Peterson #82)

McNALLY, Joe
"Carl Lewis, the grand master of Olympic champions" 1996 (Best22 128)
"Diver Mary Ellen Clark" 1996 (Best22 128a)
"An engineer focuses a projected image on a screen at the W. M. Keck Observatory, high atop Mauna Kea volcano in Hawaii" 1999* (Through 488)
"Framed by hoop and cornfields, three Indiana youngsters go for ball" 1985* (Best11 152b)
"Gail Devers, the fastest woman in the world, strikes a definitive pose" 1996 (Best22 215a)
"Glamorous Evening" 1993* (Best19 181)
"Kim Phuc and her son 23 years after she became famous in a photo from Vietnam in which she was shown running naked away from a napalm attack" 1995* (Best21 144c)
"Leonard Bernstein composes at his piano at his country home" 1988 (Best14 117a)
"Linda Sommers displays her feet" 1996 (Best22 129a)
"Mark Henry, super heavyweight lifter, his grip" 1996 (Best22 128c)
"Mark Henry trained for the Olympic games with brute strength" 1996 (Best22 129d)
"Master of 'freefall' diving, Meghan Heaney-Grier enjoys serenity down under" 1998* (Best24 52a)
"Michelle Pfeiffer" 1995* (Life 93b)
"Off the Kona coast of Hawaii, elite swimmers compete in the 2.4-mile leg of the 1999 Ironman Triathlon" 2000* (Through 448)
"Olympic fencer Sharon Monplaisir and the beauty and flexibility of her body" 1996 (Best22 129c)
"Oriental Pearl TV Tower, 1,500 feet tall, soars over the modern Pudong New Area in Shanghai, China" 1999* (Through 132)
"Peek at the perfect bodies of U. S. water polo team members" 1996 (Best22 128d; Life 148b)
"Shortstop Ozzie Smith, the wizard of the St. Louis Cardinals infield, redefines the baseball clinic of 'doing it with mirrors'" 1988* (Best14 155)

MacNAUGHTAN, William E.
"A Connecticut River" 1912 (Peterson #88)

McNEELY, Dale E., Jr.
[newspapers on a desk] c. 1992* (Graphis93 68)

McNEIL, Wendy Snyder, 1943-
"Adrian Sesto" 1977-1988 (Women \167)
"Ezra Sesto" 1977-1988 (Women \166)
"Jazimina" 1985-1987 (Women \164)
"Jazimina and Ronald" 1987-1989* (Women \165)
"Marie Baratte" 1972-1973 (Rosenblum \244)

McNEILL, Robert H., 1917-
"A couple dancing at the Savoy Ballroom in New York" 1937 (Willis \117)

[from *The Bronx Slave Market* series] 1937 (Willis \116, \118)
"Members of the National Association of Colored Women march outside the White House to protest a lynching in Georgia" 1946 (Willis \114)
"View of 'Daddy Grace' baptism" 1949 (Willis \115)

MACOR, Michael
"An Air Force plane makes a low pass over the rim of Oakland Coliseum during pregame activities at the baseball All-Star game" 1987 (Best13 108a)
"Deadly Quake" 1989 (Capture 156)

McPARLAND, Tara
"A senior at Syracuse University says dancing offers her solitude" 1986 (Best12 190c)
"Thousands of fans packed Boston's City Hall Plaza after the Celtics won their 16th NBA basketball championship" 1986 (Best12 195)

MACPHERSON, Andrew
"Light weight summer wear" c. 1991 (Graphis91 \41)

MacPHERSON, Robert, 1815/16-1872
"The Arco dei Pantani at the Entrance of the Forum of Augustus, with the Temple of Mars Ultor, Rome" before 1863 (Art \137)
"Cloaca Maxima" 1858 (Waking #73)
"Grotto at Tivoli" c. 1860 (Art \139; Rosenblum2 #127)
Palazzo dei Consoli, Gubbio" c. 1864 (Szarkowski 76c)
"Temple of Vesta and Fountain, Rome" c. 1857 (Szarkowski 76b)
"The Theater of Marcellus, from the Piazza Montanara" 1858 (Waking #74)

McRAE, Colin
"Amaryllis" c. 1997 (Graphis97 85)

MacWEENEY, Alen
[Borzoi] c. 1995* (Graphis96 195)
"Handmade lingerie" c. 1990* (Graphis90 \58)
"Michael E. Hoffman and Paul Strand" 1965 (Photography 129)
"The Ward Family" 1965 (Photography 207)

MADDEN, Blake
"Travis Scott seeks shelter as the rain pounds the field during practice" 1995* (Best21 108b)

MADERE, John
[girl on a horse] c. 1995* (Graphis96 104)

MADISON, Casey
"Alone in Rajneesh's temple in Oregon, two disciples embrace and consider a future without their guru" 1985 (Best11 87b)
"Sean Bean, 12, learns about juggling at a symposium for gifted children" 1986 (Best12 118d)

MAEDA, Yukio
"Nob Fukuda" c. 1991* (Graphis92 15)

MAGES, Evy
"Holding hands and listening in New York" 1996 (Best22 157d)

MAGNI, Tiziano
"Bananas" c. 1991* (Graphis91 \132)

"White fashion in *Vogue*" c. 1990 (Graphis90 \51)

MAGREAN, Joachim
"Summer" c. 1991* (Graphis91 \27)

MAGRITTE, Réné, 1898-1967
"Edward James in Front of *On the Threshold of Liberty*" 1937 (Hambourg \87)

MAGUBANE, Peter, 1932-
"Alexandria Township funeral" 1986* (Eyes \36)
"The boys above lost their mother in a car crash on Christmas Day" 1975 (Eyes #348)
"Child is being baptized into Zion Christian Church, in a river that runs through Soweto" 1976 (Eyes #345)
"Fenced-in Child, Vrederdorp" 1967 (Rosenblum2 #473)
"Mamelodi funeral" 1985* (Eyes \37)
"Mrs. Emily Motsieloa of Sophiatown teaches a boy to sing and play the piano" 1956 (Eyes #346)
"Untitled (The Wenela Mine recruiting agency)" 1967 (Marien \6.16)

MAHAN, Rich
[article on plastic surgery] 1986* (Best12 111b)

MAHLBERG, George E.
"Oswald/Ruby as Rock Band" 1996 (Goldberg 1996)

MAHLER, Ute
[from *Living Together*] c. 1981 (Marien \7.62)

MAHONEY, Jim
"Boston Police officers rush two children and a woman away from an apartment where they had been held hostage by a gunman" 1988 (Best14 75d)
"Police officer and his fatally injured horse" 1985 (Best11 84-85)

MAHONEY, Rob
"Stephen Jenteel was diagnosed as an AIDS victim in December" 1985 (Best11 29a)

MAHURIN, Matt
"Henry Rollins" c. 1995 (Graphis96 108)
"Key (unlocking mind)" 1993* (Best19 175)
"Lou Reed" 1987 (Rolling #60)
"O. J. Simpson" 1994* (Lacayo 171c)
[the series *Visions of Stone*] c. 1989* (Graphis89 \77)
"Tom Waits" 1986 (Rolling #61)

MAIALETTI, David
"Son peers from his dad's coat at a rally for the 'Day of Absence' in Philadelphia on the 2nd anniversary of the 'Million Man March'" 1997* (Best23 116)

MAISEL, David
[series of athletes' images to promote a drug used in AIDS treatment] c. 1999* (Photo00 186, 190)
"Storm off the California coast at Point Reyes" c. 1991* (Graphis91 \300)

MAISEL, Jay
"Announcement of a lecture" c. 1989* (Graphis89 \171)
"Leaning Tower of Pisa" c. 1990* (Graphis90 \83)
[promotion for the cruises of the Royal Viking Lines] c. 1991* (Graphis91 \303)
"United Technologies" 1982* (Rosenblum2 #633)

MAITRE, Pascal
"South Africa" 1993* (Photography 117)

MAJNO, Giorgio
[bowl of fruit] c. 1997* (Graphis97 96)

MAKOS, Christopher
"Andy Warhol" c. 1990 (Graphis90 \165)

MALANCA, Ettore
"Bucharest: The Children of North Station" 1997 (Best23 226b)

MALÉ, Jaime
"Photographs for a Spanish furniture producer" c. 1989* (Graphis89 \116-\117)

MALINOWSKI, Stan
[magazine cover] c. 1989* (Graphis89 \60)

MALOOF, Karen
"Boat on Sea" c. 1989* (Graphis89 \87)
"Skytop" c. 1989* (Graphis89 \67)

MALYSZKO, Michael
"Betty & Rita at Notre Dame" c. 1999 (Photo00 232)

MAN
[self-promotional series of models in action] c. 1995* (Graphis96 22, 24)

MAN, Felix H., 1893-1985
"Benito Mussolini in his enormous study at the Palazzo Venezia, Rome" 1931-1934 (Eyes #98; Szarkowski 213)
"Igor Stravinsky rehearsing, Berlin" 1929 (Eyes #97)
"One of the king's Indian orderly officers tries on his full-dress uniform" 1939 (Eyes #122)
"Paul von Hindenburg, President of Weimar Republic, in his study, Berlin" 1931 (Eyes #99)
"Private jazz concert in Berlin villa" 1929 (Lacayo 76a)

MAN RAY, 1890-1976
"Abstract Composition" 1921-1928 (Marien \5.21)
"Arm" c. 1935 (Hambourg \65)
"Arnold Schoenberg" 1930 (Vanity 178)
"Augustus Edwin John" 1923 (Vanity 71)
"Berenice Abbott" 1922 (Vanity 200c)
"Bronislava Nijinska" 1922 (Vanity 61)
"Compass" 1920 (Hambourg \84)
"Dust Breeding" 1920 (Art \241; Hambourg 21)
"Erik Satie" n.d. (Vanity 45)
"La Femme" 1920 (San #10)
[from *Emak Bakia*] 1927 (Hambourg \80)
"Gertrude Stein" 1922 (Vanity 50); 1934 (Vanity xviii)
"Glass Tears" c. 1930 (Art \247)
"L'Inquiétude" 1920 (San #9)
"Jacqueline Goddard" 1930 (Waking #173)
"Jacques Lipchitz" 1922 (Vanity 56)
"Male Torso" 1930 (Hambourg \63)
"Man" 1918 (Art \240)
"Marcel Duchamp" c. 1920 (Waking #184)
"The Model" c. 1933 (Hambourg \38)
"Le Monde" 1931 (Decade \32)
"Natural History (Seahorse)" 1930 (Hambourg 105)
"Neck" 1929 (Art \243)
"Pablo Picasso" 1922 (Vanity 44)
"Picasso" 1933 (Hambourg \43)

"Portrait of a tearful Woman" 1936* (Art \245)
"Rayogram" 1923 (Szarkowski 209)
"Rayograph" 1922 (Hambourg 74, \100; Waking #7)
"Rayograph" 1923-1928 (Waking #181)
"Rayograph–Lee Miller" 1931 (Icons 26)
"Reclining Nude on a satin Sheet" c. 1930 (Art \244)
"Self-Portrait" 1922 (Vanity 200a)
"Sinclair Lewis" 1925 (Vanity 74)
"Sleeping Woman" 1929 (Szarkowski 238)
"Spider Lady" c. 1930 (Photography 220)
"Tristan Tzara" 1922 (Vanity 48)
"Untitled" 1922 (San \20); 1936 (Marien \5.23;
 Rosenblum2 #644)
"Untitled (Gyroscope)" 1922 (Art \242)
Le Violon d'Ingres 1924 (Art \246; Icons 27;
 Rosenblum2 #494)
[wire spiral and smoke] 1923 (Rosenblum2 #484)
"Woman" 1918 (Art \239; Waking #182)

MANARCHY, Dennis
[ad for Harley-Davidson motorcycles] c. 1990*
 (Graphis90 \228)
[ad for large-screen TV sets] c. 1991* (Graphis91
 \284)
[ad for *The New Yorker*] c. 1990* (Graphis90 \82)

MANDEL, Mike, 1950-
"Emptying the Fridge" 1984* (Decade \XVI)

MANDEL, Rose, 1910-
"Untitled from the series *On Walls and Behind
 Glass*" 1947-1948 (Rosenblum \235)

MANDELKORN, Richard
"Atrium Mall in Newton" c. 1991* (Graphis92 \218)

MANN, David
"Lew Woods and Jake La Mote battle to a state of
 exhaustion" c. 1944 (Best22 10)

MANN, Sally, 1951-
"Drying Morels" 1988 (Women \148)
"Emmett, Jessie, and Virginia" 1989 (Icons 189)
"Jesse at 5" 1987 (Rosenblum \261)
"Jesse at 9" 1991 (Rosenblum2 #698)
"Naptime" 1989 (Marien \7.82)
"Untitled (Larry's Arm I)" 2002 (Photography 97)
"Untitled (Larry's Arm IV)" 2002 (Photography 96)
"Untitled, Virginia" 1992 (Icons 188)

MANNING, Kevin
"Fast Lane Weddings" 1996* (Best22 177d)

MANOOCHER
"Mullahs gathered near the Iranian port city of
 Abadan" c. 1990* (Graphis90 \251)
"The world of an Iranian child in the eighties" c.
 1990* (Graphis90 \267)

MANOS, Constantine
"Beaching a Fishing Boat, Greece" c. 1963
 (Rosenblum2 #617)
"Hampton Beach, New Hampshire" c. 1991*
 (Graphis92 \193)

MANSFIELD, Rick
"One policeman forgot he was on security duty when
 Vanderbilt's football team held on to a 7-0 lead"
 1985 (Best11 193d)

MANTZ, Werner, 1901-1983
"Entrance, Residential Apartment Block, Kalkerfeld,
 Cologne" 1928 (Hambourg \25)
"Kölnische Zeitung Building at Night" 1928
 (Hambourg 67c)
"X-Ray Clinic" 1926 (Hambourg 78a)

MANUAL (Suzanne Bloom, 1943- and Ed Hill, 1935-)
[from *The Constructed Forest*] 1993* (Marien \8.12)
"Identifying with Mona Lisa (The Problematic of
 Identity Theory I and II)" 1977* (Photography2
 191)

MAPPLETHORPE, Robert, 1946-1989
"Michael Roth" 1983 (Decade \104)
"Rosie" 1976 (Marien \7.83)
"Thomas and Dovanna" 1986 (Photography 87)
"Untitled (Male Nude)" 1981 (Icons 181)

MAR, Rod
"Baseball superstar Ken Griffey Jr. signs autographs
 before a Seattle Mariners game at the Kingdome"
 1991 (Best17 205)
"A family grieves for 17-year-old Moe Sterling, a
 gang member who was the victim of a drive-by
 shooting in Seattle" 1991 (Best17 201)
"A Navy reservist who was called to duty during the
 Persian Gulf war, returns to find that his neighbors
 painted his house" 1991 (Best17 202b)
"Paramedics assist a transient who fell from the third
 floor after homeless people took over the vacant
 structure" 1991 (Best17 202a)
"Steven Bryant and Demian spend a tender moment
 together" 1991 (Best17 203)
"Two young girls take their pony for a trail ride near
 Olalla" 1991 (Best17 204)
"With a little help from his mother, home-schooled
 student John Lindsey prepares for his high-school
 graduation" 1991 (Best17 205)

MARAIA, Charles
[diners] c. 1997* (Graphis97 162, 163)

MARC, Stephen, 1954-
[from the *Soul Searching* series] 1995-1999
 (Committed 148, 149; Willis \486, \559-\562)

MARCHESI, Paolo
[head of a fish] c. 1995* (Graphis96 81)
[tail of fish] c. 1995* (Graphis96 220)

MAREK, Christiane
[ad for a fashion firm] c. 1992* (Graphis93 84-85)
"Beer tent at the Munich October Festival" c. 1990*
 (Graphis90 \265)
"Beauty" c. 1990* (Graphis90 \56)
[from a series entitled *Objects on the Sea*] c. 1990*
 (Graphis90 \98)
"Hypo Bank's administrative building in Munich" c.
 1990* (Graphis90 \112)
[untitled] c. 1992* (Graphis93 108d)

MAREY, Étienne-Jules, 1830-1904
"Acceleration of falling ball" 1880s[?] (Szarkowski
 323a)
"Falling Cat Sequence" c. 1880s (Rosenblum2 #299)
"Horseman Riding the Mare Odette" c. 1887
 (Szarkowski 132a)
"Joinville Soldier Walking" 1883 (Marien \4.53)

MARGARITIS, Philippos
"Acropolis: general view from the Hill of Philopappus, southwest" 1865 (Marien \2.37)

MARGOLIES, Paul
"AIDS Memorial Quilt" 1996* (Photos 183)

MARIE, Dyan
"Learning to Count THREE; Whirlwind" 1993* (Marien \8.14)

MARINOVICH, Greg
"Human Torch" 1990* (Capture 160)
"South African demonstrators scatter as police fire tear gas, rubber bullets, and buckshot outside the Soweto soccer stadium" 1993* (Best19 184a)

MARK, Mary Ellen, 1940-
"Anton LaVey" c. 1992 (Graphis93 113)
"Blind children picking flowers" c. 1991 (Graphis92 \114)
"Blind Orphan at Shishu Bhawan, Calcutta, India" 1980 (Women \140)
"Children's ward, Korem, Ethiopia" 1985* (Eyes \28)
"Christopher Grey of Sandgap, Kentucky, community with a population of 5" 1990 (Best16 76)
"Crissy, her stepfather, Dean and mother Linda, nap in the afternoon" 1995 (Best21 185)
[Debutante LeGeanie Jones] c. 1999* (Photo00 98)
[Evening gown] c. 1997* (Graphis97 26)
[from advertising for Hasselblad cameras] c. 1990 (Graphis90 \123)
[from article entitled "Child of Silence"] c. 1989 (Graphis89 \253)
"Home for the Dying, Calcutta, India" 1980-1981 (Rosenblum \201; Women \141, \142, \143)
"Inside 'Die Place'" 1985* (Eyes \26)
"Jean Claude Van Damme" c. 1995 (Graphis96 112b)
"Jean Rowland and one of her eight children stand outside trailer in McKee, Ky." 1990 (Best16 77)
"John Grey, 4, of Sandgap, Ky." 1990 (Best16 80b)
"Lillie, Seattle" 1983 (Eyes #333)
"Marlon Brando" 1976* (Rolling #24)
"Marlon Brando during the filming of *Apocalypse Now*, Philippines" 1977 (Goldberg 189)
"Meryl Streep" c. 1995 (Graphis96 116b)
"The New Spain" 1985 (Rolling #62)
[Patrick Swayze in a dress] c. 1997 (Graphis97 113)
"Patti and Munchkin, Seattle" 1983 (Eyes #330)
"Pinky with Clown Man Passing on Left Side, Royal Circus, India" 1990 (Photography 46)
"Seattle street kids with gun" or "Rat and Mike, Seattle" 1983 (Lacayo 166; Marien \7.8)
"The Sudan" c. 1990 (Graphis90 \257-\260)
"Tiny in Her Halloween Costume" 1983 (Rosenblum2 #689)
"Tiny, Seattle" 1983 (Eyes #331)
"Victor Orellanes in Brooklyn" 1978 (Decade \86)

MARKS, Tom
"Two men try in vain to push a stalled car from rapidly rising floodwaters in Kentucky" 1992 (Best18 126d)

MARKUS, Kurt
"Peter Kotland" c. 1999* (Photo00 166)

MARMON, Lee
"White Man's Moccasins" 1954 (Photography 147)

MARQUETTE, Joe
"Ferdinand Marcos, deposed Philippines president, is helped from a U.S. Air Force plane on his arrival in the United States" 1986 (Best12 22d)

MARRISSIAUX, Gustav
"Breaker Boys" 1904 (Rosenblum2 #433)

MARSAL, Frédéric
[for modeling agency] c. 1992* (Graphis93 26)

MARSCHKA, Dan
"Cattle weave patterns of hoof prints in deep snow on a Pennsylvania farm" 1987 (Best13 165c)

MARSEL, Steve
[ad for a font cartridge] c. 1991* (Graphis92 \141)
"Matthew Carter, type designer" c. 1992* (Graphis93 108c)
"New Zealand Green Lip mussels for calendar" c. 1989* (Graphis89 \327)
[self-portrait] c. 1992* (Graphis93 126d)

MARSH, William
"Abraham Lincoln" 1860 (Waking #104)

MARSHALL, Harlan A.
"Flag woven by millworkers at Manchester, New Hampshire" 1917 (Eyes #76; Lacayo 42)

MARSHALL, Jim
"Bob Dylan" 1969 (Rolling #10)
"Janis Joplin" 1970 (Rolling #12)

MARSHALL, Joyce
"Faith, Hope and Devotion" 1996* (Best22 240b,d)
"A gunman killed himself after holding his wife hostage six hours" 1986 (Best12 86b)

MARSHALL-LINNEMEIR, Lynn, 1954-
"Sometimes I Hear Voices" 1992* (Willis \447)

MARTENS, Ernesto
[television sets] c. 1995* (Graphis96 150a,c)

MARTENS, Frederick von
"Panorama of Paris" c. 1846 (Marien \2.42)

MARTI, Enric
[ethnic Albanian women weep over the body of their relative in the Kosovo province of Yugoslavia] c. 1999* (Photo00 72)
"An Iraqi woman attends prayers at a mosque in downtown Baghdad" 1998* (Best24 77)
[racquetball by the pyramids] c. 1997* (Graphis97 144a)

MARTIN, Anton Georg
"Vienna: Winter Landscape" 1841 (Marien \2.2; Rosenblum2 #11))

MARTIN, Charles
"Kalinga Province Chiefs" 1912 (Goldberg 46)

MARTIN, Charles, 1952-
"As Meninas, Salvador da Bahia" 1994 (Willis \315)
"Carnival, Brooklyn" 1996 (Willis \313)
"Christian Procession, Salvador da Bahia" 1994 (Committed 150; Willis \314)
"Hatching" 1996 (Committed 151)

"Veneration, São" 1992 (Willis \316)

MARTIN, Ira W., 1886-1960
"The Belt Wheel" 1923 (Hambourg 31c)
"Building into the Sky" 1921 (Peterson #21)
"Design: Bee's Knees" c. 1926 (Peterson #63)

MARTIN, Louise Ozell, 1911-1995
[children's pageant] c. 1969 (Willis \190, \191)
"Coretta Scott King" 1970 (Willis \194)
"Dr. Martin Luther King, Jr.'s casket at Morehouse
College, Atlanta" 1968 (Willis \192)
"Dr. Martin Luther King, Jr.'s funeral, Atlanta" 1968
(Willis \193)

MARTIN, Paul, 1864-1944
"Dancing to the Organ, Lambeth" c. 1895 (Marien
\4.44)
"Entrance to Boulogne Harbor" 1897 (Szarkowski
131)
"Entrance to Victoria Park" c. 1893 (Rosenblum2
#307)
"Woman raking" 1893 (Szarkowski 129c, 129d)

MARTIN, Steve J., 1945-
"Shadow Self-Portrait #1" 1995* (Committed 152)
"Shadow Self-Portrait #2" 1995* (Committed 153)

MARUCHA, 1944-1991
"Caridad Cuervo, Havana" 1986 (Rosenblum \191)

MARVILLE, Charles, 1816-c. 1879
"14. *Rue des Marmousets*" n.d. (Marien \3.88)
"Landscape: Trees along a Highway, Coblentz" c.
1853-1854 (Szarkowski 60)
"*Rue Croulebarbe*, Paris" c. 1865 (Szarkowski 323c)
"*Rue de Choiseul*, Paris" c. 1865 (Szarkowski 108)
"Street Lamp" c. 1870 (Szarkowski 70)
"Street Lamp, *Parc Monceau*, Paris" c. 1870
(Szarkowski 323b)
"Tearing down the Avenue of the Opera" c. 1865
(Rosenblum2 #177)
"*Vue du Pont de la Réforme ou Pont Louis Philippe*,
Paris" 1853 (Art \68)
"Young Man reclining beneath a Horse-chestnut
Tree" 1853 (Art \74)

MARVYI
[ladies lightweight jeans] c. 1991* (Graphis92 \35,
\36)

MARX, Andreas
[annual report for Sonax] c. 1992* (Graphis93 156a)

MASAO, Horino
"Beggar" 1932 (Rosenblum2 #460)

MASCK, Brian
"Both blind from birth, Karen and Matthew Johnson
became siblings by being adopted by a Muskegon
couple" 1990 (Best16 74a)
"Worker on a Michigan celery farm fills in where the
automatic planter missed" 1986 (Best12 143a)
"Youngblood threatens suicide from the back seat of
a Muskegon police cruiser" 1990 (Best16 104c)

MASON, Charles
"Twelve hundred reindeer circle each other in a
corral north of Nome, Alaska" 1991* (Best17 69a)

MASON, Donald W.
"Sister Connie Wise" c. 1995 (Graphis96 132)
"Suzy & Niece" c. 1995 (Graphis96 133)

MASURY, Samuel, 1818-1874
"Looking Outward from the Barn, Loring Estate,
Beverly, Massachusetts" c. 1858 (National \8)
"Loring Estate, Beverly, Massachusetts" c. 1857
(Photography1 \35)

MATHENY, R. Norman
"Children in Belfast, Northern Ireland, swing from a
cord on a power-line pole" 1991* (Best17 200b)

MATHER, Jay B.
"Alice Brandenburg, Kentucky's first heart transplant
patient" 1985 (Best11 116c)
"German Baptists from Penn. marvel at the grandeur
of Yosemite National Park" 1990* (Best16 184)

MATHER, Margrethe, c. 1885-1952
"Billy Justema in Man's Summer Kimono" c. 1923
(Rosenblum \161; Rosenblum2 #534)
"Billy Justema, L.A." c. 1922 (Women \81)
"Japanese Wrestler's Belly" 1927 (Decade \15)
"Johan Hagemeyer and Edward Weston" 1921
(Decade \17)
"Moon Kwan with Yib Kirn" n.d. (Women \79)
"Semi-Nude" c. 1923 (Women \80)

MATISSE, Pierrre
"Constantin Brancusi" 1934 (Vanity 146)

MATSUBARA, Ken
[from an article about the photographer] c. 1989*
(Graphis89 \282-283)

MATTSON, George
"Bomber burns after crash in yard" 1955 (Capture
36)

MAULL AND POLYBLANK, active mid-19th century
"Professor Michael Faraday" 1859 (Szarkowski
323d)

MAUNEY, Michael
"Interracial dating" 1970 (Life 47b)

MAUNOURY, Eugenio
"Three Portraits" c. 1863 (Rosenblum2 #413)

MAXWELL, James Clerk
"Tartan Ribbon" 1861* (Rosenblum2 #337)

MAXWELL, Robert
"Anne Heche" c. 1999* (Photo00 111)
[Black man on white horse] c. 1997 (Graphis97 109)
[man pointing gun] c. 1997 (Graphis 97 110)

MAYALL, John Jabez Edwin, 1810-1901
"The Crystal Palace, Hyde Park" 1850-1851 (Art \22;
Marien \2.5)

MAYER, Bob
"It was a little tense when archrival soccer teams met
in a semifinal match" 1986 (Best12 231)

MAYER, Larry
"A lone tree is surrounded by irrigation ditches in a
farm" 1993* (Best19 74b)

"Sandbar on the Missouri River appears as a majestic mountain in aerial view" 1993* (Best19 73a)

MAYER FRÈRES AND PIERSON
"*Le Prince Impérial et Napoléon III*" c. 1858 (San #57)

MAYFIELD, Jim
"Life-sized 6-month-old gets close-up view of larger-than-life painting, 'Gorilla'" 1985 (Best11 144d)

MAYFIELD, William
"Orville and His Older Brother Rauchlin Wright at Simines Station" 1911 (Szarkowski 155)
"Orville Wright" 1913 or later (Waking #157)

MAYNARD, Hannah, 1834-1918
"Self-portrait" 1887 (Rosenblum \44)

MAYO, Michael
[cups and saucers] c. 1997* (Graphis97 76)

MAYO, Scogin
"Sterling Morrison" c. 1991 (Graphis92 \138)

MAYOR, J. P. Sotto
"Cookware" c. 1991* (Graphis92 \163, \164)

MAZE, Stephanie
"The Candomble priestesses of Brazil, in traditional ceremonial gowns, part of cult that originated in West Africa with animist gods and Catholic saints" 1987* (Best13 166)
"It's a dirty job, but gold ore at the huge federally operated Serra Pelada mine in Para, Brazil, still is hauled from the pits by hand" 1987* (Best13 163d)

MAZOURINE, Alexis
"River landscape and rowboat" n.d. (Rosenblum2 #385)

MAZZAATENTA, O. Louis
"In Paraguay, cowhands take a break on a bunkhouse porch" 1980* (Through 372)
"Paint still clings to 2,200-year-old terracotta soldiers found in the tomb of Qin Shi Huang Di, the first emperor of China" 2001* (Through 144)

MEATYARD, Ralph Eugene, 1925-1972
"Cranston Ritchie" 1964 (Rosenblum2 #760)
"Romance (N) from Ambrose Bierce, No. 3" 1962 (Marien \6.49)
"Untitled" n.d. (Photography 77); c. 1959 (San \37)

MECKES, Oliver
[fruit fly] c. 1995* (Graphis96 185)

MEEHAN, Mary Beth
"A family of sisters" 1993 (Best19 133-136)
[from *Our Times* column] 1996 (Best22 262-263)
"It's recreation hour at the Little Sisters of the Poor" 1997 (Best23 146)

MEEKS, Raymond
"Hands that tell of suffering" c. 1992* (Graphis93 58)

MEHLMAN, Janice
"Midnight Passage" 1993* (Rosenblum2 #792)

MEHTA, Dilip
"'Laying on Hands'– Ayurvedic Medicine in Bombay" 1990* (Best16 149a)
"Preschoolers at Khabarovsk's kindergarten rehearse for a pageant under the watchful eyes of 'Uncle Lenin'" 1987* (Best13 162b)
"A tailor in northwest India sews clothes for a Rabari wedding that will take place during the summer monsoon" 1993* (Through 174)
"Ushers of the Ebenezer Baptist Church on the Island of St. Helena" c. 1990* (Graphis90 \166)

MEIER, Raymond
"Eight Black Bags 5 Times" c. 1995* (Graphis96 48)
[from the series *Photographic Paintings*] c. 1992* (Graphis93 41)
[textured shoes, bag, and dress] c. 1997* (Graphis97 32-33)
"Three Mules" c. 1995* (Graphis96 49)

MEIGS, Montgomery C.
"Inauguration of Lincoln" 1861 (Photography1 #IV-22)

MEINHARDT, Michael
"Greg Forster and Mark McCoy tangled in the 60-meter hurdles final" 1987 (Best13 208c)

MEIREIS, Kent
"Ali Koen, 8, reacts to the birth of her brother at their Kansas farmhouse" 1990 (Best16 172d)

MEISEL, Steven
[ad for *Vogue Italia*] c. 1991 (Graphis91 \29)
"Bloomingdale's booklet" c. 1990 (Graphis91 \25, \31)
[for fashion catalog for Antonio Fusco] c. 1991 (Graphis91 \11, \12)

MEISELAS, Susan, 1948-
"Awaiting counterattack by the guard in Matagalpa" 1978* (Eyes \23)
"Children rescued from a house destroyed by a 1000-pound bomb dropped in Managua" 1978-1979* (Women \139)
"Cuesta del Plomo. Hillside outside Managua, well-known site of many assassinations carried out by the National Guard" 1978* (Women \138)
"Demonstrating against U.S. presence in the Philippines, held in front of Clark Air Force Base" 1985* (Eyes \24; Rosenblum \10)
"A funeral pyre in Nicaragua" 1979* (Lacayo 176b)
"Motorcycle Brigade, Monimbo, Nicaragua" 1978* (Art \431)
"Nicaragua" 1978* (Rosenblum2 #793)
"Pandora's Box, Awaiting Mistress Natasha, The Versailles Room, New York City" 1995* (Photography 213a)
"Pandora's Box, Mistress Catherine After the Whipping I, The Versailles Room, New York City" 1995* (Photography 213b)
"Returning Home, Masaya" 1978* (Art \430)
"Son killed by National Guard, El Salvador" 1980* (Eyes \25)
"Street Fighter in Managua" 1981* (Marien \7.12)
"Youths Practice throwing Contact Bombs in Forest surrounding Monimbo" 1978* (Art \429)

MEISTER, Michael
"Democratic presidential candidate Michael Dukakis

covers his ears as reporters shout questions in Arizona" 1988 (Best14 9b)

MELENA, Joe
"Pam, a 5,000 pound rhinoceros, went head to head with mechanical monster" 1985 (Best11 150d)

MELENDER, L. M. and Brother
"The Haunted Lane" c. 1880 (Rosenblum2 #279)

MELFORD, Michael
[fish] c. 1995* (Graphis96 192)
"Green Vine snake" 1982* (Life 12)
[Lake Powell Arizona] c. 1995* (Graphis96 164)

MELLON, Steve
"Bill Schroeder, the world's longest living artificial heart recipient, returns home" 1985 (Best11 116b)
"Despite putting a hex on his opponent during a billiards tournament at a pool hall, Mistick still lost" 1991 (Best17 55a)
"Dorothy Ramey and her son, Michael, live in fear since drug dealers fired bullets into their home in the East End of Pittsburgh" 1991 (Best17 53)
"An evening of fox-trots and rumbas draws to a close at a dance hall" 1991 (Best17 54b)
"An ongoing drug war outside prompted Arlie Clark, 73, to board her windows, despite the summer heat" 1991 (Best17 111)
"Prisoner to Fear" 1991 (Best17 57-60)
"Proprietor of a scrapyard takes a break in one of the junk cars in his yard" 1991 (Best17 56)
"Raymond Bowser was one of a thousand boys who were poked and prodded during a drug abuse study in Pittsburgh" 1991 (Best17 54a)
"A resident of the Homewood area of Pittsburgh, where violence has increased, keeps watch at night with a rifle and flashlight" 1991 (Best17 55b)
"The Violent City–Homewood area of Pittsburgh" 1991 (Best17 223-228)

MENCHER, Eric
"The Anderson Monarchs" 1997 (Best23 214a, 215c)
"Cuba: On the Edge" 1997 (Best23 154b, 224c)
"Kurdish refugees in a remote camp in the mountains of Turkey cower from the downdraft of a helicopter bringing relief supplies" 1991* (Best17 104a)
"A sailor on a 'Maxi' yacht gets rigging squared away at the Yacht Club" 1986 (Best12 144)
"Supporters of Pat Buchanan's presidential bid listen to him during a rally" 1996* (Best22 105c)

MENDEL, Gideon
"A Broken Landscape: HIV and AIDS in Africa" 1997 (Best23 240-241)
"Pear blossoms are pollinated by hand in Japan" 1997 (Best23 138b)

MENDELSOHN, Erich, 1887-1953
"New York, Equitable Trust Building" 1928 (Hambourg 85a)

MENDENHALL, Jim
"Larry Bird and the Celtics are knocked out of the air by the Lakers" 1985 (Best11 206b)

MENZEL, Peter
"Air instructors perform a hot dog maneuver: a three-man ring in a padded flight chamber" 1985* (Best11 152c)

"Mount Whitney with Moon" 1990* (Best16 72)
"Tehachapi windmills" 1985* (Best11 153a)

MEOLA, Eric
[from an ad campaign for Timberland shoes, boots and clothing] c. 1990* (Graphis90 \95-\97)

MERCER, Robert R.
"Family in Santiago-Atitlan, Guatemala, waits for the pastor of the Church, to visit a family member they feared was dying" 1987* (Best13 29d)

MERCIER/WIMBERG
[canvas in sand] c. 1992* (Graphis93 167a)
[life preserver] c. 1992* (Graphis93 167b)

MERILLON, Georges
"A victim of the civil war in Kosovo, Yugoslavia" c. 1991* (Graphis92 \48)

MERIPOL, Art
"Hundreds of people turn out on the Capitol steps in Little Rock as part of Hands Across America" 1986 (Best12 139)
"Joy of the Farm Aid Concert shines on the face of young participant as he floats on a sea of hands over the crowd" 1985 (Best11 63)

MERKEL, Hans-Georg
[Making linen and knitted fabrics elements of high fashion] c. 1992* (Graphis93 24)

MERLIAC, Herve
"Coffins of 16 adults and four children killed in the U.S. bombing of Libya are carried through the streets of Tripoli" 1986* (Best12 15a)
"An explosion [by hijackers] rips out the cockpit of a Royal Jordanian ALIA Airline at Beirut Airport" 1985 (Best11 55b)
"Moslem gunner rests his hand on a 75mm rocket launcher as he peers toward Christian east Beirut" 1985 (Best11 120b)

MERRICK, Nick
[Galvanized steel factory] c. 1991* (Graphis92 \220)

MESSAGER, Annette
"My Vows" 1990 (Marien \7.46)

MESSINA, Richard A.
"Public shower at the city pool" 1996* (Best22 175)
"Timmy's Dead-end Street" 1990 (Best16 96-100)

MESTRAL, O.
"Cahors: Pont Valentré" c. 1851 (Rosenblum2 #103)

METHA, Ashvin
[from poster for vacations in India] c. 1990* (Graphis90 \68)

METZKER, Ray K., 1931-
"Arches" 1967 (Rosenblum2 #753)
"Composites: Philadelphia" 1964 (Marien \6.100)
[from Moab II] 1997-1998 (Photography 179)
"Penn Center" 1966 (Photography2 98)
"Untitled" 1966-1967 (Szarkowski 284)

METZNER, Dolores
[from a series of assemblages for an article on the endangered rainforests] c. 1991* (Graphis91 \384)

METZNER, Sheila
[ad for Issey Miyake's soap and fragrance] c. 1992*
 (Graphis93 72)
"Arches of the Southwest–Red Rock Canyon" c.
 1995* (Graphis96 157d)
"As he likes it" c. 1990* (Graphis90 \45)
"Brown is the theme" 1989* (Graphis89 \3)
"A Different Stripe" c. 1991* (Graphis91 \32)
"Dress by Yves Saint Laurent" c. 1990* (Graphis90
 \40)
[Egyptian pyramids] c. 1995* (Graphis96 157c)
"Evening dress by *Saint Laurent Rive Gauche*" 1989*
 (Graphis89 \17)
"Evening wear" c. 1990* (Graphis90 \43, \44)
[from article entitled "Quintessence for your Beauty"]
 1989* (Graphis89 \2)
"Linen suit by Versace" c. 1990* (Graphis90 \41)
"Liquid Solid" c. 1995* (Graphis96 157a)
"Photograph of Tina Chow, the American jewelry
 designer" 1989* (Graphis89 \1)
"Rick, Stella, and Josie–a portrait series" c. 1991
 (Graphis92 \119-\121)
[S-class Mercedes] c. 1992* (Graphis93 160a)
"Silver cuff and bracelet" c. 1990* (Graphis90 \42)
"Uma Thurman" c. 1992* (Graphis93 22, 23)
[untitled] c. 1995* (Graphis96 28-29)

MEWS, Ray
"Home from Vietnam" 1966 (Eyes #312)

MEYER, Pedro
"Niña con Monstruo" 2001* (Photography 170)
"Temptation of the Angel" 1991* (Marien \8.13)
"Unmasking in the Square" 1981 (Rosenblum2 #705)
"Untitled (Wealthy woman with two maids and a
 male servant behind her)" 1978 (Marien \6.5)

MEYEROWITZ, Joel, 1938-
"Porch, Provincetown" 1977* (Rosenblum2 #780)
"Vivian" 1980* (Icons 172)

MEYERS, Deborah
"Community-based nursing service for cancer
 patients" c. 1991* (Graphis91 \65)

MEYERS, Peter
[based on a painting by Paul Cezanne] c. 1991*
 (Graphis91 \138)

MEYERSON, Arthur
"Company brochure for law firm" c. 1991*
 (Graphis91 \336)
"Company brochure for Prime Cable" c. 1990*
 (Graphis90 \149-\150)
"Darkness over Kuwait" c. 1992* (Graphis93 55)
[destruction of the Amazon rain forest] c. 1992*
 (Graphis93 166)
[Shell SuperRigs calendar] c. 1998* (Photo00 80, 81)

MICAUD, Christopher
"The Sources of Scent" c. 1997* (Graphis97 45)

MICHALS, Duane, 1932-
"The Bogeyman" 1973 (Marien \6.54)
"Chance Meeting" 1969 (Rosenblum2 #737)
"Joseph Cornell" 1976 (Decade \90)
"The Kentucky Kid 1-10" 2001 (Photography 58)
"Spirit Leaves the Body" 1968 (Photography2 75)

MICHELSON, Eric
[advertising for women's panty hose] c. 1990
 (Graphis90 \37)

MIDDLEBROOK, Willie, 1957-
"Black Angel No. 20" n.d.* (Committed 156)
"God Suite, Pomp No. 628" n.d.* (Committed 157)

MIDDLETON, Jim
"The United States returns to space with the launch of
 Discovery from Florida" c. 1988* (Best14 6c)

MIETH, Hansel, 1909-
"Boys on the Road" 1936 (Rosenblum \177)

MIKI, Jun
"The Smiths" 1954 (Life 43)

MILES, Bertrand, 1928-
"Congressman Adam Clayton Powell, Jr., speaking at
 the NAACP National Convention at Madison
 Square Garden" 1959 (Willis \155)
"Mary Church Terrell, civil rights and women's rights
 activist" 1953 (Willis \158)
"The Photographer's Mother, Irma Miles" 1948
 (Willis \156)
"Self-portrait" 1948 (Willis \157)

MILI, Gjon, 1904-1984
"Alice Marble" 1939 (Life 139a)
"Café Society, New York" 1943-1947 (MOMA 168)
"Carol Lynne" 1945 (Life 138)
"During this jam session in New York City, Duke
 Ellington played past four a.m." 1943 (Life 166c)
"Marcel Marceau" 1955 (Lacayo 153d)
"Patty Berg" 1938 (Life 139b)
"Shirley MacLaine" 1963* (Life 86a)

MILLAN, Manny
"Michael Jordan of the Chicago Bulls scores against
 the Philadelphia 76ers during an NBA playoff
 game" 1991* (Best17 154)

MILLER, Buck
"Wellington is the home of the New Zealand Yacht
 Club, which took part in the race for the America's
 Cup" 1987* (Best13 170d)

MILLER, Cheryl, 1953-
"Card Game" 1988 (Willis \297)
"Sunglass Corner" 1980 (Willis \296)
"Thelma Jones" 1988 (Committed 158; Willis \298)
"Tribute to the Ancestors of the Middle
 Passage–*Juneteenth*" 1995 (Committed 159)

MILLER, Dan
[silver jewelry] 1986 (Best12 113b)

MILLER, Eric
"Atlanta Braves catcher Greg Colson flips after
 colliding with Minnesota Twins runner Dan
 Gladden at home plate" 1991* (Best17 145)

MILLER, Gary B.
"Jack Baaker on the best fishing hole in the
 Sacramento River" 1986 (Best12 156b)

MILLER, George
"The Anderson Monarch baseball team playing with
 their equipment" 1997* (Best23 173b)

"Swim shorts" 1995* (Best21 149a)

MILLER, Lee, 1907-1977
"Beaten guards begging for mercy, Dachau
Concentration Camp, Germany" 1945 (Women
\73)
"Buchenwald" 1945 (Marien \5.82; Rosenblum \175)
"Dead Prisoners, Dachau Concentration Camp,
Germany" 1945 (Women \72)
"Eiffel Tower" c. 1931 (Women \70)
"Man Standing Near Asphalt" c. 1930 (Women \71)
"Murdered prison guard, Dachau" 1945 (Lacayo
115d; Photography 125)
"Nude (Self-portrait)" c. 1931 (Women \69)
"Untitled" c. 1931 (Hambourg \105)

MILLER, Milton M.
"Cantonese Mandarin and His Wife" 1861-1864
(Marien \3.36)

MILLER, Pamela
"Annie's Fight for Life" 1996* (Best22 235d)

MILLET, D. F.
"Couple and Child" 1854-1859 (Rosenblum2 #34)

MILLS, Dario Lopez
"Mexican family grieves over the open casket of one
of three brothers killed in a car accident in
California while being pursued by U.S. Border
Patrol agents" 1996* (Best22 151a)

MILLS, Doug
"Israeli Prime Minister Benjamin Netanyahu looks
around PLO Leader Yassir Arafat during a news
conference" 1996* (Best22 153c)
"President and Mrs. Ronald Reagan join families of
the Challenger astronauts at memorial services in
Houston" 1986 (Best12 12c)

MILLS, Roxann Arwen
[blurry feet on grass] c. 1999* (Photo00 141, 151)
[woman underwater in bathtub] c. 1999* (Photo00
141, 151)

MILNE, Gilbert A., 1914-
"D Day: Allied Invasion of Europe Begins" 1944
(Monk #28)

MINCHIN, James R., III
[playing a trumpet] c. 1995* (Graphis96 122)

MINKKINEN, Arno Rafael
"Self-Portrait" 1990 (Photography 174)

MINZUNO, Yasuo
"The new Mitsubishi Colt" c. 1991* (Graphis91 \274)

MIRCOVICH, Sam
"Firemen consider charred remnants of homes in
Cerritos destroyed when AeroMexico jetliner
crashed, killing 71 people" 1986 (Best12 57a)

MIRKO, Mark
"Scoring a diving competition" 1995* (Best21 112b)
"Suffering from a kidney disorder, nine-year-old
receives a morning kiss from his older brother"
1995 (Best21 142a)

MISRACH, Richard
"City Barber Shop, Clarendon, Texas" c. 1990*
(Graphis90 \89)
"Crater and Destroyed Convoy" 1986* (Goldberg
199; Marien \7.87)
"Flood, Salton Sea" 1983 (Rosenblum2 #784)
[from an article about the Nile] c. 1990* (Graphis90
\87-\88)
[from an article "Myths of Sand and Stone: The
Desert"] c. 1989* (Graphis89 \90-\91)
"Sounion (Island)" 1979* (Decade \III)
"Tootsie's Orchid Lounge, Nashville, Tennessee" c.
1990* (Graphis90 \90)
"Untitled #731-96" 2001* (Photography 184)

MITCHEL, Julio, 1942-
"Man in Lower East Side apartment" 1982 (Eyes
#328)
"Synagogue staircase" 1982 (Eyes #327)
"Vandalized synagogue" 1982 (Eyes #329)

MITCHELL, Charles L., active 1890-1905
"Crawford Notch, White Mountains" c. 1890
(National 138c)
"Pool, White Mountains" c. 1890 (National 138b)
"Walkway through a Gorge, White Mountains" c.
1890 (National 138d)

MITCHELL, Edward H.
"A Carload of Red Apples" 1910* (Szarkowski 202)

MITCHELL, Margaretta K., 1935-
"Old Rose" 1991* (Rosenblum \34)

MITCHELL, Odell
"Tears run down the face of St. Louis Cardinal
shortstop Ozzie Smith as he waits for his retirement
day ceremonies to start" 1996* (Best22 192b)

MITTELDORF, Klaus
[from the book Norami] c. 1990* (Graphis90 \70,
\103)

MIYATAKE, Toyo, 1895-1979
"Chrysanthemum Specialist" 1944 (Marien \5.50)

MIZONO, Robert
"Portraits of heavyweight champion boxers Buster
Douglass and Evander Holyfield" c. 1991*
(Graphis92 \234-\236)
[Summer activities in Wintertime] c. 1991*
(Graphis92 \201]

MOBLEY, Paul
"The Flying Cranes of the Russian circus" c. 1995
(Graphis96 126)
"A premiere clown of the Russian circus" c. 1995
(Graphis96 127)

MOCK, Stan, 1941-
"Montebello" 1975-1976* (Photography2 189)

MOCNIK, Frances
"The High Court, Canberra, Australia" c. 1995*
(Graphis96 178)

MODEL, Lisette, 1906-1983
"Albert-Alberta, Hubert's Forty-Second Street Flea
Circus, New York" c. 1945 (Marien \6.47)
"Black Dwarf, Lower East Side" 1950 (Women \129)

"Coney Island" 1941 (Icons 83; MOMA 161)
"Fifth Avenue, New York" c. 1945 (Photography 81)
"French Riviera" 1937 (Rosenblum2 #670)
"Gambler, French Riviera" 1937 (Hambourg \44)
"Lower East Side" 1940 (Women \128)
"Running Legs" 1940 (Sandler 92)
"Running Legs, Fifth Avenue" 1940-1941 (Icons 82)
"Sailor and Girl, Sammy's Bar, New York" c. 1944
 (Women \127)
"Singer at the Café Metropole, New York City" n.d.
 (Decade \37)
"Singer, Sammy's Bar, New York" 1940-1944
 (Rosenblum \220)
"Woman at Opera with Face Covered" c. 1945
 (Women \126)

MODELL, David
 "English Soccer Fans" 1996 (Best22 239b)

MODICA, Andrea
 "Treadwell, New York" 1987 (Women \150, \151)

MODOTTI, Tina, 1896-1942
 "Experiment in Related Forms" 1924 (Women \45)
 "Hands of a Marionette Player" 1926 (Women \49)
 "Interior of Church Tower, Tepotzotlan, Mexico"
 1924 (Women \46)
 "Mother and Child" c. 1929 (Szarkowski 324a)
 "Roses, Mexico" 1924 (MOMA 107; Women \44)
 "Stairs, Mexico City" 1923-1926 (Hambourg \114;
 Women \47)
 "Telephone Wire Composition, Mexico" 1925
 (Women \48)
 "Woman with Flag" 1928 (Photography 119)
 "Worker's Hands" c. 1926 (Icons 44; MOMA 109;
 Rosenblum2 #520)
 "Workers' Demonstrations, Mexico, May 1" c. 1928
 (Icons 45; Women \50)
 "Workers, Mexico" 1924-1930 (Marien \5.51;
 Rosenblum \163)

MOFFATT, Tracey
 "Fourth (No. 18)" 2001* (Photography 54)

MOFFETT, Mark
 "Each year the tarantula outgrows its skin and sheds it
 like a glove" 1996* (Best22 185c; Through 341)
 "In a Costa Rican jungle, rare and tiny trap-jaw ants
 live in small colonies within dead twigs" 1988*
 (Best14 158)
 "More than 200 feet above ground, ecologist reaches
 the summit of a Douglas Fir" 1997* (Best23 159d)
 "Robot feeds Honeybee" 1990* (Best16 148)

MOFFETT STUDIO
 "George M. Cohan" 1914 (Vanity 20)

MOFOKENG, Santu
 "Shebeen in White City, Soweto" c. 1987 (Marien
 \7.30)

MOHIN, Andrea
 "New York City Mayor Rudolph Guiliani consults
 Grand Rabbi Solomon Halberstam while
 campaigning in Brooklyn" 1993 (Best19 193b)

MOHOLY, Lucia, 1894-1989
 "Florence Henri" 1927 (Hambourg \47; Rosenblum
 \1; Rosenblum2 #518)
 "Franz Roh" 1926 (Hambourg \50; San 182b;

Women \85)
"László Moholy-Nagy" 1923-1924 (Hambourg 81);
 1925-1926 (Hambourg \51; Women \86)
"Walter Gropius" 1928 (Vanity 112)

MOHOLY-NAGY, László, 1895-1946
 "Ascona" 1926 (San #35)
 "Behind the Back of the Gods" 1928 (Hambourg \94)
 "Boats in the Old Port of Marseilles" 1929 (Art \233)
 "Decorating Work, Switzerland" 1925 (Waking
 #163)
 "From the Berlin Radio Tower" 1928 (Hambourg 87;
 Photography 107)
 "Goerz" 1925 (Marien \5.36)
 "Lucia" 1924-1928 (Hambourg \98)
 "Marseilles" 1929 (Art \234)
 "Negative" 1931 (Art \238)
 "Photogram" n.d. (Rosenblum2 #485); 1924 (Marien
 \5.14); 1925 (Hambourg \102); 1926 (Hambourg
 \99)
 "Photogram: Positive-Negative" after 1922 (Art \237)
 "Puppen" or "Dolls on the Balcony" 1926 (San \21;
 Waking #177)
 "Repose" 1924-1931 (Szarkowski 231)
 "The Schlemmer Children" 1926 (San #34)
 "Self-Portrait, Photogram" 1926 (Icons 29)
 "7 a.m. (New Year's Morning)" c. 1930 (Hambourg
 \12)
 "Untitled" 1926 (San #33); 1928 (Art \236)
 "View from the Pont Transbordeur, Marseilles" 1929
 (Art \235)

MOLE, Arthur S. and Thomas, John D.
 "The Human U.S. Shield: 30,000 Officers and Men,
 Camp Custer, Battle Creek, Michigan" 1918
 (Hambourg 90c; MOMA 79)
 "Woodrow Wilson (image formed by 21,000 men at
 Camp Sherman" 1918 (Goldberg 56)

MOLINA, Genaro
 "After placing their bets, horse-racing enthusiasts
 wait for the next race to begin" 1990* (Best16 55a)
 "Ancil Wyatt, 80, who claims to be a distant relative
 of Wyatt Earp, shot a man while trying to make a
 citizen's arrest during robbery" 1990* (Best16 56)
 "California Army National Guard troops board a 747
 destined for the Persian Gulf" 1990* (Best16 53a)
 "The Cincinnati Reds celebrate after winning the
 World Series in four straight games against the
 Oakland A's" 1990* (Best16 52a)
 "Eugene 'Happy' Gragson has been an entertainer for
 most of his 101 years" 1992* (Best18 67)
 "An exhausted Scott Robinson drops with raised fists
 after winning the men's 1600-meter run at the state
 track meet" 1987 (Best13 216d)
 "Lone shopper makes his way through the early
 morning shadows at a mall" 1990* (Best16 52d)
 "Monique, 10, waves goodbye to her father, part of
 Operation Desert Shield" 1990* (Best16 53b)
 "Professional stunt man 'Diver Dan' performs the
 'human torch' dive at the California State Fair"
 1990* (Best16 54)
 "Runaway: Teenage Prostitute" 1988 (Best14 181-
 183)
 [series on caring for parent with Alzheimers] 1990
 (Best16 49-51)
 "A tourist pauses to catch her breath on her way up a
 spiral staircase to the museum in Vatican City"
 1990* (Best16 55d)

MOLKENTHIN, Michael
[self-promotional] c. 1991* (Graphis91 \92)

MOLLINGER, Franziska, 1817-1880
"Landscape with Castle" c. 1845 (Rosenblum \40)

MOMATIUK, Yva
"Hoofing it for cover, a startled caribou makes tracks across a highway in the interior of Newfoundland" 1986* (Best12 107b)
"No one goes hungry in Slovakia" 1986* (Best12 105a)

MONDING, Jean-Baptiste
"Swimwear" c. 1990* (Graphis90 \15)

MONICO, Gerard
"Robert Doisneau" 1986 (Marien \1)

MONRO, Graham
"Athletics" c. 1999* (Photo00 189)

MONSEES, Peter
"Filters for tap water: a muddy issue" 1988 (Best14 114)

MONTALBETTI + CAMPBELL
"Karen Thorndike" c. 1999* (Photo00 118)

MONTESINOS, Ivan
"Reunited with her father, Salvadoran President Napoleon Duarte after she was freed by insurgents who kidnapped her" 1985 (Best11 90b)

MONTGOMERY, David
"Peter O'Toole" 1982* (Rolling #56)

MONTIZON, Count de (Juan Carlos María Isidro de Borbón), 1822-1887
"The Hippopotamus at the Zoological Gardens, Regent's Park" 1852 (Waking #26)

MOODIE, Geraldine, 1853-1945
"Group of Eskimo Women at Fullerton Harbour" 1905 (Rosenblum \109)

MOON, M. Scott
"Kinsley goes face to face with his former mount during a bare-back riding competition" 1996* (Best22 196b)

MOON, Sarah, 1940-
[article on Hollywood] c. 1991* (Graphis91 \42)
[evening gowns] c. 1997* (Graphis97 50-51)
"Faces" 1973* (Rosenblum2 #648)
[from an article on the French fashion designer Christian Lacroix] c. 1989 (Graphis89 \32)
"Suzanne in the Tuileries" 1974 (Rosenblum \224)

MOORE, Bob, active 1950s-1970s
"Arthur Ashe at tennis match in Los Angeles" c. 1979 (Willis 160)
"Artist Charles White at work in his studio" n.d. (Willis \159)
"Illinois Jacquet playing saxophone" n.d. (Willis \162)
"Sarah Vaughan singing in nightclub" n.d. (Willis \161)

MOORE, Charles, 1931-
"Birmingham, Alabama" 1963 (MOMA 234)
"Birmingham demonstration, May 6" or "Hoses are used on civil rights demonstrators" 1963 (Best14 218; Eyes #271; Marien \6.69)
"Black women are attacked on a street corner" 1958 (Best14 217a)
"Bloody Sunday clash between a group of marching demonstrators and state highway patrolmen at the Edmund Pettus Bridge" 1965 (Best14 217b)
"Civil rights workers are beaten by sheriff's deputies and police on horses" 1965 (Best14 211, 219a)
"A demonstrator" 1963 (Best14 216)
"Eugene 'Bull' Conner, Birmingham's Commissioner of Public Safety, orders the use of police dogs and fire hoses against civil rights activists" 1963 (Best14 215)
"Jubilant teens sing freedom songs" 1963 (Best14 214)
"Local officials await James Meredith's attempt to enroll at Ole Miss." 1962 (Best14 212)
"Man swinging club at black woman on Montgomery, Alabama, street corner" 1960-1961 (Eyes #272)
"Rev. Martin Luther King, Jr., being booked by Montgomery police" 1958 (Best14 220; Life 156)
"Segregationists at University of Mississippi react to the imminent enrollment of James Meredith, first black student at the university" 1962 (Best14 214)

MOORE, Henry P.
"Long Dock at Hilton Head, Port Royal, South Carolina" 1862 (National \15)
"Portrait Group Before DAGTYPS Gallery Tent" c. 1862-1863 (Photography1 #IV-11)

MOORE, John
"Gravely ill Hutu refugee clutches for help in a refugee camp" 1997* (Best23 127b)
"High-school ROTC members hold an American flag at the University of New Mexico football stadium during a celebration for veterans of the Persian Gulf war" 1991* (Best17 73)
"A worker for a flour-distribution company in Port-au-Prince, Haiti, unloads cargo" 1991* (Best17 19)

MOORE, Paul Franz
"NEXT computer" c. 1990* (Graphis90 \207)

MOORE, Raymond, 1920-1987
"Alderney" 1965 (Art \379)
"Allonby" 1982 (Art \382)
"Dumfriesshire" 1985 (Art \384)
"Eire" 1976 (Art \381)
"Kintyre" 1985 (Art \380)
"Raes Knowes" 1980 (Art \383)

MOORE, Robert
[from an exhibition catalog The Steuben Project: Sculptures in Crystal] c. 1989 (Graphis89 \229)

MOORE, W. Robert
"Café-goers enjoy a pleasant afternoon in Montparnasse" 1936 (Through 106)
"Fishing on the banks of the Seine is a favorite pastime for Parisians" 1936 (Through 104)
"Tethered and collared, cormorants catch and disgorge fish into a boat in Japan" 1936 (Through 178)

MOOS, Viviane
"Joy Times Three" 1997 (Best23 227a, c)

MORABITO, Rocco
"The Kiss of Life" 1967 (Capture 61)

MORAN, John, 1831-1903
"Geddes Brook, a Tributary of Tohican,
Pennsylvania" c. 1855-1865 (Photography1 \63)
"House in Mickle's Court" 1869 (Photography1 \64)
"Indian Ladder Bluff (Delaware Water Gap)" 1864
(Photography1 #V-1)
"Limón Bay, Panama, high tide" 1871 (Lacayo 27c)
"Scenery in the Region of the Delaware Water Gap"
c. 1864 (Rosenblum2 #145)
"Tropical scenery–Limón Bay" 1871 (National 139c)

MORATH, Inge, 1923-
"Buckingham Palace Mall, London" 1954
(Rosenblum2 #477)
"Marilyn Monroe, Reno" 1960 (Photography 84)
"Tarassa, Catalonia" 1961 (Rosenblum \200)

MORE, Jose M.
"On a spring day in Chicago, a photographer is
startled to find his fashion shoot snowed in by a
lake-effect snow" 1987 (Best13 124c)

MOREL, Daniel
"A Haitian stabs an alleged thief during a protest
against the murder of militant" 1996* (Best22 159)

MORELLO, Debbie
"A father comforts his wounded son as distressed
relative looks on in Bosnia-Herzegovina" 1993*
(Best19 196)
"Haiti's Sorrow: Still the Same" 1997 (Best23 131c,
204c, d)

MORGAN, Barbara, 1900-1992
"Hearts over the People" 1939 (Decade 45)
"José Limon: Cowboy Song" 1944 (Sandler 168)
"Martha Graham" 1940 (Life 166a)
"Martha Graham–American Document–Puritan Love
Duet" 1938 (Photography 61)
"Martha Graham–El Penitente–Erick Hawkins Solo
as El Flagellante" 1940 (Decade \49)
"Martha Graham–Letter to the World" 1940
(Rosenblum2 #557)
"Merce Cunningham–Totem Ancestor" 1942
(MOMA 162)
"Spring on Madison Avenue" 1938 (Rosenblum2
#556; Sandler 173)
"Valerie Bettis, Desperate Heart I" 1944-1972
(Rosenblum \230)

MORGAN, Nancy
"Harrison Ford" 1981* (Life 90a)

MORIMURA, Yasumasa
"Self-Portrait (Actress), Red Marilyn" 1996* (Marien
\8.18)

MORINI, Luciano
[birds] c. 1995 (Graphis96 180, 182)

MORIYAMA, Daido, 1938-
"Stray Dog, Misawa" 1971 (Marien \6.32;
Szarkowski 261)
"Untitled" n.d. (Photography 223a)

MORLEY, Margaret, 1858-
"Clearing Land with Oxen" c. 1900 (Sandler 24)
"Family on Porch" c. 1900 (Sandler 25)

MOROZOV, Anatoli, active 1940s
"The Victorious Troops signing their Names in the
Lobby of the Reichstag" 1945 (Art \423)

MORRELL, Lady Ottoline, 1873-1938
"Cavorting by the Pool at Garsington" c. 1916
(Rosenblum \89; Waking 206-207)

MORRIS, Christopher
"Anti-Noriega protestors battle riot police from a
rooftop" 1988 (Best14 179d)
"Baidoa and Mogadishu, Somalia" 1992* (Best18 57-
59)
"Bodies of Croatians await burial" 1991* (Best17 44)
"Bodies of Croatians in Vukovar, Yugoslavia, await
burial after federal troops overtook the town"
1991* (Best17 41)
"A Chechen soldier running from the Presidential
Palace shortly before it was captured by the
Russians" 1995 (Best21 181)
"Chechnya" 1995 (Best21 209)
"Civil War in Croatia" 1991* (Best17 185-188)
"Croatian citizens come out of shelters after the
fighting" 1991* (Best17 43a)
"Even children seem to become oblivious to the
bodies scattered throughout the town" 1991*
(Best17 43b)
"A funeral in Croatia" or "Boy grieves at the funeral
of his father" 1991* (Best17 113; Lacayo 178)
"Gen. Augusto Pinochet gives thumbs up to a
supporter trying to touch the window of his passing
car after a rally in Chile" 1988 (Best14 87)
"In July 1991, oil wells in Burgen field still burn"
1991* (Best17 39)
"Iraqi soldiers surrender to the U.S. Marines 1st
Division as it advances toward Kuwait City" 1991*
(Best17 35)
"A Kuwaiti citizens kisses an American flag after the
liberation of Kuwait" 1991* (Best17 37)
"Life goes on in Kuwait City, despite the pollution
from oil spills and fires" 1991* (Best17 38b)
"A Marine holds the passport of an Iraqi soldier who
surrendered" 1991* (Best17 36b)
"Months after the end of the Persian Gulf war, a
teacher visiting Burgen oil field in Kuwait wears a
mask against smoke pollution" 1991* (Best17 38a)
"Oil-well firefighters in Kuwait" 1991* (Best17 40)
"Panama's strongman General Manuel Noriega
attends a political rally in San Martin" 1988
(Best14 179a)
"A protester is led away during a poll-tax riot in
London" 1990* (Best16 196d)
"Rain mixes with the blood of an executed Croatian
in Vukovar" 1991* (Best17 42a)
"Red October" 1993* (Best19 213-216)
"Return to Sarajevo" 1996* (Best22 243a, c)
"Sarajevo, Bosnia-Herzegovina" 1992* (Best18 60-
62)
"The streets of Vukovar are strewn with rubble after
battle between Croatian citizens and Yugoslav
troops" 1991* (Best17 42b)
"U.S. Marine tank pushes through Kuwait, as oil
wells burn in the distance" 1991* (Best17 36a)
"A Yugoslav soldier poses with the body of an
executed Croatian" 1991* (Best17 43b)

MORRIS, Christopher L.
[from *Savannah* series] c. 1995* (Graphis96 68, 69)

MORRIS, Larry
"President Reagan points to where a growth diagnosed as a minor skin cancer was removed" 1985 (Best11 88c)

MORRIS, Wright, 1910-
"Front Room Reflected in Mirror" 1947 (Decade 50b)
"Gano Grain Elevator, Western Kansas" 1939 (Decade \41; MOMA 152)

MORSE, Ralph, 1918-
"Jackie Robinson steals home base" 1955 (Lacayo 152)
"A new plaster cast is fitted to the body of George Lott, who was wounded by mortar shell" 1944 (Eyes #188)
"Senator and Pat Nixon after his nomination as Ike's running mate, Republican National Convention, Chicago" 1952 (Life 30)
"Soldier's skull on a destroyed tank" 1943 (Lacayo 105b)
"TV-watching party at the Nubers" 1949 (Life 99)

MORSE, Samuel F. B., 1791-1872
"Graduate of Yale, Class of 1810" 1840 (Marien \2.49)
"Portrait of a Young Man" 1840 (Waking #89)

MORTENSEN, William, 1897-1965
"L'Armour" c. 1936 (Rosenblum2 #755)
"Caprice Vennois" c. 1930 (Peterson #69)
"Human Relations" 1932 (Peterson #39)
"Torso" c. 1935 (Peterson #74)

MORTON, Stephen
"A police officer tries to calm two boys outside a home officials raided in a major sweep of suspected 'crack' cocaine houses" 1986 (Best12 69d)

MORVAN, Yan
"Aftermath of a car-bomb explosion, West Beirut, Lebanon" 1983* (Life 63)

MOSCONI, Bruno
"Victims of a Palestinian terrorist attack are sprawled in lounge area of Rome's Leonardo da Vinci Airport" 1985 (Best11 104c)

MOSER, Christian
"Hyperrealistic close-up photographs" c. 1991* (Graphis91 \3)

MOSES, Stefan, 1928-
"Child and Cat with Chinese Animal Masks" 1965 (Icons 150)
"Self in the Mirror–Ernst Bloch and Hans Mayer" 1963 (Icons 151)

MOSLEY, John W., 1907-1969
"Dr. William's daughters enjoying a birthday treat" 1944 (Willis \175)
"Majorette at National Elks Convention" c. 1945 (Willis \174)

MOSTYN, Lady Augusta, 1830-1912
"Allington Castle, Kent" c. 1855 (Rosenblum \41)

"Oak Tree in Eridge Park, Sussex" 1856 (Marien \3.101)

MOTTERN, John
"Dreaming of helping the rebels, this 12-year-old boy ran down a street in San Salvador brandishing an AK-47" 1990* (Best16 73)

MOULIN, J. A.
"Étude: Séduction" c. 1852 (Marien \2.54)

MOULIN, Ludovic
[shimmering bridge] c. 1997* (Graphis97 169)
[untitled] c. 1995* (Graphis96 131)

MOUTOUSSAMY-ASHE, Jeanne, 1951-
"Beverly Hodge, Bedford Hills Women's Correctional Center" n.d. (Rosenblum \195)
"Emily's kitchen, Daufuskie Island, South Carolina" 1980 (Willis \248)
"Jake with his boat arriving on Daufuskie's shore" 1981 (Willis \246)
"Man in Front of Union Baptist Church" 1977 (Committed 160)
"A 98-year-old Edisto Islander with his family photographs, South Carolina" 1979 (Willis \247)
"Sam Gadsen and His Family Photos" 1977 (Committed 161)
"Susie standing next to holy picture in her living room, Daufuskie Island" 1980 (Willis \245)

MOYER, Matthew
"8-year-old boy carries clay pots to a kiln where burning tires harden the clay" 1997* (Best23 139c)

MUCHA, Alphonse, 1860-1939
"Study for a Decorative Panel" 1908 (Waking #150)
"Study for *Figures Décoratives*" 1903 (Rosenblum2 #357)

MUDD, James, 1821-1906
"Clouds" 1850s[?] (Szarkowski 52)

MUDFORD, Grant
"Ayers Rock" 1973* (Rosenblum2 #776)

MUGLER, Theirry
[untitled] c. 1990* (Graphis90 \32)

MUHAMMAD, Ozier, 1950-
"Mayor Richard Daley and His Enemies" 1971 (Committed 163)
"Men Smoking at Bus Stop" 1989* (Committed 162)

MUI, Kai
"American West" c. 1992* (Graphis93 168a)

MUIR, Doug, 1940-
"Brother Gary and his Girlfriend Joannie" 1959 (Marien \7.72)

MULALA, George Mwangawni
"A victim of a powerful bomb blast is evacuated from the scene of the U.S. Embassy terrorist attack in Nairobi" 1998* (Best24 21a)

MULAS, Ugo
"Marcel Duchamp" 1965 (Photography 145)

MÜLLER-POHLE, Andreas
"Vacant center" c. 1991 (Graphis92 \202)

MULLINS, William James, 1860-1917
"Children Fishing" c. 1900 (Waking 332)
"Ploughman in Landscape" c. 1900 (National \61)
"Trees Reflected in a Pond, Twilight" c. 1900
 (National 25b)

MULVANY, Colin
"A child watches her father arrested for domestic
 assault" 1995 (Best21 168)

MUNA, R. J.
[ad for Acuson Computers] c. 1991* (Graphis92
 \180, \181)
"Multi-user systems, personal computer, and
 terminals" c. 1990* (Graphis90 \208-\210)
Paso 750 c. 1989* (Graphis89 \201)
"Personal study" c. 1989* (Graphis89 \120)

MUNKÁCSI, Martin, 1896-1963
"Boys on the Shore of Lake Tanganyika" or "Liberia"
 1931 (Hambourg \59; Icons 47; Rosenblum2 #595)
"Children at Kissingen, Germany" or "Summer
 Camp, Marienruhe" 1929 (Hambourg 68; San \14)
"Cover of *Biz* magazine" 1929 (Lacayo 69;
 Rosenblum2 #589)
"Fred Astaire" 1936 (Art \440; Lacayo 84)
[from *Die Koralle*] 1929 (San #12)
"Fun During Coffee Break" or "Having Fun at
 Breakfast" 1932 (Art #16; Photography 57;
 Waking #188)
"Leni Riefenstahl" 1931 (Hambourg \61)
"Liberia, church scenes" 1930 (Eyes #103-104)
"Lucille Brokaw" 1933 (Art \439)
"Motorcyclist, Budapest" c. 1923 (Hambourg \74)
"Uncle Robert's Poor Being Served Lunch" 1926
 (Icons 36)
"Untitled" 1934 (Rosenblum2 #640)
"Vacation Fun" 1929 (Szarkowski 211)
"Washing, Berlin" c. 1929 (Art \438)

MUNZIG, Horst
"The Blue Lagoon, Iceland's 'biggest bath,' is the
 catch basin of a power plant in the hot springs
 region of Grindavik" c. 1990* (Graphis90 \86)

MURAY, Nickolas, 1892-1965
"Agnes de Mille" 1928 (Vanity 95)
"Alma Gluck" 1923 (Vanity 115)
"Arnold Genthe" 1923 (Vanity 198a)
"Babe Ruth" c. 1927 (MOMA 124); 1935 (Vanity
 xix)
"Clarence Darrow" 1928 (Vanity 81)
"Douglas Fairbanks, Jr. and Joan Crawford" 1929
 (Vanity 66-67)
"Douglas Fairbanks, Sr. and Mary Pickford" 1922
 (Vanity 64-65)
"Eugene O'Neill" n.d. (Vanity 53)
"Jascha Heifetz" 1925 (Vanity 96)
"Still Life" 1943 (Rosenblum2 #631)

MURCH, Jeremy
[woman in bathing suit on grass] c. 1999* (Photo00
 144)

MURPHEY, Lance
"Saving Benjamin" 1995 (Best21 197)

MURPHY, Paul
[shirtless man] c. 1999* (Photo00 94)
[untitled] c. 1999* (Photo00 120, 137)

MURPHY, Seamus
"Bettors at Beirut's track juggle smoking a houkah
 and watching the horse race with binoculars" 1998
 (Best24 36b)
"Jockey Mihad and racehorse Samir at the Beirut
 horse track" 1998 (Best24 82a)

MURPHY-RACEY, Patrick
"Milwaukee firefighter Dean Thomas revives a 3-
 week-old infant he rescued from a burning
 building" 1988 (Best14 73b)

MURRAY, Colin
"Water Palace at Udaipur" c. 1873 (Rosenblum2
 #137)

MURRAY, David, Jr.
"A wounded Haitian woman grieves over the body of
 her mother and other relatives surrounding her"
 1987* (Best13 19a)

MURRAY, Joan, 1927-
"Untitled, No.1 from the series *Man*" 1971
 (Rosenblum \259)

MURRAY, John, 1809-1898
"Main Street at Agra" 1856-1857 (Waking 81)
"Nude men, motion study" 1877 (Szarkowski 132c)
"Panorama of Agra" 1859 (Art \131)
"Panorama of the West Face of the Taj Mahal" c.
 1850s-1860s (Marien \3.30)
"The Taj Mahal" c. 1856 (Art \132)
"The Taj Mahal from the Bank of the River, Agra" c.
 1858 (Waking #80)

MURRAY, Ming Smith, active 1970s - 1990s
"Hill District, Pittsburgh" c. 1994 (Willis \327-\329)
"Nude Study" 1995* (Willis \423)

MURRAY, Noah K.
"Body of Knowledge" 1997 (Best23 160-161)

MUSCIONICO, Tomas
"Clinton-Gore supporters wave to the campaign bus
 as it travels to Centralia, Ill." 1992* (Best18 78a)
"Factory pollution in Romania" 1990 (Best16 161-
 164)

MUSI, Vince
"Near death and yellow from jaundice, sleeping in a
 trailer as she and her parents await her liver-
 transplant operation" 1988 (Best14 78a)
"Pittsburgh Penguin Hannah gets a rousing welcome
 from his teammates after scoring the winning goal
 in a tie with the Blackhawks" 1988 (Best14 140a)
"Pittsburgh Pirate Jose Lind argues with the umpire
 after being thrown out at second to end the inning
 in a loss to Cincinnati" 1988 (Best14 140d)
"Pittsburgh Steelers Brister shows offensive lineman
 Blankenship his appreciation for allowing him to
 complete a touchdown pass" 1988 (Best14 142)
"University of Pittsburgh basketball star Jerome Lane
 is showered with glass after shattering a backboard
 during a game" 1988 (Best14 141)

MUSSA, Mansa K., 1951-
"Harlem Girl" 1982 (Willis \280)
"Philadelphia Dance Company" 1998 (Willis \281)
"Rumba, Havana, Cuba" 1990 (Willis \279)

MUYBRIDGE, Eadweard J., 1830-1904
"Ascending and Descending Stairs" 1870s (Marien \4.58)
"Eakins's Hand" 1887 (Rosenblum2 #293)
"Evening Recreations of the Coffee Pickers, San Isidro" 1877 (National 140a)
"Falls of the Yosemite" 1872 (Lacayo 29)
"Galloping Horse" 1878 (Marien \4.52; Monk #9)
"Modoc Brave on the War Path" 1872-1873 (Marien \3.65)
"Multiple nude self-portraits" 1887 (Goldberg 50-51)
[nude stepping on chair and pouring water] 1887 (Rosenblum2 #294)
"Panorama of San Francisco" 1878 (Photography1 #III-14; Rosenblum2 #165)
"Studies of Foreshortenings; Mahomet Running" 1879 (Rosenblum2 #291)
"A Study of Clouds" c. 1869 (Rosenblum2 #149)
"Valley of the Yosemite from Mosquito Camp" 1872 (Szarkowski 116)
"Valley of the Yosemite from Union Point" c. 1872 (Marien \3.61; National \25)
"Volcano Quetzeltenango, Guatemala" 1875 (Rosenblum2 #150)
"Woman Pirouetting" 1887 (Photography1 \86)

MYDANS, Carl, 1907-2004
"Back Yard Alley Dwelling" 1941 (Marien \5.63)
"Commuters on a train to Stamford, Connecticut" 1963 (Lacayo 143c)
"Earthquake, Fukui, Japan" 1948 (Life 126)
"French women accused of sleeping with Germans during the occupation are shaved by vindictive neighbors near Marseilles" 1944 (Eyes #198)
"General Douglas MacArthur in Korea" 1950 (Lacayo 137)
"The Japanese surrender" 1945 (Lacayo 120)
"Kasakawa Family" 1955 (Goldberg 140)
"A Korean mother carrying her baby and her worldly goods flees the fighting around Seoul in the winter attack on the Korean capital" 1951 (Eyes #224)
"MacArthur landing in the Philippines" 1945 (Eyes #211; Lacayo 109)
"On the Nixon campaign trail" 1956 (Eyes #233)
"Photo of Carl Mydans and David Douglas Duncan in Korea" 1950 (Eyes #228)
"Piazza del Campidoglio" 1940 (Lacayo 76d)
"Relief rice for starving Japan" 1949 (Lacayo 78)
"Senator Joe McCarthy has his picture taken" 1951 (Eyes #234)

MYERS, Eveleen
"Untitled" 1890s (Rosenblum \100)

MYERS, Joan
"Los Angeles Frieze" 1977* (Decade \VIII)

MYERS, Keith
"AIDS-infected inmates such as Gary Brown are isolated on one floor of the Missouri State Penitentiary prison hospital" 1987 (Best13 59b)
"Exuberant Blue Jays fan leaps into mound to grab pitcher Dave Stieb" 1985 (Best11 203)
"Brett gives a lift to pitcher Saberhagen as the Royals win the World Series" 1985 (Best11 202)

"HIV carriers at Missouri State Penitentiary were isolated 24 hours a day" 1987 (Best13 59a)
"Two mothers, one family" 1986 (Best12 178-179)

MYERS, Orville, Jr.
"Rock Hudson's last public appearance came July 15" 1985 (Best11 28)

MYRENT, Debra
"A utility worker tries to shut off a fire hydrant after a car went out of control" 1985 (Best11 102c)

—N—

NACHTWEY, James, 1948-
"An Afghan boy, potentially a future Islamic holy warrior, waits in the amputee ward of a Pakistan hospital where mujahideen are fitted for artificial limbs" 1990* (Best16 40d)
"An Afghan youth, injured by a land mine while traveling with mujahideen warriors, lies dying from his wounds" 1990* (Best16 39a)
"Afghani agony" 1986* (Best12 98-99)
"After a guerrilla ambush in El Salvador, a father shields his wounded daughter" 1984* (Eyes \18)
"Albanians" 1998 (Best 24 164-165)
"An Arab feigns injury to avoid arrest by an Israeli soldier during a demonstration in Ramallah on the West Bank" 1990* (Best16 43)
"An armless man in a Romanian institution has learned to write" 1990 (Best16 48a)
"A camp for Rwandan refugees" 1994 (Lacayo 181)
"At a village church, a family mourns a Croatian soldier who was killed in battle" 1993 (Best19 52)
"Bihar, India, 'untouchables' carry bricks on their heads" 1993 (Best19 43)
"Bosnian Moslem soldiers return from battle with a bullet hole in the windshield" 1993 (Best19 47)
"A brother mourned" 1996 (Best22 156)
"A Burmese boy, shot while carrying supplies to Karen rebels, loses his leg" 1990* (Best16 40a)
"Ceausescu's Legacy" 1990 (Best16 151-156)
"Chain gang inmate works out in the prison yard" 1995 (Best21 184b)
"Chain gangs" 1995 (Best21 217)
"A child at play in Nicaragua" 1983* (Lacayo 169)
"Continuing Saga" 1988* (Best14 36-37)
"Delicate Democracy" 1988* (Best14 38-39)
"A deputy interrogates a suspect in Los Angeles" 1990* (Best16 45)
"Descent into Madness" 1998 (Best24 160-161)
"A 15-year-old was killed by police during a demonstration in Belfast" 1990* (Best16 39d)
"For a month before their initiation into manhood, young men in South Africa live outside the village, covered in clay" 1992* (Best18 27)
"A Haitian voodoo priest exhorts a crowd at a rally against ousted President Jean-Bertrand Aristide" 1993* (Best19 51)
"Hungry and sick, a mother and child struggle for life in southern Sudan" 1988 (Best14 84a)
"Indonesian Street Kids" 1998 (Best24 162-163)
"An insane elderly man" 1990 (Best16 48b)
"An insane woman hides behind a blanket" 1990 (Best16 80a)
"Institutionalized mental patients in Romania seem lonely even together at mealtime" 1990 (Best16 46)
"An 'irrecoverably' mentally ill boy is confined to a crib in Romania" 1990 (Best16 196a)
"Karen boys train to become rebel fighters in Burma"

1990* (Best16 38)
"A lone Orthodox worshiper prays at the Wailing
 Wall in Jerusalem" 1988* (Best14 34)
"A Los Angeles deputy searches for signs of drug
 use" 1990* (Best16 44a)
"Los Angeles police officers prepare for a shoot out"
 1990* (Best16 44b)
"Managua" c. 1989 (Graphis89 \247, \248)
"Members of Zionist Christian Church perform an
 exorcism on the shore of the Indian Ocean in
 Durban" 1992* (Best18 33)
"Near a mosque in Bosnia-Herzegovina shelled by
 Serbs, a makeshift morgue is used for cleaning
 bodies of dead soldiers" 1993 (Best19 46a)
"On a holy feast day, an Ixil Indian and his son offer
 prayers and candles inside the church in Chajul,
 Guatemala" 1988* (Best14 152)
"On the banks of the Ganges River, a body awaits
 cremation" 1993 (Best19 44)
"On the holy day in El Salvador, little girls were
 caught in the wind generated by a helicopter taking
 off" 1984* (Eyes \19)
"A Palestinian day worker in Tel Aviv, Israel, sweeps
 the beach front" 1990* (Best16 42a)
"Palestinian women grieve a man who was killed by
 Israeli guards during a 'disturbance' in a prison for
 political detainees" 1990* (Best16 42a)
"Palestinian youth wanted by the Israeli army hides in
 a cave" 1990* (Best16 42b)
"Point Blank" c. 1989* (Graphis89 \246) or
 "Uganda" 1986* (Eyes \20)
"Residents of Alexandra Township, while
 demonstrating against violence, are shot and gassed
 by police" 1992* (Best18 30)
"Rio Street kids" 1995 (Best21 217d)
"Rioters in Belfast" 1981* (Marien \7.16)
"Runaway children huddle together as they sleep on a
 Johannesburg street" 1992* (Best18 31d)
"Scenes of Seoul" 1988* (Best14 40)
"Seeking Refuge" 1988 (Best14 30-31)
"Shadows of Palestinian boys are cast against a
 graffiti-covered wall in Gaza" 1993 (Best19 45)
"A sick tribesman clings to life in a rebel-controlled
 hospital in Sudan" 1988 (Best14 84b)
"Somalia: War and Famine" 1992 (Best18 101-114)
"Soviet Jews immigrate to Israel" 1992* (Best18 34-
 36)
"Soweto children play on trampoline" 1992* (Best18
 28)
"Squatter's camp near Capetown, South Africa"
 1992* (Best18 32)
"A starving man in southern Sudan receives a packet
 of rehydration salt" 1993 (Best19 7a)
"A starving man in southern Sudan, too weak to walk,
 crawls at the feeding center" 1993 (Best19 49)
"Sugarcane cutters, faces black from the soot of
 burned Guatemalan fields, rest after their day's
 work" 1988 (Best14 29)
"The Tamils–Civil strife in Sri Lanka" 1986* (Best12
 100-101)
"Tehran" 1998 (Best24 104a)
"A 13-year-old boy was shot in the back by police
 during a demonstration against violence in Soweto"
 1992* (Best18 31c)
"A 13-year-old member of the rebel Karen National
 Liberation Army, an ethnic minority group that is
 fighting Burmese government" 1990* (Best16 37)
"Tutsi Genocide" 1994 (Photos 173)
"Visit to a War Zone" 1988 (Best14 32-33)
"The War in Chechnya" 1995 (Best21 216)

"When the Sinai peninsula was returned to Egypt by
 Israel in 1982, the new boundary sliced through
 Rafah" 1990* (Best16 41)

NADAR, Felix, 1820-1910
"Aerial View of Paris" c. 1858 (Monk #5; Lacayo 19)
"Alexandre Dumas" 1855 (Waking 285)
"The Arc de Triomphe and the Grand Boulevards,
 Paris, from a Balloon" 1868 (Rosenblum2 #287)
"Charles Debureau" c. 1854 (Art \50; Waking #59)
"Eugène Emmanuel Viollet-le-Duc" 1878
 (Rosenblum2 #90)
"George Sand" 1877 (Rosenblum2 #88)
"Gioacchino Rossini" 1855-1865 (Art \49)
"Gustave Doré" 1855-1865 (Art \47)
"Jean-François Millet" 1855-1865 (Art \45)
"Jean Guillaume Viennet" c. 1859 (Szarkowski 324c)
"Mère Eulalia Jamet" 1860 (Art \48)
"Pierre Petroz" 1855-1865 (Art \44)
"Pierrot the Photographer" 1854-1855 (Marien \3.0)
"Portrait of a West Indian" c. 1857 (Szarkowski 87)
"Sarah Bernhardt" 1865 (Rosenblum2 #65)
"Seated Model, Partially Draped" c. 1856 (Waking
 #60)
"Self-Portrait" c. 1855 (Rosenblum2 #84)
"The Sewers of Paris" 1864-1865 (Marien \3.95)
"The Son of Auguste Lefranc" c. 1855-1865 (Art \51)
"Théodore Rousseau" c. 1857 (Szarkowski 88)
"Théophile Gautier" 1855-1865 (Art \46; Marien
 \3.94)
"Workmen in the Paris Catacombs" 1861
 (Rosenblum2 #289)

NADAR, Paul
"The French scientist Chevreul giving an interview"
 1886 (Lacayo 36; Rosenblum2 #590-#593)
"Lillie Langtry" n.d. (Rosenblum2 #64)

NAGAO, Yasushi
"Assassination of Asanuma" 1960 (Capture 46)

NAGASHIMA, Yurie
"Self-portrait, Mother No. 2" 1993 (Marien \7.71)

NAKAMURA, Kentaro
"Evening Wave" c. 1927 (Peterson #36)

NANCE, Marilyn, 1953-
"Celebration and Mourning" 1994 (Committed 164)
"First Annual Community Baptism for the Afrikan
 Family, New York City" 1986 (Rosenblum \249;
 Rosenblum2 #693)
"Standing" 1997 (Committed 165)

NANDELL, Bob
"A high-jumping ram" 1985 (Best11 155b)
"Two crane operators ponder their next move as they
 assemble structural steel for a parking facility"
 1986 (Best12 144a)

NAPLES, Elizabeth
"Objects for Eternity" c. 1990* (Graphis90 \206)

NASA
"Apollo 11 Eva View" 1968 (Goldberg 11)
"An Apollo 17 astronaut examines enormous lunar
 boulders resting in a crater at the Taurus-Littrow
 landing site" 1973* (Through 472)
"Apollo 17 astronauts, in orbit around the moon,
 photographed as crescent Earth rising in the lunar

sky" 1973* (Through 460)
"Astronaut Mark Lee on spacewalk" 1994* (Through
14)
"Astronauts aboard the space shuttle *Discovery*
observed a massive volcanic eruption in Papua,
New Guinea" 1996* (Through 462)
"Buzz Aldrin arranging seismic equipment to gauge
lunar tremors" 1969* (Life 103)
"The *Challenger* Explodes" 1986* (Monk #49)
"Familiar to generations of Jupiter-watchers, the
Great Red Spot continues to swirl in the gas giant's
atmosphere" 1980* (Through 470)
"Family Picture on the Moon" 1969* (Goldberg 179)
"Mars as seen from Pathfinder" 1998* (Goldberg
221)
"Skylab, the United States' first manned orbiting
laboratory" 1974* (Through 478)
"View of Venus" 1993* (Marien \8.6)

NASH, Sunny
"Storefront Church, New York City" 1991 (Willis
\290)
"Woman in Church, Nashville" 1992 (Willis \291)

NASMYTH, James and CARPENTER, James
"Back of Hand. Wrinkled Apple" 1864 (Marien
\3.74)
"Moon, Crater of Vesuvius" 1864 (Marien \3.73)

NASSER, Amyn
[from Spring/Summer fashion catalog] c. 1991*
(Graphis91 \49)

NATHANSON, Melville
"Detained by police while drug suspects are rounded
up, this innocent bystander was later released"
1995* (Best21 198a)
"Members of the elite Crime Area Target Team suit
up in full body armor for a night's worth of drug
house raids" 1995* (Best21 198b)
"16-year-old sits between officers after being busted
for selling crack" 1995* (Best21 198b)

NAUMAN, Bruce, 1941-
"Self-Portrait as a Fountain" 1966-1967* (Marien
\6.89; Photography2 144; San #17)

NAYA, Carlo
"Children on a Fish Weir, Venice" c. 1870s
(Rosenblum2 #274)

NAYLOR, Genevieve, 1915-1989
"Eleanor Roosevelt" 1956 (Rosenblum \223)

NAZI Photographer
"The Warsaw Ghetto Uprising" 1943 from the Files
of SS Commander Jürgen Stroop (Monk #27)

NÈGRE, Charles, 1820-1880
"The Angel of the Resurrection on the Roof of Notre
Dame, Paris" 1853 (Szarkowski 55)
"Chartres Cathedral: Part of the Porch of the North
Transept" c. 1851 (Art \75)
"The Chimney Sweeps Walking" 1851 (Marien \2.46)
"Fame Riding Pegasus, Sculpture by Coysevox,
Tuileries Gardens, Paris" 1859 (Szarkowski 73)
"The Imperial Asylum at Vincennes" 1860
(Photography 39; Rosenblum2 #436)
"Market Scene at the Port de L'Hôtel de Ville, Paris"
1851 (Rosenblum2 #286)

"Montmajour: The Abbey's Postern" 1852 (Art \76)
"South Porch, Chartres Cathedral" c. 1856
(Szarkowski 72)
"Spartan Soldier" 1859 (Waking #48)
"Young Girl Seated with a Basket" 1852
(Rosenblum2 #256)

NEIMANAS, Joyce, 1944-
"Topographical" 1978* (Decade \VI)
"Untitled" 1981* (Rosenblum2 #754)
"Untitled No. 2" 1981* (Photography2 199)
"Untitled No. 12" 1982* (Rosenblum \18)

NELEMAN, Hans
[ad for *Ravel* shoes] c. 1990* (Graphis90 \62)
[bird and doll] c. 1999* (Photo00 213)
[bird as Christ figure] c. 1999* (Photo00 215)
"Bug in a box" c. 1995* (Graphis96 89)
[Christmas advertising] c. 1991* (Graphis92 \244)
[feathers] c. 1999* (Photo00 214)
[from an ad campaign for American Express]
c. 1989* (Graphis89 \38)
[photograph for Kodak] c. 1989* (Graphis89 \173)
[self-portrait] c. 1992* (Graphis93 207c)
"Still life" c. 1991* (Graphis91 \106)
[still life of pressed, dried flowers from the 1850s] c.
1995* (Graphis96 80)
[untitled] c. 1992* (Graphis93 207a)

NELKEN, Dan
"Bryan" c. 1999 (Photo00 133)
"Turtle" c. 1999 (Photo00 134)

NELLY'S, 1899-1998
"The Russian Dancer Nikolska at the Parthenon"
1929 (Rosenblum \139)

NELSON, Lusha
"Diego Rivera" 1933 (Vanity 148)
"Fiorello La Guardia" 1933 (Vanity 172c)
"Frank Crowninshield" n.d. (Vanity ix)
"Jean Arthur" 1935 (Vanity 193a)
"Jesse Owens" 1935 (Vanity 176)
"Joe Louis" 1935 (Vanity 175)
"Marcel Duchamp" 1934 (Vanity 152)
"Peter Lorre" 1936 (Vanity 186)

NELSON, Michael
"Photographers give Socks a taste of fame outside the
Governor's Mansion, Arkansas" 1992* (Best18 2)

NESHAT, Shirin
"Untitled" 1996 (Photography 34)

NESIUS, Steve
"Virginia Tech football players go four deep on a
fumble" 1985 (Best11 208)

NETT, Dennis
"Ski and his wife of two weeks are homeless and live
under the railroad bridge" 1996* (Best22 211c)

NETTLES, Bea, 1946-
"Birdsnest" 1977* (Rosenblum \15)
"Tomato Fantasy" 1976* (Rosenblum2 #798)

NEVEU, Roland
"Mass grave near Phnom Penh, Cambodia" 1981
(Life 62)

NEWELL, Robert, 1822-1897
"Clarence Howard Clark Estate" c. 1870 (National 140d)

NEWMAN, Arnold, 1918-
"Arp" 1949 (Decade 58)
"Georgia O'Keeffe, Ghost Ranch" 1968 (Rosenblum2 #729)
"Igor Stravinsky" 1946 (Goldberg 187; Icons 92)
"Jack and Gwen Lawrence" 1944 (MOMA 163)
"Kuniyoshi" 1941 (Decade \51)
"Max Ernst" 1942 (Icons 93)

NEWMAN, Constance, 1935-
"The Largest Marketplace in Addis Abba" n.d. (Willis \429)

NEWTON, Greg
"Two boys watch from their body boards as John Glenn returns to space aboard Discovery" 1998* (Best24 16b)

NEWTON, Helmut, 1920-
"Arielle After a Haircut" 1982 (Icons 178)
"Bordighera Detail" 1983 (Art \449)
"Capri taxi driver' 1991* (Graphis92 \94)
"Kevin Costner" 1989* (Life 93a)
[sex appeal of high heel shoes] c. 1995* (Graphis96 33, 35)
"Shoe" 1983 (Art \451)
"They're Coming!" 1981 (Icons 179)
"Untitled" c. 1965 (Art \450); c. 1995* (Graphis96 32, 34)

NEWTON, Jonathan
"Braves catcher Olson flips after colliding with Twins Gladden at home plate" 1991* (Best17 150b)

NEWTON, Ralph
[self-promotional brochure entitled *Book of Chickens*] c. 1991* (Graphis91 \340-\348)

NEWTON, William, 1785-1869
"Birnham Beeches" 1855 (Szarkowski 46)

NICHOLLS, Horace, 1867-1941
"Delivering Coal" c. 1916 (Rosenblum2 #429)
"For Queen and Country (Funeral of soldier Boer War)" 1899-1902 (Szarkowski 149)
"The Fortune Teller" 1910 (Rosenblum2 #310)
"A sea of shells at a British munitions factory" 1916 (Lacayo 51d)

NICHOLS, Michael
"At medical research facility in New York, blood plasma separation is performed on one of its chimps" n.d.* (Photography 161)
"A baby baboon clings to its mother in the highlands of Ethiopia" 2002* (Through 282)
"Bambendjelle women dance to taunt the thieving Enyomo, among dozens of spirits in central Africa's forests" 2000* (Through 242)
"Conservationists fear they are fighting a losing battle to save mountain gorillas such as these near Karisoke, Rwanda" 1995* (Through 286)
"Eager for a turn on the big blue swing, playmates frolic around Rabasa, who doubles as a surrogate parent to these chimps" 1995* (Best21 163a)
"Ecologist Michael Fay and exhausted members of his research expedition rest at their campsite in

Minkouala, Gabon" 2001 (Through 236)
"Gold miners labor to remove pay dirt at the central African outpost of Minkébé" 2001* (Through 230)
"In their travels through a forest, elephants create trails such as these in the Republic of the Congo's Noubalé National Park" 1995* (Through 208)
"Jane Goodall comforts a chimp in captivity, an aged female half-crazed from years alone in a Congolese zoo" 1995* (Best21 143)
"More thirsty than hungry, a tiger laps up water as potential prey watches warily in Banghangarh, India" 1997* (Through 198)

NICHOLS, Robert
"Aloha Airlines Flight 243" or "Crew members of Aloha Airlines evacuate passengers after the roof of the Boeing 737 blew off in midair" 1988* (Best14 86a; Life 134)

NICKLIN, Flip
"Near Stellwagen Bank, off Massachusetts Bay, a humpback whale may eat as much as a ton of food in a day" 1998* (Through 428)
"Snorkelers surround a manta ray, a friendly member of the shark family, in the Flower Garden Banks of the Gulf of Mexico" 1998* (Through 416)

NICKERSON, Steven R.
"Painter goes the extra mile, doing his part to restore Victorian Square" 1985 (Best11 141b)

NIEFIELD, Terry
[advertisement for jams] c. 1990* (Graphis90 \328)

NIELSEN, Scott
"Canada geese fly across a rising moon" 1996* (Best22 186a)
"With a furious beating of its wings, a drake wood duck dries itself after a morning bath" 1988 (Best14 161a)

NIEMEIR, Frank
"In Clinton County Perry Wilson is backed by 500 persons in a courthouse confrontation with sheriff's deputies and state troopers" 1985 (Best11 58a)
"Responding to the American farmers' distress, country music and rock-and-roll stars performed during the Farm Aid Concert" 1985 (Best11 62a)
"St. Louis Cardinal Joaquin Andujar is restrained by teammates during the seventh game of the World Series" 1985 (Best11 189)
"St. Louis Cardinal third baseman Terry Pendleton watches a loose bat coming his way during a game against the Atlanta Braves" 1990* (Best16 118d)
"6 miles of tractors move from Kismet to Plains, Kansas in concert with a national farm demonstration" 1985 (Best11 61)
"10-year-old was one of several hundred Kansas-Missouri people forced to flee autumnal flood waters" 1986 (Best12 40d)

NIEPCE, Janine, 1921-
"Young Pilot, Villacoublay" 1973 (Rosenblum \183)

NIÉPCE, Joseph Nicéphore, 1765-1833
"Cardinal d'Amboise" 1926 (Marien 1.0)
"View of the Courtyard at Gras, France" 1826 (Marien \1.10; Monk #1; Rosenblum2 #6; Szarkowski 24)

NILSSON, Lennart
"Eight weeks gestation" 1965* (Life 101)
"18 weeks gestation" 1965* (Life 100)
"A monkey embryo serves to raise questions about
 what makes humans human" 1996* (Best22 184b)

NIXON, Nicholas, 1947-
"Joel Geiger–Perkins School for the Blind" 1992
 (Rosenblum2 #697)
"Tom Moran" 1988 (Szarkowski 297)

NIZZOLI, Marcello, 1887-1969
"Untitled" c. 1924 (Hambourg \92)

NOBEL, Rolf
"Submarine in Kiel Canal" c. 1990* (Graphis90 \85)

NOBLE, Edward R.
"Sex therapist Dr. Ruth used a milk crate for
 elevation during an appearance at a town meeting"
 1986 (Best12 53a)

NOEL, Frank
"Water" 1942 (Capture 10)

NOGGLE, Anne, 1922-
"Agnes in a Fur Collar" 1979 (Rosenblum \246)
"Mary" 1981 (San \56)

NOJIMA, Kozo
"Hosokawa Chikako" 1932 (Rosenblum2 #522)

NOLTON, Gary
[from an ad campaign for Nike shoes] c. 1989*
 (Graphis89 \39)

NOMURA, Hitoshi, 1945-
"*Moon Score*" 1977-1980 (Marien \6.91)

NONG, Liu Ban
"Construction" early 1930s (Rosenblum2 #722)

NOOIJER, Paul de, 1943-
"Menno's Head" 1976 (Rosenblum2 #759)

NORBERG, Marc
"Albert Collins" c. 1991 (Graphis92 \140)
"B. B. King" c. 1991 (Graphis91 \165)
[Blues and Jazz Musicians] c. 1992* (Graphis 93
 116-117)
"Courtney Pine" c. 1991 (Graphis91 \164)
"Future Lifesavers" c. 1991 (Graphis91 \222)
"Johnny Winter" c. 1991 (Graphis91 \162)
"Lady Bianca" c. 1991 (Graphis91 \163)
"Robert Junior Lockwood" c. 1991 (Graphis91 \161)

NORCIA, Michael
"Firefighter Kevin Shea rescues Tony Lewis from a
 burning high rise" 1991 (Best17 104d)

NORDMANN, Klaus-Peter
"Metamorphosis" c. 1999* (Photo00 115)

NORFLEET, Barbara, 1926-
"Catbird and Bedspring Debris" 1984* (Rosenblum
 \23; Rosenblum2 #785)
"Muskrat and Dick Francis: Black Point Pond, MA"
 1985* (Women \199)

NORFOLK, Simon
[documents of the mass murders in Rwanda] c. 1995
 (Graphis96 60, 66, 67)

NORIKANE, Yumiko
"Orange Dress" c. 1999* (Photo00 106, 107)

NORTH, Kenda, 1951-
"Untitled" 1975* (Rosenblum \32)

NORTHRUP, Michael
[flowers in a vase] c. 1992* (Graphis93 71)
"The Gallery at Market East Mall" c. 1991*
 (Graphis92 \170)

NORTON, Michael
"Baby in Pink Blanket" c. 1995* (Graphis96 112d)

NOSÉ, Noritsune
"Personal study" c. 1991 (Graphis91 \203); c. 1991
 (Graphis92 \38)

NOSKOWIAK, Sonya, 1900-1975
"Door and Windows" 1936 (Sandler 88)
"Lumberyard" 1937 (Sandler 175)
"Untitled" c. 1930s (Decade \23)
"White Radish" 1932 (Rosenblum \162)

NOTMAN, William, 1826-1891
"Caribou Hunting: The Return of the Party" 1866
 (Rosenblum2 #277)
"Chief Sitting Bull" 1885 (Monk #10)
"Spruce Tree, 44 Feet in Circumference, Stanley
 Park, Vancouver" 1890-1892 (Szarkowski 111)
"Victoria Bridge, Framework of Tube and Staging,
 Looking In" 1859 (Rosenblum2 #183)

NOVAK, Lorie, 1954-
"Detail of 'Traces' " 1991 (Rosenblum \248)

NOVAL, Liborio
"Alberto Korda Holding Photos of Che Guevara"
 1960 (Marien \6.2)

NUBILE, James
"The body of a homeless man who froze to death lies
 in a Moscow morgue" 1992 (Best18 120)
"The Sarai Internat is a home for handicapped in
 Azerbaijan" 1992 (Best18 117a)

NUSS, Cheryl
"In California, 4-year-old Matthew has AIDS" 1985
 (Best11 31c)
"Ryan's battle" 1986 (Best12 84-85)

—O—

O'BRIEN, Ken
"The Cotton Patch, Texas" 1937 (Goldberg 9c)

O'BRIEN, Loise
[ad for footwear] c. 1991* (Graphis92 2-5)

O'BRIEN, Michael
"Annabelle Lares, Miss Austin 1989" c. 1991*
 (Graphis92 \95)
"Archie Moore" c. 1991* (Graphis91 \177)
"Australians from *National Geographic*" c. 1990*
 (Graphis90 \182-\188)
"Bill Cosby" 1985* (Life 174a)

"Country Singer in Tootsie's Bar in Nashville,
Tennessee" c. 1990* (Graphis90 \158)
"Former tennis champion Chris Evert and her
husband Andy Mill" c. 1991* (Graphis91 \176)
"Hair art" 1990* (Life 121)
"Headstrong" c. 1991* (Graphis92 \105)
"Homeless man" n.d. (Graphis91 11)
"Man in a Texas Barbershop" n.d. (Graphis91 10c)
"Portrait of a Young Boy" n.d. (Graphis91 10a)
"Robert Stone" c. 1992* (Graphis93 94)
"Roosevelt Thomas Williams" c. 1991* (Graphis92
\118)
"Willie Nelson" c. 1991* (Graphis92 \123)
"W. Roche, 92, served in the U.S. Army during
World War I" c. 1991* (Best17 84; Graphis92
\117)

O'HARA, Pam Smith
"Nell Grim was the only woman to sign up for a
week-long Mickey Mantle/Whitey Ford Yankee
Fantasy Camp" 1985 (Best11 204d)

O'NEILL, Annie
"A cobbler" 1998 (Best24 90b)
"In the Heart of Friendship" 1996 (Best22 236c)
"Once is not enough" 1997* (Best23 143)
"A woman carries a cross when joining in a protest"
1996 (Best22 157c)

O'NEILL, Michael
"Holocaust survivor William Kona came to the U.S.
and made millions" 1998 (Best24 78)
"Jay Maisel" 1985 (Graphis89 8)

O'NEILL, Paul
"Get curious about a garbage can and now look"
1985 (Best11 151a)

O'NEILL, Terry
"David Bowie and William Burroughs" 1974
(Rolling #16)
"Jasper Conran" c. 1990* (Graphis90 \121)

O'REAR, Charles
"Morning shoppers jam the market at Malang, one of
Java's finest and most neatly planned hill towns"
1989* (Through 128)

O'SULLIVAN, Timothy H., 1840-1882
"Aboriginal Life Among the Navajoe [sic] Indians
Near Old Fort Defiance, N. M." 1873
(Photography1 #III-23)
"Alfred R. Waud Sketching at Gettysburg" 1863
(Photography1 #IV-13)
"The Ancient Ruins of the Cañon de Chelle, New
Mexico" 1873 (Art \141; Marien \3.58;
Photography1 \7; Rosenblum2 #163)
"Artillery Test Grounds, No. 59, XI inch, 10 Pound
Shell" 1864 (Photography1 \45)
"Austin, Nevada" 1868 (National 141c)
"Black Cañon, Colorado River, Looking Above"
1871 (National 142c)
"Black Cañon, Colorado River, Looking Below from
Big Horn Gap" 1871 (Waking 325)
"Cañon de Chelle, Walls of the Grand Cañon, About
1200 Feet in Height" 1873 (National \36)
"Cave-in at Comstock Mine, Virginia City, Nevada"
1868 (Photography1 \55)
"Culpeper, Virginia" 1863 (Photography1 #IV-27)
"Exterior of Fort Fisher, North Carolina" c. 1864

(National 141c)
"Field where General Reynolds fell, Gettysburg"
1863 (Eyes #23; Photography1 \41; Waking #108)
"Fissure Vent of Steamboat Springs, Nevada" 1867
(Waking #4)
"Gateway of Cemetery, Gettysburg" 1863 (Eyes #28)
"Gettysburg, July" 1863 (Eyes #27)
"A harvest of death, Gettysburg" 1863 (Eyes #21;
Lacayo 24b; Marien \3.18; Photography1 #IV-7;
Rosenblum2 #209)
"Headquarters Maj. Gen. George G. Meade, during
the Battle of Gettysburg" 1863 (Eyes #29)
"The Humboldt Hot Springs" 1868 (Waking #115)
"Inscription Rock, New Mexico" or "Historic Spanish
Record of Conquest" 1873 (Art \142; National \35)
"Miner at Work in the Comstock Mine" 1868
(Marien \3.56; Rosenblum2 #430)
"Miner at Work 900 ft. Underground, Gould and
Curry Mine, Virginia City" 1868 (Waking 327)
"The Nipsic in Limón Bay at High Tide" 1871
(Marien \3.57)
"Pyramid and Tufa Domes, Pyramid Lake, Nevada"
1878 (Marien \3.55); 1867 (National \34;
Rosenblum2 #151)
"Quarters of Men in Fort Sedgwick, Known as Fort
Hell" 1865 (National 17, \17)
"Rock carved by drifting sand" 1871 (National 141d)
"Sand Dunes, Carson Desert" or "Desert Sand Hills
near Sink of Carson, Nevada" 1867 (Art \143;
Lacayo 28b)
"Shoshone Falls, Looking over Southern Half of
Falls" 1868 (Photography1 xii, #III-20)
"Shoshone Falls, Snake River, View Across the Top
of the Falls" 1874 (National \39)
"Shoshoni" 1867-1872 (Waking #117)
"Slaughter Pen, Foot of Round Top, Gettysburg"
1863 (Szarkowski 113)
"Union artillery at Fredericksburg" or "Battery D,
2D, U.S. Artillery in action, Fredericksburg" 1863
(Eyes #30; Lacayo 12-13)
"Union General Ulysses S. Grant at his headquarters"
1864 (Lacayo 10)
"Vermillion Creek Canyon" 1872 (Szarkowksi 121)
"View on Apache Lake with Apache scouts" 1873
(National 22a, 142d)

OBARZANEK, Simon
[photographer's assistant] c. 1995 (Graphis96 140)

OCHSNER, Chris
"At Heaven's Gate" 1990* (Best16 64b)

OCKENFELS 3, Frank W.
"Elvis Costello" c. 1991* (Graphis92 \91, \146)
"Queen Latifah" c. 1991 (Graphis92 \145)

OCKENGA, Starr, 1938-
"Mother and Daughter" 1974 (Rosenblum \245)

ODENHAUSEN, Detlef
[fan] c. 1992* (Graphis93 149)

OEHME, Gustav
"Group Portrait" 1847 (Marien \2.52)
"Three Young Girls" c. 1845 (Rosenblum2 #37)

OELMAN, P. H., 1880-1957
"Pagan" c. 1941 (Peterson #68)

OGBURN, Oggi, 1942-
"Backstage Pass–Gerald Levert" 1987 (Willis \257)
"Process and The Doorags" 1985 (Committed 167; Willis \256)
"World Champions (Joe Louis's Grave in Arlington Cemetery: Michael Spinks, Jersey Joe Walcott, Smokin' Joe Frazier, Muhammad Ali, Sugar Ray Leonard)" 1986 (Committed 166)

OGRODNEK, Vernon
"Michael Spinks goes down from a blow by Mike Tyson during the first round of their heavyweight title fight in Atlantic City" 1988 (Best14 125)

OKAMOTO, Yoichi, 1915-1985
"Johnson with McNamara in Cabinet Room" 1966 (Eyes #268)
"LBJ and Lady Bird share a quiet moment at the White House" 1965 (Life 28a)
"May 1966" 1966 (Eyes #266)
"The President and grandson Patrick Lyndon Nugent play cowboy, the White House" 1968 (Life 29)

OKUN, Jenny
"Exeter Cathedral" 1996* (Goldberg 227)

OLMSTEAD, Dwoyid, active 1940s
"Group of men seated around a table with a woman" c. 1949 (Willis \132)
"Man holding a child" c. 1949 (Willis \134)
"Minister at the pulpit" c. 1949 (Willis \131)
"Two children standing on a doorstep" c. 1949 (Willis \133)
"Woman standing in her deteriorated bedroom holding a picture of a man" c. 1949 (Willis \130)

OLSEN, Larry
[from a calendar cover] c. 1989* (Graphis89 \78)

OLSENIUS, Richard
"7th annual Lund family picnic, at Pelican Lake in central Minnesota, reunites up to 40 family members" 2000 (Through 362)

OLSHWANGER, Ron
"Giving Life" 1988* (Capture 151; Graphis92 \50)

OLSON, John
"Commune members" 1969* (Life 46)
"A hunter peeks from inside a decoy on the Indus River in Pakistan" 2000* (Through 180)
"Women's rights march on Fifth Avenue, New York City" 1970 (Life 159)

OLSON, Randy
"An actor holds a prop from the movie Night of the Living Dead" 1991 (Best17 28a)
"AIDS in the family" 1991 (Best17 29-34)
"Brethren Family: Church of the Brethren" 1998* (Best24 93a, 98c)
"Brothers Bouchon have been running the same barber shop for 50 years" 1991 (Best17 28b)
"Child isn't old enough to ride but dreams of the day" 1998* (Best24 46)
"County Fairs: Rural America's Last Hurrah" 1997* (Best23 225)
"Eli has a crush on the daughter of another Brethren family and he takes every moment he can to be with her" 1998* (Best24 55a)
"In Florida's Senior League, it doesn't bother anyone if you keep your dog in the locker room" 1991* (Best17 26b)
"Jack is 60 years old with Downs Syndrome" 1998* (Best24 89b)
"John McGrath works at an artificial insemination station in Republic of Ireland" 1991* (Best17 27)
"Man on the Mon–a barge hand at dusk on the Monongahela River" 1991* (Best17 25)
"The only event Amish teenagers are allowed to attend is harness racing at Ohio fair" 1997* (Best23 170d)
"Ozarks Epicenter, Death of a Music Culture" 1998* (Best24 37, 38a, 99c)
"Retired turpentine-camp owner watches afternoon rain in St. George, Georgia" 1991* (Best17 26a)
"Sophia was born in a commune after her mother came to America from Russia" 1998* (Best24 54c)
"Still wearing a sidearm into his 90s, U.S. Marshal Hooker" 1998* (Best24 83)
"There's only a gas station and general store left in Cave City, Missouri" 1998* (Best24 84)
"Using wire cutters to clip a fence, Pittsburgh paramedics rescue a man who threatened to jump" 1986 (Best12 87c)
"When the fields flood, a horse is used as an amusement park ride" 1998* (Best24 40d)
"Why won't Jimmy go to school?" 1987 (Best13 149-151)

OLSON, Rosanne
"Agave Cactus" c. 1997* (Graphis97 84)
"Beautiful Skin" 1986* (Best12 112c)
"Blackbirds / Jamie Ros" c. 1999* (Photo00 123)
"Fashion with Pears" 1988 (Best14 96d)
"Dizon, Masseur" c. 1992* (Graphis93 120b)
"Sacrifice" c. 1992* (Graphis93 120d)
[self-promotional] c. 1991* (Graphis92 \76)
"Sunflower" c. 1997* (Graphis97 83)
"Ursula B." c. 1991* (Graphis92 104)

OLUJIMI, Kambui, 1976-
"Angelo, lead singer of Fishbone at Tramps" 1997 (Willis \359)
"Greg Tate, a founding member of the Black Rock Coalition at Harlem apartment" 1998 (Willis \358)
"Lukmon, lead singer of Funkface at CBGB's" 1996 (Willis \357)
"Nature, singer and songwriter" 1996 (Willis \360)

ONDREY, Thomas
"Handcuffed to a guardrail, a youth squats on a street in Pittsburgh" 1986 (Best12 58d)
"A man's body falls from a 14-story apartment building after he fired randomly on the streets below to attract police gunfire" 1990 (Best16 104b)

OPIE, Catherine
"Chicken" 1991* (Marien \7.91)

OPPENHEIM, Dennis, 1938-
"Annual Rings" 1973 (Photography2 95)

ORKIN, Ruth, 1921-1985
"American Girl in Italy" 1951 (Rosenblum \219)
"Americans Waiting for the CIT Tour Bus, Rome" 1951 (Sandler 94)
"Balloon" 1977* (Rosenblum2 #777)

ORNELAS, Edward D., III
"Police officer photographs a man that was killed in a

bar fight" 1997* (Best23 118a)

OROSZ, Craig
"A first-grader watches as police arrest a man for painting a racial slur on the bus as it drove through Trenton" 1992* (Best18 125)

OROZCO, Gabriel
"Cats and Watermelons" 1992* (Marien \7.54)

ORR, Francine
"Bekher cries at the candlelight vigil for his father, who was killed while working as a Brinks guard" 1996* (Best22 155a)
"Beyond the Negative" 1996* (Best22 229)

OSLER, Mark T.
"Mother and son find an island of refuge after long hours of trying to rescue what they could find from their flooded home" 1996* (Best22 154c)

OSMUNDSON, Glenn
"The ball slides from the glove of a High School fielder as he hits the grass" 1986 (Best12 210)
"A Bud Lite Daredevil slam-dunks a shot after bouncing off a trampoline" 1986 (Best12 230b)
"Coach of the high school baseball team tries to argue a call" 1986 (Best12 193a)
"Football players at Westfield High School react to a field goal that won the game" 1986 (Best12 199a)
"A High School volleyball player looks for a helping hand after diving for the ball" 1986 (Best12 204)
"Infielders for High School baseball team watch their reliever warm up" 1986 (Best12 193b)
"Johanna Meehan sheds a tear during memorial services for Christa McAuliffe" 1986 (Best12 12a)
"Students at Concord High School embrace after the school held a private memorial for their teacher" 1986 (Best12 12c)

OSWALD, Jan
[untitled] c. 1991* (Graphis91 \136, \137; Graphis92 \246, \247)

OTTO (Otto Wegener), 1849-1922
"Countess Greffulhe" 1899 (Waking #136)

OUTERBRIDGE, Paul, Jr., 1896-1959
"Ad for George P. Ide Company (Ide Collar)" c. 1922 (Goldberg 62; Hambourg \112; Icons 78; MOMA 122; Marien \5.35; Peterson #48)
"Crankshaft Silhouetted against Car" 1923 (San \3)
"Marmon Crankshaft" 1923 (Hambourg \14; Rosenblum2 #527; San #23)
"Self-Portrait" c. 1927 (Waking #171)
"Shower for Mademoiselle" c. 1937* (Icons 79)

OVALLE, Tomas
"Jellyfish dance through water" 1996* (Best22 191c)

OVERBEEKE, Aernout
"Amsterdam Bach Soloists in an old church" c. 1991* (Graphis91 \146)
"Artist Jeroen Pressers in His Studio" c. 1991* (Graphis91 \145)
"Buddhist Temple in Malaysia" c. 1997* (Graphis97 154, 155)
"Construction, Sans Soucis, Berlin" c. 1991 (Graphis92 23)
[dog in Stratfordshire countryside] c. 1991

(Graphis92 \212)
[from In the Garden of Eden] c. 1991 (Graphis92 22)
[Mercedes Benz] c. 1995* (Graphis96 145)
"People and their work" c. 1992* (Graphis93 105)
"Reinhoud d'Haese" c. 1997 (Graphis97 126)
"Southern Portugal" c. 1990* (Graphis90 \69)
"There are still places in the world where time seems to stand still" c. 1995* (Graphis96 158-159)
[12 Apostles–Rocks] c. 1991* (Graphis92 \211)

OWENS, Bill
[from Suburbia] c. 1973 (Decade 90; Marien \6.57)

OZTÜRK, Ramazan
"Iraqi Kurds killed by poison gas" 1988* (Lacayo 179a)

—P—

PACH, Gotthelf, active 1870s-1880s
"Views of Charlestown, New Hampshire" 1888 (National 143c)

PADDIO, Villard, c. 1894-1947
"Louis Armstrong, his mother, Mayann, and sister Beatrice" 1922 (Willis \47)
"Portrait of Professor Henry Pritchard's Tonic Triad Band" 1928 (Willis \48)
"The Sam Morgan Jazz Band" c. 1928 (Willis \51)
"View of crowd with photographer in center" c. 1910 (Willis \49)

PAGE, Tim
"United Nations helicopters hover overhead to supervise during a Cambodian election" 1993* (Best19 197)

PAGLIUSO, Jean, 1941-
"Untitled" 1986* (Rosenblum \7)

PAIK, Nam June
"Julian Beck" 1985* (Photography 73)

PALFI, Marion, 1907-1978
"In the Shadow of the Capitol, Washington, D.C." 1946-1949 (Decade \39)
"New York City Gang" 1946-1949 (Decade 57)
"Residents of an Old Age Home" 1956 (Sandler 91)
"Saturday, Louisville, Georgia" 1949 (Rosenblum \205)
"Wife of the Lynch Victim" 1949 (Sandler 90)

PALMOUR, Hayne, IV
"Police officer trains his gun on two suspects as a helicopter hovers above" 1991* (Best17 108)

PANCRAZIO, Angela
"Comic actress Tracey Ullman stoops to bathroom humor in a hotel" 1987 (Best13 123d)
"Spuds, the black-eyed mascot for Bud Light Beer, was present for the first pitch" 1987 (Best13 115d)

PANELLA, Scott
"A two-alarm blaze roars out of control in downtown Bowling Green, Kentucky" 1995* (Best21 156b)

PANUNZI, Benito
"Settlers in Countryside" c. 1905 (Rosenblum2 #415)

PAOLUZZO, Marco
[Iceland] c. 1995* (Graphis96 166)

PAPALEO, Kenneth
"Lee Hart watches her husband, Gary, tell a crowd he is giving up his campaign for the Democratic presidential nomination" 1987 (Best13 54)

PAPERNO, Roger
[Clos du Bois Winery] c. 1991* (Graphis92 \76)

PAQUIN, Dennis
"Canada's Donovan Bailey celebrates after crossing the finish line to win the gold medal in the 100-medal race" 1996* (Best22 119a)
"In Geneva, President Reagan and Soviet leader Mikhail Gorbachev exchange laughs at the beginning of their final summit ceremony" 1985 (Best11 89a)
"U.S. Olympian Jackie Joyner-Kersee stumbles on the final hurdle of the heptathalon as the rain comes down" 1996* (Best22 119d)

PARADA, Esther, 1938-
"At the Margin" 1992* (Rosenblum \9)
"A Thousand Centuries" 1992* (Rosenblum2 #799)

PARE, Richard
"Pluto and Proserpine, Gian Lorenzo Bernini" 1991 (Rosenblum2 #682)

PAREKH, Swapan
"After a predawn earthquake in India, several survivors grieve together" 1993* (Best19 198)

PARKE-HARRISON, Robert
"Patching the Sky" 1997 (Marien \7.84)

PARKER, Ann
"Young Indian Couple with Cityscape, Sololá, Guatemala" 1973 (Marien \6.4)

PARKER, Bart, 1934-
"Tomatoe Picture" 1977* (Photography2 188)

PARKER, Craig Hyde
"Child leaving for school" c.1990* (Graphis90 \81)

PARKER, David
"A SWAT team member races to safety with a 7-year-old boy, one of four children held hostage by their father" 1985 (Best11 81)

PARKER, John
[for a culinary article] c. 1990* (Graphis90 \342)

PARKER, Olivia, 1941-
"Four Pears" 1979* (Rosenblum2 #789)
"In the Works" 1984 (Rosenblum \239)

PARKINSON, Ed
"An audience listens to Frank Sinatra at the Hollywood Bowl" c. 1943 (Best18 14)

PARKS, Gordon, 1912-
"Boys playing leapfrog near the Frederick Douglass Housing Project" 1942 (Willis \128)
"Children with Doll" 1942 (Committed 169)
"Cleaning a government office at night" 1942 (Documenting 233c)
"Ella Watson" or "American Gothic" 1942 (Committed 168; Documenting 234-235; Goldberg 103; Marien \5.58)
"Ella Watson receiving a blessing and anointment from Reverend Smith" 1942 (Documenting 238a)
"Ella Watson, right, and her adopted daughter" 1942 (Documenting 230a)
"Ella Watson waiting to be in Saint Martin's annual flower bowl ceremony" 1942 (Documenting 236b)
"Ella Watson with three grandchildren and adopted daughter" 1942 (Documenting 232a; Willis \129)
"Ella Watson's adopted daughter" 1942 (Documenting 231c)
"Ethel Shariff in Chicago" 1963 (Icons 153)
"Flavio" 1961 (Eyes #243-244)
"A flower bowl ceremony participant, receiving a blessing and anointment from the Reverend Clara Smith" 1942 (Documenting 239c)
"Harlem Gang Wars" 1948 (MOMA 199)
"Harlem Rally" 1963 (MOMA 235)
"Home altar on Ella Watson's dresser top" 1942 (Documenting 239b)
"Housewife, Washington, D.C." 1942 (Rosenblum2 #692)
"Leaving for work" 1942 (Documenting 232b)
"Muhammad Ali" 1966 (Lacayo 147d); 1970 (Icons 152)
"Reverend Gassaway stands in a bowl of sacred water banked with the roses that he blesses and gives to celebrants" 1942 (Documenting 237c)
"The Reverend Vondell Gassaway preaching the Sunday sermon at Saint Martin's Spiritual Church" 1942 (Documenting 236a)
"Saturday afternoon on 7th St. and Florida Ave., NW, Washington, D.C." 1942 (Willis \127)
"Segregation, Mobile, Alabama" 1956 (Life 14)
"Stevedore at the Fulton Fish Market, New York City" 1944 (Eyes frontispiece)
"View from Ella Watson's window" 1942 (Documenting 230b)
"A woman washing clothes in a galvanized tub" 1942 (Willis \126)

PARKS, Toni, 1940-
"Dance Theatre of Harlem Students with Teacher" 1990 (Committed 170)
"Twins" 1988 (Committed 171)

PARR, Martin, 1952-
[from New Brighton] c. 1989* (Graphis89 \130)
"Glastonbury Tor" 1976 (Art \404)
"New Brighton" 1984* (Art \406, \408)
"Passing Naturalists, Pagham Harbour" 1975 (Art \403)
"Tupperware Party" 1985* (Art \405; Marien \7.10)
"Videoshop" 1985* (Art \407)

PARRY, Roger, 1905-1977
"Locomotive" 1929 (Hambourg \21)
"Mouth" 1931 (Hambourg \116)
"Nude" 1931 (Hambourg \66)
"Untitled" c. 1928-1929 (Decade 25; San #36, \22)

PARSONS, Sara, active 1920s
"Light Bulb Study" 1927 (Hambourg 31a)

PASCHALL, Mary
"Picking Geese" n.d. (Sandler 17c)

PASSET, Stéphane
"Mongolian Horsewoman" c. 1913 (Rosenblum2 #346)

PATRICK, Bryan
"Children drawn to the brightness of an underwater light at public pool" 1998* (Best24 72d)
"Permanently paralyzed from a motocross race accident, former star athlete dances with his girlfriend" 1997* (Best23 174b)
"Teenager dodging a speedbag during a workout" 1997* (Best23 177a)
"Top area high school pitcher prays during her game" 1997* (Best23 172a)
"Young boy lifts off from a cement block in back of his grandparents' house" 1997* (Best23 164b)

PATRICK, Michael
"A Legacy of Hope" 1988 (Best14 186-187)

PATRONITE, Joe
"A youngster in Kungur, in the Soviet republic of Russia" 1990* (Best16 7)

PAUER, William
"Avery gets Bum's Rush" 1944 (Best18 9)

PAVUCHAK, Robert J.
"Two canoeists brave rushing waters of the Cheat River to inspect debris trapped by the Lake Lynn Dam" 1985 (Best11 64b)

PAWLAK, J. Peter
"Monastery, La Tourette, designed by Le Corbusier" c. 1995* (Graphis96 176)

PAWLOK, Werner
"Ad for the Austrian Tyrol" c. 1990 (Graphis90 \250)

PAYNE, John
[promotional campaign for a Norwegian paper mill] c. 1992* (Graphis93 2, 60, 75)
[self-promotional] c. 1989* (Graphis89 \233; Graphis90 \214; \291-\293)

PEARMAN, Reginald
"The Nimitz Freeway in Oakland, Calif., became a giant parking lot when a truck-trailer overturned" 1985 (Best11 110d)

PEARSON, H., and Wade, E.W.
"Sandpiper's Nest" 1903 (Szarkowski 141c)

PEASE, Greg
[incarnation of Buddha] c. 1992* (Graphis93 183)

PEATTIE, Peggy
"An Alcohol, Tobacco and Firearms agent keeps his gun on a suspected drug dealer, just awakened" 1988 (Best14 202a)
"Arcade" 1995 (Best21 226d)
"Forrest of Tustin waits for a tow truck to dislodge his car from under a truck" 1990 (Best16 187b)
"Cambodian Savoeur Sy and her daughter, Sandra Seang, share a small apartment with six other relatives" 1990* (Best16 190b)
"Chavis" 1995 (Best21 227c)
"Cheering cadet" 1995* (Best21 226a)
"The Circle Remains Unbroken" 1997 (Best23 220)
"Democratic hopeful Jesse Jackson gives a kiss to a delighted Dorothy Chambers" 1988 (Best14 205a)
"Down in Dixie" 1998 (Best24 166-167)
"Emergency-room personnel prepare a patient for a CAT scan" 1990* (Best16 186c)

"Eller undergoes an experimental treatment for cancer devised by Dr. Bicher" 1990* (Best16 186b)
"Friends and lovers say goodbye moments before the USS Missouri heads for duty in the Persian Gulf" 1990* (Best16 190a)
"George, a resident of a small community along the railroad tracks grimaces from pain of a broken rib as he reaches for cigarettes" 1990 (Best16 191a)
"Homeless couple in Wilmington, Calif." 1990 (Best16 189)
"A huge rotary for an oil refinery rests precariously on a freeway guardrail after rolling off the flatbed truck that was carrying it" 1988 (Best14 206c)
"Jesse Hunter peers through a window in the cabin in which her father was born" 1997 (Best23 186c)
"Lakers fan Jack Nicholson picks up a ball that rolled over to him and Chevy Chase during a game" 1988 (Best14 206b)
"A linebacker from the defeated team sits alone on the bench" 1988 (Best14 204d)
"M. C. Hammer performs at Long Beach Arena" 1990* (Best16 187a)
"Mark Aguirre hollers in pain after jamming his hand at a game" 1988 (Best14 206d)
"Mets pitcher Dave Cone tells Pedro Guerrero to stay away as the slugger comes after him for nearly hitting him with two pitches" 1988 (Best14 207a)
"Philippine survivors of the Bataan Death March are finally decorated with the bronze star and honored with a fly-over" 1988 (Best14 203d)
"Police look under a woman's bed for her boyfriend's weapons stash while she holds her terrified child" 1988 (Best14 202d)
"Reunion for babies cared for in St. Mary's Medical Center" 1990* (Best16 185)
"A shy running back gets a congratulatory kiss from a cheerleader" 1988 (Best14 204)
"Sister Panacratilla keeps track with her blaster as she waits for the elevator" 1988 (Best14 207b)
"Stare down" 1995 (Best21 226b)
"Stephen Schwartz, 12, gets friendly with a mouse he and Craig Jones bought to feed to Jones' boa constrictor" 1990 (Best16 188)
"A supporter uses her sign as a sun shield while waiting for Jackson to arrive" 1988 (Best14 205b)
"A testy Benoit Benjamin dukes it out with Laker John McNamara over a loose ball foul" 1988 (Best14 203a)
"Trauma nurse starts working on a gunshot victim as he is wheeled down the hall of St. Mary Medical Center" 1990* (Best16 191b)
"Wheelchair racers crest the Queensway Bridge during a half-marathon in Long Beach" 1990 (Best16 190d)
"While waiting in line for a tour, the crowd is awed outside the newly elected governor's mansion" 1995* (Best21 161d)
"A work crew installs a memorial statute to the Merchant Marines during a ceremony at Los Angeles Harbor" 1988 (Best14 203b)

PEC, Em., active early 1850s
"Bourges" 1850-1852 (Waking 282)
"Chartres" 1850-1852 (Waking #54)

PECHA, Pavel
[from the series My Intuitive Theater] 1990-1994* (Photography 181)

PEDERSEN, Robert
"Robin Wight and Peter Scott" c. 1991* (Graphis91 \158)

PELHAM, Lynn
"Astronauts Neil Armstrong, Mike Collins and Buzz Aldrin, after splashdown" 1969* (Life 102)

PELLETT, Alden
"Hiker on Mount Mansfield" 1991* (Best17 70a)

PELTUS, H. Ross
"Farmers" c. 1989* (Graphis89 \56)

PENCH, Randy
"Trying to hitch a ride" 1985 (Best11 186b)

PENN, Irving, 1917-
"Black and White Vogue Cover" 1950 (Art \441)
"Cecil Beaton" 1950 (Art \444)
"Cigarette No. 37" 1972 (Szarkowski 252)
"Coal Man" 1950 (Art \445)
"George Jean Nathan and H. L. Mencken" 1947 (MOMA 193)
"Harlequin Dress" 1950 (Goldberg 126)
"Let's not get too logical" 1990* (Graphis90 19)
"Long Sleeve (Sunny Harnett), New York" 1951 (Szarkowski 193)
"Pablo Picasso" 1957 (Icons 129)
"Régine (Balenciaga Suit)" 1950 (MOMA 195)
"Rochas Mermaid Dress" 1950 (Art \443)
"Still Life with Watermelon" 1947* (MOMA 194)
"Two Guedras, Goulimine, Morocco" 1971 (Art \442)
"Vogue Photographers" 1946 (MOMA 21)
"Woman in Moroccan Palace" 1951 (Rosenblum2 #649)

PENNY, Don
[fabric designs superimposed on nudes] c. 1991* (Graphis92 \39, \40)

PERAZZOLI, Luca
[advertising campaign] c. 1991* (Graphis92 \52)
"Still life with five lilies" c. 1991* (Graphis92 \53)

PERÉNYI, Laci
[bubbles and a swimmer] c. 1991* (Graphis92 \237)
"European women's freestyle champion Stephanie Ortwig" c. 1991* (Graphis91 \361)
[female swimmer breathing underwater] c. 1991* (Graphis92 \232)

PERESS, Gilles, 1946-
"Demonstration in Favor of the Ayatollah Shariatmadari, Iran" 1980 (Marien \7.13)
"N. Ireland: Loyalists vs. Nationalists" 1986 (Rosenblum2 #716)
"Peasants arriving at a protest in front of the U.S. embassy, Teheran" 1979 (Eyes #321)
"Posters in front of the U.S. embassy, Teheran" 1979 (Eyes #323)
"Pro-Shariatmadari demonstrations, Tabriz" 1979 (Eyes #322)
"Street, Azerbaijan" 1979 (Eyes #324)
"Street scene reflected in a mirror, Teheran" 1979 (Eyes #320)
"Telex: Iran: In the Name of the Revolution" 1984 (Eyes #314)

PEREZ, Ruben W.
"Doctors perform surgery in Providence" 1991* (Best17 207a)
"Gary Hart takes a quick nap during a plane ride to Denver" 1988 (Best14 8d)
"Gwen Littelberg grabs hold of a fence to keep from being swept away by waves in Woods Hole, Mass., during Hurricane Bob" 1991* (Best17 208)
"Irving Fryar of the New England Patriots makes a fingertip catch" 1991* (Best17 210)
"President Bush contemplates a shot on the 18th hole in Kennebunkport, Maine" 1991* (Best17 206)
"A security guard at the Springfield Armory Museum walks up the spiral staircase during a routine check of the building" 1987 (Best13 176d)
"Students in a scuba-diving class take their first open-water dive" 1991* (Best17 207b)

PERINE, Drew
"At peace with your PC" 1996* (Best22 181b)
"Long days and sleepless nights make mornings difficult" 1991 (Best17 110d)
"A long losing season shows on the faces of the basketball team" 1995* (Best21 105)
"Shannon Pfaff's mother wanted a pre-prom portrait of her daughter and boyfriend" 1986 (Best12 137)

PERKINS, Lucian
"After his first visit to the Vietnam War Memorial–on Memorial Day–Peter Kelsch of Miami is comforted by Alan Pitts" 1987 (Best13 113)
"At a high-security labor camp in Kovrov, inmates laugh as one of the repeat offenders proudly shows off his tattoos" 1993* (Best19 10a)
"At the Moscow Bridal House, two girls gossip as a couple wait to be married" 1993 (Best19 10b)
"Bloodied during a confrontation with Moscow police on May Day, an angry Nationalist marches home" 1993* (Best19 9)
"Fashion photographers huddle at the end of runway during a New York show" 1993 (Best19 2)
"Fashion Fever" 1993 (Best19 17-18)
"Fleeing Kosovo" 1999* (Capture 196)
"A girl, one of a group of refugees left behind for the night, sadly guards her family's possessions" 1993 (Best19 20b)
"Lt. Marvin's mother collapses at his graveside during his burial in Moscow" 1993* (Best19 194)
"A model returns backstage during a New York spring fashion show for designer Carolyn Roehm" 1987 (Best13 100a)
"Nablus woman cries upon hearing her son was killed in fight with Israeli soldiers" 1988 (Best14 15a)
"President Reagan and Elizabeth Taylor exchange a few words during an AIDS benefit in Washington, D.C." 1987 (Best13 100d)
"Russian Baptist minister finishes a ceremony during which 190 people were baptized in the Moscow River" 1993 (Best19 15-16)
"Swinging their batons, the Omon enter a gypsy camp" 1993 (Best19 11-14)
"When fighting broke out in Abkhazia, Georgian refugees fled to the village of Chuberi, where they could board helicopters for safe passage back to Georgia" 1993 (Best19 20)
"While PLO Chairman Yasir Arafat and Israeli Prime Minister Yitzak Rabin sign a peace accord at the White House, the scene outside is less peaceful" 1993 (Best19 19)
"A woman lifts her son onto a stage in hopes a faith

healer can cure his deformities" 1993* (Best19 8)
"A young boy peers out a window as the bus is
leaving areas of heavy fighting in war-torn, rural
Chechnya" 1995 (Best21 166)

PERNAMBUCO, Moria, 1969-
"Remembrance and Ritual: Tribute to the Ancestors
of the Middle Passage" 1997 (Willis \376-\377)

PERRY, David
"Football coach lets officials know what he thinks
about a call" 1985 (Best11 228b)
"Kentucky Derby-winning jockey Bill Shoemaker
gets an pat from wife Cindy" 1986 (Best12 222)
[self-promotional] c. 1991* (Graphis92 \142)

PERSCHEID, Nicola
"The Reaper" 1901 (Rosenblum2 #380)

PERSSON, Mike
"A Bosnian soldier returns fire at Serbian snipers
during the first peace demonstration by the people
of Sarajevo" 1992* (Best18 124b)

PESKIN, Hy
"Joe DiMaggio" 1949 (Lacayo 85)

PETERFFY, Ernest
"At dockside, Latvian women proudly display
salmon-like sea trout" 1924 (Through 66)

PETERHANS, Walter, 1897-1960
"Portrait of the Beloved" 1929 (Icons 35)
"Pythagorean Paradigm" 1929 (Icons 34)

PETERS, Greg
"Oklahoma Zappers appeal to umpire on a call at
home plate during the Girls World Softball
Tournament" 1985 (Best11 192a)

PETERSON, Brian
"Testing the Human Spirit" 1991-1996 (Best22 42-
59, 272)
"This entrant is ready to race in the John Beargrease
Sleddog Race" 1986 (Best12 132b)

PETERSON, Bruce
"Personal study" c. 1989* (Graphis89 \125)

PETERSON, Darrell
"Cory Everson, bodybuilder, 'Miss Olympia' " c.
1989* (Graphis 89 \194)
[from ad for health and fitness club] c. 1991
(Graphis91 \12)

PETERSON, David
"American Farmers' Shattered Dreams" 1986
(Capture 142, 143)
"Candidate Gary Hart recounts events that plagued
his campaign" 1988 (Best14 91d)
"Fallen runner is helped up by a fellow competitor"
1996 (Best22 121d)
"Gary Garner, coach of Drake's basketball team, uses
the game ball to show his unhappiness" 1985
(Best11 228c)
"In Marathon, Iowa, a lone tractor rumbles down the
main street of a town that has lost just about all of
its agribusiness trade" 1986 (Best12 36)
"Mike Powell, long jumper, is joyous after his lead
placed him on his third Olympic team" 1996

(Best22 121a)
"Royal, Iowa, Hagedorn pays a lonely visit to his
farmhouse–passed on to him by his parents, now
lost after 20 years of farming" 1986 (Best12 36d)
"A runner in the women's 10,000 meters cools off
and valiantly finishes the race despite coming in
last" 1996 (Best22 121c)
"Two women embrace after finishing second and
third in the 10,000 meters" 1996 (Best22 121a)

PETERSON, Grant
[for *Kodak* advertising] c. 1989* (Graphis89 \281)
[on the effect of color] c. 1989* (Graphis89 \296)
[untitled] c. 1989* (Graphis90 \299-\301)

PETERSON, Mark
"A mourner at the funeral of Army Pvt. Robert Talley
still wears a yellow ribbon" 1991* (Best17 22)
"Mourners in Brooklyn attend the funeral of Marine
Maj. Eugene McCarthy" 1991* (Best17 24)
"A photograph of Army Pvt. Robert Talley and the
letter confirming his death during the war" 1991*
(Best17 21a)
"A relative mourns the death of Navy flier Manuel
Rivera, Jr." 1991* (Best17 21b)

PETERSON, Skip
"It was no act when Coach Rollie Massimino came
off the bench in Lexington" 1985 (Best11 231)

PETERSSON, Per-Anders
"Children of bonded slaves in a release camp in
Pakistan" 1996* (Best22 213c)

PETRAKES, George
"When in *Tlaquepaque* do as the Tlaquepaguians do"
c. 1991 (Graphis91 \55)

PETROCELLI, Joseph, ?-1928
"Pastorale Arabe" 1926 (Peterson #8)

PETRUSOV, Georgii, 1903-1971
"Homecoming" 1945 (Art \424)

PETSCHOW, Robert, 1888-1945
"Balloon with Shadows" or "How Many Balloons are
in the Air" 1926 (Hambourg \108; San #26)
"Untitled" c. 1930 (San \6)

PETTY, Adam
"Australian Troy Sachs becomes airborne and
completes a jump shot during the World
Wheelchair Championship" 1998* (Best24 62)
"Camel handler is trampled during the Sheik Zamed
Cup" 1998* (Best24 75a)
"A Samoan wrestler is suplexed by a straining
Australian" 1998* (Best24 61b)

PFAHL, John, 1939-
"Australian Pines, Fort De Soto, Florida" 1977*
(Marien \7.86; San \60)
"Blue Right Angle, Buffalo, New York" 1975*
(Decade \V)
"Relaxed Euphoria, Lotusland, Montecito,
California" 2000* (Photography 186)
"Slanting Forest, Lewiston, New York" 1975*
(Photography2 154)

PFANNMÜLLER, Günter
[ad for furnishing fair] c. 1992* (Graphis93 38)

[Berthold typefaces] c. 1991 (Graphis91 \149-\154)

PFEIFFER, Albert
"Musketeer Podolski" 1913-1915* (Szarkowski 198)

PFLEGER, Mickey
"St. Louis Cardinal shortstop Ozzie Smith does his pre-game routine before game five of the 1985 World Series" 1985* (Best11 152a)

PFRIENDER, Stephanie
"Antonio Banderas" c. 1997* (Graphis97 115)
"Mickey Rourke" c. 1995 (Graphis96 116a)
"Samuel L. Jackson on the Staten Island Ferry" c. 1995* (Graphis96 112a)
"Sandra Bullock" c. 1995 (Graphis96 112c)

PHELAN, Donald
"First Ever Kennedy-Nixon Presidential TV Debate" 1960 (Goldberg 152)

PHILLIP, David J.
"It took 10 jumps to capture the perfect moment in a preview theater performance" 1987 (Best13 181c)

PHILLIPS, John, 1914-
"Explosion blazes patch into Jewish buildings in the old city of Jerusalem" 1943 (Eyes #202)

PHILLIPS, Kent
"The rising popularity of Memphis pork barbeque has a number of area restaurants shipping their products all over the country" 1998* (Best24 41a)

PHILLIPS, Mark D.
"Manny Lee of the Toronto Blue Jays mimics the umpire's signal of safe" 1992* (Best18 135)

PHILLIPS, Ronnie, active 1970s-date
[two boys in doorway] 1993* (Willis \420)

PHOTOGRAPHER UNKNOWN
"Adlai Stevenson campaign" 1952 (Eyes #147)
"Aerial View of Lower Manhattan" c. 1934 (Szarkowski 156)
"Aeroplane Packed for Transport" c. 1915-1916 (Szarkowski 142)
"Al Capone, mugshot" 1931 (Goldberg 78)
"Aldous Leonard Huxley" 1922 (Vanity 70)
"Alfred Stieglitz Photographing on a Bridge" c. 1905 (Waking #155)
"American correspondents with the First Japanese Army" 1905 (Eyes #57)
"American soldiers in battle" 1918 (Lacayo 50b)
"Amputation, Mexican–American War, Cerro Gordo" 1847 (Marien \2.32)
"Another Nazi horror camp uncovered" 1945 (Eyes #214)
"Anwar Sadat, Jimmy Carter, Menachem Begin at the Camp David Accords Signing Ceremony" 1978* (Goldberg 190)
"Arab Woman and Turkish Woman, Zangaki, Port Said" 1870-1880 (Marien \3.83)
"Armenian Genocide" 1915 (Photos 28)
"Arnold Bennett" 1927 (Vanity 69)
"Arrest of Archduke Ferdinand's Assassin" 1914 (Photos 26, 27)
"Arthur Rothstein and Roy Stryker" 1941 (Rosenblum2 #449)
"Artists' Excursion, Sir John's Run, Berkeley Springs" 1858 (National \23)
"Atomic Bomb over Nagasaki, Japan" or "Mushroom cloud resulting from atomic bombing of Nagasaki" 1945 (Goldberg 113; Life 97)
"Atomic Cloud during Baker Day blast at Bikini" 1946 (Goldberg 120; Marien \6.30)
"Augustine Lozno, Ventura County, California" 1904 (Goldberg 26)
"Baby in a Chair" c. 1870 (National 151d)
"Baby Picture" 1900 (Goldberg 14)
"Bainbridge Japanese leave home, Evacuation Day" 1942 (Eyes #126)
"The battleship Arizona" 1941 (Lacayo 103)
"The Beatles" 1963 (Photos 105)
"Bellikoff Studio in Pavlograd, Ukraine" c. 1900 (Rosenblum \46)
"Berlin jitterbug champs" 1952 (Eyes #232)
"Blacksmiths" 1850s* (Rosenblum2 #330)
"Blake Block, Brattleboro" 1860 (National 1531)
"Blind Russian Beggars" 1870 (Rosenblum2 #421)
"The Bombing of Guernica, Spain" 1937 (Monk #23)
"Boy slashed by Algerian extremists" 1997* (Best23 127a)
"Brigade de Shoe Black–City Hall Park" 1867 or before (Photography1 \8)
"Brinjara and Wife" 1868 (Marien \3.81)
"British artillerymen feed an 8-inch howitzer" 1917 (Lacayo 51a)
"British officer addressing troops" 1918 (Lacayo 48)
"Broadside for Capture of Booth, Surratt, and Herold" 1865 (Waking #111)
"Brooklyn Bridge under Construction" c. 1878 (Rosenblum2 #182)
"Brooklyn Terminal, Brooklyn Bridge" 1903 (Photography1 #V-33)
"Burial Place of Son of Henry Clay in Mexico" c. 1847 (Photography1 #III-3)
"The Burning Cross" 1948 (Photos 72)
"Cabinet portrait" n.d. (Rosenblum \65)
"Calf-Bearer and Kritios Boy shortly after exhumation of Acropolis" c. 1865 (Waking #71)
"California Forty-Niner" c. 1850* (Photography1 \3)
"Calvin Klein in Times Square" 1982 (Goldberg 194)
"Cambodian prisoners" 1975-1979 (Marien \7.29; Photos 141)
"Camp David Accords" 1978* (Photos 145)
"Caroline Greig and Sister Julia" c. 1855 (National 3)
"Charles Lindbergh and the Spirit of St. Louis, Paris" 1927 (Monk #16)
"Charles Lindbergh leaving the courthouse for the noon recess, as photographers try to get him from every angle possible" 1935 (Eyes #139)
"Charlie Chaplin" 1914 (Monk #15)
"Churchill views damage at House of Commons" 1941 (Eyes #182)
"Claude Debussy" n.d. (Vanity 43)
"Colonel Theodore Roosevelt, of the Rough Riders" c. 1889 (Eyes #68)
"Communards in Their Coffins" 1871 (Marien \3.24; Rosenblum2 #205)
"Construction of the Forth Bridge" c. 1884 (Rosenblum2 #176)
"Coronado Beach, California" c. 1930 (MOMA 130)
"Coronation of Elizabeth II" 1953 (Photos 81)
"Corporal Samuel Thummam, wounded at the Battle of Petersberg [sic]" 1865 (Marien \3.70)
"Corpse of Che Guevara" 1967 (Photos 90)
"Cow" 1853 (Szarkowski 62)
"The Crash" 1929 (Photos 43)
"Creating Independence in Mauritania" 1960 (Photos

"Lindbergh with the American Ambassador Herrick in Paris" 1927 (Photos 40)

"Lobby of Napoleon Sarony's Studio" 1882 (Photography1 #II-13)

"London AP building" c. 1940s (Eyes #178)

"London Slum" c. 1889 (Rosenblum2 #442)

"Longfellow and Daughter in the Healy Studio in Rome" 1868-1869 (Rosenblum2 #248)

"Looking Up Broadway from the Corner of Broome Street" 1868 (Marien \3.2; Photography1 \65)

"Lottery Announcement" 1852 (Marien \2.18)

"Louis Armstrong in Performance" 1965 (Photos 113)

[*Lullaby of Broadway* from *The Gold Diggers*] 1935 (Hambourg \81)

"Lumière Brothers" n.d. (Rosenblum2 #325)

"Machinist's Apprentice with File and Gear" c. 1850 (Photography1 \24)

"Magdala (Emperor Téwodros's mountain fortress and capital)" 1868 (Marien \3.46)

"Mao Tse-Tung" n.d. (Monk #38)

"Marc Chagall" n.d. (Vanity 154d)

"Margaret Bourke-White" c. 1945 (Eyes #181)

"Members of the U.S. 369th Infantry Regiment, which was awarded the Croix de Guerre for bravery" c. 1917 (Goldberg 60)

"Mexican Revolution" 1913 (Photos 24)

"Military Coup Against Salvador Allende" 1973 (Photos 139)

"Miss Elfriede Riote is the only woman airship pilot in the Kaiser's service" 1914 (Eyes #78)

"Model 95 Land Camera" 1948 (Goldberg 122)

"Mother and Son" c. 1855 (National 156d)

"Mother and twins when they began to take fortified milk" 1911 (Goldberg 44)

"Mount Vesuvius, Italy, after the Eruption of 1944" 1944 (Rosenblum2 #661)

"Mr. Daladier announcing to parliament newsmen that he has accepted the task of forming a new cabinet" 1934 (Eyes #107)

"Mrs. Ethel Wakefield of Dorchester, welder at the Bethlehem shipyard in Quincy since 1943" c. 1945 (Goldberg 111)

"Mrs. How Martyn Makes Jam" n.d. (Marien \4.30)

"Mushroom cloud, Hiroshima" 1945 (Eyes #216)

"Nagar Brahim Women" 1863 (Marien \3.31)

"Nazis march on the Champs Elysees" 1940 (Eyes #191)

"Niagara Panorama" c. 1855 (National 156b)

"Night-Blooming Cereus, Closed After Blooming" 1884 (National 4); "In Bloom" 1885 (National 157)

"Normandy Landings" 1944 (Photos 61)

"Northern troops encamped near Washington" 1861 (Lacayo 22a)

"Nuclear Disaster in Chernobyl" 1986 (Photos 155)

"Nude" c. 1850 (Waking #44)

"Nude" 1870s (Rosenblum2 #250)

"Officer and Manservant" c. 1851 (Photography1 \4)

"The *Ohio Star* Buggy" c. 1850 (National 22)

"Olympic racial protests" 1968 (Eyes #282)

"1 of 1565 Aahirs; He Sells Cow Dung" c. 1891 (Rosenblum2 #417)

"Opening Tutankhamun's Coffin" 1922 (Photos 39)

"Orphans on steps" 1911 (Goldberg 45)

"Panorama showing Talbot's Reading Establishment" c. 1845 (Marien \2.9)

"Panoramic view of Passchendaele Ridge, Belgium" 1917 (Lacayo 44a)

"Paper Boxes" c. 1870 (Szarkowski 105)

"Patronize the Disabled Soldier" c. 1866 (Marien \3.68)

"Peace brings them together" 1979 (Eyes #351)

"Pearl Harbor" 1941 (Eyes #221)

"Pelé leads Brazil to Win the World Cup" 1970 (Photos 131)

"Pennsylvania Railroad Locomotive at Atloona Repair Facility" c. 1868 (National 157d)

"People of the Depression" 1937 (Documenting 35, 36)

"Phineas T. Barnum" c. 1870 (Photography1 61b)

"Picture taken when AP first installed a new model of 'Teletype'" 1923 (Eyes #127)

"Plane crash in the Adirondacks" 1935 (Goldberg 97)

"Portrait" c. 1850 (Szarkowski 37)

"Portrait of James Taylor, Soldier and Artist" c. 1890s (Photography1 #IV-26)

"Portrait of Youth" 1850-1860s (Waking #100)

"Portrait of Frederick Ives" c. 1910 (Eyes #52)

"Portraits of prisoners" c. 1880 (Szarkowski 98)

"Portraits of workers" 1862-1867 (Szarkowski 84-85)

"The President and First Lady at the Army-Navy game" 1949 (Life 24d)

"President Nixon checks his watch" 1974 (Eyes 276; Goldberg 184)

"President Roosevelt's Choicest Recreation, Amid Nature's Rugged Grandeur, on Glacier Point, Yosemite" 1903 or earlier (Szarkowski 82)

"Prohibition in the United States" 1930s (Photos 45)

"Protective Clothing for Workers in the Furnace Room" c. 1905 (Szarkowski 332c)

"Quarters of Photographers Attached to Engineer Corps, Army of the Potomac" c. 1862-1864 (Photography1 #IV-16)

"R. C. Hickman" 1949 (Eyes #151)

"Radiology Unit, Military Hospital, Grand Palais, Paris" 1914-1916 (Szarkowski 136)

"Rafting Party" c. 1910 (National 158a)

"Rebel Soldiers in Richmond" 1861 (Lacayo 22b)

"Reichstag Fire, Berlin" 1933 (Photos 47)

"Republic Steel strike, Chicago" 1937 (Life 153)

"Rescuing the Abu Simbel Temple Complex" 1968 (Photos 123)

"Rouen Cathedral" 1890s[?] (Szarkowski 332a)

"The Royal Wedding" 1981* (Photos 151)

"Ruins of Richmond" 1865 (Rosenblum2 #210)

"Safety Device on a Milling Machine" c. 1903 (Szarkowski 145)

"Salvador Dali" 1930 (Vanity 153)

"Samuel Clemens" c. 1850 (Photography1 \17)

"Samuel F. B. Morse" c. 1845 (Rosenblum2 #13)

"Secretary of War Henry Stimson, still blindfolded, holds out the first capsule drawn October 29 in Washington, D.C., in the nation's first peacetime draft lottery" 1940 (Eyes #136)

"Senator Alban W. Barkley of Kentucky, Chairman of the House Senate Committee on War Crimes, Buchenwald" 1945 (Goldberg 118)

"Seneca Falls, New York (downstream)" 1850 (National \6)

"Seneca Falls, New York (upstream)" 1850 (National \5)

"Seven little Indian children in four stages of civilization" c. 1900 (Goldberg 33)

"Seventh Avenue, 42nd and 43rd Streets, New York City" 1914 (MOMA 78)

"74th New York Infantry at drill" 1861 (Lacayo 23b)

"Shark Egg Case" 1840-1845* (Waking #9)

"Siege of Verdun" 1916 (Photos 31)

"Signing the Treaty of Versailles" 1919 (Photos 35)

PLACHY, Sylvia, 1943-
 "Christmas card" 2001 (Photography 139)
 "Transvestite" 1988 (Rosenblum \257)

PLANK, David
 "Classic cars" c. 1991* (Graphis92 \171-\172)

PLATT, Spencer
 "An Albanian boy waits for the train to restart outside
 the city of Dorresy, Albania" 1997 (Best23 186b)

PLONKA, Brian
 "After their first holy communion girls lead the
 procession of San Miguel" 1998 (Best24 105)
 "Ballerina Merideth Benson spins with the help of
 Guillermo Leyva during a performance of the
 Nutcracker" 1998 (Best24 43)
 "Bob and Jane Jenkins make themselves at home in
 the Freedom Hotel" 1991 (Best17 200a)
 "Businessman finds himself in the wrong place at the
 wrong time as a street brawl breaks out in
 downtown Pittsburgh" 1992 (Best18 51)
 "Commuters reflected in automatic doors as they file
 into Chicago's Union Station" 1998 (Best24 45c)
 "Generations–Under the Influence" 1996 (Best22
 252-253)
 "Illinois high school athletes clear the first set of
 hurdles" 1998 (Best24 157a)
 "I'm Not David Anymore" 1992 (Best18 53-55)
 "Immediately upon securing the cell block, guards
 stripped prisoners and searched them for hidden
 contraband" 1998 (Best24 156)
 "Lethal Legacy" 1998 (Best24 158-159)
 "Lewis Valentine finds himself outmuscled by a man
 who doesn't want Lewis hanging out with his
 sister" 1992 (Best18 56)
 "Nicole Myers jumps double dutch with her friends"
 1996* (Best22 174)
 "Secret, deadly diet" 1993 (Best19 137-140)
 "Shakedown Joliet" 1998 (Best24 97)
 "Sibling rivalry" 1996* (Best22 173b)
 "Springboard diver practices her form long after her
 teammates have gone home" 1993 (Best19 148c)
 "A swan swims in the silent waters of Memorial Park
 Pond before darkness falls" 1996* (Best22 182a)
 "Tony Lopez delivers a 10th round knockout punch
 to Joey Gamache" 1992 (Best18 52)
 "Young men party and celebrate with a traditional
 band behind the church" 1998 (Best24 157d)

PLUMBE, John, 1809-1857
 "Mrs. Francis Luqueer" n.d. (Rosenblum2 #39)
 "Portrait of Couple" c. 1845 (Photography1 #I-7)
 "Sausage Maker" c. 1845 (Photography1 #I-6)
 "U.S. Capitol" 1846 (Photography1 \32; Rosenblum2
 #15)

PLUNKETT, Suzanne
 "Coming of Age" 1997 (Best23 223d)

POBLY, Max
 "Bombing by hand" c. 1917 (Lacayo 50a)

POBY
 [nude painting a wall] c. 1992* (Graphis93 211)

PODGORSKI, Al
 "Angler in Chicago's Lincoln Park Lagoon" 1986
 (Best12 156a)
 "Betty Childs cares for her husband as he nears

death" 1990 (Best16 58-59)
 "A bicyclist perches high and dry as he crosses a
 flooded sidewalk" 1990 (Best16 60a)
 "Born-again members of a Southside Chicago Baptist
 Church gather on the shores of Lake Michigan for
 baptism ceremonies" 1986 (Best12 162-163)
 "Brotherly love in Chicago projects" 1987 (Best13
 50, 51)
 "Corazon Aquino gives the L-shaped sign of her party
 at a pre-election rally in Manila" 1986 (Best12 18)
 "Faith Brandon practices yoga by hanging upside
 down from ropes" 1990 (Best16 172a)
 "Filipino youths and women show their support for
 Aquino's candidacy" 1986 (Best12 19)
 "Good friends Yvonne (left) and Sally had to take a
 senior-housing project to court to be allowed to
 room together" 1990 (Best16 57)
 "Mother Teresa cradles Maria Halley in a public
 appearance in Chicago where she helped open a
 new shelter for missionaries" 1985 (Best11 162c)
 "Mother York is a volunteer chaplain at Cook County
 Jail" 1990 (Best16 61)
 "President Bush ponders a pupil's question during a
 visit to Farnsworth School" 1990 (Best16 60b)
 "Skydiver Chuck Spidell hasn't let age slow down his
 sport" 1990 (Best16 62a)
 "Spectators watch the International Skydivers
 Convention in Illinois" 1990 (Best16 62b)
 "Using a rubber boat to negotiate floodwaters of the
 DesPlaines River" 1986 (Best12 157d)

POE, Philip Alan
 [nude on a chair] c. 1992* (Graphis93 107)

POISSON, Cloe
 "Ash Wednesday" 1996 (Best22 181a)
 "Members of the police force hold a funeral for an
 abandoned newborn who was found dead from
 exposure in a parking lot" 1988 (Best14 79)
 "Officer Melissa Piscatelli salutes the coffin holding
 the body of her finance, Milford Patrolman Daniel
 Scott Watson" 1987 (Best13 64)
 "Two dancers with the School of the Hartford Ballet
 perform in the Morgan Great Hall at the
 Wadsworth Atheneum" 1997* (Best23 149)

POLACK, Richard
 "Artist and His Model" 1914 (Rosenblum2 #364)

POLIDORI, Robert
 "Rooms of the Palace of Versailles being
 refurbished" c. 1990* (Graphis90 \110-\111)

POLK, Prentice Hall, 1898-1984
 "Jesse Redmond Fauset, Langston Hughes, and Zora
 Neale Hurston in front of Booker T. Washington's
 statue at Tuskegee Institute" c. 1932 (Willis \86)
 "Lillian Evans Evanti, a lyric soprano, with her dog"
 c. 1935 (Willis \82)
 "Mildred Hanson Baker" c. 1937-1938 (Willis \81)
 "Old Character series: The Boss" 1932 (Rosenblum2
 #392; Willis \85)
 "Old Character series: Pipe Smoker" 1932 (Willis
 \83)
 "Old Character series: Portrait of George Moore" c.
 1930 (Willis \84)

POLKE, Sigmar
 "Quetta, Pakistan" 1974-1978 (Photography 101)

POLLARD, Susan T.
"Winter Squash" 1996* (Best22 180a)

POLLOCK, Arthur
"All that form and grace is great" 1985 (Best11 136a)
"Christa McAuliffe greets well-wishers at the
 Kennedy Space Center" 1986 (Best12 8)
"Christa's parents and sister at Cape Canaveral to
 watch the lift-off of *Challenger*" 1986 (Best12 9)

POLO, William
"Blue Jay center fielder Moseby removes toilet paper
 from Boston's Fenway Park" 1985 (Best11 173b)

POLYAKOV, Aleksandr
"Two hunters share a frozen fish inside a small
 mobile cabin" c. 1990* (Graphis90 \163)

PONTI, Carlo
"San Giorgio Maggiore Seen from the Ducal Palace"
 1870s (Rosenblum2 #119)

PONTING, Herbert G.
"An Iceberg in Midsummer, Antarctica" 1910-1913
 (Rosenblum2 #159)
"Stone filigree screens near Agra, India, frame the
 garden and tomb of Emperor Akbar, who died in
 1605" 1924 (Through 126)

POOL, Smiley N.
"Aftermath of a Racial Killing" 1998 (Best24 18-19)
"Gail Devers and Gwen Torrence are all smiles after
 crossing the finish line first and third, in the finals
 of the 100-meter race" 1996* (Best22 120a)
"Houston Oilers receiver Chris Sanders prays in
 thanks after beating Lionel Washington for a
 touchdown" 1995* (Best21 109)
"Hungry's Attlia Czene celebrates his Olympic record
 and gold medal in the finals of the 200-meter
 individual medley race" 1996* (Best22 115d)
"Kerri takes her now famous ride to the victory stand
 in the arms of coach Bela Karolyi" 1996* (Best22
 127c)
"Mario Ellie basks in the celebration of the Houston
 Rocket's second consecutive NBA championship"
 1995* (Best21 111d)
"Oiler coach Fisher gets a point across with defensive
 back Tomur Barnes" 1996* (Best22 202c)
"Player Daniel Grotte leaps up to high-five coach
 Lynn Foster" 1995* (Best21 135b)
"Resting by the warm-up pool" 1996* (Best22 125d)
"Sul Ross State University pitcher Mike Gonzales
 works against the shadows during a late afternoon
 game in Austin, Texas" 1988 (Best14 13c)

POOLE, Paul, 1886-c. 1955
"Southern Belles" c. 1921 (Willis \93)

POPE, Carl, Jr., 1961-
"Divine" 1998* (Committed 175)
"Untitled" 1999* (Committed 174)

POPE, Wes
"Bystanders try to form a human shield from the
 hailstorm for Bruce Conrad and his two children at
 a minor league baseball game" 1995* (Best21 175)
"National League MVP Sammy Sosa interacts with
 fans in the outfield" 1998* (Best24 65b)

PORCELLA, Philip
[formal wear] c. 1999* (Photo00 44)

PORTER, Charles H. IV
"Oklahoma City Bombing" or "Fireman and child in
 Oklahoma City" 1995* (Best21 171; Capture 181;
 Lacayo 188a; Marien \7.14)

PORTER, Cole
"A youngster offers friendship (and a handful of
 grass) to one of the residents of the Woodland Park
 Zoo" 1985 (Best11 177a)

PORTER, Eliot, 1901-1990
"Dungeon Canyon, Glen Canyon, Utah" 1961*
 (Goldberg 157)
"October 3, 1858" 1962* (Marien \6.61)
"Pool in a Brook, Pond Brook, New Hampshire"
 1953* (Icons 115)
"Red Bud Trees in Bottomland near Red River
 Gorge, Kentucky" 1968* (Rosenblum2 #773)
"Sculptured Rock, Grand Canyon, Arizona" 1967*
 (Icons 114)
"Trees and Pond, Near Sherborn, Massachusetts"
 1957* (MOMA 187; Szarkowski 264)

PORTER, Gary
"On first warm day of spring, a motorcyclist accepts
 his fate: arrested for speeding" 1986 (Best12 71a)
"3-year-old boy arrived at a hospital in Katmandu,
 Nepal, on his sister's back" 1987 (Best13 77a)

PORTER, Kent
"Because of a lack of water to fight a house fire, a
 firefighter sets up a Floto Pump to use pool water
 instead" 1995* (Best21 192b)
"Christmas Unplugged" 1995* (Best21 150b)
"Municipal Court judge laughs at another judge's
 joke" 1995* (Best21 193)
"Paul Rossi prunes grape vine in his father's
 vineyard, filled with blooming mustard weed"
 1988* (Best14 101a)
"Self-professed 'cowboy and Marlboro man' watches
 other ropers in a calf-roping competition" 1995*
 (Best21 192a)
"SWAT officers make sure a bank robbery suspect
 gets message during arrest" 1995* (Best21 172b)
"Wavy Gravy, a popular 1960s icon, sounds the horn
 to gather participants of his adult camp" 1995*
 (Best21 193a)

PORTER, Marion James, 1908-1983
"Barbershop, New Orleans" c. 1970s (Willis \216)
"Big Joe Turner, Marion Porter, and unidentified
 man" c. 1960s (Willis \214)
"Eartha Kitt, New Orleans" c. 1960s (Willis \212)
"Easter Sunday, New Orleans" c. 1965 (Willis \211)
"H. Rap Brown" c. 1960s (Willis \215)
"Traditional jazz parade" c. 1960s (Willis \213)

PORTER, Rosemary
"Squash" c. 1997 (Graphis97 94)

PORTER, William Southgate
"Fairmount Waterworks" 1848 (Rosenblum2 #100)

PORTERFIELD, Wilbur H.
"September Morning" 1906 (Rosenblum2 #391)

PORTNOY, David
"Indonesian Forest Fires" 1997 (Best23 207a,c)

POST, Susie
"Marion Flatherty grew up in Inisheer, one of the Aran Islands off the coast of Ireland" 1996* (Best22 214a)
"Phillip Lorenz jumps down to the crossbeam on the Sixth Street Bridge in Pittsburgh" 1988 (Best14 74)
"Simon Mireego is cared for by his grandmother, who has lost seven of her nine children to the AIDS epidemic in Uganda" 1992* (Best18 66c)
"Two of nine children who live in a Ugandan house without adults because their parents have died from AIDS-related illnesses" 1992 (Best18 66b)

POST, William B., 1857-1925
"Apple Trees in Blossom" c. 1897 (National \58)
"Aspens" c. 1905 (MOMA 57)
"Path in the Snow" c. 1897 (National 143c)

POULSEN, J. Mark
"Have a heart for the lowly thistle, the artichoke" 1987* (Best13 187d)
"A model gets wrapped up in her work to show off a haunting array of jewelry" 1987* (Best13 182)

POULTER, Brian
"Sugar, a male prostitute and diagnosed AIDS victim, stares from the rear window of an abandoned Cadillac in which he lives and entertains his client" 1988 (Best14 94b)

POWELL, Mike
"Andre Agassi at the U.S. Open in New York" 1988 (Best14 144c)
"Asian foot volleyball comes to the West" 1991* (Best17 156b)
"Four-man bobsled team at the Calgary Winter Olympics" 1988 (Best14 144d)
"Jubilation at the finish of the Olympic 4x100 meter medley relay" 1988* (Best14 146)
"Long jumper Mike Powell practices at a track in California" 1991* (Best17 156a)
"Sprint cyclist Frank Weber of West Germany at the Summer Olympics in Seoul, viewed from the top of the velodome" 1988 (Best14 143)
"Super heavyweight Zawieja of the Federal Republic of Germany at the Summer Olympics in Seoul" 1988* (Best14 145)
"Yves Mankel and Thomas Rudolph of Germany compete in the Luge doubles event during the Winter Olympics" 1992* (Best18 140)

POWELL, Todd
[self-promotional] c. 1990* (Graphis90 \243)

POWERS, Carol T.
"Kozup holds back her emotions as she tells how her son contracted AIDS from a blood transfusion just after he was born" 1985 (Best11 31a)

POWERS, David
[a cancer patient] c. 1992* (Graphis93 54)

POZERSKIS, Romualdas
"Bloody Sunday in Lithuania" 1991 (Graphis92 \45-\47)

PRACHT, Ulrich
[for fashion designer Caren Pfleger] c. 1991* (Graphis92 \15)

PRATT, Charles
"Maine" 1968* (Rosenblum2 #774)

PREE, Sheila, 1967-
"Man Preaching" 1998 (Willis \324)
"Man with Bible" 1998 (Willis \326)
"Man with Sign" 1998 (Willis \322)
"Woman with Sign" 1998 (Willis \323)

PREISLER, Don
"A Haitian woman carries a basket on her head in the early morning as she walks downtown in Port-au-Prince" 1987* (Best13 170a)

PRESTON, Jim
"Philippine farmer learns to defend his home and protect his freedom from Communist guerrillas during a government training program" 1987 (Best13 112b)

PRÉVOST, Victor
"Reed and Sturges Warehouse" c. 1855 (Rosenblum2 #146)

PRICE, Larry C., 1954-
"Liberia–Executioners Celebrate" 1980 (Capture 116)
"One Atlantican offers a symbol of hope by raising a flag over a ruined residence" 1985 (Best11 66c)
"War-torn Angola" 1984* (Capture 133)
"War-torn El Salvador" 1984* (Capture 132)
"Wrapped like a gift, newborn awaits her parents at maternity hospital in Lithuania" 1990* (Through 72)

PRICE, Tommy
"A student tries to make friends with boys of the Beja tribe in the Sudan" 1985 (Best11 122a)

PRICE, William Lake, 1810-1896
"Don Quixote in His Study" early 1850s (Marien \3.96; Rosenblum2 #269)

PRIMOLI, Giuseppe, 1851-1927
"Monte Mario–Who Are They?" 1889 (Waking #128)
"Procession, Ariccia" c. 1895 (Rosenblum2 #308)

PRINCE, Doug, 1943-
"Floating Fan" 1972 (Photography2 77)

PRINCE, Richard, 1949-
"Marlboro Man" 1980* (Goldberg 192)
"Untitled (Cowboys)" 1993* (Marien \7.34)
"Untitled Gang" 1982-1984* (Photography2 220)

PROBST, Michael
"Gail Devers wins the women's 100-meter finals" 1996* (Best22 116b)

PROCTOR, Daniel
[ball sponsored by the Art Deco Society] c. 1995* (Graphis96 50)

PROKIC, Milan
[ad for *Geniun* shoes] c. 1990* (Graphis90 \64)

PRONIN, Anatoly
[still life] c. 1989 (Graphis89 \275, \276)

PSIHOYOS, Louis
"Computer Customization–A Japanese bicycle
factory" 1990* (Best16 150)
"500 television screens fire 500 different images from
the information highway" 1995* (Best21 153d)

PUDENZ, Martin
"Anthony Quinn" c. 1999* (Photo00 12)

PULFER, Karen
"Children return home to find their parents
handcuffed on the front yard, arrested on drug
charges" 1987 (Best13 65d)

PUMPHREY, William, 1817-1905
"Norman Porch of St. Margaret's Church, Walmgate,
York" c. 1852 (Szarkowski 49)

PURCELL, Rosamond W., 1942-
"Execution" 1980* (Rosenblum \20)
"Untitled" c. 1978* (Rosenblum2 #788)

PUYO, Emile Joachim Constant, 1857-1933
"Puyo, Robert Demachy, and Paul de Singly with
Model" 1909 (Marien \4.14; Waking #127)
"Summer" 1903 (Rosenblum2 #373)

—Q—

QUAILE, Jim
"Mushrooms, painted and submerged in water" c.
1991* (Graphis91 \290)

QUAN, Zhang Yin
"Cart Pullers" 1935 (Rosenblum2 #723)

QUICK, Robert
[untitled] c. 1992* (Graphis93 36)

QUIGLEY, Edward
"Crowd Scene" 1931 (Goldberg 8)

QUINN, Edward
"Pablo Picasso and his wife and frequent model,
Jacqueline" 1968 (Life 173c)

QUIRK, Philip
[approaching storm, Bondi Beach, Australia] c. 1991
(Graphis92 \205)
"For a poster for the World Expo 88 in Brisbane,
Australia" c. 1989* (Graphis89 \121, \122)

—R—

RAAB, Emanuel
[ad for briefcases and bags] c. 1991* (Graphis92
\182, \183)

RABINOVITCH, Ben M., 1881-1964
"Nude Torso" c. 1929

RAEDLE, Joseph
"With loving care a fieldworker washes her son by
hand on the kitchen floor" 1996* (Best22 162d)

RAI, Raghu
"Prayer time, Dhaka" 2000* (Photography 114b)

"Too little room for humans and animals: leopard is
drugged after killing villagers" 1992* (Best18 217)
"With Goddess Kalima, Calcutta" 2000*
(Photography 114a)

RAINER, Arnulf, 1929-
"Bündel im Gesicht" 1974 (San \52)
"Mit Augenstarker" 1971 (San #66)

RAINEY, Matt
"After the Fire" 2000 (Capture 200, 201)

RAINIER, Chris
"Men gather firewood during Pig Festival in Irian
Jaya" 1993 (Best19 77a)
"A young boy performs initiation rites in Irian Jaya,
New Guinea" 1993 (Best19 68d)

RANARD, John
"HIV in the former Soviet Union" 1997 (Best23 208)

RANDALL, Florence
"Seminole Woman" c. 1937 (Sandler 107)

RANDALL, Herbert, 1936-
"Untitled" 1963 (Committed 177); 1964 (Committed
176)

RANGEL, Ricardo, 1924-
"Untitled" 1960 (Marien \6.15)

RANGER, Henry Ward
"Bradbury's Mill Pond, No. 2" 1903 (Rosenblum2
#355)

RANIERI, Andre
"A young girl cries for her father as he and his
girlfriend are arrested" 1995* (Best21 177d)

RANKAITIS, Susan, 1949-
"Lake" 1980* (Photography2 201)

RAPPING, Anacleto
"Canada's relay team hug each other after their gold
medal victory over the U.S." 1996* (Best22 118d)
"Derek Mills and his fellow U.S. team members
celebrate their gold medal victory in the 4x400
meter relay" 1996* (Best22 119c)
"Gold medal winner in the vault competition, Simona
Amanar of Romania" 1996* (Best22 126a)
"Holly McPeak digs a shot out of the sand during a
beach volleyball match" 1996* (Best22 122b)
"Jubilant members of the U.S. freestyle team pose for
the crowd and the cameras after winning their
Olympic gold medals" 1996* (Best22 125d)
"Mary Ellen Clark completes her final dive in the 10-
meter platform competition" 1996* (Best22 124a)
"100-meter freestylers make an artistic impression as
they enter the water on the first day of Olympic
swimming" 1996* (Best22 124c)
"Phil Collins on stage during his No Jacket Required
tour" 1985 (Best11 165a)
"Russia's Ianina Batyrchina performs in the
individual all-around semi-finals of rhythmic
gymnasts" 1996* (Best22 126c)
"U.S. women huddle on the awards platform after
receiving their gold medals" 1996* (Best22 127d)

RASCONA, Rodney
"Audi" c. 1992* (Graphis93 139)

"Dancer in traditional buffalo regalia" c. 1989*
(Graphis89 \170)
"Shy 3-year-old eagle dancer" c. 1989* (Graphis89
\169)

RATHE, Joanne
"Broward County Sheriff's deputies make a drug bust
in a home" 1991 (Best17 103)
"Inside South Africa: a country at war with itself"
1986 (Best12 60-65)
"Mira Khila, a young Afghan refugee, holds a picture
of her 17-year-old husband who was killed in the
holy war against the Afghanistan government"
1987 (Best13 76a)
"Sailors on Norwegian ship 'Denmark' get a close-up
view of the Lady Liberty as tall ships parade in
honor of her 100th birthday" 1986 (Best12 96a)

RAU, William H., 1855-1920
"Cathedral Rocks, Susquehanna River near
Meghoppen" 1899 (National \40)
"Cayuga Lake, Elbow Cove" 1895-1900 (Waking
330)
"Lattimer Strippings and Coal Breaker" after 1895
(Photography1 \80)
"Maunch Chunk, From the Mountain Line, L.V.R.R."
1891-1893 (Photography1 \79)
"Main Line at Duncannon" 1906 (Rosenblum2 #186)
"Picturesque Susquehanna Near Laceyville" 1891-
1892 (MOMA 64)
"Produce" c. 1910* (Rosenblum2 #347)
"Seneca Lake and Watkins Glen" 1899 (National
144a)
"Sampson's Fleet, A Gunner of the *Iowa*" 1898
(National 143d)
"Towanda from Table Rock" 1899 (National \52)

RAUSCHENBERG, Robert, 1925-
"Untitled" 1949 (MOMA 210); 1985* (Photography
86)

RAWLINGS, John
"Untitled" 1944* (Rosenblum2 #643)

RAY, Bill
"Japanese industrialist in repose" 1964 (Lacayo 135)

RAY-JONES, Tony
"Glyndebourne" 1967 (Rosenblum2 #709)

REBBOT, Olivier, 1949-1981
"Chador, Teheran, Iran" 1979* (Eyes \16)

RECK, Oliver
[show jumping, Olympics] c. 1992* (Graphis 93 199)

RECORD, Christopher A.
"A beggar huddles against a wall in Costa Rica"
1993* (Best19 63c)
"Ernie Irvan's pit crew goes to work during the Mello
Yello 500 in Charlotte" 1993* (Best19 144)
"Exalting after a hard workout on the heavy bag at the
Charlotte Boxing Academy" 1995* (Best21 119c)

REDDY, Patrick
"Cincinnati zoo patron agreed to have a snake draped
around her neck" 1986 (Best12 120c)
"In Niles, Ohio [man] surveys tornado damage from
what was a bedroom in his parents' home" 1985
(Best11 66d)

"A zoo official brought a cheetah to a meeting of a
philanthropic group" 1986 (Best12 133b)

REDFIELD, Robert, 1848-1923
"A New England Watering Place, Near Salisbury"
1887 (Photography1 #VI-7)

REDL, Harry
"Allen Ginsberg and 'Moloch' " 1958 (Goldberg 170)

REDLER, Stuart
[untitled] c. 1999* (Photo00 18)

REECE, Jane, 1868-1961
"Interior, with Frank Mannheimer, Pianist" 1921
(Peterson #64)
"Interpretive Dance I" 1922 (Sandler 61)
"Poinsettia Girl" 1907 (Marien \4.6; Rosenblum \74)
"Takka-Takka-Yoga-Taro" 1922 (Sandler 60)

REED, Eli, 1946-
"Cholera Dorm, Benaco Refugee Camp in Tanzania"
1995 (Committed 178)
"President Reagan cutout on a busy Manhattan
sidewalk, New York City" 1986 (Goldberg 204)
"Rwanda Children in Benaco Refugee Camp in
Tanzania" 1995 (Committed 179)

REED, Rita
"Half a million people jammed the streets of
Minneapolis and St. Paul for a parade celebrating
the Twins' victory in the World Series" 1987
(Best13 203)

REED, Roland W.
"The first sail" 1907 (Lacayo 41)

REEDER, Mona
"Asian immigrant pupils play Simon Says as a way of
learning English" 1992 (Best18 227d)
"Crime and criminals in a California neighborhood"
1992 (Best18 223-225)
"Exhausted after a nasty re-election campaign,
incumbent rolls up posters" 1992 (Best18 228d)
"Finding it difficult to adjust to his new school, child
often eats by himself" 1992 (Best18 228a)
"Six-year-old cries in pain as a nurse changes the
dressing on an incision" 1992 (Best18 227a)
"Taking a peek at other voters, sisters wait for their
mothers to finish voting" 1992 (Best18 226)
"Two sets of hands reach up to remove a sewer grate
in Arizona so that illegal immigrants can enter the
U.S." 1998* (Best24 32b)

REEKIE, John, active 1860s
"A burial party, Cold Harbor, Va." 1865 (Eyes #32)
"Ruins of Gaines' Mill, Virginia" 1865 (National
144d)

REESE, Tim
"Robert Groth swings his father's mailbox in a scuffle
with deputies and their dogs" 1987 (Best13 67d)

REESE, Tom
"Lumberjack Stan Christie eyeballs a 500-year-old
cedar in the Olympic National Forest, deciding
where to make his cut" 1990 (Best16 168)
"State of the Economy" 1992 (Best18 170a)

REGAN, Ken
"Joe Namath toasts his Super Bowl win" 1969 (Life 145c)
"Less than five months after his 20th birthday, Mike Tyson finished off Trevor Berbick early in their Las Vegas title bout" 1986* (Best12 109)
"A portrait of New York Mayor Ed Koch" 1986 (Best12 53c)

REGAN, Lara Jo
"One inspiring actress and her inglorious journey through Hollywood" 1995* (Best21 199)

RÉGNAULT, Henri-Victor, 1810-1878
"Gardens of Saint Cloud" before 1855 (Waking #49)
"Group at *Château de la Faloise*" 1857 (Waking #50)
"The Ladder, Sèvres, Porcelain Manufactory" c. 1852 (Szarkowksi 58)
"The Manufactory at Sèvres, East Entrance" c. 1852 (Art \72)
"Sèvres, the Seine at Meudon" c. 1853 (Art \71; Rosenblum2 #105)
"Woods at Sèvres or Meudon" c. 1851 (Szarkowski 43)

REICHARDT, Jörg
[woman walking] c. 1997 (Graphis97 42)

REICHEK, Elaine
"Survival of the Fitting" 1994 (Photography 157)

REID, Ken, 1958-
[self-promotional] c. 1991* (Graphis91 \103)
"2 Figures with Gold Bar" 1993* (Committed 181)
"Views of the F-15E built by McDonnell-Douglas" c. 1990* (Graphis90 \222, \223)

REID, Vernon, 1958-
"Man with Newspaper" 1990 (Committed 180)

REID, Mrs. Warren
"Unidentified couple" 1840s (Sandler 14b)

REINER, T. C.
[calendar page inspired by the artist Alberto Vargas] c. 1995* (Graphis96 36)
"Nikki" c. 1997 (Graphis97 35)

REININGER, Alon, 1947-
"In Minneapolis, people infected with HIV and their friends link in a chain and laugh in a sequence" 1987 (Best13 56b)
"San Francisco, California, Patient with AIDS, Ken Meeks" 1986* (Eyes \29)
"Thomas Ramos, 30, died of AIDS in August in New York City" 1987 (Best13 56a)

REIS, Mark
"Skier is buried in snow after crashing at the Extreme Skiing Championship" 1996* (Best22 200c)
"Sweeping a golf cart tunnel after a heavy rain" 1986 (Best12 141b)

REISFELD, Bert
"Elvis Presley" 1960 (Photos 89)

REITER, O. C., 1861-1935
"The Husbandman" 1919 (Peterson #86)

REJLANDER, Oscar Gustave, 1813-1875
[from *Expression of the Emotions in Man and Animals*] c. 1872 (Rosenblum2 #78)
"Grief" 1864 (Decade 2c)
"Hard Times" 1860 (Rosenblum2 #266)
"Lewis Carroll" 1863 (Rosenblum2 #57)
"Mr. and Miss Constable" 1866 (Waking #22)
"Study of Hands" c. 1854 (Rosenblum2 #252)
"The Two Ways of Life" 1857 (Marien \3.97; Rosenblum2 #253)
"Untitled" c. 1857 (Szarkowski 93)

RENGER-PATZSCH, Albert, 1897-1966
"Beech Wood" 1936 (Icons 77)
"Fingerhut (Foxglove)" c. 1924 (Marien \5.40)
" 'Katharina' Colliery in Essen" 1954 (Icons 76)
"*Sempervivum Percarneum*" c. 1922 (Rosenblum2 #513)
"Snake Head" 1927 (Waking 355d)
"Stairwell" 1929 (Hambourg 92)
"Yawning Baboon" c. 1928 (Hambourg \75)

RENNER, Ivo V.
[from ad for underclothing] c. 1989* (Graphis89 \44)

RENTMEESTER, Co
"Female boxing championship" 1997* (Best23 177c)
"Mark Spitz, training for Olympics" 1972* (Life 144)
"Michael Jordan" 1984* (Life 146a)
"Oksana Baiul" 1994* (Life 148a)

RESSMEYER, Roger H.
"At Starfire Optical Range in New Mexico, lasers measure the distortion of starlight by the atmosphere" 1994* (Through 490)
"Australia's Molonglo Observatory Synthesis Telescope–a mile-long 'ear'–was the first radio telescope to detect the spectacular supernova" 1987* (Through 486)
"Bathed in moonlight during a 10-minute exposure from top of a weather tower" 1988* (Best14 160)
"Before their mission to repair the Hubble Space Telescope, astronauts practiced underwater in NASA's 1.3-million-gallon simulator tank" 1994* (Through 482)
"Copper and sodium lasers are used to fix star twinkling and make telescopic images more clear at the Starfire Optical Range" 1993* (Best19 113)
"The mile-long 'Wooz' has become a craze" 1988* (Best14 156a)
"Molten lava from Kilauea explodes when it flows into the Pacific Ocean" 1992* (Best18 222)
"A multiple exposure records the July 11 total solar eclipse atop Mauna Kea Observatory, Hawaii" 1991* (Best18 219)
"Presenting the AX-5, one of NASA's two prototype space suits" 1988* (Best14 157)
"Using the discovery telescope, Ian Shelton observes the Milky Way and Supernova 1987A, the brightest exploding star seen from Earth in 400 years" 1988 (Best14 161b)

REUTLINGER STUDIO
"Dinner Dress by Panem" 1906* (Rosenblum2 #635)
"Mlle. Elven" 1883 (Rosenblum2 #63)

REYES, Gary
"Antoinette Lee helps her escort overcome a little stage fright before the annual Debutante Ball" 1987 (Best13 121a)

144)
"Trouble in Paradise" 1992 (Best18 189-194)
"25th Precinct: Philadelphia" 1997 (Best23 38-39)
"A woman smoking crack with her child beside her"
 1990 (Best16 176; Lacayo 183c)

RICHARDS, Wynn, 1888-1960
"Cigarettes" c. 1925 (Rosenblum \152)

RICHARDSON, Alan
[daybeds] c. 1995* (Graphis96 152, 153)

RICHARDSON, Earl
"A young boy makes a pit stop while a Kansas
 Highway Patrol officer talks with the driver of the
 car he pulled over" 1990* (Best16 169a)

RICHARDSON, Jim
"Four generations share an ordinary moment in the
 back alleys of a town in Italy" 1990* (Best16 10a)

RICHEBOURG, Pierre-Ambrose, 1810-after 1893
"Louis-Jacques-Mandé Daguerre" c. 1844 (Waking
 279)

RICHEE, Eugene R.
"Clara Bow" 1926 (Goldberg 79a)

RICHTER, Bernie
[ad for *Fays* shoes] c. 1990* (Graphis90 \63)

RICHTER, Gerhard
"Funeral" 1988 (Photography 121)
"Shot Down" 1988 (Marien \7.38)

RICKARD, Jolene
"Untitled" 1993* (Marien \7.17)

RICKMAN, Rick
"American and Soviet volleyball players battle at net
 during the Summer Olympics" 1988 (Best14 12d)
"Bella Karoli rushes to spot Dominique Monceneau"
 1995* (Best21 125)
"Chasing a Dream" 1992* (Best18 158-160)
"City of Barcelona makes a panoramic background
 for Olympic contender in the 10-meter diving"
 1992* (Best18 157)
"A competitor in the Senior Olympics shows his first-
 place form in the pole vault" 1995* (Best21 116a)
"A hurdler crashed during the U.S. National Track
 and Field championships" 1995* (Best21 117c)
"Impromptu cliff-diving competition at Lake Havasu"
 1993* (Best19 124)
"Magic Johnson's return to the Los Angeles Lakers
 was short-lived but made for exciting moments"
 1996* (Best22 195a)
"Patty Frustaci became the first mother of septuplets"
 1985 (Best11 123a)
"Pulling out all the stops and bouncing his board off
 the top of a good wave" 1998* (Best24 73a)
"Surfboard gets air out of the compression of a wave"
 1996* (Best22 192a)
"This surfer loses his balance and dignity as his
 surfboard slaps him in the face during a wipeout"
 1996* (Best22 200c)
"White water kayaking at the Olympics" 1996*
 (Best22 122d)

RIDER-RIDER, William, 1889-1979
"Devastation on battlefield of Passchendaele taken

with a panoramic camera" 1917 (Marien \4.75)

RIEDEL, Charlie
"In Kansas, an American Agriculture Movement
 supporter, protests to troopers" 1985 (Best11 58b)

RIEDL, Martin
[for the Cashmere House in Milan] c. 1991
 (Graphis92 \29)

RIEFENSTAHL, Leni, 1902-
"Calisthenics, Olympic Games, Berlin" 1936
 (Hambourg \82)
"Nuba Dancer" 1975 (Rosenblum \185)

RIESS
"Fernand Léger" 1929 (Vanity 155b)

RIGGINS, Rich
"A first time bull-rider finds out why the sport is
 more fun to watch" 1996* (Best22 196c)
"A perfect jump at the Maryland Grand Prix Classic"
 1996* (Best22 197b)
"Teammates watch a shootout to decide the state field
 hockey champions" 1996* (Best22 201c)
"Ukranian rhythmic gymnast Elena Vitrichenko
 performs with the clubs" 1996* (Best22 126d)

RIIS, Jacob, 1849-1914
"Bandits Roost, 59½ Mulberry Street" c. 1888
 (MOMA 73; Marien \4.46)
"Baxter Street Court" c. 1895 (Lacayo 54)
"A Cave Dweller–Slept in This Cellar Four Years" c.
 1890 (Photography1 \91; Rosenblum2 #479)
"Five cents a spot, Bayard Street" c. 1889 (Eyes #48;
 Lacayo 64b; Rosenblum2 #439)
"In the Home of an Italian Rag-Picker; New Jersey"
 c. 1889 (Szarkowski 186)
"Police Station Lodgers" c. 1898 (Marien \4.47)
"Street Arabs at night" c. 1889 (Lacayo 61a)
"Yard, Jersey Street Tenement" c. 1888 (Rosenblum2
 #441)

RINEHART, Frank A., 1861-1928 and/or MUHR,
Adolf F.
"A. B. Upshaw, Interpreter" 1898 (Goldberg 31b)
"Buried Far Away, Cocapah" 1899 (National \2)
"Geronimo (Guyatle), Apache" c. 1898
 (Photography1 \76)
"In Winter, Kiowa" 1898 (National 146a)

RINGHAM, Bob
"Dotson's mother is comforted after one court
 hearing on the matter" 1985 (Best11 93b)

RINGMAN, Steve
"Accused of stealing property at gunpoint, two
 suspects find themselves looking down the wrong
 end of the barrel" 1985 (Best11 82)
"Black Monday, October 19, the day the Dow Jones
 Industrials plunged 508.32 points" 1987 (Best13
 15b)
"Bruce Springsteen performs live in Oakland" 1985
 (Best11 164a)
"A downed plane near a graveyard in Nicaragua is a
 reminder of the revolution that brought the
 Sandinistas to power" 1986 (Best12 57b)
"Karen's boot camp" 1985 (Best 180-183)
"Marilyn he ain't" 1985 (Best11 168-169)
"Robert Culp is a musician from the Northwest" 1985

(Best11 167a)
"San Franciscan clung to a ledge on a hotel, finally
fled, was captured" 1986 (Best12 87b)
"San Francisco 49ers Coach Bill Walsh right after
winning the Super Bowl" 1985 (Best11 205a)
"San Francisco Giants players take time to go along
with the music being broadcast at Candlestick
Park" 1985 (Best11 204a)
"A spectator at San Francisco's Bay to Breaker race
found a high place to watch the 100,000 runners"
1986 (Best12 160d)

RIO BRANCO, Miguel
"Door into Darkness" 2001* (Photography 228)
"In Brazil, Kayapo teenagers are dressed up and
ready to pick marriage partners" 1984* (Through
320)
"Prostitutes of Maciel, Brazil" 1976* (Rosenblum2
#794)

RITOLA, Roy
"Painted Windows" c. 1991* (Graphis91 \321-\335)

RITSCHEL, Elke
[death of a pet] c. 1992* (Graphis93 195)

RITSCHEL, Marcel
"Altered States" c. 1992* (Graphis93 210)

RITTASE, William, 1887-1968
"Untitled" 1930s (Peterson #49)

RITTENBERG, Sidney
"Glass and Color Shadows" c. 1999* (Photo00 221)
"The Runway of Time" c. 1999* (Photo00 218)

RITTS, Herb
"Batman" c. 1992* (Graphis93 97)
"Brian Bosworth" c. 1990* (Graphis90 \116)
"Dalai Lama" 1987 (Rolling #59)
"David Bowie" 1987 (Rolling #65)
"Djimon" c. 1991 (Graphis92 \100)
"Djimon with Octopus" c. 1991* (Graphis91 \226)
"Don Johnson" 1985* (Rolling #69)
"The four most expensive photo models in the world"
c. 1990 (Graphis90 \159)
"Jack Nicholson" 1986* (Rolling #70); 1987 (Rolling
#76); c. 1990* (Graphis90 \137)
"Jackie Joyner-Kersee" 1988 (Rolling #68)
"Jim Carrey" c. 1995* (Graphis96 117)
"Madonna" 1987 (Graphis89 \176; Rolling #64, #75);
c. 1990* (Graphis90 \152); c. 1991 (Graphis92
\115)
"Madonna as Breathless Mahoney and Warren Beatty
as Dick Tracy surrounded by their gangster foes" c.
1991* (Graphis91 \205)
"Mel Gibson" 1989 (Rolling #67)
"Nadja Auermann" c. 1995* (Graphis96 51)
"Nastasia Urbano" c. 1991* (Graphis92 6)
"The New Elton John" c. 1992* (Graphis93 96)
"Tom Cruise" 1986 (Rolling #66)
"Warren Beatty" c. 1991 (Graphis91 \204)

RIVENBARK, Maurice
"Family sees what Hurricane Kate did to U.S. 98 near
Eastpoint, Florida" 1985 (Best11 73b)

ROBBINS, Ken
[ad for Springer's of East Hampton] c. 1990*
(Graphis90 \236)

ROBERT, Louis-Rémy, 1811-1882
"Henriette Robert" c. 1850 (Waking #41)
"The Large Tree at La Verrerie, Romesnil" c. 1852
(Waking #51)
"The Park at Saint-Cloud" c. 1853 (Szarkowski 61)
"Still life with Statuette and Vases" 1855 (Art \83)
"Versailles, Fountain of the Pyramid of Girardon"
1853 (Art \79)
"Versailles, Neptune Basin" c. 1853 (Rosenblum2
#106)

ROBERT, Patrick
"Liberia" 1996* (Best22 234d)
"A Liberian street fighter during the civil war" 1996*
(Best22 212a)
"Terror in Sierra Leone" c. 1997* (Graphis97 55)

ROBERTS, Anthony K.
"Hollywood Fatality" 1973 (Capture 85)

ROBERTS, Elizabeth Ellen, 1875-
"Harvesting" c. 1905 (Sandler 118-119)
"Mrs. Ted Pope" c. 1905 (Sandler 13)
"Sheep" c. 1905 (Sandler 10-11)
"Threshing" c. 1905 (Sandler 12)

ROBERTS, Holly, 1951-
"Dog with Man Inside" 1986* (Photography2 202)

ROBERTS, Martha McMillan
"Three sisters at the cherry blossom festival" n.d.
(Fisher 88)
"A torpedo plant worker and her family from Ohio,
living in a trailer" 1941 (Fisher 84)

ROBERTS, Michael
"Inspired by Genet's Notre-Dame-des-Fleurs" c.
1989* (Graphis89 \30, \31)

ROBERTS, Neil Malcolm
"George Stavrinos" c. 1990 (Graphis90 \126)

ROBERTS, Richard S., 1881-1936
"Family portrait" c. 1930 (Willis 90)
"Portrait of three women" c. 1930 (Willis \89)
"Portrait of two brothers" c. 1925 (Willis \87)
"Portrait of Wilhelmina Roberts at 7 months" n.d.
(Willis \88)

ROBERTSON, Grace, 1930-
"Pub Outing" 1954 (Rosenblum \179)

ROBERTSON, James
"Balaclava Harbor, Crimean War" 1855
(Rosenblum2 #202)
"Interior of the Redan" 1855 (Marien \3.8)

ROBERTSON, Orville, 1957-
"Abandoned Car, Marine Park, Brooklyn" 1987
(Committed 182)
"Bus and World Financial Center Under
Construction" 1985 (Willis 309)
"Rainy Steps, Metropolitan Museum" 1985 (Willis
\308)
"Tennis Player, Amsterdam Ave." 1992 (Willis \308)
"Woman in Front of Macy's, Manhattan" 1992
(Committed 183)

ROBINSON, Barry
[ad for Bell Bicycle Helmets] c. 1995* (Graphis96

142, 144)

ROBINSON, Henry Peach, 1830-1901
"Bringing Home the May" 1862 (Art \147)
"Fading Away" 1858 (Marien \3.100; Rosenblum2 #268)
"The Lady of Shalott" 1860-1861 (Art \148)
"She Never Told Her Love" 1857 (Waking #20)
"Sleep" 1867 (Szarkowski 95)

ROBINSON, Herb, 1942-
"Etude No. 1" 1992* (Committed 184)
"Etude No. 3" 1992* (Committed 185)

ROBINSON, Scott
"Fruit torte" 1985* (Best11 148c)

ROBINSON-CHAVEZ, Michael
"Hoping to wash off the dust of the desert, a boy jumps into a half-filled pool" 1998 (Best24 95d)
"A mestizo woman, wearing a traditional hat of the northern Andes, walks through the morning streets" 1998 (Best24 50c)

ROBL, Monika
[ad for eyeglasses] c. 1990 (Graphis90 \67)

ROCCA, Manny
"Controversial U.S. Court of Appeals Judge Bork and Attorney General Edwin Meese" 1987 (Best13 8)

ROCHE, Thomas C., 1826/1827-1895
"Depot Field Hospital, City Point, Virginia" 1865 (Waking 319)
"Ordnance Wharf, City Point, Virginia" 1865 (Waking 318d)
"Section of the Original Big Tree, 92 Ft. in Circumference" 1870-1871 (Photography1 \62)

ROCK, Joseph
"In the 1920s, Tibetans recognized a six-year-old boy as the living Buddha of Guya" 1928 (Through 160)

ROCKWINKEL, Sherry
"Rope holding Takada breaks" 1985 (Best11 105b)

RODAMMER, Kris
[matching green chair and walls] c. 1992* (Graphis93 145)

RODCHENKO, Alexander, 1891-1956
"Asphalting street in Moscow" 1929 (Waking #192)
"Assembling for a demonstration" 1928 (Szarkowski 210)
"The Critic Osip Brik" 1924 (Art \225)
"Foxtrot" 1935* (Waking #175)
Lefortovo–studentské m ste ko" 1930 (San #31)
"Montage" c. 1923 (Rosenblum2 #491)
"Morning Wash" 1930 (Waking #174)
"Pines in Pushkin Park" 1927 (Hambourg 85c, \119)
"Pioneer" 1930 (Art \224)
"Pioneer with a Horn" 1930 (Art \227)
"Portrait of My Mother" 1924 (Rosenblum2 #516)
"Radio Listener" 1929 (Art \232)
"Rehearsal, Belomorsk Canal" 1933 (Art \229)
"Sentry of Shukhov, Tower" 1929 (Art \231)
"Somersault" 1936 (Icons 65)
"To the Demonstration" 1932 (Art \228)
"Trumpet-Playing Pioneer" 1930 (Icons 64)
"Untitled" 1923 (Marien \5.7)

"Untitled" 1928 (Marien \5.8)
"Untitled" 1930s (San \12)
"Vladimir Mayakovsky" 1924 (Art \226; Hambourg \49)
"Woman with Leica" 1934 (Art \230)

RODGER, George, 1908-
"V-1 Blitz, London" 1943 (Eyes #183)

RODGERS, David A.
"A young cat that lives aboard a sailboat leaps to a skiff while chasing ducks" 1996* (Best22 184d)

RODRIGUEZ, José Angel
"Campesina" 1977 (Rosenblum2 #707)

RODRIGUEZ, Joseph
"An illegal alien crosses the border between Mexico and California" 1996* (Best22 166a)

RODRIGUEZ, Paul E.
"At the break of day, the city of Oaxaca begins to wake" 1997* (Best23 158a)
"In the middle of a rain storm, France's Claude Issorat crosses the finish line first in the men's 1500-meter wheelchair race" 1996* (Best22 120a)

ROGERS, Julie
"A blond American girl catches the interest of residents of Seoul" 1990* (Best16 171b)

ROGIER, Gene D.
[experimental photograph] c. 1990* (Graphis90 \336)

ROGOVIN, Milton
[from the series *Buffalo's Lower West Side Revisited*] 1973-1991 (Goldberg 203)

ROGOWSKI, David James
"Hangover" 1995 (Best21 148c)

ROH, Franz, 1890-1965
Nackt im Auto/Fleisch und Metall" c. 1927-1928 (San \10)
"Nude in the Tub" c. 1926 (Hambourg 67a)
"Untitled" c. 1925 (Decade 30); c. 1927 (San #29)

ROHNER, Patrick
"Swatch watches" c. 1991* (Graphis92 \186-\188)

RÖHRSCHEID, Jürgen
"Yo-Yo Ma" c. 1990* (Graphis90 \160)

ROLLINS, Byron
"One for the books" or "Dewey Defeats Truman" 1948 (Eyes #209; Goldberg 124)

ROLSTON, Matthew
[blond woman with arms crossed] c. 1997 (Graphis97 108)
"Laura Dern" c. 1992* (Graphis93 112)
"Lisa Bonet" 1988* (Rolling #80)
"Mikhail Baryshnikov" 1987 (Rolling #58); c. 1989 (Graphis89 \126)
"Shirley Manson" c. 1997* (Graphis97 117)

ROMBACH, Robin
"Herrera holds a cocked pistol to his head as Officer Laukaiti holds his hand" 1988 (Best14 72)

RONDON, Hector
"Aid From Padre" 1962 (Capture 51)

RONDOU, Michael
"An angry Donald Singleterry of Atlanta confronts a 'skinhead' in the street outside the Democratic National Convention" 1988 (Best14 73a)
"Bobby Smith is reunited with his mother and sisters after having been kidnaped" 1985 (Best11 111b)
"British golfer Faldo searches for lost ball during the U.S. Open at Pebble Beach" 1992* (Best18 153a)
"Decathlete Zmalik of Czechoslovakia indicates that he is ready to make his vault during the Summer Olympics in Barcelona" 1992* (Best18 153b)
"Golden State Warrior coach Don Nelson is booed by a crowd" 1992 (Best18 151)
"Russian coach gives a promising young athlete a stern lecture during swim practice at Basin Moskva, Moscow" 1992* (Best18 154)
"Swiss skater Krieg performs during World Figure Skating Championships" 1992* (Best18 152)

RÖNTGEN, Wilhelm, 1845-1923
"Frau Röntgen's Hand" 1895 (Marien \4.60)

ROONEY, John
"Muhammad Ali Knocks Out Sonny Liston" 1965 (Photos 111)

ROOS, Barney
"Steam-powered engine races to a fire" 1910 (Lacayo 39c)

ROOT, Dan
"The only woman to enter track and field events at the senior games" 1985 (Best11 221a)

ROOT, Marcus
"Portrait of Couple" c. 1850 (Photography1 #I-9)

ROQUEMORE, Eugene, 1921-1993
"Cotton Club, Lubbock, Texas" c. 1955 (Willis \222)

ROSE, David
"Annie Leibovitz" c. 1990* (Graphis90 8)

ROSE, Richard Howard, 1973-
"Intense Moment" 1995* (Committed 186)
"Prayers Moment" 1995* (Committed 187)

ROSELLO, Monica
[fashion trade show, Spain] c. 1992* (Graphis93 50)

ROSENBAUM, Daniel
"Family and friends photograph Ms. Senior America Pageant contestants" 1997* (Best23 148b)

ROSENBERG, Howard
"Ian McKellan" c. 1999* (Photo00 145)

ROSENBLUM, Walter
"Mullaly Park, Bronx" 1980 (Rosenblum2 #465)

ROSENER, Ann
"All nursing and no play might make Frances Bullock a dull girl!" n.d. (Fisher 127)
"Blood donor at the American Red Cross Blood Bank" 1943 (Fisher 73)
"Blood donors have light refreshments before leaving the American Red Cross Center" 1943 (Fisher 73)
"Italian-Americans at work on a bomber in the Douglas aircraft plant" 1943 (Fisher 81)
"National Exhibition at the Library of Congress of art dealing with aspects of war" 1943 (Fisher 66)
"OWI research workers, Washington, D.C." 1943 (Fisher 80)
"Periodic complete vehicle inspection is required of all U. S. army drivers" 1943 (Fisher 82)
"Permanente Metals Corporation, Shipbuilding divisionm Yard no. 2" 1943 (Fisher 86)
"Saving waste fats and greases from which war materials will be made" 1943 (Fisher 128)
"Victory gardening in the northwest section" 1943 (Fisher 79)

ROSENTHAL, Joe, 1911-
"Fourth Marines hit Iwo Jima Beach" 1945 (Eyes #223)
"Old Glory Goes Up On Mount Suribachi" or "Raising the Flag at Iwo Jima" 1945 (Capture 16; Eyes #212; Marien \5.86; Monk #29; Lacayo 118; Photos 65)

ROSLER, Martha
"The Bowery in two Inadequate Descriptive Systems" 1974-1975 (Marien \7.32)
[from series Bringing Home the War: House Beautiful] c. 1967-1972 (Marien \7.31)

ROSS, Horatio, 1801-1886
"Stag in cart" c. 1858 (Waking #18)
"Tree" c. 1858 (Waking #19)

ROSS, Judith Joy, 1946-
[from Easton Portraits] 1988 (Szarkowski 312)
[from Eurana Park, Weatherly] 1982 (Women \152)
[from Portraits at the Vietnam Veterans Memorial, Washington, D.C.] 1983-84 (Women \153)
"Miles Davis runs the Voodoo Down" 1989* (Willis \419)
"Pearl Primus" 1990* (Willis \418)

ROSSKAM, Louise
"Air view of a cemetery and town. Lincoln, Vermont" 1940 (Fisher 51)
"Control room at the water works on Conduit Road, Washington, D.C." 1940 (Fisher 32)
"Old Edison victrola in a farm house. Vermont" 1940 (Fisher 46)
"Proprietor of general store. Lincoln, Vermont" n.d. (Fisher 37)
"Victory gardening in the northwest section" 1943 (Fisher 79)

ROSZAK, Theodore, 1907-1981
"Untitled" 1937-1941 (San \17)

ROTH, Bill
"Mark Kelly is thrown from El Toro at the Alaska State Fair Rodeo" 1988 (Best14 122)
"Two Barrow, Alaska residents say goodbye to the California gray whales that were trapped in the Arctic Ocean ice pack for more than three weeks" c. 1988 (Best14 6d)

ROTHSTEIN, Arthur
"Annie Pettway Bendolph" 1937 (Documenting 157b)
"At a Saturday night dance; a string band with its kitty for contributions [Visalia Migratory Labor

Camp, California]"1940 (Documenting 204a)
"At the end of the school day" 1937 (Documenting 159a)
"Baseball game [Visalia Migratory Labor Camp, California]"1940 (Documenting 203c)
"Bucket and gourd" 1937 (Documenting 157c)
"Cabin" 1937 (Documenting 151c)
"Cabins and outbuildings on the former Pettway plantation" 1937 (Documenting 150a)
"Camp residents [Visalia Migratory Labor Camp, California]"1940 (Documenting 191-193)
"Children in Nursery, Tulare Migrant Camp, Visalia, California" 1940 (Decade 42b)
"Cooperative store meeting [Visalia Migratory Labor Camp, California]" 1940 (Documenting 197b)
"Curing meat" 1937 (Documenting 159c)
"Embroidering a dish towel in a camp residence [Visalia Migratory Labor Camp, California] " 1940 (Documenting 195c)
"Farmhand near Goldendale, Washington" 1936 (Documenting 18a)
"Father and sons walking in the face of a dust storm, Cimarron County, Oklahoma" or "Fleeing a Dust Storm" 1936 (Lacayo 98; Marien \5.57; Rosenblum2 #450)
"Fixing a truck [Visalia Migratory Labor Camp, California]" 1940 (Documenting 196a)
"The former home of the Pettways" 1937 (Documenting 153c)
"Girl at Gee's Bend, Alabama" or "Artelia Bendolph" 1937 (Decade \38; Documenting 151b; Lacayo 95)
"Grand Central Station, New York" 1941 (Fisher 160)
"Houston or Erick Kennedy plowing" 1937 (Documenting 152a)
"In the recreation hall [Visalia Migratory Labor Camp, California]" 1940 (Documenting 202b)
"Interior of the old Pettway home, occupied by the foreman John Miller and his family" 1937 (Documenting 154a)
"Ironing clothes in the utility building [Visalia Migratory Labor Camp, California]" 1940 (Documenting 198a)
"Jennie Pettway and another girl with the quilter Jorena Pettway" 1937 (Documenting 152b)
"Mr. Hale from Snow Hill conducting school in the Pleasant Grove Baptist Church building" 1937 (Documenting 158a)
"Mimeographing the camp newspaper [Visalia Migratory Labor Camp, California]" 1940 (Documenting 197c)
"On the Pettway Plantation" 1937 (Documenting 155b)
"Rest period in the nursery [Visalia Migratory Labor Camp, California]" 1940 (Documenting 199c)
"Saturday night dance [Visalia Migratory Labor Camp, California]" 1940 (Documenting 205b)
"Steel cabins house individual families [Visalia Migratory Labor Camp, California]" 1940 (Documenting 194)
"Troupe from the Arvin migratory labor camp performing a play for the residents of the Visalia camp [Visalia Migratory Labor Camp, California]" 1940 (Documenting 200a)
"Vegetable garden in camp [Visalia Migratory Labor Camp, California]" 1940 (Documenting 194b)
"Watching the play in the recreation hall [Visalia Migratory Labor Camp, California]" 1940 (Documenting 201b)
"Well-baby clinic [Visalia Migratory Labor Camp,

California]" 1940 (Documenting 198b)
"Willie S. Pettway" 1937 (Documenting 156a)
"Women's club [Visalia Migratory Labor Camp, California]" 1940 (Documenting 202)
"Young Coal Miner, Wales" 1947 (Decade \40)

ROUGIER, Michael, 1925-
"The shock of freedom" c. 1953 (Eyes #230)

ROUNDTREE, Deborah
"Shot taken for fashion accessories" c. 1989* (Graphis89 \166, \167)
[Toyota catalog] c. 1992* (Graphis93 157)

ROVERSI, Paolo
"Decolletage worthy of a Gainsborough" c. 1995* (Graphis96 54, 55)
[nude woman in jewelry] c. 1997* (Graphis97 41)
"A Stylish Skier" c. 1991* (Graphis91 \37)
[woman in a lacy hat] c. 1997

ROWELL, Galen
"Low-impact tourism leaves only footprints in Nepal's Chitwan National Park, that now is a rhinoceros sanctuary" 1990* (Best16 11c)

ROYSTER, Ken, 1944-
"Archbishop Naomi Durant, New Refuge Deliverance Cathedral, Baltimore" 1994 (Willis \336)
"Deacon with candles, St. Elijah Holiness Church, Baltimore" 1992 (Willis \337)
"River Baptism series"1996 (Willis \338-\341)

RUBENSTEIN, Len
[diving into a swimming pool] c. 1991* (Graphis92 \231)

RUBENSTEIN, Meridel, 1948-
"The Swallow's House, Progresso, New Mexico" 1982-1983* (Rosenblum \21)

RUBIN, Laurie
"Oranges still on the branches" c. 1991* (Graphis91 \129)
[woman as top of pen] c. 1992* (Graphis93 136)

RUBIN, Steve
"A man at Cukurca refugee camp buries his baby, a victim of dysentery" 1991* (Best17 115b)

RUDOLPH, Charlotte
"Dance Image: Gret Palucca" 1923 (Rosenblum \131)

RUEBSAMEN, James
"Kareem Abdul-Jabbar goes over Bowie of the Trailblazers with his Skyhook" 1985 (Best11 207)
"Los Angeles' tallest building burns out of control" 1988 (Best14 10a)
"Ruben Castillo gets comfort and consolation from his trainer after he was knocked out by Julio Cesar Chavez" 1985 (Best11 215c)

RUFF, Thomas, 1958-
"House No. 3 II" 1988* (Icons 190)
"Portrait" 1987* (Marien \7.25)
"Portrait (Lukas Duwenhögger)" 1986* (Icons 191)

RUGE, Willi
"Olympic trainers" 1936 (Eyes #105)
"Parachute Jump" 1931 (Eyes #103; Lacayo 68)

"With our war fliers in the air" 1936 (Eyes #88)
"Zeppelin report, May Day, march of the masses"
1933 (Lacayo 66)

RUMPF, Friedrich K.
[crocodile diorama] c. 1992* (Graphis93 195a)

RUNNING, John
[ad for Kodak black-and-white film] c. 1991
(Graphis91 \219)
[dead shark in a boat] c. 1991* (Graphis92 \229)
"A hunter from the Apache tribe, ready for the deer
dance" c. 1990* (Graphis90 \161)
"Making Bread" c. 1991* (Graphis92 \148)
[painting of a schoolgirl shot by Israelis] c. 1991*
(Graphis92 \44)
"Train Clean" c. 1991 (Graphis91 \221)
"Train Hard" c. 1991 (Graphis91 \220)
"Young traditional dancer from the Shoshone tribe"
c. 1990 (Graphis90 \162)

RUSCHA, Ed, 1937-
"Every Building on the Sunset Strip" 1966
(Photography2 93)
[from Nine Swimming Pools and a Broken Glass]
1968* (Marien \6.96)
[from Thirty-four Parking Lots] c. 1967 (Rosenblum2
#735)

RUSCHIN, H.
"The Kaiser, with his aide, receiving reports at the
battle front in the San region" 1915 (Eyes #81)

RUSING, Rick
[ad for the 1990 Audi V8 Quattro] c. 1991
(Graphis91 \159, \160)
[BMW corporate calendar] c. 1991* (Graphis92
\165-\167]
"Beauty and Nature" c. 1991* (Graphis91 \19)
[Beechcraft Starship] c. 1992* (Graphis93 157)
[Infiniti J30] c. 1992* (Graphis93 160c)
[Lexus GS300] c. 1995* (Graphis96 147, 149b)
[untitled] c. 1992* (Graphis93 6)
"Working with the Environment" c. 1989*
(Graphis89 \207-\210)

RUSNAK, Benjamin
"Dunbar, Florida" 1996 (Best22 264-265)

RUSSELL, Andrew Joseph, 1830-1902
"Construction of the Railroad at Citadel Rock, Green
River, Wyoming" 1867-1868 (Rosenblum2 #185)
"East End of Tunnel No. 3, Weber Valley" 1869
(Photography1 \48)
"Experimental Bridges" 1863 (Photography1 #IV-19)
"General Herman Haupt Crossing Stream on a
Pontoon" 1863 (Photography1 #IV-18)
"Hanging Rock, foot of Echo Canyon, Utah" 1867-
1868 (Rosenblum2 #168)
"Meeting of the rails, Promontory, Utah" or "Last
Rails, Promontory Point" 1869 (Lacayo 28a;
Marien \3.54; Photography1 \49; Rosenblum2
#184)
"Slave Pen, Alexandria" c. 1863 (Waking #105)
"Sphinx of the Valley" 1869 (National \37)
"Steam Shovel at Work, Echo Cañon" 1868
(Photography1 \47)
"Stone Wall, Rear of Fredericksburg, with Rebel
Dead" 1863 (Photography1 \42)
"A Successful Attempt to Bend and Break Rails"

1863 (Photography1 #IV-20)
"Train on Embankment, Granite Cañon" 1868-1870
(Photography1 #III-6)
"Upper Wharf, Belle Plain" 1864 (Photography1 \44)
"Weber from One Thousand Feet Elevation" 1869
(National 146d)

RUSSELL, Chris
"Couple enjoy a drive-in movie–and their 1957 Ford
convertible" 1985* (Best11 145a)

RUTH, Ernst Hermann
[Vintage 1953 Buick Special Coupe] c. 1991*
(Graphis92 \178, \179)

RUTHERFORD, Michael W.
"Antique toys" c. 1991* (Graphis91 \87)
[from a catalog for saddles and bridles of exceptional
quality] c. 1989* (Graphis89 \227, \228)

RUTHERFURD, Lewis, 1816-1892
"Mary Pierrepont on Silvertail" c. 1863 (National
147)
"Moon" 1865 (Marien \3.72)

RUZICKA, D. J., 1870-1960
"Heart of Endive" 1932 (Peterson #31)
"Old Roofs, Prague" 1922 (Peterson #9)
"Pennsylvania Station" 1930s (Peterson #32)

RYAN, Anne
"Player gets hands on pass intended for opponent"
1987 (Best13 210)
"U.S. National 1-meter diving champion Shaffer
helps a 10-year-old try a lean-back dive" 1987
(Best13 194)

RYAN, Cornelius, 1920-1974
"The Dispossessed" c. 1946 (Eyes #200)

RYAN, David
"The message couldn't be clearer as a homeless,
legless man comes to a full stop in Boston's
business district" 1986 (Best12 188)
"A worker gets a foothold on the statue of
Revolutionary War Gen. John Glover on Boston's
Commonwealth Avenue mall" 1985 (Best11 174c)

RYAN, Mike
[ad for a computer software company] c. 1992*
(Graphis93 62)
[dried leaf] c. 1997* (Graphis97 82, 86)

RYAN, Tom
"Brochure for the Polar Blue Filters of the Nautilus
brand sunglasses" c. 1989* (Graphis89 \223, \224)
[self-promotional] c. 1990* (Graphis90 \314, \337)

RYNEARSON, Mike
"An Ethiopian father and son in an emergency
feeding center" 1986 (Best12 68d)

—S—

SAAL, Rich
"A slow-moving tornado hangs over southeastern
Menard County just before striking the town of
Cantrall" 1995* (Best21 174b)

SABAH, Michel
[ad for a Konica camera] c. 1991* (Graphis92 \93)

SABATIER-BLOT, Jean Baptiste
"Portrait of Louis Jacques Mandé Daguerre" 1844
(Rosenblum2 #1)

SACHA
"In the country in black and white" c. 1990
(Graphis90 \65, \66)

SACHA, Bob
"Easter Islanders extend a warm Polynesian greeting
to visitors" 1993* (Through 436)
"In Chaco Canyon, New Mexico, the great kiva of
Casa Rinconada symbolized the cosmos for the
11th-century Anasazi" 1990* (Through 498)
"A workman cleans the stained glass dome of the
Christian Science Mapparium, revealing coastlines
and political boundaries" 1998* (Best24 53)

SACKS, David
[spider and lipstick] c. 1995* (Graphis96 70)
[insects on face powder and nail polish] c. 1995*
(Graphis96, 72)

SADIQ, Muhammad
"The Holy City" c. 1880 (Marien \3.45)

SADJA, Zvia
"Last Supper in the Desert" c. 1997 (Graphis97 98)

SADY, Scott
"Zapatista Uprising in Chiapas" 1996* (Photos 181)

SAGA, Teiji
"Whooper Swan" c. 1991* (Graphis92 \224)

SAIIDI, Jamal
"A Moslem father carries his son toward help after a
car bomb blast in west Beirut" 1985 (Best11 121b)
"One of the hijackers aboard TWA Flight 847 waves
off a Shiite militiaman after he delivered
newspapers to the sky pirates" 1985* (Best11 48)

ST. JACQUES, Pierre
"A Playmate and Her Foundation" c. 1999* (Photo00
66)

ST. MARY, Jeffrey L., 1955-
"Joy Tabernacle" 1991 (Willis \374-\375)

SAKAI, Toshio
"Vietnam–Dreams of Better Times" 1967 (Capture
62)

SAKATA, Eiichiro
[from brochure for Japanese incense company] c.
1991* (Graphis91 \126, \127)

SALGADO, Sebastião, 1944-
"The Drought in Mali" 1985 (Rosenblum2 #482)
"Fight Between a Serra Pelada Mineworker and a
Policeman, Para, Brazil" 1986 (Icons 187)
"Gold miners in Brazil" or "Sera Pelada, Brazil"
1986 (Eyes #325; Lacayo 168; Marien \7.18;
Photography 108; Photos 157)
"Kabul, Afghanistan" 1996 (Photography 109)
"Region of Lake Fagubian. These nomads have had
to walk across wide expanses" 1983-1985 (Eyes

#326; Life 132)
"Workers in a Kuwait oil field install a new wellhead
that will enable them to inject a mudlike mixture
into a well to 'kill' the fire" 1991 (Best17 194)

SALINGER, Adrienne
"Fred H. from 'Teenagers in Their Bedrooms' "
1993* (Goldberg 214)

SALOMON, Erich, 1886-1944
"Ah, le voilà! Le roi des indiscrets (It's That Salomon
Again!) Paris" 1931 (Icons 51)
"Night Session of the German and French Ministers
at the War Debts Conference in The Hague" 1930
(Icons 50; Marien \5.2)
"Presidential Palace in Berlin" 1930 (Rosenblum2
#594)
"Statesmen" 1931 (Eyes #91-92)
"Summit conference" 1928 (Lacayo 74)
"Supreme Court, Chief Justice Hughes presiding"
1932 (Eyes #154)
"Visit of German statesmen to Rome" 1931 (Eyes
#93)
"William Randolph Hearst, San Simeon, California"
1930 (Eyes #94)

SALTER, Jeffrey A., 1961-
"Crew member Sergio Rocha of Brazil prepares for
the Cup of Miami sailing race" 1991 (Best17 152a)
"Spirit Dancer" 1998 (Committed 189)
"Timbuktu No 2" 1998 (Committed 188)

SALYER, Thomas W.
"A badly bruised woman receives her first drink of
water after being buried 3 days" 1985 (Best11 18d)

SALZANO, James
"Al Hirschfeld" c. 1999* (Photo00 122)
"Baldwin Artist Series" c. 1999* (Photo00 153)
"British Photographer/Director David Bailey" c.
1991* (Graphis91 \217)
"George Burns" c. 1991* (Graphis91 \218)
[ladies' lounge of New York City's Roseland
Theater] c. 1995* (Graphis96 123)
[pistol and rifle team] c. 1999* (Photo00 192)
"Russian couple in Brighton Beach, Brooklyn" c.
1995* (Graphis96 125)

SALZMANN, Auguste, 1824-1872
"Jewish Sarcophagus, Jerusalem" 1854 (Waking 298)
"Jerusalem–Helmet Found in Jordan" 1854
(Szarkowski 67)
"Jerusalem, Islamic Fountain" 1854 (Rosenblum2
#112)

SAMARAS, Lucas, 1936-
"March 19, 1983" 1983 (Rosenblum2 #790)
"Panorama" 1983* (Szarkowski 279)
"Photo-Transformation 11/1/73" 1973*
(Photography2 132)
"Photo-Transformation 11/22/73" 1973* (San #56)
"Photo-Transformation 9/19/73" 1973* (San \39)
"Photo Transformation" 1976* (Goldberg 186)
"Untitled" 1973* (Marien \6.95)
"Untitled (Self-Portrait)" 1990* (Photography 142)

SAMOJEDEN, Michael
"Test Ride (Michael Dukakis in tank)" 1988*
(Goldberg 206)

SAMORA, John
"Scarves" 1992* (Best18 174)

SAMUEL, Deborah
[ad for hair salon] c. 1989 (Graphis89 \28)

SANCETTA, Amy
"John McEnroe kicks at a television camera that he
felt got too close" 1985 (Best11 223c)
"This is how MOVE area looked June 10" 1985
(Best11 26b)

SANDER, August, 1876-1964
"Ad for Osram Company" c. 1930 (Hambourg \107)
"Anton Raderscheid and His Wife Martha
Hegemann" c. 1926 (Hambourg 78c)
"Baker" or "Pastry Cook" 1928 (Icons 20;
Rosenblum2 #447)
"Boxers Paul Roderstein and Hein Hesse" 1929
(Marien \5.67)
"The Earthbound Farmer" 1910 (Szarkowski 240)
"Eyes of an Eighteen-Year-Old Young Man" 1925-
1926 (Waking 355c)
"Fair and Circus People, Circus Workers" 1930
(Photography 78)
"Gypsy" 1938 (Art \296)
"The Hod-Carrier" c. 1928 (Art \294)
"Otto Dix" 1907 (Vanity 9)
"The Painter Gottfried Brockmann" 1924 (Art \297)
"Paul Hindemith" 1930 (Vanity 179)
"Persecuted Jew, Mr. Leubsdorf" 1938 (Art \301)
"Raoul Hausmann" 1927-1928 (Waking #187)
"SS Officer" 1937 (Art \300)
"Student, Cologne" 1926 (Hambourg \39)
"Studienrat" 1928 (San \42)
"Untitled" 1920 (Art \299)
"Widower and Sons" 1925 (Art \298)
"Wife of the Painter Peter Abelen" 1926 (Art \295)
"Young Farmers in Their Sunday Best, Westerwald"
1913 (Icons 21)
"Young girl in circus caravan" 1932 (Szarkowski
241)

SANDERS, Chris
"Bill Robinson" c. 1990* (Graphis90 \122)
[self-promotional] c. 1990* (Graphis90 \125)

SANDERS, Paul
[salt shaker pouring salt] c. 1995* (Graphis96 90)

SANDERS, Walter
"A radiation shelter in Garden City, Long Island"
1954 (Lacayo 133a)

SANKOVA, Galina, 1904-
"Fallen German Soldiers on Russian Front" 1944
(Rosenblum \172; Rosenblum2 #612)

SANTAMARIA, Juan Ignacio Delgado
[bull killing man during Fiesta San Fermin] c. 1995*
(Graphis96 64)

SANTOS, Juma, 1947-
"Enskinment, or Inauguration, of a 'Ya Na'
(Dagomba Chief), Yendi, Ghana, West Africa"
1974 (Committed 190)
"The Funeral of an Ashanti Paramount Chief, Kumau,
Ghana, West Africa" 1974 (Committed 191)

SANTUCI, Chris
"Untitled" c. 1990* (Graphis90 \179)

SARFATI, Lise
"Tieriekhino I" 2000* (Photography 40)

SARICOSTAS, Aristotle
"A Christian Lebanese woman is helped away from
the scene of a car bomb explosion in an east Beirut
suburb" 1985 (Best11 120c)

SARONY, Napoleon, 1821-1896
"Ada [sic] Isaacs Menken [in her role as Mazeppa]"
1865 (Photography1 #II-12)
"Edwin Booth as Iago in Othello" c. 1875
(Photography1 #II-14)
"Eugene Sandow with a Leopard Skin" c. 1893
(Rosenblum2 #67)
"Lillie Langtry" c. 1882 (Photography1 #II-17)
"Oscar Wilde" 1882 (Photography1 #II-18; Waking
#140)
"Sarah Bernhardt" 1880 (Photography1 #II-16;
Rosenblum2 #66)

SARTORE, Joel
"After making a mistake during a marching drill, an
errant 'poopie' responds to his drill instructor"
1992* (Best18 119b)
"Bobby Comes Home" 1988 (Best14 190)
"Brown bear takes nap after fishing in the Katmai
National Park of Alaska" 2001* (Through 332)
" 'Spots fans'–one in fake fur–wear matching coats
on Beacon Street" 1994* (Through 314)
"Declining salmon runs in the Pacific Northwest have
left this Native American dipnetter on the river"
1995* (Best21 186d)
"Designed for grizzly bears and other wildlife, an
overpass provides safe passage across a highway in
Alberta, Canada" 2001* (Through 304)
"Draped crusaders" 1992* (Best18 218d)
"Evening's last sun highlights the rolling hills of the
Paulouse region of eastern Washington State"
1995* (Best21 152)
"For a 77-year-old orange picker in northern
California, fruit is free for the taking and exercise is
plentiful" 1993* (Best19 67; Through 378)
"Gray wolf savors a fresh kill" 1998* (Through 324)
"A hunter grasps a prized ring-necked pheasant,
bagged during a popular annual shoot at Broken
Bow, Nebraska" 1998* (Through 360)
"In a place where human divers outnumber manatees
10 to 1, a manatee and her calf attempt to find
sanctuary" 1995* (Best21 158c)
"Pelicans over Barrier Island" 1992 (Best18 220)
"Refuges exist not strictly to conserve wildlife"
1996* (Best22 207d)
"Storefront features an elaborate Rocky Mountain
fantasy" 1998* (Best24 40c)
"A towering thunderhead, lightning and a crescent
moon in an August sky" 1986* (Best12 103a)
"Under the Marine Mammal Protection Act, Alaskan
airspace is regulated to prevent thousands of
walruses from stampeding" 1996* (Best22 189a)

SASAKI, Yuichiro
"Time stopped by the atom bomb" 1945 (Eyes #215)

SATTLBERGER, Chris
"The victims of the Ceaucescu terror lie here in the
open" c. 1991* (Graphis91 \84)

SAUDEK, Jan
"Nude" c. 1989* (Graphis89 \168)

SAUL, April
"...And Baby Makes 5" 1991 (Best17 85-90)
"Banfield-Walkowitz wedding" 1989 (Life 50)
"In America: Hmong mix old and new" 1987 (Best13 155-157)
"Mom Doss in her apartment, caring for her dying mother" 1985 (Best11 94-97)
"Patients in a maternity ward in Albania" 1992 (Best18 70)
"Swinging away at his first T-ball practice" 1992 (Best18 146d)

SAUNDERS, Richard, 1922-1987
"Armed Forces Day Parade on Grant Street, Pittsburgh, Pennsylvania" 1951 (Willis \146)
"Hill District, father and son" 1951 (Willis \144)
"Kerosene signal lanterns on traffic sign, New York" 1952 (Willis 145)
"Port Authority Bus Terminal" 1951 (Willis \143)

SAVAGE, Charles Roscoe
"Quarrying Granite for the Mormon Tabernacle, Cottonwood Cañon, Utah" c. 1870-1872 (Photography1 #V-3)

SAVAGE, Naomi, 1927-
"Catacombs" 1972 (Rosenblum \234)
"Enmeshed Man" 1972 (Photography2 97)

SAVOIA, Steven
"Bill Clinton addresses a group in Boston as U.S. Rep. Joe Kennedy looks on" 1992* (Best18 74b)

SAWADA, Kyoichi, 1936-1970
"Vietnam" c. 1965 (Eyes #299)

SAWYER, Andy
"Horses enter the runway to corral during wrangling at Cottonwood Ranch" 1996* (Best22 183d)

SAWYER, Lidell
"In the Twilight" 1888 (Rosenblum2 #282)

SAWYER, Samuel W.
"River Drivers, Maine" c. 1867 (National \4)

SAXTON, Joseph
"Arsenal and Cupola, Philadelphia Central High School" 1839 (Rosenblum2 #14)

SAYAD, M.
"U.S. embassy. Tehran, Iran, November 9" 1979 (Eyes #349)

SCALES, Jeffrey Henson, 1954-
"American Gothic" 1993* (Committed 193)
"Doorway, West 116th Street" 1993* (Willis \416)
"House's Barber Shop, Harlem" n.d. (Willis \249-\251)
"Revival tent, 117th Street and Lenox Avenue" 1993* (Willis \417)
"West 17th Street, NYC" 1993* (Committed 192)

SCARVILLE, Keisha, 1975-
"I Grew Up. . . Bread" 1997* (Committed 194)
"I Grew Up. . . Keys" 1997* (Committed 195)

SCHABEN, Al
"Chanel brooch" 1996* (Best22 176d)
"Firefighter helps extricate boy and his dog trapped in their car" 1998* (Best24 30b)
"In a rare moment of solitude, Mother Teresa reads the *Bible* in the early morning light of her Calcutta, India, home chapel" 1993* (Best19 68b)
"Olympic swimmer Amanda Beard swims her way to taking first place in the women's 200-meter breaststroke" 1996* (Best22 201a)

SCHAD, Christian, 1894-1982
"Schadograph" 1918 (Rosenblum2 #483)
"Schadograph 24b" c. 1920 (Marien \5.9)
"Untitled" 1918 (San #5)

SCHAEFFER, Mary T.S., 1861-1939
"A Rose" c. 1900 (Sandler 131)
"Toadstools" c. 1900 (Sandler 132)
"Trailing Arbutus" 1900 (Rosenblum \93)

SCHAMBERG, Morton, 1881-1918
"GOD" c. 1916 (Hambourg 13a)
"Untitled" 1917 (San #2)
"Untitled (Cityscape)" 1917 (Marien \5.19; Rosenblum2 #524)
"Untitled (Rooftops) 1917 (Hambourg \4)

SCHARF, Otto
"Rhine Street, Krefeld" 1898 (Rosenblum2 #382)

SCHATZ, Howard
[figure added to Seurat painting] c. 1997* (Graphis97 101)
[for dance program of Joyce Theater] c. 1998* (Photo00 51)
[from *Gifted Women*] c. 1992* (Graphis93 126b, 127)
[untitled] c. 1999* (Photo00 53)
"White on White II–#3" c. 1999* (Photo00 50)

SCHAU, Virginia
"Rescue on Pit River Bridge" 1953 (Capture 33)

SCHAUER, Mindy
"An Awesome responsibility: Teen Parenthood" 1996* (Best22 163c, 226)

SCHECHTER, Eliot Jay
"Miami Heat's Willis rebounds as New York Knick Ewing tries to tip ball away" 1995* (Best21 111a)
"Torn apart by Hurricane Kate, the sloop '*Mai Hai*' washes ashore" 1985 (Best11 73a)

SCHEERER, Geoff
"Window washer does it with ropes as he works on an 11-story building in Wilmette" 1986 (Best12 183b)

SCHEID, Jeff
"Wrestling a steer during the National finals Rodeo" 1987 (Best13 200)

SCHEIDE, Barbara
"None" c. 1999* (Photo00 143)

SCHELL, Sherril V.
"Brooklyn Bridge" n.d. (Rosenblum2 #540)

SCHENKER, Meryl
"Andie is an African-American foster child in a white

family" 1995 (Best21 205)

SCHIFFMAN, Bonnie
"Lee Marvin" 1981* (Rolling #45)

SCHIRNHOFER, Paul
"Niki Lauda, thrice Formula I World Champion" c.
1990* (Graphis90 \114)

SCHLEGEL, Erich
"Texas Gov. Ann Richards, in New York City, takes
a few minutes to try on shoes" 1992* (Best18 79d)
"Zaire to Rwanda, the Long Journey Home" 1996*
(Best22 234c)

SCHLEIPMAN, Russ
[ad for an Arizona resort] c. 1991* (Graphis91 \224)

SCHMID, Max
[penguins on grass] c. 1999* (Photo00 228)

SCHMIDT, Richard
"5-year-old Oscar Javier Vera is washed down to ease
the pain of mud, gravel, and ash imbedded in his
skin" 1985 (Best11 18c)
"Flapping its wings for balance, a cattle egret rides
bareback across a meadow on the island of Kauai"
1993* (Best19 73d)
"A flock of white pelicans takes flight over Camanche
Lake" 1988 (Best14 98)
"Trout lie dead in the drained Bridgeport Reservoir in
California" 1988 (Best14 81b)

SCHMITZ, Herb
"The Nat West building in London" c. 1991
(Graphis91 \311)

SCHMITZ, Walter
"San Siro Stadion in Milan after a soccer game" c.
1991* (Graphis91 \79)
"Smoke bombs explode on the field at the soccer
stadium in Naples" c. 1991* (Graphis91 \78)

SCHMODDE, Leif
[ad for Pirelli Tires] c. 1992* (Graphis93 31)

SCHNABEL, Michael
[untitled] c. 1995* (Graphis96 151b)

SCHNEEBERGER, Jon
"The Space shuttle *Columbia* lifts off from the
Kennedy Space Center in Cape Canaveral, Florida"
1982* (Through 480)

SCHNEIDER, Gary
"Ear" 1997 (Marien \8.8)
"Pair of Tumor Suppressor Genes on Chromosome"
1997 (Marien \8.9)

SCHNEIDER, Patrick
"Carolina return specialist Dwight Stone keeps ball
from crossing the goal line" 1997* (Best23 179b)
"Six-year-old clutches his dog as he watched his
handcuffed mother answer police" 1996* (Best22
158d)

SCHOEDSACK, Ernest B.
"Perched atop a domesticated Asian buffalo, a
farmer's child rides through fields in Thailand"
1928 (Through 196)

SCHOELKOPF, Jake
"Cintron lies on the ropes after a 3rd round knockout
by Romero in their bout" 1995* (Best21 118d)

SCHOENFELD, Bernie
"W. Eugene Smith" n.d. (Lacayo 112)

SCHOLZEN, Bernd
"Toaster in operation" c. 1991* (Graphis91 \258)

SCHOON, Tim
"A young bighorn sheep leaps across a wide stream"
1998* (Best24 44c)

SCHREIBER, Andi Faryl
"30 young women entered the New York Golden
Gloves championships" 1995 (Best21 130)

SCHREIBER, David
"Anthony Jones, 4, defiantly sticks out his tongue at
his father, after a judge awarded an extra weekend
of custody to his mother" 1990* (Best16 173)
"Family members mourn the death of a 12-year-old
hemophiliac, who contracted AIDS through blood
transfusions" 1985 (Best11 30d)
"A 19-year-old woman apologizes in court to the
family of a pregnant woman she killed in a traffic
accident while high on LSD" 1990* (Best16 108)

SCHRÖDER, Arnold
"Preston Sturges" 1930 (Vanity 192c)

SCHROTEN, Achim
[article on nuts] c. 1990* (Graphis90 \330)

SCHULKE, Flip, 1930-
"March on Washington–Aug. 28" 1963 (Eyes #276)
"Mrs. Myrlie Evers and two children, Darrell and
Rena, view Medgar Evers' body at the funeral
home" 1963 (Eyes #274)
"The National States Rights Party encourages
resistance to school integration" 1963 (Eyes #273)
"Selma, Alabama, demonstrations and marches" 1965
(Eyes #279)
"White students in Birmingham demonstrate against
integration in their high school" 1963 (Eyes #270)

SCHUSTER, Elle
[paper sample brochure] c. 1991* (Graphis92 \255)

SCHUSTER, Gregor
"Cutlery" c. 1991* (Graphis91 \93-\98)

SCHUTZ, Robert H.
"Father and son" 1963 (Eyes #285)

SCHÜTZ, Stefan
[women in laser goggles] c. 1992* (Graphis93 30)

SCHUTZER, Paul, 1930-1967
"Day of triumph, Inaugural Ball" 1961 (Eyes #283)
"A hand rises from the eastern side of the Berlin
Wall" 1961 (Lacayo 160b)
"Natalie Wood" 1962* (Life 86d)

SCHWARZ, Michael
"Business declined because kids would loiter in the
plaza, often harassing shoppers" 1987 (Best13 68a)

SCIANNA, Ferdinando
"Carmona, Spain" 1963 (Photography 51)

SCOFIELD, John
"Along Nathan Road in Kowloon, a policeman
directs traffic in Hong Kong's busiest shopping
area" 1962* (Through 138)

SCOTT, David R.
"On the moon" 1971 (Eyes xvii)

SCOTT, Nadia Borowski
"Premature baby in father's hand" 1997 (Best23 156)

SCOTT, William Anderson, III, 1923-
"Journalist C. A. Scott at the annual Butler Street
YMCA Christmas party" c. 1940s (Willis \125)

SCULL, David
"Jennifer Lawson, programming chief for PBS,
stepped down from her job" 1995 (Best21 138c)

SCURLOCK, Addison N. 1883-1964
"Kelly Miller, historian and educator" c. 1920s (Willis
\61)
"Male student surrounded by framed photographs in
dorm room, Washington, D.C." c. 1915 (Willis \62)
"Sgt. Martin Hart, World War I" c. 1919 (Willis \58)
"Sterling Brown, poet" c. 1930s (Willis \60)
"Waterfront" 1915 (Rosenblum2 #321)
"Wedding couple" c. 1920 (Willis \59)

SCURLOCK, Robert S. 1916-1994
"Drama coach" 1948 (Willis \111)
"Marian Anderson, opera and concert singer" 1939
(Willis \109)

SCURLOCK STUDIOS
"Dr. Drew, a surgeon, teaching at Freedmen's (now
Howard) University Hospital" c. 1936 (Willis \112)
"Engineering drawing class, Howard University" n.d.
(Willis \113)
"Mary McLeod Bethune, educator" 1947 (Willis
\110)

SEABROOK, Don
"3-year-old watches television on her uncle's porch"
1997 (Best23 137b)

SEAMAN, William
"Wheels of Death" 1958 (Capture 43)

SEARS, Phil
"FSU's Sura leaps over Florida's Williams,
committing a foul" 1995* (Best21 110d)

SEARS, Sarah C., 1858-1935
"Lily" n.d. (Rosenblum \92)
"Mary" 1907 (Sandler 62c)

SEAWARD, Pete
[self-promotional] c. 1989* (Graphis89 \88)

SEBAH & JOAILLIER
"Portrait of a lady in Turkey" c. 1929 (Through 92)

SECREST, Stephanie
"A hillside in fall" 1997* (Best23 152b)

SEEBERGER, Christoph
"Guggenheim Bilbao I & II" c. 1999* (Photo00 20,
21)
[industrial sections] c. 1992* (Graphis93 184)

SEEGERGER FRÈRES
"Exchange of Fire at the Place de la Concorde" 1944
(Rosenblum2 #614)
"Fishermen near Washerwoman's Boats" c. 1905-
1910 (Rosenblum2 #318)

SEELEY, George H., 1880-1955
"Blotches of Sunlight and Spots of Ink" 1907
(Goldberg 29)
"Maiden with Bowl" c. 1915 (Decade \5)
"Still life with vase and apples" 1916 (National 24a,
\70)
"Winter Landscape" 1909 (MOMA 90; Waking
#144)

SEGAL, Mark
"Jefferson Memorial for Citicorp calendar" c. 1987*
(Graphis89 \112-\113)
"View from the Lincoln Memorial towards the east"
c. 1987* (Graphis89 \114)

SEIB, Al
"Mail carrier had residents wondering just what she
was going to deliver today" 1985 (Best11 136c)

SEIDEMANN, Bob
"Janis Joplin" 1972 (Rolling #1)

SEIDNER, David
[twin sweater sets] c. 1989* (Graphis89 \25)

SEIFERT, Dan
"Carpenter checks the alignment of steel reinforcing
rods on highway construction" 1985 (Best11 142c)

SEILAND, Alfred
"Beach café at the harbor" c. 1990* (Graphis90 \91)
"Motel in Reno, Nevada" c. 1991* (Graphis91 \296)
"Promenade of Coronado, California" c. 1991*
(Graphis91 \289)
"Truro, Massachusetts" c. 1991* (Graphis91 \288)

SELF, Bob
"Death of a neighborhood" 1996* (Best22 254-255)
"Kelly Donahue relies totally on his wife after an
alleged misdiagnosis of a brain tumor by Navy
doctors cost him his vision, his Navy career—and
almost his life" 1986 (Best12 138)
"Return of members of VS 30, an anti-sub squadron"
1986 (Best12 16d)

SELIGER, Mark
"Ben Stiller" c. 1999* (Photo00 130)
"Blues Musician John Lee Hooker" c. 1991*
(Graphis92 \144)
"Brad Pitt" c. 1995* (Graphis96 115)
"Courtney Love" c. 1995 (Graphis96 114)
"Curtis Mayfield" n.d. (Graphis97 11)
"Elisabeth Shue" c. 1997 (Graphis97 114)
[floating head on a sword] c. 1997* (Graphis97 106)
[from Marilyn Manson portfolio] c. 1999* (Photo00
155)
[from the American Dream] c. 1999* (Photo00 6)
"Gillian Anderson as Lucy" c. 1999* (Photo00 99)
"Jerry Seinfeld" c. 1999* (Photo00 157)

"Kurt Cobain" n.d. (Graphis97 10)
"Laurie Kratochvil" c. 1992 (Graphis93 12)
"Liv Tyler" c. 1997* (Graphis97 127)
"Meshell Ndegéocello" c. 1997* (Graphis97 129)
"Metallica" c. 1992* (Graphis93 125)
"Red Hot Chili Peppers" c. 1992* (Graphis93 110)
"Richard Ashcroft" c. 1999* (Photo00 156)
"Self-portrait" n.d. (Graphis97 8)
"Skid Row" c. 1992* (Graphis93 111)
"Slash" c. 1991* (Graphis92 \124)

SEMCHUK, Sandra, 1948-
"Series #10" 1982* (San \57)
"Self-Portrait at Grieg Lake" 1979 (San #67)

SENGSTACKE, Robert A., 1943-
"Dr. Martin Luther King, Jr." 1966 (Willis \200)
"Savior's Day, women's section, Chicago" 1966
(Willis \201)

SENNOTT, Richard C.
"Two prairie restorationists appear through the heat
of an intentional prairie burn" 1988* (Best14 101b)

SENZAMICI, Raphael
[self-promotional] c. 1991* (Graphis91 \379-\382)

SEPPALA, Martin
"Indianapolis 500 rookie driver crashes into the turn
one wall" 1996* (Best22 204d)

SERIO, Stephen
[self-promotional] c. 1990* (Graphis90 \80)

SERRANO, Andres
"Piss Christ" 1987* (Marien \7.48; Photography 160)
"Semen and Blood III" 1990* (Marien \7.49)

SETÄLÄ, Vilho
"Little Men, Long Shadows" 1929 (Rosenblum2
#509)

SEVERSON, John
"Five-year-old Ryan Borders peers out window while
he, his younger brother and a woman are held
hostage" 1987 (Best13 67a)

SEWALL, Emma D., 1836-1919
"The Clam Diggers" c. 1895 (Rosenblum \107)

SEWARD, Chris
"Little Leaguer chats with fan during a game" 1990
(Best16 122)

SEYMOUR, David "Chim," 1911-1956
"European child" or "Poland" (Eyes #201; Lacayo
116a)
"A Hand Grenade Attack, Spain" 1936 (Icons 67)
"May Day, Barcelona" 1936 (Rosenblum2 #605)

SHACTER, Susan
[woman smoking] c. 1999* (Photo00 129)

SHADBOLT, George
"Watching the Newts" c. mid-1850s (Marien \2.16)

SHAHN, Ben
"After church" 1935 (Documenting 89d)
"At home" 1935 (Documenting 88a)
"At the end of the day" 1935 (Documenting 85b)

"Cotton on the porch of a sharecropper's home on the
Maria plantation" 1935 (Documenting 82a)
"Cotton picker" 1935 (Documenting 80b, 83c)
"Cotton pickers on the Alexander plantation at 6:30
a.m., waiting for the workday to start" 1935
(Documenting 80a)
"Cotton pickers" 1935 (Documenting 80c;
Rosenblum2 #471)
"County Fair, Central Ohio" 1938 (Rosenblum2
#467)
"Farmer sampling wheat in Central Ohio" 1938
(Documenting 19a)
"Fourteenth Street, New York City" early 1930s
(Hambourg 56c)
"Going home" 1935 (Documenting 86b)
"Mother and child" 1935 (Documenting 89c)
"New York, New York" 1931 (Hambourg 57)
"Picking cotton on the Alexander plantation" 1935
(Documenting 82b)
"Rehabilitation Clients, Boone County, Arkansas"
1935 (Decade 42a)
"Sharecropper at home on Sunday" 1935
(Documenting 87c)
"Sunday on the porch" 1935 (Documenting 88b)
"Tally at the weigh station" 1935 (Documenting 86a)
"Weighing in cotton" 1935 (Documenting 84a)

SHALYGIN, Olga
"Refugee children from Grozny play on a platform
next to the train cars in which they live with their
families" 1995* (Best21 182b)

SHAMES, Stephen, 1947-
"Among the nation's homeless, Mike and his son
Charlie" 1985 (Best11 161b)
"Eleven-year-old Tony Beck sleeps in the car after a
September storm washed out his family's tent–their
home" 1987 (Best13 42b)
"IRA gunman displays armaments" 1972* (Eyes \22)
"Outside the American Dream" 1985-1992 (Best18
87-100)

SHAMSI-BASHA, Karim
"Two brothers compete" 1997* (Best23 178b)

SHARP, Nick
"Muslim Expulsion" 1995* (Photos 177)

SHARP, Steve
"Untitled" c. 1991* (Graphis91 \233)

SHARP, Tim
"Basketball player slides into the scorer's table after
chasing a loose ball" 1991 (Best17 150a)

SHARPE, Scott
"A teenager searches for coins thrown into a sacred
mud pit during the Voodoo Festival in Haiti"
1992* (Best18 63)

SHARPE, William
[Paris Club Chair] c. 1992* (Graphis93 155)

SHAW, Jeff
"This resident brings her horse to the car wash for a
hosing-down every week" 1985 (Best11 151d)

SHAW, Mark
"Senator and Mrs. Kennedy with daughter Caroline,
Hyannis Port" 1959 (Life 26)

SHAW, Scott
"Baby Girl Rescued from Well" 1987 (Best13 16; Capture 146)

SHAY, Arthur
"Hula-hoopers" 1958 (Life 115)

SHECKELL, Thomas O., 1883-1943
"Springtime on the Jordan" c. 1942 (Peterson #87)

SHECKLER, John
"In New Bedford, Mass., three men try to keep Hurricane Gloria from smashing their craft on the rocks on Pope's Island" 1985 (Best11 71a)

SHEEDY, Gerard, active 1937
"Death of a Giant: Exclusive Colorphoto Record of the *Hindenburg* Destruction" 1937* (Eyes \2)

SHEELER, Charles, 1883-1965
"Cactus and Photographer's Lamp" 1931 (MOMA 113)
"Crisscrossed Conveyors, River Rouge Plant, Ford Motor Company" 1927 (Hambourg frontispiece; Rosenblum2 #585)
"Industry" 1932 (Marien \5.20)
"RCA Building" 1950 (Decade \58)
"Stair Well" or "Bucks County House, Interior detail" 1917 (Hambourg 17; MOMA 102; San #1)
"Stairwell" 1914 (Szarkowski 233)
"Theodore Dreiser" 1926 (Vanity 106)
"Upper Deck" c. 1928 (Photography 24; Rosenblum2 #525; Waking 360)
"White Barn, Bucks County, Pennsylvania" 1914-1917 (MOMA 101)

SHEPHERD, Harry, 1856-
"Booker T. Washington" c. 1892 (Willis \28)
"Frederick McGhee" c. 1900 (Willis \29)
"Portrait of Mary Schwandt Schmidt and Snana (Dakota Indian, wife of Good Thunder)" 1895 (Willis \27)
"Portrait of Mattie McGhee" c. 1900 (Willis \26)
"Wedding Party" c. 1905 (Willis \30)

SHEPP, Accra, 1962-
"Atlas" 1997* (Willis \462)
"Dream of Open and Closed" 1997* (Willis \463)
"Eric (Version III)" 1993* (Committed 196)
"I Am" 1993* (Willis \464)
"Untitled" 1992* (Committed 197)

SHERBELL, Shepard
"In the aftermath of the U.S. bomb strikes, Tripoli residents survey the damage" 1986* (Best12 15d)

SHERE, Joe
"Jayne Mansfield and Sophia Loren at Romanoff's, Beverly Hills, California" 1958 (Goldberg 134)

SHERE, Sam
"*Hindenburg* disaster" 1937 (Lacayo 81; Photos 52)

SHERIDAN, Sonia Landy, 1925-
"Sonia with Skull" 1971* (Photography2 129)

SHERMAN, Augustus
"Children's playground, Ellis Island roof garden" 1909 (Goldberg 35)
"Untitled (three Dutch women at Ellis Island" c. 1910

(Goldberg 31d)
"Women from Guadeloupe, French West Indies, at Ellis Island" 1911 (Goldberg 32)

SHERMAN, Cindy, 1954-
"Untitled" 1981* (Rosenblum \30); 1989* (Women \200); 1992* (Marien \7.36); 2000* (Photography 33)
"Untitled #90" 1981* (Photography2 216)
"Untitled #96" 1981* (Women \157)
"Untitled #123" 1983* (Szarkowski 277)
"Untitled #145" 1985* (Art \457)
"Untitled #156" 1985* (Rosenblum2 #743)
"Untitled #168" 1987* (Art \458)
"Untitled Film Still" 1978 (Marien \7.35)
"Untitled Film Still #21" 1978 (Icons 175)
"Untitled Film Still #35" 1979 (Goldberg 191)

SHIELDS, William Gordon, 1883-1947
"An Interior" c. 1920 (Peterson #81)

SHIFRIN, Jean
"Red purse with flowers" 1998* (Best24 48a)

SHIGETA, Harry K., 1887-1963
"Curves, A Photographer's Nightmare" 1937 (Peterson #41)
"Fantasy" 1923 (Peterson #40)
"The Last Supper from *Zion Passion Play*" c. 1947 (Peterson #11)

SHIMER, Bob
[office building Calgary, Canada] c. 1991* (Graphis92 \214)

SHING, Liu Heung, 1951-
"Chinese students watching Jiang Qing (Mrs. Mao) on television during the trial of the Gang of Four" 1980* (Eyes \21)

SHINOYAMA, Kishin
"House" 1975* (Rosenblum2 #783)

SHIRAS, George, III
"Illuminated by a flashlight, frightened deer bound into the woods near Lake Superior" 1921 (Through 338)

SHONIBARE, Yinka
"Diary of a Victorian Dandy" 1998* (Marien \7.58)

SHORE, Stephen
"Bellevue, Alberta" 1974* (Photography 25)
"Beverly Boulevard and La Brea Avenue, Los Angeles" 1975* (Rosenblum2 #781)

SHORTEN, Chris
"Miss Olive English, born 1902" c. 1990* (Graphis90 \168)

SHOTWELL, Charles
"Alarm clock and flower vase" c. 1991* (Graphis91 \113)
[book, bowl and dresser] c. 1989* (Graphis89 \304)
[camera on tripod] c. 1989* (Graphis89 \264)

SHUNK, Harry
"Yves Klein Leaping into the Void, near Paris" 1960 (Marien \6.88)

SINGH, Raghubir, 1942-1999
"Shiva Temple, Jahngira" 1983* (Marien \6.20)
"Women caught in monsoon rains, Bahir" 1967*
(Photography 111)

SIPPRELL, Clara E., 1885-1975
"El Capitán, Yosemite" 1920s (Sandler 130)
"Ivy and Old Glass" 1922 (Rosenblum \153)
"Lucy Sipprell" c. 1913 (National \71)
"Old Bottle with Woodbine" 1921 (Peterson #56)

SISKIND, Aaron, 1903-1991
"Checkers game" c. 1938 (Eyes #163)
"Chicago" 1949 (MOMA 191)
"Chicago 56" 1960 (Decade 80a)
[from series *Harlem Document*] 1936 (Decade 44b)
"Gloucester" 1944 (MOMA 178)
[Ironwork, New York City] 1947 (Decade \46)
"Jerome, Arizona" 1949 (Goldberg 125; Marien
\6.34)
"Leaves 50" 1970 (Decade \88)
"Martha's Vineyard" 1954 (MOMA 188)
"Martha's Vineyard 20" 1953 (Decade \56)
"New York 6" 1951 (Decade 63; Rosenblum2 #664)
"Reflection of a Man in a Dresser Mirror" c. 1938
(Marien \5.71)
"Untitled" 1948 (Photography2 40); 1953-1961 (San
#53, #54, \36)
"Uruapan, Mexico 4" 1955 (Szarkowski 267)

SKADDING, George
"Portable television" 1948 (Life 98)

SKALIJ, Wally
"Actress Gloria Stuart plays the role of a living
survivor in the sinking of the Titanic in the
blockbuster movie" 1997* (Best23 199b)
"At the First A.M.E. Church, women cheer the
announcement of the jury's acquittal of O.J.
Simpson on all charges" 1995* (Best21 190b)
"A battered Humberto Gonzalez after being knocked
out in the seventh round of challenger Saman
Sorjaturong" 1995* (Best21 118a)
"Bishop Montgomery [high school] teammates
celebrate" 1996* (Best22 244a)
"Jones tries to save a bad pass and crashes into
scorer's table" 1996* (Best22 244c)
"Boy takes a peek into casket of slain bicycle shop
owner during memorial" 1996* (Best22 225d)
"Cincinnati shortstop Larkin holds Dodgers Fonville
to infield single" 1995* (Best21 191c)
"Daughter of murder victim gives comfort to niece at
a candlelight vigil" 1996* (Best22 245b)
"During a tryout, Hodges holds a picture and the
ashes of his deceased wife" 1997* (Best23 197a)
"First grader chases down a ball during a game of
handball at school" 1997* (Best23 188)
"Former drug addicts bow their heads in prayer
during a wedding ceremony" 1997* (Best23 189c)
"Girl watches while residents in the Three R's
Outreach Program pray during a church service"
1997* (Best23 191b)
"Goalie is unable to stop a game-winning goal in a
playoff game" 1995* (Best21 120)
"Holding part of her boyfriend's bicycle who was
robbed and stabbed" 1995* (Best190a)
"Installing a light at the Days Inn Hotel" 1996*
(Best22 244b)
"Kevin Jenkins had to be restrained by his mother and
friends as he attempts to leap toward the casket at a

funeral for his brother" 1996* (Best22 245a)
"LAPD officers point their guns at shooting suspects
that were hiding in a house" 1996* (Best22 225c)
"Looking through a bullet-riddled window in the
living room where her mother was fatally
wounded" 1997* (Best23 196)
"Los Angeles police officers point their guns at a
group of men suspected of spray painting O.J.
Simpson–related graffiti" 1995 (Best21 191b)
"Man takes a break after competing for the queen of
the Doo Dah Parade in Pasadena" 1997* (Best23
198a)
"Minnesota player exults in victory against UCLA"
1997* (Best23 189d)
"1996 Corvette was rolled over by the driver of a
Cadillac" 1996* (Best22 245d)
"A pitbull chained to its owner's garage is used to
protect life and property" 1996* (Best22 245c)
"Sgt. Jeff Sloat of the 7th Special Forces pays his
respects to fellow veterans as he walks through the
cemetery" 1997* (Best23 197d)
"Sister Veronica Maria hits a volleyball during a
game" 1996* (Best22 225a)
"Suspect is arrested after eluding police after 40
minutes" 1997* (Best23 191a)
"[Toddler] swinging from laundry line in her
backyard" 1996* (Best22 244d)
"Well-wisher kisses the hand of Bartholomew–the
spiritual leader of the world's 250 million
Orthodox Christians" 1997* (Best23 198b)
"With his gun drawn, highway patrol officer searches
for a suspect" 1997* (Best23 190)
"A woman stands outside her apartment building
during a late afternoon walk" 1997* (Best23 199a)

SKINNER, Phil
"Black cats means bad luck, but in the instance of this
feline, the bad luck was an unwanted bath" 1986
(Best12 131)
"The McDonald's react with dismay while another
woman is overjoyed at the 'not guilty' verdict in
the O.J. Simpson trial" 1995* (Best21 176b)

SKOFF, Gail
"Lizard Mound" 1980* (Decade X)

SKOGLUND, Sandy, 1946-
"The Green House" 1990* (Rosenblum \31)
"Radioactive Cats" 1980* (Women \198)
"Revenge of the Goldfish" 1991* (Marien \7.50;
Photography2 194)
"The Wedding" 1994* (Photography 201)

SKOVMAND, James
"Boys look out an orphanage window in Cadea,
Romania" 1990* (Best16 170)

SLADEN, Charles Norman, 1858-1949
"Page from a personal journal" 1913 (MOMA 77)

SLAVIN, Neal
"National Cheerleaders Association" 1974*
(Rosenblum2 #786)
"*PC Magazine* isn't taken as gospel by all" c. 1991*
(Graphis92 \113)
"The restoration crew of Union Station, Washington,
D.C." c. 1990* (Graphis90 \113)

SLEET, Moneta, Jr., 1926-
"Deep Sorrow" or "Mrs. Martin Luther King, Jr."

orchestra at the Savoy Ballroom: Louis Jordan on saxophone" c. 1938 (Willis \121)
"Marvin and Morgan Smith" 1938 (Willis \120)
"Paul Robeson gives autograph to Ruel Lester after Robeson's concert at the Mother A.M.E. Zion Church in Harlem" 1940 (Willis \119)
"Reverend Adam Clayton Powell, Jr. leads a protest on 125th Street in Harlem–'Don't Buy Where You Can't Work' campaign" 1942 (Willis \124)
"Street-corner orator" 1938 (Willis \123)

SMITH, Richard Hamilton
[from book *Minnesota II*] c. 1992* (Graphis93 164)

SMITH, Rodney
"Compact" c. 1995* (Graphis96 30)
[from *The Hat Book*] c. 1992* (Graphis93 39)
"Inges" c. 1995* (Graphis96 31)

SMITH, Ron Baxter
"Black impressions of America" c. 1992* (Graphis93 104)
[hammer, teeth, shell and other objects] c. 1992* (Graphis93 69)
"Nude" c. 1992 (Graphis93 115)
[travel agency brochure] c. 1992* (Graphis93 162)

SMITH, Steven G.
"Contestants for Daffodil Queen eavesdrop as judges interview another competitor behind closed doors" 1992* (Best18 116)
"Dressed as 6-armed Hindu goddess, Gordon Coughlin heads for restroom" 1995* (Best21 165d)
"Dressed as pioneer children to pay their respects at Little Bog Horn battlefield memorial" 1998 (Best24 100b)
"It was an exciting night for queen and king at homecoming for a Pee Wee football league celebration" 1996* (Best22 202d)
"A Kingfisher lies dead after it failed to escape the oil spill" 1996* (Best22 190a)

SMITH, Todd A.
[ad for National car rental company] c. 1990* (Graphis90 \229)

SMITH, W. Eugene, 1918-1978
"Albert Schweitzer" 1954 (Lacayo 126)
"Battle of Iwo Jima" 1945 (Life 54a)
"Burial at Sea" c. 1943 (Art \417)
"Charlie Chaplin, Limelight" 1952 (Photography 83)
"The Congeroo, Savoy Ballroom, New York City" 1941 (Life 110)
"Country Doctor–photo essay" 1948 (Decade 66; Eyes #245-250; MOMA 196; Szarkowski 226-227)
"Earl Hines" n.d. (Decade\ 80)
[from the series *Ku Klux Klan*] 1951-1958 (Decade 65)
[from the series *Minamata*] c. 1974 (Best21 2-15)
[from the series *Nurse Midwife*] 1951 (Decade \64)
[from the series *Protest in the 1960s*] 1969 (Decade 77)
"Jeep at Guadalcanal" 1944 (Decade \57)
"Joe DiMaggio" 1941 (Life 139c)
"Madwoman in a Haitian clinic" 1958 (Lacayo 158)
"Marines at Saipan" or "Soldier with Canteen, Saipan" 1944 (Art \414; Eyes #205; Rosenblum2 #608)
"Marines blow up a cave connected to a Japanese blockhouse on Iwo Jima" or "Marine Demolition Team blasting out a Cave on Hill 382, Iwo Jima"

1945 (Art \415; Lacayo 112)
"Okinawa" 1945 (Art \416)
"Okinawa, April 19, 1945" 1945 (Art #15)
"Orson Welles" 1941 (Life 82)
"Spanish Civil Guard" 1950 (Art \413; Lacayo 161)
"Spanish Village" 1951 (Rosenblum2 #654-#658)
"Spanish women in mourning" or "The Wake" 1950 (Icons 123; Lacayo 159a)
"Tomoko in Her Bath, Japan" or "A young woman deformed by mercury pollution" 1971-1972 (Best21 \3; Eyes# 252; Monk #45; Lacayo 159d; Rosenblum2 #475)
"The Walk to Paradise Garden" 1946 (Goldberg 142; Monk #33)
"Welsh Miners" 1950 (MOMA 200)
"Wounded infant found by American soldier" 1944 (Decade 55; Lacayo 113; Marien \5.81; Photography 122)

SMITH, William J.
"The Focus of Attention" 1954 (Eyes #235)

SMITH-RODDEN, Martin
"The Taste of the Town" 1997* (Best23 142)

SMITHSON, Robert
"Seventh Mirror Displacement" 1969 (Marien \6.86)

SMOLAN, Rick
"At Moscow's Suvorov Military Academy, a cadet gets help from his friend" 1987* (Best13 162a)

SNEAD, Bill
"At a Kurdish refugee camp in Turkey, a nurse tends to a child as 2 brothers sit with their mother, whom they had carried to camp" 1991 (Best17 109)
"No sanctuary" 1991 (Best17 211-218)
"Surrounded by photographers, Professor Anita Hill testifies before the Senate Judiciary Committee during hearings to confirm Judge Clarence Thomas to the U.S. Supreme Court" 1991 (Best17 2)

SNIDER, Adrin
"Christopher Jackson gives his father a kiss" 1996* (Best22 153d)
"Flight–At Last" 1996* (Best22 179b)

SNOW, Michael, 1929-
"Press" 1969 (Photography2 150)

SNOWDON, Anthony Armstrong-Jones
[from an article entitled *Hamlet's Misgivings*] c. 1989* (Graphis89 \33, \34, \35)
"Meryl Streep" 1981* (Life 91)

SNYDER, Isabel
"Paola Pezzo, world and Olympic champion in cross-country mountain biking" c. 1999* (Photo00 164)

SNYDER, William
"An 89-year-old Romanian shows an official her identity papers in order to vote in the country's first free election in over 40 years" 1990 (Best16 103a)
"Philly 76'r Maurice Cheeks flies through a sea of Dallas Maverick arms during a pre-season NBA game" 1986 (Best12 206a)
"Ron Bratt was a Roman Catholic Priest before he became a Dallas cop" 1987 (Best13 66d)
"A woman in Copsa Mica, Romania, stands in her garden with her children" 1990 (Best16 103d)

"A young Haitian boy sits outside the National Cathedral in Port-au-Prince" 1986 (Best12 26b)

SOCHUREK, Howard
"Children with toy gun" 1952 (Lacayo 143b)
"Managers meeting at IBM" 1966 (Life 47c)

SOLLETT, Rob
"Connie Mercure breaks free from police and falls from the Verrazano-Narrows Bridge in New York" 1995 (Best21 172a)

SOLOMON, Chuck
"Detroit Tiger runner Kirk Gibson scores on a sacrifice fly as he bangs into Pat Borders of the Texas Rangers" 1995* (Best21 114a)

SOLOMON, Rosalind, 1930-
"Bathers, Guatemala" 1979 (Women \134)
"Demon Attendants of the Goddess Kali" 1981 (Rosenblum \212)
"Man at Swayamanboth Temple, Kathmandu, Nepal" 1985 (Women \135)

SOLOVIEV, Andrei
"A dog and its master, both killed during the Abkhazian assault on Sukhumi, two more victims of the civil war in Georgia" 1993* (Best19 184b)

SOLTES, Harley
"Heisman Trophy hopeful Chris Chandler of the University of Washington is decked by a University of Oregon linebacker" 1987 (Best13 220a)
"In chains, Rajneesh is led into federal court in Charlotte, N.C." 1985 (Best11 87a)
"Rajneesh is guarded by a follower with an Uzi submarine gun as the guru appears before the faithful" 1985 (Best11 86d)
"Seattle Seahawks head coach Chuck Knox prepares for his not-so-favorite event—the post-game press conference" 1987 (Best13 115a)
"Seattle Supersonic Xavier McDaniel chokes Los Angeles Laker Wes Matthews during a scuffle after a battle for a loose ball" 1987 (Best13 197)
"Supporters of Aquino pose at the desk of Ferdinand Marcos just hours after he was rescued from the Palace grounds" 1986 (Best12 20b)
"Victory shower after Coca-Cola officials announced they'd resume bottling 'old' Coke" 1985 (Best11 117b)
"When Marcos fled the country, he left behind prisons jammed with those he suspected of opposing his regime, or of being communists" 1986 (Best12 21a)

SOMMER, Frederick, 1905-1999
"Arizona Landscape" 1943 (Marien \6.36)
"Chicken Entrails" 1939 (San \32)
"Chicken Entrails 1st Series #3" 1938 (San #48)
"Cut Paper" 1971 (Decade \97)
"Dürer Variation #2" 1966 (Decade 73)
"The Giant" 1946 (Rosenblum2 #752)
"Max Ernst" 1946 (MOMA 177)
"Medallion" 1948 (Decade \45)
"Moon Culminations" 1951 (MOMA 176; Photography2 69)
"Thief Greater Than His Loot" 1955 (Decade \63)
"Untitled (Amputated foot)" 1939 (Photography 225

SOMMER, Giorgio
"Shoeshine and Pickpocket" 1865-1870 (Rosenblum2 #273)

SOMONTE, Carlos
"Woman with Rattleskin, San Luis Potosí, Mexico" 1990 (Marien \7.43)

SONGER, Joe
"First bodies of the Gander crash victims arrive at Dover, Del., AFB" 1985 (Best11 50)
"Obion County High School cheerleaders react to their basketball team's defeat to a larger and stronger team" 1986 (Best12 200a)

SONNEMAN, Eve, 1946-
"Beatrice Wyatt's Rock Garden: Rocks and Magnolia" 1988* (Rosenblum \22)
"Coney Island" 1974* (Photography2 152)
"Oranges, Manhattan" 1978* (Rosenblum2 #734)

SORGI, I. Russell
"Suicide" 1942 (Lacayo 83)

SOROKIN, Lauren
"Children's nautical fashion" c. 1991* (Graphis91 \47)

SOTIRION, Evangelia
[two horses] c. 1997 (Graphis97 185)

SOULE, John P.
"Lincoln, Skeleton Leaves" 1874 (Photography1 #IV-25)

SOULE, William, 1836-1908
"Brave in War Dress" c. 1868 (Rosenblum2 #71)
"Scalped Hunter Near Fort Dodge" 1868 (Photography1 \61)

SOULIER, Charles, c. 1840-c. 1876
"Gorge of the Tamine" c. 1865 (Rosenblum2 #118)
"The Pont-Neuf, Paris" 1865 (Art \80)

SOURCE, Wayne
"In the Philippines, guerrilla members of the New People's Army move through the jungle in a strike against government troops" 1985* (Best11 46d)

SOUTHWORTH, Albert Sands, 1811-1894
"Self-Portrait" c. 1848 (Art \31; Marien \2.62; Waking #93)

SOUTHWORTH & HAWES
"Charles Sumner" 1856 (Rosenblum2 45)
"Classroom in Emerson School for Girls" 1850s (Art \28)
"Daniel Webster" c. 1845 (Photography1 \21); c. 1851 (Art \33)
"Harriet Beecher Stowe" c. 1850 (Marien \2.61)
"Lola Montez" 1851 (Art \32)
"Operating Room, Massachusetts General Hospital, Woman Patient" 1846-1848 (Rosenblum2 #187)
"Operation under Ether" or "Early Operation Using Ether for Anesthesia" c. 1852 (Art \27; Marien \2.24)
"Portrait" c. 1850 (Szarkowski 36)
"Rufus Choate" c. 1851 (Szarkowski 38)
"Unidentified Girl with Gilbert Stuart Portrait of George Washington" 1850s (Art \34)

"Unknown Lady" n.d. (Rosenblum2 46)
"Untitled" c. 1850 (Decade 2a); c. 1852* (Art \30)
"Women in the Southworth & Hawes Studio" c. 1854
 (Art \29)
"Young Girl" c. 1845 (Photography1 \18)

SOUZA, Pete
 "Fishermen take to the shore at Montauk Point, Long
 Island" 1996* (Best22 189b)
 "Hundreds of thousands of African Americans
 gathered together in Washington, D.C., during the
 'Million Man March' " 1995* (Best21 179d)
 "Swimming, part of aerobic program at the Duke Diet
 and Fitness Center" 1995* (Best21 106b)

SOWARDS, Jeff
 [untitled] c. 1992* (Graphis93 126a)

SPACE TELESCOPE SCIENCE INSTITUTE
 "M100 Galaxy in Virgo Cluster" 1993* (Life 107)

SPEAIGHT, Limited
 "G. K. Chesterton" 1920 (Vanity 36)

SPEARMAN, Alan
 "4-year-old bolts to entrance of the New Hampshire
 State Prison for Women" 1996 (Best22 165)
 "One to Four Without Michael" 1996 (Best22 236d)

SPENCE, Jo
 "Transformations" 1986 (Marien \7.61)

SPENCE, Shawn
 "Hollonbeck races through the rain to a 2nd place in
 Olympic Wheelchair 1500" 1996* (Best22 206d)

SPENCER, David
 "It's all a matter of perspective" 1985 (Best11 170c)

SPENCER, Emma
 "A Mute Appeal" c. 1890 (Sandler 68a)

SPENCER, L. Todd
 "3-on-3 Hoop-it-Up players drive to the hoop" 1996*
 (Best22 194c)

SPENCER, Terence
 "The Beatles" 1964 (Life 170a)

SPENDER, Humphrey, 1910-
 "Midway Clowns" 1937 (Marien \5.69)
 "Street Scene in a Milltown" 1937-1938
 (Rosenblum2 #458)

SPENGLER, Christine, 1945-
 "Bombardment of Phnom-Penh" 1974 (Eyes #306)
 "Cambodia" 1975 (Eyes #307)
 "The departure of the Americans" 1973 (Eyes #308)

SPINDLER, Lisa
 "Black Protea" c. 1997* (Graphis97 73)
 "Green Leaf" c. 1997* (Graphis97 70)
 "Metal Purses" c. 1997* (Graphis97 71)

SPOERING, Uwe
 [personal study] c. 1991* (Graphis91 \378)

SPRING, Anselm
 [from article on Ireland] c. 1989* (Graphis89 \196)

SPRINGER, Andreas
 "Fall of the Berlin Wall" 1989* (Photos 165)

SQUILLANTE, Fred
 "Paul Azinger rejoices after sinking a shot from a
 bunker on the last hole" 1993* (Best19 151b)

SREEDHARAN, Satish
 [green-colored snake eating its green prey] c. 1992*
 (Graphis93 193)

STACKPOLE, Peter
 "Betty Grable" 1940 (Life 83d)
 "Gary Cooper" 1940 (Life 83c)
 "James Stewart" 1945 (Life 83b)

STADLER PHOTOGRAPHING COMPANY, active
 1847-1900
 "Babies' Lawn Caps" c. 1900 (National 148c)

STAFFORD, Sue
 "Lockheed Lounge" c. 1992* (Graphis93 144)

STALLINGS, Frank, 1946-
 "Portraits from a Brazilian Favala series" c. 1996
 (Willis \371-\373)

STANFIELD, James
 "Actors make final touches to their makeup before
 performing an opera near Quanzhou, China" 1991*
 (Through 154)
 "Actors prepare to perform in the Quanzhou Chinese
 Opera" 1991* (Best17 196)
 "A blissful Ratutow village carpenter enjoys life
 along the Polish-Czechoslovakian mountain
 border" 1987 (Best13 99d)
 "Boiled, beaten, and hung out to dry, laundry fills
 lines at Dhobi Ghat (washermen's place) in
 Karachi, Pakistan" 1981* (Through 138)
 "Embracing each other and their art, dancers of the
 Inbal troupe rehearse in Akko" 1985* (Best11 44c)
 "First snowfall in 14 years dusts worshipers leaving
 the Jan. 6 mass celebrating the Epiphany" 1985*
 (Best11 45b)
 "In Paris, I.M. Pei's stark triangular anomaly marks
 the entrance to the Louvre Museum" 1989*
 (Through 52)
 "Inside St. Peter's Basilica, candidates for priesthood
 from 22 countries lie prostrate in humility as they
 take their vows during mass celebrated by Pope
 John Paul II" 1985* (Best11 45c)
 "Like her ancestors nearly five centuries ago, a
 northern Anatolian woman delivers chickens to the
 Safronbolu Saturday morning market in Turkey"
 1987* (Best13 163a)
 "Musicians in a Prague pub pay tribute to a revered
 Czech antihero" 1993* (Through 112)
 "Polish heart surgeon monitoring a transplant patient"
 c. 1987* (Best13 29a; Graphis90 \270)
 "Pope John Paul II celebrates special sunrise mass for
 Czechoslovakians commemorating Saints Cyril and
 Methodius" 1985* (Best11 45a)
 "Schenfeld, prominent Israeli modern dance artist,
 portrays 'Divine Presence' " 1985* (Best11 44d)
 "Shadows and light surround a monastic fortress in
 Bhutan" 1991* (Through 132)
 "Yemeni Jewish bride near Gaza wears a wedding
 costume styled centuries ago" 1985* (Best11 44a)

STANFORD UNIVERSITY
"The Stanford Visible Male" 1990s* (Marien \8.10)

STANKOWSKI, Anton
"Eye-Montage" 1927 (Rosenblum2 #492)

STANMEYER, John R.
"An elderly Dinka woman clutches her cane while telling of her journey to the Atepi relief camp in southern Sudan" 1993* (Best19 61)

STAPLETON, Rob
"*Exxon Valdez* Oil Spill" 1989* (Photos 161)
"Oil-smeared red-necked grebe" 1989* (Photos 160)

STARN, Mike and Doug
"Attracted to Light #D" 1996-2001* (Photography 234a)
"Light #G" 1996-2001* (Photography 235a)
"Structure of Thought #7" 2001* (Photography 234b)

STARNES, Andy
"A man gestures as he threatens to jump from a bridge" 1986 (Best12 86c)
"Supervisors bring their roped-up charges back from a picnic" 1985 (Best11 173a)

STARR, Steven
"Racial Protest, Cornell University" 1969 (Capture 70)

STASNY, Horst
[from catalog promoting fashionable and decorative ski equipment] c. 1991* (Graphis91 \235, \236)
"The New Spirit of Skiing" c. 1990* (Graphis90 \217-\219)

STAUD, René
"Mercedes 300 SL" c. 1990* (Graphis90 \220, \221, \230)
"Porsche and Ferrari" c. 1991* (Graphis91 \260-\263)

STAUDINGER & FRANKE
[chicken foot with rings] c. 1997* (Graphis97 40)

STEAGALL, Larry
"Only a photograph could capture the emotions displayed by firefighter Tammy Corcoran as fire destroys the Elterich home" 1985 (Best11 99a)
"Seattle Supersonic Xavier McDaniel chokes Los Angeles Laker Wes Matthews during a scuffle after a battle for a loose ball" 1987 (Best13 196)

STEBER, Maggie, 1949-
"The family of Asson Vital mourn at his funeral in the national cemetery in Port-au-Prince" 1987* (Best13 18)
[from the *Malisy* catalog] c. 1990* (Graphis90 \59)
"Mother's Funeral" 1987* (Photography 115)
"An unemployed Haitian sits in his corner of the worst of the nation's slums, La Saline, in Port-au-Prince" 1987* (Best13 171d)
"When hunger overcomes fear, Haiti" 1986* (Eyes \30; Rosenblum \11)

STEBER, William N., Jr.
"Bluesman and folk artist David Johnson plays the slide guitar on his front steps" 1996 (Best22 210c)

STECHSCHULTE, Ben
"Patch Adams' annual mission to Russia's bleak orphanages and pediatric wards" 1998* (Best24 79)

STEELE-PERKINS, Christopher, 1947-
"Captured Taliban prisoners held by Massoud's forces, Afghanistan" 2001 (Photography 110)
"Gaza Palestinian Hospital–Beirut" 1982 (Eyes #359)

STEENMEIJER, Michael
"From ad campaign for *Blaupunkt*" c. 1989* (Graphis89 \220)

STEFAN, Sigurdur
[self-promotional] c. 1991* (Graphis91 \107)

STEFANCHIK, Joe
"Patients in Angolan mental asylum are chained to their beds" 1997 (Best23 138c)

STEICHEN, Edward, 1879-1973
"Adolphe Menjou" 1927 (Vanity 84)
"Aerial View of Vaux" 1918 (Hambourg 20)
"After the Grand Prix, Paris" 1907 (Art \165)
"Alfred Lunt and Lynn Fontanne" 1925 (Vanity 89)
"Alfred Stieglitz" 1909-1910 (MOMA 96); 1907 (Hambourg 9; Marien \4.23)
"Anna May Wong" 1930 (Rosenblum2 #637)
"Auguste Rodin" 1911 (Peterson #4)
"Balzac, Toward the Light, Midnight" or "Balzac, the Open Sky" 1908* (Art \166; Hambourg 5)
"Bartholomé" 1903 (Steiglitz 112)
"Big White Cloud, Lake George" 1903 (Art \169)
"Brancusi and his daughter" 1922 (Decade \16)
"Carl Sandburg" 1934 (Vanity 164)
"Cecil B. de Mille" n.d. (Vanity 118)
"Charles Spencer Chaplin" 1931 (Vanity 136-137)
"Charlie Chaplin" 1931 (Icons 16)
"Claudette Colbert" 1929 (Vanity 85)
"Colette" 1935 (Vanity 141)
"Conrad Veidt" 1929 (Vanity 101)
"Dawn-flowers" 1903 (Steiglitz 111)
"Dolor" 1903 (Steiglitz 113)
"Dorothy Parker" 1932 (Vanity 140)
"Edward Steichen" 1929 (Vanity 199a)
"Emil Jannings" 1927 (Vanity 119)
"Eva Le Gallienne" 1927 (Vanity 90d)
"Fannie Brice" 1923 (Vanity 73)
"Ferenc Molnár and Lili Darvas" 1928 (Vanity 103b)
"Flatiron Building" 1904* printed 1909 (Szarkowski 166); 1904* printed 1905 (Rosenblum2 #336; Szarkowski 167)
"Fred and Adele Astaire" 1925 (Vanity 86)
"George Gershwin" 1929 (Vanity 124)
"Gertrude Käsebier" c. 1907 (MOMA 13)
"Gertrude Lawrence" 1924 (Vanity 62); 1929 (Vanity 63)
"Gloria Swanson" 1924 (MOMA 125); 1925 (Vanity 82); 1928 (Hambourg 33; Vanity 83)
"Gorham Sterling Ad" 1930 (Rosenblum2 #579)
"Greta Garbo" 1929 (Vanity 121)
"Grumman F64 Hellcat takes off from the deck of the U.S.S. *Lexington*" 1943 (Eyes #203)
"H. L. Mencken" 1927 (Vanity 107a)
"Helen Hayes" 1927 (Vanity 91)
"Helen Menken" 1925 (Vanity 100)
"Henri Matisse" 1915 (Vanity 4); n.d. (Decade 14)
"Improvisation–*The Front Page*–Osgood Perkins and Lee Tracy, New York" 1928 (Eyes #138)

"Irving Thalberg and Norma Shearer" 1932 (Vanity 130)
"Isadora Duncan" 1923 (Vanity 59)
"J. Pierpont Morgan" 1904 (Art \164); 1924 (Vanity 77)
"Jack Dempsey" 1932 (Vanity 174c)
"Jean Walker Simpson" 1923* (National 148d)
"Jergens ad for *Ladies Home Journal*" 1926 (Goldberg 66)
"John Gilbert" 1928 (Vanity 120)
"Joseph Von Sternberg" 1932 (Vanity 183)
"Katharine Cornell" 1926 (Vanity 90c)
"Leslie Howard" 1934 (Vanity 189)
"Lippmann Walter" 1933 (Vanity 173a)
"Louise Brooks" 1929 (Vanity 123)
"Luigi Pirandello" 1935 (Vanity 144)
"Lynn Fontaine [sic]" n.d. (Decade 23)
"Marlene Dietrich" 1934 (Vanity 185)
"Martha Graham" 1931 (Vanity 151)
"The Maypole" 1932 (Szarkowski 192)
"Midnight–Rodin's Balzac" 1908 (MOMA 85)
"Moonrise–Mamaroneck, New York" or "The Pond–Moonlight" 1904* (MOMA 81; Waking #146)
"Nickolas Muray" 1926 (Vanity 199c)
"Nocturne: Orangerie Staircase, Versailles" 1907* (Art \167; Marien \4.24)
"Noel Coward" 1932 (Vanity 159)
"Packard" 1932 (Hambourg 34)
"Paul Claudel" 1929 (Vanity xv)
"Paul Robeson" 1933 (Vanity 165)
"Pillars of the Parthenon" 1921 (MOMA 104)
"Pola Negri" 1925 (Vanity 93)
"Portrait of Miss Sawyer" c. 1914* (Szarkowski 162)
"Primo Carnera" 1934 (Vanity 174d)
"Princess Yusupov" 1924 (Waking #5)
"Richard Strauss" 1904 (Icons 17)
"Rodin–*The Thinker*" 1902 (Art \163; Waking #143)
"Robert Moses" 1935 (Vanity 172d)
"Self-Portrait" 1918 (Vanity 27); 1903 (Steiglitz 110); 1917 (Waking 361a)
"Self-Portrait, Milwaukee" 1898 (MOMA 82)
"Self-Portrait with Brush and Palette" 1902 (Goldberg 22; Marien \4.22)
"Self-Portrait with Photographic Paraphernalia, New York" 1929 (MOMA 16)
"Sherwood Anderson" 1926 (Vanity 107d)
"Sidney Howard and Clare Eames" 1924 (Vanity 102c)
"Sylvia Sidney" 1929 (Vanity 105)
"Time-Space Continuum" c. 1920 (Hambourg \85)
"Trees, Long Island" 1905 (Art \168)
"Will Rogers" 1924 (Vanity 72)
"Winston Churchill" 1932 (Vanity 169)
"Woods–Interior" 1898 (Rosenblum2 #354)
"Woods–Twilight" 1898 (Photography1 #VI-11)
"World War I aerial photograph" 1917 (Goldberg 53)

STEINBRUNNER, Charles
"Memorial services for the soldiers are held in a hanger at Ft. Campbell" 1985 (Best11 51a)

STEINER, Ralph, 1899-1986
"American Rural Baroque" 1930 (MOMA 139)
"Electric Switches" or "Power Switches" 1930 (Decade \21; Hambourg \24)
"Ford Car" 1929 (Szarkowski 180)
[from *The Beater and the Pan*] 1921-1922 (San \2a-2b)
"New York" 1926 (Hambourg \5)

"Painter Henry Billings against Chevy and Tire" 1930 (Decade \27)
"Self-Portrait" 1930 (MOMA 18)
"Sign, Saratoga Springs" 1929 (MOMA 141)
"Typewriter Keys" 1921 (Hambourg \16; Rosenblum2 #580)

STEINERT, Otto, 1915-1978
"Children's Carnival" 1971 (Icons 108; Rosenblum2 #749)
"Pedestrian's Foot, Paris" 1950 (Icons 109)

STEINKAMP, Susan
"A ewe with its head in a can got much attention but no help from a trio of ponies" 1985 (Best11 150a)

STEINMETZ, George
"Academics in Georgia, a former Soviet republic, make seemingly endless rounds of banquets" 1992* (Best18 83)
"Billions of organisms flourish in the scalding-hot Grand Prismatic Spring at Yellowstone National Park" 1998* (Through 296)
"A mother and her 4-year-old son, who has Fetal Alcohol Syndrome" 1992* (Best18 172)
"Salt producers at Teguidda-n-Tessoumt, in Niger, mix brackish well water with salty earth in large depressions" 1999* (Through 216)

STEINMETZ, William F.
"MOVE members fortify a roof bunker, Philadelphia" 1985 (Best11 22c)

STEKOVICS, Janos
"The twin brothers Lukas–farmers in Hungary" c. 1990 (Graphis90 \133)

STELZNER, Carl Ferdinand, 1805-1894
"After the Great Fire of Hamburg" 1842 (Eyes #3; Lacayo 18a)
"Mother Albers, the Family Vegetable Woman" 1840s (Rosenblum2 #36)

STENZEL, Maria
"A huge colony of emperor penguins convenes at Cape Crozier in Antarctica" 2001* (Through 26)
"In 1796, a Hudson Bay expedition made the first survey of rapids on the Fond du Lac River, near the U.S.-Canadian border" 1996* (Through 306)
"Scientists study winter sea ice off Antarctica" 1996* (Through 20)

STEPHAN, Thomas
"Tiny hand of a premature infant" c. 1989* (Graphis89 \262)

STEPHENS, Jeff
[hand in spring] c. 1999* (Photo00 198)

STERN, Bert
"Martini and Pyramid" 1955* (Marien \6.59)

STERN, Grete, 1904-
"Paper in Water Glass" 1931 (Rosenblum \133)

STERNFELD, Joel, 1944-
"After a Flash Flood, Rancho Mirage, California" 1979* (Art \338)
"Approximately 17 of 41 whales which beached (and subsequently died), Florence, Oregon" 1979

(Marien \7.85)
"Buckingham, Pennsylvania" 1978* (Art \339)
"Manville Corporation World Headquarters,
 Colorado" 1980* (Art \340)
"Near Lake Powell, Arizona" 1979* (Art \341)

STEVENS, Chad
 "And we sat in silence" 1996 (Best22 102-103)
 "As results filtered in on election night Stand Reagan
 wears a Clinton mask to entertain his son" 1996
 (Best22 98)
 "As the rest of his teammates sulk on the bench,
 seventh grader celebrates his team scoring two
 more points" 1996 (Best22 100a)
 "At Summer Celebration, Bob and Emily found some
 privacy amid the hundreds of people on the
 midway" 1996* (Best22 101a)
 "In early September, Hurricane Fran ravaged the
 coastline of North Carolina after Hurricane Bertha
 came in July" 1996 (Best22 100b)
 "Little Princess Contest was one of the main
 attractions at the Hispanic Fiesta" 1996* (Best22
 99)
 "Nelson Pott returns every year to play in the
 marching band of his alma mater" 1996* (Best22
 101c)
 "On a wet, slick trampoline, Dan and Ian slide along
 the surface" 1996* (Best22 101b)
 "P. J. Smith has lived his entire life without a father"
 1996 (Best22 100d)

STEVENSON, Matilda Coxe
 "Sia Pueblo, New Mexico" c. 1888 (Sandler 100c)

STEVENSON, Monica
 [steeplechase] c. 1995* (Graphis96 200)

STEWART, Chris
 "Karee Thornock, 7, makes a wide-eyed entrance into
 a burned-out classroom where she and 150 other
 pupils and teachers were held hostage" 1986
 (Best12 135d)
 "Mat McClain goes down in the saddle bronc
 competition" 1985 (Best11 220d)
 "Roger Craig of the San Francisco 49ers goes over
 the top for a touchdown during a game with the
 Kansas City Chiefs" 1985 (Best11 209)

STEWART, Chuck, 1927-
 "Dinah Washington, vocalist" n.d. (Willis \147)
 "Eric Dolphy" 1964 (Committed 204; Willis \152)
 "John and Alice Coltrane" 1966 (Committed 205;
 Willis \149)
 "Max Roach, jazz percussionist and bandleader" n.d.
 (Willis \148)

STEWART, David
 [man with vegetables] c. 1997* (Graphis97 124)
 "Still life" c. 1989* (Graphis89 \277, \278)
 "Untitled" c. 1989* (Graphis89 \279)

STEWART, Frank, 1949-
 "Clock of the Earth, Ghana" 1998 (Committed 206)
 "Mamfe St. in Evening, Ghana" 1998 (Committed
 207)

STEWART, Gary D.
 "Japanese dancer Yoshiyuki Takada fell 50 feet to his
 death while performing before hundreds of stunned
 spectators" 1985 (Best11 105a)

STEWART, Holly
 [bowl of soup] c. 1992* (Graphis93 64d)
 "Mushroom on Green Bowl" c. 1999* (Photo00 56)
 "Red Shoes" c. 1999* (Photo00 45)
 [shirt drying in window] c. 1992* (Graphis93 64a)

STEWART, Jim
 "Racing collision of Stan Fox after his car hit Eddie
 Cheever's car on the first lap of the 1995
 Indianapolis 500" 1995* (Best21 122a)

STEWART, John
 "Passage in the Pyrenees" n.d. (Rosenblum2 #110)

STEWART, Richard H.
 "In the world's largest balloon, Captains Stevens and
 Anderson made a record-breaking ascent into the
 stratosphere" 1935 (Through 484)

STICKLER, Stephen
 "Jennifer Tilly" c. 1997* (Graphis97 111)

STIEGLITZ, Alfred, 1864-1946
 "Apples and Gable, Lake George" 1922 (Hambourg
 \115; MOMA 114)
 "The City of Ambition" 1910 (Hambourg 7)
 "Dorothy True" 1919 (Hambourg 13c)
 "Equivalent" 1924-1926 (Art \207); 1929
 Rosenblum2 #403); 1930 (Marien \4.25)
 "Equivalent No. 314" (Hambourg \124)
 "Flatiron Building" 1903 (Goldberg 20; Hambourg
 6a; MOMA 83; Szarkowski 164)
 "Francis Picabia" 1915 (Vanity 8)
 "From the Back Window, '291,' New York" 1915
 (Art \201, \202)
 "From the Shelton, West" 1935 ((Art \210, \211;
 MOMA 118, 119; Rosenblum2 #404)
 "Georgia O'Keeffe" 1918 (Art \203; Hambourg 22;
 Waking #185); 1919 (Hambourg 23; Waking
 #172); 1920 (Hambourg 42; Szarkowski 242);
 1921 (Hambourg 26); 1933 (Szarkowski 243)
 "Georgia O'Keeffe: A Portrait–Neck" 1921 (Art
 \204)
 "Grapes and Vine" 1933 (Art \209)
 "The Hand of Man" 1903 (Art \198; Hambourg 6c;
 Photography1 #V-28)
 "Hands and Thimble–Georgia O'Keeffe" 1920 (Art
 \205; MOMA 105)
 "House with Grape Leaves" 1934 (Art \208)
 "Looking Northwest from the Shelton, New York"
 1932 (Hambourg \2)
 "Marsden Hartley" 1915-1916 (Waking 350)
 "The Mauretania" 1910 (MOMA 92)
 "Music: A Sequence of Ten Cloud Photographs, No.
 VIII" 1922 (Art \206)
 "Old and New New York" 1910 (San #3)
 "Out of the Window, '291,' N. Y." 1915 (Art \200)
 "Picasso-Braque Exhibition at '291' " 1915
 (Hambourg 14; MOMA 97)
 "Savoy Hotel, New York" 1897* (Photography1 \15)
 "Steerage" 1907 (Art \199; Icons 15; Marien \4.21;
 Rosenblum2 #402)
 "Sun's Rays–Paula, Berlin" 1889 (Marien \4.20;
 Rosenblum2 #401)
 "The Terminal" 1893 (Art \197; Rosenblum2 #312)
 "Two Men Playing Chess" 1907* (Waking #134)
 "Waiting for the Return" c. 1895 (Rosenblum2 #353)
 "Weary" 1890 (Photography1 #VI-9)
 "Winter–Fifth Avenue, New York" 1893
 (Photography1 #VI-5)

STILL, John
 [self-promotional] c. 1990* (Graphis90 \303)

STILLFRIED, Raimund von, 1839-1911
 "Actor in Samurai Armor" 1870s (Waking 307)
 "Rain Shower in Studio" c. 1875 (Rosenblum2 #193)

STILLINGS, Jamey
 [corn elevator] c. 1992* (Graphis93 168b)

STILLMAN, William James, 1828-1901
 "Figure of Victory, Athens" 1869 (Szarkowski 103d)
 "Interior of the Parthenon from the Western Gate"
 1869 (Rosenblum2 #131)
 "Western Portico of the Parthenon" 1870 (Art \136)
 "Western Portico of the Parthenon, from above" 1870
 (Art \135)

STOCK, Dennis
 "James Dean in Times Square" 1955 (Lacayo 139b;
 Life 84b)

STOCKER, Mike
 "Hurricane Mitch" 1998* (Best24 24-25)

STODDARD, Seneca Ray, 1844-1917
 "The Antlers, Open Camp, Raquette Lake" c. 1889
 (National \50)
 "Big Game in Adirondacks" 1889 (Photography1 \88)
 "Englewood Cliffs, New Jersey" c. 1889 (National
 148d)
 "Hudson River Landscape" n.d. (Rosenblum2 #144)

STODDART, C. H.
 "Basil, the Blacksmith" 1889 (Photography1 #VI-3)

STODDART, Tom
 "Amputee mother and child" 1995 (Best21 222b)
 "Blind woman in Ghana, Africa" 1996 (Best22 249a)
 "Bosnian refugee finds a chocolate drink left behind
 by U.S. military forces" 1996 (Best22 248b)
 "Britain's Labor Leader, Tony Blair" 1996 (Best22
 248d)
 "Cellist plays a requiem in Heroes Cemetery" 1995
 (Best21 223d)
 "A child refugee from the Srebrenica exodus in war-
 torn Bosnia" 1995 (Best21 139)
 "Colombian Special Forces destroy airstrip used by
 drug lords to transport coke" 1996 (Best22 248a)
 "Colombia's National Police Chief, Serrano, flies to
 join his Special Forces" 1996 (Best22 249d)
 "Curing India's Cataracts" 1998 (Best24 42d)
 "A dove flies over humanitarian aid cans from the
 USA in Sarajevo" 1995 (Best21 154a)
 "French couple celebrate their marriage by climbing
 3,000 feet to the wedding reception" 1998 (Best24
 102b)
 "Good luck at the front line" 1995 (Best21 223c)
 "Israel's Settlers" 1998 (Best24 94b)
 "Muslim girls visit a mosque near Tehran, Iran" 1996
 (Best22 172b)
 "The pride and dignity of a woman in Dobrinja" 1995
 (Best21 222c)
 "Shock and horror were displayed outside the
 Dunblane School in Scotland after the tragedy of
 that day" 1996 (Best22 248c)
 "Sudan Famine" 1998 (Best24 136-145)
 "Sudan's Catastrophe" c. 1999 (Photo00 64, 65)
 "Table tennis champion practices while wearing the
 compulsory Hejab, Tehran" 1996 (Best22 249c)

 "Traumatized kids play in a bullet riddled area of
 downtown Sarjevo" 1996 (Best22 249b)
 "Victim of river blindness fishes with the help of a
 child and a stick in Africa" 1996 (Best22 172c)

STOELZLE, Hal
 "Olympics in Los Angeles" 1984* (Capture 130)

STOFFERS, Axel
 [a fashion workshop] c. 1990* (Graphis90 \60, \61)

STONE, Les
 "The aftermath of a typhoon on the island of Leyte in
 the Philippines" 1991* (Best17 117)
 "Desperate Kurdish refugees in the mountains of
 Turkey rush the first American relief helicopter for
 food" 1991* (Best17 115a)

STONE, Nancy
 "Superstar Willie Nelson was a main force in
 producing Farm Aid Concert as well as performing
 during the event" 1985 (Best11 62d)

STONE, Pete
 [empty saltwater swimming pool] c. 1991*
 (Graphis92 \209)
 "Portrait of a 92-year-old veteran of World War I" c.
 1990* (Graphis90 \177)

STOUGHTON, Cecil
 "Johnson becomes President" 1963 (Eyes #287)

STRACHAN, Eric
 "Residents of Golden Gate, Florida, watch as flames
 destroy trees and brush across a canal from their
 homes" 1985 (Best11 101a)

STRAITON, Ken
 "University building in art deco style in Montreal on
 a winter afternoon" c. 1989 (Graphis89 \98)

STRAND, Paul, 1890-1976
 "Abstraction, Bowls, Twin Lakes" 1916 (Art \186)
 "Abstraction, Porch Shadows, Twin Lakes,
 Connecticut" 1916 (Goldberg 52; Hambourg \95;
 Marien \4.43; San #19)
 "Akeley Camera" 1922 (Decade \18)
 "Akeley Motion Picture Camera" 1922-1923
 (Hambourg \13; MOMA 112; Szarkowski 185)
 "Alfred Stieglitz, Lake George, N.Y." 1929 (Art #12)
 "Bell rope, Massachusetts" 1945 (Art \191; Decade
 59d)
 "Blind Woman" 1916 (Hambourg 16; Marien \4.42;
 Photography 138)
 "Bottle, Book and Orange, Twin Lakes, Connecticut"
 1916 (San #22)
 "Chair Abstract, Twin Lakes, Conn." 1916 (San \1)
 "Church" 1944 (MOMA 189)
 "Church on the Hill, Vermont" 1946 (Art \190)
 "Couple at Rucar, Romania" 1967 (Art \196)
 "The Family, Luzzara, Italy" 1953 (Art \193; Icons
 117; Photography 130; Rosenblum2 #559)
 "Gaston Lachaise" 1927-1928 (MOMA 115)
 "Geometric Backyards" 1917 (Hambourg \104)
 "Lathe #3, Akeley Shop" 1923 (Rosenblum2 #578)
 "Leaves II" 1929 (MOMA 103)
 "Man, 5 Points Square" 1916 (Art \188; San #7)
 "Nude–Rebecca" c. 1922 (Decade \14)
 "Orange and Bowls" 1916 (Rosenblum2 #504)
 "Pears and Bowls" 1916 (Waking #180)

"People, Streets of New York, 83rd and West End Avenue" 1915 (Art \184)
"Ranchos de Taos, New Mexico" 1931 (Decade 40b)
"Rebecca Strand, New York" 1923 (Art \189; Hambourg 26c)
"Shadows, Twin Lakes, Connecticut" 1916 (Art \185; San #20)
"Still Life, Pear and Bowls, Twin Lakes, Connecticut" 1916 (Decade 17c; San #21)
"Susan Thompson, Cape Split" 1945 (Art \192)
"Tailor's Apprentice, Luzzara, Italy" 1953 (Art \195)
"Untitled" 1915 (MOMA 98); c. 1915 (MOMA 99)
"Wall Street" 1915 (Art \183; Hambourg 15)
"White Sheets, New Orleans" 1918 (Decade \12)
"Winter, Central Park" c. 1915 (Waking 335)
"Wire Wheel, New York" 1918 (Art \187)
"Young Boy, Gondeville, France" 1951 (Art \194)

STRATMANN, Rainer
[man in apron at table] c. 1997 (Graphis97 121)
[two men seated with legs crossed] c. 1997 (Graphis97 120)

STRAUSS, Pamela
[bananas] c. 1995* (Graphis96 100)
[fruit] c. 1995* (Graphis96 100-101)

STRAW, Gerald, 1943-
"Untitled" 1982 (Committed 208, 209)
"Untitled" c. 1980s (Willis \282-\284)

STREIBER, Art
"The Los Angeles sky slowly clears after an April storm" 1988* (Best14 104)

STREWE, Oliver
"Picnic Day Races in Queensland, Australia" c. 1990* (Graphis90 \247)

STRICK, David
"Björk" c. 1995* (Graphis96 113)

STRICKSTEIN, Ira
"Civil defense volunteers assist a young Colombian who survived the mud slide at Armero" 1985* (Best11 15b)

STROCK, George A., 1911-1977
"Three dead Americans on the beach at Buna" or "American Casualties at Buna Beach" 1943 (Eyes #185; Goldberg 115)

STROHMEYER, Damian
"Lycoming University's Harvey is tackled by Allegheny University" 1990* (Best16 137)

STRONG, Bruce
"A woman is overwhelmed by the number of people trying to buy bread in an Albanian store" 1992* (Best18 133)

STRONG, Craig
"A concrete foreman chases a golden Labrador retriever off a new sidewalk" 1993 (Best21 122)

STROUD, William, active c. 1860
"Sarah Howard" 1860 (National 149c)

STRUSS, Karl F., 1886-1981
"The Attic Window, Dresden" 1909* (National 149d)

"Low Tide, Arverne, New York" 1912 (Rosenblum2 #396)
"Storm Clouds" 1921 (Peterson #12)
"Vanishing Point II: Brooklyn Bridge from the New York Side" 1912 (Decade 16a)

STRUTH, Thomas
"Las Vegas, Nevada" 1999* (Photography 26)

STUART, John
"Locomotive" c. 1866 (Szarkowski 328a)

STUART, Mrs.
"Unidentified girl" c. 1860 (Sandler 16a)

STUBBLEBINE, Ray
"Watching undercover police question subway fare-cheaters, New York Mayor Ed Koch peers through a peephole" 1985 (Best11 163)

STUDIO RINGL & PIT (Gerte Stern, 1904- and Ellen Rosenberg Auerbach, 1906-)
"Komol" c. 1931 (San #40)
"Pétrole Hahn" 1931 (Marien \5.39; San \25)
"The Smoker" 1932 (Women \74)

STURK, Mike
"Lonnie Olson wrestles with a steer at the Calgary Stampede" 1991* (Best17 146b)

STURM, William
"Gay Rescue" c. 1943 (Best18 10a)

STYRANKA, J.
"Malibu Lagoon" c. 1999* (Photo00 90)

SUAU, Anthony, 1956-
"After anti-government rallies in Santiago, government responds with water cannons and a barrage of tear gas" 1988* (Best14 56a)
"Amusement park riders in Seoul, South Korea" 1988* (Best14 59b)
"Bosnian soldiers in Vitez prepare to launch a counter attack against Muslim forces" 1993 (Best19 23)
"Capturing the Parliament building by Abkhazian forces in Sukhumi" 1993 (Best19 30-32)
"A child clutches a doll in the slums of Port-au-Prince" 1987* (Best13 82)
"A child's body awaits burial at the Kurdish refugee camp in Turkey" 1991* (Best17 118)
"Croatian forces move under intense sniper fire to fortify their front-line positions against advancing Muslims" 1993 (Best19 24b)
"Croatian women in Bosnia-Herzegovina cry out in fear and anger as the thundering sound of war echoes in the distance" 1993 (Best19 22)
"A cyclist traveling in Romania sleeps along the road" 1990 (Best16 12d)
"Demonstrations by students on the streets of Seoul" 1988* (Best14 59a)
"Demonstrators in Santiago, Chile, recoil from water cannons and tear gas fired by forces of Gen. Augusto Pinochet" 1988 (Best14 180a)
"Ethiopia" 1984* (Eyes \27)
"An Ethiopian soldier walks through a cemetery of tanks" 1988* (Best14 57b)
"Finding no room at a camp for Muslim refugees in Travnik, a mother sleeps with her child in the hallway of an old schoolhouse" 1993 (Best19 24a)

"A fisherman carries frozen fish to market in South Korea" 1987* (Best13 84d)

"Fishermen float along on Lake Barombi" 1987* (Best13 83c)

"Girl in Lérida, Columbia, who was saved after being trapped for 36 hours in mud slides" c. 1989* (Graphis89 \255)

"Grain is poured from a truck in Motic, Moldavia" 1993 (Best19 26a)

"Grozny: Russia's Nightmare" 1995 (Best21 16-35)

"Gypsies return home after working in carbon factory in Copsa Mica, Romania" 1990* (Best16 9d)

"Hat of Gen. Augusto Pinochet as the president of Chile attends a Mass" 1988* (Best14 60c)

"Haitians look in horror at a body in the street" 1987* (Best13 21a)

"In Grozny, Chechnya, a man finds one of his two lost sons among the hundred of corpses in an open grave pit" 1995 (Best21 180c)

"In Lupac, workers harvest grain for the winter" 1993 (Best19 25)

"In the Siberian port city of Cherski, thousands of people have moved out since the fall of the USSR" 1995 (Best21 154b)

"In Ucea, Transylvania, a woman prepares bread for an Easter feast" 1993 (Best19 27a)

"Kim Young Sam, presidential candidate of South Korea's opposition party" 1987* (Best13 26a)

"Kurdish Saga" 1991* (Best17 179-184)

"A man pauses at a drinking well in Moldavia" 1993 (Best19 29)

"A man rests on a bed of leaves in Simbata, Transylvania" 1993 (Best19 27d)

"Memorial Day" 1983* (Capture 129)

"More than 3,000 cattle died when a lethal jet of carbon dioxide spewed from Lake Nyos in West Africa" 1986* (Best13 83a)

"Mothers of students killed in the 1980 Kwangju, South Korea, uprising mourn their loss on the anniversary of the massacre" 1987* (Best13 85)

"A Muslim mother and her child embrace in terror as Serbian artillery shells hit the building housing them and other refugees in Bosnia-Herzegovina" 1993 (Best19 21

"Pakistan's opposition party leader, Benazir Bhutto, attends a rally in Punjab Province during her campaign for prime minister" 1988* (Best14 60d)

"A priest relates a story to a group of men at an annual festival in Sieu" 1993 (Best19 28)

"A refugee's home" 1988 (Best14 116)

"Rice-growing village in Seoul, South Korea" 1988* (Best14 58)

"A Romanian couple haul their pig to a neighbor's farm for breeding" 1990 (Best16 179)

"Russian police set up a blockade against a planned anti-Yeltsin demonstration headed for Parliament building in Moscow" 1993 (Best21 123)

"Russia's Industrial Wastelands" 1992 (Best18 199-202)

"School children in Seoul walk by police as they return from demonstrations" 1987* (Best13 25c)

"South Korean riot police arrest a student protestor during May demonstrations in Central Seoul" 1987* (Best13 84a)

"Supporters carry an image of her later father, former Prime Minister Zulifikar Ali Bhutto" 1988* (Best14 60b)

"36 hours after the Colombia volcano erupted, this man makes his way through the massive mud deposit near town of Armero" 1985* (Best11 14c)

"A three-piece band performs on a Romanian street on Easter" 1990 (Best16 178)

"25 years of warfare continued as Eritereans launched major offensives against Ethiopian troops, killing thousands and forcing thousands more to become refugees" 1988* (Best14 57a)

"A woman attacks the line of riot police with her purse and is arrested in Seoul" 1987* (Best13 24)

"A young Palestinian fighter clasps the arsenal he uses to fight Israeli soldiers in the West Bank" 1988* (Best14 60a)

SUCHY, Lida and Miso
"The village of Kryvorivnya, Ukraine, and its surrounding hills" 1997 (Through 44)

SUCK, Oskar, 1845-1904
"Marketplace in Karlsruhe" 1886 (Szarkowski 128)

SUDEK, Josef, 1896-1976
"Chair in Janácek's House" 1972 (Art \353)
"Coming of Spring" 1958 (Art \358)
"My Garden with the Wash hanging" 1965 (Art \357)
"Roses" 1956 (Icons 164)
"Uneasy Night" 1959 (Art \354)
"Untitled" 1953 (Art \356); 1956 (Art \355)
"Untitled" c. 1991* (Graphis91 \213)
"A Walk in the Magic Garden" 1954-1959 (Icons 165; Photography 233)
"Window in the Rain" 1944 (Rosenblum2 #708)

SUEDE, active 1990s
"Vocalist Erykah Badu in Concert" 1998* (Willis \433)
"Vocalist Lauryn Hill Onstage" 1998* (Willis \432)

SUGAR, James
"Fiery lava fountains spew from Hawaii's Kilauea volcano" 1985* (Best11 41b)

SUGARMAN, Lynn
"After the deer came" c. 1995* (Graphis96 88)

SUGIMOTO, Hiroshi
"Aegean Sea, Pilion 1" 1990 (Marien \8.5)
"Permian-Land" 1992 (Photography 167)

SULLEY, Jim
"If you're a red socks fan, this combination may be shoe-in" 1987* (Best13 182d)

SULLIVAN, Bob
"George Bush, shortly after becoming President, takes a day off to go fishing near Palm Beach" 1988 (Best14 8c)

SULLIVAN, Cleo
"Three Nudes Laughing" c. 1999* (Photo00 43)

SULTAN, Larry, 1946- and MANDEL, Mike
[from "Evidence] 1977 (Photography2 192)
"Untitled" 1992* (Marien \7.73)

SUMMERVILLE, Hugo, 1885-1948
"Gaines Fig Farm" 1926 (Szarkowski 146)

SUN, Jianjun, 1951-
[building in Seattle] c. 1991* (Graphis92 \216)
"The Irvine Business Center in California" c. 1991* (Graphis91 \310)

SUND, Harald
"Mono Lake, California" 1981 (Life 188)

SUNDAY, Elisabeth, 1958-
"Basket of Millet" 1987 (Rosenblum \252)

SURECK, Shana
"Moe Baker, five-time world arm-wrestling
champion, with one of the rabbits he helps raise for
his girlfriend" 1988* (Best14 14a)

SÜSS, Andreas
"Light, Shadow, Architecture" c. 1991* (Graphis91
\306)

SUTCLIFFE, Frank M.
"View of the Harbor" 1880s (Rosenblum2 #370)
"Water Rats" 1886 (Rosenblum2 #283)

SUTTER, Frederick
"The *F-4 Phantom*" c. 1989* (Graphis89 \214)

SUTTON, Thomas, 1819-1875
"Ruined tower, Isle of Jersey" c. 1854 (Szarkowski
48)

SUWA, Akira
"Libyan strongman Moammar Gaddafi on the deck of
a missile patrol boat" 1986 (Best12 17)

SWADA, Kyoichi
"Vietnam–Fleeing to Safety" 1965 (Capture 56)

SWANK, Kevin
"Eggs of a different color" 1991* (Best17 171)

SWANSON, Dick
"Air force door-gunners transport the body of a
comrade killed in an ambush in El Salvador" 1988
(Best14 86d)

SWARTHOUT, Walter
[self-promotional] c. 1989* (Graphis89 \326)

SWEENEY, Tom
"Charlie's ordeal" 1985 (Best11 130-131)

SWERSEY, Bill
"A young Chechyen girl covers her ears to silence the
roar of a Russian tank" 1995* (Best21 182c)

SWOPE, John, ?-1979
"Cap d'Antibes, France" 1948 (MOMA 225)

SYMES, Budd
"Meracquas synchronized swim team performs in
Irvine, Calif" 1990* (Best16 136a)

SZABÓ, Samuel G., active c. 1854-1861
"Rogues, Study of Characters" c. 1860 (Waking #96)

SZALAY, Thomas B.
"High-tech mushrooms" 1988* (Best14 107)

SZARKOWSKI, John, 1925-
"Column Capital, Guaranty Building, Buffalo" 1952
(MOMA 192)

SZÉKESSY, Karin
"For Picasso, 1988" c. 1990* (Graphis90 \297)

SZILASI, Gabor
"*St. Joseph de Beauce*, Quebec" 1973 (Rosenblum2
#701)

SZUBERT, Awit
"Amelia Szubert" c. 1875 (Rosenblum2 #70)

SZURKOWSKI, Les
[calendar] c. 1991* (Graphis92 \75, \81-\85)

—T—

TABACCA, Joe
"James Farranda, Imperial Wizard of the Invisible
Empire of the Ku Klux Klan, drives a Klan-filled
Mercedes in Connecticut" 1986 (Best12 55a)
"A woman gasps for breath as she is helped by New
York City police officer after a terrorist bombing at
the World Trade Center" 1993* (Best19 186b)

TABARD, Maurice, 1897-1984
"Abstraction" 1936 (Hambourg 66a)
"Composition" 1929 (Hambourg \68)
"Montage" 1929 (Hambourg \106)
"Nude" 1929 (Rosenblum2 #544)
"Portrait" 1948 (Decade 24)
"Pubilcité Dunhill" 1930 (Marien \5.37)
"They will vote" 1929 (Eyes #109)

TABB, Clarence, Jr.
"Quarterback is sacked at end of the game and
players celebrate victory" 1997* (Best23 179a)

TABER, Isaiah West, 1830-1912
"Glacier Point Rock, 3201 Ft. Yosemite Valley" c.
1885 (Photography1 \73)

TABOR, Lewis P.
"Solar Eclipse" 1925 (Goldberg 38)

TAHARA, Keiiichi
[S-class Mercedes] c. 1992* (Graphis93 160b)

TAIRA, Karina
"Feather Story" c. 1997* (Graphis97 48-49)

TAIWAN GOVERNMENT
" 'Sing-song' girls in Taiwan play traditional Chinese
instruments for guests at a teahouse" 1920
(Through 164)

TAKEUCHI, Take
[chickens in costumes] c. 1997* (Graphis97 182)
[nudes] c. 1992* (Graphis93 119)

TAKUSHI, Scott
"Hmong woman sobs and clutches a relative's hand
as she waits for bus to leave the Ban Vinai refugee
camp in northern Thailand" 1987* (Best13 28)

TALAMON, Bruce W., 1949-
"Bob Marley No. 1" 1978 (Committed 210)
"Jacob Lawrence" 1992 (Committed 211)

TALBOT, William Henry Fox, 1800-1877
"Articles of China" 1844* (Art \3; Marien \2.7)
"Beech Trees, Lacock Abbey" c. 1844 (Art \6)
"Botanical Specimen" c. 1835 (Waking #1); c. 1840*
(Rosenblum2 #21; Szarkowski 29)
"Broom and Spade" c. 1842 (Art \9)

"A Bush Hydrangea in flower" mid-1840s (Art \5)
"C's Portrait" 1840 (Rosenblum2 #50)
"Carpenter and Apprentice" c. 1844 (Waking 268c)
"The Chess Players" c. 1845 (Art \13)
"Composition" 1931 (Hambourg \103)
"The Fruit Sellers" c. 1845 (Waking #15)
"Garden Scene, Lacock Abbey" 1840 (Szarkowski 47)
"Hayrick with Porter" 1841 (Marien \2.8)
"Haystack" 1844 (Art \8)
"Honeysuckle" 1840 (Art \4)
"Hungerford Suspension Bridge" c. 1845 (Waking 267)
"Lace" c. 1845* (Art \2; Szarkowski 30)
"The Ladder" 1844 (Art \11)
"Latticed Window, Lacock Abbey, England" 1835 (Marien \1.18; Monk #2; Rosenblum2 #20)
"Leaf" c. 1839 (Szarkowski 34)
"Leaf of a Plant" c. 1839* (Art \1)
"Leaf with Serrated Edge" c. 1839 (Marien \1.17)
"Man with a Crutch" 1844 (Art \12)
"The Open Door" 1843 (Art \10; Lacayo 18d; Rosenblum2 #23; Waking #12)
"Reverend Calvert Jones at Lacock Abbey" c. 1845 (Szarkowski 32)
"A Scene in a Library" 1843-1844 (Waking 266d)
"Ships in the Harbour Rouen" 1843 (Art \15)
"Street Scene, Paris" 1843 (Art \16)
"Trafalgar Square: Nelson's Column under construction" 1843 (Art \14; Rosenblum2 #22)
"Trees with Reflection" 1840s (Art \7; Waking #10)
"Vase with Medusa's Head" 1840 (Waking #11)
"View of Boulevards at Paris" 1843 (Waking 268a)
"Wheat" before 1852 (Szarkowski 328c)

TAMERIAN, Eddy
"An East Beirut apartment was devastated by a car-bomb explosion" 1986 (Best12 80c)

TANG, Ringo
"Lily reflected in a piece of slightly corrugated metal" c. 1991* (Graphis91 \128)
"Nude with veil" c. 1992* (Graphis93 118)
[series of experimental photographs] c. 1990 (Graphis90 \331)

TANNENBAUM, Allan
"Arab youths aim their slingshots at an Israel helicopter hovering over a mosque in Nablus, in the Israeli-occupied territories" 1988 (Best14 85)

TAPIE, Gilles
"A model displays designer Issey Miyake's high-fashion coat" 1985* (Best11 157a)

TARDIO, Robert
"Silver Flask" c. 1991* (Graphis91 \105)

TARVER, Ron, 1957-
"Basketball Game, Philadelphia" 1993* (Willis \427)
"Legends, Philadelphia" 1993* (Willis \428)
"On the Street Where Heroin Lived" 1992 (Best18 185-188)
"Rail and Clouds" 1997 (Committed 212)
"Rodeo Queen, Oklahoma" 1994 (Willis \426)
"South Philadelphia Barbecue" 1993* (Willis \425)
"Water Tower" 1997 (Committed 213)

TASNADI, Charles
"Nixon checking his watch" 1974 (Goldberg 184)

TATO (Guglielmo Sansoni), 1896-1974
"Il Perfecto borghese (The Perfect Bourgeois)" 1930 (Hambourg \90; San #60)
"Ritratto meccanico di Remo Chiti" 1930 (San \44)
"Untitled" 1930 (San #59)

TAUB, Doug
[Lexus] c. 1992* (Graphis93 156c)

TAYLOR, Chris
"Linda St. Germain clings to Bristol Life Saving Crew member as they are pulled to safety from wreckage of her truck" 1990 (Best16 113)

TAYLOR, Jeremy
"Malmo Marination" c. 1991* (Graphis91 \131)

TAYLOR, Paul
"Dorothea Lange" n.d. (Lacayo 100d)

TAYLOR, Ron and Valerie
"Whale sharks appear along Ningaloo Reef, Australia" 1996* (Best22 191a)

TEHAN, Patrick
"B. T. Wrinkle, 85, provides full-time care for his dying wife" 1986* (Best12 104a)
"Beans" 1992 (Best18 165)
"Braving the Bulls" 1998* (Best24 56a, 61a)
"Children play in a tree on a lake in Hanoi" 1998* (Best24 54b)
"International Family" 1992 (Best18 203-208)
"Reaching Out" 1992 (Best18 37-40)
"Robert Cannon celebrates from the atop the basket" 1992 (Best18 41)
"Route 40 Drive-in" 1992* (Best18 42)
"A surfer takes off on one of a series of waves produced by offshore storm" 1996* (Best22 187c)

TEIJI SAGA
"Swan" 1974* (Graphis91 \350; Life 192)
"Wild swans caught in a snow storm in northern Japan" c. 1991* (Graphis91 \349)

TELBERG, Val, 1910-
"Greeting" 1979 (San \40)
"Portrait of a Friend" c. 1947 (Photography2 68)
"Unmasking at Midnight" 1948 (Photography2 Frontispiece)

TELLER, Juergen
[man in suit] c. 1997* (Graphis97 30)

TENNESON, Joyce, 1945-
[from an article on breast cancer and young mothers] c. 1991* (Graphis92 \126)
[from an article on intimacy] c. 1990* (Graphis90 \171, \172)
[for a department store catalog] c. 1992* (Graphis93 46-49)
"Nightshirt" c. 1989* (Graphis89 \16)
"Peter with 'Light' in fist and hand" 1992 (Graphis93 11c)
"Peter with William" 1990* (Graphis93 11a)
"Petticoat" c. 1989* (Graphis89 \15)
"Pregnancy and birth" 1992 (Graphis93 10)
"Sleeping Beauty" 1992* (Graphis93 11b)
"Suzanne in Contortion" 1990* (Rosenblum \13)
"Suzanne with snake skeleton" 1990* (Graphis93 11c)

TEREK, Donna
"Five-year-old Tony Estes already feels himself
called to be a minister of God" 1991* (Best17 78b)
"Julie, the punk–Lifestyle" 1986 (Best12 82-83)

TERRILL, Mark J.
"A woman cries as her neighbor's house burns"
1993* (Best19 185b)

TESKE, Edmund, 1911-
"Untitled" 1962* (Photography2 73)

TEUNISSEN, Bert
"Tired Tree" c. 1999* (Photo00 76, 78)

TEYNARD, Félix, 1817-1892
"Abu Simbel" 1851-1852 (Waking #69)
"Colossus and Sphinx, Es-Sebua" 1851-1852
(Waking 297d)
"General View of the Pylon, Temple of Sebou'ah,
Nubia" 1851-1852 (Szarkowski 64)
"Portico of the Tomb of Amnemhat, Beni-Hasan"
1851-1852 (Waking 297b)

THAYER, Bob
"Oscar de la Renta" 1995 (Best21 149b)
"Wild geese weather a snowstorm in Portsmouth"
1987* (Best13 168)

THIBAULT, Eugène
"The Revolution of 1848" 1848 (Marien \2.27, \2.28)

THIÉSSON, E.
"Native Woman of Sofala" 1845 (Marien \2.19)

THODE, Scott
"Venus Williams is an intravenous drug user and
AIDS patient who is living on the streets of New
York City" 1992 (Best18 64)

THOMAS, Christopher
[ad for a Brazilian liquor] c. 1992* (Graphis93 158a)
"Leprosy patients" c. 1995* (Graphis96 63)

THOMAS, Hank Sloane, 1976-
"King of Promise Keepers" 1997* (Willis \430)
"The Late, Late Show" 1996 (Willis \382)
"Million Man March, Washington, D.C." 1995
(Willis \380)
"Million Woman March" n.d. (Willis \431)

THOMAS, Lew, 1932-
"Light on Floor" 1973 (Photography2 184)

THOMPSON, Andy
[woman in hat] c. 1992* (Graphis93 33)

THOMPSON, Elaine M.
"San Francisco residents pause in silence during the
display of The Names Project quilt for AIDS
victims in Washington, D.C." 1988 (Best14 77d)

THOMPSON, George
"A Chicago bag lady sits among her possessions and
shows the American flag" 1986 (Best12 164b)

THOMPSON, Paul
"Madame Thoumaian, the promoter of the Congress,
displays the motto of the Three Musketeers" 1915
(Eyes #82)

"School children of New York, observing
Americanization Day in City Hall Park" 1917
(Eyes #75)

THOMPSON, Robin
[for an ad campaign] c. 1989* (Graphis89 \61)

THOMPSON, William
"Teresa Weaver clings to her daughter, age 2, after
pulling her brother from an apartment fire" 1998*
(Best24 185a)

THOMSEN, Ruth Thorne, 1943-
"Cones from the Expedition series" c. 1982 (Women
\190)
"Head with Plane, from the Expedition series" 1979
(Women \191)

THOMSON, John, 1837-1921
"The Altar of Heaven" c. 1870-1871 (Art \127)
"The Cangue" 1871-1872 (Marien \3.37)
"The Crawlers" c. 1876-1877 (Lacayo 61d; Marien
\3.89; Rosenblum2 #435)
"First King of Siam" 1865 (Waking 105d)
"His Majesty Prabat Somdet Pra parame dr Mahá
Mongkut, First King of Siam, in State Costume"
1865 (Waking 305a)
"Island Temple Foochow" or "A Pagoda Island in the
Mouth of the Min River" 1870-1871 (Art \128;
Marien \3.39)
"Itinerant Tradesman, Kiu Kiang Kiangsi" c. 1868
(Rosenblum2 #192)
"Prince Kung" c. 1871-1872 (Art \126)
"Sufferers from the floods in London" c. 1876-1877
(Lacayo 60)
"Wu-Shan Gorge Szechuan" 1868 (Rosenblum2
#138)

THORACK, Max see THOREK, Max

THOREK, Max, 1880-1960
"Composition" n.d. (Peterson #14-16)
"Despair" c. 1936 (Peterson #72)
"Man the Enigma" c. 1937 (Peterson #75) or "Homo
Sapiens" 1933 (Goldberg 83)
"Odalisque" c. 1937 (Peterson #73)

THOREL, Paul
"Deserti (Deserts)" 2000 (Photography 226a)
"Doppi Onda a Donnini (Double Wave at Donnini)"
2000 (Photography 226b)

THORMANN, Ernst
"Gypsy child" 1929 (Marien \5.68)

THORNE, Harriet V. S., 1843-1926
"Man in Shower" c. 1900 (Rosenblum \85)

THORNE-THOMSEN, Ruth, 1943-
"Parable" 1991 (Rosenblum2 #747)
"September 4th, Wisconsin" 1991 (Rosenblum \236)
"Untitled, Chicago (Liberty Head)" 1978*
(Photography2 231)

THOUVENEL, Didier
"Lamborghini Countach" c. 1990* (Graphis90 \225)

THRELKELD, Scott
"David, age 11, gets kicked in the head during the
Mardi Gras Classic" 1996* (Best22 205c)

"Wildlife handler narrowly misses being bitten by a six-foot alligator" 1995* (Best21 165a)

THRONELL, Jack R.
"James Meredith Shot" 1966 (Capture 58)

THUMMA, Barry
"A frail Eritrean child sits in a medical tent at the Wad Sherife camp in Sudan" 1985 (Best11 122d)

TICE, George
"Horse and Buggy in Farmyard, Lancaster, Pennsylvania" 1965 (Decade \75)
"Joe's Barbershop" 1970 (Rosenblum2 #686)

TIEDEMANN, George
"Major league soccer championships" 1996* (Best22 205b)
"Runners hand off batons during the Penn Relays" 1993* (Best19 154)

TIERNAN, Bill
"Daisy Mayes shields her two children against an autumn wind as her older son watches for the public bus" 1990 (Best16 116)
"A modern knight in a jousting tournament" 1985 (Best11 220c)
"A somber mood envelops sailors standing under the 16-inch guns of the Battleship Iowa as it eases from its moorings [for] duty in the Persian Gulf" 1987 (Best13 10)
"Suburban Cowboys" 1998* (Best24 59c, 71c, 99b)
"White Lace" 1992* (Best18 166a)

TIFFANY, Louis Comfort, 1848-1933
"Fishermen Unloading a Boat, Sea Bright, New Jersey" 1887 (National \45)

TILLERY, David C.
"An old house still comes down one board at a time" 1985 (Best11 147a)

TILLMANS, Wolfgang
"Lutz and Alex Sitting in the Trees" 1992* (Marien \7.67)
"Victoria Line and Martha Osamor" 2000* (Marien \7.96)

TITZENTHALER, Waldemar
"Boiler Maker (Types of German Workers)" c. 1900 (Rosenblum2 #438)

TLUMACKI, John
"As a thunderstorm approaches, Ugandan refugees wait for the French Red Cross to test them for sleeping sickness" 1987 (Best13 77d)
"A Boston Bruins player trips up a Buffalo player as they tangle during game action" 1987 (Best13 223)
"A cheerleader comforts a high school football player" 1987 (Best13 206d)
"An elderly man passes the reflecting pool of the Christian Science Center in Boston's Back Bay" 1987 (Best13 173b)
"A fox sits in the windswept dune grass beneath the rising full moon" 1998* (Best24 47c)

TOBIA, Peter
"Spring breezes fill billowing curtains as flowers rest on a windowsill" 1987* (Best13 167a)

TOBIAS, Randy
"Getting caught under a bull on the final day of a four-day bull-riding school" 1996* (Best22 196a)

TOENSING, Amy
"Family struggling to get off welfare" 1998 (Best24 102c)

TOMA, Kenji
[cigarettes] c. 1997 (Graphis97 60)

TOMASZEWSKI, Tomasz
"A family comes to worship in the beautiful but politically torn town of Chiapas, Mexico" 1996* (Through 308)
"Gypsy children in Lourdes, France, play on the grass after riding with their families in a caravan of cars" 2001* (Through 74)

TOMATSU, Shomei, 1930-
"Okinawan Victim of the Atomic Bomb Explosion in Hiroshima" 1969 (Szarkowski 257)
"Sandwich Man, Tokyo" 1962 (Rosenblum2 #720)
"Time Stopped at 11:02, 1945, Nagasaki" 1961 (Marien \6.27)
"Yamaguchi Senji Who Was Injured 1.2 km from the Epicenter of the Blast" 1962 (Photography 104)

TOMBAUGH, Brian S.
"Only T-ball" 1985 (Best11 191)

TOMINAGA, Minsei
[from ad for Comme des Garçons fashions] 1989* (Graphis89 \11)

TÖNNIES, Heinrich
"Four young blacksmiths" c. 1881 (Rosenblum2 #69)

TOPELMANN, Lars
[dog's mouth] c. 1997 (Graphis97 148)
"For Anti-Gang Violence Campaign" c. 1997 (Graphis97 52)
[mountain climber on side of mountain] c. 1997 (Graphis97 202)

TOPHAM, John
"St. Paul's Cathedral" 1940 (Lacayo 107)

TOPICAL PRESS
"A horse tows a grain-and-timber barge along the River Chelmer in England" 1940 (Through 36)

TOPPERZER, Piotr
"April 1998, Portrait of a Blind Person" 1998* (Photo00 152)
"March 1998, Amaryllis Belladonna" c. 1999 (Photo00 211)

TORMEY, Don
"At the funeral for California Assemblyman Richard Longshore, his 2-year-old son wanders up the aisle to the father's coffin" 1988 (Best14 208)
"Graduate Elena Messer gets flowers, hugs and kisses from her daughter Donnie, 8" 1988 (Best14 210d)
"A happy grandmother and mother yell out during graduation ceremonies" 1988 (Best14 210a)
"Lifelight helicopter flies along Newport Beach" 1988 (Best14 209b)
"Lifelight nurse Marylee Blow aids a boy injured in a

bicycle accident" 1988 (Best14 209a)

TORRES, Marguerite Nicosia
"After breast cancer surgery" 1997 (Best23 183a)

TOTH, Carl
"Family in water with dog" 1959* (Goldberg 146)

TOUHEY, Karen
"England's Prince Andrew and Sarah Ferguson return
to Buckingham Palace after taking wedding vows
at Westminster Abbey" c. 1986* (Best12 2)

TOURNACHON, Adrien, 1825-1903
"Charles Debureau" 1854-1855 (Waking #59)
"Emile Blavier" c. 1853 (Rosenblum2 #85)
"Emmanuel Frémiet" 1854-1855 (Waking #61)
"Self-Portrait" c. 1855 (Waking #52)

TOURNASSOUD, Jean
"Army Scene" c. 1914 (Rosenblum2 #345)

TOURTIN
"Sarah Bernhardt" 1877 (Rosenblum2 #92)

TOWELL, Larry
"Demonstrators burn a homemade Israeli flag in
protest, Bethlehem" 2000 (Photography 120d)
"El Salvador: before truce" c. 1989 (Best19 97-112)
"Ghostly silhouettes from countless accused felons
manacled to a bench at detention cell in New York"
1997 (Best23 155a)
"In the Wake of a Hurricane, Honduras" 1998
(Best24 22-23)
"Mexican Mennonite Migrant Workers" 1996
(Best22 256-257, 267)
"The World From My Front Porch" 1974-1997
(Best23 224)

TRACY, Edith Hastings
"Panama Canal construction" c. 1913 (Rosenblum
\60)

TRAGER, George
"Leaders of the Hostile Indians at Pine Ridge
Agency, S.D., during the Late Sioux War" 1891
(Photography1 #III-16)

TRAINOR, Charles
"Atlanta prison riot" 1987 (Best13 70, 71, 72a)
"Elvis Presley" 1956 (Life 171)
"Miami Haitians protest the arrest of Haiti President
Jean-Bertrand Aristide" 1991* (Best17 107a)

TRASK, Harry A.
"Sinking of *Andrea Doria*" 1956 (Capture 38)

TRAVER, Joe
"A woman markets her piglets in Tbilisi, Georgia, in
the Soviet Union" 1988 (Best14 117d)

TREGEAGLE, Steve
[vegetables] c. 1995* (Graphis96 98)

TREGENZA, Patrick
[food and objects] c. 1995* (Graphis96 96)

TREMOLADA, Emilio
[glass table] c. 1992* (Graphis93 141a)
[wicker chairs] c. 1992* (Graphis93 141b)

TRENT, Paul, 1917-
"Unidentified Flying Object, McMinnville, Oregon"
1950 (Monk #35)

TRESS, Arthur
"The Actor" 1973 (Rosenblum2 #763)
"Boy in Flood Dream" 1970 (Decade \92)

TRIPE, Linneaus, 1822-1902
"Aisle on the Southside of the Puthu Mundapum"
1856-1858 (Szarkowski 66)
"The Pagoda Jewels , Madurai" 1858 (Waking 303)

TROCKEL, Rosemarie
"Beauty" 1995-1996 (Marien \8.2)

TROELLER, Linda
"Kimberly Fairbank enjoys a mineral-water spa at
Calistoga Hot Spings" 1992* (Best18 81)

TROESSER, Carmen
"Tomato on drawing" 1992* (Best18 173)
"Versatility & Variety of Melons" 1993* (Best19
182d)

TRONCALE, Bernard
"A four-month courtship culminated in marriage for
Rev. Edward Charmichael, 82, and Vera Davis, 80"
1986 (Best12 137)
"Two painters in Birmingham roll a water-repellent
coating on the sides of the Elton B. Stephens
Expessway" 1986 (Best12 147)
"A Veterans Day parade in Birmingham brings out
units from Navy and Army" 1986 (Best12 145)

TROTTER, John
"3-year-old Somali refugee cries as she hangs from a
scale in a feeding center" 1992* (Best18 132c)

TROUT, Taisie Berkeley
"What do I look like?" 1986 (Best12 172-175)

TRUESDALE, June DeLairre, active 1970s
"James Baldwin, writer and civil rights activist" 1986
(Willis \252)
"Peter Tosh, musician" 1981 (Willis \253)

TRUMBO, Craig
"Illustrate the drama and verve of red shoes" 1985*
(Best11 149b)
"No matter how you dish it out, tomato soup is ripe
for any occasion" 1987* (Best13 186b)

TSCHALDEY, Yevgeny A. *see* KHALDEI, Evgenii

TSINHNAHJINNIE, Hulleah
"Damn! There goes the Neighborhood!" 1998
(Marien \8.15)

TU, Alan David
[from a series about ties] c. 1990* (Graphis90 \22)

TURBEVILLE, Deborah, 1937-
[ad for Bloomingdales] c. 1990* (Graphis90 \23)
[ad for evening wear by fashion designer Emanuel
Ungaro] 1989* (Graphis89 \13)
[ad for Loretta di Lorenzo fashions] 1989*
(Graphis89 \8, \9)
"Bathrooms in Antiquity: Aquatic Delight" c. 1989*
(Graphis89 \14)
"Fall fashion" c. 1991* (Graphis91 \30)

"*Italian Vogue, Paris, 1981*" 1981* (Rosenblum \8)
"Paloma Picasso" c. 1990* (Graphis90 \128)
"Radio City Music Hall, New York" 1981 (Marien \6.60)
"Romantic Reprise" c. 1991* (Graphis91 \8, \9)
"Terry Covering" 1975 (Rosenblum2 #652)

TURI, Luca
"Albanian Refugees" 1991* (Photos 170)

TURNER, Benjamin Brecknell, 1815-1894
"Old Willows" c. 1856 (Rosenblum2 #108)
"Windmill at Kempsey" c. 1853 (Szarkowski 53)

TURNER, Danny
[series on portrait painting] c. 1991* (Graphis91 \189)

TURNER, Judith
"Peter Eisenman, House V. Cornwall, Connecticut" 1976 (Rosenblum \227)

TURNER, Sheila, 1966-
"An Invitation to Juke" 1996* (Willis \475)
"Untitled" 1997* (Willis \476)

TURNLEY, David C., 1955-
"At the Tuzia, Bosnia airport, a young girl pulls her brother in a carton that had contained humanitarian assistance" 1995 (Best21 167, 207)
"Freedom Uprising" 1989* (Capture 154-155)
"Grieving soldier in the Gulf war" or "American solider reacts to news that victim in a body bag is a man he knew" 1991* (Best17 10; Lacayo 175b)
"In one of the biggest refugee exodus of this century, Serbs from Krayina flee the Croatia offensive toward Serbia" 1995 (Best21 207c)
"Just seconds before, the first of a four-hour Russian barrage of shells came in, killing the man on the ground" 1995* (Best21 180b)
"A man picks up lawn-bowling balls for women at an exclusively all-white lawn-bowling club outside of Durban" 1986* (Eyes \32)
"Mrs. Winnie Mandela peers through bars on a gate that surrounds her Soweto home" 1986 (Eyes #344)
"A Muslim woman is comforted by her child in a refugee center" 1995 (Best21 207a)
"Muslims Esad and his bride Senada celebrated their wedding in Bostaric, Sarajevo" 1995 (Best21 160)
"A Palestinian father pleads with an Israeli soldier to release his son, who was arrested in clashes in Ramallah on the West Bank" 1988 (Best14 180a)
"Relatives of a man who had been accidentally killed mourn his death at his funeral" 1986* (Eyes \33)
"Serb Refugees at Banja Luka" 1995 (Goldberg 218)
"Taliban in Afghanistan" 1996 (Best22 258-259)
"Victims of an earthquake in Soviet Georgia" 1988 (Best14 194-195)
"White pupil from an English private school boards the same train, not the same compartment, as black household servants" c. 1989* (Graphis89 \245)
"A young woman bathes herself in her one-room home on the Jan Naude family farm outside Welkon" 1986* (Eyes \34)

TURNLEY, Peter
"A child from the Eritrean region of Ethiopia too weak from hunger to brush the flies covering her body" c. 1991* (Graphis91 \86)
"Death in Armenia" 1988 (Best14 173-177)

"Israeli soldiers drag an unconscious Palestinian fighter away after a beating in Ramallah on the West Bank" 1988 (Best14 178)
"Nelson Mandela meets the press shortly after his release from prison in South Africa" c. 1990* (Best16 2)
"A new era opens for Eastern Bloc countries as Soviet leader Mikhail Gorbachev launches his strategy for perestroika" 1987 (Best13 9)

TURQUETI, Roger
[article on shampoo] c. 1991* (Graphis91 \124)

TURRELL, James
"Detail of Crater Bowl with survey net and contour lines" 1985 (Photography 221)

TUSA, Susan
"These teenagers are hanging out at a recreational center in Detroit" 1986 (Best12 181a)

TUTTLE, Jeff
"Josh McCrary, 4, holds his father by the leg as McCrary prepares to leave for the Persian Gulf of Operation Desert Shield" 1990* (Best16 101)
"A Shawnee Mission North High School pole vaulter tries to clear the bar at the University of Kansas relays" 1987 (Best13 199d)

TWEEDIE, Penny
"Aboriginal boys in Australia wait for a circumcision ceremony to begin" 1980* (Through 432)

TWEEDY-HOLMES, Karen, 1942-
"Paul and Matthias" 1967 (Rosenblum \260)

TWINE, Richard Aloysius, 1896-1974
"Emancipation Day parade celebrating the end of slavery" c. 1922-1927 (Willis \98)
"Group portrait of the Roman Catholic Order of the Knights of St. John" c. 1922-1927 (Willis \95)
"Mildred Parsons Mason Larkins" c. 1922-1927 (Willis \96)
"Portrait of Mary ('Mae') Martin at home" c. 1922-1927 (Willis \94)
"Portrait of the photographer with a group of women" c. 1922-1927 (Willis \97)

TYEN
[article about make-up] c. 1990* (Graphis90 \38)
[article entitled *Quintessence for your Beauty*] c. 1989* (Graphis89 \21)

—U—

UBAC, Raoul, 1910-1985
"La Conciliabule" 1938 (Marien \5.25)
"Marquette pour un mur" 1938-1939 (San 49-50)
"Objects" 1939 (Hambourg \121)
"State of Combat" c. 1937 (Hambourg 97)

UCHIDA KYUICHI
"Haru-ko, Empress of Japan" c. 1872 (Marien \3.43)
"Mutsuhito, Emperor Meiji" c. 1872 (Marien \3.42)

UDESEN, Betty
"The Contender" 1998 (Best24 68-69)
"Fredd Young needs special assistance as his thighs are retaped" 1986 (Best12 201b)
"Houston's Akeem Olajuwon and Seattle's Clemon

Johnson exchange blows in a fourth-quarter fight"
1986 (Best12 207)
"A Leg Up" 1988 (Best14 96a)
"Seattle Seahawk defensive end Jeff Bryant gets an
ice bag where it counts after sustaining a mild
concussion" 1986 (Best12 201a)
"Senatorial candidate Patty Murray campaigns atop a
crate" 1992 (Best18 74a)

UEDA, Yoshihko
"Heaven and Earth" c. 1990* (Graphis90 \119-\120)

UELSMANN, Jerry N., 1934-
[Cloud Room] 1975 (Rosenblum2 #756)
"Equivalent" 1964 (Photography2 74)
"Fleeing Man" 1961 (San \38)
"Free but Securely Held" 1965 (San #55)
"Gifts of St. Ann" 1976 (Decade \91)
"Small Woods Where I Met Myself" 1967 (Decade
83)
"Untitled" 1959 (Decade \68)
"Untitled (Landscape with a floating tree)" 1969
(Marien \6.37)

UHL, Eugenia
"Untitled" c. 1990* (Graphis90 \28)

UHRICH, Bill
"Swans" 1990 (Best16 68)

UIMONEN, Ilkka
"Kabul, Afghanistan, after the Taliban Takeover" c.
1997* (Graphis97 56-59)
[return of the Cossack culture in southern Russia]
1998* (Photo00 62, 63)

ULEVICH, Neal
"Brutality in Bangkok" 1976 (Capture 97)

ULMANN, Doris, 1882-1934
"Baptism, South Carolina" c. 1930 (Women \28)
"Bell Ringer, South Carolina" c. 1930 (Women \29)
"Corn Shocks and Sky" c. 1925 (National \62)
"Girl with Jug" c. 1930 (Sandler 41)
[ironing] c. 1925-1934 (Rosenblum2 #393)
"Laundress, Peterken Farm, South Carolina" 1929
(Women \27)
"Man Leaning against a Wall" c. 1930 (National \77)
"Mr. and Mrs. Anderson, Saluda, North Carolina"
n.d. (Marien \5.66)
"Mrs. Hyden Hensley and child, North Carolina" c.
1933 (Rosenblum \144)
"Untitled" c. 1925-1933 (MOMA 95; Peterson #57)
"William Campbell" c. 1930 (Sandler 43)
"Woman on a Porch" c. 1930 (National 26)
"Woman Seated on Steps" c. 1930 (Women \26)
"Woman with Scrubboard" 1930 (Sandler 42)

ULRICH, Thomas
"Swiss mountain guide dangles at 9,000 feet above
sea level on the Schilthorn in the Swiss Alps"
1996* (Best22 203d)

ULTANG, Donald T. and ROBINSON, John R.
"Racial Attack on NCAA Champion" 1951
(Capture 29)

UMBO (Otto Umbehr), 1902-1980
"Berlin Artists' Rehearsal Room" 1930 (Rosenblum2
#599)

"Latest Offer–In Profile" or "Untitled" 1928 (Icons
33; Rosenblum2 #551)
"Mystery of the Street" 1928 (Hambourg \110)
"Night in a Small Town" c. 1930 (Waking #196)
"Porträt Rut Landshoff (Der Hut)" 1927 (San \43)
"René Cretin and Sylta Busse" 1930 (Decade 29)
"Rut Maske" 1927 (San #58)
"Ruth, Her Hand" 1927 (Icons 32)

UNDERHILL, Linn
"Untitled" 1995 (Marien \7.90)

UNDERWOOD, Bert Elias, 1862-1943 and
UNDERWOOD, Elmer, 1860-1947
"An American war photographer, Merl La Voy, ready
for a motion-picture flight over the Serbian front"
c. 1914-1918 (Eyes #40)
"Austrian Uhlans going into position" 1915 (Lacayo
47)
"Belgian patrol watching the German advance" 1914
(Eyes #79)
"Brave Belgian Lange, who was decorated for killing
15 German soldiers singlehanded" c. 1914-1918
(Eyes #42)
"Charles Lindbergh standing beneath the wing of
plane, Spirit of St. Louis" 1927 (Goldberg 72)
"Courtyard of a Typical Cuban Home" 1899
(Rosenblum2 #419)
"The defense of Riga" 1915 (Lacayo 46a)
"The Dying Bugler's Last Call–A Battlefield
Incident, South Africa" 1900 (Marien \4.67)
"Evolution of the sickle and flail–33-horse team
combined harvester" 1902 (National \48)
"The eyes of the army–view of German town from
British aeroplane" c. 1914-1918 (Eyes #41)
"The funeral of a murdered leader of the Ku Klux
Klan" 1920s (Lacayo 52)
"Girls in a Village of East Equatorial Africa" 1909
(Marien \4.65)
"Interior of the beautiful Rheims Cathedral damaged
in bombardment" 1914-1915 (Eyes #77, Eyes #\3)
"Near view of the Maine wreck, showing tremendous
force of the explosion, Havanna Harbor" 1898
(Eyes #39)
"The President returning from his bear hunt in
Colorado" 1905 (Eyes #70)
"President Roosevelt running a steam shovel at the
Panama Canal" 1906 (Goldberg 55)
"Pro-revolutionary soldiers during the March uprising
in Petrograd" 1917 (Lacayo 44d)
"Roosevelt at Texline, Texas" 1905 (Eyes #69)
"Soldiers of Co. M 312 Inf. with gas masks adjusted,
Camp Dix, New Jersey" c. 1917 (Eyes #45)
"Under bombardment on the heights of the Meuse"
1916 (Eyes #72)
"Wretched Poverty of a Cuban Peasant Home" 1899
(Rosenblum2 #418)

UNDERWOOD, William Lyman, 1864-1929
"Joe Mell, asleep in his canoe" c. 1895 (National
151a)

UNITED STATES AIR FORCE
"Cuban Missile Base" 1962 (Monk #39; Photos 103)
"Korean War" 1951 (Photos 77)
"Soviet freighter Ivan Polzunov faces off with a U.S.
warship" 1962 (Photos 102)
"The world's first hydrogen-fusion blast at Eniwetok"
1952* (Lacayo 123)

UNITED STATES ARMY
"U.S. Servicemen and Servicewomen, Paris, August 15" 1945 (Life 68)
"Winston Churchill, FDR and Joseph Stalin, Yalta Conference" 1945* (Life 22b)

UNITED STATES ARMY SIGNAL CORPS
"President Woodrow Wilson with U.S. General John Pershing" n.d. (Lacayo 170b)
"Russian Slave Laborer Points Out Former Nazi Guard Who Brutally Beat Prisoners" 1945 (MOMA 171)

UNITED STATES MARINE CORPS
"The New Bird of Liberty: An American warplane of the latest type" 1918 (Eyes #80)

UNITED STATES NAVY
"Explosion Following Hit on the USS Franklin by Japanese Dive Bomber" 1945 (MOMA 169)
"Pearl Harbor" 1941 (Monk #25)
"Sinking of the USS Arizona" (Photos 54)

UNITED STATES WAR DEPARTMENT
"Charlie Chaplin and Douglas Fairbanks at a Liberty Loan rally" 1918 (Lacayo 49)

UT, Nick (Huynh Cong), 1951-
"Vietnam–Terror of War" or "South Vietnamese Children Burned by Napalm" 1972 (Capture 80; Eyes #297; Lacayo 157; Marien \6.74; Monk #44; Photos 134)

UYEDA, Shigemi, 1902-1980
"Reflections on the Oil Ditch" c. 1924 (Peterson #37)

—V—

VACHON, Paul
"At the Armistice Day Parade (Omaha)" 1938 (Documenting 94b)
"Backyard and Roman Catholic church (Omaha)" 1938 (Documenting 112a)
"Blind beggar (Omaha)" 1938 (Documenting 100b)
"Boxcar and grain elevators" 1938 (Documenting 104a)
"Cars and parking meters" 1938 (Documenting 95c)
"Coronado Apartments" 1938 (Documenting 110a)
"Danbaum armored car" 1938 (Documenting 97c)
"Election campaign signs" 1938 (Documenting 109c)
"Flophouse on lower Douglas Street" 1938 (Documenting 99b)
"Girl and movie poster" 1938 (Lacayo 90c)
"High school student's car" 1938 (Documenting 103b)
"House and fence with graffiti" 1938 (Documenting 108a)
"Houses near the Nebraska Power Company plant" 1938 (Documenting 105c)
"In the Italian district" 1938 (Documenting 111b)
"In the wholesale district" 1938 (Documenting 103c)
"Mail delivery" 1938 (Documenting 106b)
"Mailbox" 1938 (Documenting 107c)
"Nebraska is the white spot of the nation: no luxury tax, no bonded debt, highways all paid for" 1938 (Documenting 94a)
"Newsstand" 1938 (Documenting 96a)
"Oak bar from a more prosperous era" 1938 (Documenting 98a)
"Omaha" 1938 (Documenting 113b)
"On a streetcar" 1938 (Documenting 96b)
"Public Works Administration housing" 1938 (Documenting 107d)
"Restaurant sign" 1938 (Documenting 102a)
"Rooming house, formerly the home of the Creighton family" (Documenting 109b)
"Rooming house window" 1938 (Documenting 105d)
"Saloon in the stockyard district" 1938 (Documenting 101c)
"Sick child" 1941 (Documenting 19c)
"Stockyard salesman and buyers" 1938 (Documenting 104b)
"Tending the flowers" 1938 (Documenting 106a)
"Unemployed men who ride the freight train from Omaha to Kansas City and St. Louis and back" 1938 (Documenting 100a)

VACK, Tom
"Philippe Starck designed furniture series" c. 1990* (Graphis90 \194-\196)

VADUKUL, Max
"Sting" c. 1997* (Graphis97 112)

VAGHI
"Arturo Toscanini" 1929 (Vanity 114)

VALBONA, Nuri
"Drug Hole Warriors" 1997 (Best23 201d)

VALDEZ, David
"Vice President and Barbara Bush–and the grandkids–at their summer home in Kennebunkport, Maine" 1987* (Life 36a)

VALENTA, Eduard, 1857-1937 and EDER, Josef Maria, 1855-1944
"Aesculapian Snake" 1896 (Marien \4.62)

VALENTE, Jerry
"Dr. Leila Denmark, born in 1898, examines Rebekah de Avila" 1990 (Best16 180d)
"Maria Carmina Iaconelli, born in 1900, lives alone in the town of San Biagio Saracinisco, Italy" 1990* (Best16 202)

VALERIO, Vicki
"Family whose home was destroyed visits the street one last time before houses were razed" 1985 (Best11 26a)
"The Junior National Rowing Team packs a teammate's room" 1998 (Best24 70)
"Two police officers rush into position as MOVE house burns, Philadelphia" 1985 (Best11 23b)

VALLBONA, Nuri
"Republican presidential candidate Alan Keyes waits offstage as he is introduced to speak" 1995 (Best21 178d)
"Rescue workers attend the needs of a youngster found buried in the mud at Armero" 1985* (Best11 15d)
"Starving cattle await auction in Freer, Texas, as a drought forces ranchers to sell their stock" 1988 (Best14 81a)

VALLHONRAT, Javier
"Ana-Marina Kregel" c. 1991* (Graphis92 \20)
"Animal-Vegetal" c. 1990 (Graphis91 \35)
"Ann Duong for Vogue Italia" c. 1991* (Graphis92

\41)
[dress with sheer jacket] c. 1996* (Graphis97 31)
[for *Vogue Italia*] c. 1990* (Graphis91 \34)
[from a fashion catalog] c. 1991 (Graphis92 7)
[from article on draped clothing] 1988* (Graphis89 \10)
"Rina Kastrelli" c. 1991* (Graphis92 28)
"Untitled #18" 1991* (Photography 229)

VALLONE, Charles S.
"A firefighter goes into a small attic window to put a line on a fire caused by faulty electrical wiring" 1985 (Best11 171b)

VALLOU DE VILLENEUVE, Julien, 1797-1866
"Reclining nude" 1851-1853 (Waking #46)
"Woman with Pitcher" c. 1855 (Rosenblum2 #251)

VAN BUREN, Amelia C.
"Madonna" 1900 (Rosenblum \99)
"Portrait" c. 1900 (Sandler 63)

VAN DER ELSKEN, Ed, 1925-1990
"Durban, South Africa" 1959-1960 (Icons 140)

VAN DER HILST, Robert
"Contrasting lifestyles of two generations" c. 1991* (Graphis91 \225)
[from series on Morocco] c. 1989* (Graphis89 \181)

van der LENDE, Craig
[camisole and pearls] c. 1992* (Graphis93 79)

VAN DER STOCKT, Laurent
"In the rubble of Kabul, Afghanistan, the city of orphans, three youngsters carry wood to sell at a market" 1995 (Best21 180a)

van der VLUGT, Marcel
"Photographic interpretation of the picture *L'heure bleue*" c. 1990* (Graphis90 \153)
"Skincolors" c. 1999* (Photo00 52)

VAN DER ZEE, James, 1886-1983
"Baptism Celebration to Maria Warma Mercado" 1927 (MOMA 128)
"Couple in Raccoon Coats" or "A Harlem couple wearing raccoon coats standing next to a Cadillac on West 127th Street" 1932 (Marien \5.72; Rosenblum2 #322; Willis 67)
"Cousin Susan Porter" 1915 (Willis \68)
"Future Expectations" c. 1926 (Willis \69)
"Madame Walker's Tea Parlor" 1929 (Goldberg 74)
"Marcus Moziah Garvey in a Universal Negro Improvement Association parade" 1924 (Willis \66)

VAN DYKE, Rich and KITCHENS, Bobbie
"Black Gloves" c. 1997* (Graphis97 104)
"Raven" c. 1997* (Graphis97 105)

VAN DYKE, Tom
"Students on the University of California's Berkeley campus refused to disperse after a week-long anti-apartheid sit-in, arrests begin" 1985 (Best11 106a)

VAN DYKE, Willard, 1908-1986
"Ansel Adams at 683 Brockhurst, San Francisco" 1932 (MOMA 32)
"Cement Works, Monolith, California" 1931 (Marien

\5.46)
"Funnels" 1932 (Rosenblum2 #581)

VAN ELK, Ger, 1941-
"Russian Diplomats" 1976* (Photography2 160)

VAN HOOK, Ben
"Vice President George Bush wearing a personalized helmet, checks out the army's M-1 tank at Fort Knox" 1987 (Best13 52d)

VAN HORN
"Beatrice Lillie and Hope Williams" 1932 (Vanity 161)
"Ginger Rogers" 1930 (Vanity 192d)

VAN LEEUWEN, Jan
"Based on the painting *The Meal at Emmaus*" n.d. (Photography 222)

VAN OVERBEEK, Will
"Bert Turner, funeral home greeter" c. 1989* (Graphis89 \152)

VAN VECHTEN, Carl, 1880-1964
"Georgia O'Keeffe" 1936 (Marien \5.73)

VAN SICKLIN, Scott
[from a series with found objects from man and nature] c. 1989* (Graphis89 \285)

van WERDEN, Hugo
"Panorama of the Fried. Krupp Cast-Steel Factory" 1864 (Szarkowski 102-103)

VANCE, Robert H., -1876
"The Great Man Has Fallen" 1856 (Waking 312a)

VANDAMM, Florence, 1883-1966
"Bertrand Russell" 1924 (Vanity 78)
"Portrait of unidentified actor" n.d. (Rosenblum \143)

VANDIVERT, William
"Rally in Cadillac Square, Detroit" 1937 (Life 152)

VANNERSON, Julian, 1827-after 1875
"Shining Metal" 1858 (National 22b, 13)

VARIN, Pierre-Amédée, 1818-1883
"Rheims Cathedral" 1854 (Szarkowski 329a)

VATHIS, Paul, 1925-
"State Treasurer commits suicide" 1987 (Best13 13; Eyes #361-362)
"Two Men With a Problem" 1961 (Capture 48)

VEDER, Slava (Sal)
"Burst of Joy" or "Lieutenant Colonel Robert Stirm returns home" 1973 (Capture 86; Lacayo 157a; Life 75)

VEDROS, Nick
[ad for Eastman Kodak] c. 1991* (Graphis91 \175)
"New Orleans unemployed and homeless chef" c. 1991* (Graphis91 \207)

VELASQUEZ, Phil
"Chicago Bears Quarterback Jim McMahon sits, hurt and dejected, after reinjuring his shoulder early in the season" 1986 (Best12 197)

"Cubs runner Gary Matthews tries to take out Philly shortstop" 1986 (Best12 208b)
"Cubs runner Shawon Dunston shows the pain as Pirate shortstop Washington lands on him during a muffed double play" 1986 (Best12 208a)
"New York Mets pitcher Dwight Gooden helps lead his team to a World Series Championship" 1986 (Best12 216)
"William 'the Refrigerator' Perry rolls into the Chicago Bears summer camp on a specially-built motorbike" 1986 (Best12 196)

VEREEN, Dixie D., 1957-
"Man and Child" 1990 (Rosenblum \196)

VERGARI, Mark
"Martina Navratilova reacts to the ball's dropping over the net to score a point" 1985 (Best11 223a)

VERTOV, Dziga, 1896-1954
"Man with a Movie Camera" 1929 (Marien \5.32)

VETSCH, Walter
"Clouds above the Matterhorn of Nepal" c. 1987 (Graphis89 \62)

VIGIER, Joseph, -1862
"Path to Chaos, Saint-Sauveur" 1853 (Waking 283)

VIGNELLI, Luca
[for JBL brochure] c. 1990* (Graphis90 \212)

VIGNES, Michelle, 1926-
"Eli Mile High Club, Oakland" 1982 (Rosenblum \211)

VIGNOLES, Mary Lommori
"Ti Vanji on her way to the Ban Napho Refugee Camp to sell food" 1996* (Best22 209c)

VILLET, Grey
"The Oster farm" 1982 (Life 48)

VINE, Terry
[woman in swimming pool] c. 1992* (Graphis93 178)

VINK, John
"Children in refugee camp" c. 1991 (Graphis91 \85)

VIRGA, Jim
"Mike Laughlin, Jr. crawls away from his blazing race car after he crashed" 1996* (Best22 204c)

VISHNIAC, Roman, 1897-1990
"Boy with Earlocks" 1937 (Marien \5.79)
"Entrance to the Ghetto, Cracow" 1937 (Rosenblum2 #456)
"Granddaughter and Grandfather, Warsaw" 1938 (Rosenblum2 #457)

VLASENKOV, Dmitriy
[untitled] c. 1999* (Photo00 40-42)

VOGEL, Hermann
"Bridge near King's Monument" 1866 (Rosenblum2 #124)

VOGEL, Susan
"Winter Swimmer" c. 1999* (Photo00 114)

VOGEL, T. Z.
"Seated Girl" c. 1860* (Rosenblum2 #332)

VOGT, Christian
"Untitled" 1972* (Rosenblum2 #748)

VOGT, Christine
[ad for insurance company] c. 1992* (Graphis93 78)

VOGT, Jeannette, c. 1860-?
"Untitled" 1890s (Rosenblum \52)

VOLKERLING, Gerd
"Oak Trees in Dessau" 1867 (Rosenblum2 #125)

VOLKMANN
[series on men's fitness and grooming] c. 1991 (Graphis92 \152)

von ALVENSLEBEN, Christian
[from book The Apocalyptic Menu] c. 1992* (Graphis93 92, 93)

von RENNER, Ivo
[for Country magazine] c. 1991* (Graphis92 \33)
[gas station in desert] c. 1999* (Photo00 175)

VONINSKI, Tamara
"Alexis Brian, 12, works at gymnastics six days a week, eight hours a day" 1995 (Best21 135b)

VROMAN, Adam Clark, 1856-1916
"Around Moki Towns, Tewa Trail" 1900 (National 161c)
"Around Zuni, From Northeast of Pueblo '99'" 1899 (National \53)
"Hopi Maiden" c. 1902 (Rosenblum2 #195)
"Indian Girls Grinding Corn, Moqui Town" 1895 (Photography1 \94)
"Interior of (Mr.) Hooker's House, Sichimovi" 1902 (Szarkowski 124)
"Pueblo of Zuni (Sacred Shrine of Taäyallona)" 1899 (MOMA 62)

—W—

W, Vincent Alan, 1960-1996
[from Queens Without a Country series] c. 1986 (Willis \394-\398)

WADE, Bill
"Pocket Square, New Under the Moon" 1988* (Best14 97b)
"Sliding safely to second base during a pickoff attempt" 1991 (Best17 148)
"A volunteer fire captain considers a nearly impossible task as the Monongahela River ebbs" 1985 (Best11 64c)

WADE, Harry
"Cheryl Moody's Jewelry" c. 1991 (Graphis92 \156-\158)

WADE, Minor B., 1874-1932
"Lynching, Russellville, Kentucky" 1908 (Waking #159)

WAGNER, Catherine, 1953-
"Northwestern Corner with Sawhorse and Cement Mixer, George Moscone Site, San Francsico,

California" 1981 (Women \178)
"Vista from Monorail, Wonderwall, Louisiana World Exposition, New Orleans" 1984 (Women \177)

WAGNER, Gert
[report on gliding] c. 1990* (Graphis90 \249)

WAGNER, Tom
"Sumo Wrestler Camp" 1996 (Best22 239a, c)

WAGNER, William G.
"Experimental work" c. 1989* (Graphis89 \172)

WAIZMANN, Joerg
"Mourning Yitzhak Rabin" 1995* (Photos 178)

WALBERG, David
"A plane awaits take-off at Chicago's busy O'Hare airport" 1995* (Best21 157b)

WALDACK, Charles
"Beyond the *Bridge of Sighs*" 1866 (Rosenblum2 #290)

WALDMAN, Max
"Marat/Sade" 1966 (Photography 94)
"Mikhail Baryshnikov" 1975 (Life 173b)

WALERY
"S. Guitry and Y. Printemps" 1926 (Vanity 103a)

WALGREN, Judy
"Alzheimer's patients at the Golden Acres Home" 1996* (Best22 167c)

WALISIEWICZ, Ania
"The brother of the photographer posing as roach" c. 1991* (Graphis92 \131)

WALKER, Christian, 1954-
"Evidence of Things Not Seen" 1986 (Willis \536)
[*Bargaining with the Dead* series] 1986 (Willis \535)

WALKER, Diana
"Clinton hugs his daughter and wife after the debate was finished" 1996 (Best22 111d)
"Clinton takes a deep breath before walking on to the convention floor to deliver his acceptance speech" 1996 (Best22 111b)
"En route to one of the Presidential debates via train, President Clinton plays cards with his aides" 1996 (Best22 111a)
"A hired entertainer exposes herself to unsuspecting guests" 1985* (Best11 160b)\
"President Clinton during preparation for a debate at the Chautauqua Institute" 1996 (Best22 111b)

WALKER, Hank
"Chatting with West Virginia coal miners during the presidential campaign" 1960 (Life 27)
"JFK and brother Robert, then his campaign manager, later his Attorney General" 1960 (Life 26d)
"Sen. Joseph McCarthy, with aide Roy Cohn, Army-McCarthy hearings" 1954 (Life 155)

WALKER, John
"Paul and Cheryle Dumont share a moment as other members of the Modified Motorcycle Assn. watch a friend kick-start his '64 Pan Head Harley-Davidson" 1986 (Best12 71b)

WALKER, Shawn W., 1940-
[from the *Self-Portraits/Shadows and Reflections* series] 1990s (Committed 214, 215; Willis \353-\354, \355)
[Hindus wear mascots shaped as elephants] 1991 (Willis \356)

WALKER, Todd, 1917-
"Agave" 1983* (Decade \XIII)
"Chris, Veiled" 1970 (Decade 94)
"A Photograph of a leaf is not a leaf. It may not even be a photograph" 1971 (Photography2 96)

WALL, Jeff, 1946-
"Dead Troops Talk (A Vision after an Ambush of a Red Army Patrol, near Moqor, Afghanistan" 1991-92 (Marien \8.17)
"A Sudden Gust of Wind (after Hokusai)" 1993* (Icons 192)

WALLACH, Louis
[self-promotional] c. 1991* (Graphis91 \133)

WALLRAFEN, Hannes
"The world of Gabriel Garcia Marquez" c. 1990* (Graphis90 \167)

WALSH, Carl D.
"Frank Russo enters one ends of an igloo he built in his yard in Maine, as his dog peers into the other end" 1993* (Best19 69)
"Rebuilding a salvaged home for a sex-member rural family" 1997 (Best23 151b)
"2 Malagasy men walk across their front porch near Madagascar's high plateau" 1998* (Best24 51d)
"An umbrella-toting pedestrian is reflected in the rain-beaded hood of a car" 1988 (Best14 100a)

WALSKI, Brian
"Judith and William Hansen grieve as a flag that covered their son's casket is folded by Navy pallbearers" 1987 (Best13 11b)
"Northern Ireland: On the Brink of Peace?" 1997 (Best23 203)
"Our Churches are Burning" 1996 (Best22 238a)
"Presidential candidate Bob Dole has a difference of opinion with Clinton supporters while campaigning in New Hampshire" 1996 (Best22 104)
"Princess Diana's brother, The Earl of Spencer, her sons Princes William and Harry and her ex-husband, Prince Charles, watch the hearse carrying her casket leave Westminster Abbey" 1997 (Best23 132)

WANG, Miao, 1951-
"Searching" 1980s (Rosenblum \19)

WANG, Ting-Li
"A bird takes flight on a misty morning at Mt. Trashmore Park" 1998* (Best24 47d)

WANG, Wen Liang
"Untitled" c. 1997* (Graphis97 90, 95)

WAPLINGTON, Nick
[from *Living Room*] 1996-1997* (Photography 210)

WARBURG, Agnes, 1872-1953
"Winter Woods" c. 1901 (Rosenblum \91)

WARD, Brant
 "A coroner's deputy surveys the wreckage of a PSA
 jet that crashed" 1987 (Best13 73a)
 "Ducks startled by a severe fall storm run out in front
 of a motorist, who jumps out of the car to shoo
 them away along a road" 1987 (Best13 122a)
 "An English pointer is outwitted by a quail during this
 first training session" 1985 (Best11 154a)
 "Indian activist Dennis Banks announces in
 California that he plans to run for president of the
 United States" 1987 (Best13 111a)
 "Prayers for Polly" 1993* (Best 19 203-206)
 "Supporter of the USS Missouri peers through an
 open door at San Francisco's City Hall during a
 rally by ship workers" 1988 (Best14 14d)
 "A young Haitian boy, alone with his thoughts,
 cowers in a corner on election day in Port au
 Prince" 1988 (Best14 95)

WARD, Catharine Barnes, 1851-1913
 "Five o'clock tea" 1888 (Rosenblum \51)

WARHOL, Andy, 1928-1987
 "Early Electric Chair" 1963* (Art \461)
 "Elvis" 1963 (Art \462)
 "Lavender Disaster" 1963* (Photography 159)

WARNEKE, William
 "The shooting of New York City's Mayor William J.
 Gaynor" 1910 (Lacayo 39d)

WARNER, John
 "Kirsten McCombs now knows what a clinker sounds
 like on handbells" 1986 (Best12 119a)
 "When John Abell, 14, was immobilized after a car
 accident, officials at Methodist Hospital bent the
 rules a bit to allow John's golden retriever to visit
 his master" 1986 (Best12 134c)

WARREN, Bill
 "Keyanna Newbhard, age 6, looks to a bright future
 with help from the Ithaca Southside Center" 1996
 (Best22 215b)
 "A young boy waits in line to blessed by the Dalai
 Lama in India" 1995* (Best21 142b)

WARREN, George, 1834-1884
 "Campus Buildings, William College" c. 1860
 (National 161d)
 "Frederick Douglass" 1876 (Photography1 61a)

WARREN, Jon
 "Hundreds of human skulls are stacked in a building
 in Nakasere, Uganda" 1986 (Best12 165a)
 "Khmer Rouge refugee girl awaits treatment in a
 crowded hospital" 1985 (Best11 161a)

WARREN, Ted S.
 "After the Attacks, New York" 2001 (Marien 3)

WARTER, Stefan
 "Decathlete Christian Schenk of Germany practices
 throwing a discus" 1991* (Best17 155)
 [2-man bobsled] c. 1992* (Graphis93 196)

WASHBURN, Bradford
 "Annual Banding ('Ogives') of Yentna Glacier, near
 Mt. Foraker, Alaska" 1964 (Decade \78)

WASHBURN, Stanley, 1878-1950
 "Parading before the Winter Palace in Petrograd"
 1917 (Eyes #74)

WASHINGTON, Augustus, 1820-1875
 "John Brown" c. 1846-1847 (Marien \2.57; Willis \3)
 "Liberian Diplomat" c. 1853 (Photography1 \20)
 "Unidentified man with beard" c. 1854-1860 (Willis \2)
 "Unidentified portrait of a woman, probably a
 member of Urias McGill family" 1855 (Willis \5)
 "Unidentified woman" n.d. (Willis \6)
 "Urias A. McGill" c. 1854-1867 (Willis \4)

WATANABE, Yoshio
 "Ochanomizu Station" 1933 (Rosenblum2 #523)

WATERS, John
 [shrimps on shoes] c. 1997* (Graphis97 44)

WATERS, Lannis
 "After the hurricane" 1992* (Lacayo 187)
 "A Haitian soldier joins a street demonstration in
 Port-au-Prince" 1993* (Best19 192b)
 "Offering moral support, a father points to the finish
 line as he runs alongside his daughter at the end of
 the kid's triathlon" 1997* (Best23 178a)

WATKINS, Carlton E., 1829-1916
 "Buckeye Tree, California" c. 1870 (Art \120)
 "Cape Horn, Columbia River, Oregon" 1867
 (Photography1 #V-2)
 "Cape Horn near Celilo, Oregon" 1867 (Art \122;
 Marien \3.59; Waking #122)
 "Casa Grande, Arizona" 1880 (Art \117)
 "Cascade, Nevada Falls, Yosemite" c. 1861 (National
 \26)
 "Cathedral Spires, Yosemite" 1861 (Art \116;
 Rosenblum2 #148)
 "The Grisly [or Grizzly] Giant, Mariposa Grove,
 Yosemite" 1861 (National 79; Szarkowski 115;
 Waking #4)
 "Magenta Flume, Nevada Co., California" c. 1871
 (Rosenblum2 #164)
 "Malakoff Diggins, North Bloomfield, Nevada
 County" c. 1871 (Photography1 \57)
 "Multnomah Falls Cascade, Columbia River" 1867
 (Art \115; Rosenblum2 #166; Waking #124)
 "Panorama of Yosemite Valley from Sentinel Dome"
 1866 (Art \112)
 "The Rapids with Indian Block House, Cascades"
 1867 (Photography1 \6)
 "Storm on Lake Tahoe" 1880-1885 (Art \119)
 "Strait of Carquennes, from South Vallejo" 1868-
 1869 (Waking #121)
 "Sugar Loaf Islands, Farallons" 1868-1869 (Art \118;
 Waking #125)
 "Three Brothers, Yosemite" c. 1865 (National 162d)
 "Union Diggings, Columbia Hill, Nevada" c. 1871
 (National \30)
 "Untitled" c. 1872 (Art \113)
 "View from Camp Grove (Yosemite Valley)" c. 1863
 (Decade 3d)
 "Witches Rock near Echo City" 1873 (National 162c)
 "The Wreck of the Viscata" 1868 (Art \121)
 "Yosemite Falls" c. 1865 (National 163d)
 "Yosemite Valley from the 'Best General View' " c.
 1866 (Art \114; Marien \3.60)

WATKINS, Margaret, 1884-1969
 [ad for Myer's gloves] 1920s (Marien \5.34;

Rosenblum \151)
"Domestic symphony" 1917 (Peterson #60; Women
\35)
"The Kitchen Sink" c. 1919 (Women \34)
"Phenix Cheese" 1925 (Rosenblum2 #629)
"Still-life–Shower Hose" 1919 (Women \33)

WATRISS, Wendy, 1943-
"Agent Orange" 1982 (Rosenblum2 #480)
"Untitled" 1987 (Rosenblum \203)

WATSON, Albert Mackenzie
"David Cronenberg" c. 1992* (Graphis93 102c)
"Ellen Barkin" c. 1989 (Graphis89 \187)
[for a fashion article in *Vogue Italia*] c. 1990
(Graphis90 \34, \52)
[from a fashion layout] c. 1991 (Graphis91 10)
[from ad for Blumarine] c. 1988*-1990* (Graphis89
\49-\52; Graphis90 \29)
[from ad for Hasselblad cameras] c. 1990 (Graphis90
\157)
[from catalog for Byblos] c. 1989* (Graphis90 \12,
\13); c. 1991* (Graphis91 \48)
"Golden Nude with 15th Century Aztec Fan" c.
1991* (Graphis91 8)
"Hamptons on Long Island" c. 1991 (Graphis91 \286,
\287)
"Jack Nicholson" 1981* (Rolling #57); c. 1999
(Photo00 159)
"Keith Richards" c. 1989* (Graphis89 \145; Rolling
#109)
"Men's coat" c. 1991* (Graphis91 61)
"Men's nautical tie" c. 1991 (Graphis91 \60)
"Mike Tyson" 1986 (Rolling #73)
[nude in high heels] c. 1995* (Graphis96 43)
"Rap Artist Slick Rick" c. 1991 (Graphis91 11)
"Scottish railway bridge" c. 1989 (Graphis89 \76)
"Seeing Red" c. 1991* (Graphis91 \1)
"Sharon Stone" c. 1992* (Graphis93 103)
"Shoulder to shoulder" c. 1991 (Graphis91 \7)
"The singer Milva" c. 1991* (Graphis91 \28)
"Tom Cruise" c. 1992* (Graphis93 102a)
"Wettkampfteilnehmer beim rodeo in calgary" c. 1991
(Graphis91 12)

WATSON, Edith S., 1861-1943
"Quebec Rural Scene" c. 1920 (Rosenblum \110)

WATSON, Norman
"Boy George" 1986 (Rolling #63)

WATSON, Paul
"Dead U.S. Soldier in Mogadishu" 1993* (Best19
188; Capture 171; Lacayo 177)

WATSON-SCHÜTZE, Eva, 1867-1935
"The Outlet of the Lake" c. 1890 (Rosenblum \87)
"Portrait of Hanni Steckner Jahrmarkt and Liese
Steckner Webel" c. 1909 (Rosenblum \72)
"The Rose" c. 1903 (Rosenblum2 #388; Sandler 34a)
"A Study Head" c. 1900 (Sandler 54)
"Untitled" c. 1900 (Rosenblum \86)

WATTS, Lewis, 1946-
"Beale Street, Memphis" 1994 (Willis \556)
"Downtown, Oakland, California" 1997 (Willis \557)
"Fresh Killed Poultry, West Oakland" 1993 (Willis
\555)
"John's Island, South Carolina" 1995 (Willis \558)

WATTS, Susan
"Gloria; Life on the Streets" 1997 (Best23 209)

WATZEK, Hans Johann Josef, 1848-1903
"Portrait" 1898 (Szarkowski 163)
"Sheep" 1906 (Marien \4.12)
"Still Life" c. 1901 (Rosenblum2 #376)

WAUD, Alfred Rudolph, 1828-1891, attribution
"A Woman in an Interior" c. 1870 (Waking #92)

WAX, Bill
"Front entrance to the Florida State Prison" 1985
(Best11 112c)
"In Florida, a commercial fisherman bails out his boat
after Hurricane Elena washed it ashore" 1985
(Best11 68c)
"John Johnston, number-one ranked wheelchair
player in Florida, smashes into the side boundary
fence" 1985 (Best11 224)
"Member of the Jacksonville sheriff's department
cheers as the hearse containing Raulerson's body
passes" 1985 (Best11 115a)
" 'Old Sparky,' the instrument of execution" 1985
(Best11 114d)
"Prison Chaplain talks about Christ and the life
hereafter with Raulerson" 1985 (Best11 114a)
"Prisoner Raulerson passes time in his cell" 1985
(Best11 112b)
"Raulerson stares out of his cell" 1985 (Best11 113)
"Three opponents of capital punishment hold an early
morning vigil outside the prison to mourn
Raulerson's death" 1985 (Best11 115b)

WAY, Terry L.
[Suicide of Pennsylvania State Treasurer R. Budd
Dwyer] 1987 (Best13 12)

WAYRYNEN, Troy
"A 300-pound sow decided to make herself welcome
to a bowl of dog food" 1995* (Best21 164d)

WEAKS, Dan
[ad for underwear] c. 1995* (Graphis96 129)
[skyscrapers combined] c. 1995* (Graphis96 165)
"Calcutta Market," "East Bound Holland Tunnel,"
"World's Largest Steam Locomotive," "New Jersey
Condos," and "Election Day, Quito, Ecuador" c.
1995* (Graphis96 174)

WEAVER, Anna K.
"No Cross, No Crown" 1874 (National \57)

WEAVER, Ben
"Nancy Reagan greets her husband (waving from his
hotel room) during her appearance at Republican
National Convention, Dallas" 1984* (Life 35)

WEBB, Alex
"East meets West in Istanbul, Turkey, where women
in black chadors might encounter females in more
revealing attire" 2002* (Through 94)
"Guantanamo Bay, Cuba" 1993* (Photography 113b)
"Street scene in Haiti" 1986* (Lacayo 167)

WEBB, Boyd, 1947-
"Day for Night" 1988* (Art \459)
"Saragasso" 1985* (Art \460)

WEBB, Todd
 "From the 48th Floor of Empire State Building, New York" 1946 (Decade 50)

WEBER, Bruce
 [ad for 'Obsession] c. 1991 (Graphis91 \53)
 [ad Ralph Lauren fashion] c. 1989* (Graphis89 \23)
 "Madonna" 1986 (Life 177d)
 "Rita Marley" 1988 (Rolling #78)
 "Ziggy Marley" 1988 (Rolling #77)

WEBER, Charles
 "The Swiss Garden" c. 1991* (Graphis92 \199, \200)

WEBER, Gary
 "Signs do the talking at a rally in Milwaukee to protest raising Wisconsin's legal drinking age" 1986 (Best12 183a)
 "Minnesota Twins teammates embrace after winning the World Series" 1987 (Best13 220b)
 "Yevgeny Vtyurin, counsel for the Soviet Embassy in Washington, D.C. gives the "okay" signal" 1985 (Best11 92d)

WEED, Charles Leander, 1824-1903
 "Mirror Lake and Reflections, Yosemite Valley" 1865 (National 21d, \27)
 "Mirror View of El Capitán, Yosemite Valley" c. 1864 (Szarkowski 119)
 "Poverty Bar, Middle Fork Mining Series" 1859 (Photography1 \38)

WEEGEE (Arthur Fellig) 1899-1968
 "Auto thief arrested, car crashed, one killed" n.d. (Lacayo 82)
 "Booked for killing a Policeman" 1939 (Art \317)
 "Brooklyn School Children See Gambler Murdered in Street" or "Their First Murder" 1941 (Art \318; Eyes #141; MOMA 166; Marien \6.44)
 "Cannon Shot" 1952 (Decade \66; Goldberg 123d)
 "Coney Island Beach" 1940 (Art \312)
 "The Critic" 1943 (Art \315; Eyes #142; Icons 95; Rosenblum2 #624)
 "Easter Sunday, Harlem" 1940 (Art \313)
 "Human Head Cake Box Murder" c. 1940 (Hambourg \35)
 "Lovers at the Movies" c. 1940 (Icons 94)
 "Harry Maxwell Shot in Car" 1936 (MOMA 167)
 "Metropolitan Opera House recital" n.d. (Decade \36)
 "Murder in Hell's Kitchen" c. 1940 (Art \316; Eyes #140)
 "On the Spot" 1940 (Goldberg 107)
 "Self-Portrait" c. 1940 (MOMA 20)
 "Seventeen-year-old Boy arrested for strangling a six-year-old Girl to death" 1944 (Art \319)
 "Tenement Fire" 1939 (Szarkowski 194)
 "Untitled" c. 1940s (Art \314)

WEEMS, Carrie Mae, 1953-
 "Diana Portraits" 1992* (Marien \7.88)
 [from Kitchen Table series] 1991 (Willis \522-\523)
 [from the Africa series] 1993 (Committed 216, 217)
 "Jim, If you choose to accept, the mission is to land on your own two feet" 1987 (Rosenblum \251; Rosenblum2 #739)
 Note Manet's Type series" 1997 (Willis \517-\521)
 "Untitled" 2001 (Photography 205)

WEEMS, Ellie Lee, 1901-1893
 "Brewster Hospital Graduation" 1935 (Willis \100)

 "Mint Jones holding a book" 1935 (Willis \99)
 "Mr. and Mrs. Ernest Tyres" 1938 (Willis \102)
 "Portrait of man and woman on porch" n.d. (Willis \101)
 "Portrait of two women with car" 1937 (Willis \103)

WEGMAN, William, 1943-
 "Family Combinations" 1972 (Photography2 161)
 "Fay Ray posing for a feature on Texas cowboy boots" c. 1991* (Graphis91 \237-\243)
 "Fay/Ruscha" 1987 (Szarkowski 329d)
 "Hot Fudge" 1994* (Photography 1994)
 "Man Ray Portfolio–Man Ray Contemplating the Bust of Man Ray" 1978 (Marien \6.101)
 "Man Ray with Sculpture" 1978 (Rosenblum2 #678)
 "Ray and Mrs. Lubner in Bed Watching TV" 1982* (Decade \XIV)
 "Ray-O-Vac" 1973 (Szarkowski 281)
 "Red/Grey–Grey/Red" 1982* (Szarkowski 281)

WEIL, Brian
 "Prince, Two-year-old with AIDS, New York City" 1986 (Photography 124)

WEIL, Mathilde
 "The Embroidery Frame" 1899 (Roenblum \71; Sandler 64c)

WEIMER, Kim
 "Fabian gets a second chance to life without drugs after nine months of intensive treatment" 1986 (Best12 147d)
 "Mother Teresa offers up a prayer before addressing a crowd in Scranton" 1987 (Best13 110a)

WEINER, Dan, 1919-1959
 "Boycotted Bus, Montgomery" 1956 (Goldberg 143)
 "Fashion show aboard a New York commuter train" 1949 (Lacayo 132)
 "El Morocco, New York" 1955 (MOMA 198)
 "Shoppers Glimpse a Movie Star at Grand Central Station, New York" 1953 (MOMA 220)

WEINER, Sandra, 1921-
 "Easter Morning, Ninth Avenue" 1973 (Rosenblum \199)

WEISBERG, Eugene
 [vase of flowers with painterly quality] c. 1991* (Graphis92 \70)

WEISENBURGER, Skip
 "Campus security in Middletown drag one of 130 protestors from the steps of Wesleyan University's administration building" 1985 (Best11 106c)

WEISS, Jeff, 1942-
 "Cross Fire" 1985-1986* (Photography2 203)

WELCH, Roger, 1948-
 "The Roger Woodward Niagara Falls Project" 1975* (Photography2 159)

WELLER, Bonnie K.
 "A man grips a pole for support during Hurricane Gloria" 1985 (Best11 70a)
 "Michael Dukakis stumps for votes at a child-care facility" 1988 (Best14 91)
 "A young Amish girl watches an auction" 1987 (Best13 106)

"Tide Pool, Point Lobos" 1940 (Art \222)
"Tina Modotti" 1924 (Art \216; Icons 44)
"Torso of Nude" 1925 (MOMA 106)
"Untitled" 1919 (Art \214)
"Wash Bowl, Mexico" 1926 (Decade \19)
"Waterfront, Monterey" 1946* (Marien \6.62)

WESTON, Jonathan
"Mike Eskimo rides the waves of Hookipa Beach in Hawaii" 1990* (Best16 135)

WHARTON, R. Todd
"Out of the Ashes" 1996* (Best22 235a, c)

WHIPPLE, John Adams, 1822-1891
"Henry Winthrop Sargent and Family" 1855* (Photography1 #I-1)
"House of General Washington, Cambridge" c. 1855 (National 164a)
"Hypnotism" c. 1845 (Marien \2.67; Waking #88)
"Moon" 1852 (Marien \2.0; Photography1 \30; Rosenblum2 #17)

WHITE, Bill
[self-promotional] c. 1989* (Graphis89 \43, \235)
[unpublished] c. 1989* (Graphis89 \360)

WHITE, Clarence H., 1871-1925
"Clarence H. White, Jr." c. 1910 (National 164c)
"Columbia College, New York" c. 1910 (Decade \6)
"Evening Interior" 1899 (Hambourg 4)
"The Faun" 1907 (Art \180)
"The Fountain" 1906 (Art \178)
"The Hillside" c. 1898 (Photography1 \101)
"Lady in Black with Statuette" 1908 (Decade 10)
"The Mirror" 1912 (Art \181)
"Miss Thompson" 1907 (Rosenblum2 #407)
"Morning" 1908 (Marien \4.16; Peterson #52)
"Mrs. Clarence H. White" 1906 (MOMA 89)
"New England Street" 1907 (MOMA 87)
"Nude" c. 1909 (Rosenblum2 #358)
"The Orchard" 1902 (Art \179; Rosenblum2 #395; Waking #126)
"Rest Hour (Columbia Teachers College)" 1912 (National \73)
"Ring Toss" 1900-1903 (Art #9; Rosenblum2 #405)
"Ship Construction, Bath, Maine" 1917 (Peterson #33)
"The Skeleton of the Ship, Bath, Maine" 1917 (MOMA 93)
"Spring, a Triptych" 1898 (Szarkowski 158)
"Still Life" 1907 (Art \182)
"Telegraph Poles, Newark, Ohio" 1898 (Photography1 \96)

WHITE, Franklin
"Trapped Boulder, White Mountains" 1859 (National 20c, \28)

WHITE, Jim
"Coffee Cups" c. 1999* (Photo00 58)

WHITE, John Claude
"Young Nepalese ladies wear elaborate costumes reminiscent of their Mongolian heritage" 1920 (Through 150)

WHITE, John H.
"Life in Chicago" 1981 (Capture 120)
"On a tour of the U.S., India's Mother Teresa shares a moment with a Chicago child" 1986 (Best12 51a)
"Shortly after being released from prison in Cape Town, South Africa, Nelson Mandela makes his first public appearance" 1990 (Best16 105)

WHITE, Ken
"Coach's excitement goes sky high after his wrestler won a match" 1987 (Best13 218a)

WHITE, Lily
"Moonlight on the Columbia" c. 1902 (Sandler 121)

WHITE, Lydia B.
"Unidentified woman" 1840s (Sandler 14d)

WHITE, Minor, 1908-1976
"Bill LaRue, Shore Acres, Oregon" 1960 (Decade 80d)
"Blowing Snow on Rock, Rye Beach, New Hampshire" 1966 (Art \346)
"Empty Head" 1962 (Marien \6.38)
"Moencopi Strata, Capitol Reef, Utah" 1962 (Rosenblum2 #665)
"Pacific" or "Sun Over the Pacific–Devil's Slide" 1947 (Decade \47; MOMA 185)
"Peeled Paint" 1959 (Art \342; MOMA 213)
"Rochester" 1954 (Szarkowski 270)
"Root and Frost, Rochester, New York" 1958 (Art \344)
"Sandblaster, San Francisco" 1949 (Art \345)
"Sun in Rock, Devil's Slide" 1947 (Art \347)
"Surf Vertical, San Mateo County" 1947 (Photography2 31)
"Toolshed in Cemetery" 1955 (San #64)
"Untitled" 1958 (San \50)
"Windowsill Daydreaming" 1958 (Art \343; Photography 17)

WHITE, Rodney
"Purdue's Kevin McCants blocks a shot" 1987 (Best13 211d)

WHITE, Timothy
"Jeremy Irons" c. 1992* (Graphis93 124)

WHITE, Wendel A., 1956-
"Starfish and Cube" 1998* (Willis \484)
"Tigerfish Landscape" 1995* (Willis \485)
"Trees with Band" 1995* (Willis \482)
"Trout and Trees" 1995* (Willis \483)

WHITESELL, Wood, 1876-1958
"Margaret Has the Floor" c. 1946 (Peterson #67)

WHITESIDE, George
[self-promotional] c. 1991* (Graphis91 \58)

WHITNEY, Joel E., 1822?-1886 and ZIMMERMAN, Charles A., 1844-after 1873
"Falls of Minnehaha in Winter" c. 1870 (National 164d)

WICK, Kevin
"Portrait of Hat Designer Carine Farley" c. 1999* (Photo00 103)

WIDE WORLD PHOTOS
"An aerial torpedo in flight photographed just after its discharge from a French trench" c. 1914 (Eyes #86)
"The Argonne" c. 1914 (Eyes #85)

"Bit by bit, a solar eclipse reaches totality, as seen from the Northwestern University observation station in Fryeburg, Maine" 1932 (Through 466)
"A new model German trench captured by the French" c. 1914 (Eyes #87)
"Protecting their eyes with crude shades, a crowd watches an eclipse from atop the Empire State Building in New York" 1932 (Through 495)
"Two would-be space travelers experience weightlessness aboard a Convair C-131 transport aircraft" 1960* (Through 474)
"A vivid picture showing early morning attack by the British on the Western Front" 1917 (Eyes #84)

WIDENER, Jeff
"Demonstrations on Tiananmen Square" 1989* (Photos 163)
"A group of Japanese schoolgirls giggle as they try to weather windy Pali Lookout in Honolulu" 1997 (Best23 151c)
"Massacre in Beijing" 1989* (Photos 163)
"Mother comforts her young daughter as her husband leaves for the Persian Gulf on the USS *Reuben James*" 1997 (Best23 121d)

WIDMAN, George
"Police man a rooftop by light from the resultant fire, which burned out of control" 1985 (Best11 23a)
"The search for evidence continues at the scene of the MOVE confrontation" 1985 (Best11 25b)
"A worker pushes a stretcher with a body recovered from the MOVE house" 1985 (Best11 25d)

WIENS, Mark
[ad for an electrical supply company] c. 1995* (Graphis96 150b)
[for the Archdiocese of Wichita, Kansas] c. 1992* (Graphis93 63)

WIGGINS, Cynthia
"Don't Hate Me Because I'm Beautiful" 1996 (Committed 221)
"Idle Hands triptych" 1995 (Willis \526-\528)
"Perception No. 11 (detail)" 1994 (Committed 220)

WIGGINS, Myra Albert, 1869-1956
"The Babe" c. 1900 (Sandler 57a)
"The Forge" 1897 (Rosenblum \95)
"Hunger is the Best Sauce" c. 1900 (Rosenblum \94; Sandler 18)

WILDBOLZ, Jost
[for an Austrian fashion house] c. 1991* (Graphis91 \59); c. 1992* (Graphis93 44, 45)
"Jumping at one's own risk" c. 1991* (Graphis92 \31)

WILDING, Dorothy, 1893-1976
"The Silver Turban" c. 1930 (Rosenblum \140)

WILHELM, Christoph
"Portrait of Poet Natasha" c. 1997* (Graphis97 100)
"Untitled" c. 1996* (Graphis97 frontispiece)

WILHELM, George
"A baby sleeps in the pressbox announcer's booth as a game progresses" 1993* (Best19 240)
"A diver competes in the 3-meter springboard event" 1993* (Best19 170b)
"Driven by wind and weather, windmills stand ready at the foot of the Tehachapi Mountains" 1998* (Best24 50b)
"Just because there's a meet scheduled in this mallard's swimming pool is no reason for the duck to leave" 1985 (Best11 178a)
"The laws of nature are black and white in the early morning stillness; water bird captures its breakfast and skims Lake Sherwood" 1987 (Best13 184)
"Minor league ballparks" 1993* (Best19 168-169)
"Players in a high school water polo match fight for control of the ball" 1993* (Best19 167)
"A weightlifter releases a bar behind her after realizing she cannot lift it overhead" 1993* (Best19 170a)
"Wendy Lian Williams swims to the surface after a dive in the 10-meter platform competition at the U.S. Olympic Festival" 1990* (Best16 122)

WILKES, Stephen
[Alvin Ailey American Dance Theater] c. 1999* (Photo00158)
[Bethlehem Steel Co.] c. 1999* (Photo00 25, 74, 75)
"Black sand beach of Kona, Hawaii" c. 1991* (Graphis91 \24)
"Diver" c. 1999* (Photo00 184)
"Ellis Island–The Forgotten Side" c. 1999* (Photo00 22, 23)
[for the Magazine Publishers of America] c. 1991* (Graphis91 \38)
[from a book entitled *California One: The Pacific Coast Highway*] c. 1989* (Graphis89 \92-96)
"Glacier National Park, Montana" c. 1991* (Graphis92 \207)
"New West fragrance" c. 1991* (Graphis91 \64)
"Totem Pole, Colorado's Monument Valley" c. 1991* (Graphis91 \282)
"Wellfleet, Massachusetts" c. 1991* (Graphis92 \206)

WILKING, Rick T.
"Bob Dole hits the ground hard, falling four feet off a stage" 1996* (Best22 105d)

WILKINS, Chris
"A favorite of many Americans and an enigma to the press corps, North ignores cameras pointing at him during the hearings" 1987 (Best13 7b)
"Lt. Col. Oliver North takes oath before the U.S. House Foreign Relations Committee" 1986* (Best12 7d)

WILKINSON, Carlton, 1958-
"Black Skin: Consciousness" 1997 (Willis \501)
"Can I Fly?" 1997 (Willis \502)
"Holding the Fate of My Ancestors" 1997 (Willis \504)
"Reaching Out" 1992 (Willis \503)

WILLIAMS, Budd, 1949-
"Double Dutch" 1990 (Committed 222)
"Snow Dancer" 1992 (Committed 223)

WILLIAMS, Carla, 1965-
"Grandmother" 1995 (Willis \393)
"Self-portrait" 1990 (Willis \392)
"Shawna and Evelyn" 1995 (Willis \391)

WILLIAMS, Charles, 1908-1986
"Duke Ellington watching card game on train" c. 1955 (Willis \164)

"Pearl Bailey on the set at Paramount Studios" 1955 (Willis \163)
"Richard Nixon with shop owner on Central Avenue in Los Angeles" 1955 (Willis 165)
" 'Sweet' Daddy Grace in Los Angeles Church" c. 1955 (Willis \166)

WILLIAMS, Clarence J., III
"Orphans of Addiction" 1997* (Capture 187)
"The 'three strikes law' is straining jails and adversely affecting poor communities" 1996* (Best22 161, 166c)

WILLIAMS, William Earle, 1950-
"Canaan Baptist Church" 1995 (Willis \540)
"8th Pennsylvania Cavalry Monument, Gettysburg" 1986 (Willis \543)
"Fort Neagley, Nashville" 1995 (Willis \541)
"Jamestown Island, Virginia" 1996 (Willis \542)

WILLIAMS, Gardiner F.
"A crude trolley carries workers into a South African diamond mine" 1906 (Through 232)

WILLIAMS, Gerald S.
"Cultist Mo Africa, who would die with 10 others in the siege and fire, Philadelphia" 1985 (Best11 22b)
"Near the Nicaraguan-Honduran border, Sandinista counter-insurgence troops cover hills and jungles, looking for Contra rebels" 1987 (Best13 76d)

WILLIAMS, Keith
"Busing in Louisville" 1975 (Capture 92)

WILLIAMS, Larry
"The Mods" 1980 (Rolling #42)

WILLIAMS, Maynard Owen
"Grotesque masks bob along in a burst of pre-Lenten revelry in Nice, France" 1926 (Through 110)

WILLIAMS, Milton, 1940-
"Parade Thrills" c. 1979 (Willis \217)

WILLIAMS, Pat Ward, 1948-
"Delia" 1992 (Willis \457)
"I Think" 1996 (Willis \509)
"No" 1996 (Willis \510)

WILLIAMS STUDIO
"A Group of Chairs" c. 1924 (National \55)

WILLIAMSON, Michael
"Building a Better Bayview" 1998 (Best24 168-171)
"Dr. Norman Gray, an entomologist, plays his clarinet while covered with bees" 1988* (Best14 15b)
"During Elvis Week, fan enjoys the antics of an Elvis impersonator in Memphis" 1997 (Best23 231a)
"Fleeing Kosovo" 1999* (Capture 197b)
"Four-year-old and dog get a good view from the family car during the Georgia Day Parade" 1997 (Best23 251)
"Graveyard Shift" 1997 (Best23 200)
"High school basketball teammates comfort a player as she is overcome with joy" 1998 (Best24 71d)
"A man waiting to cross into the U.S. from Mexico peeks through a hole in the border fence" 1997 (Best23 230a)
"Parents kissing the winner of the baby crawling contest" 1997 (Best23 231d)

"Police Captain checks a drug suspect in a part of the body where dealers are known to stash contraband" 1996 (Best22 146b)
"Second quake rocked Mexico City" 1985 (Best11 8a)
"Trying to deal with the ruin torrential rains had brought to Kentucky" 1997 (Best23 230b)

WILLIAMSON, Michael S.
"Homeless in America" 1983-1992 (Best19 81-96)
"Three brothers sit on a junked car seat near the Sacramento River" 1993 (Best19 7d)

WILLS, Bret
"Transportation" c. 1997* (Graphis97 66-67)

WILSON, George Washington
"The Silver Strand, Loch Katrine" c. 1875-1880 (Rosenblum2 #121)

WILSON, Jim
"After two days, rescue workers effected this man's release from the pervasive mud" 1985 (Best11 19a)
"Hasidic men at the funeral of a rabbi in New York City" 1986 (Best12 165b)
"A member of the Dance Theatre of Harlem rehearses before performing" 1986 (Best12 159)
"A young girl awaits help after being pulled from the mud" 1985 (Best11 18a)

WILSON, Kurt
"A Grizzly Season" 1990 (Best16 132-133)
"Missoula Big Sky High School swimmers 'shave down' before the Montana state high-school meet" 1990 (Best16 121)
"Pole vaulter Brian Schweyen of Montana State University misses clearing the bar at 17 feet, 6 inches by a shirttail" 1990 (Best16 134d)
"University of Montana's Linda Mendel and Boise State University's Becky Sievers fight for a loose ball" 1990 (Best16 134a)
"A young boy dives into an outdoor plunge at Hot Springs, Montana" 1995* (Best21 157a)

WILTSIE, Gordon
"Mere specks against the snow and ice, determined climbers approach the 6,550-foot summit of Gremlin's Cap in the Cordillera Sarmiento of southern Chile" 1994* (Through 310)

WIMPEY, Chris
[images related to time and change, and to the changing nature of beauty in objects revealing aspects previously concealed] c. 1991* (Graphis92 \57, \58, \59)
"Typical American landscape seen through front window of a car" c. 1991* (Graphis91 \305)

WINDSOR, V. Jane
"A mother-daughter modeling team illustrates the communication problems between teenagers and their parents" 1987 (Best13 142a)

WINOGRAND, Gary, 1928-1984
"American Legion Convention, Dallas, Texas" 1964 (Marien \6.46)
"Circle Line Ferry, New York" 1971 (Szarkowski 263)
"Dallas" 1964 (MOMA 240)
"Kent State Demonstration, Washington, D.C." 1970

(Goldberg 168)
"Los Angeles" 1964 (MOMA 227)
"New York" 1963 (Photography 50)
"New York City" 1969 (Decade 76a)
"Park Avenue, New York" 1959 (MOMA 245)
"Untitled" n.d. (Decade \70); 1950s (Icons 137); c. 1964 (Rosenblum2 #675)

WINOKUR, Neil, 1945-
"William Wegman: Totem" 1985* (Photography2 230)

WINTER, Conny J.
[from *Design in Europe* calendar] c. 1992* (Graphis93 159)
[self-promotional] c. 1989* (Graphis90 \26)

WINTER, Steve
"In Guatemala, a brightly feathered quetzal looks for some of its favorite foods–small avocado-like fruits" 1998* (Through 326)
"Male jaguar prowling his territory in Belize, the world's first jaguar preserve" 2001* (Through 330)

WINTERS, Daniel
"Bill Maher" c. 1999* (Photo00 100)
"Johnny Depp" c. 1999* (Photo00 160)
"Man in a swimming pool" c. 1990 (Graphis90 \178)
"Patti Smith" c. 1997* (Graphis97 116)

WINTERS, Susan
"An elderly man works his way up a steep street" 1986 (Best12 189)
"Moses Malone rides along with the women in a physical therapy center" 1986 (Best12 226d)
"Vietnam veterans embrace during dedication ceremonies for a memorial to be constructed in Philadelphia" 1986 (Best12 59a)
"When a 'senior prom' was held to celebrate the opening of a center for senior citizens, a service fraternity of young men provided dance partners for many single women" 1986 (Best12 181b)
"Youngsters in a mobile home watch as firemen douse a fire in an adjoining mobile home" 1986 (Best12 177a)

WINTERSTELLER, Nan
"The shades of summer offer a look at what's new in eyewear" 1987* (Best13 182b)

WIRTZ, Michael S.
"Afghan woman puts on her burka before leaving her home in Kabul" 1997* (Best23 181d)
"Shampoo–Nature's Ingredients" 1993* (Best19 178a)
"A sidewalk vendor's mirrors reflect street life in downtown Port-au-Prince" 1992 (Best18 86)
"Verdigre father and daughters walk on the family farm they are about to lose" 1985 (Best11 56b)
"When her grandson, Robert Tames, left to fight in the Persian Gulf war, his picture was put on the front door" 1991 (Best17 75)

WISSING, Michael
[self-promotional] c. 1990* (Graphis90 \335)
[pears] c. 1992* (Graphis93 91)

WITHERS, Ernest C., 1922-
"Bus station, colored waiting room, Memphis, Tennessee" c. 1960s (Willis \177)

"Dr. Martin Luther King, Jr., Confronted by Police at Medgar Ever's Funeral, Jackson, Mississippi" 1963 (Committed 225)
"Elvis Presley and B. B. King in Memphis, Tennessee" 1957 (Willis \178)
"Faith healer, Memphis" c. 1960s (Willis \179)
"I Am a Man: Sanitation Workers Strike, Memphis, Tennessee" 1968 (Committed 224; Goldberg 164; Marien \6.68; Willis \176)

WITHINGTON, Eliza, 1825-1877
"Miners' Headquarters by the River" c. 1874 (Rosenblum \43)

WITKIEWICZ, Stanislaw Ignacy, 1885-1939
"Self-Portrait" 1912 (Waking #160)

WITKIN, Joel-Peter, 1939-
"Expulsion from Paradise of Adam and Eve" 1980 (Photography2 200; Rosenblum2 #762)
"The Prince Imperial" 1981 (San \41)
"Still Life with Breast" 2001 (Photography 224)

WITMER, Jim
"Biscotti" 1997* (Best23 144d)
"Four phases in the life of a morning glory flower" 1998* (Best24 48d)

WITTEVEEN, Bettina
"Jon" 1997 (Marien \7.19)

WITTICK, Ben, 1845-1903
"At the Snake Dance, Moqui Pueblo of Hualpi, Arizona" 1897 (Photography1 \77)

WITTY, Patrick
"Before mounting the bull at the rodeo, Moore spends a moment alone in prayer" 1995* (Best21 96)
"Before Phoenix firemen start their attack on a tire company fire, a child rides his bike dangerously close to the fire" 1995* (Best21 97d)
"In between classes, James get a flirtatious hug" 1995 (Best21 101c)
"Junebug is playing James' football position during his injury" 1995 (Best21 100)
"On the way to a game, James gazes out the window of the team bus" 1995 (Best21 101d)
"Pulitzer Prize composer Karel Husa congratulates Marshall Scott backstage" 1995 (Best21 99b)
"Sunshine pouring through skylights casts a visitor's shadow on the floor at noon in the Phoenix Central Library" 1995* (Best21 97c)
"Western Kentucky wins the Sun Belt Basketball championship" 1995 (Best21 131)
"Western Kentucky's Allen comes down on Louisiana Tech guard after a head-fake" 1995 (Best21 98)
"While drinking in the hallway of the hotel, Whipple reacts to a friend's comments" 1995 (Best21 99a)

WOJNAROWICZ, David
"Bad Moon Rising" 1989* (Photography 164)
"Untitled" 1988-1989 (Photography 165)

WOLBOURNE, Eva
"Zylpha" c. 1890 (Sandler 68c)

WOLCOTT, Marion Post, 1910-
"Ad on the side of a drugstore window" 1939 (Fisher 152)

"Along the beach" 1939 (Documenting 184c)
"At the beach" 1939 (Documenting 186a, 187b)
"At the track, Hialeah Park" 1939 (Documenting 183c, 184b)
"Baptism in Kentucky" 1940 (Sandler 140)
"Bar in a private home" 1939 (Documenting 180a)
"A barn on rich farmland" 1939 (Fisher 34)
"Before the race, Hialeah Park" 1939 (Documenting 183a)
"Buildings on main street of a ghost town. Judith Basin, Montana" 1941 (Fisher 28, 29)
"Center of town. Woodstock, Vermont" or "After a Blizzard in Woodstock, Vermont" 1940 (Fisher 44; Sandler 128)
"Children in the bedroom of their home. Charleston, West Virginia" 1938 (Fisher 49)
"Children on way home from school" 1940 (Sandler 83)
"Coal mine tipple in foreground. Caples, West Virginia" 1938 (Fisher 50)
"Coal mining community. Welch, West Virginia" n.d. (Fisher 31)
"Corn shocks in a field. Frederick, Maryland" 1940 (Fisher 33)
"Drug store window display in a mining town" 1938 (Fisher 36)
"Day laborers waiting to be paid, Marcella Plantation, Mileston, Mississippi" 1939 (Women \116)
"Employment agency" 1939 (Documenting 182a)
"Family of Migrant Packinghouse Workers, Homestead, Florida" 1939 (Rosenblum2 #469)
"Family on Porch" 1940 (Sandler 70)
"A farm, Bucks County, Pennsylvania" 1939 (Fisher 30)
[from "Fair Is Our Land"] n.d. (Fisher 148)
"Glacier National Park, Montana" 1941 (Sandler 129)
"Horse on a cold day, Woodstock, Vermont" 1940 (Documenting 51)
"Hotel and service station" 1939 (Documenting 181c)
"Hotel entrance" 1939 (Documenting 178a)
"A juke joint and bar in the vegetable section of the Glades of south central Florida" 1941 (Fisher 41)
"A meal on the sidewalk at the beach" 1939 (Documenting 185d; Women \115)
"Migrant Vegetable Pickers Waiting to be Paid" 1939 (Goldberg 100)
"Miner who has worked in the mine since he was 14 years old. West Virginia" 1938 (Fisher 47)
"A more prosperous miner listening to the radio. West Virginia" n.d. (Fisher 48)
"Mother and Daughter" 1939 (Sandler 82)
"Movie advertisement on the side of a building. Welch, West Virginia" 1938 (Fisher 43)
"Negro man entering movie theater 'colored' entrance. Belzoni, Missouri" 1939 (Fisher 40; Sandler 81)
"Pahokee 'Hotel' (Migrant vegetable pickers' quarters near Homestead, Florida)" 1941 (Rosenblum \169)
"Post Office in Blizzard, Aspen, Colorado" 1941 (Decade 49c)
"Private home" 1939 (Documenting 180b)
"Racetrack, Hialeah Park" 1939 (Documenting 184a)
"Road , wheat and corn fields. Harvre, Montana" 1941 (Fisher 52)
"Tenant farmer's children, one with rickets, on badly eroded landed near Wadsboro, North Carolina" 1938 (Goldberg 95)
"Waterfront home" 1939 (Documenting 179b)

"Whittler, Camden, Alabama" 1939 (Women \114)
"Young people in a 'juke joint' and bar in the vegetable section of the Glades area of south central Florida" n.d. (Fisher 45)

WOLF, Bruce
[for Martex product line] c. 1991* (Graphis92 \168)

WOLF, Reinhart
[for a book entitled *Japan, the Beauty of Food*] c. 1989* (Graphis89 \329-\346)

WOLFORD, Jerry
"Tax Storm" 1995* (Best21 150a)

WOLINSKY, Cary
"Clothespins keep wet plaster in place while dead cane toads dry in a taxidermy shop in Queensland, Australia" 2000* (Through 426)
"A runner's tracks add yet another element to the sand-and-surf patterns on Cottesloe Beach in Perth, Australia" 1982* (Through 402)

WOLMAN, Baron
"B. B. King" 1968 (Rolling #6)
"Little Richard" 1968 (Rolling #3)
"Phil Spector" 1969 (Rolling #7)
"Smokey Robinson" 1968 (Rolling #2)
"Tiny Tim" 1968 (Rolling #5)

WOLS, 1913-1951
"Self-Portrait" n.d. (Icons 110)
"Untitled" n.d. (Icons 111)

WONG, H. S.
"Wounded by a bomb, a Chinese boy howls pitifully in Shanghai's railroad station" 1937 (Lacayo 80a)

WONG, Lui Kit
"A glove and a prayer: photo essay on boxer" 1985 (Best11 216-219)
"Oregon's Sally Growe comes away with the ball" 1995* (Best21 110a)
"Putting the squeeze on a rugby player" 1987 (Best13 215)

WOO, David
"Well-schooled fish know that citrus imparts a piquant treat to the palate" 1987* (Best13 186a)

WOOD, David
"Saragosa, Texas, was reduced to a pile of rubble when a tornado flattened town" 1987 (Best13 74)
"Volunteers work shoulder to shoulder, searching for survivors in quake debris" 1985* (Best11 6)

WOOD, George Bacon, 1832-1910
"Aren't They Beauties?" c. 1885 (Photography1 \97)
"Elsie" c. 1886 (Photography1 #VI-8)

WOOD, James B.
[self-promotional] c. 1991* (Graphis91 \155)

WOOD, John, 1922-
"A Summer Transmission" 1968 (Photography2 99)

WOOD, John James
[fruit] c. 1989* (Graphis89 \311)

WOODBRIDGE, Louise Deshong, 1848-1925
"Ladies' Pool" c. 1890 (Women \6)
"Outlet of the Lake" 1885 (Photography1 #VI-1;
Rosenblum2 #390)

WOODS, Suné, 1975-
"Moses and Rongee Tjiriange" 1998* (Committed
226)
"Othika" 1998* (Committed 227)

WOOLLEY, C. A., 1834-1922
"Trucanini" 1866* (Marien \3.85)

WOOTTEN, Bayard, 1875-1959
"Hands of Nell C. Graves" 1930s (Rosenblum \145)

WORCESTER, Dean
"A photographer and geologist from the Philippine
Bureau of Science get an up-close look at the
erupting Taal Volcano" 1912 (Through 394)

WORDEN, Willard
"Market Street, San Francisco" 1906 (MOMA 76)

WORTH, Don
"Aspen Trees, New Mexico" 1958 (Decade \61)

WRESZIN, Daniel
[ad for athletic fashion] c. 1992* (Graphis93 42)

WRIGHT (attributed)
"Train wreck at the Providence-Worcester Railroad
near Pawtucket, Rhode Island" 1853 (Eyes #7)

WRIGHT, Frank Lloyd, 1869-1959
"Romeo and Juliet" c. 1900 (Waking #158)

WRIGHT, Holly, 1941-
[from series Vanity] 1986 (Women \170); 1988
(Women \169)

WRIGHT, Mel, 1942-
"Boy on Beach with Mask" 1985* (Committed 228)
"Boy with Red Balloon" 1983* (Committed 229)
"Sun Ra in Flight 1-3" 1978 (Willis \285-\287)

WRINN, Joe
"Tufts' student rushes at Contra leader Calero during
speech at Harvard Law School" 1987 (Best13 69)

WULF-EIKE
[adolescents] c. 1992* (Graphis93 106c)
[twins] c. 1992* (Graphis93 106a)

WULZ, Wanda, 1903-1984
"Ich und Katze (I and Cat)" 1932 (Hambourg \56;
Icons frontispiece; Rosenblum \111; Women \87)

WYKE, Michael
"A campesino in a café in Danli, Honduras" 1986
(Best12 123a)

WYNN, Lance
"Boxer Thomas Hearns at the end of a sparring
session" 1985 (Best11 214a)
"Rhonda Christie flips teammate Amy Harris over her
shoulder as the two collide while going for a loose
ball" 1986 (Best12 205)
"A taste of victory in a junior Olympics sprint race"
1985 (Best11 172c)

—Y—

YAMAHATA, Yosuke, 1917-1966
"A Boy with a Rice Ball" 1952 (Marien \6.24)

YAMANAKA, Cindy
"2-year-old was hit in the foot by a bullet that came
through the wall of her home" 1991* (Best17 78a)

YAMASAKI, Taro M.
"Jackson State Prison" 1980* (Capture 114)

YAMASHITA, Michael S.
"Catching the Light and the imagination, the Great
Wall snakes along the crests of mountains in
China" 2003* (Through 146)
"Fashion Models in China" 1997* (Through 6)
"Tajik children go over class notes before school in a
mountain village of China's Xinjiang Province"
2001* (Through 168)
"A tourist approaches the southern most point of
China, traditionally considered to be the end of the
civilized world" 1998* (Best24 188)

YAMPOLSKY, Mariana, 1925-
"Untitled" 1965 (Rosenblum \186)

YANG LING, 1922-
"Villagers Welcome the People's Liberation Army,
Yenan" 1949 (Rosenblum \194)

YASHIRO, Toshihiro
"Yangaginoya Fukushima" 1994 (Marien \7.20)

YAVNO, Max
"Two Chinese" 1947 (Decade \52)

YEE, David
"Students cheer after adding fuel to a bonfire" 1992
(Best18 134d)

YEVONDE, Madame, 1893-1975
"Florence Lambert (Mrs. Constant Lambert)" 1933
(Women \77)
"Medusa" 1933* (Women \78)
"Self-Portrait" 1940* (Rosenblum \5)

YLEN, Mark W.
"Finish of a 400-meter race at the district track meet"
1995* (Best21 116d)

YONAN, Dennis
"A curious resident of New Haven is stopped in his
tracks by Hurricane Gloria" 1985 (Best11 70c)

YONG, Xu
"Hutong in the Rain" 1989 (Rosenblum2 #725)

YOUNG, Gene, 1948-
"Possession" 1995 (Committed 230)
"Untitled No. 12" 1998 (Committed 231)

YURCHENKO, Boris
[Soviet Army tanks line up near the Russian
Parliament] 1991* (Graphis93 57)

YVA, 1900-1942
"Hands Study" c. 1920 (Rosenblum \134)

—Z—

ZALAZNIK, David
"Highway patrolmen peer into the cab of a pickup containing the body of Iowa farmer Dale Burr, who committed suicide" 1985 (Best11 59a)

ZALE, Alan
"Horses clear a jump at Breeders Cup Steeple Chase, Belmont Park" 1993 (Best19 142a)

ZALESKI, Mark
"Paralympic athletes competing" 1996* (Best22 123)

ZANDER AND LABISCH
"Six actors in search of an author" n.d. (Vanity 145)

ZAPOTOSKY, Dave
"Pope John Paul II embraces a 5-year-old AIDS victim Brendan O'Rourke" 1987* (Best13 17c)

ZARS, Bill
"High school player reacts as she scores her third goal" 1997* (Best23 176c)

ZEALY, J. T., 1812-1893
"Jack (Driver), Guinea. Plantation of B. F. Taylor, Esq. Columbia, South Carolina" 1850 (Marien \2.21, \2.22; Photography1 \25)

ZECCHIN, Franco
"Wife and daughters of Benedetto Grado at the site of his murder, Palermo" 1983 (Photography 120a)

ZECHER, Barry L.
"Old and new sometimes travel the same road as an Amish man in a horse-drawn sleigh is followed by a snowmobile near Leola" 1987 (Best13 164b)

ZEHNDER, Bruno P.
"Adélie penguins on the Antarctic's eternal ice" c. 1989* (Graphis89 \197)
"Adult Emperor Penguin with chicks on the sea ice of the Antarctic" c. 1991* (Graphis91 \351)
"Exploitation of the South Pole" c. 1991* (Graphis91 \352)
"Iceberg and bird in the Antarctic" c. 1991* (Graphis91 \283)
"In October in Antarctica, a parent Emperor penguin tries to regurgitate food to its starving chick whose bill is frozen shut" 1995* (Best21 159c)
"U.S. Coast Guard helicopter lands on the sea ice in the Antarctic while an Emperor Penguin escapes the intrusion" c. 1991* (Graphis91 \353)

ZEHRT, Jack
"A glider crashes toward the ground after falling apart in midair" 1943 (Best18 11)

ZELCK, Andre
"Untitled" 1992-1996* (Marien \7.64)

ZELMA, Georgi, 1906-
"Assault of the 13th Guard, Stalingrad" 1942 (Art \420)
"A Tank called 'Motherland' " c. 1942 (Art \418)

ZEMLIANICHENKO, Alexander
"Russian Coup" 1991* (Capture 162)
"Two soldiers under Azerbaijani rebel commander relax on an amusement ride" 1993* (Best19 119)
"Yeltsin Rocks in Rostov" 1996* (Capture 182)

ZENT, Sherman
"Ellen Rosenberg cares for injured birds until they can be released" 1993* (Best19 72b)
"In West Palm Beach, 7-year-old offers a bouquet to Britain's Princess Diana as she and Prince Charles arrive" 1985 (Best11 89b)
"More than 500 pleasure boats accompanied the tired Mercedes I out to sea, where 360 pounds of TNT sank the hulk" 1985 (Best11 109)
"When a cold weather snap killed fish in a local Florida lake, opportunistic turkey vultures arrived to feast on the remains" 1995* (Best21 159d)

ZERBY, Steven
"Bulletproof sunglasses cross the line from high-tech to high fashion" 1987* (Best13 178d)

ZESCHIN, Elizabeth
"Yashina Kamal, New York City" c. 1991* (Graphis92 \129)

ZICH, John
"What better way for visitors from up north to cool off on a hot Florida night than with a dip in the neighborhood pool" 1987 (Best13 118)

ZIELENBACH, Tim
"In Mogadishu, a child holds his mother's hand in a center for Somalis displaced by famine and civil war" 1992* (Best18 69)

ZILLE, Heinrich, 1858-1929
"Cobbler Shop" 1899 (Icons 10)
"9 Boys Practicing Handstands" c. 1900 (Icons 11; Rosenblum2 #311)

ZIMBEROFF, Tom
"Herbert von Karajan" c. 1990* (Graphis90 \136) [promotional book] c. 1992* (Graphis93 98, 99)
"Young man from the Mexican-American district of Los Angeles" c. 1989 (Graphis89 \142)

ZIMMERMAN, John G.
"Carl Lewis after winning his fourth gold medal at the 1984 Olympics" 1984* (Life 146b)
"Kurt Thomas" 1979* (Life 147)

ZIMMERMAN, Matthew
"Marilyn Monroe" 1954 (Lacayo 151; Photos 83); 1955 (Monk #36)

ZIMMERMAN, Shaun
"Dad had gone to work and Mom was still in bed when two tots went out to play" 1990 (Best16 174)

ZINTSMASTER STUDIO, 1885-1945
"Flood, Herkimer, New York" 1910 (National 165)

ZIZOLA, Francesco
"Hospital in Sulaymaniyah" 1997 (Best23 129b)
"A heroin user sits on a curb in the Canton Region" 1998 (Best24 187)

ZOLA, Émile
"Denise Sitting, Doll in her Arms" c. 1897-1902* (Marien \4.37)
"A Restaurant, from the First Floor or Staircase of the

Eiffel Tower, Paris" 1900 (Rosenblum2 #304)

ZOVKO, Chuck
 "Philadelphia 76er Julius 'Dr. J.' Erving, fights back
 his emotions during a ceremony honoring him at
 his last regular home game" 1987 (Best13 117a)
 "Sizzling Summer Shades" 1986* (Best12 111a)

ZUMBRUNN, Michael
 "2 views of the *Talbot Lago SS* from the Guggisberg
 Collection" c. 1990* (Graphis90 \232, \233)

ZUREK, Nikolay
 "Annual Report for the Pacific Gas + Electric Co." c.
 1989* (Graphis89 \104)
 "Part of a Boeing 747" c. 1991 (Graphis91 \259)
 [steel mill in Ohio] c. 1992 * (Graphis93 173)

ZWART, Jan
 "Aernout Overbeeke" n.d. (Graphis92 20)

ZWART, Piet
 "Cabbage" 1930 (Rosenblum2 #515)

ZWICKY, Fred
 "AIDS patient thwarts a surprise attack from friend at
 a car wash" 1992 (Best18 117b)
 "Before He Leaves" 1992 (Best18 213-216)
 "John Mueller, whose company is the nation's largest
 manufacturer of fly swatters" 1993* (Best19 64a)

II
SUBJECTS

ACCIDENTS (Vehicular)

air show plane crash in "Three Italian air force jets collide during an air show over the U.S. Air Base at Ramstein, West Germany" 1988 Charles Daughty (Best14 71)

airplane crash among trees in "Plane crash in Adirondacks" 1935 Photographer Unknown (Goldberg 97)

airplane crash in hill above graveyard in "A downed plane near a graveyard in northern Nicaragua is a reminder of the revolution that brought the Sandinistas to power" 1986 Steve Ringman (Best12 57b)

airplane crash near railroad tracks in "A freight train eases past a Piedmont Airlines Boeing 737 which ran off the end of a runway" 1986 Joe Edens (Best12 57d)

airplane crash site and the remains of charred houses in "Firemen consider charred remnants of homes in Cerritos, destroyed when AeroMexico jetliner crashed, killing 71" 1986 Sam Mircovich (Best12 57a)

airplane flying over wreckage of jet in "FAA officials inspect the tail section of Delta Flight 191" 1985 Michael Delaney (Best11 52)

airplane in large sections after crash in "After taking off in near blizzard conditions, Continental Flight 1713 slammed back to the runway and flipped over at Denver's Stapleton Airport" 1987 John Betancourt (Best13 73b)

airplane wreckage strewn on side of mountain in "Rescue crews search the wreckage of a Japan Air Lines 747 in rugged terrain in central Japan" 1985 Itsuo Inoue (Best11 54c)

airplane wreckage strewn over ground in "A coroner's deputy surveys the wreckage of a PSA jet that crashed" 1987 Brant Ward (Best13 73a)

bicycle race crash in "John Ficarra crashes while traveling at more than 60 mph during a gravity bike race" 1987 John Blackmer (Best13 214a)

bloodied children sitting on ground in "After their car smashed into a tree, the children wait for word on a fourth passenger" 1985 Lois Bernstein (Best11 102d)

cab of truck hanging across overpass in "The cab of a tractor-trailer dangles over the railings of Interstate 10 in New Orleans after a rush-hour accident" 1985 Bryan S. Berteaux (Best11 103b)

cab of truck plunging over a bridge as driver and passenger are being rescued in "Rescue on Pit River Bridge" 1953 Virginia Schau (Capture 33)

Cadillac on top of a Corvette in "1996 Corvette was rolled over by the driver of a Cadillac" 1996* Wally Skalij (Best22 245d)

car on top of open fire hydrant in "A utility worker tries to shut off a fire hydrant after a car went out of control" 1985 Debra Myrent (Best11 102c)

car upside down in river in "Swift, high water of Kings River swirls over a car that crashed in Sequoia National Park in California" 1985 Robert E. Durell (Best11 103a)

car wedged under truck in "Bart Forrest of Tustin, Calif., waits for a tow truck to dislodge his car from underneath a truck" 1990 Peggy Peattie (Best16 187b)

crushed red wagon and covered body in street in "Wheels of Death" 1958 William Seaman (Capture 43)

driver escaping from burning race car in "Phillip Ross dives from a fiery race car during a qualifying race" 1991* Tom Copeland (Best17 146a)

glider with one wing, crashing to ground in "A glider crashes toward the ground after falling apart in midair" 1943 Jack Zehrt (Best18 11)

men walking through airplane wreckage among trees in "Three priests walk through the wreckage of a Midwest Airlines DC-9 that crashed after takeoff" 1985 Mark Hertzberg (Best11 55a)

ocean liner plunging beneath the sea in "Sinking of *Andrea Doria*" 1956 Harry A. Trask (Capture 38)

overhead shot of smoke billowing from airplane that crashed into a house in "Bomber Burns After Crash in Yard" 1955 George Mattson and *Daily News Staff* (Capture 36)

passengers in airplane with fuselage ripped apart in "Aloha Airlines Flight 243" 1988* Robert Nichols (Best14 86a; Life 134)

piece of machinery hanging over the edge of a highway in "A huge rotary for an oil refinery rests precariously on a freeway guardrail after rolling off flatbed truck that was carrying it" 1988 Peggy Peattie (Best14 206c)

police car hit stolen truck in "Salinas police officer explains that it wasn't his fault his car hit a stolen truck head-on during a chase" 1990* Richard D. Green (Best16 169)

pulling a woman to safety from truck hanging over a bridge in "Linda St. Germain clings to Bristol Life Saving Crew member as they are pulled to safety from the wreckage of St. Germain's truck" 1990 Chris Taylor (Best16 113)

race car in flames in "Mike Laughlin, Jr., crawls away from his blazing race car after he crashed" 1996* Jim Virga (Best22 204c); "Trapped in his car after crashing" 1996* Chuck Fadely (Best22 204a)

race car crashes in "Indianapolis 500 rookie driver crashes into the turn one wall" 1996* Martin Seppala (Best22 204d)

racing cars crash as car becomes airborne in "Racing collision of Stan Fox after his car hit Eddie Cheever's car on the first lap of the 1995 Indianapolis 500" 1995* Robert Brodbeck (Best21 122b, 123); Jim Stewart (Best21 122a)

rescuers with driver of jackknifed truck in "After his tractor-trailer jackknifed, flipped a guardrail and caught fire, trucker Tom McClanahan receives help from motorists" 1986 Pat Mc Donogh (Best12 77a)

truck crashed into beauty store window in "It was business as usual for beautician Yolanda Ponce after a pickup truck intruded" 1986 (Best12 122b)

truck rollover and rescuers with driver in "Rescue workers pull a truck driver from wreckage after a rollover" 1993* Allan Detrich (Best19 228a)

wrecked train engine dangling in midair in "An almost incredible train accident at the Montparnasse Railroad Station" 1891-1895 Burton Holmes (Eyes #67)

ACCORDION

family picnicking in bathing suits listening to accordion in "Return of the Cossacks" 1998* Gerd Ludwig (Best24 38d)

playing near a piano in "At Home in Vietnam" c. 1989* Geoffrey Clifford (Graphis89 \254)

playing in a pub in "Musicians in a Prague pub pay tribute to a revered Czech antihero" 1993* James Stanfield (Through 112)

tearful man playing near group of women in "As FDR's body is carried to the train at Warm Springs on the day after his death, CPO Graham Jackson's tear-stained face symbolizes the nation's sorrow" 1945 Edward Clark (Eyes #206)

ADDICTS

arrests, shootings, and hospitals in photo essay in "Kids, guns and blood" 1987 Manny Crisostomo (Best13 46-49)

boy watching addict shooting drugs in "Gerald, an eight-year-old addict, eyes a needle after successfully being clean for 60 days" 1995* Andre Lambertson (Best21 187a)

child in sewer home in "One of the estimated 2,000 street children in Bucharest sniffs Arviac while in his underground home" 1995 Lelen Bourgoignie (Best21 188)

construction worker sucks cocaine fumes from a can in "The Graveyard" 1987 Michel deCille (Capture 149)

couple in bed shooting drugs in "Untitled" 1963-1971 Larry Clark (San #65)

crack addict near crying child in "A woman smoking crack with her child beside her" 1990 Eugene Richards (Best16 176; Lacayo 183c)

distributing needles to people on street in "Jon Parker, founder of the National AIDS Brigade, distributes needles and alcohol to addicts" 1990 David Binder (Best16 9c)

injecting heroine in "Two brothers inject each other with heroine" 1997* Andre Lambertson (Best23 134a)

man smoking a joint in "California's Fragile Future" 1996 Carolyn Cole (Best22 238b)

photo essay on abandoned buildings being torn down in neighborhood of addicts in "On the Street Where Heroin Lived" 1992 Ron Tarver (Best18 185-188)

photo essay on addict couple and prostitution in "A. J. and Jim Bob" 1988 Merry Alpern (Best14 168-172)

photo essay on addicts and death of unintended victims in "Trouble in Paradise" 1992 Eugene Richards (Best18 189-194)

photo essay on addicts and their children in "Off Broadway" 1997 Brenda Kenneally (Best23 136c, 242-244)

photo essay on addicts, dealers, and prostitutes in "HIV in the former Soviet Union" 1997 John Ranard (Best23 208)

photo essay on drug dealers, drug addicts, and drug busts in " 'They Still Make It Cool' " 1986-1991 Eugene Richards (Best17 133-144)

photo essay on the home life of children of an addict in "Our House" 1991 Bradley Clift (Best17 219-22)

photo essay on the users, dealers, and victims of a Brooklyn neighborhood in "Crack: The Downfall of a Neighborhood" 1988 Eugene Richards (Best14 61-70)

photo essay on young dealers and addicts in "Children of the Damned" 1990 Eugene Richards (Best16 157)

photo essay showing addicts shooting-up, propositioning an elderly man, and leaving their children in "Drug addicts–a series of photographs" 1991 Bradley Clift (Best17 63-66); 1998 Bradley Clift (Best24 126-135)

pregnant woman shooting drugs in "Untitled" 1971 Larry Clark (San \51)

series on family's use of drugs and alcohol in "Darkness at home" 1981-1982* Donna Ferrato (Best16 13-20)

teenagers smoking marijuana in "13- and 14-year-old boys in New Haven smoke marijuana, using a technique called a 'shotgun' to give them a quicker, more intense high" 1986 Bradley Clift (Best12 176a)

teenagers sniffing aerosol in school restroom in "Inhaling nitrous oxide from air freshener in the restroom during nutrition break at the Hollywood High School for the Performing Arts" 1995* Lauren Greenfield (Best21 84)

using needles in a lot in Harlem in "Used hypodermic needles litter an abandoned lot in East Harlem frequented by heroin addicts" 1991 Peter Essick (Best17 51a)

young addict shooting up in "Age '21' in America" 1991 John Kaplan (Capture 164f)

young man shooting drugs in "Untitled" 1971 Larry Clark (Rosenblum2 #699)

ADOPTION

Baby Jessica and her adoptive father in "Baby Jessica" 1993* (Best19 222)

father carrying son from adoptive family in "Baby Richard reaches back for his adoptive parents as his biological father Otakar Kirchner takes custody of the child" 1995* Barry Jarvinen (Best21 179c)

photo essay on Pennsylvania couple that adopted Polish children in "International Family" 1992 Patrick Tehan (Best18 203-208)

President Clinton and adopted boy in "During the signing ceremony for the Adoption Safe Families Act, 7-year-old sits next to President Clinton" 1997 Susan Biddle (Best23 131d)

ADVERTISING PHOTOGRAPHY see also FASHION PHOTOGRAPHY

absurd photo of men sitting on kitchen wall in "Illustrate a story on off-the-wall-DJs" 1985* Gary Chapman (Best11 156)

Audi with door open in [ad for the 1990 Audi V8 Quattro] c. 1991 Rick Rusing (Graphis91 \159, \160)

bags and briefcases in [ad for briefcases and bags] c. 1991* Emanuel Raab (Graphis92 \182, \183)

bed linens on a four-poster bed in [the Martex product line] c. 1991* Bruce Wolf (Graphis92 \168)

beer bottle label for [poster to promote beer] c. 1990* Naohiko Hoshino (Graphis90 \341)

bicycle helmets on model in [ad for Bell Bicycle Helmets] c. 1995* Barry Robinson (Graphis96 142, 144)

boots for rugged work in "Cornfield after the Harvest" c. 1991 Nadav Kander (Graphis92 \189); [durability and heavy-duty properties of Dunham boots] c. 1991 Nadav Kander (Graphis92 \176, \177, \208)

bottle on table with beans in [advertising photograph] c. 1990 Andre Baranowski (Graphis90 \313)

bottles and glass in "Smirnoff Vodka" c. 1991* Jody Dole (Graphis91 \143)

bras and girdles on woman in various poses in "Playtex" c. 1950 Ralph Bartholomew (Goldberg 70)

car seat in [ad for Infiniti by Nissan] c. 1990* Clint Clemens (Graphis90 \231)

champagne coming out of a glass in "Champagne jumps out of the glass" 1985* Michael P. Franklin (Best11 148a)

chair and chest in "Photographs for a Spanish furniture producer" c. 1989* Jaime Malé (Graphis89 \116-\117)

classic cars and outdoor café in [ad for a car insurance company] c. 1995* Hans Pieler (Graphis96 163)

collar on checker-board pattern in "Advertisement for George P. Ide Company (Ide Collar)" c. 1922 Paul Outerbridge, Jr. (Goldberg 62; Hambourg \112; Icons 78; MOMA 122; Marien \5.35; Peterson #48)

colorful bodysuits from [self-promotional] c. 1989* Alexandar Josephs (Graphis89 \45-\48)

combs in "Conran Shop Combs" c. 1999* Michael Davies (Photo00 173)

computer in [Apple iMac] c. 1999* Mark Laita (Photo00 170)

computer details in [ad for Acuson Computers] c. 1991* R. J. Muna (Graphis92 \180, \181)

contemporary buildings for [a leasing brochure] c. 1992* Jim Hedrich (Graphis93 180, 181)

convertible parked in front of train station in [ad for National car rental company] c. 1990* Todd A. Smith (Graphis90 \229)

couple picnicking on bright blanket from [series of posters to promote artificial sweeteners] c. 1990* Bishin Jumonji (Graphis90 \155)

duck on top of black helmet of person in black leather jacket from [self-promotional] c. 1989* Bill White (Graphis89 \43)

flashlight on leather jacket in "Chia Bean, Inc." c. 1989* Rick English (Graphis89 \234)

flowers, soap and perfume bottle in [ad for Issey Miyake's soap and fragrance] c. 1992* Sheila Metzner (Graphis93 72)

fruit and draped leather in "Fruits and leather" c. 1989* Myron Beck (Graphis89 \225, \226)

fruits and vegetables arranged like a painting in "Assignment was to show the how and why of exotic fruit and vegetables" 1985* Brian Hagiwara (Best11 157b)

house on canal used for coffee ad in "An abandoned house on the bank of the Canal du Midi" c. 1990* Harry DeZitter (Graphis90 \71)

large cup and saucer labeled "hot coffee" on ground in "Hot Coffee, Mojave Desert" 1937 Edward Weston (MOMA 153)

glass objects for [Marsberger Glassworks] c. 1992* Michael Sieger (Graphis93 142, 143)

hands doing various tasks in "Jergens ad for *Ladies Home Journal*" 1926 Edward Steichen (Goldberg 66)

lace caps in advertising photograph in "Babies' Lawn Caps" c. 1900 Stadler Photographing (National 148c)

laptop being used outdoors in [ad for Librex notebook computers] c. 1991* Nadav Kander (Graphis92 \175)

lipstick ad showing woman in hat and veil in "Veiled Red" 1978* Richard Avedon (Rosenblum2 #634)

liquor bottles and South American animals in [ad for a Brazilian liquor] c. 1992* Christopher Thomas (Graphis93 158a)

looking down at a white Lexus in [Lexus] c. 1992* Doug Taub (Graphis93 156c)

male nude holding female on his shoulder in [ad for Obsession] c. 1991 Bruce Weber (Graphis91 \53)

mannequin holding a small bottle in "Pétrole Hahn" 1931 Studio Ringl & Pit (Marien \5.39; San \25)

martini in "Martini and Pyramid" 1955* Bert Stern (Marien \6.59)

men in eyeglasses and trench coats in [ad for eyeglasses] c. 1990 Monika Robl (Graphis90 \67)

miniature figures passing through cutoff section of telephone in "Telephone by SEL" c. 1989* Dietmar Henneka (Graphis89 \222)

miniature figures playing soccer on horizontal flat screen in "Sony TV" c. 1989* Dietmar Henneka (Graphis89 \221)

nude in [advertising for ad agency] c. 1989* François Gillet (Graphis89 \193)

overhead view of patterned carpets in "Ad for carpet producers" c. 1989* Frank Herholdt (Graphis89 \118-\119)

pen on wheel of 1925 Hispano Suiza automobile in [ad for Parker pens and pencils] c. 1989* Daniel Jounneau (Graphis89 \231)

perfume bottle in [ad for Azzaro eau de parfum] c. 1991* Marc Le Mene (Graphis91 \232)

perfume bottle in [ad for Escada perfume] c. 1991* Jody Dole (Graphis92 \173)

Porsches in garage openings in "Porsche, Driving at its Most Beautiful" c. 1989* Dietmar Henneka (Graphis89 \205)

Porsches in silhouette in "Porsche, Driving at its Most Beautiful" c. 1989* Dietmar Henneka (Graphis89 \204)

portion of a Mercedes in "A 1936 Mercedes 540K as used in an ad campaign" c. 1989* Dietmar Henneka (Graphis89 \206)

pyramid shapes in [ad for Macintosh software] c. 1989* Rick English (Graphis89 \288)

razors in a row in "Duplex Razors" 1934 (Goldberg 68)

roses in pinks and white for perfume in [ad for Tea Rose perfume] c. 1989* John Chan (Graphis89 \29)

saddles on a bench and bridle on wall in [a catalog for saddles and bridles of exceptional quality] c. 1989* Michael W. Rutherford (Graphis89 \227, \228)

service for eight laid out in "Gorham Sterling Ad" 1930 Edward Steichen (Rosenblum2 #579)

serving cheese at a party in "Photographic reproduction of Pieter Brueghel's *The Wedding Feast*" c. 1989* Bert Bell (Graphis89 \186)

shirt and tie from [self-promotional] c. 1989* Dirk Karsten (Graphis89 \53)

shuttered stores at street corner in "Café Diderot" c. 1989* Neil Lukas (Graphis89 \66)

skates, roller blades in [Roller Blades] c. 1999* Craig Cutler (Photo00 174)

sneakers and shirts on hangers from [ad for the Nike line of products]c. 1989* Aaron Jones (Graphis89 \230)

sneakers in [Shimano bicycle shoes] c. 1999* Mark Laita (Photo00 168, 171)

sunglasses with bright blue lenses in "Advertising brochure for the Polar Blue Filters of the Nautilus brand sunglasses" c. 1989* Tom Ryan (Graphis89 \223, \224)

television and headset from [ad campaign for *Blaupunkt*] c. 1989* Michael Steenmeijer (Graphis89 \220)

television sets in [television sets] c. 1995* Ernesto Martens (Graphis96 150a, c)

tire in "All-terrain tire" c. 1991* Todd Merritt Haiman (Graphis92 \169)

tools in [ad for an electrical supply company] c. 1995* Mark Wiens (Graphis96 150b)

toothbrush in "Starck Toothbrush" c. 1999* Michael Davies (Photo00 172)

top of Chrysler Building, Empire State Building, World Trade Center and Queen Elizabeth II in [ad for

Cunard Line voyages to New York] c. 1990* John Claridge (Graphis90 \84)

Toyota in amusement park in [Toyota catalog] c. 1992* Deborah Roundtree (Graphis93 157)

tractor trailer truck on bridge span in "United Technologies" 1982* Jay Maisel (Rosenblum2 #633)

underwear ad with seated woman in slip in [ad for underwear] c. 1995* Andrej Gusgold (Graphis96 56)

underwear on woman in [advertising for underwear] c. 1995* Dan Weaks (Graphis96 129)

watch on seltzer bottle from [self-promotional] c. 1989* Bill White (Graphis89 \235)

woman at beach at standing telescope from [self-promotional] c. 1989 Rick Hornick (Graphis89 \19)

woman holding a thermometer in "A Little Glass Tube" 1938 Victor Kepler (Goldberg 69)

woman holding Kodak camera in "Kodak Girl Poster" 1913 Photographer Unknown (Rosenblum \50)

woman sitting on stool from [self-promotional] c. 1989* Steve Hathaway (Graphis89 \20)

woman's hand holding cigarette in holder in ad for Myer's gloves 1920s Margaret Watkins (Marien \5.34; Rosenblum \151)

woman's lips in [ad for Zippo] c. 1999* Jim Erickson (Photo00 2)

ADVERTISING SIGNS AND BILLBOARDS

ad for *Nehi* on clapboard building in "Sign, Saratoga Springs" 1929 Ralph Steiner (MOMA 141)

airport billboard of large pigs with airplane wings in "The rising popularity of Memphis pork barbeque has a number of area restaurants shipping their products all over the country" 1998* Kent Phillips (Best24 41a)

billboard for "World's Highest Wages" in "Billboard on U.S. Highway 70 in California 'World's Highest Wages' " 1937 Dorothea Lange (Fisher 16)

billboard of man in underwear in "Calvin Klein in Times Square" 1982 Photographer Unknown (Goldberg 194)

campaign billboard in "Adlai Stevenson campaign" 1952 Photographer Unknown (Eyes #147)

campaign posters on store window in "Campaign posters in a garage window, just before the primaries. Waco, Texas" 1938 Dorothea Lange (Fisher 39)

cigarette ads behind painted letters on window in "Bar-B-Q" 1952 or earlier Philip Elliott (MOMA 222)

election campaign signs on lawn in "Election campaign signs (Omaha)" 1938 John Vachon (Documenting 109c)

line of African Americans waiting for food under billboard in "At the Time of the Louisville Flood" 1937 Margaret Bourke-White (Eyes #123; MOMA 149; Szarkowski 224)

man walking upstairs under billboards in "Negro man entering movie theater 'colored' entrance. Belzoni, Missouri" 1939 Marion Post Wolcott (Fisher 40; Sandler 81)

movie billboards lining street in "Houses and Billboards in Atlanta" 1936 (MOMA 142)

movie poster on window in "Girl and movie poster" 1938 Paul Vachon (Lacayo 90c)

movie posters covering the side of a building as boys play in rubble in "Movie advertisement on the side of a building. Welch, West Virginia" 1938 Marion Post Wolcott (Fisher 43)

people walking on sidewalk in front of large sign in "Advertisement on the side of a drugstore window" 1939 Marion Post Wolcott (Fisher 152)

repairing a section in "A Gannett Outdoors Co. employee does some legwork on a billboard in Flint" 1990 Jack Gruber (Best16 192c)

rips down faces of a man and a woman in "Torn Movie Poster" 1930 Walker Evans (MOMA 133)

sign for a bed or a room in "Flophouse on lower Douglas Street" John Vachon (Documenting 99b)

structure of large billboards on buildings in "Manhattan (U.S. Rubber Sign)" c. 1928 Walker Evans (Hambourg \7)

superimposed mannequins on ads in "The Eye That Never Sleeps" 1946 Clarence John Laughlin (MOMA 175)

windows of drugstore filled with products in "Drug store window display in a mining town" 1938 Marion Post Wolcott (Fisher 36)

women carrying items on their head as they walk past sign for Coca-Cola in "Ghana: Things Go Better?" 1970 Reginald L. Jackson (Committed 133)

wooden sign for stew in "Restaurant sign" 1938 John Vachon (Documenting 102a)

young people eating in front of open refrigerator in "Kodak Advertisement" c. 1950 Ralph Bartholomew (MOMA 233)

AERIAL PHOTOGRAPHY

airplane crash among the trees in "Plane crash in the Adirondacks" 1935 Photographer Unknown (Goldberg 97)

balloon casting shadow on fields in "Balloon with Shadows" 1926 Robert Petschow (Hambourg \108; San #26)

bombs dropping in "World War I aerial photograph" 1917 Edward Steichen (Goldberg 53)

Boston taken from hot-air balloon in "Boston, as the Eagle and the Wild Goose See It" 1860 James Wallace

Black (Waking 315)

Boston's street grid in "Boston From Hot-Air Balloon" 1860 James Wallace Black (Photography1 \66; Rosenblum2 #288)

clouds around lower Manhattan in "Aerial View of Lower Manhattan" c. 1934 Photographer Unknown (Szarkowski 156)

golf course by the shore in [golf course by the shore] c. 1997* Cameron Davidson (Graphis97 147)

houses around circular roadways in "Sun City, Arizona" c. 1995* Randy Wells (Graphis96 170)

New York City at night in "New York at Night" 1933-1936 Berenice Abbott (Rosenblum2 #454; Sandler 86)

parachute jumper in a photo story in "Parachute Jump" 1931 Willi Ruge (Eyes #102; Lacayo 68)

river in winter with chunks of ice in "Untitled" c. 1930 Robert Petschow (San \6)

rows of umbrellas on a beach in "Lido di Jesolo, Venice" c. 1990* Yann Arthus-Bertrand (Graphis90 \102)

soldier dropping a hand-held bomb from an airplane in "Bombing by hand" c. 1917 Max Pobly (Lacayo 50a)

suburban housing in "Aerial view of suburban Los Angeles" 1949 Loomis Dean (Lacayo 124)

town in ruins in "Aerial View of Vaux" 1918 Edward Steichen (Hambourg 20)

viewing mass demonstration in Germany from the Zeppelin in "Zeppelin report, May Day, march of the masses" 1933 Willi Ruge (Lacayo 66)

AFGHANISTAN

children carrying heavy loads on their backs as they walk through rubble in "In the rubble of Kabul, Afghanistan, the city of orphans, three youngsters carry wood to sell at a market" 1995 Laurent Van Der Stockt (Best21 180a)

commander against the Taliban in "Commander Ahmed Shah Massoud" 1998* Stephen Dupont (Best24 178-179)

men of the Mujahideen in "Mujahideen in Afghanistan" 1988 Axel Grünewald (Graphis90 \253-\256)

men sitting by open fire in rubble of town in "Amid the rubble of 14 years of civil war, Afghan refugees return to rebuild Herat" 1993* Steve McCurry (Best19 78)

Mujahideen and refugees in camps in "Afghani agony" 1986* James Nachtwey (Best12 98-99)

people near ruined buildings in "Kabul, Afghanistan" 1996 Sebastião Salgado (Photography 109)

photo essay on life under the rule of the Taliban in "Taliban in Afghanistan" 1996 David Turnley (Best22 258-259)

seated men guarded by men with guns in "Afghan government soldiers captured by freedom fighters ponder their uncertain fate" 1986 Jack Chiang (Best12 76d)

Taliban and their victims in "Kabul, Afghanistan, after the Taliban Takeover" c. 1997* Ilkka Uimonen (Graphis97 56-59)

tanks and troops fighting Taliban in "Afghanistan That Still Bleeds" 1996* Luc Delahaye (Best22 242d, 243d)

woman wearing head-to-toe burka holds diploma in "A woman, forbidden by Taliban law to work, study or show her face, sits proudly with one of her diplomas at home in Kabul" 1998* Nina Berman (Best24 82)

woman wearing head-to-toe burka in "Afghan woman puts on her burka before leaving her home in Kabul" 1997* Michael Wirtz (Best23 181d)

young woman holding photograph in "Mira Khila, Afghan refugee, holds a picture of her 17-year-old husband, killed in the holy war against the Afghanistan government" 1987 Joanne Rathe (Best13 76a)

AFRICAN AMERICANS see also BLACK PANTHER PARTY; CIVIL RIGHTS MOVEMENT; GEE'S BEND, Alabama; NATION OF ISLAM

adults holding hands at edge of water in "Memorial to African ancestors who perished in Atlantic Ocean during transfer from Africa to American enslavement" 1990 Chester Higgins, Jr. (Goldberg 208)

African American soldiers posing for group portrait in "Members of the U.S. 369th Infantry Regiment, which was awarded the *Croix de Guerre* for bravery" c. 1917 Photographer Unknown (Goldberg 60)

baseball team with their bats by their bus in honor of old Negro League teams in "The Anderson Monarch baseball team playing with their equipment" 1997* George Miller (Best23 173b)

boy peering out from father's coat in "Son peers from his dad's coat at a rally for the 'Day of Absence' in Philadelphia on the second anniversary of the Million Man March" 1997* David Maialetti (Best23 116)

crowd of men carrying signs in "I Am a Man: Sanitation Workers Strike, Memphis, Tennessee" 1968 Ernest C. Withers (Committed 224; Goldberg 164; Marien \6.68; Willis \176)

drinking from "Colored Only" drinking fountain in "Segregation, Mobile, Alabama" 1956 Gordon Parks (Life 14)

family posing in den with man holding rifle on his lap in "American Gothic" 1993* Jeffrey Henson Scales (Committed 193)

girl looking out bus window in "A first-grader watches as police arrest a man for painting a racial slur on the bus as it drove through Trenton" 1992* Craig Orosz (Best18 125)

group of adults with outstretched arms, outdoors in "First Annual Community Baptism for the Afrikan Family, New York City" 1986 Marilyn Nance (Rosenblum \249; Rosenblum2 #693)

group waiting to be paid in "Day laborers waiting to be paid, Marcella Plantation, Mileston, Mississippi" 1939 Marion Post Wolcott (Women \116)

heavy-set older woman wearing an apron and a kerchief in "*Old Character* series: The Boss" 1932 Prentice Hall Polk (Rosenblum2 #392; Willis \85)

line of African Americans waiting for food under billboard in "At the Time of the Louisville Flood" 1937 Margaret Bourke-White (Eyes #123; MOMA 149; Szarkowski 224)

lined up with bags of cotton in field in "Weighing in cotton" 1935 Ben Shahn (Documenting 84a)

man being paid for bundle of cotton in "South Carolina" 1962 Bruce Davidson (Lacayo 148)

man crying by burned-out church, and women with *Bible* in "Our Churches are Burning" 1996 Brian Walski (Best22 238a)

man holding folded American flag in "Vernon Baker, 76, learned he will be the first African American veteran of World War II to receive the Congressional Medal of Honor" 1996* Jim LoScalzo (Best22 216c)

man shoveling snow under poster of Black man in tuxedo in "Snow Dancer" 1992 Budd Williams (Committed 223)

man walking upstairs under billboards in "Negro man entering movie theater 'colored' entrance. Belzoni, Missouri" Marion Post Wolcott 1939 (Fisher 40; Sandler 81)

march with sign for Black Power in "Million Youth March: Power" 1998* Salimah Ali (Committed 44)

men and boys looking out toward the Capitol building in "Hundreds of thousands of African-Americans gathered together in Washington, D.C., during the 'Million Man March' " 1995* Pete Souza (Best21 179d)

men and women seated on wooden benches in a classroom in "Geography: Studying the Cathedral Towns" 1899-1900 Frances Benjamin Johnston (Szarkowski 169)

men and women waiting with sacks in "Cotton pickers on the Alexander plantation at 6:30 a.m., waiting for the workday to start" 1935 Ben Shahn (Documenting 80a-c)

men at outdoor rally in "Harlem Rally" 1963 Gordon Parks (MOMA 235)

Muslim woman on street corner in "North Avenue, Image No. 85" 1994* Linda Day Clark (Committed 74; Willis \421)

Muslim women walking in "Day of Atonement at the UN Plaza, Muslim Women" 1996 Salimah Ali (Committed 45; Willis \299)

Nation of Islam women in white in "Savior's Day, women's section, Chicago" 1966 Robert A. Sengstacke (Willis \201)

profile of young woman with ribbon in her hair in "Tennessee Girl with Ribbon" 1948 Consuelo Kanaga (Sandler 44c)

Pullman porter posing in "Pullman porter" 1943 Jack Delano (Documenting 283b)

sharecroppers with sacks climbing into wagon in "Going home" 1935 Ben Shahn (Documenting 86b)

sharecroppers on porch in "Sharecropper at home on Sunday" 1935 Ben Shahn (Documenting 87c) and "Sunday on the porch" 1935 (Documenting 88b)

stove being polished by two men in "Two Workmen Polishing a Stove" c. 1865 (National \11)

woman holding white infant in "Charleston, South Carolina" 1955 Robert Frank (Art \321; Eyes #239)

woman with arms outstretched at shore in "Tribute to the Ancestors of the Middle Passage–'Juneteenth' " 1995 Cheryl Miller (Committed 159)

women holding tea cups in "Madame Walker's Tea Parlor" 1929 James Van Der Zee (Goldberg 74)

AFRICANS *see also* names of individual countries; STARVATION

bare-breasted young women in skirts and beaded necklaces in "Girls in a Village of East Equatorial Africa" 1909 Underwood & Underwood (Marien \4.65)

church choir in Liberia in "Liberia, church scenes" 1930 Martin Munkacsi (Eyes #103-104)

dancing naked in "Nuba Dancer" 1975 Leni Riefenstahl (Rosenblum \185)

elder telling stories to children in Kalahari Desert in "Bushmen children" 1947 N. R. Farbman (Lacayo 92)

endless line of men and women carrying large bundles on their heads and on bicycles in "Trek of Tears: An African Journey" 1997* Martha Rial (Capture 188)

Ethiopian chief's portrait in "An Ethiopian Chief" c. 1896 F. Holland Day (Rosenblum2 #386)

formal portrait of man in suit in "Liberian Diplomat" c. 1853 Augustus Washington (Photography1 \20)

group with a rifle and umbrella posing for a portrait in "The Funeral of an Ashanti Paramount Chief, Kumau, Ghana, West Africa" 1974 Juma Santos (Committed 191)

people with drums in "Enskinment, or Inauguration, of a 'Ya Na' (Dagomba Chief), Yendi, Ghana, West Africa" 1974 Juma Santos (Committed 190)

photo essay on traditions, disease and community of the Hausa in "Journey to Safo" 1997 Eugene Richards (Best23 44-57)

starving child huddled on ground while a vulture waits in "Waiting Game for Sudanese Child" 1993* Kevin Carter (Best19 195; Capture 172; Lacayo 180)

woman in profile in "Native Woman of Sofala" 1845 E. Thiésson (Marien \2.19)

women carrying buckets on their heads in "Clock of the Earth, Ghana" 1998 Frank Stewart (Committed 206)

women in long, matching print dresses in "Two Women" 1959 Seydou Keita (Marien \6.13)

AGED

African American couple in trench coats in "Terrells, Andrew and Veetta" 1996 Gary Jackson Kirksey (Committed 141)

African American couple sitting with guitar in "Mr. Rushing plays the blues" 1982 Keith Calhoun (Willis \262)

African American man in "A ninety-eight-year-old Edisto Islander with his family photographs, South Carolina" Jeanne Moutoussamy-Ashe 1979 (Willis \247)

African American man in hat and suit in "Man on Central Avenue, Los Angeles" c. 1970-1995 Roland Charles (Willis \242)

African American sisters in "Kirksey Sisters, Claudia May, and Caressa" 1997 Gary Jackson Kirksey (Committed 140)

African American woman holding photograph of her father in "Geneva Clark Celestin holding portrait of her father, Robert" c. 1970-1995 Roland Charles (Willis \244)

African American woman in "Rehova Bennett, a client of the Catholic Social Services Adult Daycare in Indianapolis, awaits the start of the day at the center" 1988 Michael Bryant (Best14 42a)

African American woman in black coat in "Lady in Black" 1988 Earlie Hudnall, Jr. (Willis \305)

African American woman in hat in "Aunt B." 1979 Earlie Hudnall, Jr. (Willis \304)

blanket on man in a tomb in "Ahmad, a man in his 80s who cannot move, lies in a tomb" 1993 Stan Grossfeld (Best19 57)

brothers on their farm in a photo essay in "The Kahle Brothers" 1995 Torsten Kjellstrand (Best21 46-51)

café owner holding a gun in "Peggy Briller, 78, owner of a grill in Detroit's Cas Corridor explains how she stopped a would-be robber the day before" 1988 David C. Coates (Best14 94a)

children watching woman with water pistol in "81-year-old woman takes careful aim with a squirt gun" 1985 Bob Gwaltney (Best11 136d)

condos behind elderly woman's home in 'I stay right here,' proclaims 85-year-old resident of Hilton Head 1987* Karen Kasmauski (Best13 163c)

couple married 60 years holding portrait taken in their younger days from [ad for Eastman Kodak] c. 1991* Nick Vedros (Graphis91 \175)

cowboy marshal with badge, beard, and cowboy hat in "Still wearing a sidearm into his 90s, U.S. Marshal Hooker" 1998* Randy Olson (Best24 83)

cowboy sitting on porch in "Cowboy, Houston, Texas" 1993 Earlie Hudnall, Jr. (Willis \303)

daily routine of son caring for mother with Alzheimer's in [series on caring for parent with Alzheimer's] 1990 Genaro Molina (Best16 49-51)

Dinka woman in "An elderly Dinka woman clutches her cane while telling of her journey to the Atepi relief camp in southern Sudan" 1993* John R. Stanmeyer (Best19 61)

grandfather speaking with granddaughter in "Granddaughter and Grandfather, Warsaw" 1938 Roman Vishniac (Rosenblum2 #457)

group of seated Japanese-American women in "After spending the earlier part of their lives as strangers in a foreign land, living in the shadows of their husbands, this group of elderly Japanese immigrant women share a home" 1985 Judy Griesdieck (Best11 139a)

kissing at their wedding in "A four-month courtship culminated in marriage for Rev. Edward Charmichael, 82, and Vera Davis, 80" 1986 Bernard Troncale (Best12 137)

man about to drive his truck in "92-year-old will not give up driving his pickup" 1997 Eugene Richards (Best23 42b)

man and grandchild over an 18-year span from [series "Buffalo's Lower West Side Revisited"] 1973-1991 Milton Rogovin (Goldberg 203)

man sitting by the bedside of his dying wife in "B. T. Wrinkle, 85, provides full-time care for his dying wife" 1986* Patrick Tehan (Best12 104a)

man with cane standing by flags he removed from cemetery in "Myron Skinner stands outside his home" 1996 Bill Greene (Best22 247b)

man with cane walking up a street in "An elderly man works his way up a steep street" 1986 Susan Winters (Best12 189)

men crossing finish line in "220-yard dash for ages 65-69" 1985 Allen Eyestone (Best11 221c)

men in pajamas sitting on couches in "Residents of an Old Age Home" 1956 Marion Palfi (Sandler 91)

Native American woman holding her head in "Topsy Swain, a Paiute Indian, is one of the few remaining elders on Arizona's Hualapah Reservation" 1986 James Kenney (Best12 164a)

Native American woman standing outside her traditional round home in "Alice Yazzi, a Navajo Indian, learns she will lose her home in a dispute over Arizona reservation land" 1986 Dayna Smith (Best12 164c)

nursing-home women laughing at man in a skirt in "Gilbert Grossman, 67, brings down the house when he swishes out in elephantine drag" 1986 Daniel A. Anderson (Best12 136b)

people walking in room in [elderly people] c. 1999* Jim Erickson (Photo00 124)

photo essay about an elderly woman returning to high school in "A Senior Senior" 1990 Ronald Cortes (Best16 89-95)

photo essay on the daily life of first generation of Japanese women to come to America at the turn of the century in "Last of the Issei" 1986 Judy Griesedieck (Best12 124-129)

photo essay on the daily life of women in a nursing home in "No place to die" 1986 Judy Griesdieck (Best12 150-155)

photo essay on the difficult life of elderly Russian women in "Russian Babushkas" 1992 Carol Guzy (Best22 17-22)

pole vaulter clearing pole in "Defying gravity, 85-year-old C. Johnson pole vaults" 1997* Karen Kasmauski (Best23 178c)

smiling woman in black hat with red feather in "Mary Elizabeth Johnson" c. 1991* Dmitri Kasterine (Graphis91 \190)

veteran in uniform in "Winston Roche, 92, who served in the U.S. Army during World War I" c. 1991* Michael O'Brien (Best17 84; Graphis92 \117)

white-bearded man holding a cup in "A beggar huddles against a wall in Costa Rica" 1993* Christopher A. Record (Best19 63c)

white-haired woman in fur collar in "Agnes in a Fur Collar" 1979 Anne Noggle (Rosenblum \246)

white women on bench marked *Europeans Blankes* in "Durban, South Africa" c. 1959 Ed van de Elsken (Icons 140)

woman and plank she slept on in "Police Station Lodgers" c. 1898 Jacob Riis (Marien \4.47)

woman crossing finish line in "Only woman in track and field events at the senior games" 1985 Dan Root (Best11 221a)

woman crying in wheelchair in "Loving memories for those in nursing facilities can also be unkind memories" 1997 Eugene Richards (Best27 42a)

woman holding baby in "Elderly residents of the Irish countryside" c. 1991 Eberhard Grames (Graphis91 16)

woman holding plate with image of Martin Luther King, Jr., in "Eighty-year-old Rose Mabry had a dream that finally came true, that her dilapidated home was to be demolished and a new home built for her" 1987 Michael Ewen (Best13 110c)

woman in apron and kerchief, sitting on stoop on cobblestone street in "Warmth of the Winter Sun" 1937 Frank R. Fraprie (Peterson #7)

woman in chair with photograph of younger woman in "Nanna (Emily Barrows)" 1987* Ronald Barboza (Committed 51)

woman in hat posing for portrait in "Miss Olive English, born 1902" c. 1990* Chris Shorten (Graphis90 \168)

woman in wheelchair in "Francesca Casillas, 74, almost blind and barely able to lift her arms, sits at the bedside of her adult daughter" 1993 Stan Grossfeld (Best19 60)

woman leaning over metal bed looking at a doll in "Old woman in an Indiana poorhouse" 1952 (Lacayo 154)

woman on chair in "Portrait of Charlotte" c. 1991 Chrysantha (Graphis92 \133, 134)

woman peering between tree trunks in "Hilda East, who won't reveal her age but admits to probably being older than the tree she's peering from" 1988 John Kaplan (Best14 22a)

woman pulling man to dance in "Dancing at the Happy Hour, at Adult Daycare" 1998 Juana Arias (Best24 101d)

woman showing her photograph as a young woman in "Gertrude Baccus, 18 and 84" 1984 Timothy Bullard (Goldberg Overleaf)

woman sitting in crowded room in "Maria Carmina Iaconelli, born in 1900, lives alone in the town of San Biagio Saracinisco, Italy" 1990* Jerry Valente (Best16 202)

woman sitting on porch in "Ma Burnham" 1939 Dorothea Lange (Marien \5.56)

woman sitting with her possessions in plastic bags in "A Chicago bag lady sits among her possessions and shows the American flag" 1986 George Thompson (Best12 164b)

woman with cane in "Portrait study (woman with cane)" 1922 Elise Forrest Harleston (Willis \76)

woman with tattooed body in "Irene 'Bobby' Libarry" n.d. Imogen Cunningham (Marien \5.48)

woman with walker speaking with her friend in "Good friends Yvonne and Sally had to take a senior-housing project to court to be allowed to room together" 1990 Al Podgorski (Best16 57)

women sitting on porch in "Two Women, Lansdale, Arkansas" 1936 Margaret Bourke-White (Rosenblum2 #452)

women whispering in room with rocking chairs in "Longtime friends tell a secret at the homestead of Anna Jarvis, the founders of Mothers Day" 1995 John Beale (Best21 194c)

women with walkers in nursing home recreation room in "More and more older women are becoming Bat Mitzvah" 1997 Nancy Andrews (Best23 15d)

World War I veteran in his uniform in "Jim DiNardo, 96, can still fit into the uniform he wore in World War I, where he fought in the Battle of Argonne Forest" 1988 Raymond Gehman (Best14 196)

young man dancing with elderly woman in "When a 'senior prom' was held to celebrate the opening a senior center a service, fraternity of young men provided dance partners for many single women" 1986 Susan Winters (Best12 181b)

AIDS (Disease)

AIDS quilts fill the mall as seen from the air in "AIDS Memorial Quilt" 1996* Paul Margolies (Photos 183)

alone in a chapel in "Following radiation therapy, Dan Bradley, who has AIDS, cries in a Miami hospital chapel after reading the 23rd Psalm, the passage he chose to have read at his funeral" 1987 Carol Guzy (Best13 121b)

bodies of small children in "The bodies of AIDS victims lie unclaimed at a hospital in Romania" 1990* Frank Fournier (Best16 197b)

boy bouncing ball in "Ilja Miller dribbles a ball in front of a rainbow painted on the garage by his father, who died of AIDS" 1993* Allan Detrich (Best19 5)

boy with friends and family in "Ryan's battle" 1986 Cheryl Nuss (Best12 84-85)

boy with intravenous tubes in "In California, 4-year-old Matthew has AIDS" 1985 Cheryl Nuss (Best11 31c)

chalk drawings on the street in "A passer-by strolls over the outlines of 610 Dallas AIDS victims who have died" 1987 Louis DeLuca (Best13 60d)

child in "Prince, two-year-old with AIDS, New York City" 1986 Brian Weil (Photography 124)

child's casket on seat of hearse in [funeral for child with AIDS] 1997 Eugene Richards (Best23 31)

circle of people on the floor in "In Minneapolis, people infected with HIV and their friends link in a chain and laugh in a sequence–one of the many unconventional therapies that have sprung up as medicine fails" 1987 Alon Reininger (Best13 56b)

elderly couple at a grave in "Couple from a small town lost son to AIDS" 1985 Frederic Larson (Best11 31b)

family around man in bed in "Untitled (AIDS patient)" 1992* David Kirby (Marien \7.97)

father shaving son in "Ray Gubser, who admitted having problems dealing with his son's impending death, took part in Paul's care, including shaving and showering him" 1987 Brad Alan Graverson (Best13 60c)

group standing with candles in "In San Francisco, people concerned with the lack of medical progress in AIDS cases hold a candlelight vigil near City Hall" 1985 Craig Lee (Best11 30a)

man dying at home among family in "Bobby Comes Home" 1988 Joel Sartore (Best14 190)

man holding friend in last stages of AIDS in "Peter Lornardi, with the AIDS Action Committee, helps his friend Fernando, who went to the Deaconess Hospital in Boston for treatment of the disease" 1985 Janet Knott (Best11 29b)

man in hospital bed in "Thomas Ramos, 30, died of AIDS in August in New York City" 1987 Alon Reininger (Best13 56a)

man lying in bed in "S. Jenteel was diagnosed as an AIDS victim in December 1984" 1985 Bob Mahoney (Best11 29a)

man with lesions on his arm, sitting in wheelchair in "San Francisco, California, Patient with AIDS, Ken Meeks" 1986* Alon Reininger (Eyes \29)

masked and gowned person holding sick child in "A baby with AIDS is treated in Romania" 1990* Bernard Bisson (Best16 180a)

men embracing in "Dan Webber, an AIDS victim, is comforted by Rick Holderman during an October gay rights march in Washington, D.C." 1987 Timothy Barmann (Best13 60a)

men embracing and crying in "Founders of an AIDS quilt project grieve at the loss of friends whose name are added to the commemorative quilt" 1987 Chris Hardy (Best13 57)

men holding candles in "Mourners hold a candlelight vigil and prayer in memory of loved ones who have passed away from AIDS" 1996 Khue Bui (Best22 222b)

mother holding son on her lap in "Susan Kozup holds back her emotions in Washington, D.C., as she tells how her son Matthew contracted AIDS from a blood transfusion just after he was born" 1985 Carol T. Powers (Best11 31a)

parents carrying a coffin and a cross through the street in "Romanian parents carry a coffin and a cross to a Bucharest hospital to collect the body of their child, who died of an AIDS-related illness" 1990* Rady Sighiti (Best16 171a)

parents with AIDS and their children in "Living with death" 1995* Matt Kryger (Best21 196)

photo essay about Africans educating African children about AIDS in "A Broken Landscape: HIV and AIDS in Africa" 1997 Gideon Mendel (Best23 240-241)

photo essay chronicling the life of death of a child and her mother, and the fate of her brothers and father in "Testing the Human Spirit" 1991-1996 Brian Peterson (Best22 42-59, 272)

photo essay describing a teen's mission to talk about AIDS in "Before He Leaves" 1992 Fred Zwicky (Best18 213-216)

photo essay on one family living and dying with AIDS in "A Bronx Family Album: The Legacy of AIDS" 1997 Steve Hart (Best23 244-245)

photo essay on residence for children with AIDS in "New York's Incarnation Children's Center" 1997 Eugene Richards (Best23 36-37)

pouring water on hand of man who has died in Thailand in "A patient who has died of AIDS is ritually cleansed prior to cremation" 1997 Chien-Chi Chang (Best23 234d)

prisoner behind gate in "AIDS-infected inmates such as Gary Brown are isolated on one floor of the Missouri State Penitentiary prison hospital" 1987 Keith Myers (Best13 59b)

prisoners in solitary confinement leaning through slots in doors in "HIV carriers at the Missouri State Penitentiary were isolated virtually 24 hours a day" 1987 Keith Myers (Best13 59a)

son playing chess on father's bed in "Ilja Miller and his uncle play chess to help pass the time as Ilja's father lies near death, a victim of AIDS" 1993* Allan Detrich (Best19 118)

twin girls with AIDS and their family in "AIDS in the family" 1991 Randy Olson (Best17 29-34)

two men supporting each other with Capitol in background in "San Francisco residents pause in silence during the display of The Names Project Quilt for AIDS victims in Washington, D.C." 1988 Elaine M. Thompson (Best14 77d)

women crying by side of casket in "In San Bernardino, family members mourn the death of a 12-year-old hemophiliac, who contracted AIDS through blood transfusions" 1985 David Schreiber (Best11 30d)

young woman on prison bed in "Wendy Blankenship, a 19-year-old prostitute with AIDS, is sentenced to one year at the Miami Women's Detention Center" 1987 Carol Guzy (Best13 58)

Zambian man with his children from [series *AIDS in Zambia*] 2001 Don McCullin (Photography 126)

Zambian woman having her hair combed in hospital from [series *AIDS in Zambia*] 2001 Don McCullin (Photography 127)

AIR RAID SHELTERS

family with cots, food, and radio in bomb shelter in "A radiation shelter in Garden City, Long Island" 1954 Walter Sanders (Lacayo 133a)

AIRPLANES *see also* AIRPLANES–HISTORY; AIRSHIPS; HELICOPTERS

airplane flying over wreckage of jet in "FAA officials inspect the tail section of Delta Flight 191" 1985 Michael Delaney (Best11 52)

airplane wreckage strewn on side of mountain in "Rescue crews search the wreckage of a Japan Air Lines 747 in rugged terrain in central Japan" 1985 Itsuo Inoue (Best11 54c)

bomber flying over island in "A Douglas SBD Dauntless dive bomber over Wake Island" 1943 Charles Kerlee (Lacayo 106c)

bomber just missing small plane which is flying upside down in "Air Show High Drama" 1949 Bill Crouch (Capture 24)

cockpit exploding in "An explosion [by hijackers] rips out the cockpit of a Royal Jordanian ALIA Airline at Beirut Airport" 1985 Herve Merliac (Best11 55b)

downed plane on ocean floor in "Sponges and coralline algae encrust a Japanese Zero downed in World War II in the southwestern Pacific" 1988* David Doubilet (Best14 153a)

engine of a Boeing 747 in "Part of a Boeing 747" c. 1991 Nikolay Zurek (Graphis91 \259)

engines being fixed by women in "Women supporting the men by working as airplane mechanics" 1942 Photographer Unknown (Goldberg 110)

F-15E views in "Views of the F-15E built by McDonnell-Douglas" c. 1990* Ken Reid (Graphis90 \222, \223)

facing the airplane in [Beechcraft Starship] c. 1992* Rick Rusing (Graphis93 157)

flying close to stadium crowd in "An Air Force plane makes a low pass over the rim of Oakland Coliseum during pregame activities at the baseball All-Star game" 1987 Michael Macor (Best13 108a)

flying through the clouds in "An Air Force C-5A Galaxy transport drops out of low clouds at the air show" 1990 Jack Gruber (Best16 192d)

glider in flight in "Barron Hilton Soaring Cup" c. 1988* Kevin Cruff (Graphis89 \237)

glider in flight accompanying from [a report on gliding] c. 1990* Gert Wagner (Graphis90 \249)

group of airplanes from the air in [self-promotional] c. 1990* Cameron Davidson (Graphis90 \99)

hijacked plane on ground in "One of the hijackers aboard TWA Flight 847 waves off a Shiite militiaman after

he delivered newspapers to the sky pirates" 1985* Jamal Saiidi (Best11 48)

in museum exhibit in "Military Museum, Beijing, China" 2000 Lois Connor (Photography 29a)

looking across the top of a plane in "*Tornado* belonging to the manufacturing program of the MBB aircraft company" c. 1989* Bernhard Lehn (Graphis89 \212)

looking into the engines of a plane in "*Tornado* belonging to the manufacturing program of the MBB aircraft company" c. 1989* Bernhard Lehn (Graphis89 \211)

man and woman riveting parts of a plane in "Italian-Americans at work on a bomber in the Douglas aircraft plant. Santa Monica, California" 1943 Ann Rosener (Fisher 81)

meal being served by waiter on airplane in "Passengers on a German Junkers trimotor enjoy first-class service on a flight between Berlin and Amsterdam" 1933 Acme (Through 100)

men walking through airplane wreckage among trees in "Three priests walk through the wreckage of a Midwest Airlines DC-9 that crashed after takeoff" 1985 Mark Hertzberg (Best11 55a)

model airplanes hanging from the station ceiling in "Model military aircraft hanging from the ceiling of the train concourse" 1943 Jack Delano (Documenting 290b)

overhead shot of smoke billowing from plane that crashed into a house in "Bomber Burns After Crash in Yard" 1955 George Mattson and *Daily News Staff* (Capture 36)

passengers in plane with fuselage ripped apart in "Aloha Airlines Flight 243" 1988* Robert Nichols (Best14 86a; Life 134)

seen through cockpit in "Planes of the *Patrouille de France* carry out loopings" c. 1990* Alain Ernoult (Graphis90 \246)

several planes on runway in "The *F-4 Phantom*" c. 1989* Frederick Sutter (Graphis89 \214)

silhouette against sunset in "A single-engine airplane is silhouetted against the setting sun" 1986 Glenn Koenig (Best12 56d)

small plane flying over island in "Aerial view of Turtle Island" c. 1991* Geoffrey Clifford (Graphis91 \292)

soldiers carrying flag-draped coffin from plane in "First bodies of the Gander crash victims arrive at Dover, Delaware AFB" 1985 Joe Songer (Best11 50)

stunt plane near runway in "Stunt pilot gets too close to the runway for crew members" 1995* Brad Garrison (Best21 177a)

taking off of flight deck in "Grumman F64 Hellcat takes off from the deck of the U.S.S. *Lexington*" 1943 Edward Steichen (Eyes #203)

Voyager touching down in "Piloted by Dick Rutan and Jeana Yeager, *Voyager* touches down at Edwards Air Force base, after a historic, nonstop, non-refueling, globe-circling flight" 1986 Eric Luse (Best12 56a)

woman holding propellor in "Amelia Earhart" 1932 Acme Newspictures (Vanity 128)

AIRPLANES–HISTORY

early airplanes and balloons in "Aerial exposition at the *Grand Palais*, Paris" 1909* Leon Gimpel (Lacayo 30)

first flight with Orville Wright in "The first powered flight ever" 1903 John T. Daniels (Photos 18)

flying over a crowd in "Wright Brothers' Airplane" 1909 Photographer Unknown (Photos 19)

flying over Main Street in "Wright Brothers Postcard" 1915 Photographer Unknown (Goldberg 49)

gliding on multiwinged plane in "Octave Chanute, a 19th-century American aviation pioneer, designed the multiwinged Katydid glider" 1907* Gilbert H. Grosvenor (Through 476)

Lindbergh standing under the wing of his plane in "Charles Lindbergh standing beneath the wing of his plane, *The Spirit of St. Louis*" 1927 Underwood & Underwood (Goldberg 72)

looking up at Orville Wright in flight in "Orville Wright" 1913 or later William Mayfield (Waking #157)

man and boy sitting on old airplane in "Men's fashion photographed on an old private airport" c. 1991* John Goodman (Graphis91 \62)

man leaning against a small plane in "Men's fashion photographed on an old private airport" c. 1991* John Goodman (Graphis91 \63)

man standing in small plane with motion picture camera in "An American war photographer, Merl La Voy, ready for a motion-picture flight over Serbian front" c. 1914-1918 Underwood & Underwood (Eyes #40)

men sitting in early plane in "Orville and His Older Brother Rauchlin Wright at Simines Station" 1911 William Mayfield (Szarkowski 155)

overlooking thousands surrounding *Spirit of St. Louis* in "*Spirit of St. Louis* in Paris" 1927 Photographer Unknown (Photos 41)

plane taking off in "Orville Wright Takes Off" 1908 James H. Hare (Goldberg 34)

warplane in flight in "The New Bird of Liberty: An American warplane of the latest type" 1918 U.S. Marine (Eyes #80)

AIRSHIPS *see also* HINDENBURG (AIRSHIP)

in air in "*Lighter than Air Machine* in Flight over Pasadena, California" 1912 Photographer Unknown

(Szarkowski 332d)

men on top repairing a tear in "The Dirigible Graf Zeppelin Being Repaired Over the South Atlantic on a Flight to Rio de Janeiro" 1934 Alfred Eisenstaedt (Icons 62)

ALBANIA

anti-government protestors in "Albanian Unrest" 1997* Santiago Lyon (Best23 122, 204a, b)

fleeing to Italy fill ship and the entire dock in "Albanian Refugees" 1991* Luca Turi (Photos 170)

mentally ill, poor, and injured people in "Albanians" 1998 James Nachtwey (Best 24 164-165)

ALCOHOLISM

photo essay on the death, injuries, and arrests due to alcohol in [effects of alcohol on the public] 1993* Patrick Davison (Best19 34-37)

photo essay on the death of a man from cirrhosis in "Lethal Legacy" 1998 Brian Plonka (Best24 158-159)

photo essay on the results of alcoholism on Native Americans in "Gallup: A Town Under the Influence" 1988 Joe Cavaretta (Best14 191-193)

photo essay on the results of using and abusing of alcohol in "Generations–Under the Influence" 1996 Brian Plonka (Best22 252-253)

ALLIGATORS see REPTILES

THE ALPS see MOUNTAINS

ALZHEIMER'S DISEASE

daily routine of son caring for mother with Alzheimer's in [series on caring for parent with Alzheimer's] 1990 Genaro Molina (Best16 49-51)

photo essay on Max Greenberg and his wife Bert in "Losing Max" 1985 Sarah Leen (Best11 126-129)

AMISH / PENNSYLVANIA DUTCH

Amish child in "A young Amish girl watches an auction" 1987 Bonnie K. Weller (Best13 106)

Amish youths with buggies on overpass above trucks in "Three Amish youths urge oncoming truckers to blast their horns while passing at an overpass south of Mansfield, Ohio" 1987 Curt Chandler (Best13 108)

coatless men gesturing towards unseen object in "German Baptists from Pennsylvania marvel at the grandeur of Yosemite National Park" 1990* Jay B. Mather (Best16 184)

flames rushing through window in "New Wilmington volunteer firefighters retreat from flames that exploded through a window at the home of an Amish farmer in Pennsylvania" 1990 Bill Lyons (Best16 106d)

snowmobile and horse-drawn sleigh on same road in "Old and new sometimes travel the same road as an Amish man in a horse-drawn sleigh is followed by a snowmobile rider " 1987 Barry Zecher (Best13 164b)

teenage girls at fence watching horse race in "The only event Amish teenagers are allowed to attend is harness racing at rural Ohio fair" 1997* Randy Olson (Best23 170d)

AMMUNITION see also BOMBS AND BOMBING

bullet seen in mid-flight in ".30 Caliber Bullet as It Crashes through a Bar of Soap" n.d. Harold Edgerton (Decade \33)

factory filled with large munitions in "A sea of shells at a British munitions factory" 1916 Horace Nicholls (Lacayo 51d)

hands checking boxes of bullets in "Mrs. Julian Bachman checking the size of a bullet before the cartridge is assembled" 1942 Marjory Collins (Documenting 265c)

women checking boxes of bullets in factory in "Twenty-three-year-old Mrs. Julian Bachman and two other gauge inspectors at the Animal Trap Company" 1942 Marjory Collins (Documenting 264b)

young man carrying large clips of bullets on his head in "Biafra" 1968 Gilles Caron (Eyes #259)

AMUSEMENT PARKS

aerial view of rides overlooking shoreline in "Seaside Park" c. 1989* Scott Barrow (Graphis89 \97)

armed soldiers and civilian women riding on a park ride in "Two soldiers under Azerbaijani rebel commander relax on an amusement ride" 1993* Alexander Zemlianichenko (Best19 119)

magazine pages of rides in a fair in "Fairs" 1928 Germaine Krull (Eyes #110)

ride in motion in "Kern County Fair" c. 1992* Terry Husebye (Graphis93 170a)

riders on roller coaster in "Amusement park riders in Seoul, South Korea" 1988* Anthony Suau (Best14 59b)

soldier on swing in "Soviet soldier, off duty" 1948 Dmitri Kessel (Lacayo 111)

teenage couple at the rides in "At Summer Celebration, Bob and Emily found some privacy amid the hundreds of people on the midway" 1996* Chad Stevens (Best22 101a)

women in roller coaster car in "October: Month of Fairs" 1938 Kurt Hutton (Eyes #118)

ANDREA DORIA (Steamship)

lifeboats rowing away from sinking ship in "Andrea Doria sinking" 1956 Dean Loomis (Life 128)

ocean liner plunging beneath the sea in "Sinking of Andrea Doria" 1956 Harry A. Trask (Capture 38)

ANGKOR WAT, Cambodia

collecting lotus plants in water in front of temple in "Pilgrims who travel to the temple of Angkor Wat, in

Cambodia, offer locally grown lotus flowers to Buddhas at the site" 2000* Steve McCurry (Through 134)

portion of the complex in "Angkor Wat, Cambodia" 1866 M. Gsell (Waking #85)

ANIMAL REMAINS (ARCHAEOLOGY)

leg and back bones of a Moa on display in "Dinornis Elephantopus" c. 1858 Roger Fenton (Szarkowski 78)

ANIMALS

drugged leopard being carried from village in "Too little room for humans and animals: A leopard is drugged after killing two villagers" 1992* Raghu Rai (Best18 217)

panther in "Florida Panther" c. 1991* James Balog (Graphis91 \355)

pig sniffing dog in [dog and pig] c. 1995* Steve Grubman (Graphis96 188)

ANTARCTICA

adult with large chicks in "Adult Emperor Penguin with chicks on the sea ice of the Antarctic" c. 1991* Bruno J. Zehnder (Graphis91 \351)

bird flying over iceberg in "Iceberg and bird in the Antarctic" c. 1991* Bruno Zehnder (Graphis91 \283)

colony of penguins in "A huge colony of emperor penguins convenes at Cape Crozier in Antarctica" 2001* Maria Stenzel (Through 26)

helicopter behind penguin in "U.S. Coast Guard helicopter lands on the sea ice in the Antarctic while an Emperor Penguin escapes the intrusion" c. 1991* Bruno J. Zehnder (Graphis91 \353)

men and tent in "Scott's Expedition Sights Amundsen's Tent" c. 1912 W. R. Bowers (Photos 23)

penguin in front of large ship in "Exploitation of the South Pole" c. 1991* Bruno J. Zehnder (Graphis91 \352)

penguins on an iceberg in "Chinstrap penguins hitch a ride on an intricately sculpted blue iceberg in the sub-Antarctic" 1995* Cherry Alexander (Best21 159a)

sinking of Shackleton's ship *Endurance* while dog teams search for food in "Foraging for food in the Antarctic" 1915 Photographer Unknown (Lacayo 43d)

snow and ice landscapes in [Antarctica] c. 1995* Rob Badger (Graphis96 161)

suspended over the water, men study round accumulation of sea ice in "Scientists study winter sea ice off Antarctica" 1996* Maria Stenzel (Through 20)

two penguins running along icy ridge in "Adélie penguins on the Antarctic's eternal ice" c. 1989* Bruno J. Zehnder (Graphis89 \197)

ANTIQUITIES

circular building and fountain in "Temple of Vesta and Fountain, Rome" c. 1857 Robert Macpherson (Szarkowski 76b)

piece of stone from building in "Ancient Ruin, North Africa" 1855-1856 John B. Greene (Szarkowski 45)

section of a cathedral near cemetery in "East Gable of the Cathedral and St. Rule's Tower, St. Andrews, Scotland" c. 1844 Hill & Adamson (Szarkowski 41)

APARTHEID *see* SEGREGATION

APARTMENT HOUSES

abandoned building with graffiti on wall in "Untitled" 1982 Gerald Straw (Committed 209)

balconies in "Apartment building, 311 East Sixty-first Street" 1938 Walker Evans (Documenting 132a)

balconies over stores in "Apartments and stores, 309 and 311 East 64th Street" 1938 Walker Evans (Documenting 145b)

car in front, people sitting on stoop in "345 East Sixty-First Street" 1938 Walker Evans (Documenting 135b)

children running and laughing in front of apartment house in "Life in Chicago" 1981 John H. White (Capture 120)

elderly African American woman walking by apartment building in "Awake" 1951 Inge Hardison (Committed 120)

fire escapes and windows in "Apartment buildings, 315 and 317 East 61st Street" 1938 Walker Evans (Documenting 134a)

flat facade with rows of windows in "Entrance, Residential Apartment Block, Kalkerfeld, Cologne" 1928 Werne Mantz (Hambourg \25)

sign for rooms for rent in "Apartments for rent, 326 East Sixty-first Street" 1938 Walker Evans (Documenting 134a)

three 4-story buildings in "Fifth Avenue and West 8th Street, New York" 1935 Berenice Abbott (Hambourg 53)

APPLES

bobbing for apples in "Apple's eye view of a childhood tradition makes Halloween art" 1985* Jeff Alexander (145b)

four on a piece of wood in "Untitled" 1964 Paul Caponigro (Szarkowski 274)

hanging from tree in front of shingled gable in "Apples and Gable, Lake George" 1922 Alfred Stieglitz (Hambourg \115; MOMA 114)

in baskets, and for sale in "Mennonite apple seller at the farmers' market" 1942 Marjory Collins (Documenting 262a)

series of images with apple coming closer to viewer in "Apple Advancing" 1975 Hollis Frampton (Photography2 151)

APPLIANCES

electronic components for [a brochure for Bang & Olufsen] c. 1991* Paul IB Henriksen (Graphis91 \250-\256)

toaster and plug in "Toaster in operation" c. 1991* Bernd Scholzen (Graphis91 \258)

AQUEDUCTS

double-tiered arches over river in "Pont de Gard" c. 1855 Edouard-Denis Baldus (Szarkowski 75)

ARAB-ISRAELI CONFLICT *see also* PALESTINIAN ARABS

armed man walking with his son in "An Israeli settler and his son walk away from a roadblock set up to keep Palestinians away from the area where a young Israeli girl was shot during a scuffle in the Israeli-occupied territories" 1988 Jon Kral (Best14 78d)

casualties in Gaza hospital in "Visit to a War Zone" 1988 James Nachtwey (Best14 32-33)

girl peering over painting of dead girl in [painting of a schoolgirl shot by Israelis] c. 1991* John Running (Graphis92 \44)

girl running from shooting soldiers in "Young girl runs for safety during a clash between Palestinian demonstrators and Israeli border police in the Gaza Strip" 1993* Patrick Baz (Best19 183)

Hamas followers reaching for a coffin carried aloft in "Coffin of Yamya Ayyash is carried into a mosque" 1996* Jim Hollander (Best22 150c)

Israeli sailors relaxing on beach and settlers waving Israeli flag in "Gaza: Where Peace Walks a Tightrope" 1996* Alexandra Avakian (Best22 242a)

Israeli soldiers firing against Palestinians in "A stone-throwing Palestinian demonstrator recoils the instant he is shot by Israeli soldiers" 1997* Wendy Lamm (Best23 125a)

Jewish youth pulling on Palestinian flag to start a fight in "While PLO Chairman Yasir Arafat and Israeli Prime Minister Yitzak Rabin sign a peace accord at the White House, scene outside is less peaceful" 1993 Lucian Perkins (Best19 19)

men running through streets and throwing rocks in "Intifada" 1987* Photographer Unknown (Photos 158)

Palestinian man speaking with an Israeli soldier in "Palestinian father pleads with an Israeli soldier to release his son, who was arrested in clashes in Ramallah on the West Bank" 1988 Peter Turnley (Best14 180a)

Palestinian men with their hands raised in "Residents of the West Bank town of Habla react to the injuries of a fellow Palestinian who was shot in the head in a protest over land" 1996* Nati Harnik (Best22 144b)

Palestinian youth being dragged away by Israeli soldiers in "Israeli soldiers drag an unconscious Palestinian fighter away after a beating in Ramallah on the West Bank" 1988 Peter Turnley (Best14 178)

photo essay on events in the West Bank, flaming roadblocks and shooting of Israeli soldier in "Continuing Saga" 1988* James Nachtwey (Best14 36-37)

woman with Arabic signs yelling in "Demonstrations of Palestinians in Hebron against the Israeli settlements" 1996* Sebastian Bolesch (Best22 167d)

women pleading with armed soldiers lifting man from street in "An Arab feigns injury to avoid arrest by an Israeli soldier during a demonstration in Ramallah on the West Bank" 1990* James Nachtwey (Best16 43)

youths shooting rocks at helicopter in "Arab youths aim their slingshots at an Israeli helicopter hovering over a mosque in Nablus, in the Israeli-occupied territories" 1988 Allan Tannenbaum (Best14 85)

ARCTIC

Eskimos on ice petting whales in "Two Barrow, Alaska, residents say goodbye to the California gray whales that were trapped in the Arctic Ocean ice pack for more than three weeks" c. 1988 Bill Roth (Best14 6d); "Malik, an Inupiat Eskimo who helped engineer a path out to open water for California gray whales trapped near Alaska, stays to wish final goodbye before Soviet ice breaker approaches" 1988 Bill Hess (Best14 88)

hunters and dead polar bears near ship in Arctic in "Hunting by Steam in Melville Bay" 1869 John L. Dunmore (National 19d, \43)

jumping on ice rafts in "An Arctic wolf leaps from ice raft to ice raft in the wilds of northern Canada" 1987* Jim Brandenburg (Best13 90; Graphis90 \190; Through 336)

photo essay on Arctic wolves in "Arctic wolves" 1987* Jim Brandenburg (Best13 86-93)

wolf sitting on an iceberg in "An Arctic wolf surveying his domain from an iceberg throne" c. 1990* Jim Brandenburg (Best13 93; Graphis90 \191)

ARGENTINA

angry women with pictures of missing children in "Mothers and Grandmothers of the Plaza de Mayo" 1979 Eduardo di Baia (Photos 147)

ARIZONA (Battleship)

 battleship sinking and in flames at Pearl Harbor in "The battleship *Arizona*" 1941 Photographer Unknown (Lacayo 103)

ARMED FORCES *see also* PARAMILITARY

 African American man in uniform in "Unidentified World War II Merchant marine" n.d. Florestine Perrault Collins (Willis \56)

 African American man in World War I uniform in "Sgt. M. Hart, World War I" c. 1919 Addison N. Scurlock (Willis \58)

 African American man standing behind Army officer in "Officer and Manservant" c. 1851 Photographer Unknown (Photography1 \4)

 African American sailor standing with woman in front of brick wall in "Jack and Gwen Lawrence" 1944 Arnold Newman (MOMA 163)

 African American soldiers posing for group portrait in "Members of the U.S. 369th Infantry Regiment, which was awarded the *Croix de Guerre* for bravery" c. 1917 Photographer Unknown (Goldberg 60)

 American solider trying to protect man on ground from crowd in "Crisis in Haiti" 1994 Carol Guzy (Capture 174)

 Americans marching through *Arc de Triomphe* in "Yanks parade through Paris" 1944 Peter J. Carroll (Eyes #193)

 Angolan soldier with anti-tank weapons, standing in truck in "War-Torn Angola" 1984* Larry C. Price (Capture 133)

 armed federal agents near child in closet in "Elian" 2000* Alan Diaz (Capture 198)

 armed soldiers dragging bodies in "El Salvador: The Killing Ground" 1982 James B. Dickman (Capture 125)

 back of George Bush waving at the troops in "The President and First Lady make a Thanksgiving visit to U.S. troops in Saudi Arabia" 1990* Jean-Louis Atlan (Life 36d)

 calvary on a large field in "Cavalry Maneuvers, *Camp de Châlons*" 1857 Gustave Le Gray (Art \93, \94; Szarkowski 322b; Waking #58)

 carrying man from his office in "Avery gets Bum's Rush" 1944 William Pauer (Best18 9)

 Chilean troops marching in [soldiers in Chile] c. 1999* Craig Cutler (Photo00 69)

 Civil War soldiers in uniforms and with guns in "John and Nicholas Marien of Terre Haute, Indiana" c. 1862-1864 Photographer Unknown (Marien \3.12)

 collection of formal portraits of Civil War military in "Soldiers' Photographs Received at Dead Letter Office" 1861-1865 Photographer Unknown (Photography1 #IV-1)

 Confederate soldiers gathered for a portrait in "Rebel Soldiers in Richmond" 1861 Photographers Unknown (Lacayo 22b)

 crowd attending memorial service in hanger in "Memorial services for the soldiers are held in a hanger at Ft. Campbell" 1985 Charles Steinbrunner (Best11 51a)

 dead soldier in helicopter in "Air force door-gunners transport the body of a comrade killed in an ambush in El Salvador" 1988 Dick Swanson (Best14 86d)

 decorated Belgian soldier in "Brave Belgian Lange, who was decorated for killing 15 German soldiers singlehanded" c. 1914-1918 Underwood & Underwood (Eyes #42)

 draft lottery in "Secretary of War Henry Stimson, blindfolded, holds out the first capsule drawn October 29 in Washington, D.C., in nation's first peacetime draft lottery" 1940 Photographer Unknown (Eyes #136)

 drill instructor yelling at man in basic training in "After making a mistake during a marching drill, an errant 'poopie' responds to his drill instructor" 1992* Joel Sartore (Best18 119b)

 drilling in large indoor space in "Great Nave: Wounded Soldiers Performing Arms Drill at the End of Their Medical Treatment, Military Hospital, Paris" 1914-1916 Photographer Unknown (Szarkowski 171)

 dying soldier holding onto priest in street in "Aid From Padre" 1962 Hector Rondon (Capture 51)

 enthusiastic soldiers with guns in air in "Liberia–Executioners Celebrate" 1980 Larry C. Price (Capture 116)

 Ethiopian soldiers in dress uniform in "Ethiopian soldiers" 1935 Alfred Eisenstaedt (Eyes #96)

 family rushing toward soldier in "Burst of Joy" 1973 Slava Veder (Capture 86; Lacayo 157a; Life 75)

 father and soldier son in "Hispanic Father and Son" 1943 Harry Annas (Goldberg 114)

 group including soldiers waiting for bus in "Waiting for a bus at the Memphis terminal" 1943 Esther Bubley (Documenting 327c)

 group of soldiers sitting in front of White House in "The First Lady at a party she threw for Army troops" 1942 Thomas McAvoy (Life 22a)

 helmeted Marine drinking from a canteen in "Marines at Saipan" 1944 W. Eugene Smith (Art \414; Eyes #205; Rosenblum2 #608)

 honor guard at airport in "An Air Force honor guard escorts the remains of nine Americans brought home–after a decade–from Vietnam" 1985 Eric Luse (Best1 91b)

hundreds of servicemen and servicewomen holding newspaper declaring "Peace" in "U.S. Servicemen and Servicewomen, Paris" 1945 U.S. Army (Life 68)

in battle in ruins of Stalingrad in "The Assault of the 13th Guard, Stalingrad" 1942 Georgi Zelma (Art \420)

Indian officer in full-dress in "One of the king's Indian orderly officers tries on his full-dress uniform" 1939 Felix Man (Eyes #122)

Israeli soldier standing guard in "An Israeli soldier stands watch in the Old City of Jerusalem" 1990 David H. Wells (Best16 198)

Israeli soldier with gun kissing woman in city square in "An off-duty sergeant in the Israeli Army lets down his guard for a kiss in West Jerusalem's Zion Square" 1996* Annie Griffiths Belt (Through 276)

line of men removing their hats in "For Queen and Country (Funeral of soldier Boer War)" 1899-1902 Horace Nicholls (Szarkowski 149)

lone soldier holding gun, standing among tree stumps in "Vietnam–Lone U.S. Soldier" 1971 David Hume Kennerly (Capture 78)

man in uniform having picture taken in [Soldier in Photo Booth] n.d. Esther Bubley (Fisher 58)

man in uniform in front of poster in "Soldier in front of Capitol Theatre" 1943 Esther Bubley (Fisher 59)

Marines capturing Iraqi forces in the desert in "Iraqi soldiers surrender to the U.S. Marines 1st Division as it advances toward Kuwait City" 1991* Christopher Morris (Best17 35)

Marines dashing off landing craft in "Fourth Marines hit Iwo Jima Beach" 1945 Joe Rosenthal (Eyes #223)

Marines raising American flag in rubble in "Old Glory Goes Up on Mount Suribachi" or "Raising the Flag at Iwo Jima" 1945 Joe Rosenthal (Capture 16; Eyes #212; Lacayo 118; Marien \5.86; Monk #29; Photos 65)

men hugging families in "Members of the VAQ 137 Airborne are greeted by their families" 1986 Jimi Lott (Best12 16a); "Return of members of VS 30, an anti-sub squadron" 1986 Bob Self (Best12 16d)

midshipmen in dress uniforms standing in lines in "Midshipmen at Annapolis Naval Academy" 1990* Richard Kozak (Best16 182)

naked young girl running and screaming on road, followed by soldiers in "Vietnam–Terror of War" or "South Vietnamese Children Burned by Napalm" 1972 Nick Ut (Capture 80; Eyes #297; Lacayo 157d; Marien \6.74; Monk #44; Photos 134)

parade of Russian troops in "Parading before Winter Palace in Petrograd" 1917 Stanley Washburn (Eyes #74)

parade of sailors in "A Veterans Day parade in Birmingham, Alabama, brings out units from both Navy and Army" 1986 Bernard Troncale (Best12 145a)

parade of soldiers in "A Veterans Day parade in Birmingham, Alabama, brings out units from both Navy and Army" 1986 Bernard Troncale (Best12 145b)

parade of troops on horseback in "General Wool leading his troops down the street in Saltillo, Mexico" c. 1847 Photographer Unknown (Eyes #8; Marien \2.30)

parade of troops through city streets in "French troops returning from Italy" c. 1859 Photographer Unknown (Eyes #1)

photo of sailor and flags posted on house door in "When her grandson, Robert Tames, left to fight in the Persian Gulf war, his picture was put on the front door" 1991 Michael Wirtz (Best17 75)

photo of solider killed in battle in "A photograph of Army Pvt. Robert Talley and the letter confirming his death during the war" 1991* Mark Peterson (Best17 21a)

photo of Marine killed by friendly fire hangs on railing in "A photo of Marine Lance Cpl. Thomas A. Jenkins hangs outside his family home" 1991* Lois Bernstein (Best17 12a)

portrait of seated soldiers in "Portrait Group Before DAGTYPS Gallery Tent" c. 1862-1863 Henry P. Moore (Photography1 #IV-11)

portraits on display in window in "Photographer's display on Bleeker [sic] Street. New York" 1942 Marjory Collins (Fisher 70; Rosenblum \167)

sailor and wife embracing in "Tony Rementer and his wife, Deborah, embrace under the Iowa's big guns" 1988 Lois Bernstein (Best14 47b)

sailor sitting with cup of coffee in "Blood donors enjoying light refreshments before leaving the American Red Cross Center" 1943 Ann Rosener (Fisher 73)

sailor reflected in mirror and soldier sitting at desk in "In the lounge at the United Nations service center" 1943 Esther Bubley (Fisher 69)

sailor kissing nurse in street in "V-J Day in Times Square" 1945 Alfred Eisenstaedt (Eyes #210; Lacayo 121)

sailors eating at table in ship's mess hall in "Aboard Commodore Dewey's Flagship" 1899 Frances Benjamin Johnston (Sandler 145)

sailors hugging their girlfriends in "Friends and lovers say goodbye moments before the USS Missouri heads for duty in the Persian Gulf" 1990* Peggy Peattie (Best16 190a)

sailors standing by railing of ship in "Mother comforts her young daughter as her husband leaves for the

Persian Gulf on the USS *Reuben James*" 1997 Jeff Widener (Best23 121d)

sailors standing under battleship's guns in "A somber mood envelops sailors standing under the 16-inch guns of the Battleship *Iowa* as it eases from its Norfolk moorings . . . duty in the Persian Gulf" 1987 William Tiernan (Best13 10)

Scottish Highlanders in uniform in "Gordon Highlanders at Edinburgh Castle" 1845-1846 Hill and Adamson (Art \38)

Scottish Highlanders with rifles in "Sergeant of the 42nd Gordon Highlanders reading the Orders of the Day" 1846 Hill and Adamson (Art \37)

soldier hugging crying son in "Private says goodbye to his son" 1940 Robert Jakobsen (Lacayo 104)

soldier in poncho, sleeping on sandbags in rain in "Vietnam–Dreams of Better Times" 1967 Toshio Sakai (Capture 62)

soldier standing near seated woman who is sewing in "In the Hall of a boarding house" 1943 Esther Bubley (Fisher 71)

soldiers carrying flag-draped coffin from plane in "First bodies of the Gander crash victims arrive at Dover, Delaware AFB" 1985 Joe Songer (Best11 50)

soldiers in long coats running into battle in "Attack" 1941 Dmitri Baltermants (Art \419)

soldiers outside ruined building in "A British entrenchment during the Indian Mutiny" 1858 Félice Beato (Lacayo 15)

soldiers with rifles running in grass in "Korea" 1950 David Douglas Duncan (MOMA 201)

South Vietnamese soldier, with a knife, threatening Viet Cong collaborator in "Vietnam–Crime and Punishment" 1964 Horst Faas (Capture 54)

Soviet soldiers walking in line with helmets and long overcoats in "The Sea of War. Arctic Ocean" 1941 Yevgeny A. Tschaldey (Icons 98)

troops and supplies being unloaded from ships three days after D-Day in "Normandy Landings" 1944 Photographer Unknown (Photos 61)

troops in formation in front of tents in "Northern troops encamped near Washington" 1861 Photographer Unknown (Lacayo 22a)

Turkish soldiers in black jackets and helmets in "Empowered as guardians of the republic, military men in Ankara, Turkey, attend the funeral of President Turgut Ozal" 1933* (Through 68)

two soldiers looking at statute of man pulling back horse in "Soldiers looking at the statue in front of the Federal Trade Commission Building. Washington, D.C." 1943 Esther Bubley (Fisher 57)

uniformed men holding bedrolls and posing for picture in "Army Scene" c. 1914 Jean Tournassoud (Rosenblum2 #345)

Union officers seated for portrait in "New York 7th Regiment Officers" c. 1863 Egbert Guy Fowx (National \16)

Union officers seated on chairs for portrait in "General John F. Hartranft and Staff, Responsible for Securing the Conspirators" 1865 Alexander Gardner (Rosenblum2 #232)

Union soldiers leaning against a tree in "Three Soldiers" 1860s Photographer Unknown (Rosenblum2 #213)

women in formal dresses and men in uniform in "All nursing and no play might make Frances Bullock a dull girl!" n.d. Ann Rosener (Fisher 127)

World War I veteran in uniform seated by an American flag in "Portrait of a 92-year-old veteran of World War I" c. 1990* Pete Stone (Graphis90 \177)

ARMENIA

Armenian victims of starvation and genocide in "Armenian Genocide" 1915 Photographer Unknown (Photos 28)

ARMORED CAR

parked on street in "Danbaum armored car" 1938 John Vachon (Documenting 97c)

ARTILLERY

cannon on grass in "Cannon, Vicksburg" 1986 Richard Benson (Szarkowski 315a)

cannons behind dirt mounds in "Rebel Works in Front of Atlanta, Georgia" 1864 George N. Barnard (Rosenblum2 #211)

cannons by large stone dragons in "Artillery in front of Stone Dragons, Prome, Burma" 1852 John McCosh (Marien \2.33)

line of cannons behind a wall in "Battery No. 4–Near Yorktown, Mounting 10 13-inch Mortars, Each Weighing 20,000 Pounds" 1862 James F. Gibson (Photography1 #IV-5)

looking down a line of cannons in "Union artillery at Fredericksburg" 1863 Timothy O'Sullivan (Eyes #30; Lacayo 12-13)

men standing by large cannon in "Mortar Dictator, in Front of Petersburg" 1864 David Knox (Photography1 #IV-4)

row of cannons being fired in "Artillery Battery, Pensacola, Florida" 1861 Jay Dearborn Edwards (Photography1 #IV-12)

row of decoy tanks in "Decoy Tanks of Tin and Wooden Guns" 1939 or earlier Margaret Bourke-White (Szarkowski 315c)

stacks of cannonballs waiting to be loaded on ships in "Matériel assembled for the Peninsular Campaign" 1862 Mathew Brady, attribution (Lacayo 23c)

ARTISTS' STUDIOS, ARTISTS, and ARTISANS

artist sitting by easels and canvases in "Artist Jeroen Pressers in His Studio" c. 1991* Aernout Overbeeke (Graphis91 \145)

carver with long wooden chain in "Folk Artist with Carved Wooden Chain" c. 1855 Photographer Unknown (National 155b)

glassblower in studio in [glassblower] c. 1991 Raymond Depardon (Graphis92 \215)

Japanese man with paint brush in "Beato's Artist" c. 1868 Félice A. Beato (Marien \3.41)

man carrying sculpture in "Alberto Giacometti at work in his Paris studio" 1960 Henri Cartier-Bresson (Lacayo 138b)

man at desk in studio in "Picasso in his studio" 1960* David Douglas Duncan (Lacayo 138c)

man pulling wagon with easel in "A Polish artisan ambles home through Krakow Square at the end of his workday" 1992 Thomas Dallal (Best18 82)

man sketching on rock in "Alfred R. Waud Sketching at Gettysburg" 1863 Timothy H. O'Sullivan (Photography1 #IV-13)

painter with long brush and walls filled with line drawings in "Henri Matisse, at his studio in Nice, France" 1950 Dmitri Kessel (Life 169)

woman standing with sketch book in field in "The Sketch" 1902 Gertrude Käsebier (Photography1 #V-31)

wood carver with chisel in "Artist Cruz Lopez finishes a wood carving of Nuestra Señora de Guadalupe" 1997* Richard Hartog (Best23 195a)

ASSASSINATION see also MURDER

gunmen shooting into reviewing stand in "Sadat: The parade of death" 1981 Mohamed Rachad El Koussy (Eyes #353)

police arresting assassin as Bosnians try to grab him in "Arrest of Archduke Ferdinand's Assassin" 1914 Photographer Unknown (Photos 26, 27)

Reagan, immediately before and after being shot in "Assassination Attempt" 1981 Ron Edmonds (Capture 118-119)

young Japanese using Samurai sword to kill older man in "Assassination of Asanuma" 1960 Yasushi Nagao (Capture 46)

ASTRONAUTS / COSMONAUTS see also SPACE FLIGHT

astronaut saluting flag near lunar module on moon in "On the moon" 1971 David R. Scott (Eyes xvii)

cosmonaut in his spacecraft in "Gagarin, First Man in Space" 1961 Photographer Unknown (Photos 97)

first man on moon in "Edwin 'Buzz' Aldrin on the Moon" 1969* Neil Armstrong (Eyes #367; Monk #47; Photos 125)

floating in space near space shuttle in "Astronaut Mark Lee on spacewalk" 1994* NASA (Through 14)

interview of Challenger astronauts in "Christa and fellow astronauts" 1986* Michael R. Brown (Best12 11)

a line of hearses in "Three months after the tragedy, the remains of the astronauts are brought to Dover Air Force Base in Delaware" 1986 Jed Kirschbaum (Best12 13c)

on flight deck near space capsule in "Alan Shepard after trip in Mercury capsule" 1961 Dean Conger (Eyes #368)

on moon by American flag in "Apollo 11 Eva View" 1968 NASA (Goldberg 11)

space suits with boots and gloves hanging on rod in "Apollo Training Suits" 1978* Hiro (Rolling #41)

underwater training in "Before their mission to repair the Hubble Space Telescope, astronauts practiced underwater in NASA's 1.3-million-gallon simulator tank" 1994* Roger H. Ressmeyer (Through 482)

upside down in a training area in "Two would-be space travelers experience weightlessness aboard a Convair C-131 transport aircraft" 1960* Wide World Photos (Through 474)

walking on moon in "Buzz Aldrin arranging seismic equipment to gauge lunar tremors" 1969* NASA (Life 103)

woman in flight suit waving in "Christa McAuliffe greets well-wishers at the Kennedy Space Center" 1986 Arthur Pollock (Best12 8)

ASTRONOMICAL OBSERVATORIES

ancient kiva of the Anasazi in "In Chaco Canyon, New Mexico, the great kiva of Casa Rinconada symbolized the cosmos for its 11th-century Anasazi builders" 1990* Bob Sacha (Through 498)

beacons of light into the night sky in "At Starfire Optical Range in New Mexico, lasers measure the distortion

BMW convertible and sedan in [BMW corporate calendar] c. 1991* Rick Rusing (Graphis92 \165-\167)

black car by brick building in "Black car" c. 1989* Bruno Joachim (Graphis89 \203)

black cars parked randomly in plaza in "Piazza del Campidoglio" 1940 Carl Mydans (Lacayo 76d)

Buick 1953 Special Coupe front and rear in [Vintage 1953 Buick Special Coupe] c. 1991* Ernst Hermann Ruth (Graphis92 \178, \179)

Cadillac and couple in raccoon coats in "Couple in Raccoon Coats" or "A Harlem couple wearing raccoon coats standing next to a Cadillac on West 127th Street" 1932 (Marien \5.72; Rosenblum2 #322; Willis \67)

car in "180 Objectiv" c. 1999* Peter Allert (Photo00 177)

casting white shadow in "Stockholm" 1967 Kenneth Josephson (Decade \77)

Citroën automobile partially covered in car port in "Citroën" c. 1989* Nadav Kander (Graphis89 \88)

classic car in "Two views of the *Talbot Lago SS* from the Guggisberg Collection" c. 1990* Michael Zumbrunn (Graphis90 \232, \233)

classic cars, details in [classic cars] c. 1995* Hunter Freeman (Graphis96 146)

classic cars, side view in [classic cars] c. 1995* Michael Furman (Graphis96 148)

classic red car in "Big American car in front of a cattle barn" c. 1991* Hubert Croisille (Graphis91 \285)

classic sports car in "Classic Car" c. 1999* Hubertus Hamm (Photo00 176)

convertible at drive-in movie in "Couple enjoy a drive-in movie–and their 1957 *Ford* convertible" 1985* Chris Russell (Best11 145a)

convertible parked in front of train station in [ad for National car rental company] c. 1990* Todd A. Smith (Graphis90 \229)

couple driving in convertible in "Los Angeles" 1964 Garry Winogrand (MOMA 227)

couple in a convertible in [self-promotional] c. 1990* Jim Erickson (Graphis90 \227)

couple with monkey in convertible in "Park Avenue, New York" 1959 Garry Winogrand (MOMA 245)

covered up in desert from [self-promotional] c. 1989* Harry De Zitter (Graphis89 \79)

details of classic cars in "Details of old cars" c. 1991* Michael Furman (Graphis91 \264-\270)

driving a car down the dunes in "Thrill-seekers descend steep dunes at White Sands National Monument in New Mexico" 1935 G. A. Grant (Through 352)

Ferrari and a Porsche in "Porsche and Ferrari" c. 1991* René Staud (Graphis91 \260-\263)

Ford in carport near cornfield in ['39 Ford, Beaufort County, North Carolina] c. 1991* Guy Kloppenburg (Graphis92 \190)

front of an Audi Horsch *853* in "Audi" c. 1992* Rodney Rascona (Graphis93 139)

front of 1925 Hispano Suiza automobile in [ad for Parker pens and pencils] c. 1989* Daniel Jounneau (Graphis89 \231)

front tire and headlight in "Ford Car" 1929 Ralph Steiner (Szarkowski 180)

gardener standing by car in [ad for Isotta-Fraschini automobile] 1931 Grancel Fitz (Szarkowksi 188)

in man's living room, without wheels in "In Cuba, waiting for wheels" c. 1990* Robert van der Hilst (Graphis90 \268)

Infiniti J30 in [Infiniti J30] c. 1992* Rick Rusing (Graphis93 160c)

jeep on beach in surf in "Jeep at Guadalcanal" 1944 W. Eugene Smith (Decade \57)

Lamborghini Diablo side view in [Lamborghini Diablo] c. 1995* Steve Hathaway (Graphis96 149a)

Lexus GS300 in [Lexus GS300] c. 1995* Rick Rusing (Graphis96 147, 149b)

lighter in "Crushed Objects" c. 1999* Craig Cutler (Photo00 178)

Lincoln Coupe Capri and 1957 T-Bird wheel and door handle in "Classic cars" c. 1991* David Plank (Graphis92 \171-\172)

line of cars at parking meters in "Cars and parking meters" 1938 John Vachon (Documenting 95c)

Mercedes Benz in [Mercedes Benz] c. 1995* Aernout Overbeeke (Graphis96 145)

Mercedes S-Class in [S-class Mercedes] c. 1992* Keiichi Tahara (Graphis93 160b); Sheila Metzner (Graphis93 160a)

multiple images of a car in front of stores in "Detroit" 1943 Harry Callahan (MOMA 182)

Packard on display in "Packard" 1932 Edward Steichen (Hambourg 34)

partial wheel and partial headlight in "Wire Wheel, New York" 1918 Paul Strand (Art \187)

Porsche details in [Porsche 917K and Porsche 718 RSK] c. 1992* Michael Furman (Graphis93 162a, 163)

Porsches in garage openings in "Porsche, Driving at its Most Beautiful" c. 1989* Dietmar Henneka (Graphis89 \205)

Porsches in silhouette in "Porsche, Driving at its Most Beautiful" c. 1989* Dietmar Henneka (Graphis89 \204)

portion of a Mercedes in "A 1936 Mercedes 540K as used in an advertising campaign" c. 1989* Dietmar Henneka (Graphis89 \206)

prototype automobile in "Prototype automobile" c. 1990* Daniel M. Hartz (Graphis90 \226)

race car in "Grand Prix at the Automobile Club of France" 1912 Jacques-Henri Lartigue (Icons 23; Waking #156)

race car in pit being serviced in "Ernie Irvan's pit crew goes to work during the Mello Yello 500 in Charlotte" 1993* Christopher A. Record (Best19 144)

race car on track in "Indianapolis 500 Memorial Day classic had a late entry, a rabbit came under a fence and ran with the cars" 1986 Mark Welsh (Best12 132)

rear of car in "*Lamborghini Countach*" c. 1990* Dieder Thouvenel (Graphis90 \225)

sections of Audis in "Working with the Environment" c. 1989* Rick Rusing (Graphis89 \207-\210)

sports car in [self-promotional] c. 1992* Alexander Bayer (Graphis93 138)

white car in desert from [self-promotional] c. 1989* Harry De Zitter (Graphis89 \82)

—B—

BALLET *see* DANCE

BARBERSHOPS

African American barber and customers in "Big Ray" 1998 (Committed 129);"Barbershop, New Orleans" c. 1970s Marion James Porter (Willis \216); "House's Barber Shop, Harlem" n.d. Jeffrey Henson Scales (Willis \249-\251)

barber asleep in his chair in "On a slow day, barber Jack McGleish stretches out in his favorite chair for a snooze" 1987 Mark Fraser (Best13 105)

barber shaving man in chair in "Mr. Pennepacker, one of Lititz's seven barbers" 1942 Marjory Collins (Documenting 261b)

empty barber chairs and walls covered with newspaper in "Negro barbershop, Atlanta, Georgia" 1936 Walker Evans (Lacayo 99a)

empty shop in "Joe's Barbershop" 1970 George Tice (Rosenblum2 #686)

empty store in "City Barber Shop, Clarendon, Texas" c. 1990* Harry De Zitter (Graphis90 \89)

red chair among other barbershop objects in [Barber's chair] c. 1991* Thomas Hollar (Graphis92 \60)

striped storefront and barber pole in "Sidewalk and Barber Shop Front, New Orleans" 1935 Walker Evans (Art \309)

young boy crying in "The first haircut" 1969 Chester Higgins, Jr. (Willis \347)

BARNS

boarded-over door and windows in "White Barn, Bucks County, Pennsylvania" 1914-1917 Charles Sheeler (MOMA 101)

cow painting on side in "Freshly-painted feed wagons are arranged outside Nebraska State Fair dairy barn in Lincoln, awaiting start of activities" 1985* Ted Kirk (Best11 47a)

door painted on a barn in "Painting on a Barn near Thompsonville, Connecticut, along Route 5" 1940 Jack Delano (Decade 43d)

white barn and silos in "A barn on rich farmland" 1939 Marion Post Wolcott (Fisher 34)

BARS *see* RESTAURANTS AND BARS

BASEBALL

adult catching with boys in "San Diego's Craig Nettles plays catch with sons Tim and Jeff during All-Star game warm-up" 1985 Bruce Bisping (Best11 201a)

African American baseball team from an innercity little league playing and on a bus in "The Anderson Monarchs" 1997 Eric Mencher (Best23 214a, 215c)

African American team at bat in "Homestead Grays Baseball Game" n.d Charles (Teenie) Harris (Willis \136)

African American player posing in field in "Negro League Baseball Player" n.d. Charles (Teenie) Harris (Willis \141)

African American team with their bats by their bus in honor of old Negro League teams in "The Anderson Monarch baseball team playing with their equipment" 1997* George Miller (Best23 173b)

amateur player running to base in "Mark Riashi is tagged out despite running over second baseman during a company softball game" 1993* Alan Lessig (Best19 223)

antique glove, bat, and ball in "Baseball memorabilia of James 'Cool Papa' Bell, one of the first Black Leaguers to be accepted in the Baseball Hall of Fame" c. 1991* Terry Heffernan (Graphis92 \56)

arguing with umpires in "Coach of the high school baseball team tries to argue a call" 1986 Glenn Osmundson (Best12 193a)

argument between players in "Mets pitcher Dave Cone tells Pedro Guerrero to stay away as the slugger comes after him for nearly hitting him with two pitches" 1988 Peggy Peattie (Best14 207a)

axe as a bat in "Lacking a bat didn't stop Cortez Traylor from playing baseball near his home" 1993* Alan

Lessig (Best19 221)

Babe Ruth looking at teammates and cheering fans in stadium in "Babe Ruth Retires No. 3" 1948 Nathaniel Fein (Capture 22; Goldberg 81)

Babe Ruth sitting and holding bat in "Babe Ruth" c. 1927 Nickolas Muray (MOMA 124)

ball gets loose after player falls in "The ball slides from the glove of a High School fielder as he hits the grass" 1986 Glenn Osmundson (Best12 210)

bat flying toward player in "St. Louis Cardinal third baseman Terry Pendleton watches a loose bat coming his way during a game against the Atlanta Braves" 1990* Frank Niemeir (Best16 118d)

boy catching ball on outfield wall in "Yankee fan competes with Oriole utfielder for the catch in the ALCS championship" 1996* Karl Merton Ferron (Best22 198b)

boy standing on wooden fence to watch game in "12-year-old watches the Lynn Mad Dog's game from the cheap seats behind right field" 1996* Bill Greene (Best22 198a)

boy talking to girls over a fence in "Little Leaguer chats with fan during a game" 1990 Chris Seward (Best16 122)

boys changing into uniforms in "Little Leaguers" 1954 Yale Joel (Life 42a)

catcher flips over after catching ball in "Atlanta Braves catcher Greg Colson flips after colliding with Minnesota Twins runner Dan Gladden at home plate" 1991* Eric Miller (Best17 145); Jonathan Newton (Best17 150b)

catching a foul ball in the dugout in "After missing the catch on a foul ball, Texas Ranger Chad Kreiter watches Chicago's King and Woodson make the play in the dugout" 1990* (Best16 131)

celebrating a World Series win in "Half a million people jammed the streets of Minneapolis and St. Paul for a parade celebrating the Minnesota Twins' victory in the World Series" 1987 Rita Reed (Best13 203)

cheering by players after the World Series in "Dodger teammates hoist Orel Hershiser after he pitched a four-hitter to help Los Angeles win the World Series" 1988 Kim Kulish (Best14 12a)

cheering by players after winning the World Series in "Minnesota Twins teammates embrace after winning the World Series" 1987 Gary Weber (Best13 220b)

college players yelling from bench in "The Harbor College bench erupts in celebration at strike out" 1997* Richard Hartog (Best23 172b)

colliding players on the ground in "Cubs runner Shawon Dunston shows the pain as Pirate shortstop Washington lands on him during a muffed double play" 1986 Phil Velasquez (Best12 208a)

community residents playing baseball in "Diamonds in the Rough" 1992 Ronald Cortes (Best18 148-150)

diving for a ball in "Cincinnati shortstop Barry Larkin holds Chad Fonville of the Dodgers to an infield single" 1995* Wally Skalij (Best21 191c)

diving into first base in "A remote camera records the action, from inside first base, as a minor league player dives back safely" 1995* Bill Alkofer (Best21 115)

dog pulling on player's belt in locker room in "In Florida's Senior League, it doesn't bother anyone if you keep your dog in the locker room" 1991* Randy Olson (Best17 26b)

double play in "Cubs infielder gets out of the way as he doubles the runner" 1986 Bernard Brault (Best12 209a)

double play in "Double play throw despite a rough slide" 1986 Sam Forencich (Best12 209b)

falling and missing a ball in "Kansas City right fielder Mike Kingery grimaces as he dives and misses a looping double hit by Boston's Tony Armas" 1986 Calvin Hom (Best12 211)

fans watching game from balcony far above the stadium in "The Pirates win the World Series, Pittsburgh" 1960 George Silk (Life 10)

game from the air in "Playing Baseball, Allen's Creek, New York" c. 1997 Marilyn Bridges (Graphis97 140b)

glove, ball, and other memorabilia for [50th anniversary of the National Baseball Hall of Fame] c. 1991* Terry Heffernan (Graphis91 \108)

home plate as player hits ball in "Cal Ripken: 2,131" 1995* Lloyd Fox (Best21 133)

hugging after winning the World Series in "George Brett gives a lift to pitcher Bret Saberhagen as the Kansas City Royals win the World Series" 1985 Keith Myers (Best11 202)

hundreds of players exercising in "Brooklyn Dodgers Rookie Spring Training" 1948 George Silk (Life 141)

in dugout, holding a bat in "Oakland Athletics star Jose Canseco checks his bat after whittling it a bit" 1988 Lois Bernstein (Best14 50a)

Jackie Robinson stealing home plate in World Series in "Jackie Robinson steals home base" 1955 Ralph Morse (Lacayo 152)

Joe DiMaggio at home plate, hitting a ball in "Joe DiMaggio" 1949 Hy Peskin (Lacayo 85)

leaping over sliding runner in "San Francisco Giants infielder Jeff Leonard loses his cap as he avoids a sliding LA Dodger base runner" 1985 Paul Chinn (Best11 201c)

lightning in sky above a pitcher in "Adam Meinershagen pitching for Sydney during an electrical storm"

1995* Tim Clayton (Best21 113)

Little League international teams in "Little League World Series" 1990 Gerard Lodriguss (Best16 126-127)

Little League winners in a pile in "Teammates mob Lou Russell after his two-run, 10th inning home run brought the players a trip to the Little League World Series" 1986 Ronald Cortes (Best12 228a)

Little Leaguer falling over a base in "It may be only T-ball, but for these Little Leaguers it's as tough as the 'Bigs'" 1986 Don Kelsen (Best12 192)

Little Leaguer hitting t-ball in "Only T-ball" 1985 Brian S. Tombaugh (Best11 191)

Little Leaguer sad after losing a game in "Paige's Palace" 1998 Dudley M. Brooks (Best24 64)

Little Leaguer sliding into base in "Waiting for umpire's call on slide into second base" 1985 Ted Jackson (Best11 192b)

Little Leaguer throwing ball in "Infield play in North Carolina" 1985 Charles F. Eaton, Jr. (Best11 190)

Little Leaguers slap hands in "Paige's Palace" 1998 (Best24 96)

Little Leaguers on field and parents at scoreboard in "Field of Dreams" 1997 Khue Bui (Best23 167b, 216a,c)

Little Leaguers trying to catch fly balls in "I've got it" 1985 James P. McCoy (Best11 193a)

man throwing dirt in his own face in "The clown prince of baseball, Max Patkin, throws dirt in his face to get a laugh during a minor-league game" 1987* J. Kyle Keener (Best13 190a)

migrant workers playing and watching a baseball game in "Baseball game [at the Visalia Migratory Labor Camp, California]" 1940 Arthur Rothstein (Documenting 203c)

minor league ballparks and the fans in "Minor league ballparks" 1993* George Wilhelm (Best19 168-169)

near collision in short right field in "Kansas City's second baseman, Frank White, takes the ball away from right fielder Mike Brewer in a near collision in short right field" 1986 Calvin Hom (Best12 213)

Ozzie Smith in mid-somersault in "St. Louis Cardinal shortstop Ozzie Smith does his pre-game routine before game five of the 1985 World Series" 1985* Mickey Pfleger (Best11 152a)

Pete Rose at bat, in stadium, with reporters in "Bye-bye, Ty! Pete Rose photo essay" 1985 Bill Frakes (Best11 194-199)

photo essay about playing in the minor leagues in "Chasing a Dream" 1992* Rick Rickman (Best18 158-160)

pitching a baseball in "Texas Ranger Nolan Ryan hurls a pitch against the New York Yankees in his quest fo his 300th career win" 1990* Louis DeLuca (Best16 128-129)

player arguing with umpire in "Pittsburgh Pirate Jose Lind argues with the umpire after being thrown out at second to end the inning in a loss to Cincinnati" 1988 Vince Musi (Best14 140d)

player colliding in "Detroit Tiger runner Kirk Gibson scores on a sacrifice fly as he bangs into Pat Borders of the Texas Rangers" 1995* Chuck Solomon (Best21 114a)

player warming up in "Infielders for the Westhill High School baseball team watch their reliever warm up" 1986 Glenn Osmundson (Best12 193b)

player removing toilet paper from outfield in "Toronto Blue Jay center fielder Lloyd Moseby removes toilet paper from Boston's Fenway Park" 1985 William Polo (Best11 173b)

player's image in several mirrors on field in "Shortstop Ozzie Smith, the wizard of the St. Louis Cardinals infield, redefines the baseball cliche of 'doing it with mirrors'" 1988* Joe McNally (Best14 155)

players in locker room in "San Francisco Giants players take time to go along with the music being broadcast at Candlestick Park" 1985 Steve Ringman (Best11 204a)

players jumping after winning World Series in "The Cincinnati Reds celebrate after winning the World Series in four straight games against the Oakland A's" 1990* Genaro Molina (Best16 52a)

players on bench in "Nell Grim was the only woman among 60 baseball buffs to sign up for a week-long Mickey Mantle/Whitey Ford Yankee Fantasy Camp" 1985 (Best11 204d)

players stopping a fight in "St. Louis Cardinal Joaquin Andujar is restrained by teammates during the seventh game of the World Series" 1985 Frank Niemeir (Best11 189)

playing baseball in [fund raising for Rickwood Field, Alabama] c. 1995 John Huet (Graphis96 203)

pushing Little Leaguer in wheelchair in "Keith Darling, 10, heads for third base, powered by his brother, Greg, 12, during a Challenger Division Little League baseball game" 1990 Eric Hegedus (Best16 119)

running to base in "First-base action on an errant throw from short stop caught the runner on his hip during a high school game" 1987 Gary Cameron (Best13 192c)

running to base in "New York Mets rookie Mookie Wilson runs for third base during a World Series game against the Boston Red Sox in Fenway Park" 1986 Bill Greene (Best12 212)

scoreboard of wood in city park in "[Boys] keep score for the Kingsbridge All-Stars vs. Westside game in the Bronx" 1996 Jennifer Sue Altman (Best22 199b)

shadows on field in "In a late afternoon playoff game at Busch Stadium" 1996* James D. Baird (Best22 199a)

signing autographs in the dugout in "Rookie outfielder Jose Gonzalez playing on the expanded Dodgers team signs autographs before an exhibition game" 1987 John Blackmer (Best13 202a)

small town bleachers behind a fence in "At the baseball game" 1941 Russell Lee (Documenting 220a)

softball player arguing with umpire in "Oklahoma Zappers appeal to umpire on a call at home plate during the Girls World Softball Tournament" 1985 Greg Peters (Best11 192a)

stepping on player's head as he slides to second base in "Sliding safely to second base during a pickoff attempt" 1991 Bill Wade (Best17 148)

stickball on a playground in "Cuban boys play stickball on an inner city lot in Havana" 1996* Jerry McCrea (Best22 193)

T-ball player trying to hit ball in "Swinging away at his first T-ball practice" 1992 April Saul (Best18 146d)

tagging a player in "Infielder Mark Gunther is late with his tag as he tries to catch Darren Tyson" 1985 Jonathan Kirk (Best11 200)

throwing the ball in "California Angels second baseman Mark McLemore twists and strains as he throws a player out" 1987 Paul Chinn (Best13 198a)

trying to catch a ball and a broken bat in "Philadelphia Phillies third baseman Mike Schmidt has to contend with a broken bat as well as fielding the ball" 1988 Jerry Lodriguss (Best14 136a)

trying to make a play in "Cubs runner Gary Matthews tries to take out Philly shortstop" 1986 Phil Velasquez (Best12 208b)

umpire signaling "safe" in "Manny Lee of the Toronto Blue Jays mimics the umpire's signal of 'safe' after breaking up a double play" 1992* Mark D. Phillips (Best18 135)

watching game from a distance in "11-year-old watches a minor league game from a hilltop behind the right field wall" 1997* Stephen D. Cannerelli (Best23 172a)

watching players through a fence in "Players complete for major-league positions at a Milwaukee Brewers training facility near Phoenix, Arizona" 1991* William Albert Allard (Through 354)

winning the pennant in "The Boston Red Sox celebrate their American League pennant victory at Fenway Park" 1986 Paula Bronstein (Best12 214d)

winning the World Series in "New York Mets catcher Gary Carter jumps on relief pitcher Jesse Orosco after the Mets downed the Boston Red Sox in the seventh game of the World Series" 1986 Linda Cataffo (Best12 215)

BASKET MAKING

women weaving baskets in "Pocumtuck basket makers" c. 1900 Frances S. Allen and Mary E. Allen (Rosenblum \53)

BASKETBALL

African American team in group portrait in "Company E. (all male) basketball team" c. 1920s Allen L. Cole (Willis \106)

African American women's team in group portrait in "Councilman L. O. Payne's (all female) basketball team" 1935 Allen L. Cole (Willis \105)

backboard on fire escape of apartment building in "Untitled" c. 1980s (Willis \284)

backboard shattering in "Traylor shatters the glass after a monster dunk" 1996* Jack Gruber (Best22 194a)

backboard shattering in pieces in "University of Pittsburgh basketball star Jerome Lane is showered with glass after shattering a backboard during a game" 1988 Vince Musi (Best14 141)

blocked from getting a loose ball in "Drury's Rod Gorman runs into a roadblock in the form of Charleston's Antonio Martin as he goes after a loose ball" 1986 Calvin Hom (Best12 203)

blocking a shot as ball is pushed away in "Purdue's Kevin McCants blocks a shot" 1987 Rodney White (Best13 211d)

boys jumping for the ball in "Framed by hoop and cornfields, three Indiana youngsters go for ball" 1985* Joe McNally (Best11 152b)

calling a timeout in "With just a few seconds left in the NCAA final game, Chris Webber of Michigan calls a timeout his team doesn't have" 1993* Joseph DeVera (Best19 161)

chasing a loose ball on court in "Atlanta Hawks guard Spud Webb gets a noseful of Philadelphia 76er Ben Coleman while going for a loose ball" 1988 Jerry Lodriguss (Best14 133)

choking player on floor in "Seattle Supersonic Xavier McDaniel chokes Los Angeles Laker Wes Matthews during a scuffle after a battle for a loose ball" 1987 Larry Steagall (Best13 196); 1987 Harley Soltes (Best13 197)

coach holding player with ball in "Portland Trailblazer Coach Jack Ramsey takes personal charge of Celtic Guard Dennis Johnson" 1985 Barry Chin (Best11 229)

crowd of cheering fans in "Thousands of fans packed Boston's City Hall Plaza to cheer after the Celtics won their 16th NBA basketball championship" 1986 Tara McParland (Best12 195)

dunking ball in basket in "UCLA's McCoy finishes off slam dunk" 1997* Richard Hartog (Best 23 192)

elbow in player's face in "Charles Barkley of the Philadelphia 76ers gets hit with an elbow by Michael Jordan of the Chicago Bulls" 1991 Jerry Lodriguss (Best17 163)

father and daughter playing basketball in "Of fathers and family" 1993* Patrick Davison (Best19 40d)

fight between players in "Houston's Akeem Olajuwon and Seattle's Clemon Johnson exchange blows in a fourth-quarter fight" 1986 Betty Udesen (Best12 207)

girls colliding to get loose ball in "Rhonda Christie flips teammate Amy Harris over her shoulder as the two collide while going for a loose ball" 1986 Lance Wynn (Best12 205)

girls on the sidelines during a game in "Members of the girls basketball team watch the clock in the closing seconds of the game" 1986 Bob Baker (Best12 200d)

girls reaching for ball in "A frenzied circle forms around the basketball" 1996* Eugene Garcia (Best22 194b)

hand holding ball in [hand holding basketball] c. 1995* John Huet (Graphis96 198)

hands flying in a game in "Philly 76r Maurice Cheeks flies through a sea of Dallas Maverick arms during a pre-season NBA game" 1986 William Snyder (Best12 206a)

hoop on wooden pole in desert in "Near Lake Powell, Arizona" 1979* Joel Sternfeld (Art \341)

jumping at net in "A Louisville player gets a North Carolina hand in the face during the second-round game of the NCAA West division playoffs" 1986* Phil Huber (Best12 108)

jumping for a basket on playground with a horse nearby in "The Basketball Game, Philadelphia" 1993* Ron Tarver (Willis \427)

jumping toward net in [jumping with basketball] c. 1995* John Huet (Graphis96 196)

leaping across other players in "FSU's Bob Sura leaps over Florida's Greg Williams, committing a foul in the process" 1995* Phil Sears (Best21 110d)

leaping up for basket in "The Philadelphia Sixers' Dr. J isn't the young player he once was, but he shows the Chicago Bulls that he can still fly" 1985 Ronald Cortes (Best11 206a)

leaping with basketball in "Michael Jordan" 1984* Co Rentmeester (Life 146a)

losing team sitting in classroom in "A long losing season shows on the faces of the basketball team" 1995* Drew Perine (Best21 105)

photo essay on players and practice in "High school basketball games" 1993 Joseph DeVera (Best19 162-165)

player at basket in "UCLA's Jelani McCoy blocks a shot by putting his hand through the basket" 1996* Richard Hartog (Best22 195d)

player cheering from the bench in "As the rest of his teammates sulk on the bench, seventh grader celebrates his team scoring two more points" 1996 Chad Stevens (Best22 100a)

player grabbing another player in "Andre Turner of the Philadelphia 76ers is mugged from behind by Lester Connors of the Milwaukee Bucks" 1991 Ronald Cortes (Best17 157)

player holds top of rim in "Herman Reid slams one for two during basketball at the Summer Olympics in Seoul" 1988* David Drapkin (Best14 148)

player talking to the referee in "St. Thomas' Curtis Washington unsuccessfully pleads his case with referee" 1986 Calvin Hom (Best12 202)

player trying to block the ball in "Center Kareem Abdul-Jabbar goes over Sam Bowie of the Portland Trailblazers with his Skyhook" 1985 James Ruebsamen (Best11 207)

players colliding in "A North Carolina guard finds no dribbling room through a Georgian defender during an NCAA semifinal game" 1995* Doug DeVoe (Best21 110b)

players reaching for the ball in "Larry Bird and the Celtics are knocked out of the air by the Lakers" 1985 Jim Mendenhall (Best11 206b)

playing on the beach near water from [a book entitled *California One: The Pacific Coast Highway*] c. 1989* Stephen Wilkes (Graphis89 \96)

police and children playing in street in "Policemen play basketball along with local children as part of their efforts to reduce crime" 1996* Steve Liss (Best22 170c)

shirtless man holding ball behind him in [street basketball player] c. 1992* John Huet (Graphis93 200)

shooting a basketball into a plastic crate in "Andy Vasquez dreams of a basketball scholarship so he can go to college" 1997 Brenda Kenneally (Best23 166a)

shooting hoops in a large backyard in "Young boy lifts off from a cement block in back of his grandparents' house" 1997* Bryan Patrick (Best23 164b)

tipping ball into the net in "Michael Jordan of the Chicago Bulls scores against the Philadelphia 76ers during an NBA playoff game" 1991* Manny Millan (Best17 154)

wheelchair jump shot in "Australian Troy Sachs becomes airborne and completes a jump shot during the World Wheelchair Championship" 1998* Adam Petty (Best24 62)

women on court chasing a loose ball in "University of Montana's Linda Mendel and Boise State University's Becky Sievers fight for a loose ball" 1990 Kurt Wilson (Best16 134a)

women players fighting for ball on court floor in "Oregon's Sally Growe comes away with the ball" 1995* Lui Wong (Best21 110a)

women professional players in "Suzie McConnell jumps for joy after winning in the opener of the WNBA"

1998* Peter Diana (Best24 57)

BATHROOMS
back of nude African American woman sitting on edge of tub in "Patiently Waiting" 1995 Delphine A. Fawundu (Committed 95)
father holding child while shaving in bathroom in "With an extra little shaver in his hand, Jim Roland continues his morning routine" 1987 Guy A. Reynold (Best13 123a)
faucet running in pink sink in [bathroom faucet] c. 1989* Rick English (Graphis89 \287)
head appearing over rim of footed bathtub in "Turtle" c. 1999 Dan Nelken (Photo00 134)
man with three arms entering portable toilet in "Dressed as a six-armed Hindu goddess, Gordon Coughlin heads for the restroom" 1995* Steven G. Smith (Best21 165d)
public Japanese baths in "Yangaginoya Fukushima" 1994 Toshihiro Yashiro (Marien \7.20)
sink on display in [sink] c. 1992* Daniel M. Hartz (Graphis93 140)
sink with breakfast tray in [hand-colored series] c. 1990* Didier Gaillard (Graphis90 \307)
sinks and toilet bowls from [a catalog for sanitary installations] c. 1991* Bernhard Angerer (Graphis91 \257)
water running from faucet in [faucet running in bathroom sink] c. 1992* Jennifer Baumann (Graphis93 73)
woman underwater in bathtub in [woman underwater in bathtub] c. 1999* Roxann Arwen Mills (Photo00 141, 151)
women at mirror in rest room in "In the ladies's room at the Chicago Greyhound bus terminal" 1943 Esther Bubley (Documenting 326b)

BATHS AND BATHING
baby in plastic tub on floor in "With loving care a fieldworker washes her son by hand on the kitchen floor" 1996* Joseph Raedle (Best22 162d)
boy being washed off in "5-year-old Oscar Javier Vera is washed down to ease the pain of mud, gravel, and ash imbedded in his skin" 1985 Richard Schmidt (Best11 18c)
boy in basin in "Morning Wash" 1930 Alexander Rodchenko (Waking #174)
boy in washtub in house in "Rico Harvey bathes in an old washtub, with stove-heated water inside the three-room house" 1998 Donald Anderson (Best24 109a)
boys taking baths in kitchen sinks in "Shenan, a 17-year-old mother of two, bathes her children in the sinks before going to school" 1991 Eugene Richards (Best17 130)
chamber maid leaning over filled bathtub in "Madam Has a Bath" 1934 Bill Brandt (Waking #170)
families in indoor communal stone bath in "Bathers, Guatemala" 1979 Rosalind Solomon (Women \134)
girl covered with soap lather in "Ten-year-old lathers up for her bath in the courtyard of her apartment in the Ivory Coast" 1997 Carol Guzy (Best23 229c)
girl on girl side of showers, crowd of boys on boy side in "Public shower at the city pool" 1996* Richard Messina (Best22 175)
head and feet sticking out of brown pool of water in "A head by two feet: soaking in a health-giving pool near the Japan Sea" 1985* Lynn Johnson (Best11 160b)
man in bathtub watching television in "Portable television" 1948 George Skadding (Life 98)
man in bathtub with rubber duck in "Sting" c. 1997* Max Vadukul (Graphis97 112)
mother and deformed young woman in bath in "Tomoko in Her Bath, Japan" or "A young woman deformed by mercury pollution" 1971-1972 W. Eugene Smith (Eyes #252; Lacayo 159d; Monk #45; Rosenblum2 #475)
nude behind shower curtain in "Shower for Mademoiselle" c. 1937* Paul Outerbridge, Jr. (Icons 79)
nude man in outdoor shower in "Man in Shower" c. 1900 Harriet V. S. Thorne (Rosenblum \85)
row of infants in the same clothes waiting to be washed in "Lined up like loaves at a market, infants nearly fill a counter top at a hospital washing station in Shanghai, China" 1994* Stuart Franklin (Through 170)
topless women washing their hair outdoors in "Beauty is abundant in Bali, an Indonesian paradise where villagers enjoy a refreshing open-air bath" 1927 W. Douglas Burden (Through 152)
woman using basin to wash in home with no running water in "A young woman bathes herself in her one-room home" 1986* David Turnley (Eyes \34)
woman washing infant in pan in "Life continues for a 5-day-old girl found buried in the rubble with her mother" 1985 Eric Luse (Best11 13a)
women in pool in wooden structure in "Ladies' Pool" c. 1890 Louise Deshong Woodbridge (Women \6)
women washing in hot spring in "Migratory workers from Oklahoma washing in a hot spring in the desert" 1937 Dorothea Lange (Documenting 120a)

BATTERED WOMEN see DOMESTIC VIOLENCE

BATTLEFIELDS
desolate landscape filled with used cannonballs in "The Valley of the Shadow of Death" 1855 Roger Fenton (Art \99; Rosenblum2 #203)

devastated island and scorched bodies after a battle in "Tarawa" 1943 Frank Filan (Capture 12; Eyes #222)

mud and burned trees in "Devastation on the battlefield of Passchendaele taken with a panoramic camera" 1917 William Rider-Rider (Marien \4.75)

silhouettes of soldiers crossing field in "World War I, Western Front" 1917 Photographer Unknown (Goldberg 61)

soldiers walking across large field in "South of Bastogne, Belgium" 1944 Robert Capa (Art \411)

trench of soldiers on battlefield in Brazil in "First Battalion April 24 in the Trenches of Tuyuty" 1866 Esteban Garcia (Marien \3.23)

U.S. Civil war battlefields and re-creationists in "Henry Hill, Manassas" c. 1999* Jan Faul (Photo00 88d); "Marching Order for Antietam" c. 1999* Jan Faul (Photo00 88b); "Table Rock, Gettysburg" c. 1999* Jan Faul (Photo00 88a)

BEACHES

aerial view of beach and surf in "A runner's tracks add yet another element to the sand-and-surf patterns on Cottesloe Beach in Perth, Australia" 1982* Cary Wolinsky (Through 402)

beach grass in "Beach Grass" c. 1920 William E. Dassonville (Peterson #54)

beach stones by shore in [from *Landscape* series] 1998 John Pinderhughes (Willis \539)

beached whales in distance in "Approximately 17 of 41 whales which beached (and subsequently died), Oregon" 1979 Joel Sternfeld (Marien \7.85)

bearded man in robe, holding surfboard in "Brian Wilson" 1976* Annie Leibovitz (Rolling # 22)

bench behind beach wall in "Seaside in Wales" 1997 David Hurn (Marien \7.9)

birds flying over waders in the shadow of cliffs from [a book entitled *California One: The Pacific Coast Highway*] c. 1989* Stephen Wilkes (Graphis89 \95)

black sand beach and person with surfboard in "Black sand beach of Kona, Hawaii" c. 1991* Stephen Wilkes (Graphis91 \24)

boardwalk raised off beach in "Low Tide, Arverne, New York" 1912 Karl Struss (Rosenblum2 #396)

boy in mask in "Boy on Beach with Mask" 1985* Mel Wright (Committed 228)

cabins on the beach in the winter in [beach cabins] c. 1995 István Lábady (Graphis96 162b)

child playing with a beach ball under the boardwalk in "Under the boardwalk at Coney Island" 1990 Kenneth Jarecke (Best16 181)

children kissing on the beach in "Rio Street kids" 1995 James Nachtwey (Best21 217d)

clouds over seashore in "Clouds and Sea" 1987* John Claridge (Graphis89 \65)

coat and hat on lifeguard stand from [*The Hat Book*] c. 1992* Rodney Smith (Graphis93 39)

comparison of beach in Summer and Winter in [a visual study of Summer and Winter at Craigville Beach on Cape Cod] c. 1991* Christopher Green (Graphis92 \203-\204)

couple on beach chairs and bulldozer lifting rowboat in "Paradise" 1994* Eric Chu (Goldberg 210)

couple standing on beach where child has drowned in "Tragedy by the Sea" 1954 John L. Gaunt, Jr. (Capture 34)

dead dolphin on beach in "As tourists swamped the summer shores, dead dolphins began washing up on the beaches from New Jersey to North Carolina" 1987 Lois Bernstein (Best13 97a)

empty beach chairs and closed umbrellas in "An early-morning summer storm builds over the Gulf of Mexico near Sarasota" 1991* Steve Apps (Best17 74)

filled with people in "Coney Island" 1974* Eve Sonneman (Photography2 152)

group in bathing suits sitting on sand in "South Beach" 1886 Alice Austen (Photography1 \84)

horizon and line of men in white suits from [the book *Norami*] c. 1990* Klaus Mitteldorf (Graphis90 \70, \103)

house on the beach in "Hamptons on Long Island" c. 1991 Albert Watson (Graphis91 \287)

Kuwaiti beach with polluted air in "Life goes on in Kuwait City, despite the pollution from oil spills and fires" 1991* Christopher Morris (Best17 38b)

large woman in bathing suit lying on beach in "Coney Island" 1941 Lisette Model (Icons 83; MOMA 161)

line of men at water's edge in "Karate enthusiasts brave the brisk, 45-degree waters of the Atlantic Ocean during a workout designed to improve strength and discipline" 1985 Raymond Gehman (Best11 144a)

man in dark suit standing at water's edge in "Sting" 1988 Lou Salvatori (Rolling #112)

man in swimsuit on beach with shower in "Just add water" c. 1991* Nadav Kander (Graphis91 \50)

man in swim trunks and snorkel mask, knee deep in water in "Norman Mailer" 1975* Annie Leibovitz (Rolling #23)

man in white suit and shirt standing in the surf in "Don Johnson" 1985* Herb Ritts (Rolling #69)

man lifting woman into the air in "Coronado Beach, California" c. 1930 Photographer Unknown (MOMA 130)

men and woman lying on beach blanket in "Coney Island" 1946 Henri Cartier-Bresson (Lacayo 110)

men on small fishing boat on beach in "Fishermen Unloading a Boat, Sea Bright, New Jersey" 1887 Louis Comfort Tiffany (National \45)

models in bathing suits on beach from [an article on fashion] c. 1989* Gilles Bensimon (Graphis89 \40)

naked boys near white umbrella in sand in "The Artist's Umbrella" 1908 Heinrich Kühn (Rosenblum2 #400; Szarkowski 153; Waking #152)

rows of umbrellas on a beach seen from the air in "Lido di Jesolo, Venice" c. 1990* Yann Arthus-Bertrand (Graphis90 \102)

smiling woman in bathing suit near old man in chair, at trees in sand in "Moscow Beach" 1959 William Klein (MOMA 224; Szarkowski 256)

solitary person on beach from [a book entitled *California One: The Pacific Coast Highway*] c. 1989* Stephen Wilkes (Graphis89 \93)

tube float in air over water in "Vacation on the beach" c. 1992* Stuart Dee (Graphis93 169)

with people in bathing suits and Santa hats on towels at beach in "Sunbathers on Bondi Beach in Sydney, Australia, bask in warmth of Southern Hemisphere Christmas" 2000* Annie Griffiths Belt (Through 440)

with people on towels in "Honolulu beachgoers stake out a place in the sand in preparation for a day in the sun" 1988* Jim Jennings (Best14 105)

woman in blouse and shorts sitting in sand by ocean in "Sissy Spacek" 1979* Annie Leibovitz (Rolling #21)

woman sunbathing on a patio in "At the beach" 1939 Marion Post Wolcott (Documenting 187b)

BEARS

polar bears relaxing in snow in "Polar bears enjoy the good life along Canada's Hudson Bay" 1993* Michio Hoshino (Best19 116)

sleeping in the woods in "Safely bedded down, a brown bear takes a nap after fishing in the Katmai National Park and Preserve of southern Alaska" 2001* Joel Sartore (Through 332)

BEAUTY CONTESTANTS

football player escorting homecoming queen in "It was an exciting night for queen and king at homecoming for a Pee Wee football league celebration" 1996* Steven G. Smith (Best22 202d)

girls in matching dress leaning against doors in "Contestants for Daffodil Queen eavesdrop as judges interview another competitor behind closed doors" 1992* Steven G. Smith (Best18 116)

infant girl with crown being kissed by parents in "Parents kissing the winner of the baby crawling contest" 1997 Michael Williamson (Best23 231d)

young African American woman on car in "Beauty Queen" n.d. Charles (Teenie) Harris (Willlis \140)

young girls in party dresses in "The Little Princess Contest was one of the main attractions at the Hispanic Fiesta" Chad Stevens 1996* (Best22 99)

young girls in fancy dresses in "Sibling rivalry" 1996* Brian Plonka (Best22 173b)

BEAUTY, PERSONAL

girl combing hair in front of mirror on cigarette machine in [the series *Teenagers*] 1959 Bruce Davidson (Goldberg 149; MOMA 226)

hair setting in "Rag curls and men's pajamas" 1944 Nina Leen (Life 111d)

hairstyles in "Global beauty calendar" c. 1989 Fabrizio Ferri (Graphis91 \4-\6)

initials cut into boy's hair in "Hair art" 1990* Michael O'Brien (Life 121)

Japanese woman seated on a mat in "Woman Using Cosmetics" c. 1867* Félice Beato (Rosenblum2 #333)

looking in a compact in "Compact" c. 1995* Rodney Smith (Graphis96 30)

woman putting lipstick on at a mirror in "Eckstein with Lipstick" 1930 Ellen Auerbach (Icons 37)

woman's hairstyle in "Woman Seen from the Back" c. 1862 Onésipe Aguado (Waking #45)

women doing hair of each other in "Alicante, Spain" 1933 Henri Cartier-Bresson (Icons 59)

women under hair driers in "Village women enjoy a bit of pampering in a beauty salon near the Zambezi River" 1996* Chris Johns (Through 246)

women under hair driers in "Cuba: On the Edge" 1997 Eric Mencher (Best23 224c)

women's hair being curled by cords attached to machines in "Women in Shanghai, China, trust their tresses to a hairdresser–and perm machines more than 50 years old" 1980* Bruce Dale (Through 148)

BEES

magnified in "Robot feeds Honeybee" 1990* Mark Moffett (Best16 148)

man covered with bees in "Dr. Norman Gray, an entomologist, plays his clarinet while covered with bees" 1988* Michael Williamson (Best14 15b)

BEGGING

men in small boat begging for water in "Water" 1942 Frank Noel (Capture 10)

physically deformed man on mat in "Man at Swayamanboth Temple, Kathmandu, Nepal" 1985 Rosalind Solomon (Women \135)

white-bearded man holding a cup in "A beggar huddles against a wall in Costa Rica" 1993* Christopher A.

Record (Best19 63c)

woman and child at car window in "Thousands in Bombay, India–like this woman and child–survive only by begging in the streets" 1995* Steve McCurry (Best21 162b)

young boy with hand out in "Outside a five-star hotel in Bombay, India, children work as beggars for a syndicate run by adults" 1987 Melanie Stetson Freeman (Best13 78)

BEIRUT, LEBANON

aerial view of city during bombing in "Beirut, August 8, 1982. Israeli shelling from the air, the ground, sea" 1982* Catherine Leroy (Eyes \35)

after bombing of hospital, woman holds disabled children in "One of the Lebanese nurses who stayed on was able to pacify some patients by her presence" 1982 Don McCullin (Eyes #315)

apartment house front blown off in "An East Beirut apartment was devastated by a car-bomb explosion" 1986 Eddy Tamerian (Best12 80c)

child being held aloft in "Aftermath of a car-bomb explosion, West Beirut, Lebanon" 1983* Yan Morvan (Life 63)

cockpit exploding in "An explosion [by hijackers] rips out the cockpit of a Royal Jordanian ALIA Airline at Beirut Airport" 1985 Herve Merliac (Best11 55b)

crying people with hands raised in "Palestinians surrendering to Phalange troops" 1976 Don McCullin (Eyes #316)

crying woman covered in blood in "A Christian Lebanese woman is helped away from the scene of a car bomb explosion in an east Beirut suburb" 1985 Aristotle Saricostas (Best11 120c)

crying woman in the ruins of her home in "Palestinian woman whose husband has been murdered discovering the destruction of her home" 1982 Don McCullin (Eyes #317)

family crouched for shelter in "A family takes shelter under a bridge in west Beirut during a heavy artillery barrage" 1985 Lamaa (Best11 121a)

man carrying boy between wrecked cars in "A Moslem father carries his son toward help after a car bomb blast in west Beirut" 1985 Jamal Saiidi (Best11 121b)

man holds launcher barrel through wall in "Moslem gunner rests his hand on a 75mm rocket launcher as he peers toward Christian east Beirut" 1985 Herve Merliac (Best11 120b)

man with gun, kicking another man in "A Christian kicking a Palestinian who has been selected for death behind this factory wall" 1976 Don McCullin (Eyes #319)

man with gun kneeling in ruined hotel lobby in "Christian fighters in the lobby of the Holiday Inn" 1976 Don McCullin (Eyes #318)

man with machine gun running across empty street in "Christian Phalangist militiaman fires to cover himself as he races for a new position in the shattered streets of Beirut" 1978 Raymond Depardon (Eyes #261)

people on balconies of war-torn building in "Beirut residents living in a war-torn building wave as Pope John Paul II makes his way from the airport" 1997* Jerome Delay (Best23 126)

BELLS

large outdoor bell on wood frame in "Bell Ringer, South Carolina" c. 1930 Doris Ulmann (Women \29)

trying to ring handbells in "Kirsten McCombs now knows what a clinker sounds like on handbells" 1986 John Warner (Best12 119a)

BERLIN WALL, Berlin, Germany, 1961-1989

border guard leaping over barbed wire, before the wall was in place in "East Berlin" 1961 Peter Leibing (Life 58; Photos 99)

dismantling of the wall in "Events surrounding the dismantling of the Berlin Wall" 1989 Tadeusz Czerniawski (Graphis91 \74-\77)

hand extending over top of wall in "A hand rises from the eastern side of the Berlin Wall" 1961 Paul Schutzer (Lacayo 160b)

hundreds of people standing on and in front of Wall at Brandenburg Gate in "Fall of the Berlin Wall" 1989* Andreas Springer (Photos 165)

leather-jacketed youth chiseling away at graffiti-painted wall in "Freedom Uprising" 1989* David C. Turnley (Capture 155a)

man hitting wall with sledge hammer in "The fall of the Berlin Wall" 1989* (Lacayo 172; Life 78)

painting of kiss by Brezhnev and Honeker in "Taking liberties–a political painting on the Berlin Wall shows former Soviet Premier Leonid Brezhnev and East German leader Erich Honeker locked in a mock embrace" 1996* Gerd Ludwig (Through 58)

BEVERAGES

federal agents dumping barrels of bootleg liquor in "Prohibition in the United States" 1930s Photographer Unknown (Photos 45)

glass of water on table in "Les Beaux, Provence" c. 1997* Craig Cutler (Graphis97 87)

hands cradling glass of wine in [Clos du Bois Winery] c. 1991* (Graphis92 \76)

open bottles in front of drinking man in "Academics in Georgia, a former Soviet republic, make seemingly endless rounds of banquets" 1992* George Steinmetz (Best18 83)

passing water through strainers into a glass in "Filters for tap water: a muddy issue" 1988 Peter Monsees (Best14 114)

wine of different colors in "Glasses of wine" 1991* John Luke (Best17 172)

BHOPAL UNION CARBIDE PLANT DISASTER, Bhopal, India, 1984

Indian woman crying in "Woman cries after she tells of her medical problems after the Bhopal Union Carbide gas tragedy" 1985 Paula Bronstein (Best11 118)

BICYCLES

bicycle and rider leaning against wall from "ad campaign for Nike" c. 1989* Gary Nolton (Graphis89 \39)

bicycle race in "Bicyclists streak around a turn in the Mayor's Cup International Bike Race in Indianapolis" 1987 David Eulitt (Best13 206a)

bicycle race in "Spectators lean over a retaining wall to congratulate the gold medal ride of the U.S. team pursuit cycling team at the Pan-American games" 1987 David Eulitt (Best13 202d)

bicycle race crash in "John Ficarra crashes while traveling at more than 60 mph during a gravity bike race" 1987 John Blackmer (Best13 214a)

bicycles and riders on terrace formation in "Bicyclists Group on Minerva Terrace Yellowstone National Park" 1896 F. Jay Haynes (Photography1 #V-19)

bike racers tumbling over each other in "Biker Brian Griffith tumbles over a fallen Ed Bernasky" 1985 John Blanding (Best11 225a)

four on bikes on flat field in "Sunday Cyclists" 1966 Manuel Alvarez Bravo (Icons 48)

four-seat bicycle ridden by people with bubbles of light on their heads in "Like extraterrestrials heading home, four artists ride a 'Bubbleheads' sculpture towards Baltimore's Inner Harbor to promote an exhibit" 1987 Amy Davis (Best13 188a)

gears and spokes in [bicycle gears] c. 1991* Hans Hansen (Graphis92 \154, \155)

gears and spokes in [bicycle gears and spokes] c. 1992* Michael Furman (Graphis93 146)

going through large puddle in "A bicyclist perches high and dry as he crosses a flooded sidewalk" 1990 Al Podgorski (Best16 60a)

handlebars and part of front wheel in "Cover of a special issue of *Bicycle Magazine*" c. 1989 David Holt (Graphis89 \199)

leaning against small stand and storefront in "Bill's Peanut Stand and Lutz's Central Market" 1942 Marjory Collins (Documenting 258c)

man holding bicycle tires in "Men's sportswear" c. 1991 Sue Bennett (Graphis91 \51, \52)

man holding up bicycle in one hand in "Racing cyclist" c. 1990 Sue Bennett (Graphis90 \239)

man on bicycle riding next to racing car in "Paris, *Avenue des Acacias*" 1912 Jacques-Henri Lartigue (Szarkowski 130)

next to goat in photographer's studio in "for cycling magazines" c. 1989* Curt Fischer (Graphis89 \202)

on top of car surrounded by sheep in "Support crews for bicycle racers are snarled in a flock of sheep in Idaho" 1990 Jim Evans (Best16 10c)

racer on double white line of road in "Betsy King rides alone, far ahead of the pack, in the 70-kilometer women's road race" 1985 Guy Reynolds (Best11 225d)

racing on a track in "Cyclists negotiate a turn during a race on the world's steepest and shortest outdoor Velodrome" 1993* Mathew McCarthy (Best19 143a)

rainbow over bridge and man on bicycle in "A cyclist is treated to a rainbow as he rides to work" 1993* Christopher Anderson (Best19 70)

rider sleeping along the road in "A cyclist traveling in Romania sleeps along the road" 1990 Anthony Suau (Best16 12d)

riding downstairs on a bike in [going downstairs on a bike] c. 1997* Walter Iooss (Graphis97 194)

rider falling off bike in bike race in "Two competitors collide during the Dan D'Lion Pro-Am Criterium Bicycle race in Anaheim, Calif" 1988 Ed Carreon (Best14 13d)

riding on a unicycle and playing a sousaphone in "Expressing herself, a sousaphone player makes music at the annual Burning Man Festival in Nevada's Black Rock Desert" 2001* Melissa Farlow (Through 350)

sprint racer in "Sprint cyclist Frank Weber of West Germany at the Summer Olympics in Seoul, viewed from the top of the velodome" 1988 Mike Powell (Best14 143)

woman sitting on cardboard boxes loaded on top of bicycle in "A woman and her belongings are carried through Beijing by a bicycle taxi" 1993* Erica Lansner (Best19 126d)

women in long lace skirts and hats riding on dirt road in "Large fancy hats adorn ladies from the Spreewald swamps near Berlin" 1937 (Through 84)

BIRDS AND BIRD NESTS *see also* CRANES; GEESE; PENGUINS; SWANS

above a flock of birds flying over an island in "Pelicans over Barrier Island" 1992 Joel Sartore (Best18 220)

albatross pair on ground in "A pair of black-browed albatross court in the Falkland Islands" 1987* Frans Marten Lanting (Best13 175b)

bird and curtain in "Dignity" c. 1995* Deborah Brackenburg (Graphis96 77)

bird's body on man's head as decoy in "A hunter peeks from inside a decoy on the Indus River in Pakistan" 2000* Randy Olson (Through 180)

cattle egret on back of horse in "Flapping its wings for balance, a cattle egret rides bareback across a meadow on the island of Kauai" 1993* Richard Schmidt (Best19 73d)

chickadee in flight in "A black-capped chickadee's landing maneuvers are so complex that a split-second image can only hint at how it flies" 1996* Russell C. Hansen (Best22 188b)

chickens in studio photographs in [self-promotional] c. 1991* Ralph Newton (Graphis91 \340-\348)

dead bird caught in metal springs in "Catbird and Bedspring Debris" 1984* Barbara Norfleet (Rosenblum \23; Rosenblum2 #785)

dead gannet in "Dead Gannet" 1984 John Claridge (Graphis89 \198)

dead goose with wings spread in "Goose" 1985* Gwen Akin and Allan Ludwig (Decade \IX)

dead heron hanging from wall in "Heron" 1863 Francis Edmund Currey (Szarkowski 79)

ducks walking across the highway in "Ducks startled by a severe fall storm run out in front of a motorist, who jumps out of the car to shoo them away along a California road" 1987 Brant Ward (Best13 122a)

eagle with outstretched wings holding a fish in "Eagle with a salmon in Alaska" c. 1988 Bob Hallinem (Best14 7c)

egret fanning out its wings to shield glare in water in "Black egret fishing in the Okavango" c. 1991* Frans Marten Lanting (Graphis92 \226)

feathers covering beak in [bird] c. 1995* Michael Kammerdiener (Graphis96 190)

fighting cocks in "Fighting Cocks" c. 1999* Clang (Photo00 229)

flamingos by the hundreds in "Flamingos in Botswana" c. 1991* Frans Mareten Lanting (Graphis92 \225)

flamingos feeding at lake in "Tens of thousands of flamingos flock into Kenya's Rift Valley to feed on algae in an alkaline lake" 1986* Robert Caputo (Best12 106b)

flamingos standing together in "Lesser flamingos gather at dawn at Lake Nakuru, Kenya" 1987* Frans Mareten Lanting (Best13 174)

flock flying over roof of building in "End of the Day" 1986 Jamyl Oboong Smith (Committed 202)

flock in flight in [birds in flight] c. 1997* Randy Wells (Graphis97 184)

flying over lake in "The laws of nature are black and white in the early morning stillness as a water bird captures its breakfast and skims Lake Sherwood" 1987 George Wilhelm (Best13 184)

flying over man's head in "*Señor de Pájoros*" 1984 Graciela Iturbide (Rosenblum2 #706)

grebe trying to fly, but falling in "This grebe can't get off the ground" 1985 Alan Berner (Best 179)

gulls surrounding whale with mouth open in "Near Stellwagen Bank, in the Atlantic off Massachusetts Bay, a humpback whale may eat as much as a ton of food in one day" 1998* Flip Nicklin (Through 428)

hand-feeding an injured bird in "Ellen Rosenberg cares for injured birds until they can be released" 1993* Sherman Zent (Best19 72b)

hawk superimposed over herd of bison in "Lead me around the circle" 1994 Walter Bigbee (Photography 169)

heron at edge of water and reeds in "A great blue heron finds refuge from the California desert at a watering hole" 1987* Daniel Anderson (Best13 175c)

holding an oil-covered duck in "Oil-soaked mallard ready for cleaning at the International Bird Rescue Center in Berkeley after a spill contaminated a nesting area" c. 1988 Scott Henry (Best14 7d)

hornbill in "New Delhi Dolly, Greater Indian Hornbill" c. 1991 James Balog (Graphis91 \354)

head and beak in "Distinctive markings identity this denizen of the rain forest: a red-knobbed hornbill on the Indonesian island of Sulawesi" 1999* Tim Laman (Through 192)

in flight bringing food to nest in "Storks" 1884 Ottomar Anschütz (Rosenblum2 #300; Szarkowski 133)

large nest on edge of rock in "Hawk's Nest" c. 1900 Evelyn Cameron (Sandler 117a)

loons in lake in "North Woods Journal" 1997* Jim Brandenburg (Best23 246b)

men in field with birds and dog in "A hunter grasps a prized ring-necked pheasant, bagged during a popular annual shoot at Broken Bow, Nebraska" 1998* Joel Sartore (Through 360)

near a fence in "Birds Inside and Out" 1935 Clarence John Laughlin (Hambourg \109)

nest with eggs in "Sandpiper's Nest" 1903 H. Pearson and E. W. Wade (Szarkowski 141c)

nest with eggs and birds in "Birdsnest" 1977* Bea Nettles (Rosenblum \15)

oil-covered bird in "Oil-smeared red-necked grebe" 1989* Rob Stapleton (Photos 160)

owl behind a curtain in [owl] c. 1997 Jayne Hinds Bidaut (Graphis97 178a)

owl flying over a group of students in auditorium in "A Eurasian Owl swoops over the excited students" 1995* John D. Simmons (Best21 164a)

owl in flight in "Barn Owl alights at night with its prey" c. 1991* Hugo A. Lambrechts (Graphis91 \339)

parrot on a perch in [parrot] c. 1997* Chris Collins (Graphis97 179)

peacock with raised tail in [peacock] c. 1997 Jayne Hinds Bidaut (Graphis97 178d)

peasant in the undergrowth in "Hoar frost on a pheasant in the undergrowth" c. 1990* Louis Bencze (Graphis90 \192)

pelicans ready to take flight in [white pelicans living among the flamingos] c. 1992* Hara (Graphis93 190)

pigeons in coops in "White king pigeons roost at a breeding farm" 1993 Aaron Kamelhaar (Best19 77b)

quetzal with long tail, in flight in "In Guatemala, a brightly feathered quetzal looks for some of its favorite foods–small avocado-like fruits" 1998* (Through 326)

rooster in "Chanteclair, the unofficial national bird of France" c. 1991* Hiro (Graphis91 \337)

rooster and parrot in "Rooster and Parrot" 1879* Louis Ducos du Hauron (Rosenblum2 #340)

ruffling its feathers in "With a furious beating of its wings, a drake wood duck dries itself after a morning bath" 1988 Scott Nielsen (Best14 161a)

skua with wings spread in "A curious skua hovers in front of the camera in the Falkland Islands" 1987* Frans Marten Lanting (Best13 94d)

swan with neck bending to wings in "Whooper Swan" c. 1991* Teiji Saga (Graphis92 \224)

taking flight over lake in "A bird takes flight on a misty morning at Mt. Trashmore Park" 1998* Ting-Li Wang (Best24 47d)

turkey vultures in "When a cold weather snap killed fish in a local Florida lake, opportunistic turkey vultures arrived to feast on the remains that floated ashore" 1995* Sherman Zent (Best21 159d)

used to catch fish from boat in "Tethered and collared, cormorants catch and disgorge fish into a boat in Japan" 1936 W. Robert Moore (Through 178)

various birds in [birds] c. 1995 Luciano Morini (Graphis96 180, 182)

white flock of birds flying against black sky in "A flock of white pelicans takes flight over Camanche Lake, Calif." 1988 Richard Schmidt (Best14 98)

woman holding a dove on a rooftop in "In the battle-weary Gaza Strip, a woman holds a symbol of freedom and peace" 1996* Alexandra Avakian (Best22 242a; Through 248)

BLACK MUSLIMS

African American woman covered in white, except her eyes in "New York City (a young Moslem woman in Brooklyn)" 1990 Chester Higgins, Jr. (Willis \344)

African American women in white, walking on plaza in "Family Day, Members of the Nation of Islam" 1994 Ken Jones (Willis \351)

Muslim women walking in "Day of Atonement at the UN Plaza, Muslim Women" 1996 Salimah Ali (Committed 45; Willis \299)

Nation of Islam women in white in "Savior's Day, women's section, Chicago" 1966 Robert A. Sengstacke (Willis \201)

BLIND

attorney in a courtroom in "Scales of Justice" 1988 John Kaplan (Best14 28)

boy touching man's hand on his shoulder in "Joel Geiger–Perkins School for the Blind" 1992 Nicholas Nixon (Rosenblum2 #697)

children feeling window in "Both blind from birth, children became siblings by being adopted by a Muskegon couple" 1990 Brian Mascek (Best16 74a)

children picking flowers in "Blind children picking flowers" c. 1991 Mary Ellen Mark (Graphis92 \114)

elderly man eating at table in "Blind Home" 1963 Jerome Liebling (Rosenblum2 #685)

Russian beggars, girls and women, with walking sticks in a studio in "Blind Russian Beggars" 1870 Photographer Unknown (Rosenblum2 #421)

photo essay on the daily life of a young blind girl in "What do I look like?" 1986 Taisie Berkeley Trout (Best12 172-175)

woman with sign on chest in "Blind Woman" 1916 Paul Strand (Hambourg 16; Marien \4.42; Photography 138)

BLOOD DONORS

woman on hospital bed giving blood in "Blood donor at the American Red Cross Blood Bank" 1943 Ann Rosener (Fisher 73)

BOATS AND BOATING see also SHIPS AND SHILBUILDING; names of individual ships

and jet skis on lake in "Lake Powell, near Wahweap Marina, Utah" 1987* Karen Halverson (Women \182)

bailing out a boat that was washed ashore in "In Florida a commercial fisherman bails out his boat after Hurricane Elena washed it ashore" 1985 Bill Wax (Best11 68c)

beached boat at low tide in "Halong Bay" 1993 Lois Conner (Rosenblum2 #680)

boat in dry-dock near ship-shaped monument in "*Padrao des Descobrimentos* monument in Lisbon" c. 1990* Serge Cohen (Graphis90 \93)

boats being tossed into rocks in "In New Bedford, Mass., three men try to keep Hurricane Gloria from smashing their craft on the rocks on Pope's Island" 1985 (Best11 71a)

boats crashing into beach in "At Mystic the sign was superfluous, and Hurricane Gloria blew everything up on shore" 1985 John Long (Best11 71b)

cabin cruiser in bay in "Morro Bay" c. 1999* Michele Clement (Photo00 93)

canoe bottom on lake-front in "Blue Canoe" c. 1999* Charlie Harris (Photo00 92)

climbing a mast in [climbing a mast] c. 1995* Matthew Atanian (Graphis96 201)

couple on shore with rowboat in "In the Twilight" 1888 Lidell Sawyer (Rosenblum2 #282)

cruise ship in [promotion for the cruises of the Royal Viking Lines] c. 1991* Jay Maisel (Graphis91 \303)

dynamiting an abandoned ship in "The *Renegade Reef*, a 26-year-old Dutch coaster abandoned in Miami River in 1981, went up in an 80-foot cloud of smoke after officials loaded her with 100 pounds of dynamite" 1985 Marc Clery (Best11 108)

ejecting from a speed boat in "Pilot John Voss is ejected from his 2.5 liter boat during the 50th annual Valleyfield Regatta in Quebec" 1988 Bernard Brault (Best14 124a)

elderly couple in rowboat on flooded street in "[Elderly couple] take an aquatic route from their home after Lake Erie's windblown water threatened 100 family dwellings" 1985 Thomas J. Hawley (Best11 65a)

explosion of ship surrounded by small boats in "More than 500 pleasure boats accompanied the tired *Mercedes I* out to sea where 360 pounds of TNT sank the hulk off Fort Lauderdale" 1985 Sherman Zent (Best11 109)

ferry boat filled with people in "Circle Line Ferry, New York" 1971 Garry Winogrand (Szarkowski 263)

fishing boat in mist on bay in "A Vietnamese couple row a fishing boat in Halong Bay on the Gulf of Tonkin" 1993* Lars Gelfan (Best19 80d)

fishing boats in harbor in "Southern Portugal" c. 1990* Aernout Overbeeke (Graphis90 \69)

gathering of boats and people as one man dives off cliff in "Impromptu cliff-diving competition at Lake Havasu" 1993* Rick Rickman (Best19 124)

hand on oar in water in "Untitled" c. 1989 Bernd Grundmann (Graphis89 \240)

harbor with small boats in "Entrance to Boulogne Harbor" 1897 Paul Martin (Szarkowski 131)

in harbor in "A beach café at the harbor" c. 1990* Alfred Seiland (Graphis90 \91)

kayaks racing in [automobile company calendar] c. 1991* Charles Compère (Graphis92 \233)

life preserver secured to side of ship in [life preserver] c. 1992* Mercier/Wimberg (Graphis93 167b)

maneuvering small boat ashore in "Jake with his boat arriving on Daufuskie's shore" 1981 Jeanne Moutoussamy-Ashe (Willis \246)

men in blankets near canoe and teepees in "The first sail" 1907 Roland W. Reed (Lacayo 41)

men in rowboat removing parking meters in "City workers in Peoria remove parking meters so they won't rust as the Illinois River went over flood stage" 1985 Renee C. Byer (Best11 65)

men in small boat begging for water in "Water" 1942 Frank Noel (Capture 10)

men standing in canoes in Everglades in "Canoes based on Seminole Indian designs still ply the waters of the Florida Everglades" 1994* Chris Johns (Through 370)

overhead view of small boats in harbor in "Small Harbor, Marseilles" 1928 Herbert Bayer (Hambourg \96)

poleman relaxing on bottom of boat as river is crossed in [Mali and travel on the Niger River] 1993 Chester Higgins, Jr. (Willis \343)

rowboat anchored on shore in "Boat on the shores of Cape Cod" c. 1991 Paul McGuirk (Graphis91 \294)

rowboat crashing over a wave in "The Avoca Beach female surfboard crew is sent airbourne in Sydney" 1996* Tim Clayton (Best22 200a)

rowboat near boy standing on wooden dock in "Untitled" c. 1910 John G. Bullock (MOMA 86)

rowboat reflecting in water in "Sugar Bowl with Rowboat, Wisconsin Dells" c. 1889 Henry Hamilton Bennett (Rosenblum2 #162)

rowboat with two people in "Gathering Water-Lilies" 1886 Peter Henry Emerson (Decade 7; Monk #11)

rowboats on a dock in "Just before daylight, a lobsterman rows a dinghy out to his lobster boat moored off Spruce Island, Maine" 1988* Darryl Heikes (Best14 106)

rubber raft going over dam in "Group of women in a World War II-era life raft go over the 10-foot-high dam" 1993 Jim Collins (Best19 149)

scullers in motion in [automobile company calendar] c. 1991* Charles Compère (Graphis92 \238)

sailboat in "Traveller's Boat at Ibrim" c. 1859 Francis Frith (Rosenblum2 #132)

sailboat anchored off grasslands in "Wellfleet, Massachusetts" c. 1991* Stephen Wilkes (Graphis92 \206)

sailboat in a stand of mangrove trees in "A sailboat rests in a stand of mangrove trees after being pushed

ashore by Hurricane Andrew at Key Biscayne, Fla." 1993* Cameron Davidson (Best19 115)

sailboat in race in "The *Merit* during training for the 'Whitebread Round the World Race' " c. 1990* Daniel Forster (Graphis90 \241)

sailing in heavy weather in [documenting heavy weather sailing] c. 1991* Clint Clemens (Graphis91 \367-\371)

sailing race in "Dennis Connor and his crew sail the *Stars and Stripes* during a practice run the week before they raced–and beat–*Kookaburra II* for the America's Cup" 1987 Bob Breidenbach (Best13 221b)

sailing ship in tow in "U.S.S. *Adams* in Tow by the *Yorktown*" 1894 Photographer Unknown (Szarkowski 331c)

sailing ships in [illustration for *Moby Dick*] c. 1992* Lou Jones (Graphis93 175)

sailing with a crew in red shirts in "Sailing, *Matador²*" c. 1999* David Forster (Photo00 195)

schooner sailing past chalk cliffs in [schooner sailing past chalk cliffs, Isle of Wight, England] c. 1999* Daniel Forster (Photo00 84)

scuba diving off of a boat in "Cozumel, Mexico" c. 1990* Tim Bieber (Graphis90 \248)

several small boats on rocky shore in "Waterfront" 1915 Addison N. Scurlock (Rosenblum2 #321)

silhouette of man rowing in "Rowing Home the Schoof-stuff" 1886 Peter Henry Emerson (Art \150)

small boats in lines in port in "Boats in the Old Port of Marseilles" 1929 László Moholy-Nagy (Art \233)

small sailboat on water in "Moonlight on the Columbia" c. 1902 Lily White (Sandler 121)

small sailboats in a harbor in "View of the Harbor" 1880s Frank Meadow Sutcliffe (Rosenblum2 #370)

small tugboat pushing a large freighter in "Tugs help a freighter turn on a dime" 1986 Bruce Chambers (Best12 157a)

small wooden boats at edge of water in "Cloud Shadows" c. 1941 Edward C. Crossett (Peterson #76)

solitary skiff on river in [ad for Springer's of East Hampton] c. 1990* Ken Robbins (Graphis90 \236)

tied up at docks at foot of city on mountainside in "Wellington is the home of the New Zealand Yacht Club, which took part in the race for the America's Cup" 1987* Buck Miller (Best13 170d)

yacht near iceberg in "Eric Tabarly's yacht, Côte d'Or, close to an enormous iceberg" c. 1991* Christian Février (Graphis91 \291)

BODY PIERCING

eyebrows, ears and lip piercings in "Once is not enough" 1997* Annie O'Neill (Best23 143)

green eye and pierced eyebrow in "Body Pierce" 1993* John Luke (Best19 179)

BODYBUILDERS

African American men and women posing in [ladies' lounge of New York City's Roseland Theater] c. 1995* James Salzano (Graphis96 123)

woman with weight belt in [ad for Kodak black- and white-film] c. 1991 John Running (Graphis91 \219)

women holding weights in "Train Clean" c. 1991 John Running (Graphis91 \221); "Train Hard" c. 1991 John Running (Graphis91 \220)

BOMB SHELTERS *see* AIR RAID SHELTERS

BOMBS AND BOMBING

aerial view of city during bombing in "Beirut, Israeli shelling from the air, the ground, sea" 1982* Catherine Leroy (Eyes \35)

American troops watch atomic explosion in desert in "Troops get 'feel' of atomic warfare" 1951 Photographer Unknown (Eyes #217)

apartment house front blown off in "An East Beirut apartment was devastated by a car-bomb explosion" 1986 Eddy Tamerian (Best12 80c)

atomic bomb test in "Atomic Cloud during Baker Day blast at Bikini" 1946 Photographer Unknown (Goldberg 120; Marien \6.30)

bomb test site with mannequins and cars in "Test mannequins at an atom bomb site" 1955 Loomis Dean (Lacayo 133d)

bomb test site with wreckage in "Crater and Destroyed Convoy" 1986* Richard Misrach (Goldberg 199; Marien \7.87)

bombers dropping hundreds of bombs over rural Korea in "Korean War" 1951 U.S. Air Force (Photos 77)

cathedral dome during bombing of London in "St. Paul's Cathedral" 1940 John Topham (Lacayo 107)

crying child sitting on bombed-out railroad tracks in "Wounded by a bomb, a Chinese boy howls pitifully in Shanghai's railroad station" 1937 H. S. Wong (Lacayo 80a)

crying girl with hands on head in "Nairobi Embassy Bombings" 1998* Jean-Marc Bouju (Capture 191)

debris from hairdressing store in "London bomb damage" 1940 Cecil Beaton (Lacayo 106d)

explosion near men with guns in "Colombian Special Forces destroy an airstrip used by drug lords to transport cocaine" 1996 Tom Stoddart (Best22 248a)

explosion near soldiers in "Marines blow up a cave connected to a Japanese blockhouse on Iwo Jima" 1945 W. Eugene Smith (Art \415; Lacayo 112)

hand-held bomb dropped by solder from an airplane in "Bombing by hand" c. 1917 Max Pobly (Lacayo 50a)

mannequins and cars at test site in "Test mannequins at an atom bomb site" 1955 Loomis Dean (Lacayo 133d)

masked men throwing Molotov cocktails in "Rioters in Belfast, Northern Ireland" 1981* James Nachtwey (Marien \7.16)

mines on deck of ship in "Defused mines on the deck of captured Iranian ship provide the proof the United States was looking for" 1987 Mark Duncan (Best13 11c)

Molotov cocktail being thrown by student in "South Korean student armed with a bottle to be used as a Molotoff [sic] cocktail" c. 1990* Heesoon Yim (Graphis90 \252)

mushroom cloud from the air in "Mushroom cloud, Hiroshima" 1945 Photographer Unknown (Eyes #216)

mushroom cloud of atomic bomb in "First Atomic Bomb Explosion" 1945 Los Alamos National Laboratory (Monk #32)

mushroom cloud of atomic bomb in "Atomic Bomb over Nagasaki, Japan" 1945 Photographer Unknown 1945 (Goldberg 113; Life 97)

mushroom cloud of hydrogen bomb in "The world's first hydrogen-fusion blast at Eniwetok" 1952* U.S. Air Force (Lacayo 123)

mushroom cloud on a man's hat in "D.C. Moons" 1995 Alan Berner (Best21 218a)

pulling man from bomb blast in "A victim of a powerful bomb blast is evacuated from the scene of the U.S. Embassy terrorist attack in Nairobi" 1998* George Mwangawni Mulala (Best24 21a)

sailors standing on deck and shielding their eyes in "Atomic bomb test, Bikini" 1947 Fritz Goro (Lacayo 122)

ship sinking after being bombed at Pearl Harbor in "Sinking of USS *Arizona*" 1941 U.S. Navy (Photos 54)

smoke in soccer stadium stands in "Smoke bombs explode on the field at the soccer stadium in Naples" c. 1991* Walter Schmitz (Graphis91 \78)

BONES *see* ANIMAL REMAINS (ARCHAEOLOGY); SKULLS

BONUS ARMY MARCH *see* BONUS EXPEDITIONARY FORCES

BONUS EXPEDITIONARY FORCES

police fighting with veterans in "March on Washington" 1932 Joe Costa (Eyes #165)

BOOKS

shelf of books over doors in "Law Books, Hinsdale County Courthouse, Colorado" c. 1975 William Clift (Decade \94)

two shelves in "A Scene in a Library" 1843-1844 William Henry Fox Talbot (Waking 266d)

BOSNIA AND HERCEGOVINA *see also* SARAJEVO

Bosnian soldiers in a village in "Bosnian soldiers in Vitez prepare to launch a counter attack against Muslim forces" 1993 Anthony Suau (Best19 23)

child smoking in a crib in "People live in these cribs all their lives at Bosnia home for children" 1997 Nancy Andrews (Best23 17a)

child with head bandaged in hospital in "A father comforts his wounded son as distressed relative looks on in Bosnia-Herzegovina" 1993* Debbi Morello (Best19 196)

children physically and mentally injured in "War children of Bosnia" 1995 Jack Picone (Best21 206)

Croatian fighters in the bushes in "Croatian forces move under intense sniper fire to fortify their front-line positions against advancing Muslims" 1993 Anthony Suau (Best19 24b)

family in bombed-out building and children playing in street in "Bosnia: A Hopeful Peace" 1997 Nancy Andrews (Best23 129a, 202)

morgue workers with dead soldier in "Near a mosque in Bosnia-Herzegovina that was shelled by Serbs, a makeshift morgue is used for cleaning bodies of dead soldiers" 1993 James Nachtwey (Best19 46a)

mother and child embrace in terror in "A Muslim mother and her child embrace in terror as Serbian artillery shells hit the building housing refugees in Bosnia-Herzegovina" 1993 Anthony Suau (Best19 21)

soldier returns to his decimated village in [at the scene of a massacre by Serbs in Bosnia] c. 1995* Ron Haviv (Best21 183a; Graphis96 65)

women and children sleeping on the floor in "Finding no room at a camp for Muslim refugees in Travnik, a mother sleeps with her child in the hallway of an old schoolhouse" 1993 Anthony Suau (Best19 24a)

women outside a house trying to block out the noise in "Croatian women in Bosnia-Herzegovina cry out in fear and anger as the thundering sound of war echoes in the distance" 1993 Anthony Suau (Best19 22)

women walking with children and with old people in wheelbarrows to escape a massacre in "Muslim Expulsion" 1995* Nick Sharp (Photos 177)

young woman on hospital bed in "An 18-year-old Muslim woman hides her head in shame after having an abortion when she became pregnant after being raped by Serbs" 1993* Nina Berman (Best19 66b)

BOSTON (Massachusetts)
 panorama of city ruins in "Ruins of the Boston fire" 1872 James Wallace Black (Eyes #37; Photography1
 \67)
 photograph taken from hot-air balloon in "Boston, as the Eagle and the Wild Goose See It" 1860 James
 Wallace Black (Photography1 \66; Waking 315)
 street grid in "Boston From Hot-Air Balloon" 1860 James Wallace Black (Rosenblum2 #288)
BOWLING
 women in white dresses lawn bowling in "A [black] man picks up lawn-bowling balls for women at an
 exclusively all-white lawn-bowling club outside of Durban" 1986* David Turnley (Eyes \32)
BOXING
 boxer down on ropes in "Michael Spinks goes down from a blow by Mike Tyson during the first round of
 their heavyweight title fight in Atlantic City" 1988 Vernon Ogrodnek (Best14 125)
 boxer hanging across the ropes in "Javier Cintron lies on the ropes after a third round knockout by a
 celebrating Danny Romero in their super flyweight bout" 1995* Jake Schoelkopf (Best21 118d)
 boxer hanging across the ropes in "Johnny DuPlessis of New Orleans hangs through the ropes after being
 pushed by Louie Lomelli during their fight" 1988 Charles Cherney (Best14 126d)
 boxer landing a punch on opponent's face in "Bobby Czyz makes a quick statement to Bash Ali during a 12-
 round World Boxing Association cruiserweight championship" 1991 Ron Cortes (Best17 147)
 boxer leaping after a surprise win in "Olympic boxer David Reid" 1996* Barry Chin (Best22 113)
 boxer leaping into coach's arms in "An underdog U.S. Olympic boxer David Reid leaps into the arms of his
 coach after a surprise knockout" 1996* Michael Goulding (Best22 268)
 boxer on his knees in "Lew Woods and Jake La Mote battle to a state of exhaustion" c. 1944 David Mann
 (Best22 10)
 boxer on mat after knockout in "Muhammad Ali Knocks Out Sonny Liston" 1965 John Rooney (Photos 111)
 boxer on the floor of the ring in "A battered Humberto 'Chiquita' Gonzalez after being knocked out in the
 seventh round of challenger Saman Sorjaturong" 1995* Wally Skalij (Best21 118a)
 boxers at corner of ring in "Tony Lopez delivers a 10th round knockout punch to Joey Gamache" 1992 Brian
 Plonka (Best18 52)
 boxers in heavyweight bout in "Less than five months after his 20th birthday, Mike Tyson finished off Trevor
 Berbick early in their Las Vegas title bout" 1986* Ken Regan (Best12 109)
 boxing match in "Heavyweight boxer Ray Mercer pounds opponent Wesley Watson" 1990 Gerard Lodriguss
 (Best16 124)
 boys in protective gear in corner of ring in "Chris Purpura, 8, gives moral support to Matt Johnson, 8,
 between rounds at a weekly boxing clinic" 1988 Peter Ackerman (Best14 128c)
 child boxers in "Young Professionals" 1996 Frazer Dryden (Best22 239d)
 child in ring in "At young age a Thai kickboxer is already an efficient fighter in the ring" 1998* David
 McIntyre (Best24 87d)
 declaring a winner in Silver Gloves competition in "12-year-old boxer met his match" 1997 Dudley M.
 Brooks (Best23 232d)
 female boxers in ring in "Female boxing championship" 1997* Co Rentmeester (Best23 177c)
 fighters in ring in "Mitch Green as undefeated Mike Tyson rocks him" 1986 Richard Harbus (Best12 218a)
 fighters in ring in "William 'The Hammer' Jones takes a punch on the jaw during a bout with Reginald Little"
 1991 Jerry Lodriguss (Best17 165a)
 fighters in ring in "Sugar Ray Leonard avoids a Marvin Hagler right during their match" 1987 (Best13 193b)
 landing a punch in "Buster Drayton connects with a right to the head of Carlos Santos" 1986 Richard Harbus
 (Best12 219a)
 man hitting boxing bag in "Sammy Hagar" 1988* E. J. Camp (Rolling #83)
 man in boxing gloves on pedestal in "Ray 'Boom Boom' Mancini" 1983* Moshe Brakha (Rolling #101)
 man's hands wrapped in bandages in "The Boxer" c. 1991 Mark Ferri (Graphis91 \360)
 men holding rope for makeshift boxing ring in "Sheepherders' Boxing Match" 1905 Evelyn Cameron
 (Sandler 8)
 nude male boxing in multiple images in "The Kentucky Kid 1-10" 2001 Duane Michals (Photography 58)
 photo essay of boxer in "A glove and a prayer: photo essay on boxer" 1985 Lui Kit Wong (Best11 216-219)
 photo essay on an Olympic hopeful in "The Contender" 1998 Betty Udesen (Best24 68-69)
 punching head of boxer in "Heavyweight champion Evander Holyfield receives a crushing blow from Larry
 Holmes" 1992* Robert Hanashiro (Best18 136b)
 raising hands in victory in "Cassius Clay after knocking out Charley Powell" 1963 Harry Coughanour (Life
 142)
 series on boxing in "Golden Gloves tournaments" 1993* Patrick Davison (Best19 155)

two men in ring in "Rocky Marciano and Ezzard Charles" 1954 Charles Hoff (MOMA 228)

women in boxing gear in "In the spring of 1995, thirty young women entered the New York Golden Gloves championships, the first year that women have been permitted" 1995 Andi Faryl Schreiber (Best21 130)

young African American men practicing in [boxers] c. 1997 John Huet (Graphis97 204, 205)

BREAD

baker carrying large basket of bread from cellar to street in "Zito's Bakery, Bleeker Street, New York" 1937 Berenice Abbott (MOMA 143; Szarkowski 225)

crowd of people with money trying to buy bread in "A woman is overwhelmed by the number of people trying to buy bread in an Albanian store" 1992* Bruce Strong (Best18 133)

end cut off loaf of bread in [bread] c. 1992* Gerrit Buntrock (Graphis93 89)

making bread in a large tub in "In Ucea, Transylvania, a woman prepares bread for an Easter feast" 1993 Anthony Suau (Best19 27a)

seated woman taking loaf of bread out of oven in "Making Bread" c. 1991* John Running (Graphis92 \148)

still life of watermelon, grapes and bread in "Still Life with watermelon" 1947* Irving Penn (MOMA 194)

BRIDES see MARRIAGE CUSTOMS AND RITES

BRIDGES see also names of bridges

angular metal structure of a bridge under construction in "Construction of the Forth Bridge" c. 1884 Photographer Unknown (Rosenblum2 #176)

beams of bridge in shadows in "Bridge Beam Shadows" c. 1927 Charles K. Archer (Peterson #80)

bridge and flat boats on river in "Bridge and Boats on the Thames" 1851 Jean-Baptiste-Louis Gros (Rosenblum2 #9)

covering over center of bridge in "Martorell, Spain: Devil's Bridge" 1850s[?] Charles Clifford (Szarkowski 76a)

crossing over to city at night in [bridge at night] c. 1995* Hale Coughlin (Graphis96 179)

example of military architecture in "Cahors: Pont Valentré" c. 1851 O. Mestral (Rosenblum2 #103)

footbridge over river in "A 700-foot-long footbridge bobs and sways over the Zambezi River at Chinyingi, Zambia" 1997* Chris Johns (Through 214)

framework of bridge in early stage of construction in "Victoria Bridge, Framework of Tube and Staging, Looking In" 1859 William Notman (Rosenblum2 #183)

horse-drawn wagon crossing a large bridge in "Bridge at Halle" c. 1929 Hans Finsler (Rosenblum2 #539)

horses and riders crossing natural stone bridge in "Edwin Natural Bridge, in San Juan County, Utah, rises nearly 100 feet and measures 194 feet long" 1910 Charles Goodman (Through 298)

hundreds of refugees fleeing across upper girders of bombed bridge in "Korean War" 1950 Max Desfor (Capture 27; Eyes #226)

in Paris in "Vue du Pont de la Réforme ou Pont Louis Philippe, Paris" 1853 Charles Marville (Art \68)

people walking on side of bridge in "Walkway, Manhattan Bridge, New York" 1936 Berenice Abbott (Women \102)

railroad bridge across river in "Rail Road Bridge Across Chattanooga Creek, Tennessee" c. 1863-1864 R. M. Cressey (Photography1 #IV-17)

road and rail bridges in city in "Runcorn Railway and Road Bridges, Runcorn, Cheshire" 1986 John Davies (Art \375)

section of underside in "Bridge" 1860s[?] Albert Collard (Szarkowski 99)

silhouette of a bridge in "Douglas Hill walks across the 2nd Street Bridge from his job in Louisville, Ky., to his home in Jeffersonville, Ind." 1986 Pat Mc Donogh (Best12 148)

a suspension bridge over rapids in "The Rapids, Below the Suspension Bridge" c. 1870 Charles Bierstadt (National 2)

thousands of people crossing Golden Gate Bridge in "More than 500,000 people flocked to the 50th anniversary of San Francisco's Golden Gate Bridge" 1987 Doug Atkins (Best13 109a)

tractor trailer truck on bridge span in "United Technologies" 1982* Jay Maisel (Rosenblum2 #633)

train on bridge over Niagara River in "Niagara Suspension Bridge" 1859 William England (Rosenblum2 #174)

two types of bridges over a river in "Two Bridges" n.d. Bisson Freres (Rosenblum2 #175)

view of bottom of bridge as ship passes under in "Brooklyn Bridge" 1929 Walker Evans (MOMA 135)

with construction in foreground in "Williamsburg Bridge" 1910 Alvin Langdon Coburn (Photography1 #V-32)

BROOKLYN BRIDGE, Brooklyn, New York

dignitaries at early stage of construction in "Brooklyn Bridge under Construction" c. 1878 Photographer Unknown (Rosenblum2 #182)

fireworks filling sky over river and bridge in "Happy 100th, Brooklyn Bridge" 1983* Henry Groskinsky (Life

76)
looking across pedestrian walk in "Vanishing Point II: Brooklyn Bridge from the New York Side" 1912 Karl Struss (Decade 16a)
pedestrians crossing bridge in "Brooklyn Bridge" n.d. Sherrill V. Schell (Rosenblum2 #540)
railroad tracks and roads leading onto bridge in "Brooklyn Terminal, Brooklyn Bridge" 1903 Photographer Unknown (Photography1 #V-33)
span of bridge in "The Great Brooklyn Bridge" 1900 Photographer Unknown (Photography1 #V-34)
suspension bridge and old boats on the river banks in "Hungerford Suspension Bridge" c. 1845 William Henry Fox Talbot (Waking 267)
tugboats at base of bridge in "Brooklyn Bridge" 1910-1912 Alvin Langdon Coburn (Rosenblum2 #397)
view of bottom of bridge as ship passes under in "Brooklyn Bridge" 1929 Walker Evans (MOMA 135)

BROOMS AND BRUSHES
African American man holding broom in front of window in 'I ain't no deacon,' says Mark Face, janitor and parishioner at Mount Zion Baptist Church in Pittsburgh 1988 John Kaplan (Best14 17)
African American woman in front of office flag [in manner of Grant Wood] in "Ella Watson" or "American Gothic" 1942 Gordon Parks (Committed 169; Documenting 234-235; Goldberg 103)
broom in front of open door in "The Open Door" 1843 William Henry Fox Talbot (Art \10; Lacayo 18d; Marien \2.6; Rosenblum2 #23; Waking #12)
leaning against bushes in "Broom and Spade" c. 1842 William Henry Fox Talbot (Art \9)
like a flower in "Floral Brushes" c. 1999* Craig Cutler (Photo00 200)
old man in paint splattered clothes in "Handyman in Washington, D.C." 1909 Lewis W. Hine (National \78)

BUBBLES
children in street with bubbles in "Children play in bubbles in Barcelona, Spain" 1998* David Alan Harvey (Through 108)
close-up of soap bubbles in "Soap Bubble" c. 1940 Berenice Abbott (Rosenblum \208)

BUCHENWALD (Concentration Camp)
dead prisoners stacked in a pile in "Buchenwald" 1945 Lee Miller (Rosenblum \175)
male prisoners looking out behind barbed wire in "The Living Dead at Buchenwald" 1945 Margaret Bourke-White (Eyes #213; Lacayo 116d; Monk #30)
man looking at mound of dead bodies in "Senator Alban W. Barkley of Kentucky, Chairman of the House Senate Committee on War Crimes, Buchenwald" 1945 Photographer Unknown (Goldberg 118)
men lying on stacked wooden shelves they used for beds in "Liberation of Buchenwald concentration camp" 1945 Photographer Unknown (Photos 67)
prisoners standing by pile of bones in "Buchenwald" 1945 Lee Miller (Marien \5.82; Rosenblum \175)

BUFFALO
animals falling over cliff in "Untitled" 1988-1989 David Wojnarowicz (Photography 165)
boy jumping into muddy water with herd of water buffalo in "A young herder performs a black flip off a water buffalo in the Turag River west of Dhaka, Bangladesh" 1993* James P. Blair (Through 162)
herd of animals with superimposed hawk in "Lead me around the circle" 1994 Walter Bigbee (Photography 169)
small child on buffalo with large horns in "Perched atop a domesticated Asian buffalo, a farmer's child rides through fields in Thailand" 1928 Ernest B. Schoedsack (Through 196)

BULLFIGHTERS AND BULLS
boy matador kneels as he faces down bull in "Braving the Bulls" 1998* Patrick Tehan (Best24 56a)
bull chasing men in street in "Running of the bulls, Pamplona, Spain" 1997 John Kimmich (Best23 171a); 1998 (Best24 74a)
bull chasing men onto tower in "Would-be matadors take refuge during the running of the bulls in Segovia, Spain" 1990* Paul Hanna (Best16 166)
bull pounding barrier in "David Agular and three Forcaderos find protection from the bull behind a barrier during Portuguese-style bloodless bullfighting in Artesia, Calif." 1988 Brian Gadbery (Best14 127)
bull ring filled with cushions and retreating matadors in "Spanish bullfighters are protected by police while trying to leave the bull ring as fans throw cushion seats in protest of a poor performance" 1988 Raul de Molina (Best14 131a)
feet of people running from the bulls in "The running of the bulls in Pamplona, Spain" 1993* Jim Hollander (Best19 141, 143b)
forcado practices arching his back to provoke a bull in "Braving the Bulls" 1998* Patrick Tehan (Best24 61a)
man being killed during the running of the bulls in [bull killing man during Fiesta San Fermin] c. 1995* Juan Ignacio Delgado Santamaria (Graphis96 64)
man being pursued by bull, leaps over fence in "A white-clad razeteur dodges the horns of a charging bull

and thrills spectators at a bullfight in St. Remy-de-Provence" 1995* William Albert Allard (Best21 127)

matador cheering at dead bull in "At the time of the *Alternativa* ceremony where the novice Torero is elevated to Matador status" 1996* Lucien Clergue (Best22 197d)

matadors adjusting their clothes in "In Lima, Peru, the Plaza de Acho–oldest bullring in the Americas–attracts matadors from Spain and Latin America" 1982* William Albert Allard (Through 374)

sword stuck in a bull's back in "With the sword stuck in its back, the bull has just moments to live" 1997 John Kimmich (Best23 171c)

throwing a cowboy in the mud of a rodeo in "Cowboy is stunned and wet after being thrown by his bull at the Rodeo Championships" 1997* Christian Fuchs (Best23 171d)

BURMA

cannons by large stone dragons in "Artillery in front of Stone Dragons, Prome, Burma" 1852 John McCosh (Marien \2.33)

people standing by large rock at edge of a cliff in "It is believed that Burma's 'Golden Rock' is balanced by a single strand of the Buddha's hair" 1995* Steve McCurry (Best21 201a)

BUSES and BUS TERMINALS

African American children on bus with police protection in "Busing in Louisville" 1975 Keith Williams (Capture 92)

African American girl looking out bus window in "A first-grader watches as police arrest a man for painting a racial slur on the bus as it drove through Trenton" 1992* Craig Orosz (Best18 125)

bus driver in office in "The drivers' room at the Pittsburgh Greyhound garage" 1943 Esther Bubley (Documenting 318b)

buses under repair in "The Pittsburgh Greyhound Garage" 1943 Esther Bubley (Documenting 319c)

"colored waiting room" signs at bus station in "Bus station, colored waiting room, Memphis, Tennessee" c. 1960s Ernest C. Withers (Willis \177)

couple standing at bus door in "At the Indianapolis terminal" 1943 Esther Bubley (Documenting 326a)

crowd waiting around bus at terminal with sign for "White Waiting Room" in "At the Memphis Greyhound terminal" 1943 Esther Bubley (Documenting 329c)

driver on roof, throwing down baggage in "Unloading baggage in Chattanooga" 1943 Esther Bubley (Documenting 328b)

group with soldiers in "Waiting for a bus at the Memphis terminal" 1943 Esther Bubley (Documenting 327c)

laughing on the bus in "Passengers exchanging moron jokes between Pittsburgh and St. Louis" 1943 Esther Bubley (Documenting 325b)

looking through door to waiting passengers in "Passenger in a small Pennsylvania town waiting to board a Greyhound bus" 1943 Esther Bubley (Documenting 317b)

men and luggage near bus in "Men Smoking at Bus Stop" 1989* Ozier Muhammad (Committed 162)

men sitting on a bus in "Men Riding Bus, Las Vegas" 1981 Thomas Frederick Arndt (Rosenblum2 #696)

on city street in "View from Ella Watson's window" 1942 Gordon Parks (Documenting 230b)

on road in "A young boy peers out a window as the bus is leaving areas of heavy fighting in war-torn, rural Chechnya" 1995 Lucian Perkins (Best21 166)

one passenger on a bus in "Boycotted Bus, Montgomery" 1956 Dan Weiner (Goldberg 143)

passengers looking out windows in "Trolley, New Orleans" c. 1955 Robert Frank (Rosenblum2 #671)

people near open baggage sections of bus in "A driver removing the baggage from a bus that broke down en route to Pittsburgh" 1943 Esther Bubley (Documenting 316a)

people seated with luggage in "Bus Terminal in Pittsburgh, Pennsylvania" 1943 Esther Bubley (Sandler 151)

people sitting on wooden benches in "The Pittsburgh Greyhound bus station waiting room" 1943 Esther Bubley (Documenting 321b)

people standing in aisles of bus in "Between Knoxville and Bristol, Tennessee" 1943 Esther Bubley (Documenting 328a)

people with luggage sitting in bus terminal in "The Waiting Room at the Greyhound Bus Terminal. Pittsburgh, Pennsylvania" 1943 Esther Bubley (Fisher 55)

people with luggage sitting on a bench in "Portrait of photographer and film maker Robert Frank, taken in a Greyhound Bus Station" c. 1989 Tom Levy (Graphis89 \151)

photo essay on riding the bus daily in Columbia, South Carolina in "A world apart" Jamie Francis 1993 (Best19 127-132)

San Francisco cable car being delivered in "Tram 106 arrives in San Francisco, but not by foot, as it appears here" 1986 Tom Levy (Best12 183)

school bus and girl hugging mother goodbye in "At Alpha Farm, an 'intentional community' in Orgeon, the day begins at 6 a.m." 1991 Eugene Richards (Best17 128)

woman mopping the floor of a bus in "Mopping the floor of a bus in the Pittsburgh Greyhound garage" 1943

Esther Bubley (Documenting 318a)
women at mirror in rest room in "In the ladies' room at the Chicago Greyhound bus terminal" 1943 Esther Bubley (Documenting 326b)

BUTTERFLIES
composition of wings in "Butterfly wings" 1960s Virna Haffer (Sandler 134)
on a leaf in "American Copper Butterfly" c. 1954 Jeanette Klute (Sandler 133)

—C—

CABINS
several log cabins on dry land in "Cabins and outbuildings on the former Pettway plantation" 1937 Arthur Rothstein (Documenting 150a)
side of log cabin in "Cabin" 1937 Arthur Rothstein (Documenting 151c)

CACTUS
flowering in "American West" c. 1992* Kai Mui (Graphis93 168a)
lamp near cactus in pot in "Cactus and Photographer's Lamp" 1931 Charles Sheeler (MOMA 113)
lone cactus in "Some Hi-Way, Arizona" n.d. George Durr (Willis \550)
part of a cactus in "Agave Cactus" c. 1997* Rosanne Olson (Graphis97 84); in "Cactus" 1937 Ruth Bernhard (Sandler 135); in "Cactus" c. 1990* Eugenia De Olazabal (Graphis90 \298)
varieties of cactus in front of house in "Relaxed Euphoria, Lotusland, California" 2000* John Pfahl (Photography 186)

CAMBODIANS
numerous pictures of men with numbers on their chests from the Cambodian Genocide Photographic Database in "Cambodian prisoners" 1975-1979 Photographer Unknown (Marien \7.29; Photos 141)

CAMELS
camel near people in "Travelers in the Sahara bow in praise to Allah" 1911 Lehnert and Landrock (Through 224)
grazing on arid land in "Pushkar Camel Fair, India" 1978* Mitch Epstein (Rosenblum2 #782)
in a small zoo enclosure in [camel] c. 1992* Britta Jaschinski (Graphis93 192a)
racing on a race course in "A camel handler is trampled during the Sheik Zamed Cup" 1998* Adam Petty (Best24 75a)
waiting for woman to take a drink from a kettle in "A Somali woman drinks from a kettle provided by relief workers at refugee camp in Kenya" 1992* Yunghi Kim (Best18 68)

CAMP DAVID, Maryland
Kennedy and Eisenhower, with backs to camera, walking on path in Camp David in "Two Men With a Problem" 1961 Paul Vathis (Capture 48)

CAMP DAVID AGREEMENTS, 1978
Jimmy Carter shaking hands with Begin and Sadat in "Anwar Sadat, Jimmy Carter, Menachem Begin at the Camp David Accords Signing Ceremony" 1978* Photographer Unknown (Goldberg 190; Photos 145)

CANALS
pedestrian bridge over shimmering water in "A Back Canal (probably Venice)" 1894 James Craig Annan (Rosenblum2 #369)
running between rows of buildings in "Canal at Bièvre" 1907-1920* Jules Gervais-Courtellemont (Rosenblum2 #344)

CANCER see also SICK
father with rare cancer is comforted by son in "[Father] is comforted by son" 1996 Ron Cortes (Best22 210b)
female cancer patient holding small child in "Community-based nursing service for cancer patients" c. 1991* Deborah Meyers (Graphis91 \65)
hairless person in [a cancer patient] c. 1992* David Powers (Graphis93 54)
last days of a woman with cancer and the neighbor who cared for her in "And we sat in silence" 1996 Chad Stevens (Best22 102-103)
photo essay on cancer patients in a hospital in "Dana-Farber [Cancer Institute]: Living with hope and fear" 1995 Eugene Richards (Best21 57, 72-75)
photo essay on treatment and support for woman with cancer in "Beyond the Negative" 1996* Francine Orr (Best22 229)
woman screaming in "Annie's Fight for Life" 1996* Pamela Miller (Best22 235d)

CANNONS AND CANNONBALLS see ARTILLERY
CANOES AND CANOEING see BOATS AND BOATING

CANYON DE CHELLY, Arizona
 behind two Native Americans in [Canyon de Chelly] c. 1992* Greg Booth (Graphis93 129)
 cliff dwellings in "White House Ruin, Canyon de Chelly, Arizona" 1942 Ansel Adams (Icons 97); "The
 Ancient Ruins of the Cañon de Chelle, New Mexico" 1873 Timothy H. O'Sullivan (Art \141; Marien \3.58;
 Photography1 \7; Rosenblum2 #163)
 straight rock formations of the canyon in "Cañon de Chelle, Walls of the Grand Cañon, About 1200 Feet in
 Height" 1873 Timothy H. O'Sullivan (National \36)
CANYONS *see also* GRAND CANYON NATIONAL PARK
 craggy walls in "Gorge of the Tamine" c. 1865 Charles Soulier (Rosenblum2 #118)
 deep canyon walls of colored rock in "Dungeon Canyon, Glen Canyon, Utah" 1961* Eliot Porter (Goldberg
 157)
 large canyon in "Marble Canyon, Shinumo Altar" 1872 John K. Hillers (Rosenblum2 #153)
 river running through canyon in "Currecanti Needle, Black Cañon of the Gunnison" c. 1880 William H.
 Jackson (National 132d)
 straight canyon walls in "Vermillion Creek Canyon" 1872 Timothy H. O'Sullivan (Szarkowksi 121)
 train tracks running in canyon in "East Entrance, Jefferson Canyon" 1890 Frank Jay Haynes (National 130b)
 view of the canyon in "Bryce Canyon" 1930 Laura Gilpin (Rosenblum \157)
CARD GAMES
 African American men playing cards on a counter in "Card Game" 1988 Cheryl Miller (Willis \297)
 grandson and grandfather playing cards on small board in "Sholumbo playing cards with his grandpa" c.
 1970-1995 Roland Charles (Willis \243)
 men playing cards by campfire near wooden lean-to in "Big Game in the Adirondacks" 1889 Seneca Ray
 Stoddard (Photography1 \88)
 wealthy couples at table in "Drawing Room in Mayfair" 1932-1935 (Art \292)
 woman sleeping near men and women playing cards in [Men and women playing cards near sleeping woman]
 1943 Esther Bubley (Fisher 90)
CAREGIVERS
 daily routine of son caring for mother with Alzheimer's in [series on caring for parent with Alzheimer's] 1990
 Genaro Molina (Best16 49-51)
 wife comforting ill husband until death in "Betty Childs cares for her husband as he nears death" 1990 Al
 Podgorski (Best16 58-59)
CARIBOU
 crossing a highway in "Hoofing it for cover, a startled caribou makes tracks across a highway in the interior
 of Newfoundland" 1986* Yva Momatiuk (Best12 107b)
CARNIVALS *see also* AMUSEMENT PARKS; MERRY-GO-ROUND
 adults on a ride in "On the midway" 1941 Russell Lee (Documenting 224a)
 Ferris wheel and games in "On the midway" 1941 Russell Lee (Documenting 223b)
 girls on merry-go-round in "Father and daughters on the midway merry-go-round" 1941 Russell Lee
 (Documenting 222a)
 sideshow posters at fair in "County Fair, Central Ohio" 1938 Ben Shahn (Rosenblum2 #467)
 women looking at game with clown heads in "Midway Clowns" 1937 Humphrey Spender (Marien \5.69)
CARRIAGES AND CARTS
 horse-drawn carriage in Central Park in "A carriage ride in New York City's Central Park takes on a surreal
 quality after a snowstorm" 1993* Jose Azel (Best19 80a)
 horse-drawn carriage on snow-covered street in "Winter–Fifth Avenue, New York" 1893 Alfred Stieglitz
 (Photography1 #VI-5)
 horse-drawn cart in "The Gardner's Cart" c. 1924 King Daniel Ganaway (Willis \71)
 looking down on horse-drawn cart traveling on cobblestone street in "*Carrefour Blois*" 1930 André Kertész
 (Rosenblum2 #508)
 mule pulling wagon on dirt road in "Wayside Scene, Stoney CreeK" 1887 George Barker (Photography1 \74)
 small cart with dead stag in "Stag in cart" c. 1858 Horatio Ross (Waking #18)
 worn velvet seat on wheels in "Untitled" 1949 Robert Rauschenberg (MOMA 210)
CASTLES
 castle on hill in "Landscape with Castle" c. 1845 Franziska Mollinger (Rosenblum \40)
 remnants of stone castle in "Allington Castle, Kent" c. 1855 (Rosenblum \41)
CATHEDRALS
 dark Gothic interior with sarcophagi in "Interior, Salisbury Cathedral" c. 1858 Roger Fenton (Waking #36)
 details of the tower sculpture with restoration scaffolding in "Tower of Kings, Rheims Cathedral" 1851 Henri
 Le Secq (Marien \2.44)

domes of two churches in "Dome of the Cathedral of the Assumption in the Kremlin, Moscow" 1852 Roger Fenton (Waking #79)

figures on the transept in "Chartres Cathedral: Part of the Porch of the North Transept" c. 1851 Charles Nègre (Art \75)

interior of Cathedral crowded for funeral in "The coffin bearing the body of Winston Churchill is borne slowly down the aisle of Saint Paul's Cathedral in his funeral ceremony" 1965* Dmitri Kessel (Eyes \6)

interior of cathedral after bombing in "Interior of the beautiful Rheims Cathedral, damaged in the bombardment" 1914 Underwood & Underwood (Eyes #77; Eyes \3)

multiple images in "Exeter Cathedral" 1996* Jenny Okun (Goldberg 227)

on cobblestone street in "St. Louis Cathedral" 1842 Jules Lion (Willis \1)

scaffolding around section of Cathedral in "Rouen Cathedral" 1890s[?] Photographer Unknown (Szarkowski 332a)

sculpture-filled entryway and rose window in "Strasbourg Cathedral" 1851 Henri Le Secq (Rosenblum2 #102)

spire and façade seen from across river in "Salisbury Cathedral: The Spire" c. 1860 Roger Fenton (Szarkowski 114)

steps and transept in "Lichfield Cathedral: Portal of the South Transept" 1858 Roger Fenton (Art \107)

view of city from across the river in "Notre-Dame from the Pont des Trounelles" 1838-1839* Louis Jacques Mandé Daguerre (Art \17)

view of porch and steps in "South Porch, Chartres Cathedral" c. 1856 Charles Nègre (Szarkowski 72)

CATS

boy holding up a kitten by the scruff of its neck in "Matthew Stubbs and his cousin Alyssa plead with passing motorists to adopt a kitten" 1988 Timothy Barmann (Best14 121c)

cat and wagon, after a fire in "Badly burned but purring loudly, this cat waited for her owners to return after a devastating forest fire" 1985 Eric Luse (Best11 101c)

cat being dropped and landing on its feet in "Falling Cat Sequence" c. 1880s Etienne Jules Marey (Rosenblum2 #299)

cat face superimposed on woman's face in "Ich und Katze (I and Cat)" 1932 Wanda Wulz (Hambourg \56; Icons frontispiece; Rosenblum \111; Women \87)

eating on graves in "In Rome, a woman brings flowers and cat food to a grave in the Protestant cemetery" 1998 Amelia Kunhardt (Best24 40a)

girl holding cat and daffodils in "Portrait of Miss Sawyer" c. 1914* Edward Steichen (Szarkowski 162)

green cats in grey kitchen in "Radioactive Cats" 1980* Sandy Skoglund (Women \198)

in the air with a chair and easels in "Dali Atomicus" 1948 Philippe Halsman (Rosenblum2 #727; San #52)

jumping onto a boat in "A young cat that lives aboard a sailboat leaps to a skiff while chasing ducks" 1996* David A. Rodgers (Best22 184d)

on woman's shoulder as she reads in "Amelia Van Buren with a Cat" c. 1891 Thomas Eakins (Rosenblum2 #297)

photo essay on woman who takes care of unwanted cats in "Feline Haven" 1997 Nancy Andrews (Best23 22-23)

photographers and black-and-white cat owned by the Clintons in "Photographers give Socks a taste of fame outside the Governor's Mansion in Arkansas" 1992* Michael Nelson (Best18 2)

sitting near young boy in navy outfit in "diary of the shipping company American President Lines" c. 1989* Terry Heffernan (Graphis89 \140)

sleeping on ledge in "Sleeping Cat" 1850-1855 Calvert Richard Jones (Waking 269d)

wet cat in "Black cats means bad luck, but for this feline, the bad luck was an unwanted bath" 1986 Phil Skinner (Best12 131)

young girl in long dress holding plate for a cat in "A Mute Appeal" c. 1890 Emma Spencer (Sandler 68a)

CATTLE

back ends of two cows at barbed wire fence in "The Swiss Garden" c. 1991* Charles Weber (Graphis92 \200)

back of reclining cow in "Cow" 1853 Photographer Unknown (Szarkowski 62)

bull and surrogate cow in "John McGrath works at an artificial insemination station in the Republic of Ireland" 1991* Randy Olson (Best17 27)

dead cattle in the brush in "More than 3,000 herd of cattle died when a lethal jet of carbon dioxide spewed from Lake Nyos in West Africa" 1986* Anthony Suau (Best13 83a)

dying from starvation in "The Last of the Herd, Madras Famine" 1876-1878 W. W. Hooper (Rosenblum2 #316)

going into a truck in "A Santa Gertrudis cow that wandered away from the San Antonio Union Stockyards

tried to take over a moving van" 1986 Joe Barrera, Jr. (Best12 133b)

grazing at small pond in "Chouteau's Pond, drained" 1851 Thomas M. Easterly (Photography1 #III-11)

in stockyard with men on horses in "Stockyard salesman and buyers" 1938 John Vachon (Documenting 104b)

livestock sale in center of small town in "Fair in Fribourg, Switzerland" c. 1902 Ernest Bloch (Decade \11)

making paths in snow in "Cattle weave patterns of hoof prints in deep snow on a Pennsylvania farm" 1987 Dan Marschka (Best13 165c)

older couple with portable table and chairs, and cows and sheep grazing in "Glyndebourne" 1967 Tony Ray-Jones (Rosenblum2 #709)

on snow-covered field in "Snow-sugared prairie like a vast gingerbread, raisined with feeding cattle" c. 1989* Robert Llewellyn (Graphis89 \69)

one cow on hillside in "Glastonbury Tor" 1976 Martin Parr (Art \404)

one has head in a garbage can in "Get curious about a garbage can and now look" 1985 Paul O'Neill (Best11 151a)

staring through barbed wire fence in [cattle] c. 1997* Leigh Beisch (Graphis97 174)

starving cattle in a pen in "Starving cattle await auction in Freer, Texas, as a drought forces ranchers to sell their stock" 1988 Nuri Vallbona (Best14 81a)

CAVES

men working in a cave in "Beyond the *Bridge of Sighs*" 1866 Charles Waldack (Rosenblum2 #290)

CEMETERIES *see also* FUNERALS

aerial view of cemetery and small town in valley in "Air view of a cemetery and town. Lincoln, Vermont" 1940 Louise Rosskam (Fisher 51)

airplane crash in hill above graveyard in "A downed plane near a graveyard in northern Nicaragua is a reminder of the revolution that brought the Sandinistas to power" 1986 Steve Ringman (Best12 57b)

black-hooded men holding candles in a cemetery in "A celebration of Easter in Atacama Desert, Chile, reflects an extension of European brotherhood" 1988* David Alan Harvey (Best14 153d)

blessings at unearthed burial site in "African Burial Ground, uncovered in New York City" 1992 Chester Higgins, Jr. (Willis \342)

cats eating on graves in "In Rome, a woman brings flowers and cat food to a grave in the Protestant cemetery" 1998 Amelia Kunhardt (Best24 40a)

cellist weeping in cemetery in "Cellist plays a requiem in Heroes Cemetery" 1995 Tom Stoddart (Best21 223d); in "A requiem in Sarajevo, Bosnia-Herzegovina" 1992* Paul Lowe (Best18 50)

couple walking toward casket in cemetery in "Mourners in Brooklyn, N.Y., attend the funeral of Marine Maj. Eugene McCarthy" 1991* Mark Peterson (Best17 24)

elderly couple at grave in "Couple from a small California town lost their son to AIDS" 1985 Frederic Larson (Best11 31b)

empty coffins stacked on top of each other in "So many deaths, so quickly; so little time, so little space" 1985 Ed Hille (Best11 21b)

family cemetery in "Canaan Baptist Church" 1995 William Earle Williams (Willis \540)

flowers on graves in "On All Saints' Day in Plougastel Daoulas, graves are decorated" c. 1989* Martin Kers (Graphis89 \72)

hearse drivers waiting at cemetery in [cemetery, New Orleans] 1993 Gerald Cyrus (Willis \332)

Korean mothers at cemetery in "Mothers of students killed in the 1980 Kwangju, South Korea, uprising mourn their loss on the anniversary of the massacre" 1987* Anthony Suau (Best13 85)

large cross in foreground of steel mills and houses in "Graveyard, Houses, and Steel Mill, Bethlehem, Pennsylvania" 1935 Walker Evans (Decade 41d; Documenting 44; MOMA 140; Marien \5.54)

man with shovel and 3 fresh graves near city in "Cemetery in Sarajevo" 1993* Antoine Gyori (Lacayo 179d)

mass grave surrounded by sailors in "Mass grave for the dead *Lusitania* victims" 1915 James Hare (Eyes #59)

mourners hiding behind headstones in "During the burial of three members of the outlawed Irish Republican Army in Belfast, Northern Ireland, snipers launch a grenade and gun attack on mourners" 1988* Kenneth Jarecke (Best14 51)

people raking ground in cemetery in "Cleaning the cemetery before evacuation, San Benito County" 1942 Russell Lee (Documenting 247c)

row of wooden crosses at sunset in "Columbine" 1999* Rudolpho Gonzalez (Capture 194)

section of a cathedral near cemetery in "East Gable of the Cathedral and St. Rule's Tower, St. Andrews, Scotland" c. 1844 Hill & Adamson (Szarkowski 41)

small fenced cemetery in "Slave ancestors are buried in a plot outside of his front door" 1998 Donald Anderson (Best24 108a)

tomb seen through stone filigree in "Stone filigree screens near Agra, India, frame the garden and tomb of Emperor Akbar, who died in 1605" 1924 Herbert G. Ponting (Through 126)

tombstone with withered flowers in " Insect-Headed Tombstone" 1953 Clarence John Laughlin (MOMA 179)

veteran in uniform, walking through cemetery in "Sgt. Jeff Sloat of the 7th Special Forces pays his respects to fellow veterans as he walks through the cemetery" 1997* Wally Skalij (Best23 197d)

a veteran salutes at a grave in "A Vietnam veteran observes Memorial Day by visiting the graves of friends" 1986* Scott Goldsmith (Best12 103b)

wearing a peace sign, man kneels at grave in "Peace activist Jerry Rubin spends a quiet moment alone at the graveside of a longtime friend and political activist" 1996* Richard Hartog (Best22 220a)

woman sitting on ground, hugging tombstone in "Memorial Day" 1983* Anthony Suau (Capture 129)

CHAIRS AND BENCHES

and table in garden in "A Walk in the Magic Garden" 1954-1959 Josef Sudek (Icons 165)

and teapot and cups in "Hollywood 1932" c. 1991 Michel Dubois (Graphis91 \309)

arm chair in "Os Chair" c. 1999 Rob Davidson (Photo00 180)

black-and-white wicker in [wicker chairs] c. 1992* Emilio Temolada (Graphis93 141b)

club chair on wood floor in [the Paris Club Chair] c. 1992* William Sharpe (Graphis93 155)

designer chairs in "Chairs designed by the architect Richard Meier" c. 1991 Mario Carrieri (Graphis91 \271, \272)

easy chair near wall with peeling paint in [self-promotional] c. 1990* Scott Dorrance (Graphis90 \202)

empty chairs and trumpet players in "Five trumpet players provide the only live music for commencement" 1986 Paul Kuroda (Best12 171)

green chair and matching wall in [matching green chair and walls] c. 1992* Kris Rodammer (Graphis93 145)

group of different style chairs in a line on a snowy street in "A Group of Chairs" c. 1924 Williams Studio (National \55)

men on rocking chairs on porch in "We got troubles enough without going communist" n.d. Dorothea Lange (Fisher 143)

on pedestal near bicycle from a public relations campaign for Knoll International c. 1990* Günter Derleth (Graphis90 \201)

on top of a mountain in "Santa Lucia Mountain Range between Carmel and San Simeon, California" 1945 Nina Leen (Lacayo 89)

on wrinkled background for [a chair catalog] c. 1990* George Diebold (Graphis90 \198)

recliner in sky with wings in "Heaven" 1995* Pat McDonogh (Best21 151d)

rows of empty park benches in "On a bitterly cold day, Lou Sciloa finds he has his choice of park benches as he surveys the field for the next race at Philadelphia Park" 1988 Michael Bryant (Best14 42d)

several photographed for a catalog in "Philippe Starck designed furniture series" c. 1990* Tom Vack (Graphis90 \194-\196)

shiny lounge chair in "Lockheed Lounge" c. 1992* Sue Stafford (Graphis93 144)

Toledo chair [from *Design in Europe* calendar] c. 1992* Conny J. Winter (Graphis93 159)

with missing leg in "Chair" c. 1999* Hubertus Hamm (Photo00 217)

wooden chairs on porch facing ocean in "Hamptons on Long Island" c. 1991 Albert Watson (Graphis91 \286)

CHALLENGER (Spacecraft), *COLUMBIA* (Spacecraft), etc. *see* SPACE FLIGHT

CHAMELEONS

capturing prey with its tongue in "Survivors from the age of dinosaurs, chameleons abound in Madagascar, where half the world's species are found" 1987* Frans Marten Lanting (Best13 96d)

CHARACTERS IN MOTION PICTURES

Batman in "Batman" c. 1992* Mark Hanauer (Graphis 93 122b)

Batman's back in "Batman" c. 1992* Herb Ritts (Graphis93 97)

Dick Tracy movie characters in "Madonna as Breathless Mahoney and Warren Beatty as Dick Tracy, surrounded by their gangster foes" c. 1991* Herb Ritts (Graphis91 \205)

the Tin Man in "Jerry Seinfeld" c. 1999* Mark Seliger (Photo00 157)

CHARLESTON (South Carolina)

city in ruins in "The aftermath of war in Charleston" 1865 Mathew Brady, attribution (Lacayo 25c)

man sitting on ruins of the city in "Ruins in Charleston, S.C." c. 1865 George N. Barnard (Eyes #36)

ruins of the railroad station in "Ruins of the Railroad Depot, Charleston, South Carolina" 1864-1865 George N. Barnard (Szarkowski 314b)

CHARTISTS

large crowd in "Great Chartist Meeting at Kennington Common" 1848* William Edward Kilburn (Art \19; Marien \2.29; Rosenblum2 #321)

CHECHNIA (RUSSIA) *see also* GROZNYI (RUSSIA)

funeral and boy with legs blown off in "The War in Chechnya" 1995 (Best21 216)

girl with doll standing in rubble in "A young Chechyen girl covers her ears to silence the roar of a Russian

tank" 1995* Bill Swersey (Best21 182c)

man in hospital bed in "A relative weeps as she sits on the bed in a Chechen hospital ward with an injured relative" 1995* Misha Japaridze (Best21 183b)

mourning women for bomb victims in "Chechnya War" 1995* Paul Lowe (Best21 225-226)

soldier running from building in "A Chechen soldier running from the Presidential Palace shortly before it was captured by the Russians" 1995 Christopher Morris (Best21 181)

widows and noose hanging in street in "What Happened to Fred Cuny?" 1996 Stanley Greene (Best22 237b)

CHECKERS

being played on wooden table in "In the recreation hall [at the Visalia Migratory Labor Camp, California]" 1940 Arthur Rothstein (Documenting 202b)

well-dressed men standing as they play checkers in "Two Men Playing Checkers" 1850-1852 Photographer Unknown (Waking 311)

CHEERLEADING

girls waiting for a competition in "Cheerleaders in Jasper" 1995 Torsten Kjellstrand (Best21 52-53)

CHEETAHS

a group at night in "Admired for their genetic hardiness but reviled as pesky predators, cheetahs in Nambia prowl under the cover of night" 1999* Chris Johns (Through 288)

CHERNOBYL NUCLEAR ACCIDENT, CHERNOBYL, UKRAINE, 1986

doctor checking boy for radiation in "A mother from Kiev, 80 miles from the Chernobyl nuclear explosion, has her boy checked out for radiation" 1986* Frederique Hiben (Best12 6c)

fetus in person's hands in "Chernobyl Fetus" 1990* Igor Kostin (Best16 146)

flying over the ruins of the Chernobyl power plant in "Nuclear Disaster in Chernobyl" 1986 Photographer Unknown (Photos 155)

mother at memorial to her son in "Mother wipes snow off a memorial to her son and other victims of the Chernobyl nuclear accident" 1993 Stan Grossfeld (Best19 59)

CHESS

men in hats at outdoor table in "Two Men Playing Chess" 1907* Alfred Stieglitz (Waking #134)

men playing chess in a studio in "The Chess Players" c. 1845 William Henry Fox Talbot (Art \13)

men watching others play in "Chess Game" c. 1850 Aloïs Löcherer (Rosenblum2 #258)

CHICAGO, Illinois

Chicago Board of Trade building at night in "Chicago Board of Trade building" c. 1991 Wayne Cable (Graphis92 \221)

city view in "View of the Marina City Building in Chicago" c. 1989* Karen J. Hirsch (Graphis89 \105)

CHILD LABOR

African American newsboys posing outside of newspaper office in "Group portrait of *Call* and *Post* newsboys" c. 1930s Allen E. Cole (Willis \104)

boy near glass blower in "A carrying boy in a Virginia glass factory" 1911 Lewis Wickes Hine (Lacayo 62b)

boy with blackened face and wearing a miner's lamp in "Young Coal Miner, Wales" 1947 Arthur Rothstein (Decade \40)

boys lined up on curb carrying newspapers in "Sunday Noon, Some of the Newsboys Returning Sunday Papers" 1909 Lewis Wickes Hine (Icons 19)

boys and men sorting coal in "Kohinore Mine, Shenandoah City" 1891 Frances Benjamin Johnston (Photography1 \92)

boys at end of coal chute in "Breaker Boys" 1904 Gustav Marrissiaux (Rosenblum2 #433)

boys smoking in "Newsies at Skeeter's Branch, St. Louis" 1910 Lewis Wickes Hine (Hambourg 56a)

boys sorting coal in "Breaker Boys, Eagle Hill, Colliery" c. 1884 George Bretz (Rosenblum2 #432)

boys with coal on their faces in "Coalbreakers, Pennsylvania" or "Breaker boys in a coal chute" 1910-1911 Lewis W. Hine (Eyes #62; Goldberg 40; MOMA 74; Lacayo 63; Rosenblum2 #474)

child sitting at a machine in "A girl at work in a cotton mill" 1911 Lewis Wickes Hine (Lacayo 64c)

children and parents making flowers at table in "Homework, Artificial Flowers, NYC" 1908 Lewis Wickes Hine (Decade 12)

children carrying heavy loads on their backs as they walk through rubble in "In the rubble of Kabul, Afghanistan, the city of orphans, three youngsters carry wood to sell at a market" 1995 Laurent Van Der Stockt (Best21 180a)

children sitting with mother and making wreaths in "A family works at home making flower wreaths" 1912 Lewis Hine (Lacayo 65b)

Egyptian boy carrying large clay pots in "8-year-old boy carries clay pots to a nearby kiln where burning tires harden the clay wares" 1997* Matthew Moyer (Best23 139c)

hard, dirty work done by children in "Child Labor–Cairo" 1996 Colin H. Finlay (Best22 230)

poster depicting healthy children before the factory and ruined children from the factory in "Making Human Junk" c. 1915 Lewis Wickes Hine (Rosenblum2 #466)

young girl at large spinning machine in "Child Spinner, North Carolina" 1909 Lewis Wickes Hine (Goldberg 42; Marien \4.49; Monk #14; Lacayo 62a; Photos 17)

young girl at large spinning machine in "Ten-Year-Old Spinner" 1908-1909 Lewis Wickes Hine (Rosenblum2 #476)

CHILDBIRTH

abandonment of a female infant on a hospital bed in "Female infanticide in India" 1995 (Best21 211b)

birth of a boy in India in "Female infanticide in India" 1995 Zana Briski (Best21, 221d)

father at birth of baby in "Of fathers and family" 1993* Patrick Davison (Best19 39a)

newborn baby with parents at moment of birth in "Moment of Life" 1972 Brian Lanker (Capture 82)

newborns sleeping head to feet in boxes in maternity hospital in "El Salvador: Before the truce" c. 1989 Larry Towell (Best19 112)

photo essay on passage from pregnancy to childbirth in "Sara and Jim Vogt enjoy their firstborn" 1991* Eugene Richards (Best17 119-123)

CHILDREN see CHILD LABOR; MOTHER/FATHER AND CHILD

CHIMPANZEES see PRIMATES

CHINA

addict on the street in "A heroin user sits on a curb in the Canton Region" 1998 Francesco Zizola (Best24 187)

Chinese couple seated in formal portrait in "Cantonese Mandarin and His Wife" 1861-1864 Milton M. Miller (Marien \3.36)

Chinese couples in multiple photographs in "Parents" 1998* Wang Jinsong (Marien \7.63)

crowd of people linking arms in "Trying to buy gold before the Red Army enters Shanghai" Henri Cartier-Bresson (Lacayo 90a)

group of Chinese children with flags in "Tien An Men Square, Beijing" 1965 René Burri (Rosenblum2 #615)

itinerant Chinese tradesmen: barber, calligrapher, etc. set up in street in "Itinerant Tradesman, Kiu Kiang Kiangsi" c. 1868 John Thomson (Rosenblum2 #192)

mist-veiled hills of the Yangtze River valley in "Wushan Gorge, China" 1946 Dmitri Kessel (Life 182)

mountain gorge in "Wu-Shan Gorge Szechuan" 1868 John Thomson (Rosenblum2 #138)

napping and walking to lunch break at shoe factory in "Chinese shoe factory and workers" 1997* Paul Kitagaki, Jr. (Best23 210a,c)

overlooking the water to Shanghai in "Oriental Pearl TV Tower, 1,500 feet tall, soars over the modern Pudong New Area in Shanghai, China" 1999* Joe McNally (Through 132)

plaza filled with recruits for the army of Chiang Kai-shek to fight against the communists in "Chinese Nationalist recruits massing in Beijing" 1948 Henri Cartier-Bresson (Lacayo 160)

watching television below large portrait of Mao Tse Tung in "Chinese students watching Jiang Qing (Mrs. Mao) on television during the trial of the Gang of Four" 1980* (Eyes \21)

woman with umbrella at shore in "A tourist approaches the southernmost point of China, traditionally considered to be the end of the civilized world" 1998* Michael Yamashita (Best24 188)

young women running in street in "Chinese Parade" c. 1958 Henri Cartier-Bresson (Eyes #255)

CHINA–ANTIQUITIES

ornately carved portal in "Damaged Portal of Yuen-Ming-Yuan, Summer Palace, Peking, after the Fire of 1860" 1872 Thomas Child (Rosenblum2 #140)

painted terracotta soldiers in "Paint still clings to 2,200-year-old terracotta soldiers found in the tomb of Qin Shi Huang Di, the first emperor of China" 2001* O. Louis Mazzatenta (Through 144)

CHINESE AMERICANS

Chinese men in hats, on street in "Chinatown, San Francisco" 1896-1906 Arnold Genthe (MOMA 72)

man walking with two children in "Holiday Visit, Chinatown, San Francisco" c. 1897 Arnold Genthe (Photography1 \95)

parades, wedding, and decorative food in "New York's Chinatown" 1998* Chien-Chi Chang (Best24 124-125)

two men in coats standing in doorways in "Two Chinese" 1947 Max Yavno (Decade \52)

CHOCOLATE

shells made from and covered with chocolate in "Chocolate shells delight" 1988* Stan Badz (Best14 108)

CHRISTMAS

electric lights all over house in "Christmas Unplugged" 1995* Kent Porter (Best21 150b)

small white tree in window in "Xmas Tree in Window" 1976* Patty Carroll (Women \179)

CHRYSLER BUILDING (New York, N.Y.)
 section of the tower in "A section of the Chrysler Building" c. 1989* Richard Berenholtz (Graphis89 \103)
 tower at the top of the building in "Chrysler Building, New York" c. 1932 Margaret Bourke-White (Hambourg \11)
 upper floors and tower in [Chrysler Building] c. 1995* Harry De Zitter (Graphis96 172)
CHURCH BUILDINGS *see also* CATHEDRALS
 African American man crying by burned-out church, and women with *Bible* in "Our Churches are Burning" 1996 Brian Walski (Best22 238a)
 African American Reverend sitting with *Bible* by burned-out church building in "You Can Burn the Building, But Not the Spirit, Charlotte, North Carolina" 1996 Jason Miccolo Johnson (Committed 137),
 columns of Westminster Abbey in "Westminster Abbey, South Nave Aisle" c. 1911 Frederick H. Evans (Art \162)
 gated storefront of boarded-up apartment building in "Storefront Church, New York City" 1991 Sunny Nash (Willis \290)
 inside of a revival tent with chairs and pulpit in "Revival tent, 117th Street and Lenox Avenue" 1993* Jeffery Henson Scales (Willis \417)
 interior of New Mexican church with wood floor and no benches in "Father Walter Cassidy celebrates mass at the Trampas church" 1943 John Collier, Jr. (Documenting 310a)
 Mexican family on way to church in "A family comes to worship in the beautiful but politically torn town of Chiapas, Mexico" 1996* Tomasz Tomaszewski (Through 308)
 richly carved capitals in "Cloister of Saint-Trophîme, Arles" c. 1861 Édoaurd-Denis Baldus (Marien \2.43; Waking #47)
 Romanesque entrance with closed doors in "Portal of Saint-Ursin, Bourges" c. 1855 Bisson Frères (Art \78; Waking #37)
 small chapel and picket fence in "Bellevue, Alberta" 1974* Stephen Shore (Photography 25)
 small church in the forest in "Snow dusts the Anderson Memorial Church in Webster, N.H., on a frosty January morning" 1987 Garo Lachinian (Best13 165d)
 small church on prairie with illuminated cross and bolt of lightning in "At Heaven's Gate" 1990* Chris Ochsner (Best16 64b)
 small wooden church with pillars in "Negro Church, South Carolina" 1936 Walker Evans (Waking #6)
 storefront clapboard church in "Church of the Nazarene, Tennesse" 1936 Walker Evans (Goldberg 101)
 stucco church in "Los Ranchos de Taos Church" 1930 Laura Gilpin (Decade 40a); c. 1930 Ansel Adams (Decade 41c); 1931 Paul Strand (Decade 40b); 1939 Laura Gilpin (Sandler 124); c. 1989* Doug Keats (Graphis89 \106-\109)
 stucco church with bell and cross in "Church of San Lorenzo, New Mexico" 1963 Laura Gilpin (Rosenblum2 #529)
 Westminster Abbey at time of Queen's coronation before thousands of people in "Coronation of Elizabeth II" 1953 Photographer Unknown (Photos 81)
 white clapboard building with closed doors in "Church" 1944 Paul Strand (MOMA 189)
 white wooden church in "Church on the Hill, Vermont" 1946 Paul Strand (Art \190)
CIGARETTES
 ash and label remaining in [cigarettes] c. 1997 Kenji Toma (Graphis97 60)
 cigarette butts in ash tray in [cigarettes in ash tray] c. 1999* Craig Cutler (Photo00 204)
 different types arranged on a table in "Cigarettes" c. 1925 Wynn Richards (Rosenblum \152)
 tobacco without the wrapper in "Cigarette" 1936 Marcel Duchamp (Hambourg \120)
 two burnt cigarettes in "Cigarette No. 37" 1972 Irving Penn (Szarkowski 252)
CINCINNATI, OHIO
 panoramic view of the city in "View of Cincinnati" Henry Rohrer, attribution c. 1865-1866 (Waking #98)
CIRCUS *see also* CLOWNS
 girl in cape in "Girl in her circus costume" 1970 Diane Arbus (Photography 91)
 girls in costume and clown in "Pinky with Clown Man Passing on Left Side, Royal Circus, India" 1990 Mary Ellen Mark (Photography 46)
 person in barrel of cannon in "Cannon Shot" 1952 Weegee (Decade \66; Goldberg 123d)
 portrait of trapeze troupe in "The Flying Cranes of the Russian circus" c. 1995 Paul Mobley (Graphis96 126)
 tall man and spectators in "The Tall Man at the Circus" c. 1920s Laura Gilpin (Women \32)
 trapeze artists in mid-air in "The Trapeze Act" 1928 Florence B. Kemmler (Rosenblum \159)
 woman swallowing a sword near a tent in "Albino Sword Swallower at a Carnival" 1970 Diane Arbus (Women \130)

CIVIL RIGHTS MOVEMENTS–U.S.

African American girl carrying schoolbooks in "Elizabeth Eckford pursued by mob, Little Rock, Arkansas" 1957 Pete Harris (Goldberg 144)

African American girl looking out bus window in "A first-grader watches as police arrest a man for painting a racial slur on the bus as it drove through Trenton" 1992* Craig Orosz (Best18 125)

African American man and woman sitting in police wagon in "Alabama" 1963 Bruce Davidson (Eyes #275)

African American men with signs protesting employment discrimination in "Workers Outside United Steelworkers of America Office" n.d. Charles (Teenie) Harris (Willis \137)

African American woman being attacked by White men in "Black women are attacked on a street corner" 1958 Charles Moore (Best14 217a)

African American women marching with signs in "Members of the National Association of Colored Women march outside the White House to protest a lynching in Georgia" 1946 Robert H. McNeill (Willis \114)

African American women marching with signs in front of a store in "Fair Employment Practice Demonstration" n.d. Charles (Teenie) Harris (Willis \135)

African American youth pointing and jeering at police officer in "Jubilant teens sing freedom songs" 1963 Charles Moore (Best14 214)

African Americans marching in protest in "The Reverend Adam Clayton Powell, Jr., leads a protest on 125th Street in Harlem–'Don't Buy Where You Can't Work' campaign" 1942 Morgan and Marvin Smith (Willis \124)

Civil Rights gathering of thousands from the Lincoln Memorial to the Washington Monument in "The March on Washington" 1963 Robert W. Kelley (Monk #40); "The march on Washington" 1963 Flip Schulke (Eyes #276)

"colored waiting room" signs at bus station in "Bus station, colored waiting room, Memphis, Tenn." c. 1960s (Willis \177)

crowd of African American men carrying signs in "I Am a Man: Sanitation Workers Strike, Memphis, Tennessee" 1968 Ernest C. Withers (Committed 224; Goldberg 164; Marien \6.68; Willis \176)

fight between marchers and police in gas masks in " 'Bloody Sunday' clash between a group of marching demonstrators and state highway patrolmen at the Edmund Pettus Bridge" 1965 Charles Moore (Best14 217b)

fire fighters hosing demonstrators sitting at curb in "Birmingham demonstration" 1963 Charles Moore (Best14 218; Eyes #271; Marien \6.69)

flags behind Dr. Martin Luther King, Jr., as he marches in "Selma, Alabama, demonstrations and marches" 1965 Flip Schulke (Eyes #279)

injured civil rights workers walking away from police in "Civil rights workers are beaten by sheriff's deputies and police on horses" 1965 Charles Moore (Best14 211, 219)

line of marchers on hilltop in "March for integration in Selma" 1968 James H. Karales (Lacayo 149)

line of marchers silhouetted against the sky in "Marchers, Selma to Montgomery" 1965 James Karales (Goldberg 167)

man drenched in water from police hoses in "A demonstrator" 1963 Charles Moore (Best14 216)

man in police station in "Rev. Martin Luther King, Jr., being booked by the Montgomery, Alabama, police" 1958 Charles Moore (Best14 220; Life 156)

one passenger on a bus in "Boycotted Bus, Montgomery" 1956 Dan Weiner (Goldberg 143)

police dogs attacking African American man in "Birmingham Protest" 1963 Bill Hudson (Goldberg 165); "Eugene 'Bull' Conner, Birmingham's Commissioner of Public Safety, orders the use of police dogs and fire hoses against civil rights activists" 1963 Charles Moore (Best14 215; MOMA 234)

Rosa Parks speaking from a podium filled with microphones in "Civil rights leaders and celebrities join Rosa Parks as she addresses demonstrators in front of State Building in Montgomery, Alabama" 1965 Jack T. Franklin (Willis \171)

Selma to Montgomery march including Dr. Martin Luther King, Jr., in "Coretta Scott King and C. Delores Tucker, left of Dr. Martin Luther King, Jr., with other marchers at Selma to Montgomery March" 1963 Jack T. Franklin (Willis \172)

sitting near fire with Washington Monument in background in "Resurrection City, Washington, D.C., Poor People's March" 1968 Robert Houston (Eyes #281)

Virginia Military Institute and the first female cadets in "Historic Entrance" 1997 Nancy Andrews (Best23 24-25)

white men waiting with sheriff in "Local officials await James Meredith's attempt to enroll at Ole Miss." 1962 Charles Moore (Best14 212)

white student striking African American man with flag pole as crowd watches in "The Soiling of Old Glory" 1976 Stanley J. Forman (Capture 98; Eyes #309; Lacayo 128)

white students cheering and holding Confederate flag in "Segregationists at the University of Mississippi, Ole Miss., react to the imminent enrollment of James Meredith, the first black student at the university" 1962 Charles Moore (Best14 214)

CIVIL WAR–U.S. *see* UNITED STATES–HISTORY–CIVIL WAR, 1861-1865

CLERGY

African American elderly man and votive candles in "Deacon with candles, St. Elijah Holiness Church, Baltimore" 1992 Ken Royster (Willis \337)

African American elderly woman seated in robes in "Archbishop Naomi Durant, New Refuge Deliverance Cathedral, Baltimore" 1994 Ken Royster (Willis \336)

African American minister at pulpit in "Minister at the pulpit" c. 1949 Dwoyid Olmstead (Willis \131)

African American ministers praying in [Rev. Calvin O. Butts III with ministers] n.d. Bob Gore (Willis \294)

African American preacher at podium in "The Reverend Vondell Gassaway preaching the Sunday sermon at Saint Martin's Spiritual Church" 1942 Gordon Parks (Documenting 236a)

African American preacher in long cape in "Reverend Gassaway stands in a bowl of sacred water banked with the roses that he blesses and gives to celebrants" 1942 Gordon Parks (Documenting 237c)

dying soldier holding onto priest in street in "Aid From Padre" 1962 Hector Rondon (Capture 51)

man speaking at pulpit in "Brother Edwin Foote preaching a sermon at the First Wesleyan Methodist Church" Esther Bubley 1943 (Fisher 42)

minister ready to baptize people in the Moscow River in "Russian Baptist minister finishes a ceremony during which 190 people were baptized in the Moscow River" 1993 Lucian Perkins (Best19 15-16)

overhead view of St. Peter's "Inside St. Peter's Basilica, candidates for priesthood from 22 countries lie prostrate in humility as they take their vows during mass celebrated by Pope John Paul II" 1985* James Stanfield (Best11 45c)

parishioners and clergy at a mass in [Roman Catholic Church in Russia] c. 1992* Jeffrey Aaronson (Graphis93 52)

Pope John Paul II being blessed by an American Indian in "In Phoenix, the pope was blessed by Emmett White, a Pima Indian, in a special ceremony"1987* Vickie Lewis (Best13 17b)

Pope John Paul II embracing a child in "Pope John Paul II embraces a 5-year-old AIDS victim Brendan O'Rourke" 1987* Dave Zapotosky (Best13 17c)

priest and men under a tree in "A priest relates a story to a group of men at an annual festival in Sieu" 1993 Antony Suau (Best19 28)

priest bending over kneeling man, near firing squad in "Castro Firing Squad Execution" 1959 Andrew Lopez (Capture 45)

priest blessing bodies under ice packs in "A priest makes the sign of the cross over ice-packed bodies of quake victims" 1985* Lennox McLendon (Best11 11)

turbaned men in black robes near reflecting pool in "Mullahs of the Faizeh Theological School in the holy city of Qom" 1985* Michael Coyne (Best11 40d)

CLOCKS AND WATCHES

ad for colorful watches in "Swatch watches" c. 1991* Patrick Rohner (Graphis92 \186-\188)

clock face in [self-promotional] c. 1991* Steve Gerig (Graphis92 \174)

statue of Atlas holding clock on facade of building in "Atlas (with clock)" at Tiffany's No. 727 Fifth Avenue (crafted by Harry Frederick Metzler)" c. 1989* Richard Berenholtz (Graphis89 \102)

watch wrapped around seltzer bottle from [self-promotional] c. 1989* Bill White (Graphis89 \235)

worn clock face and gears in "Neverending deadlines" 1992* Jay Koelzer (Best18 169)

wristwatch advertisement in "Omega Watch" c. 1991* Stefano Bianchi (Graphis91 \228)

CLOUDS

circle of storm clouds in "Storm clouds over Wyoming" c. 1987* Larry Dale Gordon (Graphis89 \64)

clouds in "Cloud Study" c. 1925 Forman Hanna (National \64)

clouds in "Equivalent" 1929 Alfred Stieglitz (Rosenblum2 #403)

clouds in *Nature* series flowers" 1995 John Brown (Willis \547)

foehn clouds over mountain in "Lens-shaped foehn clouds over Central Switzerland" c. 1987* Beat Kaslin (Graphis89 \63)

layers of altocumulus lenticularis over the mountains in "Clouds above the Matterhorn of Nepal" c. 1987 Walter Vetsch (Graphis89 \62)

over beach stones [from *Landscape* series] 1998 John Pinderhughes (Willis \537)

over seashore in "Clouds and Sea" 1987* John Claridge (Graphis89 \65)

over the sea in "View on the Sea: The Cloudy Sky" c. 1856 Gustave Le Gray (Szarkowski 110)

sunrise in "Sunrise over Haleakala, Maui, Hawaii" c. 1997* Randy Wells (Graphis97 151)

various types of clouds in "A Study of Clouds" c. 1869 Eadweard Muybridge (Rosenblum2 #149)

white cloud over lake in "The Big White Cloud, Lake George" 1903 Edward Steichen (Art \169)

COLUMNS *see also* CIRCUS
bird on clown's fake nose in "A premiere clown of the Russian circus" c. 1995 Paul Mobley (Graphis96 127)
man on one foot in "Charles Debureau" 1854-1855 Tournachon and Nadar (Waking #59)
a Pierrot as a photographer in "Pierrot the Photographer" 1854-1855 Nadar (Marien \3.0)
sitting by circus posters and drum in "Madonna with Clown" 1986* Matthew Rolston (Rolling #102)

COLUMBIA (SPACECRAFT) *see also* SPACE FLIGHT
Columbia blasting off in "The Space shuttle *Columbia* lifts off from the Kennedy Space Center in Cape Canaveral, Florida" 1982* Jon Schneeberger (Through 480)

COLUMBINE HIGH SCHOOL (Littleton, Colorado)
crying and hugging youth in "Columbine" 1999* George Kochaniec, Jr. (Capture 194, 195b)
row of wooden crosses at sunset in "Columbine" 1999* Rudolpho Gonzalez (Capture 194)

COMETS *see also* ASTRONOMY
children watching the sky in "A celestial dazzler, Comet Hale-Bopp delights earthbound observers in Arizona's Sonoran Desert" 1997* Jerry Lodriguss (Through 500)
comet streaking across the sky in "Halley's Comet" 1910 Photographer Unknown (Goldberg 36)
Halley's Comet over the stone faces of Easter Island in "Returning every 76th year, Halley's Comet made its appearance right on time" 1986* James Balog (Best12 106c)
streaking across desert in "The newly discovered comet Hyakutake streaks through the starry sky" 1996* John B. Gibbins III (Best22 183c)

COMFORT WOMEN
photo essay on elderly Japanese women who had been forced to serve as comfort women in World War II in "Forgotten Women: Comfort Women" 1996 Yunghi Kim (Best22 30-35)

COMMENCEMENT CEREMONIES
adult graduate kissing daughter in "Graduate Elena Messer gets flowers, hugs and kisses from her daughter Donnie, age 8" 1988 Don Tormey (Best14 210d)
boy walking past cheering women in "Arriving in a tuxedo for his middle school graduation" 1998 Bill Greene (Best24 111)
empty chairs and trumpet players in "Five trumpet players provide the only live music for commencement" 1986 Paul Kuroda (Best12 171)
girls running out of the rain in caps and gowns in "Graduates" 1995 Alan Berner (Best21 219)
kindergartner making faces at graduation in "Kindergarten graduate reacts to the commencement address" 1985 Rich Hein (Best11 137b)
line of African American men and women on large lawn in "Commencement" 1917 C. M. Battey Willis \37)
preschool children in "At a Head Start preschool not every five-year-old can be persuaded to wear a cap for graduation" 1993 Brian Davies (Best19 226a)
putting on cap and gown at home in "With a little help from his mother, home-schooled student John Lindsey prepares for his high-school graduation" 1991 Rod Mar (Best17 205)
students waiting for commencement in "Paula Villarreal embraces her boyfriend before commencement exercises" Brian Davies 1993 (Best19 226c)

COMMUNES
hippies near tipi in "Commune members" 1969* John Olson (Life 46)

COMPUTERS
computer in [Apple iMac] c. 1999* Mark Laita (Photo00 170)
computer details in [ad for Acuson Computers] c. 1991* R. J. Muna (Graphis92 \180, \181)
computer on tables and floor in unfinished office space in "Multi-user systems, personal computer, and terminals" c. 1990* R. J. Muna (Graphis90 \208-\210)
displayed on pedestals in "New equipment introductions of Apple Computer" c. 1987* Ernie Friedlander (Graphis89 \216)
figures on monitors looking at each other in "Dating Software" 1995* Stephen D. Cannerelli (Best21 148a)
meditating with PC components in "At peace with your PC" 1996* Drew Perine (Best22 181b)
monitor on the edge of a desk in "NEXT computer" c. 1990* Paul Franz Moore (Graphis90 \207)
laptop being used outdoors in [ad for Librex notebook computers] c. 1991* Nadav Kander(Graphis92 \175)
seemingly floating in air in "A NEXT computer, designed by frogdesign" c. 1990* Dietmar Henneka (Graphis90 \211)

CONCERTS
crowd of smiling women in "Audience listens to Frank Sinatra at the Hollywood Bowl" c. 1943 Ed Parkinson (Best18 14)

CONCERTS–FARM AID

thousands watching acts on stage in "Responding to the American farmers' distress, country music acts and rock-and-roll stars performed for 14 hours during the Farm Aid Concert" 1985 Frank Niemeir (Best11 62a)

Willie Nelson holding his guitar in "Superstar Willie Nelson was a main force in producing Farm Aid Concert as well as performing during the event" 1985 Nancy Stone (Best11 62d)

young people at concert with hands raised in "Joy of the Farm Aid Concert shines on the face of young participant as he floats on a sea of hands over the crowd" 1985 Art Meripol (Best11 63)

CONCERTS–USAfrica

famous singers singing for African relief in "United Support of Artists for Africa" 1985* Harry Benson (Best11 2)

rehearsing for concert in "Quincy Jones and all-stars doing solos with Stevie Wonder" 1985* Harry Benson (Best11 42c)

two men talking in "Willie Nelson and Michael Jackson exchange confidences" 1985* Harry Benson (Best11 42b)

woman in earphones singing in "Cyndi Lauper hits her mark" 1985* Harry Benson (Best11 42d)

CONEY ISLAND (New York, N.Y.)

beach completely filled with people looking at camera in "Coney Island Beach" 1940 Weegee (Art \312)

beach filled with people in "Coney Island" 1974* Eve Sonneman (Photography2 152)

CONTESTS

men pulling on rope in "Tug-of-war" 1941 Russell Lee (Documenting 219b)

COSMONAUTS see ASTRONAUTS / COSMONAUTS

COSTUME, ETHNIC see ETHNIC COSTUME

COSTUMES see also MASKS

boy as Elvis Presley in "The people of Jasper, Indiana" 1995 Torsten Kjellstrand (Best21 44)

boy as Superman in "Dressed as his favorite comic book hero, 3-year-old pauses before attempting a third try to fly" 1998 Barbara Davidson (Best24 39b)

children in costumes with decorated bicycles in "Waiting for the parade to begin" 1941 Russell Lee (Documenting 212c)

couple in white gauzy costumes in "Carnival participants in whimsical costumes stroll along a street in Venice" 1995* Sam Abell (Through 114)

elderly man in "Popeye" outfit in "Man in 'Popeye' costume" c. 1989* Joe Baraban (Graphis89 \174)

feathers and flowers in a celebration in "Celebrants at the Festival of the Virgin of Guadalupe in Mexico City mix traditional costumes and Roman Catholic images" 1996* Stuart Franklin (Through 346)

girl as majorette for a parade in "Majorette at National Elks Convention" c. 1945 John W. Mosley (Willis \174)

girl dressed as Lady Liberty in "Jamie Leverentz is a Liberty lookalike who kept her torch aloft even as she quenched her thirst" 1986 Bruce Chambers (Best12 96d)

girls in bras and skirts imitating Selena in "Young girls compete to see who can look the most like their idol, the singer Selena" 1995* Claudio Edinger (Best21 163b)

man in robes at Black and Latino Gay Ball from [Walk in the Park series] 1997 Gerard H. Gaskin (Committed 104, 105)

man with three arms entering portable toilet in "Dressed as a six-armed Hindu goddess, Gordon Coughlin heads for the restroom" 1995* Steven G. Smith (Best21 165d)

masked cowboy in a café in "The Black Lone Ranger" c. 1991* Tim Bieber (Graphis92 \136)

person in blue face paint and pine cones in "Blue Man" 1995* Chuck Fadely (Best21 228d)

person in feathers in "Metamorphosis" c. 1999* Klaus-Peter Nordmann (Photo00 115)

women dressed like Jackie Kennedy in "Jackie wannabes" 1961 Yale Joel (Life 114a)

women with paper wings over their arms in "Bird Pageant Costumes" before 1935 Eudora Welty (Women \106)

COUNTY FAIRS

pig race, parading, and dancing in "County Fairs: Rural America's Last Hurrah" 1997* Randy Olson (Best23 225)

COURTS

woman appearing in court surrounded by armed police in "In a terrorist court in Turkey, Alpodogan denies charges of belonging to the violently separatist Kurdistan Worker's Party" 1992* Ed Kashi (Best18 115)

COWBOYS

African American cowboy riding by mural of Malcolm X in "Legends, Philadelphia" 1993* Ron Tarver (Willis \428)

African American cowboys at a rodeo in "Bull's Eye" 1995 Ken Jones (Willis \350); "Mr. Journet's Repose,

Houston" 1996 Ken Jones (Willis \348); "Rough Rider, Rodeo Patron at an African American Rodeo" 1995 Ken Jones (Willis \349)

at a rodeo in "Before his turn in a rodeo, Bill Cline surveys his draw" 1995 Denny Simmons (Best21 134c)

male model leaning on railing filled with saddles from [self-promotional] c. 1989* Harry De Zitter (Graphis89 \84)

man mounting horse, with other holding reins in "Mounting a Bronc" c. 1910 Erwin E. Smith (MOMA 61)

men in bunkhouse with saddles in "In Paraguay, cowhands take a break on a bunkhouse porch" 1980* O. Louis Mazzatenta (Through 372)

men in open range working with cattle in "Cowboys in Montana" 1984* Sam Abell (Through 10)

men on horseback in "Marlboro Man" 1980* Richard Prince (Goldberg 192)

men on horseback herding cattle in "Cutting Out" c. 1895 Charles D. Kirkland (Photography1 #III-15)

men posing with saddles and ropes in "Mule wranglers of the Grand Canyon" c. 1990 Sue Bennett (Graphis90 \175-\176)

pilot-cowboy flying a helicopter in "The American Cowboy" 1979 Erwin "Skeeter" Hagler (Capture 113)

portraits with ropes and saddles in [cowboys] c. 1991 Sue Bennett (Graphis93 \108-\111)

rounding-up horses in "Untitled (Cowboys)" 1993* Richard Prince (Marien \7.34)

silhouette of man leading a horse in "As a winter storm approaches at dusk, New Mexico rancher heads home" 1988* Pat Davison (Best14 100d)

silhouette of man on horse in "Cowboy looks over the land where he carries on the tradition of his great-grandfather–being a cowboy" 1987 Jimi Lott (Best13 177a)

sitting in back of truck looking out at prairie in "Cowboy works 14-hour days in south-central Nevada" 1992* Chris Johns (Best18 71)

smoking a cigarette in "Self-professed 'cowboy and Marlboro man' watches other ropers in a calf-roping competition" 1995* Kent Porter (Best21 192a)

COWS see CATTLE

CRABS

blue crab in [blue crab] c. 1997* Jody Dole (Graphis97 173)

crabs and fish in boxes in "Diptych with Fish and Crabs" c. 1999 Craig Cutler (Photo00 57)

CRANES

cranes feeding on island in winter in "In the heart of winter, rare red-crowned cranes scoop up feed laid out by farmers on Japan's Hokkaido Island" 2003* Tim Laman (Through 202)

flock in flight in "In Ngorongroro Crater, Tanzania, a flock of crowned cranes take flight" 1985* Stephen J. Krasemann (Best11 153b)

CREEKS see RIVERS

CRIMEAN WAR, 1853-1856

barracks and tents above harbor in "Balaclava Harbor, Crimean War" 1855 James Robertson (Rosenblum2 #202)

destruction of Redan in "Interior of the Redan" 1855 James Robertson (Marien \3.8)

narrow port in small village in "Landing Place, Railway Stores, Balaklava" 1855 (Waking 302b)

officer being served a drink in "British officer at ease in the Crimea" 1855 Roger Fenton (Lacayo 11)

officers and men in front of tents in "Col. Doherty, officers and men, 13th Light Dragoon" c. 1856 Roger Fenton (Eyes #14)

part of the battlefield in "Taking of Sebastopol (detail)" 1885 Charles Langlois (Marien \3.9)

road through two hills in "Into the valley of the shadow of death" 1855 Roger Fenton (Eyes #15; Rosenblum2 #203)

tents near a ship in the harbor in "The Genoese fort at the entrance to Balaclava Harbour" 1855 Roger Fenton (Eyes #16)

vast empty field in "Sebastopol from Cathcart's Hill" 1855 Roger Fenton (Szarkowski 106; Waking 302c)

CROATIA

armed men walking through rubble in "The streets of Vukovar are strewn with rubble after battle between Croatian citizens and Yugoslav troops" 1991* Christopher Morris (Best17 42b)

civilians walking in line through rubble on street in "Croatian citizens come out of shelters after the fighting" 1991* Christopher Morris (Best17 43a)

cots in a gymnasium in "In Zagreb, refugees from Eastern Croatia find shelter in this camp" c. 1992* Wilfried Bauer (Graphis93 59d)

death and fighting of Serbs and Croats in "Civil War in Croatia" 1991* Christopher Morris (Best17 185-188)

executed Croatian on street in "Rain mixes with the blood of an executed Croatian in Vukovar" 1991* Christopher Morris (Best17 42a)

wreckage of a plane on a city street in "In Zagreb, the wreckage of a Yugoslavian fighter brought from the

East now serves as a memorial" c. 1992* Wilfried Bauer (Graphis93 59a)

CRYSTAL PALACE, Hyde Park

interior view in "The Crystal Palace, Hyde Park" 1850-1851 John Jabez Edwin Mayall (Art \22; Marien \2.5)

open porch in "The Open Colonnade, Garden Front" c. 1853 Philip Henry Delamotte (Rosenblum2 #170)

trusses of metal in "View through Circular Truss, Crystal Palace" 1853-1854 Philip Henry Delamotte (Szarkowski 74)

CUBA

decrepit street of Havanna in "Cuba: On the Edge" 1997 Eric Mencher (Best23 224c)

mother and children in shack in "Wretched Poverty of a Cuban Peasant Home" 1899 Underwood & Underwood (Rosenblum2 #418)

well-dressed women having tea in "Courtyard of a Typical Cuban Home" 1899 Underwood & Underwood (Rosenblum2 #419)

CUBA MISSILE CRISIS, 1962

aerial photograph of missile base in "Cuban Missile Base" 1962 U.S. Air Force (Monk #39; Photos 103)

Soviet freighter and U.S. warship in "Soviet freighter *Ivan Polzunov* faces off with a U.S. warship" 1962 U.S. Air Force (Photos 102)

CULTS

cult leader with beard in "In chains, Rajneesh is led into federal court in Charlotte, N.C." 1985 Harvey Soltes (Best11 87a)

man with machine gun guarding speaker in "Rajneesh is guarded by a follower with an Uzi submarine gun as the guru appears before the faithful" 1985 Harvey Soltes (Best11 86d)

men from militant cult building a bunker in "MOVE members fortify a roof bunker, Philadelphia" 1985 William F. Steinmetz (Best11 22c)

two people hugging on floor in large, empty hall in "Alone in Rajneesh's temple in Oregon, two disciples embrace and consider a future without their guru" 1985 Casey Madison (Best11 87b)

young people laughing and clapping in "During happier times in Oregon, the guru's followers bliss out over their leader during one of his 'drive-by' appearances" 1985 Kurt E. Smith (Best11 86)

CUSTER EXPEDITION

view from hill, of wagons in his expedition "Indian's Eye view of Custer Expedition Entering the Black Hills" 1874 W. H. Illingsworth (Marien \3.67)

CUTLERY

fork on rim of plate in "The Fork" 1928 André Kertész (Art \251; Hambourg \113; Icons 31)

knives standing on end in "Razor Sharp" c. 1992* Luzia Ellert (Graphis93 82)

knife and spoon from mess kit from [the book *The Apocalyptic Menu]* c. 1992* Christian Von Alvensleben (Graphis93 92)

old tarnished knives in [tarnished knives] c. 1997* Karen Capucilli (Graphis97 79)

service for eight laid out in "Gorham Sterling Ad" 1930 Edward Steichen (Rosenblum2 #579)

CZECHOSLOVAKIA–HISTORY–INTERVENTION, 1968

man standing in front of tank in "The End of the Prague Spring" 1968 Ladislav Bielik (Photos 121)

—D—

D-DAY, June 1944 (Normandy Invasion)

Canadian troops coming ashore in "D-Day: Allied Invasion of Europe Begins" 1944 Gilbert A. Milne (Monk #28)

soldiers wading ashore in "Normandy invasion on D-Day" 1944 Robert Capa (Art \409; Eyes #189; Goldberg 116; Lacayo 105d; Marien 5.85; Rosenblum2 #607)

troops and supplies being unloaded from ships three days after D-Day in "Normandy Landings" 1944 Photographer Unknown (Photos 61)

DAMASCUS (Syria)

view of the city by men eating on a balcony in "Saudi visitors view a dust storm over the suburbs of Damascus, Syria" 1996* Ed Kashi (Through 266)

DAMS

constructing pipes used in the Fort Peck Dam in "Fort Peck Dam" 1936 Margaret Bourke-White (Lacayo 97)

large cement sections of dam on *Life* cover in "Fort Peck Dam, Montana" 1936 Margaret Bourke-White (Eyes #167; Goldberg 88; Hambourg \26; Marien \5.61; Rosenblum2 #602)

DANCE

adults dancing in "Foxtrot" 1935* Alexander Rodchenko (Waking #175)

adults dancing in "Dance Party" 1972 Malick Sidibé (Icons 154)

adults doing the 'Twist' in "Twist" 1965 Malick Sidibé (Icons 155)

African American dancers in pose in " Philadelphia Dance Company" 1998 Mansa K. Mussa (Willis \281)

African American girl in ballet shoes and ballet costume in "Untitled" 1993 LeRoy W. Henderson, Jr. (Committed 126)

African American girl leaping on dance floor in "Tracy's Dance" 1996 Stephanie Welsh (Best22 241a, c)

ballerina being spun in "Ballerina Merideth Benson spins with the help of Guillermo Leyva during a performance of the Nutcracker" 1998 Brian Plonka (Best24 43)

ballerina fixing her belt in "A Ballerina" 1900 Robert Demachy (Rosenblum2 #372)

ballerina teaching young girl in [photograph for Kodak] c. 1989* Hans Neleman (Graphis89 \173)

ballet student being lifted by a professional in "Ballet student Mette Boving, 13, finds out what it's like to be lifted by a professional dancer" 1986 Joe Abell (Best12 121c)

ballet school practice, girl making faces in "All that form and grace is great" 1985 Arthur Pollock (Best11 136a)

ballet class for very young girls in "In a ballet class for the youngest pupils, 4-year-old leaps up to try and reach the hand of her teacher" 1996* David P. Gilkey (Best22 168)

ballet as a way to reach troubled and poor youth in a photo essay in "Shelter on Stage" 1996* Gail Fisher (Best22 80-97)

couple dancing in street in "Jitterbug, New Orleans" 1937 John Gutmann (MOMA 160)

couple dancing in "Embracing each other and their art, dancers of the Inbal troupe rehearse in Akko" 1985* James Stanfield (Best11 44c)

couple dancing to accordion in "Immigrants waiting at Ellis Island" c. 1905 Lewis Wickes Hine (Lacayo 65c)

couple leaping off the ground as they dance in the hall in "Two dancers with the School of the Hartford Ballet perform in the Morgan Great Hall at the Wadsworth Atheneum" 1997* Cloe Poisson (Best23 149)

couples dancing in "Saturday night dance [at the Visalia Migratory Labor Camp, California]" 1940 Arthur Rothstein (Documenting 205b)

couples in "Taxi dancers, Fort Peck, Montana" 1936 Margaret Bourke-White (Goldberg 91; Lacayo 96; Sandler 146)

couples dancing under trees in park in "Bal Champétre" 1898 Amélie Galup (Rosenblum \105)

disco crowded with dancers and filled with soap suds in "A flood of suds at Amnesia, a popular disco on the island of Ibiza" 1992* David Alan Harvey (Best18 119a)

doing the tango in "With professional aplomb, a couple in Buenos Aires performs the tango, the national dance of Argentina" 1994* Stuart Franklin (Through 348)

duet in "Martha Graham–American Document–Puritan Love Duet" 1938 Barbara Morgan (Photography 61)

high school students at dance in " 'Circle of Love' prom for mentally retarded students at Jersey City School" 1995* Monika Graff (Best21 184a)

man in white shirt and tie dancing on stage with young women in "Yeltsin Rocks in Rostov" 1996* Alexander Zemlianichenko (Capture 182)

man upside down in [Alvin Ailey American Dance Theater] c. 1999* Stephen Wilkes (Photo00 158)

man with legs bent, jumping in air in "Merce Cunningham–Totem Ancestor" 1942 Barbara Morgan (MOMA 162)

man with mask over eyes at dance in "Carnival, Zürs, Austria" 1950 Robert Capa (Photography 217)

metallic body paint on couple in "Disco fever at Xenon, New York City" 1978* Roxanne Lowit (Life 118)

motion picture stage filled with dancers from [*Lullaby of Broadway* from *The Gold Diggers*] 1935 Photographer Unknown (Hambourg \81)

night club dancers in "Can-Can Dancers at the Moulin Rouge" 1931 Ilse Bing (Women \60)

nude male dancers in air in "Untitled (Daniel Ezralow and David Parsons)" 1982 Lois Greenfield (Rosenblum 231)

Romeo and Juliet in "Romeo and Juliet" c. 1992* Gilles Larrain (Graphis93 114)

scene from a ballet in [A scene from Naumeier's ballet version of *Magnificat*] c. 1992* Dieter Blum (Graphis93 120a)

seminarians in long coats, whirling in street in "I Have No Hands to Caress My Face" 1961-1963 Mario Giacomelli (Icons 135)

Senegalese woman dancing together in "Senegal (women dancing)" 1993 Alfred Olusegun Fayemi (Willis \334)

student in wheelchair with his date on his lap at homecoming dance in "Permanently paralyzed from a motocross race accident, former star athlete dances with his girlfriend" 1997* Bryan Patrick (Best23 174b)

woman covered in sheer fabric in "Rina Schenfeld, prominent Israeli modern dance artist, portrays 'divine Presence' " 1985* James Stanfield (Best11 44d)

woman dancing with yards of fabric in "Loie Fuller Dancing" c. 1900 Samuel Joshua Beckett (Waking #135)

woman in form-fitting mesh dress in "A member of the Dance Theatre of Harlem rehearses before performing" 1986 Jim Wilson (Best12 159)

woman in mid-air in "It took 10 jumps to capture the perfect moment in a preview theater performance" 1987 David J. Phillip (Best13 181c)

women in formal dresses and men in uniform in "All nursing and no play might make Frances Bullock a dull girl!" n.d. Ann Rosener (Fisher 127)

young African Americans dancing in "The Congeroo, Savoy Ballroom, New York City" 1941 W. Eugene Smith (Life 110)

young ballet dancer in studio in "A ballet dancer of tomorrow" 1939 Tim Gidal (Eyes #119)

young man dancing with elderly woman in "When a 'senior prom' was held to celebrate the opening senior center, a service fraternity of young men provided dance partners for many single women" 1986 Susan Winters (Best12 181b)

young people painted with mud in "Mud-streaked revelers dance the night away during Carnival in Port of Spain, Trinidad" 1994* David Alan Harvey (Through 430)

DEAFNESS

boy doing hearing experiments in "A deaf child hears for the first time" 1993* James W. Kubus (Life 18)

DEATH see also AIDS (DISEASE); ASSASSINATION; CEMETERIES; EXECUTIONS; FUNERALS; LYNCHING; STARVATION; UNITED STATES–HISTORY–CIVIL WAR, 1861-1865; and names of conflicts, e.g.: SARAJEVO

Accidents:

bull killing man during the running of the bulls in [bull killing man during Fiesta San Fermin] c. 1995* Juan Ignacio Delgado Santamaria (Graphis96 64)

couple standing on beach by seashore after child has drowned in "Tragedy by the Sea" 1954 John L. Gaunt, Jr. (Capture 34)

crushed red wagon and covered body in street in "Wheels of Death" 1958 William Seaman (Capture 43)

man crying over woman's body on road in "A man grieves over the body of Dreama Combs, who died in a car crash" 1995* Greg Fight (Best21 177b)

performer suspended in air before falling in "Japanese dancer fell 50 feet to his death while performing before stunned spectators" 1985 Gary D. Stewart (Best11 105a); Sherry Rockwinkel (Best11 105b)

police checking body of man on street in "Police detectives inspect the body of a man who was deliberately run over after a dispute" 1997* Doral Chenoweth III (Best23 118c)

police photographing dead man in street in "Police officer photographs a man that was killed in a bar fight" 1997* Edward D. Ornelas III (Best23 118a)

soldiers carrying flag-draped coffin from plane in "First bodies of the Gander crash victims arrive at Dover, Delaware, AFB" 1985 Joe Songer (Best11 50)

two girls falling off broken fire escape in "Boston Fire" 1975 Stanley J. Forman (Capture 95)

Civil Strife:

armed soldiers dragging away bodies in "El Salvador: The Killing Ground" 1982 James B. Dickman (Capture 125)

Armenian victims of starvation and genocide in "Armenian Genocide" 1915 Photographer Unknown (Photos 28)

barbed wire on legs of body on white cloth in "The victims of the Ceaucescu terror lie here in the open" c. 1991* Chris Sattlberger (Graphis91 \84)

blood and footsteps in the snow in "Blood stains frozen snow as the living try to deal with the carnage caused by Russian airstrikes in Chechnya" 1995* Paul Lowe (Best21 169d)

bodies in open coffins in "Communards in Their Coffins" 1871 Photographer Unknown (Marien \3.24; Rosenblum2 #205)

body on stretcher in "A worker pushes a stretcher bearing a body recovered from the MOVE house" 1985 George Widman (Best11 25d)

boy turned away from teenager in open coffin in "A 15-year-old was killed by police during a demonstration in Belfast, Northern Ireland" 1990* James Nachtwey (Best16 39d)

burning body of one of Somoza's National Guard in "A funeral pyre in Nicaragua" 1979* Susan Meiselas (Lacayo 176b)

child being held aloft in "Aftermath of a car-bomb explosion, West Beirut, Lebanon" 1983* Yan Morvan (Life 63)

child on ground and wrapped in shawl in "A child's body awaits burial at the Kurdish refugee camp in Turkey" 1991* Anthony Suau (Best17 118)

children in piles on shelves in "Sent to identify a murder victim inside Port-au-Prince's only morgue, U.S.

MP's discover children the city can't afford to bury" 1995* Jim LoScalzo (Best21 182a); "A Playmate and Her Foundation" c. 1999* Pierre St. Jacques (Photo00 66)

children touching boy in casket in "Robert Sandifer, executed at age11" 1994 Steve Liss (Lacayo 183c)

crying man holds body parts of his relatives in "Fleeing Kosovo" 1999* Michael Williamson (Capture 197a)

dead bodies stacked on the floor in "Bodies of suspected communist sympathizers are stacked in a makeshift mortuary in the city of Davao, Philippines" 1985 John Kaplan (Best11 76b)

dead man being pulled through crowd in "Dead U.S. Soldier in Mogadishu" 1993* Paul Watson (Capture 171; Lacayo 177)

digging a grave among other graves in "Hussein Fiiffiddo digs a grave for his daughter in what once was a Mogadishu botanical garden" 1992* Howard Castleberry (Best18 131)

dying soldier holding onto priest in street in "Aid From Padre" Hector Rondon 1962 (Capture 51)

gassed mother and child in street in "Iraqi Kurds killed by poison gas" 1988* Ramazan Oztürk (Lacayo 179a)

gathering the dead in bulldozers in "At a camp for Rwandan refugees" 1994 James Nachtwey (Lacayo 181)

Haitian man covered in mud in "Days before the election, a man lies slumped in a stairwell after being shot in the back by soldiers in a Port-au-Prince alley" 1987* John J. Lopinot (Best13 20)

headless skeleton dumped by railroad tracks in "War-torn El Salvador" 1984* Larry C. Price (Capture 132)

legs of dead people in grass in "Bodies of Croatians in Vukovar, Yugoslavia, await burial after federal troops overtook the town" 1991* Christopher Morris (Best17 41)

Lithuanian man's bloody face, a funeral, and candles by a cross in "Bloody Sunday in Lithuania" 1991 Romualdas Pozerskis (Graphis92 \45-\47)

man looking through pile of corpses in "In Grozny, Chechnya, a man finds one of his two lost sons among the hundred of corpses in an open grave pit" 1995 Anthony Suau (Best21 180c)

ropes around boy with his throat slashed, in a well in "Boy slashed by Algerian extremists" 1997* Photographer Unknown (Best23 127a)

Rwandan massacre in series showing rooms full of corpses, land mine victim, and bullet-riddled sign in [documents of the mass murders in Rwanda] c. 1995 Simon Norfolk (Graphis96 60, 66, 67)

series on armed forces, prisoners, and death in the burning of the Parliament in "Capturing the Parliament building by Abkhazian forces in Sukhumi" 1993 Anthony Suau (Best19 30-32)

shadows of people watching child die on hard ground in "Watching a child die in Baidoa, Somalia" 1992 Paul Lowe (Best18 128)

teenager in sunglasses in coffin in "A family grieves for 17-year-old Moe Sterling, a gang member who was the victim of a drive-by shooting in Seattle" 1991 Rod Mar (Best17 201)

teens looking at dead man in street in "Haitians look in horror at a body in the street" 1987* Anthony Suau (Best13 21a)

washing a body with wounds in "Two Axeri men wash the body of a Khojali refugee who was killed while fleeing fighting in Nagorno Karabakh" 1992* David Brauchli (Best18 124a)

women grieving over body of a young man in [ethnic Albanian women weep over the body of their relative in the Kosovo province of Yugoslavia] c. 1999* Enric Marti (Photo00 72)

young woman screaming over the body of a dead student in "Kent State Massacre" or "After the massacre of students at Kent State University"1970 John Paul Filo (Capture 72; Eyes #311; Goldberg 180; Lacayo 145; Marien \6.73; Monk #43; Photos 129)

Disease:

adult soothing head of dying child in "At the International Center for Diarrheal Research in Bangladesh, this child is near death from pneumonia" 1990* John Chiasson (Best16 175)

parents carrying a coffin and a cross in "Romanian parents carry a coffin and a cross to a Bucharest hospital to collect the body of their child, who died of an AIDS-related illness" 1990* Rady Sighiti (Best16 171a)

Natural Disasters:

arm, coated in mud, reaching out from body trapped in mud in "Volcanic Mudslide in Colombia" 1985* Carol Guzy and Michel duCille (Capture 140); "Four days after the mud slide, the arm of a corpse sends a grim signal" 1985 Kathy Anderson (Best11 21a)

man's hands in rubble in "The body of one of the estimated 10,000 persons who died in the second earthquake" 1985 Paul Kitgaki, Jr. (Best11 8d)

priest blessing bodies under ice packs in "A priest makes the sign of the cross over ice-packed bodies of quake victims" 1985* Lennox McLendon (Best11 11)

woman in rubble in "A dying woman lies amidst volcanic mud and Armero's rubble" 1985 Carol Guzy (Best11 17)

woman searching for husband in long line of bodies in "In tiny Guayabal, the town square was used as a collection spot for the bodies of the dead" 1985 Jay Dickman (Best11 20)

woman with cloth over her mouth in "A woman waiting for news of relatives reacts to the smell of

death"1985 Paul Kitagaki, Jr. (Best11 12a)

woman with cloth tied around her mouth and nose in "Masked against the smell of decomposition, a woman waits outside a makeshift morgue in Mexico City" 1985 Ted Jackson (Best11 12c)

women holding shawls and hands over their mouths in "Survivors at Benito Juarez Hospital in Mexico City, waiting for word of their loved ones, face the agony of covered stretchers" 1985 Eric Luse (Best11 12b)

Terrorism:

crying and hugging youth in "Columbine" 1999* George Kochaniec, Jr. (Capture 194, 195b)

firefighter holding bloodied, dead child in "Oklahoma City Bombing" 1995* Charles H. Porter IV (Best21 171; Capture 180; Lacayo 188a; Marien \7.14); Lester LaRue (Best21 170c)

flag-draped coffin near airplane in "Marilyn Klinghoffer kisses the coffin of her husband on its arrival in New York" 1985 Richard L. Harbus (Best11 91a)

War:

bodies in a line on the ground in "Confederate Dead Gathered for Burial" 1862 Mathew Brady (print by Alexander Gardner) (Marien \3.20; Photography1 #IV-14)

bodies stacked in a pile in "Buchenwald" 1945 Lee Miller (Rosenblum \175)

body covered in oil in "Victims of the war in the desert surrounding Kuwait City" 1991* Steve McCurry (Goldberg 212)

body floating in water in "Murdered prison guard, Dachau" 1945 Lee Miller (Lacayo 115d; Photography 125)

burned soldier in vehicle in "The charred body of an Iraqi soldier still clings to the side of an armored personnel carrier" 1991* Kenneth Jarecke (Best17 9)

dead soldiers on battlefield in "A harvest of death, Gettysburg" 1863 Timothy O'Sullivan (Eyes #21; Lacayo 24b; Marien \3.18; Photography1 #IV-7; Rosenblum2 #209)

death and fighting of Serbs and Croats in "Civil War in Croatia" 1991* Christopher Morris (Best17 185-188)

devastated island and scorched bodies after a battle in "Tarawa" 1943 Frank Filan (Capture 12; Eyes #222)

families looking for dead soldiers on battlefield in the Crimea in "Grief or The eastern front: Searching for loved ones at Kerch" 1942 Dmitri Baltermants (Art \422; Lacayo 114; Photos 57; Rosenblum2 #613)

gallows and a hanging in "Hanging the Lincoln conspirators" 1865 Alexander Gardner (Eyes #33-35; Marien \3.22; Rosenblum2 #233-#239; Waking #113)

German soldier on ground in "Fallen German soldier near Belfort, France, in World War II" 1944 Constance Stuart Larrabee (Rosenblum \173)

German soldiers covered with snow in "Fallen German Soldiers on Russian Front" 1944 Galina Sankova (Rosenblum \172)

hundreds of bodies on ground in destroyed concentration camp in "Nordhausen, Germany" 1945 Johnny Florea (Life 55)

Kosovo man's death with his family around him in "A victim of the civil war in Kosovo" c. 1991* Georges Merillon (Graphis92 \48)

man looking at mound of dead bodies in "Senator Alban W. Barkley of Kentucky, Chairman of the House Senate Committee on War Crimes, Buchenwald" 1945 Photographer Unknown (Goldberg 118)

men lying dead on fort walkways in "After the Capture of the Taku Forts" 1860 Félice Beato (Rosenblum2 #204; Waking #84)

mound of bodies on ground in "Another Nazi horror camp uncovered" 1945 Photographer Unknown (Eyes #214)

photo essay on the death and starvation of Somalis despite relief efforts in "Somalia: War and Famine" 1992 James Nachtwey (Best18 101-114)

photo of solider killed in battle in "A photograph of Army Pvt. Robert Talley and the letter confirming his death during the war" 1991* Mark Peterson (Best17 21a)

photograph of man in uniform at base of Vietnam Memorial Wall in "Untitled" 1987 Wendy Watriss (Rosenblum \203)

photographs scattered by body in "Corpse of North Vietnamese Soldier" 1968 Don McCullin (Marien \6.102)

pile of bodies in "Dead Prisoners, Dachau Concentration Camp, Germany" 1945 Lee Miller (Women \72)

scarred skull of Japanese solider in "Soldier's skull on a destroyed tank" 1943 Ralph Morse (Lacayo 105b)

skulls in a group in "Mass grave near Phnom Penh, Cambodia" 1981 Roland Neveu (Life 62)

soldier at the moment of being shot in "Death of a Loyalist Soldier" 1936 Robert Capa (Art \410; Eyes #187; Icons 68; Lacayo 88; Marien \5.84; Monk #22; Photos 50; Rosenblum2 #606)

soldier lying on muddy road in "Outskirts of Moscow" 1941 Dmitri Baltermants (Art \421)

soldiers on beach in "Three dead Americans on the beach at Buna" 1943 George A. Strock (Eyes #185; Goldberg 115)

suicides of family in office in "Nazi suicides" 1945 Margaret Bourke-White (Eyes #199)

Vietnamese mother crying over her son's body in plastic bag in "Vietnamese woman and the body of her son" 1966* Larry Burrows (Eyes \10)

Other:

African American man in a coffin in "William Biggerstaff in a coffin" 1896 J.P. Ball & Son (Willis \12)

body on table near window in "The Spirit Leaves the Body" 1968 Duane Michals (Photography2 75)

child on mother's lap in formal portrait in "Father and Mother Holding a Dead Child" c. 1850s-1860s Photographer Unknown (Marien \2.56)

coffin in man's living room in "A proponent of physician-assisted suicide has a coffin delivered to his home" 1997* John Freidah (Best23 141d)

girl on a bed attended by two women in "Fading Away" 1858 Henry Peach Robinson (Marien \3.100; Rosenblum2 #268)

Guatemalan woman holding candle near man in bed in "A family in Guatemala, waits for the pastor of the Catholic Church, who was called out late to visit a family member they feared was dying" 1987* Robert R. Mercer (Best13 29d)

lying on floor being held by busboy in "Robert F. Kennedy after he was shot" 1968 Bill Eppridge (Eyes #288; Lacayo 144)

man in coffin in "Unidentified mortuary portrait" c. 1845 Glenalvin J. Goodridge (Willis \17)

man shot by police in "In Oklahoma City an unidentified man falls to the ground, shot by members of an Oklahoma City SWAT team" 1985 David Longstreath (Best11 79b)

suicide of woman falling to her death outside hotel in "Suicide" 1942 I. Russell Sorgi (Lacayo 83)

woman's head encased in ice in "The cryonics controversy: We have seen the future, and it is cold" 1988 Susan Gardner (Best14 113)

women at bedside of dead man in "Spanish women in mourning" 1950 W. Eugene Smith (Icons 123; Lacayo 159a)

young girl caring for mother in "Mom Doss in her apartment, caring for her dying mother" 1985 April Saul (Best11 94-97)

DEATH VALLEY (California and Nevada)

dramatic colors on dunes in "Death Valley at Dawn" c. 1992* Intae Kim (Graphis93 174a); "Dream in the Desert" c. 1992* Intae Kim (Graphis93 174a); "Light of Symphony" c. 1992* Intae Kim (Graphis93 174b)

view of formations in "Dry Wash with Alluvium, Death Valley, California" 1957 William A. Garnett (MOMA 190)

DEER

doe and fawn in forest in "North Woods Journal" 1997* Jim Brandenburg (Best23 246a)

eating leaves of a weeping willow tree in "During hot August weather, two young deer seek shade under a weeping willow" 1987 Charlaine Brown (Best13 177d)

jumping from being frightened by light in "Illuminated by a flashlight, frightened deer bound into the woods near Lake Superior" 1921 George Shiras III (Through 338)

small cart with dead stag in "Stag in cart" c. 1858 Horatio Ross (Waking #18)

DEMONSTRATIONS *see* PROTEST MOVEMENTS / DEMONSTRATIONS

DENTISTS

man pulling patient's tooth in "Dentist, pulling teeth" c. 1845 Photographer Unknown (Photography1 \22); c. 1855 (National 154b)

DEPRESSIONS–1929–U.S. *see also* FARMS AND FARMING; WORK AND WORKING CLASSES

baby sitting in dirty truck in "Farm Security in Administration mobile camp for migratory farm labor. Baby from Mississippi left in a truck in camp" 1939 Dorothea Lange (Fisher 18)

billboard for "World's Highest Wages" in "Billboard on U.S. Highway 70 in California 'World's Highest Wages' " 1937 Dorothea Lange (Fisher 16)

carrying a banner "feed us" in "Demonstration, San Francisco" 1933 Dorothea Lange (Waking #193)

children and men as seen in a newspaper in "People of the Depression" 1937 Photographer Unknown (Documenting 35, 36)

destitute family sitting in log cabin in "Sharecropper Family, Alabama" 1936 Walker Evans (Goldberg 102; Monk #19)

family sitting on mattress on top of truck in "Migratory family traveling across the desert, U.S. Highway 70, in search of work in the cotton" 1937 Dorothea Lange (Fisher 13)

family standing by truck at side of road in "Migrants on Road" 1936 Dorothea Lange (Sandler 78)

family walking on empty highway in "Oklahoma" 1938 Dorothea Lange (Eyes #166)

father and sons walking to wooden cabin in "Father and sons walking in the face of a dust storm, Cimarron County, Oklahoma" 1936 Arthur Rothstein (Lacayo 98; Marien \5.57; Rosenblum2 #450)

girl on mattress in truck in "Girl in Truck" 1936 Dorothea Lange (Sandler 79)

men in hats waiting in line behind barricade in "White Angel bread line, San Francisco" 1932 Dorothea Lange (Eyes #164; Goldberg 82)

out-of-work man holding sign for a job in "Desperate for work, a Detroiter advertises" 1932 Milton Brooks (Eyes #162)

people waiting near stores in "Waiting for relief checks in Calipatria" 1936 Dorothea Lange (Documenting 127b)

sad-looking woman with two children leaning on her shoulders in "Migrant Mother, Nipomo, California" 1936 Dorothea Lange (Documenting 16-17, 69; Fisher 26; Goldberg 92; Icons 71; MOMA 148; Monk #20; Lacayo 101; Photos 49; Rosenblum2 #451; Sandler 158)

thin woman in print dress in "A mother in California who, with her husband and two children will be returned to Oklahoma by the relief administration" n.d. Dorothea Lange (Fisher 14)

woman in apron standing at opening of tent in "Greek Migratory Woman in Cotton Camp" 1936 Dorothea Lange (Sandler 80)

wood house, windmill and withered crops in "Dustbowl farm, Coldwater district" 1938 Dorothea Lange (Fisher 27)

DESERTS

camel near people in "Travelers in Sahara bow in praise to Allah" 1911 Lehnert and Landrock (Through 224)

drilling for water in the desert in "Bedouin in Syria drill for water in the northern steppe" 1993* Ed Kashi (Through 226)

expanse of ridges in "Kalahari Desert of Botswana" c. 1991* Stephanie Hollyman (Graphis91 \302)

family walking across desert in "Region of Lake Fagubian. These nomads have had to walk across wide expanses" 1983-1985 Sebastiao Salgado (Eyes #326; Life 132)

fort in desert in "Only women may enter an old fortress on Tarut Island in Saudi Arabia" 1987* Jodi Cobb (Through 222)

horses and wagons which carried equipment in desert in "Sand Dunes, Carson Desert" 1867 Timothy O'Sullivan (Art \143; Lacayo 28b)

mountain in distance in "Sunrise, San Luis Desert" 1921 Laura Gilpin (Women \30)

photo essay on the life of the nomadic Tuareg people Mali in "Nomads" 1996 Carol Guzy (Best22 24-27)

sand dunes in "Desertscape, Death Valley, California" c. 1997 Marilyn Bridges (Graphis97 138)

sand dunes in "White Sands" 1941 Laura Gilpin (Sandler 114)

woman walking with goat in "Timbuktu No. 2" 1998 Jeffrey A. Salter (Committed 188)

DINERS (Restaurants) see also RESTAURANTS AND BARS

back of men sitting on stools at counter in [from *Our Times* column] 1996 Mary Beth Meehan (Best22 262a)

diners of various styles in [diners] c. 1997* Charles Maraia (Graphis97 162, 163)

two diners in "Diner" c. 1999* Craig Cutler (Photo00 17)

DIRIGIBLES see AIRSHIPS

DISABLED PERSONS see PEOPLE WITH DISABILITIES

DISCRIMINATION see CIVIL RIGHTS MOVEMENT

DIVING

Barcelona as background to diver in "The city of Barcelona makes a panoramic background for an Olympic contender in the 10-meter diving" 1992* Rick Rickman (Best18 157)

beads of water spinning off diver in "Edward Morse is caught in a midair spin during his dive off the one-meter springboard at the U.S. Outdoor Nationals" 1988 Tim DeFrisco (Best14 130)

boy diving into hole in ground in "A young boy dives into an outdoor plunge at Hot Springs, Montana" 1995* Kurt Wilson (Best21 157a)

boy with legs tucked diving in "High school student takes a dive during competition" 1992* Nark Henle (Best18 138)

boys diving off of a pier in "Cooling off in the summer heat, kids illegally dive from a Miami-area pier" 1995* Chuck Fadely (Best21 front cover)

diver against backdrop of flag in "With his country's flag as a backdrop, Olympic diver Kent Ferguson practices at a pool in Florida" 1992* Bill Frakes (Best18 163)

diver viewed from above in "A diver competes in the 3-meter springboard event" 1993* George Wilhelm (Best19 170b)

diver hitting head on board in "Diver Greg Louganis strikes his head during Olympic preliminary competition on the three-meter springboard" 1988 Brian Smith (Best14 123)

diver jumping off board in "Mary Ellen Clark completes her final dive in the 10-meter platform competition" 1996* Anacleto Rapping (Best22 124a)

diver off board with hands on his knees in "Mark Bradshaw is upward bound in his final one-meter springboard dive at the International Diving Championship" 1988 Catherine Krueger (Best14 137b)

diver's hand touching toes in "Diver Kent Ferguson practices before the indoor diving championship" 1987 Jerry Lodriguss (Best13 195a)

divers off the board in tandem in "U.S. divers at an international meet in the tandem competition" 1995* Bill Frakes (Best21 106a)

gathering of boats and people as one man dives off cliff in "Impromptu cliff-diving competition at Lake Havasu" 1993* Rick Rickman (Best19 124)

girl upside down off diving board in "Florida state high school champion does a one and a half with a twist from the high dive springboard during practice" 1987 Jon Kral (Best13 221a)

in spread-eagle form and touching toes in [man diving] c. 1997* John Huet (Graphis97 190, 191)

looking down at man jumping on diving board in [diver leaving a diving board] c. 1997 Annie Leibovitz (Graphis97 201)

multiple positions of man diving from diving board in "A diving exhibition at Sea World in San Diego" 1990* Michael Ging (Best16 120d)

off a block into a pool in [diving into a swimming pool] c. 1991* Len Rubenstein (Graphis92 \231)

perfect entrance into the water in "Mexican diver Fernando Platos displays perfect form" 1995* Rich Addicks (Best21 107)

silhouetted against American flag in "Olympians practice in front of giant American flag" 1996* Bill Frakes (Best22 203a)

teacher helping a student on the diving board in "U.S. National 1-meter diving champion Doug Shaffer helps a 10-year-old try a lean-back dive" 1987 Anne Ryan (Best13 194)

woman diving in "Springboard diver practices her form long after her teammates have gone home" 1993 Brian Plonka (Best19 148c)

woman diving into a lake in "The Header" c. 1991 Max Jacot (Graphis92 \254)

woman holding back of legs in dive in "Diver" c. 1999* Stephen Wilkes (Photo00 184)

woman in the Olympics in "Fu Mingxia, Chinese diving gold medalist" c. 1992* Neil Leifer (Graphis93 201a)

woman parallel to diving board in "Diver" 1936 John Gutmann (Hambourg \77)

woman's feet hit the board in "Russia's Yulia Pakhalina hits the springboard during her last dive" 1997* Preston Mack (Best23 169c)

DJUKA PEOPLE

men and women doing daily chores in [Djuka people] 1969 Adger W. Cowans (Willis \218-\221)

DOCTORS *see* PHYSICIANS

DOGS

and boy hanging out car window in "Four-year-old and dog get a good view from the family car during the Georgia Day Parade" 1997 Michael Williamson (Best23 251)

and horses ready for fox-hunting in "Unaware of a hound's activity, the Rev. Jim Rubbs prepares to bless the dogs for the opening of fox-hunting season" 1990* Fritz Hoffmann (Best16 165)

and pig in [dog and pig] c. 1995* Steve Grubman (Graphis96 188)

around woman in man's clothing [from the *American Dream*] c. 1999* Mark Seliger (Photo00 6)

Borzoi or Russian wolfhound in [Borzoi] c. 1995* Alen MacWeeney (Graphis96 195)

bulldog in lace collar in a waiting room in "Pampered pooch" 1995 Carol Guzy (Best21 212b)

children playing with a dog in "After a mudslide Nicaraguan young people play with a dog" 1998 Dudley M. Brooks (Best24 93b)

dalmatian in [death of a pet] c. 1992* Elke Ritschel (Graphis93 195)

dalmatian and spotted shoes on porch in "Interior designer Michael McQuiston's dalmatian-spotted shoes are enough for you to beg for more" 1987 Alan Berner (Best13 180d)

dalmatian and woman in spotted fake fur in "Couple of 'spots fans'—one in fake fur—wear matching coats on Beacon Street in Boston" 1994* Joel Sartore (Through 314)

dalmatian and woman in spotted shawl in forest in "Blotches of Sunlight and Spots of Ink" 1907 George H. Seeley (Goldberg 29)

dalmatians sitting in theater seats in "Dog day at the movie *101 Dalmatians*" 1991* Melanie Rook D'Anna (Best17 168)

dog in grass, looking at flying bird in "An English pointer is outwitted by a quail during this first training session" 1985 Brant Ward (Best11 154a)

dog looking at dog sculpture on pedestal in "Man Ray with Sculpture" 1978 William Wegman (Rosenblum2 #678)

dog watching hunter in water in "Hunting for a goose" 1985 Eric Luse (Best11 154b)

Fay and William Wegman in "Portrait of William Wegman with Fay" c. 1991* Timothy Greenfield-Sanders (Graphis92 \130)

growling dog in spiked collar in [growling dog] c. 1995* Steve Grubman (Graphis96 189)

in hospital bed with injured boy in "When John Abell was immobilized after a car accident, officials at the Hospital bent the rules a bit to allow John's golden retriever to visit" 1986 John Warner (Best12 134c)

in boots in "Fay Ray posing for a feature on Texas cowboy boots" c. 1991* William Wegman (Graphis91 \237-\243)

looking out limo window in "Spuds, the black-eyed mascot for Bud Light Beer, was present for the first pitch" 1987 Angela Pancrazio (Best13 115d)

looking through broken door in "Watch Dog" c. 1995* Joseph Brazan (Graphis96 183)

nude woman sitting and petting dog in "Elisabeth Shue" c. 1997 Mark Seliger (Graphis97 114)

one sitting by feet of man in white suit sitting in chair in "Tom Wolfe" 1987 Charles Ford (Rolling #89)

pitbull straining at its leash in "A pitbull chained to its owner's garage is used to protect life and property" 1996* Wally Skalij (Best22 245c)

police dogs attacking African American man in "Birmingham Protest" 1963 Bill Hudson (Goldberg 165); "Eugene 'Bull' Conner, Birmingham's Commissioner of Public Safety, orders the use of police dogs and fire hoses against civil rights activists" 1963 Charles Moore (Best14 215; MOMA 234)

poodle at feet of man in a dress in [Patrick Swayze in a dress] Mary Ellen Mark c. 1997 (Graphis97 113)

profile of a dog in "Dog" 1841-1849 Louis-Auguste Bisson (Waking #42)

pulling on baseball player's belt in locker room in "In Florida's Senior League, it doesn't bother anyone if you keep your dog in the locker room" 1991* Randy Olson (Best17 26b)

race dog looking out through crate in "This entrant is ready to race in the John Beargrease Sleddog Race" 1986 Brian Peterson (Best12 132b)

running in [dog running] c. 1992* Clint (Graphis93 194)

sitting in "Red/Grey–Grey/Red" 1982* William Wegman (Szarkowski 281)

sitting on box in "Man Ray Portfolio–Man Ray Contemplating the Bust of Man Ray" 1978 William Wegman (Marien \6.101)

sitting with a stick in its mouth in [dog with stick] c. 1997* Jan Erickson (Graphis97 181)

smiling boy holding up two dogs by the scruff of their necks in "Aren't They Beauties?" c. 1885 George Bacon Wood (Photography1 \97)

standing dog in "Stray Dog, Misawa" 1971 Daido Moriyama (Marein \6.32; Szarkowski 261)

surrounding a woman in "The woman who feeds the dogs at an animal shelter has no doubt she's appreciated" 1986 Bill Greene (Best12 134)

tattooed youth pulling back mouth of dog in "Untitled" c. 1990* Chris Santuci (Graphis90 \179)

tongue sticking out in "Xina" 1994* David Graham (Photography 199)

two fighting in "Betty & Rita at Notre Dame" c. 1999 Michael Malyszko (Photo00 232)

two with woman in fur coat in *Avenue du Bois de Boulogne* 1911 Jacques-Henri Lartigue (Rosenblum2 #309)

under the bed covers in "Ray and Mrs. Lubner in Bed Watching TV" 1982* William Wegman (Decade \XIV)

waiting with a cowboy in "An Australian shepherd awaits the next command from a cowboy during the farm's last roundup" 1988 Raymond Gehman (Best14 199d)

walking across wet cement in "A concrete foreman chases a golden Labrador retriever off a new sidewalk" 1993 Craig Strong (Best21 122)

walking seven dogs at one time in "Petsitter untangles herself during her daily walk with her clients' dogs" 1998 Bill Greene (Best24 41b)

with man's hands, waiting to order at restaurant window in "Hot Fudge" 1994* William Wegman (Photography 1994)

DOLPHINS

bloodied dolphin in "The killing of dolphins" c. 1991* Steve Hart (Graphis91 \69)

swimming close to people wading in the water in "A dolphin swims near people at Monkey Mia, a fishing community in Shark Bay, Western Australia" 1991* David Doubilet (Best17 176)

DOMES

stained glass map on dome of building in "A workman cleans the stained glass dome of the Christian Science Mapparium, revealing the coastlines and political boundaries" 1998* Bob Sacha (Best24 53)

DOMESTIC VIOLENCE

battered man with police in "After answering a domestic complaint police take a photograph of injuries this man sustained in an argument with his wife" 1986 Dennis Lee (Best12 80b)

battered women and children in "Battered women and their children seek refuge at the Women's Advocates Shelter in St. Paul, Minn." 1988 Donna Ferrato (Best16 21)

battered women in photo essay in "Battered women and their abusers; photo essay" 1982-1990 Donna Ferrato (Best16 22-26; Best14 162-167; Eyes #339-342)

hospitalized woman with acid burns in "At the Mayo Hospital, a victim of 'wife burning' receives treatment after her estranged husband threw acid on her face" 1997 Ed Kashi (Best23 135)

man arrested in his home as son screams at him in "I hit you with the pot to make you stop hitting her. I hate you!" 1988 Donna Ferrato (Best14 82)

series on family's use of drugs and alcohol leads to violence in "Darkness at home" 1981-1982* Donna Ferrato (Best16 13-20)

woman with her face slashed by husband in "Four days after the O.J. Simpson verdict Dake-Smith's estranged husband slashed her with a butcher's knife" 1995* Brian Davies (Best21 145d)

woman with two black eyes from [Living with the Enemy] 1991 Donna Ferrato (Marien \7.15)

DOMESTICS

African American man standing behind Army officer in "Officer and Manservant" c. 1851 Photographer Unknown (Photography1 \4)

African American woman holding white infant in "Charleston, South Carolina" 1955 Robert Frank (Art \321; Eyes #239)

African American women in uniforms seated at long tables in "Domestic Services Class, Tuskegee Institute" c. 1917 C. M. Battey (Willis \38)

maids and butler standing behind woman seated in garden in "Untitled (Wealthy woman with two maids and a male servant behind her)" 1978 Pedro Meyer (Marien \6.5)

woman ironing on the side of the road in [Maid ironing at the side of the highway] c. 1995* Geof Kern (Graphis96 151a)

women in uniforms standing at foot of dining room table in "Parlourmaid and Under-Parlourmaid Ready to Serve Dinner" 1934 Bill Brandt (Art \289; Hambourg \45; Marien \5.70)

DOMINOES

laid out on table in "Dominoes" 1930 Laura Gilpin (Decade \22)

DONKEYS

television tied to the back of a donkey in "A donkey carries prized cargo through the narrow streets of Fex, Morocco" 1986* Bruno Barbey (Through 270)

DOORS

boarded-over barn door and windows in "White Barn, Bucks County, Penn." 1914-1917 Charles Sheeler (MOMA 101)

broom in front of open door in "The Open Door" 1843 William Henry Fox Talbot (Art \10; Lacayo 18d; Marien \2.6; Rosenblum2 #23; Waking #12)

double wooden door in "Barred Door, Rocky Hill Meeting House" c. 1910 Clifton Johnson (MOMA 63)

many floors of hotel balconies in "Guest at Disneyland Hotel checks out the territory" 1985 Al Fuchs (Best11 141a)

open red door behind gate in "Doorway, West 116th Street" 1993* Jeffrey Henson Scales (Willis \416)

woman in slip and stockings, standing in front of door in "Untitled" c. 1912 Ernest J. Bellocq (MOMA 71; Rosenblum2 #315)

woman starting to open keyhole shaped door in "The Forbidden Door" c. 1927 Arthur F. Kales (Peterson #18)

wooden door and windows with peeling paint in "Door and Windows" 1936 Sonya Noskowiak (Sandler 88)

DRAG QUEENS see TRANSVESTITES

DROUGHTS

aerial view of river bed during a drought in "Boaters on the Ohio River examine the shoreline on the Kentucky side after a record drought dropped the water to its lowest level since 1930" 1988 Todd Buchanan (Best14 80)

cattle ranchers despondent during a drought in "Texas Dustbowl" 1996 Nicola Kurtz (Best22 238c, d)

dog stands on parched lake bottom in "In August, a dog stands on what used to be a 12-foot-deep lake just outside Athens, Ga." 1986 Bradley Clift (Best12 37d)

drought destroyed crops in "Gilbertville, Iowa, farmer surveys the damage to his drought-stricken crop" 1988 John Caps III (Best14 10d)

farmer on bed frame in desert in "A farmer waits for rain in the heat of the afternoon outside his home near Lake Chad" 1987* Steve McCurry (Best13 163b)

farmer standing near his stunted crop in "Calvin Spence's 350-acre farm straddles the North Carolina-Virginia border, looks over his drought-damaged peanut crop" 1986 Bill Kelley III (Best12 37a)

starving cattle in a pen in "Starving cattle await auction in Freer, Texas, as a drought forces ranchers to sell their stock" 1988 Nuri Vallbona (Best14 81a)

DRUGS see ADDICTS

DUCKS

duck in front of swimmers in "Just because there's a meet scheduled in this mallard's swimming pool is no reason for the duck to leave" 1985 George Wilhem (Best11 178a)

on top of black helmet of person in black leather jacket from [self-promotional] c. 1989* Bill White (Graphis89 \43)

DUNES *see* SAND DUNES

DUST STORMS

father and sons walking to wooden cabin in "Father and sons walking in the face of a dust storm, Cimarron County, Oklahoma" 1936 Arthur Rothstein (Lacayo 98; Marien \5.57; Rosenblum2 #450)

DWARFS

man outside hotel in "Black Dwarf, Lower East Side" 1950 Lisette Model (Women \129)

—E—

EARTH

clouds over earth as seen from space in "Earth as viewed from ATS Satellite" 1967* ATS Satellite (Marien \6.67)

earthrise in black sky seen from the moon in "Earthrise" 1968* William Anders (Goldberg 178; Lacayo 163; Monk #51)

EARTHQUAKES

homeless and injured people in "Victims of an earthquake in Soviet Georgia" 1988 David C. Turnley (Best14 194-195)

medical team helping earthquake victims near collapsed freeway in "Deadly Quake" 1989 Michael Macor (Capture 156)

EARTHQUAKES–ARMENIA

photo essay on the burials of victims of the earthquake in "Death in Armenia" 1988 Peter Turnley (Best14 173-177)

EARTHQUAKES–JAPAN–FUKUI

people running across cracked roadway in "Earthquake, Fukui, Japan" 1948 Carl Mydans (Life 126)

EARTHQUAKES–MEXICO–MEXICO CITY

clothing hanging from floors of building in "New clothing hangs from protruding reinforcing rods in a building in Mexico City's garment district" 1985* J. B. Forbes (Best11 10)

human chain of rescue workers in rubble in "Volunteers form a human chain to remove the bodies of earthquake victims from one collapsed structure" 1985 Eric Luse (Best11 9a)

man's hands in rubble in "The body of one of the estimated 10,000 persons who died in the second earthquake" 1985 Paul Kitgaki, Jr. (Best11 8d)

medical team helping earthquake victims near collapsed freeway in "Deadly Quake" 1989 Michael Macor (Capture 156)

people running after earthquake in "The second quake rocked Mexico City" 1985 Michael Williamson (Best11 8a)

priest blessing bodies under ice packs in "A priest makes the sign of the cross over ice-packed bodies of quake victims" 1985* Lennox McLendon (Best11 11)

rescue worker on ladder in rubble in "Rescue workers carry an 8-day-old baby from the rubble of Benito Juarez Hospital, five days after the building was destroyed" 1985* J. B. Forbes (Best11 7)

woman being carried out of rubble in "A 26-year-old woman is rescued by Swiss and French volunteers" 1985 Scott R. Sines (Best11 9b)

workers digging in rubble after an earthquake in Mexico City in "Volunteers work shoulder to shoulder, searching for survivors in quake debris" 1985* David Wood (Best11 6)

EARTHQUAKES–UNITED STATES–SAN FRANCISCO

people in streets after earthquake in "Smoke and flames after the San Francisco earthquake" 1906 Arnold Genthe (Eyes #65; Lacayo 38; Photos 15)

people on hill overlooking city with smoke and fire in "The San Francisco Fire" 1906 Arnold Genthe (Rosenblum2 #586)

EATING DISORDERS

photo essay on anorexia and bulimia in "Secret, deadly diet" 1993 Brian Plonka (Best19 137-140)

EELS

head sticking out of a tire in " 'Nightmare flat tire'–home to a moray eel" 1990* (Best16 145)

with spots in "Blackspotted Moray Eel" c. 1999* Mark Laita (Photo00 224)

EGGS

and white cups of food colors in "Eggs of a different color" 1991* Kevin Swank (Best17 171)

different colors and sizes in [eggs] c. 1989* Kathryn Kleinman (Graphis89 \313)

Elephant bird egg held by a man in "Many of the Island of Madagascar's larger animals, such as the Aepyornis–the world's largest known bird–disappeared in a wave of extinctions ending 500 years ago" 1987* Frans Lanting (Best13 94a)

salmon eggs under microscope in "A shoot on salmon eggs–part of a Pacific salmon photo project–took an unexpected turn when the eggs hatched into alevins (larvae)" 1987* Natalie Fobes (Best13 95c)

EGYPT–ANTIQUITIES *see also* PYRAMIDS

Abu Simbel Temple being reconstructed above Aswan Dam in "Rescuing the Abu Simbel Temple Complex" 1968 Photographer Unknown (Photos 123)

broken columns in a courtyard in "Medinet Habu" 1841 Hector Horeau (Marien \2.34)

columns of a rock-cut tomb in "Portico of the Tomb of Amnemhat, Beni-Hasan" 1851-1852 Félix Teynard (Waking 297b)

columns with hieroglyphics in "Interior of Temple of Horus, Edfu" after 1862 Antonio Beato (Rosenblum2 #135)

columns with hieroglyphics in "Karnak: Pillars of the Great Hall" c. 1859 Gustave Le Gray (Art \96)

deeply incised outer gate in "First Pylon View of the Great Temple" 1850s Francis Frith (Marien \3.44)

face of figure carved in stone and covered in sand in "Westernmost Colossus of the Temple of Re, Abu Simbel" 1850 Maxime Du Camp (Waking #65)

figure carved in stone in "Colossus of Ramses II at Abu Simbel, Egypt" 1850 Maxime Du Camp (Monk #4; Lacayo 16; Rosenblum2 #111)

funeral statues in "Group of Funeral Statues Associated with Osiris" c. 1890 Photographer Unknown (Szarkowski 138)

installation of Egyptian sculpture in "Setting up the Colossi of Ramses the Great" 1853 Philip Henry Delamotte (Rosenblum2 #179)

large stone figures in "Abu Simbel" 1851-1852 Félix Teynard (Waking #69); "Abu Simbel" 1840 Hector Horeau (Rosenblum2 #99)

Philae seen from rocky shore across water in "Approach to Philae" c. 1858 Francis Frith (Rosenblum2 #133)

portal with carvings in "Entrance Portal, Dendera" 1860 Louis de Clercq (Waking #66)

pylon in "General View of Pylon, Temple of Sebou'ah, Nubia" 1851-1852 Félix Teynard (Szarkowski 64)

seated colossus in "Colossus of Memnon" 1850 Maxime Du Camp (Marien \2.40)

several columns in "Temple of Kertassi, Kerdasah, Egypt" 1849-1851 Maxime Du Camp (Szarkowski 318b)

Temple at Philæ in "Hypæthral Temple (Kiosk of Trajan) at Philæ" 1858 Francis Frith (Art #7)

Temple at Philæ and tourists in "Philæ, near view [sic] Hypæthral Temple" c. 1870-1875 Frank M. Good (Art #8)

tomb sculpture in "Statue V" 1989* Lynn Davis (Rosenblum2 #681)

tourists at base of huge broken figure in "Fallen Colossus, Ramasseum, Thebes" 1858 Francis Frith (Art \129)

Tutankhamen's mummy in coffin "Opening Tutankhamun's Coffin" 1922 Photographer Unknown (Photos 39)

two figures in the sand in "Colossus and Sphinx, Es-Sebua" 1851-1852 Félix Teynard (Waking 297d)

wall with hieroglyphics in "Dakkeh" 1853-1854 John Beasley Greene (Waking #68)

EIFFEL TOWER (Paris, France)

looking down through the tower in "Eiffel Tower, Paris" 1929 André Kertész (Hambourg \10)

out of focus at night in [Eiffel Tower] c. 1999* Felix Holzer (Photo00 19)

view from bottom to top of tower in "Eiffel Tower" 1928 Germaine Krull (Hambourg 95)

EL CAPITÁN

mirror image in water in "Mirror View of El Capitán, Yosemite Valley" c. 1864 Charles Leander Weed (Szarkowski 119)

mountain rising above a river in "El Capitán" n.d. Edward and Henry T. Anthony (Decade 5)

EL SALVADOR

girl hiding face behind piece of paper in "Child victims of political strife in El Salvador" c. 1991 Jim Sims (Graphis91 \66)

girl standing in niche in "Child victims of political strife in El Salvador" c. 1991 Jim Sims (Graphis91 \66, \67)

girls in party dresses near helicopter in "On the holy day in El Salvador, little girls were caught in the wind generated by a helicopter taking off after picking up army officers" 1984* James Nachtwey (Eyes \19)

photo series on the poverty, guerilla warfare, and life and death before a cease fire was called in "El Salvador: Before the truce" c. 1989 Larry Towell (Best19 97-112)

teenage girl with rifle in "Adolescent girl who fights with the rebel forces" c. 1991* Jim Sims (Graphis91 \68)

woman grieving over son in "Son killed by National Guard, El Salvador" 1980* Susan Meiselas (Eyes \25)

wounded fighters and child in field in "After a guerrilla ambush in El Salvador, a father shields his wounded daughter" 1984* James Nachtwey (Eyes \18)

ELDERLY PERSONS *see* AGED

ELECTRIC POWER

towers at electric power plant in "Southern California Edison Plant at Long Beach" 1932 Will Connell (Peterson #83)

ELEPHANTS

behind a group wedding picture in Taipei Zoo, and in limo in "Yes, I Do" 1997 Chien-Chi Chang (Best23 227d)

closeup of foot and toenails in "From toenails to tail, the Asiatic elephant is a massive creature that feeds 18 hours a day" 1997* Mattias Klum (Through 201)

in an indoor enclosure in [elephant in its zoo house] c. 1991 Dirk Fischer (Graphis92 \228)

in a zoo enclosure in [elephant] c. 1992* Britta Jaschinski (Graphis93 192b)

in zoo with trunk reaching over wall for food in "New York" 1963 Garry Winogrand (Photography 50)

kneeling in the forest in "An old female elephant is set loose to wander as far as her chain will allow after daily treatment at an animal hospital" 1997 Chien-Chi Chang (Best23 158b)

moving large logs in "Much less costly than using tractors, elephants move teak logs with ease" 1995* Steve McCurry (Best21 20a,b)

nude woman laying on elephant in [nude on elephant] c. 1989 Lee Crum (Graphis89 \149)

on trails to water hole in "In their travels through a forest, elephants create trails such as these in the Republic of the Congo's Noubalé National Park" 1995* Michael Nichols (Through 208)

reaching for a peanut from boy in "It's a long stretch for a peanut" 1985 Chuck Beckley (Best11 176b)

silhouettes at water hole in "The African night gives way to another dawn" 1993* Frans Lanting (Best19 75)

swimming underwater in "Around the Andaman Island in the Bay of Bengal, elephants swim" 1995* Oliver Blaise (Best21 158a)

tail end of elephant in [elephant] c. 1995* Steve Grubman (Graphis96 193)

taking grass from a young child in "A youngster offers friendship (and a handful of grass) to one of the residents of the Woodland Park Zoo" 1985 Cole Porter (Best11 177a)

training elephants in "Elephants of Way Kambas" 1997 Steven Siewert (Best23 163)

trunks entwined in "Two junior members of the Carson & Barnes Circus get all wound up in their act" 1985 Rob Goebel (Best11 176c)

walking across desert in "An elephant on his way to a water borehole as thunderheads approach in the Namibian Desert" c. 1991* Hugo A. Lambrechts (Graphis91 \338)

walking in line past a bus across a bridge in "Just one more line of commuters on their way to work: elephants from the Ringling Brothers, Barnum & Bailey Circus" 1985 Milan Chuckovich (Best11 176c)

with man near building in "Another Impossible Task" 1854 Louis-Pierre-Théophile Dubois de Nehaut (Waking #56)

woman pushing elephant in "A zookeeper takes the problem of parking Bella the elephant into her own hands" 1985 John Eggitt (Best11 177)

woman in black dress posing between elephants in "Dovima with Elephants" 1955 Richard Avedon (MOMA 229)

women watching elephants sit on circus stools in "In Sarasota" 1947 Louise Dahl-Wolfe (Decade \53)

ELLIS ISLAND IMMIGRATION STATION (New York and New Jersey)

couple dancing to an accordion in "Immigrants waiting at Ellis Island" c. 1905 Lewis Wickes Hine (Lacayo 65c)

deteriorating rooms on Ellis Island in "Ellis Island–The Forgotten Side" c. 1999* Stephen Wilkes (Photo00 22, 23)

mother and her two children in "A Russian family on Ellis Island" 1905 Lewis Wickes Hine (Lacayo 58)

EMBRYOS

monkey embryo in "A monkey embryo serves to raise questions about what makes humans human" 1996* Lennart Nilsson (Best22 184b)

ENDURANCE (Ship)

sinking of Shackleton's ship *Endurance* while dog teams search for food in "Foraging for food in the Antarctic" 1915 Photographer Unknown (Lacayo 43d)

ETHIOPIA

arm of women soothing malnourished children in "Children's ward, Korem, Ethiopia" 1985* Mary Ellen Park (Eyes \28)

crowded area with tents in "Korem Camp, Wollo, Ethiopia" 1984* David Burnett (Eyes \15)

emaciated child covered with flies in "A child from the Eritrean region of Ethiopia too weak from hunger to brush the flies covering her body" c. 1991* Peter Turnley (Graphis91 \86)

family walking across desert in "Region of Lake Fagubian. These nomads have had to walk across wide expanses" 1983-1985 Sebastiao Salgado (Eyes #326; Life 132)

landscape with underground structures in "Ethiopian Landscape I" 1982 Suliaman Ellison (Committed 91)

man holding child across his arms in "25 years of warfare continued as Eritereans launched major offensives against Ethiopian troops, killing thousands and forcing thousands more to become refugees" 1988* Anthony Suau (Best14 57a)

mountain fortress of the emperor in "Magdala (Emperor Téwodros's mountain fortress and capital" 1868 Photographer Unknown (Marien \3.46)

person placing body of child near others who died in the famine in "Inside 'Die Place' " 1985* Mary Ellen Mark (Eyes \26)

walking through an area of destroyed tanks in "An Ethiopian soldier walks through a cemetery of tanks" 1988* Anthony Suau (Best14 57b)

ETHNIC COSTUME *see also* INDIANS OF NORTH AMERICA; INDIANS OF SOUTH AND CENTRAL AMERICA

Afghan burqa covering woman holding a photograph in "An Afghan woman poses with a picture of herself, taken 17 years earlier" 2002* (Through 157)

Afghan woman wearing burqa in "Afghan woman puts on her burqa before leaving her home in Kabul" 1997* Michael Wirtz (Best23 181d)

Amish child in "A young Amish girl watches an auction" 1987 Bonnie K. Weller (Best13 106)

Amish youths with buggies on overpass above trucks in "Three Amish youths urge oncoming truckers to blast their horns while passing at an overpass south of Mansfield, Ohio" 1987 Curt Chandler (Best13 108)

Anatolian woman holding chickens in "Like her ancestors nearly five centuries ago, a northern Anatolian woman delivers chickens to the Safronbolu Saturday morning market in Turkey" 1987* James Stanfield (Best13 163a)

Andean woman walking in "A mestizo woman, wearing a traditional hat of the northern Andes, walks through the morning streets" 1998 Michael Robinson-Chavez (Best24 50c)

bare-breasted woman in elaborate headdress in "Samoa Princess Fa'ane, Apia" c. 1895 John Davis (Marien \4.68)

bare-breasted young women in skirts and beaded necklaces in "Girls in a Village of East Equatorial Africa" 1909 Underwood & Underwood (Marien \4.65)

Bolivian women in "Women of Bolivia" n.d. Sara Facio (Rosenblum \193)

boy in elaborate clothes in "In the 1920s, Tibetans recognized a six-year-old boy as the living Buddha of Guya" 1928 Joseph Rock (Through 160)

boys decorated with white face paint, lay on ground in "Aboriginal boys in Arnhem Land, Australia, wait for a circumcision ceremony to begin" 1980* Penny Tweedie (Through 432)

bride in black jacket, white skirt in "Sailor's bride from Fohr Island in her costume" c. 1989 Susan Lamar (Graphis89 \24)

Burma's Padaung women wearing brass neck and legs rings in "In a modern link with the past, two Padaung women wear heavy stacks of brass neck rings, a legendary protection from tiger attacks" 1995* Steve McCurry (Best21 201d)

Chinese couple seated in formal portrait in "Cantonese Mandarin and His Wife" 1861-1864 Milton M. Miller (Marien \3.36)

Chinese men in studio setting selling pears from baskets in "Selling Pears (Shanghai, China)" 1870s L. F. Fisler (Marien \3.35)

Cossack uniforms on some men in [return of Cossack culture in southern Russia] 1998* Ilkka Uimonen (Photo00 62, 63)

Cossacks revitalizing their culture in photo essay in "Cossack Thunder" 1993 Ellen Binder (Best19 207-212)

costumed men performing before young boys in "Makishi dancers in western Zambia perform for a group recently circumcised boys" 1997* Chris Johns (Through 258)

Croatian couple in staged natural setting in "A Croat Couple from the Valley of the Serezan near Zagreb" 1867 Photographer Unknown (Marien \3.80)

dancers in stilts leaning against hit roof in "Dan stilt dancers rest their legs and backs after a performance in Côte d'Ivoire" 1982* Michael and Aubine Kirtley (Through 260)

Dutch women in "Untitled (three Dutch women at Ellis Island)" c. 1910 Augustus Sherman (Goldberg 31d)

elderly man holding decorated box under word "Singapore" in "Used for the diary of the shipping company American President Lines" c. 1989* Terry Heffernan (Graphis89 \141)

entertaining men seated at table in "In Japan, the life of a geisha still requires hours of preparation before a date" 1985* Jodi Cobb (Best11 46c)

Ethiopian chief's portrait in "An Ethiopian Chief" c. 1896 F. Holland Day (Rosenblum2 #386)

formal portrait of woman with bare breasts in "Portrait of a West Indian" 1854-1859 Nadar (Szarkowski 87)

girls and boy in wooden shoes in "Wearing wooden shoes and other traditional garb, three children greet each other with smiles in the village of Staphorst, Holland" 1929* Donald McLeish (Through 80)

Guatemalan Indians in "Young Indian Couple with Cityscape, Sololá, Guatemala" 1973 Ann Parker (Marien \6.4)

holding straw hat in "Geisha in Japan" 1995* Jodi Cobb (Through cover)

Hutterite children doing farm chores in "Hutterite children" 1997 Andrew Holbrooke (Best23 184-185)

Indian couple in "Brinjara and Wife" 1868 Photographer Unknown (Marien \3.81)

Indian man at sewing machine in "A tailor in northwest India sews clothes for a Rabari wedding that will take place during the summer monsoon" 1993* Dilip Mehta (Through 174)

Indian women standing by tree in "Nagar Brahim Women" 1863 Photographer Unknown (Marien \3.31)

Islamic woman completely wrapped in cloth in "Following strict Islamic tradition, a Libyan woman in the Tripoli airport is swathed from head to toe" 2000* Reza (Through 250)

Japanese Emperor seated in a chair in "Mutsuhito, the Emperor Meiji" c. 1872 Uchida Kyuichi (Marien \3.42)

Japanese man with paint brush in "Beato's Artist" c. 1868 Félice A. Beato (Marien \3.41)

Japanese men performing on ladders for large crowd in "New Year Drill of Japanese Fire Brigade" c. 1890 Kusakabe Kimbei (Rosenblum2 #194)

Japanese woman in formal portrait in "Haru-ko, the Empress of Japan" c. 1872 Uchida Kyuichi (Marien \3.43)

Japanese woman near hot springs in "A housewife in Beppu, Japan, boils eggs over bubbling hot springs, which also heat stoves around the town" 1942 Japanese Government Railways (Through 158)

Japanese woman with parasol in "Rain Shower in the Studio" c. 1875 Raimund von Stillfried (Rosenblum2 #193)

Japanese women bow to man in car in "With elaborate good manners, hotel maids in Matsuyama, Japan, bow in farewell to a departing guest" 1960* John Launois (Through 190)

male models near Africans in native dress in [article on men's fashions] c. 1989 Aldo Fallai (Graphis89 \22)

Mennonite family that is farming in Mexico in "Mexican Mennonite Migrant Workers" 1996 Larry Towell (Best22 256-257, 267)

Mennonite women on city street in "A group of Mennonite women exchange uneasy glances with [African American men] on a street corner" 1996* Jim Gehrz (Best22 171a)

Mongolian woman on a horse in "Mongolian Horsewoman" c. 1913 Stéphane Passet (Rosenblum2 #346)

Mongolian wrestler looking in mirror in "A wrestler inspects himself in a mirror in Mongolia" 1997 Stephen Dupont (Best23 237a)

Moroccan family in an empty room from [series on Morocco] c. 1989* Robert van der Hilst (Graphis89 \181)

Moroccan man at table [from a cigarette ad in southern Morocco] c. 1991* Tim Bieber (Graphis92 \99)

Muslim girls wearing head coverings in "Muslim girls visit a mosque near Tehran, Iran" 1996 Tom Stoddart (Best22 172b)

North African woman wearing headdress of coins in "Wearing her dowry, this young woman belongs to the Ouled Nails tribe of North Africa" 1922 Lehnert and Landrock (Through 244)

Papua New Guinea man and child seated on ground in "Untitled (Papua New Guinea)" 1994* Bob Greene (Committed 116)

Papua New Guinea man wearing long extensions on his figures in "Untitled (Papua New Guinea)" 1994* Bob Greene (Committed 116, 117)

Papua New Guinea men in "Inhabitants of Papua, New Guinea" c. 1991* (Graphis91 \179-\182)

Papua New Guinea women, bare breasted in "Gangaja Village, Papua New Guinea" 1997 Lonnie Graham (Willis \370)

Papua tribesmen in swimming trunks in [Hulis men, a tribe from Papua, wearing swimming trunks] c. 1991* Yann Arthus-Bertrand (Graphis92 \37)

person in skirt of beads putting on makeup in "Zulu in South Africa" 1996* Chris Johns (Through 16)

Peruvian women in hats in "Two Peruvian women, ill with cholera, await medical attention at a Cajamarca hospital" 1991* Gustavo Gilabert (Best17 116b)

Plomarc'h girls sewing in "On the Coast of Plomarc'h, Douarnenez" 1912 Charles L'Hermitte (Rosenblum2 #420)

Polish woman sewing in "Amelia Szubert" c. 1875 Awit Szubert (Rosenblum2 #70)

Russian beggars, girls and women, with walking sticks in a studio in "Blind Russian Beggars" 1870 Photographer Unknown (Rosenblum2 #421)

Russian girl holding milk pails in "Russian Types (Milkgirl)" c. 1859 William Carrick (Rosenblum2 #411)

Russian man playing an instrument in "Russian Types (Balalaika Player)" c. 1859 William Carrick (Rosenblum2 #412)

Russian peasants outside log house in "Peasant Scene" late 1890s Sergei Lobovikov (Rosenblum2 #384)

Samburu men from Kenya in Nike ad in "Members of the Samburu tribe wearing Nike walking shoes" c. 1991* Harry De Zitter (Graphis91 \33)

Samurai with raised sword in "Samurai with raised sword" c. 1860 Félice Beato (Art \125)

seated Nepalese young women wearing traditional costumes in "Young Nepalese ladies wear elaborate costumes reminiscent of their Mongolian heritage" 1920 John Claude White (Through 150)

Sere tribe wrestler in "Abdul Rahman, Sere Tribe champion wrestler" 1997 Stephen Dupont (Best23 237b)

Syrian bedouin women and their children in "Group of Syrian Bedouin Women" c. 1870 Marie Lydie Cabannis Bonfils (Rosenblum2 #414)

Tajik children are seated near door and reading books in "Tajik children go over class notes before school in a mountain village of China's Xinjiang Province" 2001* Michael S. Yamashita (Through 168)

tall woven body covers in "In Urama, Papua New Guinea, tribal elders wear goblin masks to perform certain ceremonial functions" 1927 Frank Hurley (Through 439)

Tasmanian woman in "Trucanini" 1866* C. A. Woolley (Marien \3.85)

Turkish veiled women in a studio photograph in "Arab Woman and Turkish Woman, Zangaki, Port Said" 1870-1880 (Marien \3.83)

veiled woman in her home in "Palestinian security forces rousted this woman when they raided the house of a suspected member of Hamas" 1996* Alexandra Avakian (Through 268)

veiled Yemeni woman in black "Women in Sanaa, Yemen line up to vote in a parliamentary election" 2000 (Through 254)

woman in lace shawl with head and face covered with scarf in "Portrait of a lady in Turkey" c. 1929 Sebah & Joaillier (Through 92)

women in long lace skirts and hats riding bicycles on dirt road in "Large fancy hats adorn ladies from the Spreewald swamps near Berlin" 1937 (Through 84)

Yemeni traditional beaded head covering in "Yemeni Jewish bride near Gaza wears a wedding costume styled centuries ago" 1985* James Stanfield (Best11 44a)

EVERGLADES (Florida)

men standing in canoes in Everglades in "Canoes based on Seminole Indian designs still ply the waters of the Florida Everglades" 1994* Chris Johns (Through 370)

EXECUTIONS AND EXECUTIONERS

electric chair in a room in "Early Electric Chair" 1963* Andy Warhol (Art \461)

firing squad crouching, as blindfolded men are shot in "Justice and Cleansing in Iran" 1979 Photographer Unknown (Capture 110)

gallows and a hanging in "Hanging the Lincoln conspirators" 1865 Alexander Gardner (Eyes #33-35; Marien \3.22; Rosenblum2 #233-239; Waking #113)

hanging of a black man in "Execution of William Biggerstaff, hanged for the murder of 'Dick' Johnson, flanked by the Rev. Victor Day and Henry Jurgens, sheriff" 1896 J. P. Ball & Son (Willis \11)

Lebanese execution in "Gunmen form Amal, Lebanon's Shiite Muslim militia, took Mohieddin Saleh, a Sunni Muslim and killed him with assault rifles" 1986* Haidar (Best12 102)

men hanging from post in "Taliban fighters greet each other in Kabul as the bodies of former Afghanistan President Najibullah and his brother hang from a traffic post" 1996* B. K. Bangash (Best22 158a)

men in the jungle in "A rebel with the Karen National Liberation Army executes a man suspected of collaborating with the government in Burma" 1990* Bruce Haley (Best16 199)

militiamen execute an enemy on the street in "Militia soldiers execute a Krahn faction enemy on the streets of Monrovia" 1996* Christopher Simone (Best22 271d)

Priest bending over kneeling man, near firing squad in "Castro Firing Squad Execution" 1959 Andrew Lopez (Capture 45)

South Vietnamese general shooting a Viet Cong prisoner in the head in "Viet Cong Execution" or "Execution of a Viet Cong Suspect, Vietnam" 1968 (Capture 64; Eyes #300-302; Goldberg 174; Lacayo 156; Marien \6.72; Monk #42; Photos 115)

two men being hanged in "The Execution of Mutineers in the Indian Mutiny" 1857 Félice A. Beato (Marien \3.39)

woman strapped in an the electric chair in "The execution of Ruth Snyder" 1928 Tom Howard (Goldberg 73; Lacayo 53; Marien \5.3)

Zairean rebels execute man in street in "Man tumbles after being executed by victorious Zairean rebels" 1997* Jean-Marc Bouju (Best23 125b)

EXERCISE
aerobics class near pool and snow-covered mountain in "Aerobics class at the Snowbird Ski Resort, Little Cottonwood Canyon, Utah" 1981* Enrico Ferorelli (Life 119)
balancing on chairs to do pushups in "Man doing Pushups" 1984-1985* Jo Ann Callis (Women \196)
basketball player and older women riding stationary bicycles in "Moses Malone ride along with the women in a physical therapy center" 1986 Susan Winters (Best12 226d)
boys doing handstands in "Nine Boys Practicing Handstands" c. 1900 Heinrich Zille (Icons 11; Rosenblum2 #311)
group of lifeguards doing push-ups in the sand in "Junior lifeguards on the California coast during training" c. 1990* Roger Camp (Graphis90 \170)
hundreds of people doing pushups under Olympic flag in "Calisthenics, Olympic Games, Berlin" 1936 Leni Riefenstahl (Hambourg \82)
hundreds of players exercising in "Brooklyn Dodgers Rookie Spring Training" 1948 George Silk (Life 141)
lifting grate in prison yard in "Chain gang inmate works out in the prison yard" 1995 James Nachtwey (Best21 184b)
man bending over in [series on men's fitness and grooming] c. 1991 Volkmann (Graphis92 \152)
man doing sit-ups from [article on boxing arenas] c. 1990* Wolfgang Wesener (Graphis90 \237)
man on mat with legs over his head in "Condition training on the mat" c. 1990* Stephen Green-Armytage (Graphis90 \242)
men and women exercising from [a sportswear catalog] c. 1990* Sue Bennett (Graphis90 \47-\50)
model stretching from [ad for health and fitness club] c. 1991 Darrell Peterson (Graphis91 \12)
woman hanging upside down against wall in "Faith Brandon practices yoga by hanging upside down from ropes" 1990 Al Podgorski (Best16 172a)
woman using a machine in "Fighting fat with the splendid massager" 1940 Alfred Eisenstaedt (Life 111c)
EXHIBITIONS
early airplanes and balloons in "Aerial exposition at the Grand Palais, Paris" 1909 Leon Gimpel (Lacayo 30)
large wheel in "Ferris Wheel: World Columbian Exposition" 1893 Charles Dudley Arnold (Szarkowski 154)
looking over balcony to Exposition of buildings in "World's Columbian Exposition, Chicago" 1893 Charles Dudley Arnold (Photography1 \13)
reflecting pool and surrounding buildings in "Basin and the Court of Honor" 1893 Charles Dudley Arnold (Marien \4.51)
EXPLOSIONS see also ATOMIC BOMBS; BOMBS AND BOMBING
burning battleship sinking at Pearl Harbor in "The battleship Arizona" 1941 Photographer Unknown (Lacayo 103)
cockpit exploding in "An explosion [by hijackers] rips out the cockpit of a Royal Jordanian ALIA Airline at Beirut Airport" 1985 Herve Merliac (Best11 55b)
dirigible bursting into flames in "The Hindenburg disaster" 1937 Sam Shere (Lacayo 81; Photos 52); "Explosion of the Hindenburg" 1937 Murray Becker (Goldberg 94)
dynamiting an abandoned ship in "The Renegade Reef, a 26-year-old Dutch coaster abandoned in Florida's Miami River in 1981, went up in an 80-foot cloud of smoke after officials loaded her with 100 pounds of dynamite" 1985 Marc Clery (Best11 108)
explosion of ship surrounded by small boats in "More than 500 pleasure boats accompanied the tired Mercedes I out to sea where 360 pounds of TNT sank the hulk off Fort Lauderdale" 1985 Sherman Zent (Best11 109)
in backyard of home in "Backyard Sales Demonstration, California" 1983 Greg MacGregor (San \66)
moment of explosion in blue sky in "The Challenger Explodes" 1986* NASA (Monk #49)
mushroom cloud of atomic bomb in "First Atomic Bomb Explosion" 1945 Los Alamos National Laboratory (Monk #32)
soldiers kneeling near explosion in "Battle of Iwo Jima" 1945 W. Eugene Smith (Life 54a)
EXPOSITIONS see EXHIBITIONS
EXXON VALDEZ OIL SPILL, ALASKA, 1989
many people hosing off rocks in "Exxon Valdez Clean Up" 1989* Natalie Fobes (Goldberg 207)
two oil tankers after oil spill in aerial photo in "Exxon Valdez Oil Spill" 1989* Rob Stapleton (Photos 161)
EYE
and distorted colors in "Untitled" 1973* Lucas Samaras (Marien \6.95)
eye and eyebrow in "Infanta" 1987 (Icons 183)
eye and nostrils in [eye and nose] c. 1997 Ralph Gibson (Graphis97 125)
eye superimposed on a back-lit hand in "Conscience" 1941* Axel Bahnsen (Peterson #38)
eyes with mascara and glass beads for tears in "Glass Tears" c. 1930 Man Ray (Art \247)

green eye and pierced eyebrow in "Body Pierce" 1993* John Luke (Best19 179)

left eye of a man in "Eyes of an Eighteen-Year-Old Young Man" 1925-1926 August Sander (Waking 355c)

makeup on eye in "Bordighera Detail" 1983 Helmut Newton (Art \449)

EYEGLASSES / SUNGLASSES

audience wearing 3-D glasses in theater in "Premiere of *Bwana Devil*, Paramount Theater, Hollywood" 1952 J. R. Eyerman (Life 113)

man in metal-frame glasses with candy cane in mouth in "Phil Spector" 1969 Baron Wolman (Rolling #7)

man in sunglasses reflecting green light in "Stevie Wonder" 1987* Mark Handauer (Rolling #74)

man in yellow sunglasses in "Untitled" c. 1991* Steve Sharp (Graphis91 \233)

peeking through window blinds in "The shades of summer offer a look at what's new in eyewear" 1987* Nan Wintersteller (Best13 182b)

round colored frames in [eyeglasses] c. 1997* Terry Heffernan (Graphis97 132)

round colored sunglasses in "Sizzling Summer Shades" 1986* Chuck Zovko (Best12 111a)

round sunglasses on woman in "Sahara" c. 1991* Barbara Cole (Graphis92 \43)

row of sunglasses in " 'Shades' of Summer" 1993* Jeff Horner (Best19 177)

sunglasses on map from [annual report for Weyerhaeuser, the paper and cartonage manufacturers] c. 1989* Terry Heffernan (Graphis89 \291)

sunglasses on models and mannequins in "Bulletproof sunglasses cross the line from high-tech to high fashion" 1987* Steven Zerby (Best13 178d)

two pairs near pipe in bowl in "Mondrian's Glasses and Pipe, Paris" 1926 André Kertész (Art \252)

with bright blue lenses in "Ad for the Polar Blue Filters of the Nautilus brand sunglasses" c. 1989* Tom Ryan (Graphis89 \223, \224)

—F—

FACIAL EXPRESSION

babies crying from [*The Expressions of the Emotions*] before 1872 Guilaume-Benjamin-Amand Duchenne de Boulogne (Marien \3.78)

facial expressions of man with metal probes on his face in "Fright" or "Electrical contraction of the eyelids, the forehead with voluntary lowering of the jaw" c. 1870 Guilaume-Benjamin-Amand Duchenne de Boulogne (Marien \3.77; Rosenblum2 #79; Szarkowski 97d)

facial expressions of infants in "Neck," "Sneeze," "Ear," "Angry Girl" c. 1995 Amy Arbus (Graphis96 124)

FACTORIES *see* INDUSTRIES

FAIRS *see* MARKETS

FAMINES *see* STARVATION

FANS

of feathers between woman's legs in "Golden Nude with 15th Century Aztec Fan" c. 1991 Albert Watson (Graphis91 8)

woman holding fan beneath shadow of flowers in vase in "Epilogue" 1919 Edward Weston (Peterson #62)

FANS (MACHINERY)

off the ground in hallway in "Floating Fan" 1972 Doug Prince (Photography2 77)

on table in [fan] c. 1992* Detlef Odenhausen (Graphis93 149)

FARMS AND FARMING; RANCHES

African American man being paid for bundle of cotton in "South Carolina" 1962 Bruce Davidson (Lacayo 148)

African American men resting by road in "At the end of the day" 1935 Ben Shahn (Documenting 85b)

African Americans lined up with bags of cotton in field in "Weighing in cotton" 1935 Ben Shahn (Documenting 84a)

African men and women in field in "South Africa" 1993* Pascal Maitre (Photography 117)

bare feet by rows of crops in "Organic farmer works in his bare feet" 1996* Alan Berner (Best22 160a)

barn, having fallen on its side in field in "The Oster farm" 1982 Grey Villet (Life 48)

barn, house, and farm in "A farm, Bucks County, Pennsylvania" 1939 Marion Post Wolcott (Fisher 30)

barns and farmhouse in "Horse and Buggy in Farmyard, Lancaster" 1965 George Tice (Decade \75)

Black woman with large knife in "Gail Dorsey, Cane Scrapper" 1986 Keith Calhoun (Committed 61; Willis \260)

buildings covered in snow in "Vienna: Winter Landscape" 1841 Anton Georg Martin (Marien \2.2; Rosenblum2 #11)

carrying pails from farmhouse in "Quebec Rural Scene" c. 1920 Edith S. Watson (Rosenblum \110)

cattle on snow-covered field in "Snow-sugared prairie like a vast gingerbread, raisined with feeding cattle"

c. 1989* Robert Llewellyn (Graphis89 \69)

chickens in yard being fed by young girl in "Feeding the Hens, Maine" c. 1900 Chansonetta Emmons (Sandler 22)

corn elevator in a field in [corn elevator] c. 1992* Jamey Stillings (Graphis93 168b)

corn field after harvesting as an ad for work boots in "Cornfield after the Harvest" c. 1991 Nadav Kander (Graphis92 \189)

corn field and two women in "Harvesting" c. 1905 Elizabeth Ellen Roberts (Sandler 118-119)

corn shocks in field covered with snow in "Corn shocks in a field. Frederick, Maryland" 1940 Marion Post Wolcott (Fisher 33)

corn shocks in silhouette in "Corn Shocks and Sky" c. 1925 Doris Ulmann (National \62)

cotton being picked by African Americans in "Picking cotton on the Alexander plantation" 1935 Ben Shahn (Documenting 82b, 83c)

cotton piled up in "Cotton on the porch of a sharecropper's home on Maria plantation" 1935 Ben Shahn (Documenting 82a)

crops growing near river in "Picturesque Susquehanna Near Laceyville" 1891-1892 William H. Rau (MOMA 64)

curved lines for irrigation in aerial view in "A lone tree is surrounded by irrigation ditches in a farm" 1993* Larry Mayer (Best19 74b)

dirt road cutting through fields in "Road , wheat and corn fields, Montana" 1941 Marion Post Wolcott (Fisher 52)

drought destroyed crops in "Iowa farmer surveys the damage to his drought-stricken crop" 1988 John Caps III (Best14 10d)

elderly brothers on their farm in photo essay in "Kahle Brothers" 1995 Torsten Kjellstrand (Best21 46-51)

farm boy in overalls and straw hat in "Untitled" c. 1930 Doris Ulmann (MOMA 95)

farm couple and their house in "John Curry House Near West Union, Custer County, Nebraska" 1886 Solomon Butcher (Photography1 \90)

farm couple embracing by bales of hay in "American Farmers' Shattered Dreams" 1986 David Peterson (Capture 143)

farm equipment in warehouse in "Warehouse of Agricultural Implements" n.d. Piallat (Photography 19b)

farm horse plowing field in "The Farm Horse" c. 1935 Nora Dumas (Rosenblum \136)

farmer in box of wheat in "Farmer sampling wheat in Central Ohio" 1938 Ben Shahn (Documenting 19a)

farmer on bed frame in desert in "A farmer waits for rain in the heat of the afternoon outside his home near Lake Chad" 1987* Steve McCurry (Best13 163b)

farmers sitting on ground near building in "Tenant farmers who have been displaced from their land by tractor farming" n.d. Dorothea Lange (Fisher 23)

farmers standing by building in "Tenant farmers displaced by power farming" 1937 Dorothea Lange (Fisher 22)

farmer standing near his stunted crop in "Calvin Spence, whose 350-acre farm straddles the North Carolina-Virginia border, looks over his drought-damaged peanut crop" 1986 Bill Kelley III (Best12 37a)

farmhouse and fences in snow in "Winter Eve" 1938 Gustav Anderson (Peterson #51)

farmyard in "Farmyard Scene, near *St. Leu-d'Esserent*" c. 1852* Henri Le Secq (Marien \2.45)

field in Texas in "Vanishing Texas" c. 1991* Harry de Zitter (Graphis92 \196-\198)

field in "December 20, 1983/3:30 p.m." 1983* Robert Glenn Ketchum (Photography 182)

field of onions in "Onion Field" 1889-1890 George Davison (Decade 9; Marien \4.7; Rosenblum2 #366)

Filipino rice farmers in the field in "Filipino peasants revitalize their land by burning the husks of the rice that they harvest" 1985 John Kaplan (Best11 74)

four views of farms in "Fair Is Our Land" n.d. Marion Post Wolcott (Fisher 148)

grain elevator, side view in "Gano Grain Elevator, Western Kansas" 1939 Wright Morris (Decade \41; MOMA 152)

harvester being pulled in field by horses in "Evolution of the sickle and flail–33-horse team combined harvester" 1902 Underwood & Underwood (National \48)

hay baler knives in "Detail of a hay baler showing rotating knives which cut hay into proper lengths" 1944 Pauline Ehrlich (Fisher 83)

hay baling machine picking up hay in "Detail of a baling machine showing hay being picked up at the Spring Run Farm" 1944 Pauline Ehrlich (Fisher 85)

haystack and ladder in "Haystack" 1844 William Henry Fox Talbot (Art \8)

haystack and man with farm tools in "Hayrick with Porter" 1841 William Henry Fox Talbot (Marien \2.8)

haystacks in field in "Haycocks with Haystack Mountains" c. 1890 Maire Hartig Kendall (Rosenblum \56)

Hutterite children doing farm chores in "Hutterite children" 1997 Andrew Holbrooke (Best23 184-185)

inmates picking cotton in "A mounted guard keeps close watch over inmates from the Mississippi State Penitentiary in Parchman" 1989* William Albert Allard (Through 376)

items at an auction in "Farm auction, Chariton, Iowa" 1984* Jeff Jacobson (Eyes \39)

lettuce growing on a government-built migrant camp in "Vegetable garden in camp" 1940 Arthur Rothstein (Documenting 194b)

line of tractors traveling through farms in protest in "Six miles of tractors move from Kismet, Kan., to Plains, Kan., in concert with national farm demonstration" 1985 Frank Niemeir (Best11 61)

long rows of trees in "Gaines Fig Farm (and detail)" 1926 Hugo Summerville (Szarkowski 146)

man and woman in field in "Field Hands on a Cotton Plantation, Green County, Georgia" 1937 Dorothea Lange (Icons 70)

man in farm wife's dress, standing in field, holding a gun in "Marlon Brando" 1976* Mary Ellen Mark (Rolling #24)

man on tractor as brush fire blackens sky in "Farmer watches a brush fire roll across his land in Brevard County, Fla." 1985 J. Gillis Courson (Best11 56a)

man plowing with horses in "The Husbandman" 1919 O. C. Reiter (Peterson #86)

many men harvesting the field in "Harvesting, Dalrymple Farm, Red River Valley, Dakota Territory" 1877 F. Jay Haynes (Photography1 #V-17)

men in field in "In the Barley Harvest" 1888 Peter Henry Emerson (Rosenblum2 #281)

men picking lettuce in "A crew of thirty-five Filipinos cut and load lettuce" 1936 Dorothea Lange (Documenting 121d)

man standing by deserted farm buildings in "Foreclosed farmer, Battle Creek, Iowa" 1983* Jeff Jacobson (Eyes \38)

migrant worker man in field, carrying tall, filled basket on his shoulder in "Migration to Misery" 1969 Dallas Kinney (Capture 69)

migrant worker woman, sitting on her stoop in "Migration to Misery" 1969 Dallas Kinney (Capture 68)

mother and children sitting in shade of truck on cotton field in "The Cotton Patch" 1937 Ken O'Brien (Goldberg 9c)

old man crouching on field in "A migrant agricultural worker in Holtville" 1936 Dorothea Lange (Documenting 122a)

oxen and men in "Clearing Land with Oxen" c. 1900 Margaret Morley (Sandler 24)

photo essay on Honduran subsistence farmer and family in "De-pulping coffee beans in Honduras" 1997 Eugene Richards (Best23 32-35)

photo essay on the auctioning off of family farm in "Selling the Farm" 1998 Bill Greene (Best24 112-115)

pig in wagon being pulled in "A Romanian couple haul their pig to a neighbor's farm for breeding" 1990 Anthony Suau (Best16 179)

Pilgrim settlement reproduction covered in snow in "Pilgrim Winter" c. 1990* Erik Leigh Simmons (Graphis90 \93)

plowing behind a mule in "Houston or Erick Kennedy plowing" 1937 Arthur Rothstein (Documenting 152a)

plowing behind two horses in "Ploughman in Landscape" c. 1900 William James Mullins (National \61)

plows in "Two Plows" c. 1870 Photographer Unknown (Szarkowski 68)

pumpkins in field with family in "In the Pumpkin Field at Lewes" 1898 James Bartlett Rich (National \49)

rice-field with one tree in "Rice-growing village in Seoul, South Korea" 1988* Anthony Suau (Best14 58)

rows of celery in the ground in "Worker on a western Michigan celery farm fills in where the automatic planter missed" 1986 Brian D. Masck (Best12 143a)

sagging wooden house with wood pile in "The former home of the Pettways" 1937 Arthur Rothstein (Documenting 153c)

several log cabins on dry land in "Cabins and outbuildings on the former Pettway plantation" 1937 Arthur Rothstein (Documenting 150a)

sisal plants and worker in "A worker on a Kenya estate on the coast of the Indian Ocean begins harvesting sisal, one of the country's major exports" 1986* Robert Caputo (Best12 105b)

sugar cane farm and workers cutting cane in [cane workers] 1987 Chandra McCormick (Willis \269-\271)

threshing machine and men on mounds of hay in "Threshing" c. 1905 Elizabeth Ellen Roberts (Sandler 12)

thunderstorm and lightning over wheatfields in "Thunderstorm threatens wheatfields west of Dodge City" 1985* Cotton Coulson (Best11 41a)

tools on ground in [Farm tools] c. 1855 Photographer Unknown (Szarkowski 10)

two men looking at farm equipment in "A farmer about to be relocated shows his equipment to a prospective buyer, Los Angeles County" 1942 Russell Lee (Documenting 245c)

walking with a scythe in "The Reaper" 1901 Nicola Perscheid (Rosenblum2 #380)

woman bending to pick tomatoes in "Mexican migrant woman harvesting tomatoes" 1938 Dorothea Lange

(Fisher 20)

woman holding bucket near mound of hay in "[Mabel Williams] Bringing Water to the Threshing Crew" 1909 Evelyn Cameron (Rosenblum \55; Sandler 6)

woman holding plow in "Woman with Plough, Hamilton, Alabama" 1936 Margaret Bourke-White (Rosenblum \164)

woman in print dress leaning against house in "Alabama Cotton Tenant Farmer Wife" 1936 Walker Evans (MOMA 145)

women in corral with horses in "The Buckley Sisters in Their Corral" c. 1905 Evelyn Cameron (Sandler 7)

women picking grain by hand in "Lupac workers harvest grain for winter" 1993 Anthony Suau (Best19 25)

wood house, windmill, and withered crops in "Dustbowl farm, Coldwater district" 1938 Dorothea Lange (Fisher 27)

FASHION PHOTOGRAPHY

athletic clothing in [ad for athletic fashion] c. 1992* Daniel Wreszin (Graphis93 42)

babies holding carrots while on bench in "Farmers" c. 1989* H. Ross Peltus (Graphis89 \56)

baby playing with foot in [child in overalls] c. 1992* Linda Bohm (Graphis93 35)

back of evening gown in [a department store catalog] c. 1992* Joyce Tenneson (Graphis93 47, 49)

back of woman in evening gown with large bow in "Model Facing Jefferson Memorial" 1948 Toni Frissell (Sandler 164)

bathing suit in [fashion catalog] c. 1991 Peter Lindbergh (Graphis92 \42)

bathing suit in neon colors in [bathing suit in neon colors] c. 1992* Tak Kojima (Graphis93 43)

bathing suit in polka-dot fabric in "Forties Style Suits" 1990* Mary M. Kelley (Best16 141a)

bathing suits from [article on fashion] c. 1989* Gilles Bensimon (Graphis89 \40)

bathing suits in "Swimwear" c. 1991* Gilles Bensimon (Graphis91 \13-\16)

bicycle and rider leaning against a wall from [ad campaign for Nike shoes] c. 1989* Gary Nolton (Graphis89 \39)

Black and White couple walking from camera from [article describing fashion styles from the 1920s to 1950s] c. 1989* David Ken (Graphis89 \57)

black dress and large black hat and veil in "Black and White Vogue Cover" 1950 Irving Penn (Art \441)

black dress on mannequin in [mannequin and spiral forms] c. 1999* Todd Eberle (Photo00 26)

blouse with hood in [shimmering blouse and hood] c. 1992* Miko Lajcyk (Graphis93 37)

blurred evening gowns in [evening gowns] c. 1997* (Graphis97 50-51)

boy fixing tie in large mirror from [the Cashmere House in Milan] c. 1991 Martin Riedl (Graphis92 \29)

boy in tuxedo for [an article] c. 1990* John Curtis (Graphis90 \31)

boy swimming in "Swim shorts" 1995* George Miller (Best21 149a)

bracelets on model in "Silver cuff and bracelet" c. 1990* Sheila Metzner (Graphis90 \42)

bridal gown and veil being modeled in "Bride2" 1997* Michael MacMullan (Best23 145)

cape and skirt on model for [a fashion article in *Vogue Italia*] c. 1990* (Graphis90 \52)

car, cactus and men and women in [car, cactus and fashion] c. 1992 Klaus Kampert (Graphis93 25)

casual black-and-white striped dress in [black-and-white striped dress] c. 1997* Patrick Demarchelier (Graphis97 29)

children in paper hats and holding old books in [Japanese children in paper hats] c. 1991* (Graphis92 \24)

children in velvet suite and lace dress in [children's fashions] c. 1989* Frank Horvat (Graphis89 \26, \27)

coats and jackets from [ad for Dayton's department store] c. 1991* John Dugdale (Graphis91 \20-\23)

colorful shoes, skirt, and hat in "Colors: a Divertimento on the Theme of Black" 1989* Barry Lategan (Graphis89 \4-\6)

couple in [series of couturier Christian Lacroix] c. 1990* Françoise Huguier (Graphis90 \147)

couple dancing at top of steps in [self-promotional] 1990* John Dyer (Graphis90 \18)

couples walking by small plane in "For Mayon Company" c. 1990* Dieter Elsässer (Graphis90 \14)

dark gloves and dress and light colored hat in [formal wear] c. 1999* Philip Porcella (Photo00 44)

dark suit on woman in plaza in "Renée, The New Look of Dior" 1947 Richard Avedon (Goldberg 128)

design on shoe and black stockings in "Illustrate the texture of autumn shoe fashions" 1985* Erwin Gebhard (Best11 149d)

dress and shawl in [linen and knitted fabrics as elements of high fashion] c. 1992* Hans-Georg Merkel (Graphis93 24)

dress cut apart at midriff in "Cut to pieces" c. 1995* Nick Knight (Graphis96 44)

dress of large black-and-white squares in "Harlequin Dress" 1950 Irving Penn (Goldberg 126)

dress with sheer jacket, 3 images in [dress with sheer jacket] c. 1997* Javier Vallhonrat (Graphis97 31)

evening dress in "Evening dress by *Saint Laurent Rive Gauche*" 1989* Sheila Metzner (Graphis89 \17)

evening gown in [department store catalog] c. 1992* Joyce Tenneson (Graphis93 48)

evening gown in [Evening gown] c. 1997* Mary Ellen Mark (Graphis97 26)

evening gown bodice in "Decolletage worthy of a Gainsborough" c. 1995* Paolo Roversi (Graphis96 54, 55)

evening gown on one woman with her hand on other nude woman in "Two Tall Women" c. 1995* Richard Avedon (Graphis96 45)

evening gown skirt caught in wind in "Nadja Auermann" c. 1995* Herb Ritts (Graphis96 51)

evening gown with full bottom in "Rochas Mermaid Dress" 1950 Irving Penn (Art \443)

evening gowns at beach in "Sweet Dreams" c. 1995* Nick Knight (Graphis96 58-59)

evening gowns shown in places in a city in [Evening gowns] c. 1997* Dennis Hopper (Graphis97 18-19)

fabric designs on female nudes in [fabric designs superimposed on nudes] c. 1991* Don Penny (Graphis92 \39, \40)

floral dinner dress in "Dinner Dress by Panem" 1906* Reutlinger Studio (Rosenblum2 #635)

folded shirts from [catalog for Mustang apparel] c. 1991* Hans Hansen (Graphis92 8, 9)

fur coat on woman with a dalmatian in "Boom for Brown Beavers" 1939 Toni Frissell (Rosenblum2 #641)

girl and woman in Fall fashions in "Fashion with Pears" 1988 Rosanne Olson (Best14 96d)

girl in nautical dress in "Children's nautical fashion" c. 1991* Lauren Sorokin (Graphis91 \47)

girls in party dresses from [brochure for an exclusive children's clothing designer] c. 1991* Karen Levy (Graphis91 \43-\46)

half-nude woman in skirt in [ad for women's panty hose] c. 1990 Eric Michelson (Graphis90 \37)

handbags and shoes in [textured shoes, bag, and dress] c. 1997* Raymond Meier (Graphis97 32-33)

hat on woman in [woman in hat] c. 1992* Andy Thompson (Graphis93 33)

hats on women from [article on French fashion designer Christian Lacroix] c. 1989 Sarah Moon (Graphis89 \32)

hats on women from [article on hats and hat-makers] c. 1990* Ron Berg (Graphis90 \3, \4)

heavy necklace on dark dress in [Ferré's spring collection for Christian Dior] c. 1995* (Graphis96 40)

horse near woman in chaps in [ad for fashion by Ralph Lauren] c. 1989* Bruce Weber (Graphis89 \23)

in black dress in "Inspired by Genet's *Notre-Dame-des-Fleurs*" c. 1989* Michael Roberts (Graphis89 \30, \31)

in dress of chiffon from [article on draped clothing] 1989* Javier Vallhonrat (Graphis89 \10)

in underwear serving breakfast from [ad for underclothing] c. 1989* Ivo V. Renner (Graphis89 \44)

jacket with squares of color in "Untitled" 1944* John Rawlings (Rosenblum2 #643)

jeans on a clothesline and a coat rack in [ladies lightweight jeans] c. 1991* Marvyi (Graphis92 \35, \36)

jewelry being modeled in "Chanel brooch" 1996* Al Schaben (Best22 176d)

jewelry highlighted on nude model in "Cheryl Moody's Jewelry" c. 1991 Harry Wade (Graphis92 \156-\158)

lace color on model in "The Big Game" 1989* Steven Klein (Graphis89 \7)

large hat to show off makeup from [article on new makeup colors] c. 1989* Marianne Chemetov (Graphis89 \58)

leather jacket on woman for [fashion trade show in Spain] c. 1992* Monica Rosello (Graphis93 50)

lingerie on woman head down in chair in "Handmade lingerie" c. 1990* Alen MacWeeney (Graphis90 \58)

male model from [fashion collection of Augostino Nori] c. 1990 Sergej Kischnick (Graphis92 10)

male models near Africans in native dress from [article on men's fashions] c. 1989 Aldo Fallai (Graphis89 \22)

man and boy sitting on old airplane in "Men's fashion photographed on an old private airport" c. 1991* John Goodman (Graphis91 \62)

man biting a flower in "Editorial on men's fashion" c. 1991* John Chan (Graphis91 \56)

man in coat facing the surf in "Men's coat" c. 1991* Albert Watson (Graphis91 61)

man in suit holding two dogs by a leash in "The Anglophile character of the Fall/Winter Collection by McGregor" c. 1991* Jürgen Kriewald (Graphis91 \54)

man in swim suit on beach in "Just add water" c. 1991* Nadav Kander (Graphis91 \50)

man in trench coat and reading a map for [Austrian fashion house] c. 1992* Jost Wildbolz (Graphis93 44)

man in white suit from catalog for [Byblos] c. 1989* Albert Watson (Graphis90 \12)

man in yellow coat and hat in "The Tracy Look" 1990* Ted Jackson (Best16 144b)

man sitting on bench in "When in *Tlaquepaque* do as the Tlaquepaguians do" c. 1991 George Petrakes (Graphis91 \55)

man standing by discarded material for [self-promotional] c. 1991* George Whiteside (Graphis91 \58)

man with hand on ceiling for [fashion feature on what famous people would wear] c. 1991* Josef Astor (Graphis91 \57)

matching dress and long gloves in "Sundress Sweet" 1990* Daniel Anderson (Best16 143)

matching dress and upholstered chair in "From Sofas to Sundresses" 1990* Guy Reynolds (Best16 144a)

men at hotel desk from [Spring/Summer fashion catalog] c. 1991* Amyn Nasser (Graphis91 \49)

men and women exercising from [sportswear catalog] c. 1990* Sue Bennett (Graphis90 \47-\50)

men's coats and suits from [article on men's fashion] c. 1989* Fabrizio Gianni (Graphis89 \54, \55)

metallic pieces to form dress in "Donyale Luna in Dress by Paco Rabanne" 1966 Richard Avedon (Rosenblum2 #651)

model in "Fashion photograph for the *Wiener Werkstätte*" 1921 Madame D'Ora (Rosenblum \114)

model leaning against a jukebox in "Hand-painted backgrounds, hand-colored prints and period props highlight a fashion series on the look that's new–déjà vu" 1987* Gary Chapman (Best13 179b)

model on top of hill in "Beauty and Nature" c. 1991* Rick Rusing (Graphis91 \19)

models in evening wear in "Evening wear" c. 1990* Sheila Metzner (Graphis90 \43, \44)

models in fall dresses in "Several yards of cheap muslin and seven well-paid models show the season's new dress shapes" 1987* Gary S. Chapman (Best13 178a)

models on ice skates from [ad for Amadeus Fashions] 1989 Rafael Betzler (Graphis89 \12, \12a)

models outside motels from [ad for Bluemarine] c. 1988* Albert Watson (Graphis89 \49-\52)

necktie with squares of many colors from [the series *Photographic Paintings*] c. 1992* Chris Meier (Graphis93 41)

nightshirt in "nightshirt" c. 1989* Joyce Tenneson (Graphis89 \16)

nude woman brushing hair from [advertising for hair care] c. 1990* Leonard Fradelizio (Graphis90 \25)

open net as blouse in "Light weight summer wear" c. 1991 Andrew Macpherson (Graphis91 \41)

ornate room full of women with notebooks watching model in hat in "New York" 1964 Elliott Erwitt (MOMA 231)

pants and a shirt wrapped in tissue paper from "an article on fashion entitled 'Cottonwear' " c. 1989 Nicoletta Giordano (Graphis89 \41, \42)

petticoat in "petticoat" c. 1989* Joyce Tenneson (Graphis89 \15)

polka dot dress in "As he likes it" c. 1990* Sheila Metzner (Graphis90 \45)

polka dot dress in "Nikki" c. 1997 T. C. Reiner (Graphis97 35)

polka dots and checkerboards in "A Different Stripe" c. 1991* Sheila Metzner (Graphis91 \32)

raindrops on man's suit in "Teflon Suits" 1996* Kenneth D. Lyons (Best22 176a)

raincoat filled with air in "Let's not get too logical" 1990* Irving Penn (Graphis90 19)

red-and-white striped dress on woman on sofa in [red-and-white striped dress] c. 1997* Patrick Demarchelier (Graphis97 36)

red dress and hat on young woman jumping in "The Young Fashion" c. 1999* Vlado Ba a (Photo00 49)

red shoe splashing color on white shoes in "Illustrate the drama and verve of red shoes" 1985* Craig Trumbo (Best11 149b)

red sweater in "Seeing Red" c. 1991* Albert Watson (Graphis91 \1)

scarf of gauzy material outstretched from woman's face in "Scarves" 1992* John Samora (Best18 174)

seated woman in blue evening gown from [ad for Bloomingdales] c. 1990* Deborah Turbevbille (Graphis90 \23)

seated woman in pink suit from [ad for clothing by Barry Bricken] c. 1990* Clint Clemens (Graphis90 \16)

seated woman in red-and-white polka dot dress spread around her in "Show how to dress for the hot south Florida climate" 1985* Murrary Sill (Best11 149a)

seated woman in white slacks and blouse in "White fashion in *Vogue*" c. 1990 (Graphis90 \51)

seated woman smoking for [fashion catalog] c. 1990* Nick Knight (Graphis90 \30)

sheer jacket with hood for [department store catalog] c. 1992* Joyce Tenneson (Graphis93 46)

sitting on bed from [ad for Michelle Marc] c. 1989* Andrea Blanch (Graphis89 \59)

skirt in [Guess? Fall collection] c. 1991 Dominick Guillemot (Graphis92 \27)

smoking on steps in "Schiaparelli Beachwear" 1930 George Hoyningen-Huene (Marien \5.43)

socks in rainbow colors in "Socks Appeal" 1990* Daniel Anderson (Best16 142b)

socks with stripes on a clothesline in "A Leg Up" 1988 Betty Udesen (Best14 96a)

standing by a mirror in [Ferré's spring collection for Christian Dior] c. 1995* (Graphis96 41)

striped jacket and tall hat from [ad for *Comme des Garçons* fashions] 1989* Minsei Tominaga (Graphis89 \11)

striped silk suit in "French Bastille Day in fashion" c. 1991* Steve Hiett (Graphis91 \2)

sunglasses on man in waiting room in [catalog for new fall fashion] c. 1992 John Huet (Graphis93 51)

sweater set in [twin sweater sets] c. 1989* David Seidner (Graphis89 \25)

sweaters on men in [men's sweaters] c. 1997* Phillip Dixon (Graphis97 34)

swimming trunks on tribesmen in [Hulis men, a tribe from Papua, wearing swimming trunks] c. 1991* Yann Arthus-Bertrand (Graphis92 \37)

tie on figure from a series about ties c. 1990* Alan David Tu (Graphis90 \22)

touching her toes in spiked heels in [magazine cover] c. 1989* Stan Malinowski (Graphis89 \60)

turtleneck sweater and coat from [ad for fashions of the *Complice* brand] c. 1989* Marc Hispard (Graphis89 \18)

two-piece bathing suit on woman underwater in [two-piece bathing suit] c. 1997 Enrique Badulescu (Graphis97 38)

wedding dress on seated woman in "Wedding Dress Modeled by Helen Lee Worthing" 1920 Baron Adolf De Meyer (Rosenblum2 #636)

woman carrying trench coat [for fashion designer Caren Pfleger] c. 1991* Ulrich Pfleger (Graphis92 \15)

woman casting shadow on wall for a fashion article in *Vogue Italia* c. 1990 Albert Watson (Graphis90 \34)

woman holding fire hose in [calendar page inspired by the artist Alberto Vargas] c. 1995* T. C. Reiner (Graphis96 36)

woman in backless dress "Dress by Yves Saint Laurent" c. 1990* Sheila Metzner (Graphis90 \40)

woman in castle in [untitled] c. 1999* Dmitry Vlasenkov (Photo00 40-42)

woman in black dress with sash posing between elephants in "Dovima with Elephants" 1955 Richard Avedon (MOMA 229)

woman in black jacket and pants in "Black Magic" 1988 J. Kyle Keener (Best14 97a)

woman in blue suit in "Take off on painter Otto Dix" c. 1990* Petra Bohne (Graphis90 \36)

woman in brown suit, hat and gloves in "For a walk on the wild side, leopard trim complements an elegant suit" 1987* Don Ipock (Best13 182d)

woman in dark, tight dress photographed against floral pattern in "The Covert Look" 1949 Louise Dahl-Wolfe (Rosenblum \6; Rosenblum2 #646; Sandler 167)

woman in empty room from [ad for Loretta di Lorenzo] 1989* Deborah Turbeville (Garphis89 \8, \9)

woman in fish tank in "Woman in Fish Tank" 1941 Toni Frissell (Goldberg 130)

woman in gondola in "Spring Fashion Dreams #1" 1995* G. Andrew Boyd (Best21 151a)

woman in grey dress in [untitled] c. 1995* Sheila Metzner (Graphis96 28)

woman in large coat in "A model displays designer Issey Miyake's high-fashion coat" 1985* Gilles Tapie (Best11 157a)

woman in long gown in "The Model" c. 1933 Man Ray (Hambourg \38)

woman in short white dress in [untitled] c. 1995* Sheila Metzner (Graphis96 29)

woman in suit [for an Austrian fashion house] c. 1992* Jost Wildbolz (Graphis93 45)

woman in suit with large shawl and hat in "Régine (Balenciaga Suit)" 1950 Irving Penn (MOMA 195)

woman in white linen suit in "Linen suit by George Versace" c. 1990* Sheila Metzner (Graphis90 \41)

woman on platform in "Jumping at one's own risk" c. 1991* Jost Wildbolz (Graphis92 \31)

woman on sand dune in "Dune Magic" 1990* Daniel Anderson (Best16 141d)

woman reclining in brown dress in "Brown is the theme" 1989* Susan Metzner (Graphis89 \3)

woman screaming in "Jeremy Scott fashion show, Paris" 1997 Stephen Dupont (Best23 236)

women in brightly colored dresses looking at window in [ad for evening wear by fashion designer Emanuel Ungaro] 1989* Deborah Turbeville (Graphis89 \13)

women kneeling in mini-dresses in "Knit Minidresses" 1967* (Life 117)

women on fashion show runway in "Fashion Models in China" 1997* Michael S. Yamashita (Through 6)

women recreating *Last Supper* in "Last Supper" c. 1995* Frank Herholdt (Graphis96 57a)

FEET *see* FOOT

FENCES

filled with duplicate pictures of young women in "Beauty" 1995-1996 Rosemarie Trockel (Marien \8.2)

girl holding barbed wire in "A Cambodian girls stares beyond a barbed wire fence surrounding the refugee camp where she lives in Thailand" 1987 Bill Greene (Best13 2)

man jumping over picket fence in "Man Jumping Fence" 1889 Ellen Andrus, attribution (Photography1 \81a)

picket fence posts in "Number 10" 1958 Walter Chappell (MOMA 211)

woman standing by barbed wire fence in "When the Sinai peninsula was returned to Egypt by Israel in 1982, the new boundary sliced through Rafah" 1990* James Nachtwey (Best16 41)

FENCING

fencer getting jabbed in "Dale Schrauth takes a jab from his instructor while practicing epee fencing" 1988 Caol Cefaratti (Best14 124d)

fencers with a strobe flash in "Two Fencers" c. 1991* Alain Ernoult (Graphis91 \364)

head of kendo fighter in "Japanese Kendo fighter in a traditional outfit" c. 1991* Dirk Karsten (Graphis92 \150)

Japanese kendo fencers in "Wellington Kendo Club, Waitarere" c. 1999* Michael Hall (Photo00 127)

woman in fencing attire as if dancing in "Fencer" c. 1999* Mel Lindstrom(Photo00 102)

FERRIES *see* BOATS AND BOATING

man holding gun on man with knife at woman's throat in "Hollywood Fatality" 1973 Anthony K. Roberts (Capture 85)

man holds launcher barrel through wall in "Moslem gunner rests his hand on a 75mm rocket launcher as he peers toward Christian east Beirut" 1985 Herve Merliac (Best11 120b)

man in farm wife's dress, standing in field, holding a gun in "Marlon Brando" 1976* Mary Ellen Mark (Rolling #24)

man on steps with rifle in "William Eggleston, Memphis" 1988* Maude Schuyler Clay (Women \163)

man pointing gun at camera in [man pointing gun at camera] c. 1997 Robert Maxwell (Graphis 97 110)

men shooting from corner of building in "Street fighting in Juárez" 1911 James Hare (Lacayo 40d)

police at target practice in [pistol and rifle team] c. 1999* James Salzano (Photo00 192)

police officer showing elderly woman how to hold a gun in "Youngstown police Officer Robert Hawkins shows Jean Westveld how to aim a handgun" 1990 Christine Keith (Best16 109a)

police officers after a shooting in "Fifteen seconds after fatally wounding a gunman in a downtown office building, Pittsburgh policeman is comforted by a fellow officer" 1985 John Kaplan (Best11 80)

several guns displayed on bed by masked man in "IRA gunman displays armaments" 1972* Stephen Shames (Eyes \22)

shirtless man aiming handgun in "Randy Travis, Nashville" 1987* Annie Leibovitz (Women \160)

South Vietnamese general shooting a Viet Cong prisoner in the head in "Viet Cong Execution" or "Execution of a Viet Cong Suspect, Vietnam" 1968 (Capture 64; Eyes #300-302; Goldberg 174; Lacayo 156; Marien \6.72; Monk #42; Photos 115)

FIREPLACES

old couple near pot on fire and set table in "Couple at Home" 1899 Frances Benjamin Johnston (Sandler 75)

FIRES AND FIRE FIGHTERS

aerial view of burned-out neighborhood in "Police work with crane to search for evidence in the burned-out neighborhood, Philadelphia" 1985 Chuck Isaacs (Best11 25a); "The search for evidence continues at the scene of the MOVE confrontation" 1985 George Widman (Best11 25b)

African American Reverend sitting with Bible by burned-out church building in "You Can Burn the Building, But Not the Spirit, Charlotte, North Carolina" 1996 Jason Miccolo Johnson (Committed 137)

airplane passing over fire in canyon in "A DC-6 dives into a canyon at Yosemite National Park to fight a huge forest fire that threatened the park" 1987 Jim Byous (Best13 75b)

ashes and ruins of a city in "After the Great Fire of Hamburg" 1842 Carl Ferdinand Stelzner (Eyes #3; Lacayo 18a); "Ruins of Hamburg Fire" 1842 Hermann Biow (Marien \2.25)

at demonstration with riot police in "Demonstrations by students on the streets of Seoul" 1988* Anthony Suau (Best14 59a)

Berlin's Reichstag on fire in "Reichstag Fire, Berlin" 1933 Photographer Unknown (Photos 47)

black smoke-filled sky over a beach in "Smoke rises from the Oakland Hills fire in the distance as sunbathers enjoy the afternoon in San Francisco's Dolores Park" 1991 Wendy Lamm (Best17 107b)

body covered in oil as fires burn at horizon in "Victims of the war in the desert surrounding Kuwait City" 1991* Steve McCurry (Goldberg 212)

bonfire and students in "Students cheer after adding fuel to a bonfire" 1992 David Yee (Best18 134d)

burn victim's ordeal in therapy in "Charlie's ordeal" 1985 Tom Sweeney (Best11 130-131)

burned out trees and woman planting rice seedlings in "Indonesian Forest Fires" 1997 David Portnoy (Best23 207a,c)

burned out block of buildings in "Blake Block, Brattleboro, After the Fire" 1869 Caleb Lysander Howe (National 153b)

burning body of one of Somoza's National Guard in "A funeral pyre in Nicaragua" 1979* Susan Meiselas (Lacayo 176b)

burning mill in "Mill fire in Oswego, New York" 1853* George N. Barnard (Eyes #5-6; Lacayo 20; Marien \2.26; Photography1 \2; Rosenblum2 #188)

burning stables in "An employee at Churchill Downs tries to get firefighters to save horses still trapped in the burning building behind her" 1986 Pat Mc Donogh (Best12 78)

cat and wagon, after a fire in "Badly burned but purring loudly, this cat waited for her owners to return after a devastating forest fire" 1985 Eric Luse (Best11 101c)

child with burns in "Out of the Ashes" 1996* R. Todd Wharton (Best22 235c)

crowd of firefighters from above in "Chicago firefighters cluster around the body of one of three comrades killed in a fire in northwest Chicago" 1985 Tom Cruze (Best11 100c)

deck of the *Intrepid* burning in "Firefighters of the U.S.S. *Intrepid* battling blazes caused by kamikaze hit during the battle for Leyte Gulf" 1944 Barrett Gallagher (Eyes #220)

fire truck near block of houses in flames in "A West Philadelphia residential block goes up in flames" 1985

Bruce Johnson (Best11 24)

firefighter being held back in "Fireman is both restrained and comforted after he attempted to reenter a burning building where a fellow firefighter perished" 1997 Dayna Smith (Best23 121b)

firefighter giving mouth-to-mouth to baby in his arms in "Giving Life" 1988* Ron Olshwanger (Capture 151; Graphis92 \50)

firefighter holding hose as fire destroys house in "Only a photograph could capture the emotions displayed by firefighter Tammy Corcoran as fire destroys the Elterich home" 1985 (Best11 99a)

firefighter in life vest helping girl in flood waters in "Teen Rescued from Flood Waters" 1996* Annie Wells (Best22 224d; Capture 184)

firefighters speaking with child in "With his mother at his side, 3-year-old talks to fire department battalion chief after using a lighter to ignite a mattress" 1997* Robert Cohen (Best23 119d)

fireman stands on steps overlooking rubble of city in "An arsonist's fire destroyed virtually the entire industrial area of Passaic, N.J." 1985 Nick Kelsh (Best11 98d)

firestorm passing homes in "Susan Stanfield watches a firestorm sweep near her home at midnight" 1993* Richard Hartog (Best19 186a)

flames rushing through window in "New Wilmington volunteer firefighters retreat from flames that exploded through a window at the home of an Amish farmer in Pennsylvania" 1990 Bill Lyons (Best16 106d)

forest burning in "Amazon rainforest ablaze" 1997* Harald Herzog (Photos 152)

four firefighters taking a break on charred brush in "Lull in the Battle" 1974 Gerald H. Gay (Capture 90)

holding bloodied, dead child in "Oklahoma City Bombing" 1995* Charles H. Porter IV (Capture 180; Lacayo 188a)

horse-drawn fire truck racing down street in "Steam-powered engine races to a fire" 1910 Barney Roos (Lacayo 39c)

hosing down a grass fire viewed from above in "Firefighters battle a spreading grass fire in Palo Alto, Calif." 1985 Sam Forencich (Best11 98a)

hosing down burning tires in "Firefighters fighting a four-hour blaze at a tire storage sending black toxic smoke billowing over Louisville's skyline" 1985 Pat McDonogh (Best 100b)

house after a fire in "Out of the Ashes" 1996* R. Todd Wharton (Best22 235a)

house completely ablaze in "A woman cries as her neighbor's house burns" 1993* Mark J. Terrill (Best19 185b)

intentional burn on the prairie in "Two prairie restorationists appear through the heat of an intentional prairie burn" 1988* Richard C. Sennott (Best14 101b)

legs of firefighter going through window in "A firefighter crawls into the attic of a burning home in an effort to avoid fumes from the blaze" 1985 John Dunn (Best11 171a); "A firefighter goes into a small attic window to put a line on a fire caused by faulty electrical wiring" 1985 Charles S. Vallone (Best11 171b)

looter running in front of burning store after Rodney King verdict in "Rioting in Los Angeles" 1992* Ed Carreon (Best18 127; Lacayo 182; Life 163)

man on tractor as brush fire blackens sky in "Farmer watches a brush fire roll across his land in Brevard County" 1985 J. Gillis Courson (Best11 56a)

monk burning to death in "A Buddhist monk burns himself to death to protest the Diem government in South Vietnam" 1963 Malcolm Browne (Goldberg 162; Lacayo 129)

musician setting his guitar on fire in "Jimi Hendrix at the Monterey Pop Festival" 1967 Ed Caraeff (Life 173d)

oil on the ground burning in Kuwait in "Environmentalist examines a field where the ground has become encrusted with oil" 1991* Steve McCurry (Best17 20)

oil wells burning in "In July 1991, oil wells in Burgen field still burn" 1991* Christopher Morris (Best17 39)

oil wells burning behind camels in "Camels search for food as Kuwait's oil wells burn" 1991* Bruno Barbey (Best17 12b); "Camels search for untainted shrubs and water in the burning oil fields of southern Kuwait after the Persian Gulf war" 1991* Steve McCurry (Best17 173)

panorama of city ruins in "Ruins of Boston fire" 1872 James Wallace Black (Eyes #37; Photography1 \67)

people standing amidst ruins of a city "Ruins of the Boston fire" 1872 James Wallace Black (Eyes #37)

people watching fire from across a canal in "Residents of Golden Gate, Fla., watch as flames destroy trees and brush across a canal from their homes" 1985 Eric Strachan (Best11 101a)

race car in flames in "Mike Laughlin, Jr., crawls away from his blazing race car after he crashed" 1996* Jim Virga (Best22 204c); "Trapped in his car after crashing" 1996* Chuck Fadely (Best22 204a)

remains of a home covered in ice in "4 persons died in this mid-winter blaze in Chicago" 1985 John Dziekan (Best11 99b)

riding a bicycle near a burning store in "Before Phoenix firemen start their attack on a tire company fire, a child rides his bike dangerously close to the fire" 1995* Patrick Witty (Best21 97d)

sequence of photographs of the burning of the *Hindenburg* in "Amateur sequence of photographs of the burning of the *Hindenburg*" 1937 Arthur Codfod, Jr. (Eyes #171)

sequence of photographs of the burning of the *Hindenburg* "Death of a Giant: The Exclusive Colorphoto Record of the Destruction of the *Hindenburg*" 1937* Gerard Sheedy (Eyes \2)

series of photographs of oil well fires in "Darkness over Kuwait" c. 1992* Arthur Meyerson (Graphis93 55)

series showing people escaping from burning house in "Dorchester fire" 1986 Stan Forman (Best12 24-25)

skyscraper on fire in "Los Angeles' tallest building burns out of control" 1988 James Ruebsamen (Best14 10a)

small brick home engulfed in flames in "A two-alarm blaze roars out of control in downtown Bowling Green, Kentucky" 1995* Scott Panella (Best21 156b)

smoke engulfing oil complex in "Smoke and flames envelop Shell Oil Co.'s Wood River complex in Illinois" 1985 John Badman (Best11 98c)

swimming pool water to put out a raging house fire in "Because of a lack of water to fight a house fire, a firefighter sets up a Floto Pump to use pool water instead" 1995* Kent Porter (Best21 192b)

three-story building consumed by flames, as men in street watch in "Market Street, San Francisco" April 18, 1906 Willard Worden (MOMA 76)

townspeople with fire hose in "Fighting a grass fire" 1941 Russell Lee (Documenting 216a)

volunteers and forest fire in "Volunteer firefighter takes a break during a forest fire in Lee County" 1987 Charles Bertram (Best13 75a)

walking across ladder to "rescue" a Muppet in "Newark firefighter rescues a *Sesame Street* character during taping of a fire-safety video" 1990 Gerald P. McCrea (Best16 167b)

wall collapsing from fire in "Firefighters flee a rooftop as a church wall begins to collapse toward them" 1944 Dwight Boyer (Best18 13)

woman walking away from dark billowing smoke in "Minneapolis Fire" 1962 Irwin Klein (MOMA 244)

Yellowstone National Park forest burning intensely in "Two firefighters study the south flank of Yellowstone National Park's Storm Creek inferno after it jumped fire lines" 1988* Craig Fujii (Best14 10c)

FIREWORKS

filling sky over river and bridge in "Happy 100th, Brooklyn Bridge" 1983* Henry Groskinsky (Life 76)

flag on porch over children with sparklers in "Independence Day" 1954* Nat R. Farbman (Life 70)

in Sydney's harbor in "Australia welcomes the New Year with a spectacular fireworks display, lighting up Sydney Harbor and the renowned Opera House" 1982* Annie Griffiths Belt (Through 400)

surrounding the Statue of Liberty in "Fireworks over the Statue of Liberty during Liberty Weekend" 1986* Rick Friedman (Best12 97)

FISHES *see also* FOOD

black cod underwater in "A 150-pound black cod lives in a sunken Japanese fishing ship at New South Wales" 1991* David Doubilet (Best17 175a)

crabs and fish in boxes in "Diptych with Fish and Crabs" c. 1999 Craig Cutler (Photo00 57)

distorted underwater in "Swimmin' with the fish" 1992* Jay Koelzer (Best18 166d)

fish in plastic wrap in "Ocean perch" c. 1991* Hans Hansen (Graphis91 \140)

fishing flies on the body of a fish in "U.S. President Grover Cleveland's Flies on an Atlantic Salmon" c. 1991* Terry Heffernan (Graphis91 \135)

fly-fishing equipment in "Andrew Carnegie's Fly-fishing Equipment" c. 1991* Terry Heffernan (Graphis91 \125)

goldfish all over a green bedroom in "Revenge of the Goldfish" 1991* Sandy Skoglund (Marien \7.50; Photography2 194)

goldfish in bowl on ledge overlooking sea in "Santorin" 1937 Herbert List (Hambourg \123; San \27)

head of a fish in [head of a fish] c. 1995* Paolo Marchesi (Graphis96 81)

lines of fish and lemon slices in "Well-schooled fish know that citrus imparts a piquant treat to the palate" 1987* David Woo (Best13 186a)

many species in a lagoon in "Fish swim in a lagoon at Lord Howe Island" 1991* David Doubilet (Best17 175b)

sea horse in "Natural History (Seahorse)" 1930 Man Ray (Hambourg 105)

sea horses clinging to reeds in "Anchored to twigs and grasses by their tails, tiny sea horses drift with the currents in waters off Australia" 1994* (Through 409)

skate camouflaging itself in "Only four inches long, this baby clear-nose skate has already gained its ability to camouflage itself with shades of red, blue and yellow" 1996* Richard Haberkern (Best22 190b)

small fish and jellyfish in "Small fish seek safety amid the kinks, frills, and tentacles of jellyfish in the Tasman Sea" 2000* David Doubilet (Through 412)

small fish in front of large sunfish in "Awaiting scraps, three hungry pilot fish swim just ahead of a hundred-

pound ocean sunfish in the Pacific Ocean" 1993 Richard Herrmann (Best19 114)

stingray in crystal-clear water in "A stingray flaps its fins like wings in the sky-clear waters of North Sound, off Grand Cayman Island" 2000* David Doubilet (Through 392)

swimming in a plastic bottle at the beach in "Holy Water" 1998* Wendy Sue Lamm (Best24 54d)

tail of a fish in [tail of fish] c. 1995* Paolo Marchesi (Graphis96 220)

three out of water in "Fresh Fish" 1998* Bob Fila (Best24 49)

tropical fish in "Golden Butterfly Fish" c. 1999* Mark Laita (Photo00 225)

under glass plate on table in [fish, lemon and tableware] c. 1991* Nob Fukuda (Graphis92 17)

underwater in [fish] c. 1995* Michael Melford (Graphis96 192)

underwater view of boots and fish in "Trout fishing in Patagonia" 1988* Jose Azel (Best14 103)

underwater view of weedyseadragon in "Cold, deep and remote waters are filled with fanciful creatures such as the weedyseadragon" 1997* David Doubilet (Best23 162b)

with open mouth in [fish] c. 1999* Jody Dole (Photo00 202)

women carry tray of small fish in "At dockside, Latvian women proudly display salmonlike sea trout" 1924 Ernest Peterffy (Through 66)

wrapped in lace in [self-promotional] c. 1991* Gaby Brink (Graphis92 \90)

wrapped in paper in [fish] c. 1989* Kathryn Kleinman (Graphis89 \319)

FISHING

antique rod and reel in "Antique fishing equipment" c. 1991* Ira Garber (Graphis91 \101)

birds used to catch fish from boat in "Tethered and collared, cormorants catch and disgorge fish into a boat in Japan" 1936 W. Robert Moore (Through 178)

children at stream in "Young Anglers" 1896 John Bullock (Photography1 \99)

children fishing in a canal from a series of baskets in "Children on a Fish Weir, Venice" c. 1870s Carlo Naya (Rosenblum2 #274)

children fishing off wooden dock extending into lake in "Children Fishing" c. 1900 William James Mullins (Waking 332)

dead shark in a boat in [dead shark in a boat] c. 1991* John Running (Graphis92 \229)

fish farm with thatched huts in "Lake Sebu, in the Southern Philippines is a breeding spot for fish" 1996* Debra Bicking-Byers (Best22 182d)

fisherman holding net near boat in "Fishermen use nets to harvest the waters off Newfoundland" 1974 Sam Abell (Through 368)

group pushing a boat onto the beach in "Beaching a Fishing Boat, Greece" c. 1963 Constantine Manos (Rosenblum2 #617)

man in tuxedo fishing off a pier in "Pricey catch" 1988 Anne Lennox (Best14 109b)

man standing in beached rowboat in "Untitled" 1964 Herbert Randall (Committed 176)

man standing in small boat in "Small bay and swaying cattails" c 1991 Kevin Hutchison (Graphis91 \298)

man throwing a net into the water in "A victim of river blindness fishes with the help of a child and a stick in Mail, Africa" 1996 Tom Stoddart (Best22 172c)

men fishing from beach in "Fishermen take to the shore at Montauk Point, Long Island" 1996* Pete Souza (Best22 189b)

men fishing from walk in "Fishermen near Washerwoman's Boats" c. 1905-1910 Seeberger Frères (Rosenblum2 #318)

men holding a large fish near a wooden shack in "Hemingway's Double with a Fish" c. 1991* Serge Cohen (Graphis91 \156)

men on banks of river in "Fishing on the banks of the Seine is a favorite pastime for Parisians" 1936 W. Robert Moore (Through 104)

men on small fishing boat on beach in "Fishermen Unloading a Boat, Sea Bright, New Jersey" 1887 Louis Comfort Tiffany (National \45)

men on wooden poles in the ocean in "Like outlandish herons, a flock of men fish the Sri Lankan south coast on their traditional wooden perches" 1996* Steve McCurry (Best22 171a)

men standing with nets on long poles in river in "Cascades of Columbia" c. 1885 F. Jay Haynes (Photography1 \11)

sitting in easy chair on river bank in "Jack Baaker on the best fishing hole in the Sacramento River" 1986 Gary B. Miller (Best12 156b)

sitting on pole in icy lake in "Angler in Chicago's Lincoln Park Lagoon" 1986 Al Podgorski (Best12 156a)

FLAGS

guard at China's flag at half staff in "A member of the People's Armed Police Honor Guard stands at attention as the flag commemorating the death of Deng Xiao Peng hangs at half staff" 1997 Steve Lehman (Best23 120)

Israeli settlers waving Israeli flag in "Gaza: Where Peace Walks a Tightrope" 1996* Alexandra Avakian (Best22 242a)

Mexican woman carrying a dark flag in "Woman with Flag" 1928 Tina Modotti (Photography 119)

Soviet flag held by soldier on top of ruins of the Reichstag in Berlin in "The Reichstag" or "Raising of the Hammer and Sickle over the Reichstag" 1945 Yevgeny (Evengii) A. Khaldei (Icons 99; Marien \5.87; Rosenblum2 #601)

FLAGS, AMERICAN

across porch-front in "With patriotic pride, a resident of a blue-collar neighborhood displays a large U.S. flag and a big American-made automobile" 1991* Nathan Benn (Through 364)

African American woman in front of office flag [in manner of Grant Wood] in "Ella Watson" or "American Gothic" 1942 Gordon Parks (Committed 168; Documenting 234-235; Goldberg 103; Marien \5.58)

along wall at memorial service in hanger in "Memorial services for the soldiers are held in a hanger at Ft. Campbell" 1985 Charles Steinbrunner (Best11 51a)

behind girl and woman wearing patriotic dresses in "Nellie G. Morgan and Tammie Pruitt Morgan, Granddaughter, in Their Bicentennial Outfits Made by Mrs. Morgan, Kemper County, Mississippi" 1976 Roland L. Freeman (Committed 102; Willis \239)

boy in suit and straw hat holding a flag "Boy with Straw Hat Waiting to March in a Pro-War Parade, New York City" 1967 Diane Arbus (Icons 159; MOMA 237)

bullets and guns depicting the American flag in "This bullet-spangled banner takes aim at America's love affair with weapons" 1987 Sig Bokalders (Best13 143a)

cadets taking flag down in "The white-gloved cadets at Virginia Military Institute take down the flag at sunset" 1997 Nancy Andrews (Best23 19d)

children in wagon holding small flags in "Children's playground, Ellis Island roof garden" 1909 Augustus Sherman (Goldberg 35)

diver against backdrop of flag in "With his country's flag as a backdrop, Olympic diver Kent Ferguson practices at a pool in Florida" 1992* Bill Frakes (Best18 163)

divers silhouetted against flag in "Olympians practice in front of giant American flag" 1996* Bill Frakes (Best22 203a)

faded flag hanging over porch in [self-promotional] c. 1989* Harry De Zitter (Graphis89 \84)

family on hill waving flags to buses on highway in "Clinton-Gore supporters wave to the campaign bus as it travels to Centralia, Illinois" 1992* Toma Muscionico (Best18 78a)

50-foot by 95-foot flag on side of building in "Flag woven by millworkers at Manchester, New Hampshire" 1917 Harlan A. Marshall (Eyes #76; Lacayo 42)

flag patches on space suits with boots and gloves hanging on rod in "Apollo Training Suits" 1978* Hiro (Rolling #41)

flags behind Dr. Martin Luther King, Jr., as he marches in "Selma, Alabama, demonstrations and marches" 1965 Flip Schulke (Eyes #279)

flying from street lamp in "Decorations on the main street" 1941 Russell Lee (Documenting 225b)

girl waving small flag in "A girl on top of her father's shoulders waves her flag at President Clinton's helicopter" 1996* Beth A. Keiser (Best22 106a)

hanging over picnic area in "Fourth of July–Jay, New York" 1955 Robert Frank (Art \327; Eyes #242)

held by people standing on top of 4-story statue in the Philippines in "Ferdinand Marcos Takes a Fall" 1986 Kim Komenich (Capture 145)

honor guard at airport in "An Air Force honor guard escorts the remains of nine Americans brought home–after a decade–from Vietnam" 1985 Eric Luse (Best1 91b)

huge American flag being used as a kite in "American flag being flown at the annual kite festival" c. 1990* Bruce Hands (Graphis90 \74)

Kuwaiti kissing an American flag in "A Kuwaiti citizens kisses an American flag after the liberation of Kuwait" 1991* Christopher Morris (Best17 37)

large crowd holding small flags in "New York City" 1969 Garry Winogrand (Decade 76a)

man attaching flag to remains of home in "One Atlantican offers a symbol of hope by raising a flag over a ruined residence" 1985 Larry C. Price (Best11 66c)

man carrying flag from flagpole in "Edward Steichen" 1963 Bruce Davidson (MOMA 37)

man from Salvation Army with flag in "At the open-air meeting" 1939 Dorothea Lange (Documenting 173b)

men forming a shield with stars and stripes in "The Human U.S. Shield: 30,000 Officers and Men, Camp Custer, Battle Creek, Michigan" 1918 Arthur S. Mole and John D. Thomas (Hambourg 90c; MOMA 79)

Marines raising American flag in rubble in "Old Glory Goes Up on Mount Suribachi" or "Raising the Flag at Iwo Jima" 1945 Joe Rosenthal (Capture 16; Eyes #212; Lacayo 118; Marien \5.86; Monk #29; Photos 65)

Olympic winner greeted in front of large American flag by teammates in bleachers in "Olympics in Los Angeles" 1984* Hal Stoelzle (Capture 130)

on door over picture of sailor in uniform in "When her grandson, Robert Tames, left to fight in the Persian Gulf war, his picture was put on the front door" 1991 Michael Wirtz (Best17 75)

on moon by astronaut in "Apollo 11 Eva View" 1968 NASA (Goldberg 11)

on porch over children with sparklers in "Independence Day" 1954* Nat R. Farbman (Life 70)

one flag in crowd watching parade in "Armistice Day parade. Lancaster, Pennsylvania" 1942 Marjory Collins (Fisher 67)

park filled with children holding American flags in "School children of New York, observing Americanization Day in City Hall Park" 1917 Paul Thompson (Eyes #75)

protestors with flag from [series *Protest in the 1960s*] 1969 W. Eugene Smith (Decade 77)

sailors and stars in "Bicentennial Polka" 1975 Barbara Crane (Decade 86d)

sailors folding flag in "Judith and William Hansen grieve as a flag that covered their son's casket is folded by Navy pallbearers" 1987 Brian Walski (Best13 11b)

shirtless veteran waving flag in "A sudden downpour fails to dampen the patriotic spirit of flag-waving Chris Grisham at a May welcome home rally for Vietnam War veterans" 1987 Steve Campbell (Best13 112c)

small flags near woman sitting on ground, hugging tombstone in "Memorial Day" 1983* Anthony Suau (Capture 129)

upside-down flag at anti-Klan confrontation in "As the Ku Klux Klan marched through Charlotte, N.C., in September, bystanders shouted anti-Klan slogans" 1986 Candace Freeland (Best12 55d)

white student striking African American man with flag pole as crowd watches in "The Soiling of Old Glory" 1976 Stanley J. Forman (Capture 98; Lacayo 128; San #309)

wife with flag on lap, holding hands of her sons in "Arlington National Cemetery" 1991* Martin Simon-Saba (Life 64)

women standing at windows and flying flag in "Parade, Hoboken, New Jersey" 1955 Robert Frank (Eyes #237; MOMA 215; Szarkowski 258)

World War I veteran in uniform seated by an American flag in "Portrait of a 92-year-old veteran of World War I" c. 1990* Pete Stone (Graphis90 \177)

FLAGS, CONFEDERATE

African Americans marching past boy wrapped in Confederate flag in "Arcade" 1995 Peggy Peattie (Best21 226d)

photo essay on "migrant labor, re-enactors, and the status of integration in South Carolina" 1998 (Best24 166-167)

white students cheering and holding Confederate flag in "Segregationists at the University of Mississippi, Ole Miss., react to the imminent enrollment of James Meredith, the first black student at the university" 1962 Charles Moore (Best14 214)

THE FLATIRON BUILDING (New York, N.Y.)

from the street to the top in "Flatiron Building, New York" 1928 Walter Gropius (Hambourg \9)

night view in "Flatiron Building" 1904* printed 1909 Edward Steichen (Szarkowski 166); 1904* printed 1905 Edward Steichen (Rosenblum2 #336; Szarkowski 167)

snow-covered tree and park benches in foreground in "Flatiron Building" 1903 Alfred Stieglitz (Goldberg 20; Hambourg 6a; MOMA 83; Szarkowski 164)

street lights on as people walk in front of building in "Flatiron Building" 1912 Alvin Langdon Coburn (Szarkowski 165)

FLOODS

building a sandbag dike in "Pam Christian lies asleep from exhaustion after helping to build a sandbag dike during flooding in Des Moines" 1993* Jeff Beiermann (Best19 187a)

boat on water at tree-top level in "Small boat motors through the tree tops after winter rains flooded the area" 1996* Annie Wells (Best22 224a)

bus in flooded area in "Monsoon, Jaimahal, Jaipur" 1985* Mitch Epstein (Photography 113a)

cars driving through deep water in "A lot of wind combined with a lot of rain to provide an adventure in driving for motorists on Interstate 94" 1986 David Brewster (Best12 180b)

cars parked along flooded city street in "Main Street, Saratoga Springs, New York" 1931 Walker Evans (Art \303)

child saved from rushing waters by men on safety line in "Rescue workers struggle to keep tiny 1-year-old from falling into rushing waters" 1996* John McConnico (Best22 145)

city with flooded streets in "Lyons During the Floods of 1856" 1856 Édoaurd-Denis Baldus (Waking #55)

elderly couple in rowboat on flooded street in "[Elderly couple] take an aquatic route from their home after Lake Erie's windblown water threatened 100 family dwellings" 1985 Thomas J. Hawley (Best11 65a)

exhausted man sitting on window sill as he cleans up the mud in his home in "Trying to deal with the ruin torrential rains had brought to Kentucky" 1997 Michael Williamson (Best23 230b)

farmer holding piglets in "Farmer Norman Brown searches for day-old piglets during flooding" 1993* Marc Gallant (Best19 187b)

father carrying his son on his back through flood waters in "Flood waters" 1995* Thomas Alleman (Best21 214b)

firefighter in life vest helping girl in flood waters in "Teen Rescued from Flood Waters" 1996* Annie Wells (Best22 224d; Capture 184)

firefighter rescues a youth caught in a flood in "Firefighter rescues Rene Molina, 17, after a flood-swollen creek in San Antonio swept Molina into submerged trees" 1986 Mike Davis (Best12 41d)

firefighter standing in river in "In Fayette City, Pa., a volunteer fire captain considers a nearly impossible task as the Monongahela River ebbs" 1985 Bill Wade (Best11 64c)

girl with plastic bag walking through flood waters in "10-year-old Lisa Beaman of Iola was one of several hundred Kansas-Missouri people forced to flee autumnal flood waters" 1986 Frank Niemier (Best12 40d)

holding onto horse's tail in flood waters in "When the fields flood a horse is used as an amusement park ride" 1998* Randy Olson (Best24 40d)

house floating in flooded river in "The great Mississippi flood" 1993* Bill Gillette (Lacayo 186)

large pile of debris trapped by a dam in "Two canoeists brave rushing waters of the Cheat River to inspect debris trapped by the Lake Lynn Dam" 1985 Robert J. Pavuchak (Best11 64b)

man holding onto speed limit sign in "During the rainy season, a levee break in Yuba City put part of the town underwater" 1986 Craig Lee (Best12 39)

man trapped in his car during flood in "Leo Vyvjala, 61, sits helplessly in his car as rising waters surround him" 1986 Philip Barry (Best12 41a)

men in rowboat removing parking meters in "City workers in Peoria remove parking meters so they won't rust as the Illinois River went over flood stage" 1985 Renee C. Byer (Best11 65)

overturned house with large tree in window in "A slightly damaged house, Johnston, Pennsylvania" 1889 George Barker (Eyes #38; Lacayo 21b)

photo series on flooded houses, sandbagging a dike, trying to save possessions in "The Great Flood of '93" 1993* Bill Greene (Best19 199-202)

pushing a car through high water in "When a spring flash flood hit Fort Worth two passersby pushed a stranded auto out of the high water" 1986 Ron Jenkins (Best12 40a)

pushing stalled car through flood waters in "Two men try in vain to push a stalled car from rapidly rising floodwaters in Kentucky" 1992 Tom Marks (Best18 126d)

rowing a small rubber boat in "Using a rubber boat to negotiate floodwaters of the DesPlaines River" 1986 Al Podgorski (Best12 157d)

small fenced home surrounded by water in "Equinox Flood Tide, Greatham Creek, Teesmouth" 1974 Ian MacDonald (Art \386)

small houses flooded in "Flood, Salton Sea" 1983 Richard Misrach (Rosenblum2 #784)

statute of *David* in flooded museum in "Flood in Florence museum" 1966* David Lees (Life 130)

street with houses flooded to first floor in "Flood, Herkimer, New York" 1910 Zintsmaster Studio (National 165)

woman standing on roof of shack in "A woman pleads for help from her roof after being stranded by floods in Bangladesh" 1988 Carol Guzy (Best14 11c)

women walking through flooded street in "In Tampa, residents move to safety along a flooded causeway as Hurricane Elena moves in" 1985 Raul DeMolina (Best11 68a)

FLOWERS *see also* PLANTS

amaryllis in "March 1998, Amaryllis Belladonna" c. 1999 Piotr Topperzer (Photo00 211)

amaryllis on a stem in "Amaryllis" c. 1997 Colin McRae (Graphis97 85)

arranging Chrysanthemums in "The Chrysanthemum Specialist" 1944 Toyo Miyatake (Marien \5.50)

beetle on calla lily in "Beetle on Calla Lily" c. 1999* Mark Laita (Photo00 233)

bowl of narcissus in "Narcissus" 1928 Laura Gilpin (Decade \20)

calla lilies in "Two Callas" 1929 Imogen Cunningham (Rosenblum2 #535)

calla lily in "Calla" c. 1929 Imogen Cunningham (Women \42)

Cereus before and after blooming in "Night-Blooming Cereus, Closed After Blooming" 1884 Photographer Unknown (National 4); "In Bloom" 1885 (National 157d)

closed flower in "*Papaver orientale*, Oriental Poppy" 1915-1925 Karl Blossfeldt (Icons 24)

cyanotype in "Papaver Rhoeas" 1845* Anna Atkins (Rosenblum \2)

dahlia, dried flower from [book entitled *Les Immortelles: Everlasting Blooms*] c. 1995* Kathryn Kleinman (Graphis96 2, 82)

two flowers in "Mariposa Lily" 1922 Laura Gilpin (Rosenblum \156)

two tulips in glass vase in [self-promotional] c. 1990 Hing/Norton (Graphis90 \308)

vase of flowers in [flowers in a vase] c. 1992* Michael Northrup (Graphis93 71)

vase of flowers in [self-promotional] c. 1990* Jennifer Baumann (Graphis90 \299)

vase of flowers with painted background in [vase of flowers with painterly quality] c. 1991* Eugene Weisberg (Graphis92 \70)

water lilies in a vase in "Water Lilies" 1906 Adolf de Meyer (Rosenblum2 #399)

white flowers in [flowers] c. 1992* Kenro Izu (Graphis93 81)

wilted flowers in [ad for a computer software company] c. 1992* Mike Ryan (Graphis93 62)

woman in bonnet picking water lilies from a boat in "The Lily Gatherer" 1892 Rudolf Eickemeyer (Photography1 \100)

yellow flowers in "Untitled" c. 1852* Southworth & Hawes (Art \30)

yellow flowers in [personal study of flowers] c. 1991* Parish Kohanim (Graphis92 \62)

yellow tulips in glass vase in "Yellow Tulips" c. 1990* Sandra Eisner (Graphis90 \286)

FOOD *see also* FISHES; FRUIT; VEGETABLES

arrangement with asparagus, cabbage and other food in [self-promotional] c. 1990* Tom Ryan (Graphis90 \337)

arrangement with cheese, chalk, and other objects [unpublished] c. 1989* Bill White (Graphis89 \360)

artichoke halved on a plate in "Have a heart for the lowly thistle, the artichoke" 1987* J. Mark Poulsen (Best13 187d)

asparagus and clothespins in [food and objects as sculpture] c. 1995* Patrick Tregenza (Graphis96 96b)

berries and cream in a spoon in "To tame wild blackberries, all you need is a spoon and some cream" 1987* Nancy N. Andrews (Best13 183d)

biscotti with cappuccino in "Biscotti" 1997* Jim Witmer (Best23 144d)

canapes arranged on plates in [canapes] c. 1989* Kathryn Kleinman (Graphis89 \314-\317)

canned fruit and jars of food filling stairs and shelves of cellar in "Farm Cellar" 1945 Charlotte Brooks (Rosenblum \207)

cheese and eggs in an ad in "Phenix Cheese" 1925 Margaret Watkins (Rosenblum2 #629)

chickens with feathers held by the feet in "A girl proudly displays her family's dinner in the Dominican Republic" 1992 Yunghi Kim (Best18 72b)

contaminated food from [book *The Apocalyptic Menu*] c. 1992* Christian Von Alvensleben (Graphis93 93)

duck egg in "Ad for Galleria fashions" c. 1989* Buck Holtzmer (Graphis89 \350)

egg in egg cup in "Eggs" c. 1999* Axel Hoedt (Photo00 59)

family with shopping cart standing among all types of food in "A Year's Supply of Food" 1951 Alex Henderson (Goldberg 132)

fish and lemons in "Photo-Cubism" c. 1989* François Gillet (Graphis89 \210)

fish on checkered background in "Malmo Marination" c. 1991* Jeremy Taylor (Graphis91 \131)

fish photographed in blue and black in [flounder] c. 1990* Hans Hansen (Graphis90 \338)

fish wrapped in paper from [book *Openers* on appetizers] c. 1989* Kathryn Kleinman (Graphis89 \319)

halved pumpkin in "Pumpkin" c. 1991* Hans Hansen (Graphis91 \141)

herbs on food in "Cooks with good taste turn to fresh herbs for unmatched, just-picked flavor and fragrance" 1987* Mary Kelley (Best13 186c)

herring on a plate in "Herring and Vodka are Like Brother and Sister" c. 1991* Hans Hansen (Graphis91 \139)

ice cream, cake and coffee on set table in "Still Life" 1943 Nickolas Muray (Rosenblum2 #631)

ice cream cones in [ice cream cones] c. 1991* Carol Kaplan (Graphis92 \77, \78)

Japanese food styling for [book, *Japan, the Beauty of Food*] c. 1989* Reinhart Wolf (Graphis89 \329-\346)

mocha in [ad for Galleria fashions] c. 1989* Buck Holtzmer (Graphis89 \351)

mushrooms and toothpicks in [food and objects as sculpture] c. 1995* Patrick Tregenza (Graphis96 96a)

mussels in [mussels] c. 1989* Kathryn Kleinman (Graphis89 \320)

mussels in "New Zealand Green Lip mussels for calendar" c. 1989* Steve Marsel (Graphis89 \327)

mussels on paper from [book *Openers* on appetizers] c. 1989* Kathryn Kleinman (Graphis89 \321)

mustard in spoons in "For a saucy change of pace, mustard comes in a variety of flavors" 1987* Mary Circelli (Best13 183a)

olive in [ad for Galleria fashions] c. 1989* Buck Holtzmer (Graphis89 \352)

olives on sticks in [food and objects as sculpture] c. 1995* Patrick Tregenza (Graphis96 96d)

onions made into a necklace in "Pearl onions make a fashion statement at any dinner party" 1987 Lois Bernstein (Best13 187a)

oysters and beer in "There's nothing work with a little raw pleasure–especially when it comes to oysters"

1987* Mark B. Sluder (Best13 183b)

shrimp on a lemon in "Hood Canal shrimp" 1985* Alan Berner (Best11 148)

soup in bowl in "Winter Squash" 1996* Susan T. Pollard (Best22 180a)

squid in "Squid" c. 1991* Hans Hansen (Graphis91 \142)

sugar with imprint of spoon in "Brown Sugar" 1995* Jason M. Grow (Best21 147d)

tomato in [ad for Galleria fashions] c. 1989* Buck Holtzmer (Graphis89 \349)

tomato soup in bowl and spoon in "No matter how you dish it out, tomato soup is ripe for any occasion" 1987* Craig Trumbo (Best13 186b)

various arrangements with peppers, eggs, and tomatoes in "Personal studies" c. 1989* Karen Capucilli (Graphis89 \354-\357)

vegetables and fish in *Le Soupe de Daguerre* 1976* Marcel Broodthaers (Marien \6.90; Photography2 149)

FOOT

foot cut open in "Untitled (Amputated foot)" 1939 Frederick Sommer (Photography 225)

hardened feet of barefoot soldier in "Feet of Ethiopian Soldier" 1935 Alfred Eisenstaedt (Rosenblum2 #596)

in-turned feet and unlaced shoes in "Agent Orange" 1982 Wendy Watriss (Rosenblum2 #480)

FOOTBALL

catching the football in "Fryar of the Patriots makes a fingertip catch" 1991* Ruben Perez (Best17 210)

coach and player in "Oiler coach Jeff Fisher gets a point across with defensive back Tomur Barnes" 1996* Smiley N. Pool (Best22 202c)

coaches, players, and umpires on field in "Assistant football coach emotes in response to a delay-of-game call against his team" 1985 Blair Kooistra (Best11 230a)

college players before and after a losing season in "A Grizzly Season" 1990 Kurt Wilson (Best16 132-133)

college players cheering at sideline in "One policeman forgot he was on security duty when Vanderbilt's football team held onto a 7-0 lead" 1985 Rick Mansfield (Best11 193d)

college players in a pile in "Virginia Tech football players go four deep on a fumble" 1985 Steve Nesius (Best11 208)

crowd surrounding goalpost in "A Florida State University football fan jumps from the goalpost" 1996* Colin Hackley (Best22 202a)

crowd toppling goalpost in "Goalpost goes over at the University of Oklahoma in Norman" 1985 William H. Batson (Best11 226)

fan standing on car in "Fans of the 49ers went crazy on Market Street after their team won the Super Bowl before a hometown crowd" 1985 Eric Luse (Best11 188)

fans completely filling street around buses in "After the Chicago Bears beat the New England Patriots in Super Bowl XX, fans turned out for the biggest ticker-tape parade since Neil Armstrong visited the Windy City after walking on the moon" 1986 Rich Hein (Best12 194)

foot at moment of contact with football in "Wes Fesler Kicking a Football" c. 1935 Harold Edgerton (Hambourg \71)

football player being punched in jaw in "Racial Attack in NCAA Championship" 1951 Donald T. Ultang and John R. Robinson (Capture 29)

girl on football team in "Sherri Sutherland is the only girl on the Junior League football team" 1986 Keith Anderson (Best12 198a)

high school players and coach in "Game of Life" 1997 Dudley M. Books (Best23 214b, 215b,d)

intercepted pass in "Player gets hands on pass intended for opponent" 1987 Anne Ryan (Best13 210)

line of players ready to tackle in "Lycoming University's Matt Harvey is tackled by Allegheny University defenders" 1990* Damian Strohmeyer (Best16 137)

losing one's pants in a tackle in "Running back loses more than yardage as he is hit by a tackle" 1986 Bill Fox (Best12 198d)

pile of football players in "Roger Craig of the San Francisco 49ers goes over the top for a touchdown during a game with the Kansas City Chiefs" 1985 Chris Stewart (Best11 209)

player holding shoelace of man with football in "Texas Christian University's Richard Booker tackles Southern Methodist University's Mike Romo during a game" 1990* Donna Bagby (Best16 118a)

player kneeling near goal posts in "New York Giants Quarterback Y. A. Tittle, after being sacked by a Pittsburgh Steeler" 1964 Morris Berman (Life 143d)

player stopping ball in "Carolina return specialist Dwight Stone keeps the ball from crossing the goal line" 1997* Patirck Schneider (Best23 179b)

players and midshipmen at football game in "Army-Navy game photo essay" 1985 Fred Comegys (Best11 210-213)

players cheering from the sidelines in "Football players at Westfield High School react to a field goal that won the game for them" 1986 Glenn Osmundson (Best12 199a)

players falling on ground in "Ray Mickens appears about to be beaned by a penalty flag as he goes down with Miami receiver" 1996* Richard Graulich (Best22 202b)

players grabbing at ball in "University of Pittsburgh defensive back Marcus Washington knocks the ball out of the hands of the intended receiver" 1990 Gerard Lodriguss (Best16 125d)

players hugging in "Pittsburgh Steelers quarterback Brister shows offensive lineman Blankenship his appreciation for allowing him to complete an 80-yard touchdown pass" 1988 Vince Musi (Best14 142)

players sitting in mud in "Football game was postponed due to heavy rain" 1997 Danielle P. Richard (Best23 179d)

players waiting to go onto field in "Pumped up?" 1988* Kenneth Jarecke (Best14 54b)

quarterback sitting on ground as other team celebrates in "Quarterback is sacked at end of the game and players celebrate victory" 1997* Clarence Tabb, Jr. (Best23 179a)

sitting on the head of another player in "Kansas State University fullback comes down hard on the head of Missouri safety who made the tackle on a short gain" 1987 David Eulitt (Best13 207)

running with the ball in "The University of Miami's quarterback, Vinny Testaverde, rolls out as he scrambles to score a touchdown" 1986 Brian Smith (Best12 217)

tackling a player in "Heisman Trophy hopeful Chris Chandler of the University of Washington is decked by a University of Oregon linebacker" 1987 Harley Soltes (Best13 220a)

tackling a player in "A pass play is broken up during the annual Oyster Bowl between the Virginia Military Institute and The Citadel" 1988 Raymond Gehman (Best14 198)

tackling player with ball in "Green Bay Packer Sterling Sharpe makes a tippy-toe catch in bounds for the first down as the Chicago Bears' Donnell Woolford defends" 1990* Mark Welsh (Best16 117)

three players in a line in "Age '21' in America" 1991 John Kaplan (Capture 164e)

touchdown in "Houston Oilers receiver Chris Sanders prays in thanks after beating Lionel Washington for a touchdown" 1995* Smiley N. Pool (Best21 109)

FORMER SOVIET republics, 1992-
photo essay on civil war to oust Georgian President in "Tbilisi, Soviet Georgia" 1992 Carol Guzy (Best18 175-180)

photo essay on the disintegration of Moscow, homelessness, jails, concerts, bodies in morgue, and party in Czarist palace in "Moloch Moscow" 1992* Hans-Juergen Burkard (Best18 195-198)

FORTIFICATIONS
dead men on angled path to top of fort in "Interior of the Angle of North Fort" 1860 Félice Beato (Marien \3.32)

in desert in "Only women may enter an old fortress on Tarut Island in Saudi Arabia" 1987* Jodi Cobb (Through 222)

many men lying dead on fort walkways in "After the Capture of the Taku Forts" 1860 Félice Beato (Rosenblum2 #204; Waking #84)

maze of sticks around stick huts in "In Nambia, a protective labyrinth of stick walls can be moved to confound foes who try to reach the Ovambo headman's hut" 1982* Jim Brandenburg (Through 220)

medieval towers and wall in "Ramparts of Carcassonne" 1851 Gustave Le Gray and O. Mestral (Waking #39)

men, ropes, and cannons on top of fort in "Interior of Pehtang Fort Showing the Magazine and Wood Gun" 1860 Félice Beato (Szarkowski 314c)

on outskirts of town in "Bird's Eye View of Fort Marion and City Gates, St. Augustine, Florida" 1886 George Barker (Photography1 #V-15)

soldiers' quarters dug into ground in "Quarters of Men in Fort Sedgwick, Known as Fort Hell" 1865 Timothy H. O'Sullivan (National 17, \14)

FOUNTAINS
water cascading over fountain in "Versailles, Fountain of the Pyramid of Girardon" 1853 Louis-Rémy Robert (Art \79)

woman sitting alongside small fountain in "The Fountain" 1906 Clarence White (Art \178)

youth standing under city's fountain in "A youth seeks relief from the heat wave that gripped the Northeast by cooling off at the Perry Square Fountain" 1995* Jack Hanrahan (Best21 153c)

FRANKLIN (Aircraft carrier)
ship under attack in "Explosion Following Hit on the USS Franklin by Japanese Dive Bomber" 1945 U.S. Navy (MOMA 169)

FRATERNAL ORGANIZATIONS see FRIENDLY SOCIETIES

FRIENDLY SOCIETIES
African American men posing on steps in special uniforms in "Group portrait of the Roman Catholic Order of the Knights of St. John" c. 1922-1927 Richard Aloysius Twine (Willis \95)

FROGS / TOADS
>green frog on leaf in [frog on leaf] c. 1995* Mark Laita (Graphis96 191b)
>three frogs in a pile in [frogs] c. 1992* Adrian Burke (Graphis93 195)
>toads lined up on shelves with clothespins on mouths in "Clothespin keep wet plaster in place while dead cane toads dry in a taxidermy shop in Queensland, Australia" 2000* Cary Wolinsky (Through 426)

FRONTIER AND PIONEER LIFE
>children dressed in pioneer clothes in "Dressed as pioneer children to pay their respects at Little Big Horn battlefield memorial" 1998 Steven G. Smith (Best24 100b)
>covered wagons on the trail in "Mormon Emigrant Train, Echo Canyon" c. 1870 Charles William Carter (Waking #118)
>family on porch of wooden house encircled by wood fence in "A Frontier Home" 1860s-1870s Photographer Unknown (Waking #116)
>horse-drawn wagons in desert near small town in "Santo Domingo, New Mexico" c. 1875 John K. Hillers (Szarkowski 123)
>men and horse and side of scalped man in "Scalped Hunter Near Fort Dodge" 1868 William Soule (Photography1 \61)
>sleeping ground, wrapped in blankets near horse in "The Night Hawk in His Nest" c. 1885-1890 Laton Alton Huffman (Photography1 \10)
>wooden wagon near old fence in "Base of Acoma, New Mexico" 1970 Liliane De Cock (Rosenblum \241)

FRUIT see also ORCHARDS; STILL LIFE
>apple and oranges in [fruit] c. 1989* John James Wood (Graphis89 \311)
>apple on branch in "Orchard Apple" 1996* Mary Circelli (Best22 180)
>apple on covered pedestal in [self-promotional] c. 1990* Michael Wissing (Graphis90 \335)
>apricots, halved and whole [apricots] c. 1989* Kathryn Kleinman (Graphis89 \318)
>arrangement on stone table from [article entitled "The New Crop of Fruits and Vegetables"] c. 1989* Jerry Simpson (Graphis89 \359)
>banana in a straw-lined box in "Bananas: handle with care" 1988* Dennis Hamilton, Jr. (Best14 108a)
>bananas in "Bananas" c. 1991* Tiziano Magni (Graphis91 \132)
>bananas cut lengthwise in [bananas] c. 1995* Achim Falkenthal (Graphis96 99)
>bananas, melon, pineapple, and coconut in [fruit] c. 1995* Pamela Strauss (Graphis96 100-101)
>blueberries, coconut, and strawberries in form of the flag in "The Fourth of July" 1990* Robert Cohen (Best16 140)
>bowl of mixed fruit in [bowl of fruit] c. 1997* Giorgio Majno (Graphis97 96)
>cherries on white gloves and plate in [cherries took on a high key elegance] 1986* Joe Luper (Best12 110d)
>fruit and various types of paper in [promotional calendar] c. 1991* (Graphis92 81-\85)
>grapes in basket with handle in "Muscats" c. 1934 Christine B. Fletcher (Peterson #65; Rosenblum \150)
>lemon in [lemon] c. 1989* Kathryn Kleinman (Graphis89 \318)
>limes, some cut in [limes] c. 1989* Kathryn Kleinman (Graphis89 \312)
>mangoes, whole and cut in "Mango magic" 1991* Peter Battistoni (Best17 172a)
>melons, cut, balled, and whole in "Versatility & Variety of Melons" 1993* Carmen Troesser (Best19 182d)
>melons, mango, papaya and plums from [cookbook entitled Fruit] c. 1990* Kathryn Kleinman (Graphis90 \321-\324)
>oranges in a box from [annual report for Weyerhaeuser, the paper and cartonage manufacturers] c. 1989* Terry Heffernan (Graphis89 \293)
>peaches with leaves in a basket in "Still Life" 1912* Laura Gilpin (Rosenblum2 #352)
>a pear in [self-promotional] c. 1991* Joel Conison (Graphis92 86); in "William Pear" 1972 (Rosenblum2 #765); in [a pear] c. 1997* Amy Lamb (Graphis97 92)
>pear halves in [pear halves] c. 1992* Ramesh Amruth (Graphis93 87)
>pears and apple in "Fruit" 1997* Nita Lusk (Best23 144a)
>pears and bones in [bones, flowers, and fruit] c. 1991* Philip Bekker (Graphis92 \80)
>pears and mug in [pears] c. 1992* André Baranowksi (Graphis93 88)
>pears as still life in [self-promotional] c. 1991* Rosanne Olson (Graphis92 \76)
>pears in a bowl and on table in [bowls and pears] c. 1992* Carol Kaplan (Graphis93 86)
>pears in [pears] c. 1992* Michael Wissing (Graphis93 91)
>pears sitting on windowsill in "Pears ripen on a windowsill near the Kremlin in Moscow" 1986* Sam Abell (Through 38)
>pears tied to red strings in "Four Pears" 1979* Olivia Parker (Rosenblum2 #789)
>pomegranates and a bowl in "Pomegranates" c. 1999* Carol Kaplan (Photo00 54)
>reflections in mirrors in "Abstract Composition" 1929 Florence Henri (Rosenblum2 #502)

stairs and shelves filled with fruit and jars of food in "Farm Cellar, New York" 1945 Charlotte Brooks (Rosenblum \207)

strawberries and pie knife in "Fruit torte" 1985* Scott Robinson (Best11 148c)

strawberries on strings in [food and objects as sculpture] c. 1995* Patrick Tregenza (Graphis96 96c)

tomato on the edge of a drawing of a tomato in "Tomato on drawing" 1992* Carmen Troesser (Best18 173)

watermelon, grapes and bread in "Still Life with watermelon" 1947* Irving Penn (MOMA 194)

watermelons in a box in "Cats and Watermelons" 1992* Gabriel Orozco (Marien \7.54)

FUNERAL RITES AND CEREMONIES

African American boy in suit holding folded American flag by coffin in "Untitled" 1989 LeRoy W. Henderson, Jr. (Committed 127; Willis \288)

African American crowd trying to touch passing casket in "Big Chief Joe Pete Adams' Jazz Funeral" 1992 Keith Calhoun (Willis \258)

African American men standing for group portrait by open casket in "Postmortem portrait, Tyler, Texas" c. 1959 Curtis Humphrey (Willis \210)

African American youth in open casket in "A Young Life Lost" 1995* Andre Lambertson (Willis \434)

angry crowd holding small casket in "Alexandria Township funeral" 1986* Peter Magubane (Eyes \36)

body wrapped in cloth in "On the banks of the Ganges River, a body awaits cremation" 1993 James Nachtwey (Best19 44)

boy looking into a casket in "Boy takes a peek into the casket of slain bicycle shop owner during a memorial service" 1996* Wally Skalij (Best22 225d)

building draped in bunting after the death of James King of William in "The Great Man Has Fallen" 1856 Robert Vance (Waking 312a)

casket for newborn being carried in child's wagon by police in "Members of the police force hold a funeral for abandoned newborn found dead from exposure in a parking lot" 1988 Cloe Poisson (Best14 79)

casket held high over head of crowd in "New Orleans Jazz Drummers' Jazz Funeral of James Black" 1987 Chandra McCormick (Willis 267)

caskets on display in "Bert Turner, funeral home greeter" c. 1989* Will Van Overbeek (Graphis89 \152)

children touching young boy in casket in "Robert ('Yummy') Sandifer, executed at age 11" 1994 Steve Liss (Lacayo 183c)

child's casket on seat of hearse in [funeral for child with AIDS] 1997 Eugene Richards (Best23 31)

coffins being carried by crowd in "Death of people trying to cross into California" 1990* (Best16 36)

coffins being carried by crowd through dirt street in "Mamelodi funeral" 1985* Peter Magubane (Eyes \37)

Coretta Scott King and daughter in pew at funeral in "Deep Sorrow" 1968 Moneta Sleet, Jr. (Capture 67; Eyes #280; Willis \188)

crowd surrounding open mass grave in "Some 35 coffins are placed in a common grave in Tereso, Italy" 1985 Dieter Endlicher (Best11 92a)

Dr. Martin Luther King, Jr.'s, casket surrounded by group of African American men in "Dr. Martin Luther King, Jr.'s casket at Morehouse College, Atlanta" 1968 Louise Ozell Martin (Willis \192)

Dr. Martin Luther King, Jr.'s, casket being carried in farm wagon and followed by crowds in "Dr. Martin Luther King, Jr.'s, funeral, Atlanta" 1968 Louise Ozell Martin (Willis \193)

flags along wall at memorial service in hanger in "Memorial services for the soldiers are held in a hanger at Ft. Campbell" 1985 Charles Steinbrunner (Best11 51a)

girl looking up at Scots-guard at barricade in "A Scots-guard mourns with the crowd at Princess Diana's funeral" 1997 Stephen Dupont (Best23 237d)

graves, parades, and mourners in Ulster from [the series The Troubles: An Artist's Document of Ulster] 1979 Les Levine (Photography2 165)

grieving family around man in open casket in "Funeral of an Albanian shot on the Kosovo border" 1998 Roger Lemoyne (Best24 92)

Haitian family at funeral in "The family of Asson Vital mourn at his funeral in the national cemetery in Port-au-Prince" 1987* Maggie Steber (Best13 18)

Hamas followers reaching for a coffin carried aloft in "Coffin of Yamya Ayyash is carried into a mosque" 1996* Jim Hollander (Best22 150c)

interior of Cathedral crowded for funeral in "The coffin bearing the body of Winston Churchill is borne slowly down the aisle of Saint Paul's Cathedral in his funeral ceremony" 1965* Dmitri Kessel (Eyes \6)

Ku Klux Klan members walking in robes past large crowd in "The funeral of a murdered leader of the Ku Klux Klan" 1920s Underwood & Underwood (Lacayo 52)

a line of hearses in "Three months after the tragedy, the remains of the astronauts are brought to Dover Air Force Base in Delaware" 1986 Jed Kirschbaum (Best12 13c)

line of soldiers removing their hats in "For Queen and Country (Funeral of soldier Boer War)" 1899-1902

Horace Nicholls (Szarkowski 149)

line of walking mourners followed by long line of cars down city street in "Funeral at Louisiana Street and Preston Avenue, Houston, Texas" 1920 Photographer Unknown (Goldberg 58)

long lines of police at funeral in "New England police officers, 5,000 strong, pay final tributes to slain patrolman who was killed in the line of duty" 1985 Dan Gould (Best11 83)

man crying in "Kevin Jenkins had to be restrained by his mother and friends as he attempts to leap toward the casket at a funeral for his brother" 1996* Wally Skalij(Best22 245a)

man crying in grief in "Mother's Funeral" 1987* Maggie Steber (Photography 115)

men carrying coffins through the streets in "Coffins of 16 adults and four children killed in the U.S. bombing of Libya are carried through the streets of Tripoli" 1986* Herve Merliac (Best12 15a)

Mercedes-shaped coffin carried by mourners in "Pallbearers carry Holala's special Mercedes-inspired coffin through the streets" 1997 Carol Guzy (Best23 228a)

mother and children viewing open casket in "Mrs. Myrlie Evers and two children, Darrell and Rena, view Medgar Evers' body at the funeral home" 1963 Flip Schulke (Eyes #274)

Nun saying prayers at body of Mother Teresa in "Legacy of Love" 1997 Carol Guzy (Best23 201c)

overhead view of hundreds of Hasidic men gathered in street in "Hasidic men at the funeral of a rabbi in New York City" 1986 Jim Wilson (Best12 165b)

pall bearers carrying casket in "A Young Life Lost" 1995* Andre Lambertson (Willis \437)

parents holding each other in "John Read holds his ex-wife, at the funeral of their slain 8-year-old daughter" 1990* Robert Cohen (Best16 107)

photo essay on burials of victims of earthquake in "Death in Armenia" 1988 Peter Turnley (Best14 173-177)

police dog and female police officer at funeral in "Officer Melissa Piscatelli salutes the coffin holding the body of her finance, Milford Patrolman Daniel Scott Watson" 1987 Cloe Poisson (Best13 64)

President Reagan and line of mourners in "President and Mrs. Reagan meet with each bereaved family to offer consolation after the service" 1985 Bill Luster (Best11 51d)

Royal family watching hearse in "Princess Diana's brother, The Earl of Spencer, her sons Princes William and Harry and her ex-husband, Prince Charles, watch the hearse carrying her casket leave Westminster Abbey" 1997 Brian Walski (Best23 132)

sailors folding flag in "Judith and William Hansen grieve as a flag that covered their son's casket is folded by Navy pallbearers" 1987 Brian Walski (Best13 11b)

supporting young woman holding a flag as she passes a crowd in "Scotia Mine Disaster" 1976 Earl Dotter (Rosenblum2 #694)

toddler walking toward flag-draped coffin in "At the funeral for California Assemblyman Richard Longshore, his 2-year-old son wanders up the aisle to the father's coffin" 1988 Don Tormey (Best14 208)

waiting by casket in hut in "Relatives of a man who had been accidentally killed, mourn his death on the day of his funeral" 1986* David Turnley (Eyes \33)

wife with flag on lap, holding hands of her sons in "Arlington National Cemetery" 1991* Martin Simon-Saba (Life 64)

woman with her arm across casket in "A relative mourns the death of a Navy flier" 1991* Mark Peterson (Best17 21b)

women crying by side of casket in "In San Bernardino, family members mourn the death of a 12-year-old hemophiliac, who contracted AIDS through blood transfusions" 1985 David Schreiber (Best11 30d)

wrapped body falling from ship in "Burial at Sea" c. 1943 W. Eugene Smith (Art \417)

young people at graveside in "Friends and family attend a funeral for a teenage tagger from the Los Angeles suburbs" 1995* Lauren Greenfield (Best21 87)

FUR GARMENTS

African American couple wearing raccoon coats and standing near Cadillac in "Couple in Raccoon Coats" 1932 James Van Der Zee (Marien \5.72; Rosenblum2 #322; Willis \67)

fur blanket and coat on woman in coach in "Buckingham Palace Mall, London" 1954 Inge Morath (Rosenblum2 #477)

fur coat on woman with a dalmatian in "Boom for Brown Beavers" 1939 Toni Frissell (Rosenblum2 #641)

man in long white fur in "Liberace and Chauffeur" 1981* Annie Leibovitz (Rolling #25)

woman in fur coat walking two small dogs in "Avenue du Bois de Boulogne" 1911 Jacques-Henri Lartigue (Rosenblum2 #309)

woman in fur coat with scarf over face in "Woman at Opera with Face Covered" c. 1945 Lisette Model (Women \126)

woman in spotted fake fur in "Couple of 'spots fans'—one in fake fur—wear matching coats on Beacon Street in Boston" 1994* Joel Sartore (Through 314)

woman sitting with sailor in "Sailor and Girl, Sammy's Bar, New York" c. 1944 Lisette Model (Women \127)

women in fur coats passing poor woman on street in "The Critic" 1943 Weegee (Art \315; Eyes #142; Icons 95; Rosenblum2 #624)

women in fur coats waiting to board train in [untitled] c. 1995* Jeanloup Sieff (Graphis96 13a)

—G—

GANGS

boys fighting in street in "Harlem Gang Wars" 1948 Gordon Parks (MOMA 199)

forehead tattoo in "Payasito is a member of the 18th Street gang" 1996* Aurelio José Barrera (Best22 216a)

gang members in "18th Street gang" 1996* Aurelio José Barrera (Best22 235b)

photo essay on youth gang and their drugs and guns in "Fremont Street Hustlers" 1995 Eugene Richards (Best21 56, 68-71)

work of man who helps members of gangs in "Brotherly love in Chicago projects" 1987 Al Podgorski (Best13 50, 51)

youth gangs, their dogs, and death of a bystander in "Miami Gangs" 1988 Jon Kral (Best14 188-189)

youths with guns, in hotel room, in prison, and mother at grave from [series on Vietnamese gangs] 1990 Paul Kuroda (Best16 81-88)

GARBAGE

discarded sewing machine and couch in "Sectional" c. 1995* Deborah Brackenburg (Graphis96 169a)

refrigerator with light on in garbage dump in "With energy plentiful and cheap, few corporations or consumers put conservation on their priority lists" 1997* Kevin Horan (Best23 153c)

GARDENS AND GARDENING

floral arranger and unfinished portraits of George and Martha Washington in "Security guard watches as garden club member works on her floral interpretation" 1996* Bill Greene (Best22 246b)

formal garden on terrace in "Terrace and Park, Harewood House" 1861 Roger Fenton (Rosenblum2 #120)

formal garden with urns on pedestals in "Gardens of Saint Cloud" before 1855 Henri-Victor Regnault (Waking #49)

woman in hat, on sidewalk pulling weeds in "Spring in Berkeley" 1951 Dorothea Lange (MOMA 203; Photography 43)

young woman carrying shovel and rake in "Victory gardening in the northwest section" 1943 Louise Rosskam (Fisher 79)

GAS MASKS

soldiers in gas masks in lines in "Soldiers of Co. M 312 Inf. with gas masks adjusted, Camp Dix, New Jersey" c. 1917 Underwood & Underwood (Eyes #45)

GAS STATIONS see SERVICE STATIONS

GAY MEN

African American boy sitting on a bus with white students in "A gay teen sits on the bus to school alone" 1995* Dan Habib (Best21 189a)

embracing in corner each wearing part of a suit in "On Suit for Two" 1932-1933 Brassaï (Art \286)

leaning on each other in "Steven Bryant and Demian spend a tender moment together" 1991 Rod Mar (Best17 203)

GEE'S BEND, Alabama

African American girl at newspaper-covered window of log cabin in "Girl at Gee's Bend, Alabama" 1937 Arthur Rothstein (Decade \38; Documenting 151b; Lacayo 95)

African American man in worn jacket in "Willie S. Pettway" 1937 Arthur Rothstein (Documenting 156a)

African American woman at sewing machine in "Jennie Pettway and another girl with the quilter Jorena Pettway" 1937 Arthur Rothstein (Documenting 152b)

African American woman carrying bucket in "Annie Pettway Bendolph" 1937 Arthur Rothstein (Documenting 157b)

bags hanging from tree in "Curing meat" 1937 Arthur Rothstein (Documenting 159c)

bucket and gourd on porch in "Bucket and gourd" 1937 Arthur Rothstein (Documenting 157c)

children running from church in "At the end of the school day" 1937 Arthur Rothstein (Documenting 159a)

family in old plantation room in "Interior of the old Pettway home, occupied by the foreman John Miller and his family" 1937 Arthur Rothstein (Documenting 154a)

girl and dog by picket fence in "On the Pettway Plantation" 1937 Arthur Rothstein (Documenting 155b)

man teaching rows of children sitting on benches in "Mr. Hale from Snow Hill conducting school in the Pleasant Grove Baptist Church building" 1937 Arthur Rothstein (Documenting 158a)

plowing behind a mule in "Houston or Erick Kennedy plowing" 1937 Arthur Rothstein (Documenting 152a)

sagging wooden house with wood pile in "The former home of the Pettways" 1937 Arthur Rothstein

(Documenting 153c)

several log cabins on dry land in "Cabins and outbuildings on the former Pettway plantation" 1937 Arthur Rothstein (Documenting 150a)

GEESE

flock barely visible through the snow in "Wild geese weather a snowstorm in Portsmouth" 1987* Bob Thayer (Best13 168)

flying over house in "Geese by the gaggle fly past a house near Bombay Hook Wildlife Refuge in Delaware" 1987 Pat Crowe (Best13 164a)

man holding goose as he walks on street in "In Albania, a fat goose holds the promise of simple pleasures–a good meal for a man and his family" 1992* Nicole Bengiveno (Through 118)

silhouetted against copper-colored moon in "Canada geese fly across a rising moon" 1996* Scott Nielsen (Best22 186a)

GEISHAS

aspects of Geisha life in "Geisha" 1995* Jodi Cobb (Best21 220-221)

entertaining men seated at table in "In Japan, the life of a geisha still requires hours of preparation before a date" 1985* Jodi Cobb (Best11 46c)

holding straw hat in "Geisha in Japan" 1995* Jodi Cobb (Through cover)

women resting on mat in "Geisha Resting" c. 1885 Kusakabe Kimbei (Marien \3.84)

GENEVA (Switzerland)

view of city from river in "Panorama of Geneva" c. 1850* Jean-Gabriel Eynard-Lullin (Art \18)

GEORGE WASHINGTON BRIDGE (New York, N.Y.)

looking up across the cables to the top of the bridge in "George Washington Bridge" 1930s Margaret Bourke-White (Sandler 154; Women \56)

looking through arches in "George Washington Bridge" 1953 Margaret Bourke-White (Decade \59)

GEORGIAN-ABKHAZIAN CONFLICT

man and dog on ground in "A dog and its master, both killed during the Abkhazian asssault on Sukhumi, become two more victims of the civil war in Georgia" 1993* Andrei Soloviev (Best19 184b)

series on armed forces, prisoners, and death in the burning of the Parliament in "Capturing the Parliament building by Abkhazian forces in Sukhumi" 1993 Anthony Suau (Best19 30-32)

sniper in building in "A Georgian loyalist exults after shooting a rebel sniper in the Abkhazia region" 1993* Malcolm Linton (Best19 65)

GEYSERS

mineral-covered river from hot springs in "Hot Springs on the Gardiner River, Upper Basin" 1871 William Henry Jackson (Rosenblum2 #156)

shooting upwards in "Geyser, Yellowstone, Wyoming" c. 1885 Frank J. Haynes (Rosenblum2 #167)

shooting upwards in "Old Faithful Geyser, Yellowstone National Park" 1871 William Henry Jackson (Art \146; Monk #7); 1942 Ansel Adams (MOMA 120, 121)

steam rising from the earth in "Mud Geyser in Action" 1871 William Henry Jackson (Marien \3.63)

GIRAFFES

at windows in zoo building in "Giraffes at the London Zoo" 1986 Celeste La Brosse (Best12 133a)

eating among white bark trees in "A giraffe feeds among fever trees in the Ndumo Game Reserve of South Africa" 2001* Chris Johns (Through 284)

GLACIERS

banding of a glacier in "Annual Banding ('Ogives') of Yentna Glacier, near Mt. Foraker, Alaska" 1964 Bradford Washburn (Decade \78)

GLASSWARE

champagne coming out of a glass in "Champagne jumps out of the glass" 1985* Michael P. Franklin (Best11 148a)

champagne glasses and bowl with flower on table in [Waterford Crystal] c. 1991* Kathryn Kleinman (Graphis92 \87)

empty goblet in [goblet] c. 1991* Stefano Bianchi (Graphis92 \64)

plates and cup as still life in "Curves" c. 1930 Hiromu Kira (Peterson #35)

GLOVES

dirty work glove attached to wooden board in "Gloucester" 1944 Aaron Siskind (MOMA 178)

GOATS

girl herding goats in "Texas Dustbowl" 1996 Nicola Kurtz (Best22 238c, d)

next to bicycle in photographer's studio in "For cycling magazines" c. 1989* Curt Fischer (Graphis89 \202)

scratching itself from [article on Ireland] c. 1989* Anselm Spring (Graphis89 \196)

woman walking with goat in "Timbuktu No 2" 1998 Jeffrey A. Salter (Committed 188)

GOLF
crowd watching man celebrating in a bunker in "Paul Azinger rejoices after sinking a shot from a bunker on the last hole" 1993* Fred Squillante (Best19 151b)

man trying to putt in strong wind in "A golfer loses his hat, but the games goes on" 1986 Paul Kuroda (Best12 224)

woman hitting ball in "Patty Berg" 1938 Gjon Mili (Life 139b)

GOLDEN GATE BRIDGE (San Francisco, California)
looking down at one of the towers in "Golden Gate Bridge" c. 1995* Dudley DeNador (Graphis96 175)

thousands of people crossing Golden Gate Bridge in "More than 500,000 people flocked to the 50th anniversary of San Francisco's Golden Gate Bridge"1987 Doug Atkins (Best13 109a)

GORILLAS see PRIMATES

GRADUATION CEREMONIES see COMMENCEMENT CEREMONIES

GRAFFITI
Arabic writing on wall in "Shadows of Palestinian boys are cast against a graffiti-covered wall in Gaza" 1993 James Nachtwey (Best19 45)

chalk drawing of woman on brick wall in "Untitled" c. 1942 Helen Levitt (San \45)

in Harlem in "Harlem Colors" c. 1995* Kiyoko Horvath (Graphis96 109)

spray painting the back of a bus in "Members of the tagging crew LCK (Loving Crime Kings) spray paint their 'tags' on a bus in East Los Angeles" 1995* Lauren Greenfield (Best21 79)

GRAND ARMY PLAZA (Brooklyn, New York)
elaborate figures on triumphal arch in "Grand Army Plaza, Brooklyn" 1997 Craig Cutler (Graphis97 168b)

GRAND CANYON NATIONAL PARK
canyon and man with telescope in "Grand Canyon of the Colorado" 1883 William Henry Jackson (Art \145; National 21b, \24; Rosenblum2 #169)

clouds over the canyon in "Grand Canyon" 1911 Alvin Langdon Coburn (MOMA 91)

looking along river and canyon walls in "Grand Cañon, Colorado River, Looking West" 1872 William Bell (National 122c)

looking into canyon and river in "Looking South into the Grand Cañon, Colorado River" 1872 William Bell (National \33)

man sitting on edge of canyon in "Northern Wall of the Grand Cañon of the Colorado" 1872 William Bell (Photography1 \51)

overlooking the canyon, in subdued effect in "Grand Canyon" 1920s Forman G. Hanna (Peterson #53)

GRAND CENTRAL TERMINAL (New York, New York)
mural in support of war effort in "Grand Central Station, New York" 1941 Arthur Rothstein (Fisher 160)

GRASSES
beach grass in "Beach Grass" c. 1920 William E. Dassonville (Peterson #54)

blades of grass in [*Nature* series flowers] 1995 John Brown (Willis \546)

GREAT BARRIER REEF
aerial view of the reefs in "Australia's Great Barrier Reef–actually a group of more than 2,800 reefs–supports a diversity of species rivaled only by that of tropical rain forests" 2001* David Doubilet (Through 388)

GREAT WALL OF CHINA (China)
wall winds its way through the mountains in "Catching the Light and the imagination, the Great Wall snakes along the crests of mountains in China" 2003* Michael S. Yamashita (Through 146)

GREECE–ANTIQUITIES
base of Parthenon columns in "Western Portico of the Parthenon" 1870 William J. Stillman (Art \136)

interior space in "Interior of the Parthenon from the Western Gate" 1869 William J. Stillman (Rosenblum2 #131)

monument in city in "Monument of Lysicrates, Athens" 1850* Baron Jean-Baptiste-Louis Gros (Art \24)

Parthenon from the roof in "Western Portico of the Parthenon, from above" 1870 William J. Stillman (Art \135)

ruins of the Acropolis in "Athens, the Acropolis" 1850* Baron Jean-Baptiste-Louis Gros (Art \23)

temple columns at Sounion in "Sounion (Island)" 1979* Richard Misrach (Decade \III)

view of the Acropolis from an adjacent hill in "Acropolis: general view from the Hill of Philopappus, southwest" 1865 Philippos Margaritis (Marien \2.37)

GREENPEACE
activists in small boat near oil rig in "Greenpeace Confronts Shell Oil" 1995* David Sims (Photos 175)

GRIEF
bandaged infant crying in "18-month-old survivor of the tragedy cries in hospital bed" 1985 Joanna Pinneo (Best11 19b)

boy and family crying for father in "A funeral in Croatia" 1991* Christopher Morris (Best17 113; Lacayo 178)

bullet holes in door and walls in "Ellistine Gaines grieves for her grandfather, killed by Miami police in a fusillade of bullets during a drug raid" 1996* Chuck Fadely (Best22 154b)

comforting woman holding bicycle wheel in "Holding part of her boyfriend's bicycle who was robbed and stabbed" 1995* Wally Skalij (Best190a)

covered woman touching tombstone in "A brother mourned" 1996 James Nachtwey (Best22 156)

crying child sitting bombed-out railroad tracks in "Wounded by a bomb, a Chinese boy howls pitifully in Shanghai's railroad station" 1937 H. S.Wong (Lacayo 80a)

crying while holding a lighted candle in "Anthany Bekher cries at the candlelight vigil for his father, who was killed while working at a Brinks guard" 1996* Francine Orr (Best22 155a)

family crying and wringing their hands in "At a village church, a family mourns a Croatian soldier who was killed in battle" 1993 James Nachtwey (Best19 52)

helping a woman at a funeral in "Muslim women reach to try to revive a woman at the funeral of a man believed to be her husband" 1998 Dayna Smith (Best24 32c)

high school football players crying in "After winning a high-school football game dedicated to four teammates who had recently died in a traffic accident, teammates share a private moment" 1991 Mark Garfinkel (Best17 151)

Indian women crying after earthquake in "After a predawn earthquake in India, several survivors grieve together" 1993* Swapan Parekh (Best19 198)

man crying in "Kevin Jenkins had to be restrained by his mother and friends as he attempts to leap toward the casket at a funeral for his brother" 1996* Wally Skalij (Best22 245a)

man crying in "Relatives weep at the funeral of a quake victim" 1985 Paul Kitagaki, Jr. (Best11 13c)

man crying over woman's body on road in "A man grieves over the body of Dreama Combs, who died in a car crash" 1995* Greg Fight (Best21 177b)

man holding flag and leaning on a casket in "His wife was a deputy police officer" 1996* Robert Goebel (Best22 151b)

mother holding crying child in "Bangladesh" 1971 Don McCullin (Lacayo 162)

mother holding flag and covering eyes in "The mother of a police officer weeps quietly at this burial" 1997 Dudley M. Brooks (Best23 232a)

mourning women for bomb victims in "Chechnya War" 1995* Paul Lowe (Best21 225-226)

photo essay on police reactions to death of an officer in "The Twenty-fifth Precinct: Philadelphia" 1997 Eugene Richards (Best23 38-39)

photo essay on town's prayer vigils after torture-murder of James Byrd in "Aftermath of a Racial Killing" 1998 Smiley N. Pool (Best24 18-19)

Russian mother collapsing at funeral in "Lt. Marvin's mother collapses at his graveside during his burial in Moscow" 1993* Lucian Perkins (Best19 194)

shooting victim's mother collapses in "Mother's Grief" 1995* Chuck Fadely (Best21 229d)

sister of kidnaped woman crying in "Lethu T. Nguyen cries as she looks at the present her sister bought for the family before she was kidnaped" 1996 Carol Guzy (Best22 11a)

soldier crying with other wounded soldiers in plane in "Grieving soldier in the Gulf war" 1991* David Turnley (Best17 10; Lacayo 175b)

soldier hugging his crying son in "Private John Winbury says goodbye to his son" 1940 Robert Jakobsen (Lacayo 104)

supporting young woman holding a flag as she passes a crowd in "Scotia Mine Disaster" 1976 Earl Dotter (Rosenblum2 #694)

teenage girls holding hands in "Teenagers grieve for classmates who vanished from their home and were later found dead near a river" 1997 Nancy Andrews (Best23 21a)

woman holding hands in "Grandmother of shooting victim mourns at prayer vigil" 1998 Rob Finch (Best24 33c)

woman screaming in "Maria and Alberto Gomes arrive on the scene of a fatal fire which claimed the lives of their two grandsons" 1996* Bill Greene (Best22 246d)

woman sitting alone on beach in "A woman mourns next to a rose she placed at the sand at Smith Point Beach in Fire Island, New York" 1996* Mark Lennihan (Best22 150a)

women crying over man in coffin in "Mexican family grieves over the open casket of one of three brothers killed in a car accident in California while being pursued by U.S. Border Patrol agents" 1996* Dario Lopez Mills (Best22 151a)

young women comforting each other in "University students mourn the loss of a friend who was murdered" 1996 Khue Bui (Best22 223a)

GROOMING *see* BEAUTY, PERSONAL

GROZNYI, RUSSIA

children playing near train cars in "Refugee children from Grozny play on a platform next to the train cars in which they live with their families" 1995* Olga Shalygin (Best21 182b)

death and soldiers in the city in "Chechnya" 1995 Christopher Morris (Best21 209)

injured people, and women sweeping bombed building in "Chechnya: the war for Grozny" 1995* Peter Dejong (Best21 208)

man looking through pile of corpses in "In Grozny, Chechnya, a man finds one of his two lost sons among the hundred of corpses in an open grave pit" 1995 Anthony Suau (Best21 180c)

photo essay on the Russian destruction of the Chechen city and the plight of the residents in "Grozny: Russia's Nightmare" 1995 Anthony Suau (Best21 16-35)

GRUNGE

entangled group in mud pit in "Mud-moshing" 1994* Paul Fusco (Life 120)

GUATEMALA

photo essay on the poor and the military in "Delicate Democracy" 1988* James Nachtwey (Best14 38-39)

GUITAR

guitar-playing couple standing by guitar-shaped trailer in [guitar-shaped trailer] c. 1995* George Sinhoni (Graphis96 134a)

in background held by man leaning against wall in "INXS" 1988* Paul Schirnhofer (Rolling #92)

man on swivel chair playing guitar in the middle of a street in "We All Got the Blues" 1998 Steven Cummings (Willis \364)

Willie Nelson holding his guitar in "Superstar Willie Nelson was a main force in producing Farm Aid Concert as well as performing during the event" 1985 Nancy Stone (Best11 62d)

young man playing a guitar in front of painted scenery in "Bob Dylan" 1969 Jim Marshall (Rolling #10)

GULF WAR, 1991 *see* PERSIAN GULF WAR, 1991

GUNS *see* FIREARMS

GYMNASTICS

bending backward in "Ukranian rhythmic gymnast Elena Vitrichenko performs with the clubs" 1996* Rich Riggins (Best22 126d)

coach rushing to catch a gymnast in "Bella Karoli rushes to spot Dominique Monceneau" 1995* Rick Rickman (Best21 125)

doing a split in the air in "Russia's Ianina Batyrchina performs in the individual all-around semi-finals of rhythmic gymnasts" 1996* Anacleto Rapping (Best22 126c)

injured gymnast landing a vault in "Kerri nails the landing on that final vault effort" 1996* Marlene Karas (Best22 127a)

leg raised on balance beam in "Cathy Rigby" 1972* John Dominis (Life 145d)

multiple images of man on horizontal bar in "Kurt Thomas" 1979* John G. Zimmerman (Life 147)

series on the training of gymnasts in "Romania's Gymnasts" 1996 Lynn Johnson (Best22 231)

soldiers making a human pyramid in "Gymnastic Field Sports of the Gallant 7th. The Human Pyramid" 1861 George N. Barnard (Photography1 #IV-9)

vault in multiple exposures in "A multiple exposure capture this gymnast's vault in the men's individual finals" 1996* Barry Chin (Best22 126b)

GYPSIES *see* ROMANIES

—H—

HAIR

ad for hair products for [Christmas article for Dellaria Hair Products] c. 1990 John Curtis (Graphis90 \53)

African American man in dread locks in "Hairpiece #5 (Jamika-Dreads)" 1994 Andrea Davis Kronlund (Committed 143)

African American man in suit with long straight hair in "Kenny, Proud Lady Beauty Show, Chicago, Illinois" 1994 Bill Gaskins (Committed 107)

African American women with elaborate hair styles in "Tamara and Tireka, Easter Sunday, Baltimore" 1994 Bill Gaskins (Committed 106)

comb lines in shampoo from [article on shampoo] c. 1991* Roger Turqueti (Graphis91 \124)

curly-haired man with bandana on forehead in "Doo Rag" 1985 Coreen Simpson (Rosenblum \253)

hairstyles in "Global beauty calendar" c. 1989 Fabrizio Ferri (Graphis91 \4-\6)

reflection of woman having her hair set in rollers in "Doing Hair" c. 1970-1995 Roland Charles (Willis \241)

shaved head at military school in "A look inside VMI" 1995 Nancy Andrews (Best21 211)

waist-length hair on young girl in "Una Hija de Jesus (Daughter of Jesus), Guatemala" 1992 Tony Gleaton (Committed 109)

woman with long blond hair in "Girl with golden hair" c. 1990* David Holt (Graphis90 \55)

women with hair reaching to floor in "Three women" 1898 Belle Johnson (Rosenblum \78)

young boy crying in "The first haircut" 1969 Chester Higgins, Jr. (Willis \347)

HAITI

American solider trying to protect man on ground from crowd in "Crisis in Haiti" 1994 Carol Guzy (Capture 174)

armed police and dead bodies in "A uniformed police officer on the scene of an election day massacre in a school where 15 people were slain while trying to vote" 1987* Viorel Florescu (Best13 18d)

boy sitting against a wall in "A young Haitian boy sits outside the National Cathedral in Port-au-Prince" 1986 William Snyder (Best12 26b)

boy walking through garbage dump in "In Port-au-Prince, a child wanders through a trash heap filled with human waste" 1986 Brian Smith (Best12 27a)

burning body on the street in [Death in the streets of Port-au-Prince in pre-election violence] 1987 Janet Knott (Best 22-23)

child sliding underneath metal door near armed soldiers in "When hunger overcomes fear, Haiti" 1986* Maggie Steber (Eyes \30; Rosenblum \11)

children at cemeteries and church in "Haiti's Sorrow: Still the Same" 1997 Debbie Morello (Best23 131c, 204c,d)

children playing in building with no doors in "Street scene in Haiti" 1986* Alex Webb (Lacayo 167)

colorful flags in crowd in "A Haitian voodoo priest exhorts a crowd at a rally against ousted President Jean-Bertrand Aristide" 1993* James Nachtwey (Best19 51)

crying women in "Peasant women weep when they arrive at the Marche Soloman and discover the marketplace has burned during the night" 1987 Carol Guzy (Best13 22a)

dead children in piles on shelves in "Sent to identify a murder victim inside Port-au-Prince's only morgue, U.S. MP's discover children the city can't afford to bury" 1995* Jim LoScalzo (Best21 182a); "A Playmate and Her Foundation" c. 1999* Pierre St. Jacques (Photo00 66)

dead man covered in mud in "Days before the election, a man lies slumped in a stairwell after being shot in the back by soldiers in a Port-au-Prince alley" 1987* John J. Lopinot (Best13 20)

elderly woman in prayer in "An elderly Haitian attends mass" 1986 Bill Kelley III (Best12 26c)

family at funeral in "The family of Asson Vital mourn at his funeral in the national cemetery in Port-au-Prince" 1987* Maggie Steber (Best13 18)

garbage dump as source of food in "Haitians swarm all over garbage dumped by U.N. outside Port-au-Prince" 1995 Gerald Herbert (Best21 181a)

man smashing store window in "Protestors smash store windows in riots that led to Duvalier's flight from the country" 1986 Bill Greene (Best14 27b)

photo essay on looting and death, post-Duvalier in "Haiti, post-Duvalier" 1986 Brian Smith (Best12 30-31)

photo essay on the medical help given by American and Haitian doctors in "Medical mission to Haiti" 1986 Bill Kelley III (Best12 32-33)

photo essay on the riots, injuries and Tonton Macoute (secret police) in "Haitian change–Tension mounts" 1986 Bill Greene (Best12 28-29)

photo essay on the training of a new police force in "Haiti's new police" 1996 Carol Guzy (Best22 22-23)

reactions to street killings in "Street Justice" 1996 Carol Guzy (Best22 18-19)

teenagers looking at dead man in street in "Haitians look in horror at a body in the street" 1987* Anthony Suau (Best13 21a)

woman carrying large basket on her head in "A Haitian woman carries a basket on her head in the early morning as she walks downtown in Port-au-Prince" 1987* Don Preisler (Best13 170a)

woman praying alone in church in "During the violent days before the election, a woman prays in the main Port-au-Prince cathedral" 1987* Carol Guzy (Best13 21b)

wounded woman and dead family members on floor in "A wounded Haitian woman grieves over the body of her mother and other relatives surrounding her" 1987* David Murrary, Jr. (Best13 19a)

HAMBURG, GERMANY

ashes and ruins of a city in "After the Great Fire of Hamburg" 1842 Carl Ferdinand Stelzner (Eyes #3; Lacayo 18a); "Ruins of Hamburg Fire" 1842 Hermann Biow (Marien \2.25)

HAND

African American hands folded across the body in "Idle Hands triptych" 1995 Cynthia Wiggins (Willis \526-\528)

arm, coated in mud, reaching out from body trapped in mud in "Volcanic Mudslide in Colombia" 1985*

Carol Guzy and Michel duCille (Capture 140); "Four days after the mud slide, the arm of a corpse sends a grim signal" 1985 Kathy Anderson (Best11 21a)

back of hand and knuckles in "Self-Portrait (Standing Hand)" 1987 John Coplans (Photography 75)

bent fingers of hands in "Georgia O'Keeffe" 1918 Alfred Stieglitz (Waking #185)

child's hand reaching over spiked fence in "Fenced in Child, Vrederdorp" 1967 Peter Magubane (Rosenblum2 #473)

child's hands around adult wrist in "Hands" 1978 Touhami Enndre (Icons 185)

child's hands clasped over writing book in "Child's Hands (Helga)" 1928 Aenne Biermann (Rosenblum \1928; Rosenblum2 #519)

clean hand in "Adrian Sesto" 1977-1988 W. Snyder MacNeil (Women \167)

clenched in "Equivalent" 1964 Jerry Uelsmann (Photography2 74)

clenched, severed hand in "The Clenched Hand" before 1898 Eugène Druet (Waking #1898)

coated with dry clay in "Mexican Potter" 1932 Anton Bruehl (Decade \24)

dead Iraqi's hand covered in oil in "The oil-covered hand of a dead Iraqi soldier is grim testimony to the Persian Gulf War" 1991* Steve McCurry (Best17 15)

dirty hand in "Ezra Sesto" 1977-1988 W. Snyder MacNeil (Women \166)

doing various tasks in "Jergens ad for *Ladies Home Journal*" 1926 Edward Steichen (Goldberg 66)

elderly woman pointing at hymns in "Grandmother's Hands: #1 with hymnal" 1993 Cary Beth Cryor (Willis \201)

elderly woman threading needle in "Grandmother's Hands: #2 with sewing needle" 1993 Cary Beth Cryor (Willis \202)

eye superimposed on a back-lit hand in "Conscience" 1941* Axel Bahnsen (Peterson #38)

face of man appearing in shape of hand in "George Michael" 1988 Matthew Rolston (Rolling #115)

forming handle on clay cup in "Hands of Nell Cole Graves" 1930s Bayard Wootten (Rosenblum \145)

hand holding razor blade after ritual circumcision in "Ritual of Oppression" 1995* Stephanie Welsh (Capture 178, 179)

hands near feet in "Untitled, No.1 from the series 'Man' " 1971 Joan Murray (Rosenblum \259)

holding a needle and thread in "Hands Threading a Needle" c. 1929 Anton Bruehl (Rosenblum2 #630)

holding puppet strings in "Hands of a Marionette Player" 1926 Tina Modotti (Women \49)

holding toy figure of a man in "Fleeing Man" 1961 Jerry N. Uelsmann (San \38)

in a spring in [hand in spring] c. 1999* Jeff Stephens (Photo00 198)

man's hands resting on shovel handle in "Worker's Hands" c. 1926 Tina Modotti (Icons 44; MOMA 109; Rosenblum2 #520)

men's hands on slated gate in "Somalians eager for work peel through a large gate outside the Mogadishu port" 1992* Robert Gauthier (Best18 84)

movements of a hand in "Eakins's Hand" 1887 Eadweard Muybridge (Rosenblum2 #293)

old man's fingers on piano keys in "The Last Chord" c. 1935 Hillary G. Bailey (Peterson #28)

on breast in "Hand on Breast" c. 1923 Edward Weston (Art \219)

on oar in "Untitled" c. 1989 Bernd Grundmann (Graphis89 \240)

one hand perpindicular to another in "Poonie" 1985 Edward West (Committed 218)

one hand with prayer beads in "Dalai Lama" 1987 Herb Ritts (Rolling #59)

pinning fabric in "Hands and Thimble–Georgia O'Keeffe" or "Georgia O'Keeffe" 1920 Alfred Stieglitz (Art \205; Hambourg 42; MOMA 105; Szarkowski 242)

premature infant's hand in an adult's in "Tiny hand of a premature infant" c. 1989* Thomas Stephan (Graphis89 \262)

protruding from snow in "This pair of tied hands was found protruding from the snow at Yangii on the central front, Korea" 1951 Max Desfor (Eyes #225)

pushing over sewer grate in "Two sets of hands reach up to remove a sewer grate in Arizona so that illegal immigrants can enter the U.S." 1998* Mona Reeder (Best24 32b)

rough hands around person's back in "Hands that tell of suffering" c. 1992* Raymond Meeks (Graphis93 58)

seemingly wrapped in string in "Hands" 1978 Dieter Appelt (Rosenblum2 #731)

two hands and door in "Untitled" 1959 Jerry Uelsmann (Decade \68)

with bracelets in "Hands Study" c. 1920 Yva (Rosenblum \134)

with bracelet on tire in "Georgia O'Keeffe" 1933 Alfred Stieglitz (Szarkowski 243)

with ring in "Blues Musician John Lee Hooker" c. 1991* Mark Seliger (Graphis92 \144)

woman holding small vase in "Study of Hands" c. 1854 Oscar Gustav Rejlander (Rosenblum2 #252)

woman's hand holding cigarette in holder in [ad for Myer's gloves] 1920s Margaret Watkins (Marien \5.34; Rosenblum \151)

woman's hands playing piano in "Untitled" before 1930 Laure Albin Guillot (Rosenblum \113)

wooden hand under man's hat in [hat on wooden hand] c. 1997* Jayne Hinds Bidaut (Graphis97 78)

wrinkles on hand compared to wrinkles on apple in "Back of Hand. Wrinkled Apple" 1864 James Nasmyth (Marien \3.74)

HANDBAGS

metal handbags and handles in "Metal Purses" c. 1997* Lisa Spindler (Graphis97 71)

multiples of black handbags in "Eight Black Bags Five Times" c. 1995* Raymond Meier (Graphis96 48)

textured bag in [ad for handbags] c. 1991* David Holt (Graphis91 \229)

woman holding red purse in "Red purse with flowers" 1998* Jean Shifrin (Best24 48a)

HARLEM (New York, New York)

African Americans marching in protest in "Reverend Adam Clayton Powell, Jr., leads a protest on 125th Street in Harlem–'Don't Buy Where You Can't Work' campaign" 1942 Morgan and Marvin Smith (Willis \124)

children playing on city street in "Harlem, New York" 1939 Sid Grossman (Decade 44a)

crowd listening to man on platform in "Street-corner orator" 1938 Morgan and Marvin Smith (Willis \123)

elevated part of the subway going past apartment house in "City noises in West Harlem, accentuated by the rumble of a train, make the task of placing a phone call nearly impossible" 1991 Peter Essick (Best17 50a)

families dressed for Easter Sunday in "Easter Sunday, Harlem" 1940 Weegee (Art \313)

man in top hat in "Easter Sunday in Harlem" 1939 Morgan and Marvin Smith (Willis \122)

saxophone playing and people drinking in a pub in [St. Nick's Pub, Harlem] 1994 Gerald Cyrus (Willis \330)

police checking bags of garbage in "Officers of the New York Recycling Police check for compliance with the recycling program in Harlem" 1991 Peter Essick (Best17 51b)

rope across stoop of boarded-up building as swing for girl in "Harlem Girl" 1982 Mansa K. Mussa (Willis \280)

snow on front steps of attached houses in "Harlem Snowstorm" c. 1969 St. Clair Bourne (Willis \224)

using needles in a lot in Harlem in "Used hypodermic needles litter an abandoned lot in East Harlem frequented by heroin addicts" 1991 Peter Essick (Best17 51a)

HATS

blonde woman wearing veil as hat in "Chicago" 1950 Harry Callahan (MOMA 209)

boy in suit and straw hat holding a flag "Boy with Straw Hat Waiting to March in a Pro-War Parade, New York City" 1967 Diane Arbus (Icons 159; MOMA 237)

Chinese men in hats, on street in "Chinatown, San Francisco" 1896-1906 Arnold Genthe (MOMA 72)

lace caps in advertising photograph in "Babies' Lawn Caps" c. 1900 Stadler Photographing (National 148c)

large white hat with large flower in front in "Mrs. Clarence H. White" 1906 (MOMA 89)

line of women in hats in "Shoppers Glimpse a Movie Star at Grand Central Station, New York" 1953 Dan Weiner (MOMA 220)

man in bowler in "Untitled" c. 1915 Paul Strand (MOMA 99)

Mexican men marching in large hats in "Workers' Demonstrations, Mexico" c. 1928 Tina Modotti (Icons 45; Women \50)

model in hat in "Chinese hat" c. 1991* Michael Biondo (Graphis92 \151)

of large flowers in [Woman with floral hat] c. 1997 Lillian Bassman (Graphis97 16)

older woman in feathered hat from [Gifted Women] c. 1992* Howard Schatz (Graphis93 127)

on potted morning glory plant in "Morning Glory" c. 1999* Hugh Kretschmer (Photo00 30)

over wooden hand in [hat on wooden hand] c. 1997* Jayne Hinds Bidaut (Graphis97 78)

trying on hats in mirror in "Portrait of Hat Designer Carine Farley" c. 1999* Kevin Wick (Photo00 103)

with veil in [hat with veil] c. 1997 * Marcia Lippman (Graphis97 47)

HAWAIIANS

seated girl in grass skirt holding a ukulele in "A pure-blooded Hawaiian girl wears native dress, a style handed down from generation to generation, and plays the ukulele–a small guitar popularized in Hawaii in the 1880s" 1924 Henry W. Henshaw (Through 323)

HAYSTACKS see STACKS (HAY, GRAIN, etc.)

HAZARDOUS WASTES

blind, mentally disabled boy in "Berik Syzdykov, 14, lives downwind of the Semipalatinski test site in Kazakhstan" 1993 Stan Grossfeld (Best19 58)

mother and deformed young woman in bath in "Tomoko in Her Bath, Japan" or "A young woman deformed by mercury pollution" 1971-1972 W. Eugene Smith (Best21 2; Eyes #252; Lacayo 159d; Monk #45; Rosenblum2 #475)

photo essay chronicling the Japanese victims of industrial mercury poisoning and the fight for compensation [from Minamata] c. 1974 W. Eugene Smith (Best21 2-15)

photo essay on town polluted by leakage from chemical plants in "Mossville, Louisiana" 1997 Eugene

Richards (Best23 40-41)

river and tree made blue from mine runoff in "The Colonial Mine with blue asbestos tailings, Wittenoom, Western Australia" 1999* David Goldblatt (Photography 187a)

workers and fields in Romania in "Factory pollution in Romania" 1990 Tomas Muscionico (Best16 161-164)

HEALERS

woman caring for young girl in "Josefa, Healer of the Evil Eye" 1980 Sandra Eleta (Rosenblum \189)

woman holding her adult son in "A woman lifts her son onto a stage in hopes a faith healer can cure his deformities" 1993* Lucian Perkins (Best19 8)

HELICOPTERS

ammunition being carried from helicopter in "Ammunition airlift into besieged Khesanh" 1968* Larry Burrows (Eyes \7)

carrying man out of mud in "Colombian police chopper lifts a volcano victim from Armero's mud" 1985 Michel duCille (Best11 16c)

former President Nixon's helicopter taking off from the White House lawn behind uniformed men rolling up carpet in "Nixon leaving" 1974 Annie Leibovitz (Rolling #31)

hovering over crowd in "United Nations helicopters hover overhead to supervise during a Cambodian election" 1993* Tim Page (Best19 197)

in grassy field in "Black Hawk Helicopter" c. 1991* Geoffrey Clifford (Graphis91 \293)

pilot-cowboy flying a helicopter in "The American Cowboy" 1979 Erwin "Skeeter" Hagler (Capture 113)

refugees rushing to relief helicopter in "Desperate Kurdish refugees in the mountains of Turkey rush the first American relief helicopter for food" 1991* Les Stone (Best17 115a)

seen from above in "Helicopter belonging to the manufacturing program of the MBB aircraft company" c. 1989* Bernhard Lehn (Graphis89 \213)

HIEROGLYPHICS see PICTURE WRITING

HIJACKING OF AIRCRAFT

cockpit exploding in "An explosion [by hijackers] rips out the cockpit of a Royal Jordanian ALIA Airline at Beirut Airport" 1985 Herve Merliac (Best11 55b)

hijacker in cockpit window with pilot in "TWA Pilot John Testrake answers journalists' questions under hijacker's gun" 1985 Ismail (Best11 51a)

plane on ground in "One of the hijackers aboard TWA Flight 847 waves off a Shiite militiaman after he delivered newspapers to the sky pirates" 1985* (Best11 48)

HINDENBURG (AIRSHIP)

bursting into flames in "Explosion of the Hindenburg, Lakehurst, New Jersey" 1937 Charles Hoff (Hambourg \73); Murray Becker (Goldberg 94); 1937 Sam Shere (Lacayo 81; Photos 52)

flying over New York City in "Hindenburg" 1937 Rudy Arnold (Eyes #170)

sequence of photographs of the burning of the Hindenburg in "Amateur sequence of photographs of the burning of the Hindenburg" 1937 Arthur Codfod, Jr. (Eyes #171); "Death of a Giant: The Exclusive Colorphoto Record of the Destruction of the Hindenburg" 1937* Gerard Sheedy (Eyes \2)

HIPPOPOTAMUS

sleeping in cage in "The Hippopotamus at the Zoological Gardens, Regent's Park" 1852 Count de Montizon (Waking #26)

HIROSHIMA (Japan)–HISTORY–BOMBARDMENT, 1945

city in ruins after the bomb in "Hiroshima destroyed" 1945 George R. Caron (Photos 68)

mushroom cloud from the air in "Mushroom cloud, Hiroshima" 1945 Photographer Unknown (Eyes #216); "Atomic Bomb from the bomber" 1945 George R. Caron (Photos 69)

remains of a wristwatch after the explosion in "Time stopped by the atom bomb" 1945 Yuichiro Sasaki (Eyes #215)

rubble remains after the atomic bomb in "Hiroshima's radiators remain, but not her houses" 1945 Photographer Unknown (Eyes #218)

HISPANIC AMERICANS

bedroom with floral wallpaper in "Bedroom" 1943 John Collier, Jr. (Documenting 304a)

child sleeping in bed beneath crucifix and papercut in "The youngest child asleep" 1943 John Collier, Jr. (Documenting 308a)

children sitting on wood floor with grandfather in "In grandfather Juan Romero's room" 1943 John Collier, Jr. (Documenting 307c)

children washing in basin in "Washing up" 1943 John Collier, Jr. (Documenting 302b)

couple reading from a catalog in "Considering the purchase of a sixty-dollar harness in a mail-order catalog" 1943 John Collier, Jr. (Documenting 306b)

family sitting at simple dinner table in "Serving dinner" 1943 John Collier, Jr. (Documenting 302a)

interior of New Mexican church with wood floor and no benches in "Father Walter Cassidy celebrates mass at the Trampas church" 1943 John Collier, Jr. (Documenting 310a)

mother helping children at table in "Maclovia Lopez helping her children with their homework" 1943 John Collier, Jr. (Documenting 306a)

photo essay on the Spanish part of Manhattan's Lower East Side, children, wedding, drugs, and street life in "Loisaida: unchanging, unrelenting" 1986 Geoffrey Biddle (Best12 42-49)

portrait of a gang member in "Young man from the Mexican–American district of Los Angeles" c. 1989 Tom Zimberoff (Graphis89 \142)

woman in print dress in "Maclovia Lopez" 1943 John Collier, Jr. (Documenting 303c)

woman spinning wool on small bench in "Maclovia Lopez spinning wool" 1943 John Collier, Jr. (Documenting 309b)

HISTORIC BUILDINGS

home occupied by General George Washington in "House of General Washington, Cambridge" c. 1855 John Adams Whipple (National 164a)

HITCHHIKING

man with backpack and large comedy thumb on highway in "Trying to hitch a ride" 1985 Randy Pench (Best11 186b)

HOLLYWOOD

photo essay on homeless, tourists, and performers on the street in "Dreaming of Stars" 1996 David Butow (Best22 260-261)

HOLOCAUST, JEWISH *see also* BUCHENWALD (Concentration Camp)

concentration camp guards on their knees in "Beaten Guards Begging for Mercy, Dachau Concentration Camp, Germany" 1945 Lee Miller (Women \73)

crowd around informer in "Dessau: Exposing a Gestapo informer" 1945 Henri Cartier Bresson (Eyes #254; Marien \5.83)

group of people being marched through street at gunpoint in "Deportation from the Warsaw Ghetto" 1943 Photographer Unknown (Photos 58, 59)

hundreds of bodies on ground in destroyed concentration camp in "Nordhausen, Germany" 1945 Johnny Florea (Life 55)

man looking at mound of dead bodies in "Senator Alban W. Barkley of Kentucky, Chairman of the House Senate Committee on War Crimes, Buchenwald" 1945 Photographer Unknown (Goldberg 118)

men lying on stacked wooden shelves they used for beds in "Liberation of Buchenwald concentration camp" 1945 Photographer Unknown (Photos 67)

mound of bodies in "Another Nazi horror camp uncovered" 1945 Photographer Unknown (Eyes #214)

pile of bodies in "Dead Prisoners, Dachau Concentration Camp, Germany" 1945 Lee Miller (Women \72)

HOMELESS PERSONS

boy sleeping in a car in "Eleven-year-old Tony Beck sleeps in the car after a September storm washed out his family's tent–their home" 1987 Stephen Shames (Best13 42b)

children in diapers playing on fire escape in "New York City Hotel Holland for the homeless" 1987 Nicole Bengiveno (Best13 45)

children sleeping on radiators and on train platform in "Bucharest: The Children of North Station" 1997 Ettore Malanca (Best23 226b)

couple embracing on squalid street in "Ski and his wife of two weeks are homeless and live under the railroad bridge" 1996* Dennis Nett (Best22 211c)

couple holding hands in "Homeless couple in Wilmington, California" 1990 Peggy Peattie (Best16 189)

covered with blanket in entryway in "Grayson, California" 1938 Dorothea Lange (Rosenblum2 #481)

dead man in morgue in "The body of a homeless man who froze to death lies in a Moscow morgue" 1992 James Nubile (Best18 120)

diaper changing on floor of public bathroom in "Two days after Christmas, 23-year-old Barbara Trango changes her daughter's diapers on floor of a public restroom in the Travelers Aid offices in Jacksonville" 1987 Ron Bell (Best13 43)

eating from garbage bin in "A man eats from a garbage bin in a Philadelphia alley" 1987 Rebecca Barger (Best13 33b)

family in old car in "Brian Brunner lost his job and lives with his family in a 1971 station wagon" 1993 Stan Grossfeld (Best19 54a)

fist fight in a shelter in "Bobby Burton, a transient from Georgia, tries to strike a man during a fight that broke out in a homeless shelter" 1988 Joe Burbank (Best14 75a)

homeless man sitting on sidewalk in cardboard box and eating in "Philadelphia's Homeless" 1985 Tom Gralish (Capture 139)

hundreds of bed for homeless men in "800 homeless men sleep on the drill floor in Brooklyn's Franklin Street Armory on winter nights" 1986 Sara Krulwich (Best12 70a)

individual homeless people in "Homeless people of New York City" c. 1991 William Coupon (Graphis91 \70-\73)

Indonesian children sleeping on train station floor in "Indonesian Street Kids" 1998 James Nachtwey (Best24 162-163)

man covered as he is on a vent in "A homeless man keeps warm over a steam vent on the streets of New York City" 1987* Andrew Holbrooke (Best13 32)

man in front of bedsprings in "New Orleans unemployed and homeless chef" c. 1991* Nick Vedros (Graphis91 \207)

man in hat in "A homeless man sits in the afternoon sun in the streets of Greenwich Village" 1988 Andrew Holbrooke (Best14 119)

man in wheelchair drinking from bottle in "Wheelchair-bound Mike Haven has his 'wake-up' in the Second Avenue Seattle storefront that he often calls home" 1987 Alan Berner (Best13 42a)

man in wheelchair leaning against lamppost with a stop sign in "The message couldn't be clearer as a homeless, legless man comes to a full stop in Boston's business district" 1986 David L. Ryan (Best12 188)

mother and children waiting on street in "Daisy Mayes shields her two children against an autumn wind as her older son watches for the public bus" 1990 Bill Tiernan (Best16 116)

mother and son on their porch in "Brenda Young and her son are one of 424 families that received lease terminations for their Lafayette Shores apartment" 1987 Dawn Feary (Best13 44)

mother feeding children in "A mother with 6 children and no home of her own feeds her famished kids with leftovers brought back by her mother-in-law from a party" 1997 Marice Cohn Band (Best23 140b)

photo essay on a Russian boy who lives in an airport in "Sergei: A Child Alone" 1992 John Kaplan (Best18 209-212)

photo essay on children living in residential motels in "Loss of Hope: Motel Children" 1998* Daniel A. Anderson (Best24 146-155)

photo essay on the life of homeless people living on the streets in "Seattle's homeless" 1987 Jimi Lott (Best13 34-41)

photo essay on the plight of homeless people in "Homeless in America" 1983-1992 Michael S. Williamson (Best19 81-96)

shoeless man reading a book on street in "Robert Monaghan, reading a book on the streets of downtown San Diego, refuses money offered by a passerby" 1987 Christine Cavanaugh (Best13 33a)

South African children sleeping on floor in "Runaway children huddle together as they sleep on a Johannesburg Street" 1992* James Nachtwey (Best18 31d)

teenage boy resting on ledge in "A homeless teen in Fort Lauderdale" 1990* Andrew Itkoff (Best16 8c)

unwashed boys sitting on car seat in "Three brothers sit on a junked car seat near the Sacramento River" 1993 Michael S. Williamson (Best19 7d)

various homeless children in rooms with beds from [book entitled *We the Homeless*] c. 1989 Stephenie Hollyman (Graphis89 \258-\261)

women walking in park in Winter in "Untitled" 1988 Kristine Larsen (Rosenblum \197)

HONG KONG (CHINA)

panorama of city and harbor in "Panorama of Hong Kong, Showing the Fleet for the North China Expedition" 1860 Félice A. Beaton (Marien \3.34)

shop displaying lanterns in "Hong Kong" 1964 Josef Breitenbach (Photography 44)

studios in three-story building in "Photographers' Studios, Hong Kong" c. 1870 William Pryor Floyd (Marien \3.33)

HORSES

Amish teenage girls at fence watching horse race in "The only event Amish teenagers are allowed to attend is harness racing at rural Ohio fair" 1997* Randy Olson (Best23 170d)

and jockey in "Jockey Mihad and racehorse Samir at Beirut horse track" 1998 Seamus Murphy (Best24 82a)

and man in plaid shirt in "Untitled" c. 1990* Robert Garvey (Graphis90 \127)

archery from horseback in "Japanese bowman keeps alive the samurai art of yabusame, or mounted archery" 1996* Peter Essick (Best22 197c)

at the blacksmith in "Basil, the Blacksmith" 1889 C. H. Stoddart (Photography1 #VI-3)

being ridden down steep hill in "Horses and riders careen down Suicide Hill into the Okanogan River" 1986 Kit King (Best12 221)

bird on horse's back in "Flapping its wings for balance, a cattle egret rides bareback across a meadow on the island of Kauai" 1993* Richard Schmidt (Best19 73d)

Black man on white horse in [Black man on white horse] c. 1997 Robert Maxwell (Graphis97 109)

boy on horse drinking water in "A New England Watering Place, Near Salisbury, Conn." 1887 Robert Redfield (Photography1 #VI-7)

boys and horse in snow in "Kids move their horse to their warm barn during a blustery winter snow storm" 1996* Kurt E. Smith (Best22 154a)

bronc rider going down in rodeo in "Mat McClain goes down in the saddle bronc competition" 1985 Chris Stewart (Best11 220d)

calvary on maneuvers in snow in *Black Avni* Turkish Calvary on Maneuvers" 1948 David Douglas Duncan (Rosenblum2 #609)

child leading small horse in "2-year-old leads world's smallest horse" 1985 Jeff Alexander (Best11 172a)

cowboys roundingup horses in "Untitled (Cowboys)" 1993* Richard Prince (Marien \7.34)

despondent police officer holding his injured horse in "Police officer and his fatally injured horse" 1985 Jim Mahoney (Best11 84-85)

exercising a race horse in "Exhibition Park Racetrack exercise boy shares his feelings of mutual disrespect with a Canada Goose guarding its nest next to the track" 1988 Les Bazso (Best14 128d)

fallen cowboy protecting himself from horse in "Dumped by his mount during National Rodeo Finals" 1986 James Kenney (Best12 220)d

farm horse plowing field in "The Farm Horse" c. 1935 Nora Dumas (Rosenblum \136)

galloping horse in still images in "Galloping Horse" 1878 Eadweard J. Muybridge (Monk #9)

galloping into a corral in "Horses enter the runway to the corral during morning wrangling at Cottonwood Ranch" 1996* Andy Sawyer (Best22 183d)

girl on horse in stable in [girl on a horse] c. 1995* John Madere (Graphis96 104)

girls riding through a forest in "Two young girls take their pony for a trail ride near Olalla" 1991 Rod Mar (Best17 204)

girl sitting on horse in barn in "Child isn't old enough to ride but dreams of the day" 1998* Randy Olson (Best24 46)

group of men riding horses in "Mexican revolutionaries Francisco I. Madero and Pancho Villa" 1911 James Hare (Lacayo 40a)

helicopter round-up of wild horses in "Flying less than 50 feet above the Nevada desert, pilot herds wild mustangs toward a corral trap set by the Bureau of Land Management" 1987 Chuck Bigger (Best13 97b)

holding onto horse's tail in flood waters in "When the fields flood a horse is used as an amusement park ride" 1998* Randy Olson (Best24 40d)

horse catching up to harness driver in "At the Monticello raceway in upstate New York a harness driver barely stays ahead of the second place horse" 1997* Bill Frakes (Best23 170b)

horse-drawn wagon filled with mattresses outside apartment in "Moving possessions, 317 East Sixty-first Street" 1938 Walker Evans (Documenting 133c)

horses and riders crossing natural stone bridge in "Edwin Natural Bridge, in San Juan County, Utah, rises nearly 100 feet and measures 194 feet long" 1910 Charles Goodman (Through 298)

horses grazing in "Transylvania" 1999 Josef Koudelka (Photography 175)

in jousting tournament in "A modern knight in a jousting tournament" 1985 Bill Tiernan (Best11 220c)

in winter "Horse on a cold day, Woodstock, Vermont" 1940 Marion Post Wolcott (Documenting 51)

injured civil rights workers walking away from police in "Civil rights workers are beaten by sheriff's deputies and police on horses" 1965 Charles Moore (Best14 211, 219)

jockey falling off horse in "Jockey Jack Kaenel leaves his mount, Years of Fun, in the second race of opening day at Hollywood Park" 1986 Steve Dykes (Best12 223)

jockey on race horse in "Thunder Gulch wins the 1995 Kentucky Derby" 1995* Bill Frakes (Best21 126a)

jockey standing on race horse in "Jockey celebrates atop 40-1 longshot Dare-and-Go as he defeats Cigar" 1996* James D. Baird (Best22 197c)

jumping a fence in "A perfect jump at the Maryland Grand Prix Classic" 1996* Rich Riggins (Best22 197b)

jumping over fences in race in [steeplechase] c. 1995* Monica Stevenson (Graphis96 200)

jumping over gates in competition in "Bobby Ginsberg successfully takes State Hill over a jump at the U.S. Open Horse Jumping Championships" 1985 Mark B. Sluder (Best11 220a)

large man on white horse in "A Judge at the Horse Races" 1941 Margaret Bourke-White (Sandler 161)

man looking through binoculars while standing on the back of a horse in "Belgian patrol watching the German advance" 1914 Underwood & Underwood (Eyes #79)

man mounting horse, with other holding reins in "Mounting a Bronc" c. 1910 Erwin E. Smith (MOMA 61)

man on horse in "The President returning from his bear hunt in Colorado" 1905 Underwood & Underwood (Eyes #70)

man nailing in horseshoe in "Farrier, with His Clients" c. 1848 Photographer Unknown (Photography1 \23)

man playing polo on horseback in "Stewart Copeland" 1988* E. J. Camp (Rolling #84)

man plowing with horses in "The Husbandman" 1919 O. C. Reiter (Peterson #86)

man squatting to talk to his horse in "Rumania" 1968 Josef Koudelka (Rosenblum2 #717)

men on horseback behind fathers with young boys in "A dancer entertains at a circumcision ceremony in the Altay mountains of Xianjiang, China, where Kazakh herders gather in summer" 1996* Reza (Through 186)

men on horseback herding cattle in "Cutting Out" c. 1895 Charles D. Kirkland (Photography1 #III-15)

men with rifles on horseback in "Traditional 'Fantasia' Fete of Morocco" c. 1991* John Isaac (Graphis91 \295)

miniature horse around man's neck in "Larry Seitz carries a miniature horse at his farm" 1993* Allan Detrich (Best19 228)

Mongolian woman on a horse in "Mongolian Horsewoman" c. 1913 Stéphane Passet (Rosenblum2 #346)

mounted soldiers going to battle in "Austrian Uhlans going into position" 1915 Underwood & Underwood (Lacayo 47)

moving on hind legs in [two horses] c. 1997 Evangelia Sotirion (Graphis97 185)

Native Americans recreating Wounded Knee massacre in "Wounded Knee, South Dakota on the 100th anniversary of the massacre" 1990 Don Doll (Best22 66)

near female model in chaps in [ad for fashion by Ralph Lauren] c. 1989* Bruce Weber (Graphis89 \23)

one being washed in a car wash in "Only in Texas, perhaps, but this resident brings her horse to the car wash for a hosing-down every week" 1985 Jeff Shaw (Best11 151d)

pulling a barge along a river in "A horse tows a grain-and-timber barge along the River Chelmer in England" 1940 Topical Press (Through 36)

pulling man on sled across snow-covered field in "A workman makes his way across the former estate of Alexander Pushkin" 1992* Lynn Johnson (Through 64)

race horse and sulky in silhouette in "Trotter is taken back to a barn at a raceway after a workout" 1996* Bill Frakes (Best22 197a)

racing in steeplechase in "Horses clear a jump at Breeders Cup Steeple Chase, Belmont Park" 1993 Alan Zale (Best19 142a)

rearing up with woman riding in "Candice Bergen" c. 1989* Annie Leibovitz (Graphis89 \153)

rider and horse crashing into fence in "Moira Laframboise and her steed part company during the Rolex Three-Day Event at Kentucky Horse Park" 1990* Ron Garrison (Best16 120a)

a sheep with its head in a can walking past three ponies in "A ewe with its head in a can got much attention but no help from a trio of ponies" 1985 Susan Steinkamp (Best11 150a)

stages of horse walking with man on horseback in "Horseman Riding the Mare Odette" c. 1887 Etienne-Jules Marey (Szarkowski 132a)

standing by a barbed wire fence in [horse in a pasture] c. 1997* Jayne Hinds Bidaut (Graphis97 176)

turning around a trolley car in "The Terminal" 1893 Alfred Stieglitz (Art \197; Rosenblum2 #312)

white horse on hind legs, behind man in black in "Jon Bon Jovi" 1989* Timothy White (Rolling #103)

women in corral with horses in "The Buckley Sisters in Their Corral" c. 1905 Evelyn Cameron (Sandler 7)

young woman working with race horses in photo essay in "Ready to Ride" 1988 Catherine Krueger (Best14 138-139)

HOSPITALS *see also* SICK; WOUNDS AND INJURIES

child on cot in "Cholera Dorm, Benaco Refugee Camp in Tanzania" 1995 Eli Reed (Committed 178)

dog in hospital bed with injured boy in "When John Abell, 14, was immobilized after a car accident, officials bent the rules a bit to allow John's golden retriever to visit his master" 1986 John Warner (Best12 134c)

group of nursing mothers in overcrowded hospital in "The conditions of hospital nurseries in Romania" c. 1991* Francine Bajande (Graphis91 \80-\83)

machines and bed in clinic in "X-Ray Clinic" 1926 Werner Mantz (Hambourg 78a)

man lying in bed in "Jenteel was diagnosed as an AIDS victim in 1984" 1985 Bob Mahoney (Best11 29a)

men in beds near sandbagged window in "Gaza Palestinian Hospital–Beirut" 1982 Christopher Steele-Perkins (Eyes #359)

men in suits standing around woman on operating table in "Operating Room, Massachusetts General Hospital, Woman Patient" 1846-1848 Southworth & Hawes (Rosenblum2 #187)

newborn in blanket with large pink bows in "Wrapped like a gift, a newborn awaits her parents at a maternity hospital in Vinius, Lithuania" 1990* Larry C. Price (Through 72)

mother sitting on son's bed in "A mother keeps a vigil over her sick son in a Kikwit, Zaire, hospital" 1991* Charles Ledford (Best17 80)

nurse and crying child in "Six-year-old cries in pain as a nurse changes the dressing on an incision" 1992 Mona Reeder (Best18 227a)

nurse cutting shirt of patient in "Trauma nurse starts working on a gunshot victim as he is wheeled in the hall of St. Mary Medical Center" 1990* Peggy Peattie (Best16 191b)

nurse tending bandaged man in hospital ward in "Ghostly glimpse of wounded Belgians in hospital, Antwerp, Belgium" c. 1914-1918 Keystone View Company (Eyes #43)

people in beds in "Home for the Dying, Calcutta" 1980-1981 Mary Ellen Mark (Rosenblum \201; Women \141, \142, \143)

photo essay on cancer patients in a hospital in "Dana-Farber [Cancer Institute]: Living with hope and fear" 1995 Eugene Richards (Best21 57, 72-75)

photo essay on the doctors, waiting patients and the dead in a hospital in "Graveyard Shift" 1997 Michael Williamson (Best23 200)

photo essay on the medical help given by American and Haitian doctors in "Medical mission to Haiti" 1986 Bill Kelley III (Best12 32-33)

radiology equipment in "Radiology Unit, Military Hospital, Grand Palais, Paris" 1914-1916 Photographer Unknown (Szarkowski 136)

readying a patient in "Emergency-room personnel prepare a patient for a CAT scan" 1990* Peggy Peattie (Best16 186c)

row of infants in the same clothes waiting to be washed in "Lined up like loaves at a market, infants nearly fill a countertop at a hospital washing station in Shanghai, China" 1994* Stuart Franklin (Through 170)

surgeon holding liver in operating room in "Liver transplant surgery" 1982* Ergun Cagatay (Life 105)

women on hospital beds in "Patients in a maternity ward in Albania" 1992 April Saul (Best18 70)

HOSTAGES

American blindfolded and handcuffed being led by two men in "One of the hostages held at the American Embassy, Tehran" 1979 P. Ledru (Eyes #350; Life 160)

boy holding gun at hostage in front of wood fence in "Teen-Age Shooter" 1947 Frank Cushing (Capture 20)

couple crying in "Relatives of Navy diver Robert Dean Stetham meet plane that brought his body home" 1985 Dudley M. Brooks (Best11 49d)

hijacker in cockpit window with pilot in "TWA Pilot John Testrake answers journalists' questions under hijacker's gun" 1985 Ismail (Best11 51a)

hostage with shotgun to head in "Money-borrowers Revenge" 1977 John H. Blair (Capture 102)

man holding gun at woman's head in "Steven Burch jams a cocked pistol into clerk Pamela Hinkle's neck after taking her hostage at a local grocery store" 1996* Mike Bordo (Best22 149c)

man holding gun on man with knife at woman's throat in "Hollywood Fatality" 1973 Anthony K. Roberts (Capture 85)

man hugging girl in "San Franciscan Victor Amburgy is welcomed home by niece Danelle Kruse after his release from Flight 847" 1985 Dennis Cook (Best11 49c)

man in gas mask running with child in "A SWAT team member in Yuba City race to safety with a 7-year-old boy, one of four children held hostage by their father" 1985 David Parker (Best11 81)

man with guns chained to hostage in "Kidnapper Georges Courtois shoots at a crowd of journalists while running out a high court in Nantes, France" 1985 Pierre Gleizes (Best11 79a)

people hugging returning hostages in "Freed hostages return from Entebbe" 1976 Micha Bar-Am (Eyes #356)

HOT AIR BALLOONS

balloon over a city park in "Balloon" 1977* Ruth Orkin (Rosenblum2 #777)

HOT SPRINGS

aerial view of hot spring in "Billions of organisms flourish in the scalding-hot Grand Prismatic Spring at Yellowstone National Park" 1998* George Steinmetz (Through 296)

Japanese woman near hot springs in "A housewife in Beppu, Japan, boils eggs over bubbling hot springs, which also heat stoves around the town" 1942 Japanese Government Railways (Through 158)

steam coming from fissure in ground in "Fissure Vent of Steamboat Springs, Nevada" 1867 Timothy H. O'Sullivan (Waking #4)

swimming in hot springs in Iceland in "Despite the chilly air, bathers in Iceland keep warm in a thermal spring dubbed the Blue Lagoon" 2000* Sisse Brimberg (Through 442); "The Blue Lagoon, Iceland's 'biggest bath,' is the catch basin of a power plant in the hot springs region of Grindavik" c. 1990* Horst Munzig (Graphis90 \86)

wagon and horses near hot springs in "Humboldt Hot Springs" 1868 Timothy H. O'Sullivan (Waking #115)

HOTELS

carriages in front of hotel at night in "Savoy Hotel, New York" 1897* Alfred Stieglitz (Photography1 \15)

elaborate hotel entrance in "Hotel entrance" 1939 Marion Post Wolcott (Documenting 178a)

hotel on the water in "Hotel and service station" 1939 Marion Post Wolcott (Documenting 181c)

many floors of hotel balconies in "Guest at Disneyland Hotel checks out the territory" 1985 Al Fuchs (Best11 141a)

old town and ships in courtyard of hotel in "Las Vegas, Nevada" 1999* Thomas Struth (Photography 26)

photo essay on children living in residential motels in "Loss of Hope: Motel Children" 1998* Daniel A. Anderson (Best24 146-155)

single-story motel in red light in "Motel in Hell, Michigan" 1975* Patty Carroll (Women \180)

sprawling hotel and ice skaters from [series *Nights to Remember*] c. 1997* Peter Guttman (Graphis97 164b)

wallpapered lobby with one chair and one plant in "Fontainebleau Hotel, Miami Beach" 1962 Elliott Erwitt (MOMA 239; Szarkowski 248)

HULA-HOOPS

family using hula-hoops in suburban backyard in "Hula-hoopers" 1958 Arthur Shay (Life 115)

girl near beach in "Helen and Her Hula Hoop" 1983 Chris Killip (Photography 55); "Untitled" 1987 Chris Killip (Szarkowski 289)

young woman in bathing suit using a hula-hoop by pool in "Liv Tyler" c. 1997* Mark Seliger (Graphis97 127)

HUNTING

archer in camouflage in "Longbow hunter draws back his trusty arrow" 1997 Frank B. Johnston (Best23 167a)

bird's body on man's head as decoy in "A hunter peeks from inside a decoy on the Indus River in Pakistan" 2000* Randy Olson (Through 180)

deer hanging from tree near hunters and camp fire in "The Antlers, Open Camp, Raquette Lake" c. 1889 Seneca Ray Stoddard (National \50)

dogs attacking a bird in "Hunting dogs in Papua New Guinea make a meal of a northern cassowary, a flightless bird they cornered and killed" 1994* Jay Dickman (Through 424)

growling wolf and dead prey in "A gray wolf savors a fresh kill" 1998* Joel Sartore (Through 324)

hunters and dead polar bears near ship in Arctic in "Hunting by Steam in Melville Bay" 1869 John L. Dunmore (National 19d, \43)

man running with dogs through the brush in "A hunter and his dogs search the brush for delectable cane rats in KwaZulu-Natal Province, South Africa" 2001* Chris Johns (Through 228)

men carrying guns in marsh in "Snipe Shooting" 1886 Peter Henry Emerson (Art \153)

men in field with birds and dog in "A hunter grasps a prized ring-necked pheasant, bagged during a popular annual shoot at Broken Bow, Nebraska" 1998* Joel Sartore (Through 360)

men sitting at a campfire in "Caribou Hunting: The Return of the Party" 1866 William Notman (Rosenblum2 #277)

men with guns and dead birds, leaning over a fence in "A Day's Shooting" c. 1857 William Grundy (Rosenblum2 #270)

small cart with dead stag in "Stag in cart" c. 1858 Horatio Ross (Waking #18)

HURRICANES

bailing out a boat that was washed ashore in "In Florida a commercial fisherman bails out his boat after Hurricane Elena washed it ashore" 1985 Bill Wax (Best11 68c)

blankets, pillows, and laundry in gym shelter in "A volleyball net in the gym serves as a clothes line for Floridians whose homes were flooded or cut off by high water from Tampa Bay during Hurricane Elena" 1985 Fred Fox (Best11 69d)

boats being tossed into rocks in "In New Bedford, Mass., three men try to keep Hurricane Gloria from smashing their craft on the rocks on Pope's Island" 1985 John Sheckler (Best11 71a)

boats crashing into beach in "At Mystic, Conn., the sign was superfluous, and Hurricane Gloria blew everything up on shore" 1985 John Long (Best11 71b)

couple holding onto a street sign in "People cling to a street sign in Old Saybrook, Conn., as they experience Hurricane Gloria's force" 1985 Paula Bronstein (Best11 70d)

fishing boat pushed into a hotel in "Hurricane Gilbert pushed a Cuban fishing ship against a hotel in Cancun, Mexico, despite its two anchors" 1988 Ricardo Ferro (Best14 11d)

highway destroyed by hurricane in "Family sees what Hurricane Kate did to U.S. 98 near Eastpoint, Florida" 1985 Maurice Rivenbark (Best11 73b)

home torn off its foundation in "[Mother and daughter] comfort each other after seeing the damage Hurricane Elena caused the home" 1985 Mike Ewen (Best11 69a)

line of people moving sandbags in "Residents of a subdivision in Braithwaite, Louisiana, sandbag a levee to help protect their property from rising waters caused by the storm" 1985 Chuck Cook (Best11 72a)

man holding onto a pole in high winds in "A man grips a pole for support during Hurricane Gloria" 1985 Bonnie K. Weller (Best11 70a)

man holding puppy by the scruff of its neck near wreckage of his mobile home in "After the hurricane [Andrew]" 1992* Lannis Waters (Lacayo 187)

man in hip boots bailing water from his house in "Thanks to Hurricane Juan, Claude Boudreaux bails water

from his home near Houma, Louisiana" 1985 Bryan S. Berteaux (Best11 72d)

man leaning into hurricane winds in "A curious resident of New Haven is stopped in his tracks by Hurricane Gloria" 1985 Dennis Yonan (Best11 70c)

man lifted into air as he holds onto giant flag in "Fighting to lower a giant flag, Deputy Lloyd Dupuy is lifted into the air by the winds of Hurricane Opal" 1995* John McCusker (Best21 170)

man walking in hurricane in "On Orient, Long Island, an unhappy owner tried to get to his auto" 1985 Judy Ahrens (Best11 71b)

man with surfboard walking past beached boat in "Torn apart by Hurricane Kate, the sloop *Mai Hai* washes ashore" 1985 Eliot Jay Schechter (Best11 73a)

photo essay on the destruction to homes by Hurricane Andrew in "Andrew's Legacy" 1992 Carol Guzy (Best18 23-26)

photo essay on the mud, floods and death from Hurricane Mitch in "In the Wake of a Hurricane, Honduras" 1998 Larry Towell (Best24 22-23); in "Hurricane Mitch" 1998* Mike Stoker (Best24 24-25); in "Mitch Destruction" 1998 Juana Arias (Best24 26-27)

sailboat in a stand of mangrove trees in "A sailboat rests in a stand of mangrove trees after being pushed ashore by Hurricane Andrew at Key Biscayne, Fla." 1993* Cameron Davidson (Best19 115)

standing at railing during a storm in "Gwen Littelberg grabs hold of a fence to keep from being swept away by waves in Woods Hole, Mass., during Hurricane Bob" 1991* Ruben Perez (Best17 208)

women walking through flooded street in "In Tampa, residents move to safety along a flooded causeway as Hurricane Elena moves in" 1985 Raul DeMolina (Best11 68a)

HYPNOTISM

four seated people with their eyes shut in "Hypnotism" c. 1845 John Adams Whipple (Marien \2.67; Waking #88)

—I—

ICE

melting cube held by ice tongs in "Water Fire Smoke" c. 1999* Craig Cutler (Photo00 201)

ICE SKATING *see* SKATING

ICEBERGS

bird flying over iceberg in "Iceberg and bird in the Antarctic" c. 1991* Bruno Zehnder (Graphis91 \283)

by cliff in [iceberg] c. 1997* Randy Wells (Graphis97 136)

large iceberg with some melting ice in "An Iceberg in Midsummer, Antarctica" 1910-1913 Herbert Ponting (Rosenblum2 #159)

penguins on an iceberg in "Chinstrap penguins hitch a ride on an intricately sculpted blue iceberg in the sub-Antarctic" 1995* Cherry Alexander (Best21 159a)

sailing ships in an ice field in "Sailing Ships in an Ice Field" 1869 John L. Dunmore (Rosenblum2 #158)

with hole in "Liquid Solid" c. 1995* Sheila Metzner (Graphis96 157a)

yacht near iceberg in "Eric Tabarly's yacht, close to an enormous iceberg" c. 1991* Christian Février (Graphis91 \291)

ICELAND

bathers in the water of a geothermal plant in "In a land of volcanoes, earthquakes and glaciers, Icelanders survive–and prosper" 1987* Bob Krist (Best13 95b)

ships, buildings, and machinery in [Iceland] c. 1995* Marco Paoluzzo (Graphis96 166)

views of the water in [landscapes in Iceland] c. 1992* Nadav Kander (Graphis93 177)

IGUANAS

several worn like a hat by a woman in *"Nuestra Señora de las Iguanas, Juchitán"* 1980 Graciela Iturbide (Women \136)

ILLEGAL ALIENS

photo essay on the life of Chinese men who have been smuggled into New York City in "Bachelor Society–Illegal Chinese Immigrants in New York" 1998 Chien-Chi Chang (Best24 116)

coffins being carried by crowd in "Death of people trying to cross into California" 1990* (Best16 36)

hands pushing over sewer grate in "Two sets of hands reach up to remove a sewer grate in Arizona so that illegal immigrants can enter the U.S." 1998* Mona Reeder (Best24 32b)

Mexican crawling under a metal fence in "An illegal alien crosses the border between Mexico and California" 1996* Joseph Rodriguez (Best22 166a)

series on the dangers faced in "Hispanic immigrants trying to cross into California" 1990* Paul Kuroda (Best16 33-35)

IMITATION IN ART
 figure added to Seurat's painting, *Sunday in the Park* in [figure added to Seurat painting] c. 1997* Howard Schatz (Graphis97 101)
 living room and car [from Hommage à Edward Hopper] c. 1992* Dietmar Henneka (Graphis93 161)
 recreation of *Last Supper* with nude woman as Christ in "Yo Mama's Last Supper" 1996* Renée Cox (Committed 84d)
 reminiscent of Ingres in "Inges" c. 1995* Rodney Smith (Graphis96 31)
 seated nude women with arms overhead in "Photographic interpretation of the picture *L'heure bleue*" c. 1990* Marcel van der Vlugt (Graphis90 \153)
 serving cheese at a party in "Photographic reproduction of Pieter Brueghel's *The Wedding Feast*" c. 1989* Bert Bell (Graphis89 \186)
 violin-like f holes on back of nude woman in turban in "*Le Violon d'Ingres*" 1924 Man Ray (Art \246; Icons 27; Rosenblum2 #494)
 women recreating *Last Supper* in "Last Supper" c. 1995* Frank Herholdt (Graphis96 57a)
 women picking through a field in [similarity to Millet's *The Gleaners*] c. 1992* George Simhoni (Graphis93 172)
IMMIGRANTS *see also* ILLEGAL ALIENS
 child eats by himself at school in "Finding it difficult to adjust to his new school, child often eats by himself" 1992 Mona Reeder (Best18 228a)
 children in school in "Asian immigrant pupils play Simon Says as a way of learning English" 1992 Mona Reeder (Best18 227d)
 children in wagon holding small flags in "Children's playground, Ellis Island roof garden" 1909 Augustus Sherman (Goldberg 35)
 couple dancing to an accordion in "Immigrants waiting at Ellis Island" c. 1905 Lewis Wickes Hine (Lacayo 65c)
 deteriorating rooms on Ellis Island in "Ellis Island–The Forgotten Side" c. 1999* Stephen Wilkes (Photo00 22, 23)
 Hmong lives and rituals in America in "In America: Hmong mix old and new" 1987 April Saul (Best13 155-157)
 Dutch women in "Untitled (three Dutch women at Ellis Island" c. 1910 Augustus Sherman (Goldberg 31d)
 men and women carrying suitcases up stairs in "Climbing into America" 1908 Lewis Wickes Hine (Eyes #61; Lacayo 57)
 Mexican men sitting in a jail cell in "Illegal immigrants await deportation" 1951 Loomis Dean (Lacayo 140)
 a mother with her two children in "A Russian family on Ellis Island" 1905 Lewis Wickes Hine (Lacayo 58)
 mother with three children standing by their luggage in "Looking for lost baggage, Ellis Island" 1905 Lewis Wickes Hine (Photography 206)
 ship crowded with people in "Steerage" 1907 Alfred Stieglitz (Art \199; Icons 15; Marien \4.21; Rosenblum2 #402)
 woman holding child near bags of rags in "In the Home of an Italian Rag-Picker; New Jersey" c. 1889 Jacob Riis (Szarkowski 186)
 women in long dresses and hats standing outside Ellis Island building in "Women from Guadeloupe, French West Indies, at Ellis Island" 1911 Augustus Sherman (Goldberg 32)
 young woman with scarf on head in "Albanian Woman, Ellis Island" 1905 Lewis Wickes Hine (Decade \10)
INDIA *see also* TAJ MAHAL
 hundreds of people crowding streets in "Untitled (People pouring into the streets of Calcutta after the news of Gandhi's assassination" 1948 Sunil Janah (Marien \6.19)
 panorama of walled courtyard in "Panorama of Agra" 1859 John Murray (Art \131)
 photo essay on daily life and poverty in Calcutta in "Calcutta, India" 1986 Joanna Pinneo (Best12 166-169)
 photo essay on the last of India's steam trains and the people who ride and service them in "India's last steam trains" 1996 Stephen Dupont (Best22 250-251)
 photo essay on the life of a family that lives on the street in "Rickshaw Family" 1986 Joanna Pinneo (Best12 88-93)
 rowboat with island palace in distance in "The Water Palace at Udaipur" c. 1873 Colin Murray (Rosenblum2 #137)
 small boat crossing river to Temple in "Shiva Temple, Jahngira" 1983* Raghubir Singh (Marien \6.20)
 street in Agra with awnings over shops in "Main Street at Agra" 1856-1857 John Murray (Waking 81)
 women sitting on ground in "Women Grinding Paint, Calcutta" c. 1845 Photographer Unknown (Waking #82)

INDIA–HISTORY–SEPOY REBELLION, 1857-1858
 soldiers outside ruined building in "A British entrenchment during the Indian Mutiny" 1858 Félice Beato (Lacayo 15)
INDIANS OF NORTH AMERICA
 adobe houses seen from a roof in "Tewa, Cicomavi, Wolpi, Mokitowns, Arizona" or "Hopi Mesa" c. 1879 John Hillers (National \41; Photography1 \9)
 adobe houses 3 stories high in "Around Moki Towns, Tewa Trail" 1900 Adam Clark Vroman (National 161c)
 ancient kiva of the Anasazi in "In Chaco Canyon, New Mexico, the great kiva of Casa Rinconada symbolized the cosmos for its 11th-century Anasazi builders" 1990* Bob Sacha (Through 498)
 arm holding staff of feathers and eagle claws in "Eaglestaff, Boise, Idaho" 1990* Ken Blackbird (Photography 168)
 backs of Hopi women, sitting on steps, with elaborate hairstyles in "Watching the Dancers–Hopi" 1906 Edward S. Curtis (MOMA 60)
 backs of men on horseback in "Vanishing Indian Types" 1906 Edward S. Curtis (Marien \4.36; Rosenblum2 #196)
 boy in feathered headdress in "Young traditional dancer from the Shoshone tribe" c. 1990 John Running (Graphis90 \162)
 candidate for U.S. president in "Indian activist Dennis Banks announces in California that he plans to run for president of the United States" 1987 Brant Ward (Best13 111a)
 carved wooden figures in ground in "Pueblo of Zuni (Sacred Shrine of Taäyallona)" 1899 Adam Clark Vroman (MOMA 62)
 chief in feather headdress with face to wall in corridor in "Chief Illiniwik pulls his thoughts together as he prepares to perform his halftime routing for a University of Illinois basketball game" 1987 Herb Soldounik (Best13 172a)
 chief's portrait in "Geronimo (Guyatle), Apache" c. 1898 Frank A. Rinehart (Photography1 \76)
 chief's portrait in "Keokuk, or the Watchful Fox" 1847 Thomas M. Easterly (Marien \2.66; Rosenblum2 #47)
 chief's portrait in "Kno-Shr, Kansas Chief" 1853* John H. Fitzgibbon (Art \26; Waking #87)
 chief's portrait in "Na-che-ninga, Chief of the Iowas" 1845 Thomas M. Easterly (Photography1 \26)
 chief's portrait in "Red Cloud, Ogalalla Sioux" 1872 (Photography1 \58); 1880 Charles Milton Bell (Waking 329)
 chief's portrait in "Shining Metal" 1858 Julian Vannerson (National 22b)
 chief's portrait in "A Sioux Chief" c. 1898* Joseph Keiley (Photography1 \14)
 chief's portrait in "Upshaw–Apsaroke–in Headdress" 1906 (Goldberg 28)
 chiefs and tipis in "Leaders of the Hostile Indians at Pine Ridge Agency, S.D., During the Late Sioux War" 1891 George Trager (Photography1 #III-16)
 child in traditional feather costume in "Shy three-year-old eagle dancer" c. 1989* Rodney Roscona (Graphis89 \169)
 children and women on terraces of pueblo home in "Terraced Houses, Acoma, Pueblo" 1939 Laura Gilpin (Sandler 98)
 children in a line in native and western clothing in "Seven little Indian children in four stages of civilization" c. 1900 Photographer Unknown (Goldberg 33)
 cliff dwellings in "Puye Cliff Dwelling" 1990* Barbara Kasten (Women \181)
 cliff dwellings in "White House Ruin, Canyon de Chelly, Arizona" 1942 Ansel Adams (Icons 97); "The Ancient Ruins of the Cañon de Chelle, New Mexico" 1873 Timothy H. O'Sullivan (Art \141; Marien \3.58; Photography1 \7; Rosenblum2 #163)
 cliff dwellings behind two Native Americans in [Canyon de Chelley] c. 1992* Greg Booth (Graphis93 129)
 close-up of man's face in "Hopi Indian, New Mexico" 1923 Dorothea Lange (Sandler 108)
 dancer holding bow in "A hunter from the Apache tribe, ready for the deer dance" c. 1990* John Running (Graphis90 \161)
 dancer in traditional buffalo dress in "Dancer in traditional buffalo regalia" c. 1989* Rodney Roscona (Graphis89 \170)
 elderly man holding his chest in "Phillip Lee, suffers from a uranium-related lung disease" 1993 Stan Grossfeld (Best19 56)
 elderly woman holding her head in "Topsy Swain, a Paiute Indian, is one of the few remaining elders on Arizona's Hualapah Reservation" 1986 James Kenney (Best12 164a)
 elderly woman standing outside her traditional round home in "Alice Yazzi, a Navajo Indian, learns she will lose her home in a dispute over Arizona reservation land" 1986 Dayna Smith (Best12 164c)
 erection of a tipi and Native American with a rifle in "Wounded Knee Takeover" 1973 Photographer Unknown (Photos 137)

Eskimo woman in "This Eskimo woman's husband accompanied explorer Vihjalmur Stefansson on a journey in the Canadian Arctic" 1912 Photographer Unknown (Through 318)

Eskimo women in traditional dress in "Group of Eskimo Women at Fullerton Harbour" 1905 Geraldine Moodie (Rosenblum \109)

face seen above blanket in "The Red Man" 1903 Gertrude Käsebier (Peterson #3; Sandler 102a; Women \19)

fur parkas on couple in "Nick and Laura Therchik wear the mountain-squirrel parkas of Laura's handiwork" 1996 Don Doll (Best22 69a)

girls in adobe house grinding corn in "Indian Girls Grinding Corn, Moqui Town" 1895 Adam Clark Vroman (Photography1 \94)

group of men posing for photograph in "Shoshoni" 1867-1872 Timothy H. O'Sullivan (Waking #117)

holding staff with Bald Eagle head in "Kootenai Indian tribe member Virgil Mathias raises his Bald Eagle staff while singing traditional songs during a celebration of the Hellgate treaty" 1987 Dwan Feary (Best13 111b)

Hopi woman on steps of house in "Hopi Maiden" c. 1902 Adam Clark Vroman (Rosenblum2 #195)

hunting, funerals and play on the reservation in "Rosebud Sioux Reservation" 1996 Don Doll (Best22 73-77)

Inuit mother and child in "Portrait of Mother and Child, Ungava Peninsula" 1910-1912 Robert Flaherty (Rosenblum2 #197)

Lakota people in western and traditional dress in "Vision Quest: Men, Women and Sacred Sites of the Sioux Nation" 1993-1996* Don Doll (Best22 60-65)

long line of Apache Indians waiting for distribution of food and clothing in "Issue Day at San Carlos, Arizona" c. 1899 Katherine T. Dodge (Sandler 101)

man and hot dog car in "Damn! There goes the Neighborhood!" 1998 Hulleah Tsinhnahjinnie (Marien \8.15)

man crouching behind rocks aiming rifle in "A Modoc Brave on the War Path" 1872-1873 Eadweard Muybridge (Marien \3.65)

man holding axe in "Sky Chief" c. 1867 Edric L. Eaton, attribution (Waking #120)

man holding cross and wearing a medal around his neck in "Wolf Robe" 1904 Mamie and Emma Gerhard (Sandler 106a)

man in long coat holding pistol from [ad for an Arizona resort] c. 1991* Russ Schleipman (Graphis91 \224)

man in native dress in "Samuel American Horse" c. 1900 Gertrude Käsebier (Sandler 100a)

man in western suit in "Sho-E-Tat" 1872 Alexander Gardner (Photography1 #III-18)

man leaning against a ladder at a pueblo in "The Ladder" 1939 Laura Gilpin (Sandler 112)

man on motorcycle in "Gordon Swift Hawk decorated motorcycle with 'Red Power' stickers" 1996 Don Doll (Best22 70)

man with bow and arrow in "Maricopa Indian, Arizona" c. 1875 Elias A. Bonine (National 123a)

men in blankets near canoe and tipis in "The first sail" 1907 Roland W. Reed (Lacayo 41)

mother with child in swing attached to two trees in "Woman's Costume & Baby Swing–Assiniboin" c. 1900-1906 Edward S. Curtis (Decade 11c)

mother with child in traditional infant holder in "Mother and Child" c. 1890 E. Jane Gay (Sandler 103)

Navajo silversmith at bench in "Navaho Silversmith" 1939 Laura Gilpin (Sandler 113)

Navajo woman surrounded by woven rugs in "Hedipa, a Navajo Woman" c. 1880 John K. Hillers (National 131)

passing some of the old ways in "Tooksook Bay, Alaska" 1996 Don Doll (Best22 71-79)

performance of Snake Dance in Indian village as watched by visitors in "At the Snake Dance, Moqui Pueblo of Hualpi, Arizona" 1897 (Photography1 \77)

photo essay on the results of alcoholism on Native Americans in "Gallup: A Town Under the Influence" 1988 Joe Cavaretta (Best14 191-193)

portrait of a Chief in "Chief Sitting Bull" 1885 William Notman (Monk #10)

portrait of a young woman with intricate hairstyle in "A Young Hopi Girl" 1905-1912 Kate Cory (Rosenblum \80)

profile of man in "San Diego" 1904 (Sandler 106c)

profile of woman in decorative dress in "Zitkala-Sa" 1898 Gertrude Käsebier (Sandler 102c)

scouts by a lake in "View on Apache Lake with Apache scouts" 1873 Timothy H. O'Sullivan (National 22a)

seated old man wearing native beads and sneakers in "White Man's Moccasins" 1954 Lee Marmon (Photography 147)

seated women with piles of corn in "Indian Women Shucking Corn" c. 1905 Kate Cory (Sandler 105)

seating for negotiations with the Army in "Commissioner, General Sherman among them, seated with Indians" 1868 Alexander Gardner (Marien \3.66)

Seminole woman in long dress by pond in "Seminole Woman" c. 1937 Florence Randall (Sandler 107)

shaman seated in "A Navajo Shaman" 1870s John Hillers (Photography1 \59)

shamans in ceremonial tent invoking the power of the bear to cure a boy in "Sia Pueblo, New Mexico" c. 1888 Matilda Coxe Stevenson (Sandler 100c)

shirtless young man in "Buried Far Away, Cocapah" 1899 Frank A. Rinehart (National \2)

standing and wrapped in blankets in "In Winter, Kiowa" 1898 Frank A. Rinehart (National 146a)

studio portrait of seated man in "Brave in War Dress" c. 1868 (Rosenblum2 #71)

two men in blankets and head bands in "Americans" 1930s Laura Adams Armer (Sandler 109)

weaving in "Aboriginal Life Among the Navajoe [sic] Indians Near Old Fort Defiance, N.M." 1873 Timothy H. O'Sullivan (Photography1 #III-23)

with bows and arrows in "Apaches in Ambush" 1885 Henry Buehman and F. A. Hartwell (Photography1 #III-17)

woman in fur-collared cape in [a Native American] c. 1992* Sue Bennett (Graphis93 128)

woman weaving in staged situation in "Kwakiutl woman in the process of cedar-bark weaving" n.d. George Hunt (Marien \4.77)

women and children in "Piute Squaws and Children, at Reno" 1867-1870 attributed to A. A. Hart (Photography1 \60)

women in traditional dress in "Untitled" 1993* Jolene Rickard (Marien \7.17)

Wounded Knee massacre recreation in "Wounded Knee, South Dakota on the 100th anniversary of the massacre" Don Doll 1990 (Best22 66)

young man in hat in "Sewel Makes Room for Them died of a cardiac arrest due to drinking when he was 25" 1996 Don Doll (Best22 68)

young woman laying on a rock in "Indian Woman" 1939 Laura Gilpin (Sandler 111)

INDIANS OF SOUTH AND CENTRAL AMERICA

bare-breasted women in a stream in "Evening Recreations of the Coffee Pickers, San Isidro" 1877 Edweard Muybridge (National 140a)

boy being carried on father's back in "A young Indian boy from the highlands of Ecuador visits the weekly Ambato market with his father" 1988 Ric Egenbright (Best14 118)

boy playing a flute in "On the Way to Cuzco, Peru" 1954 Werner Bischof (Icons 119)

children looking through makeshift curtains in refugee camp in "Children in Tapamlaya, a makeshift camp in Honduras that is home for some 7,000 Miskito Indians who fled their villages in neighboring Nicaragua because of harassment by Sandinista soldiers" 1986 Guy Reynolds (Best12 67b)

Kayapo girls in western dress with traditional face painting in "In Brazil, Kayapo teenagers are all dressed up and ready to pick marriage partners" 1984* Miguel Rio Branco (Through 320)

llama on mountain near native man playing the flute in "Flute-Playing Indio with Llama" 1933 Martín Chambi (Icons 61)

Machu Picchu after it had been cleared of overgrowth in "Hiram Bingham discovered the ancient Inca site of Machu Picchu, high in the Peruvian Andes" 1912 Hiram Bingham (Through 300)

Machu Picchu having been excavated in "Urubamba Valley near Cuzco" 1925 Martín Chambi (Photos 21)

man and boy lighting candles in "On a holy feast day, an Ixil Indian and his son offer prayers and candles inside the church in Chajul, Guatemala" 1988* James Nachtwey (Best14 152)

Yanomami children in forest in "Yanomami" 1976 Claudia Andujar (Rosenblum \190)

Yanomami man with face markings in "Destruction of the Yanomami Territory" 1983* Harald Herzog (Photos 152, 153)

Yanomami youth in "Yanomami Youth During a Traditional Reahu Festival" 1978 Claudia Andujar (Marien \6.6)

Zapatista masked and armed men and women near their horses in "Zapatista Uprising in Chiapas" 1996* Scott Sady (Photos 181)

INDONESIA

carrying away an injured protestor in [a man allegedly shot by police is carried following clashes in Jakarta] c. 1999* Achmad Ibrahim (Photo00 67)

children sleeping on train station floor in "Indonesian Street Kids" 1998 James Nachtwey (Best24 162-163)

photo essay on the violence and protests around the resignation of President Suharto in "Overthrowing a Dynasty" 1998 Yunghi Kim (Best24 20-21)

scenes of protestors and police in Indonesia in [portraying the real struggle to oust the corrupt Suharto government in Indonesia] c. 1998* Yunghi Kim (Photo00 73)

INDUSTRIES

aging buildings in [steel mill in Ohio] c. 1992 * Nicolay Zurek (Graphis93 173)

bicycles designed by computer in "Computer Customization–A Japanese bicycle factory" 1990* Louis Psihoyos (Best16 150)

building sections and stairs in "Image Folder Isoge" c. 1999* Stefan Kiess (Photo00 14, 16)

closed gate at entrance to sugar factory in "Entrance to Amalgamated Sugar Company factory at the opening of the second best season" 1939 Dorothea Lange (Fisher 19)

condenser coils in "Winding Condensor Coils" c. 1933 Margaret Bourke-White (Sandler 150)

constructing pipes used in the Fort Peck Dam in "Fort Peck Dam" 1936 Margaret Bourke-White (Lacayo 97)

construction of large wind tunnel in "Wind Tunnel Construction, Ft. Peck Dam" 1936 Margaret Bourke-White (Rosenblum frontispiece; Rosenblum2 #582)

construction site in "Northwestern Corner with Sawhorse and Cement Mixer, George Moscone Site, San Francisco, California" 1981 Catherine Wagner (Women \178)

funnels in "Funnels" 1932 Willard Van Dyke (Rosenblum2 #581)

gas storage tower next to small gas station in "Gas Tower (Telescoping Type), off Pulaski Bridge, Jersey City, New Jersey, U.S.A" 1981 Bernd & Hilla Becher (Marien \6.87)

generators in "Hydro Generators, Niagara Falls Power Co." 1928 Margaret Bourke-White (Women \58)

grain elevators in "Chicago Grain Elevator on Cermak Road" 1941 Andreas Feininger (Decade 49d)

grain elevators and freight cars in "Boxcar and grain elevators" 1938 John Vachon (Documenting 104a)

large cross in foreground of steel mills and houses in "Graveyard, Houses, and Steel Mill, Bethlehem, Pennsylvania" 1935 Walker Evans (Decade 41d; Documenting 44; MOMA 140; Marien \5.54)

large piece of machinery in "Safety Device on a Milling Machine" c. 1903 Photographer Unknown (Szarkowski 145)

large smokestacks near soccer field in "Agecroft Power Station, Pendlebury, Salford, Greater Manchester" 1983 John Davies (Art \373)

large tubes in "Plant for Styrofoam Production" 1997 Bernd and Hilla Becher (Photography 19a)

large wheels in "Untitled" c. 1930s Sonya Noskowiak (Decade \23)

logs on a river in "Logs" c. 1940 Margaret Bourke-White (Sandler 149)

machine parts from [Die Koralle] 1929 Martin Munkacsi (San #12)

machinery in "Untitled" late 1920s Margaret Bourke-White (Women \57)

man climbing steps that circle a storage tank in "Exxon employee climbs a 630,000-gallon storage tank to retrieve a sample of the gasoline within" 1985 Michael Gallacher (Best11 141d)

man measuring opening of large tube in "Inside of the Turbine Tube" 1911 Photographer Unknown (Szarkowski 161)

network of large pipes in "Crude Oil Pipe Still No. 7" n.d. Esther Bubley (Sandler 160)

part of a chemical plant in [chemical plant] c. 1999* Lonnie Duka (Photo00 24)

photo essay on life in and around outdated steel factory in "Russia's Industrial Wastelands" 1992 Anthony Suau (Best18 199-202)

pipes and storage in "Tombal, Texas, Gasoline Plant" 1945 Esther Bubley (Sandler 155)

power plants in [Power plants] c. 1992* Lonnie Duka (Graphis93 187)

room with rows of dials, and man at desk in "Control room at the water works on Conduit Road, Washington, D.C." 1940 Louise Rosskam (Fisher 32)

round storage tanks in "Ammonia Storage Tanks" 1930 Margaret Bourke-White (Sandler 153)

rows of ventilator pipes in "Fagoel Ventilators" 1934 Imogen Cunningham (Decade 37c)

scrap metal, office, wheels and workers' room after mill's closure in [Bethlehem Steel Company] c. 1999* Stephen Wilkes (Photo00 74, 75)

section of the Ford Motor Company in "Industry" 1932 Charles Sheeler (Marien \5.20)

smokestacks in "Enterprise Sugar Mill" 1987 Debbie Fleming Caffery (Women \145)

smokestacks and building in "Cement Works, Monolith, California" 1931 Willard Van Dyke (Marien \5.46)

smokestacks and lava in [Iceland] c. 1992* Ron Bambridge (Graphis93 171)

smokestacks in a row in "Armco Steel, Ohio" 1922 Edward Weston (Art \212; Decade 22; Rosenblum2 #584)

steel mill buildings in [Bethlehem Steel Company] c. 1999 Stephen Wilkes (Photo00 25)

stacks of cut lumber in "Lumberyard" 1937 Sonya Noskowiak (Sandler 175)

structural elements in "No. 37 from the book Metal" 1927 Germaine Krull (Rosenblum \112)

train going past buildings in "Plant of the U.S. Potash Company, Carlsbad, N.M." 1941 Ansel Adams (Photography 21)

views of a factory in "Panorama of the Fried. Krupp Cast-Steel Factory" 1864 Hugo van Werden (Szarkowski 102-103)

walkways, smokestacks, and towers in "Crisscrossed Conveyors, River Rouge Plant, Ford Motor Company" 1927 Charles Sheeler (Hambourg frontispiece; Rosenblum2 #585)

water tower from below in "Shredded Wheat Water Tower" 1928 Imogen Cunningham (Rosenblum2 #583)

wheel with belt in "The Belt Wheel" 1923 Ira Martin (Hambourg 31c)

winding towers in "Winding Towers" 1983 Brend & Hilla Becher (Rosenblum2 #736)

women working in goggles and using welding torches in "Female 'Burners' bevel armor plating for tanks"

1943 Margaret Bourke-White (Life 41)

INSECTS *see also* SPIDERS

ants catching other insects in "Shown under natural conditions in a Costa Rican jungle, rare and tiny trap-jaw ants live in small colonies withing dead twigs" 1988* Mark Moffett (Best14 158)

beetle on flower in "Beetle on Calla Lily" c. 1999* Mark Laita (Photo00 233)

fruit fly magnified in [fruit fly] c. 1995* Oliver Meckes (Graphis96 185)

green beetle with yellow spots in [beetle] c. 1997* Jody Dole (Graphis97 170)

in a box with dried flowers in "Bug in a box" c. 1995* Hans Neleman (Graphis96 89)

insect on curled leaf in [insect on a leaf] c. 1997* Mark Laita (Graphis97 187)

mosquitos in "Bearing the Yellow Death" 1993* J. Kyle Keener (Best19 176a)

on dry leaf in [bugs on leaves] c. 1995* Mark Laita (Graphis96 191a, c)

on nail polish and face powder in [insects on face powder and nail polish] c. 1995* David Sacks (Graphis96 72)

pair of prayer mantis in "Bug from Food Chain" 1994-1996 Catherine Chalmers (Marien \8.11)

smashed beetle in [ad for Nintendo] c. 1995* Markku Lahdesmaki (Graphis96 78)

wasp nest in [wasp nest] c. 1997* Jody Dole (Graphis97 172)

IRAN

American blindfolded and handcuffed being led by two men in "One of the hostages held at the American Embassy, Tehran" 1979 P. Ledru (Eyes #350; Life 160)

crowd in "Pro-Shah meeting, Teheran, Iran" 1979* David Burnett (Eyes \17)

crowd at Holy Shrine in "Tehran" 1998 James Nachtwey (Best24 104a)

large demonstration of students in "U.S. embassy. Tehran, Iran, November 9, 1979" 1979 M. Sayad (Eyes #349)

large poster of cleric behind woman in black cloak in "Chador, Teheran" 1979* Olivier Rebbot (Eyes \16)

man with blood on his hands in "Shi'ite after dipping his hands in the blood of a 'martyr' killed by the Shah's troops" 1979* David Burnett (Eyes \14)

men with hands raised at gate in "Peasants arriving at a protest in front of the U.S. embassy, Teheran" 1979 Gilles Peress (Eyes #321)

people standing on wall in Iran in "Pro-Shariatmadari demonstrations, Tabriz" 1979 Gilles Peress (Eyes #322)

posters with photographs in "Posters in front of the U.S. embassy, Teheran" 1979 Gilles Peress (Eyes #323)

turbaned men at seashore in "Mullahs gathered near the Iranian port city of Abadan" c. 1990* Manoocher (Graphis90 \251)

IRAN-CONTRA AFFAIR, 1985-1990

photographers and Oliver North in "A favorite of many Americans and an enigma to the press corps, North ignores an array of cameras pointing at him during the hearings" 1987 Chris Wilkins (Best13 7b)

taking oath in middle of packed congressional hearing room in "Oliver North taking the stand during the Iran Contra hearings" c. 1987* Terry Ashe (Graphis89 \252); Chris Wilkins (Best12 7d)

television sets with face of Oliver North in "During July's testimony on the Iran-Contra affair, the face of Lt. Col. Oliver North shone from television sets across America" 1987 Bill Greene (Best13 7a)

IRAQ *see also* KURDS

gassed mother and child in street in "Iraqi Kurds killed by poison gas" 1988* Ramazan Oztürk (Lacayo 179a)

Kurdish families loading up their possessions in photo essay in "Seeking Refuge" 1988 James Nachtwey (Best14 30-31)

mothers in polka dot scarfs carrying children in "Iraqi Innocents" c. 1999* Hien Lam Duc (Photo00 68)

woman's face in "An Iraqi woman attends prayers at a mosque in downtown Baghdad" 1998* Enric Marti (Best24 77)

IRISH REPUBLICAN ARMY

several guns displayed on bed by masked man in "IRA gunman displays armaments" 1972* Stephen Shames (Eyes \22)

ISLANDS

overlooking a flock of birds flying over an island in "Pelicans over Barrier Island" 1992 Joel Sartore (Best18 220)

pagoda built on an island in a river in "Island Temple Foochow" or "A Pagoda Island in the Mouth of the Min River" 1870-1871 John Thomson (Art \128; Marien \3.39)

sunset in [Vlieland Island, the North Sea, a region of Friesland] c. 1992* Harry De Zitter (Graphis93 176)

vertical cliffs in "Evening light coats the stark 1,000-foot cliffs of Tasmar Island" 1997* David Doubilet (Best23 162a)

waves crashing on the island in "Sugar Loaf Islands, Farallons" 1868-1869 Carleton E. Watkins (Art \118;

Waking #125)

ISRAEL *see also* ARAB-ISRAELI CONFLICT; JERUSALEM

Dead Sea in "Dead Sea, A View of the Expanse" 1860-1890 Felix Bonfils (Rosenblum2 #134)

elderly Russian couple looking at photo album in "Soviet Jews immigrate to Israel" 1992* James Nachtwey (Best18 34-36)

lighting memorial candles for Yitzhak Rabin in "A year after the assassination of Israeli Prime Minister Yitzhak Rabin, people gather to light candles at site of the incident" c. 1996* Zio Koren (Graphis97 54)

man sweeping near palm trees on beach in "A Palestinian day worker in Tel Aviv, Israel, sweeps the beach front" 1990* James Nachtwey (Best16 42a)

Orthodox Rabbis praying with newly circumcised men in hospital beds in "Soviet Jews immigrate to Israel" 1992* James Nachtwey (Best18 34)

police on horseback knocking over an ultra-orthodox Jew on a dirt road in "An Israeli policeman charges an ultra-orthodox protester in East Jerusalem" 1998* Menehem Kahana (Best24 16c)

protesting burning flag in "Demonstrators burn a homemade Israeli flag in protest, Bethlehem, West Bank" 2000 Larry Towell (Photography 120d)

young family with small children in "Israel's Settlers" 1998 Tom Stoddart (Best24 94b)

ISRAEL-ANTIQUITIES

sarcophagus near stone wall in "Jewish Sarcophagus, Jerusalem" 1854 Auguste Salzmann (Waking 298)

stone fountain in a niche in "Jerusalem, Islamic Fountain" 1854 Auguste Salzmann (Rosenblum2 #112)

ITALY

steps leading down to water in "*Porta della Ripetta*, Rome" 1846 Calvert Jones (Rosenblum2 #101)

ITALY-ANTIQUITIES

arch and columns in "The Arco dei Pantani at the Entrance of the Forum of Augustus, with the Temple of Mars Ultor, Rome" before 1863 Robert MacPherson (Art \137)

IWO JIMA, BATTLE OF, JAPAN, 1945

Marines dashing off landing craft in "Fourth Marines hit Iwo Jima Beach" 1945 Joe Rosenthal (Eyes #223)

Marines raising American flag in rubble in "Old Glory Goes Up on Mount Suribachi" 1945 Joe Rosenthal (Capture 16; Eyes #212; Lacayo 118; Marien \5.86; Monk #29; Photos 65)

soldiers kneeling near explosion in "Battle of Iwo Jima" 1945 W. Eugene Smith (Life 54a)

—J—

JAGUARS

in forest in "A male jaguar prowling his territory in Belize, site of the world's first jaguar preserve" 2001* Steve Winter (Through 330)

JAPAN *see also* HIROSHIMA; IWO JIMA, BATTLE OF, JAPAN, 1945; NAGASAKI

archery from horseback in "Japanese bowman keeps alive the samurai art of *yabusame*, or mounted archery" 1996* Peter Essick (Best22 197c)

clouds across the mountain in "Mount Fuji" 1868 Félice A. Beato (Marien \3.40)

mother holding son on lap in "Mother and child at Hiroshima" 1945 Alfred Eisenstaedt (Lacayo 79)

old man and child selling wares in "Scene at a Fair" 1936 Kuwabara Kineo (Rosenblum2 #461)

photo essay on elderly Japanese women who had been forced to serve as comfort women in World War II in "Forgotten Women: Comfort Women" 1996 Yunghi Kim (Best22 30-35)

portrait of a Samurai warrior in "Actor in Samurai Armor" 1870s Raimund von Stillfried, attribution (Waking 307)

rice being unloaded from a ship in "Relief rice for starving Japan" 1949 Carl Mydans (Lacayo 78)

wendo fencers in "Wellington Kendo Club, Waitarere" c. 1999* Michael Hall (Photo00 127)

women cooking near hot springs in "A housewife in Beppu, Japan, boils eggs over bubbling hot springs, which also heat stoves around the town" 1942 Japanese Government Railways (Through 158)

JAPANESE AMERICANS

family in field with rakes in "Kasakawa Family" 1955 Carl Mydans (Goldberg 140)

family sitting on wooden porch in "Farm family, Los Angeles County" 1942 Russell Lee (Documenting 244a)

group of seated Japanese-American women in "After spending the earlier part of their lives as strangers in a foreign land, living in the shadows of their husbands, this group of elderly Japanese immigrant women share a home" 1985 Judy Griesdieck (Best11 139a)

man leaning on shovel in "A farmer awaiting final evacuation orders, San Benito County, California" 1943 (Documenting 246a)

photo essay on the daily life of women who came as the first generation of Japanese to come to America at the turn of the century in "Last of the Issei" 1986 Judy Griesedieck (Best12 124-129)

walking across street in "Little Tokyo, Los Angeles" 1942 Russell Lee (Documenting 243a)

JAPANESE AMERICANS–EVACUATION AND RELOCATION, 1942-1945

armed soldiers watching line of people behind barricades in "Waiting to register at the Santa Anita reception center" 1942 Russell Lee (Documenting 250b)

boy and luggage with identification tags in "Child tagged for evacuation" 1942 Russell Lee (Documenting 249c)

child sitting on luggage in "A young evacuee of Japanese ancestry waits with the family baggage before leaving by bus for an assembly center" 1942 Clem Albers (Goldberg 112)

closing notices on store window in "Shop in Little Tokyo, Los Angeles" 1942 Russell Lee (Documenting 246b)

farmer packing his tools in wooden cases in "Farmer packing his tools before he is relocated, Los Angeles County" 1942 Russell Lee (Documenting 244b)

hundreds of barracks in "Housing at the Santa Anita reception center" 1942 Russell Lee (Documenting 251c)

line of people crossing a bridge in "Bainbridge Japanese leave home, Evacuation Day" 1942 Photographer Unknown (Eyes #126)

man with tag on lapel being detained in "San Francisco" c. 1942 Dorothea Lange (Eyes #124; MOMA 170)

officials looking through the luggage taken from a car in "Examining the baggage of evacuees at the Santa Ana reception center" 1942 Russell Lee (Documenting 250a)

parcels and people in "Waiting for the train to Owen Valley, Los Angeles" 1942 Russell Lee (Documenting 248b)

people raking ground in cemetery in "Cleaning the cemetery before evacuation, San Benito County" 1942 Russell Lee (Documenting 247c)

people reading notices on board in "Reading evacuation orders on a bulletin board at Maryknoll Mission" 1942 Russell Lee (Documenting 243b)

posting of evacuation notice in "Soldier posting Civilian Exclusion Order No. 1 together with instructions for evacuation procedures" 1942 Photographer Unknown (Eyes #125)

table full of hot dogs in "Picnic lunch for members of the Japanese-American citizens' league just before their evacuation, San Benito County" 1942 Russell Lee (Documenting 248a)

two men looking at farm equipment in "A farmer about to be relocated shows his equipment to a prospective buyer, Los Angeles County" 1942 Russell Lee(Documenting 245c)

JEFFERSON MEMORIAL, Washington, D.C.

back of woman in evening gown with large bow in "Model Facing Jefferson Memorial" 1948 Toni Frissell (Sandler 164)

in panoramic view in "Jefferson Memorial for Citicorp calendar" c. 1987* Mark Segal (Graphis89 \112-\113)

JELLYFISHES

around a small fish in "Small fish seek safety amid the kinks, frills, and tentacles of jellyfish in the Tasman Sea" 2000* David Doubilet (Through 412)

floating in "Jellyfish dance through the water" 1996* Tomas Ovalle (Best22 191c)

floating in "Jellyfish floats through silt-filled water off of Key Biscayne" 1998* Sean Dougherty (Best24 52b)

floating in water near leaves in "Jellyfish in Pacific lagoon" 2000* David Doubilet (Through 12)

two in opposite directions in [jellyfish] c. 1999 Steve Lu (Photo00 231)

JERUSALEM

Dome of the Rock and the Wailing Wall in "The Dome of the Rock and the Wailing Wall" c. 1850 J. P. Girault de Prangey (Marien \2.39)

explosion of buildings in "Explosion blazes patch into Jewish buildings in the old city of Jerusalem" 1943 John Phillips (Eyes #202)

Israeli soldier standing guard in "An Israeli soldier stands watch in the Old City of Jerusalem" 1990 David H. Wells (Best16 198)

Orthodox Jew at the Wailing Wall in "A lone Orthodox worshiper prays at the Wailing Wall in Jerusalem" 1988* James Nachtwey (Best14 34)

Orthodox Jew at Wailing Wall in "An Orthodox Jew carries the hats of his comrades who are covered with taleth during the Passover prayer at Jerusalem's Wailing Wall" 1993* Patrick Baz (Best19 121d)

Orthodox Jews walking in Jerusalem in "Jews in Jerusalem's Old City are confronted by a new reality following an accord between Israel and the PLO" 1993* Eric Feferberg (Best19 121a)

JESUS CHRIST see also LAST SUPPER

Crucifixion in [Christ's crucifixion] c. 1992* David Huet (Graphis93 126c)

head of Christ figure in various poses in "The Seven Last Words of Christ" c. 1898 F. Holland Day (Photography1 #VI-10)

reenactment of the Crucifixion in "Crucifix with Roman soldiers" c. 1896 F. Holland Day (Marien \4.17;

Rosenblum2 #363)

JEWELRY

blue rings and bracelet on chicken foot in [chicken foot with rings] c. 1997* Staudinger & Franke (Graphis97 40)

bracelet designed in the Bronze Age in "Objects for Eternity" c. 1990* Elizabeth Naples (Graphis90 \206)

bracelets being worn over long gloves in [bracelets over long gloves] c. 1997* Marcia Lippman (Graphis97 46)

gold and diamond necklace on women for [the Italian Trade Commission] c. 1991* David Holt (Graphis91 \230)

in fashion layouts in [partial view of model with jewelry and handbags] c. 1997* Geof Kern (Graphis97 20-25)

model wearing silver jewelry in [silver jewelry] 1986 Dan Miller (Best12 113b)

worn and held by model wrapped in black in "A model gets wrapped up in her work to show off a haunting array of jewelry" 1987* J. Mark Poulsen (Best13 182)

JEWS

boy looking in store window with Jewish items in "Window of a Jewish religious shop on Broom Street. New York City" 1942 Marjory Collins(Fisher 68)

boy with sidelocks in "Boy with Earlocks" 1937 Roman Vishniac (Marien \5.79)

gathering at consulate in Soviet Union to get immigration papers approved in "Soviet Jews immigrate to Israel" 1992* James Nachtwey (Best18 35c)

group of people being marched through street at gunpoint in "Deportation from the Warsaw Ghetto" 1943 Photographer Unknown (Photos 58, 59)

highlighted on nude model in "Cheryl Moody's Jewelry" c. 1991 Harry Wade (Graphis92 \156-\158)

Orthodox Jew at the Wailing Wall in "A lone Orthodox worshiper prays at the Wailing Wall in Jerusalem" 1988* James Nachtwey (Best14 34)

Orthodox Jew at Wailing Wall in "An Orthodox Jew carries the hats of his comrades who are covered with taleth during the Passover prayer at Jerusalem's Wailing Wall" 1993* Patrick Baz (Best19 121d)

Orthodox Jews walking in Jerusalem in "Jews in Jerusalem's Old City are confronted by a new reality following an accord between Israel and the PLO" 1993* Eric Feferberg (Best19 121a)

Orthodox Rabbis praying with newly circumcised men in hospital beds in "Soviet Jews immigrate to Israel" 1992* James Nachtwey (Best18 34)

overhead view of hundreds of Hasidic men gathered in street in "Hasidic men at the funeral of a rabbi in New York City" 1986 Jim Wilson (Best12 165b)

people sitting at table for Passover Sedar in "Last Supper in the Desert" c. 1997 Zvia Sadja (Graphis97 98)

police on horseback knocking over an ultra-orthodox Jew on a dirt road in "An Israeli policeman charges an ultra-orthodox protester in East Jerusalem" 1998* Menehem Kahana (Best24 16c)

Rudolph Guiliani speaking with Hasidic Rabbi in "New York City Mayor Rudolph Guiliani consults Grand Rabbi Solomon Halberstam while campaigning in Brooklyn" 1993 Andrea Mohin (Best19 193b)

silhouette of Orthodox men wearing hats in "Orthodox Jews at Sunset" 1990* David H. Wells (Best16 64a)

JUGGLING

boy juggling with one hand and playing brother's violin with the other in "Ozarks Epicenter, Death of a Music Culture" 1998* Randy Olson (Best24 37)

boy trying to juggle two balls in "Sean Bean, 12, learns more about juggling at a symposium for gifted children" 1986 Casey Madison (Best12 118d)

JUKEBOXES

man checking selections in "Fergie at the juke box, Harlem" 1994 Gerald Cyrus (Willis \331)

model leaning against a jukebox in "Hand-painted backgrounds, hand-colored prints and period props highlight a fashion series on the look that's new–déjà vu" 1987* Gary Chapman (Best13 179b)

JUMPING

African American girl with braid, jumping rope in "Nicole Myers jumps double Dutch with her friends" 1996* Brian Plonka (Best22 174)

African American girls in school uniforms jumping rope in "Washington, D.C., series" 1997-1998 Steven Cummings (Willis \362)

African American girls jumping rope on sidewalk in "Double Dutch" 1990 Budd Williams (Committed 222)

boy jumping into dingy pool in "Hoping to wash off the dust of the desert coast, a boy jumps into a half-filled pool" 1998 Michael Robinson-Chavez (Best24 95d)

boys jumping against white background in "Untitled" 1953-1961 Aaron Siskind (San #53, #54, \36)

boys jumping on old mattress under tree in "Bouncing Boys, Houston" 1981 Earlie Hudnall, Jr. (Willis \306)

illusion of man jumping while handcuffed to another in "Penn and Teller" 1985* Chris Callis (Rolling #97)

man in suit flipping in air from trampoline in "Untitled" 1950s Garry Winogrand (Icons 137)

man jumped off bridge in "Man in top hat and tails jumped off the Brooklyn Bridge" 1985 David Handschuh (Best11 78)

man jumping across puddle in "Paris, Gare, St. Lazare" 1932 Henri Cartier-Bresson (Art \274; Marien \5.31; Rosenblum2 #619)

man jumping off a building on a residential street in "Yves Klein Leaping into the Void, near Paris" 1960 Harry Shunk (Marien \6.88)

man playing guitar jumping in air in "Bruce Springsteen" Lynn Goldsmith 1978 (Rolling #11)

man with clenched fist, bended knees, and rope in "Martha Graham–El Penitente–Erick Hawkins Solo as El Flagellante" 1940 Barbara Morgan (Decade \49)

person jumping from apartment window in "Leap from the window" c. 1990* Marcel Crozet (Graphis90 \266)

seated man holding one end of jump rope in "Helping his grandchildren jump rope while he gets a jump on the news" 1987 Rob Goebel (Best13 99)

stages of man jumping in motion study in "Marey Wheel Photographs of Unidentified Model" 1884 Thomas Eakins (Photography1 \85)

stages of man jumping with a pole in "History of a Jump" 1884-1885 Thomas Eakins (Rosenblum2 #298)

trampoline and children jumping in "Soweto children play on trampoline" 1992* James Nachtwey (Best18 28)

woman in bathing suit in mid-air in "High Jump, Terrace of the Trocadero" 1938 Denise Bellon (Rosenblum \138)

woman jumping rope in "Moving Skip Rope" 1952 Harold Edgerton (Goldberg 133)

woman jumps to her save herself from hotel fire in "Death Leap from Blazing Hotel" 1946 Arnold E. Hardy (Capture 19)

—K—

KASHMIR, VALE OF (INDIA)
women and children overlooking a valley in "Kashmir" 1948 Henri Cartier-Bresson (Lacayo 93)

KELLOGG-BRIAND PACT (1928)
statesmen, Briand, Stresemann, Chamberlain, Zaleski, Adachi, and Scialoja, sitting at table in "Summit conference"1928 Erich Salomon (Lacayo 74)

KENNEDY, JOHN F.–Assassination
commuters reading newspapers about Kennedy assassination in "Commuters on a train to Stamford, Connecticut" 1963 Carl Mydans (Lacayo 143c)

John F. Kennedy, Jr., saluting in "John Fitzgerald Kennedy, Jr." 1963 Harry Leder (Monk #41)

man being shot in "Jack Ruby Shoots Lee Harvey Oswald" or "The murder of Lee Harvey Oswald"1963 Robert Jackson (Capture 52; Eyes #286; Lacayo 142; Marien \6.103)

men and women with small cameras and postcards of Texas School Book Depository in "Dallas" 1964 Garry Winogrand (MOMA 240)

KENNEDY, ROBERT F.–Assassination
lying on floor being held by busboy in "Robert F. Kennedy after he was shot" 1968 Bill Eppridge (Eyes #288; Lacayo 144)

KENT STATE UNIVERSITY–RIOT, May 4, 1970
young woman screaming over the body of a dead student in "Kent State Massacre" or "After the massacre of students at Kent State University"1970 John Paul Filo (Capture 72; Eyes #311; Goldberg 180; Lacayo 145; Marien \6.73; Monk #43; Photos 129)

KINGS AND RULERS see ROYALTY

KISSING
couple in bedroom in "Soho Bedroom" 1936 Bill Brandt (Hambourg \36)

couples kissing in movie theater in "Lovers at the Movies" c. 1940 Weegee (Icons 94)

in city square in "An off-duty sergeant in the Israeli Army lets down his guard for a kiss in West Jerusalem's Zion Square" 1996* Annie Griffiths Belt (Through 276)

nude man wrapped around women in jeans and black shirt in "Yoko Ono and John Lennon" 1981* Annie Leibovitz (Rolling #32)

sailor kissing nurse in street in "V-J Day in Times Square" 1945 Alfred Eisenstaedt (Eyes #210; Lacayo 121)

teenagers kissing in classroom in "Class Act in Southwestern High" 1987 Manny Crisostomo (Capture 152)

while walking on street in "Kiss in front of the Hôtel de Ville, Paris" 1950 Robert Doisneau (Icons 107)

woman sitting on man's lap in bar in "At 'Charlie Brown's,' London" c. 1936 Bill Brandt (Szarkowski 218)

KITCHEN UTENSILS
 antique strainer, mallets, rolling pins in "Wooden kitchen utensils" c. 1991* Dieter Klein (Graphis92 \65, \66)
 fish hanging over automatic coffeepot in "Regal" c. 1995* Deborah Brackenburg (Graphis96 97)
 salt shaker pouring salt in [salt shaker pouring salt] c. 1995* Paul Sanders (Graphis96 90)
 shiny pots with golden handles in "Cookware" c. 1991* J. P. Sotto Mayor (Graphis92 \163, \164)

KITCHENS *see also* CUTLERY
 absurd photograph of men sitting on kitchen wall in "Illustrate a story on off-the-wall-DJs" 1985* Gary Chapman (Best11 156)
 bearded man shelling corn in kitchen in "Shelling Corn, Kingfield, Maine" 1901 Chansonetta Emmons (Sandler 20)
 chefs in large kitchen in "The Imperial Asylum at Vincennes" 1860 Charles Nègre (Photography 39)
 child in Dutch dress eating at table in "Hunger is the Best Sauce" c. 1900 Myra Albert Wiggins (Rosenblum \94; Sandler 18)
 children doing dishes in "The Cochran children doing dishes after Sunday dinner" 1943 Esther Bubley (Documenting 323c)
 children in tenement kitchen in "Family in Tenement" n.d. Jesse Tarbox Beals (Sandler 142)
 children sitting at breakfast table in "The Graham Cracker Box" 1983* Tina Barney (Women \159)
 dishes, food, silverware, and laundry lined up to represent housework in "A week's housework" 1947 Nina Leen (Lacayo 94)
 dishes in sink near woman carrying baby from [the series *Suburbia*] c. 1973 Bill Owens (Marien \6.57)
 food removed from refrigerator in "Emptying the Fridge" 1984* Mike Mandel (Decade \XVI)
 mother and daughter making tortillas in brick kitchen in "Mexican woman and her daughter making tortillas" 1950 Leonard McCombe (Lacayo 1950)
 open shelves with cups, cans, plates, and kitchen supplies in "Corner of the Dazey kitchen in the Homedale district" 1939 (Fisher 35)
 sailors eating at table in ship's mess hall in "Aboard Commodore Dewey's Flagship" 1899 Frances Benjamin Johnston (Sandler 145)
 seated woman peeling apples in "Contentment" c. 1895 Sarah J. Eddy (Sandler 17a)
 sink with milk bottle and dishes in "The Kitchen Sink" c. 1919 Margaret Watkins (Women \34)
 stove, oven, and kitchen table in "Kitchen in the Vicinity of Boston, Massachusetts" c. 1900 Charles H. Currier (MOMA 70)
 wiping nose of boy holding vacuum cleaner in [mother and children in kitchen] c. 1995* Lizzie Himmel (Graphis96 141)
 woman in apron at stove in "Saving waste fats and greases from which war materials will be made" 1943 Ann Rosener (Fisher 128)
 woman in floral dress washing dishes near sunlit window in "Sunday Morning" 1939 Paul L. Anderson (Peterson #5; Szarkowski 172)
 woman washing diapers in basin on stove in [Washing diapers in the kitchen] 1943 Esther Bubley (Fisher 138)
 young people eating food in front of open refrigerator in "Kodak Advertisement" c. 1950 Ralph Bartholomew (MOMA 233)

KNIVES / SWORDS
 South Vietnamese soldier, with a knife, threatening Viet Cong collaborator in "Vietnam–Crime and Punishment" 1964 Horst Faas (Capture 54)
 sword through chair and holding up a floating head in [floating head on a sword] c. 1997* Mark Seliger (Graphis97 106)
 young man with a knife in "An unidentified man wields a knife in a photo that convinced police that an additional man should have been arrested after a dispute erupted at a high school track meet" 1987 Paul Aiken (Best13 62)
 young Japanese man using Samurai sword to kill older man in "Assassination of Asanuma" 1960 Yasushi Nagao (Capture 46)

KOREA
 lines of riot police in protective clothing in "School children in Seoul walk by police as they return from demonstrations" 1987* Anthony Suau (Best13 25c)
 mothers at cemetery in "Mothers of students killed in the 1980 Kwangju, South Korea, uprising mourn their loss on the anniversary of the massacre" 1987* Anthony Suau (Best13 85)
 student being carried off by riot police in "South Korean riot police arrest a student protestor during May demonstrations in Central Seoul" 1987* Anthony Suau (Best13 84a)
 students cornering riot police in "Demonstrators overwhelm police in downtown Seoul" 1987* Nathan Benn

(Best13 27a)

students propelling rocks in [Korean student protestors with slingshot and firebomb] 1987* Nathan Benn (Best13 24b, 25d)

woman hitting riot police in "A woman attacks the line of riot police with her purse and is arrested in Seoul" 1987* Anthony Suau (Best13 24)

KOREAN WAR, 1950-1953

bombers dropping hundreds of bombs over rural Korea in "Korean War" 1951 U.S. Air Force (Photos 77)

face of soldier in heavy coat and hood in "U.S. Marine, South Korea" or "Christmas in Korea" 1950 David Douglas Duncan (Lacayo 136; Life 57; Marien \6.33)

hands protruding from snow in "This pair of tied hands was found protruding from the snow at Yangii on the central front, Korea" 1951 Max Desfor (Eyes #225)

hundreds of refugees fleeing across upper girders of bombed bridge in "Korean War" 1950 Max Desfor (Capture 27; Eyes #226)

line of armed Marines in "U.S. Marines in Korea" 1950 David Douglas Duncan (Lacayo 119a)

Korean mother with child carries her belongings on her head in "A Korean mother carrying her baby and her worldly goods flees the fighting around Seoul in the winter attack on the Korean capital" 1951 Carl Mydans (Eyes #224)

soldier in shock after being released from capture in "The shock of freedom" c. 1953 Michael Rougier (Eyes #230)

soldiers comforting each other after a battle in "Korea" 1950 Al Chang (Eyes #229)

soldiers with rifles running in grass in "Korea" 1950 David Douglas Duncan (MOMA 201)

wounded soldier being carried in "Wounded soldier near the Naktong River" 1950 David Douglas Duncan (Life 56)

KOSOVO (Serbia)

Kosovo man's death with his family around him in "A victim of the civil war in Yugoslavia" c. 1991* Georges Merillon (Graphis92 \48)

KU KLUX KLAN

group of hooded figures from [the series *Ku Klux Klan*] 1951-1958 W. Eugene Smith (Decade 65)

hooded figure in doorway from [the series *The Klan Room*] 1982* William Christenberry (Photography 163)

Ku Klux Klan members walking in robes past large crowd in "The funeral of a murdered leader of the Ku Klux Klan" 1920s Underwood & Underwood (Lacayo 52)

person in hood and long white robe in "Ku Klux Klansman" c. 1869 Photographer Unknown (Waking #102)

robed Klansmen in a car in "James Farranda, new Imperial Wizard of the Invisible Empire of the Ku Klux Klan, drives a Klan-filled Mercedes in Connecticut" 1986 Joe Tabacca (Best12 55a)

rows of hooded Klan members around a burning cross in "The Burning Cross" 1948 Photographer Unknown (Photos 72)

KURDS

family warming themselves by a fire in the snow in "After fleeing war-torn Kirkuk, Iraq, Kurdish family clings to life in the ruins of a town destroyed by Iraqi forces" 1992* Ed Kashi (Best18 122)

gassed mother and child in street in "Iraqi Kurds killed by poison gas" 1988* Ramazan Oztürk (Lacayo 179a)

photo essay on the crowded situation in the refugee camps, children suffering from chemical burns and malnutrition in "No sanctuary" 1991 Bill Snead (Best17 211-218)

photo essay on the harsh life in Turkish refugee camps and the death of the children in "Kurdish Saga" 1991* Anthony Suau (Best17 179-184)

KUWAIT *see also* PERSIAN GULF WAR, 1991

covered in oil, men try to cap a well in "Capping a burning oil well in Kuwait" 1991* Stephane Compoint (Lacayo 174)

series of photographs of oil well fires in "Darkness over Kuwait" c. 1992* Arthur Meyerson (Graphis93 55)

—L—

LABORING CLASSES *see* WORKING CLASSES

LACE

detail in "Lace" c. 1845* William Henry Fox Talbot (Art \2; Szarkowski 30)

LADDERS

from kitchen level to opening in wall in "Interior of (Mr.) Hooker's House, Sichimovi" 1902 Adam Clark Vroma (Szarkowski 124)

haystack and ladder in "Haystack" 1844 William Henry Fox Talbot (Art \8)

Japanese men performing on ladders for large crowd in "New Year Drill of Japanese Fire Brigade" c. 1890

Kusakabe Kimbei (Rosenblum2 #194)

leaning against wall in "The Ladder, Sèvres, Porcelain Manufactory" c. 1852 Henri-Victor Regnault (Szarkowksi 58)

men holding ladder to large window in "The Ladder" 1844 William Henry Fox Talbot (Art \11)

men painting a wall in "Untitled" 1930 Gertrud Arndt (San \13)

woman in bathing suit standing near ladder in field from [a series] c. 1990 Richard Litt (Graphis90 \20)

women on ladders picking apples in orchard in "Basuto women pick apples in the Prairie Province of South Africa" 1931* Melville Chater (Through 238)

LAKES, LAGOONS, AND PONDS

and sandy shore in "Hite Crossing, Lake Powell, Utah" 1988* Karen Halverson (Women \183)

canoe on lake in "Outlet of the Lake" 1885 Louise Deshong Woodbridge (Photography1 #VI-1; Rosenblum2 #390)

children sitting on a tree over lake in "Children play in a tree on a lake in Hanoi" 1998* Patrick Tehan (Best24 54b)

domed rock formations in lake in "Pyramid and Tufa Domes, Pyramid Lake, Nevada" 1878 (Marien \3.55); 1867 (National \34; Rosenblum2 #151)

dugout boats on lake in "Fishermen float along on Lake Barombi" 1987* Anthony Suau (Best13 83c)

exposed limestone turrets due to overuse of lake in "Mono Lake, California" 1981 Harald Sund (Life 188)

family by lake in "The seventh annual Lund family picnic, at Pelican Lake in central Minnesota, reunites up to 40 family members" 2000 Richard Olsenius (Through 362)

fog over pond in "Pond in the Fog" c. 1900 John Chislett (National \59)

iced-over lake and park in "A couple in Montreal, Canada, enjoys a quiet moment on Mount Royal Park's iced-over Beaver Lake" 1991* (Through 344)

lake from a distance in "Seneca Lake and Watkins Glen" 1899 William H. Rau (National 144a)

leaves growing on pond in "Quiet Pool (Early Evening)" c. 1905 Dwight A. Davis (National \60)

red cliffs around lake in [Lake Powell, Arizona] c. 1995* Michael Melford (Graphis96 164)

reflection of mountains and trees in "Mirror Lake and Reflections, Yosemite Valley" 1865 Charles Leander Weed (National 21d, \27); in "Echo Lake, White Mountains" c. 1870 Photographer Unknown (National 155a)

reflection of tree and hills in [Self-promotional] c. 1989* Pete Seaward (Graphis89 \88)

rocks and grass in lake in "Rocks and Grass, Moraine Lake, Sequoia National Park, California" c. 1932 Ansel Adams (Szarkowski 223)

rowboat with two people in "Gathering Water-Lilies" 1886 Peter Henry Emerson (Decade 7; Monk #11)

small boat under trees in "The Pond, Ville-d'Avray" 1923-1925 Eugène Atget (Art \264)

small island on lagoon in "Malibu Lagoon" c. 1999* J. Styranka (Photo00 90)

steam boats on lake in "Lake Steamers at Winter Mooring, Switzerland" c. 1865 Adolphe Braun (Rosenblum2 #119)

storm on lake in "Storm on Lake Tahoe" 1880-1885 Carlton E. Watkins (Art \119)

surrounded by mountains in "The Silver Strand, Loch Katrine" c. 1875-1880 George Washington Wilson (Rosenblum2 #121)

surrounded by pine trees and mountains in "Mount Hoffman, Sierra Nevada Mts., from Lake Tenaya" 1872 Eadweard Muybridge (Photography1 \54)

surrounded by soft mountains in "Lake McDonald, Glacier National Park" 1942 Ansel Adams (MOMA 117)

trees reflecting in water in "Saint-Cloud" 1915-1919 Eugène Atget (Szarkowski 235); 1926 Eugène Atget (Szarkowski 234)

white streaks in lake in "The ghostly fingers of a shrinking lake reach across the Makgadikgadi Pans of Botswana" 1990* Frans Lanting (Through 218)

with boats and jet skis in "Lake Powell, near Wahweap Marina, Utah" 1987* Karen Halverson (Women \182)

with small boats in "Chouteau's Pond" 1850 Thomas M. Easterly (Photography1 #III-10)

woman standing in lake in "Lake Michigan" 1953 Harry Callahan (Art \348)

LAST SUPPER

recreation of *Last Supper* with nude woman as Christ in "Yo Mama's Last Supper" 1996* Renée Cox (Committed 84d)

LAUGHING

audience laughing in "Untitled" c. 1940s Weegee (Art \314)

laughing on the bus in "Passengers exchanging moron jokes between Pittsburgh and St. Louis" 1943 Esther Bubley (Documenting 325b)

LAUNDRY

African American woman hanging sheets in "Laundress, Peterken Farm, South Carolina" 1929 Doris Ulmann

(Women \27)

being blown between balconies in "Laundry in Sicily" 1995* Willaim Albert Allard (Through 4)

children and laundry hanging in tenement courtyard in "Baxter Street Court" c. 1895 Jacob Riis (Lacayo 54)

clothes and lines in courtyard in "Court of the First Model Tenements, New York" 1936 Berenice Abbott (Women \105)

clothesline as swing in "[Toddler] swinging from laundry line in backyard" 1996* Wally Skalij (Best22 244d)

elderly woman hanging socks on a clothesline in "May, the stepmother of a member, hangs the wash out to dry" 1991 Eugene Richards (Best17 129)

hanging across front porch in "Family of Migrant Packinghouse Workers, Homestead, Florida" 1939 Marion Post Wolcott (Rosenblum2 #469)

hundreds of clotheslines filled with laundry in "Boiled, beaten, and hung out to dry, laundry fills lines at Dhobi Ghat (washermen's place) in Karachi, Pakistan" 1981* James Stanfield (Through 138)

ironing by an African American woman in [ironing] c. 1925-1934 Doris Ulmann (Rosenblum2 #393)

ironing done by migrant women ironing at ironing boards in "Ironing clothes in the utility building [at the Visalia Migratory Labor Camp, California]" 1940 Arthur Rothstein (Documenting 198a)

jeans and t-shirts on a clothesline in [ladies lightweight jeans] c. 1991* Marvyi (Graphis92 \35, \36)

lace dress on clothesline on a farm in "White Lace" 1992* William Tiernan (Best18 166a)

laundry hanging over alley and men in hats in "Bandits Roost, 59½ Mulberry Street" c. 1888 Jacob Riis (Marien \4.46; MOMA 73) or Richard Hoe Lawrence (Eyes #47)

lines of laundry hanging between apartment buildings in "Laundry, near the intersection of First Avenue and East Sixty-First Street" 1938 Walker Evans (Documenting 141c)

sheets hanging on clothesline in "In the Armenian village of Voskevaz, a doll keeps an eye on the day's wash" 1987* Jodi Cobb (Best13 171d)

sheets hanging on clothesline in "White Sheets, New Orleans" 1918 Paul Strand (Decade \12)

sheets hanging on clothesline near church in "Backyard and Roman Catholic church (Omaha)" 1938 John Vachon (Documenting 112a)

woman in washing machine in "Washable silks" 1988 John Kaplan (Best14 25c)

woman washing clothes in a tub in the kitchen in "A woman washing clothes in a galvanized tub" 1942 Gordon Parks (Willis \126)

LEANING TOWER (PISA, ITALY)

base of tower in "Leaning Tower of Pisa" c. 1990* Jay Maisel (Graphis90 \83)

LEAVES

curled leaves in a stream in "Natural oils seeping from decayed plants diffuse the reflections of sandstone cliffs on the surface of a stream in Zion National Park" 1988* Bob and Clara Calhoun (Best 14 102b)

dry leaf on piece of wood in [dried leaf] c. 1997* Mike Ryan (Graphis97 82, 86)

frog on leaf in [frog on leaf] c. 1995* Mark Laita (Graphis96 191b)

insect on curled leaf in [insect on a leaf] c. 1997* Mark Laita (Graphis97 187)

insect on dry leaf in [bugs on leaves] c. 1995* Mark Laita (Graphis96 191a, c)

pale green in "Green Leaf" c. 1997* Lisa Spindler (Graphis97 70)

single leaves and flowers in "Diaphanie (Leaves)" 1869* Louis Ducos de Hauron (Rosenblum2 #338)

with serrated edge in "Leaf with Serrated Edge" c. 1839 William Henry Fox Talbot (Marien \1.17)

LEG

feet to thighs in "Legs" 1927 Edward Weston (Art \218)

hanging from window in "A bright sunny day, a good book, and a good window to take advantage of" 1985 Jeff Greene (Best11 170c)

hanging over balcony in "A painter takes a lunch break" 1985 Robbie Bedell (Best11 170a)

man's legs hanging over brick wall in "Portrait" n.d. Chris Killip (Art \391)

of firefighter going through window in "A firefighter crawls into the attic of a burning home in an effort to avoid fumes from the blaze" 1985 John Dunn (Best11 171a); in "A firefighter goes into a small attic window to put a line on a fire caused by faulty electrical wiring" 1985 Charles S. Vallone (Best11 171b)

people on street in "Running Legs" 1940 Lisette Model (Sandler 92)

student's legs crossing over aisles in a bus in "The people of Jasper, Indiana" 1995 Torsten Kjellstrand (Best21 36)

with toes pointed down in "Legs" c. 1991* Nadav Kander (Graphis92 \248)

woman's leg in "Running Legs, Fifth Avenue" 1940-1941 Lisette Model (Icons 82)

woman's leg with face in "Dorothy True" 1919 Alfred Stieglitz (Hambourg 13c)

LEOPARD

in a tree eating its kill in "Leopard, Botswana, Africa" 1966* John Dominis (Life 186)

running with its kill in "Coming down from a tree with the remains of a kill, this leopard is heading for the

bush" 1985* Stephen J. Krasmann (Best11 153b)

LEPCHA (South Asian people)

man sitting on rock in "Lepcha Man" 1868 Samuel Bourne (Art \134)

LESBIANS

couple at restaurant in "Lesbian Couple at The Monocle" 1932 (Waking #168)

LETTER CARRIERS

giving mail to old woman on porch in "Mail delivery (Omaha)" 1938 John Vachon (Documenting 106b)

mail carrier behind row of mailboxes in "Mailman works his way down a rack of mailboxes at a trailer park" 1985 Mike Adaskaveg (Best11 143b)

pregnant woman holding large amount of mail and mail bag in "Mail carrier Minette Sheller had residents on her route wondering just what she was going to deliver today" 1985 Al Seib (Best11 136c)

LETTER WRITING

woman at desk in living room in "Mrs. Julian Bachman, living at home, writes to her husband in an Army Air Corps officer candidate school in Kentucky. The couple has been married for one year" 1942 Marjory Collins (Documenting 273b)

woman in hat sitting at table in "Sun's Rays–Paula, Berlin" 1889 Alfred Stieglitz (Marien \4.20; Rosenblum2 #401)

LEVIATHAN (Steamship)

large ship under construction in "The *Leviathan* under construction" c. 1857 Robert Howlett (Lacayo 26d)

LIBERIA

armed men in "Liberia in Turmoil" 1996* David Guttenfelder (Best22 234a, b)

armed men dragging a man on the street in "Fighters of the National Patriotic Front of Liberia drag a wounded man off a street in Monrovia during factional fighting" 1996* David Guttenfelder (Best22 150b)

burned corpse and fighter in "Liberia" 1996* Patrick Robert (Best22 234d)

militiamen execute an enemy on the street in "Militia soldiers execute a Krahn faction enemy on the streets of Monrovia" 1996* Christopher Simone (Best22 271d)

street executions in "Liberia: From a Dead Man's Wallet" 1996* Corinne Dufka (Best22 227)

youth with machine gun and dagger in "A Liberian street fighter during the civil war" 1996* Patrick Robert (Best22 212a)

LIBYA

men carrying coffins through the streets in "Coffins of 16 adults and four children killed in the U.S. bombing of Libya are carried through the streets of Tripoli" 1986* Herve Merliac (Best12 15a)

searchlights searching the sky in "Searchlight beams and anti-aircraft fire rise from Tripoli during the American bombing raid" 1986* Catherine Leroy (Best12 14)

LIGHT BULBS

against dark background in "Untitled" n.d. Wols (Icons 111)

and extinguished candle in [ad for Ridomil] c. 1992* Terry Heffernan (Graphis93 65)

clear bulb in [light bulb] c. 1992* Jody Dole (Graphis93 152b)

on ceiling with cords along ceiling in "Greenwood, Mississippi" 1970* William Eggleston (Marien \6.94)

Western Electric bulb in [light bulb] c. 1997* Jody Dole (Graphis97 130)

LIGHTHOUSES

lights on in lighthouse in "The North Head Lighthouse at the south end of Long Beach Peninsula" 1998* Ben Benschneider (Best24 42c)

men fishing from beach in "Fishermen take to the shore at Montauk Point, Long Island" 1996* Pete Souza (Best22 189b)

near shore in "Breakwater at Sète" c. 1855 Gustave Le Gray (Art \85)

waves, the height of the lighthouse, crashing around it, in "Blizzard Rams New England" 1978 Kevin Cole (Capture 108)

LIGHTNING

and a crescent moon in "A towering thunderhead, lightning and a crescent moon in an August sky" 1986* Joel Sartore (Best12 103a)

lightning in sky above a baseball pitcher in "Adam Meinershagen pitching for Sydney during an electrical storm" 1995* Tim Clayton (Best21 113)

small church on prairie with illuminated cross and bolt of lightning in "At Heaven's Gate" 1990* Chris Ochsner (Best16 64b)

thunderstorm and lightning over wheatfields in "Thunderstorm threatens wheatfields west of Dodge City, Kan." 1985* Cotton Coulson (Best11 41a)

LINCOLN MEMORIAL, Washington, D.C.

thousands of people in front of the Lincoln Memorial in "The march on Washington–August 28" 1963 Flip

—M—

compressed air equipment in "Compressed air equipment" c. 1991 Ian McKinnell (Graphis92 \159)

crankshaft in "Crankshaft Silhouetted against Car" 1923 Paul Outerbridge (San \3)

drill bit from [cover of a catalog] c. 1990* Magrit Hankel-Puentener (Graphis90 \215)

lathe in "Lathe #3, Akeley Shop" 1923 Paul Strand (Rosenblum2 #578)

part of crankshaft in "Marmon Crankshaft" 1923 Paul Outerbridge (Hambourg \14; Rosenblum2 #527; San #23)

parts of machine in "Art paper coating machine" c. 1991* Hermann Josef (Graphis91 \247-\249)

pipes and cylinders in "Photomontage" 1928 Cesar Domela (Hambourg \18)

woman working at machine in "Emma Dougherty cleaning our her end-grinding machine" 1942 Marjory Collins (Documenting 266a)

MACHU PICCHU SITE (Peru)

having been excavated in "Urubamba Valley near Cuzco" 1925 Martín Chambi (Photos 21)

site after it had been cleared of overgrowth in "Hiram Bingham discovered the ancient Inca site of Machu Picchu, high in the Peruvian Andes" 1912 Hiram Bingham (Through 300) or "Machu Picchu after ten days of clearing" 1911 Hiram Bingham (Goldberg 30)

MAGNIFYING GLASSES

held up to man's mouth and chin in "Jack Nicholson" 1987 Herb Ritts (Rolling #76)

large round glass enabling elderly woman to read in "Sylvia Hayes reads using a magnifier" 1996 John Beale (Best22 218c)

MAIL CARRIERS see LETTER CARRIERS

MAILBOXES

mail carrier behind row of mail boxes in "Mailman works his way down a rack of mailboxes at a trailer park" 1985 Mike Adaskaveg (Best11 143b)

near door, holding newspaper in "Mailbox (Omaha)" 1938 John Vachon (Documenting 107c)

MAINE (Battleship)

view of a portion of the wreck in "Near view of the Maine wreck, showing tremendous force of the explosion, Havana Harbor" 1898 Underwood & Underwood (Eyes #39)

wreckage barely above water in "Wreck of the battleship Maine" 1898 Photographer Unknown (Lacayo 34)

wreckage of ship in harbor in "Wreckage of the Maine in Havana Harbor" 1898 James Hare (Eyes #54)

MANATEES

mother and calf swimming alongside a diver in "In a place where human divers outnumber manatees 10 to one, a manatee and her calf attempt to find sanctuary" 1995* Joel Sartore (Best21 158c)

MANNEQUINS

children's clothes in store window in "Avenue des Gobelins" 1925 Eugène Atget (Rosenblum2 #319)

clothed in slip in "R. H. Macy & Co., department store during the week before Christmas. New York" n.d. Marjory Collins (Fisher 122)

female legs on chairs modeling shoes in "New York" 1955* Harry Callahan (Decade \I)

headless mannequin in pants and shirt outside store in "Avenue des Gobelins" 1925 Eugène Atget (Art \270)

illustrating back pain in "Back pain problems get graphic" 1985* Gary Fandel (Best11 145d)

unclothed female figures in "The Latest Offer–In Profile" 1928 Umbo (Icons 33; Rosenblum2 #551)

MAPS

stained glass map on dome of building in "A workman cleans the stained glass dome of the Christian Science Mapparium revealing the coastlines and political boundaries" 1998* Bob Sacha (Best24 53)

MARKETS

crowds at open-air market in "Largest Marketplace in Addis Abba" n.d. Constance Newman (Willis \429)

livestock sale in center of small town in "Fair in Fribourg, Switzerland" c. 1902 Ernest Bloch (Decade \11)

street filled with people in "Morning shoppers jam the market at Malang, one of Java's finest and most neatly planned hill towns" 1989* Charles O'Rear (Through 128)

MARRIAGE see WEDDINGS

MARS (PLANET)

surface of Mars in "Mars as seen from Pathfinder" 1998* NASA (Goldberg 221)

MARSHES

carrying hay on poles in "Poling the Marsh Hay" 1886 Peter Henry Emerson (Art \152; Marien \4.5; Waking 331)

hunters carrying guns in "Snipe Shooting" 1886 Peter Henry Emerson (Art \153)

men walking with scythes in "Coming Home from the Marshes" 1886 Peter Henry Emerson (Art \151)

tall grass in water in "In Marsh Land" c. 1885 Peter Henry Emerson (Art \149)

MARY KAY COSMETICS

photo essay of annual convention in "Pink Cadillacs, White Rocks" 1993* Nina Berman (Best19 217-220)

MASKS

bird mask on woman in "Blackbirds / Jamie Ros" c. 1999* Rosanne Olson (Photo00 123)

boy and cat lying down with masks on in "Child and Cat with Chinese Animal Masks" 1965 Stefan Moses (Icons 150)

boy in weathered doorway in "Untitled" c. 1959 Ralph Eugene Meatyard (San \37)

boy on beach in "Boy on Beach with Mask" 1985* Mel Wright (Committed 228)

boys and girl wearing masks while standing on stoop in "Masked Kids, Brownstone" c. 1945 Helen Levitt (Sandler 93) or "New York" 1939 (MOMA 159) or "Three Kids on a Stoop" 1940 (Hambourg \28)

children in masks sitting on numbered steps in "Romance (N) from Ambrose Bierce, No. 3" 1962 Ralph Eugene Meatyard (Marien \6.49)

couple dancing in street in "Jitterbug, New Orleans" 1937 John Gutmann (MOMA 160)

couple in large masks posing for portrait in "Tarassa, Catalonia" 1961 Inge Morath (Rosenblum \200)

elderly women in coats with masks over their eyes in "Untitled" 1970-1971 Diane Arbus (Szarkowski 260)

huge masks on men in parade in "Grotesque masks bob along in a burst of pre-Lenten revelry in Nice, France" 1926 Maynard Owen Williams (Through 110)

man with mask over eyes at dance in "Carnival, Zürs, Austria" 1950 Robert Capa (Photography 217)

masked men with arms raised in "Demonstrating against U.S. presence in the Philippines, held in front of Clark Air Force Base" 1985* Susan Meiselas (Eyes \24; Rosenblum \10)

men in hats and scarves near sandbags in "Awaiting counterattack by the guard in Matagalpa" 1978* Susan Meiselas (Eyes \23)

nude woman in long gloves and sheer cape in "Black Gloves" c. 1997* Rich Van Dyke (Graphis97 104)

Republican father in Clinton mask in "As results filtered in on election night, Stan Reagan wears a Clinton mask to entertain his son" 1996 Chad Stevens (Best22 98)

students in lion masks in "More than 1,000 students donned lion masks and posed for this Halloween portrait" 1985 Fred Comegys (Best11 184)

woman in dark mask across her eyes in "Rut Maske" 1927 Umbo (San #58)

women with masks over their eyes, and drapes over one shoulder in "Three Masked Women" 1935 Brassaï (Szarkowski 221)

wrestlers in capes and robes from [series on masked Mexican wrestlers] c. 1997* Vern Evans (Graphis97 102, 103)

MATADORS *see* BULLFIGHTERS AND BULLS

MAURETANIA (Steamship)

view of ship beyond pier in *"The Mauretania"* 1910 Alfred Stieglitz (MOMA 92)

MAURITANIA

dancers and speeches after the declaration of independence in "Creating Independence in Mauritania" 1960 Photographer Unknown (Photos 92, 93)

MAZES

light paths through a maze in "The mile-long 'Wooz' has become a craze" 1988* Roger Ressmeyer (Best14 156a)

MECCA (SAUDI ARABIA)

view of the city and draped Sacred Mosque in "The Holy City" c. 1880 Muhammad Sadiq (Marien \3.45)

MEDALS

hands holding medal in box in "Congressional Medal of Honor, posthumous, Chesterfield, Mass" 1983* Jeff Jacobson (Eyes \42)

Nicaraguan men pinning medals on themselves in "Managua" c. 1989 James Nachtwey (Graphis89 \248)

MEDICAL PHOTOGRAPHY

sisters in dresses with eye deformities in "Deformity about the left eye in two sisters" c. 1847 Photographer Unknown (Marien \2.23)

MEERKAT

sitting upright on fallen branches in "Staying alert, a meerkat keeps watch while its groupmates forage in the Kalahari Desert" 2002* Mattias Klum (Through 278)

MEMORIALS

AIDS quilts fill the mall as seen from the air in "AIDS Memorial Quilt" 1996* Paul Margolies (Photos 183)

candles being lit around gate with photo of Rabin in "Mourning Yitzhak Rabin" 1995* Joerg Waizmann (Photos 178)

crowd passing by rows of bouquets in "Shock and horror were displayed outside the Dunblane School in Scotland after the tragedy of that day" 1996 Tom Stoddart (Best22 248c)

floral bouquets by the thousands left on the street in "Flowers in front of Kensington Palace" 1997* Photographer Unknown (Photos 150)

installation of a sculpture in "A work crew installs a memorial statute to the Merchant Marines during a ceremony at Los Angeles Harbor" 1988 Peggy Peattie (Best14 203b)

lighting memorial candles for Yitzhak Rabin in "A year after the assassination of Israeli Prime Minister Rabin, people gather to light candles at the site of the incident" c. 1996* Zio Koren (Graphis97 54)

man kneeling by wreath at memorial with numerous photographers in "Willy Brandt at the Warsaw Ghetto Memorial" 1970 Sven Simon (Photos 133)

photograph of man in uniform at base of Vietnam Memorial Wall in "Untitled" 1987 Wendy Watriss (Rosenblum \203)

Vietnam veterans embrace at site of memorial marked by boot, helmet and rifle in "Vietnam veterans embrace during dedication ceremonies for a memorial to be constructed in Philadelphia near the Delaware River" 1986 Susan Winters (Best12 59a)

MENTALLY ILL

adult men waving in "Fred Morey and Andy Prather, roommates at the Group Home, wave to passersby" 1993* Allan Detrich (Best19 228d)

adults playing basketball in "Mentally retarded adults, residents of a home, play basketball in a neighborhood park" 1991 Suzanne Kreiter (Best17 198a)

autistic boy on swing and doing arithmetic in "World of His Own" 1997 Carol Guzy (Best23 221)

autistic girl playing the piano from [Child of Silence] c. 1989 Mary Ellen Mark (Graphis89 \253)

child watching TV in "Autistic, mentally retarded 7-year-old watches favorite channel" 1997* Vicki Cronis (Best23 141a)

children in small cribs in "An 'irrecoverably' mentally ill boy is confined to a crib in Romania" 1990 James Nachtwey (Best16 196a)

girl drawing scribbled picture in "European child" 1948 David "Chim" Seymour (Eyes #201; Lacayo 116a)

high school students at dance in " 'Circle of Love' prom for mentally retarded students at Jersey City School" 1995* Monika Graff (Best21 184a)

man chained to bed in "Patients in Angolan mental asylum are chained to beds" 1997 Joe Stefanchik (Best23 138c)

man seated at long table and cat on floor in "Scene in an Asylum" 1980 Roberto Fontana (Rosenblum2 #703)

men peering through openings in door in "Residents at an insane asylum in Port-au-Prince, Haiti, peer through openings in their padlocked door" 1996 Carol Guzy (Best22 11b)

mentally disabled adults walking outside in pajamas in "Untitled (7)" 1970-1971 Diane Arbus (Women \133)

naked man stares into a mirror in a jail cell in " 'John' of the mental ward: Naked he stares into the mirror all day long in the Dade County jail" 1986 Tim Chapman (Best12 191a)

people sitting and laying down in courtyard of asylum in "Untitled" c. 1976 Sara Facio (Marien \6.7)

person hiding head under jacket in "In an insane asylum, Turin" 1979 Raymond Depardon (Lacayo 155d)

photo essay comparing the daily life in an adult group home and life in a state institution for mentally disabled adults in "Caring for Special Adults" 1991 Suzanne Kreiter (Best17 91-96)

portraits of people with mental disabilities in "Putting People First" c. 1991 John Claridge (Graphis91 \166-\174)

retarded children on wooden deck at group home in "Stephen Rothstein pauses to take in his new surroundings at a group home for retarded children" 1991 Bradley Clift (Best17 62)

retarded man, lying naked in one of a roomful of cribs and beds in "Illinois State Schools for the Retarded" 1970 Jack Dykinga (Capture 74)

Taiwanese mental patients chained together in pairs in "The Chain" 1998 Chien-Chi Chang (Best24 118-119)

toothless man in "An insane elderly man" 1990 James Nachtwey (Best16 48b)

wide-eyed woman in darkness in "A madwoman in a Haitian clinic" 1958 W. Eugene Smith (Lacayo 158)

woman covering her face with a blanket in "An insane woman hides behind a blanket" 1990 Jame Nachtwey (Best16 80a)

woman in plaid dress in "Seated Woman with Bird" c. 1855 Hugh Welch Diamond (Marien \2.17)

women eating bowls of soup in "Institutionalized mental patients in Romania seem lonely even while together at mealtime" 1990 James Nachtwey (Best16 46)

women exercising on lawn in "Untitled (6)" 1970-1971 Diane Arbus (Art \328)

women posing in "Patients, Surrey County Lunatic Asylum" 1850-1858 Hugh Welch Diamond (Rosenblum2 #77; Waking #33)

MERRY-GO-ROUND see also AMUSEMENT PARKS

spinning quickly in "A traditional merry-go-round spins at the foot of the Cathedral of Sacre Coeur which stands on a hill overlooking Paris" 1987 Paul Brown (Best13 176a)

MEXICANS see also MEXICO–HISTORY–REVOLUTION, 1910-1920

man with leaf covering his back in "Campesino Covered with a Leaf" 1965 Héctor García (Marien \6.9)

Dorothea Lange (Documenting 118a)
string band playing on wooden benches in "At a Saturday night dance; a string band with its kitty for contributions [Visalia Migratory Labor Camp, California]" 1940 Arthur Rothstein (Documenting 204a)
trash near cars and tents in "Refugee camp near Holtville" 1937 Dorothea Lange (Documenting 119b)
water bucket in "The water supply in a squatter camp near Calipatria is an open settling basin fed by an irrigation ditch" 1936 Dorothea Lange (Documenting 120b)
women ironing at ironing boards in "Ironing clothes in the utility building [Visalia Migratory Labor Camp, California]" 1940 Arthur Rothstein (Documenting 198a)
woman washing dishes in a straw shed in "A drought refugee living in a camp on the bank of an irrigation ditch" 1936 Dorothea Lange (Documenting 121c)
woman sewing in living room in "Embroidering a dish towel in a camp residence [Visalia Migratory Labor Camp, California]" 1940 Arthur Rothstein (Documenting 195c)
women sitting on benches at meeting in "Women's club [Visalia Migratory Labor Camp, California]" 1940 Arthur Rothstein (Documenting 202)
women washing in hot spring in "Migratory workers from Oklahoma washing in a hot spring in the desert" 1937 Dorothea Lange (Documenting 120a)

MILITARY EDUCATION
drill instructor yelling at man in basic training in "After making a mistake during a marching drill, an errant 'poopie' responds to his drill instructor" 1992* Joel Sartore (Best18 119b)

MILITARY PERSONNEL see ARMED FORCES

MILK
drop falling and creating crown-shape in "Drop of Milk" 1931 Harold Edgerton (Monk #18) or "Milk Drop Coronet" 1936 Harold Edgerton (Goldberg 105; Marien \5.77)
girl carrying bottles of milk in "New York" c. 1940 Helen Levitt (Marien \6.53)
half-empty bottle of milk from [a cookbook] c. 1990* Hans Hansen (Graphis90 \340)
ladles and pails in [milk ladles and pails] c. 1992* Gerrit Buntrock (Graphis93 70)

MILLION MAN MARCH, Washington, D.C.
crowd of African American men in "Million Man March, Washington, D.C." 1995 Hank Sloane Thomas (Willis \380, \381); 1995 Jeffrey John Fearing (Willis \554)

MILLS AND MILL-WORK
child sitting at a machine in "A girl at work in a cotton mill" 1911 Lewis Wickes Hine (Lacayo 64c)
young girl at large spinning machine in "Child Spinner, North Carolina" 1909 Lewis W. Hine (Goldberg 42; Marien \4.49; Monk #14; Lacayo 62a; Photos 17)
young girl at large spinning machine in "Ten-Year-Old Spinner" 1908-1909 Lewis Wickes Hine (Rosenblum2 #476)

MINERS AND MINING
bearded man in hat in "California Forty-Niner" c. 1850* Photographer Unknown (Photography1 \3)
boy with blackened face and miner's lamp in "Young Coal Miner, Wales" 1947 Arthur Rothstein (Decade \40)
boys and men sorting coal in "Kohinore Mine, Shenandoah City, Pennsylvania" 1891 Frances Benjamin Johnston (Photography1 \92)
boys at end of coal chute in "Breaker Boys" 1904 Gustav Marrissiaux (Rosenblum2 #433)
boys sorting coal in "Breaker Boys, Eagle Hill, Colliery" c. 1884 George Bretz (Rosenblum2 #432)
car on cables carrying men to mine in "A crude trolley carries workers into a South African diamond mine" 1906 Gardiner F. Williams (Through 232)
children with coal on their faces in "Coalbreakers, Pennsylvania" or "Breaker boys in a coal chute" 1910-1911 Lewis W. Hine (Eyes #62; Goldberg 40; MOMA 74; Lacayo 63; Rosenblum2 #474)
equipment and wooden shacks in "Poverty Bar, Middle Fork Mining Series" 1859 Charles Weed (Photography1 \38)
flume built to bring water to mine in "Magenta Flume, Nevada Co., California" c. 1871 Carleton E. Watkins (Rosenblum2 #164)
freight cars filled with coal at mining camp in "Coal mine tipple in foreground. Caples, West Virginia" 1938 Marion Post Wolcott (Fisher 50)
gold pan and pick axe for [the American President Lines] c. 1989* Terry Heffernan (Graphis89 \290)
hillside filled with men cutting into side of mine in "Gold miners in Brazil" 1986 Sebastião Salgado (Eyes #325; Lacayo 168; Marien \7.18; Photography 108; Photos 157)
landscape of a mine in "Union Diggings, Columbia Hill, Nevada" c. 1871 Carleton E. Watkins (National \30)
man covered in dirt and sweat in "It's a dirty job, but gold ore at the huge federally operated Serra Pelada mine in Para, Brazil, still is hauled from the pits by hand" 1987* Stephanie Maze (Best13 163d)

man covered in soot eating at table with wife in "Northumberland Miner at his Evening Meal" 1937 Bill Brandt (Art \288)

man digging rock underground in "Miner at Work in the Comstock Mine" 1868 Timothy H. O'Sullivan (Marien \3.56; Rosenblum2 #430)

man working in close quarters underground in "Miner at Work 900 ft. Underground, Gould and Curry Mine, Virginia City, Nevada" 1868 Timothy H. O'Sullivan (Waking 327)

men at flume with gold pans in "Goldminers, California" 1850 Photographer Unknown (Rosenblum2 #431)

men in hard hats standing around a seated Kennedy in "Chatting with West Virginia coal miners during the presidential campaign" 1960 Hank Walker (Life 27)

men made to stand nude in office in "Untitled (The Wenela Mine recruiting agency)" 1967 Peter Magubane (Marien \6.16)

men taking dirt out of a hole in "Gold miners labor to remove pay dirt at the central African outpost of Minkébé" 2001* Michael Nichols (Through 230)

men with blackened faces on hilltop in "Welsh Miners" 1950 W. Eugene Smith (MOMA 200)

men with buckets in "Gold Miners" c. 1850 Photographer Unknown (Photography1 #III-1)

neatly dressed man holding large nugget in "James Warner Woolsey, Nevada City Miner, with Nugget Weighing over Eight Pounds" 1849-1850 Photographer Unknown (Marien \2.53)

river and tree made blue from mine runoff in "The Colonial Mine with blue asbestos tailings, Wittenoom, Western Australia" 1999* David Goldblatt (Photography 187a)

soot-covered miner listening to radio in "A more prosperous miner listening to the radio. West Virginia" n.d. Marion Post Wolcott (Fisher 48)

woman who cleaned the coal with mining tools in "Pit Brow Girl, Shevington" 1867 T. G. Dugdale (Rosenblum2 #410)

MIRRORS

African American man reflected in dresser mirror in "Reflection of a Man in a Dresser Mirror" c. 1938 Aaron Siskind (Marien \5.71)

baseball player's image in several mirrors on field in "Shortstop Ozzie Smith, the wizard of the St. Louis Cardinals infield, redefines the baseball cliche of 'doing it with mirrors' " 1988* Joe McNally (Best14 155)

boy fixing tie in large mirror [for the Cashmere House in Milan] c. 1991 Martin Riedl (Graphis92 \29)

broken and discarded mirror reflecting outside of house in "Twain" c. 1995* Deborah Brackenbury (Graphis96 169b)

girl combing hair in front of mirror on cigarette machine in [Untitled, from the series *Teenagers*] 1959 Bruce Davidson (Goldberg 149; MOMA 226)

girl in fancy dress at long mirror in "Girl in Fancy Dress" c. 1860 Clementina Hawarden (Marien \3.105; Rosenblum \37; Rosenblum2 #272)

girl reflected in wall mirror near navy pennant in "Sally Dessez, a student at Woodrow Wilson High School, in her room" 1943 Esther Bubley (Fisher 63)

leaning against a wall in "A sidewalk vendor's mirrors reflect street life in downtown Port-au-Prince" 1992 Michael S. Wirtz (Best18 86)

looking in hand mirror and reflected in dresser mirror in "A return to the look of the early 1900s" 1987 Steve Harper (Best13 180c)

model touching long mirror on floor in "Annaliese" c. 1999* Sanjay Kothari (Photo00 36)

ornate mirror above dresser near mother putting child in bassinet in "Mrs. Frank Romano putting her baby to bed" n.d. Marjory Collins (Fisher 62)

sailor reflected in mirror and soldier sitting at desk in "In the lounge at the United Nations service center" 1943 Esther Bubley (Fisher 69)

small mirrors positioned at the base of a tree in "Seventh Mirror Displacement" 1969 Robert Smithson (Marien \6.86)

using side car mirrors to put on makeup in "Lyn Hale and Karen King put on makeup before performing with the New Frontier Gunfighter's Association" 1987 Catharine Krueger (Best13 4)

woman looking into small mirror as she stands by window in "The Mirror" 1912 Clarence White (Art \181)

MONASTERIES AND MONKS

group of monks in "Monks, Phiyang Monastery, Ladakh, India" 1985 Linda Connor (Women \188)

in a valley in "Shadows and light surround a monastic fortress, Bhutan" 1991* James Stanfield (Through 132)

island monastery in "San Giorgio Maggiore seen from the Ducal Palace" 1870s Carlo Ponti (Rosenblum2 #119)

line of hooded Trappist monks in hallway in "The house of silence" 1929 André Kertész (Lacayo 77)

La Tourette in "Monastery, *La Tourette*, designed by Le Corbusier" c. 1995* J. Peter Pawlak (Graphis96 176)

monastery in need of repair in "Rev. Pastorius of St. Peter and Paul Catholic Church walks past the 19th-

century monastery" 1996 Yunghi Kim (Best22 22d)

MONKEYS *see* PRIMATES

MONUMENT VALLEY (Arizona and Utah)
 view of formations in "Artist Point / Monument Valley View #1" c. 1999* Wes Hardison (Photo00 86);
 "Monument Valley / Navajo Nation" c. 1999* Wes Hardison (Photo00 87)

MONUMENTS *see also* SCULPTURE
 boat in dry-dock near ship-shaped monument in "*Padrao des Descobrimentos* monument in Lisbon" c. 1990*
 Serge Cohen (Graphis90 \93)
 column under construction in "Trafalgar Square: Nelson's Column under construction" 1843 William Henry
 Fox Talbot (Art \14; Rosenblum2 #22)

MOON
 American flag on moon near astronaut in "Apollo 11 Eva View" 1968 NASA (Goldberg 11)
 astronaut walking on moon in "Buzz Aldrin arranging seismic equipment to gauge lunar tremors" 1969*
 NASA (Life 103)
 astronaut saluting flag near lunar module on moon in "On the moon" 1971 David R. Scott (Eyes xvii)
 behind leaves in "Fantasy" 1923 Harry K. Shigeta (Peterson #40)
 coming over a town in "Moonrise Over Hernandez, New Mexico" c. 1941 Ansel Adams (Icons 96)
 earthrise in black sky seen from the moon in "Earthrise" 1968* William Anders (Goldberg 178; Lacayo 163;
 Monk #51)
 earthrise over the moon in "Apollo 17 astronauts, in orbit around the moon, photographed as crescent Earth
 rising in the lunar sky" 1973* NASA (Through 460)
 first man on moon in "Edwin 'Buzz' Aldrin on the Moon" 1969* Neil Armstrong (Eyes #367; Monk #47;
 Photos 125)
 full moon over sand dunes in "A fox sits in the windswept dune grass beneath the rising full moon" 1998*
 John Tlumacki (Best24 47c)
 geese silhouetted against copper-colored moon in "Canada geese fly across a rising moon" 1996* Scott
 Nielsen (Best22 186a)
 half of moon in "Moon" 1852 John Whipple (Marien \2.0; Photography1 \30; Rosenblum2 #17); "Moon"
 1865 Lewis Rutherfurd (Marien \3.72)
 model of the moon with erupting volcano in "Moon, Crater of Vesuvius" 1864 James Nasmyth (Marien \3.73)
 phases of the moon in " 'Moon' Score" 1977-1980 Hitoshi Nomura (Marien \6.91)
 photograph in plastic on surface of the moon in "Family Picture on the Moon" 1969* NASA (Goldberg 179)
 rising between line of trees reflected in water in "Moonrise–Mamaroneck, New York" 1904* Edward
 Steichen (MOMA 81; Waking #146)
 rocks near the lunar rover in "An Apollo 17 astronaut examines enormous lunar boulders resting in a crater
 at the Taurus-Littrow landing site" 1973* NASA (Through 472)
 surface of the moon in "Untitled (The far side of the moon)" 1969* Apollo II (Marien \6.65)

MOSCOW (Russia)
 buildings seen from window in "Pears ripen on a windowsill near the Kremlin in Moscow" 1986* Sam Abell
 (Through 38)
 Cathedral at night in winter in "St. Basil's Cathedral in Moscow's Red Square" 1998* Sisse Brimberg
 (Through 42)
 domes of two churches in "Dome of the Cathedral of the Assumption in the Kremlin, Moscow" 1852 Roger
 Fenton (Waking #79)
 mobs fighting in the streets of Moscow in "Red October" 1993* Christopher Morris (Best19 213-216)
 thousands cheering in "Events in Moscow: solidarity with Russian President Boris Yeltsin" 1991* Andy
 Hernandez (Graphis93 56)
 walls and structures in "External Walls of the Kremlin, Moscow" 1852 Roger Fenton (Art \97)

MOTELS *see* HOTELS

MOTHER / FATHER AND CHILD
 African American woman nursing an infant in "Mother and child" 1935 Ben Shahn (Documenting 89c)
 boy watching mother hold child on lap in "Madonna of the Tenements" c. 1911 Lewis Wickes Hine (Marien
 \4.48)
 child on woman's lap in "Mrs. Ward and Baby" 1903 Gertrude Käsebier (Goldberg 24)
 destitute mother holding children in "Mother with Children" 1922-1924 Consuelo Kanaga (Rosenblum \170)
 doorway with girl in black dress and mother in "Blessed Art Thou Among Women" 1899 Gertrude Käsebier
 (Marien \4.32; Sandler 50)
 father and young child in hats and coats in "Hill District, father and son" 1951 Richard Saunders (Willis \144)
 father holding child while shaving in bathroom in "With an extra little shaver in his hand, Jim Roland

continues his morning routine" 1987 Guy A. Reynold (Best13 123a)
father and child reading in bedroom in "Of fathers and family" 1993* Patrick Davison (Best19 39b)
father and daughter at graduation in "Of fathers and family" 1993* Patrick Davison (Best19 41a)
father and daughter playing basketball in "Of fathers and family" 1993* Patrick Davison (Best19 40d)
father and daughter in prison yard in "Of fathers and family" 1993* Patrick Davison (Best19 40a)
girl with mother holding infant on chair in "The Babe" c. 1900 Myra Albert Wiggins (Sandler 57a)
grandmother with infant in "A grandmother and child in Tia Aicha, Mali, East Africa" 1986 R. Todd
 Hoffman (Best12 67a)
Japanese mother with son on lap in "Mother and child at Hiroshima" 1945 Alfred Eisenstaedt (Lacayo 79)
man and woman sleeping with child in "Elizabeth Taylor, Mike Todd, and Daughter Liza (from *Life*
 magazine)" 1957 Toni Frissell (Sandler 147)
man holding naked child in "Father and son" 1988 Joey Ivansco (Best14 16)
mother and son in "A mother and her young son, who has Fetal Alcohol Syndrome" 1992* George Steinmetz
 (Best18 172)
mother holding emaciated and starving child on her lap in "Ethiopian Famine" 1984 Stan Grossfeld (Capture
 135; Eyes #347)
mother putting child in bassinet in "Mrs. Romano putting her baby to bed" n.d. Marjory Collins (Fisher 62)
mother with head and face covering feeding a baby in "Muslim Woman and Child, New Jersey" 1991
 Collette Fournier (Willis \367)
mother's hand on head of nude teenager in "Mother and Daughter" 1974 Starr Ockenga (Rosenblum \245)
Native American mother with child in traditional infant holder in "Mother and Child" c. 1890 E. Jane Gay
 (Sandler 103)
newborn and parents on bed in "Vogt's enjoy their firstborn" 1991* Eugene Richards (Best17 119)
Nigerian mother holding her child in "Supported by her mother, a starving child receives soy milk at the
 Kersey Home for Children in Ogbomosho, Nigeria" 1991* Lynn Johnson (Through 274)
nude man holding naked child in "Paul and Matthias" 1967 Karen Tweedy-Holmes (Rosenblum \260)
nude mother and children in "Nude" 1909 Alice Boughton (Marien \4.26)
nursing a child near an unmade bed in "Motherhood" 1906 Minna Keene (Rosenblum \148)
photo essay on the daily routines of a single father in "Every day is Father's Day" 1997 Nancy Andrews
 (Best23 28-29)
pregnant woman holding naked child on hip in "Mother and Child" c. 1929 Tina Modotti (Szarkowski 324a)
sitting with malnourished child in "An Ethiopian mother holds her malnourished son at a Belgian medical
 station in northern Ethiopia" 1987 William Campbell (Best13 120)
sleeping child on woman's chest in "Mrs. Hensley and child, North Carolina" c. 1933 Doris Ulmann
 (Rosenblum \144)
soldier kissing his son in "Christopher Jackson give his father a kiss" 1996* Adrin Snider (Best22 153d)
son helping elderly father walk in "Of fathers and family" 1993* Patrick Davison (Best19 41d)
woman in white gauzy material breast-feeding infant in "The Manger" 1899 Gertrude Käsebier (Decade \3;
 MOMA 84; Rosenblum \76)
woman standing naked infant on her lap in "Madonna" 1900 Amelia C. Van Buren (Rosenblum \99)

MOTION PICTURE THEATERS
 cars parked at drive-in movie in "Drive-in Movie, Detroit" 1955 Robert Frank (Art \324); "Youngsters watch
 the movie *Dances With Wolves* at a drive-in theater near Jackson Hole" 1991 Todd Anderson (Best17 72)
 changing the marquee in "Late at night, workers change the movie marquee" 1993 Christopher T. Assaf
 (Best19 72a)
 Dalmatians sitting in theater seats in "Dog day at the movie *101 Dalmatians*" 1991* Melanie Rook D'Anna
 (Best17 168)
 the front of the Roxy theater from [self-promotional] c. 1989* Harry De Zitter (Graphis89 \83)
 Kennedy in motorcade on screen at drive-in in "Monsey, New York" 1963 Lee Friedlander (Art \332)
 movie screen and concession stand in "Route 40 Drive-in" 1992* Patrick Tehan (Best18 42)
 parked cars at drive-in movie as train goes by in "Hot Shot East Bound at Iager, West Virginia" 1956 O.
 Winston Link (MOMA 232)
 small-town movie theater in "Vanishing Texas" c. 1991* Harry de Zitter (Graphis92 \196-\198)

MOTION PICTURES
 audience wearing 3-D glasses in theater in "Premiere of *Bwana Devil*, Paramount Theater, Hollywood" 1952
 J. R. Eyerman (Life 113)
 couples kissing in movie theater in "Lovers at the Movies" c. 1940 Weegee (Icons 94)
 crowd of people at a party in "Film Still for *The Common Law*" 1931 Photographer Unknown (MOMA 127)
 marquis of movie theater from [ad for large-screen TV sets] c. 1991* Dennis Manarchy (Graphis91 \284)

motion picture stage filled with dancers in [*Lullaby of Broadway* from *The Gold Diggers*] 1935 Photographer Unknown (Hambourg \81)

MOTION STUDY

cat being dropped and landing on its feet in "Falling Cat Sequence" c. 1880s Etienne Jules Marey (Rosenblum2 #299)

galloping horse in still images in "Galloping Horse" 1878 Eadweard J. Muybridge (Marien \4.52; Monk #9)

man jumping in "Pole Vaulter" 1884-1885 Thomas Eakins (Marien \4.57)

men in stages of jumping in "Nude men, motion study" 1877 Eadweard Muybridge (Szarkowski 132c)

nude man moving in "Multiple nude self-portraits" 1887 Eadweard Muybridge (Goldberg 50-51)

nude woman stepping on chair and pouring water on second woman in [nude stepping on chair and pouring water] 1887 Eadweard Muybridge (Rosenblum2 #294)

pattern of soldier walking in "Joinville Soldier Walking" 1883 Étienne-Jules Marey (Marien \4.53)

pattern of woman stacking buttons in "Chronocyclegraph of Woman Stacking Buttons" 1917 Frank B. Gilbreth (Marien \4.59)

person at table in "Motion Study" 1913 Frank B. Gilbreth (Goldberg 47)

stages of horse walking with man on horseback in "Horseman Riding the Mare Odette" c. 1887 Etienne-Jules Marey (Szarkowski 132a)

stages of man jumping with a pole in "History of a Jump" 1884-1885 Thomas Eakins (Rosenblum2 #298)

stages of woman dancing in "Woman Pirouetting" 1887 Eadweard Muybridge (Photography1 \86)

woman walking up and down the steps in "Ascending and Descending Stairs" 1870s Eadweard Muybridge (Marien \4.58)

MOTORCYCLES

African American man sitting on motorcycle in "Biker" 1990* Joe Harris (Committed 122)

African American man sitting on motorcycle in street in "Man on a Harley Motorcylce, Buffalo" 1985 Collette Fournier (Committed 98)

being ridden by man in suit and hat in "The Mods" 1980 (Rolling #42)

cheering youths on motorcycles in "Motorcycle Brigade, Nicaragua" 1978* Susan Meiselas (Art \431)

couple kissing near motorcycles in "Dumonts share a moment as other members of the Modified Motorcycle Assn. watch a friend kick-start his '64 Pan Head Harley-Davidson" 1986 John Walker (Best12 71b)

dancer lying prone on seat of motorcycle in "Ethan Stiefel" c. 1995 Ruven Afanador (Graphis96 137)

dials of motorcycle in [motorcycle near motel sign] c. 1997* Jim Erickson (Graphis97 133)

in kitchen next to refrigerator from [ad for Harley-Davidson motorcycles] c. 1990* Dennis Manarchy (Graphis90 \228)

in photographer's studio in "Honda motorcycle" c. 1989* Jon Kubly (Graphis89 \200)

in park in "Motorcycle with stunt bar" 1941 Russell Lee (Documenting 215b)

lone rider on road with curves in "A lone motorcyclist rides through the twilight on Mount Tamalpais" 1993* Norma Jean Gargasz (Best19 76)

looking down on motorcycle, gloves, and old license plates in [motorcycle and license plates] c. 1991* George Kamper (Graphis92 \184)

man lying on motorcycle in "Hunter S. Thompson" 1987* Annie Leibovitz (Rolling #107)

man on motorcycle in "Newburgh, New York" 1955-1956 Robert Frank (Decade 70)

man reclining on his motorcycle in "On the first warm day of spring, a motorcyclist accepts his fate: arrested for speeding" 1986 Gary Porter (Best12 71a)

near café sign in [motorcycle near café sign] c. 1997* Jim Erickson (Graphis97 134)

on desert highway from [self-promotional] c. 1989* Harry De Zitter (Graphis89 \80)

people walking away from motorcycles on grass in "Eikhorn, Wisconsin" 1966 Danny Lyon (Marien \6.51)

portraits of different motorcycles in [Harley Davidson motorcycles] c. 1992* Clint Clemens (Graphis93 147)

riding through a puddle in "Motorcyclist, Budapest" c. 1923 Martin Munkacsi (Hambourg \74)

under cloud of smoke in "Smokin' " 1997 (Committed 64)

with flowing fabric in "Paso 750" c. 1989* R. J. Muna (Graphis89 \201)

MOUNT SURIBACHI

Marines raising American flag in rubble in "Old Glory Goes Up on Mount Suribachi" 1945 Joe Rosenthal (Capture 16; Eyes #212; Lacayo 118; Marien \5.86; Monk #29; Photos 65)

MOUNTAINEERING

distant view of climbers nearing peak in "Mere specks against the snow and ice, climbers approach the 6,550-foot summit of Gremlin's Cap in the Cordillera Sarmiento of Chile" 1994* Gordon Wiltsie (Through 310)

distant view of line of climbers in snow-covered pass in the Himalayas in "The Manirung Pass" 1866 Samuel Bourne (Waking 304)

group of climbers from a distance in "*Passage des Echelles*, the second ascent of Mont Blanc" 1862 Bisson

Freres (Lacayo 27c; Waking 293)

group of climbers in "*Passage des Echelles*, the ascent of Mont Blanc" 1862 Bisson Freres (Rosenblum2 #117)

man on side of mountain in [mountain climber on side of mountain] c. 1997 Lars Topelmann (Graphis97 202)

man hanging onto edge of cliff in "Swiss mountain guide dangles at 9,000 feet above sea level on the Schilthorn in the Swiss Alps" 1996* Thomas Ulrich (Best22 203d)

man climbing mountain in "Ad for the Austrian Tyrol" c. 1990 Werner Pawlok (Graphis90 \250)

repelling cliff in "Totem Pole, Colorado's Monument Valley" c. 1991* Stephen Wilkes (Graphis91 \282)

MOUNTAINS

around lake in "The Rapids with Indian Block House, Cascades" 1867 Carleton Watkins (Photography1 \6)

clouds over dark mountain in "Black Giant near Muir Pass, King's Canyon" 1930 Ansel Adams (Goldberg 75)

man hanging onto edge of cliff with Alps in background in "Swiss mountain guide dangles at 9,000 feet above sea level on the Schilthorn in the Swiss Alps" 1996* Thomas Ulrich (Best22 203d)

monastery in valley in "Shadows and light surround a monastic fortress in Bhutan" 1991* James Stanfield (Through 132)

moon over mountain peaks in "Mount Whitney with Moon" 1990* Peter Menzel (Best16 72)

panorama of the Alps in "Circular Panorama Taken from Bella Tolla" 1866 Aimé Civiale (Marien \3.76)

path through the mountains in "Path to Chaos, Saint-Sauveur" 1853 Joseph Vigier (Waking 283)

pronghorn overlooking the distant mountains in "Unique to North America, the pronghorn is an unforgettable sight" 1984* Sam Abell (Through 334)

valley between the mountains in "Valley and Snowy Peaks Seen from the Hamta Pass, Spiti Side" 1863-1866 Samuel Bourne (Marien \3.28)

MOUTH

close-up of mouth in "Mouth" 1931 Roger Parry (Hambourg \116)

MOVING OF BUILDINGS, BRIDGES, etc.

brick structure being moved in "Movers took five days to move San Antonio's Hotel Fairmount six blocks away" 1985 Joe M. Barrera, Jr. (Best11 158b)

house at top of hill in "A Victorian Florida cracker house is poised on the crest of a bridge while being towed" 1985 Jon Kral (Best11 159)

house cut in two in "A house in Massachusetts was split in two so it could be more easily moved to a new location" 1985 Christopher Fitzgerald (Best11 158a)

MUDSLIDES–COLOMBIA

arm, coated in mud, reaching out from body trapped in mud in "Volcanic Mudslide in Colombia" 1985* Carol Guzy and Michel duCille (Capture 140); "Four days after the mud slide, the arm of a corpse sends a grim signal" 1985 Kathy Anderson (Best11 21a)

bandaged infant crying in "An 18-month-old survivor of the tragedy cries in his hospital bed" 1985 Joanna Pinneo (Best11 19b)

boy being washed off in "5-year-old Oscar Javier Vera is washed down to ease the pain of mud, gravel, and ash embedded in his skin" 1985 Richard Schmidt (Best11 18c)

bruised woman getting water in "A badly bruised woman receives her first drink of water after being buried three days" 1985 Thomas W. Salyer (Best11 18d)

empty coffins stacked on top of each other in "So many deaths, so quickly; so little time, so little space" 1985 Ed Hille (Best11 21b)

face of girl covered in mud in "A young girl awaits help after being pulled from the mud" 1985 Jim Wilson (Best11 18a)

girl caught in mudslide, being helped by rescuers in "Volcanic Mudslide in Colombia" 1985 Carol Guzy and Michel duCille (Capture 141)

girl trapped in water hole in "13-year-old Omayra Sanches died after 60 hours were spent in attempts to free her from the water-filled hole in which she was trapped" 1985* Frank Fournier (Best11 14b)

man sitting on large mud deposit in "36 hours after the Colombia volcano erupted, this man makes his way through the massive mud deposit near the town of Armero" 1985* Anthony Suau (Best11 14c)

man sitting on rubble of his home in "Dazed survivor sits atop his house in Armero, waiting for the next Red Cross helicopter" 1985 Eduardo Gonzalez (Best11 16d)

man stuck in mud, amid rubble in "After two days, rescue workers effected this man's release from the pervasive mud" 1985 Jim Wilson (Best11 19a)

mud-covered naked girl being helped onto stretcher in "Civil defense volunteers assist a young Colombian who survived the mud slide at Armero" 1985* Ira Strickstein (Best11 15b)

mud-covered young girl in "Rescue workers attend the needs of a youngster found buried in the mud at

Armero" 1985* Nuri Vallbona (Best11 15d)

washing girl's body covered in mud in "Girl in Lérida, Columbia, who was saved after being trapped for 36 hours in mud slides" c. 1989* (Graphis89 \255)

woman lying among rubble in "A dying woman lies amidst volcanic mud and Armero's rubble" 1985 Carol Guzy (Best11 17)

woman searching for husband in long line of bodies in "In tiny Guayabal, the town square was used as a collection spot for the bodies of the dead" 1985 Jay Dickman (Best11 20)

MURAL PAINTING AND DECORATION

in courtyard of apartment house in "The current inner court of the Alwyn Court apartment house with a trompe l'œil mural by Richard Haas" c. 1989* Richard Berenholtz (Graphis 89 \101)

large mural for war effort in "Grand Central Station, New York" 1941 Arthur Rothstein (Fisher 160)

Malcolm X's image painted on side of building in "Legends, Philadelphia" 1993* Ron Tarver (Willis \428)

man walking past mural in "Charm City, Baltimore" 1995* Andre Lambertson (Willis \435)

MURDER

African man beating another man who has been set on fire in "Human Torch" 1990* Greg Marinovich (Capture 160)

armed police and dead bodies in "A uniformed police officer on the scene of an election day massacre in a school where 15 people were slain while trying to vote" 1987* Viorel Florescu (Best13 18d)

bodies of victims lying on floor in "Victims of a Palestinian terrorist attack are sprawled in lounge area of Rome's Leonardo da Vinci Airport" 1985 Bruno Mosconi (Best11 104c)

body covered with a sheet in "The wife and daughters of Benedetto Grado at the site of his murder, Palermo" 1983 Franco Zecchin (Photography 120a)

group of children and adults in "Brooklyn School Children See Gambler Murdered in Street" or "Their First Murder" 1941 Weegee (Art \318; Eyes #141; MOMA 166; Marien \6.44)

man lying face down on pavement in "Murder in Hell's Kitchen" c. 1940 Weegee (Art \316; Eyes #140)

men and photographer at crime scene in "Human Head Cake Box Murder" c. 1940 Weegee (Hambourg \35)

Muslim rioters beating a Christian man to death after a mosque was damaged in "Descent into Madness" 1998 James Nachtwey (Best24 160-161)

partial body on a hillside in "Cuesta del Plomo. Hillside outside Manaagua, well-known site of many assassinations carried out by the National Guard" 1978* Susan Meiselas (Women \138)

photo essay on the arrest and trial of a murder suspect in "Rodney's Crime" 1988 John Kaplan (Best14 18-21)

photo essay tracking murder to suspect in "Providence homicide" 1990 Timothy Barmann (Best16 203-210)

police and photographer at scene of crime in "Harry Maxwell Shot in Car" 1936 Weegee (MOMA 167)

police standing by dead body covered with a sheet in "On the Spot" 1940 Weegee (Goldberg 107)

student who was lynched, being beaten with a chair in front of crowd in "Brutality in Bangkok" 1976 Neal Ulevich (Capture 96)

wounded woman and dead family members on floor in "A wounded Haitian woman grieves over the body of her mother and other relatives surrounding her" 1987* David Murrary, Jr. (Best13 19a)

MUSEUMS

couple off the ground as they dance in the hall in "Two dancers with the School of the Hartford Ballet perform in the Morgan Great Hall at the Wadsworth Atheneum" 1997* Cloe Poisson (Best23 149)

display of polar bears and reindeer in "Spokane" 2001* Virginia Beahan (Photography 166)

elderly woman looking at a painting of nudes in "Exhibition, Pompidou Center" 1977 Martine Franck (Photography 214)

exhibit of Permian period in "Permian-Land" 1992 Hiroshi Sugimoto (Photography 167)

exterior in "Guggenheim Bilbao I & II" c. 1999* Christoph Seeberger (Photo00 20, 21)

floral arranger and unfinished portraits of George and Martha Washington in "Security guard watches as garden club member works on her floral interpretation" 1996* Bill Greene (Best22 246b)

installation of Egyptian sculpture in "Setting up the Colossi of Ramses the Great" 1853 Philip Henry Delamotte (Rosenblum2 #179)

looking up through spiral staircase in "A security guard at the Springfield Armory Museum in Massachusetts walks up the spiral staircase during a routine check of the building" 1987 Ruben W. Perez (Best13 176d)

older woman sitting by a painting in "Woman sitting in a museum in the Soviet Union" c. 1990* Clint Clemens (Graphis90 \174)

rooms with large painting being refurbished in "Rooms of the Palace of Versailles being refurbished" c. 1990* Robert Polidori (Graphis90 \110-\111)

sculpture gallery in "Layton Art Gallery, Milwaukee" c. 1890 Henry Hamilton Bennett (MOMA 65)

statue of *David* in flooded museum in "Flood in Florence museum" 1966* David Lees (Life 130)

MUSHROOMS

arranged like a fan in "High-tech mushrooms" 1988* Thomas B. Szalay (Best14 107)

arrangement of mushroom, cracked walnut, and cheese in "Mushroom on Green Bowl" c. 1999* Holly Stewart (Photo00 56)

arrangement with plates for [self-promotional] c. 1989* Ron Crofoot (Graphis89 \358)

a cluster growing in "Toadstools" c. 1900 Mary T. S. Schaeffer (Sandler 132)

painted to look like stones in "Mushrooms, painted and submerged in water" c. 1991* Jim Quaile (Graphis91 \290)

snail on mushroom in [snail on mushroom] c. 1995* Mark Laita (Graphis96 191d)

various kinds in arrangement for a culinary article c. 1990* John Parker (Graphis90 \342)

MUSICIANS

accordion playing in a pub in "Musicians in a Prague pub pay tribute to a revered Czech antihero" 1993* James Stanfield (Through 112)

accordion playing near piano from [series *At home in Vietnam*] c. 1989* Geoffrey Clifford (Graphis89 \254)

African American jazz band posing for group portrait with their instruments in "The Louisiana Shakers" c. 1920 A. P. Bedou (Willis \46); "Portrait of Professor Henry Pritchard's Tonic Triad Band" 1928 Villard Paddio (Willis \48)

African American man playing guitar in "Bluesman and folk artist David Johnson plays the slide guitar on his front steps in Alabama" 1996 William N. Steber, Jr. (Best22 210c)

African American men in marching band and long lines along parade street in "Commencement Sunday" 1917 C. M. Battey (Willis \39)

African American men with instruments for parade in "Traditional jazz parade" c. 1960s Marion James Porter (Willis \213)

African American orchestra and singer performing in "Ella Fitzgerald performing with Chick Webb and his orchestra at Savoy Ballroom: Louis Jordan on saxophone" c. 1938 Morgan and Marvin Smith (Willis \121)

African American string ensemble in "Summit Avenue Ensemble" c. 1880s Thomas E. Askew (Willis \34)

African American tuba player as part of a band in "Mr. Jerry Green, New Orlean's oldest, upright tuba player still active" c. 1986 Keith Calhoun (Willis \264)

back of man playing the cello in "Pablo Casals" 1954 Yousuf Karsh (Icons 127)

boy playing a flute in "On the Way to Cuzco, Peru" 1954 Werner Bischof (Icons 119)

causal family band in "Playing the blues–often called America's music–is a family affair in Clarksdale, Mississippi" 1999* William Albert Allard (Through 358)

cellist weeping in cemetery in "Cellist plays a requiem in Heroes Cemetery" 1995 Tom Stoddart (Best21 223d); in "A requiem in Sarajevo, Bosnia-Herzegovina" 1992* Paul Lowe (Best18 50)

Chinese girls holding traditional instruments in " 'Sing-song' girls in Taiwan play traditional Chinese instruments for guests at a teahouse" 1920 Taiwan Government (Through 164)

Chinese man with instrument in "Moon Kwan with Yib Kirn" n.d. Margrethe Mather (Women \79)

conductor in front of music stands in "Igor Stravinsky rehearsing, Berlin" 1929 Felix Man (Eyes #97)

Elvis with microphone and guitar in "Elvis Presley" 1956 Charles Trainor (Life 171)

empty music stands and man playing cello in "Yo-Yo Ma" c. 1990* Jürgen Röhrscheid (Graphis90 \160)

harmonica playing by old man in "Sam Hung, master sneakbox builder, bayman, hunter and folk musician, plays the songs of the pines on the harmonica he's had for decades" 1996* Peter Ackerman (Best22 209d)

jazz trio playing near banister in "Private jazz concert in a Berlin villa" 1929 Felix H. Man (Lacayo 76a)

llama on mountain near native man playing the flute in "Flute-Playing Indio with Llama" 1933 Martín Chambi (Icons 61)

man in cowboy outfit near wall with graffiti in "A Country Singer in Tootsie's Bar in Nashville, Tennessee" c. 1990* Michael O'Brien (Graphis90 \158)

man playing for Salvation Army in "Salvation Army Lt. Col. Ray Robinson braves wet weather to bring the Christmas spirit" 1985 Eric Luse (Best11 167b)

man playing guitar jumping in air in "Bruce Springsteen" Lynn Goldsmith 1978 (Rolling #11)

man with trumpet in "Louis Armstrong" 1935 Anton Bruehl (Vanity 163)

men and women playing in Salvation Army band in "At the open-air meeting" 1939 Dorothea Lange (Documenting 170a)

men in uniforms marching with instruments in "Parade, Valencia" 1952 Robert Frank (MOMA 204)

partial view of man playing trumpet in "Trumpet-Playing Pioneer" 1930 Alexander Rodchenko (Icons 64)

playing the harmonica in "Folksingers I–Sonny Terry" c. 1946-1948 Sid Grossman (Decade \50)

playing the piano and trombones in "During this jam session in New York City, Duke Ellington played past four a.m." 1943 Gjon Mili (Life 166c)

riding on a unicycle and playing a sousaphone in "Expressing herself, a sousaphone player makes music at

the annual Burning Man Festival in Nevada's Black Rock Desert" 2001* Melissa Farlow (Through 350)

Springsteen with guitar on stage in "Bruce Springsteen plays the crowd during the second stop of his 'Tunnel of Love' tour in Chapel Hill, N.C." 1988 Lois Bernstein (Best14 46a)

string band playing on wooden benches in "At a Saturday night dance; a string band with its kitty for contributions [Visalia Migratory Labor Camp, California]" 1940 Arthur Rothstein (Documenting 204a)

trumpeter sitting on broken brick wall in [playing a trumpet] c. 1995* James R. Minchin III (Graphis96 122)

tuba player with face covered in "Political Rally, Chicago" c. 1955 Robert Frank (Rosenblum2 #672)

women playing viola, violin and piano in "The Prelude" 1917 Laura Gilpin (Peterson #55)

MUSLIMS *see also* BLACK MUSLIMS

African American woman covered in white, except her eyes in "New York City (a young Moslem woman in Brooklyn)" 1990 Chester Higgins, Jr. (Willis \344)

African American women in white walking on plaza in "Family Day, Members of the Nation of Islam" 1994 Ken Jones (Willis \351)

helping a woman at a funeral in "Muslim women reach to try to revive a woman at the funeral of a man believed to be her husband" 1998 Dayna Smith (Best24 32c)

Lebanese execution in "Gunmen from Amal, Lebanon's Shiite Muslim militia, took Mohieddin Saleh, a Sunni Muslim and killed him with assault rifles" 1986* Haidar (Best12 102)

mother with head and face covering feeding a baby in "Muslim Woman and Child, New Jersey" 1991 Collette Fournier (Willis \367)

Muslim girls wearing head coverings in "Muslim girls visit a mosque near Tehran, Iran" 1996 Tom Stoddart (Best22 172b)

Muslim mother and child in "A Muslim woman is comforted by her child in a refugee center" 1995 David Turnley (Best21 207a)

Muslim woman on street corner in "North Avenue, Image No. 85" 1994* Linda Day Clark (Committed 74; Willis 421)

Muslim women walking in "Day of Atonement at the UN Plaza, Muslim Women" 1996 Salimah Ali (Committed 45; Willis \299)

Nation of Islam women in white in "Savior's Day, women's section, Chicago" 1966 Robert A. Sengstacke (Willis \201)

MY LAI MASSACRE, Vietnam, 1968

crying women and children in "My Lai massacre" 1968* Ronald Haeberle (Goldberg 177)

women and children dead on the road in "My Lai massacre scene" 1968 Ronald Haeberle (Eyes #298; Marien \6.75)

—N—

NAGASAKI (JAPAN)–HISTORY–BOMBARDMENT, 1945

boy from Nagasaki in "A Boy with a Rice Ball" 1952 Yosuke Yamahata (Marien \6.24)

mushroom cloud of atomic bomb in "Atomic Bomb over Nagasaki, Japan" 1945 Photographer Unknown 1945 (Goldberg 113; Life 97)

stopped watch in "Time Stopped at 11:02, 1945, Nagasaki" 1961 Shomei Tomatsu (Marien \6.27)

NATION OF ISLAM

hundreds of women in white in "Savior's Day, women's section, Chicago" 1966 Robert A. Sengstacke (Willis \201)

NATURAL DISASTERS *see types of disasters*: DROUGHTS; EARTHQUAKES; FIRES; HURRICANES; MUDSLIDES; TORNADOES

NAZIS

Berlin's Reichstag on fire in "Reichstag Fire, Berlin" 1933 Photographer Unknown (Photos 47)

collage of Goebbels ordering books burned in "Through Light to Night" 1933 John Heartfield (Marien \5.80)

hawk on man's hand in "Hitler's dove of peace" 1935 (Eyes #106; Rosenblum2 #597)

large crowd in front of picture of Hitler in "Hitler speaks at the opening of the International Auto-Show in Berlin" 1933 Photographer Unknown (Eyes #180)

man in uniform in "SS Officer" 1937 August Sander (Art \300)

marching through *Arc de Triomphe* in "Nazis march on the *Champs Elysées*" 1940 Photographer Unknown (Eyes #191)

suicides of family in office in "Nazi suicides" 1945 Margaret Bourke-White (Eyes #199)

NEW YORK (New York) *see also* FLATIRON BUILDING; STATUE OF LIBERTY

aerial view of city in "New York at Night" 1933-1936 Berenice Abbott (Rosenblum2 #454; Sandler 86)

aerial view of clouds around lower Manhattan in "Aerial View of Lower Manhattan" c. 1934 Photographer

Unknown (Szarkowski 156)

aerial view with *Hindenburg* in "*Hindenburg*, May 6" 1937 Rudy Arnold (Eyes #170)

Atlas holding the world in "World of Today" c. 1940 Harvey A. Falk (Peterson #29)

billboards and statue in "New York City" 1974 Lee Friedlander (Art \333)

bridge crossing over street in "Lower East Side, Waterfront, South Street" 1935 Berenice Abbott (Icons 104)

city at night in "From the 48th floor of Empire State Building, New York" 1946 Todd Webb (Decade 50)

columns framing windows on side of building in "Haughwout Building, New York" 1975 Evelyn Hofer (Rosenblum \226)

crowd gathering on Wall Street at the Federal Hall National Memorial as stock prices fell in "The Crash" 1929 Photographer Unknown (Photos 43)

Daily News Building in "Daily News Building" 1939 Berenice Abbott (Marien \5.64)

Equitable Trust Building in "New York, Equitable Trust Building" 1928 Erich Mendelsohn (Hambourg 85a)

facade of World Trade Center behind 90 West Street in "A picture of the contrasts in New York's financial district–a building at 90 West St. and World Trade Center" c. 1989* Richard Berenholtz (Graphis89 \100)

horse-drawn carriages on street in "Looking Up Broadway from the Corner of Broome Street" 1868 Photographer Unknown (Marien \3.2; Photography1 \65)

horse-drawn carriages on street in "New York Street Scene" 1859 Edward Anthony (Rosenblum2 #189)

looking between skyscrapers in "New York" 1966 Ernst Haas (Icons 100)

looking down to the Singer Building with lights in the street in "Singer Building, New York" 1909-1910 Alvin Langdon Coburn (Art \172)

looking down to the Singer Building in "Singer Building, Noon" c. 1910 Alvin Langdon Coburn (Decade 15d)

looking down a small alley between skyscrapers in "Exchange Place, New York" 1934 Berenice Abbott (Decade 39; Hambourg \3; Lacayo 86d)

narrow street with parked car in "Cedar Street from William Street, New York" 1939 Berenice Abbott (Rosenblum2 #453)

skeleton of skyscraper behind 4-story walk-ups in "Old and New New York" 1910 Alfred Stieglitz (San #3)

skyscraper near another under construction in "Looking Northwest from the Shelton, New York" 1932 Alfred Stieglitz (Hambourg \2)

three nuns with New York City skyline in background in "City, Thy Name is Blessed" 1934 Adolf Fassbender (Peterson #90)

Times Square at night with trucks and lights in "Times Square, in New York City, has long been a gaudy center of neon lights and lively diversions" 1990* Jodi Cobb (Through 312)

top of Chrysler Building, Empire State Building and World Trade Center and Queen Elizabeth II in [ad for Cunard Line voyages to New York] c. 1990* John Claridge (Graphis90 \84)

Trinity Church from above the spires in "Trinity Church" 1912 Alvin Langdon Coburn (Art \173)

view from Hudson River in "Hudson River Waterfront, New York" 1942 Andreas Feininger (Icons 87)

view from Hudson River in "Mighty Manhattan" c. 1951 Otto Litzel (Peterson #89)

NEW YORK WORLD'S FAIR (1939-1940)

obelisk and sphere from [*World of Tomorrow* in *Dynamic Symbol*] 1939 Adolf Fassbender (Peterson #24)

segment of a building from [*World of Tomorrow* in *Semi-Lunar*] 1939 Arthur Hammond (Peterson #23)

NEWSSTANDS AND NEWSPAPERS

African American boy selling paper to a woman in "Harlem Newspaper Boy" 1949 Inge Hardison (Committed 121)

boys lined up on curb carrying newspapers in "Sunday Noon, Some of the Newsboys Returning Sunday Papers" 1909 Lewis Wickes Hine (Icons 19)

elderly man holding newspaper under his arm in "Man with Newspaper" 1990 Vernon Reid (Committed 180)

folded papers for sale near soda cooler in "Newspapers for sale at a grocery, 324 East Sixty-first Street" 1938 Walker Evans (Documenting 138a)

newsstand filled with magazines in front of large building in "Metropolitan Life Insurance Building" 1955-1956 Robert Frank (Art \323)

newsstand on street full of magazines in "Newsstand" 1938 John Vachon (Documenting 96a)

rack of newspapers with headline in "Gun, Gun, Gun, New York" 1955 William Klein (MOMA 219)

Truman holding up newspaper in "One for the books" 1948 Byron Rollins (Eyes #209; Goldberg 124)

NIAGARA FALLS *see* WATERFALLS

NICARAGUA

armed men in jungle in "Near the Nicaraguan-Honduran border, Sandinista counter-insurgence troops cover hills and jungles looking for Contra rebels" 1987 Gerald S. Williams (Best13 76d)

boy walking through ruins of house in "Nicaragua" 1985 John Gaps III (Best11 119b)

burning body of one of Somoza's National Guard in "A funeral pyre in Nicaragua" 1979* Susan Meiselas (Lacayo 176b)

cheering youths on motorcycles in "Motorcycle Brigade, Nicaragua" 1978* Susan Meiselas (Art \431)

family going through rubble of their home in "Returning Home, Masaya" 1978* Susan Meiselas (Art \430)

man with handkerchief over face carrying a gun in "Street Fighter in Managua" 1981* Susan Meiselas (Marien \7.12)

masked youths with homemade bombs in "Youths Practice throwing Contact Bombs in Forest surrounding Monimbo" 1978* Susan Meiselas (Art \429)

partial body on a hillside in "Cuesta del Plomo. Hillside outside Manaagua, well-known site of many assassinations carried out by the National Guard" 1978* Susan Meiselas (Women \138)

silhouette of soldier on street of ruined stores in "Nicaragua" 1978* Susan Meiselas (Rosenblum2 #793)

young men in military uniforms with guns in "Nicaragua" 1985 John Gaps III (Best11 119a)

NORMANDY INVASION, June 6, 1944 (Military Operation) *see* D-DAY, June 1944 (Normandy Invasion)

NORTHERN IRELAND

burned fences and man in ski mask in "N. Ireland: Loyalists vs. Nationalists" 1986 Gilles Peress (Rosenblum2 #716)

masked men throwing Molotov cocktails in "Rioters in Belfast, Northern Ireland" 1981* James Nachtwey (Marien \7.16)

mourners hiding behind headstones in "During the burial of three members of the outlawed Irish Republican Army, in Belfast, Northern Ireland, snipers launch a grenade attack on mourners" 1988* (Best14 51)

photo essay on Catholic protesters and Protestant bonfire in "Northern Ireland: On the Brink of Peace?" 1997 Brian Walski (Best23 203)

NUDES

Children:

boys running into the surf in "Boys on the Shore of Lake Tanganyika" 1931 Martin Munkácsi (Hambourg \59; Icons 47; Rosenblum2 #595)

children in a group in "Children–Nude" 1902 Alice Boughton (Rosenblum2 #361)

girls dancing in garden in "Cavorting by the Pool at Garsington" c. 1916 Lady Ottoline Morrell (Rosenblum \89; Waking 206-207)

naked young girl running and screaming on road, followed by soldiers in "Vietnam–Terror of War" or "South Vietnamese Children Burned by Napalm" 1972 (Marien \6.74; Eyes #297; Lacayo 157d; Monk #44)

Couples / Groups:

bride and groom walking away in "A Nudist Wedding" 1984 Elliott Erwitt (Photography 202)

cardboard boxes filled with nude people in "Overpopulation" 1968 Will Mcbride (Icons 160)

couple in "On the Hillside (A Study in Values)" before 1910 Heinrich Kühn (Marien \4.9; Waking #129)

couple on wood floor in "Untitled" c. 1991* Jan Sudek (Graphis91 \213)

men and women underwater in [part of a series to transport viewer to another world] c. 1991 Christina Hope (Graphis92 \101-\103)

mother and children in "Nude" 1909 Alice Boughton (Marien \4.26)

Men:

African American male in several poses in "Can I Fly?" "Reaching Out;" "Holding the Fate of My Ancestors" 1997 Carlton Wilkinson (Willis \502-\504)

African male in "Djimon" c. 1991 Herb Ritts (Graphis92 \100)

Black nude male dancing with white woman in white dress in "Thomas and Dovanna" 1986 Robert Mapplethorpe (Photography 87)

male dancers in air in "Untitled (Daniel Ezralow and David Parsons)" 1982 Lois Greenfield (Rosenblum 231)

male holding female on his shoulder in advertisement for "Obsession" c. 1991 Bruce Weber (Graphis91 \53)

male in profile in "Untitled (Male Nude)" 1981 Robert Mapplethorpe (Icons 181)

male legs underneath sleeping male nude in "Sleepwalker" 1935 George Platt Lynes (Hambourg \70)

male on leopard skin in *"Académie de l'Album Delacroix réunissant"* 1853-1854 Eugéne Durieu (Marien \2.55)

male torso in "Male Torso" 1930 Man Ray (Hambourg \63)

male torso in "Torso of Nude" 1925 Edward Weston (MOMA 106)

male underwater in "Whiteman Coming" 1981* Laurie Simmons (Women \194)

male with feathers around genitals in "Feather Torso Ceremonial" 1967 Walter Chappell (Photography 76)

man face down and woman laying on ball in [nudes] c. 1992* Toshiaki Takeuchi (Graphis93 119)

man holding naked child in "Paul and Matthias" 1967 Karen Tweedy-Holmes (Rosenblum \260)

man in cowboy boots, hat and holster in "Le Cowboy–Victor" 1978* Pierre et Gilles (Marien \8.1)

man looking at himself in mirror in "Self-Analysis" c. 1940 George Platt Lynes (MOMA 174)

man on back in bed in "Ron Vawter" 1993 Annie Leibovitz (Photography 36)

man with hands behind his head in "Nude Youth with Laurel Wreath Standing Against Rocks" c. 1907 F. Holland Day (Marien \4.18)

man with woman's arms and legs wrapped around him in "James Taylor and Carly Simon" 1979* Annie Leibovitz (Rolling #27)

man wrapped around women in jeans in black shirt in "Yoko Ono and John Lennon" 1981* Annie Leibovitz (Rolling #32)

men holding balls in "Peek at the perfect bodies of U.S. water polo team members" 1996 Joe McNally (Best22 128d; Life 148b)

men in stages of jumping in "Nude men, motion study" 1877 Eadweard Muybridge (Szarkowski 132c)

racial study of man from Malaya in "Front and Profile Views of a Malayan Male" c. 1868-1869 John Lamprey (Marien \3.82)

young men reclining on animal skins in "Nude Sicilian Youths" c. 1885 Wilhelm van Gloeden (Marien \4.27)

Women:

African American woman holding an apple in "Eve" 1994 Renée Cox (Willis \531)

African American woman in fake breasts and backside in "Hott-en-tot" 1996 Renée Cox (Willis \529)

African American woman reclining in "Nude Study" 1995* Ming Smith Murray (Willis \423)

African American woman with children in "*Yo Mama* series: The Sequel" 1995 Renée Cox (Willis \530)

African American woman's seated back in "Nude Form" 1985 Calvin Hicks (Willis \545)

arms crossed under breasts, modeling bracelets in "Sheer swag" c. 1990* Piero Gemelli (Graphis90 \46)

back of African American woman sitting on tub in "Patiently Waiting" 1995 Delphine A. Fawundu (Committed 95)

back of woman in "Nude" c. 1850 Photographer Unknown (Waking #44)

back of woman curled up in "Nude" 1926 Edward Weston (Rosenblum2 #547)

back of woman curled up in "Nude (Self-portrait)" c. 1931 Lee Miller (Women \69)

back of woman holding her hair up in "Dolor" 1903 Edward Steichen (Steiglitz 113)

back of woman holding large water jug in "The Water Nymph" c. 1949 Thomas Limborg (Peterson #70)

back of woman in huddled position in "Nude" 1932 Imogen Cunningham (Icons 130; MOMA 111; Women \38)

back of woman kneeling on shape in "Studie" 1929 František Drtikol (San #28)

back of woman lying on her back in "Nude" 1925 Edward Weston (Waking #179)

back of woman on blanket in grass in "Eleanor, Port Huron" 1954 Harry Callahan (Rosenblum2 #663)

back of woman reclining in "Nude" 1931 Roger Parry (Hambourg \66)

back of woman standing at tall radiator in "Eleanor, Chicago" 1949 Harry Callahan (MOMA 181)

bare-breasted woman sitting in chair in "Study for *Figures Décoratives*" 1903 Alphone Mucha (Rosenblum2 #357)

behind shower curtain in "Shower for Mademoiselle" c. 1937* Paul Outerbridge, Jr. (Icons 79)

Black woman in profile in "Diana Portraits" 1992* Carrie Mae Weems (Marien \7.88)

body suits on women in [untitled] c. 1995* Helmut Newton (Graphis96 32, 34)

breast and partial thigh and arm in "Breast" c. 1927 Imogen Cunningham (Women \39)

chest, arms and knees of seated woman from "Perspective of Nudes" 1953 Bill Brandt (Szarkowski 255)

crouched over in "Despair" c. 1936 Max Thorek (Peterson #72)

crouching with high heels in [nude in high heels] c. 1995* (Graphis96 43)

distorted female body in "Distortion No. 6" 1932 André Kertész (Hambourg \64)

elderly woman in bed in "Eve finds her g-spot" 2000 Donna Ferrato (Photography 218b)

fabric designs on female nudes in [fabric designs superimposed on nudes] c. 1991* Don Penny (Graphis92 \39, \40)

face and arm of woman in "Eleanor" c. 1947 Harry Callahan (MOMA 180)

face-down in sand in "Nude on Sand" 1936 Edward Weston (Szarkowski 236)

four women sitting huddled on floor in "The four most expensive photo models in the world" c. 1990 Herb Ritts (Graphis90 \159)

hairy breasts and arms of woman in "Arielle After a Haircut" 1982 Helmut Newton (Icons 178)

hands holding up knees to chest in "Black-and-white studies" c. 1991 Yuri Dojc (Graphis91 \196)

in tub in "Nude in the Tub" c. 1926 Franz Roh (Hambourg 67a)

kneeling woman in "Rockport Nude" c. 1946 Ruth Bernhard (Decade \48)

kneeling woman wrapped in curled forms in "Woman from Mars" 1955 Lee Wellington (Peterson #26)

lying on her back in "Dawn" c. 1937 Buck Hoy (Peterson #71)

masked woman in dark stockings in "Nude with a Mask" c. 1912 E. J. Bellocq (Waking #153)

model with bronze skin-tone from [article about make-up] c. 1990* Tyen (Graphis90 \38)

nude woman as Christ in "Sacrifice" c. 1992* Rosanne Olson (Graphis93 120d)

nude women in togas in "Bathrooms in Antiquity: Aquatic Delight" c. 1989* Deborah Turbeville (Graphis89 \14)

nude women meeting man in hallway in "Introduction at Suzy's" 1932-1933 Brassaï (Hambourg \34)

on back in sand in "Nude on Sand" 1936 Edward Weston (Szarkowski 237)

on couch under mural of panther in "Radio City Music Hall" 1981 Deborah Turbeville (Marien \6.60)

one black nude figure and one white nude in "Black and White Nude" 1936 Heinz Hajek-Halke (Icons 57)

partial breast and stomach in "Triangles" 1928 Imogen Cunningham (Peterson #61; Rosenblum2 #546; Women \36)

posing as artist's model in "Artist and His Model" 1914 Richard Polack (Rosenblum2 #364)

pregnant woman in "Pregnant Nude" 1959 Imogen Cunningham (Icons 131)

reclining woman in "Nude" 1870s Photographer Unknown (Rosenblum2 #250)

reclining woman in "Reclining nude" 1851-1853 Julien Vallou de Villeneuve (Waking #46)

reclining woman wearing headphones in "Nude" c. 1989* Jan Sudek (Graphis89 \168)

reclining woman with arm raised in "Nude Study" c. 1850 Hermann Krone (Rosenblum2 #249)

recreation of *Last Supper* with nude woman as Christ in "Yo Mama's Last Supper" 1996* Renée Cox (Committed 84d)

reflection of nude woman in a mirror in "Nude" c. 1909 Clarence White (Rosenblum2 #358)

reminiscent of Ingres in "Inges" c. 1995* Rodney Smith (Graphis96 31)

seated woman's back in "Nude" c. 1854 Eugène Durieu (Waking #62)

seated woman in "La Cigale" 1904 Frank Eugene (Decade \1)

seated woman, holding a cocktail in "Pagan" c. 1941 P. H. Oelman (Peterson #68)

seated woman wearing a beaded turban in "The Silver Turban" c. 1930 Dorothy Wilding (Rosenblum \140)

seated woman with arm in several positions in "Nude, London" 1956 Bill Brandt (Photography2 67)

seated women with arms overhead in "Photographic interpretation of the picture *L'heure bleue*" c. 1990* Marcel van der Vlugt (Graphis90 \153)

sitting and petting dog in "Elisabeth Shue" c. 1997 Mark Seliger (Graphis97 114)

sitting with arms across folded legs in "Sonya Noskowiak" 1934 Edward Weston (Decade \25)

standing with leg through piece of material in "Arthur Lee's Model" 1940 George Platt Lynes (Rosenblum2 #548)

standing woman behind spider web in "Spider Lady" c. 1930 Man Ray (Photography 220)

standing woman encircled by swirls in "Curves, A Photographer's Nightmare" 1937 Harry K. Shigeta (Peterson #41)

standing woman in shadows in "Georgia O'Keeffe" 1919 Alfred Stieglitz (Hambourg 23; Waking #172)

torso in "Untitled" c. 1929 Germaine Krull (Women \100); in "Of Neil" 1925 Edward Weston (Art \217)

torso with lines of light in "Rayograph–Lee Miller" 1931 Man Ray (Icons 26)

two seated women in "Two Sisters" 1928 Imogen Cunningham (Rosenblum \155)

veiled woman dancing at the Parthenon in "The Russian Dancer Nikolska at the Parthenon" 1929 Nelly (Rosenblum \139)

violin-like f holes on back of woman in turban in "*Le Violon d'Ingres*" 1924 Man Ray (Art \246; Icons 27; Rosenblum2 #494)

wet veil covering woman's upper body in "Wet Veil, Paris" 1937 Erwin Blumenfeld (Rosenblum2 #552)

woman in "Miss Thompson" 1907 Clarence H. White (Rosenblum2 #407)

woman doing handstand on front lawn in "Katherine Cronin, Lakewood, Ohio" 2001 Donna Ferrato (Photography 218a)

woman holding small camera in [from *Food for the Spirit*] 1971 Adrian Piper (Photography 216)

woman in dark shadow in "Untitled" c. 1927 František Drtikol (San \9)

woman in her living room in "Linda in Her Birthday Suit" 1975 Jack Welpott (Decade 87)

woman in long gloves, mask, and sheer cape in "Black Gloves" c. 1997* Rich Van Dyke (Graphis97 104)

woman in mask and sheer material in "Caprice Vennois" c. 1930 William Mortensen (Peterson #69)

woman in silhouette in "Composition" n.d. Max Thorek (Peterson #14-16)

woman in skirt underwater in "Vertical Water Ballet" 1981* Laurie Simmons (Women \195)

woman lying down, with head thrown back in "Torso" c. 1935 William Mortensen (Peterson #74)

woman on chair in [nude on a chair] c. 1992* Philip Alan Poe (Graphis93 107)

woman on stomach in "Charis" 1936 Edward Weston (Photography 35)

woman only wearing strands of beads in "Janis Joplin" 1972 Bob Seidemann (Rolling #1)

woman posing against wall in "Los Angeles Frieze" 1977* Joan Myers (Decade \VIII)

woman standing with a fan in "Maureen with Fan" 1972 Judy Dater (Marien \7.45)

woman wearing large earrings and bracelets in "Odalisque" c. 1937 Max Thorek (Peterson #73)

woman's torso in "Torso, San Francisco" 1923 Dorothea Lange (Women \43)
woman's torso in "Nude Torso" c. 1929 Ben M. Rabinovitch (Peterson 58)
woman's torso and upper thighs in "Nude–Rebecca" c. 1922 Paul Strand (Decade \14)
women in underpants in "Three Nudes Laughing" c. 1999* Cleo Sullivan (Photo00 43)
women leaning on elbows while lying on wall in "Cameo" c. 1922 Arthur F. Kales (Peterson #17)
women sitting at kitchen table in "Self-portrait, Mother No. 2" 1993 Yurie Nagashima (Marien \7.71)
women walking in high heels in "They're Coming!" 1981 Helmut Newton (Icons 179)
young woman holding breasts in "Lisa Bonet" 1988* Matthew Rolston (Rolling #80)
Unknown:
African American person sitting on chair only wearing pointed shoes in "The Amazon's New Clothes, No. 1" 1999 Mfon (Mmekutmfon) Essien (Committed 92)
back of person with leg up on box in "No. 45006" 1979 Marsha Burns (Rosenblum \258)
two people embracing in "Two Forms" 1963 Ruth Bernhard (Rosenblum \254)

NUNS
back of women on snowshoes in "At the Benedictine Monastery nuns use recreation time to go snowshoeing" 1996 Bill Greene (Best22 247d)
hitting a volleyball in "Sister Veronica Maria hits a volleyball in a game" 1996* Wally Skalij (Best22 225a)
initiation of a nun in "Married to Christ" 1995 Carol Guzy (Best21 212a)
Nun saying prayers at body of Mother Teresa in "Legacy of Love" 1997 Carol Guzy (Best23 201c)
older women laughing in room in "It's recreation hour at Little Sisters of the Poor" 1997 Mary Beth Meehan (Best23 146)
older women standing alongside piano in "*PC Magazine* isn't taken as gospel by all" c. 1991* Neal Slavin (Graphis92 \113)
photo essay of nuns praying and working in their new house in "A new life in the hills of Virginia" 1988 Lois Bernstein (Best14 48-49)
reading bulletin on a wall [from *Italy* series] c. 1999* Charles Harris (Photo00 138)
Sister in wheelchair holding large radio and baseball in "Sister Panacratilla keeps track of play with her blaster as she waits for the elevator" 1988 Peggy Peattie (Best14 207b)

NURSES
African American women holding bouquets and diplomas in "Brewster Hospital Graduation" 1935 Ellie Lee Weems (Willis \100)
injured boy and nurse in helicopter in "Lifelight nurse Marylee Blow aids a boy injured in a bicycle accident" 1988 Don Tormey (Best14 209a)
sitting in lounge in operating room clothing in "Operating-room nurses take a break in their lounge" 1988 Raymond Gehman (Best14 200d)
with hat and mask in an operating room in "Scrub nurse Mattie Davis remains at the doctor's side throughout the operation" 1988 Raymond Gehman (Best14 200a)
with patients in a tent hospital in "At a Kurdish refugee camp in Turkey, a nurse tends to a child as two brothers sit with their mother, whom they had carried to the camp" 1991 Bill Snead (Best17 109)
working with patients in Appalachia in a photo essay in "Home health care on Stinking Creek" 1987 Melissa Farlow (Best13 152-153)

NURSING HOMES
husband at home, wife in nursing home in "Nursing Home Dilemma" 1997 Steve Healey (Best23 207b, d)
photo essay on the daily life of women in a nursing home in "No place to die" 1986 Judy Griesdieck (Best12 150-155)
woman crying in wheelchair in "Loving memories for those in nursing facilities can also be unkind memories" 1997 Eugene Richards (Best27 42a)
women with walkers in nursing home recreation room in "More and more older women are becoming Bat Mitzvah" 1997 Nancy Andrews (Best23 15d)

NUTS
open and closed nuts for [an article on nuts] c. 1990* Achim Schroten (Graphis90 \330)

—O—

OATHS
woman taking oath of office by table covered with microphones in "Aquino takes the oath of office as president of the Republic of the Philippines" 1986 Kim Komenich (Best12 23c)
women taking an oath in "Recently employed women being sworn into the Rubber Workers Union at a Sunday meeting" 1945 Marjory Collins (Fisher 78)

OBESITY
 overweight swimmer as seen underwater in "Swimming is an integral part of the aerobic program at the Duke Diet and Fitness Center" 1995* Pete Souza (Best21 106b)
 woman walking on city street in winter coat in "Lower East Side" 1940 Lisette Model (Women \128)
OCEAN see also SHIPS, STORMS
 amusement park overlooking shoreline in "Seaside Park" c. 1989* Scott Barrow (Graphis89 \97)
 calm water and sun's reflection in "Pacific" 1947 Minor White (Decade \47; MOMA 185)
 couple on beach where child has drowned in "Tragedy by the Sea" 1954 John L. Gaunt, Jr. (Capture 34)
 golf course by the shore in [golf course by the shore] c. 1997* Cameron Davidson (Graphis97 147)
 lifeboats rowing away from sinking ship in "Andrea Doria sinking" 1956 Loomis Dean (Life 128)
 long line of rolling waves in "Evening Wave" c. 1927 Kentaro Nakamura (Peterson #36)
 looking from shore to horizon in "Mediterranean Sea at Sète" 1856-1859 Gustave Le Gray (Marien \2.70; Waking #64)
 looking through boardwalk binoculars in [at the harbor entrance to Cuxhaven] c. 1991 Andreas Paul Ellmerer (Graphis92 \213)
 man standing in surf in "The president-elect relaxes in the surf in Gulfstream, Florida, after the election" 1988 Allen Eyestone (Best14 90d)
 mist over mountains and water from [book entitled California One: The Pacific Coast Highway] c. 1989* Stephen Wilkes (Graphis89 \94)
 ocean liner plunging beneath the sea in "Sinking of Andrea Doria" 1956 Harry A. Trask (Capture 38)
 palm tree stretching from beach to shore in "The palm-fringed sands of Bora Bora lie about 150 miles northwest of Tahiti in the Society Islands" 1996* Jodi Cobb (Through 382)
 stingray in crystal-clear water in "A stingray flaps its fins like wings in the sky-clear waters of North Sound, off Grand Cayman Island" 2000* David Doubilet (Through 392)
 storm taking woman's body away in "Storm on Plum Island" 1990 Marc Halevi (Best16 211-214)
 sunlight across the water in "Path of Light" c. 1943 Hans Kaden (Peterson #30)
 warship in the water, just beyond a Ferris wheel in "War in Lebanon" 1983 Stan Grossfeld (Capture 126)
 waves breaking on rocks in "Turbulence and Rocks" c. 1995* Chip Forelli (Graphis96 156a)
 waves breaking on shore and distant boat in "Boat on Sea" c. 1989* Karen Maloof (Graphis89 \87)
 waves crashing on rocks near lighthouse in "Wind and waves near the Thacher's Island Lighthouse, Cape Anne, Mass." 1962* Leonard McCombe (Life 184)
 waves, the height of the lighthouse, crashing around it, in "Blizzard Rams New England" 1978 Kevin Cole (Capture 108)
 windsurfers sunbathing on the boards with sails in water from [a calendar] c. 1989* David Kramer (Graphis89 \68)
 woman looking out from porch with pay binoculars in "Hampton Beach, New Hampshire" c. 1991* Constantine Manos (Graphis92 \193)
 women standing by the shore in "Vivian" 1980* Joel Meyerowitz (Icons 172)
OCTOPUS
 on black background in "Octopus" c. 1999* Mark Laita (Photo00 226)
 on red background in [octopus] c. 1997* Brad Bartholomew (Graphis97 97)
OIL SPILLS
 bird covered in oil in "A Guillemot seabird, covered with oil from the tanker Sea Empress oil spill" 1996* Paul Glendell (Best22 191d); in "Oil-smeared red-necked grebe" 1989* Rob Stapleton (Photos 160)
 dead bird in "Kingfisher lies dead after it failed to escape the oil spill" 1996* Steven G. Smith (Best22 190a)
 holding an oil-covered duck in "Oil-soaked mallard ready for cleaning at the International Bird Rescue Center in Berkeley after a spill contaminated a nesting area" c. 1988 Scott Henry (Best14 7d)
 many people hosing off rocks in "Exxon Valdez Clean Up" 1989* Natalie Fobes (Goldberg 207)
 thick brown oil in "Texas Oil Spill–Galveston Bay" 1990* J. B. Diedrich (Best16 149d)
 two oil tankers after oil spill in aerial photo in "Exxon Valdez Oil Spill" 1989* Rob Stapleton (Photos 161)
OIL WELLS
 burning oil wells behind camels in "Camels search for food as Kuwait's oil wells burn" 1991* Bruno Barbey (Best17 12b); "Camels search for untainted shrubs and water in the burning oil fields of southern Kuwait after the Persian Gulf war" 1991* Steve McCurry (Best17 173)
 covered in oil, men help fallen comrade in "Exhausted firemen in mud and oil of burning oil wells" c. 1991* Stephane Compoint (Graphis92 \49)
 covered in oil, men installing a wellhead in "Workers in a Kuwait oil field install a new wellhead that will enable them to inject a mudlike mixture into a well to 'kill' the fire" 1991 Sebastiao Salgado (Best17 194)
 covered in oil, men try to cap a well in "Capping a burning well in Kuwait" 1991* Stephane Compoint

(Lacayo 174)

men working on oil wells in "Oil-well firefighters at work in Kuwait" 1991* Christopher Morris (Best17 40)

series of photographs of oil well fires in "Darkness over Kuwait" c. 1992* Arthur Meyerson (Graphis93 55)

worker kneels near a raging oil well fire in "The Gulf War" 1991* Michael Lipchitz (Photos 169)

OKLAHOMA CITY FEDERAL BUILDING BOMBING, 1995

firefighter holding bloodied, dead child in "Oklahoma City Bombing" or "Fireman and child in Oklahoma City"1995* (Capture 181; Lacayo 188a; Marien \7.14)

young boy at candlelight vigil in "Remembering the victims of the bomb" 1995* Steve Liss (Lacayo 188d)

OLD FAITHFUL *see* GEYSERS; YELLOWSTONE NATIONAL PARK

OLYMPICS

Barcelona as background to diver in "The city of Barcelona makes a panoramic background for an Olympic contender in the 10-meter diving" 1992* Rick Rickman (Best18 157)

Barcelona venues without people in [Barcelona, one year before the Olympic games] c. 1992* Miquel Gonzalez (Graphis93 182)

basketball players with hands together in "U.S. men's basketball team, Chamshil Gymnasium, in Seoul" 1988* David Drapkin (Best14 150)

Ben Johnson with head down at starting block in "Concentration before start" c. 1990* Peter Ginter (Graphis90 \238)

bobsled on course in "Four-man bob at Olympic games in Calgary" c. 1991* Alain Ernoult (Graphis91 \359)

bobsled on course in "Four-man bobsled team at Calgary Winter Olympics" 1988 Mike Powell (Best14 144d)

boxer leaping after a surprise win in "Olympic boxer David Reid" 1996* Barry Chin (Best22 113)

boxer leaping into coach's arms in "An underdog U.S. Olympic boxer David Reid leaps into the arms of his coach after a surprise knockout" 1996* Michael Goulding (Best22 268)

celebrating winning a race in "Carl Lewis celebrates as he crosses the 100-meter finish line with the fastest time ever recorded" 1992* Bill Frakes (Best18 139)

diver jumping off board in "Mary Ellen Clark completes her final dive in the 10-meter platform competition" 1996* Anacleto Rapping (Best22 124a)

esplanade in "Glowing pillars and a telephone tower mark the Olympic Esplanade in Barcelona, Spain, host of the 1992 Olympic Games" 1998* (Through 54)

fallen runner in pain in "Mary Decker falls at the 1984 Olympics" 1984* David Burnett (Lacayo 184)

Greco-Roman wrestling match in "Greco-Roman wrestling match" 1996* James D. Baird (Best22 122d)

gymnast being carried by coach in "Kerri takes her now famous ride to the victory stand in the arms of coach Bela Karolyi" 1996* Smiley N. Pool (Best22 127c)

gymnast bending backward in "Ukranian rhythmic gymnast Elena Vitrichenko performs with the clubs" 1996* Rich Riggins (Best22 126d)

gymnast coming off uneven parallel bars in "A Chinese gymnast competes in Seoul" 1988* David Drapkin (Best14 149a)

gymnast doing a split in the air in "Russia's Ianina Batyrchina performs in the individual all-around semi-finals of rhythmic gymnasts" 1996* Anacleto Rapping (Best22 126c)

gymnast on pummel horse in "Romanian gymnast Nicolae Bejenaru competes during the Summer Olympics in Barcelona" 1992* José Azel (Best18 142a)

gymnast with injury landing a vault in "Kerri nails the landing on final vault effort" 1996* Marlene Karas (Best22 127a)

gymnastic team in a huddle in "U.S. women huddle on the awards platform after receiving their gold medals" 1996* Anacleto Rapping (Best22 127d)

hands and ball at the volleyball net in "American and Soviet volleyball players battle at the net during the Summer Olympics" 1988 Rick Rickman (Best14 12d)

hundreds of people doing pushups under Olympic flag in "Calisthenics, Olympic Games, Berlin" 1936 Leni Riefenstahl (Hambourg \82)

hurdles and runner in "U.S. Olympian Jackie Joyner-Kersee stumbles on the final hurdle of the heptathalon as the rain comes down" 1996* Denis Paquin (Best22 119d)

kayak racer in "White water kayaking at the Olympics provided aquatic drama as competitors skillfully maneuvered the tricky course" 1996* Rick Rickman (Best22 122d)

long jumper in sand in "Long jump world record holder Mike Powell lies in the sand after his final attempt at the 1996 Olympics" 1996* Rick Addicks (Best22 118a)

luge doubles on track in "Yves Mankel and Thomas Rudolph of Germany compete in the Luge doubles event during the Winter Olympics" 1992* Mike Powell (Best18 140)

men cheering at the end of a swimming relay in "Jubilation at the finish of the Olympic 4x100 meter medley relay" 1988* Mike Powell (Best14 146)

Olympic runners raising black-gloved hands in "Olympic racial protests" 1968 Photographer Unknown (Eyes #282)

Olympic winner greeted in front of large American flag by teammates in bleachers in "Olympics in Los Angeles" 1984* Hal Stoelzle (Capture 130)

opening ceremonies with athletes parading in "Basketball superstar Magic Johnson is surrounded by other athletes during the opening ceremonies of the Summer Olympics" 1992* Bill Frakes (Best18 164b)

on winner's platform in "U.S. Olympian Carl Lewis cries and looks upward after receiving his last Olympic gold medal" 1996* Robert Deutsch (Best 22 118b)

people exercising in "Olympic trainers" 1936 Willi Ruge (Eyes #105)

photographers near woman with American flag in "Florence Griffith-Joyner takes a victory lap after winning the 100-meter dash at the Summer Olympics in Seoul, South Korea" 1988* Fred Comegys (Best14 2)

pole vaulter holding pole in "Decathlete Robert Zmalik of Czechoslovakia indicates that he is ready to make his vault during the Summer Olympics in Barcelona" 1992* Michael Rondou (Best18 153b)

relay winners in "U.S. Olympians Inger Miller, Chryste Gaines and Gail Devers are pumped up after their 4x100-meter relay gold medal victory" 1996* Barry Chin (Best22 116c)

relay winners hug in "Canada's 4x100-meter relay team hug each other after their gold meal victory over the U.S." 1996* Anacleto Rapping (Best22 118d)

relay winners with arms raised in "Derek Mills and his fellow U.S. team members celebrate their gold medal victory in the 4x400 meter relay" 1996* Anacleto Rapping (Best22 119c)

runner showing his number in "Michael Johnson left nothing to question after winning the 200-meter race in world record time" 1996* Joey Ivansco (Best22 115a)

runners cross the finish line in "Canada's Donovan Bailey celebrates after crossing the finish line to win the gold medal in the 100-meter race" 1996* Denis Paquin (Best22 119a)

series of photos in "CLICK–Photos of the XXVI Olympiad" 1996* John Glenn (Best22 124a)

show jumping and water splashed in [Show jumping, Olympics] c. 1992* Oliver Reck (Graphis 93 199)

sports of the Olympics in "The XXIV Olympiad Summer Games in Seoul boasted a record 13,000 athletes from 161 nations" 1988* Kenneth Jarecke (Best14 52-53)

sprinter winning race in "Jose Marie Perec wins the 200 meters, completing an historic double sprint victory while the rest of the field struggles to place" 1996* Bill Frakes (Best22 120d)

swimmer celebrating win in "Hungry's Attlia Czene celebrates his Olympic record and gold medal in the finals of the 200-meter individual medley race" 1996* Smiley N. Pool (Best22 115d)

swimmer cheering at end of race in "Dassler of the German Democratic Republic cheers his world record time as he wins the 400 meter freestyle gold at the Summer Olympics" 1988 Mark Duncan (Best14 13b)

swimmer resting in the pool in "Pablo Morales rests after capping a comeback from a layoff by winning the gold medal in the 100-meter butterfly" 1992* Daniel A. Anderson (Best18 144)

swimmers jumping into pool in "100-meter freestylers make an artistic impression as they enter the water on the first day of Olympic swimming" 1996* Anacleto Rapping (Best22 124c)

swimmers, women, posing in "Jubilant members of the U.S. 4x100-meter freestyle team pose for the crowd and the cameras after winning their Olympic gold medals" 1996* Anacleto Rapping (Best22 125d)

tae kwon do in "Men's tae kwon do competition: France vs. Korea" 1988* David Drapkin (Best14 149b)

torch bearer circling the track at night in "During opening ceremonies for the Summer Olympics in Barcelona, the torch bearer circles the track" 1992* Daniel Anderson (Best18 156a)

vault in multiple exposures in "A multiple exposure capture this gymnast's vault in the men's individual finals" 1996* Barry Chin (Best22 126b)

vaulter in "Gold medal winner in the vault competition, Simona Amanar of Romania" 1996* Anacleto Rapping (Best22 126a)

volleyball player with ball near the sand in "Holly McPeak digs a shot out of the sand during a beach volleyball match" 1996* Anacleto Rapping (Best22 122b)

weightlifter in "Super heavyweight Zawieja of the Federal Republic of Germany at the Summer Olympics in Seoul" 1988* Mike Powell (Best14 145)

weightlifter celebrates in "Mark Henry reacts to setting his personal best of 468 pounds in the clean-and-jerk lift in the super heavyweights during the Summer Olympics" 1992* Daniel Anderson (Best18 155)

wheelchair race winner crosses the line in "In the middle of a rain storm, France's Claude Issorat crosses the finish line first in the men's 1500-meter wheelchair race" 1996* Paul E. Rodriquez (Best22 120a)

wheelchair racer in the rain in "Scott Hollonbeck races through the rain to a second place in the Olympic Wheelchair 1500" 1996* Shawn Spence (Best22 206d)

winner crosses finish line and falls on track in "Czechoslovakia's Pribilinec crosses the finish line to win the 20-kilometer walk and the gold medal during the Summer Olympics" 1988 Jerry Lodriguss (Best14 134)

winners saluting on pedestal in "Jesse Owens, Olympics, Berlin" 1936 Photographer Unknown (Eyes #176;

Monk #21)

winning at track and field in "Carl Lewis after winning his fourth gold medal at the 1984 Olympics" 1984* John G. Zimmerman (Life 146b)

woman diving in "Fu Mingxia, Chinese diving gold medalist" c. 1992* Neil Leifer (Graphis93 201a)

woman holding flag in "U.S. sprinter Gwen Torrence is jubilant after winning an Olympic gold medal in the 200-meter dash in Barcelona" 1992* Jean-Loup Gautreau (Best18 137)

woman winning race in "Florence Griffith-Joyner wins the gold for the 100 meters at the Summer Olympics in Seoul" 1988 Rich Clarkson (Best14 131d)

women runners from Nigeria, yelling for joy in "Olympics in Barcelona" 1992* Ken Geiger (Capture 167); Bill Frakes (Best18 142d); Daniel Anderson (Best18 156d)

OPERATION DESERT SHIELD, 1990-1991 / OPERATION DESERT STORM, 1991 see PERSIAN GULF WAR, 1991

OPOSSUMS

baby emerging from water bowl in "This baby opossum cools off in a St. Petersburg animal shelter" 1985 Ricardo J. Ferro (Best11 178d)

ORCHARDS

man holding orange in orchard in "For a 77-year-old orange picker in northern California, fruit is free for the taking and exercise is plentiful" 1993* Joel Sartore (Best19 67; Through 378)

masked person pollinating flowers in "Pear blossoms are pollinated by hand in Japan" 1997 Gideon Mendel (Best23 138b)

women on ladders picking apples in orchard in "Basuto women pick apples in the Prairie Province of South Africa" 1931* Melville Chater (Through 238)

women picking fruit from trees and on the ground in "The Orchard" 1902 Clarence White (Art \179; Rosenblum2 #395; Waking #126)

ORDNANCE see AMMUNITION

ORGAN-GRINDERS see also STREET MUSICIANS

girl singing next to man in "The Organ-Grinder and the Singing Girl" 1898-1899 Eugène Atget (Icons 13; Waking #162)

man and woman on street in "An Organ-Grinder Couple, New York" 1896 Alice Austen (Marien \4.45)

ORGAN–MUSICAL INSTRUMENT

in front of church pews in "Church Organ, Alabama" 1936 Walker Evans (Szarkowski 214)

ORIGAMI

paper bird on paper rectangles in "Study, Paperwork" 1927 Hiromu Kira (Peterson #34)

OSWEGO (New York)

burning mill in "Mill fire in Oswego, New York" 1853* George N. Barnard (Eyes #5-6; Lacayo 20; Marien \2.26; Photography1 \2; Rosenblum2 #188)

OUTDOOR LIFE

rowboat, canoe, and camp fire from [ad campaign for Timberland shoes, boots and clothing] c. 1990* Eric Meola (Graphis90 \95-\97)

OUTER SPACE see also ASTRONOMY; COMETS; EARTH; ECLIPSES; MARS (Planet); MOON; VENUS (Planet)

earthrise in black sky seen from the moon in "Earthrise" 1968* William Anders (Goldberg 178; Lacayo 163; Monk #51)

earthrise over the moon in "Apollo 17 astronauts, in orbit around the moon, photographed as crescent Earth rising in the lunar sky" 1973* NASA (Through 460)

galaxies in "M100 Galaxy in Virgo Cluster" 1993* Space Telescope Science Institute (Life 107)

galaxy in "Whirling millions of light-years from Earth, Galaxy NGC 2997 resembles our spiral galaxy–the Milky Way" 1983* Anglo-Australian Observatory (Through 454)

Jupiter's red spot in "Familiar to generations of Jupiter-watchers, the Great Red Spot continues to swirl in the gas giant's atmosphere" 1980* NASA (Through 470)

moon rocks near the lunar rover in "An Apollo 17 astronaut examines enormous lunar boulders resting in a crater at the Taurus-Littrow landing site" 1973* NASA (Through 472)

nebula in "Eagle Nebula" 1995* Jeff Hester (Life 106)

part of a constellation in "A Section of the Constellation Cygnus (August 13)" 1885 Paul and Prosper Henry (Waking #154)

Skylab circling earth in "Skylab, the United States' first manned orbiting laboratory" 1974* NASA (Through 478)

stars around the Orion nebula in "Scattered stars amid the Orion nebula illuminate an evolving cloud of gas and dust" 1995* NASA (Through 464)

stars over ruins of building in "Scorpius Milky Way Rising" 1997 Neil Folberg (Photography 180)

Venus' surface as seen from Magellan spacecraft in "Venus–a brilliant light in Earth's morning and evening skies–presents a craggy face to the orbiting Magellan spacecraft" 1993* David P. Anderson/NASA (Marien \8.6; Through 468)

volcanic eruption seen from space in "Astronauts aboard the space shuttle *Discovery* observed a massive volcanic eruption in Papua, New Guinea" 1996* NASA (Through 462)

OXEN

oxen and men in "Clearing Land with Oxen" c. 1900 Margaret Morley (Sandler 24)

pair of oxen near two children in "Yoked and Muzzled–Marriage" c. 1915 Gertrude Käsebier (Sandler 53)

—P—

PAINT

paint peeling in "Jerome, Arizona" 1949 Aaron Siskind (Goldberg 125; Marien \6.34)

paint peeling in "Peeled Paint" 1959 Minor White (Art \342; MOMA 213)

PAKISTAN

crowd cheering liberators in "East Pakistan: Villagers Welcoming Liberation Forces" 1971 Romano Cagnoni (Rosenblum2 #610)

crowd at a rally in "Supporters carry an image of her later father, former Prime Minister Zulifikar Ali Bhutto" 1988* Anthony Suau (Best14 60b)

PALESTINIAN ARABS *see also* ARAB ISRAELI CONFLICT

blindfolded men and armed guard in "Palestinian prisoners, tied and blindfolded, await their fates in the Gaza Strip" 1990 James Lukoski (Best16 8a)

crying woman and youth with rocks in "Nablus woman cries upon hearing her son has been killed in a fight with Israeli soldiers" 1988 Lucian Perkins (Best14 15a)

holding rocks behind his back in "A young Palestinian fighter clasps the arsenal he uses to fight Israeli soldiers in the West Bank" 1988* Anthony Suau (Best14 60a)

men running through streets and throwing rocks in "Intifada" 1987* Photographer Unknown (Photos 158)

woman and child crying in "Palestinian women grieve a man who was killed by Israeli guards during a 'disturbance' in a prison for political detainees" 1990* James Nachtwey (Best16 42a)

PANAMA

man in bloodied shirt about to be beaten in "Politics in Panama" 1989* Ron Haviv (Lacayo 176a)

partially submerged trees in "Limón Bay, Panama, at high tide" 1871 John Moran (Lacayo 27c)

trees growing from rocks in bay in "The Nipsic in Limón Bay at High Tide" 1871 Timothy H. O'Sullivan (Marien \3.57)

PANAMA CANAL (PANAMA)

view of construction from base of locks' structure in "Panama Canal Construction" c. 1913 Edith Hastings Tracy (Rosenblum \60)

PAPAL VISITS

Castro and the pope in "Fidel Castro greets the pope upon his arrival in Havanna" 1998 Bill Greene (Best24 29d)

large group of people outdoors in "Worshipers bidding good-bye to Pope John Paul II as his helicopter takes off after open-air mass in Quetzaltenango, Guatemala" 1983* (Eyes \31)

thousands watch the Popemobile drive by in "Pope John Paul II is greeted by thousands who line the streets as he arrives in the 'Popemobile' in Cuba" 1998 Bill Greene (Best24 29c)

woman kissing picture of Pope in "A woman gestures as she listens to remarks by Pope John Paul II during one of the masses he presided over in Cuba" 1998 Dudley M. Brooks (Best24 28)

PAPER

cut paper in "Cut paper" c. 1928 Francis Joseph Bruguière (Szarkowski 179)

PAPERBOYS

African American boys posing outside of newspaper office in "Group portrait of *Call* and *Post* newsboys" c. 1930s Allen E. Cole (Willis \104)

boys lined up on curb carrying newspapers in "Sunday Noon, Some of the Newsboys Returning Sunday Papers" 1909 Lewis W. Hine (Icons 19)

boys smoking in "Newsies at Skeeter's Branch, St. Louis" 1910 Lewis Wickes Hine (Hambourg 56a)

PARADES

African American men in parade car in "Marcus Moziah Garvey in a Universal Negro Improvement Association parade" 1924 James VanDerZee (Willis \66)

African American men in marching band and long lines along parade street in "Commencement Sunday"

1917 C. M. Battey (Willis \39)

African American men with instruments for parade in "Traditional jazz parade" c. 1960s Marion James Porter (Willis \213)

African Americans parading in the street in "Emancipation Day parade (celebrating the end of slavery)" c. 1922-1927 Richard Aloysius Twine (Willis \98)

band leader flipping upside down while marching in "Parade Thrills" c. 1979 Milton Williams (Willis \217)

children in costumes with decorated bicycles in "Waiting for the parade to begin" 1941 Russell Lee (Documenting 212c)

Fourth of July float in small town in "Parade float" 1941 Russell Lee (Documenting 212b)

huge masks on men in parade in "Grotesque masks bob along in a burst of pre-Lenten revelry in Nice, France" 1926 Maynard Owen Williams (Through 110)

men in uniforms marching with instruments in "Parade, Valencia" 1952 Robert Frank (MOMA 204)

one flag in crowd watching parade in "Armistice Day parade. Lancaster" 1942 Marjory Collins (Fisher 67)

parade of Russian troops in "Parading before Winter Palace in Petrograd" 1917 Stanley Washburn (Eyes #74)

parade of troops on horseback in "General Wool leading his troops down the street in Saltillo, Mexico" c. 1847 Photographer Unknown (Eyes #8; Marien \2.30)

parade of Salvation Army members with flags and accordion in "Marching through downtown San Francisco" 1939 Dorothea Lange (Documenting 167c)

playing keyboards while wearing clear raincoats in "Each spring Taiwanese followers of Saint Matsu make a pilgrimage to honor her" 1997 Chien-Chi Chang (Best23 234a)

troops march through city in "French troops returning from Italy" c.1859 Photographer Unknown (Eyes #1)

Union soldiers marching in victory up Pennsylvania Avenue in "Grand Army Review, Washington, D.C." 1865 Alexander Gardner (Waking 321)

women in flag capes in "A woman's-suffrage parade in New York City" 1915 Photographer Unknown (Lacayo 43c)

youngster saluting with crowd on sidewalk in "Armed Forces Day Parade on Grant Street, Pittsburgh, Pennsylvania" 1951 Richard Saunders (Willis \146)

PARAMILITARY FORCES

Angolan soldier with anti-tank weapons, standing in truck in "War-Torn Angola" 1984* Larry C. Price (Capture 133)

armed men in "Liberia in Turmoil" 1996* David Guttenfelder (Best22 234a, b)

armed men dragging a man on the street in "Fighters of the National Patriotic Front of Liberia drag a wounded man off a street in Monrovia during factional fighting" 1996* David Guttenfelder (Best22 150b)

black men forced into push-up stance by white man with gun in "Anti-Guerrilla Operations in Rhodesia" 1977 J. Ross Baughman (Capture 104; Eyes #364)

boy in bed with fatal wounds in "An Afghan youth, injured by a land mine while traveling with mujahideen warriors, lies dying from his wounds" 1990* James Nachtwey (Best16 39a)

boy in hospital bed holding the stump of his leg in "A Burmese boy, shot while carrying supplies to Karen rebels, loses his leg" 1990* James Nachtwey (Best16 40a)

boys practicing with rifles in "Karen boys train to become rebel fighters in Burma" 1990* James Nachtwey (Best16 38)

burned corpse and fighter in "Liberia" 1996* Patrick Robert (Best22 234d)

Filipino man with machine gun in jungle in "Philippine Army Rangers comb the jungle of Davao del Norte in search of New People's Army communist guerillas" 1985 John Kaplan (Best11 76a)

firing squad crouching, as blindfolded men are shot in "Justice and Cleansing in Iran" 1979 Photographer Unknown (Capture 110)

hacking a man to death in "Four days before the elections, a commando group formed to protect Haitians against pre-election violence hacked a man to death in the streets" 1987* Carol Halebian (Best13 19d)

in the jungle in "A rebel with the Karen National Liberation Army executes a man suspected of collaborating with the government in Burma" 1990* Bruce Haley (Best16 199)

Lebanese execution in "Gunmen from Amal, Lebanon's Shiite Muslim militia, took Mohieddin Saleh, a Sunni Muslim and killed him with assault rifles" 1986* Haidar (Best12 102)

man standing on beheaded body in street in "A fighter of the National Patriotic Front of Liberia steps on the beheaded body of a rival Krahn fighter in downtown Monrovia" 1996* Jean-March Bouju (Best22 148c)

man with handkerchief over face carrying a gun in "Street Fighter in Managua" 1981* Susan Meiselas (Marien \7.12)

playing a guitar in " 'Cobra' rebels sit on a sofa set up near a roadblock in Republic of Congo" 1997* David Guttenfelder (Best23 133)

Sandinistas with captured American in "A downed American flyer is led out of the Nicaraguan jungle to a

waiting helicopter after Sandinista soldiers captured him" 1986 Louis Dematteis (Best12 76a)

seated men guarded by men with guns in "Afghan government soldiers captured by freedom fighters ponder their uncertain fate" 1986 Jack Chiang (Best12 76d)

series on armed forces, prisoners, and death in the burning of the Parliament in "Capturing the Parliament building by Abkhazian forces in Sukhumi" 1993 Anthony Suau (Best19 30-32)

sniper in building in "A Georgian loyalist exults after shooting a rebel sniper in the Abkhazia region" 1993* Malcolm Linton (Best19 65)

street executions in "Liberia: From a Dead Man's Wallet" 1996* Corinne Dufka (Best22 227)

young boy with machine gun in "A 13-year-old member of the rebel Karen National Liberation Army, and ethnic minority group that is fighting the Burmese government" 1990* James Nachtwey (Best16 37)

young man with saw over his shoulder in "Member of KNLA" 1999* Chan Chao (Marien \7.0)

youth with machine gun and dagger in "A Liberian street fighter during the civil war" 1996* Patrick Robert (Best22 212a)

PARIS (France)

aerial photograph in "Aerial View of Paris" 1858 Nadar (Monk #5; Lacayo 19)

aerial photograph in "The *Arc de Triomphe* and the Grand Boulevards, Paris, from a Balloon" 1868 Nadar (Rosenblum2 #287)

Americans marching through *Arc de Triomphe* in "Yanks parade through Paris" 1944 Peter J. Carroll (Eyes #193)

bridges and view of city in "The *Pont-Neuf*, Paris" 1865 Charles Soulier (Art \80)

carrying a package on a street near a trestle in "Meudon" 1928 André Kertész (Marien \5.30)

group posing for portrait at base of destroyed tower in "Vendôme Column after its Destruction" 1871 Bruno Braquehais (Marien \3.25)

large building near river and bridge in "The *Pavillon de Flore* and the Tuileries Gardens" 1849 Marie Charles Isidore Choiselat (Waking #2)

narrow street in "14. *Rue des Marmousets*" n.d. Charles Marville (Marien \3.88)

Nazis marching through *Arc de Triomphe* in "Nazis march on the *Champs Elysées*" 1940 Photographer Unknown (Eyes #191)

neon signs for the *Moulin Rouge* in [neon signs in Paris] c. 1995* Jonathan Exley (Graphis96 160)

panoramic view in "Panorama of Paris" c. 1846 Frederick van Martens (Marien \2.42)

rooftops of Paris in late afternoon in [Paris] c. 1995* Francisco Hidalgo (Graphis96 167)

street corners in "View of the Boulevards at Paris" 1843 William Henry Fox Talbot (Waking 268a)

street scene in "Remains of the Barricades of the Revolution of 1848, rue Royale, Paris" 1849 Hippolyte Bayard (Rosenblum2 #198)

street scene of Paris in "*Boulevard du Temple*, Paris" 1839 Louis Jacques Mandé Daguerre (Lacayo 8; Marien \1.13; Monk #3; Rosenblum2 #7)

street scene with cars and horse-drawn carriages in "Porte St. Denis, Paris" c. 1860 Hippolyte Jouvin (Rosenblum2 #190)

PARKING LOTS

vertical parking garage in "Elevator Garage, Chicago" 1936 John Gutmann (Decade \29; Hambourg 17)

PARKING METERS

line of cars at parking meters in "Cars and parking meters" 1938 John Vachon (Documenting 95c)

PARKS

boy making menacing face in "Child with Toy Hand Grenade in Central Park, New York City" 1962 Diane Arbus (MOMA 243; Photos 101)

park with radiating streets as seen from above in "The Octopus, New York" 1912 Alvin Langdon Coburn (Decade 15c; Hambourg \1; Rosenblum2 #398)

seen from apartment window in "Untitled" c. 1928 Marjorie Content (Women \63)

small children walking in park in "Three Children in the Park" 1971 Robert Doisneau (Rosenblum2 #625)

smiling woman in bathing suit near old man in chair, at trees in sand in "Moscow Beach" 1959 William Klein (MOMA 224; Szarkowski 256)

snow-covered tree and park benches in foreground of Flatiron Building in "Flatiron Building" 1903 Alfred Stieglitz (Hambourg 6a; MOMA 83; Szarkowski 164)

PARTHENON (Athens, Greece)

base of Parthenon columns in "Western Portico of the Parthenon" 1870 William J. Stillman (Art \136)

Parthenon from the roof in "Western Portico of the Parthenon, from above" 1870 William J. Stillman (Art \135)

partial view of Greek pillars in "Pillars of the Parthenon" 1921 Edward Steichen (MOMA 104)

woman in tunic and scarves posing between pillars in "Isadora Duncan" 1923 Edward Steichen (Vanity 59)

PATRIOTISM

African American girl and woman wearing patriotic dresses in "Nellie and Tammie Morgan, in their Bicentennial outfits made by Mrs. Morgan, Mississippi" 1976 Roland L. Freeman (Committed 102; Willis \240)

group of immigrant children, with hands over heart, reciting the pledge in "Pledge of Allegiance, San Francisco" 1942 Dorothea Lange (Rosenblum \204)

men with hats over hearts in "The pledge of allegiance at the ball field" 1941 Russell Lee (Documenting 221b)

shirtless veteran waving flag in "A sudden downpour fails to dampen the patriotic spirit of flag-waving at a May welcome-home rally in Houston for Vietnam War veterans" 1987 Steve Campbell (Best13 112c)

PEARL HARBOR (Hawaii), Attack on, 1941

battleship sinking and in flames in "The battleship *Arizona*" 1941 Photographer Unknown (Lacayo 103); "Sinking of the USS *Arizona*" 1941 U.S. Navy (Photos 54)

bombed ship on fire and sinking in "Pearl Harbor" 1941 U.S. Navy (Eyes #221; Monk #25)

man in pajamas, watching bombing of harbor from his patio in "Pearl Harbor inhabitant watches bombing by Japanese planes" 1941 Kelso Daly (Goldberg 108; Lacayo 102)

PEDDLERS AND PEDDLING

Anatolian woman holding chickens in "Like her ancestors five centuries ago, a northern Anatolian woman delivers chickens to the Safronbolu morning market in Turkey" 1987* James Stanfield (Best13 163a)

cow dung seller in "1 of 1565 Aahirs; Sells Cow Dung" c. 1891 Photographer Unknown (Rosenblum2 #417)

flower seller under umbrella in "*Place St. André des Arts*, Paris" 1949 Izis (Rosenblum2 #626)

fruit stands with prices in "Fruit vendor's wagon in front of the rectory, 323 East Sixty-first Street" 1938 Walker Evans (Documenting 144a)

man pushing pool table on dirt road in "Asking 20 cents a game, a Uygur entrepreneur pushes his portable pool table in Xinjiang Province, China" 1996* Reza (Through 172)

man with bucket of fish on head in studio in "A Fishmonger, St. Petersburg" 1859-1878 William Carrick (Marien \3.86)

market in the street in "Market Scene at the *Port de L'Hôtel de Ville*, Paris" 1851 Charles Nègre (Rosenblum2 #286)

men selling apples from table in park in "Patronize the Disabled Soldier" c. 1866 Photographer Unknown (Marien \3.68)

open-air marketplace filled with people in "Marketplace in Karlsruhe" 1886 Oskar Suck (Szarkowski 128)

orange juice seller on the sidewalk in "Oranges, Manhattan" 1978* Eve Sonneman (Rosenblum2 #734)

people with baskets of fruit and vegetables in a garden in "The Fruit Sellers" c. 1845 William Henry Fox Talbot (Waking #15)

piglets on table in front of woman in "A woman markets her piglets in Tbilisi, Georgia, in the Soviet Union" 1988 Joe Traver (Best14 117d)

portrait of woman with vegetable basket in "Mother Albers, the Family Vegetable Woman" 1840s Carl Ferdinand Stelzner (Rosenblum2 #36)

river filled with small wooden boats in "On a branch of the Saigon River, traders sell rice from the Mekong Delta" 1989* (Through 176)

sleeping man leaning on basket in "Barrio Chino, Barcelona" 1933 Henri Cartier-Bresson (Hambourg \33)

staged scene of selling pears from baskets in "Selling Pears (Shanghai)" 1870s L. F. Fisler (Marien 11\3.35)

vegetable seller with vegetables in "Announcement of a lecture" c. 1989* Jay Maisel (Graphis89 11\171)

woman selling apples in baskets in "Mennonite apple seller at the farmers' market" 1942 Marjory Collins (Documenting 262a)

woman selling fruit from baskets in "Fruit Vendors" 1870s Cruces and Co. (Rosenblum2 #409)

women vendors selling eggs on street in "Hester Street Egg Stand Group" 1895 Alice Austen (Rosenblum \104; Rosenblum2 #317; Sandler 27)

PENGUINS

adult among many chicks in "Adult Emperor Penguin searching for a chick" 1996* Frans Lanting (Best22 188a)

adult with large chicks in "Adult Emperor Penguin with chicks on the sea ice of the Antarctic" c. 1991* Bruno J. Zehnder (Graphis91 \351)

adults and chick in "Parents bowing over their chick in an Emperor Penguin greeting ritual" 1996* Frans Lanting (Best22 184a)

colony of penguins in "A huge colony of Emperor Penguins convenes at Cape Crozier in Antarctica" 2001* Maria Stenzel (Through 26)

colony on rocky land in "Bull kelp clings to the Snares Islands coastline, hiding sea lions that prey on Snares

crested penguins" 2002* Frans Lanting (Through 406)

helicopter behind penguin in "U. S. Coast Guard helicopter lands on the sea ice in the Antarctic while an Emperor Penguin escapes the intrusion" c. 1991* Bruno J. Zehnder (Graphis91 \353)

in a blizzard in "An Emperor Penguin colony during a spring blizzard" 1996* Frans Lanting (Best22 187b)

in front of large ship in "Exploitation of the South Pole" c. 1991* Bruno J. Zehnder (Graphis91 \352)

line of penguins under tree limb in "Like an amiable group of theatergoers, crested penguins queue up in the Snares Islands of New Zealand" 2002* Frans Lanting (Through 414)

on an iceberg in "Chinstrap penguins hitch a ride on an intricately sculpted blue iceberg in the sub-Antarctic" 1995* Cherry Alexander (Best21 159a)

on grass in [penguins on grass] c. 1999* Max Schmid (Photo00 228)

parent penguin trying to feed chick in "In October in Antarctica, a parent Emperor penguin tries to regurgitate food to its starving chick whose bill is frozen shut" 1995* Bruno P. Zehnder (Best21 159c)

three on ice in "Penguins Three" c. 1939 Eleanor Parke Custis (Peterson #19)

PENNSYLVANIA DUTCH see AMISH / PENNSYLVANIA DUTCH

PEOPLE WITH DISABILITIES see also BLIND; DEAFNESS

abandoned, ill, and disabled children in Romanian institutions in "Ceausescu's Legacy" 1990 James Nachtwey (Best16 151-156)

athletes in wheelchair with tennis racket, and with prosthetics in long jump in "Paralympic athletes in competition" 1996* Mark Zaleski (Best22 123)

boy sitting on floor by amputees with crutches in "Afghan boy, waits in the amputee ward of a Pakistan hospital where mujahideen are fitted for artificial limbs" 1990* James Nachtwey (Best16 40d)

crying child wearing a body and leg brace in "Tyana, 3, was born with spina bifida" 1990 Sean Dougherty (Best16 74b)

legless man on street being ignored by others in "American Legion Convention, Dallas, Texas" 1964 Garry Winogrand (Marien \6.46)

man with artificial leg running in front of a police car in "Terry Fox" 1980 Gail Harvey (Monk #46)

man writing with pencil in mouth in "An armless man in a Romanian institution has learned to write" 1990 James Nachtwey (Best16 48a)

men selling apples from table in park in "Patronize the Disabled Soldier" c. 1866 Photographer Unknown (Marien \3.68)

pushing Little Leaguer in wheelchair in "Keith Darling, 10, heads for third base, powered by his brother, Greg, 12, during a Challenger Division Little League baseball game" 1990 Eric Hegedus (Best16 119)

rock climber's wheelchair dangling from his belt in "Paraplegic rock climber Nick Morozoff dangles precariously" 1995 Tim Clayton (Best21 124)

soldier with one leg embracing a woman in "Home from Vietnam" 1966 Ray Mews (Eyes #312)

student in wheelchair with his date on his lap at homecoming dance in "Permanently paralyzed from a motocross race accident, former star athlete dances with his girlfriend" 1997* Bryan Patrick (Best23 174b)

veteran, in wheelchair, wearing rain poncho, holding small child in "Moment of Reflection" 1976 Robin Hood (Capture 101)

wheelchair racers at top of hill in "Wheelchair racers crest the Queensway Bridge during a half-marathon in Long Beach" 1990 Peggy Peattie (Best16 190d)

PERSIAN GULF WAR, 1991

boy hugging his army father's leg in "Josh McCrary, 4, holds his father, John, by the leg as the elder McCrary prepares to leave for the Persian Gulf as part of Operation Desert Shield" 1990* Jeff Tuttle (Best16 101)

burned soldier in vehicle in "The charred body of an Iraqi soldier still clings to the side of an armored personnel carrier" 1991* Kenneth Jarecke (Best17 9)

burning oil wells in "In July 1991, oil wells in Burgen field still burn" 1991* Christopher Morris (Best17 39)

burning oil wells behind camels in "Camels search for food as Kuwait's oil wells burn" 1991* Bruno Barbey (Best17 12b); "Camels search for untainted shrubs and water in the burning oil fields of southern Kuwait after the Persian Gulf War" 1991* Steve McCurry (Best17 173)

child waving to men boarding plane in "Monique Abeyta, 10, waves goodbye to her father part of Operation Desert Shield" 1990* Genaro Molina (Best16 53b)

covered in oil, men try to cap a well in "Capping a burning oil well in Kuwait" 1991* Stephane Compoint (Lacayo 174)

dead Iraqi's hand covered in oil in "The oil-covered hand of a dead Iraqi soldier is grim testimony to the Persian Gulf War" 1991* Steve McCurry (Best17 15)

diners reading newspapers declaring war in "America gets the news: War in the Gulf" 1991* Steve Liss (Lacayo 175c)

firefighters spraying foam in "Firefighters from Kuwait Oil Co. spray foam to smother a 2-week-old blaze

at a sabotaged farm" 1991* Steve McCurry (Best17 17b)

fires burning the oil on the ground in "Environmentalist examines a field where the ground has become encrusted with oil" 1991* Steve McCurry (Best17 20)

Kuwaiti kissing an American flag in "A Kuwaiti citizens kisses an American flag after the liberation of Kuwait" 1991* Christopher Morris (Best17 37)

Kuwaitis celebrating with flags and guns in "A Kuwaiti soldier embraces his father on the morning of the liberation of his country" 1991* Wesley Bocxe (Best17 14)

line of soldiers climbing into plane in "California Army National Guard troops board a 747 destined for the Persian Gulf" 1990* Genaro Molina (Best16 53a)

Marines capturing Iraqi forces in the desert in "Iraqi soldiers surrender to the U.S. Marines 1st Division as it advances toward Kuwait City" 1991* Christopher Morris (Best17 35)

photo of Marine killed by friendly fire hangs on railing in "A photo of Marine Lance Cpl. Thomas A. Jenkins hangs outside his family home" 1991* Lois Bernstein (Best17 12a)

tank in ruins in "An oil-covered corpse and a Soviet-built tank waste away in a Kuwait oil field" 1991* Steve McCurry (Best17 19)

trucks, buses, and cars destroyed in "The highway out of Kuwait City became the last battleground for many retreating Iraqi troops" 1991* Steve McCurry (Best17 16)

U.S. soldiers searching Iraqi soldiers on ground in "U.S. Army Special Forces troops detain Iraqi soldiers during the liberation of Kuwait City" 1991* Wesley Bocxe (Best17 13)

U.S. tanks in the desert of Kuwait in "U.S. Marine tank pushes through Kuwait, as oil wells burn in the distance" 1991* Christopher Morris (Best17 36a)

worker kneels near a raging oil well fire in "The Gulf War" 1991* Michael Lipchitz (Photos 169)

wounded soldiers in plane in "Grieving soldier in Gulf war" 1991* David Turnley (Best 17 10; Lacayo 175b)

PHILADELPHIA (Pennsylvania)

street scene of mob during the Native American riots of Philadelphia in "North-East Corner of Third Dock streets, Girard Bank, at the time the latter was occupied by the Military during the riots" 1844 William and Frederick Langenheim (Eyes #4; Rosenblum2 #16)

views of buildings and streets in "Three Views of Philadelphia" 1871 James Cremer (Photography1 #V-5)

the Waterworks building in "The Waterworks, Fairmount, Philadelphia" 1855 James McClees (National \10)

PHILIPPINES

armed men in jungle in "In the Philippines, guerrilla members of the New People's Army move through the jungle in a strike against government troops" 1985* Wayne Source (Best11 46d)

crowd totally surrounding a car in "Filipinos stop a car to retrieve ballots that Marcos supporters were trying to steal from one polling area" 1986 Karen T. Borchers (Best12 21c)

dead bodies stacked on the floor in "Bodies of suspected communist sympathizers are stacked in a makeshift mortuary in the city of Davao" 1985 John Kaplan (Best11 76b)

Filipino rice farmers in the field in "Filipino peasants revitalize their land by burning the husks of the rice that they harvest" 1985 John Kaplan (Best11 74)

flag-waving men at Marcos' desk in "Supporters of Aquino pose and posture at the desk of Ferdinand Marcos just hours after he was rescued from the Palace grounds" 1986 Harley Soltes (Best12 20b)

group of students carrying wounded student in "Student protestors rush a wounded comrade along a Manila street to a hospital" 1985 John Kaplan (Best11 75d)

jailed men standing at bars in "When Marcos fled the country, he left behind prisons jammed with those he suspected of opposing his regime, or of being communists" 1986 Harley Soltes (Best12 21a)

man being kicked in "A Marcos loyalist is kicked down a street by Aquino supporters after Marcos fled" 1986 Kim Komenich (Best12 20a)

man with machine gun in jungle in "Philippine Army Rangers comb the jungle of Davao del Norte in search of New People's Army communist guerillas" 1985 John Kaplan (Best11 76a)

men squatting near phonograph in "Kalinga Province Chiefs" 1912 Charles Martin (Goldberg 46)

shacks of people who live on garbage dump in " 'Smoky Mountain,' a garbage dump in Manila where poor people live in a squatter village and pick through trash looking for scraps of plastic" 1985 Karen T. Borchers (Best11 75d)

smiling women in "Filipino youths and women show their support for Aquino's candidacy" 1986 Al Podgorski (Best12 19)

woman taking oath of office by table covered with microphones in "Aquino takes the oath of office as president of the Republic of the Philippines" 1986 Kim Komenich (Best12 23c)

young man with rifle in "A young Philippine farmer learns how to defend his home and protect his freedom from Communist guerrillas during a formal government training program" 1987 Jim Preston (Best13 112b)

PHOTOGRAPHY–EQUIPMENT AND SUPPLIES

children and men in photography studio in "Bellikoff Studio in Pavlograd, Ukraine" c. 1900 Photographer Unknown (Rosenblum \46)

daguerreotype camera and photographer in "Daguerreotype Camera" c. 1866-1867 Photographer Unknown (Szarkowski 39)

exterior of camera in "Akeley Camera" 1922 Paul Strand (Decade \18)

horses and wagons which carried equipment in desert in "Sand Dunes, Carson Desert" 1867 Timothy O'Sullivan (Art \143; Lacayo 28b)

interior of motion picture camera in "Akeley Motion Picture Camera" 1923 Paul Strand (Hambourg \13; MOMA 112; Szarkowski 185)

lamp near cactus in pot in "Cactus and Photographer's Lamp" 1931 Charles Sheeler (MOMA 113)

looking through a stereo camera in "Photographer Guido Rosenmann peering through an old stereo camera" c. 1991* Steve Hathaway (Graphis91 \246)

man in uniform having picture taken in [Soldier in Photo Booth] n.d. Esther Bubley (Fisher 58)

photographer's wagon in "Self-Portrait with Staff" c. 1864 Samuel A. Cooley (Photography1 #IV-24)

Polaroid Land camera in "Model 95 Land Camera" 1948 Photographer Unknown (Goldberg 122)

small portraits of sitters in "Penny Picture Display, Savannah, Georgia" 1936 Walker Evans (Hambourg \89; MOMA 144)

woman holding Kodak camera in "Kodak Girl Poster" 1913 Photographer Unknown (Rosenblum \50)

PHOTOGRAPHY–HISTORY

aerial view of town in "The eyes of the army–view of German town from British aeroplane" c. 1914-1918 Underwood & Underwood (Eyes #41)

log cabins for photographers in "Quarters of Photographers Attached to Engineer Corps, Army of the Potomac" c. 1862-1864 Photographer Unknown (Photography1 #IV-16)

man standing in small plane with motion picture camera in "American war photographer, Merl La Voy ready for a motion-picture flight over the Serbian front" c. 1914-1918 Underwood & Underwood (Eyes #40)

photographers and cameras where copies of photographs were made in "Panorama showing Talbot's Reading Establishment" c. 1845 Photographer Unknown (Marien \2.9)

pulling apart a Polaroid photograph in "Edwin Land holding a positive print just made with the new Polaroid process" 1947 Photographer Unknown (Goldberg 121)

stages of man jumping in "Marey Wheel Photographs of Unidentified Model" 1884 Thomas Eakins (Photography1 \85)

stages of woman dancing in "Woman Pirouetting" 1887 Eadweard Muybridge (Photography1 \86)

studios in three-story building in "Photographers' Studios, Hong Kong" c. 1870 William Pryor Floyd (Marien \3.33)

woman holding camera in "The Spirit of Photography" c. 1903 Anne W. Brigman (Sandler 2)

women at tintype tent in "Selling Tintypes at County Fair" 1903 Frances Benjamin Johnston (Sandler Frontispiece)

PHOTOMICROGRAPHY

cross-section in "The Stanford Visible Male" 1990s* Stanford University (Marien \8.10)

fruit fly magnified in [fruit fly] c. 1995* Oliver Meckes (Graphis96 185)

photomicrograph in "Photomicrographic Daguerreotype" 1856 John Draper (Photography1 \29)

part of the cerebellum in "Four-Diameter Cross-Section of Segments of Cerebellum" c. 1873 Jules Luys (Marien \3.71)

plant's cell structure in "Section of Climatis" 1840* Andreas Ritter von Ettingshausen (Marien \2.11)

salmon eggs in "A shoot on salmon eggs–part of a Pacific salmon photo project–took an unexpected turn when the eggs hatched into alevins (larvae)" 1987* Natalie Fobes (Best13 95c)

slide of cells in "Blood cells of a frog" 1843 Léon Foucault (Goldberg 39)

symmetrical design of a diatom in "Diatom" 1931 Laure Albin Guillot (Marien 5.74)

various studies in "Microscopic Studies" 1845 Leon Foucault (Marien \2.12)

PHYSICIANS

African American physician teaching students at patient's bedside in "Dr. Charles Drew, a surgeon, teaching at Freedmen's (now Howard) University Hospital" c. 1936 Scurlock Studios (Willis \112)

arms of a doctor operating on a young boy in "A doctor from Doctors Without Borders works to save the arm of a child in Mogadishu, Somalia" 1991* Frank Fournier (Best17 178)

examining an infant's ears in "Dr. Leila Denmark, born in 1898, examines R. de Avila" 1990 Jerry Valente (Best16 180d)

in masks and gowns in "Emergency room" 1981 Eugene Richards (Eyes #334)

looking down at men in suits performing an operation in "Operation under Ether" c. 1852 Southworth &

Hawes (Art \27; Marien \2.24)

masked doctor in operating room in "Polish heart surgeon monitoring a transplant patient" 1987* James Stanfield (Best13 29a; Graphis90 \270)

masked doctors putting body cast on man in "A new plaster cast is fitted to the body of George Lott, who was wounded by mortar shell" 1944 Ralph Morse (Eyes #188)

photo essay of doctor's day in "Karen's boot camp" 1985 Steve Ringman (Best 180-183)

photo essay of doctor's work in "Country Doctor–photo essay" 1948 W. Eugene Smith (Decade 66; Eyes #245-250; MOMA 196; Szarkowski 226-227)

photo essay on medical students in gross anatomy class in "Body of Knowledge" 1997 Noah K. Murray (Best23 160-161)

watching patient on bed in "Frank Eller undergoes an experimental treatment for cancer devised by Dr. Haim Bicher" 1990* Peggy Peattie (Best16 186b)

PIANO

accordion playing near a piano from ["At Home in Vietnam"] c. 1989* Geoffrey Clifford (Graphis89 \254)

autistic girl playing the piano from [article "Child of Silence"] c. 1989 Mary Ellen Mark (Graphis89 \253)

boy singing while playing the piano in "Mrs. Emily Motsieloa of Sophiatown teaches a boy to sing and play the piano" 1956 Peter Magubane (Eyes #346)

composing at the piano in "Leonard Bernstein composes at his piano at his home" 1988 Joseph McNally (Best14 117a)

girl playing while teacher is watching in "Naomi Singleton, 77, assumes a characteristic hands-on-hip stance while listening to 9-year-old Wei Wei Huang during lessons at Singleton's apartment" 1988 Guy Reynolds (Best14 92)

man in bathing suit standing on piano bench in "Brian Wilson" 1987* Mark Hanauer (Rolling #81)

man in tuxedo leaning against piano in palatial room in "Baldwin Artist Series" c. 1999* Jame Salzano (Photo00 153)

man leaning on open grand piano in "Igor Stravinsky" 1946 Arnold Newman (Goldberg 187; Icons 92)

man standing among unfinished pianos in [inserting piano strings] c. 1999* Randy Duchaine (Photo00 183)

old man's fingers on piano keys in "The Last Chord" c. 1935 Hillary G. Bailey (Peterson #28)

piano in background, man at corner of wall in "Interior, with Frank Mannheimer, Pianist" 1921 Jane Reece (Peterson #64)

teacher leaning over student at piano in "Nine-year-old smiles up at his music teacher as the two were rehearsing together" 1996 Barbara Davidson (Best22 108)

upright piano in living room in "Portrait of Mary ('Mae') Martin at home" c. 1922-1927 Richard Aloysius Twine (Willis \94)

vase of flowers on top of piano from [On Flowers] c. 1990* Kathryn Kleinman (Graphis90 \302)

woman's hands playing piano in "Untitled" before 1930 Laure Albin-Guillot (Rosenblum \113)

women playing viola, violin and piano in "The Prelude" 1917 Laura Gilpin (Peterson #55)

PICNICKING

couple picnicking on bright blanket from a series of posters to promote artificial sweeteners c. 1990* Bishin Jumonji (Graphis90 \155)

couples under large umbrella in "Untitled" c. 1888 Photographer Unknown (Marien \4.2)

family eating by car in "Family picnic" 1941 Russell Lee (Documenting 216b)

family in bathing suits listening to accordion in "Return of the Cossacks" 1998* Gerd Ludwig (Best24 38d)

men pulling on rope in "Tug-of-war" 1941 Russell Lee (Documenting 219b)

older couple with portable table and chairs, and cows and sheep grazing in "Glyndebourne" 1967 Tony Ray-Jones (Rosenblum2 #709)

older couples on grassy slope near river in "On the Banks of the Marne" 1938 Henri Cartier-Bresson (Art \277; Rosenblum2 #621)

women sitting under stone arch in "The Picnic Party" 1854 Mary Dillwyn (Rosenblum \38)

PICTURE WRITING

cliffs covered with inscriptions in "Utah Series No. 10, Hieroglyphic Pass, Opposite Parowan, Utah" 1872 William Bell (Rosenblum2 #152)

columns with hieroglyphics in "Interior of Temple of Horus, Edfu" after 1862 Antonio Beato (Rosenblum2 #135)

columns with hieroglyphics in "Karnak: Pillars of the Great Hall" c. 1859 Gustave Le Gray (Art \96)

PIGS

back of pig wearing a ballet costume in "Pig on Point" 1993 Ellen Jaskol (Best19 180)

eating food in a dog house in "A 300-pound sow decided to make herself welcome to a bowl of dog food" 1995* Troy Wayrynen (Best21 164d)

PIKES PEAK
 view of mountains in "Pikes Peak and Colorado Springs" c. 1926 Laura Gilpin (National \65)
PLANTS
 algae in *Lycopodium Flagellatum (Algae)*" 1840s-1850s* (Rosenblum2 #329)
 blade-like leaves in "Leaves II" 1929 Paul Strand (MOMA 103)
 bottle on table with leaves in "Old Bottle with Woodbine" 1921 Clara E. Sipprell (Peterson #56)
 bud of an aloe plant in "Aloe Bud" c. 1926 Imogen Cunningham (Women \40)
 bulbs in "Bulb" c. 1995* Terry Heffernan (Graphis96 92)
 chili peppers in [chili peppers] c. 1995* Eivind Lindberget (Graphis96 94)
 cyanotype leaves in "American Senna, *Cassia Marylandica*, South Haven River Bank" 1909 Bertha Evelyn
 Jaques (Rosenblum \39)
 dandelion seeds on stem in "Dandelion Seeds, *Taraxacium Officinale*" c. 1910 Bertha Jaques (National \56)
 dried leaves in "Leaves 50" 1970 Aaron Siskind (Decade \88)
 honeysuckle bush in "Honeysuckle" 1840 William Henry Fox Talbot (Art \4)
 houseplants on shelves in [Everything will be okay/Everything will work out/Everything is fine] 2001*
 Barbara Kruger (Photography 171)
 hydrangeas in bloom in "A Bush Hydrangea in flower" mid-1840s William Henry Fox Talbot (Art \5)
 ivy growing in a vase on a table in "Ivy and Old Glass" 1922 Clara Sipprell (Rosenblum \153)
 large leaves in "Rubber Tree" c. 1927 Aenne Biermann (Waking 359)
 lavender in "Lavender, *Lavendula Labiatae*" c. 1910 Bertha Jaques (National 133c)
 leaf in "Agave" 1983* Todd Walker (Decade \XIII)
 leaf in "Leaf of a Plant" c. 1839* William Henry Fox Talbot (Art \1)
 leaf in *Polypodium aureum (Jamaica)*" c. 1854* Anna Atkins (Women \2)
 leaves in "Botanical Specimen" c. 1840* William Henry Fox Talbot (Rosenblum2 #21; Szarkowski 29)
 leaves in "Hawaii" 1983 Brett Weston (Decade \101)
 leaves and flowers in "Iris pseudacorus" c. 1861* Anna Atkins (Women \3)
 leaves and gourd in [ad for a fashion firm] c. 1992* Christiane Marek (Graphis93 84)
 leaves and nuts in [ad for a fashion firm] c. 1992* Christiane Marek (Graphis93 85)
 leaves and stems in "Leaves" 1929 Ladislav Berka (Rosenblum2 #514)
 milkwood in "Milkweed Pods, *Asclepias Cornuti*" c. 1910 Bertha Jaques (National 133d)
 part of an agave plant in "Agave Design I" c. 1929 Imogen Cunningham (Decade 33; Goldberg 63; San \5)
 part of an aloe plant in "Aloe" 1925 Imogen Cunningham (Hambourg \118; San #25)
 part of plant in *Sempervivum Percarneum*" c. 1922 Albert Renger Patzsch (Rosenblum2 #513); in
 Delphinium" 1928 Karl Blossfeldt (Hambourg 91c); in *Eryngium Bourgatti*" 1928 Karl Blossfeldt
 (Hambourg 91a); in *Lavandula Angustifolia*" c. 1984 Joan Fontcuberta (Rosenblum2 #769)
 roots and gourds in [Taro root, Lotus root, Cameroonian gourd, Turia gourd] c. 1995* Stephan Abry
 (Graphis96 93)
 several leaves in shadow in "Untitled" 1910s Edward R. Dickson (Peterson #13)
 textured leaves in "False Hellebore" 1926 Imogen Cunningham (Rosenblum \141)
 thistle plants stems in "Thistle" 1893-1907 Edwin Hale Lincoln (MOMA 66)
 tight curls of fern fronds in *Adiantum pedatum*, Maidenhair Fern" 1920-1930 Karl Blossfeldt (Icons 25)
PLAY
 adults using bingo cards printed on a skirt in "Bingo skirt for four players" 1953 Louis Faurer (Life 112)
 African American boy and girl on vine swing in "The Grape-Vine Swing" c. 1895 Photographer Unknown
 (National 155d)
 African American girl with white Barbie doll in "North Avenue, Image No. 24" 1993 Linda Day Clark
 (Willis \422)
 boy chasing red balloon in "Boy with Red Balloon" 1983* Mel Wright (Committed 229)
 boy flying model planes in "Flight–At Last" 1996* Adrin Snider (Best22 179b)
 boy half-way up a tree near apartment house in "New York" c. 1942 Helen Levitt (Rosenblum \218)
 boy on monkey bars in "Carmona, Spain" 1963 Ferdinando Scianna (Photography 51)
 boy on swing in "Swing and Boy and Girl" 1954 William Klein (Marien \6.43)
 boy playing with ball against a wall in "First grader chases down a ball during a game of handball at school"
 1997* Wally Skalij (Best23 188)
 boys fighting on ledge over doorway in "New York" c. 1945 Helen Levitt (Rosenblum2 #683)
 boys playing in front of wall with small squares in "Madrid, Spain" 1933 Henri Cartier-Bresson (Art \276)
 boys playing on sidewalk in "Boys playing leapfrog near the Frederick Douglass Housing Project" 1942
 Gordon Parks (Willis \128)
 boys swinging on branches in vacant lot in "New York" c. 1940 Helen Levitt (Icons 85)

Chechen children playing near train cars in "Refugee children from Grozny play on a platform next to the train cars in which they live with their families" 1995* Olga Shalygin (Best21 182b)

child playing with a beach ball under the boardwalk in "Under the boardwalk at Coney Island" 1990 Kenneth Jarecke (Best16 181)

child swinging on the gun barrel of a rusted tank in "A child at play in Nicaragua" 1983* James Nachtwey (Lacayo 169)

children digging in sand in "Groundbreaking" 1995* Chuck Fadely (Best21 229a)

children faces in "Children watching a puppet show" 1963 Alfred Eisenstaedt (Lacayo 153a)

children in street full of bubbles in "Children play in bubbles in Barcelona, Spain" 1998* David Alan Harvey (Through 108)

children on grass near car covered with blankets in "Gypsy children in Lourdes, France, play on the grass after riding with their families in a caravan of cars" 2001* Tomasz Tomaszewski (Through 74)

children on swings and monkey bars in "To play outside with his friends, a 14-year-old boy wears a protective outfit designed by NASA" 2002* Sarah Leen (Through 366)

children playing by front steps in "Children on East 61st Street" 1938 Walker Evans (Documenting 143c)

children playing with toy gun on dirt road in "Children with toy gun" 1952 Howard Sochurek (Lacayo 143b)

clothesline as swing in "[Toddler] swinging from laundry line in backyard" 1996* Wally Skalij (Best22 244d)

domino game played on card table in "Rupert Brooks slams down the winning domino as he plays with friends" 1991 Bradley Clift (Best17 61)

girl pulling baby in a box in "At the Tuzia, Bosnia airport, a young girl pulls her brother in a carton that had contained humanitarian assistance" 1995 David Turnley (Best21 167)

girl stacking corn husks and bearded man shelling corn in kitchen in "Shelling Corn, Kingfield, Maine" 1901 Chansonetta Emmons (Sandler 20)

girls in dresses playing ring toss in room in "Ring Toss" 1900-1903 Clarence H. White (Art #9; Rosenblum2 #405)

girls on backyard swings in "Rev. Susan Luttner watches her adopted daughters swing in the yard" 1995 John Beale (Best21 194b)

girls sitting on building steps with dolls in "Two Girls with Dolls" 1990 Faith Goodin (Committed 111)

riding a rocking horse tied to a tree in "Little Sam Flucke gets lots of mileage from an old rocking horse his grandfather tied to a tree" 1986 Eric Albrecht (Best12 170)

rope across stoop of boarded-up building being used as swing for girl in "Harlem Girl" 1982 Mansa K. Mussa (Willis \280)

rusted swings in field in "The Settlement, Colonial Mine, Western Australia" 1999* David Goldblatt (Photography 187b)

sitting on floor playing backgammon in hotel in "Drawing Room in Mayfair" 1930s Bill Brandt (Icons 89)

swinging from an electrical cord on pole in "Children in Belfast, Northern Ireland, swing from a cord on a power-line pole" 1991* R. Norman Matheny (Best17 200b)

tossing coins on the ground near a small school in "Village schoolchildren in Ecuador play a coin-toss game during recess" 1991 Candace B. Barbot (Best17 197)

wading in water, children watch boy with toy boat in "Tide pools in Lynmouth, England delight a budding yachtsman and his friends" 1929 A. W. Cutler (Through 78)

POINT LOBOS (California)

rocks and small plants in "North Shore, Point Lobos" 1946 Edward Weston (Art \223; MOMA 184)

tide pool in "Tide Pool, Point Lobos" 1940 Edward Weston (Art \222)

wave crashing on rocks in "Point Lobos Wave" 1958 Wynn Bullock (Rosenblum2 #667)

POLAND

men walking on the streets of the ghetto in "Entrance to the Ghetto, Cracow" 1937 Roman Vishniac (Rosenblum2 #456)

striking workers listening to Lech Walesa speak in "Strike at the Lenin Shipyards" 1980 Peter Knopp (Photos 148)

POLICE

African American children on bus with police protection in "Busing in Louisville" 1975 Keith Williams (Capture 92)

angry farmers arguing with police in "In Gove, Kansas an American Agriculture Movement supporter, protests to troopers" 1985 Charlie Riedel (Best11 58b)

armed men on rooftop in "Police man a rooftop by light from the resultant fire, which burned out of control" 1985 George Widman (Best11 23a)

armed police surrounding men in large room in "U.S. Marshalls and Washington, D.C., police level guns at fugitives caught in a sting operation" 1985 Bernie Boston (Best11 104a)

arresting a man in "A man is arrested after shooting two police officers who responded to a fight" 1995 Stuart Bauer (Best21 173b)

arresting a man accused of domestic violence as son screams at him in "I hit you with the pot to make you stop hitting her. I hate you!" 1988 Donna Ferrato (Best14 82)

arresting a protester in "Police arrest an anti-apartheid protester on the University of California campus in Berkeley" 1986 Doug Atkins (Best12 54c)

arresting a suspect in a motel room in "Vice officers arrest a man on charges of soliciting prostitution" 1988 Bruce Chambers (Best14 76)

arresting a suspect in the grasslands in "Police officer trains his gun on two suspects as a helicopter hovers above in California" 1991* Hayne Palmour IV (Best17 108)

arresting an Hispanic man in "Pasadena police officers surround and arrest an unruly soccer fan after a fight" 1996* Richard Hartog (Best22 221a)

beating a striking worker in "A striking janitor is clubbed by Los Angeles police officers after breaking through police lines during a protest march" 1990* Bernardo Alps (Best16 111)

casket for newborn being carried in child's wagon by police in "Members of the police force hold a funeral for abandoned newborn who was found dead from exposure in parking lot" 1988 Cloe Poisson (Best14 79)

chasing after running man in "Zaboroski flees from Sharon police Officer after crashing his car during a police chase" 1990 David E. Dale (Best16 106a)

checking a parked truck in "Highway patrolmen peer into the cab of a pickup containing the body of Iowa farmer who committed suicide" 1985 David Zalaznik (Best11 59a)

checking a suspect's shoe as he stands by police car in "Police officer searches a man's shoe after seizing a bucket of marijuana plants from his house" 1996* Allison Corbett (Best22 152)

Civil rights marchers in fight with police in gas masks in "*Bloody Sunday* clash between a group of marching demonstrators and state highway patrolmen at the Pettus Bridge" 1965 Charles Moore (Best14 217b)

despondent police officer holding his injured horse in "Police officer and his fatally injured horse" 1985 Jim Mahoney (Best11 84-85)

dog and female police officer at funeral in "Officer Piscatelli salutes the coffin holding the body of her fiancé, Milford Patrolman Watson" 1987 Cloe Poisson (Best13 64)

drug suspects handcuffed on ground in "Children return home to find their parents handcuffed on the front yard, arrested on drug charges" 1987 Karen Pulfer (Best13 65d)

fire at demonstration with riot police in "Demonstrations by students on the streets of Seoul" 1988* Anthony Suau (Best14 59a)

Franco's men of the *Guardia Civil* in "Spanish Civil Guard" 1950 W. Eugene Smith (Art \413; Lacayo 161)

French police in riot gear and student being pursued in "Paris" 1968 Gilles Caron (Eyes #257-258)

Ghanian officer holding rifle on man in chains in "A Ghanian police officer threatens a man with a rifle after he was caught stealing goods from hotel room in Accra" 1996* Kirk D. McKoy (Best22 143a)

gun drawn near a house in "With his gun drawn, highway patrol officer searches for a suspect" 1997* Wally Skalij (Best23 190)

gun pointed at suspect on ground in "A mounted police officer orders a murder suspect to freeze just moments after witnesses saw security guard stabbed to death in Manhattan" 1987 Don Halasy (Best13 65a)

guns drawn behind a car in "Los Angeles police officers prepare for a shoot out" 1990* James Nachtwey (Best16 44b)

handcuffed man in car in "Auto thief arrested, car crashed, one killed" n.d. Weegee (Lacayo 82)

handcuffing shirtless man in "Suspect is arrested after eluding police after 40 minutes" 1997* Wally Skalij (Best23 191a)

handcuffing suspects in "Accused of stealing property at gunpoint, two suspects find themselves looking down the wrong end of the barrel in San Francisco" 1985 Steve Ringman (Best11 82)

helping a woman in "A woman gasps for breath as she is helped by New York City police officer after a terrorist bombing at the World Trade Center" 1993* Joseph Tabacca (Best19 186b)

holding a man for photograph in police station in "Booked for killing a Policeman" 1939 Weegee (Art \317)

holding a suspect in "A deputy interrogates a suspect in Los Angeles" 1990* James Nachtwey (Best16 45)

in riot gear, with smiley faces on their shields in "South Korean police with riot shields during a demonstration in Masan" 1987* Charlie Cole (Graphis89 \256)

interacting with community children in "Community Policing" 1996* Steve Liss (Best22 228)

long lines of police at funeral in "New England police officers, 5,000 strong, pay final tributes to slain patrolman who was killed in the line of duty" 1985 Dan Gould (Best11 83)

looking through a couple's trunk in "A young boy makes a pit stop while a Kansas Highway Patrol officer talks with the driver of the car he pulled over" 1990* Earl Richardson (Best16 169a)

man putting flowers in gun barrels of police in "Antiwar protest at the Pentagon" 1967 Bernie Boston

(Goldberg 172; Life 158)

man shot by police in "In Oklahoma City an unidentified man falls to the ground, shot by members of an Oklahoma City SWAT team" 1985 David Longstreath (Best11 79b)

officer standing next to fence painted with word "GUNS" in "In Santa Ana, Calif., a police officer responds to a silent alarm, and waits to see if anyone's inside a closed gun shop" 1985 Glenn Koenig (Best11 82b)

officers after a shooting in "Fifteen seconds after fatally wounding a gunman in a downtown office building, Pittsburgh policeman is comforted by a fellow officer" 1985 John Kaplan (Best11 80)

photo essay on police reactions to death of an officer in "The Twenty-fifth Precinct: Philadelphia" 1997 Eugene Richards (Best23 38-39)

photo essay on the arrest and trial of a murder suspect in "Rodney's Crime" 1988 John Kaplan (Best14 18-21)

photo essay on the crime in a neighborhood in "Crime and criminals in a California neighborhood" 1992 Mona Reeder (Best18 223-225)

playing basketball with children in street in "Policemen play basketball along with local children as part of their efforts to reduce crime" 1996* Steve Liss (Best22 170c)

pointing a gun at man on hands and knees in "Police reservist points a gun at a young man who attempted to rob him" 1998* Themba Hadebe (Best24 31b)

pointing guns at men on street in "Los Angeles police officers point their guns at a group of men suspected of spray painting O. J. Simpson–related graffiti" 1995 Wally Skalij (Best21 191b)

police and photographer at scene of crime in "Harry Maxwell Shot in Car" 1936 Weegee (MOMA 167)

police dogs attacking African American man as crowd watches in "Birmingham Protest" 1963 Bill Hudson (Goldberg 165); "Eugene 'Bull' Conner, Birmingham's Commissioner of Public Safety, orders the use of police dogs and fire hoses against civil rights activists" 1963 Charles Moore (Best14 215; MOMA 234)

police grabbing student in "When students on the University of California's Berkeley campus refused to disperse after a week-long anti-apartheid sit-in, the arrests begin" 1985 Tom Van Dyke (Best11 106a)

police officer leaning over to speak to boy in "Faith and Confidence" 1957 William C. Beall (Capture 41)

police officer standing in front of a crowd of men with placards in "Street Demonstration, San Francisco" 1933 Dorothea Lange (MOMA 136)

police officer standing near crushed red wagon and covered body lying in street in "Wheels of Death" 1958 William Seaman (Capture 43)

protestors behind policeman in "Street Meeting, San Francisco" 1937 Dorothea Lange (Decade 38)

putting on protective gear in "Members of the elite Crime Area Target Team suit up in full body armor for a night's worth of drug house raids" 1995* Melville Nathanson (Best21 198b)

questioning drug suspect in a home in "Police officer listens to a drug suspect's story" 1992 Mary F. Calvert (Best18 126a)

questioning handcuffed man in "Police officers question a man apprehended after allegedly purchasing crack" Kue Bui 1996 (Best22 223d)

removing hostages in "Boston Police officers rush two children and a woman away from an apartment where they had been held hostage by a gunman" 1988 Jim Mahoney (Best14 75d)

riot police behind barriers as student sprays flames at them in "South Korean student squares off in a duel with riot police during an anti-government demonstration at Yonsei University in Seoul" 1987* Itsuo Inouye (Eyes #366)

Russian police lined up with shields as elderly woman picks up flyers from ground in "Russian police set up a blockade against a planned anti-Yeltsin demonstration headed for the Parliament building in Moscow" 1993 Anthony Suau (Best21 123)

searching a suspect for drugs in "A Los Angeles deputy searches for signs of drug use" 1990* James Nachtwey (Best16 44a)

showing elderly woman how to hold a gun in "Youngstown police Officer shows Westveld how to aim a handgun" 1990 Christine Keith (Best16 109a)

silhouettes of three police officers in "On the Beat" 1966 Omar Kharem (Committed 138)

standing by dead body covered with a sheet in "On the Spot" 1940 Weegee (Goldberg 107)

strikers being beaten by police in "Republic Steel strike, Chicago" 1937 Photographer Unknown (Life 153)

student being dragged by security in "Campus security in Middletown drag one of 130 protestors from the steps of Wesleyan University's administration building" 1985 Skip Weisenburger (Best11 106c)

surrounding suspects on highway in "Police and sheriff's deputies bear down on armed robbery suspects" 1995* Russ Carmack (Best21 176a)

SWAT team carrying a dummy in competition in "SWAT team competes in the five-man tag team event during the SWAT challenge" 1996* Bill Greene (Best22 246c)

SWAT team cornering a suspect in "SWAT officers make sure a bank robbery suspect gets the message during an arrest" 1995* Kent Porter (Best21 172b)

SWAT team with guns drawn in "A Denver SWAT team approaches the apartment of a man after a shootout with police" 1987 Brian Brainerd (Best13 66a)

transporting teen in police car in "16-year-old sits squashed between officers after being busted for selling crack" 1995* Melville Nathanson (Best21 198b)

undercover police officer holding gun to mugger in "A decoy police officer arrests a mugger on a New York subway" 1985* Bruce Davidson (Best11 160a)

walking naked toddlers back to their home in "Dad had gone to work and Mom was still in bed when these two tots went out to play" 1990 Shaun Zimmerman (Best16 174)

walking with a man in "Pittsburgh police officers lead Matthew Armstrong away from the Allegheny River where his brother, Larry, drowned" 1988 John Kaplan (Best14 24)

with guns drawn, in hallway in "Two policemen with backs turned" 1978 Jill Freedman (Eyes #335)

POLITICAL CAMPAIGNS

Alan Keyes waiting to speak in "Republican presidential candidate Alan Keyes waits offstage as he is introduced to speak" 1995 Nuri Vallbona (Best21 178d)

Bill and Hillary Clinton relaxing on couch in "Bill and Hillary Clinton relax after a late-night pizza party in their hotel suite" 1992 P. F. Bentley (Best18 76a)

Bill Clinton entering a small plane in "Bill Clinton stands at the door of a plane and waves" 1992 Dan Habib (Best18 77)

Bill Clinton sitting in a steam room in "The afternoon before giving his nomination-acceptance speech presidential candidate Bill Clinton rests in a steam room" 1992 P. F. Bentley (Best18 73)

Bill Clinton speaking with Rev. Jesse Jackson in "Bill Clinton meets with the Rev. Jesse Jackson in the candidate's suite" 1992* P. F. Bentley (Best18 80a)

Bill Clinton standing on stage with painted flags in "Bill Clinton addresses a group in Boston as U.S. Rep. Joe Kennedy, D-Mass, looks on" 1992* Steven Savoia (Best18 74b)

Bill Clinton washes his face in restroom sink in "A brutal New Hampshire primary campaign catches up with Bill Clinton in a Manchester restroom" 1992 Dan Habib (Best18 75)

Bob Dole in a restaurant in "Presidential candidate Bob Dole has a difference of opinion with Clinton supporters while campaigning in New Hampshire" 1996 Brian Walski (Best22 104)

Bob Dole in photo essay from resigning from Senate to offering concession speech in "Bob Dole during Presidential campaign" 1996 P. F. Bentley (Best22 108-109)

campaign billboard in "Adlai Stevenson campaign" 1952 Photographer Unknown (Eyes #147)

campaign posters on store window in "Campaign posters in a garage window, just before the primaries. Waco, Texas" 1938 Dorothea Lange (Fisher 39)

candidate in tank in "Test Ride (Michael Dukakis in tank)" 1988* Michael Samojeden (Goldberg 206); "Michael Dukakis takes a tank ride in a presidential campagin visit to General Dynamic factory in Detroit" 1988 Tracy Baker (Best14 8a)

candidate kissing a supporter in "Democratic hopeful Jesse Jackson gives a kiss to a delighted Dorothy Chambers at a rally" 1988 Peggy Peattie (Best14 205a)

candidate talking in diner in "Coffee mug in hand, George Bush makes small talk with diners at Couzzin Richie's truck stop" 1988* Kenneth Jarecke (Best14 55d)

cheering near tally board in "The first couple and Vice President Richard Nixon and his wife, Pat, celebrate Ike's reelection" 1956 Photographer Unknown (Life 25)

child walking away from speaker in "Michael Dukakis stumps for votes at a child-care facility" 1988 Bonnie Weller (Best14 91)

crowd applauding images of Nixon and Eisenhower in "On the Nixon campaign trail" 1956 Carl Mydans (Eyes #233)

Dan Quayle taking a picture of a young boy in "Vice President Dan Quayle snaps a picture of a young fan in New Hampshire" 1992* Jim Bourg (Best18 80b)

election campaign signs on lawn in "Election campaign signs" 1938 John Vachon (Documenting 109c)

family on hill waving flags to buses on highway in "Clinton-Gore supporters wave to the campaign bus as it travels to Centralia, Illinois" 1992* Toma Muscionico (Best18 78a)

family watching John F. Kennedy on television in their living room in "First Ever Kennedy-Nixon Presidential TV Debate" 1960 Donald Phelan (Goldberg 152)

Gary Hart in "Lee Hart watches her husband, Gary, tell a crowd he is giving up his campaign for the Democratic presidential nomination" 1987 Kenneth Papaleo (Best13 54)

Gary Hart with hands folded in "Candidate Gary Hart recounts events that plagued his campaign" 1988 David Peterson (Best14 91d)

gubernatorial candidate and opponent supporter in "On Beyer's Trail" 1997 Vicki Cronis (Best23 222a, b)

John F. Kennedy giving speeches and interviews as presidential candidate in "Camelot and the Kennedy

mystique" Jacques Lowe 1957-1960 (Best23 58-65, 71)

Kennedy's shaking hands of people in crowd in "JFK and Jackie, New York" 1960 Cornell Capa (Photography 149)

men in hard hats standing around seated Kennedy in "Chatting with West Virginia coal miners during the presidential campaign" 1960 Hank Walker (Life 27)

Nancy Reagan at podium in "Nancy Reagan greets her husband (waving from his hotel room) during her appearance at the Republican National Convention, Dallas" 1984* Ben Weaver (Life 35)

overweight men in Buchanan hats in "Supporters of Pat Buchanan's presidential bid listen to their candidate during a rally" 1996* Eric Mencher (Best22 105c)

Pat Schroeder at microphones in "U.S. Congresswoman Pat Schroeder gets a tear wiped away by her husband after she announced she would not be running for the Democratic nomination of president" 1987 Ed Kosmicki (Best13 55a)

Paul and Niki Tsongas asleep on plane in "Paul Tsongas and his wife, Niki, sleep after a campaign stop in Georgia" 1992* Rick Friedman (Best18 76d)

Paul Tsongas being photographed in a swimming pool in "Presidential candidate Paul Tsongas takes a media dip" 1992* David Burnett (Best18 78d)

photo essay on Bill Clinton and campaigning in New Hampshire in "Clinton Survives a Primary" 1992 Dan Habib (Best18 181-184)

Ronald and Nancy Reagan's image on campaign button in "Republican Convention, Dallas" 1984* Jeff Jacobson (Eyes \41)

row of seated candidates before a debate in "Democratic presidential hopefuls Richard Gephardt, Bruce Babbitt and Jesse Jackson get a few finishing touches on their makeup as Paul Simon waits his turn before a debate in New Orleans" 1987 Guy A. Reynolds (Best13 52a)

Rudolph Guiliani speaking with Hasidic Rabbi in "New York City Mayor Rudolph Guiliani consults Grand Rabbi Solomon Halberstam while campaigning in Brooklyn" 1993 Andrea Mohin (Best19 193b)

standing in a truck to hang a poster on a telephone pole in "Hanging campaign poster in a cotton field" 1998 Donald Anderson (Best24 109c)

television broadcast of candidate showing in empty room in "Gary Hart's five-minute television speech plays to an empty house in the lobby of the Kirkwood Hotel in Des Moines" 1988 Jim Curley (Best14 112b)

POLITICAL CONVENTIONS

balloons and cameramen in empty seats in "TV cameramen seem weary and bored at the 1996 convention" 1996* Thomas Alleman (Best22 110a)

confetti falling on the Clintons in "President Clinton, Hilary Rodham Clinton and other VIPs celebrate at the Democratic National Convention's closing festivities" 1996* Bob Fila (Best22 107a)

crowded floor at the Clinton/Gore convention in "Political conventions" 1996 Carol Guzy (Best22 20-21)

delegate and balloons in convention hall in "Stetson-hatted Arizona delegate looms above Ohioans of a different sartorial persuasion while all listen to Bob Dole" 1996* Thomas Alleman (Best22 110d)

POOL (Game)

elderly man playing pool in "Hill District, Pittsburgh" c. 1994 (Willis \328)

man pushing pool table on dirt road in "Asking 20 cents a game, a Uygur entrepreneur pushes his portable pool table in Xinjiang Province, China" 1996* Reza (Through 172)

man standing against pool table in "A customer in a pool hall in Tulsa, Okla." 1986 Erik Hill (Best12 123b)

players in pool hall in "Despite putting a hex on his opponent during a billiards tournament at a pool hall, Bill Mistick still lost" 1991 Steve Mellon (Best17 55a)

woman leaning against pool table in "Prostitute playing Russian Billiards, boulevard Rochechouart, Montmartre" 1932 Brassaï (Art \282)

women hitting ball in "Gertrude Käsebier O'Malley at Billiards" c. 1909 Gertrude Käsebier (Women \21)

POVERTY see also HOMELESS PERSONS; MIGRANT LABOR

African American children playing in the slums in sight of the Capitol in "In the Shadow of the Capitol, Washington, D.C." 1946-1949 Marion Palfi (Decade \39)

African American children walking on dirt road in child with rickets on dirt road in "Tenant farmer's children, one with rickets, on badly eroded landed near Wadsboro, North Carolina" 1938 Marion Post Wolcott (Goldberg 95)

African American girl at newspaper-covered window of log cabin in "Girl at Gee's Bend, Alabama" 1937 Arthur Rothstein (Decade \38; Documenting 151b; Lacayo 95)

African American woman in bedroom in "Woman standing in her deteriorated bedroom holding a picture of a man" c. 1949 Dwoyid Olmstead (Willis \130)

barber chairs and walls covered with newspaper in "Negro barbershop, Atlanta, Georgia" 1936 Walker Evans (Lacayo 99a)

blind man with stool on street corner in "Blind beggar" 1938 John Vachon (Documenting 100b)

boy and empty refrigerator in "Francisco Bautista, 2, stands next to a nearly empty refrigerator" 1993 Stan Grossfeld (Best19 55)

boy in washtub in house in "Rico Harvey bathes in an old washtub, with stove-heated water inside the three-room house" 1998 Donald Anderson (Best24 109a)

children and women in yard with chickens and laundry in "London Slum" c. 1889 Photographer Unknown (Rosenblum2 #442)

children gathered near burlap sacks in "Children with Burlap Sacks" n.d. Jesse Tarbox Beals (Sandler 143; Women \25)

children in one-room shack in "Living Room (One-Room Shack)–Southern U.S.A." 1971 Jim Collier (Committed 79)

children in tenement apartment in "Family in Tenement" n.d. Jesse Tarbox Beals (Sandler 142)

children sitting with mother and making wreaths in "A family works at home making flower wreaths" 1912 Lewis Hine (Lacayo 65b)

children sleeping on steam grate in "Street Arabs at night" c. 1889 (Lacayo 61a)

children under hanging laundry in tenement yard in "Baxter Street Court" c. 1895 Jacob Riis (Lacayo 54)

couple in tent in "Migrant farm worker, Klamath County, Oregon" 1939 Dorothea Lange (Lacayo 100)

couple walking on large pipe through slum housing in "A pipeline carrying water to a wealthier suburb of Bombay stretches through a part of town where poor residents must share public spigots" 1998* Robb Kendrick (Through 166)

Cuban mother and children in shack in "Wretched Poverty of a Cuban Peasant Home" 1899 Underwood & Underwood (Rosenblum2 #418)

destitute family sitting in log cabin in "Sharecropper Family, Alabama" 1936 Walker Evans (Goldberg 102; Monk #19)

dirty children sitting on bed in room with cereal boxes as wallpaper in "Children in the bedroom of their home. Charleston, West Virginia" 1938 Marion Post Wolcott (Fisher 49)

families near store in "Sufferers from the floods in London" c. 1876-1877 John Thomson (Lacayo 60)

girl sleeping in chair in a shack in "Sick child" 1941 John Vachon (Documenting 19c)

hanging clothes in "A canal of contaminated water near their cardboard-and-wood house" 1997* Julián Cardona (Photography 116a)

homeless man sitting on sidewalk in cardboard box and eating in "Philadelphia's Homeless" 1985 Tom Gralish (Capture 139)

infant sitting in a cooking pot in "A cooking pot doubles as a pen for this five-month-old child in Dhravi, the worst slum in Bombay, India" 1986 Bill Greene (Best12 68a)

line of men holding plates in "Uncle Robert's Poor Being Served Lunch" 1926 Martin Munkácsi (Icons 36)

man on bedding across top of barrels in "A Cave Dweller–Slept in This Cellar Four Years" c. 1890 Jacob Riis (Photography1 \91; Rosenblum2 #479)

men and woman with a child sitting by shacks in a tenement yard in "Yard, Jersey Street Tenement" c. 1888 Jacob Riis (Rosenblum2 #441)

men sleeping in cramped quarters in "Five cents a spot, Bayard Street" c. 1889 Jacob Riis (Eyes #48; Lacayo 64b; Rosenblum2 #439)

migrant family's life in a photo essay in "Family of migrant workers" 1979-1987 Herman LeRoy Emmet (Best13 130-141)

migrant worker man in field, carrying tall, filled basket on his shoulder in "Migration to Misery" 1969 Dallas Kinney (Capture 69)

migrant worker woman, with unlaced sneakers, sitting on her stoop in "Migration to Misery" 1969 Dallas Kinney (Capture 68)

old woman and daughter by log cabin in "Mother and Daughter" 1939 Marion Post Wolcott (Sandler 82)

old woman sitting on stoop, holding small child in "The Crawlers" c. 1876-1877 John Thomson (Lacayo 61d; Marien \3.89; Rosenblum2 #435)

old wooden houses in "Houses near Nebraska Power Company" 1938 John Vachon (Documenting 105c)

photo essay of children and adults living on the fringes of society in "Outside the American Dream" 1985-1992 Stephen Shames (Best18 87-100)

photo essay on a community of African Americans that is trying to rebuild itself in "Building a Better Bayview" 1998 Michael Williamson (Best24 168-171)

photo essay on children living in residential motels in "Loss of Hope: Motel Children" 1998* Daniel A. Anderson (Best24 146-155)

photo essay of life in town of severe poverty in "Tunica, Mississippi" 1986 Jeff Mc Adory (Best12 114-117)

row of tenement balconies and windows in "Tenement in New York" 1970 Bruce Davidson (Lacayo 146)

sad-looking woman with two children leaning on her shoulders in "Migrant Mother, Nipomo, California" 1936 Dorothea Lange (Documenting 16-17, 69; Fisher 26; Goldberg 92; Icons 71; MOMA 148; Monk #20; Lacayo 101; Photos 49; Rosenblum2 #451; Sandler 158)

shacks of people who live on garbage dump in " 'Smoky Mountain,' a garbage dump in Manila where poor people live in a squatter village and pick through trash looking for scraps of plastic" 1985 Karen T. Borchers (Best11 75d)

shoeless family in wooden shack in "Bud Fields and His Family, Alabama" 1936 Walker Evans (Icons 73)

son hugging father in their trailer in "Among the nation's homeless, Mike and his son Charlie" 1985 Stephen Shames (Best11 161b)

woman holding child near bags of rags in "In the Home of an Italian Rag-Picker, New Jersey" c. 1889 Jacob Riis (Szarkowski 186)

women outside wooden housing in "Pahokee 'Hotel' (Migrant vegetable pickers' quarters near Homestead, Florida)" 1941 Marion Post Wolcott (Rosenblum \169)

PRAIRIE DOGS

two marked males about to fight in "Vanishing prairie dog" 1998* Raymond Gehman (Best24 75b)

PRAYER AND PRAYING

African American congregation raising their hands in song in "Joy Tabernacle" 1991 Jeffrey L. St. Mary (Willis \374-\375)

baseball player in "Top area high school pitcher prays during her game" 1997* Bryan Patrick (Best23 172a)

by a crucifix in "On Good Friday, a pilgrim worships in a Jerusalem grotto" 1996* Annie Griffiths Belt (Through 240)

children in church and in bed in "Faith, Hope and Devotion" 1996* Joyce Marshall (Best22 240b, d)

enthusiastic prayer service in "As he receives the spirit of the Lord at a church altar, a worshiper falls to his knees" 1987 Bill Greene (Best13 128a)

football players praying on the field in "Miami Dolphins wide receiver, the Rev. Irving Fryar, leads teammates and opponents in a post-game prayer at midfield" 1995* Jim Davis (Best21 108a)

Haitian woman alone in church in "During the violent days before the election, a woman prays in the main Port-au-Prince cathedral" 1987* Carol Guzy (Best13 21b)

man sitting in wooden pew in "Eugene White finds shelter and prayer at the New Life Institute" 1988* Nick Kelsh (Best14 102a)

mother and child reading the *Bible* at church in "A young boy receives some help reading the *Bible* from his mother inside Grace Community Church" 1987 Bill Greene (Best13 128b)

people kneeling in street in "Prayer time, Dhaka" 2000* Raghu Rai (Photography 114b)

photo essay of town's prayer vigils after torture-murder of James Byrd in "Aftermath of a Racial Killing" 1998 Smiley N. Pool (Best24 18-19)

woman with clasped hands holding cross in "Lopez was one of hundreds who went to St. Charles Catholic Church in San Francisco to pray for relatives in Mexico City" 1985 Deanne Fitzmaurice (Best11 12d)

PREACHING

men and women with signs and *Bible* on street corners in "Man Preaching" 1998 Sheila Pree (Willis \324); "Man with Sign" 1998 Sheila Pree (Willis \322); "Woman with Sign" 1998 Sheila Pree (Willis \323); "Man with Bible" 1998 (Willis \326)

PREAH KHAN (Cambodia)

ruins of the ancient temple in "Visitors walk among the ruins of 12th-century Khmer temples at Angkor's Preah Khan in Cambodia" 2000* Steve McCurry (Through 142)

PREGNANCY

giving birth on floor of home in "Ali Koen, 8, reacts to the birth of her brother at their Kansas farmhouse" 1990 Kenbt Meireis (Best16 172d)

nude African American woman covering breasts in "I Am Seven Months Pregnant" 1997 Delphine A. Fawundu (Committed 94)

nude woman holding tulips in "Lorraine, pregnant nude study no. 2" c. 1991* Lisa Bogdan (Graphis91 \183)

nude woman seen through window into backyard in [Self-promotional] c. 1989 Kam Hinatsu (Graphis89 \182)

pregnant woman in "Pregnant Nude" 1959 Imogen Cunningham (Icons 131)

pregnant woman holding large amount of mail and mail bag in "Mail carrier had residents on her route wondering just what she was going to deliver today" 1985 Al Seib (Best11 136c)

pregnant woman shooting drugs in "Untitled" 1971 Larry Clark (San \51)

silhouette of woman and computer in "Are VDTs hazardous to pregnant women in the workplace?" 1988 David Crane (Best14 115)

young woman in [article on breast cancer and young mothers] c. 1991* Joyce Tenneson (Graphis92 \126)

young woman and girl carrying bottles of milk in "New York" c. 1940 Helen Levitt (Marien \6.53)

PRESIDENTS–United States

after death of FDR, people sit and stand on lawn in front of White House in "A crowd gathered in front of the White House awaits further news after the announcement of FDR's death" 1945 Charles Fenno Jacobs (Eyes #207)

after death of FDR tearful man plays accordion near women in "As FDR's body is carried to the train at Warm Springs on the day after his death, CPO Graham Jackson's tear-stained face symbolizes the nation's sorrow" 1945 Edward Clark (Eyes #206)

back of George Bush waving at the troops in "The President and First Lady make a Thanksgiving visit to U.S. troops in Saudi Arabia" 1990* Jean-Louis Atlan (Life 36d)

Bill and Chelsea Clinton getting autograph of Cal Ripken in "Cal Ripken and cheering for his game streak record" 1995* Richard Lipski (Best21 132)

Bill and Hillary Clinton after impeachment vote in "Clinton Impeachment" 1998* Susan Walsh (Capture 193)

Bill and Hillary Clinton dancing in "Bill and Hillary Clinton, Inauguration Gala" 1993* David Burnett (Life 37d)

boy in red sweater talking to President Clinton at counter in "Small Talk" 1992* Greg Gibson (Capture 168)

Bush giving a speech with family watching in "As President-elect Bush gives his acceptance speech, granddaughter Barbara yawns with campaign weariness" 1988 Richard J. Carson (Best14 90a)

Bush in water, fishing in "George Bush, shortly after becoming President, takes a day off to go fishing near Palm Beach, Fla." 1988 Bob Sullivan (Best14 8c)

Bush sitting in a library with young children in "President Bush ponders a pupil's question during a visit to Farnsworth School" 1990 Al Podgorski (Best16 60b)

Carter between Sadat and Begin after signing peace treaty in "Peace brings them together" 1979 Photographer Unknown (Eyes #351)

Carter on top of a car in the midst of a large crowd in "President Carter takes to the road" 1979 Bob Daugherty (Life 33)

cheering near tally board in "The first couple and Vice President Richard Nixon and his wife, Pat, celebrate Ike's reelection" 1956 Photographer Unknown (Life 25)

Clinton and adopted boy in "During the signing ceremony for the Adoption Safe Families Act, 7-year-old sits next to President Clinton" 1997 Susan Biddle (Best23 131d)

Clinton and other heads of state adjusting ties in "Israel's Yitzak Rabin, Egypt's Hosni Mubarak, Jordan's King Hussein and President Bill Clinton adjust their ties before signing the Middle East peace accord while P. L. O. Yassir Arafat waits" Barbara Kinney 1995 (Best21 178a)

Clinton backstage in "Clinton takes a deep breath before walking on to the convention floor to deliver his acceptance speech" 1996 Diana Walker (Best22 111b)

Clinton listening to questions in "Near the end of a violent year in politics, President Clinton listens to a reporter's question about the first government shutdown" 1995* Kenneth Lambert (Best21 203a)

Clinton playing cards in "En route to one of the Presidential debates via train, President Clinton plays cards with his aides" 1996 Diana Walker (Best22 111a)

Clinton playing touch football in "President Clinton finds the pigskin beyond his reach during a touch football game" 1993* Robert Giroux (Best19 192a)

Clinton preparing for debate in "President Clinton during preparation for one of the debates at the Chautauqua Institute" 1996 Diana Walker (Best22 111b)

Clinton standing in middle of student band in "President-elect Clinton joins the band at a Democratic Rally" 1992* David Longstreath (Life 37a)

Clinton waving to a crowd in "President Clinton waves in the rain during a campaign stop" 1996* Luke Frazza (Best22 107c)

Clinton with wife and daughter in "Clinton hugs his daughter and wife after the debate was finished" 1996 Diana Walker (Best22 111d)

crowd waiting for inauguration concert in lining the reflecting pool in "A crowd of thousands gathers near the Lincoln Memorial for a concert kicking off the Clinton Inauguration" 1993 Paul F. Gero (Best19 191)

Eisenhower shaking hands with a young girl in "Dwight D. Eisenhower" c. 1952 Durwood Hayes (Eyes #146)

Ford gesturing to Henry Kissinger in "Ford and Secretary of State Kissinger conferencing in Oval Office" 1976 David Hume Kennerly (Eyes #267)

Ford, Nixon, Reagan, and Bush standing among sculptures of world leaders in "The president and 3 former presidents gather for the opening of Nixon Library in Yorba Linda" 1990* Paul Kuroda (Best16 28)

Ford speaking across table with Emperor Hirohito in "President Ford meeting with Emperor Hirohito of Japan" 1976 David Hume Kennerly (Eyes #265)

former President Nixon's helicopter taking off from the White House lawn behind uniformed men rolling up

carpet in "Nixon leaving" 1974 Annie Leibovitz (Rolling #31)

Franklin Delano Roosevelt smoking a cigarette in "Franklin Delano Roosevelt" 1939 Photographer Unknown (Eyes #137; Monk #24)

Gerald Ford with daughter in formal attire in "While the First Lady recovered from a mastectomy, daughter Susan accompanied the President to a reception at White House" 1974 David Hume Kennerly (Life 32)

JFK and Robert Kennedy speaking with each other in "JFK and brother Robert, then his campaign manager, later his Attorney General" 1960 Hank Walker (Life 26d)

Jimmy Carter shaking hands with Begin and Sadat in "Anwar Sadat, Jimmy Carter, Menachem Begin at the Camp David Accords Signing Ceremony" 1978* Photographer Unknown (Goldberg 190; Photos 145)

Johnson and Dean Rusk standing by doors in "May 1966" 1966 Yoichi Okamaoto (Eyes #266)

Johnson in conversation with McNamara in "Johnson with McNamara in Cabinet Room" 1966 Yoichi Okamaoto (Eyes #268)

Johnson speaking with Lady Bird in "LBJ and Lady Bird share a quiet moment at the White House" 1965 Yoichi Okamoto (Life 28a)

Johnson taking the oath of office near Jacqueline Kennedy in "Johnson becomes President" 1963 Cecil Stoughton (Eyes #287)

Kennedy and Eisenhower, with backs to camera walking on path in Camp David in "Two Men With a Problem" 1961 Paul Vathis (Capture 48)

Kennedy bending over to kiss his son in "Father and son" 1963 Robert H. Schutz (Eyes #285)

Kennedy in motorcade on screen at drive-in in "Monsey, New York" 1963 Lee Friedlander (Art \332)

Kennedy in Paris and Oval Office in "Camelot and the Kennedy mystique" Jacques Lowe 1957-1960 (Best23 70, 72)

Kennedy speaking outdoors before large crowd in "President John F. Kennedy" n.d. Charles (Teenie) Harris (Willis \139)

Kennedys in balcony above the crowd at the Inaugural Ball in "Day of triumph, Inaugural Ball" 1961 Paul Schutzer (Eyes #283)

Kennedys playing with young daughter on beach in "Senator and Mrs. Kennedy with daughter Caroline, Hyannis Port" 1959 Mark Shaw (Life 26)

Lincoln before a large crowd in "Lincoln reading his Second Inaugural Address" 1865 Alexander Gardner (Art \66)

Lincoln inauguration in front of unfinished Capitol building in "Inauguration of Lincoln" 1861 Montgomery C. Meigs (Photography1 #IV-22)

Nixon eating at a Chinese dinner in "President Nixon at a dinner hosted by Chinese Premier Chou En-Lai, Hangchow" 1972* Ollie Atkins (Life 31d)

Nixon shaking hands and looking at his watch in "President Nixon checks his watch" 1974 Photographer Unknown or Charles Tasnadi (Eyes 276; Goldberg 184)

Reagan and Gorbachev in "President Ronald Reagan and Soviet leader Mikhail Gorbachev" 1986* Dennis Brack (Best12 7a)

Reagan and Gorbachev shaking hands in "In Geneva, President Reagan and Soviet leader Mikhail Gorbachev exchange laughs at the beginning of their final summit ceremony" 1985 Dennis Paquin (Best11 89a)

Reagan and Nancy at a dance in "A month before the attempt on his life, Reagan cut in on Nancy's dance with Frank Sinatra" 1981* Michael Evans (Life 34d)

Reagan holds up an oversized gavel in "President Ronald Reagan gets a going-away gavel during the Republican convention" 1988 Bernie Boston (Best14 9d)

Reagan sitting next to Gorbachev in "Reagan and Soviet leader Mikhail Gorbachev, Geneva Summit" 1985* David Burnett (Life 34a)

Reagan speaking with Elizabeth Taylor in "President Reagan and Elizabeth Taylor exchange a few words during an AIDS benefit in Washington, D.C." 1987 Lucian Perkins (Best13 100d)

Ronald and Nancy Reagan's images on campaign button in "Republican Convention, Dallas" 1984* Jeff Jacobson (Eyes \41)

Ronald and Nancy Reagan sitting at memorial service in "President and Mrs. Ronald Reagan join families of the *Challenger* astronauts at memorial services in Houston" 1986 Doug Mills (Best12 12c)

Ronald Reagan consoling line of mourners in "President and Mrs. Reagan meet with each bereaved family to offer consolation after the service" 1985 Bill Luster (Best11 51d)

Ronald Reagan giving OK sign in "President Ronald Reagan gives the OK sign from the window of his hospital room" 1985 Dennis Cook (Best11 88a)

Ronald Reagan, immediately before and after being shot in "Assassination Attempt" 1981 Ron Edmonds (Capture 118-119)

Ronald Reagan on satiric poster in "The Safety Net (Proposal for Gand Central Station)" 1982* Hans Haacke

(Photography2 147)

Ronald Reagan pointing to his nose in "President Reagan points to where a growth diagnosed as a minor skin cancer was removed" 1985 Larry Morris (Best11 88c)

Theodore Roosevelt in the seat of a steam shovel in "President Roosevelt running a steam shovel at the Panama Canal" 1906 Underwood & Underwood (Goldberg 55)

Truman holding up newspaper in "One for the books" 1948 Byron Rollins (Eyes #209; Goldberg 124)

Woodrow Wilson and General Pershing walking (retouched photograph) in "President Woodrow Wilson with U.S. General John Pershing" n.d. U.S. Army Signal Corps (Lacayo 170b)

PRIESTS *see* CLERGY

PRIMATES

baboon yawning in "Yawning Baboon" c. 1928 Albert Renger-Patzch (Hambourg \75)

baby holding onto mother in "A young proboscis monkey clings to its mother in Borneo, where they live among the trees" 2002* Tim Laman (Through 194)

baby on mother's back in "A baby baboon clings to its mother in the highlands of Ethiopia" 2002* Michael Nichols (Through 282)

chimp with arm around woman in "Jane Goodall comforts a chimp in captivity, an aged female half-crazed from years alone in a Congolese zoo" 1995* Michael Nichols (Best21 143)

chimps swinging around man in "Eager for a turn on the big blue swing, playmates frolic around Ludovic Rabasa, who doubles as a surrogate parent to these chimps" 1995* Michael Nichols (Best21 163a)

couple with monkey in convertible in "Park Avenue, New York" 1959 Garry Winogrand (MOMA 245)

gorilla family in jungle in "Conservationists fear they are fighting a losing battle to save mountain gorillas such as these near Karisoke, Rwanda" 1995* Michael Nichols (Through 286)

gorilla holding child who fell into habitat in "Binti-Jua rescues a 3-year-old toddler who fell into the primate habitat at the Brookfield Zoo" 1996* Robert Allison (Best22 143)

gorilla's face through the leaves in "This silverback gorilla, found in the mountains bordering Rwanda, is an endangered species" 1995* Daniel A. Anderson (Best21 158b)

in profile in "Chuka, the Drill" c. 1991* James Balog (Graphis91 \356)

infant sitting on floor looking at painting of gorilla in "Life-sized 6-month-old gets close-up view of larger-than-life painting, 'Gorilla' " 1985 Jim Mayfield (Best11 144d)

monkey embryo in "A monkey embryo serves to raise questions about what makes humans human" 1996* Lennart Nilsson (Best22 184b)

monkey's body in [from *Specimens* series] c. 1995* Deborah Brackenbury (Graphis96 8)

monkeys at a banquet, on a city street, and at a lottery booth in Thailand in "Asia's Urban Monkeys" 1998* Jim Leachman (Best24 176-177)

on operating table in "At medical research facility in New York, blood plasma separation is performed on one of its chimps" n.d.* Michael Nichols (Photography 161)

snow monkeys in water in "Two Japanese macaques, or snow monkeys, while away a cold winter's day in the waters of a hot spring" 2003* Tim Laman (Through 204)

with arm behind his head in [chimpanzee] c. 1999* David Allan Brandt (Photo00 222)

PRISMS

and path of light beams in "Light Rays Through a Prism" c. 1958 Berenice Abbott (Marien \5.76)

PRISONS AND PRISONERS

AIDS prisoner behind gate in "AIDS-infected inmates such as Gary Brown are isolated on one floor of the Missouri State Penitentiary prison hospital" 1987 Keith Myers (Best13 59b)

armed police taking a man away from crowd in "During a funeral for victims of the Tonton Macoutes in Haiti, a suspected member of the Macoutes is led away from a mob intent on killing him" 1990 Carol Guzy (Best16 11d)

arrest of man in front of young child in "A child watches her father arrested for domestic assault" 1995 Colin Mulvany (Best21 168)

back of young man in handcuffs in "Juvenile handcuffed" 1986 Angel Franco (Eyes #336)

benches for felons in "Ghostly silhouettes from countless accused felons manacled to a bench at detention cell in New York" 1997 Larry Towell (Best23 155a)

blindfolded men and armed guard in "Palestinian prisoners, tied and blindfolded, await their fates in the Gaza Strip" 1990 James Lukoski (Best16 8a)

Bolivian prison corruption in "Bolivia Prison" 1995 Ricky Davila (Best21 210)

boy in profile and front view in "Claude F. Hankins: Murderer" 1904 Clara Sheldon Smith (Marien \4.70)

boy running on sidewalk lined by barbed wire fences in "Four-year-old bolts toward the entrance of the New Hampshire State Prison for Women" 1996 Alan Spearman (Best22 165)

Chaplain with *Bible* at prison cell in "Prison Chaplain talks about Christ and the life hereafter with

Raulerson" 1985 Bill Wax (Best11 114a)

child chained to a bunk in "A child is chained to his bunk to keep him from wandering off at a camp for Vietnamese boat people in Hong Kong" 1990* Jodi Cobb (Best16 197c)

child holding phone at jail visit in "The 'three strikes law' is straining jails and adversely affecting poor communities" 1996* Clarence J. Williams III (Best22 161)

Chinese man with chains and wooden boards around his neck in "The Cangue" 1871-1872 John Thomson (Marien \3.37)

concentration camp male prisoners looking out behind barbed wire in "The Living Dead at Buchenwald" 1945 Margaret Bourke-White (Eyes #213; Lacayo 116d; Monk #30)

Congolese soldier pointing rifle at neck of prisoner in "Congolese Soldiers Ill-Treating Prisoners Awaiting Death in Stanleyville" 1964 Donald McCullin (Rosenblum2 #611)

daily life in the prison system, including man in chains and hood in "Behind Bars" 1997-1999* Andrew Lichtenstein (Best23 210d; Photo00 70, 71)

electric chair in " 'Old Sparky,' the instrument of execution" 1985 Bill Wax (Best11 114d)

exercising by lifting grate in prison yard in "Chain gang inmate works out in the prison yard" 1995 James Nachtwey (Best21 184b)

feet of man in chains in "Captured Taliban prisoners held by Massoud's forces, Afghanistan" 2001 Chris Steele-Perkins (Photography 110)

guard at prison gate in "Front entrance to the Florida State Prison" 1985 Bill Wax (Best11 112c)

HIV prisoners in solitary confinement leaning through slots in doors in "HIV carriers at the Missouri State Penitentiary were isolated virtually 24 hours a day" 1987 Keith Myers (Best13 59a)

inmates holding bundles in "The 'three strikes law' is straining jails and adversely affecting poor communities" 1996* Clarence J. Williams III (Best22 166c)

inmates picking cotton in "A mounted guard keeps close watch over inmates from the Mississippi State Penitentiary in Parchman" 1989* William Albert Allard (Through 376)

lines of men with hoes in "The Line, Ferguson Unit, Texas" 1967-1969 Danny Lyon (Decade 78a; Rosenblum2 #688)

looking through a slit in a door in "A prisoner in solitary confinement peers through a slit in his cell door" 1986 Charles F. Eaton, Jr. (Best12 138)

man in cell with toilet and bed in "Prisoner Raulerson passes time in his cell" 1985 Bill Wax (Best11 112b)

man in prison uniform pointing out soldier in "Russian Slave Laborer Points Out Former Nazi Guard Who Brutally Beat Prisoners" 1945 U.S. Army Signal Corps (MOMA 171)

men and chaplain holding hands through the bars in "Mother York is a volunteer chaplain at Cook County Jail" 1990 Al Podgorski (Best16 61)

men and women in frontal and profile portraits in "Portraits of prisoners" c. 1880 Photographer Unknown (Szarkowski 98)

men in hallways, doorways, and at long table in [from *Portraits of Death Row* series] 1992-1994 Lou Jones (Willis \402-405)

men with plastic bags in "Chain gangs" 1995 James Nachtwey (Best21 217)

mothers and children with hands raised marching past armed Nazi soldiers in "The Warsaw Ghetto Uprising" 1943 from the Files of SS Commander Jürgen Stroop (Monk #27)

photo essay on elderly inmates in "America's Aging Inmates" 1997 Ed Kashi (Best23 213)

photo essay on Soviet women's life in prison in "U.S.S.R. Women's Prisons" 1990 Joan Evelyn Atwood (Best16 215-228)

photo essay on the life in prison of children of inmates in "Innocence Lost" 1998 Penny De Los Santos (Best24 174-175)

photo essay on women with their children, and pregnant inmates in "Women Behind Bars" 1997 Jane Evelyn Atwood (Best23 212)

police and prisoner in "Immediately upon securing the cell block, guards stripped prisoners and searched them for hidden contraband" 1998 Brian Plonka (Best24 156)

prison riot photo essay with prison burning and inmates walking out in chains in "Atlanta prison riot" 1987 Charles Trainor (Best13 70, 71, 72a)

Sandinistas with captured American in "A downed American flyer is led out of the Nicaraguan jungle to a waiting helicopter after Sandinista soldiers captured him" 1986 Louis Dematteis (Best12 76a)

talking to visitors through phones separated by glass in "Haitian political prisoner being held in a Virginia jail" 1997 Susan Biddle (Best23 138a)

tattooed men in prison yard in "Member of the Aryan Brotherhood in a recreation yard" 1997* Andrew Lichtenstein (Best23 210b)

viewing man through slot in jail door in "Crack addict from Virginia says he feels safer in the county jail than

on the streets" 1996* James LoScalzo (Best22 211d)

view of inmates in prison cells in "Jackson State Prison" 1980* Taro M. Yamasaki (Capture 114)

white man inspecting black man with outstretched arms in "Shakedown, Ramsey Unit, Texas" c. 1967-1969 Danny Lyon (Decade \84)

women in prison for killing their abusers in "Imprisoned battered women" 1990 Donna Ferrato (Best16 26)

women pleading with armed soldiers lifting man from street in "An Arab feigns injury to avoid arrest by an Israeli soldier during a demonstration in Ramallah on the West Bank" 1990* James Nachtwey (Best16 43)

Yankee prisoners standing in prison yard with guards on upper walkway in "Charleston Cadets Guarding Yankee Prisoners" 1861 George Cook (Rosenblum2 #208)

young man behind grating of cell in "Seventeen-year-old boy arrested for strangling a six-year-old girl to death" 1944 Weegee (Art \319)

young mother and her son in "One to Four Without Michael" 1996 (Best22 236d)

young woman on prison bed in "Wendy Blankenship, a 19-year-old prostitute with AIDS, is sentenced to one year at the Miami Women's Detention Center" 1987 Carol Guzy (Best13 58)

PROBLEM YOUTH

photo essay on a young truant in "Why won't Jimmy go to school?" 1987 Randy Olson (Best13 149-151)

photo essay on life of young boy in "Timmy's Dead-end Street" 1990 Richard A. Messina (Best16 96-100)

photo essay on using ballet as a way to reach troubled and poor youth in "Shelter on Stage" 1996* Gail Fisher (Best22 80-97)

photo essay on youth gang and their drugs and guns in "Fremont Street Hustlers" 1995 Eugene Richards (Best21 56, 68-71)

PRONGHORN

overlooking the distant mountains in "Unique to North America, the pronghorn is an unforgettable sight" 1984* Sam Abell (Through 334)

PROSTITUTES

bar with man and women in "Inside Big 4, legal bordello and bar in Nevada" 1992* Chris Johns (Best18 72a)

child prostitutes in Kenya in "The Gone Ones" 1996 Stephanie Welsh (Best22 237a, c)

dowdy woman outside doorway in "*La Villette, rue Asselin*, prostitute taking a break" 1921 Eugène Atget (Art \269; Rosenblum2 #327)

face of man in old car in "Sugar, a male prostitute and diagnosed AIDS victim, stares from the rear window of an abandoned Cadillac in which he lives and entertains his client" 1988 Brain Poulter (Best14 94b)

heavy makeup on women in cutouts in doors in "*Calle Cuauhtemoctzin*, Mexico City" 1934 Henri Cartier-Bresson (Art \278; Hambourg \41)

man and woman under arch in "A Monastic Brothel, *rue Monsieur Le Prince, Quartier Latin*" 1932 Brassaï (Art \283)

men and women on street corners in "Prostitutes of Maciel" 1976* Miguel Rio Branco (Rosenblum2 #794)

nude women meeting man in hallway in "Introduction at Suzy's" 1932-1933 Brassaï (Hambourg \34)

older women in print dresses in doorway in "Rue Asselin" 1924-1925 Eugène Atget (Waking #166)

photo essay on a prostitute in "Gloria: Life on the Streets" 1997 Susan Watts (Best23 209)

photo essay on a teenage male prostitute in "Runaway: Teen-age Prostitute" 1988 Genaro Molina (Best14 181-183)

photo essay on a transsexual in "I'm Not David Anymore" 1992 Brian Plonka (Best18 53-55)

photo essay on addict couple and prostitution in "A. J. and Jim Bob" 1988 Merry Alpern (Best14 168-172)

with umbrellas standing in the rain in "Prostitutes look for customers on a rainy night" 1995 Nancy Andrews (Best21 186a)

woman leaning against pool table in "Prostitute playing Russian Billiards, *Boulevard Rochechouart*, Montmartre" 1932 Brassaï (Art \282)

women sitting at a bar in "Prostitutes in a Bar, *Boulevard Rochechouart*, Montmartre" 1932 Brassaï (Hambourg 101)

young woman on prison bed in "Wendy Blankenship, a 19-year-old prostitute with AIDS, is sentenced to one year at the Miami Women's Detention Center" 1987 Carol Guzy (Best13 58)

PROTEST MOVEMENTS / DEMONSTRATIONS

African American men with signs protesting employment discrimination in "Workers Outside United Steelworkers of America Office" n.d. Charles (Teenie) Harris (Willis \137)

African American women marching with signs in "Members of the National Association of Colored Women march outside the White House to protest a lynching in Georgia" 1946 Robert H. McNeill (Willis \114)

African Americans marching in protest in "Reverend Adam Clayton Powell, Jr., leads a protest on 125th Street in Harlem–'Don't Buy Where You Can't Work' campaign" 1942 Morgan and Marvin Smith (Willis \124)

angry farmers arguing with police in "In Gove, Kansas, an American Agriculture Movement supporter protests to troopers" 1985 Charlie Riedel (Best11 58b)

car on fire in street in "Miami Haitians protest the arrest of Haiti President Jean-Bertrand Aristide" 1991* Charles Trainor (Best17 107a)

Chileans being spread with water cannons in "After anti-government rallies in Santiago, government responds with water cannons and a barrage of tear gas" 1988* Anthony Suau (Best14 56a)

crowd burns effigy in "Demonstrators burn an effigy of Uncle Sam, Tehran" 1979 P. Ledru (Life 161)

crowd carrying signs to "Bring Home the *Missouri*" in "Supporter of the USS *Missouri* peers through an open door at San Francisco's City Hall during a rally by ship workers" 1988 Brant Ward (Best14 14d)

crowd of farmers yelling in "These men were among some 600 farmers who shouted 'No Sale!' at a foreclosure auction of land" 1985 Thomas Dodge (Best11 59c)

crowd of people with signs, protesting forced school busing in "Busing in Louisville" 1975 *Courier-Journal* (Capture 93)

crowd to impeach the "red mayor" in with flag from [series *Protest in the 1960s*] 1969 W. Eugene Smith (Decade 77)

death penalty opponents hug each other in "Three opponents of capital punishment hold an early morning vigil outside the prison to mourn Raulerson's death" 1985 Bill Wax (Best11 115b)

elderly couple holding white crosses in "In Audubon, Iowa, a farm couple holds crosses in silent protest during bankruptcy hearing" 1985 Mel Evans (Best11 60a)

fire fighters hosing demonstrators sitting at curb in "Birmingham demonstration" 1963 Charles Moore (Best14 218; Eyes #271; Marien \6.69)

group of Filipino students carrying wounded student in "Student protestors rush a wounded comrade along a Manila street to a hospital" 1985 John Kaplan (Best11 75d)

Korean students propelling rocks in [Korean student protestors with slingshot and firebomb] 1987* Nathan Benn (Best13 24b, 25d)

large demonstration of students in "U.S. embassy. Tehran, Iran" 1979 M. Sayad (Eyes #349)

line of marchers on hilltop in "A march for integration in Selma, Alabama" 1968 James H. Karales (Lacayo 149)

line of people walking in road in "Participants in the Great Peace March trudge under a hot Iowa sun" 1986 Manny Crisostomo (Best12 139b)

line of tractors traveling through farms in protest in "Six miles of tractors move from Kismet, Kan., to Plains, Kan., in concert with national farm demonstration" 1985 Frank Niemeir (Best11 61)

looking down on marching crowd in "To the Demonstration" 1932 Alexander Rodchenko (Art \228)

man putting flowers in gun barrels of police in "Antiwar protest at the Pentagon" 1967 Bernie Boston (Goldberg 172; Life 158)

masked men with arms raised in "Demonstrating against U.S. presence in the Philippines, held in front of Clark Air Force Base" 1985* Susan Meiselas (Eyes \24; Rosenblum \10)

masked people being sprayed with water in "Demonstrators in Santiago, Chile, recoil from water cannons and tear gas fired by forces of Gen. Augusto Pinochet" 1988 Anthony Suau (Best14 180a)

men fighting in the street in "Anti-Noriega protestors battle riot police from a rooftop" 1988 Christopher Morris (Best14 179d)

men listening to speaker in "Beleaguered Nebraskans listen impassively to federal officials explaining their financial prospects" 1985 Mel Evans (Best11 60b)

men with hands raised at gate in "Peasants arriving at a protest in front of the U.S. embassy, Teheran" 1979 Gilles Peress (Eyes #321)

Mexican men marching in large hats in "Workers' Demonstrations, Mexico" 1928 Tina Modotti (Icons 45; Women \50)

monk burning to death in "A Buddhist monk burns himself to death to protest the Diem government in South Vietnam" 1963 Malcolm Browne (Goldberg 162; Lacayo 129)

Olympic runners raising black-gloved hands in "Olympic racial protests" 1968 Photographer Unknown (Eyes #282)

people gathering in street as seen from a balcony in "Assembling for a Demonstration" 1928 Alexander Rodchenko (Szarkowski 210)

people standing on wall in Iran in "Pro-Shariatmadari demonstrations, Tabriz" 1979 Gilles Peress (Eyes #322)

police arresting a protester in "Police arrest an anti-apartheid protester on the University of California campus in Berkeley" 1986 Doug Atkins (Best12 54c)

police beating a striking worker in "A striking janitor is clubbed by Los Angeles police officers after breaking through police lines during a protest march" 1990* Bernardo Alps (Best16 111)

police grabbing student in "When students on the University of California's Berkeley campus refused to disperse after a week-long anti-apartheid sit-in, the arrests begin" 1985 Tom Van Dyke (Best11 106a)

police officer standing in front of a crowd of men with placards in "Street Demonstration, San Francisco" 1933 Dorothea Lange (MOMA 136)

posters with photographs in "Posters in front of the U.S. embassy, Teheran" 1979 Gilles Peress (Eyes #323)

protestors behind policeman in "Street Meeting, San Francisco" 1937 Dorothea Lange (Decade 38)

riot police behind barriers as student sprays flames at them in "South Korean student squares off in a duel with riot police during an anti-government demonstration at Yonsei University in Seoul" 1987* Itsuo Inouye (Eyes #366)

row of Chinese tanks blocked by one man in "One man blocking a line of Chinese government tanks" 1989* Stuart Franklin (Lacayo 165)

signs to save the drinking age in "Signs do the talking at a rally in Milwaukee to protest raising Wisconsin's legal drinking age" 1986 Gary Weber (Best12 183a)

sitting on rock-filled street in "Student protestors at Seoul University" 1987* Charlie Cole (Best13 27d)

student being carried off by riot police in "South Korean riot police arrest a student protestor during May demonstrations in Central Seoul" 1987* Anthony Suau (Best13 84a)

student being dragged by security in "Campus security in Middletown drag one of 130 protestors from the steps of Wesleyan University's administration building" 1985 Skip Weisenburger (Best11 106c)

students backing riot police into a corner in "Demonstrators overwhelm police in downtown Seoul" 1987* Nathan Benn (Best13 27a)

students in "Kent State Demonstration, Washington, D.C." 1970 Garry Winogrand (Goldberg 168)

The Thinker holding protest sign in "Replica of Auguste Rodin's statue, *The Thinker*" 1985 Durell Hall, Jr. (Best11 175d)

thousands of people gathered in large square in St. Petersburg in "Demonstration by Revolutionary Democrats, Petrograd" 1917 Photographer Unknown (Marien \4.76)

Veterans carrying anti-war signs in "Union Square, New York" 1967 Benedict J. Fernandez (San #310)

women marching with linked arms in "Women's rights march on Fifth Avenue, New York City" 1970 John Olson (Life 159)

PULITZER PRIZE PHOTOGRAPHS

addict mother holding child on her lap in "Orphans of Addiction" 1997* Clarence J. Williams III (Capture 186)

Adlai Stevenson sitting on chair, reading notes, with hole in shoe in "Adlai Bares His Sole" 1952 William M. Gallagher (Capture 30)

African American man lying on street, screaming in pain in "James Meredith Shot" 1966 Jack R. Thornell (Capture 58)

African American students armed with rifles, leaving a building in "Racial Protest at Cornell University" 1969 Steven Starr (Capture 70)

African man beating another man who has been set on fire in "Human Torch" 1990* Greg Marinovich (Capture 160)

American solider trying to protect man on ground from crowd in "Crisis in Haiti" 1994 Carol Guzy (Capture 174)

Angolan soldier with anti-tank weapons, standing in truck in "War-Torn Angola" 1984* Larry C. Price (Capture 133)

arm, coated in mud, reaching out from body trapped in mud in "Volcanic Mudslide in Colombia" 1985* Carol Guzy and Michel duCille (Capture 140)

armed federal agents near child in closet in "Elian" 2000* Alan Diaz (Capture 198)

armed soldiers dragging away bodies in "El Salvador: The Killing Ground" 1982 James B. Dickman (Capture 125)

Babe Ruth looking at teammates and cheering fans in stadium in "Babe Ruth Retires No. 3" 1948 Nathaniel Fein (Capture 22; Goldberg 81)

begging for water, men in small boat in "Water" 1942 Frank Noel (Capture 10)

black men forced into push-up stance by white man with gun in "Anti-Guerrilla Operations in Rhodesia" 1977 J. Ross Baughman (Capture 104; Eyes #364)

Bomber just missing small plane which is flying upside down in "Air Show High Drama" 1949 Bill Crouch (Capture 24)

bombing victims being pulled from building in "Nairobi Embassy Bombings" 1998* Sayyid Azim (Capture 190)

boy in red sweater talking to President Clinton at counter in "Small Talk" 1992* Greg Gibson (Capture 168)

burned faces and hands of students in fire in "After the Fire" 2000 Matt Rainey (Capture 200, 201)

Robert Jackson (Capture 52; Eyes #286; Lacayo 142; Marien \6.103)

man holding gun on man with knife at woman's throat in "Hollywood Fatality" 1973 Anthony K. Roberts (Capture 85)

man in glasses holding a document in "1970s Washington Lifestyle" 1974 Matthew Lewis (Capture 88)

man in white shirt and tie dancing on stage with young women in "Yeltsin Rocks in Rostov" 1996* Alexander Zemlianichenko (Capture 182)

Marines raising American flag in rubble in "Old Glory Goes Up on Mount Suribachi" or "Raising the Flag at Iwo Jima" 1945 Joe Rosenthal (Capture 16; Eyes #212; Lacayo 118; Marien \5.86; Monk #29; Photos 65)

Mexican men swimming to the United States in "Mexicans Cross Rio Grande" 1984 Stan Grossfeld (Capture 136)

migrant worker man in field, carrying tall, filled basket on his shoulder in "Migration to Misery" 1969 Dallas Kinney (Capture 69)

migrant worker woman, with unlaced sneakers, sitting on her stoop in "Migration to Misery" 1969 Dallas Kinney (Capture 68)

model, football players, addict shooting up, man with snake in "Age '21' in America" 1991 John Kaplan (Capture 164e)

mother holding emaciated and starving child on her lap in "Ethiopian Famine" 1984 Stan Grossfeld (Capture 135; Eyes #347)

naked young girl running and screaming on road, followed by soldiers in "Vietnam–Terror of War" or "South Vietnamese Children Burned by Napalm" 1972 Nick Ut (Capture 80; Eyes #297; Lacayo 157d; Marien \6.74; Monk #44; Photos 134)

newborn baby with parents at moment of birth in "Moment of Life" 1972 Brian Lanker (Capture 82)

ocean liner plunging beneath the sea in "Sinking of *Andrea Doria*" 1956 Harry A. Trask (Capture 38)

Olympic winner greeted in front of large American flag by teammates in bleachers in "Olympics in Los Angeles" 1984* Hal Stoelzle (Capture 130)

overhead shot of smoke billowing from plane that crashed into a house in "Bomber Burns After Crash in Yard" 1955 George Mattson and *Daily News Staff* (Capture 36)

Palestinian women angry after a massacre in a refugee camp in "Angry Scene at Sabra" 1982 Bill Foley (Capture 122)

people standing on top of 4-story statue in the Philippines in "Ferdinand Marcos Takes a Fall" 1986 Kim Komenich (Capture 145)

people walking near burned-out cars and trucks near Tiananmen Square in "Freedom Uprising" 1989* David C. Turnley (Capture 155b)

picketers assaulting man with coat over his head in "The Picket Line; Ford Plant, River Rouge, Michigan" 1941 Milton Brooks (Capture 8; Lacayo 91)

pilot-cowboy flying a helicopter in "The American Cowboy" 1979 Erwin "Skeeter" Hagler (Capture 113)

police officer leaning over to speak to boy in "Faith and Confidence" 1957 William C. Beall (Capture 41)

priest bending over kneeling man, near firing squad in "Castro Firing Squad Execution" 1959 Andrew Lopez (Capture 45)

Reagan, immediately before and after being shot in "Assassination Attempt" 1981 Ron Edmonds (Capture 118-119)

refugee child being passed through barbed wire at refugee camp in "Fleeing Kosovo" 1999* Carol Guzy (Capture 197)

retarded man, lying naked in one of a roomful of cribs and beds in "Illinois State Schools for the Retarded" 1970 Jack Dykinga (Capture 74)

returning soldier hugging young daughter, with wife and son looking on in "A Hero's Return" 1943 Earle L. Bunker (Capture 14; Eyes #208)

Romanian men flashing victory sign in "Freedom Uprising" 1989* David C. Turnley (Capture 154)

row of wooden crosses at sunset in "Columbine" 1999* Rudolpho Gonzalez (Capture 194)

shirtless man running from house after murdering his wife in "Tragedy on Sanatoga Road" 1978 Thomas J. Kelly III (Capture 106)

small flags near woman sitting on ground, hugging tombstone in "Memorial Day" 1983* Anthony Suau (Capture 129)

soldier in poncho, sleeping on sandbags in rain in "Vietnam–Dreams of Better Times" 1967 Toshio Sakai (Capture 62)

South Vietnamese general shooting a Viet Cong prisoner in the head in "Viet Cong Execution" or "Execution of a Viet Cong Suspect, Vietnam" 1968 (Capture 64; Eyes #300-302; Goldberg 174; Lacayo 156; Marien \6.72; Monk #42; Photos 115)

South Vietnamese soldier, with a knife, threatening Viet Cong collaborator in "Vietnam–Crime and Punishment" 1964 Horst Faas (Capture 54)

starving child huddled on ground while a vulture waits in "Waiting Game for Sudanese Child" 1993* Kevin Carter (Best19 195; Capture 172; Lacayo 180)

student who was lynched, being beaten with a chair in front of crowd in "Brutality in Bangkok" 1976 Neal Ulevich (Capture 96)

teenagers kissing in classroom in "Class Act in Southwestern High" 1987-1988 Manny Crisostomo (Capture 152)

telephone lineman doing "mouth-to-mouth" on other lineman who is dangling from a pole in "The Kiss of Life" 1967 Rocco Morabito (Capture 61)

truck plunging over bridge, as driver is rescued in "Rescue on Pit River Bridge" 1953 Virginia Schau (Capture 33)

two girls falling off broken fire escape in "Boston Fire" 1975 Stanley J. Forman (Capture 95)

veteran wearing rain poncho, in wheelchair, holding small child in "Moment of Reflection" 1976 Robin Hood (Capture 101)

Vietnamese mother and children swimming to safety in "Vietnam–Fleeing to Safety" 1965 Kyoichi Sawada (Capture 56)

view of inmates in prison cells in "Jackson State Prison" 1980* Taro M. Yamasaki (Capture 114)

warship in the water, just beyond a ferris wheel in "War in Lebanon" 1983 Stan Grossfeld (Capture 126)

waves, the height of the lighthouse, crashing around it, in "Blizzard Rams New England" 1978 Kevin Cole (Capture 108)

white student striking African American man with flag pole as crowd watches in "The Soiling of Old Glory" 1976 Stanley J. Forman (Capture 98; Eyes #309; Lacayo 128)

woman jumping to her save herself from hotel fire in "Death Leap from Blazing Hotel" 1946 Arnold E. Hardy (Capture 19)

woman lying among rubble in "A dying woman lies amidst volcanic mud and Armero's rubble" 1985 Carol Guzy (Best11 17)

women runners from Nigeria, yelling for joy in "Olympics in Barcelona" 1992* Ken Geiger (Capture 167)

young Japanese man using Samurai sword to kill older man in "Assassination of Asanuma" 1960 Yasushi Nagao (Capture 46)

young woman screaming over the body of a dead student in "Kent State Massacre" or "After the massacre of students at Kent State University" 1970 (Capture 72; Eyes #311; Goldberg 180; Lacayo 145; Marien \6.73; Monk #43; Photos 129)

PUMPING MACHINERY

intricate roof over well pump in "Maine Pump" 1933 Walker Evans (MOMA 138)

woman pumping water into bucket in "Mrs. Ted Pope" c. 1905 Elizabeth Ellen Roberts (Sandler 13)

PUNK CULTURE

punkers and their dress in "Julie, the punk–Lifestyle" 1986 Donna Terek (Best12 82-83)

PYRAMIDS

men climbing up side of pyramid in "Ascending the Great Pyramid" c. 1878 Henri Béchard (Rosenblum2 #178)

pre-Columbian pyramid in Mexico in "Pirámide del Sol" 1923 Edward Weston (San \4)

pyramids in [Egyptian pyramids] c. 1995* Sheila Metzner (Graphis96 157c)

three large, two small pyramids in "Pyramids from the Southwest, Giza" 1858 Francis Frith (Art \130)

view from a distance in "The Pyramids of Dahshur" 1858 Francis Frith (Lacayo 26a; Szarkowksi 77)

—Q—

QUARRIES AND QUARRYING

men with sledge hammers on large rocks in "Quarrying Granite for the Mormon Tabernacle, Cottonwood Cañon, Utah" c. 1870-1872 Charles Roscoe Savage (Photography1 #V-3)

QUEEN MARY (STEAMSHIP)

smokestacks of ship from [article about the ocean liner *Queen Mary* permanently anchored at Long Beach] c. 1989* Stephan Erfurt (Graphis89 \74)

tables on deck of ship from [article about the ocean liner *Queen Mary* permanently anchored at Long Beach] c. 1989* Stephan Erfurt (Graphis89 \75)

—R—

RCA BUILDING (New York, New York)
 view from street, straight up side of building in "RCA Building" 1950 Charles Sheeler (Decade \58)
RACETRACK
 horse catching up to harness driver in "At the Monticello raceway in upstate New York, a harness driver barely stays ahead of the second-place horse" 1997* Bill Frakes (Best23 170b)
 horses and riders on dirt track in "Picnic Day Races in Queensland, Australia" c. 1990* Oliver Strewe (Graphis90 \247)
 horses walking before crowd in "Before the race, Hialeah Park" 1939 Marion Post Wolcott (Documenting 183a)
 jockey falling off horse in "Jockey Jack Kaenel leaves his mount, Years of Fun, in the second race of opening day at Hollywood Park" 1986 Steve Dykes (Best12 223)
 jockey on racehorse in "Thunder Gulch wins the 1995 Kentucky Derby" 1995* Bill Frakes (Best21 126a)
 jockey standing on racehorse in "Jockey celebrates atop 40-1 longshot Dare-and-Go as he defeats Cigar" 1996* James D. Baird (Best22 197c)
 people reading newspapers in "At the track, Hialeah Park" 1939 Marion Post Wolcott (Documenting 183c)
RADIOS
 cabinet radio in living room with couple reading and sewing in "Miner who has worked in the mine since he was 14 years old. West Virginia" 1938 Marion Post Wolcott (Fisher 47)
 girl with headphones in "Radio Listener" 1929 Alexander Rodchenko (Art \232)
 soot-covered miner listening to radio in "A more prosperous miner listening to the radio. West Virginia" n.d. Marion Post Wolcott (Fisher 48)
 woman sleeping near radio and alarm clock in [Girl lying on bed, near radio] 1943 Esther Bubley (Fisher 104)
RAILROADS AND RAILROAD STATIONS *see also* LOCOMOTIVES
 an approaching train at area with four tracks in "New Main Line at Duncannon" 1906 William Rau (Rosenblum2 #186)
 bridge with train at base of a mountain in "Scottish railway bridge" c. 1989 Albert Watson (Graphis89 \76)
 bridge with train over Niagara River in "Niagara Suspension Bridge" 1859 William England (Rosenblum2 #174)
 car used as tourist site in "Students on Field Trip" 1899 Frances Benjamin Johnston (Sandler 73)
 commuters reading newspapers about Kennedy assassination in "Commuters on a train to Stamford, Connecticut" 1963 Carl Mydans (Lacayo 143c)
 construction of railroad track in "Construction of the Railroad at Citadel Rock, Green River, Wyoming" 1867-1868 Andrew J. Russell (Rosenblum2 #185)
 controls for railroad tracks in "In the interlocking tower, where inbound and outbound traffic is controlled" 1943 Jack Delano (Documenting 285c)
 couple with luggage, talking in "In the concourse" 1943 Jack Delano (Documenting 293c)
 covered wagons on flatbed railroad cars in "Train on Embankment, Granite Cañon" 1868-1870 A. J. Russell (Photography1 #III-6)
 family with luggage in "Greeting relatives" 1943 Jack Delano (Documenting 284a)
 female telephone operators on the telephones in "Timetable information room" 1943 Jack Delano (Documenting 288a)
 filled freight cars in yard in "Railroad Yard, Superior, Wisconsin" c. 1945 Esther Bubley (Sandler 162)
 freight cars in "Rail and Clouds" 1997 Ron Tarver (Committed 212)
 freight cars filled with coal at mining camp in "Coal mine tipple in foreground. Caples, West Virginia" 1938 Marion Post Wolcott (Fisher 50)
 freight cars and railroad station in "Depot, Leavenworth" 1867 Alexander Gardner (Photography1 \50)
 freight cars and tracks from a distance in "Maunch Chunk, From the Mountain Line, L.V.R.R." 1891-1893 William Rau (Photography1 \79)
 freight cars in front of grain elevators in "Boxcar and grain elevators" 1938 John Vachon (Documenting 104a)
 gateman in uniform in "Gateman Charles Sawyer, who serves as an interpreter for speakers of Yiddish, Polish, German, Russian, Slovak, and Spanish" 1943 Jack Delano (Documenting 282a)
 headless skeleton dumped by railroad tracks in "War-torn El Salvador" 1984* Larry C. Price (Capture 132)
 India's last steam trains and the people who ride and service them, photo essay in "India's last steam trains" 1996 Stephen Dupont (Best22 250-251)
 line at the ticket counter in "Lining up for train reservations in the concourse" 1943 Jack Delano

waiting room with wooden benches in "Main waiting room at 1 a.m." 1943 Jack Delano (Documenting 292a)

wrecked train engine dangling in midair in "An almost incredible train accident at the Montparnasse Railroad Station" 1891-1895 Burton Holmes (Eyes #67)

young men and older man waiting on bench in "Contrasting lifestyles of two generations" c. 1991* Robert van der Hilst (Graphis91 \225)

RAINBOW

ending at church spire in "God's Light" 1996* Tom Copeland (Best22 185a)

over bridge and man on bicycle in "A cyclist is treated to a rainbow as he rides to work" 1993* Christopher Anderson (Best19 70)

RAINFALL

prostitutes with umbrellas standing in the rain in "Prostitutes look for customers on a rainy night" 1995 Nancy Andrews (Best21 186a)

seated women caught in rain in "Women caught in monsoon rains, Bahir" 1967* Raghubir Singh (Photography 111)

soldier in poncho, sleeping on sandbags in rain in "Vietnam–Dreams of Better Times" 1967 Toshio Sakai (Capture 62)

umbrellas folding in rain in "As umbrellas collapse, a crowd races for the Connecticut state capitol during an April storm that dumped up to 5 inches of rain on the area" 1987 Tony Bacewicz (Best13 124d)

RAMS

jumping off the ground in "A high-jumping ram" 1985 Bob Nandell (Best11 155b)

RANCHOS DE TAOS (New Mexico)

stucco church in "Los Ranchos de Taos Church" 1939 Laura Gilpin (Sandler 124); 1930 Laura Gilpin (Decade 40a); c. 1930 Ansel Adams (Decade 41c); 1931 Paul Strand (Decade 40b); c. 1989* Doug Keats (Graphis89 \106-\109)

RASTAFARI MOVEMENT

elderly women posing in "Women of Rastafari, Jamaica" 1983 Collette Fournier (Willis \366)

RAYS (FISHES)

swimmers around a manta ray in "Snorkelers surround a manta ray, a friendly member of the shark family, in the Flower Garden Banks of the Gulf of Mexico" 1998* Flip Nicklin (Through 416)

swimming in [a ray swimming] c. 1997* Henry Horenstein (Graphis97 175b)

with black background in "Southern Stingray" c. 1999* Mark Laita (Photo00 227)

READING

Adlai Stevenson sitting on chair, reading notes, with hole in shoe in "Adlai Bares His Sole" 1952 William M. Gallagher (Capture 30)

commuters reading newspapers about Kennedy assassination in "Commuters on a train to Stamford, Connecticut" 1963 Carl Mydans (Lacayo 143c)

diners reading newspapers declaring war in "America gets the news: War in the Gulf" 1991* Steve Liss (Lacayo 175c)

elderly woman pointing at hymns in "Grandmother's Hands: #1 with hymnal" 1993 Cary Beth Cryor (Willis \201)

Hispanic couple reading from a catalog in "Considering the purchase of a sixty-dollar harness in a mail-order catalog" 1943 John Collier, Jr. (Documenting 306b)

lobsterman sitting on lobster traps near buoys on building walls from [ad for *The New Yorker*] c. 1990* Dennis Manarchy (Graphis90 \82)

man in deep-sea diving suit reading newspaper in [ad for the *Daily Mail*] c. 1990* Art Kane (Graphis90 \104)

man reading book on beach chair in "Taking advantage of warm weather" 1997* Richard Hartog (Best23 195b)

man reading newspaper at bus stop in snow storm in "Foul weather doesn't stop avid reader as he waits for a bus during a spring snowstorm" 1987 Barry Gray (Best13 125)

man sitting by wheel in "Gandhi Beside His Spinning Wheel" 1946 Margaret Bourke-White (Icons 103; Monk #34; Photos 71)

Mexican man in hat reading page from newspaper in "Campesino" 1949 Nacho Lopez (Marien \6.8)

mother and child reading the *Bible* at church in "A young boy receives some help reading the *Bible* from his mother inside Grace Community Church" 1987 Bill Greene (Best13 128b)

old man reading in rocking chair in "Reverend Brown" 1980 Keith Calhoun (Committed 60; Willis 263)

seated men reading paper in "California News" c. 1850 Gabriel Harrison (Photography1 \27)

Tajik children are seated near door and reading books in "Tajik children go over class notes before school in a mountain village of China's Xinjiang Province" 2001* Michael S. Yamashita (Through 168)

woman reading to child under a tree in "The Picture Book" 1903 Gertrude Käsebier (Rosenblum2 #356;

Sandler 48)

young girl reading a book by a window in "Reading" c. 1900 Alice Austin (Rosenblum \77; Sandler 64a)

RECREATIONAL VEHICLES

lined up at edge of desert race track from [article entitled "Myths of Sand and Stone: The Desert"] c. 1989* Richard Misrach (Graphis89 \90-\91)

REFUGEES

African children by tattered walls in "Rwanda Children in Refugee Camp in Tanzania" 1995 Eli Reed (Committed 179)

Albanian supported by friends in "Six months as a refugee, Albanian returns to find his home in ruins" 1998 Dayna Smith (Best24 30a)

Albanians fleeing to Italy fill ship and the entire dock in "Albanian Refugees" 1991* Luca Turi (Photos 170)

Bosnian Muslim women walking with children and with old people in wheelbarrows to escape a massacre in "Muslim Expulsion" 1995* Nick Sharp (Photos 177)

Chechen children playing near train cars in "Refugee children from Grozny play on a platform next to the train cars in which they live with their families" 1995* Olga Shalygin (Best21 182b)

child waiting on medical line in "In Zaire, a young Rwandan refugee waits in line outside a medical tent for treatment" 1997* Radhika Chalasani (Best23 187d)

children and women standing in a line in "As a thunderstorm approaches, Ugandan refugees wait for the French Red Cross to test them for sleeping sickness" 1987 John Tlumacki (Best13 77d)

children dressed in heavy clothes, bent-over with heavy packs in "Refugees on railroad tracks en route to Gradletza, Serbia" 1918 Lewis Wickes Hine (Eyes #63)

cots in a gymnasium in "In Zagreb, refugees from Eastern Croatia find shelter in this camp" c. 1992* Wilfried Bauer (Graphis93 59d)

crowd of families waiting to leave refugee camp in "Fleeing Kosovo" 1999* Lucian Perkins (Capture 196)

elderly woman on bus in "A Hmong woman sobs and clutches a relative's hand as she waits for a bus to leave the Ban Vinai refugee camp in northern Thailand" 1987* Scott Takushi (Best13 28)

endless line of men and women carrying large bundles on their heads and on bicycles in "Trek of Tears: An African Journey" 1997* Martha Rial (Capture 188)

Georgian woman on a helicopter in "When fighting broke out in Abkhazia, Georgian refugees fled to the village of Chuberi where they could board helicopters for safe passage back to Georgia" 1993 Lucian Perkins (Best19 20)

girl holding barbed wire in "A Cambodian girls stares beyond a barbed wire fence surrounding the refugee camp where she lives in Thailand" 1987 Bill Greene (Best13 2)

girl in hammock in "Khmer Rouge refugee girl awaits treatment in a crowded hospital" 1985 Jon Warren (Best11 161a)

guards beating women on the ground in "Somalian refugees in the Kebre Beyah camp in Ethiopia are beaten by a guard after trying to storm the food lines" 1991 Ronald Cortes (Best17 105)

Haitians behind barbed wire fence in "A young Haitian refugee jumps the wire fence surrounding a tent city in Guantanamo Bay, Cuba" 1991* Patrick Farrell (Best17 110a)

Hmong children in "Two Hmong children, a brother and a sister, pose inside Phanat Nikom refugee camp near Bangkok, Thailand" 1987 Bill Greene (Best13 129c)

Hmong children in lines in "Driven from their home in the mountains of Laos, refugees from the ancient Hmong tribe have been living in camps" 1997 Chien-Chi Chang (Best23 234b)

hundreds of refugees fleeing across girders of bombed bridge in "Korean War" 1950 Max Desfor (Capture 27; Eyes #226)

Hutu struggling for help in "Gravely ill Hutu refugee clutches for help in a refugee camp" 1997* John Moore (Best23 127b)

Hutus loaded into and dying on trains as they return to Rwanda in "Lost in Zaire: Hutu Refugees" 1997 Roger Lemoyne (Best23 128c, 205)

Korean mother with child carries belongings on her head in "A Korean mother carrying her baby and her worldly goods flees fighting around Seoul in winter attack on the capital" 1951 Carl Mydans (Eyes #224)

Kurdish families loading up their possessions in photo essay in "Seeking Refuge" 1988 James Nachtwey (Best14 30-31)

Kurdish life in Turkish refugee camps and the death of their children photo essay in "Kurdish Saga" 1991* Anthony Suau (Best17 179-184)

Kurdish people in photo essay on the crowded situation in the refugee camps, children suffering from chemical burns and malnutrition in "No sanctuary" 1991 Bill Snead (Best17 211-218)

large group of people in heavy clothes in "Refugee group, Lescowatz, Serbia" 1918 Lewis Wickes Hine (Eyes #64)

lining up for food in "Palestinian refugees in Baqaa camp in Jordan line up outside the food distribution center for weekly provisions" 1987 Janet Knott (Eyes #357)

malnourished people waiting for food and water in "Sudan's Refugees" 1988 Michael Bryant (Best14 41, 44-45)

man carrying dead child in "A man at Cukurca refugee camp buries his baby, a victim of dysentery" 1991* Steve Rubin (Best17 115b)

man holding child across his arms in "Twenty-five years of warfare continued as Eritereans launched major offensives against Ethiopian troops, killing thousands and forcing thousands more to become refugees" 1988* Anthony Suau (Best14 57a)

men and women in vehicles in "Serb Refugees at Banja Luka" 1995 David Turnely (Goldberg 218)

Muslim mother and child in "A Muslim woman is comforted by her child in a refugee center" 1995 David Turnley (Best21 207a)

nurse working with sick child in "At a Kurdish refugee camp in Turkey, a nurse tends to a child as two brothers sit with their mother, whom they had carried to the camp" 1991 Bill Snead (Best17 109)

photo essay on Cambodian refugees in "Cambodian refugees living along the Thailand-Cambodian border" 1987 Bill Greene (Best13 126, 127)

photo essay on the plight of refugees returning to Rwanda from the camps in Zaire where there was fighting and little food in "Deadly Road Home" 1996 Yunghi Kim (Best22 36-41)

photo essay showing Rwandan refugees boarding trucks and returning to their homes in "Exodus–Rwandan Hutu refugees" 1996 Carol Guzy (Best22 12-17)

refugee child being passed through barbed wire at refugee camp in "Fleeing Kosovo" 1999* Carol Guzy (Capture 197)

rushing to relief helicopter in "Desperate Kurdish refugees in the mountains of Turkey rush the first American relief helicopter for food" 1991* Les Stone (Best17 115a)

Rwandan Hutus boarding a bus in "Rwandan Hutu refugees scramble to board a bus that was transporting them to their home villages after their long exodus home" 1996 Carol Guzy (Best22 147b)

Rwandans walked for months to camps in "Waiting in Jungle" 1997 Radhika Chalasani (Best23 128a, 206)

Rwandans with heavy bundles walking in "Hundreds of thousands of Rwandan refugees stream toward their homeland after leaving a camp in Zaire" 1996* David Guttenfelder (Best22 158c)

Serbs on road clogged with trucks and cars filled with possessions in "In one of the biggest refugee exodus of the century, Serbs from Krayina flee Croatia offensive" 1995 David Turnley (Best21 207c)

Somali woman with camel taking a drink from a kettle in "A Somali woman drinks from a kettle provided by relief workers at refugee camp in Kenya" 1992* Yunghi Kim (Best18 68)

woman lying on a mat in "A refugee's home" 1988 Anthony Suau (Best14 116)

REINDEER

hundreds in concentric circles in a corral in "Twelve hundred reindeer circle each other in a corral north of Nome, Alaska" 1991* Charles Mason (Best17 69a)

thousands of head of reindeer in "For days after the Soviet Union's Chernobyl accident in 1987, reindeer herds in Sweden and Norway were showered with radiation" 1988* Karen Kasmauski (Best14 159)

RELIGIOUS ARTICLES

African American girl looking at a sculpture of the Pieta in "Hill District, Pittsburgh" c. 1994 Ming Smith Murray (Willis \327)

Chinese altar on mountain top in "The Altar of Heaven" c. 1870-1871 John Thomson (Art \127)

Chörten in a field of stones in "Chörten, Ladakh, India" 1985 Linda Connor (Women \186)

Chörtens below the mountains in "Prayer Flag with Chörtens, Ladakh, India" 1988 Linda Connor (Women \187)

clay-like sculptures of women in "Demon Attendants of the Goddess Kali" 1981 Rosalind Solomon (Rosenblum \212)

cross on tall column in "Celts offered sacrifices to one of their gods under this cross" c. 1989* Martin Kers (Graphis89 \73)

dashboard Saint in [dashboard religious icons] c. 1999* David Emmite (Photo00 85)

elephant masks and objects in [Hindus wear mascots shaped as elephants] 1991 Shawn W. Walker (Willis \356)

figure on a cross in a courtyard in "Crucifixion #2" 1994 Joe Harris (Willis \255)

lighted cross over a television [for the Archdiocese of Wichita] c. 1992* Mark Wiens (Graphis93 63)

praying at a statue of Buddha in "Giving Prayer to Buddha" c. 1865 Félice Beato (Art \124)

praying by a crucifix in "On Good Friday, a pilgrim worships in a Jerusalem grotto" 1996* Annie Griffiths Belt (Through 240)

religious pictures with lit candle in "A Beninese boy displays a Christmas ornament he made in school"

1991* Charles Ledford (Best17 83)

Saint holding a crucifix in "Statue of Saint Bruno in the Carthusian Monastery of Our Lady of Miraflores, Burgos" 1853 Charles Clifford (Waking #3)

statue of saint covered with jewelry in "At a summer festival in Boston, Italian Americans honor St. Anthony, whose statute bears offerings for miracles" 2000* William Albert Allard (Through 292)

REPTILES

alligator on a driveway in "Wildlife handler narrowly misses being bitten by a six-foot alligator" 1995* Scott Threlkeld (Best21 165a)

alligator from overhead in "American alligator in the Okefenokee National Wildlife Refuge in Georgia" 1992* Melissa Farlow (Best18 218a)

a tuatara on a rock in "The tuatara, whose name means 'dorsal spine' in Maori, grows up to two-and-a-half feet long and lives only in New Zealand" 2002* Frans Marten Lanting (Through 418)

RESCUE WORK

airplane wreckage strewn on side of mountain in "Rescue crews search the wreckage of a Japan Air Lines 747 in rugged terrain in central Japan" 1985 Itsuo Inoue (Best11 54c)

bombing victims being pulled from building in "Nairobi Embassy Bombings" 1998* Sayyid Azim (Capture 190)

boy and dog in overturned car in "Firefighter helps extricate boy and his dog trapped in their car" 1998* Allen J. Schaben (Best24 30b)

burned faces and hand of students in fire in "After the Fire" 2000 Matt Rainey (Capture 200, 201)

cab of truck plunging over a bridge as driver and passenger being rescued in "Rescue on Pit River Bridge" 1953 Virginia Schau (Capture 33)

child saved from rushing waters by men on safety line in "Rescue workers struggle to keep tiny 1-year-old from falling into rushing waters" 1996* John McConnico (Best22 145)

crowd of rescuers around baby in bandages in "Baby Girl Rescued from Well" 1987 Scott Shaw (Best13 16; Capture 146)

firefighter giving mouth-to-mouth to baby in his arms in "Giving Life" 1988* Ron Olshwanger (Capture 151; Graphis92 \50)

firefighter holding man as they are lowered down the side of a building in "Firefighter Kevin Shea rescues Tony Lewis from a burning high rise" 1991 Michael Norcia (Best17 104d)

firefighter in life vest helping girl in flood waters in "Teen Rescued from Flood Waters" 1996* Annie Wells (Best22 224d; Capture 184)

firefighter rescues a youth caught in a flood in "Firefighter rescues Rene Molina, 17, after a flood-swollen creek in San Antonio swept Molina into submerged trees" 1986 Mike Davis (Best12 41d)

firefighters on roof of building in "Firefighters await the report of a fellow firefighter, who pokes his head through the roof after inspecting an attic fire in an apartment" 1986 Stephanie Gay (Best12 79)

girl caught in mudslide, being helped by rescuers in "Volcanic Mudslide in Colombia" 1985* Carol Guzy and Michel duCille (Capture 141)

helicopter carrying man out of mud in "Colombian police chopper lifts a volcano victim from Armero's mud" 1985 Michel duCille (Best11 16c)

human chain of rescue workers in rubble in "Volunteers form a human chain to remove the bodies of earthquake victims from one collapsed structure" 1985 Eric Luse (Best11 9a)

man running with mud-covered child in "A volunteer yells to alert medical personnel as he rushes a mud-covered child from a helicopter to a Colombian aid station" 1985 Thomas E. Landers (Best11 16a)

missing child returned to parents in "Five-year-old Nathaniel Todd Murphy is surrounded by relieved family members after the boy was returned home" 1986 Bob Westenhouser (Best12 81b)

mouth-to-mouth on infant in "Milwaukee firefighter Dean Thomas revives a 3-week-old infant he rescued from a burning building" 1988 Patrick Murphy-Racey (Best14 73b)

mud-covered naked girl being helped onto stretcher in "Civil defense volunteers assist a young Colombian who survived the mud slide at Armero" 1985* Ira Strickstein (Best11 15b)

mud-covered young girl in "Rescue workers attend the needs of a youngster found buried in the mud at Armero" 1985* Nuri Vallbona (Best11 15d)

pulling man from quicksand in "Reno Young screams in pain as he is pulled from quicksand on the banks of the Ohio River" 1986 Pat McDonogh (Best12 81a)

pulling man from bomb blast in "A victim of a powerful bomb blast is evacuated from the scene of the U.S. Embassy terrorist attack in Nairobi" 1998* George Mwangawni Mulala (Best24 21a)

pulling man from river in "California teenager is clutched by three men who rescued him from the Kern River" c. 1988* Casey Christie (Best14 6b)

pulling woman to safety from truck hanging over a bridge in "Linda St. Germain clings to Bristol Life Saving

Crew member as they are pulled to safety from the wreckage of truck" 1990 Chris Taylor (Best16 113)

rescue worker on ladder in rubble in "Rescue workers carry an 8-day-old baby from the rubble of Benito Juarez Hospital, five days after the building was destroyed" 1985* J. B. Forbes (Best11 7)

telephone lineman doing "mouth-to-mouth" on other lineman who is dangling from a pole in "The Kiss of Life" 1967 Rocco Morabito (Capture 61)

truck rollover and rescuers with driver in "Rescue workers pull a truck driver from wreckage after a rollover" 1993* Allan Detrich (Best19 228a)

whale being loaded onto a stretcher in "Rescuers load an abandoned newborn gray whale on a stretcher" 1997* Bernardo Alps (Best23 119c)

woman being carried out of rubble in "A 26-year-old woman is rescued by Swiss and French volunteers" 1985 Scott R. Sines (Best11 9b)

workers carrying girl on stretcher in "A 12-year-old girl was one of two persons who survived the JAL crash" 1985 Katsumi Kasahara (Best11 54d)

workers digging in rubble after an earthquake in Mexico City in "Volunteers work shoulder to shoulder, searching for survivors in quake debris" 1985* David Wood (Best11 6)

RESTAURANTS AND BARS *see also* DINERS (Restaurants)

accordion playing in a pub in "Musicians in a Prague pub pay tribute to a revered Czech antihero" 1993* James Stanfield (Through 112)

beauty queen and tables and chairs in "Annabelle Lares, Miss Austin 1989" c. 1991* Michael O'Brien (Graphis92 \95)

café with outdoor seating in "Paris Café" c. 1997* Craig Cutler (Graphis97 167)

countertop with condiments in "Untitled" 1980* William Eggleston (Icons 171)

couple about to kiss in "Lovers in a Café on the *Place d'Italie*, Paris" or "*Rue de Lappe*" 1932 Brassaï (Art \284; Icons 53)

couples sitting at booth with table in "Young people in a 'juke joint' and bar in the vegetable section of the Glades area of south central Florida" n.d. Marion Post Wolcott (Fisher 45)

crowded outdoor café in "Café-goers enjoy a pleasant afternoon in Montparnasse" 1936 W. Robert Moore (Through 106)

crowded restaurant in "Restaurant Scene" c. 1940s Charles (Teenie) Harris (Willis \138)

dancing to band in small bar in "Back Room of the Commercial, Friday Night, South Bank" 1983 Graham Smith (Art \400)

dog with man's hands, waiting to order at restaurant window in "Hot Fudge" 1994* William Wegman (Photography 1994)

elderly couple waiting at table from [the series *New Brighton*] c. 1989* Martin Parr (Graphis89 \130)

empty chairs and tables of outdoor café in "Café, *Avenue de la Grande-Armée*" 1924-1925 Eugène Atget (Marien \5.65; Waking #169)

empty tables near walls filled with paintings in "Tootsie's Orchid Lounge, Nashville, Tennessee" c. 1990* Harry De Zitter (Graphis90 \90)

geishas entertaining men seated at table in "In Japan, the life of a geisha still requires hours of preparation before a date" 1985* Jodi Cobb (Best11 46c)

large hall filled with people at tables in "Beer tent at the Munich October Festival" c. 1990* Christiane Marek (Graphis90 \265)

line of men eating at drug store lunch counter in "Drug Store, Detroit" 1955 Robert Frank (Marien \6.39)

man at booth in "Hill District, Pittsburgh" c. 1994 Ming Smith Murray (Willis \329)

man in beach chair being served on patio in "A meal on the sidewalk at the beach" 1939 Marion Post Wolcott (Documenting 185d; Women \115)

meal being served by waiter on airplane in "Passengers on a German Junkers trimotor enjoy first-class service on a flight between Berlin and Amsterdam" 1933 Acme (Through 100)

men and women drinking at bar in "Lumberjacks–Saturday Night, Minnesota" 1937 Russell Lee (MOMA 151)

men at table with bottles and glasses in "Rural Tavern, Puszta, Hungary" 1947 Werner Bischof (Icons 118)

men dancing to fiddle player in "Turkish night club on Allen Street" 1942 Marjory Collins (Fisher 76)

men eating by window in "Cold drinks inside the Red Robin café" 1941 Russell Lee (Documenting 210a)

men eating lunch at counter in "City Lunch Counter" 1929 Walker Evans (MOMA 137)

men eating lunch at counter behind window in "New York, New York" 1931 Walker Evans (Hambourg 57)

men in tuxedos standing by restaurant patrons in "El Morocco, New York" 1955 Dan Weiner (MOMA 198)

men sitting in front of window in "Outside the Red Robin café" 1941 Russell Lee (Documenting 211b)

ornate wall and mirrors in "Oak bar from a more prosperous era" 1938 John Vachon (Documenting 98a)

people at tables and counter in [restaurant] c. 1997* Guy Klopppenburg (Graphis97 156a)

people drinking at bar in "Montana Saturday Nights: Finis" 1936 Margaret Bourke-White (Eyes #168; Goldberg 90)

people smoking at bar table in "I Thought I saw Liz Taylor and Bob Mitchum in the back room of the Commercial, South Bank" 1984 Graham Smith (Art \397)

prostitutes in bar with man and women in "Inside the Big 4, a legal bordello and bar in Nevada" 1992* Chris Johns (Best18 72a)

serving cheese at a party in "Photographic reproduction of Pieter Brueghel's *The Wedding Feast*" c. 1989* Bert Bell (Graphis89 \186)

table with used cups and glasses in "*Café Martinho da Arcada* in Lisbon" c. 1990* Wout Berger (Graphis90 \305)

two men sitting at booth with table in "A juke joint and bar in the vegetable section of the Glades area of south central Florida" 1941 Marion Post Wolcott (Fisher 41)

two women by bar in "Prostitutes in a Bar, Boulevard Rochechouart" 1932 Brassaï (Hambourg 101)

two women in hats and print dresses sitting outside among many empty tables in "Americans Waiting for the CIT Tour Bus, Rome" 1951 Ruth Orkin (Sandler 94)

waiters looking out of windows in "Waiters, St. Moritz" 1932 Alfred Eisenstaedt (Lacayo 86)

waitress behind lunch counter in "Ranch Market, Hollywood" 1958 Robert Frank(Eyes #238; Monk #37)

woman at table with used cups from [ad for Blumarine] c. 1990* Albert Mackenzie Watson (Graphis90 \29)

woman sitting at long table in "Girl sitting alone in the Sea Grill, a bar and restaurant, waiting for a pickup" 1943 Esther Bubley (Fisher 95)

woman wearing a great deal of jewelry sitting at a table in "*Bijou* of Montmartre" c. 1933 Brassaï (Marien \5.28; Rosenblum2 #623)

woman with microphone singing in crowded nightclub in "Café Society, New York" 1943-1947 Gjon Mili (MOMA 168)

RHINOCEROSES

dead rhinoceros near zoo personnel in "Audubon Zoo officials discuss the death of a female rhinoceros" 1990* Bryan Berteaux (Best16 114)

face-to-face rhinos in [East African rhinos in a zoo] c. 1991* Dieter Blum (Graphis92 \227)

in a pen in "Gawk at the Animals" c. 1999* Chip Simons (Photo00 230)

rear view in "Jordy, The Great Indian Rhinoceros" c. 1991* James Balog (Graphis91 \358)

rhino walking toward steam shovel in "Pam, a 5,000 pound rhinoceros went head to head with mechanical monster"1985 Joe Melena (Best11 150d)

tourists riding elephants to follow rhinoceroses in "Low-impact tourism leaves only footprints in Nepal's Chitwan National Park, a former hunting reserve that now is a rhinoceros sanctuary" 1990* Galen Rowell (Best16 11c)

wounded on the ground in "A picture of a black rhino helped illustrate *Where Roosevelt Will Hunt*" 1909 C. E. Akeley (Through 280)

RICHMOND (Virginia)

burned-out buildings in "Ruins of Richmond" 1865 Photographer Unknown (Rosenblum2 #210)

silhouette of the ruins of a city in "Ruins of Richmond" 1865 Alexander Gardner (Lacayo 25b)

RIOTS

carrying away an injured protestor in [a man allegedly shot by police is carried following clashes in Jakarta] c. 1999* Achmad Ibrahim (Photo00 67)

French police in riot gear and student being pursued in "Paris, 1968" Gilles Caron (Eyes #257-258)

mobs fighting in the streets of Moscow in "Red October" 1993* Christopher Morris (Best19 213-216)

picketers assaulting man with coat over his head in "The Picket Line: Ford Plant, River Rouge, Michigan" 1941 Milton Brooks (Capture 8; Lacayo 91)

police in riot gear, with smiley faces on their shields in "South Korean police with riot shields during a demonstration in Masan" 1987* Charlie Cole (Graphis89 \256)

scenes of protestors and police in Indonesia in [portraying the real struggle to oust the corrupt Suharto government in Indonesia] c. 1998* Yunghi Kim (Photo00 73)

street scene of mob during the Native American riots of Philadelphia in "North-East Corner of Third Dock streets, Girard Bank, at the time the latter was occupied by the Military during the riots" 1844 William and Frederick Langenheim (Eyes #4; Rosenblum2 #16)

streets after Watts riot in [series on Watts Riot] 1965 Joe Flowers (Willis \195-\199)

students clashing with riot police in "Student Uprising in Paris" 1968 Photographer Unknown (Photos 117)

RITES AND CEREMONIES *see also* CIRCUMCISION; FUNERALS

adult baptism ceremonies in "Born-again members of a Southside Chicago Baptist Church gather on the shores of Lake Michigan for sunrise baptism ceremonies" 1986 Al Podgorski (Best12 162-163)

adult baptism viewed by large crowd of African Americans in "A view of a 'Daddy Grace' baptism" 1949 Robert H. O'Neill (Willis \115)

African American girls in white dresses and scarfs in "The Prayer, Louisiana" 1986 Chandra McCormick (Willis \266)

African American men, women, and children, waist deep in water in "River Baptism series" 1996 Ken Royster (Willis \338)

African American woman coming out of water in [baptism] 1992 Bob Gore (Willis \292)

African American woman receiving a blessing in "Ella Watson receiving a blessing and anointment from Reverend Smith" 1942 Gordon Parks (Documenting 238a)

African American woman standing with men in knee-deep water in "Baptism, Louisiana" 1986 Keith Calhoun (Willis \259)

African American woman undergoing baptism in "Renee Johnson, after being baptized, rushes into the arms of Mother Arlgo Jordan" 1997 Nancy Andrews (Best23 20a)

African American women and children dressed in fancy Easter clothes in "Easter Sunday, New Orleans" c. 1965 Marion James Porter (Willis \211)

African American women holding flowers in the water in "Remembrance and Ritual: Tribute to the Ancestors of the Middle Passage" 1997 Moira Pernambuco (Willis \376-\377)

African Bushman in a trance in "A Bushman of southern Africa enters a trance state and tries to rid a girl of the evil that caused her to hoard meat" 2001* Chris Johns (Through 264)

African people with drums in "Enskinment, or Inauguration, of a 'Ya Na' (Dagomba Chief), Yendi, Ghana, West Africa" 1974 Juma Santos (Committed 190)

African women in forest in "Bambendjelle women dance to taunt the thieving Enyomo, among dozens of spirits in central Africa's forests" 2000* (Through 242)

American Indian blessing the Pope in "In Phoenix, the pope was blessed by Emmett White, a Pima Indian, in a special ceremony" 1987* Vickie Lewis (Best13 17b)

ashes on forehead of woman in veil in "Ash Wednesday" 1996 Cloe Poisson (Best22 181a)

baptism in the Moscow River in "Russian Baptist minister finishes a ceremony during which 190 people were baptized in the Moscow River" 1993 Lucian Perkins (Best19 15-16)

barefooted men carrying large crosses on their backs in "Pilgrimage from Lumbier, Spain" 1980 Cristina Garcia (Rosenblum \213; Rosenblum2 #713)

black-hooded men holding candles in a cemetery in "A celebration of Easter in Atacama Desert, Chile, reflects an extension of European brotherhood" 1988* David Alan Harvey (Best14 153d)

blessings at uncovered burial site in "African Burial Ground, uncovered in New York City" 1992 Chester Higgins, Jr. (Willis \342)

boy in elaborate clothes in "In the 1920s, Tibetans recognized a six-year-old boy as the living Buddha of Guya" 1928 Joseph Rock (Through 160)

Brazilian women in long lacy white dresses in "The Candomble priestesses of Brazil, in traditional ceremonial gowns, are part of a cult that originated in West Africa and includes animist gods and Catholic saints" 1987* Stephanie Maze (Best13 166)

cannibals near bloody body in "Cannibals undergo bloody and dangerous trial initiation rites near the Septik River in Papua, New Guinea" 1929 F. J. Kirschbaum (Through 434)

circumcision rites where boys decorated with white face paint lay on ground in "Aboriginal boys in Arnhem Land, Australia, wait for a circumcision ceremony to begin" 1980* Penny Tweedie (Through 432)

circumcision rites where costumed men are performing before young boys in "Makishi dancers in western Zambia perform for a group of recently circumcised boys" 1997* Chris Johns (Through 258)

circumcision rites where men on horseback behind other fathers with young boys in "Dancer entertains at circumcision ceremony in Altay mountains of Xianjiang, China, where Kazakh herders gather in summer" 1996* Reza (Through 186)

clergy and parishioners at a mass in [Roman Catholic Church in Russia] c. 1992* Jeffrey Aaronson (Graphis93 52)

crowd looking on at people at river baptism in "Baptism in Kentucky" 1940 Marion Post Wolcott (Sandler 140)

crowd of people holding tall candles in "Festival in Ayaviri, Puno" 1940 Martín Chambi (Rosenblum2 #448)

Ethiopian youth in ceremonial garb in "Young Ethiopian Orthodox deacon is holding a processional cross" 1993 Chester Higgins, Jr. (Willis \346)

exorcism with man and woman at the shore in "Members of Zionist Christian Church perform an exorcism on the shore of the Indian Ocean in Durban" 1992* James Nachtwey (Best18 33)

faith healer with hands on face of African American woman in small church in "Faith healer, Memphis, Tennessee" c. 1960s Ernest C. Withers (Willis \179)

feathers and flowers in a celebration in "Celebrants at the Festival of the Virgin of Guadalupe in Mexico City mix traditional costumes and Roman Catholic images" 1996* Stuart Franklin (Through 346)

formal portrait of adults surrounding a child in "Baptism Celebration to Maria Warma Mercado" 1927 James Van Der Zee (MOMA 128)

girl kneeling in "First Communion, Texas" 1904 Photographer Unknown (Goldberg 17)

girls dressed for their First Communion in "First Communion, Little Haiti, Florida" 1987 Melissa Farlow (Best13 154)

girls walking through mud in their communion dresses in "After their first holy communion girls lead the procession of San Miguel" 1998 Brian L. Plonka (Best24 105)

group of adults with outstretched arms, outdoors in "First Annual Community Baptism for the Afrikan Family, New York City" 1986 Marilyn Nance (Rosenblum \249; Rosenblum2 #693)

Haitian boy with mud on face in "A teenager searches for coins thrown into a sacred mud pit during the Voodoo Festival in Haiti" 1992* Scott Sharpe (Best18 63)

Hmong lives and healing rituals in America in "In America: Hmong mix old and new" 1987 April Saul (Best13 155-157)

Indian woman by statute in "With Goddess Kalima" 2000* Raghu Rai (Photography 114a)

laying of hands in "Laying of Hands: Rev. Valeria Lassiter Offers Prayers During Deacon's Ordination Service at Metropolitan Baptist Church" 1996 Jason Miccolo Johnson (Committed 136)

man and boy lighting candles in "On a holy feast day, an Ixil Indian and his son offer prayers and candles inside the church in Chajul, Guatemala" 1988* James Nachtwey (Best14 152)

man putting child into river in "This child is being baptized into the Zion Christian Church, one of the most popular churches, in a river that runs through Soweto" 1976 Peter Magubane (Eyes #345)

men and women knee-deep in water in "Baptism, South Carolina" c. 1930 Doris Ulmann (Women \28)

men on horseback behind fathers with young boys in "A dancer entertains at a circumcision ceremony in the Altay mountains of Xianjiang, China, where Kazakh herders gather in summer" 1996* Reza (Through 186)

men with ropes parading in street to mortify the flesh in "Sri Lanka: A Continuing Ethnic War Tarnishes the Pearl of the Indian Ocean" 1996* Steve McCurry (Best22 240b)

nude boy shooting an arrow in "A young boy performs initiation rites in Irian Jaya, New Guinea" 1993 Chris Rainier (Best19 68d)

Orthodox Jewish men at river during Yom Kippur in "Yom Kippur–East River, New York City" 1955 Robert Frank (Eyes #241)

photo essay on people in various places of worship in "Religious Row" 1997 Nancy Andrews (Best23 26-27)

piles of unclothed men jumping off a ledge in "Men scramble to find camphor-scented batons tossed to them by a priest at a New Year's celebration in Okayama, Japan" Post-WWII Horace Bristol (Through 188)

procession in cemetery on All Saints' Day in "On All Saints' Day in Plougastel Daoulas, a mass is held for the dead" c. 1989* Martin Kers (Graphis89 \71)

red powder on woman's face in "Celebrants powder their faces for the Ganesh Chaturthi festival in Mumba, formerly known as Bombay" 1997* Steve McCurry (Best23 180)

Saints and *Bible* on dresser in "Home altar on Ella Watson's dresser top" 1942 Gordon Parks (Documenting 239b)

scene from *The Last Supper* in "The Last Supper from *Zion Passion Play*" c. 1947 Harry K. Shigeta (Peterson #11)

seated people in "The Oracle of Sabu in Trance, Ladakh, India" 1988 Linda Connor (Women \189)

South African boy covered in mud in "For about a month before their initiation into manhood, young men in South Africa live outside village, without clothes, covered in clay" 1992* James Nachtwey (Best18 27)

tall woven body covers in "In Urama, Papua New Guinea, tribal elders wear goblin masks to perform certain ceremonial functions" 1927 Frank Hurley (Through 439)

veiled woman by crosses in "He is Risen" c. 1934 Hillary G. Bailey (Peterson #10)

woman with armed raised in "Revival Meeting in a Garage" 1938 Dorothea Lange (Sandler 159)

RIVERS

aerial view of riverbed during a drought in "Boaters on the Ohio River examine the shoreline on the Kentucky side after a record drought dropped water to its lowest level" 1988 Todd Buchanan (Best14 80)

aerial view of sandbar in "A sandbar on the Missouri River appears as a majestic mountain in this aerial view" 1993* Larry Mayer (Best19 73a)

banks of the river in "The Banks of the Nile at Thebes" 1854 John B. Greene (Marien \2.41)

bridge and flat boats on river in "Bridge and Boats on the Thames" 1851 Jean-Baptiste-Louis Gros (Rosenblum2 #9)

colored leaves on colored water in "Pool in a brook, New Hampshire" 1953* Eliot Porter (Icons 115)

crowd looking on at people in river being baptized in "Baptism in Kentucky" 1940 Marion Post Wolcott

(Sandler 140)

dead fish in bottom of drained river in "Trout lie dead in the drained Bridgeport Reservoir in California" 1988 Richard D. Schmidt (Best14 81b)

dugout canoe and standing men in "The fire of dawn lights a path across Africa's Zambezi River where villagers travel in a dugout canoe" 1997* Christopher Johns (Best23 153d)

filled with small wooden boats in "On a branch of the Saigon River, traders sell rice from the Mekong Delta" 1989* David Alan Harvey (Through 176)

flooding of river to city wall in "Flooding of the Rhône at Avignon" 1856 Edouard Denis Baldus (Rosenblum2 #104)

footbridge over river in "A 700-foot-long footbridge bobs and sways over the Zambezi River at Chinyingi, Zambia" 1997* Chris Johns (Through 214)

horse pulling a barge along a river in "A horse tows a grain-and-timber barge along the River Chelmer in England" 1940 Topical Press (Through 36)

in mist in [destruction of the Amazon rainforest] c. 1992* Arthur Meyerson (Graphis93 166)

large building near river and bridge in "The Pavillon de Flore and the Tuileries Gardens" 1849 Marie Charles Isidore Choiselat (Waking #2)

looking across river to trees on far bank in "The Nile" 1853-1854 John Beasley Greene (Waking #67)

man fishing in "Declining salmon runs in the Pacific Northwest have left many fisherman empty-handed, including this Native American dipnetter on the river" 1995* Joel Sartore (Best21 186d)

man sitting on sandbar in "The Heart of Lodore, Green River" 1871 E. O. Beaman (Rosenblum2 #154)

member of the crew beneath the barge on the river in "Man on the Mon–a barge hand at dusk on the Monongahela River" 1991* Randy Olson (Best17 25)

men fishing in "The Wharfe and Pool Below the Stride" 1854-1858 Roger Fenton (Waking #8)

metal boat houses [from the book *Minnesota II*] c. 1992* Richard Hamilton Smith (Graphis93 164)

mist-veiled hills of the Yangtze River Valley in "Wushan Gorge, China" 1946 Dmitri Kessel (Life 182)

man trapped in fast-moving river in "Stranded in the Niagara River" 1853 Platt D. Babbitt (Lacayo 21a)

panoramic view of the city from river in "View of Cincinnati" Attributed to Henry Rohrer c. 1865-1866 (Waking #98)

passing through cliffs in "Black Cañon, Colorado River, Looking Below from Big Horn Gap" 1871 Timothy H. O'Sullivan (Waking 325)

picnic in "Stopping Off for Lunch, Route 143, The Ontelaunee Creek, Near Kempton, Berks County, Pennsylvania" 1931 James Bartlett Rich (MOMA 131)

railroad tracks running along river and rounded mountain in "Entrance to the Highlands, Hudson River" c. 1898 William Henry Jackson (National \42)

rapids on river in "In 1796, a Hudson Bay expedition made the first survey of these rapids on the Fond du Lac River, near the U.S.-Canadian border" 1996* Maria Stenzel (Through 306)

rowboat in river in "Hudson River Landscape" n.d. Seneca Ray Stoddard (Rosenblum2 #144)

rowboat on a flooded river in "Spring flood on the St. Lawrence" 1865 Alexander Henderson (Rosenblum2 #160)

rowboats on a river in "View at Gervanda Looking Downstream from the Bridge" c. 1880 Photographer Unknown (National \46)

rowboats on river bank in "Cape Horn, Columbia River, Oregon" 1867 Carleton Emmons Watkins (Photography1 #V-2)

ships at docks in "Moonlight on the St. Johns River" 1886 George Barker (Rosenblum2 #161)

small boats on the banks in "Sèvres, the Seine at Meudon" c. 1853 Henri-Victor Régnault (Art \71; Rosenblum2 #105)

small boats on the river from [article about the Nile] c. 1990* Richard Misrach (Graphis90 \87-\88)

small boats on tree-lined river in "La Marne à la Varenne" 1925-1927 Eugène Atget (Rosenblum2 #328)

small bridge over river in "Claudy River, County Donegal" c. 1890 Robert French (Rosenblum2 #320)

small river flowing between trees in "Springtime on the Jordan" c. 1942 Thomas O. Sheckell (Peterson #87)

small river with trees and flowers in "A Connecticut River" 1912 William E. MacNaughtan (Peterson #88)

stream in winter in "Woodland Stream, Winter" c. 1900 John Chislett (National 25a)

a suspension bridge over rapids in "The Rapids, Below the Suspension Bridge" c. 1870 Charles Bierstadt (National 2)

train passing river in "Excursion Train and Niagara Rapids, Lewiston Branch, N.Y." 1890 William Henry Jackson (Photography1 \12)

view of river beyond overhang in "Panorama from the Overhanging Cliff, Wisconsin Dells" 1897-1898 Henry Hamilton Bennett (MOMA 58-59; Photography1 \78)

wetlands with birds in "Oklawaha River, Florida" 1886 George Barker (Photography1 #V-12)

ROADS
 covered with leaves and puddles in "Palo Colorado Road" 1952 Wynn Bullock (Decade \62)
 dirt road cutting through fields in "Road, wheat and corn fields. Harvre, Montana" 1941 Marion Post Wolcott (Fisher 52)
 highway destroyed by hurricane in "Family sees what Hurricane Kate did to U.S. 98 near Eastpoint, Fla." 1985 Maurice Rivenbark (Best11 73b)
 highway going up and down hills in "Highway between Gettysburg and Pittsburgh photographed through the windshield of a bus" 1943 Esther Bubley (Documenting 315)
 highway through forest in "Designed for grizzly bears and other wildlife, an overpass provides safe passage across a highway in Alberta, Canada" 2001* Joel Sartore (Through 304)
 unbending two-lane highway to horizon in "The Road West, New Mexico" or "Desert Highway 70: the route on which many refugees cross" 1938 Dorothea Lange (Fisher 15; MOMA 147)
 young boy in cap and white shirt walking in flowers by a dirt road in "The Road to Rome" 1903 Gertrude Käsebier (MOMA 88)
ROCK FORMATIONS
 arches in red rocks in "Arches of the Southwest–Red Rock Canyon" c. 1995* Sheila Metzner (Graphis96 157d)
 red rocks in [Lake Powell, Arizona] c. 1995* Michael Melford (Graphis96 164b)
ROCKS
 balancing rocks in "Martha's Vineyard" 1954 Aaron Siskind (MOMA 188)
 blue rocks in "Maine" 1968* Charles Pratt (Rosenblum2 #774)
 boulder wedged between sides of mountain in "Trapped Boulder, White Mountains" 1859 Franklin White (National 20c, \28)
 boulders on road in "Boulders on the Road to Muddan Mahal" c. 1867 Samuel Bourne (Rosenblum2 #136)
 couple on ledge in "Beaumont and Nancy Newhall, Point Lobos" 1945 Edward Weston (MOMA 33)
 in mist in "Ghost Rock" 1919 Laura Gilpin (MOMA 94)
 pebbles in a pond in "Pebbles and Pool" c. 1995* Chip Forelli (Graphis96 154)
 rock balancing on larger rocks in "Buttes in the Badlands of Eastern Montana" c. 1900 Evelyn Cameron (Sandler 116)
 rocks off an island in "Three Rocks and an Island" c. 1995* Chip Forelli (Graphis96 156b)
 solitary boulder in "Perched Rock, Rocker Cree, Arizona" 1872 William Bell (National Back \29)
RODEOS
 African American cowboys at a rodeo in "Bull's Eye" 1995 Ken Jones (Willis \350); "Mr. Journet's Repose, Houston" 1996 Ken Jones (Willis \348); "Rough Rider, Rodeo Patron at an African American Rodeo" 1995 Ken Jones (Willis \349)
 African American woman riding a horse in "Rodeo Queen, Oklahoma" 1994 Ron Tarver (Willis \426)
 boy practicing roping with a bale of hay in "11-year-old competes against–and beats–adult men on the rodeo circuit" 1992 Kristy MacDonald (Best18 143)
 bull pushing man on ground in "A first-time bull-rider finds out why the sport is more fun to watch" 1996* Rich Riggins (Best22 196c)
 bull stomping on rider in "Bull-rider gets stomped during the final round of competition" 1996* Lennox McLendon (Best22 196d)
 bull throwing a cowboy in the mud of a rodeo in "Cowboy is stunned and wet after being thrown by his bull at the Rodeo Championships" 1997* Christian Fuchs (Best23 171d)
 cowboy riding bronc in "Rump out of the saddle and knees high are what score points in this tough sport" 1995 Denny Simmons (Best21 135a)
 cowboy thrown from bull in "M. Kelly is thrown from El Toro at the Alaska State Fair Rodeo" 1988 Bill Roth (Best14 122)
 fallen cowboy protecting himself from horse in "Dumped by his mount during National Rodeo Finals" 1986 James Kenney (Best12 220)
 rider pinned by bull in "Getting caught under a bull on the final day of a four-day bull-riding school" 1996* Randy Tobias (Best22 196a)
 rider under a horse in "Rich Kinsley goes face to face with his former mount during a bareback riding competition" 1996* M. Scott Moon (Best22 196b)
 underneath a steer in "Wrestling a steer during the National Finals Rodeo" 1987 Jeff Scheid (Best13 200)
 woman mounting a bull in "Suburban Cowboys" 1998* Bill Tiernan (Best24 71c)
ROLLER COASTERS
 men walking the tracks of a roller coaster in "Racer Repairs" 1990* Rob Clark, Jr. (Best16 65)

ROMANIANS
abandoned, ill, and disabled children in institutions in "Ceausescu's Legacy" 1990 James Nachtwey (Best16 151-156)
bodies of small children in "The bodies of AIDS victims lie unclaimed at a hospital in Romania" 1990* Frank Fournier (Best16 197b)
children in small cribs in "An 'irrecoverably' mentally ill boy is confined to a crib in Romania" 1990 James Nachtwey (Best16 196a)
girls with dirty clothes and faces in "Suffering from the effects of pollution and malnutrition, four sisters stand their ground in Copsa Mica, Romania" 1990 Kathi Lipcius (Best16 75)
guard sitting on downed statue of Lenin in "A statue of Lenin is taken down in Bucharest, Romania" 1990* Gad Gross (Best16 200)
mother and children in sparse garden in "A woman in Copsa Mica, Romania, stands in her garden with her children" 1990 William Snyder (Best16 103d)
parents carrying a coffin and a cross through the street in "Romanian parents carry a coffin and a cross to a Bucharest hospital to collect the body of their child, who died of an AIDS-related illness" 1990* Rady Sighiti (Best16 171a)
pig in wagon being pulled in "A Romanian couple haul their pig to a neighbor's farm for breeding" 1990 Anthony Suau (Best16 179)
showing identity cards in order to vote in "An 89-year-old Romanian shows an official her identity papers in order to vote in the country's first free election in over 40 years" 1990 William Snyder (Best16 103a)
violins and bass violin being played on the street in "A three-piece band performs on a Romanian street on Easter" 1990 Anthony Suau (Best16 178)
workers and fields in Romania in "Factory pollution in Romania" 1990 Tomas Muscionico (Best16 161-164)
ROMANIES (used for gypsies)
police beating families in tents in "Swinging their batons, the Omon enter a gypsy camp" 1993 Lucian Perkins (Best19 11-14)
two men in "Gypsies, Seville" 1933 Henri Cartier-Bresson (Hambourg 100)
walking from factory in "Gypsies return home after working in the carbon factory in Copsa Mica, Romania" 1990* Anthony Suau (Best16 9d)
ROME–ANTIQUITIES
Cloaca Maxima part of Rome's drainage system in "Cloaca Maxima" 1858 Robert Macpherson (Waking #73)
columns in Rome in "Night View of the Roman Forum" 1865-1875 Gioacchino Altobelli (Rosenblum2 #128)
part of the exterior wall of the theater in "The Theater of Marcellus, from the Piazza Montanara" 1858 Robert Macpherson (Waking #74)
ROOFS
intricate roof over well pump in "Maine Pump" 1933 Walker Evans (MOMA 138)
looking across rooftops to large church in "Old Roofs, Prague" 1922 D. J. Ruzicka (Peterson #9)
overlooking roofs of town in "View from Hotel Window, Butte, Montana" 1956 Robert Frank (Art \326)
roofs in city in "Untitled (Rooftops)" 1917 Morton Schamberg (Hambourg \4)
roofs over long neon arrow in "Los Angeles" 1955-1956 Robert Frank (MOMA 217)
snow on city buildings in "From the Back Window, '291' New York" 1915 Alfred Stieglitz (Art \201)
woman holding a dove on a rooftop in "In the battle-weary Gaza Strip, a woman holds a symbol of freedom and peace" 1996* Alexandra Avakian (Best22 242a; Through 248)
ROOTS (BOTANY)
undulating roots and undergrowth in "Roots, Foster Gardens, Honolulu, Hawaii" 1948 Ansel Adams (Photography2 30)
ROWBOATS see BOATS AND BOATING
ROYALTY
bride speaking with flower girls in "Queen Elizabeth and her new daughter-in-law, Diana, prepare to greet the public, Buckingham Palace" 1981* Patrick Lichfield (Life 8)
children in matching outfits on palace grounds in "The Royal Family in Buckingham Palace Garden" 1854 Roger Fenton (Marien \3.7)
man being carried through crowd in "In Kumasi, Ghana, Asante sword bearers escort their king on the 25th anniversary of his coronation" 1996* Carol Beckwith and Angela Fisher (Through 256)
Prince Charles and Lady Diana kissing after wedding in "The Royal Wedding" 1981* Photographer Unknown (Photos 151)
Queen's coronation in Westminster Abbey before thousands of people in "Coronation of Elizabeth II" 1953 Photographer Unknown (Photos 81)
walking past saluting guards in "Investiture of the Prince of Wales at Carnarvon Castle" 1911-1912*

Photographer Unknown (Eyes \1)

RUINS *see* ANTIQUITIES; PYRAMIDS

RUNNING

children running in front of apartment house in "Life in Chicago" 1981 John H. White (Capture 120)

girl running in t-shirt next to her father in a suit in "Offering moral support, a father points to the finish line as he runs alongside his daughter at the end of the kid's triathlon" 1997* Lannis Waters (Best23 178a)

man in desert landscape in "Kenyan marathon runner Ibrahim Hussein during training" c. 1992* Gregory Heisler (Graphis93 201c)

man with artificial leg running in front of a police car in "Terry Fox" 1980 Gail Harvey (Monk #46)

men's legs as they run on track in "Athletics" c. 1999* Graham Monro (Photo00 189)

people running after an earthquake in "The second quake rocked Mexico City" 1985 Michael Williamson (Best11 8a)

solitary runner in aerial view of beach and surf in "A runner's tracks add yet another element to the sand-and-surf patterns on Cottesloe Beach in Perth, Australia" 1982* Cary Wolinsky (Through 402)

woman in mid-air in "Evelyn Ashford" c. 1989* Annie Leibovitz (Graphis89 \160)

woman in two-piece bathing suit in "Jackie Joyner-Kersee" 1988 Herb Ritts (Rolling #68)

RUNNING RACES

celebrating winning a race in "Carl Lewis celebrates as he crosses the 100-meter finish line with the fastest time ever recorded" 1992* Bill Frakes (Best18 139)

elderly woman crossing finish line in "The only woman to enter track-and-field events at the senior games" 1985 Dan Root (Best11 221a)

high school boys race up a hill in "Cross-country runners struggle over the top of 'Goat Hill' " 1993 Blair Eliot Kooistra (Best19 142b)

leader looking back at marathon pack in "Early in the Boston Marathon, Partev Popalian looks back as he takes the lead" 1993 Jim Collins (Best19 147)

men bending in a line in [athletes running in race] c. 1997 John Huet (Graphis97 197)

men crossing finish line in "220-yard dash for ages 65-69" 1985 Allen Eyestone (Best11 221c)

runner celebrating his win in "An exhausted Scott Robinson drops with raised fists after winning the men's 1600-meter run at the state track meet" 1987 Genaro Molina (Best13 216d)

runner holding up a sign in the middle of a marathon in "A runner in the Revco-Cleveland 10-K marathon gets her message across" 1986 Richard T. Conway (Best12 225)

track-and-field event in "Phil Foubert grimaces after falling on track during the steeplechase event" 1985 (Best11 205d)

winner of relay race in "Jonathan Drummond of Texas Christian University finishes first in the 400-meter relay at the Penn relays" 1990 Gerard Lodriguss (Best16 123)

winning at track-and-field in "Carl Lewis after winning his fourth gold medal at the 1984 Olympics" 1984* John G. Zimmerman (Life 146b)

woman relay racer crossing finish line in "Penn Relays runner stays on track to finish first in the 400 relay" 1986 Fred Comegys (Best12 142)

woman running in "Marion Jones, the world champion in the 100-meter dash, runs in the woods" 1998* Bill Frakes (Best24 63)

women racing in line in "Maciel Malone and Arlise Emerson run the 400-meter race at the Athletics Congress 1989 national championships in Houston" 1990* Tim DeFrisco (Best16 137a)

RWANDA

barefooted boy and his parents in "A young boy clings to his parents as he waits to cross the border in Rwanda" 1996 Yunghi Kim (Best22 29)

gathering the dead in bulldozers in "At a camp for Rwandan refugees" 1994 James Nachtwey (Lacayo 181)

Hutu man with machete marks on his face in "Tutsi Genocide" 1994 James Nachtwey (Photos 173)

photo essay on the plight of refugees returning to Rwanda from the camps in Zaire where there was fighting and little food in "Deadly Road Home" 1996 Yunghi Kim (Best22 36-41)

photo essay showing refugees boarding trucks and returning to their homes in "Exodus–Rwandan Hutu refugees" 1996 Carol Guzy (Best22 12-17)

series showing rooms full of corpses, land mine victim, and bullet-riddled sign in [documents of the mass murders in Rwanda] c. 1995 Simon Norfolk (Graphis96 60, 66, 67)

—S—

SADDLERY

male model leaning on railing filled with saddles from [self-promotional] c. 1989* Harry De Zitter

(Graphis89 \84)
saddles on a bench and bridle on wall in "From a catalog for saddles and bridles of exceptional quality" c. 1989* Michael W. Rutherford (Graphis89 \227, \228)

ST. PETER'S (BASILICA: Vatican City)
overhead view of St. Peter's in "Inside St. Peter's Basilica, candidates for priesthood lie prostrate in humility as they take their vows during mass celebrated by Pope John Paul II" 1985* James Stanfield (Best11 45c)

SALT
aerial view of multi-colored salt ponds in "Salt producers at Teguidda-n-Tessoumt, in Niger, mix brackish well water with salty earth in large depressions" 1999* George Steinmetz (Through 216)

SALVATION ARMY
girls in street reading books in "Girls' Sunday school class at the open-air meeting" 1939 Dorothea Lange (Documenting 172a)
man playing accordion for singing woman in "Adjutant Nock and his wife" 1939 Dorothea Lange (Documenting 166a)
man playing for Salvation Army in "Salvation Army Lt. Col. Ray Robinson braves wet weather to bring the Christmas spirit" 1985 Eric Luse (Best11 167b)
man with flag in "At the open-air meeting" 1939 Dorothea Lange (Documenting 173b)
men and women by flag in "Selling Easter edition of *War Cry*" 1939 Dorothea Lange (Documenting 166b)
men and women playing in band in "At the open-air meeting" 1939 Dorothea Lange (Documenting 170a)
men kneeling in prayer together in "Altar call" 1939 Dorothea Lange (Documenting 165b)
men on street corner in "Passerby at the open-air meeting" 1939 Dorothea Lange (Documenting 171c)
men reading in hotel lobby in "Return from the open-air meeting, as seen through a hotel lobby" 1939 Dorothea Lange (Documenting 170a)
men sitting on chairs in "Waiting for the service to begin" 1939 Dorothea Lange (Documenting 163a)
men watching a meeting in "Bystanders watching the open-air meeting" 1939 Dorothea Lange (Documenting 169c)
parade of Salvation Army members with flags and accordion in "Marching through downtown San Francisco" 1939 Dorothea Lange (Documenting 167c)
Salvation Army "lassie" collecting money from seated men in "Opening the service with a collection" 1939 Dorothea Lange (Documenting 163b)
Salvation Army members playing guitar for children in "At the open-air meeting" 1939 Dorothea Lange (Documenting 168a)
Salvation Army women sitting on chairs in rows in "Salvation Army 'lassies' at the service" 1939 Dorothea Lange (Documenting 164a)
speaker in front of Salvation Army band in "A soldier with twelve years' Salvation Army service preaches at the open-air meeting" 1939 Dorothea Lange (Documenting 169b)

SAMURAI
archery from horseback in "Japanese bowman keeps alive the samurai art of yabusame, or mounted archery" 1996* Peter Essick (Best22 197c)

SAN FRANCISCO (California)
burned tree on hill above ruins of city in "The Burned Tree" 1906 Edith Irvine (Rosenblum \59)
heavy smoke as seen from water in "San Francisco in flames" 1906 John D. Howe (Marien \4.1)
people in streets after earthquake in "Smoke and flames after the San Francisco earthquake" 1906 Arnold Genthe (Eyes #65; Lacayo 38; Photos 15)
people on hill overlooking smoke and fire in "San Francisco Fire" 1906 Arnold Genthe (Rosenblum2 #586)
skyline seen from deck of bridge in "San Francisco, California, seen from the First Street ramp of the San Francisco–Oakland Bay Bridge" n.d. Dorothea Lange (Fisher 53)
street corner with horse-drawn carriages in "San Francisco, Corner of California and Montgomery Streets" c. 1857 James Ford (possibly Carleton Watkins) (National \9)
street of small stores in "Kearny Street, San Francisco" 1856 George Fardon (Photography1 \37)
three-story building consumed by flames, as men in street watch in "Market Street, San Francisco" 1906 Willard Worden (MOMA 76)
view from hilltop in "Panorama of San Francisco" 1878 Eadweard Muybridge (Photography1 #III-14; Rosenblum2 #165)

SAND DUNES
dramatic colors on dunes in "Death Valley at Dawn" c. 1992* Intae Kim (Graphis93 174a); "Dream in the Desert" c. 1992* Intae Kim (Graphis93 174a); in "Light of Symphony" c. 1992* Intae Kim (Graphis93 174b)
driving a car down the dunes in "Thrill-seekers descend steep dunes at White Sands National Monument in

New Mexico" 1935 G. A. Grant (Through 352)

mounds of sand in various patterns in "Dunes, Oceano" 1934 (Goldberg 4); 1936 Edward Weston (Art \221; Decade 36; Hambourg \117; Icons 75; Life 180; MOMA 116)

multiple images of dunes in "The Great Sand Dunes" 1979 Michel Szulc Krzyzanowski (San \63)

tilted on an angle in "*Düne, Kurische Nehrung, Ostdeutschland*" 1936 Alfred Ehrhardt (San \48)

truck tracks across the dunes in "Tracks on Arid Land, Coral Sand Dunes" 1984* Mark Klett (Decade \XII)

SARAJEVO (Bosnia and Hercegovina)–Siege, 1992-1996

building set on fire in "Return to Sarajevo" 1996* Christopher Morris (Best22 243a)

children playing on bullet-riddled truck in "Traumatized kids play in a bullet-riddled area of downtown Sarjevo" 1996 Tom Stoddart (Best22 249b)

death, bloody street and armed patrols in "Sarajevo, Bosnia-Herzegovina" 1992* Christopher Morris (Best18 60-62)

man with shovel and 3 fresh graves near city in "Cemetery in Sarajevo" 1993* Antoine Gyori (Lacayo 179d)

soldier firing over heads of demonstrators in "A Bosnian soldier returns fire at Serbian snipers during the first peace demonstration by the people of Sarajevo" 1992* Mike Persson (Best18 124b)

SCHOOLS

African American boys building a staircase in "Stairway of Treasurer's Residence, Students at Work, The Hampton Institute, Hampton, Virginia" or "Student Carpenters" 1899-1900 Frances Benjamin Johnston (MOMA 67; Rosenblum2 #443; Sandler 74; Women \22)

African American boys in shoe-making classroom in "Cobblers Class" 1902 Frances Benjamin Johnston (Sandler 4)

African American children in hats and aprons in cooking class in "Cooking class, Armstrong High School" c. 1925 Browns' Studio (Willis \33)

African American children looking at a Native American in a classroom in "Class in American History" 1899-1900 Frances Benjamin Johnston (Photography1 \93)

African American children sitting at desks with typewriters in "Typewriting club, Armstrong High School" c. 1930 Browns' Studio (Willis 31)

African American men, women, and children posing for group picture in front of building in "New Rising Star School, Macon County, Alabama" n.d. C. M. Battey (Willis \40)

African American physician teaching students at patient's bedside in "Dr. Charles Drew, a surgeon, teaching at Freedmen's (now Howard) University Hospital" c. 1936 Scurlock Studios (Willis \112)

African American women in uniforms seated at long tables in "Domestic Services Class, Tuskegee Institute" c. 1917 C. M. Battey (Willis \38)

boy sitting with dunce cap in "Kids were re-enacting an average 1924 school day as part of a history unit" 1998 Bill Greene (Best24 107b)

child standing at blackboard in "First grader gets teary as she tries a math problem in front of class" 1998 Susan Biddle (Best24 86)

children tossing coins on the ground near a small school in "Village schoolchildren in Ecuador play a coin-toss game during recess" 1991 Candace B. Barbot (Best17 197)

classroom filled with children at their desks in "The sixth-grade current events class" 1942 Marjory Collins (Documenting 272a)

exterior of city school in "Arsenal and Cupola, Philadelphia Central High School" 1839 Joseph Saxton (Rosenblum2 #14)

father showing globe to daughter in "Brethren Family" 1998* Randy Olson (Best24 93a)

field trip note-taking on each other's backs in "Elementary school children take notes on a field trip at a local nature preserve" 1987 Leland Holder (Best13 122d)

girls around man with globe in "Geography Lesson" 1851 J. F. A. Claudet (Marien \2.51; Rosenblum2 #31)

girls behind music stand playing recorders in "Playing their recorders during the last day of school" 1998 John Freidah (Best24 36a)

girls dancing under portrait of Lenin in "Preschoolers at Khabarovsk's kindergarten rehearse for a pageant under the watchful eyes of 'Uncle Lenin'" 1987* Dilip Mehta (Best13 162b)

handprints of chalk on blackboard in "Young Kenyan girl, responsible for erasing the blackboard, plays with the chalk residue instead" 1996 Carol Guzy (Best22 271c)

large window behind boy writing at desk in "Mathematics Detention, Secondary School, Cleveland" 1983 Ian MacDonald (Art \387)

line of police cadets in "Commemorative Picture of Teachers and Students of Loyang Police School, Hunan Province" 1997 Zhuang Hui (Marien \7.21)

man teaching rows of children sitting on benches in "Mr. Hale from Snow Hill conducting school in the Pleasant Grove Baptist Church building" 1937 Arthur Rothstein (Documenting 158a)

men and women seated on wooden benches in a classroom in "Geography: Studying the Cathedral Towns" 1899-1900 Frances Benjamin Johnston (Szarkowski 169)

men in drawing class in "Engineering drawing class, Howard University" n.d. Scurlock Studios (Willis \113)

men lined up in hazing in "Last all-male class at Virginia Military Institute lines up 'nuts to butts' during ritualized hazing" 1997 Nancy Andrews (Best23 18)

photo essay about an elderly women returning to high school in "A Senior Senior" 1990 Ronald Cortes (Best16 89-95)

photo essay on medical students in gross anatomy class in "Body of Knowledge" 1997 Noah K. Murray (Best23 160-161)

podium and charts in classroom in "Lecture Hall" n.d. Lynne Cohen (Women \175)

smoke-filled room in fire drill in "Preschool deaf students react as nontoxic smoke fills the room for a fire safety program" 1996 John Beale (Best22 219d)

student cheating in class at Moscow military academy in "At Moscow's Suvorov Military Academy, a cadet gets by with a little help from his friend" 1987* Rick Smolan (Best13 162a)

teen mother taking quiz with infant on her lap in "While taking a make-up quiz after school, teen mother tries to concentrate as her crying baby lays in her lap" 1996* Vicki Cronis (Best22 162c)

Virginia Military Institute and the first female cadets in "Historic Entrance" 1997 Nancy Andrews (Best23 24-25)

woman standing on desk as part of experiment in "Physics teacher uses librarian to demonstrate how much weight bathroom-size dixie cups will support" 1996 John Beale (Best22 219a)

young women at desks in "Classroom in Emerson School for Girls" 1850s Southworth & Hawes (Art \28)

SCREAMING

African American man lying on street, screaming in pain in "James Meredith Shot" 1966 Jack R. Thornell (Capture 58)

naked young girl running and screaming on road, followed by soldiers in "South Vietnamese Children Burned by Napalm" or "Vietnam–Terror of War" 1972 Huynh Cong Ut (Capture 80; Eyes #297; Lacayo 157; Marien \6.74; Monk #44; Photos 134)

women runners from Nigeria, yelling for joy in "Olympics in Barcelona" 1992* Ken Geiger (Capture 167); Bill Frakes (Best18 142d); Daniel Anderson (Best18 156d)

young woman screaming over the body of a dead student in "Kent State Massacre" or "After the massacre of students at Kent State University"1970 (Capture 72; Eyes #311; Goldberg 180; Lacayo 145; Marien \6.73; Monk #43; Photos 129)

SCUBA DIVING

several people underwater in "Students in a scuba-diving class take their first open-water dive" 1991* Ruben Perez (Best17 207b)

SCULPTURE

between two city streets in "Statue of Virtue, New York" 1909 Robert L. Bracklow (Rosenblum2 #313)

bust of Dr. Martin Luther King in "After unveiling a bust of Dr. Martin Luther King in ceremonies in the U.S. Capitol rotunda, his widow, Coretta Scott King, smiles up at his image" 1986 Bernie Boston (Best12 58a)

child walking on base of monument in "Playing on a monument [of Daniel Boone] at Fort Harrod State Park" 1985 J. Carl Ganter (Best11 174d)

children sitting under Alice and the Mad-Hatter in "Alice spreads her sheltering arms over wet weather drop-ins at her New York Wonderland" 1985 Fred R. Conrad (Best11 175a)

elaborate figures on triumphal arch in "Grand Army Plaza, Brooklyn" 1997 Craig Cutler (Graphis97 168b)

equestrian statue in "Statue of Frederick the Great, Berlin" 1851 Wilhelm Haffter (Rosenblum2 #10)

glass sculpture from an exhibition catalog entitled "The Steuben Project: Sculptures in Crystal" c. 1989 Robert Moore (Graphis89 \229)

in a museum gallery in "Layton Art Gallery, Milwaukee, Wisconsin" c. 1890 Henry Hamilton Bennett (MOMA 65)

Isamu Noguchi works in a gallery from a book on the Isamu Noguchi Garden Museum c. 1991 Shigeo Anzai (Graphis91 \316-\320)

Lenin's statue in Seattle in "Lenin" 1995 Alan Berner (Best21 218b)

Lenin's statue on ground in "A statue of Lenin is taken down in Bucharest, Romania" 1990* Gad Gross (Best16 200)

man playing violin in niche in "The Violin Player, Maison des Musiciens, Rheims" c. 1851 Jean-Louis Henri Le Secq (Szarkowski 56)

Monument to Victor Hugo and The Thinker, with profile of Rodin in "Rodin–The Thinker" 1902 Edward Steichen (Art \163; Waking #143)

Moses in "Michelangelo's Moses from the Tomb of Julius II" early 1850s James Anderson (Rosenblum2

#284)

mythological figure on horse in "Fame Riding Pegasus, Sculpture by Coysevox, Tuileries Gardens, Paris" 1859 Charles Nègre (Szarkowski 73)

reclining male nude in "Spartan Soldier" 1859 Charles Nègre (Waking #48)

Saint holding a crucifix in "Statue of Saint Bruno in the Carthusian Monastery of Our Lady of Miraflores, Burgos" 1853 Charles Clifford (Waking #3)

Saints along the wall in "Chartres" 1850-1852 Em. Pec (Waking #54)

standing angel on point of roof in "The Angel of the Resurrection on the Roof of Notre Dame, Paris" 1853 Charles Nègre (Szarkowski 55)

standing figure in "Midnight–Rodin's Balzac" 1908 Edward Steichen (MOMA 85)

statue of *David* in flooded museum in "Flood in Florence museum" 1966* David Lees (Life 130)

statue with missing head in "Figure of Victory, Athens" 1869 William James Stillman (Szarkowski 103d)

The Thinker holding protest sign in "Replica of Auguste Rodin's statue, *The Thinker*" 1985 Durell Hall, Jr. (Best11 175d)

three girls sitting at base of sculpture of nude holding a sphere in "Children Playing in a Fountain in DuPont Circle. Washington, D.C." 1943 Esther Bubley (Fisher 56)

two soldiers looking at statute of man pulling back horse in "Soldiers looking at the statue in front of the Federal Trade Commission Building. Washington, D.C." 1943 Esther Bubley (Fisher 57)

winged torso being moved into place in "Transport of the *Bavaria* (torso)" 1850 Aloïs Löcherer (Rosenblum2 #181)

with drawings, in a gallery in "Picasso-Braque Exhibition at '291' " 1915 Alfred Steiglitz (Hambourg 14; MOMA 97)

with man on its lap in "Taking advantage of an available lap in Philadelphia's Logan Circle" 1985 G. Loie Grossman (Best11 174a)

woman watching men work on marble sculpture in "The Marble Cutters" 1917 Laura Gilpin (Decade \7)

worker cleaning statue in "A worker gets a foothold on the statue of Revolutionary War Gen. John Glover on Boston's Commonwealth Avenue mall" 1985 David Ryan (Best11 174c)

SEA ANEMONES

sea anemones in "Boab trees near Australia's northwest coast may descend from plants that took root there 75 million year ago" 1991* Sam Abell (Through 398)

SEA LIONS

swimming in "A Steller sea lion patrols rich Pacific feeding grounds near Canada's Bowie Seamount" 1996* Bill Curtsinger (Through 420)

SEALS (Animals)

harp seal pup on ice in "Harp Seal Pup" 1977* Fred Bruemmer (Monk #48)

SEGREGATION

African American students surrounded by jeering white students in "Stopped at school's door" 1957 Photographer Unknown (Eyes #269)

Black South-African women walk past white student in "A white pupil from a private school boards the same train, not the same compartment, as black household servants" c. 1989* David Turnley (Graphis89 \245)

crowd waiting around bus at terminal with sign for "White Waiting Room" in "At the Memphis Greyhound terminal" 1943 Esther Bubley (Documenting 329c)

drinking from "Colored Only" drinking fountain in "Segregation, Mobile" 1956 Gordon Parks (Life 14)

elderly women sitting on bench marked *Europeans Blankes* in "Durban, South Africa" 1959-1960 Ed van de Elsken (Icons 140)

man walking upstairs under billboards in "Negro man entering movie theater 'colored' entrance. Belzoni, Missouri" Marion Post Wolcott 1939 (Fisher 40; Sandler 81)

people meeting outside "colored city hall" in "Colored City Hall, Italy, Texas. White city hall officers at installation of council-men" 1953 R. C. Hickman (Eyes #150)

police dogs attacking man in street as crowd watches in "Birmingham, Alabama" 1963 Charles Moore (MOMA 234)

white high school students yelling in "White students in Birmingham demonstrate against integration in their high school" 1963 Flip Schulke (Eyes #270)

white man trying to beat black woman on the street in "Man swinging club at black woman on Montgomery, Alabama, street corner" 1960-1961 Charles Moore (Eyes #272)

white protestors with signs and Confederate flags in "The National States Rights Party encourages resistance to school integration" 1963 Flip Schulke (Eyes #273)

SEPTEMBER 11 TERRORIST ATTACKS, 2001

photos of missing persons on building wall in "After the Attacks, New York" 2001 Ted Warren (Marien 3)

SERVANTS *see* DOMESTICS
SERVICE STATIONS
 car and pump in desert in [gas station in desert] c. 1999* Ivo von Renner (Photo00 175)
 gas station on highway corner in "Highway Corner, Reedsville, West Virginia" 1935 Walker Evans (Art \305)
 old gasoline pumps from [self-promotional] c. 1989* Harry De Zitter (Graphis89 \84)
 row of gas stations in "Beverly Boulevard and La Brea Avenue, Los Angeles" 1975* Stephen Shore (Rosenblum2 #781)
SEWERAGE
 underground tunnels and tracks in "The Sewers of Paris" 1864-1865 Nadar (Marien \3.95)
SEWING
 hands holding a needle and thread in "Hands Threading a Needle" c. 1929 Anton Bruehl (Rosenblum2 #630)
 man at sewing machine in "A tailor in northwest India sews clothes for a Rabari wedding that will take place during the summer monsoon" 1993* Dilip Mehta (Through 174)
 old woman teaching young girl in "Threading the Needle" c. 1907 Nancy Ford Cone (Sandler 18)
 old woman threading needle in "Grandmother's Hands: #2 with sewing needle" 1993 Cary Beth Cryor (Willis \202)
 profile of girl with embroidery hoop in "The Embroidery Frame" 1899 Mathilde Weil (Rosenblum \71; Sandler 64c)
 woman in living room sewing white towel in "Embroidering a dish towel in a camp residence" 1940 Arthur Rothstein (Documenting 195c)
 woman sewing at treadle machine in "Seamstress" 1930 Alice Lex-Nerlinger (Rosenblum \127; Rosenblum2 #495)
 women sewing a checkerboard quilt in "The Moravian church sewing circle" 1942 Marjory Collins (Documenting 256a)
SHADOWS
 hand on wall in "Shadow Self-Portrait No. 1" 1995* Steve J. Martin (Committed 152)
 looking down on shadows cast by men in plaza in "Little Men, Long Shadows" 1929 Vilho Setälä (Rosenblum2 #509)
 of man taking pictures in "Canyon de Chelly, Arizona" 1983 Lee Friedlander (Szarkowski Frontispiece)
 person with umbrella reflected in car hood in "An umbrella-toting pedestrian is reflected in the rain-beaded hood of a car" 1988 Carl D. Walsh (Best14 100a)
 rectangular shapes from porch railing in "Abstraction, Porch Shadows, Twin Lakes, Connecticut" 1916 (Goldberg 52; Hambourg \95; Marien \4.43; San #19)
 series of shadows on the grass in "Myself as . . ." 1976* Andrzej Lachowicz (Rosenblum2 #740)
SHARKS
 group of swimming sharks in "Sharks an yellowtail snappers feed on scarps tossed from a dive boat" 2002* David Doubilet (Through 422)
 open mouth of feeding shark in "Whale sharks appear along Ningaloo Reef, Australia" 1996* Ron and Valerie Taylor (Best22 191a)
 Southern Saw Shark in "Underside view of Southern Saw Shark" 1997* David Doubilet (Best23 162c)
SHEEP
 Dolly looking in a mirror at other Dollys in "Dr. Ian Wilmut, a genetic pioneer, in a field across from his Roslin Institute" 1997 Remi Benali (Best23 155d)
 flock of sheep on highway in "Flock of sheep" 1985 Bill Alkofer (Best11 155a)
 flock surrounding car with bicycles on top in "Support crews for bicycle racers are snarled in a flock of sheep in Idaho" 1990 Jim Evans (Best16 10c)
 large flock on open range and man on horseback in "Sheep" c. 1903 Elizabeth Ellen Roberts (Sandler 10-11)
 man with long candle holding lamb under his coat in "Shepherd during Christmas celebrations, Provence, France" 1954 Marc Riboud (Photography 146)
 a sheep leaping in the air in [sheep bounding in the air to catchup with other sheep] 1995 Alan Berner (Best21 234)
 a sheep with its head in a can walking past three ponies in "A ewe with its head in a can got much attention but no help from a trio of ponies" 1985 Susan Steinkamp (Best11 150a)
 shepherds herding sheep on street with palm trees in "Pastorale Arabe" 1926 Joseph Petrocelli (Peterson #8)
 two grazing on grass in "Sheep" 1906 Hans Watzek (Marien \4.12)
SHELLS
 collection on shelves in "Collection of shells and miscellany" 1839 Louis-Jacques-Mandé Daguerre (Szarkowski 27)
 inside of chambered nautilus in [chambered nautilus] c. 1992* Jim DiVitale (Graphis93 74)

made from and covered with chocolate in "Chocolate shells delight" 1988* Stan Badz (Best14 108)

open and empty clam shell in "Pelecypoda" 1997* David C. Driskell (Willis \481)

shells in "Spondylus Princeps–Pacific Thorny Oyster" c. 1999* Steven E. Knyszek (Photo00 234b);
"Strombus Listeri–Lister's Conch" c. 1999* Steven E. Knyszek (Photo00 234a)

two nautilus shells together in "Shells" 1927 Edward Weston (Rosenblum2 #560)

SHIPS AND SHIPBUILDING *see also* BOATS AND BOATING; names of ships

bombed ship on fire and sinking in "Pearl Harbor" November 26, 1941 U.S. Navy (Monk #25)

cargo ship and tugboat in harbor behind iron gate in "Fels Point, Baltimore" 1950 A. Aubrey Bodine
(Peterson #47)

crowded with people in "Steerage" 1907 Alfred Stieglitz (Art \199; Icons 15; Marien \4.21; Rosenblum2
#402)

engine room of a sloop with Lincoln onboard in "Engine of USS *Kearsarge*" c. 1861 Kellogg Brothers
(National \21)

a flotilla of tall ships in "Arrival of the Body of Admiral Bruat and Flagship *Montebello* at Toulon" 1855
Gustave Le Gray (Art \90)

large sailing ship against New York skyline in "*Theolone* Pier II, East River, Manhattan" 1936 Berenice
Abbott (Sandler 85)

large ship under construction in "The *Great Eastern* Being Built in the Docks at Millwall" 1857 Robert
Howlett (Rosenblum2 #171)

large ship under construction in "The *Leviathan* under construction" c. 1857 Robert Howlett (Lacayo 26d)

life ring on railing of ship in ocean in "The Life Ring" c. 1940 John R. Hogan (Peterson #79)

lone sailing ship on the water in "Brig Upon the Water" 1856 Gustave Le Gray (Rosenblum2 #116)

man taking pictures near portholes on deck of ship in "George Eastman with Kodak Camera" 1890 Frederick
Fargo Church (Monk #12)

man with cigar standing in front of large chains in "Isambard Kingdom Brunel Standing Before the
Launching Chains of the *Great Eastern*" 1857 Robert Howlett (Waking #24)

men pulling mooring lines in "Securing mooring lines for the *Queen Elizabeth II*, Capetown, South Africa"
1998 Bruce Davidson (Photography 30)

ocean liner's motors, fans, and machinery in "Upper Deck" c. 1928 Charles Sheeler (Photography 24;
Rosenblum2 #525; Waking 360)

sailing ship in rough sea in "Crossing the Stream" c. 1938 John R. Hogan (Peterson #78)

sailing ships in an ice field in "Sailing Ships in an Ice Field" 1869 John L. Dunmore (Rosenblum2 #158)

sailing ships in port in "Port of Dreams" c. 1936 Eleanor Parke Custis (Peterson #20)

sandblasting in dry dock in "The *Queen Elizabeth II* during sand blast operation while in dry dock,
Southampton, England" 1996 Bruce Davidson (Photography 31)

shipyard strewn with lumber in "McKay's Shipyard, East Boston" c. 1855 Josiah Johnson Hawes (Marien
\2.60)

shipyard with large ship under construction in "The bow of the *Great Eastern*" 1857 Richard Howlett
(Waking #25)

side of an ocean liner from the dock in "The *Queen Mary*" 1932 Anton Bruehl (Hambourg \20)

stern of a large ship with scaffolds in "Stern of the *Great Eastern*" 1857 Robert Howlett (Szarkowski 71d;
Waking #23)

tall ship in harbor in "Imperial Yacht, *La Reine Hortense*, Le Havre" 1856 Gustave Le Gray (Art \88)

tall ships in harbor in "Ships in the Harbour Rouen" 1843 William Henry Fox Talbot (Art \15)

tall ships in harbor in "The Harbour of Balaklava, the Cattle Pier" 1855 Roger Fenton (Art \18)

tall ships in port in "Port of Marseilles" 1855 Adolphe Braun (Photography 19d)

tugboat and large ships on river in "On the Elbe" c. 1933 Edward P. McMurtry (Peterson #82)

tugboats escorting large ship in "Baltimore Harbor" 1940s A. Aubrey Bodine (Peterson #25)

various types of working boats at dock in "Waterfront, Monterey" 1946* Edward Weston (Marien \6.62)

view of bottom of bridge as ship passes under in "Brooklyn Bridge" 1929 Walker Evans (MOMA 135)

warship in the water, just beyond a Ferris wheel in "War in Lebanon" 1983 Stan Grossfeld (Capture 126)

wooden ship under construction in "Ship Construction, Bath, Maine" 1917 Clarence H. White (Peterson
#33); "The Skeleton of the Ship, Bath, Maine" 1917 Clarence H. White (MOMA 93)

SHIPWRECKS *see also* names of ships

people looking at ships under the water in "Wreck of the Steamers *Leonor* and *Albay* Praya and Douglas
Wharf Destroyed by Typhoon" 1874 Afong Lai (Marien \3.38)

SHOES, BOOTS, AND SNEAKERS

advertisement for shoes in [ad for footwear] c. 1991* Loise O'Brien (Graphis92 2-5)

advertising work boots in [durability and heavy duty properties of Dunham boots] c. 1991 Nadav Kander

(Graphis92 \176, \177, \208)

arrangement of sneakers in "An array of trendy sneakers" c. 1991* Gilles Bensimon (Graphis91 \234)

beaded high-heel shoe for [*Lears* magazine] c. 1991* Jody Dole (Graphis91 \245)

black shoes with colored high heels in "Art and Fashion" c. 1992* Paulo Greuel (Graphis93 150)

design on shoe and black stockinged legs in "Illustrate the texture of autumn shoe fashions" 1985* Erwin Gebhard (Best11 149d)

displayed near wooden sculpture in [ad for *Ravel* shoes] c. 1990* Hans Neleman (Graphis90 \62)

dogs modeling boots in "Fay Ray posing for a feature on Texas cowboy boots" c. 1991* William Wegman (Graphis91 \237-\243)

feet of girls wearing mis-matched pairs of shoes in "Shoe swapping" 1947 Edward Clark (Life 112)

heel of woman's shoe on vase in [shoe on vase] c. 1992* Victoria Huber (Graphis93 151)

high-heel mules in colors in "Three Mules" c. 1995* Raymond Meier (Graphis96 49)

high-heel shoes in purple in "Elegance in technicolor" c. 1995* Piero Gemelli (Graphis96 42)

high-heel shoes on models with crutches and in a wheelchair in [sex appeal of high-heel shoes] c. 1995* Helmut Newton (Graphis96 33, 35)

in-turned feet and unlaced shoes in "Agent Orange" 1982 Wendy Watriss (Rosenblum2 #480)

left on dock in "Sunday school picnic on the edge of the Patuxent river" 1942 Majory Collins (Fisher 77)

man at machine to make shoes in "Lasting Machine Shaping Shoes, in a Massachusetts Shoe Factory" 1900-1915 Photographer Unknown (Photography1 #V-35)

napping and walking to lunch break at shoe factory in "Chinese shoe factory and workers" 1997* Paul Kitagaki, Jr. (Best23 210a,c)

red shoe splashing color on white shoes in "Illustrate the drama and verve of red shoes" 1985* Craig Trumbo (Best11 149b)

red shoes and socks in "If you're a red socks fan, this combination may be a shoe-in" 1987* Jim Sulley (Best13 182d)

red with curly bow in "Red Shoes" c. 1999* Holly Stewart (Photo00 45)

sandal with high heels in [toy dinosaur on shoe] c. 1997* Nobuyoski Araki (Graphis97 43)

shoes on top of shoeshine box from [Doorways of Santo Domingo] c. 1990* Irene L. Grove (Graphis90 \306)

shrimps on strapless shoes in [shrimps on shoes] c. 1997* John Waters (Graphis97 44)

snake by shoe in [ad for Geniun shoes] c. 1990* Milan Prokic (Graphis90 \64)

snake on ankle, shoe on beach ball in [ad for Fays shoes] c. 1990* Bernie Richter (Graphis90 \63)

sneaker in [sneaker] c. 1992* Axel Döhler (Graphis93 152)

underwater in [custom-made shoes] c. 1992* Bernhard Angerer (Graphis93 40)

with embroidery in "Nan's Shoes" c. 1999* Carol Kaplan (Photo00 47)

woman's foot in high-heeled shoe in "Shoe" 1983 Helmut Newton (Art \451)

women in shoe store in "Texas Gov. Ann Richards, in New York City, takes a few minutes to try on shoes" Erich Schlegel 1992* (Best18 79d)

women's shoes on wooden shelves near seated man in "Santa Clara, Mexico" 1934 Henri Cartier-Bresson (Szarkowski 220)

women's yellow shoes in [yellow shoe] c. 1999* Steve Greenberg (Photo00 46)

young boys making shoes in "Cobbler Shop" 1899 Heinrich Zille (Icons 10)

young child polishing many pairs of military boots in "The departure of the Americans" 1973 Christine Spengler (Eyes #308)

SICK

Alzheimer's patients on chairs in "Alzheimer's patients at the Golden Acres Home" 1996* Judy Walgren (Best22 167c)

anorexic girl in "Anorexic shows off how skinny she is" 1997* Nina Berman (Best23 140a)

blind, mentally disabled boy in "Berik Syzdykov, 14, lives downwind of the Semipalatinski test site in Kazakhstan" 1993 Stan Grossfeld (Best19 58)

cancer patient's last days with friend, and her death in "Death Be Not Proud" 1997 Paul Carter (Best23 219b,d)

coffin in man's living room in "A proponent of physician-assisted suicide has a coffin delivered to his home" 1997* John Freidah (Best23 141d)

daily routine of son caring for mother with Alzheimer's in [series on caring for parent with Alzheimer's] 1990 Genaro Molina (Best16 49-51)

elderly man holding his chest in "P. Lee, suffers from a uranium-related lung disease" 1993 Stan Grossfeld (Best19 56)

girls with dirty clothes and faces in "Suffering from the effects of pollution and malnutrition, four sisters stand their ground in Copsa Mica, Romania" 1990 Kathi Lipcius (Best16 75)

infant with an aging disease in "17-month-old who suffers from an 'aging' disease called projeria" 1986 Durell Hall, Jr. (Best12 68a)

legs of people with polio in "Polio victims at Binzhou Medical College in China" 1990* Robb Kendrick (Best16 195)

leprosy patients from Nepal in "Leprosy patients" c. 1995* Christopher Thomas (Graphis96 63)

mother and son in "A mother and her young son, who has Fetal Alcohol Syndrome" 1992* George Steinmetz (Best18 172)

Parkinsons' patient being given injections in head in "To Make a Man Whole" 1996 Roger Jerkovich (Best22 241b, d)

photo essay chronicling the Japanese victims of industrial mercury poisoning and the fight for compensation [from *Minamata*] c. 1974 W. Eugene Smith (Best21 2-15)

photo essay chronicling the last days of a anencephalic child's life in "A Legacy of Hope" 1988 Michael Patrick (Best14 186-187)

photo essay chronicling the last days of a comatose child in "A Family Lets Go" 1991 Pauline Lubens (Best17 97-102)

photo essay illustrating the physicians treating patients suffering from sleeping sickness in "Sleeping sickness–Uganda" 1991 Eugene Richards (Best17 122, 189-193)

photo essay of child with kidney disease in "Saving Benjamin" 1995 Lance Murphey (Best21 197)

photo essay of family with children who cannot be exposed to sunlight in "The Dark Side of Light" 1988 Lois Bernstein (Best14 184-185)

photo essay of girl with a form of dwarfism and her family in "Wee Davina" 1986 Kit King (Best12 184-187)

photo essay on mother and sister caring for autistic son in "Reaching Out" 1992 Patrick Tehan (Best18 37-40)

severely dehydrated boy in "This 3-year-old boy arrived at a hospital in Katmandu, Nepal, on his sister's back" 1987 Gary Porter (Best13 77a)

wife comforting ill husband until death in "Betty Childs cares for her husband as he nears death" 1990 Al Podgorski (Best16 58-59)

SINAI (EGYPT)

woman standing by barbed wire fence in "When the Sinai peninsula was returned to Egypt by Israel in 1982, the new boundary sliced through Rafah" 1990* James Nachtwey (Best16 41)

SINGING AND SINGERS

African American congregation raising their hands in song in "Joy Tabernacle" 1991 Jeffrey L. St. Mary (Willis \374-\375)

boys in choir attire in "Junior choir performance in the Moravian Sunday school" 1942 Marjory Collins (Documenting 268a)

famous singers singing for African relief in "United Support of Artists for Africa" 1985* Harry Benson (Best11 2)

man holding microphone in "Smokey Robinson" 1968 Baron Wolman (Rolling #2)

man in plaid jacket playing ukelele in "Tiny Tim" 1968 Baron Wolman (Rolling #5)

man playing piano and singing into microphone in "Little Richard" 1968 Baron Wolman (Rolling #3)

men in suits singing in "Metropolitan Opera House recital" Weegee n.d. (Decade \36)

older woman at microphone in "Singer, Sammy's Bar, N.Y." 1940-1944 Lisette Model (Rosenblum \220)

photographers behind a singer in "Photographers cover Rick Springfield at Live Aid concert" 1985 Dennis McDonald (Best11 4d)

rehearsing for concert in "Quincy Jones and all-stars run through solos with Stevie Wonder" 1985* Harry Benson (Best11 42c)

Spanish girls in hoods holding music and singing in "Young Singers" c. 1934 José Ortíz Echagüe (Rosenblum2 #383)

thousands watching acts on stage in "Responding to the American farmers' distress, country music acts and rock-and-roll stars performed for 14 hours during the Farm Aid Concert" 1985 Frank Niemeir (Best11 62a)

woman in earphones in "Cyndi Lauper hits her mark" 1985* Harry Benson (Best11 42d)

woman with hair flying while singing at microphone in "Singer at the Café Metropole, New York City" n.d. Lisette Model (Decade \37)

SKATING

collage of man spinning on ice in "The Skater, New York" 1983* David Hockney (Icons 177)

crying woman showing judges her skate in "Tonya Harding pleads for mercy" 1994* Jack Smith (Lacayo 185)

fashion models on ice skates from [ad for Amadeus Fashions] 1989 Rafael Betzler (Graphis89 \12, \12a)

ice hockey rink in "O'Neill Rink" c. 1999* William Huber (Photo00 188)

ice skater holding her foot to her head in "Swiss skater Nathalie Krieg performs during World Figure Skating

Championships" 1992* Michael Rondou (Best18 152)

ice skater in bathing trunks in "Eric Heiden" c. 1989* Annie Leibovitz (Graphis89 \156)

jumping in skates in [jumping in skates] c. 1995* Jim Erickson (Graphis96 199)

speedskaters in "Collision during a 500-meter speedskating heat" 1987 Lois Bernstein (Best13 199b)

woman leaping in air in "Carol Lynne" 1945 Gjon Mili (Life 138)

SKINHEADS

African American man yelling at a skinhead in "An angry Donald Singleterry of Atlanta confronts a 'skinhead' in the street outside the Democratic National Convention" 1988 Michael Rondou (Best14 73a)

saluting the Nazi flag in "Skinheads salute a Nazi flag" 1988 Marc Asnin (Best14 14b)

young men in uniform in "Skinheads" 1988 Brian Smale (Rolling #108)

SKIS AND SKIING

crashing in snow in "Skier is buried in snow after crashing at the U.S. Extreme Skiing Championship" 1996* Mark Reis (Best22 200c)

man skiing in a business suit in "On his lunch hour, John Bys tackles the gentle inclines of the Boston Commons, which was transformed for one day into a ski slope" 1986 Phyllis Graber Jensen (Best12 227a)

models holding skis in "The New Spirit of Skiing" c. 1990* Horst Stasny (Graphis90 \217-\219)

models with skis from [catalog for fashionable and decorative ski equipment] c. 1991* Horst Stasny (Graphis91 \235, \236)

skier at night in [self-promotional] c. 1990* Todd Powell (Graphis90 \243)

skier in mid-air in "Balance" c. 1989* John McDermott (Graphis89 \236)

torso of skier with poles in [self-promotional] c. 1990* Derek Smith (Graphis90 \11)

SKULLS

and bone in wooden box in [images related to time and change, and to the changing nature of beauty in objects revealing aspects previously concealed] c. 1991* Chris Wimpey (Graphis92 \58)

hundreds of lined up on the floor in "Hundreds of human skulls are stacked in a building in the center of Nakasere, Uganda" 1986 Jon Warren (Best12 165a)

in a group in "Mass grave near Phnom Penh, Cambodia" 1981 Roland Neveu (Life 62)

man pulling cart of bones and skulls in underground tunnel in "Workmen in the Paris Catacombs" 1861 Nadar (Rosenblum2 #289)

on ground with leaves and tree limbs in "Wilderness Battlefield Scene" 1863 Alexander Gardner (Photography1 \5)

part of a still life in "Still Life" c. 1901 Hans Watzek (Rosenblum2 #376)

pile of skulls in "Village children before one of many mounds of skulls in Cambodia" 1996 Philip Jones Griffiths (Photography 123d)

pile of skulls and bones in "Zaire to Rwanda, the Long Journey Home" 1996* Erich Schlegel (Best22 234c)

SKYDIVING

man with outstretched hands before parachute opens in "Skydiver Chuck Spidell hasn't let age slow down his sport" 1990 Al Podgorski (Best16 62a)

spectators, most with parachutes on, looking up in "Spectators watch the International Skydivers Convention in Illinois" 1990 Al Podgorski (Best16 62b)

three men forming a mid-air ring "Air instructors perform a hot dog maneuver: a three-man ring in a padded flight chamber" 1985* Peter Menzel (Best11 152c)

SKYSCRAPERS

almost windowless in "The Henninger Tower in Frankfurt am Main" c. 1991 Stefan Kiess (Graphis92 \217)

changing shadows on buildings in "From the Shelton, West" 1935 Alfred Stieglitz (Art \210, \211; MOMA 118, 119; Rosenblum2 #404)

combination of buildings in [skyscrapers combined] c. 1995* Dan Weaks (Graphis96 165)

framework of building under construction in "Building into the Sky" 1921 Ira W. Martin (Peterson #21)

office building in [office building Calgary, Canada] c. 1991* Bob Shimer (Graphis92 \214)

skeleton of skyscraper behind 4-story walk-ups in "Old and New New York" 1910 Alfred Stieglitz (San #3)

towering over outdoor sculpture in [building, downtown Seattle] c. 1991* Jianjun Sun (Graphis92 \216)

SKYWRITING

heart in sky over church cross in "A sky-typed heart floats over the Angelus Temple memoralizing gang shooting victim" 1995* Eugene Garcia (Best21 156c)

SLAVERY–HISTORY

building for company that dealt in slaves in "Slave Pen, Alexandria, Virginia" c. 1863 Andrew J. Russell (Waking #105)

former slaves in formal portrait in "Emancipated Slaves" 1863 Myron H. Kimball (Waking #103)

profile of African American man in "Jack (Driver), Guinea. Plantation of B. F. Taylor, Esq. Columbia, S.C."

1850 J. T. Zealy (Marien \2.21, \2.22; Photography1 \25)

SLEEP

bicycle rider sleeping along the road in "A cyclist traveling in Romania sleeps along the road" 1990 Anthony Suau (Best16 12d)

child on floral couch in "In Seattle, Washington, an artist's baby sleeps while a party gets under way elsewhere in the house" 2000* Sam Abell (Through 342)

child sleeping with adults in "Crissy, her stepfather, Dean, and mother Linda, nap in the afternoon" 1995 Mary Ellen Mark (Best21 185)

child with newspapers on steps in "A Sleeping Newsboy" 1912 Lewis Wickes Hine (Waking #161)

couple on blanket in park in "After lunch" 1941 Russell Lee (Documenting 217c)

family under mosquito net in "In Niger, a family of cattle herders relies on mosquito netting to protect themselves against malaria" 2002* Karen Kasmauski (Through 252)

girl sleeping on bundle of twigs in field in "Weary" 1890 Alfred Stieglitz (Photography1 #VI-9)

man sleeping in park grass in "A trusting sleeper finds peace and privacy among the 843 acres of Central Park in New York City" 1993* Jose Azel (Through 356)

man with open shirt sleeping on chair in "Keith Richards" 1972 Annie Leibovitz (Rolling #13)

men in blankets sleeping on hill over highway in "Highway Camp" 1989 Don Barletti (Goldberg 211)

men on the subway in "Subway Portrait" 1938-1941 Walker Evans (Hambourg \32; MOMA 156)

napping and walking to lunch break at shoe factory in "Chinese shoe factory and workers" 1997* Paul Kitagaki, Jr. (Best23 210a,c)

on forest floor next to his bicycle in "A man rests on a bed of leaves in Simbata, Transylvania" 1993 Anthony Suau (Best19 27d)

partially nude woman on mat in "Good Reputation Sleeping" c. 1938 Manuel Alvarez Bravo (Marien \6.12)

person on curb in "The Dreamer" 1931 Manuel Alvarez Bravo (Icons 49)

recording a man's sleep in "Sleep disorder clinic" 1987 Melissa Farlow (Best13 158-159)

retarded man, lying naked in a roomful of cribs and beds in "Illinois State Schools for the Retarded" 1970 Jack Dykinga (Capture 74)

soldier in poncho, sleeping on sandbags in rain in "Vietnam–Dreams of Better Times" 1967 Toshio Sakai (Capture 62)

two girls in a bed by a window in "Sleep" 1867 Henry Peach Robinson (Szarkowski 95)

woman asleep in a convertible in "Sleeping in a car on Sunday in Rock Creek park" 1942 Marjory Collins (Fisher 93)

woman sleeping near men and women playing cards in [Men and women playing cards near sleeping woman] 1943 Esther Bubley (Fisher 90)

woman sleeping near radio and alarm clock in [Girl lying on bed, near radio] 1943 Esther Bubley (Fisher 104)

SMOKING

African American man with cigarette in "Retired Araber takes a drag" 1997 Dudley M. Brooks (Best23 233)

bald man with cigarette in "The Smoker" 1932 Studio Ringl & Pit (Women \74)

boy smoking in "An Albanian child smokes a cigarette in Kosovo" 1993 Michele McDonald (Best19 64d)

boy smoking in "Skin Deep, Ann Arbor, Michigan" 1990* Martin Dixon (Committed 89)

cowboy smoking a cigarette in "Self-professed 'cowboy and Marlboro man' watches other ropers in a calf-roping competition" 1995* Kent Porter (Best21 192a)

Franklin Delano Roosevelt smoking a cigarette in "Franklin Delano Roosevelt" 1939 Photographer Unknown (Eyes #137; Monk #24)

individuals smoking in "Smoking enjoyment" c. 1995* John Huet (Graphis96 118-121)

man holding cigarette near face in "Michael J. Fox" 1987* Deborah Feingold (Rolling #85)

man in feather headdress in [feather headdress on man smoking] c. 1997 Ruven Afanador (Graphis97 107)

man in goggles smoking cigar in "John Belushi" 1976* Bonnie Schiffman (Rolling #39)

man in ruffled shirt smoking a cigar in "B. B. King" 1968 Baron Wolman (Rolling #6)

man laying on motorcycle in "Hunter S. Thompson" 1987* Annie Leibovitz (Rolling #107)

man with cigarette and sunglasses in "Man Smoking (Larry), New York" 1974 Paul Diamond (Decade 89)

man with cigarette standing behind large chains in "Arnold Schwarzenegger" 1985* Moshe Brakha (Rolling #71)

man with cigarette wearing an open leather jacket in "David Bowie" 1987 Herb Ritts (Rolling #65)

man with smoke across his mouth in "Keith Richards" 1988 Albert Watson (Rolling #109)

masked women with long hair and short skirts in "Trude & I Masked, Short Skirts" 1891 Alice Austen (Sandler 26)

men and woman sitting in circle, smoking and talking in "Margaret Has the Floor" c. 1946 Wood Whitesell

(Peterson #67)

person in zebra body paint, leaning on milk crate in "The Zero Generation" 1985* Moshe Brakha (Rolling #95)

pipe-smoking woman with scrub board in "Woman with Scrub board" 1930 Doris Ulmann (Sandler 42)

smoking a cigar in "Earl Hines" n.d. W. Eugene Smith (Decade\ 80)

woman in shirt and underpants in [woman smoking] c. 1999* Susan Shacter (Photo00 129)

woman sitting with legs crossed in "Self-Portrait" 1895 Frances Benjamin Johnston (Lacayo 37; Marien \4.0; Rosenblum \49; Sandler 34c)

women in hats smoking and talking at table in "Women gossiping in a drugstore over Cokes" 1943 Esther Bubley (Fisher 65)

women in hats smoking at a table in "Where there is so much smoke, there is always a little fire" c. 1906 Gertrude Käsebier (Sandler 52)

SNAILS

snail on mushroom in [snail on mushroom] c. 1995* Mark Laita (Graphis96 191d)

two shells in "Violet Snailshow" 1943 Ruth Bernhard (Sandler 136)

SNAKES

by shoe in [ad for *Geniun* shoes] c. 1990* Milan Prokic (Graphis90 \64)

coiled orange-and-black snake in "Snake" c. 1996* Craig Cutler (Graphis97 6)

eating prey in [green-colored snake eating its green prey] c. 1992* Satish Sreedman (Graphis93 193)

green snake in [ad for the Nevamar Corporation] c. 1991* Fred Bender (Graphis91 \273)

head in coil in "Snake Head" 1927 Albert Renger-Patzch (Waking 355d)

in a bucket in "Snake in Bucket" 1929 Imogen Cunningham (Marien \5.47; Women \37)

man gesturing to snake in "In northeastern Thailand, a man-snake encounter amuses villagers and tempts them to buy snakebite remedies" 2001* Mattias Klum (Through 182)

on man's boots in [Western Diamondback rattlesnake on man's feet] c. 1991* Steve Fukuda (Graphis92 \230)

open mouth in "Green Vine snake" 1982* Michael Melford (Life 12)

shirtless young man with snake over his shoulder in "Age '21' in America" 1991 John Kaplan (Capture 165)

smiling man with snake around his head and neck in "Alice Cooper" 1972 Annie Leibovitz (Rolling #18)

striking a mouse in "Black timber rattlesnake strikes a mouse" 1987* Bianca Lavies (Best13 96a)

SNOW *see also* WINTER

city square with tracks of carriages in the snow in "View of the Square in Melting Snow" 1854-1856 Louis-Pierre-Théophile Dubois de Nehaut (Waking 290)

elderly woman walking with cane between snow drifts in "An old woman struggles through 20-foot high snow drifts left by a blizzard" 1997* Bill Alkofer (Best23 117)

farmhouse and fences in snow in "Winter Eve" 1938 Gustav Anderson (Peterson #51)

flock of geese barely visible through the snow in "Wild geese weather a snowstorm in Portsmouth" 1987* Bob Thayer (Best13 168)

girl and snowball in "Naomi Lane is on the receiving end during a snowball fight with her brother in Burlington" 1986 Debbie Dlott (Best12 120b)

man reading newspaper at bus stop in snowstorm in "Foul weather doesn't stop avid reader as he waits for a bus during a spring snowstorm" 1987 Barry Gray (Best13 125)

photographer shooting pictures of a model during a snowstorm in "On a spring day in Chicago, a freelance photographer is startled to find his fashion shoot snowed in by a lake-effect snow" 1987 Jose M. More (Best13 124c)

snow covering ground under arch of bare trees in "Winter in Chicago can be a study in patterns, textures — and snow shovels" 1985 Chuck Berman (Best11 142a)

snowboarder falls as his glasses and hat fly off in "A snowboarder in New Hampshire wipes out while trying a jump" 1995* Jim Davis (Best21 121)

snowmobile and horse-drawn sleigh on same road in "Old and new sometimes travel the same road as an Amish man in a horse-drawn sleigh is followed by a snowmobile rider" 1987 Barry Zecher (Best13 164b)

tracks in snow by fence in "Path in the Snow" c. 1897 (National 143c)

walking against storm with broken umbrella in "His umbrella a victim of the wind, a pedestrian braves the elements in downtown Boston" 1987 Bill Greene (Best13 129d)

SOCCER

fans celebrate with British flag and alcohol in "English Soccer Fans" 1996 David Modell (Best22 239b)

girl scores goal in "High school player reacts as she scores her third goal" 1997* Bill Zars (Best23 176c)

girls at goal in "Goalkeeper and player struggle for control of the ball" 1996 Khue Bui (Best22 222c)

goalie missing the ball at the net in "Goalie does unsuccessful dive to save a shot" 1998* Richard Hartog (Best24 66a)

goalie with leg in her face in "Despite the proximity of her opponent's leg, goalie stops a shot" 1998* Chris Crewell (Best24 67)

high school soccer players in a line in "Only girl on the high school soccer team, waits with teammates for a direct free kick on their goal, hoping their hands will protect them" 1988 Brian K. Johnson (Best14 129)

kicking the ball in the rain in "Major league soccer championships" 1996* George Tiedemann (Best22 205b)

player in air kicking ball in "Eric Wynalda, the volatile top scorer for the U.S. soccer team, has raised his game" 1996* Bill Frakes (Best22 205a)

soccer ball missed by goalie at net in "Goalie is unable to stop a game-winning goal in a playoff game" 1995* Wally Skalij (Best21 120)

soccer players arguing with each other in "It was a little tense when archrival soccer teams met in a semifinal match" 1986 Bob Mayer (Best12 231)

soccer referee standing against striped walls in "The referee isn't trying to be part of a study on contrasts; he's just working a soccer game" 1986 Dennis Mc Donald (Best12 141)

viewed through makeshift net in "A soccer ball slips through an opening of a makeshift goal during a game played by Bosnian children" 1998* Amel Emric (Best24 66d)

SOLAR ECLIPSES

crowd on observation deck with paper glasses in "Protecting their eyes with crude shades, a crowd watches an eclipse from atop the Empire State Building in New York" 1932 Wide World Photos (Through 495)

observatory and progression of solar eclipse in "A multiple exposure records the July 11, 1991, total solar eclipse atop Mauna Kea Observatory, Hawaii" 1991* Roger Ressmeyer (Best18 219)

progression of the eclipse in "Bit by bit, a solar eclipse reaches totality, as seen from the Northwestern University observation station in Fryeburg, Maine" 1932 Wide World Photos (Through 466)

progression of the eclipse in "Eclipse of the Sun" 1854* William and Frederick Langenheim (Marien \2.13)

total solar eclipse with solar flares in "Solar Eclipse" 1925 Lewis P. Tabor (Goldberg 38)

SOLDIERS *see* ARMED FORCES

SOMALIA

dead man being pulled through crowd in "Dead U.S. Soldier in Mogadishu" 1993* Paul Watson (Best19 188; Capture 171; Lacayo 177)

digging a grave among other graves in "Hussein Fiiffiddo digs a grave for his daughter in what once was a Mogadishu botanical garden" 1992* Howard Castleberry (Best18 131)

feeding center, corpses, and international armed forces in "Baidoa and Mogadishu, Somalia" 1992* Christopher Morris (Best18 57-59)

Marine helping get wheat to Somalians "Mission of Mercy" 1992 Carol Guzy (Best18 5,16)

photo essay on the death and starvation of Somalis despite relief efforts in "Somalia: War and Famine" 1992 James Nachtwey (Best18 101-114)

shadows of people watching child die on hard ground in "Watching a child die in Baidoa, Somalia" 1992 Paul Lowe (Best18 128)

Somalis running from Marines in "U.S. Marines in Somalia must get along with residents who sing their praises one minute, only to steal from their packs the next" 1992 Dayna Smith (Best18 134c)

starving people, skeletal remains in "Starvation in Somalia" 1992 Paul Lowe (Best18 43-45)

SOUTH AFRICA

angry crowd holding small casket in "Alexandria Township funeral" 1986* Peter Magubane (Eyes \36)

carrying a young boy, who was killed by police bullet in Soweto in "A sister's agony" 1976 Photographer Unknown (Eyes #343; Photos 143)

coffins being carried by crowd through dirt street in "Mamelodi funeral" 1985* Peter Magubane (Eyes \37)

crowd being fired upon in "Residents of Alexandra Township, while demonstrating against violence, are shot and gassed by police" 1992* James Nachtwey (Best18 30)

people living in rubble in "Untitled" c. 1967 Ernest Cole (Marien \6.17)

photo essay on the funerals, death and violence of rival groups in "Inside South Africa: a country at war with itself" 1986 Joanne Rathe (Best12 60-65)

police and boy he shot in "A 13-year-old boy was shot in the back by police during a demonstration against violence in Soweto" 1992* James Nachtwey (Best18 31c)

police firing on demonstrators in "South African demonstrators scatter as police fire tear gas, rubber bullets, and buckshot outside the Soweto soccer stadium" 1993* Greg Marinovich (Best19 184a)

waiting by casket in hut in "Relatives of a man who had been accidentally killed mourn his death on the day of his funeral" 1986* David Turnley (Eyes \33)

women in white dresses are lawn bowling in "A [black] man picks up lawn-bowling balls for women at an exclusively all-white lawn-bowling club outside of Durban" 1986* David Turnley (Eyes \32)

SOUTH CAROLINA
 photo essay on children, debutantes, and wrestlers in "This South Carolina Life" 1998 Jamie Francis (Best24 172-173)
SOUTH KOREA
 fire at demonstration with riot police in "Demonstrations by students on the streets of Seoul" 1988* Anthony Suau (Best14 59a)
 rice-field with one tree in "Rice-growing village in Seoul, South Korea" 1988* Anthony Suau (Best14 58)
SOUTH POLE
 various photographers in magazine in "Pictures from the South Pole" 1930 Richard E. Byrd (Eyes #100-101)
SOVIET UNION, 1923-1991 see also FORMER SOVIET republics, 1992-
 families looking for dead soldiers on battlefield in the Crimea in "Grief" or "The eastern front: Searching for loved ones at Kerch" 1942 Dmitri Baltermants (Art \422; Lacayo 114; Photos 57; Rosenblum2 #613)
 girls dancing under portrait of Lenin in "Preschoolers at Khabarovsk's kindergarten rehearse for a pageant under the watchful eyes of 'Uncle Lenin' " 1987* Dilip Mehta (Best13 162b)
 man in Cossack uniform in "Old lumberjack in Sakhalin is rallying the Cossacks to keep the Kuriles Russian" 1992 Antonin Kratocvil (Best18 65)
 photo essay on addicts, dealers, and prostitutes in "HIV in the former Soviet Union" 1997 John Ranard (Best23 208)
 photo essay on life in and around outdated steel factory in "Russia's Industrial Wastelands" 1992 Anthony Suau (Best18 199-202)
 photo essay on Russian boy who lives in an airport in "Sergei: A Child Alone" 1992 John Kaplan (Best18 209-212)
 photo essay on the difficult life of elderly Russian women in "Russian Babushkas" 1992 Carol Guzy (Best22 17-22)
 portraits of decorated veterans in "Richly decorated Soviet military veterans: Gordiyevsky Mitrofanovich, Krapivko Borisovich, and Arkhipov Aleksnrovich" c. 1991 Linkevicius Kazmieras (Graphis92 \96-\98)
 soldiers in battle in ruins of Stalingrad in "The Assault of the 13th Guard, Stalingrad" 1942 Georgi Zelma (Art \420)
 students in class at military academy in "At Moscow's Suvorov Military Academy, a cadet gets by with a little help from his friend" 1987* Rick Smolan (Best13 162a)
SOVIET UNION–HISTORY–REVOLUTION, 1917-1921
 thousands of people gathered in large square in St. Petersburg in "Demonstration by Revolutionary Democrats, Petrograd" 1917 Photographer Unknown (Marien \4.76)
SPACE FLIGHT
 boys watching from the ocean the trail of Discovery in "Two boys watch from their body boards as John Glenn returns to space aboard Discovery" 1998* Greg Newton (Best24 16b)
 Columbia blasting off in "The Space shuttle Columbia lifts off from the Kennedy Space Center in Cape Canaveral, Florida" 1982* Jon Schneeberger (Through 480)
 cosmonaut in his spacecraft in "Gagarin, First Man in Space" 1961 Photographer Unknown (Photos 97)
 Discovery blasting off in "The United States returns to space with the launch of Discovery from Florida on September 29" c. 1988* Jim Middleton (Best14 6c)
 hard-shell space suit in "Presenting the AX-5, 1 of NASA's 2 prototype space suits" 1988* Roger Ressmeyer (Best14 157)
 men who made early flight into stratosphere in "In the world's largest balloon, Captains Stevens and Orvil A. Anderson made a record-breaking ascent into the stratosphere" 1935 Richard H. Stewart (Through 484)
 moment of explosion in blue sky in "The Challenger Explodes" 1986* Michele McDonald (Best12 10); NASA (Monk #49)
 people walking under the airborne remains of the Challenger explosion in "Subdued spectators of the Challenger explosion leave the launch viewing area" 1986 Karl Gehring (Best12 13a)
SPAIN see also OLYMPICS; BULLFIGHTERS and BULLS
 Franco's men of the Guardia Civil in "Spanish Civil Guard" 1950 W. Eugene Smith (Art \413; Lacayo 161)
 part of the courtyard in "The Court of the Alhambra in Granada" c. 1856 Charles Clifford (Rosenblum2 #130)
 photo essay on life in a Spanish village in "Spanish Village" 1951 W. Eugene Smith (Rosenblum2 #654-#658)
 sailing ships in port near tower in "The Tower of Gold, Seville" 1860 Louis de Clercq (Waking #78)
 sport of lifting heavy stones in "A Basque rural sport 'Lelanta Piedras' lifting heavy granite stones" 1998 John Kimmich (Best24 60b)
SPAIN–ANTIQUITIES
 carved panels in "Courtyard of house Known as Los Infantes, Zaragoza" 1860 Charles Clifford (Waking #75)

SPAIN–HISTORY–CIVIL WAR, 1936-1939
 men running with grenades in "A Hand Grenade Attack, Spain" 1936 David Seymour (Icons 67)
 people on street looking up in "Air-raid alarm" 1936 Robert Capa (Lacayo 80b)
 shattered buildings after aerial bombing in "The Bombing of Guernica, Spain" 1937 Photographer Unknown
 (Monk #23)
 soldier at the moment of being shot in "Death of a Loyalist Soldier" 1936 Robert Capa (Art \410; Eyes #187;
 Icons 68; Marien \5.84; Monk #22; Lacayo 88; Photos 50; Rosenblum2 #606)
SPANISH-AMERICAN WAR, 1898
 carrying a wounded man down a hill in "Carrying out the Wounded During the Fighting at San Juan" c. 1914
 James Hare (Marien \4.72; Rosenblum2 #587)
 cheering men in field in "¡Viva Cuba Libre-Viva Americanos!" 1898 James Hare (Eyes #56)
 gunner on a ship in "Sampson's Fleet, A Gunner of the Iowa" 1898 William H. Rau (National 143d)
 men pointing guns from stumps in "Cuban scouts concealed behind stumps of trees" 1898 John C. Hemment
 (Eyes #55)
SPIDERS
 and tube of yellow lipstick in [spider and lipstick] c. 1995* David Sacks (Graphis96 70)
 tarantula shedding its skin in "Found in many parts of the Americas, the tarantula has a life span of more than
 two decades; each year this spider outgrows its skin and sheds it like a glove" 1996* Mark Moffett (Best22
 185c; Through 341)
 tarantula walking on girl's hands in "It's probably the last time this Detroit fourth-grader will ever volunteer
 to hold a visiting tarantula" 1986 Pauline Lubens (Best12 119b)
SPINNING
 man sitting cross-legged by wheel in "Gandhi Beside His Spinning Wheel" 1946 Margaret Bourke-White
 (Icons 103; Monk #34; Photos 71)
 woman spinning wool on small bench in "Maclovia Lopez spinning wool" 1943 John Collier, Jr.
 (Documenting 309b)
 woman standing at wheel in home in "Spinning Wool, West Portland, Maine" 1910 Chansonetta Emmons
 (Rosenblum \54)
SPORTS AND STADIUMS see also BASEBALL; BASKETBALL; FOOTBALL; OLYMPICS; SKIS AND
SKIING; SKY DIVING; SWIMMING; TRACK AND FIELD
 aboriginal men, women, and children playing football and baseball in "Australia's Black Olympics" 1998
 Stephen Dupont (Best24 180-181)
 arm-wrestling by two men in "Far from Barcelona, two men compete in the Yukon-Jack arm-wrestling
 championship" 1992* Bill Frakes (Best18 162d)
 bobsled on course in "Four-man bob at Olympic games in Calgary" c. 1991* Alain Ernoult (Graphis91 \359)
 boys standing on beach with surfboards in "15-year-old lost his right leg in a motorcycle accident when he
 was 10, but he still surfs with his buddies" 1986 Dennis Hamilton, Jr. (Best12 226a)
 discus throwing from overhead in "Decathlete Christian Schenk of Germany practices throwing a discus"
 1991* Stefan Warter (Best17 155)
 gymnast in balance beam, weight lifter, track-and-field in "The XXIV Olympiad Summer Games in Seoul
 boasted a record 13,000 athletes from 161 nations" 1988* Kenneth Jarecke (Best14 52-53)
 handball players leaping in "A Cuban team handball player leaps into the air, trying to make a shot past the
 outstretched arms of U.S. player during the gold medal match at the Pan American Games" 1987 Robert
 Hanashiro (Best13 218d)
 ice hockey players crashing into each other in "A Boston Bruins player trips up a Buffalo player as they
 tangle during game action" 1987 John Tlumacki (Best13 223)
 ice hockey players on and off ice in "Pittsburgh Penguin Hannah gets a welcome from teammates after
 scoring winning goal with 5 seconds left in a tie game with Blackhawks" 1988 Vince Musi (Best14 140a)
 ice hockey player holding onto net in "Minnesota North Stars Mark Pavelich checks St. Louis Blues Cliff
 Ronning into the Blues' net" 1987 Marlin Levison (Best13 224a)
 lacrosse players celebrating in a pile in "A wave of lacrosse players celebrate after scoring the winning goal
 in overtime" 1986 Ronald Cortes (Best12 228)
 litter all over stadium benches in "San Siro Stadion in Milan after a soccer game" c. 1991* Walter Schmitz
 (Graphis91 \79)
 long jumper in "Long-jumper Carl Lewis checks his distance during Pan Am Games" 1987 Gary Cameron
 (Best13 192b)
 long jumper in "Polish athlete lets the effort show during her long jump at the European track-and-field
 championships" 1986 Dieter Endlicher (Best12 121a)
 man and child shooting a bow and arrow in "Centaur Teaching the Young Hercules to use the Bow and

Arrow" c. 1990* Evergon (Graphis90 \130)

miniature figures from trophies or cakes in [trophy sports figures] c. 1997* Sherrie Hunt (Graphis97 80-81)

photo essay on neighborhood basketball and coaches in "Inner city sports" 1997 David Butow (Best23 166c, 218)

pole vaulter crossing bar in "Pole vaulter Brian Schweyen of Montana State University misses clearing the bar at 17 feet, 6 inches by a shirttail" 1990 Kurt Wilson (Best16 134d)

pole vaulting in "A Shawnee Mission North High School pole vaulter tries to clear the bar at the University of Kansas relays" 1987 Jeff Tuttle (Best13 199d)

polo players swinging mallet while on horseback in "Stewart Copeland" 1988* E. J. Camp (Rolling #84)

racquetball court outdoors at night in [racquetball by the pyramids] c. 1997* Enric Marti (Graphis97 144a)

rowers celebrating in "Teammates celebrate their second-place finish in the National Rowing Championship" 1987 David Eulitt (Best13 216a)

rugby player tackled as he tries to score in "An Australian rugby rover is slammed to the ground as he tries to score in Grand Final" 1992* Bill Frakes (Best18 162a)

rugby players in fight in "Putting the squeeze on a rugby player" 1987 Lui Kit Wong (Best13 215)

shirtless man on the ground to throw a ball in [throwing a ball] c. 1997 Annie Leibovitz (Graphis97 203)

skateboarding on a ramp in [skateboarding] c. 1997* Walter Iooss (Graphis97 193)

small bowling alley in [bowling alley] c. 1997* Guy Kloppenburg (Graphis97 157)

smoke in soccer stadium stands in "Smoke bombs explode on the field at the soccer stadium in Naples" c. 1991* Walter Schmitz (Graphis91 \78)

stadium seats with only three people in "Three die-hard fans stay dry during an NFL replacement game at Sullivan Stadium in Foxboro, Mass." 1987 Bill Greene (Best13 128d)

surfer riding the foam of a wave in "Mike Eskimo rides the waves of Hookipa Beach in Hawaii" 1990* Jonathan Weston (Best16 135)

table tennis player in "Table tennis champion practices while wearing the compulsory Hejab in Tehran, Iran" 1996 Tom Stoddart (Best22 249c)

tug-of-war in the dirt in "The people of Jasper, Indiana" 1995 Torsten Kjellstrand (Best21 43)

water polo players with ball in "Players in a high school water polo match fight for control of the ball" 1993* George Wilhelm (Best19 167)

weightlifter releases the bar in "A weightlifter releases a bar behind her after realizing she cannot lift it overhead" 1993* George Wilhelm (Best19 170a)

wheelchair racer in [wheelchair athlete] c. 1997* John Huet (Graphis97 192)

wheelchair racers at top of hill in "Wheelchair racers crest the Queensway Bridge during a half-marathon in Long Beach" 1990 Peggy Peattie (Best16 190d)

woman throwing javelin in [series of athletes' images to promote a drug used in AIDS treatment] c. 1999* David Maisel (Photo00 186, 190)

woman wins a marathon in "An ecstatic Margaret Groos qualifies for the U.S. Olympic team by placing first in the Pittsburgh Marathon" 1988 John Kaplan (Best14 24)

STAIRS

African American boys building a staircase in "Stairway of Treasurer's Residence, Students at Work, The Hampton Institute, Hampton, Virginia" 1899-1900 Frances Benjamin Johnston (MOMA 67; Rosenblum2 #443; Sandler 74; Women \22)

back of stairs in "Stair Well" 1917 Charles Sheeler (Hambourg 17; MOMA 102; San #1)

back of stairs in wall opening in "Stairwell" 1914 Charles Sheeler (Szarkowski 233)

backs of Hopi women, sitting on steps, with elaborate hairstyles in "Watching the Dancers–Hopi" 1906 Edward S. Curtis (MOMA 60)

Cathedral steps in two directions in " 'A Sea of Steps' Wells Cathedral: Stairs to the Chapter House and Bridge to Vicar's Close" 1903 Frederick H. Evans (Art \160; Marien \4.19)

cement steps in "Calaveras Dam II" 1932 Alma Lavenson (Rosenblum 158; Rosenblum2 #538; Women \55)

enclosed, circular, exterior staircase in "Wooden Staircase at Chartres" 1852 Henri Le Secq (Waking #40)

flights of stairs in [colorful staircase] c. 1992* Richard Eastwood (Graphis93 185)

industrial building in "Image Folder Isoge" c. 1999 Stefan Kiess (Photo00 16)

lined with urns in "The Park at Saint-Cloud" c. 1853 Louis-Rémy Robert (Szarkowski 61)

long set of steps at side of brick wall in "Castle Staircase" 1927 Jan Lauschmann (Rosenblum2 #506)

looking down staircase to front door in "Synagogue staircase" 1982 Julio Mitchel (Eyes #327)

looking down stairs in a park in "Montmartre" 1926 André Kertész (Szarkowski 222)

looking up through spiral staircase in "A security guard at the Springfield Armory Museum in Massachusetts walks up the spiral staircase during a routine check of the building" 1987 Ruben W. Perez (Best13 176d)

man climbing steps that circle a storage tank in "Exxon employee climbs a 630,000-gallon storage tank to

retrieve a sample of the gasoline within" 1985 (Best11 141d)

men sitting on steps to the river in "Three Men on Steps at the Seine" 1931 Ilse Bing (Icons 38)

metal step on hotel roof in "The Los Angeles sky slowly clears after an April storm" 1988* Art Streiber (Best14 104)

partial view of woman climbing stairs in [walking upstairs] c. 1995* Lizzie Himmel (Graphis96 37)

people waiting by tracks at bottom of staircase in "Railroad Station, Poughkeepsie, New York" 1937 André Kertész (Hambourg \23; MOMA 158)

rain on lighted stairs in "Rainy Steps, Metropolitan Museum" 1985 Orville Robertson (Willis \308)

snow-covered fire escape on side of brick building in "Worker cleans snow from a fire escape" 1985 Jeff Greene (Best11 140a)

staircase and banister in "Architectural Site 7" 1986* Barbara Kasten (Rosenblum \16)

stone steps in park in "Parc de Sceaux" 1921 Eugène Atget (Art \267)

wide steps near fence in "Versailles, The Orangerie Staircase" 1901 Eugène Atget (Waking #165)

woman leaping down steps in "Cousin 'Bichonade' in Flight" 1905 Jacques-Henri Lartigue (Decade 16b; Marien \4.39)

woman walking down steps in "Leaving for work at 4:30 p.m." 1942 Gordon Parks (Documenting 232b)

woman with umbrella climbing several levels of rain-soaked stairs in "Diane Peterson, umbrella well in hand, heads for work" 1985 Steve Jones (Best11 140b)

wooden steps from porch in "Stairs, Mexico City" 1923-1926 (Hambourg \114; Women \47)

STARS *see* OUTER SPACE

STARVATION

arm of woman soothing malnourished children in "Children's ward, Korem, Ethiopia" 1985* Mary Ellen Park (Eyes \28)

child being weighed in "3-year-old Somali refugee cries as she hangs from a scale in a feeding center" 1992* John Trotter (Best18 132c)

crying, starving child holding sick mother in "Despair of Rwanda" 1994* Javier Bauluz (Capture 176)

dying and burial of emaciated children in "Sudan's Catastrophe" c. 1999 Tom Stoddart (Photo00 64, 65)

dying cattle, with man and child in "The Last of the Herd, Madras Famine" 1876-1878 W. W. Hooper (Rosenblum2 #316)

emaciated child covered with flies in "A child from the Eritrean region of Ethiopia who was too weak from hunger to brush the flies covering her body" c. 1991* Peter Turnley (Graphis91 \86)

emaciated child drinking from mother's breast in "Ethiopia" 1984* Anthony Suau (Eyes \27)

emaciated family in "Victims of the Madras Famine" 1876-1878 W. W. Hooper (Marien \3.107)

emaciated group of children and fed group of children in "Before and After" 1899-1900 Raja Lala Deen Dayal (Rosenblum2 #427-#428)

family walking across desert in "Region of Lake Fagubian. These nomads have had to walk across wide expanses" 1983-1885 Sebastiao Salgado (Eyes #326; Life 132)

father holding son at food center in "An Ethiopian father and son in an emergency feeding center" 1986 Mike Rynearson (Best12 68d)

feeding center, corpses, and international armed forces in "Baidoa and Mogadishu, Somalia" 1992* Christopher Morris (Best18 57-59)

girl sitting on hard ground in "A starving girl tugs at her brother's robe at a feeding station in Baidoa, Somalia" 1992* Andrew Holbrooke (Best18 130)

line of starving children in "War and Famine in Biafra" 1968 Photographer Unknown (Photos 118)

malnourished people waiting for food and water in "Sudan's Refugees" 1988 Michael Bryant (Best14 41, 44-45)

Marine helping get wheat to Somalians "Mission of Mercy" 1992 Carol Guzy (Best18 5,16)

mother holding emaciated child on her lap in "Ethiopian Famine" 1984 Stan Grossfeld (Capture 135; Eyes #347)

mother sitting with malnourished child in "An Ethiopian mother holds her malnourished son at a Belgian medical station in northern Ethiopia" 1987 William Campbell (Best13 120)

Nigerian mother holding her child in "Supported by her mother, a starving child receives soy milk at the Kersey Home for Children in Ogbomosho, Nigeria" 1991* Lynn Johnson (Through 274)

person placing body of child near others who died in the famine in "Inside 'Die Place' " 1985* Mary Ellen Mark (Eyes \26)

photo essay on the death and starvation of Somalis despite relief efforts in "Somalia: War and Famine" 1992 James Nachtwey (Best18 101-114)

photo essay on the death and starvation of Sudanese and conditions around a feeding center in "Sudan Famine" 1998 Tom Stoddart (Best24 136-145)

shirtless boys looking out window in "Children in kindergarten and victims of famine in North Korea" 1997*
(Best23 139d)

skeleton-like body of a young boy in [a starving Sudanese boy roams around a compound run by Doctors
Without Borders" c. 1999* Brennan Linsley (Photo00 60)

skeleton-like boy with a walking stick in "The Drought in Mali" 1985 Sebastiáo Salgado (Rosenblum2 #482)

starving child in "A frail Eritrean child sits in a medical tent at the Wad Sherife camp in the Sudan" 1985
Barry Thumma (Best11 122d)

starving child huddled on ground while a vulture waits in Waiting Game for Sudanese Child 1993* Kevin
Carter (Best19 195; Capture 172; Lacayo 180)

starving people, skeletal remains in "Starvation in Somalia" 1992 Paul Lowe (Best18 43-45)

Sudanese man of skin and bones on the ground in "A starving man in southern Sudan receives a packet of
rehydration salt from an aid worker" and "A starving man in southern Sudan, too weak to walk, crawls at
the feeding center" 1993 James Nachtwey (Best19 7a; 49)

young African boy in "Chan Gai, 13, is hospitalized for malnutrition in Sudan" 1991* Hoda Bkhshandagi
(Best17 82d)

STATUE OF LIBERTY (New York, New York)

arm and book of the statute under construction in the workshop in "Construction of the Statue of Liberty,
Workshop View, Paris" c. 1880 Albert Fernique (Rosenblum2 #180)

fireworks surrounding the statue in "Fireworks over the Statue of Liberty during Liberty Weekend" 1986*
Rick Friedman (Best12 97)

sailors on the masts of a tall ship pass by the statute in "Sailors on Norwegian ship *Denmark* get a close-up
view of Lady Liberty as tall ships parade in honor of her 100th birthday" 1986 Joanne Rathe (Best12 96a)

upper part of the statute in "The Statute of Liberty" 1980* Aram Gesar (Monk #50)

woman on crown of statue in "Chillin with Liberty" 1998* Renée Cox (Committed 84a)

STATUES *see* SCULPTURE

STEAMBOATS

coming into a dock in "Silver Springs, Florida, From the Morgan House, Steamboat Approaching Dock"
1886 George Barker (Photography1 #V-16)

piles of cotton on dock in "Princess Steamboat" 1857-1860 Jay Dearborn Edwards (Photography1 \33)

STILL LIFE

antique camera in [self-promotional] c. 1991* Yutaka Kawachi (Graphis91 \116)

apple and chocolate pot in "Chocolate Pot and Apples I" 1950 Leslie Gill (Rosenblum2 #650)

apple and coffee pot in "Still life with colored light" c. 1989* Aaron Jones (Graphis89 298)

apples and vase in "Still life with vase and apples" 1916 George Seeley (National 24a, \70)

artichoke and lemons on plate in [self-promotional] c. 1990* Rick Etkin (Graphis90 \332)

balance with large and small ball, tipped in wrong direction in [ad campaign] c. 1991* Luca Perazzoli
(Graphis92 \52)

ball and bust in "Still Life" 1937 Horst P. Horst (Icons 80)

basin, eggs, and towel in "Domestic Symphony" 1917 Margaret Watkins (Peterson #60; Women \35)

beans in lines and a fork in "Beans" 1992 Patrick Tehan (Best18 165)

bedpan on end in "Bedpan" 1930 Edward Weston (Hambourg 49)

blue liquid in bottles in "Blue Salad Dressings" 1995* Kenneth D. Lyons (Best21 147a)

bottle, cutlery, and paper bag in [still life on table] c. 1995* Andre Baranowski (Graphis96 84-85)

bottle of ink in [bottle of ink] c. 1992* Zefar and Barbara Baran (Graphis93 153)

bottle on table with leaves in "Old Bottle with Woodbine" 1921 Clara E. Sipprell (Peterson #56)

bowl and book on chest for [self-promotional] c. 1989* Chuck Shotwell (Graphis89 \304)

bowl of fruit on a table in [self-promotional] c. 1990* Gene D. Rogier (Graphis90 \337)

bowl of fruit on a table in "Untitled" c. 1909-1912 Heinrich Kühn (Art \174)

bowl of mixed fruit in [bowl of fruit] c. 1997* Giorgio Majno (Graphis97 96)

bowl of narcissus in "Narcissus" 1928 Laura Gilpin (Decade \20)

bowl of soup and napkin in [bowl of soup] c. 1992* Holly Stewart (Graphis93 64d)

bowls, pitcher, and vase in [bowls, pitcher, and vase] c. 1997* Carol Kaplan (Graphis97 62)

boxes stacked in piles in "Paper Boxes" c. 1870 Photographer Unknown (Szarkowski 105)

bread slice in "I Grew Up. . . Bread" 1997* Keisha Scarville (Committed 194)

breakfast table with toaster, coffee, and newspaper in [breakfast] c. 1995* Alan Blakely (Graphis96 95)

bucket, towel, and bowl on table for [self-promotional] c. 1989* Sicco Kolff (Graphis89 \305)

bud vase with flower for [self-promotional] c. 1989* Sinan Koçaslan (Graphis89 \284)

cabbage leaves in "Savoy Cabbage, Baby's Breath Blade" 1995* Darryl Curran (Goldberg 226)

camera on tripod in [camera on tripod] c. 1989* Chuck Shotwell (Graphis89 \264)

chair and coffee cup and shadows in "Personal study" c. 1989* R. J. Muna (Graphis89 \120)

champagne coming out of a glass in "Champagne jumps out of the glass" 1985* Michael P. Franklin (Best11 148a)

cigarette lighter and Ace of clubs in "Pubilcité Dunhill" 1930 Maurice Tabard (Marien \5.37)

cigarette types arranged on a table in "Cigarettes" c. 1925 Wynn Richards (Rosenblum \152)

clear ball in water in "Spheres in Glass" c. 1929 Lotte Beese (Rosenblum \123)

clear light bulbs in "Untitled" 1927 Anton Bruehl (Decade 21a)

coat hanging on hook in [personal work] c. 1991* Jonathan Lovekin (Graphis92 \51)

collar on checkerboard pattern in "Ad for George P. Ide Company (Ide Collar)" c. 1922 Paul Outerbridge, Jr. (Goldberg 62; Hambourg \112; Icons 78; MOMA 122; Marien \5.35; Peterson #48)

comb, toothbrush, and belt in [personal study of common objects] c. 1995* Craig Cutler (Graphis96 73)

compass, pocket watch, glasses, and pen holder in [annual report for a mining company] c. 1991* Terry Heffernan (Graphis92 \68)

crucifix and bowl with pear in [self-promotional] c. 1990* (Graphis90 \314)

cup, saucer, and leaves in [cup, saucer, and leaves] c. 1997* Susie Cushner (Graphis97 72)

cups and saucers and statuette in "Still life with Statuette and Vases" 1855 Louis-Rémy Robert (Art \83)

cups and saucers on a slant in [cups and saucers] c. 1997* Michael Mayo (Graphis97 76)

curtain and vase in [self-promotional] c. 1990* Howard Bjornson (Graphis90 \315)

cutlery in "Still life with cutlery" c. 1991* Gregor Schuster (Graphis91 \93-\98)

deer and fowl in "Still Life with Deer and Wildfowl" c. 1865 Adolphe Braun (Rosenblum2 #263)

desk lamp in [desk lamp] c. 1992* Chris Aiery (Graphis93 152c)

egg and metal vases in "For a brochure" c. 1989* Gerald Bybee (Graphis89 \219)

eggbeater in "La Femme" 1920 Man Ray (San #10)

eggbeater in "Man" 1918 (Art \240)

eggbeater and wooden bowl in [*The Beater and the Pan*] 1921-1922 Ralph Steiner (San \2a)

eggs on thermoses in [eggs on thermoses] c. 1999* Craig Cutler (Photo00 205)

explorers implements [for cruises] c. 1990* Terry Heffernan (Graphis90 \317, \319)

flower in pot in "Wall flower" c. 1991* Kathryn Kleinman (Graphis91 \114)

flowers and other objects in [self-promotional] c. 1991* Didier Gaillard (Graphis91 \120-\123)

flowers and other objects in "Still life from a calendar" c. 1991* Eberhard Grames (Graphis91 \88-\91)

flowers and pears on table from [book entitled *On Flowers*] c. 1989* Kathryn Kleinman (Graphis89 \263)

flowers and photograph from [series with found objects from man and nature] c. 1989* Scott Van Sicklin (Graphis89 \285)

flowers in a bowl in "Flowers in a Bowl" 1908-1910* Heinrich Kühn (Art \175; Waking #132)

flowers laid out on background from [still life with flowers series] c. 1989* Michael Geiger (Graphis89 \269-\272)

flowers on colored plates for [Kodak ad] c. 1989* Grant Peterson (Graphis89 \281)

food on a plate in [self-promotional] c. 1990* Philip Bekker (Graphis90 \333)

fork and leaves on bowl in "Untitled" 1978* Jan Groover (Decade \IV)

fork on rim of plate in "The Fork" 1928 André Kertész (Art \251; Hambourg \113; Icons 31)

forks in "Untitled" 1978* Jan Groover (Photography 100)

fruit and a key in [fruit and a key] c. 1997* Chloe Atkins (Graphis97 88)

fruit and draped leather in "Fruits and leather" c. 1989* Myron Beck (Graphis89 \225, \226)

fruit and flowers in [self-promotional] c. 1989* (Graphis90 \291-\293)

fruit and jug in "Water Jug, engraved Glass and Pears on a Plate" c. 1862 Henri Le Secq (Art \81)

fruit and mirrors in "Obst" 1929 Florence Henri (Decade 26)

fruit and small statues in "Still Life with Statue" Roger Fenton (Art \110)

fruit arrangement in "Still Life with Fruit" 1860 Roger Fenton (Art \111; Rosenblum2 #260; Waking #27)

fruit on a plate in [untitled] c. 1991* Jan Oswald (Graphis91 \136, \137)

fruit on a plate in [self-promotional] c. 1990* Parish Kohanim (Graphis90 \326)

fruits and vegetables arranged like a painting in "Assignment was to show the how and why of exotic fruit and vegetables" 1985* Brian Hagiwara (Best11 157b)

game birds in "Still life with Game" 1865 Adolphe Braun (Art \82)

game birds in "Still Life with Waterfowl" c. 1873 Charles Philippe Auguste Carey (Rosenblum2 #265)

garden tools on ground in "Landscape architecture" 1992* Mark B. Sluder (Best18 168)

glassware in "Bolla and Murano–The Italian Classic" c. 1990* Cara H. Luckett (Graphis90 \294)

grapes in basket with handle in "Muscats" c. 1934 Christine B. Fletcher (Peterson #65; Rosenblum \150)

green beans on plate from [article on the effect of color] c. 1989* Grant Peterson (Graphis89 \296)

insects on nail polish and face powder in [insects on face powder and nail polish] c. 1995* David Sacks

(Graphis96 72)

irises from [still life with flowers series] c. 1989* Michael Geiger (Graphis89 \268)

jam jar and teapot in [ad for jams] c. 1990* Terry Niefield (Graphis90 \328)

jewels in the Great Temple of Madurai in "The Pagoda Jewels, Madurai" 1858 Linneaus Tripe (Waking 303)

key, teeth, and hammer in [hammer, teeth, shell, and objects] c. 1992* Ron Baxter Smith (Graphis93 69)

key and other abstract objects in "Untitled" 1922 Man Ray (San \20)

keys in "I Grew Up. . . Keys" 1997* Keisha Scarville (Committed 195)

knife and pear half on plate for [self-promotional] c. 1989* Tony Cenicola (Graphis89 \323)

knife and small figures on table in "Untitled" 1984 Jan Groover (Women \173)

knife, egg, quarter, and string in "Objects" 1939 Raoul Ubac (Hambourg \121)

knife with jam on plate in "Ad for the gastronomic profession" c. 1989* Bernhard Angerer (Graphis89 \328)

leather jacket on wooden hanger in [images related to time and change, and to the changing nature of beauty in objects revealing aspects previously concealed] c. 1991* Chris Wimpey (Graphis92 \58)

leaves in "Leaf arrangement" 1860s Charles Hippolyte Aubry (Szarkowski 100)

leaves on drapery in "A Study of Leaves" 1864 Charles Hippolyte Aubry (Art \84; Rosenblum2 #262)

light bulb in fixture in "Light Bulb Study" 1927 Sara Parsons (Hambourg 31a)

lilies in vase in "Alarm clock and flower vase" c. 1991* Charles Shotwell (Graphis91 \113)

lock and keys in [company brochure] c. 1990* Terry Heffernan (Graphis90 \316)

loudspeakers in an arrangement for [JBL loudspeaker brochure] c. 1990* Luca Vignelli (Graphis90 \212)

medical capsules on background of squares in [medical capsules] c. 1990* Antal Farkas (Graphis90 \295)

metal tools and objects in [promotional project for paper company] c. 1995* Colin Faulkner (Graphis96 74, 75)

miscellaneous objects in "Still Life (Interior of a cabinet of curiosities)" 1837 Louis-Jacques-Mandé Daguerre (Marien \1.12; Rosenblum2 #27)

napkin holders from restaurants in [napkin holders] c. 1999* Craig Cutler (Photo00 206)

nuts, bolts, and wrenches in oil in [nuts and bolts] c. 1992* Michael Hogrefe (Graphis93 134)

nuts in a bowl in "Still life" c. 1989* David Stewart (Graphis89 \278)

objects on pedestals in "Untitled" 1988* Jan Groover (Women \174)

onions and drapery on a table [based on a painting by Paul Cezanne] c. 1991* Peter Meyers (Graphis91 \138)

orange on book near bottle in "Bottle, Book and Orange Twin Lakes" 1916 Paul Strand (San #22)

oranges on a plate in "Oranges still on the branches" c. 1991* Laurie Rubin (Graphis91 \129)

paper bags and half-empty plates in [still life with paper bags] c. 1992* André Baranowski (Graphis93 90)

pear and bowls in "Still Life, Pear and Bowls, Twin Lakes" 1916 Paul Strand (Decade 17c; San #21)

pear and bowls in "Pears and Bowls" 1916 Paul Strand (Waking #180)

pear and knife on a plate in "Art as Food" c. 1991* Mark Wendell Hutchison (Graphis91 \134)

pear and lemon in "Still Life with Lemon and Pear" c. 1929 Florence Henri (Hambourg \111; Rosenblum \125; Women \67)

pear and onions on a board in "Untitled" 1983 Jan Groover (Women \171)

pelts, birds, and flowers from [series with dead birds, pelts, and blossoms] c. 1990* Eberhard Grames (Graphis90 \287-\290)

pen in "Pen on perforated metal" c. 1991* Hunter Freeman (Graphis92 \185)

pens and shadows in [self-promotional] c. 1990* Claus Dieter Geissler (Graphis90 \213)

perfume bottles in [perfume bottles] c. 1992* Jim DiVitale (Graphis93 148)

perfume bottles and lilies in [article "Quintessence for your Beauty"] 1989* Susan Metzner (Graphis89 \2)

petals falling from flower in [self-promotional] c. 1991* Yutaka Kawachi (Graphis91 \117)

picture frames on a table in "Towards the Mirror" 1998* Camille Gustus (Willis \460)

piece of paper in glass of water in "Paper in Water Glass" 1931 Grete Stern (Rosenblum \133)

pizza and glass of beer for [culinary festival with beer] c. 1990* Peter Franz-Moore (Graphis90 \326)

plate and leaves in [self-promotional] c. 1991* Carol Kaplan (Graphis91 \130)

plate with fig, flowers, and breast in "Still Life with Breast" 2001 Joel-Peter Witkin (Photography 224)

plates and cup as still life in "Curves" c. 1930 Hiromu Kira (Peterson #35)

plumbing pipes in "GOD" c. 1916 Morton Schamberg (Hambourg 13a)

pomegranates in a bowl in [self-promotional] c. 1991* Louis Wallach (Graphis91 \133)

pumpkin and book on a table in "Still Life with Pumpkin, Book, and Sweet Potato" c. 1855* Photographer Unknown (National 166)

record player needle on record in "Electrola" 1930 Werner Feist (Hambourg 66c)

rope in a box in "Rope" c. 1991* Jim Krantz (Graphis91 \99)

rose in pitcher and cosmetic mirrors in [Rose and Mirrors] c. 1997* Geog Kern (Graphis97 14)

roses in [flowers] c. 1997* Carol Kaplan (Graphis97 63)

roses in vase in "Still life with roses and white table cloth" c. 1991* Douglas Benezra (Graphis91 \119)

scissors, paper clip, and crumbled paper on plate in [self-promotional] c. 1991* Michael Wolkenthin (Graphis91 \92)

seltzer bottle on floor in "Still life" c. 1989* David Stewart (Graphis89 \277)

shower hose wrapped around bar in "Still-life–Shower Hose" 1919 Margaret Watkins (Women \33)

shrimp photographed on a lemon in "Hood Canal shrimp" 1985* Alan Berner (Best11 148)

skull, crucifix, and sand hour glass in "Still life with skull" c. 1850 Louis Jules Duboscq-Soleil (Szarkowski 318a)

sleek coffee pot in shadows for [self-promotional] c. 1989* John Payne (Graphis89 \233)

snake in [company brochure] c. 1990* Terry Heffernan (Graphis90 \318)

spider on tube of yellow lipstick in [spider and lipstick] c. 1995* David Sacks (Graphis96 70)

spools of thread in a box in "Threads" 1930 Ellen Auerbach (Rosenblum \132)

stones with line in middle in [stones] c. 1997* Dennis Letbetter (Graphis97 64-65)

strawberries and pie knife in "Fruit torte" 1985* Scott Robinson (Best11 148c)

toilet bowl in "Excusado" 1925 Edward Weston (Marien \5.52; Waking 354c)

toothbrush and toothpaste in "Untitled" c. 1930 Hans Finsler (Marien \5.38; San \15)

vase and plate in [self-promotional] c. 1990* Adrian Flowers (Graphis90 \301)

vase between pillars for [folder] c. 1990* Jody Dole (Graphis90 \296)

vase with flower from [still life with flowers series] c. 1989* Jody Dole (Graphis89 \306-\308)

vase with head of Medusa in "Vase with Medusa's Head" 1840 William Henry Fox Talbot (Waking #11)

vases on a shelf in [ad for a designer] c. 1990* Hans Hansen (Graphis90 \285)

wash bowl and base of sink in "Wash Bowl, Mexico" 1926 Edward Weston (Decade \19)

wash bowls, buckets and laundry in "Still Life of the Washerwoman" 1853 Hermann Krone (Rosenblum2 #259)

watch, gun and leather jacket in [self-promotional] c. 1991* Yutaka Kawachi (Graphis91 \118)

watermelon, grapes and bread in "Still Life with Watermelon" 1947* Irving Penn (MOMA 194)

wilted flower in "Still life" c. 1850 William Collie (Szarkowski 65)

wine bottles and fruit from [wine auction catalog] c. 1989* Mike Borum (Graphis90 \327)

STILTS

dancers in stilts leaning against roof in "Dan stilt dancers rest their legs and backs after a performance in *Côte d'Ivoire*" 1982* Michael and Aubine Kirtley (Through 260)

man in patriotic costume on stilts in "While waiting in line for a tour, the crowd is awed outside the newly elected governor's mansion" 1995* Peggy Peattie (Best21 161d)

STOCK EXCHANGE

trader on phone above stock ticker in "Black Monday, October 19, the day the Dow Jones Industrials plunged 508.32 points" 1987 Bill Greene (Best13 15a)

traders at computers in "Black Monday, October 19, the day the Dow Jones Industrials plunged 508.32 points" 1987 Steve Ringman (Best13 15b)

STONEHENGE (England)

several of the stones in "Stonehenge, England" 1967 Paul Caponigro (Decade \100)

STORES *see also* types of stores

bicycle leaning against small stand and storefront in "Bill's Peanut Stand and Lutz's Central Market" 1942 Marjory Collins (Documenting 258c)

boy looking in store window with Jewish items in "Window of a Jewish religious shop on Broom Street. New York City" 1942 Marjory Collins (Fisher 68)

children's clothes in store window in *Avenue des Gobelins* 1925 Eugène Atget (Rosenblum2 #319)

couple shopping in clothing store in "On a shopping expedition, a couple in Moscow seem oblivious to the eye-catching ad behind them" 2001* Gerd Ludwig (Through 102)

diners of various styles in [diners] c. 1997* Charles Maraia (Graphis97 162, 163)

front of bait shop from [series on Texas Intercoastal Waterway] c. 1997* Kent Barker (Graphis97 160)

front of restaurant and bakery and cobblestone street in "Restaurant and bakery, 1113 and 1115 First Avenue" 1938 Walker Evans (Documenting 142b)

furniture store window reflecting outside lampposts in "Cincinnati" 1963 Lee Friedlander (Art \337; MOMA 241; Rosenblum2 #676)

general store with gas pumps in "Vanishing Texas" c. 1991* Harry de Zitter (Graphis92 \196-\198)

glass cases with boxes of cigars and newspapers hanging around the store in "Interior view of tobacco and newspaper store" c. 1917 Daniel Freeman (Willis \25)

groceries and lunch tables in [small general store] c. 1997* Guy Kloppenburg (Graphis97 156d)

helmeted motorcycle rider in video store in "Videoshop" 1985* Martin Parr (Art \407)

housewares and hardware in "Window Display, Bethlehem, Pennsylvania" 1935 Walker Evans (Rosenblum2 #472)

inside a crowded butcher shop in "Benjamin Lutz presiding at this butcher shop at 4:30 p.m., when the shifts changed in Lititz's factories" 1942 Marjory Collins (Documenting 260a)

jewelry store window being arranged by shop owner in "The Fulton Mall in Brooklyn serves a largely black clientele, but there are no black-owned businesses on the mall" 1991 Peter Essick (Best17 52)

movie theater in "Vanishing Texas" c. 1991* Harry de Zitter (Graphis92 \196-\198)

shelves of goods under mounted deer heads in "There's only a gas station and general store left in Cave City, Missouri" 1998* Randy Olson (Best24 84)

shelves of pots, pans, and other hardware items in "Mrs. Morris Kreider, the wife of the hardware store owner, and Dr. Posey" 1942 Marjory Collins (Documenting 264a)

shuttered stores at street corner in "Café Diderot" c. 1989* Neil Lukas (Graphis89 \66)

statue of Colonel Sanders outside store in "Scenes of Seoul" 1988* James Nachtwey (Best14 40)

statues and chairs outside store in "Sumner Healy Antique Shop" 1936 Berenice Abbott (Sandler 84)

stealing toilet paper from trashed store in "Drenched by a store's sprinkler system, a looter makes off with wet toilet paper during a Los Angeles riot" 1992 Dayna Smith (Best18 121)

store window filled with cheese in "Cheese Store, Bleecker Street" c. 1937 Berenice Abbott (Rosenblum \168)

teenagers in record store in "Lemcke's Record Store" 1944 Nina Leen (Life 41a)

tires hanging on outside of store in "Second Hand Tires" 1940 Russell Lee (Rosenblum2 #468)

truck crashed into beauty store window in "It was business as usual for beautician Yolanda Ponce after a pickup truck intruded" 1986 Bruce McClelland (Best12 122b)

window of men's clothing store in "Magasin, Avenue des Gobelins" 1925 Eugène Atget (Art \271; Decade 11a; Hambourg \31)

windows of drug store filled with products in "Drug store window display in a mining town" 1938 Marion Post Wolcott (Fisher 36)

STORMS

approaching storm over city in [approaching storm, Bondi Beach, Australia] c. 1991 Philip Quirk (Graphis92 \205)

at horizon in "Storm off the California coast at Point Reyes" c. 1991* David Maisel (Graphis91 \300)

sailing ship in rough sea in "Crossing the Stream" c. 1938 John R. Hogan (Peterson #78)

uprooted trees, homes, and dead body in water in "The aftermath of a typhoon on the island of Leyte in the Philippines" 1991* Les Stone (Best17 117)

wave crashing through windows of a home in "Dave Foley of West Palm Beach is taken by surprise as a monstrous wave crashes through the plate glass windows of a beachfront home on Jupiter Island, Florida" 1991* David A. Lane (Best17 106)

waves crashing on rocks near lighthouse in "Wind and waves near the Thacher's Island Lighthouse, Cape Anne, Mass." 1962* Leonard McCombe (Life 184)

waves taking woman's body away in "Storm on Plum Island" 1990 Marc Halevi (Best16 211-214)

waves, the height of the lighthouse, crashing around it, in "Blizzard Rams New England" 1978 Kevin Cole (Capture 108)

STORYTELLING

elder telling stories to children in Kalahari Desert in "Bushmen children" 1947 N. R. Farbman (Lacayo 92)

STOVES

contemporary design in "A contemporary tile oven designed by Manfred Lang" c. 1989* Frank Exner (Graphis89 \215)

stove being polished by two African American men in "Two Workmen Polishing a Stove" c. 1865 Photographer Unknown (National \11)

stove, oven, and kitchen table in "Kitchen in the Vicinity of Boston, Massachusetts" c. 1900 Charles H. Currier (MOMA 70)

STREAKING

nude man held by police in "Rugby match streaker" 1974 Ian Bradshaw (Life 116)

STREET FIGHTING

children on street in "Children on the streets of West Belfast" 1997* (Best23 150c)

men fighting on street in "Businessman finds himself in the wrong place at the wrong time as a street brawl breaks out in downtown Pittsburgh" 1992 Brian Plonka (Best18 51)

pile of youths near wall with graffiti in "Untitled" 1987 Jules Allen (Committed 47)

teenage girls fighting on street in "Business declined at Midtown Plaza in Rochester, New York, because kids would loiter in the plaza, often harassing shoppers" 1987 Michael Schwarz (Best13 68a)

STREET LIGHTING
 on top of wall in "Street Lamp" c. 1870 Charles Marville (Szarkowski 70)
STREET MUSICIANS
 children gathered around man with organ on cart in "Dancing to the Organ, Lambeth" c. 1895 Paul Martin
 (Marien \4.44)
 girls dancing to street organ in "Street Organ, Amsterdam" 1933 Ilse Bing (Women \61)
 violins and bass violin being played on the street in "A three-piece band performs on a Romanian street on
 Easter" 1990 Anthony Suau (Best16 178)
STREETCARS
 looking through car to conductor in "On a streetcar" 1938 John Vachon (Documenting 96b)
STREETS
 aerial view of burned-out neighborhood in "Police work with crane to search for evidence in the burned-out
 neighborhood, Philadelphia" 1985 Chuck Isaacs (Best11 25a); "The search for evidence continues at the
 scene of the MOVE confrontation" 1985 George Widman (Best11 25b)
 aerial view of wide intersection with only one couple and bicycle rider in "7 a.m. (New Year's Morning)"
 c. 1930 László Moholy-Nagy (Hambourg \12)
 alley between apartment buildings in "Downtown Baltimore, Maryland" 1998* Ken D. Ashton (Willis \424)
 bar on street corner in "Saloon in the stockyard district" 1938 John Vachon (Documenting 101c)
 boys fighting in street in "Harlem Gang Wars" 1948 Gordon Parks (MOMA 199)
 cars and trucks on city street with five-story buildings in "First Avenue and East Sixty-first Street" 1938
 Walker Evans (Documenting 140b)
 cobblestone, vacant street in "Rue de Choiseul, Paris" c. 1865 Charles Marville (Szarkowski 108);
 in "Rue Croulebarbe, Paris" c. 1865 Charles Marville (Szarkowski 323c)
 deserted street near mill in "Street Scene in a Milltown" 1937-1938 Humphrey Spender (Rosenblum2 #458)
 deserted, tree-lined street in "New England Street" 1907 Clarence H. White (MOMA 87)
 donkey cart on small street in "Charlotte Street–St.Augustine, Florida" 1886 George Barker (Photography1
 #V-14)
 empty stores and street in "In Marathon, Iowa, a lone tractor rumbles down the main street of a town that has
 lost just about all of its agribusiness trade–which is all the trade it had" 1986 David Peterson (Best12 36)
 fire truck near block of houses in flames in "A West Philadelphia residential block goes up in flames" 1985
 Bruce Johnson (Best11 24)
 laundry hanging over alley and men in hats in "Bandits Roost, 59½ Mulberry Street" c. 1888 Jacob Riis
 (Marien \4.46; MOMA 73) Richard Hoe Lawrence (Eyes #47)
 lights of street on a rainy night in "Steamy Streets" 1990* Jodi Cobb (Best16 70)
 long shadows of people on street from overhead in "Mystery of the Street" 1928 Umbo (Hambourg \110)
 looking down from elevated tracks to street in "Third Avenue and 42nd Street from the steps leading to the
 elevated train" 1942 Marjory Collins (Fisher 74)
 men in hats on street corner in "Seventh Avenue, 42nd and 43rd Streets, New York City" 1914 Photographer
 Unknown (MOMA 78)
 men in suits and hats on street corner in "Men pause a moment to watch the Salvation Army and then pass
 on. San Francisco, California" 1939 Dorothea Lange (Fisher 38)
 men walking past parks cars in "In front of 310 East 61st Street" 1938 Walker Evans (Documenting 132b)
 men whistling and staring at women walking on street in "American Girl in Italy" 1951 Ruth Orkin
 (Rosenblum \219)
 overhead view of people crossing street in "Paris" 1929 Marianne Breslauer (Rosenblum \137)
 people with umbrellas at street corner in "New York" c. 1893 John Beeby (Photography1 #VI-6)
 roofs over long neon arrow in "Los Angeles" 1955-1956 (MOMA 217)
 row of small houses in "In the Italian district (Omaha)" 1938 John Vachon (Documenting 111b)
 shoppers and neon signs on city buildings in "Shopping district just before closing time at 9 p.m. on Thursday
 night. Baltimore, Maryland" 1943 Marjory Collins (Fisher 54)
 silhouette of a man waking on a wide street in "Untitled" 1915 Paul Strand (MOMA 98)
 small child playing in puddle on deserted street in "Untitled" 1955 Roy DeCarava (MOMA 205)
 snow-covered sidewalk in small town with lampposts in "Center of town. Woodstock, Vermont" 1940 Marion
 Post Wolcott (Fisher 44)
 solid white line on empty city street in "Street Line, New York" 1951 Robert Frank (MOMA 208)
 taxi near the elevated tracks in "St. Mark's Place and the Bowery at midnight. New York City" 1942 Marjory
 Collins (Fisher 75)
STRIKES AND LOCKOUTS
 crowd of African American men carrying signs in "I Am a Man: Sanitation Workers Strike, Memphis,

Tennessee" 1968 Ernest C. Withers (Committed 224; Goldberg 164; Marien \6.68; Willis \176)

picketers assaulting man with coat over his head in "The Picket Line; Ford Plant, River Rouge, Michigan" 1941 Milton Brooks (Capture 8; Lacayo 91)

police beating men to ground in "Republic Steel strike, Chicago" 1937 Photographer Unknown (Life 153)

rally of men in support of strikers in "Rally in Cadillac Square, Detroit" 1937 William Vandivert (Life 152)

STRIPTEASE

outside "girlie" theater in "Burlesque in New York" c. 1941 Andreas Feininger (Decade \55)

STROBOSCOPES

drop falling and creating crown-shape in "Drop of Milk" 1931 Harold Edgerton (Monk #18) or "Milk Drop Coronet" 1936 Harold Edgerton (Goldberg 105; Marien \5.77)

path of bullet through bursting apple in "Bullet Through the Apple" 1964 Harold Edgerton (Goldberg 123a)

woman jumping rope in "Moving Skip Rope" 1952 Harold Edgerton (Goldberg 133)

STUNT PERFORMERS

man on fire flying through the air in "Professional stunt man 'Diver Dan' performs the 'human torch' dive at the California State Fair" 1990* Genaro Molina (Best16 54)

SUBMARINES (Ships)

above the water in calm canal in "Submarine in the Kiel Canal" c. 1990* Rolf Nobel (Graphis90 \85)

SUBURBS

aerial view of houses around circular roadways in "Sun City, Arizona" c. 1995* Randy Wells (Graphis96 170)

couple on chaise lounges in backyard in "A Family on their Lawn one Sunday in Westchester, New York" 1969 Diane Arbus (Art \329)

front door and window of small tract house in "Colorado Springs, Colorado" 1968 Robert Adams (Art \369)

mound of dirt with toy trucks in backyard in "Buckingham, Pennsylvania" 1978* Joel Sternfeld (Art \339)

new construction of houses in desert in "Newly occupied tract houses, Colorado Springs, Colorado" 1968 Robert Adams (Goldberg 201; Marien \6.56)

photo essay on school, commuting, proms, church services, play, and traffic deaths in "Aurora, Illinois 60504" 1997 Scott Lewis (Best23 74-89)

swing set in backyard in "Untitled" 1973 Robert Adams (Art \370)

SUBWAYS

brother holding brother in subway car in "Maximillano Chaves Vidals cradles his brother, Edwardo, who was shot on a subway in Brooklyn" 1990 Osman Karakas (Best16 102)

elevated part of the subway going past apartment house in "City noises in West Harlem, accentuated by the rumble of a train, make the task of placing a phone call nearly impossible" 1991 Peter Essick (Best17 50a)

elevated tracks, mailbox and street lamp in "Second Avenue and East Sixty-first Street" 1938 Walker Evans (Documenting 139c)

looking down from elevated tracks in " 'El' at Columbus Avenue and Broadway" 1929 Berenice Abbott (Hambourg \27; MOMA 134; Rosenblum2 #530)

looking down from elevated tracks to street in "Third Avenue and 42nd Street from the steps leading to the elevated train" 1942 Marjory Collins (Fisher 74)

man in costume riding on the subway in "Riders on a New York subway managed to keep their enthusiasm under control when 'George Washington' rode with them on the Fourth of July" 1986 Bill Frakes (Best12 136a)

shadows below elevated subway lines in " 'El,' Second and Third Avenue Lines" 1936 Berenice Abbott (Sandler 87)

taxi near the elevated tracks in "St. Mark's Place and the Bowery at midnight. New York City" 1942 Marjory Collins (Fisher 75)

THE SUDAN

dying and burial of emaciated children in "Sudan's Catastrophe" c. 1999 Tom Stoddart (Photo00 64, 65)

homeless children in "The Sudan" c. 1990 Mary Ellen Mark (Graphis90 \257-\260)

malnourished people waiting for food and water in "Sudan's Refugees" 1988 Michael Bryant (Best14 41, 44-45)

photo essay on the death and starvation of Sudanese and conditions around a feeding center in "Sudan Famine" 1998 Tom Stoddart (Best24 136-145)

skeleton-like body of a young boy in [a starving Sudanese boy roams around a compound run by Doctors Without Borders] c. 1999* Brennan Linsley (Photo00 60)

skeleton-like man of skin and bones on the ground in "A starving man in southern Sudan receives a packet of rehydration salt from an aid worker" 1993 James Nachtwey (Best19 7a)

SUFFRAGE
 crowd around women speaking on platform in "Christabel Pankhurst speaking on women's suffrage in Hyde
 Park" c. 1909 (Rosenblum \63)
 man unhappily doing laundry in "Is Your Wife a Suffragette" 1908 Photographer Unknown (Marien \4.29)
 Suffragist making jam at home in "Mrs. How Martyn Makes Jam" n.d. Photographer Unknown (Marien \4.30)
 women in flag capes in "A woman's-suffrage parade in New York City" 1915 Photographer Unknown
 (Lacayo 43c)
SUICIDE
 falling from building in "A man's body falls from a 14-story apartment building after a five-hour ordeal in
 which he fired randomly on the streets below in an effort to attract police gunfire" 1990 Thomas Ondrey
 (Best16 104b)
 girl and police officer sitting on large sculpture in "Three hundred feet above Grand Central Station, New
 York police Officer Andy Nugent talks to a 14-year-old girl who was threatening suicide" 1990 David
 Handschuh (Best16 109b)
 man on bridge in "A man gestures as he threatens to jump from a bridge" 1986 Andy Starnes (Best12 86c)
 man on ledge of hotel in "A distraught San Franciscan clung to a ledge on a downtown hotel, finally fled, was
 captured" 1986 Steve Ringman (Best12 87b)
 man on top of building in "A despondent lover was talked down from a 40-story Los Angeles building after
 four hours" 1986 John Mc Coy (Best12 87a)
 man with gun in mouth in "Billy Ray Youngblood threatens suicide from the back seat of a Muskegon police
 cruiser" 1990 Brian Masck (Best16 104c)
 police officer holds hand of man with gun in "Paul Herrera holds a cocked pistol to his head in Pittsburgh
 as Officer Paul Laukaiti holds his hand" 1988 Robin Rombach (Best14 72)
 rescuers reach man on bridge in "Using wire cutters to clip a fence, Pittsburgh parmedics rescue a man who
 threatened to jump" 1986 Randy Olson (Best12 87c)
 series showing man putting gun in mouth in [Suicide of Pennsylvania State Treasurer R. Budd Dwyer] 1987
 Terry L. Way (Best13 12); Paul Vathis (Best 13 13d; Eyes #361-362)
 silhouette of man holding a gun to his head in "A gunman killed himself after holding his wife hostage six
 hours" 1986 Joyce Marshall (Best12 86b)
 talking from window to man on ledge in "It took police three hours to talk this man off a fifth-floor hospital
 ledge" 1986 Victor Calzada (Best12 86a)
 woman waves for help after jumping in icy river in "A potential suicide changes her mind after jumping into
 the icy waters of the Allegheny River in Pittsburgh" 1986 Melissa Farlow (Best12 38)
SUMO
 holding a boy, and showing ceremonial garb in "The Grand Sumo" 1997* Craig Golding (Best23 216b)
 playing video games and bending over in "Sumo Wrestler Camp" 1996 Tom Wagner (Best22 239a, c)
 wrestlers in a parade before event in "Sumo wrestlers in Nigata, Japan, parade in pre-tournament ceremony"
 1997* Robb Kendrick (Through 184)
SUN
 midnight sun in multiple exposures in "Eight exposures on the same photographic plate, made at 20-minute
 intervals, capture the midnight sun over Littleton Island near Greenland" 1925 Donald B. MacMillan
 (Through 492)
SURFING
 in the air in "Surfboard gets air out of the compression of a wave" 1996* Rick Rickman (Best22 192a)
 on a wave in "A surfer takes off on one of a series of waves produced by an offshore storm" 1996* Patrick
 Tehan (Best22 187c)
 on crashing waves in "Pulling out all the stops and bouncing his board off the top of a good wave" 1998*
 Rick Rickman (Best24 73a)
 on crashing waves in "With El Niño pounding the coastline of California, surfers got out their fastest boards
 to try to tame the 15-foot surf" 1998* Sean M. Haffey (Best24 60a)
 surfboard hitting surfer in "This surfer loses his balance and dignity as his surfboard slaps him in the face
 during a wipeout" 1996* Rick Rickman (Best22 200c)
SURGERY
 before and after breast reconstruction in "Breast reconstruction" 1987 Lynn Johnson (Best13 160-161)
 doctors and patient during an operation in "Doctors perform surgery in Providence" 1991* Ruben Perez
 (Best17 207a)
 eye surgeon applying drops in "A surgeon applies fluorescent drops to a patient's eye" 1993* Matthew Craig
 (Best19 74c)
 eye surgery in "Curing India's Cataracts" 1998 Tom Stoddart (Best24 42d)

men in suits standing around woman on operating table in "Operating Room, Massachusetts General Hospital, Woman Patient" 1846-1848 Southworth & Hawes (Rosenblum2 #187)

photo essay on patient needing a heart transplant in "A Life in the Balance" 1988 John Kaplan (Best14 26-27)

teenager after a nose job in "Lindsay, 18, after her nose job, with a nurse showing the doctor's photograph of Lindsay's preoperative nose" 1995* Lauren Greenfield (Best21 80a)

woman with breast removed in "After breast cancer surgery" 1997 Marguerite Nicosia Torres (Best23 183a)

SURVEYING

cutting through a forest for a survey in "Cutting on the Forty-Ninth Parallel, on the Right Bank of the Mooyie River, Looking West" 1860-1861 Photographer Unknown (Marien \3.51)

SWANS

flock of swans on water in "Swans" 1990 Bill Uhrich (Best16 68)

group of swans covered with snow in "Wild swans caught in a snowstorm in northern Japan" c. 1991* Teiji Saga (Graphis91 \349)

head tucked over its back and underneath its wings in winter in "Swan" 1974* Teiji Saga (Graphis91 \350; Life 192)

one by tree in pond in "A swan swims in the silent waters of Memorial Park Pond before darkness falls" 1996* Brian Plonka (Best22 182a)

swan with neck bending to wings in "Whooper Swan" c. 1991* Teiji Saga (Graphis92 \224)

two near rocky inlet in "Swans, Cass-ny-Hawin, Santon, Isle of Man" 1969 Chris Killip (Art \396)

with wings spread in "My Ghost" 1999* Adam Fuss (Photography 236)

SWIMMING

boy jumping into muddy water with herd of water buffalo in "A young herder performs a black flip off a water buffalo in the Turag River west of Dhaka, Bangladesh" 1993* James P. Blair (Through 162)

boys in water in "Niger (boys swimming in river)" 1995 Alfred Olusegun Fayemi (Willis \335)

boys running into the surf in "Boys on the Shore of Lake Tanganyika" 1931 Martin Munkácsi (Hambourg \59; Icons 47; Rosenblum2 #595)

boys waiting for results of race in "Competitors in the boys group wait as the winners are called" 1997 Nancy Andrews (Best23 17d)

boy's swim team members shaving their legs and bodies in "Missoula Big Sky High School swimmers 'shave down' before the Montana state high-school meet" 1990 Kurt Wilson (Best16 121)

bubbles made by a swimmer in [bubbles and a swimmer] c. 1991* Laci Perényi (Graphis92 \237)

celebrating a win in "U.S. swimmer Andy Gill is elated as his record time in the 100-meter backstroke is displayed on the scoreboard at the Pan-American Games" 1987 David Eulitt (Best13 195d)

child standing under sprinkler in street in "New York City" 1937 Fenno Jacobs (Life 40)

children playing in water from fire hydrant in "Children and Fire Hydrant" c. 1945 Helen Levitt (Women \122)

crowded man-made beach and swimming pool from the series "New Brighton" c. 1989* Martin Parr (Graphis89 \130)

duck in front of swimmers in "Just because there's a meet scheduled in this mallard's swimming pool is no reason for the duck to leave" 1985 George Wilhem (Best11 178a)

face of man in water in "Mark Spitz, training for the Olympics" 1972* Co Rentmeester (Life 144)

female swimmer breathing underwater in [female swimmer breathing underwater] c. 1991* Laci Perényi (Graphis92 \232)

forming a pyramid underwater in [swimmers forming a pyramid] c. 1997 Annie Leibovitz (Graphis97 200)

hundreds of swimmers in a race in "More than 1,300 men and women from around the world compete in the Ironman Triathlon near Kailua-Kona, Hawaii" 1987* Chris Covatta (Best13 190b)

in hot springs in Iceland in "Despite the chilly air, bathers in Iceland keep warm in a thermal spring dubbed the Blue Lagoon" 2000* Sisse Brimberg (Through 442); "The Blue Lagoon, Iceland's 'biggest bath' is the catch basin of a power plant in hot springs region of Grindavik" c. 1990* Horst Munzig (Graphis90 \86)

in race in "Despite losing his goggles, Brad Shinn finishes first in a swim meet" 1996* Mary Chind (Best22 200b)

jumping into pool in "100-meter freestylers make an artistic impression as they enter the water on the first day of Olympic swimming" 1996* Anacleto Rapping (Best22 124c)

lone swimmer in ocean near beach house in "The Swimmer" c. 1999 Malinda Kilmer (Photo00 82, 83)

man in water in "Olympic backstroker Stephen Dewick training" 1996* Tim Clayton (Best22 201b)

man underwater in "Swimmer Under Water" 1917 André Kertész (Icons 30)

men in a swimming pool "The Beatles in the swimming pool of a Miami Beach Hotel" 1964 John Loengard (Lacayo 150a)

men underwater in pool in "Underwater commando training of the *Kampfschwimmerkompanie*" 1999 Giorgia

Fiorio (Photography 53)

Mexican men swimming to the U. S. in "Mexicans Cross Rio Grande" 1984 Stan Grossfeld (Capture 136)

model crouched underwater in "Strange, but helpful: the swimming cap" c. 1990* Susan Lamèr Graphis90 \21)

model in swimsuit with stars in "Swimwear" c. 1990* Jean-Baptiste Monding (Graphis90 /15)

naked boys in water and on rowboat in "Water Rats" 1886 Frank M. Sutcliffe (Rosenblum2 #283)

naked boys standing on rowboat and in water in "Boys with a Boat, Ohio River" 1880 Thomas Anshutz (National \44)

overweight swimmer as seen underwater in "Swimming is an integral part of the aerobic program at the Duke Diet and Fitness Center" 1995* Pete Souza (Best21 106b)

people standing under spray of open fire hydrant in "Harlem" 1963 Leonard Freed (Lacayo 147a; Photography 49)

reaching for end of pool in "Swimmer for high school reaches for the wall during an early-morning practice" 1993* Patrick Davison (Best19 160)

starting a triathlon in "All 462 competitors hit the water for a half-mile swim to begin the Allegheny County Triathlon" 1986 Peter Diana (Best12 229d)

swimmer cheering at end of race in "Uwe Dassler of the German Democratic Republic cheers his world record time as he wins the 400 meter freestyle gold medal at the Summer Olympics" 1988 Mark Duncan (Best14 13b)

swimmer from below in "A halo of light surrounds a swimmer as he relaxes in the cool-down pool" 1997* Steve Healey (Best23 168b)

swimmer in water in "Swimming through a wall of water during the championship" 1997* Al Bello (Best23 168a)

swimmer taking a breath in "Olympic swimmer Amanda Beard swims her way to taking first place in the women's 200-meter breaststroke" 1996* Al Schaben (Best22 201a)

swimmers around a manta ray in "Snorkelers surround a manta ray, a friendly member of the shark family, in the Flower Garden Banks of the Gulf of Mexico" 1998* Flip Nicklin (Through 416)

swimming underwater after a dive in "Wendy Lian Williams swims to the surface after a dive in the 10-meter platform competition at the U.S. Olympic Festival in Minneapolis" 1990* George Wilhelm (Best16 122)

underwater view of girls in same bathing suits in "Aquacade Championships, Silver Springs, Florida" 1953 Philippe Halsman (Life 7)

underwater view of swimmer in "Butterfly swimmer Emma Johnson reflected off the underside of the water" 1995* Tim Clayton (Best21 106c)

underwater view of swimmers in "Off the Kona coast of Hawaii, elite swimmers compete in the 2.4-mile leg of the 1999 Ironman Triathlon" 2000* Joe McNally (Through 448)

underwater view of swimmers in pool in "What better way for visitors from up north to cool off on a hot Florida night than with a dip in the neighborhood pool" 1987 John Zich (Best13 118)

Vietnamese mother and children swimming to safety in "Vietnam–Fleeing to Safety" 1965 Kyoichi Sawada (Capture 56)

waiting in water for race to start in "Swimmers warm up in the early morning sun before the Farmers Branch Triathlon" 1993 Patrick Davison (Best19 42b)

woman and lots of underwater bubbles in "A 'mermaid' for the Weeki Wachee show in Florida models a new swimsuit" 1991* Red Huber (Best17 170)

woman lying underwater in "Weeki Wachi Spring, Florida" 1947 Toni Frissell (Sandler 166)

woman underwater after dive in "European women's freestyle champion Stephanie Ortwig" c. 1991* Laci Perényi (Graphis91 \361)

woman underwater wearing gauzy dress in "A master of 'freefall' diving, Meghan Heaney-Grier enjoys the serenity down under" 1998* Joe McNally (Best24 52a)

women synchronized swimmers in a line on their backs in [synchronized swimming] c. 1997 Chritiana Ceppas (Graphis97 206; Photo00 187)

women synchronized swimmers underwater in "Meracquas synchronized swim team performs in Irvine, California" 1990* Budd Symes (Best16 136a)

young men in lake in "Eakins' Students at the Site of 'The Swimming Hole' " 1883 Circle of Eakins (Photography1 \71; Rosenblum2 #254)

SWIMMING POOLS

and lounge chairs in [swimming pool] c. 1991* Tim Bieber (Graphis92 \192)

boys standing in empty pool in [empty saltwater swimming pool] c. 1991* Pete Stone (Graphis92 \209)

boys underwater in "Children are drawn to the brightness of an underwater light at a public swimming pool" 1998* Bryan Patrick (Best24 72d)

by ocean in [swimming pool and ocean] c. 1991 Angelica M. Alvarez (Graphis92 \210)

children helping to carry plastic pool on their heads in "When the hottest day of summer hit Connecticut, Michael Kirkland got plenty of help from his children in a pool-moving project" 1986 Bradley Clift (Best12 161a)

crowded man-made beach and swimming pool from [the series *New Brighton*] c. 1989* Martin Parr (Graphis89 \130)

firefighter using swimming pool water to put out a raging house fire in "Because of a lack of water to fight a house fire, a firefighter sets up a Floto Pump to use pool water instead" 1995* Kent Porter (Best21 192b)

girl, looking bored, in hotel pool in "Emily, 10, at the Peninsula Hotel, where her family and staff have been living in the presidential suite for the past three months" 1995* Lauren Greenfield (Best21 82)

girl diving from edge of pool in [promotion for a printing firm] c. 1990* Tim Bieber (Graphis90 \245)

indoor pool in [swimming pool] c. 1997* Guy Kloppenburg (Graphis97 157b)

man in pool in [man with goggles in pool] c. 1997* Patrick Harbron (Graphis97 119)

men in swimming lanes in [transformation of the human body in water] c. 1992* Susan Alinsangan (Graphis93 199)

pool with lights at night in "Night view of the swimming pool of a Caribbean-style house designed by architect Hugh Newell Jacobsen" c. 1989* Robert Lautman (Graphis89 \115)

sitting at edge of pool in "Untitled" 1919 Edward Weston (Art \214)

squares reflecting in pool in [woman in swimming pool] c. 1992* Terry Vine (Graphis93 178)

surrounded by pool chairs in [promoting tourism to Waikiki Beach] c. 1991* Geir Jordahl(Graphis91 \301)

swimmer in jacket looking at pool in [swimmer] c. 1995* John Huet (Graphis96 202)

two pools from "Nine Swimming Pools and a Broken Glass" 1968* Ed Ruscha (Marien \6.96)

water polo tryouts in "Girls trying out for the U.S. national water polo team" 1997* Richard Hartog (Best23 168d)

woman in pool, man holding towel in [self-promotional] c. 1990* John Curtis (Graphis90 \57)

woman in pool with floating lane dividers in "Chinese diving champion Xi relaxes during a break in the XXV Summer Olympics" 1992* Bill Frakes (Best18 161)

SYDNEY (New South Wales)

fireworks in the harbor in "Australia welcomes the New Year with a spectacular fireworks display, lighting up Sydney Harbor and the renowned Opera House" 1982* Annie Griffiths Belt (Through 400)

—T—

TABLES

cups of coffee on a table in "Coffee Cups" c. 1999* Jim White (Photo00 58)

glass table in [glass table] c. 1992* Emilio Tremolada (Graphis93 141a)

long, sleek, black table in [Rosenthal products] c. 1992* AK-Werbefotografie (Graphis93 144)

woman sitting behind long wooden table in "Owner of the Big Table" 1989 Flor Garduño (Photography 204)

TABLEWARE

bowls in [glass objects] c. 1992* Craig Cutler (Graphis93 158c)

ceramic cups, bowls, jars and industrial tubing in "Ceramic Tubing" c. 1930 Hans Finsler (Rosenblum2 #513)

plates, bowls and vases in "Sunnyside dinnerware" 1992* Melanie Stetson Freeman (Best18 167)

shelves of china items in "Articles of China" 1844* William Henry Fox Talbot (Art \3; Marien 2.7)

TAJ MAHAL (Agra, India)

in the background from the banks of the river in "The Taj Mahal from the Bank of the River, Agra" c. 1858 John Murray (Waking #80)

negative in "The Taj Mahal" c. 1856 John Murray (Art \132)

panorama of the facade in "Panorama of the West Face of the Taj Mahal" c. 1850s-1860s John Murray (Marien \3.30)

TALIBAN

men hanging from post in "Taliban fighters greet each other in Kabul as the bodies of former Afghanistan President Najibullah and his brother hang from a traffic post" 1996* B. K. Bangash (Best22 158a)

photo essay on life under Taliban rule in "Taliban in Afghanistan" 1996 David Turnley (Best22 258-259)

Taliban, and their victims in "Kabul, Afghanistan, after the Taliban Takeover" c. 1997* Ilkka Uimonen (Graphis97 56-59)

TAMIL (Indic people)

photo essay of the life of the Tamils in "The Tamils–Civil strife in Sri Lanka" 1986* James Nachtwey (Best12 100-101)

TANKS (Military Science)

child swinging on the gun barrel of a rusted tank in "A child at play in Nicaragua" 1983* James Nachtwey (Lacayo 169)

in museum exhibit in "Military Museum, Beijing, China" 2000 Lois Connor (Photography 28a)

row of Chinese tanks blocked by one man in "One man blocking a line of Chinese government tanks" 1989* Stuart Franklin (Lacayo 165); "Massacre in Beijing" 1989* Jeff Widener (Photos 163)

Russian tank moving through dirt in "A Tank called 'Motherland' " c. 1942 Georgi Zelma (Art \418)

two rows of hundreds of tanks in [Soviet Army tanks line up near the Russian Parliament] 1991* (Graphis93 57)

walking through an area of destroyed tanks in "An Ethiopian soldier walks through a cemetery of tanks" 1988* Anthony Suau (Best14 57b)

TATTOOING

back of seated woman with feet in small pool in "Flower Lady" c. 1990* Pascal Chevallier (Graphis90 \141)

elderly woman with tattooed body in "Irene 'Bobby' Libarry" n.d. Imogen Cunningham (Marien \5.48)

man and woman with body tattoos in "Australians from *National Geographic*" c. 1990* Michael O'Brien (Graphis90 \182)

man with bone through nose and body tattoos in "Jon" 1997 Bettina Witteveen (Marien \7.19)

men in prison yard in "Member of the Aryan Brotherhood in a recreation yard" 1997* Andrew Lichtenstein (Best23 210b)

on man's arms in "Tattoos: The Human Canvas" c. 1999* Malinda Kilmer (Photo00 108)

prisoner's chest tattoos in "At a high-security labor camp in Kovrov, inmates laugh as one of the repeat offenders proudly shows off his tattoos" 1993* Lucian Perkins (Best19 10a)

views of men with tattoos on their arms in "Tattoos" 1986* E. J. Camp (Rolling #72)

youth showing his chest in " 'Reckon' from the 'tag-banger' crew 'Kings with style' considered to be the most violent tagging crew in the city, displays his tattoos" 1995* Lauren Greenfield (Best21 83d)

TAXIS

driver in a convertible in "Capri taxi driver" 1991* Helmut Newton (Graphis92 \94)

in line at an underground driveway in "Parmelee transfer cabs carry connecting passengers to other Chicago stations" 1943 Jack Delano (Documenting 292b)

man emerging from cab under theater marquis in "Orson Welles" 1941 W. Eugene Smith (Life 82)

TEAPOTS / TEA KETTLES

sleek kettle with straight spout in "Kettle" c. 1991* Stefan Kirchner (Graphis92 \153)

steam coming from tea kettle in "Alessi kettle on a gas flame" c. 1990* Chris Collins (Graphis90 \203)

steam coming from tea kettle in [self-promotional] c. 1989* John Payne (Graphis90 \214)

tea cups and teapot for tea ceremony in "Kyoto 1885" c. 1991* Michel Dubois (Graphis91 \115)

water pouring out of tea kettle in [ad campaign for WMF] c. 1990* Hans Hansen (Graphis90 \234)

whistling copper kettle as a directional board in "The Gallery at Market East Mall" c. 1991* Michael Northrup (Graphis92 \170)

TEENAGE PARENTS

African American girls sitting on a stoop with their babies in "North Avenue, Image #30" 1993 Linda Day Clark (Willis \320)

photo essay on teenager and her son in "The Circle Remains Unbroken" 1997 Peggy Peattie (Best23 220)

teen mother taking quiz with infant on her lap in "While taking a make-up quiz after school, teen mother tries to concentrate as her crying baby lays in her lap" 1996* Vicki Cronis (Best22 162c)

teenagers and their children in "Awesome responsibility: Teen Parenthood" 1996* Mindy Schauer (Best22 163c, 226)

TELECOMMUNICATION

satellite dish in "MCI telephone company's earth stations" c. 1989* Lonnie Duka (Graphis89 \217)

TELEGRAPHS

woman reading telegraph tape in "Miss Genie Lee Neal reading a perforated tape at the Western Union telegraph office" 1943 Esther Bubley (Fisher 87)

TELEPHONE / TELEGRAPH POLES

between street and canal in "Telegraph Poles, Newark, Ohio" 1898 Clarence H. White (Photography1 \96)

multiple telephone wires from one pole in "Telephone Wire Composition, Mexico" 1925 Tina Modotti (Women \48)

numerous lines on poles in "Utility Lines" 1928 (Hambourg \22)

telephone lineman doing "mouth-to-mouth" on other lineman who is dangling from a pole in "The Kiss of Life" 1967 Rocco Morabito (Capture 61)

TELEPHONES
miniature figures passing through cutoff section of telephone in "Telephone by SEL" c. 1989* Dietmar Henneka (Graphis89 \222)

old woman speaking on mobile phone in "Displaced Albanian woman uses a mobile telephone of an aid worker" 1998 Roger Lemoyne (Best24 91d)

telephone booth near ocean wall from [series entitled *Objects on the Sea*] c. 1990* Christiane Marek (Graphis90 \98)

woman with hair pinned up speaking on the telephone in "The telephone in a boarding house is always busy" n.d. Esther Bubley (Fisher 64)

TELESCOPES *see also* ASTRONOMICAL OBSERVATORIES
cowboy on horse riding near telescope in "Listening to the universe in quiet isolation the Very Large Array radio telescope includes this giant dish on the Plains of San Augustin, New Mexico" 1987* Danny Lehman (Through 496)

faint view in early photograph in "Williams Herschel's Telescope Seen Through the Window at Slough" 1839 John Herschel (Marien \1.15)

radio telescope in "Australia's Molonglo Observatory Synthesis Telescope–a mile-long 'ear'–was the first radio telescope to detect the spectacular supernova of 1987" 1987* Roger H. Ressmeyer (Through 486)

TELEVISION
advertising for television sets in [television sets] c. 1995* Ernesto Martens (Graphis96 150a, c)

and headset in "From ad campaign for Blaupunkt" c. 1989* Michael Steenmeijer (Graphis89 \220)

boy in shabby room with bed and couch, watching TV in [boy with television] c. 1987 Chandra McCormick (Willis \268)

child watching on empty porch in "3-year-old watches television on her uncle's porch" 1997 Don Seabrook (Best23 137d)

child watching TV in "Autistic, mentally retarded 7-year-old watches favorite channel" 1997* Vicki Cronis (Best23 141a)

families watching television in living room in "TV-watching party at the Nubers" 1949 Ralph Morse (Life 99)

family watching John F. Kennedy on television in their living room in "First Ever Kennedy-Nixon Presidential TV Debate" 1960 Donald Phelan (Goldberg 152)

four screens with women in "Waking Up in News America" 1984* Robert Heinecken (Decade \XV)

lighted cross over a television [for the Archdiocese of Wichita] c. 1992* Mark Wiens (Graphis93 63)

man in bathtub watching television in "Portable television" 1948 George Skadding (Life 98)

miniature figures playing soccer on horizontal flat screen in "Sony TV" c. 1989* Dietmar Henneka (Graphis89 \221)

multiple screens in a room in "500 television screens fire 500 different images from the global information highway" 1995* Louis Psihoyos (Best21 153d)

multiple television sets with face of Oliver North in "During July's testimony on the Iran-Contra affair, the face of Lt. Col. Oliver North shone from television sets across America" 1987 Bill Greene (Best13 7a)

old television set on shelves in "State of the Economy" 1992 Tom Reese (Best18 170a)

set wrapped in sheets on mattress from [*Black Dreams/White Sheet* series] 1996 Anthony Barboza (Committed 49)

small television with picture of infant at foot of bed in "Galax, Virginia" 1962 Lee Friedlander (Decade 76b; Icons 145; MOMA 247)

teenage girls yelling at television in "In Catania, Sicily, soccer fans react as World Cup action unfolds on their TV screen" 1995* William Albert Allard (Through 90)

tied to the back of a donkey in "A donkey carries prized cargo through the narrow streets of Fex, Morocco" 1986* Bruno Barbey (Through 270)

TENEMENT HOUSES
children and family in alley between houses in "Men and Children in Tenement Back Yard, New York" n.d. Jessie Tarbox (Women \24)

children under hanging laundry in tenement courtyard in "Baxter Street Court" c. 1895 Jacob Riis (Lacayo 54)

laundry hanging across alley in "Close No. 37, High Street" 1868 Thomas Annan (Marien \3.87); "Close No. 75, High Street" 1868 Thomas Annan (Rosenblum2 #437)

men and woman with a child sitting by shacks in a tenement yard in "Yard, Jersey Street Tenement" c. 1888 Jacob Riis (Rosenblum2 #441)

row of tenement balconies and windows in "Tenement in New York City" 1970 Bruce Davidson (Lacayo 146)

TENNIS

bowing at net in "John McEnroe, trying for a comeback, drops to his knees and bows to Tim Mayotte, who won the match" 1987 Fred Comegys (Best13 217a)

boy with racket running on court in "Tennis Player, Amsterdam Ave." 1992 Orville Robertson (Willis \308)

hitting ball at net in "Andre Agassi at the U.S. Open in New York" 1988 Mike Powell (Best14 144c)

holding hand to throat in "Eighth-seed John McEnroe 'chokes' and loses a game" 1987 Richard Harbus (Best13 117d)

man hitting ball in "Arthur Ashe" 1965 Bob Gomel (Life 143c)

man jumping on court in "Bill Tilden" 1934 Acme Newspictures (Vanity 177)

running on the court in "Arthur Ashe at tennis match in Los Angeles" c. 1979 Bob Moore (Willis 160)

woman jumping over net in "Alice Marble" 1939 Gjon Mili (Life 139a)

THEATERS

African American man sitting in empty theater in "Nashville" 1932 Louise Dahl-Wolfe (MOMA 150)

awning of closed theater in "The Howard Theatre, Washington, D.C." 1998 Ken D. Ashton (Willis \325)

man with drawing pad in empty theater in "Al Hirschfeld" c. 1990* Annie Leibovitz (Graphis90 \145)

orchestra section of the conservatory in "Interior views of the Royal Conservatory in Liege" c. 1991 Alain Janssens (Graphis91 \307)

overhead view of conservatory seats in "Interior views of the Royal Conservatory in Liege" c. 1991 Alain Janssens (Graphis91 \308)

THEATRICAL MAKEUP

group of women putting on makeup around table in "Actors make final touches to their makeup before performing an opera near Quanzhou, China" 1991* James L. Stanfield (Through 154)

TIANANMEN SQUARE

group of Chinese children with flags in "Tien An Men Square, Beijing" 1965 René Burri (Rosenblum2 #615)

TIANANMEN SQUARE INCIDENT, China, 1989

flags and crowd of people gathered on street in "Demonstrations on Tiananmen Square" 1989* Jeff Widener (Photos 163)

people walking near burned-out cars and trucks near Tiananmen Square in "Freedom Uprising" 1989* David C. Turnley (Capture 155b)

row of Chinese tanks blocked by one man in "One man blocking a line of Chinese government tanks" 1989* Stuart Franklin (Lacayo 165); "Massacre in Beijing" 1989* Jeff Widener (Photos 163)

young man standing on wall in "Tiananmen Square, Beijing" 1989* Stuart Franklin (Life 162)

TIBETANS

father and daughter walking through the Himalayan mountains in "To gain freedom from China's rule, a Tibetan man takes his six-year-old daughter on a perilous journey through the world's highest, harshest mountains" 1995 Manuel Bauer (Best21 200)

line of prisoners being led from Potala Palace in a possible Chinese propaganda photograph in "Deportation of Tibetan Prisoners" 1959 Photographer Unknown (Photos 87)

TIGERS

drinking water in a field in "More thirsty than hungry, a tiger laps up water as potential prey watches warily in Banghangarh, India" 1997* Michael Nichols (Through 198)

TIPIS

erection of a tipi and Native American with a rifle in "Wounded Knee Takeover" 1973 Photographer Unknown (Photos 137)

men in blankets near canoe and tipis in "The first sail" 1907 Roland W. Reed (Lacayo 41)

TIRES

advertisement for a tire in "All-terrain tire" c. 1991* Todd Merritt Haiman (Graphis92 \169)

hanging on outside of store in "Second Hand Tires" 1940 Russell Lee (Rosenblum2 #468)

hosing down burning tires in "Firefighters fighting a four-hour blaze at a tire storage sending black toxic smoke billowing over Louisville's skyline" 1985 Pat McDonogh (Best 100b)

used tires piled up in "Recalled tires at the train station ready for shipment to Harrisburg" 1942 Marjory Collins (Documenting 262b)

woman in bathing suit walking on rocks and holding up a tire from [a series] c. 1990 Richard Litt (Graphis90 \19)

TITANIC (Steamship)

prow of the Titanic "Bearded in rust, the prow of R.M.S. Titanic rests two-and-a-half miles below the surface of the North Atlantic" 1991* Emory Kristof (Through 404)

TODA (Indic people)

seated people by huts in "Group of Todas" c. 1868 Samuel Bourne (Art \133)

TOOLS
hand tool as still life in [handtool] c. 1997* Duda Carvalho (Graphis97 75)
handsaws as still life in [saws] c. 1997* Duda Carvalho (Graphis97 74)
metal file in [metal file] c. 1999* Craig Cutler (Photo00 206)

TORNADOES
aerial view of destroyed houses in "Debris in residential section of Albion, Pa., shows the path of a tornado" 1985 Mark Duncan (Best11 67a)
black funnel cloud reaching from sea to black clouds in "A tornado moves out onto the open waters of Tampa Bay after ripping apart a condominium complex" 1995* Brian Baer (Best21 174a)
man attaching flag to remains of home in "One Atlantican offers a symbol of hope by raising a flag over a ruined residence" 1985 Larry C. Price (Best11 66c)
man sitting in remains of second-floor room in "In Niles, Ohio [man] surveys tornado damage from what was a bedroom in his parents' home" 1985 Patrick Reddy (Best11 66d)
men in hard hats resting on log amidst debris in "Firemen rest after sifting through rubble seeking survivors of five tornadoes that ripped through area" 1985 William E. Lyons (Best11 67d)
small town completely flattened in "Saragosa, Texas, was reduced to a pile of rubble when a tornado flattened the town" 1987 David Wood (Best13 74)
touching down in farm land in "Tornado" 1943 Lucille Handberg (Life 124)
wide tornado coming across field in "A slow-moving tornado hangs over southeastern Menard County just before striking the town of Cantrall" 1995* Rich Saal (Best21 174b)

TORTURE
barbed wire on legs of body on white cloth in "The victims of the Ceaucescu terror lie here in the open" c. 1991* Chris Sattlberger (Graphis91 \84)
black men forced into push-up stance by white man with gun in "Anti-Guerrilla Operations in Rhodesia" 1977 J. Ross Baughman (Capture 104; Eyes #364)
guerrillas with cigarettes and guns torturing men on ground in "Torture in Dacca" 1971 Horst Faas and Michel Laurent (Capture 77; Eyes #363)
word 'terror' carved into a man's chest in "Terror in Sierra Leone" c. 1997* Patrick Robert (Graphis97 55)

TOURISM
men and women with small cameras and postcards of Texas School Book Depository in "Dallas" 1964 Garry Winogrand (MOMA 240)
men, women, and camel near base of huge broken figure in "Fallen Colossus, Ramasseum, Thebes" 1858 Francis Frith (Art \129)
riding elephants to follow rhinoceros in "Low-impact tourism leaves only footprints in Nepal's Chitwan National Park, former hunting reserve is now a rhinoceros sanctuary" 1990* Galen Rowell (Best16 11c)
woman being carried ashore in "High and dry, a French tourist gets carried ashore after an outrigger cruise in Tahiti" 1997* Jodi Cobb (Best23 148a; Through 450)

TOYS
antique metal plane and car hood in "Transportation" c. 1997* Bret Wills (Graphis97 66-67)
boat and rocking horse in "Antique toys" c. 1991* Michael W. Rutherford (Graphis91 \87)
ceramic animals in "Mexican Toys" 1925 Edward Weston (San #24)
dollhouse rooms and figures in [from the series *Thomas' Dollhouse*] c. 1995* David Everitt (Graphis96 173)
dolls lying on ground under shadows of fence in "*Puppen*" 1926 László Moholy-Nagy (San \21; Waking #177)
girl holding doll in "Child with Doll" 1932 Alma Lavenson (Women \53)
girl with broken doll in "Fazenda Rio des Preda" 1930s Margaret Bourke-White (Women \121)
small boy with toy gun in "Watching the parade" 1941 Russell Lee (Documenting 214a)

TRACK AND FIELD
avoiding a fallen hurdler in "A hurdler tries to avoid landing on another racer who had an epileptic seizure and collapsed" 1987 Bill Lyons (Best13 214d)
broad-jumper landing in "U.S. jumper Jennifer Innis takes a broad jump at the Pan-American Games" 1987 Annalisa Kraft (Best13 219)
fallen woman runner at finish line in "Finish of a 400-meter race at the district meet" 1995* Mark W. Ylen (Best21 116d)
handing off the baton in a relay race in "Satanata's Sue Sprenkle strains to hand off the baton to the anchor" 1987 Gregory Drezdzon (Best13 212)
handing off the batons in a relay race in "People of Jasper, Indiana" 1995 Torsten Kjellstrand (Best21 40)
handing off the batons in "Runners hand off batons during the Penn Relays" 1993* George Tiedemann (Best19 154)

TREES

against beach in "Australian Pines, Fort De Soto, Florida" 1977* John Pfahl (Marien \7.86; San \60)

and gully in "Trees" c. 1854 Thomas Keith (Waking #17)

apple trees in bloom "Apple Trees in Blossom" c. 1897 William B. Post (National \58)

around private home in "Private home" 1939 Marion Post Wolcott (Documenting 180b)

beech tree in forest in "Beech Tree in the Forest of Fontainbleau" before 1858 Gustave Le Gray (Art \92)

bending trunk of tree in "Tired Tree" c. 1999* Bert Teunissen (Photo00 76, 78)

buds on trees in "Red Bud Trees in Bottomland near Red River Gorge, Kentucky" 1968* Eliot Porter (Rosenblum2 #773)

cedar in "The Dying Cedar" 1906 Anne W. Brigman (National 24d, \66)

covered with Spanish Moss in "Spanish Moss on the Banks of St. Johns River, Florida" 1886 George Barker (Photography1 #V-11)

cutting through a forest for a survey in "Cutting on the Forty-Ninth Parallel, on the Right Bank of the Mooyie River, Looking West" 1860-1861 Photographer Unknown (Marien \3.51)

dark forest of slim trees in "Aspens, Northern New Mexico" 1958 Ansel Adams (MOMA 186)

deserted, tree-lined street in "New England Street" 1907 Clarence H. White (MOMA 87)

dirt road cutting through forest in "Forest of Fontainebleau" c. 1856 Gustave Le Gray (Marien \2.69; Waking #63)

downed trees from volcanic eruption in "Aerial View, Downed Forest Near Elk Rock, Approximately Ten Miles Northwest of Mount St. Helens, Washington" 1981 Frank Gohlke (Szarkowski 296)

expanse of tree trunks and lower limbs without leaves in "Winter Woods" c. 1901 Agnes Warburg (Rosenblum \91)

fallen section of huge tree in "Section of the Original Big Tree, 92 Ft. in Circumference" 1870-1871 Thomas C. Roche (Photography1 \62)

floating above lake in "Untitled (Landscape with a floating tree)" 1969 Jerry Uelsmann (Marien \6.37)

forest in "Beech Trees, Lacock Abbey" c. 1844 William Henry Fox Talbot (Art \6)

forest in "Woods at Sèvres or Meudon" c. 1851 Henri-Victor Regnault (Szarkowski 43)

forest in "Slanting Forest, Lewiston, New York" 1975* John Pfahl (Photography2 154)

forest and pond in Winter in "Trees and Pond, Near Sherborn, Massachusetts" 1957* Eliot Porter (MOMA 187; Szarkowski 264)

forest by a stream in "Aspens" c. 1905 William B. Post (MOMA 57)

forest of new and old pine trees in fog in "Monterey Pine and Fog" 1962 Brett Weston (Photography 183)

forest of trees in "Aspen Trees, New Mexico" 1958 Don Worth (Decade \61)

forest of trees in Autumn in "Beech Wood" 1936 Albert Renger-Patzsch (Icons 77)

huge tree in forest in "The Grisly Giant, Mariposa Grove, Yosemite" 1861 Carleton E. Watkins (National 79; Szarkowski 115; Waking #4)

in forest in "Tree Study in the Forest of Fontainbleau" 1856 Gustave Le Gray (Art \91)

in silhouette in "Storm Clouds" 1921 Karl F. Struss (Peterson #12)

large tree by stream in "Oak Tree in Eridge Park, Sussex" 1856 (Marien \3.101)

large tree in farmyard in "Landscape with Tree Planted by Hernán Cortés, Mexico" 1856 Désiré Charnay (Marien \3.49)

large tree in forest in "Spruce Tree, Forty-four Feet in Circumference, Stanley Park, Vancouver" 1890-1892 William Notman (Szarkowski 111)

large tree with leaves near short wall in "Spanish Chestnut in Summer" early 1860s E. Fox (Szarkowski 80)

large tree without leaves near short wall in "Spanish Chestnut in Winter" early 1860s E. Fox (Szarkowski 81)

looking down on man at top of tree in "More than 200 feet above ground, ecologist reaches the summit of a Douglas Fir" 1997* Mark W. Moffett (Best23 159d)

looking up trunk of pine trees in "Pines in Pushkin Park" 1927 Alexander Rodchenko (Hambourg 85c, \119)

lumberjack with chain saw in "Lumberjack Stan Christie eyeballs a 500-year-old cedar in the Olympic National Forest, deciding where to make his cut" 1990 Tom Reese (Best16 168)

lumberjacks standing by huge tree in "Felling a Fir Tree, 51 Feet in Circumference" 1906 Darius Kinsey (MOMA 75)

men standing near very large tree in "The Walnut Tree of Emperor Charles V, Yuste" 1858 Charles Clifford (Waking #76)

moon rising between line of trees reflected in water in "Moonrise–Mamaroneck, New York" 1904* Edward Steichen (MOMA 81; Waking #146)

multiple images in "Structure of Thought #7" 2001* Mike and Doug Starn (Photography 234b)

oak trees without leaves in "Oak Trees in Dessau" 1867 Gerd Volkerling (Rosenblum2 #125)

palm tree stretching from beach to shore in "The palm-fringed sands of Bora Bora lie about 150 miles

—U—

UGANDA
 soldier and boy in dawn raid in "Uganda" 1986* James Nachtwey (Eyes \20; Graphis89 \246)
UKULELES
 seated girl in grass skirt holding a ukulele in "A pure-blooded Hawaiian girl wears native dress, a style
 handed down from generation to generation, and plays the ukulele–a small guitar popularized in Hawaii
 in the 1880s" 1924 Henry W. Henshaw (Through 323)
 man in plaid jacket playing ukulele in"Tiny Tim" 1968 Baron Wolman (Rolling #5)
ULSTER (NORTHERN IRELAND AND IRELAND)
 graves, parades, and mourners in Ulster from [series The Troubles: An Artist's Document of Ulster] 1979 Les
 Levine (Photography2 165)
UMBRELLAS AND PARASOLS
 on patio by the beach in "Along the beach" 1939 Marion Post Wolcott (Documenting 184c)
 open umbrella on the beach in "The Artist's Umbrella" c. 1908 Heinrich Kühn (Rosenblum2 #400;
 Szarkowski 153; Waking #152)
 people with umbrellas walking through a garden in "In Tokyo, Japan, guests of the emperor attend a garden
 party honoring statesmen, scientists, and other exceptional citizens" 2001* Sam Abell (Through 138)
 running across wooden bridge with parasol in "Kaxuo Ohno Dancing in Kushiro Marsh IV" 1994 Eikoh
 Hosoe (Photography 85)
 standing against the wall in [umbrella] c. 1991* Stefano Bianchi (Graphis92 \63)
 woman with umbrella climbing several levels of rain-soaked stairs in "Diane Peterson, umbrella well in hand,
 heads for work" 1985 Steve Jones (Best11 140b)
UNDERWEAR
 back of woman in laced-up corset in "Mainbocher Corset, Paris" 1939 Horst P. Horst (Icons 81)
 woman in slip and stockings, standing in front of door in "Untitled" c. 1912 Ernest J. Bellocq (MOMA 71;
 Rosenblum2 #315)
UNDERWATER PHOTOGRAPHY
 man holding pipe in "Underwater Self-Portrait" 1898 Louis Boutan (Monk #13)
 sea anemones in "Boab trees near Australia's northwest coast may descend from plants that took root there
 75 million year ago" 1991* Sam Abell (Through 398)
 prow of the Titanic "Bearded in rust, the prow of R.M.S. Titanic rests two-and-a-half miles below the surface
 of the North Atlantic" 1991* Emory Kristof (Through 404)
UNIDENTIFIED FLYING OBJECTS
 saucer shape flying over hills in "Unidentified Flying Object, McMinnville, Oregon" 1950 Paul Trent (Monk
 #35)
UNITED NATIONS
 delegates giving speeches in "Soviet sound off" 1953 John Lindsay (Eyes #236)
 delegates studying chart in "UN Council decide to await results of talks between parties concerned during
 the Cuban missile crisis" 1962 Photographer Unknown (Goldberg 158)
UNITED STATES–HISTORY–CIVIL WAR, 1861-1865 see also SLAVERY–HISTORY
 battlefield in "Antietam Battlefield" 1862 Alexander Gardner (Waking #106)
 battlefield of the "Battle of the Wilderness" in "The Wilderness Battlefield" 1865-1867 Photographer
 Unknown (Waking #110, 318b); 1864 Photographer Unknown (National 159d)
 battlefields and recreationists in "Henry Hill, Manassas" c. 1999* Jan Faul (Photo00 88d); "Marching Order
 for Antietam" c. 1999* Jan Faul (Photo00 88b); "Table Rock, Gettysburg" 1999* Jan Faul (Photo00 88a)
 bodies in a line on the ground in "Confederate Dead Gathered for Burial" 1862 Mathew Brady (print by
 Alexander Gardner) (Marien \3.20; Photography1 #IV-14)
 brick ruins of a mill in "Ruins of Gaines' Mill, Virginia" 1865 John Reekie (National 144d)
 bridge being tried out in "Experimental Bridges" 1863 Andrew J. Russell (Photography1 #IV-19)
 broadside with photographs of Booth, Surratt, and Herold in "Broadside for Capture of Booth, Surratt, and
 Herold" 1865 (Waking #111)
 buckets, plates, etc. from the Andersonville Prison in "Andersonville Still Life" 1866 Brady Studio (Waking
 #109)
 cannons behind dirt mounds in "Rebel Works in Front of Atlanta, Georgia" 1864 George N. Barnard
 (Rosenblum2 #211)
 city in ruins in "The aftermath of war in Charleston" 1865 Brady Studio (Lacayo 25c)
 city in ruins in "Ruins of Richmond" 1865 Photographer Unknown (Rosenblum2 #210)
 Confederate soldiers gathered for a portrait in "Rebel Soldiers in Richmond" 1861 Photographer Unknown

(Lacayo 22b)

dead soldier in a trench in "Home of a rebel sharpshooter" 1863 Alexander Gardner (Eyes #31; Lacayo 14; Marien \3.21)

dead soldier in field in "A sharpshooter's last home" 1863 Alexander Gardner (Eyes #24; Lacayo 24a)

dead soldier on ground in "A Contrast: Federal buried, Confederate unburied where they fell, on the battlefield of Antietam" 1862 Alexander Gardner (Eyes #20)

dead soldiers in trench behind stone wall in "Stone Wall, Rear of Fredericksburg, with Rebel Dead" 1863 Andrew J. Russell (Photography1 \42)

dead soldiers on battlefield in "A harvest of death, Gettysburg" 1863 Timothy O'Sullivan (Eyes #21; Lacayo 24b; Marien \3.18; Photography1 #IV-7; Rosenblum2 #209)

dead soldiers on battlefield in "Field where General Reynolds fell, Gettysburg" 1863 Timothy O'Sullivan (Eyes #23; Photography1 \41; Waking #108)

engine room of a sloop with Lincoln onboard in "Engine of USS *Kearsarge*" c. 1861 Kellogg Brothers (National \21)

fallen horse and wagon in "Incidents of the War. Unfit for service at the battle of Gettysburg" 1863 Alexander Gardner (Eyes #25)

field filled with tents in "Gettysburg" 1863 Timothy O'Sullivan (Eyes #27)

gallows and a hanging in "Hanging the Lincoln conspirators" 1865 Alexander Gardner (Eyes #33-35; Marien \3.22; Rosenblum2 #233-239; Waking #113)

gateway to cemetery in "Gateway of Cemetery, Gettysburg" 1863 Timothy O'Sullivan (Eyes #28)

general on pontoon in river in "General Herman Haupt Crossing Stream on a Pontoon" 1863 Andrew J. Russell (Photography1 #IV-18)

general standing by a tent in "Union General Ulysses S. Grant at his headquarters" 1864 Timothy O'Sullivan (Lacayo 10)

Lincoln and McClellan sitting in a tent in "The President (Abraham Lincoln) and General McClellan on the Battlefield of Antietam" 1862 Alexander Gardner (Photography1 \43)

Lincoln and officers by tent in "President Lincoln on battlefield of Antietam" 1862 Alexander Gardner (Eyes #18; Photography1 #IV-6)

looking down a long line of cannons in "Union artillery at Fredericksburg" 1863 Timothy O'Sullivan (Eyes #30; Lacayo 12-13)

men burying cart full of skeletons in "A burial party, Cold Harbor, Virginia" 1865 John Reekie (Eyes #32)

observers above battlefield in "View of Battle of December 15 and 16, 1864, From Front of State House, Nashville" 1864 Jacob F. Coonley (Photography1 #IV-3)

paddle-wheeler and other ships at dock in "Landing Supplies on the James River" c. 1861 Brady Studio (Rosenblum2 #207)

parade of soldiers marching in victory up Pennsylvania Avenue in "Grand Army Review, Washington, D.C." 1865 Alexander Gardner (Waking 321)

port and railroad tracks to unload ordnance in "Ordnance Wharf, City Point, Virginia" 1865 Thomas C. Roche (Waking 318d)

prisoners standing in prison yard with guards on upper walkway in "Charleston Cadets Guarding Yankee Prisoners" 1861 George Cook (Rosenblum2 #208)

silhouette of the ruins of a city in "Ruins of Richmond" 1865 Alexander Gardner (Lacayo 25b)

stacks of cannonballs waiting to be loaded on ships in "Matériel assembled for the Peninsular Campaign" 1862 Brady Studio (Lacayo 23c)

tent encampment in "Culpeper, Virginia" 1863 Timothy H. O'Sullivan (Photography1 #IV-27)

tents forming a field hospital in "Depot Field Hospital, City Point, Virginia" 1865 Thomas C. Roche (Waking 319)

troops in formation in "The 74th New York Infantry at drill" 1861 Photographer Unknown (Lacayo 23b)

troops in formation in front of tents in "Northern troops encamped near Washington" 1861 Photographer Unknown (Lacayo 22a)

Union officers seated for portrait in "New York 7th Regiment Officers" c. 1863 Egbert Guy Fowx (National \16)

Union soldiers leaning against a tree in "Three Soldiers" 1860s Photographer Unknown (Rosenblum2 #213)

well-to-do family, with military guards and black servant on house steps in "Family Group" 1861-1865 Photographer Unknown (Waking #99)

wharf on pontoons in "Upper Wharf, Belle Plain" 1864 Andrew J. Russell (Photography1 \44)

UNITED STATES. CONGRESS. HOUSE. COMMITTEE ON UN-AMERICAN ACTIVITIES

standing at meeting in "Actors Danny Kaye, June Havoc, Humphrey Bogart, and Lauren Bacall, House Committee on Un-American Activities hearings" 1947 Martha Holmes (Life 154)

UNITED STATES CAPITOL (Washington, D.C.)
 African American children playing in the slums in sight of the Capitol in "In the Shadow of the Capitol, Washington, D.C." 1946-1949 Marion Palfi (Decade \39)
 Capitol building without dome in "U.S. Capitol" 1846 John Plumbe (Photography1 \32; Rosenblum2 #15)
 Lincoln inauguration in front of unfinished Capitol building in "Inauguration of Lincoln" 1861 Montgomery C. Meigs (Photography1 #IV-22)
URBAN RENEWAL
 city buildings turned to rubble in "Tearing down the Avenue of the Opera" c. 1865 Charles Marville (Rosenblum2 #177)
 photo essay on the demolition of houses and the people forced to leave their homes in "Death of a neighborhood" 1996* Bob Self (Best22 254-255)

—V—

V-J DAY, August 14, 1945
 sailor kissing nurse in street in "V-J Day in Times Square" 1945 Alfred Eisenstaedt (Eyes #210; Lacayo 121)
VACATIONS see also TOURISM
 family loading luggage into station wagon with boat on top in "Colorama (Blue 'Woody' Stationwagon in Front of Summer Cottage)" n.d. Ralph Amdursky (Marien \6.64)
VACCINATIONS
 child wincing in "Polio vaccination drive" 1960 Bill McCombe (Life 44)
 line of cars filled with people getting vaccinated in "Polio vaccination drive" 1960 Bill McCombe (Life 45)
VATICAN PALACE (Vatican City)
 snow at the Vatican in "First snowfall in 14 years dusts worshipers leaving the Jan. 6 mass celebrating the Epiphany" 1985* James Stanfield (Best11 45b)
VEGETABLES
 artichoke in [vegetables] c. 1995* Steve Tregeagle (Graphis96 98)
 baby wearing straw hat decorated with vegetables in "Baby Vegetables" 1996* Nadia Borowski (Best22 180c)
 baskets filled with vegetables outside of a store in "Produce" c. 1910* William Rau (Rosenblum2 #347)
 cabbage leaf in "Cabbage Leaf" 1931 Edward Weston (Icons 74)
 cabbage plant in "Cabbage" 1930 Piet Zwart (Rosenblum2 #515)
 carrots, beets, and scallions on Chinese newspaper for [personal studies] c. 1989* Tony Cenicola (Graphis89 \324)
 chili peppers for [personal studies] c. 1989* Tony Cenicola (Graphis89 \325)
 corn from annual report for [Weyerhaeuser, paper and cartonage manufacturers] c. 1989* Terry Heffernan (Graphis89 \291)
 ear of corn in [corn] c. 1989* Kathryn Kleinman (Graphis89 \321)
 endive subject of photograph in "Heart of Endive" 1932 D. J. Ruzicka (Peterson #31)
 man holding vegetables in [man with vegetables] c. 1997* David Stewart (Graphis97 124)
 man's hands holding yellow peppers in [company report] c. 1990* Terry Heffernan (Graphis90 \334)
 one ear of corn from [book entitled Openers, on appetizers] c. 1989* Kathryn Kleinman (Graphis89 \322)
 single pepper in "Pepper No. 30" 1930 Edward Weston (Art \220; MOMA 110; Peterson #42)
 pickles in a jar for [self-promotional] c. 1989* Walter Swarthout (Graphis89 \326)
 red and yellow peppers in [peppers] c. 1989* Philip Bekker (Graphis89 \265, \266, \267)
 red pepper in [vegetables] c. 1995* Steve Tregeagle (Graphis96 98)
 rinsing off asparagus in a colander in "Wishy washy asparagus" 1988* Hoyt Carrier II (Best14 108d)
 squash in [vegetables] c. 1995* Steve Tregeagle (Graphis96 98)
 tomatoes in "Tomatoe Picture" 1977* Bart Parker (Photography2 188)
 vegetable seller with array of vegetables in "Announcement of a lecture" c. 1989* Jay Maisel (Graphis89 \171)
 white radish with many roots in "White Radish" 1932 Sonya Noskowiak (Rosenblum \162)
VENUS (Planet)
 Venus' surface as seen from Magellan spacecraft in "Venus–a brilliant light in Earth's morning and evening skies–presents a craggy face to the orbiting Magellan spacecraft" 1993* David P. Anderson/NASA (Marien \8.6; Through 468)
VERSAILLES (France)
 pond bordered by sculpture in "Versailles, Neptune Basin" c. 1853 Louis Robert (Rosenblum2 #106)

VETERANS

African American man holding folded American flag in "Vernon Baker, 76, learned he will be the first African-American veteran of World War II to receive the Congressional Medal of Honor" 1996* Jim LoScalzo (Best22 216c)

decorated veteran in "Philippine survivors of the Bataan Death March are finally decorated with the bronze star and honored with a fly-over" 1988 Peggy Peattie (Best14 203d)

decorated World War II veterans in "Russian World War II veterans lead a group of other Russian war veterans observing V-E Day at the Jewish Center" 1995 John Beale (Best21 195d)

decorated World War I veteran in "Winston Roche, 92, who served in the U.S. Army during World War I" c. 1991* Michael O'Brien (Best17 84; Graphis92 \117)

in uniform, walking through cemetery in "Sgt. Jeff Sloat of the 7th Special Forces pays his respects to fellow veterans as he walks through the cemetery" 1997* Wally Skalij (Best23 197d)

men comforting each other in "After his first visit to the Vietnam War Memorial–on Memorial Day–Peter Kelsch of Miami is comforted by Alan Pitts" 1987 Lucian Perkins (Best13 113)

saluting in navy uniform in "World War II navy veteran Russell Richardson salutes during a Memorial Day observance" 1993* Christopher Fitzgerald (Best19 66a)

shirtless veteran waving flag in "A sudden downpour fails to dampen the patriotic spirit of flag-waving at a May welcome home rally in Houston for Vietnam War veterans" 1987 Steve Campbell (Best13 112c)

veteran salutes at a grave in "A Vietnam veteran observes Memorial Day by visiting the graves of friends" 1986* Scott Goldsmith (Best12 103b)

Vietnam veterans embrace at site of memorial marked by boot, helmet and rifle in "Vietnam veterans embrace during dedication ceremonies for a memorial to be constructed in Philadelphia" 1986 Susan Winters (Best12 59a)

VETERINARIANS

doing surgery on a cow in "Untitled" 1977 Aleksandras Macijauskas (San \54)

donkey restrained to a wall in "In the Veterinary Clinic" 1977 Aleksandras Macijauskas (Rosenblum2 #718)

VIETNAMESE CONFLICT, 1961-1975

after bombardment in "The bombardment of Phnom-Penh" 1974 Christine Spengler (Eyes #306)

battle scenes in "Khesanh, Vietnam" 1968* Robert Ellison (Eyes \11-13)

bodies of women and children dead on the road in "My Lai massacre scene" 1968 Ronald Haeberle (Eyes #298; Marien \6.75)

crowd of men near helicopters in "One ride with Yankee Papa 13" 1965 Larry Burrows (Eyes #289)

crying women and children in "My Lai Massacre" 1968* Ronald Haeberle (Goldberg 177)

dead soldier near his personal effects in "Fallen North Vietnamese Soldier with his personal Effects scattered by body-plundering Soldiers" 1968 Don McCullin (Art \426)

deformed child begging in "Twelve-year-old deformed child of victim of Agent Orange" 1995 Phillip Jones Griffiths (Photography 123a)

family crying and soldier looking at bodies near house in "A Stillness–Then Shock, Pain, and Hysterical Wonder" 1965 Horst Faas (Eyes #303)

lone soldier holding gun, standing among tree stumps in "Vietnam–Lone U.S. Soldier" 1971 David Hume Kennerly (Capture 78)

man sitting on ground near soldiers in "Interrogation of peasant, Vietnam" 1967 Gilles Caron (Eyes #260)

Marine chest-high in water in "American Marine in 'Demilitarized' Zone" 1966* Larry Burrows (Eyes \9)

naked young girl running and screaming on road, followed by soldiers in "Vietnam–Terror of War" 1972 Huynh Cong Ut (Capture 80; Eyes #297; Lacayo 157; Marien \6.74; Monk #44; Photos 134)

North Vietnamese carrying man on stretcher to net-covered operating room in swamp in "U Minh Forest, CA Mau" 1970 Vo Anh Khanh (Marien \6.76)

person with bandaged face and head and burned hand in "Napalm victim" 1967 Philip Jones Griffiths (Eyes #296; Marien \6.71)

photographs scattered by body in "Corpse of North Vietnamese Soldier" 1968 Don McCullin (Marien \6.102)

pile of skulls in "Village children before one of many mounds of skulls in Cambodia" 1996 Philip Jones Griffiths (Photography 123d)

soldier crying on foot lockers in "Farley gives way" 1965 Larry Burrows (Eyes #290)

soldier firing through the window of a house in "Company of U.S. 9th Division pinned down in some houses in District 8, Saigon" 1968 Philip Jones Griffiths (Eyes #294)

soldier holding knife near informant in "The dirty, nasty war in Vietnam" 1964 Horst Faas (Eyes #304)

soldier in poncho, sleeping on sandbags in rain in "Vietnam–Dreams of Better Times" 1967 Toshio Sakai (Capture 62)

soldier throwing a grenade in "Tet Offensive, Hue" 1968 Don McCullin (Eyes #291-292)

soldier with eye patch holding head of injured man in "Wounded medic works on soldier" 1966 Henri Huet (Eyes #305)

soldier with one leg embracing a woman in "Home from Vietnam" 1966 Ray Mews (Eyes #312)

soldiers lying on ground in "Vietnam" c. 1965 Kyoichi Sawada (Eyes #299)

South Vietnamese general shooting a Viet Cong prisoner in the head in "Viet Cong Execution" or "Execution of a Viet Cong Suspect, Vietnam" 1968 (Capture 64; Eyes #300-302; Goldberg 174; Lacayo 156; Marien \6.72; Monk #42; Photos 115)

South Vietnamese soldier, with a knife, threatening Viet Cong collaborator in "Vietnam–Crime and Punishment" 1964 Horst Faas (Capture 54)

throwing a grenade in "Man throwing Grenade, Hué" 1968 Don McCullin (Art \428)

Vietcong prisoner on ground in "Captured Vietcong" 1970 Philip Jones Griffiths (Eyes #295)

Vietnamese mother and children swimming to safety in "Kyoichi Sawada (Capture 56)

Vietnamese mother crying over her son's body in plastic bag in "Vietnamese woman and the body of her son" 1966* Larry Burrows (Eyes \10)

wounded soldiers in "First-aid station near the demilitarized zone, South Vietnam" 1966* Larry Burrows (Life 60; Marien \6.70)

wounded soldiers after battle in "Reaching out (during the aftermath of taking the hill 484, South Vietnam)" 1966* (Eyes \8)

wounded soldiers in muddy field in "South of the DMZ, South Vietnam" 1966* Larry Burrows (Lacayo 130)

young woman screaming over the body of a dead student in "Kent State Massacre" or "After the massacre of students at Kent State University"1970 (Capture 72; Eyes #311; Goldberg 180; Lacayo 145; Marien \6.73; Monk #43; Photos 129)

VINEYARDS

man and a truck in large vineyard in "Paul Rossi prunes grape vine in his father's vineyard, filled with blooming mustard weed" 1988* Kent Porter (Best14 101a)

panoramic view of town and rolling hills in "Vineyards near the hilltop town of La Morra, Italy" 2002* William Albert Allard (Through 40)

VIOLENCE

African American woman shielding a white man in "Keshia Thomas uses her body to shield a man–who was spotted wearing a Confederate flag shirt–from being beaten by a violent mob of anti-Klan demonstrators" 1996* Andrew Cutraro (Best22 142)

crowd being fired upon in "Residents of Alexandra Township, while demonstrating against violence, are shot and gassed by police" 1992* James Nachtwey (Best18 30)

man in shorts with a Confederate flag being beaten in "During a KKK rally, anti-Klan demonstrators beat a man suspected of being a Klan supporter" 1996* Jonathan Lurie (Best22 159c)

man lying on sidewalk in "Yechiel Bitton, 12, cowers near his father, Isaac, during violence directed at Hasidic Jews in the Crown Heights section of New York" 1991 Robin Graubard (Best17 112a)

photo essay illustrating the fear and dangers for people living in Homewood in "The Violent City–Homewood area of Pittsburgh" 1991 Steve Mellon (Best17 223-228)

photo essay of the violence surrounding the children and adults of the Ida B. Wells Housing project in "The Killing Zone" 1995 Eugene Richards (Best21 64-67)

stabbing of man lying on street in "A Haitian stabs an alleged thief during a protest against the murder of a militant" 1996* Daniel Morel (Best22 159)

VIOLIN / VIOLA

bearded man holding violin and two girls "The Whisper of the Muse" 1865 Julia Margaret Cameron (Art \56)

girl with violin on swing for two in "Hattie practices the violin with her mother in their backyard" 1993* Brian Davies (Best19 225)

man playing in "Charles Boyer" 1934 George Hoyningen-Huené (Vanity 184)

women playing viola, violin and piano in "The Prelude" 1917 Laura Gilpin (Peterson #55)

VISCATA

wrecked on shore in "The Wreck of the *Viscata*" 1868 Carlton E. Watkins (Art \121; Photography1 \53)

VOLCANOES

dead cattle in the brush in "More than 3,000 herd of cattle died when a lethal jet of carbon dioxide spewed from Lake Nyos in West Africa" 1986* Anthony Suau (Best13 83a)

eruption in the ocean in "Molten lava from Kilauea explodes when it flows into the Pacific Ocean" 1992* Roger Ressmeyer (Best18 222)

eruption seen from space in "Astronauts aboard the space shuttle *Discovery* observed a massive volcanic eruption in Papua, New Guinea" 1996* NASA (Through 462)

looking down cone of volcano in "Mount Vesuvius, Italy, after the Eruption of 1944" 1944 Photographer

Unknown (Rosenblum2 #661)

people with umbrellas walking through streets covered in grey ash in "Ash rains downs after the eruption of Mount Pinatubo, Luzon Islands, the Philippines" 1991* Philippe Bourseiller (Life 17)

photographer and scientist at edge of erupting volcano in "A photographer and geologist from the Philippine Bureau of Science get an up-close look at the erupting Taal Volcano" 1912 Dean Worcester (Through 394)

red lava erupting from volcano in "Fiery lava fountains spew from Hawaii's Kilauea volcano" 1985* James Sugar (Best11 41b)

small building amidst plumes of smoke in "Solfatara Volcano, Pozzuoli, Naples, Italy" 1990-1995 Mimmo Jodice (Photography 176)

smoke and mist-filled latent volcano in "Volcano Quetzeltenango, Guatemala" 1875 Eadweard Muybridge (Rosenblum2 #150)

standing by an erupting volcano in heat-protective clothing in "Eruption of the Krafla, Iceland" c. 1990* Maurice Krafft (Graphis90 \100)

VOLLEYBALL

air-born players kicking volleyball across net in "Asian foot volleyball comes to West" 1991* Mike Powell (Best17 156b)

diving across the sand to hit the ball in "Pro beach volleyball player Mike Dodd gets horizontal as he dives to dig the ball" 1996* Richard Hartog (Best22 220d)

hands and ball at the volleyball net in "American and Soviet volleyball players battle at the net during the Summer Olympics" 1988 Rick Rickman (Best14 12d)

nun hitting a volleyball in "Sister Veronica Maria hits a volleyball during a game" 1996* Wally Skalij (Best22 225a)

VOTING

girls looking out from voting booth curtain in "Taking a peek at other voters, sisters wait for their mothers to finish voting" 1992 Mona Reeder (Best18 226)

showing identity cards in order to vote in "An 89-year-old Romanian shows an official her identity papers in order to vote in the country's first free election in over 40 years" 1990 William Snyder (Best16 103a)

—W—

WALRUS

one looking over edge of pool in "Meet Nuka the walrus, who turned the tables by staring back at visitors to the New York Aquarium in Coney Island" 1985 Valerie Hodgson (Best11 151b)

thousands of walrus near shoreline in "Under the Marine Mammal Protection Act, Alaskan airspace is regulated to prevent thousands of walruses from stampeding" 1996* Joel Sartore (Best22 189a)

WAR see also CRIMEAN WAR; KOREAN WAR; SPANISH-AMERICAN WAR; VIETNAMESE CONFLICT, 1961-1975; WORLD WAR I; WORLD WAR II

WAR MEMORIALS see MEMORIALS

WASHINGTON (D.C.)

African American children playing in the slums in sight of the Capitol in "In the Shadow of the Capitol, Washington, D.C." 1946-1949 Marion Palfi (Decade \39)

AIDS quilts fill the mall as seen from the air in "AIDS Memorial Quilt" 1996* Paul Margolies (Photos 183)

Capitol building without current dome in "U.S. Capitol" 1846 John Plumbe (Photography1 \32; Rosenblum2 #15)

Lincoln inauguration in front of unfinished Capitol building in "Inauguration of Lincoln" 1861 Montgomery C. Meigs (Photography1 #IV-22)

men and boys looking out toward the Capitol building in "Hundreds of thousands of African-Americans gathered together in Washington, D.C., during the 'Million Man March'" 1995* Pete Souza (Best21 179d)

three African American girls sitting at base of sculpture of nude holding a sphere in "Children Playing in a Fountain in DuPont Circle. Washington, D.C." 1943 Esther Bubley (Fisher 56)

two soldiers looking at statute of man pulling back horse in "Soldiers looking at the statue in front of the Federal Trade Commission Building. Washington, D.C." 1943 Esther Bubley (Fisher 57)

Union Station being restored in "The restoration crew of Union Station, Washington, D.C." c. 1990* Neal Slavin (Graphis90 \113)

view of Washington Monument from Lincoln Memorial in "View from the Lincoln Memorial towards the east" c. 1987* Mark Segal (Graphis89 \114)

WASHINGTON MONUMENT (Washington, D.C.)

Civil Rights gathering of thousands from the Lincoln Memorial to the Washington Monument in "The March on Washington" 1963 Robert W. Kelley (Monk #40)

men holding candles in "Mourners hold a candlelight vigil and prayer in memory of loved ones who have passed away from AIDS" 1996 Khue Bui (Best22 222b)

WATER TOWERS

different types in "Water Towers" 1980 Bernd and Hilla Becher (Photography2 146; Rosenblum \216)

WATERFALLS

falls through the trees in "Multnomah Falls Cascade, Columbia River" 1867 Carleton E. Watkins (Art \115; Rosenblum2 #166; Waking #124)

near cabin and small bridge in "Waterfall in Saxon, Switzerland" 1857 Hermann Krone (Rosenblum2 #123)

Niagara Falls in a panorama view in "Niagara Panorama" c. 1855 Photographer Unknown (National 156b)

Niagara Falls looking up from the base in "Niagara from Below" or "Niagara in Summer, from Below" c. 1888 George Barker (National 121a; Photography1 #V-8)

Niagara Falls with ice on falls and large dome of ice at base in "The Falls in Winter" c. 1888 George Barker (National \38)

overlooking the Falls and valley in "Falls of the Yosemite" 1872 Eadweard Muybridge (Lacayo 29)

overlooking the top of the falls in "Shoshone Falls, Looking over Southern Half of Falls" 1868 Timothy H. O'Sullivan (Photography1 xii, #III-20); in "Shoshone Falls, Snake River, View Across the Top of the Falls" 1874 Timothy H. O'Sullivan (National \39)

people walking on frozen Niagara River in front of Niagara Falls in "Ice Bridge, Ice Mound and American Fall, Niagara, Instantaneous" 1883 George Barker (Photography1 \69)

rocks at base of falls in "Gibbons Falls, 84 Feet" 1884-1888 F. Jay Haynes (Photography1 \72)

small falls in a forest in "Glas Pwil Cascade" 1865 Francis Bedford (Rosenblum2 #122)

trees covered in snow and ice in "Falls of Minnehaha in Winter" c. 1870 Joel E. Whitney and Charles A. Zimmerman (National 164d)

view of falls cascading into river in "Lower Falls of the Yellowstone" 1903 Frances Benjamin Johnston (Sandler 117c)

waterfalls in "Falls of Minnehaha, Minnesota" c. 1855 Alexander Hesler (National \7)

WEDDINGS

African American bride and groom in "Wedding couple" c. 1920 Addison N. Scurlock (Willis \59)

African American bride and groom and image of children at their feet in "Future Expectations" c. 1926 James Van Der Zee (Willis \69)

African American bridesmaid seated with a bouquet in "Lastinia Martinez Warren, a bridesmaid in the DeCuir wedding, New Orleans" 1939 Florestine Perrault Collins (Willis \57)

after a group wedding in Taipei Zoo, and in limo in "Yes, I Do" 1997 Chien-chi Chang (Best23 147a, 227d)

bridal party seated for photograph in "Moses and Rongee Tjiriange" 1998* Suné Woods (Committed 226)

bride and groom at wedding reception in "Tina lunges for Michael as their wedding reception begins" 1995* Dan Habib (Best21 162a)

bride and groom on field in "Kennedy Wedding" 1953 Toni Frissell (Sandler 163)

bride and groom waiting in "At the Moscow Bridal House two girls gossip as a couple wait their turn to be married" 1993 Lucian Perkins (Best19 10b)

bride dancing with flower girl in "Sabra Fair and daughter waltz away the minutes before Fair's wedding" 1996* Samuel Hoffman (Best22 174c)

bride driving with veil caught in car door in "Fast Lane Weddings" 1996* Kevin Manning (Best22 177d)

bride looking out window near her wedding party in "Grace Kelly before her wedding" 1956 Howell Conant (Life 70)

bride on the ground in "Fainting Bride, *Bois de Boulogne*, Paris, France" 1956 Raymond Depardon (Photography 203)

bride seated by window in "The Bride" c. 1900 Sarah J. Eddy (Rosenblum \66)

bride speaking with flower girls in "Queen Elizabeth and her new daughter-in-law, Diana, prepare to greet the public, Buckingham Palace" 1981* Patrick Lichfield (Life 8)

bride trying on wedding gown in "Soviet Jews immigrate to Israel" 1992* James Nachtwey (Best18 35d)

children walking their mother down the aisle in "Mijanou, 17, and her brother Nick, 12, give away their mother in the ceremony of their mother's second wedding" 1995* Lauren Greenfield (Best21 93a)

couple hiking up mountain in "French couple celebrate their marriage by climbing 3,000 feet to the wedding reception" 1998 Tom Stoddart (Best24 102b)

elderly couple kissing at their wedding in "A four-month courtship culminated in marriage for Rev. Edward Charmichael, 82, and Vera Davis, 80" 1986 Bernard Troncale (Best12 137)

elderly woman looking at sisters in wedding dresses in "Sisters model their wedding gowns for their grandmother" 1992 Nancy Andrews (Best18 118)

groom sleeping on bride's lap on floor in "A couple wait to be photographed during a mass wedding in

Taiwan" 1993* Jodi Cobb (Best19 126a)

nude bride and groom walking away in "A Nudist Wedding" 1984 Elliott Erwitt (Photography 202)

portrait of bride sitting on ornate chair in "Wedding picture" 1901 Photographer Unknown (Goldberg 18)

posing in photographer's studio and at outdoor locations in "Say Cheese" 1998 Chien-Chi Chang (Best24 117, 120-121)

Prince Charles and Lady Diana kissing after wedding in "The Royal Wedding" 1981* Photographer Unknown (Photos 151)

red wedding cake and couple in red clothes in "The Wedding" 1994* Sandy Skoglund (Photography 201)

son refusing to take place as ring bearer at a second marriage in "Banfield-Walkowitz wedding" 1989 April Saul (Life 50)

wedding party with bride, groom, best man and maid of honor in "Wedding Party" c. 1905 Harry Shepherd (Willis \30)

WEIGHT CONTROL

photo essay on the surgery of an overweight woman in "The metamorphosis of Wendy Fraser" 1987 Melissa Farlow (Best13 144-148)

WELLS

children pumping water into a wooden basket in "Children at Well" 1900 Chansonetta Emmons (Rosenblum \96; Rosenblum2 #316)

drilling for water in the desert in "Bedouin in Syria drill for water in the northern steppe" 1993* Ed Kashi (Through 226)

WESTMINSTER (London, England)

Big Ben and the Palace of Westminster in "Big Ben competes with cell phones on Westminster Bridge in London, England" 2000* Jodi Cobb (Through 60)

WHALES

diving near sailboarder in "A sailboarder looking for whales on Newfoundland's Bonavista Bay is rewarded by a close encounter with two humpbacks" 1986* John Eastcott (Best12 107a)

Eskimos on ice petting whales in "Two Barrow, Alaska residents say goodbye to the California gray whales that were trapped in the Arctic Ocean ice pack for more than three weeks" c. 1988 Bill Roth (Best14 6d); "Malik, Inupiat Eskimo who helped engineer a path out to open water for California gray whales trapped near Alaska, stays to wish goodbye before a Soviet ice breaker approaches" 1988 Bill Hess (Best14 88)

fluke of a whale in [whale's fluke] c. 1997* Henry Horenstein (Graphis97 175a)

surface with mouth open and surrounded by gulls in "Near Stellwagen Bank, in the Atlantic off Massachusetts Bay, a humpback whale may eat as much as a ton of food in one day" 1998* Flip Nicklin (Through 428)

WHEELCHAIRS

basketball player making a jump shot in wheelchair jump shot in "Australian Troy Sachs becomes airborne and completes a jump shot during the World Wheelchair Championship" 1998* Adam Petty (Best24 62)

crowd holding up young man in wheelchair in "A disabled rock 'n' roll fan gets a better view at the Monsters of Rock heavy metal concert in Pittsburgh" 1988 John Kaplan (Best14 23)

homeless man in wheelchair drinking from bottle in "Wheelchair-bound Mike Haven has his 'wake-up' in the Second Avenue Seattle storefront that he often calls home" 1987 Alan Berner (Best13 42a)

man in wheelchair in "Untitled" 1992* David Hevey (Marien \7.93)

man leaning against lamppost with a stop sign in "The message couldn't be clearer as a homeless, legless man comes to a full stop in Boston's business district" 1986 David L. Ryan (Best12 188)

rock climber's wheelchair dangling from his belt in "Paraplegic rock climber Nick Morozoff dangles precariously" 1995 Tim Clayton (Best21 124)

student in wheelchair with his date on his lap at homecoming dance in "Permanently paralyzed from a motocross race accident, former star athlete dances with his girlfriend" 1997* Bryan Patrick (Best23 174b)

veteran, in wheelchair, wearing rain poncho, holding small child in "Moment of Reflection" 1976 Robin Hood (Capture 101)

wheelchair race winner crosses the line in "In the middle of a rain storm, France's Claude Issorat crosses the finish line first in the men's 1500-meter wheelchair race" 1996* Paul E. Rodriquez (Best22 120a)

wheelchair racer in the rain in "Scott Hollonbeck races through the rain to a second place in the Olympic Wheelchair 1500" 1996* Shawn Spence (Best22 206d)

wheelchair racer in [wheelchair athlete] c. 1997* John Huet (Graphis97 192)

wheelchair racers at top of hill in "Wheelchair racers crest the Queensway Bridge during a half-marathon in Long Beach" 1990 Peggy Peattie (Best16 190d)

wooden chair in hallway in "Floating Fan" 1972 Doug Prince (Photography2 77)

WHIRLIGIGS

several on poles on small houses in "Whirligigs" c. 1995* Deborah Brackenburg (Graphis96 168)

WHITE HOUSE (Washington, D.C.)
 group of soldiers sitting in front of White House in "The First Lady at a party she threw for Army troops" 1942 Thomas McAvoy (Life 22a)
 with crowd in foreground in "Dan Rather" 1974 Annie Leibovitz (Rolling #30)

WINDMILLS
 Frank Lloyd Wright's wooden structure in "Romeo and Juliet" c. 1900 Frank Lloyd Wright (Waking #158)
 hundreds of windmills at foot of mountain in "Driven by wind and weather, windmills stand ready at the foot of the Tehachapi Mountains" 1998* George Wilhelm (Best24 50b)
 in motion in "Windmill, Owens Valley" 1938 Ansel Adams (Decade \35)
 near houses in "Windmill at Kempsey" c. 1853 Benjamin Becknell Turner (Szarkowski 53)
 on distant hilltop in "Windmills, Montmartre" 1839 Hippolyte Bayard (Waking #38)
 wind farm and moon in blue sky in "Tehachapi windmills" 1985* Peter Menzel (Best11 153a)
 wood house, windmill and withered crops in "Dustbowl farm, Coldwater district" 1938 Dorothea Lange (Fisher 27)

WINDOWS
 boy sitting by window of streetcar in "Little boy riding on a streetcar. Washington, D.C." 1943 Esther Bubley (Fisher 89)
 children sitting on windowsill in "New York" c. 1942 Helen Levitt (Women \124)
 flat facade with rows of windows in "Entrance, Residential Apartment Block, Kalkerfeld, Cologne" 1928 Werne Mantz (Hambourg \25)
 from a fire escape in "Wall and Windows" c. 1929 Walker Evans (Rosenblum2 #531)
 front of an apartment house in "The Coronado Apartments" 1938 John Vachon (Documenting 110a)
 gated window with bullet holes in "Looking through a bullet-riddled window in the living room where her mother was fatally wounded" 1997* Wally Skalij (Best23 196)
 latticed windows in "Latticed Window, Lacock Abbey, England" 1835 William Henry Fox Talbot (Marien \1.18; Monk #2; Rosenblum2 #20)
 looking up toward window in "Spring breezes fill billowing curtains as flowers rest on a windowsill" 1987* Peter Tobia (Best13 167a)
 open window and curtain in "Windowsill Daydreaming" 1958 Minor White (Art \343; Photography 17)
 paint around windows in building in southwest in "Painted Windows" c. 1991* Roy Ritola (Graphis91 \321-\335)
 painter hanging out window to paint brick in "Painter goes the extra mile, doing his part to restore Victorian Square" 1985 Steven R. Nickerson (Best11 141b)
 potted plants on windowsill in "The Attic Window, Dresden" 1909* Karl Struss (National 149d)
 pussy willows in a vase in "Window in the Rain" 1944 Josef Sudek (Rosenblum2 #708)
 shirt drying in the window in [shirt drying in window] c. 1992* Holly Stewart (Graphis93 64a)
 stained glass window with round details in "Rooming house window" 1938 John Vachon (Documenting 105d)
 window open to outside in "Kelmscott Manor: through a window in the tapestry room" 1896 Frederick H. Evans (Art \157)
 window washer on a rope in "Window washer does it with ropes as he works on an 11-story building in Wilmette, Illinois" 1986 Geoff Scheerer (Best12 183b)
 woman in silhouette looking out of window to large house in "Boarders often speculate on the identity of the owner of the house across the street. Washington, D.C." 1943 Esther Bubley (Fisher 60)

WINTER *see also* SNOW
 African American man shoveling snow under poster of African American man in tuxedo in "Snow Dancer" 1992 Budd Williams (Committed 223)
 boys and horse in snow in "Kids move their horse to their warm barn during a blustery winter snowstorm" 1996* Kurt E. Smith (Best22 154a)
 boys hovering over inner tube in "First snowfall of the year brought these three youngsters to one of Seattle's steepest hills" 1985 Denis W. Law (Best11 187)
 boys on inner tubes in "Students used everything from inner tubes to garbage can lids to take advantage of wintry weather" 1985 Robert Jordan (Best11 187a)
 cars covered in snow in "A motorist exits his snow-covered car during a fierce storm that dumped 10 inches of snow in one day" 1987 Gary Lawson (Best13 173a)
 child pulling sled past slender tree in "Winter, Central Park, New York" c. 1915 Paul Strand (Waking 335)
 children playing in snow in park in "First Snow, *Jardin du Luxembourg*" 1955 Edouard Boubat (Icons 133)
 farmhouse and fences in snow in "Winter Eve" 1938 Gustav Anderson (Peterson #51)
 frost on window in "Frosted Window" 1957 Paul Caponigro (Photography2 33)

homemade snow igloo in "Frank Russo enters one ends of an igloo he built in his yard in Maine, as his dog peers into the other end" 1993* Carl D. Walsh (Best19 69)

horse pulling man on sled across snow-covered field in "A workman makes his way across the former estate of Alexander Pushkin" 1992* Lynn Johnson (Through 64)

horse-drawn carriage on snow-covered street in "Winter–Fifth Avenue, New York" 1893 Alfred Stieglitz (Photography1 #VI-5)

iced-over lake and park in "A couple in Montreal, Canada, enjoys a quiet moment on Mount Royal Park's iced-over Beaver Lake" 1991* (Through 344)

landscape of snow and conifers from window shaved clear of ice in "In this pastoral scene, camera captures familiar features of Russia–snow and ice and a stand of conifers" 1998* Gerd Ludwig (Through 48)

Niagara Falls with ice on falls and large dome of ice at base in "The Falls in Winter" c. 1888 George Barker (National \38)

Niagara Falls with people walking on frozen Niagara River in "Ice Bridge, Ice Mound and American Fall, Niagara, Instantaneous" 1883 George Barker (Photography1 \69)

park with radiating streets as seen from above in "The Octopus, New York" 1912 Alvin Langdon Coburn (Decade 15c; Hambourg \1; Rosenblum2 #398)

path made in snowy parking lot in "Cars carve an oval path through a snowy downtown parking lot" 1987 Wally Emerson (Best13 172d)

Pilgrim settlement reproduction covered in snow in "Pilgrim Winter" c. 1990* Erik Leigh Simmons (Graphis90 \93)

pine trees covered with thick snow in "Luna Island in Winter" 1888 George Barker (Photography1 #V-10)

remains of a home covered in ice in "Four persons died in this mid-winter blaze in Chicago" 1985 John Dziekan (Best11 99b)

rowboat in snow in [Summer activities in Wintertime] c. 1991* Robert Mizono (Graphis92 \201)

sled and boots in hallway in "Winter" c. 1991* Dave Jordano (Graphis92 \55)

snow at the Vatican in "First snowfall in 14 years dusts worshippers, leaving the Jan. 6 mass celebrating the Epiphany" 1985* James Stanfield (Best11 45b)

snow-covered forest with stream in "Winter Scene in Fairmount Park" c. 1910 James Bartlett Rich (National 145d)

snow-covered sidewalk in small town with lampposts in "Center of town. Woodstock, Vermont" 1940 Marion Post Wolcott (Fisher 44)

snow covering ground around six trees in "Chicago" c. 1950 Harry Callahan (MOMA 173)

snow covering ground under arch of bare trees in "Winter in Chicago can be a study in patterns, textures – and snow shovels" 1985 Chuck Berman (Best11 142a)

snow on front steps of attached houses in "Harlem Snowstorm" c. 1969 St. Clair Bourne (Willis \224)

snow on Red Square in "St. Basil's Cathedral in Moscow's Red Square" 1998* Sisse Brimberg (Through 42)

swan with head tucked over its back and underneath its wings in "Swan" 1974* Teiji Saga (Graphis91 \350; Life 192)

swans covered with snow in "Wild swans caught in a snowstorm in northern Japan" c. 1991* Teiji Saga (Graphis91 \349)

tractor dragging Christmas tree on snow in "Hardly reminiscent of an old-timey Yule log, but a youngster on a Vermont tree farm brings out a Christmas tree to last-minute patrons" 1986 Bill Greene (Best12 146)

tree and park benches, covered in snow, in foreground of Flatiron Building in "Flatiron Building" 1903 Alfred Stieglitz (Goldberg 20; Hambourg 6a; MOMA 83; Szarkowski 164)

walking on snowy steps in "A woman walks through new-fallen snow at Boston's City Hall Plaza" 1986 Bill Greene (Best12 146d)

walking through snow-covered streets in a snowstorm in "Harlem Snowstorm" c. 1969 St. Clair Bourne (Willis \225)

WITNESSES

men leaving building with faces covered in "De Marco witnesses" 1959 Clinton B. Jones (Goldberg 9b)

WOLVES

growling wolf and dead prey in "A gray wolf savors a fresh kill" 1998* Joel Sartore (Through 324)

jumping on ice rafts in "An Arctic wolf leaps from ice raft to ice raft in the wilds of northern Canada" 1987* Jim Brandenburg (Best13 90; Graphis90 \190; Through 336)

lone wolf chasing ravens in "North Woods Journal" 1997* Jim Brandenburg (Best23 246a)

photo essay on Arctic wolves in "Arctic wolves" 1987* Jim Brandenburg (Best13 86-93)

walking through the forest in "The grey wolf is considered the spirit of the forest by some Native Americans" 1991* Jim Brandenburg (Best17 174)

wolf sitting on an iceberg in "An Arctic wolf surveying his domain from an iceberg throne" c. 1990* Jim

Brandenburg (Best13 93; Graphis90 \191)

WOMEN EMPLOYEES

African American woman at sewing machine in "Jennie Pettway and another girl with the quilter Jorena Pettway" 1937 Arthur Rothstein (Documenting 152b)

African American woman in front of office flag in "Ella Watson" or "American Gothic" 1942 Gordon Parks (Committed 168; Documenting 234-235; Goldberg 103; Marien \5.58)

African American woman sweeping an office floor in "Cleaning a government office at night" 1942 Gordon Parks (Documenting 233c)

Calcutta women sitting on ground in "Women Grinding Paint, Calcutta" c. 1845 Photographer Unknown (Art \25; Waking #82)

carrying a large sack of coal in "Delivering Coal" c. 1916 Horace W. Nicholls (Rosenblum2 #429)

carrying a rake in the field in "The Haymaker" c. 1904 Oskar and Theodor Hofmeister (Rosenblum2 #379)

carrying hay on poles in "Poling the Marsh Hay" 1886 Peter Henry Emerson (Art \152; Marien \4.5; Waking 331)

coal mine worker posing with tools in "Pit Brow Girl, Shevington" 1867 T. G. Dugdale (Rosenblum2 #410)

collecting sisal from piles in "Sisal Women, Bahia" 1985 Nair Benedicto (Rosenblum \192)

cotton being picked by African American in "Picking cotton on the Alexander plantation" 1935 Ben Shahn (Documenting 82b, 83c)

fishermen's wives with large basket in "Cottage Door" 1843 Hill and Adamson (Waking 269a)

fixing airplane engines in "Women supporting the men by working as airplane mechanics" 1942 Photographer Unknown (Goldberg 110)

hands checking boxes of bullets in "Mrs. Julian Bachman checking the size of a bullet before the cartridge is assembled" 1942 Marjory Collins (Documenting 265c)

hanging towels to dry on indoor line in "Carmen Sotelo, a laundress at the Masso fish cannery in Cangas, Galicia, hangs towels to dry in the early morning" 1987* Sarah Leen (Best13 167d)

making shoes in "Lynn Shoeworker" 1895 Frances Benjamin Johnston (Sandler 144c)

man and woman riveting parts of a plane in "Italian-Americans at work on a bomber in the Douglas aircraft plant. Santa Monica, California" 1943 Ann Rosener (Fisher 81)

man seated with books, paper, and pen on desk in "Editor" c. 1855* Photographer Unknown (National 12)

on ladders picking apples in orchard in "Basuto women pick apples in the Prairie Province of South Africa" 1931* Melville Chater (Through 238)

pregnant woman holding large amount of mail and mail bag in "Mail carrier Minette Sheller had residents on her route wondering just what she was going to deliver today" 1985 Al Seib (Best11 136c)

raking seaweed in "Woman raking" 1893 Paul Martin (Szarkowski 129c, 129d)

rows of women in factory assembling electrical appliances in "Female Employees at AEG" 1906 Photographer Unknown (Marien \4.50)

sitting at teletype machines in "Picture taken at 383 Madison Ave., when AP first installed a new model of 'Teletype' " 1923 Photographer Unknown (Eyes #127)

surrounded by week's load of housework and supplies in "Week's housework" 1947 Nina Leen (Lacayo 94)

teachers wearing large hats sitting near large window in "Rest Hour (Columbia Teachers College)" 1912 Clarence H. White (National \73)

telephone operators on the telephones in "Timetable information room" 1943 Jack Delano (Documenting 288a)

walking seven dogs at one time in "Petsitter untangles herself during her daily walk with her clients' dogs" 1998 Bill Greene (Best24 41b)

welding pipes in "Mrs. Ethel Wakefield of Dorchester, welder at the Bethlehem shipyard in Quincy since 1943" c. 1945 Photographer Unknown (Goldberg 111)

woman in hat, sitting on sidewalk pulling weeds in "Spring in Berkeley" 1951 Dorothea Lange (MOMA 203; Photography 43)

woman mopping the floor of a bus in "Mopping the floor of a bus in the Pittsburgh Greyhound garage" 1943 Esther Bubley (Documenting 318a)

woman reading telegraph tape in "Miss Genie Lee Neal reading a perforated tape at the Western Union telegraph office" 1943 Esther Bubley (Fisher 87)

woman selling baskets of apples in "Mennonite apple seller at the farmers' market" 1942 Marjory Collins (Documenting 262a)

woman working at machine in "Emma Dougherty cleaning out her end-grinding machine" 1942 Marjory Collins (Documenting 266a)

women at filing cabinet in "OWI research workers. Washington, D.C." 1943 Ann Rosener (Fisher 80)

women checking boxes of bullets in factory in "Twenty-three-year-old Mrs. Julian Bachman and two other

Wisconsin" 1986 John Froelich (Best12 143d)

construction worker and mass of metal rods in "Vision and strength are evident in the construction of the Sagrada Familia Church in Barcelona, Spain" 1998* David Alan Harvey (Through 62)

cotton carders, men on floor with pile of cotton in "Group of Cotton Carders" 1856 William Johnson (Rosenblum2 #191)

covered in oil, men try to cap a well in "Capping a burning oil well in Kuwait" 1991* Stephane Compoint (Lacayo 174)

delivering items from a car in "Watkin's Products delivery man" c. 1930s Allen E. Cole (Willis 108)

delivery man with crates of Pepsi in bottles in "Pepsi, New York" 1964 Roy DeCarava (Rosenblum2 #684)

dusting a nude male statue in "The 400-plus statues are dusted off four times a year" 1986 Bradley Clift (Best12 160a)

elderly man in apron leaning on hand truck in "Proprietor of general store. Lincoln, Vermont" n.d. Louise Rosskam (Fisher 37)

farmhand with pitchfork on pile of hay in "Farmhand near Goldendale, Washington" 1936 Arthur Rothstein (Documenting 18a)

fixing yacht rigging in "A sailor on a 'Maxi' yacht gets rigging squared away at the St. Petersburg, Florida, Yacht Club" 1986 Eric Mencher (Best12 144)

framing a home in "(Omaha) Indians Building Houses for the Tribe" 1877 William Henry Jackson (Marien \3.62)

frozen fish on man's shoulders in "A fisherman carries frozen fish to market in South Korea" 1987* Anthony Suau (Best13 84d)

furnace workers in protective clothing in "Protective Clothing for Workers in the Furnace Room" c. 1905 Photographer Unknown (Szarkowski 332c)

gathering wood by woman in white apron in "Alice Baker" c. 1890 Emma Coleman (Sandler 23)

geese being plucked by family in barn in "Picking Geese" n.d. Mary Paschall (Sandler 17c)

greased-stained men in hard hats, with tools in "It took this crew eight weeks to dismantle a 1,250 ton hydraulic bending press" 1985 Arnold Gold (Best11 139b)

grist mill machinery and men in "Grist Mill, West New Portland, Maine" c. 1901 Chansonetta Emmons (Sandler 21)

hillside filled with men cutting into side of mine in "Gold miners in Brazil" 1986 Sebastião Salgado (Eyes #325; Lacayo 168; Marien \7.18; Photography 108; Photos 157)

horse with man nailing in horseshoe in "Farrier, with His Clients" c. 1848 Photographer Unknown (Photography1 \23)

hundreds of men carrying shovels in "Construction Site of the Fergana Grand Canal" 1939 Max Alpert (Rosenblum2 #600)

itinerant Chinese tradesmen: barber, calligrapher, etc. set up in street in "Itinerant Tradesman, Kiu Kiang Kiangsi" c. 1868 John Thomson (Rosenblum2 #192)

large basket on woman's head in "Basket of Millet" 1987 Elisabeth Sunday (Rosenblum \252)

large flock on open range and man on horseback in "Sheep" c. 1903 Elizabeth Ellen Roberts (Sandler 10-11)

lifting sacks of flour by flour-covered worker in "A worker for a flour-distribution company in Port-au-Prince, Haiti, unloads cargo" 1991* John Moore (Best17 19)

line of men at time-clock in "Punching out for lunch at the Animal Trap Company. This firm was converted to the production of ammunition during the war" 1942 Marjory Collins (Documenting 258a)

loading firewood into a cart in the snow in "Loading firewood in the Santa Fe National Forest" 1943 John Collier, Jr. (Documenting 298a)

lumberjack with chain saw in "Lumberjack Stan Christie eyeballs a 500-year-old cedar in the Olympic National Forest, deciding where to make his cut" 1990 Tom Reese (Best16 168)

lumberjacks standing by huge tree in "Felling a Fir Tree, 51 Feet in Circumference" 1906 Darius Kinsey (MOMA 75)

man and woman riveting parts of a plane in "Italian-Americans at work on a bomber in the Douglas aircraft plant. Santa Monica, California" 1943 Ann Rosener (Fisher 81)

man climbing steps that circle a storage tank in "Exxon employee climbs a 630,000-gallon storage tank to retrieve a sample of the gasoline within" 1985 Michael Gallacher (Best11 141d)

man in foundry in "Thursday, Barthelemy Foundry Crest" c. 1991 Raymond Depardon (Graphis92 \128)

man in hat and work gloves leaning on shovel in "Native of Indiana in a migratory labor contractor's camp" 1937 Dorothea Lange (Fisher 21)

man in white coat near stove in "Baker" 1928 August Sander (Icons 20; Rosenblum2 #447)

man inspecting undercarriage of truck in "Periodic complete vehicle inspection is required of all US army drivers" 1943 Ann Rosener (Fisher 82)

man making sausage in "Sausage Maker" c. 1845 John Plumbe (Photography1 #I-6)

man on ladder in shipbuilding yard in "Permanente Metals Corporation, Shipbuilding division Yard no. 2" 1943 Ann Rosener (Fisher 86)

man rolling large metal tire in "Worker with locomotive wheel tire" c. 1900 Photographer Unknown (Szarkowski 143)

man standing among unfinished pianos in [inserting piano strings] c. 1999* Randy Duchaine (Photo00 183)

man sweeping near palm trees on beach in "A Palestinian day worker in Tel Aviv, Israel, sweeps the beach front" 1990* James Nachtwey (Best16 42a)

man using wrench on large bolt and nut in "Steamfitter" 1920 Lewis Wickes Hine (Hambourg \19; MOMA 129; Rosenblum2 #446)

man's hands resting on shovel handle in "Worker's Hands" c. 1926 Tina Modotti (Icons 44; MOMA 109; Rosenblum2 #520)

masons at work on griffin figure in workshop in "Masons working on a carved Griffin for the Scott Monument" c. 1844 Hill and Adamson (Art \36)

men moving a galvanized sheet from one pile to another in "Galvanized Sheets" c. 1948 Fred G. Korth (Peterson #46)

men moving large sacks with hand truck in "Dock Workers, Pratt Street" 1925 A. Aubrey Bodine (Peterson #50)

men pulling large cart filled with poles in "Cart Pullers" 1935 Zhang Yin Quan (Rosenblum2 #723)

men with implements of various occupations in "Portraits of workers" 1862-1867 Photographer Unkown (Szarkowski 84-85)

men working at a forge in "The Forge" 1897 Myra Albert Wiggins (Rosenblum \95)

men working with horse in "The Clay Mill" before 1888 Peter Henry Emerson (Szarkowski 140)

Mexican men standing on steps in "Mexican field laborers, on strike in the cotton picking season, applying to FSA for relief" 1938 Dorothea Lange (Fisher 24)

migrant worker man in field, carrying tall, filled basket on his shoulder in "Migration to Misery" 1969 Dallas Kinney (Capture 69)

miner confronting police in "Fight Between a Serra Pelada Mineworker and a Policeman, Para, Brazil" 1986 Sebastião Salgado (Icons 187)

mowing lawn on steep slope in "Two students rig up a buddy system to mow lawns on the steep campus" 1985 Mark Courtney (Best11 172d)

mud-covered workers standing on rods across side of building in "Workers make repairs on the walls of the Great Mosque in Djénné, Mali" 2001* Esha Chiocchio (Through 234)

Navaho silversmith at bench in "Navaho Silversmith" 1939 Laura Gilpin (Sandler 113)

numerous floors under construction in "On the Construction Site" 1929 Mieczyslaw Berman (Hambourg \8)

olive oil being poured into large urns in "Ceramic urns hold the 'liquid gold' known as Italian olive oil, produced at this Tuscan estate for more than a thousand years" 1999* Ira Block (Through 70)

old man holding two shovels in "Coal Dock Worker" 1933 Walker Evans (Waking 366)

old man in paint splattered clothes in "Handyman in Washington, D.C." 1909 Lewis W. Hine (National \78)

painter hanging out window to paint brick in "Painter goes the extra mile, doing his part to restore Victorian Square" 1985 Steven R. Nickerson (Best11 141b)

painting a wall from ladders in "Untitled" 1930 Gertrud Arndt (San \13)

painting the expressway in "Two painters in Birmingham, Ala., roll a water-repellent coating on the sides of the Elton B. Stephens Expessway" 1986 Bernard Troncale (Best12 147)

people with various occupations in "Australians from National Geographic" c. 1990* Michael O'Brien (Graphis90 \183-\188)

pretzel company factory in "Father and son Lewis and Bob Haines packing pretzels at their Lititz Springs Pretzel Company" 1942 Marjory Collins (Documenting 258b)

pulling and pushing heavily loaded hand trucks in "Three Men with Hand Trucks, New York" 1963 Roy DeCarava (Decade 78b)

rice being unloaded from a ship in "Relief rice for starving Japan" 1949 Carl Mydans (Lacayo 78)

seated Native American women with piles of corn in "Indian Women Shucking Corn" c. 1905 Kate Cory (Sandler 105)

shepherds herding sheep on street with palm trees in "Pastorale Arabe" 1926 Joseph Petrocelli (Peterson #8)

shoeshine man and boy picking pockets in "Shoeshine and Pickpocket" 1865-1870 Giorgio Sommer (Rosenblum2 #273)

silhouette of man against vertical bars in "Carpenter checks the alignment of steel reinforcing rods on a highway construction job" 1985 Dan Siefert (Best11 142c)

silhouette of window washer through blinds in "Silhouette and shadow of a window washer play on window

and blinds" 1985 Grant M. Haller (Best11 146)

slaughterhouse with blood-splattered cows in "Slaughterhouse, South Saint Paul, Minnesota" 1962 Jerome Liebling (Decade \74; Photography 162)

standing on top of a crane at construction site in "Two crane operators ponder their next move as they assemble structural steel for a parking facility" 1986 Bob Nandell (Best12 144a)

steam shovel and train in "Steam Shovel at Work, Echo Cañon" 1868 Andrew J. Russell (Photography1 \47)

steamrollers on street in "Asphalting a Street in Moscow" 1929 Alexander Rodchenko (Waking #192)

sugarcane workers in "Sugarcane cutters, faces black from the soot of burned Guatemalan fields, rest after their day's work" 1988 John Kaplan (Best14 29)

telephone lineman doing "mouth-to-mouth" on other lineman who is dangling from a pole in "The Kiss of Life" 1967 Rocco Morabito (Capture 61)

threshing machine and men on mounds of hay in "Threshing" c. 1905 Elizabeth Ellen Roberts (Sandler 12)

tools in "Sculptor's Tools, San Francisco, California" c. 1930 Ansel Adams (Decade 37d)

truck driver leaning on doorway in "Truck driver from Meissen" c. 1991* Eberhard Grames (Graphis92 \147)

trucks in a line in "Delivery Vehicles and Staff of the Fame Laundry Company" c. 1915 Photographer Unknown (National 154a)

Union Station being restored in "The restoration crew of Union Station, Washington, D.C." c. 1990* Neal Slavin (Graphis90 \113)

walking and carrying beams, shot from below in "At work" 1929 Boris Ignatovich (Lacayo 72)

waxing an office floor in "Waxing the geometric pattern of a floor" c. 1991* Gordon Baer (Graphis91 \312)

welder with his equipment in "Welder" c. 1999* Chris Gordaneer (Photo00 110)

window washer on a rope in "Window washer does it with ropes as he works on an 11-story building in Wilmette, Illinois" 1986 Geoff Scheerer (Best12 183b)

woman holding bucket near mound of hay in "[Mabel Williams] Bringing Water to the Threshing Crew" 1909 Evelyn Cameron (Rosenblum \55; Sandler 6)

woman in hat, sitting on sidewalk pulling weeds in "Spring in Berkeley" 1951 Dorothea Lange (MOMA 203; Photography 43)

woman making shoes in "Lynn Shoeworker" 1895 Frances Benjamin Johnston (Sandler 144c)

woman reading telegraph tape in "Miss Genie Lee Neal reading a perforated tape at the Western Union telegraph office" 1943 Esther Bubley (Fisher 87)

women at filing cabinet in "OWI research workers. Washington, D.C." 1943 Ann Rosener (Fisher 80)

working on cable at top of Empire State Building in "Icarus, Empire State Building" 1930 Lewis Wickes Hine (Hambourg \6)

WORLD WAR, 1914-1918

aerial torpedo in flight in "An aerial torpedo in flight photographed just after its discharge from a French trench" c. 1914 Wide World Photos (Eyes #86)

battlefield of mud and burned trees in "Devastation on the battlefield of Passchendaele taken with a panoramic camera" 1917 William Rider-Rider (Marien \4.75)

crowd filling Wall Street on behalf in "Charlie Chaplin and Douglas Fairbanks at a Liberty Loan rally" 1918 United States War Department (Lacayo 49)

diplomats gathered to sign the treaty in "Signing the Treaty of Versailles" 1919 Photographer Unknown (Photos 35)

factory filled with large munitions in "A sea of shells at a British munitions factory" 1916 Horace Nicholls (Lacayo 51d)

hillside filled with troops in "British officer addressing troops" 1918 Photographer Unknown (Lacayo 48)

machine gun battle in "The Argonne" c. 1914 Wide World Photos (Eyes #85)

man walking on burned-out battlefield in "Panoramic view of Passchendaele Ridge, Belgium" 1917 Photographer Unknown (Lacayo 44a)

men and weapons in trenches in "Soldiers in World War I trenches" n.d. Photographer Unknown (Marien \4.74)

men loading a howitzer in "British artillerymen feed an 8-inch howitzer" 1917 Photographer Unknown (Lacayo 51a)

mounted soldiers going into battle in "Austrian Uhlans going into position" 1915 Underwood & Underwood (Lacayo 47)

sand bags on a trench in "A new model German trench captured by the French" c. 1914 Wide World Photos (Eyes #87)

soldier dropping a hand-held bomb from an airplane in "Bombing by hand" c. 1917 Max Pobly (Lacayo 50a)

soldiers in bombed-out forest shooting large machine gun in "American soldiers in battle" 1918 Photographer Unknown (Lacayo 50b)

soldiers in trench in "In the trenches near Arras, France" 1915 Photographer Unknown (Lacayo 46d)

soldiers on the attack across a field in "A vivid picture showing early morning attack by the British on the Western Front" 1917 Wide World Photos (Eyes #84)

soldiers running across a field and being shot in "Siege of Verdun" 1916 Photographer Unknown (Photos 31)

women in skirts digging trenches in "The defense of Riga" 1915 Underwood & Underwood (Lacayo 46a)

WORLD WAR, 1939-1945 *see also* AIRPLANES; BOMBS AND BOMBING; MILITARY; PEARL HARBOR

aftermath of bombing in "V-1 Blitz, London" 1943 George Rodger (Eyes #183)

air raid damage done to House of Commons, London, in "Churchill views damage at House of Commons" 1941 Photographer Unknown (Eyes #182)

body floating in water in "Murdered prison guard, Dachau" 1945 Lee Miller (Lacayo 115d; Photography 125)

bombed ship on fire and sinking in "Pearl Harbor" November 26, 1941 U.S. Navy (Monk #25)

boy sitting on ruins on home in "Boys in Ruins of His Bombed Out Home" 1945 Toni Frissell (Sandler 89)

boys pulling scrap metal on a wagon in "Youngsters bringing scrap metal from their barn to the curb for collection" 1942 Marjory Collins (Documenting 271c)

Buchenwald male prisoners looking out behind barbed wire in "The Living Dead at Buchenwald" 1945 Margaret Bourke-White (Eyes #213; Lacayo 116d; Monk #30)

Canadian troops coming ashore in "D-Day: Allied Invasion of Europe Begins" 1944 Gilbert A. Milne (Monk #28)

car with note of membership in Omaha's German bund in "High school student's car" 1938 John Vachon (Documenting 102b)

Cathedral dome during bombing of London in "St. Paul's Cathedral" 1940 John Topham (Lacayo 107)

crying women hold photographs of teenage partisans in "Naples" 1943 Robert Capa (Eyes #195; Lacayo 115)

dead soldiers in snow in "Fallen German Soldiers on Russian Front" 1941 Galina Sanko (Rosenblum2 #612)

Dresden in ruins after the bombing in "Dresden Destroyed" 1945 Walter Hahn (Photos 63)

devastated island and scorched bodies after a battle in "Tarawa" 1943 Frank Filan (Capture 12; Eyes #222)

explosion near soldiers in "Marines blow up a cave connected to a Japanese blockhouse on Iwo Jima" 1945 W. Eugene Smith (Art \415; Lacayo 112)

families looking for dead soldiers on battlefield in the Crimea in "Grief" or "The eastern front: Searching for loved ones at Kerch" 1942 Dmitri Baltermants (Art \422; Lacayo 114; Photos 57; Rosenblum2 #613)

fires on deck of the *Intrepid* in "Firefighters of the U.S.S. *Intrepid* battling blazes caused by kamikaze hit during the battle for Leyte Gulf" 1944 Barrett Gallagher (Eyes #220)

general and others wading ashore from landing craft in "MacArthur landing in the Philippines" 1945 Carl Mydans (Eyes #211; Lacayo 109)

hundreds of servicemen and servicewomen holding newspaper declaring "Peace" in "U.S. Servicemen and Servicewomen, Paris, August 15" 1945 U.S. Army (Life 68)

Japanese-American man being detained in "San Francisco" c. 1942 Dorothea Lange (Eyes #124; MOMA 170)

large mural in support of war effort in "Grand Central Station, New York" 1941 Arthur Rothstein (Fisher 160)

male prisoners looking out behind barbed wire in "The Living Dead at Buchenwald" 1945 Margaret Bourke-White (Eyes #213; Lacayo 116d; Monk #30)

man in prison uniform pointing out soldier in "Russian Slave Laborer Points Out Former Nazi Guard Who Brutally Beat Prisoners" 1945 U.S. Army Signal Corps (MOMA 171)

Marines raising American flag in rubble in "Old Glory Goes Up on Mount Suribachi" or "Raising the Flag at Iwo Jima" 1945 Joe Rosenthal (Capture 16; Eyes #212; Lacayo 118; Marien \5.86; Monk #29; Photos 65)

mothers and children with hands raised marching past armed Nazi soldiers in "The Warsaw Ghetto Uprising" 1943 from the Files of SS Commander Jürgen Stroop (Monk #27)

prisoners of war walking past crowd in "Returning prisoner of war" 1945 Ernst Haas (Eyes #196; Icons 101; Lacayo 117)

returning soldier hugging young daughter, with wife and son looking on in "A Hero's Return" 1943 Earle L. Bunker (Capture 14; Eyes #208)

Russian troops writing their names on wall in "The Victorious Troops signing their Names in the Lobby of the Reichstag" 1945 Anatoli Morozov (Art \423)

sandbagging the front of news building in "London AP building" c. 1940s Photographer Unknown (Eyes #178)

scarred skull of Japanese solider in "Soldier's skull on a destroyed tank" 1943 Ralph Morse (Lacayo 105b)

shaving woman's head in "French women accused of sleeping with Germans during the occupation are shaved by vindictive neighbors in a village near Marseilles" 1944 Carl Mydans (Eyes #198)

ship under attack in "Explosion Following Hit on the USS *Franklin* by Japanese Dive Bomber" March 19, 1945 U.S. Navy (MOMA 169)

soldier holding infant in "Wounded infant found by American soldier" 1944 W. Eugene Smith (Decade 55; Lacayo 113; Marien \5.81; Photography 122)

soldiers wading ashore in "Normandy invasion on D-Day" 1944 Robert Capa (Art \409; Eyes #189; Goldberg 116; Lacayo 105d; Marien \5.85; Rosenblum2 #607)

U.S. military watching the signing of the surrender document aboard the USS *Missouri* in "The Japanese surrender" 1945 Carl Mydans (Lacayo 120)

view from an airplane gunner in "With our war fliers in the air" 1936 Willi Ruge (Eyes #88)

woman sitting with baggage in ruins of a city in "Cologne, Germany" 1945 Johnny Florea (Life 54b)

woman working at machine in "Emma Dougherty cleaning out her end-grinding machine" 1942 Marjory Collins (Documenting 266a)

WORLD WAR, 1939-1945–JAPANESE SURRENDER

U.S. military watching the signing of the surrender document aboard the USS *Missouri* in "The Japanese surrender" 1945 Carl Mydans (Lacayo 120)

WORLD'S COLUMBIAN EXPOSITION (1893: Chicago, Illinois)

large wheel in "Ferris Wheel: World Columbian Exposition" 1893 Charles Dudley Arnold (Szarkowski 154)

looking over balcony to Exposition of buildings in "World's Columbian Exposition, Chicago" 1893 Charles Dudley Arnold (Photography1 \13)

WOUNDED KNEE (South Dakota)–INDIAN OCCUPATION, 1973

erection of a tepee and Native American with a rifle in "Wounded Knee Takeover" 1973 Photographer Unknown (Photos 137)

WOUNDS AND INJURIES

boy in bed with fatal wounds in "An Afghan youth, injured by a land mine while traveling with mujahideen warriors, lies dying from his wounds" 1990* James Nachtwey (Best16 39a)

boy in hospital bed holding the stump of his leg in "A Burmese boy, shot while carrying supplies to Karen rebels, loses his leg" 1990* James Nachtwey (Best16 40a)

boy with scars across his head in "Dreaming of helping the rebels, this 12-year-old boy ran down a street in San Salvador brandishing an AK-47" 1990* (Best16 73)

brother holding brother in subway car in "Maximillano Chaves Vidals cradles his brother, Edwardo, who was shot on a subway in Brooklyn" 1990 Osman Karakas (Best16 102)

casualties in Gaza hospital in "Visit to a War Zone" 1988 James Nachtwey (Best14 32-33)

child with head bandage in hospital in "A father comforts his wounded son as distressed relative looks on in Bosnia-Herzegovina" 1993* Debbi Morello (Best19 196)

eye patch on boy with facial burns in "A blind Kurdish shepherd who stepped on a mine is hugged by his father" 1985* Michael Coyne (Best11 40a)

face of soldier with bloody bandages in "Wounded G.I. Cassino Valley, Italy" 1943-1944 Margaret Bourke-White (Rosenblum \176)

girl with bandage on her leg standing in her doorway in "Two-year-old was hit in the foot by a bullet that came through the wall of her home" 1991* Cindy Yamanaka (Best17 78a)

grieving, wounded soldiers in plane in "Grieving soldier in the Gulf war" 1991* David Turnley (Best 17 10; Lacayo 175b)

head wound on Russian Nationalist in "Bloodied during a confrontation with Moscow police on May Day in which scores of people were wounded, an angry Nationalist marches home" 1993* Lucian Perkins (Best19 9)

man on bed with gunshot wound from [the series *Tulsa*] 1963-1971 Larry Clark (Marien \6.52)

man praying on stretcher in "Okinawa, April 19, 1945" 1945 W. Eugene Smith (Art #15)

man with amputated leg in "Pvt. Charles Myer, Amputation of the Right Thigh" 1865 William Bell (National 121d)

man's back covered with stab wounds in "Gay bashing: Three years after this man was stabbed 21 times, he still is healing" 1990* Mark Sluder (Best16 78)

North Vietnamese carrying man on stretcher to net covered operating room in swamp in "U Minh Forest, CA Mau" 1970 Vo Anh Khanh (Marien \6.76)

photo essay on the daily life a boy severely scarred from a fire in "Paul and Cheryle Dumont share a moment as other members of the Modified Motorcycle Assn. watch a friend kick-start his '64 Pan Head Harley-Davidson" 1986 Bradley Clift (Best12 71b)

scarred face and neck in "Yamaguchi Senji Who Was Injured 1.2 km from the Epicenter of the Blast" 1962 Shomei Tomatsu (Photography 104)

scars on back of man leaning down from bed in "Okinawan Victim of the Atomic Bomb Explosion in

Hiroshima" 1969 Shomei Tomatsu (Szarkowski 257)

soldier staring blankly in "Shell-shocked Soldier awaiting Transportation away from the Front Line, Hué" 1968 Don McCullin (Art \425)

soldier who has lost one arm in "Corporal Samuel Thummam, wounded at the Battle of Petersberg [sic]" 1865 Photographer Unknown (Marien \3.70)

soldier with arm in sling leaning against log wall in "The Sick Soldier" c. 1863 Brady Studio (National \19)

soldiers during amputation in "Amputation, Mexican–American War, Cerro Gordo" 1847 Photographer Unknown (Marien \2.32)

wounded soldiers in muddy field in "South of the DMZ, South Vietnam" 1966* Larry Burrows (Lacayo 130)

young men who are amputees resting on bridge in "Managua" c. 1989 James Nachtwey (Graphis89 \247)

WRESTLING *see also* SUMO

entering ring in mask and costume in "Mexican wrestling, 'Grand entrance' " 1995* Thomas Alleman (Best21 215a)

Gambian wrestlers facing each other in "Wrestling in Gambia" 1997 Stephen Dupont (Best23 217)

Greco-Roman wrestling match in Olympics in "Greco-Roman wrestling match" 1996* James D. Baird (Best22 122d)

high school wrestler in "High school wrestler looks up at the referee while pinning opponent" 1996* Richard Hartog (Best22 206c)

high school wrestler pinning opponent in "Pinning a high school wrestling opponent" 1997* Richard Hartog (Best23 176a)

Mongolian wrestler looking in mirror in "A wrestler inspects himself in a mirror in Mongolia" 1997 Stephen Dupont (Best23 237a)

portraits of wrestlers in wrestlers in capes and robes from [series on masked Mexican wrestlers] c. 1997* Vern Evans (Graphis97 102,103)

Sere tribe wrestler in "Abdul Rahman, Sere Tribe champion wrestler" 1997 Stephen Dupont (Best23 237b)

twisted together on mat in "Doing the 'twist' during a wrestling match" 1987 Ted Kirk (Best13 222)

two men fighting in ring in "Double Wrestling" c. 1980 Lourdes Grobet (Rosenblum \188)

two men on mat in "Samoan wrestler is suplexed by a straining Australian" 1998* Adam Petty (Best24 61b)

—X—

X-RAYS

bullet near bone in "X-Ray with Bullet" 1917 Photographer Unknown (Szarkowski 333d)

man's skull and neck in "Man the Enigma" c. 1937 Max Thorek (Peterson #75) or "Homo Sapiens" 1933 Max Thorek (Goldberg 83)

skeletal system of rabbit in "Newborn Rabbit" c. 1896 Josef Maria Eder and E. Valenta (Szarkowski 137)

snake in "Aesculapian Snake" 1896 Josef Maria Eder and Eduard Valenta (Marien \4.62)

woman's hand in "Frau Röntgen's Hand" 1895 Wilhelm Röntgen (Marien \4.60)

—Y—

YALTA CONFERENCE (1945)

retouched photograph includes Groucho Marx and Sylvester Stallone in "Yalta Conference?" 1990 Paul Higdon (Lacayo 171)

seated at the conference in "Winston Churchill, FDR and Joseph Stalin, Yalta Conference" 1945* U.S. Army (Life 22b)

YELLOWSTONE NATIONAL PARK

aerial view of hot spring in "Billions of organisms flourish in the scalding-hot Grand Prismatic Spring at Yellowstone National Park" 1998* George Steinmetz (Through 296)

bicyclists on terrace formation in "Bicyclists Group on Minerva Terrace Yellowstone National Park" 1896 F. Jay Haynes (Photography1 #V-19)

comparing book illustration to real cliffs in "Viewing Thomas Moran at the source, Artist's Point, Yellowstone" 2000* Mark Klett (Photography 173a)

deep angular canyon walls in "Grand Canyon of the Yellowstone (Looking East), Yellowstone National Park" c. 1880 F. Jay Haynes (Photography1 #V-18)

forest burning intensely in "Two firefighters study the south flank of Yellowstone National Park's Storm Creek inferno after it jumped fire lines" 1988* Craig Fujii (Best14 10c)

frozen geyser cone in "Lone Star Geyser Cone, Yellowstone National Park" 1884 F. Jay Haynes (National 130a)

geyser shooting upwards in "Old Faithful Geyser, Yellowstone National Park" 1942 Ansel Adams (MOMA 120, 121); 1871 William Henry Jackson (Monk #7)

geyser shooting upwards in "Geyser, Yellowstone, Wyoming" c. 1885 F. J. Haynes (Rosenblum2 #167)

view of falls cascading into river in "Lower Falls of the Yellowstone" 1903 Frances Benjamin Johnston (Sandler 117c)

YOSEMITE NATIONAL PARK

banks of a river in "Valley of the Yosemite from Mosquito Camp" 1872 Eadweard Muybridge (Szarkowski 116)

El Capitán seen in mirror image in water in "Mirror View of El Capitán, Yosemite Valley" c. 1864 Charles Leander Weed (Szarkowski 119)

falls ending in cone of ice in "Upper Yosemite Falls and Ice Cone" c. 1878 George Fiske (Decade 4)

Half Dome in winter in "Monolith, The Face of Half Dome, Yosemite Valley" c. 1927 Ansel Adams (Rosenblum2 #537)

lone tree at edge of valley in "Yosemite Valley from the 'Best General View' " c. 1866 Carleton E. Watkins (Art \114; Marien \3.60)

men standing on rock over deep canyon in deep angular canyon walls in "Glacier Point Rock, 3201 Ft. Yosemite Valley, Ca." c. 1885 Isaiah West Taber (Photography1 \73)

mountains and trees in "View from Camp Grove (Yosemite Valley)" c. 1863 Carleton Watkins (Decade 3d)

overlooking the Falls and valley in "Falls of the Yosemite" 1872 Eadweard Muybridge (Lacayo 29)

panorama of from Domes to Merced Group in "Panorama of Yosemite Valley from Sentinel Dome" 1866 Carlton E. Watkins (Art \112)

President Roosevelt standing on ridge in "President Roosevelt's Choicest Recreation, Amid Nature's Rugged Grandeur, on Glacier Point, Yosemite" 1903 or earlier Photographer Unknown (Szarkowski 82)

reflection of mountains and trees in "Mirror Lake and Reflections, Yosemite Valley" 1865 Charles Leander Weed (National 21d)

snow-covered mountains in "Half Dome from Glacier Point, Yosemite National Park" c. 1956 Ansel Adams (Decade \60)

snow on mountain top in "North Dome, Basket Dome, Mount Hoffman, Yosemite" c. 1935 Ansel Adams (National \63)

tall pine trees and mountains in "Cathedral Spires, Yosemite" 1861 Carleton E. Watkins (Art \116; Rosenblum2 #148)

valley in "Valley View, Yosemite National Park, California" c. 1933 Ansel Adams (Marien \5.49)

valley with El Capitán in "Valley of the Yosemite from Union Point" c. 1872 Eadweard Muybridge (Marien \3.61; National \25)

waterfalls among trees in "Cascade, Nevada Falls, Yosemite" c. 1861 Carleton E. Watkins (National \26)

waterfalls in the distance in "Yosemite Falls" c. 1865 Carleton E. Watkins (National 163d)

—Z—

ZEBRAS

several zebra amidst herd of wildebeests in "Zebras and wildebeests in Africa" 1986* Mitsuaki Iwago (Through 8)

ZOO ANIMALS

at windows in zoo building in "Giraffes at the London Zoo" 1986 Celeste La Brosse (Best12 133a)

camel in a small zoo enclosure in [camel] c. 1992* Britta Jaschinski (Graphis93 192a)

elephant in an indoor enclosure in [elephant in its zoo house] c. 1991 Dirk Fischer (Graphis92 \228)

elephant in a zoo enclosure in [elephant] c. 1992* Britta Jaschinski (Graphis93 192b)

elephants behind a group wedding picture in Taipei Zoo, and in limo in "Yes, I Do" 1997 Chien-chi Chang (Best23 227d)

face-to-face rhinos in [East African rhinos in a zoo] c. 1991* Dieter Blum (Graphis92 \227)

gorilla holding child who fell into habitat in "Binti-Jua rescues a 3-year-old toddler who fell into the primate habitat at the Brookfield Zoo" 1996* Robert Allison (Best22 143)

in zoo with trunk reaching over wall for food in "New York" 1963 Garry Winogrand (Photography 50)

sleeping in cage in "The Hippopotamus at the Zoological Gardens, Regent's Park" 1852 Count de Montizon (Waking #26)

tiger pacing in "This Siberian tiger, oblivious to the tram ride, lives at the St. Louis zoo" 1986 Peter Essick (Best12 180c)

ZULU (African people)

in beaded dress putting on makeup in "Zulu in South Africa" 1996* Chris Johns (Through 16)

III
PORTRAITS OF NAMED INDIVIDUALS

Children

—B—

Barker, May
1864 Lewis Carroll (Szarkowski 96)
Booth, Edwina
1866 Mathew Brady (Photography1 #II-11)
Burroughs, Lucille
1936 Walker Evans (Art \307)

—C—

Carr, Elizabeth
1982* Frank Cowan (Life 104)
Clinton, Chelsea
1993* Stephen Jaffe (Best19 120)

—F—

Frank, Anne
1939 Self-Portrait (Monk #31)

—G—

Gonzalez, Elian
2000* Alan Diaz (Capture 198)

—H—

Harry, Prince, grandson of Elizabeth II
1997 Brian Walski (Best23 132)
Hatch, Beatrice
1873* Lewis Carroll (Rosenblum2 #334)

—J—

Jackson, Michael
1971 Henry Diltz (Rolling #8)

—K—

Kennedy, John Fitzgerald, Jr.
1963 Harry Leder (Monk #43)

King, Bernice
1968 Moneta Sleet Jr. (Capture 67; Eyes #280; Willis \188)

—L—

Liddell, Alice
c. 1859 Lewis Carroll (Marien 3.106; Waking #28)
Liddell, Edith
c. 1859 Lewis Carroll (Rosenblum2 #73)
Lincoln, Thomas (Tad)
1865 Alexander Gardner (Art \64)

—M—

McClure, Jessica
1987 Scott Shaw (Best13 16; Capture 146)
MacDonald, Irene
1863 Lewis Carroll (Szarkowski 92; Waking #31)
MacDonald, Mary
1863 Lewis Carroll (Waking #31)

—N—

Nugent, Patrick Lyndon
1968 Yoichi Okamoto (Life 29)

—R—

Rankin, Flo
1863 Lewis Carroll (Waking #31)

—V—

Victoria, Princess
1844-1845 Henry Collen (Rosenblum2 #49)

—W—

William, Prince, grandson of Elizabeth II
1997 Brian Walski (Best23 132)
Wilson, Mara
1995* Lauren Greenfield (Best21 85

Groups

—B—

The Beatles
 1963 Photographer Unknown (Photos 105)
 1964 John Leongard (Lacayo 150a); Terence Spencer
 (Life 170a)
Becher, Bernd and Hilla
 n.d. Detlef Conrath (Icons 156)

—D—

Daughters of the American Revolution
 1963 Richard Avendon (Icons 148)
Dick Tracy movie characters
 c. 1991* Herb Ritts (Graphis91 \205)

—E—

Eurythmics
 1983* David Montgomery (Rolling #93)

—F—

Fleetwood Mac
 1977* Annie Leibovitz (Rolling #28)
The Flying Cranes of the Russian circus
 c. 1995 Paul Mobley (Graphis96 126)

—G—

The Grateful Dead
 1969 Herb Greene (Rolling #4)

—H—

Hutchinson Family Singers
 1845 Photographer Unknown (Waking #91)

—I—

INXS
 1988* Paul Schirnhofer (Rolling #92)

—K—

Kennedy family
 1960 Jacques Lowe (Best23 73c)
Kray Brothers
 1965 David Bailey (Art \447)
Kris Kross
 c. 1992* Michael Biondo (Graphis93 130)

—L—

Les Six
 1921 Isabey (Vanity 46-47)
The Louisiana Shakers
 c. 1920 A. P. Bedou (Willis \46)

—M—

Metallica
 c. 1992* Mark Seliger (Graphis93 125)
The Mods
 1980 Larry Williams (Rolling #42)

—P—

Penn and Teller
 1985* Chris Callis (Rolling #97)
Peter, Paul, and Mary
 1986 Mark B.Sluder (Best12 50a)

—R—

Red Hot Chili Peppers
 c. 1992* MarkSeliger (Graphis93 110)

—S—

Sacco and Vanzetti
 1927 Leslie Jones (Goldberg 54)
The Sam Morgan Jazz Band
 c. 1928 Villard Paddio (Willis \51)
Sargent, Henry Winthrop, and Family
 1855* John Whipple (Photography1 #I-1)
Skid Row
 c. 1992* Mark Seliger (Graphis93 111)
The Summit Avenue Ensemble
 c. 1880s Thomas E. Askew (Willis \34)

—T—

Tonic Triad Band
 1928 Villard Paddio (Willis \48)

—Z—

The Zero Generation
 1985* Moshe Brakha (Rolling #96)

Men

—A—

Abbé, James
1934 Howard Coster (Vanity 199c)
Abernathy, Ralph
c. 1960 Jack Davis (Willis \169)
Adams, Ansel
1932 Willard Van Dyke (MOMA 33)
1975 Imogen Cunningham (Icons 96)
Adams, Edward T.
n.d. Photographer Unknown (Capture 203)
Adams, John Quincy
c. 1843 Philip Haas (Photography1 #II-2)
Adams, Patch
1998* Ben Stechschulte (Best24 79)
Adams, Robert
1967 Kerstein Adams (Icons 169)
Adamson, Robert
c. 1843 David Octavius Hill (Rosenblum2 #81)
Adenauer, Konrad
1954 Chargesheimer (Icons 125)
Adrian, Dennis
c. 1991* Marc Hauser (Graphis91 \211)
Africa, Mo
1985 Gerald S. Williams (Best11 22b)
Aguirre, Mark
1988 Peggy Peattie (Best14 206d)
Albert Edward Prince of Wales
1860 Mathew Brady (Photography1 #II-8)
Alcindor, Lew
1963 Richard Avedon (Photography 140)
Aldrin, Edwin "Buzz"
1969* Neil Armstrong (Eyes #367; Monk #47; Photos 125)
1969* Lynn Pelham (Life 102)
Ali, Muhammad
1964 Robert L. Haggins (Willis \180)
1965 (Photos 111)
1966 Gordon Parks (Lacayo 147d); 1970 (Icons 152)
1972 Ptah Hotep (Willis \232)
1985 Scott Goldsmith (Best11 166d)
1986 Oggi Ogburn (Committed 166)
1997 Carol Guzy (Best23 229d)
Allende, Salvador
1973 Photographer Unknown (Photos 139)
American Horse, Samuel
c. 1900 Gertrude Käsebier (Sandler 100a)
Amundsen, Roald
c. 1912 W. R. Bowers (Photos 22)
Anderson, Orvil A.
1935 Richard H. Stewart (Through 484)
Anderson, Robert
1860-1865 George S. Cook (Marien \3.10)
Anderson, Sherwood
1926 Edward Steichen (Vanity 107d)
Andrew, Prince
1986*Karen Touhey (Best12 2)
Andujar, Joaquin
1985 Frank Niemeir (Best11 189)
Anselmo, Phil
1991 John Kaplan (Capture 165)
Arafat, Yassir
c. 1990* Abbas (Graphis90 \115)
1995 Barbara Kinney (Best21 178a)
1996* Doug Mills (Best22 153c)
Arlen, Michael
1925 Gallo (Vanity 116)

Arliss, George
1918 Baron de Meyer (Vanity 24)
Armstrong, Louis
1922 Villard Paddio (Willis \47)
1935 Anton Bruehl (Vanity 163)
1965 Photographer Unknown (Photos 113)
Armstrong, Neil
1969* Lynn Pelham (Life 102)
Arnold, Samuel
1865 Alexander Gardner (Rosenblum2 #229)
Arp, Jean
1949 Arnold Newman (Decade 58)
Asanuma, Inejiro
1960 Yasushi Nagao (Capture 46)
Ashcroft, Richard
c. 1999* Mark Seliger (Photo00 156)
Ashe, Arthur
1965 Bob Gomel (Life 143c)
c. 1979 Bob Moore (Willis 160)
Astaire, Fred
1925 Edward Steichen (Vanity 86)
1936 Martin Munkacsi (Art \440; Lacayo 84)
Atget, Eugène
n.d. Berenice Abbott (Icons 12); c. 1927 (Rosenblum2 #326)
Atzerodt, George A.
1865 Alexander Gardner (Rosenblum2 #230)
Auric, Georges
n.d. Photographer Unknown (Vanity xiii)
1921 Isabey (Vanity 46-47)
Avedon, Richard
n.d. Self-Portrait (Icons 148)
Avery, Sewell
1944 William Pauer (Best18 9)

—B—

Bacon, Francis
1952 John Deakin (Icons 113)
Bailey, David
c. 1991* James Salzano (Graphis91 \217)
Bailey, Donovan
1996* Denis Paquin (Best22 119a)
Baker, James
1992* Dirck Halstead (Best18 79a)
Baker, Moe
1988* Shana Sureck (Best14 14a)
Baker, Vernon
1996* Jim LoScalzo (Best22 216c)
Bakker, Jim
1987* Harry Benson (Best13 30)
Baldwin, James
1963 Jack T. Franklin (Willis \170)
1986 June DeLairre Truesdale (Willis \252)
Baldwin, Roger
1976 Richard Avedon (Rolling #37)
Balkin, Serge
1946 Irving Penn (MOMA 21)
Ballard, J. G.
c. 1989* Richard Croft (Graphis89 \127)
Baltz, Lewis
1972 Joan Murray San 166b)
Banderas, Antonio
c. 1997* Stephanie Pfriender (Graphis97 115)
Baraka, Amiri
c. 1970 C. Daniel Dawson (Willis \231)

Barbey, Bruno
 1985 Mike Davis (Best11 233c)
Barkley, Alban W.
 1945 Photographer Unknown (Goldberg 118)
Barkley, Charles
 c. 1991* Michael O'Brien (Graphis92 \105)
 1991 Jerry Lodriguss (Best17 163)
Barnack, Oskar
 1936 Self-Portrait (Eyes #153)
Barnum, H. A.
 1865 William Bell (National 18a, \14)
Barr, Alfred H., Jr.
 1931-1933 Jay Leyda (MOMA 29)
Barrow, Thomas F.
 1984 Laurie A. Barrow (San 167a)
Barrs, Jay L.
 c. 1991 Kevin Gruff (Graphis91 \362)
Barrymore, John
 1920 Baron de Meyer (Vanity 38)
 1925 James Abbé (Vanity 39)
 1933 George Hurrell (Goldberg 79c)
Barrymore, Lionel
 1918 Colotta (Vanity 23)
Bartholomew, Archbishop of Constantinople
 1997* Wally Skalij (Best23 198b)
Baryshnikov, Mikhail
 1975 Max Waldman (Life 173b)
 1987 Matthew Rolston (Rolling #58); c. 1989
 (Graphis89 \126)
Basie, Count
 c. 1957 Milton Hinton (Willis \154)
Bass, J. F.
 1905 Photographer Unknown (Eyes #57)
Baudelaire, Charles
 c.1862 Étienne Carjat (Marien \3.92); 1878
 (Rosenblum2 #93)
Baughman, J. Ros
 n.d. Photographer Unknown (Capture 203)
Bayard, Hippolyte
 c. 1842-1850 Self-Portrait (Szarkowski 33)
 1840 Self-Portrait (Marien\1.14; Rosenblum2 #25);
 1850 (Marien \2.10)
Bayer, Herbert
 1932 Self-Portrait (Icons 55)
Beall, William
 n.d. Photographer Unknown (Capture 203)
Bearden, Romare
 1983 Fern Logan (Willis \389)
Beardsley, Aubrey
 c. 1894 Frederick H. Evans (Waking #141)
Beaton, Cecil
 n.d. Self-Portrait (Vanity 200c); 1951 (Icons 146)
 1946 Irving Penn (MOMA 21); 1950 (Art \444)
Beatty, Warren
 1968* Ralph Crane (Life 89a)
 c. 1991 Herb Ritts (Graphis91 \204, \205)
Begin, Menachem
 1978* Photographer Unknown (Goldberg 190;
 Photos 145); 1979 (Eyes #351)
Belafonte, Harry
 1963 Jack T. Franklin (Willis \170)
Bellmer, Hans
 c. 1950 Self-Portrait (San 167b)
Belushi, John
 1976* Bonnie Schiffman (Rolling #39);
 1982* Annie Leibovitz (Rolling #47)
Benetton, Luciano
 c. 1991* Giuseppe Pino (Graphis91 \201)
Bennett, Arnold
 1927 Photographer Unknown (Vanity 69)
Berg, Alban

 1934 Trude Fleischmann (Rosenblum \115)
Bergson, Henri
 1917 Campbell Studio (Vanity 18)
Bernard, Walter
 c. 1991* William Coupon (Graphis91 26a)
Beyer, Donald
 1997 Vicki Cronis (Best23 222a, b)
Biden, Joseph R., Jr.
 1987 Ronald Cortes (Best13 55b)
Biggerstaff, William
 1896 J. P. Ball & Son (Willis \10, \12)
Billings, Henry
 1930 Ralph Steiner (Decade \27)
Bird, Larry
 1985 Jim Mendenhall (Best11 206b)
Bischof, Werner
 n.d. Photographer Unknown (Icons 118)
Blair, John
 n.d. Photographer Unknown (Capture 203)
Blair, Tony
 1996 Tom Stoddart (Best22 248d)
Blavier, Emile
 c. 1853 Adrien Tournachon (Rosenblum2 #85)
Blei, Franz
 1914 Hugo Erfurth (Icons 40)
Blitzstein, Marc
 1937 George Platt Lynes (MOMA 164)
Bloch, Ernst
 1963 Stefan Moses (Icons 151)
Blossfeldt, Karl
 1930 Self-Portrait (Icons 24)
Blume, Bernhard Johannes
 1984 Photographer Unknown (San 167b)
Blumenfeld, Erwin
 1943 Self-Portrait (San 168a)
 1946 Irving Penn (MOMA 21)
Bobbit, John Wayne
 1995* Harry Benson (Best21 141a)
Boesky, Ivan
 1986 John Collier (Best12 51b)
Bon Jovi, Jon
 1989* Timothy White (Rolling #103)
Bono
 1987 Matthew Rolston (Rolling #105)
Booth, Edwin
 1866 Mathew Brady (Photography1 #II-11);
 c. 1875 Napoleon Sarony (Photography1 #II-14)
Booth, John Wilkes
 n.d. Photographer Unknown (Rosenblum2 #227)
Bork, Robert
 1987 Manny Rocca (Best13 8)
Boscoe, Philip
 c. 1992* Peter Liepke (Graphis93 108b)
Bosworth, Brian
 c. 1990* Herb Ritts (Graphis90 \116)
Boucher, Pierre
 1980 Self-Portrait (San 168b)
Boutan, Louis
 1898 Self-Portrait (Monk #13)
Bowers, Harry
 1982 Self-Portrait (San 168b)
Bowie, David
 1974 Terry O'Neill (Rolling #16);
 1987 Herb Ritts (Rolling #65)
Boy George
 1984* Richard Avedon (Rolling #53);
 1986 Norman Watson (Rolling #63)
Boyer, Charles
 1934 George Hoyningen-Huené (Vanity 184)
Brancusi, Constantin
 1922 Edward Steichen (Decade \16)

—C—

Chaliapin, Feodor Ivanovich
 1923 Arnold Genthe (Vanity 54-55)
Chamberlain, Neville
 1933 Culver Pictures (Vanity 168)
Chamberlain, Wilt
 c. 1989* Annie Leibovitz (Graphis89 \158)
Chambi, Martin
 1923 Self-Portrait (Icons 60)
Chaplin, Charlie
 1914 Photographer Unknown (Monk #15); 1921
 (Vanity 40)
 1921 Baron de Meyer (Vanity 41)
 1931 Edward Steichen (Icons 16; Vanity 136-137)
 1952 W. Eugene Smith (Photography 83)
Chapman, Tracy
 1988 Herb Ritts (Rolling #111)
Chapnick, Howard
 c. 1991* William Coupon (Graphis91 26c)
Chargesheimer
 n.d. L. Fritz Gruber (Icons 124)
Charles, Ezzard
 1954 Charles Hoff (MOMA 228)
Charles, Prince of Wales
 1997 Brian Walski (Best23 132)
Charles, Ray
 c. 1960 Jack Davis (Willis \167)
 c. 1989* Chris Callis (Graphis89 \144)
Chavis, Ben
 1995 Peggy Peattie (Best21 227c)
Chesteron, G. K.
 1920 Speaight, Ltd. (Vanity 36)
Chevalier, Maurice
 1928 George Hoyningen-Huené (Vanity 102d)
Chevreul, Michel-Eugène
 1886 Paul Nadar (Lacayo 36; Rosenblum2 #590-
 #593)
Chiti, Remo
 1930 Tato (San \44)
Choate, Rufus
 c. 1851 Southworth & Hawes (Szarkowski 38)
Churchill, Winston
 1932 Edward Steichen (Vanity 169)
 1941 Yousuf Karsh (Icons 126; Monk #26;
 Rosenblum2 #728)
 1945* U.S. Army (Life 22b)
 1950 Toni Frissell (Sandler 47)
 1990 Paul Higdon (Lacayo 171)
Clark, Larry
 1984 Amy Clark (San 170a)
Claudel, Paul
 1929 Edward Steichen (Vanity xv)
Clay, Cassius
 1963 Harry Coughanour (Life 142)
Clay, Langdon
 1988* Maude Schuyler Clay (Women \162)
Cleaver, Eldridge
 1969 Jonathan Eubanks (Willis \204)
Clemens, Samuel
 c. 1850 Photographer Unknown (Photography1 \17)
Clinton, Bill
 1992 Dan Habib (Best18 73, 75, 77, 181-184)
 1992* Greg Gibson (Capture 168)
 1993* Robert Giroux (Best19 192a)
 1995 Barbara Kinney (Best21 178a)
 1995* Kenneth Lambert (Best21 203a)
 1996* Bob Fila (Best22 107a)
 1997 Susan Biddle (Best23 131d)
 1998 Charles Krupa (Best24 17)
 1998* Susan Walsh (Capture 193)
Close, Chuck
 1979* Self Portrait (Photography2 163; Rosenblum2

 #806)
Cobain, Kurt
 n.d. Mark Seliger (Graphis97 10)
Cocteau, Jean
 1921 Isabey (Vanity 46-47); 1922 (Vanity 49)
 1922 Delphi (Vanity xi)
 1926 Berenice Abbott (Women \82)
Cohan, George M.
 1914 Moffett Studio (Vanity 20)
Cole, Nat King
 1954 R. C. Hickman (Eyes #149)
Collins, Albert
 c. 1991 Marc Norberg (Graphis92 \140)
Collins, Michael
 1969* Lynn Pelham (Life 102)
Collins, Phil
 1985 Anacleto Rapping (Best11 165a)
Collins, R. M.
 1905 Photographer Unknown (Eyes #57)
Coltrane, John
 c. 1956 Milton Hinton (Willis \150)
 1966 Chuck Stewart (Committed 205; Willis \149)
Connors, Lester
 1991 Ronald Cortes (Best17 157)
Conrad, Joseph
 1924 Malcolm Arbuthrot (Vanity 68)
Conran, Jasper
 c. 1990* Terry O'Neill (Graphis90 \121)
Cooper, Alice
 1972 Annie Leibovitz (Rolling #18); 1973* (Rolling
 #14)
Cooper, Gary
 n.d. Cecil Beaton (Vanity 190)
 1934 George Hoyningen-Huené (Hambourg \37)
 1940 Peter Stackpole (Life 83c)
 1957 Slim Aarons (Lacayo 150)
Copeland, Stewart
 1988* E. J. Camp (Rolling #84)
Cosby, Bill
 1985* Michael O'Brien (Life 174a)
Costello, Elvis
 c. 1991* Frank W. Ockenfels 3 (Graphis92 \91, \146)
Costner, Kevin
 1989* Helmut Newton (Life 93a)
 c. 1991* Brian Lanker (Graphis91 \199)
Courbet, Gustave
 c. 1867-1875 Etienne Carjat et Cie (Szarkowski 83)
Coward, Noel
 1932 Edward Steichen (Vanity 159)
Cramer, Konrad
 1948 Florence Ballin Cramer (San 170b)
Cray, Robert
 1987 Brian Smale (Rolling #90)
Crisostomo, Manny
 n.d. Photographer Unknown (Capture 204)
Cronauer, Adrian
 1988 Michael Bryant (Best14 43a)
Cronenberg, David
 c. 1992* Albert Watson (Graphis93 102c)
Crouch, Bill
 1949 (Capture 204)
Crowe, Russell
 c. 1999* Jim McHugh (Photo00 128)
Crowninshield, Frank,
 n.d.Lusha Nelson (Vanity ix)
Cruise, Tom
 1986 Herb Ritts (Rolling #66)
 c. 1992* Albert Watson (Graphis93 102a)
Cumming, Robert
 1976 Self-Portrait (San 170b)

Friedlander, Lee
　1965 Self-Portrait (MOMA 24); 1969 (Icons 144,
　　San 173b)
Fukuda, Nob
　c. 1991* Yukio Maeda (Graphis92 15)
Funke, Jaromír
　1940 Photographer Unknown (San 174a)

—G—

Gable, Clark
　1957 Slim Aarons (Lacayo 150)
Gaddafi, Moammar
　1986 Akira Suwa (Best12 17)
Gallagher, William
　n.d. Photographer Unknown　(Capture 206)
Gallego, Mike
　1992* Mark D. Phillips (Best18 135)
Gandhi, Mahatma
　1946 Margaret Bourke-White (Icons 103; Monk #34)
Garvey, Marcus
　1924 James Van Der Zee (Willis \66)
Gaunt, John L., Jr.
　n.d. Photographer Unknown　(Capture 206)
Gautier, Théophile
　1855-1865 Felix Nadar (Art \46; Marien \3.94)
Gay, Gerald H.
　n.d. Photographer Unknown　(Capture 206)
Gaynor, William J.
　1910 William Warneke (Lacayo 39d)
Geiger, Ken
　n.d. Photographer Unknown　(Capture 206)
Geldzahler, Henry
　1990* David Hockney (Photography 89)
Genthe, Arnold
　1923 Nickolas Muray (Vanity 198a)
Geronimo
　c. 1898 Frank A. Rinehart (Photography1 \76)
Gershwin, George
　1929 Edward Steichen (Vanity 124)
Giacomelli, Mario
　n.d. Paolo Mengucci (Icons 134)
Giacometti, Alberto
　1960 Henri Cartier-Bresson (Lacayo 138b)
Gibson, Mel
　1989 Herb Ritts (Rolling #67)
Gibson, Ralph
　1998 Lesley Loudon (Icons 182)
Gide, André
　1928 Berenice Abbott (Vanity 109)
　1939 Gisèle Freund (Icons 90)
Gilbert, John
　1928 Edward Steichen (Vanity 120)
Gillespie, William
　c. 1844 Hill & Adamson (Szarkowski 42)
Gingrich, Newt
　1995 P. F. Bentley (Best21 202b, c)
Ginsberg, Allen
　1958 Harry Redl (Goldberg 170)
Glaser, Milton
　c. 1991* Andrew Eccles (Graphis92 112)
Goebbels, Joseph
　1933 Alfred Eisenstaedt (Eyes #179; Lacayo 75;
　　Marien \5.78)
Gonzalez, Jose
　1987　(Best13 202a)
Gooden, Dwightx
　1986 Phil Velasquez (Best12 216)
Goodridge, Wallace and William
　1879 self-portrait (Willis \15)

Gorbachev, Mikhail
　1985 Dennis Paquin (Best11 89a)
　1985* David Burnett (Life 34a)
　1986* Dennis Brack (Best12 7a)
　1987 Peter Turnely (Best13 9)
Gorky, Maxim
　1914 Alice Boughton (Vanity 6)
Grace, "Sweet" Daddy
　c. 1955 Charles Williams (Willis \166)
Gragson, Eugene
　1992* Genaro Molina (Best18 67)
Grainger, Percy
　1917 Maurice Goldberg (Vanity x)
Gralish, Tom
　n.d. Photographer Unknown　(Capture 206)
Grant, Cary
　1934 George Hoyningen-Huené (Vanity 131)
Grant, Ulysses S.
　1864 Timothy O'Sullivan (Lacayo 10); Photographer
　　Unknown (Photography1 #IV-8)
　c. 1864-1865 Photographer Unknown (Photography1
　　#IV-2)
Graves, Morris
　1950 Imogen Cunningham (Photography 95)
Groos, Margaret
　1988 John Kaplan (Best14 24)
Gropius, Walter
　1928 Lucia Moholy-Dessau (Vanity 112)
Grossfield, Stan
　n.d. Photographer Unknown　(Capture 206)
Grosz, George
　n.d. E. Bieder (Vanity 57)
Grünbein, Durs
　c. 1999* Jan Wenzel (Photo00 13)
Gründgens, Gustav
　n.d. George Hoyningen-Huené (Vanity 182d)
Guevara, Che
　1960 Alberto Korda (Icons 143; Photos 91)
　1967 Photographer Unknown (Marien \6.3; Photos 90)
Guitry, Sacha
　1926 Walery (Vanity 103a)
Guy, Buddy
　c. 1999* Richard Burbridge (Photo00 163)

—H—

Haas, Ernst
　1948 Photographer Unknown (Icons 100)
Hagar, Sammy
　1988* E. J. Camp (Rolling #83)
Hagemeyer, Johan
　1921 Margrethe Mather　(Decade \17)
Hagler, Erwin H.
　n.d. Photographer Unknown　(Capture 206)
Hagler, Marvin
　1985 Jim Laurie (Best11 214d)
　1987 Gary Cameron (Best13 192a, 193b)
Hakim, Joe
　c. 1999* Thomas Broening (Photo00 117)
Halsman, Philippe
　c. 1959 Photographer Unknown (San 174b)
Hamed, Naseem
　c. 1999* David LaChapelle (Photo00 161)
Hammer, M. C.
　1990* Peggy Peattie (Best16 187a)
Hanks, Tom
　1988* E. J. Camp (Life 93d)
Hannah, Duncan
　c. 1990* William Coupon (Graphis90 \134)
Hardy, Arnold
　n.d. Photographer Unknown　(Capture 207)

Hare, James H.
 1905 Photographer Unknown (Eyes #57)
Harrison, George
 1987* William Coupon (Graphis89 \129; Rolling
 #110)
Harrison, Richard B.
 1933 James Latimer Allen (Willis \75)
Hart, Gary
 1987 Kenneth Papaleo (Best13 54)
 1988 Ruben W. Perez (Best14 8d); David Peterson
 (Best14 91d)
Hartley, Marsden
 1915-1916 Alfred Stieglitz (Waking 350)
Hartmann, Sadakichi
 c. 1920 Edward Weston (Decade 13)
Hausmann, Raoul
 1927-1928 August Sander (Waking #187)
Hawkins, Erick
 1940 Barbara Morgan (Decade \49)
Hearns, Thomas
 1985 Lance Wynn (Best11 214a)
Hearst, William Randolph
 c. 1898 Photographer Unknown (Eyes #53)
 1930 Erich Salomon (Eyes #94)
Heflin, Van
 1957 Slim Aarons (Lacayo 150)
Heiden, Eric
 c. 1989* Annie Leibovitz (Graphis89 \156)
Heifetz, Jascha
 1925 Nickolas Muray (Vanity 96)
Hemingway, Ernest
 1928 Helen Breaker (Vanity 51)
 1941 Robert Capa (Life 167)
Henderson, Douglass
 1997* Don Camp (Willis \442)
Hendrix, Jimi
 1987 Ed Caraeff (Life 173d; Rolling #9)
Henneka, Dietmar
 c. 1990* Dino Eisele (Graphis 90 12)
Henri, Robert
 c. 1900 Gertrude Käsebier (Rosenblum \64)
 c. 1907 (Rosenblum2 #387)
 1916 Gertrude Käsebier (Vanity 14d)
Henry, Mark
 1992* Daniel Anderson (Best18 155)
Herman, Pee Wee
 c. 1990* Xavier Lambours (Graphis90 \132)
Herriott, Edouard
 1932 Lucien Aigner (Eyes #156)
Herschel, John
 1867 Julia Margaret Cameron (Art \62; Marien
 \3.102; Rosenblum2 #74; Waking #32)
Hershiser, Orel
 1988 Kim Kulish (Best14 12a)
Hesse, Hein
 1929 August Sander (Marien \5.67)
Hickman, R. C.
 1949 Photographer Unknown (Eyes #151)
Hillary, Sir Edmund
 1953 Photographer Unknown (Photos 79)
Hindemith, Paul
 1930 August Sander (Vanity 179)
Hindenburg, Paul von
 1931 Felix Man (Eyes #99)
Hine, Lewis Wickes
 1935 Photographer Unknown (Icons 18)
Hines, Earl
 n.d. W. Eugene Smith (Decade\ 80)
Hirohito, Emperor
 1945 Photographer Unknown (Marien \6.29)

Hirschfeld, Al
 c. 1990* Annie Leibovitz (Graphis90 \145);
 c. 1991* Wolfgang Wesener (Graphis91 \157)
 c. 1999* James Salzano (Photo00 122)
Hitler, Adolf
 1929 Tim Gidal (Lacayo 108)
Hockney, David
 n.d. Reinhold Misselbeack (Icons 176)
 c. 1999* Jim McHugh (Photo00 167)
Hoffman, Dustin
 c. 1990 William Coupon (Graphis90 \118)
Hoffman, Michael E.
 1965 Alen MacWeeney(Photography 129)
Hollonbeck, Scott
 1996* Shawn Spence (Best22 206d)
Holmes, Larry
 1985 Wayne C. Kodey (Best11 215b)
Holmes, Oliver Wendell
 c. 1860 Mathew Brady (Photography1 61c)
Holy Eagle, James
 1993-1996* Don Doll (Best22 61)
Holyfield, Evander
 1992* Robert Hanashiro (Best18 136b)
 1996* Jed Jacobsohn (Best22 206b)
Honneger, Arthur
 1921 Isabey (Vanity 46-47)
Hood, Robin
 n.d. Photographer Unknown (Capture 207)
Horowitz, David
 1990* Paul Kuroda (Best16 32a)
Horowitz, Vladimir
 1928 Photographer Unknown (Vanity 97)
Horst
 1946 Irving Penn (MOMA 21)
Hounsou, Djimon
 c. 1991 Herb Ritts (Graphis91 \226; Graphis92 \100)
Howard, Leslie
 1934 Edward Steichen (Vanity 189)
Howard, Sidney
 1924 Edward Steichen (Vanity 102c)
Howe, Peter
 1985 Mike Davis (Best11 233a)
 c. 1991* William Coupon (Graphis91 26b)
Hudson, Rock
 1985 Orville Myers, Jr. (Best11 28)
Hughes, Langston
 c. 1927 James Latimer Allen (Willis \73)
 c. 1932 P. H. Polk (Willis \86)
Hugnet, Georges
 1934 Man Ray (San 175a)
Hugo, Victor
 1876 Etienne Carjat (Rosenblum2 #94)
Humbert, Chris
 1996 Joe McNally (Best22 128d; Life 148b)
Humboldt, Alexander von
 1847 Hermann Gunther Biow (Rosenblum2 #35)
Husa, Karel
 1995 Patrick Witty (Best21 99b)
Hussein, Ibrahim
 c. 1992* Gregory Heisler (Graphis93 201c)
Hussein, King of Jordan
 1995 Barbara Kinney (Best21 178a)
Huston, John
 1987 Herb Ritts (Rolling #88)
Huxley, Aldous Leonard
 1922 Photographer Unknown (Vanity 70)

—I—

Iacocca, Lee A.
 1985 Don Fisher (Best11 162a)

Marvin, Lee
1981* Bonnie Schiffman (Rolling #45)
Marx, Groucho
1990 Paul Higdon (Lacayo 171)
Masakela, Hugh
1980 O'Neal Lancy Abel (Willis \273)
Massimino, Rollie
1985 Skip Peterson (Best11 231)
Massine, Léonide
1923 Maurice Beck and Helen Macgregor (Vanity 60)
Massoud, Ahmed Shah
1998* Stephen Dupont (Best24 178-179)
Matisse, Henri
n.d.Edward Steichen (Decade 14)
1915 Edward Steichen (Vanity 4)
1939 Brassï (Hambourg \67)
1944 Henri Cartier-Bresson (Rosenblum2 #620)
1950 Dmitri Kessel (Life 169)
Matsushita, Konosuke
1964 Bill Ray (Lacayo 135)
Matthews, Wes
1987 Larry Steagall (Best13 196); Harley Soltes
(Best13 197)
Maugham, W. Somerset
1933 Cecil Beaton (Vanity 139)
Mauriac, François
1929 Berenice Abbott (Vanity 108a)
Mayakovsky, Vladimir
1924 Alexander Rodchenko (Art \226; Hambourg \49)
Mayer, Hans
1963 Stefan Moses (Icons 151)
Mayfield, Curtis
n.d. Mark Seliger (Graphis97 11)
Meatyard, Ralph Eugene
c. 1959 Cranston Ritchie (San 179a)
Meese III, Edwin
1987 Manny Rocca (Best13 8)
Meiji, Emperor of Japan
c. 1872 Uchida Kyuichi (Marien \3.42)
Mencken, H. L.
1947 Irving Penn (MOMA 193)
1927 Edward Steichen (Vanity 107a)
Menjou, Adolphe
1927 Edward Steichen (Vanity 84)
Mercer, Ray
1990 Gerard Lodriguss (Best16 124)
Meredith, James
1966 Jack T. Thornell (Capture 58)
Merkin, Richard
1967* Marie Cosindas (Rosenblum \25)
Messier, Mark
1996 Gregory Heisler (Best22 217d)
Michael, George
1988 Matthew Rolston (Rolling #115)
Miles, Bertrand
1948 Self-portrait (Willis \157)
Milhaud, Darius
1921 Isabey (Vanity 46-47)
Mill, Andy
c. 1991* Michael O'Brien (Graphis91 \176)
Miller, Hugh
1843-1847 Hill and Adamson (Art \43)
Miler, Kelly
c. 1920s Addison N. Scurlock (Willis \61)
Millet, Jean-François
1855-1865 Felix Nadar (Art \45)
Mills, Derek
1996*Anacelo Rapping (Best22 119c)
Moholy-Nagy, Lázló
n.d. Photographer Unknown (Icons 28)
1923-1924 Lucia Moholy (Hambourg 81)

c. 1925 Lucia Moholy (Hambourg \51; Women \86)
1945 Vories Fisher (San 179b)
Molnár, Ferenc
1928 Edward Steichen (Vanity 103b)
Molokhov, Vladimir
c. 1999* Dieter Blum (Photo00 97)
Monet, Claude
1921 Baron de Meyer (Vanity 42)
Mongkut, the King of Siam
1865 John Thomson (Waking 305a, 105d)
Moore, Al
c. 1925 Edward Elcha (Willis 80)
Moore, Archie
c. 1991* Michael O'Brien (Graphis91 \177)
Moore, Cecil
1965 Jack T. Franklin (Willis \173)
Moore, Dan and Pat
c. 1989 Kent Barker (Graphis89 \178)
Morabito, Rocco
n.d. Photographer Unknown (Capture 208)
Morgan, J. Pierpont
1924 Edward Steichen (Art \164; Vanity 77)
Morrison, Sterling
c. 1991 Scogin Mayo (Graphis92 \138)
Morse, Samuel F. B.
c. 1845 Photographer Unknown (Rosenblum2 #13)
Moses, Edwin
1995* Rich Addicks (Best21 117d)
Moses, Robert
1935 Edward Steichen (Vanity 172d)
Moses, Stefan
n.d. Self-Portrait (Icons 150)
Moskvin
1923 Arnold Genthe (Vanity 54-55)
Mould, Bob
c. 1990* Glen Erler (Graphis90 \164)
Mubarak, Hosni
1995 Barbara Kinney (Best21 178a)
Mullen, Herbert
1965 Jack T. Franklin (Willis \173)
Munkacsi, Martin
1935 Self-Portrait (San 179b)
Muray, Nickolas
1926 Edward Steichen (Vanity 199c)
Murphy, Eddie
1983* Richard Avedon (Rolling #51)
Murphy, Sean
c. 1990* Glyn Howells (Graphis90 \240)
Mussolini, Benito
1933-1934 Felix Man (Eyes #98; Szarkowski 213)
1935 Lucien Aigner (Eyes #157)
Mydans, Carl
1950 Carl Mydans (Eyes #228)

—N—

Nadar, Felix
c. 1855 Self-Portrait (Rosenblum2 #84)
Nagao, Yasushi
n.d. Photographer Unknown (Capture 208)
Namath, Joe
1969 Ken Regan (Life 145c)
Namphy, Henri
1987 Carol Guzy (Best13 114)
Nathan, George Jean
1947 Irving Penn (MOMA 193)
Nauman, Bruce
1966-1967* (Marien \ 6.89; Photography2 144; San
#17)
Ndegéocello, Meshell
c. 1997* Mark Seliger (Graphis97 129)

—O—

—P—

Pirandello, Luigi
 1935 Edward Steichen (Vanity 144)
Pitt, Brad
 c. 1995* Mark Seliger (Graphis96 115)
Poe, Edgar Allan
 1848 Photographer Unknown (Photography1 #II-1)
 1849 Photographer Unknown (Marien \2.4)
Poindexter, John
 1986* Larry Downing (Best12 7b)
Polanski, Roman
 1969 David Bailey (Art \448)
Porter, Charles IV
 n.d. Photographer Unknown (Capture 209)
Porter, Cole
 1934 Horst (Vanity 160)
Poulenc, Francis
 1921 Isabey (Vanity 46-47)
Powell, Adam Clayton, Jr.
 1942 Morgan and Marvin Smith (Willis \124)
 1959 Bertrand Miles (Willis \155)
Powell, Frank
 c. 1906-1909 Perry A. Keith (Willis \50)
Powell, George
 c. 1906-1909 Perry A. Keith (Willis \50)
Powell, Mike
 1991* Mike Powell (Best17 156a)
 1996* Rick Addicks (Best22 118a)
 1996 David Peterson (Best22 121a)
Powell, William
 1930 Barnaba (Vanity 193d)
Prendergast, Maurice
 1915 Gertrude Käsebier (Vanity 14c)
Presley, Elvis
 1956 Photographer Unknown (Eyes #231); Charles
 Trainor (Life 171)
 1957 Ernest C. Withers (Willis \178)
 1960 Bert Reisfeld (Photos 89)
 1963 Andy Warhol (Art \462)
Pressers, Jeroen
 c. 1991* Aernout Overbeeke (Graphis91 \145)
Pressman, Edward
 c. 1990* Wolfgang Wesener (Graphis90 \135)
Price, Larry C.
 n.d. Photographer Unknown (Capture 209);
 1985 Mike Davis (Best11 232c)
Prince
 1983* Richard Avedon (Rolling #50)
Princip, Gavrilo
 1914 Photographer Unknown (Photos 26, 27)
Proctor, Samuel D.
 n.d. Bob Gore (Willis \295)

—Q—

Quayle, Dan
 1988* P. F. Bentley (Best14 110)
Quinn, Aidan
 c. 1995 David Bailey (Graphis96 116d)
Quinn, Anthony
 c. 1999* Martin Pudenz (Photo00 12)

—R—

Rabin, Yitzak
 1995 Barbara Kinney (Best21 178a)
Raderscheid, Anton
 c. 1926 August Sander (Hambourg 78c)
Rainer, Arnulf
 1984 Rolf Hoffmann (San 181b)
Rainey, Matt
 n.d. Photographer Unknown (Capture 209)

Rajneesh, Bhagwan Shree
 1985 Harvey Soltes (Best11 86d; 87a)
Ramirez, Richard
 1985 Michael Goulding (Best11 107)
Ramsey, Jack
 1985 Barry Chin (Best11 229)
Rather, Dan
 1974 Annie Leibovitz (Rolling #30)
Raulerson, James
 1985 Bill Wax (Best11 113)
Rawlings, John
 1946 Irving Penn (MOMA 21)
Reagan, Ronald
 1976 Richard Avedon (Rolling #33)
 1985 Bill Luster (Best11 51d); Dennis Cook (Best11
 88a); Larry Morris (Best11 88c); Dennis Paquin
 (Best11 89a)
 1985* David Burnett (Life 34a)
 1986 Dennis Brack (Best12 7a)
 1987 Lucian Perkins (Best13 100d)
 1988 Bernie Boston (Best14 9d)
Red Cloud
 1872 Alexander Gardner (Photography1 \58);
 1880 Charles Milton Bell (Waking 329)
Redford, Robert
 1970 John Dominis (Life 88)
Reed, Lou
 1987 Matt Mahurin (Rolling #60)
Regan, Donald
 1986* Larry Downing (Best12 7b)
Reid, Herman
 1988* David Drapkin (Best14 148)
Reinhardt, Max
 1928 Alexander Bengsch (Vanity 110)
Renoir, Pierre Auguste
 1895 Edgar Degas (Marien \4.38; Szarkowski 318a)
Richards, Keith
 1972 Annie Leibovitz (Rolling #13); 1975 (Rolling
 #15)
 1988 Albert Watson (Graphis89 \145; Rolling #109)
Ripken, Cal
 1995* Karl Merton Ferron (Best21 114b); Richard
 Lipski (Best21 132); Lloyd Fox (Best21 133)
Rivera, Diego
 1933 Lusha Nelson (Vanity 148)
Roach, Max
 n.d. Chuck Stewart (Willis \148)
Roberts, Anthony K.
 n.d. Photographer Unknown (Capture 210)
Robeson, Paul
 1933 Edward Steichen (Vanity 165)
 1940 Morgan Smith (Willis \119)
Robinson, Bill
 c. 1990* Chris Sanders (Graphis90 \122)
Robinson, Bill (Bojangles)
 1935 George Hurrell (Vanity 162)
Robinson, Eddie
 1997* Rusty Costanza (Best23 174a)
Robinson, Jackie
 1955 Ralph Morse (Lacayo 152)
Robinson, John
 1985 Alexander Gallardo (Best11 230d)
Robinson, John R.
 n.d. Photographer Unknown (Capture 210)
Robinson, Smokey
 1968 Baron Wolman (Rolling #2)
Roche, Winston
 c. 1991* Michael O'Brien (Best17 84; Graphis92
 \117)
Rockefeller, John D.
 1919 Arnold Genthe (Vanity 2)

Rodchenko, Alexander
 1921 M. A. Kaufman (San 182a)
Roderstein, Paul
 1929 August Sander (Marien \5.67)
Rodin, Auguste
 1902 Edward Steichen (Art \163; Waking #143)
 1911 (Peterson #4)
 1918 Alvin Langdon Coburn (Vanity 5)
Rodman, Dennis
 1996* Harry Benson (Life 149); Bill Frakes (Best22
 194d)
Rodriguez, Jose "Pepe Caliente"
 1959 Andrew Lopez (Capture 45)
Rogers, Richard
 1993* Nina Berman (Best19 217-220)
Rogers, Will
 1924 Edward Steichen (Vanity 72)
Roh, Franz
 c. 1926 Lucia Moholy (Hambourg \50; San 182b;
 Women \85)
Roh, Tae Woo
 1987* Sunkyu Im (Best13 26b)
Rollins, Henry
 c. 1995 Matt Mahurin (Graphis96 108)
Rondon, Hector
 n.d. Photographer Unknown (Capture 210)
Roosevelt, Franklin Delano
 1932 Keystone View Company (Vanity 166); Harris
 and Ewing (Vanity 167); Marie Hansen (Life 23)
 1935 Thomas MacAvoy (Goldberg 85)
 1939 Photographer Unknown (Eyes #137; Monk #24)
 1945* U.S. Army (Life 22b)
 1990 Paul Higdon (Lacayo 171)
Roosevelt, Theodore
 c. 1889 Photographer Unknown (Eyes #68)
 1903 or earlier Photographer Unknown (Szarkowski
 82)
 1905 Underwood & Underwood (Eyes #70)
Rose, Pete
 1985 Bill Frakes (Best11 194-199)
Röseler, Clemens
 c. 1928 Lux Feininger (Hambourg \55; Rosenblum2
 #510)
Rosenthal, Joe
 n.d. Photographer Unknown (Capture 210)
Rossini, Gioacchino
 1855-1865 Felix Nadar (Art \49)
 1877 Etienne Carjat (Rosenblum2 #89)
Roszak, Theodore
 c. 1931 Self-Portrait (San 182b)
Roth, David Lee
 1985 Tom Jagoe (Best11 164d)
Roth, Michael
 1983 Robert Mapplethorpe (Decade \104)
Rothstein, Arthur
 n.d. Mark Courtney (Best11 1)
 1941 Photographer Unknown (Rosenblum2 #449)
Rourke, Mickey
 c. 1995 Stephanie Pfriender (Graphis96 116a)
Rousseau, Alex
 1996 Joe McNally (Best22 128d; Life 148b)
Rousseau, Théodore
 c. 1857 Nadar (Szarkowski 88)
Russell, Bertrand
 1924 Florence Vandamm (Vanity 78)
Russell, George
 c. 1956 Milton Hinton (Willis \150)
Ruth, Babe
 1927 Nickolas Muray (MOMA 124); 1935(Vanity
 xix)
 1948 Nathaniel Fein (Capture 22; Goldberg 81)

Ryan, Nolan
 1990* Louis DeLuca (Best16 128)

—S—

Saberhagen, Bret
 1985 Keith Myers (Best11 202)
Sadat, Anwar
 1978* Photographer Unknown (Goldberg 190;
 Photos 145); 1979 (Eyes #351)
 1981 Bill Foley (Eyes #352)
Sakai, Toshio
 n.d. Photographer Unknown (Capture 210)
Samaras, Lucas
 1978 Philip Tsiaras (San 183a)
Salomon, Erich
 n.d. Photographer Unknown (Lacayo 74d)
Sandburg, Carl
 1934 Edward Steichen (Vanity 164)
Sander, August
 c. 1960 Gunther Sander (San 183b)
Sandow, Eugene
 c. 1893 Napoleon Sarony (Rosenblum2 #67)
Sapp, Warren
 1995* Bill Frakes (Best21 140d)
Satie, Eric
 n.d. Man Ray (Vanity 45)
Saura, Carlos
 c. 1990* Serge Cohen (Graphis90 \146)
Sawada, Kyoichi
 n.d. Photographer Unknown (Capture 210)
Scappini, M.
 1927 Berenice Abbott (Women \84)
Schlemmer, Oskar
 1926 László Moholy-Nagy (San #33)
Schoenberg, Arnold
 1930 Man Ray (Vanity 178)
Schroeder, Bill
 1985 Steve Mellon (Best11 116b)
Schroeder, Jim
 1987 Ed Kosmicki (Best13 55a)
Schultz, George
 c. 1987* Enrico Ferorelli (Graphis89 \249)
Schuschnigg, Kurt
 1935 Lucien Aigner (Eyes #158)
Schwarzenegger, Arnold
 1985* Moshe Brakha (Rolling #71)
Schweitzer, Albert
 1954 W. Eugene Smith (Lacayo 126)
Scorsese, Martin
 c. 1992* Max Aguilera-Hellweg (Graphis93 122a)
Scott, C. A.
 c. 1940s William Anderson Scott III (Willis \125)
Scott, Peter
 c. 1991* Robert Pedersen (Graphis91 \158)
Seale, Bobby
 1969 Jonathan Eubanks (Willis \205)
Seaman, William
 n.d. Photographer Unknown (Capture 211)
Seinfeld, Jerry
 c. 1999* Mark Seliger (Photo00 157)
Seliger, Mark
 n.d. Self-Portrait (Graphis97 8)
Setzer, Brian
 1986* E. J. Camp (Rolling #72)
Seward, William Henry
 1856 Mathew B. Brady (Eyes #12)
Sharpe, Sterling
 1990* Mark Welsh (Best16 117)
Shaw, George Bernard
 1920 Malcolm Arbuthnot (Vanity 35)

Shaw, Scott
 n.d. Photographer Unknown (Capture 211)
Shepard, Alan
 1961 (Eyes #368)
Shining Metal
 1858 Julian Vannerson (National 22b, 13)
Shoemaker, Willie
 1986 David Perry (Best12 222)
 c. 1989* Annie Leibovitz (Graphis89 \158)
Simon, Paul
 1985* Harry Benson (Best11 42c)
 1986* Deborah Feingold (Rolling #86)
 c. 1989 Annie Leibovitz (Graphis89 \164)
Simpson, O. J.
 1994* Matt Mahurin (Lacayo 171c)
Sinatra, Frank
 1943 Herbert Gehr (Life 166b)
Sintenis, Renée
 c. 1925 Hugo Erfurth (Szarkowski 175)
Siskind, Aaron
 c. 1956 Arthur Siegel (San 184a)
Sitting Bull, Chief
 1885 William Notman (Monk #10)
Sitwell, Osbert
 1929 Cecil Beaton (Vanity 117)
Sitwell, Sacheverell
 1929 Cecil Beaton (Vanity 117)
Sky Chief
 c. 1867 Edric L. Easton, attribution (Waking #120)
Slash
 c. 1991* Mark Seliger (Graphis92 \124)
Sleet, Moneta J., Jr.
 n.d. Photographer Unknown (Capture 211)
Slick Rick
 c. 1991 Albert Mackenzie Watson (Graphis91 11)
Smith, Andre Raphel
 n.d.* Don Camp (Committed 63)
Smith, Marvin
 1938 Self Portrait (Willis \120)
Smith, Morgan
 1938 Self Portrait (Willis \120)
Smith, Ozzie
 1985* Mickey Pfleger (Best11 152a)
 1988* Joe McNally (Best14 155)
 1996* Odell Mitchell, Jr. (Best22 192b)
Smith, W. Eugene
 n.d. Bernie Schoenfeld (Lacayo 112)
Smutty
 1986* E. J. Camp (Rolling #72)
Snyder, William
 n.d. Photographer Unknown (Capture 211)
Sommer, Frederick
 1980 Bill Jay (San 184b)
Sorin, Savely
 1923 Arnold Genthe (Vanity 54-55)
Southworth, Albert Sands
 c. 1848 Self-Portrait (Art \31; Marien \2.62; Waking #93)
Spangler, Edward
 1865 Alexander Gardner (Rosenblum2 #228)
Spector, Phil
 1969 Baron Wolman (Rolling #7)
Spender, Stephen
 1985 David Hockney (Szarkowski 278)
Spengler, Otto
 n.d. James Abbé (Vanity 171)
Spielberg, Steven
 1976* Hiro (Rolling #40)
Spindler, Mark
 1991 John Kaplan (Capture 164e)

Spinks, Michael
 1986 Oggi Ogburn (Committed 166)
Spinner, Francis Elias
 1856 Mathew B. Brady (Eyes #12)
Spitz, Mark
 1972* Co Rentmeester (Life 144)
Springfield, Rick
 1985 Dennis McDonald (Best11 4d)
Springsteen, Bruce
 1978 Lynn Goldsmith (Rolling #11)
 1985 Steve Ringman (Best11 164a)
 1987 Bruce Weber (Rolling #87)
Stalin, Josef
 n.d. Acme Newspictures (Vanity 76)
 1945* U.S. Army (Life 22b)
Stallone, Sylvester
 1990 Paul Higdon (Lacayo 171)
Stanislavsky, Konstantin
 1923 Arnold Genthe (Vanity 54-55)
Stankiewicz, Andy
 1992* Mark D. Phillips (Best18 135)
Stanley, Henry Morton
 c. 1872 Photographer Unknown (Marien \4.64)
Starr, Kenneth
 1998* Doug Mills (Capture 193)
Starr, Steven
 n.d. Photographer Unknown (Capture 211)
Stavrinos, George
 c. 1990 Neil Malcolm Roberts (Graphis90 \126)
Steichen, Edward
 1898 Self-Portrait (MOMA 82); 1902 (Goldberg 22;
 Marien \4.22); 1917 (Waking 361a); 1918 (Vanity
 27); 1929 (MOMA 16; (Vanity 199a)
 1907 Frank Eugene (Rosenblum2 #408)
 1963 Bruce Davidson (MOMA 37)
Steiner, Ralph
 1930 Self-Portrait (MOMA 18)
 1981 Eleanor Briggs (San 184b)
Stevens, Richard H.
 1935 Richard H. Stewart (Through 484)
Stevenson, Adlai
 1952 William M. Gallagher (Capture 30)
Stewart, Jimmy
 1945 Peter Stackpole (Life 83b)
 1957 Slim Aarons (Lacayo 150)
Stiefel, Ethan
 c. 1995 Ruven Afanador (Graphis96 137)
Stieglitz, Alfred
 1907 Edward Steichen (Hambourg 9; Marien \4.23);
 1909-1910 (MOMA 96)
 1907 Frank Eugene (Rosenblum2 #408); 1909
 (Peterson #1)
 1929 Paul Strand (Art #12)
Stiller, Ben
 c. 1999* Mark Seliger (Photo00 130)
Sting
 1982 David Bailey (Rolling #55)
 1988 Lou Salvatori (Rolling #112)
 c. 1997* Max Vadukul (Graphis97 112)
Stone, Robert
 c. 1992* Michael O'Brien (Graphis93 94)
Strand, Paul
 1917 Alfred Stieglitz (San 185b)
 1965 Alen MacWeeney (Photography 129)
 c. 1975 Richard Benson (Photography 136)
Strauss, Richard
 1904 Edward Steichen (Icons 17)
Stravinsky, Igor
 n.d. Photographer Unknown (Vanity 99)
 1927 Hoyningen-Huené, George (Vanity xvi)
 1929 Felix Man (Eyes #97)

1946 Arnold Newman (Goldberg 187; Icons 92)
Stryker, Roy
1941 Photographer Unknown (Rosenblum2 #449)
Sturges, Preston
1930 Arnold Schröder (Vanity 192c)
Suau, Anthony
n.d. Photographer Unknown (Capture 211)
Sumner, Charles
1856 Southworth & Hawes (Rosenblum2 #45)
Sun Ra
1978 Mel Wright (Willis \285-\287)
Swayze, Patrick
c. 1997 Mary Ellen Mark (Graphis97 113)
Sym, Rev. John
c. 1843 Hill and Adamson (Art \35)
Szarkowski, John
1963 André Kertész (MOMA 39)

—T—

Talbot, William Henry Fox
c. 1844 Antoine Claudet (Rosenblum2 #2)
c. 1855 Photographer Unknown (Szarkowski 28)
Tato
1923 Self-Portrait (San 186a)
Taylor, James
1979* Annie Leibovitz (Rolling #27)
Tczinski, Zbigniew
c. 1991 Sergej Kischnick (Graphis92 \139)
Telberg, Val
c. 1947 Self-Portrait (San 186b)
Tennyson, Hallam
1867 Julia Margaret Cameron (Women \11)
Terry, Sonny
c. 1946-1948 Sid Grossman (Decade \50)
Testrake, John
1985 1985 Ismail (Best11 51a)
Thalberg, Irving
1932 Edward Steichen (Vanity 130)
Thom, George
1956 O. Winston Link (Goldberg 231; MOMA 23)
Thomas, Kurt
1979* John G. Zimmerman (Life 147)
Thomas, Philip Michael
1985 Acey Harper (Best11 165b)
Thompson, Hunter S.
1987* Annie Leibovitz (Rolling #107)
Thon, Dickie
1991 Jerry Lodriguss (Best17 166a)
Thornell, Jack R.
n.d. Photographer Unknown (Capture 212)
Tilden, Bill
1934 Acme Newspictures (Vanity 177)
Tiny Tim
1968 Baron Wolman (Rolling #5)
Tittle, Y. A.
1964 Morris Berman (Life 143d)
Tomes, William W.
1987 Al Podgorski (Best13 50, 51)
Toombs, Robert Augustus
1856 Mathew B. Brady (Eyes #12)
Toscanini, Arturo
1929 Vaghi (Vanity 114)
Tosh, Peter
1981 June DeLairre Truesdale (Willis \253)
Tournachon, Adrien
c. 1855 Self-Portrait (Waking #52)
Townshend, Pete
1980* Annie Leibovitz (Rolling #19)
Tracey, Spencer
1934 Imogen Cunningham (Vanity 195)

Tracy, Lee
1928 Edward Steichen (Eyes #138)
Trask, Harry A.
n.d. Photographer Unknown (Capture 212)
Travis, Randy
1987* Annie Leibovitz (Women \160)
Truman, Harry
1946 Photographer Unknown (Life 24);1949 (Life 24d)
1948 Byron Rollins (Eyes #209; Goldberg 124)
Tse-Tung, Mao
n.d. in Official Portrait (Monk #38)
Turner, Andre
1991 Ronald Cortes (Best17 157)
Turner, Big Joe
c. 1960s Marion James Porter (Willis \214)
Turner, Joe
c. 1980 Leroy Henderson (Willis \289)
Turnley, David
n.d. Photographer Unknown (Capture 212)
Twain, Mark
1906 Frances Benjamin Johnston (Sandler 35)
Twine, Richard Aloysius
c. 1922-1927 Self-Portrait (Willis \97)
Tyres, Ernest
1938 Ellie Lee Weems (Willis \102)
Tyson, Mike
1986 Albert Watson (Rolling #73); Richard Harbus (Best12 218a)
1997 Richard Lipski (Best23 167c)
Tzara, Tristan
1922 Man Ray (Vanity 48)

—U—

Ubac, Raoul
1964 C. Gaspari (San 186b)
Uelsmann, Jerry N.
1982 Diane Farris (San 187a)
Ulevich, Neal
n.d. Photographer Unknown (Capture 212)
Ultang, Donald T.
n.d. Photographer Unknown (Capture 212)
Umbo
c. 1930 Self-Portrait (San 187b)
Upshaw, A. B.
1898 F. A. Rinehart (Goldberg 31b)
Ut, Huynh Cong
n.d. Photographer Unknown (Capture 213)

—V—

Valentino, Rudolph
1923 Maurice Goldberg (Vanity 92)
Valéry, Paul
1929 Aubes (Vanity 108b)
Van Buren, Martin
c. 1856 Mathew Brady (Photography1 #II-6)
Van Damme, Jean Claude
c. 1995 Mary Ellen Mark (Graphis96 112b)
Van der Elsken, Ed
1990 Paul Levitton (Icons 141)
van der Rohe, Mies
c. 1930 Hugo Erfurth (Szarkowski 174)
Van Der Zee, James
1979 Collette Fournier (Committed 99)
Vathis, Paul
n.d. Photographer Unknown (Capture 213)
Veder, Slava
n.d. Photographer Unknown (Capture 213)

—X—

—Y—

—Z—

Women

—A—

Abbott, Berenice
 n.d. Lotte Jacobi (Icons 104)
 1922 Man Ray (Vanity 200c)
 c. 1930 Self-Portrait (Hambourg \54; MOMA 17)
Adjani, Isabelle
 c. 1991 Patrick Demarchelier (Graphis91 \148)
Altimus, Jeannette Warburg
 1925 in Florestine Perrault Collins (Willis \54)
Anderson, Gillian
 c. 1999* Mark Seliger (Photo00 99)
Anderson, Marian
 1939 Robert S. Scurlock (Willis \109)
 1955 Richard Avedon (Decade \67)
Aquino, Corazon
 1985 John Kaplan (Best11 77b)
 1986 Al Podgorski (Best12 18); Jim Gensheimer
 (Best12 23a)
Arbus, Diane
 1967 John Gossage (Icons 158)
 1970 Stephen Frank (Marien \6.48)
Armstrong, Mayann
 1922 Villard Paddio (Willis \47)
Arndt, Gertrud
 c. 1929 Self-Portrait (San 166a)
Arthur, Jean
 1935 Lusha Nelson (Vanity 193a)
Ash, Mary Kay
 1993* Nina Berman (Best19 217-220)
Ashford, Evelyn
 c. 1989* Annie Leibovitz (Graphis89 \160)
Astaire, Adele
 1925 Edward Steichen (Vanity 86)
Auerbach, Ellen
 1980 Barbara Klemm (Icons 36; San 166b)
Auermann, Nadja
 c. 1995* Herb Ritts (Graphis96 51)
Ayers-Allen, Phylicia
 1974 Bill Lathan (Willis \236)

—B—

Baccus, Gertrude
 1984 Timothy Bullard (Goldberg Overleaf)
Badu, Erykah
 1998* Suede (Willis \433)
Bailey, Pearl
 1955 Charles Williams (Willis \163)
Baiul, Oksana
 1994* Co Rentmeester (Life 148a)
Baker, Josephine
 c. 1923 Adolph De Meyer (Art \436; Hambourg \46)
Baker, Mildred Hanson
 c. 1937-1938 P. H. Polk (Willis \81)
Bakker, Tammy
 1987* Harry Benson (Best13 30)
Ball, Lucille
 1950 Philippe Halsman (Life 168b)
Bankhead, Tallulah
 1931 Cecil Beaton (Vanity 138)
Bardot, Brigitte
 1959 Richard Avedon (MOMA 230; Szarkowski
 273)
Barkin, Ellen
 c. 1989 Albert Watson (Graphis89 \187)
Barton, Clara
 c. 1866 Mathew Brady (Marien \3.69)

Baum, Jamie
 c. 1992* Sandra Eisner (Graphis93 123)
Beard, Amanda
 1996* Al Schaben (Best22 201a)
Belafonte, Julie
 1963 Jack T. Franklin (Willis \170)
Berg, Patty
 1938 Gjon Mili (Life 139b)
Bergen, Candice
 c. 1989* Annie Leibovitz (Graphis89 \153)
Bergner, Elisabeth
 1933 George Hoyningen-Huené (Vanity 182c)
Bernhardt, Sarah
 1865 Nadar (Rosenblum2 #65)
 1877 Tourtin (Rosenblum2 #92)
 1880 Napoleon Sarony (Photography1 #II-16;
 Rosenblum2 #66)
Bethune, Mary McLeod
 1947 Scurlock Studios (Willis \110)
Bhutto, Benazir
 1988* Anthony Suau (Best14 60d)
Bianca, Lady
 c. 1991 Marc Norberg (Graphis91 \163)
Biden, Jill
 1987 Ronald Cortes (Best13 55b)
Bing, Ilse
 1931 Self-Portrait (Icons 39)
 n.d. Reinhold Misselbeck (Icons 38)
Björk
 c. 1995* David Strick (Graphis96 113)
Blondell, Joan
 1933 Imogen Cunningham (Vanity 132)
Bonet, Lisa
 1988* Matthew Rolston (Rolling #80)
Both, Katt
 c. 1928 Lotte Beese (Women \89)
Bourke-White, Margaret
 n.d. Photographer Unknown (Lacayo 96d)
 c. 1945 Photographer Unknown (Eyes #181)
 1946 Sunil Jahah (Icons 102)
Bow, Clara
 1926 Eugene R. Richee (Goldberg 79a)
Brice, Fannie
 1923 Edward Steichen (Vanity 73)
Brokaw, Clare Boothe
 1934 Cecil Beaton (Vanity 173b)
Brokaw, Lucille
 1933 Martin Munkácsi (Art \439)
Brooks, Louise
 1929 Edward Steichen (Vanity 123)
Bullock, Sandra
 c. 1995 Stephanie Pfriender (Graphis96 112c)
Burke, Billie
 1920 Alfred Cheney Johnston (Vanity 31)
Burroughs, Allie Mae
 1936 Walker Evans (Marien \5.0)
Bush, Barbara
 1987* David Valdez (Life 36a)
 1990* Sean Dougherty (Best16 110)

—C—

Carter, Betty
 1979 Harlee Little (Willis \278)
Castle, Irene
 1919 Malcolm Arbuthnot (Vanity 26)

—G—

Gaines, Chryste
1996* Barry Chin (Best22 116c)
Garbo, Greta
1926 Arnold Genthe (Vanity xi)
1929 Edward Steichen (Vanity 121)
1930 Clarence Sinclair Bull (Monk #17); 1931 (Goldberg 76)
George, Grace
1920 Baron de Meyer (Vanity 30)
Gish, Dorothy
1921 James Abbé (Vanity 32)
Gish, Lillian
c. 1920 Baron de Meyer (Vanity 33)
1921 James Abbé (Vanity 32)
Gluck, Alama
1923 Nickolas Muray (Vanity 115)
Goldberg, Whoopi
1985 Mark B. Sluder (Best11 166b)
Golden, Judith
c. 1978 Self-Portrait (San 174b)
Goldin, Nan
n.d. Christine Frenzl (Icons 194)
Goldstein, Joyce
1969 Judy Dater (Decade \85)
Goncharova, Natalya Sergeevna
1953 Denise Colomb (Rosenblum \181)
Goodall, Jane
1995* Michael Nichols (Best21 143)
Gordon, Ruth
1929 Cecil Beaton (Vanity 104)
Grable, Betty
1940 Peter Stackpole (Life 83d)
Graham, Martha
1931 Edward Steichen (Vanity 151)
1938 Barbara Morgan (Photography 61); 1940 (Life 166a; Rosenblum2 #557)
Green, Loretta
1974 Bill Lathan (Willis \234)
Greffulhe, Countess
1899 Otto (Waking #136)
Griffith-Joyner, Florence
1988* Fred Comegys (Best14 2); Rich Clarkson (Best14 131d)
Guadalupe, Ines
1985 Ivan Montesinos (Best11 90b)
Guzy, Carol
n.d. Photographer Unknown (Capture 206)

—H—

Hamer, Fannie Lou
c. 1967* Carroll Parrott Blue (Willis \414)
Hannah, Daryl
1984* E. J. Camp (Rolling #95)
Hanscom, Adelaide
c. 1905 Emily H. Pitchford (Rosenblum \73)
Harding, Tonya
1994* Jack Smith (Lacayo 185)
Harlow, Jean
1935 George Hurrell (Vanity 135)
Harry, Deborah
c. 1990* David Michael Kennedy (Graphis90 \144)
Hart, Lee
1987 Kenneth Papaleo (Best13 54)
1988 Ruben W. Perez (Best14 8d)
Hayes, Helen
1927 Edward Steichen (Vanity 91)
c. 1989 Annie Leibovitz (Graphis89 \163)

Heche, Anne
c. 1999* Robert Maxwell (Photo00 111)
Hegemann, Martha
c. 1926 August Sander (Hambourg 78c)
Henley, Beth
c. 1989* Annie Leibovitz (Graphis89 \159)
Henri, Florence
1927 Lucia Moholy (Hambourg \47; Rosenblum \1; Rosenblum2 #518)
Hepburn, Audrey
1959 Philippe Halsman (Life 86c)
Hepburn, Katharine
1934 Cecil Beaton (Vanity 194)
1932 Photographer Unknown (Vanity 196)
1939 Alfred Eisenstaedt (Life 83a)
Hibbard, Harriet
c. 1903 A. K. Boursault (Rosenblum \69)
Hill, Anita
1991 Bill Snead (Best17 2); Terry Ashe (Best17 116a)
Hill, Lauryn
1998* Suede (Willis \432)
Holiday, Billie
1956 Hugh Bell (Committed 52)
c. 1957 Milton Hinton (Willis \154)
Hudak, Julie
n.d. Elizabeth Buehrmann (Rosenblum \79)
Hurston, Zora Neale
c. 1932 P. H. Polk (Willis \86)
Hutchison, Kay Bailey
1993* Patrick Davison (Best19 189)

—I—

Innis, Jennifer
1987 Annalisa Kraft (Best13 219)

—J—

Jackson, Glenda
c. 1992* Fi McGhee (Graphis93 109)
Jackson, Julia
1867 Julia Margaret Cameron (Rosenblum2 #75)
Jackson, Mahalia
c. 1960 Jack Davis (Willis \168)
Jacobi, Lotte
n.d. Self-Portrait (Icons 42)
Jacquin, Lisa Ann
c. 1991 Kevin Gruff (Graphis91 \363)
Jahrmarkt, Hanni Steckner
c. 1909 Eva Watson-Schutze (Rosenblum \72)
Jamenison, Betty
1996* Bill Frakes (Best22 213b)
Jamet, Mère Eulalia
1860 Felix Nadar (Art \48)
Janis, Elsie
n.d. Malcolm Arbuthnot (Vanity 25)
Jessye, Eva
c. 1991 Brain Lanker (Graphis91 \216)
Johnson, Claudia Taylor "Lady Bird"
1963 Cecil Stoughton (Eyes #287)
Johnson, Mary Elizabeth
c. 1991* Dmitri Kasterine (Graphis91 \190)
Johnston, Frances Benjamin
1895 Self-Portrait (Lacayo 37; Marien \4.0; Rosenblum \49; Sandler 34c)
Johnstone, Elizabeth
c. 1846 Hill and Adamson (Art \40)
Jones, Grace
1985 Chris Hardy (Best11 166a)
c. 1989* Jean-Paul Goude (Graphis89 \165)

Jones, Marion
 1998* Bill Frakes (Best24 63)
Jones, Mint
 1935 Ellie Lee Weems (Willis \99)
Jones, Paula
 1998* Ron Heflin (Capture 192)
Joplin, Janis
 1968 David Gahr (Life 172)
 1970 Jim Marshall (Rolling #12)
 1972 Bob Seidemann (Rolling #1)
Joyner-Kersee, Jackie
 1988 Herb Ritts (Rolling #68)
 1996* Denis Paquin (Best22 119d)

—K—

Kane, Carol
 c. 1990* Mark Hanauer (Graphis90 \139)
Karsavina, Tamara
 1911-1914* Adolph de Meyer (Waking #133)
Käsebier, Gertrude
 c. 1903 A. K. Boursault (Rosenblum \69)
 c. 1907 Edward Steichen (MOMA 13)
Keller, Helen
 1919 George Grantham Bain (Vanity 17)
Keller, Mae Fuller
 c. 1925 Florestine Perrault Collins (Willis \55)
Kennedy, Jacqueline
 1953 Toni Frissell (Sandler 163)
 1958-1961 Jacques Lowe (Best23 66-67)
 1960 Cornell Capa (Photography 149); 1960 Jacques
 Lowe (Eyes #284)
 1963 Cecil Stoughton (Eyes #287)
Kennedy, Rose
 1976 Richard Avedon (Rolling #35)
King, Coretta Scott
 1968 Moneta Sleet, Jr. (Capture 67; Eyes #280;
 Willis \188)
 1970 Louise Ozell Martin (Willis \194)
 c. 1991 Brian Lanker (Graphis91 \215)
Kinski, Nastassja
 1982 Richard Avedon (Rolling #49)
Kitt, Eartha
 c. 1960s Marion James Porter (Willis \212)
Klinghoffer, Marilyn
 1985 Richard L. Harbus (Best11 91a)
Kollwitz, Käthe
 c. 1925 Hugo Erfurth (Marien \4.35)
 1929 Lotte Jacobi (Icons 43)
Kastrelli, Rina
 c. 1991* Javier Vallhonrat (Graphis92 28)
Krabacher, Susie Scott
 c. 1999* Pierre St. Jacques (Photo00 66)
Krieg, Nathalie
 1992* Michael Rondou (Best18 152)

—L—

Lacroze de Fortabat, Amalia
 c. 1991* Lisa Bogdan (Graphis91 \184)
Lambert, Florence
 1933 Madame Yevonde (Women \77)
Lancaster, Elsa
 1938 Angus McBean (Rosenblum2 #642)
Landshof, Ruth
 1927 Umbo (San 116-117)
Lane, Mrs. James Henry
 1861-1866 Brady Studio (Waking #95)
Lange, Dorothea
 1955 Paul Taylor (Icons 70; Lacayo 100d)

Langtry, Lillie
 n.d. Paul Nadar (Rosenblum2 #64)
 c. 1882 Napoleon Sarony (Photography1 #II-17)
Lansing, Sherry
 c. 1991* Annie Leibovitz (Graphis91 \197)
Larkins, Mildred Parsons Mason
 c. 1922-1927 Richard Aloysius Twine (Willis \96)
Lathan, Melvina
 1974 Bill Lathan (Willis \235)
Latifah, Queen
 c. 1991 Frank Ockenfels 3 (Graphis92 \145)
Lauper, Cyndi
 1984* Richard Avedon (Rolling #52)
 1985* Harry Benson (Best11 42d)
Laurencin, Marie
 1926 Berenice Abbott (Rosenblum \122)
Lawrence, Gertrude
 1924 Edward Steichen (Vanity 62);1929(Vanity 63)
Le Gallienna, Gwen
 1927 Berenice Abbott (Women \83)
Le Gallienne, Eva
 1927 Edward Steichen (Vanity 90d)
Lea, Sarah
 c. 1991* Danny Turner (Graphis91 \189)
Leibovitz, Annie
 c. 1990* David Rose (Graphis 90 8)
Leigh, Jennifer Jason
 c. 1995* Annie Leibovitz (Graphis96 25-27)
Levitt, Helen
 1944-1945 Self-Portrait (Icons 84)
 c. 1952 Emma Ling (San 177a)
Lewinsky, Monica
 1998* Dan Loh (Capture 192)
Likarz, Maria
 1916 Madame D'Ora (Rosenblum \84)
Lillie, Beatrice
 1932 Von Horn (Vanity 161)
Logan, Fern
 1985 Self-Portrait (Willis \387)
Lombard, Carole
 n.d. Cecil Beaton (Vanity 191)
Lopez, Maclovia
 1943 John Collier, Jr. (Documenting 303c)
Loren, Sophia
 1958 Joe Shere (Goldberg 134)
 1961 Alfred Eisenstaedt (Life 87)
Losch, Tilly
 1934 Cecil Beaton (Vanity 158)
Love, Courtney
 c. 1995 Mark Seliger (Graphis96 114)
Luqueer, Mrs. Francis
 n.d. John Plumbe (Rosenblum2 #39)
Lynne, Carol
 1945 Gjon Mili (Life 138)

—M—

Maar, Dora
 c. 1936 Man Ray (San 177d)
McAuliffe, Christa
 1986 Arthur Pollock (Best12 8)
Macbeth, Helen
 1979 Bill Lathan (Willis \233)
McGhee, Mattie
 c. 1900 Harry Shepherd (Willis \26)
MacLaine, Shirley
 1963* Gijon Mili (Life 86a)
Maclean, Joan
 1921 Photographer Unknown (Vanity 40)
McPeak, Holly
 1996* Anacleto Rapping (Best22 122b)

Madonna
 1986* Matthew Rolston (Rolling #102)
 1986 Bruce Weber (Life 177d)
 1987 Herb Ritts (Graphis89 \176; Rolling #64, #75, #113*)
 c. 1990* Herb Ritts (Graphis90 \152)
 c. 1991* Herb Ritts (Graphis91 \205; Graphis92 \115)
 c. 1991 Patrick Demarchelier (Graphis92 \116)
Mandela, Winnie
 1986 David Turnley (Eyes #344)
 1990* Greg English (Photos 167)
Mann, Sally
 1992 Photographer Unknown (Icons 188)
Mansfield, Jayne
 1958 Joe Shere (Goldberg 134)
Manson, Shirley
 c. 1997* Matthew Rolston (Graphis97 117)
Marble, Alice
 1939 Gjon Mili (Life 139a)
Marcos, Imelda
 1985 John Kaplan (Best11 77a)
Marden, Mary Carroll
 1985 Mike Davis (Best11 232a)
Marley, Rita
 1988 Bruce Weber (Rolling #78)
Marley, Ziggy
 1988 Bruce Weber (Rolling #77)
Masakela, Miriam
 1980 O'Neal Lancy Abel (Willis \273)
Maude, Clementina
 c. 1863-1864 Clementina Hawarden (Szarkowski 90)
Maynard, Hannah
 1887 Self-Portrait (Rosenblum \44)
Mead, Andrea
 1948 George Silk (Life 140)
Menken, Adah Isaacs
 1865 Napoleon Sarony (Photography1 #II-12)
Menken, Helen
 1925 Edward Steichen (Vanity 100)
Merkel, Anne-Marie
 1926 André Kertész (Art \250)
Miles, Irma
 1948 Bertrand Miles (Willis \156)
Miller, Inger
 1996* Barry Chin (Best22 116c)
Milva
 c. 1991* Albert Watson (Graphis91 \28)
Mingxia, Fu
 c. 1992* Neil Leifer (Graphis93 201a)
Model, Lisette
 n.d. Imogen Cunningham (Icons 82)
Modjeská, Helena
 c. 1909 Elizabeth Buerhmann (Sandler 62a)
Modotti, Tina
 1924 Edward Weston (Art \216; Icons 44)
Monplaisir, Sharon
 1996 Joseph McNally (Best22 129c)
Monroe, Marilyn
 1953 Alfred Eisenstaedt (Life 84d)
 1954 Matthew Zimmerman (Lacayo 151; Photos 83); 1955 (Monk #36)
 1960 Inge Morath (Photography 84)
Montez, Lola
 1851 Southworth & Hawes (Art \32)
Moore, Audley (Queen Mother)
 1980 O'Neal Lancy Abel (Willis \274)
Morgan, Debbi
 1974 Bill Lathan (Willis \234)
Morrell, Lady Ottoline
 c. 1912 Adolphe de Meyer (Waking #138)

Mullarkey, Karen
 1985 Mike Davis (Best11 233c)
Murdoch, Iris
 late 1950s Ida Kar (Rosenblum \180)

—N—

Nash, Mary
 1921 Photographer Unknown (Vanity 40)
Navratilova, Martina
 1985 Mark Vergari (Best11 223a)
Negri, Pola
 1925 Edward Steichen (Vanity 93)
Nesbitt, Evelyn
 1902 Gertrude Käsebier (Marien \4.33)
Newhall, Nancy
 1945 Edward Weston (MOMA 33)
Nijinska, Bronislava
 1922 Man Ray (Vanity 61)
Nixon, Patricia
 1952 Ralph Morse (Life 30)
Nixon, Tricia
 1971 Harry Benson (Life 31c)
Noggle, Anne
 1984 Self-Portrait (San 180a)
Norskaya, Niura
 1930s Lotte Jacobi (Sandler 30; Women \76)
Norton, Eleanor Holmes
 1997 Nancy Andrews (Best23 21d)

—O—

O'Keeffe, Georgia
 1918 Alfred Stieglitz (Art \203; Hambourg 22; Waking #185)
 1936 Carl Van Vechten (Marien \5.73)
 1968 Arnold Newman (Rosenblum2 #729)
Olin, Nahui
 1923 Edward Weston (Waking 354); 1924 (MOMA 108)
Ono, Yoko
 1981* Annie Leibovitz (Rolling #32)
Overbeeke, Aernout
 n.d. Jan Zwart (Graphis92 20)

—P—

Palucca, Gret
 1923 Charlotte Rudolph (Rosenblum \131)
Parker, Dorothy
 1932 Edward Steichen (Vanity 140)
Parker, Joy
 1953 John Deakin (Icons 112)
Parks, Rosa
 1986 Roland L. Freeman (Willis \238)
Parton, Dolly
 1986* Enrico Ferorelli (Life 177b)
 1986 Bernard Brault (Best12 50d)
Pavlova, Anna
 1915 Eugene Hutchinson (Vanity 10)
Perrault, Emily Jules
 c. 1920s Florestine Perrault Collins (Willis \52)
Pezzo, Paola
 c. 1999* Isabel Snyder (Photo00 164)
Pfeiffer, Michelle
 1995* Joe McNally (Life 93b)
 c. 1995 Brigitte Lacombe (Graphis96 116c)
Phuc, Kim
 1995* Joe McNally (Best21 144c)
Picasso, Paloma
 c. 1990* Deborah Turbeville (Graphis90 \128)

ABOUT THE AUTHOR

Martha Kreisel, Associate Professor of Library Services, is the Humanities Librarian at Hofstra University, Hempstead, New York. She received an MA in Library Science from the University of Chicago and an MA in Humanities from the State University of New York at Buffalo. She holds membership in the American Library Association, the Association of College and Research Libraries, and the Guild of American Papercutters. Previous publications include *American Women Photographers: A Selected and Annotated Bibliography, Papercutting: An International Bibliography and Selected Guide to U.S. Collections,* and *Directory of Craft Cooperatives*, an Internet resource.